John Singer Sargent

Figures and Landscapes, 1874–1882

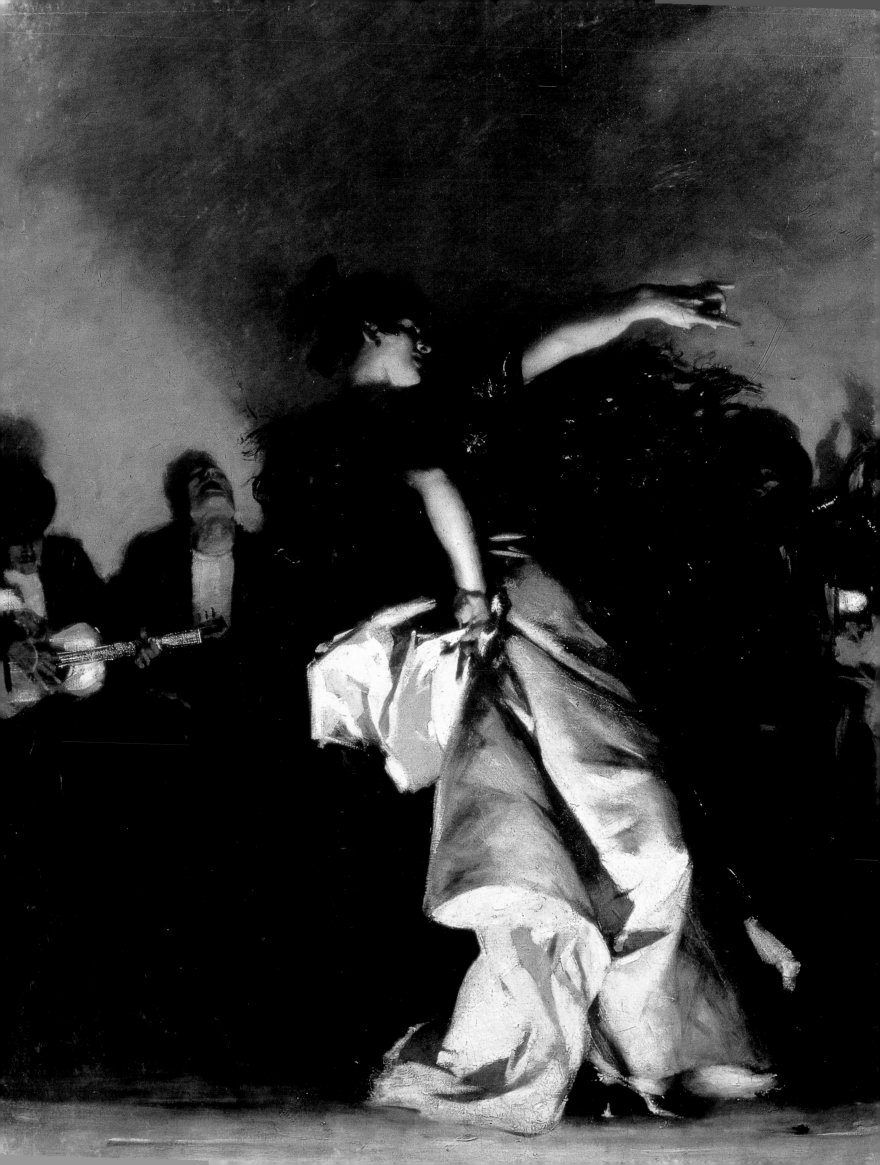

JOHN SINGER SARGENT

FIGURES AND LANDSCAPES, 1874–1882

COMPLETE PAINTINGS VOLUME IV

Richard Ormond

Elaine Kilmurray

With research assistance from Richard H. Finnegan

Published for
The Paul Mellon Centre for Studies in British Art
by Yale University Press, New Haven and London

Library of Congress Cataloging-in-Publication Data

Ormond, Richard.
John Singer Sargent: complete paintings / Richard
Ormond, Elaine Kilmurray.
p. cm.
Includes bibliographical references and index.
Contents: v. 1. Early portraits.
ISBN 0-300-07245-7 (v. 1: cloth)
1. Sargent, John Singer, 1856–1925—Catalogues
raisonnés. I. Kilmurray, Elaine. II. Sargent, John
Singer, 1856–1925. III. Title.
ND237.S3A4 1997a
759.13 – dc21 97-27380
CIP

ISBN 0-300-09806-5

Editor: Jane Watkins
Designer: Maria Miller Design
Picture Editor: Cynthia Bird
Indexer: Frances Bowles
Printed in Singapore

Frontispiece: Detail of *El Jaleo* (no. 772)
Page 6: Detail of *Venise par temps gris* (no. 819)

The Complete Paintings of John Singer Sargent
is a project supported by Adelson Galleries, Inc., New York, in collaboration with
Warren Adelson and Elizabeth Oustinoff

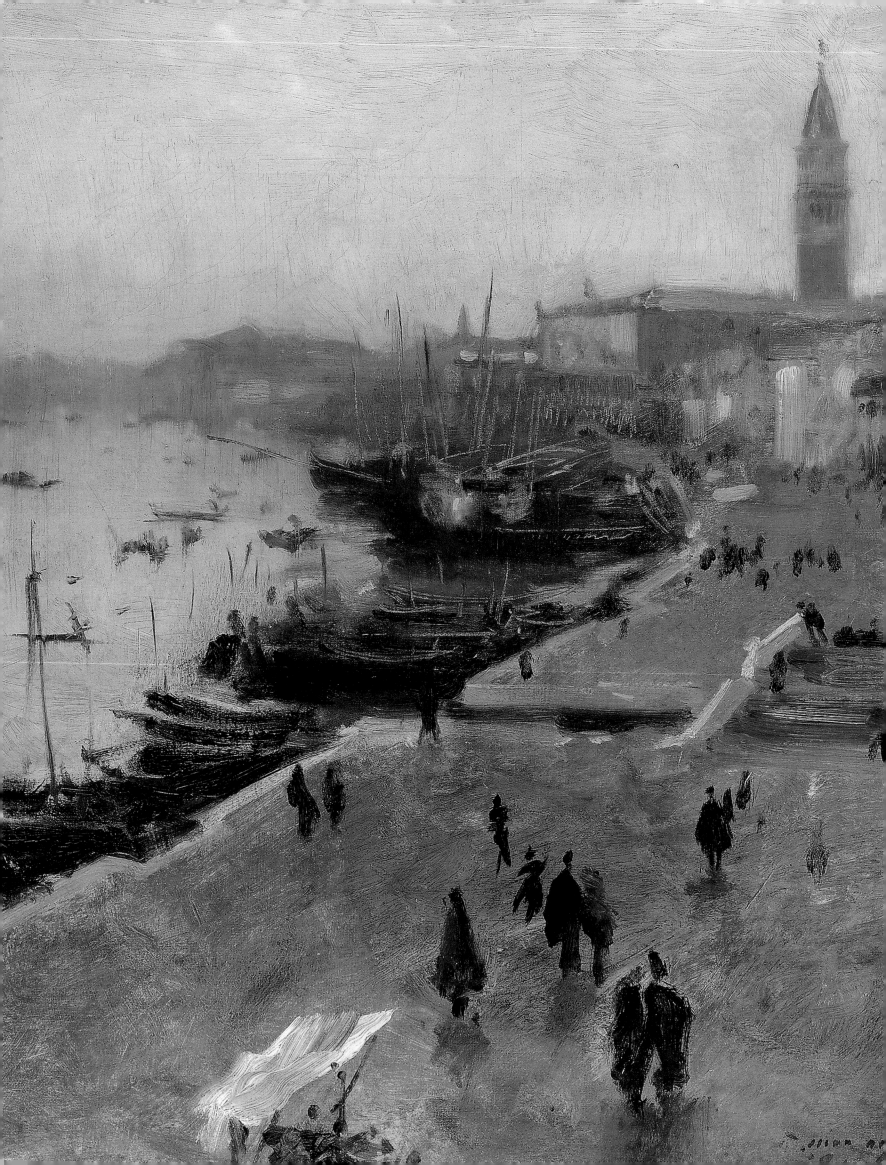

CONTENTS

PREFACE

This is the first volume of the John Singer Sargent catalogue raisonné of works in oil and water-colour devoted to landscapes and figure subjects. The first three volumes catalogue his portraits; subsequent volumes are planned for the later work. The authors have decided not to include the artist's juvenilia, because an excellent catalogue of the Metropolitan Museum of Art's large holding in this area has recently been published (Herdrich and Weinberg 2000). The other main repository of juvenilia is the Fogg Art Museum, Harvard University Art Museums, Cambridge, Massachusetts, and it is to be hoped that a similar catalogue of their large Sargent collection will be published in due course. Much of the material is already available on the Web.

The first scholar to map out the framework of the catalogue raisonné was the late David McKibbin, art librarian at the Boston Athenaeum, who undertook a huge amount of primary research. His notes, cards and correspondence, going back to 1947, are a resource from which the authors have drawn liberally. The authors would also like to pay tribute to those scholars and researchers who carried out further pioneering work on Sargent's landscapes and figure subjects at Coe Kerr Gallery, New York, during the 1980s and 1990s, in particular, Meg Robertson Galluci, Donna Seldin Janis and Odile Duff.

Like its predecessors, this volume would never have seen the light of day without the enlightened patronage of Warren Adelson. Not only has he borne the great expense inseparable from a project of this magnitude, but he continues to develop the computerized database and supports research activities in New York. His passion for Sargent remains as keen as ever, he is a knowledgeable student of the artist in his own right, and his commitment has been unswerving.

Elizabeth Oustinoff, a director at Adelson Galleries, New York, has been a pillar of the project for several years and a wonderfully supportive colleague. The present catalogue owes much to her active collaboration in ways too numerous to specify.

The authors have been fortunate in being able to draw on the services of Richard H. Finnegan, a research associate at Adelson Galleries, who is listed on the title page. It is he who marshalled all the M. Knoedler & Co. records, and his prodigious knowledge of art dealers and auction sales, not to mention genealogy and topography, and a fluent command of French and Italian, have stood the authors in good stead and saved them from many an egregious error. He has been over every entry with a fine-tooth comb, and his corrections and well-researched additions are a testament to his painstaking scholarship.

Cynthia Bird of Adelson Galleries has been another important contributor to the project, updating the database and files, answering numerous queries and administering the photography and copyright permissions. The authors are grateful to her and the many other colleagues at Adelson Galleries who have taken Sargent to their hearts and given us their support: Jan Adelson, Fran Bird, Chris Blythe, Jay Cantor, Pamela Ivinski, Andrea Maltese, Susan Mason, Tom Moran, Alexis Oustinoff, Caroline Owens, Richard Reilly and Hubbard Toombs. The elegant and stylish design of the catalogue is the work of Maria Miller. Her skill in orchestrating this large corpus of material and matching picture to text has been exceptional. The professionalism and commitment of the editor, Jane Watkins, have been second to none, and she has supported the authors at every turn.

The Paul Mellon Centre in London has continued its financial support of the publication, and the authors would like to express their appreciation to Brian Allen, the director of the centre and to his trustees. Richard Ormond carried out research on the catalogue during his year as the Samuel H. Kress professor at the National Gallery of Art, Washington, D.C., and wishes to record his thanks to the trustees of both the National Gallery of Art and the Kress Foundation.

The authors remain indebted to their publishers, Yale University Press, who have continued to back this multi-volume project with enthusiasm. John Nicoll, who saw the first three volumes through the press, has retired, and volume four has been ably supervised by Sally Salvesen, with whom the authors have enjoyed the happiest of working relationships.

—*Richard Ormond and Elaine Kilmurray*

ACKNOWLEDGEMENTS

Innumerable people have helped us over the years with information and answers to queries. We would specially like to thank the long-suffering staff of many libraries and research archives, in particular: the Archives of American Art, Washington, D.C.; the Biblioteca del Centro Caprense Ignazio Cerio, Capri; the Bodleian Library, Oxford; the British Library, London; the Frick Art Reference Library, New York; the Houghton Library, Harvard University; the Library of Congress, Washington, D.C.; the London Library; the Marciana Library, Venice; the Library of the National Gallery of Art, Washington, D.C.; the National Academy Museum and School of Fine Arts, New York; the National Library of Ireland, Dublin; the National Portrait Gallery Library and Archive, London; and the Witt Library, Courtauld Institute, London.

Among the individuals to whom we are especially beholden are the following: Michael Archer; Julie A. Aronson, Cincinnati Art Museum; Linda Ayres; Gabriel Badéa-Paün; Sofia Bakis, Allentown Art Museum, Pennsylvania; Katie Banser, The Metropolitan Museum of Art, New York; Martin Beisly, Christie's, London; Sally E. Bierer; Annette Blaugrund, National Academy Museum and School of Fine Arts, New York; Marie Bourke, National Gallery of Ireland, Dublin; Abigail Brandwinn, Wadsworth Atheneum Museum of Art, Hartford, Connecticut; David Brigham, formerly Worcester Art Museum, Massachusetts; Rachel Brodie, Beaverbrook Art Gallery, Fredericton, New Brunswick; David Brown, National Gallery of Art, Washington, D.C.; Jean-Pierre Brown, St Malo Bibliothèque; Elizabeth Bryant, Davis Museum and Cultural Center, Wellesley College, Massachusetts; Andrea Buzzoni, Ferrara Arte; Dr.ssa Floriana Carosi; the late Jacques Chaveau; Brett K. Chema, Museum of Fine Arts, Houston; the Hon Charles Cholmondeley; the Marquess of Cholmondeley; Professor Hollis Clayson; Margaret C. Conrads, Nelson-Atkins Museum of Art, Kansas City, Missouri; Professor Elizabeth Cropper, National Gallery of Art, Washington, D.C.; Melissa De Medeiros, Knoedler & Co., New York; Lady Dilke; K. J. van Egmond, Archiefdienst voor Kennemerland, Haarlem; June Eiffe; Trevor Fairbrother; Rachel Fannen, Merseyside Maritime Museum, Liverpool; Marie-France Faudi; Dr Nicola Figgis; Manonmani Filliozat, Archives Municipales, St Malo; Christina Finlayson, Davis Museum and Cultural Center, Wellesley College, Massachusetts; Carmelina Fiorentino, Biblioteca del Centro Caprense Ignazio Cerio, Capri; Carol Flechner; Laura Fleischmann, Albright-Knox Art Gallery, Buffalo, New York; Martha Fleischmann, Kennedy Galleries, New York; the late John Fleming; Ilene

Susan Fort, Los Angeles County Museum of Art; Kathy Foster, Philadelphia Museum of Art; John Fox; Ann Freedman, Knoedler & Co., New York; Barbara Gallati, formerly Brooklyn Museum of Art; Charlotte Gere; Stephen Gleissner, Wichita Art Museum, Kansas; Jane Glover, The Fine Arts Museums of San Francisco; Mary Anne Goley, Federal Reserve, Washington, D.C.; Constance C. Grant, Gulf States Paper Corporation; Professor Alistair Grieve, University of East Anglia; Dr Randall Griffey, Nelson-Atkins Museum of Art, Kansas City, Missouri; Jane Hamilton, Agnew's, London; Deborah Harris; Gregory Hedberg, Hirschl & Adler, New York; Professor Nancy G. Heller; Mark Henderson, Getty Research Institute, Los Angeles; Stephanie H. Herdrich, formerly The Metropolitan Museum of Art, New York; Erica Hirshler, Museum of Fine Arts, Boston; Alan Hobart, Pyms Gallery, London; Erica Holmquist-Wall, Minneapolis Institute of Arts; Hugh Honour; Gordon Howard, Northern Trust Co., Miami; Dr Hans Hubert, German Institute, Florence; Joël Huthwohl, Comédie-Française, Paris; David Hyde; Remko Jansonius, Vizcaya Museum and Gardens, Miami; David Fraser Jenkins, Tate, London; William R. Johnston, Walters Art Museum, Baltimore; Dr Frances S. Jowell; Laura Kalas, formerly Terra Foundation for the Arts, Chicago; Philip Kelley; Helena Komulainen, Finnish National Gallery, Helsinki; Cecily Langdale, Davis & Langdale, New York; Richard Lingner, Isabella Stewart Gardner Museum, Boston; Lulu Lippincott, Carnegie Museum of Art, Pittsburgh; Professor Margaretta M. Lovell, University of California at Berkeley; Marie-Sofie Lundström, Department of Languages and Culture/Art History, Åbo Akalemi University, Finland; Dr Margaret MacDonald, University of Glasgow; Professor Kenneth McConkey; Connal McFarlane, formerly Christie's, London; Kathleen McKeever, Cleveland Museum of Art; James Martin, formerly Sterling and Francine Clark Art Institute, Williamstown, Massachusetts; Mitchell Merling, Richmond Museum of Art, Virginia; Mrs Elizabeth Miller; Jill Mitchell; Mark D. Mitchell, National Academy Museum and School of Fine Arts, New York; Dorothy Moss; Emily Ballew Neff, Museum of Fine Arts, Houston; Christopher Newall; Roberta J. M. Olson, The New-York Historical Society; Flavia and John Ormond; Marcus Ormond; Meg J. Perlman; Joseph Pichot-Louvet; Mary Pixley, National Gallery of Art, Washington, D.C.; Marc Porter, Christie's, New York; Kathryn Price, Sterling and Francine Clark Art Institute, Williamstown, Massachusetts; Professor Sally Promey, University of Maryland; Cathy Ricciardelli, Terra Foundation for the

Arts, Chicago; Joseph Rishel, Philadelphia Museum of Art; Bruce Robertson, Los Angeles County Museum of Art; Timothy Rogers, Bodleian Library, Oxford; Danielle Routhier, Western Reserve Historical Society, Cleveland; Deirdre Rowsome, Alfred Beit Foundation, Russborough, Ireland; Dr William Keyse Rudolph, Dallas Museum of Art; Dr Zsuzsanna van Ryven-Zeman; Kathleen Salisbury, Munson-Williams-Proctor Art Institute, Utica, New York; Anne Salsich, Western Reserve Historical Society, Cleveland; Kerry Schauber, Fogg Art Museum, Harvard University Art Museums, Cambridge, Massachusetts; Lauren Schell, Dallas Museum of Art; Marc Simpson, Sterling and Francine Clark Art Institute, Williamstown, Massachusetts; Kim Sloan, Department of Prints and Drawings, British Museum, London; Donna Sprunger, Society of the Four Arts, Palm Beach; Ted Stebbins, Fogg Art Museum, Harvard University Art Museums, Cambridge, Massachusetts; Ann Stewart, National Gallery of Ireland, Dublin; Jessica Stewart, Birmingham Museum of Art, Alabama; Marion C. Stewart, Fine Art Museums of San Francisco; Miriam Stewart, Fogg Art Museum, Harvard University Art Museums, Cambridge, Massachusetts; Rosie Stynes, Christie's, London; Lynn M. Summers, Vizcaya Museum and Gardens, Miami; D. Dodge Thompson, National Gallery of Art, Washington, D.C.; Jennifer A. Thomson, Philadelphia Museum of Art; Professor Richard Thompson; Bob Todd, National Maritime Museum, Greenwich, London; Carol Troyen, Museum of Fine Arts, Boston; Margaret Trusted, Victoria and Albert Museum, London; Dr Pieter van der Merwe, National Maritime Museum, Greenwich, London; Jennifer Vanim, Philadelphia Museum of Art; Patricia Curtis Vigano; Mary Crawford Volk; H. Barbara Weinberg, The Metropolitan Museum of Art, New York; Eyde Weissler, Knoedler & Co., New York; Tammy Wells-Angerer, Ackland Art Museum, University of North Carolina at Chapel Hill; Christine Wooding; Tia Woodruff; Professor John Woolford; Angus Wrenn; the late Dr Michael Wynne; Nancy Yeide, National Gallery of Art, Washington, D.C.; Sirkka-Liisa Yrjänä, Finnish National Gallery, Helsinki; Elaine Zair; Dr Marino Zorzi, Biblioteca Nazionale Marciana, Venice; and Dr Rosella Mamoli Zorzi, Università Ca' Foscari, Venice.

The principal sources of information for the early years of Sargent's life are the letters of his father, Dr Fitzwilliam Sargent, to George Bemis in the Massachusetts Historical Society, Boston, and to his family in the Archives of American Art, Smithsonian Institution, Washington, D.C.; Sargent's letters and those of his sister Emily to their childhood friend Violet Paget (the author Vernon Lee); and Vernon Lee's letters to her mother. With regard to the Vernon Lee material, unpublished letters are held in Special Collections, Millar Library, Colby College, Waterville, Maine, and a private collection. A collection of her letters, edited by Irene Cooper Willis, was privately printed as *Vernon Lee's Letters,* in 1937.

References to individual documents have not been cited for the years before 1874. After 1874, references to important sources are cited.

Initials are used in the endnotes for the chronology for the principal correspondents and collections:

JSS (Sargent)
VL (Vernon Lee [Violet Paget])
ES (Emily Sargent)
FWS (Dr Fitzwilliam Sargent)
AAA (Archives of American Art, Smithsonian Institution, Washington, D.C.)
CC (Special Collections, Millar Library, Colby College, Waterville, Maine)
ISGM (Isabella Stewart Gardner Museum, Boston)
MHS (Massachusetts Historical Society, Boston)
NAM (National Academy Museum and School of Fine Arts, New York).

1856 12 January: John Singer Sargent is born in Florence, the son of American parents, Dr Fitzwilliam Sargent (1820–1889) and Mary Newbold Sargent (1826–1906). They had left Philadelphia for Europe in the autumn of 1854. Their first child, Mary Newbold, born in May 1851, had died in July 1853. The family spends the summer in Geneva and the winter in Rome.

1857 27 January: His sister Emily Sargent is born in Rome.
Fitzwilliam Sargent submits his resignation as attending surgeon, Wills Hospital, Philadelphia.
The family spends the spring and summer in Vienna.

1858 Summer: The family lives outside Rome in the grounds of the Palazzo Sforza.

1859 12 November: Sargent's maternal grandmother dies in the Sargents' apartment at 13 Piazza di Spagna, Rome.

1860 18 December: Sargent's first known drawing, a portrait of his father writing a letter, is enclosed in a letter from Fitzwilliam Sargent to his father Winthrop Sargent.[1]

1861 1 February: A third daughter, Mary Winthrop, is born to Fitzwilliam and Mary Sargent.
The family spends the spring and summer in Switzerland and September in Nice.

1862 Nice. The family lives in the Maison Virello, rue Grimaldi. Sargent finds a friend of a similar age in Ben del Castillo, the son of neighbours, Rafael del Castillo and his wife.
The family visits London in June, where they consult surgeons about Emily's back, and Switzerland in July. By October they have returned to Nice.

1863 The family is in Switzerland from June to October and returns to Nice in November.

1865 18 April: Mary Winthrop Sargent dies in Pau, France.
May: Biarritz.
Fitzwilliam Sargent sails to America. The rest of the family remains in Switzerland and rejoins him in London in September. They spend October in Paris and November in Nice.

1866 Nice. Sargent meets Violet Paget (Vernon Lee).
The family spends the summer around Lake Como and the Engadine and returns to Nice in the autumn.

1867 7 March: Fitzwilliam Winthrop, the Sargents' second son, is born in Nice.
The summer is spent travelling—Paris, the Rhine, Munich, the Tyrol, Salzburg, Milan and Genoa. In October, the family returns to Nice.

1868 They are in Spain in March, Biarritz in May and Nice in October.
Sargent attends, very briefly, a school run by an English clergyman and his wife.
November: The family is in Rome, where they live at 17 Trinità de' Monti, above the Piazza di Spagna. Sargent helps in the studio of the German-American landscape painter Carl Welsch (1828–1904), where he copies some water-colours.[2] The Pagets are also in Rome.

1869 The year begins in Rome. By May, the family is travelling to Naples and Sorrento, and from Padua to Bolzen.
28 June: Sargent's brother Fitzwilliam Winthrop dies at Kissingen.

The family is in St Moritz in July and in Florence in October, where Sargent does copy work at the Bargello.

1870 9 February: Violet Sargent is born in Florence.

Sargent attends M. Joseph Domengé's day school in Florence, in the former convent I Servi di Maria in the Piazza della SS Annunziata, and has dancing lessons at 43 via Romana.

May: Venice and Lake Maggiore.

June–October: Switzerland, where Sargent executes a number of Alpine water-colours.[3]

October: Florence.

1871 April: Fitzwilliam Sargent's mother dies.

The Sargents spend the summer in the Tyrol and are in Munich by October.

In November, the family moves to Dresden, where Sargent studies Latin, Greek, mathematics, geography, history and German in preparation for the entrance examination for Das Gymnasium zum Heiligen Kreuz. He does some copy work in the Albertina.

1872 January: Emily is seriously ill. By the early spring, Sargent's first foray into formal education is abruptly truncated. The family travels to Berlin, Leipzig, Carlsbad, Munich and Auchensee. They spend the summer in the Tyrol. Sargent contracts typhoid fever.

In September, the family returns to Florence, to apartments in the Villino Torrigiani, 115 via de' Serragli.

1873 May–July: Mrs Sargent and her children are in Venice, while Fitzwilliam Sargent is in America.

July: The family is reunited in Pontresina, Switzerland, and they travel in the Alps.

September: Sargent and Emily spend ten days in Bologna with Vernon Lee. They engage in discussions on art and aesthetics.[4]

October: Florence. They live in a new apartment, 15 via Magenta. Sargent enrolls in the Accademia delle Belle Arti, which closes in December. He meets the American artists Walter Launt Palmer, Edwin White and Frank Fowler, and the English artists Edward Clifford and Heath Wilson. Palmer writes in his diary: 'He is but 17 & had done a most remarkable amount of work very little oil'.[5]

1874 March: the Accademia in Florence reopens.

Sargent writes to Mrs Austin (22 March) about obtaining photographs of pictures he has seen in Dresden, and about his admiration for Titian, Tintoretto and Michelangelo. He expresses frustration with the unsatisfactory Accademia and writes of the family's intention of visiting Paris and the good reports they have heard of the art education available there (25 April).[6]

April: They change their plans and, instead of going to Venice for the summer, they decide to go to Paris to look into ateliers for Sargent.[7] They arrive in Paris on 16 May.[8]

26 May: Sargent visits Carolus-Duran's atelier at 81, boulevard du Montparnasse with his father. By 30 May he has been placed in Duran's atelier.[9]

In two letters to Heath Wilson, Sargent records his first impressions of Paris and the system of art training. In the first, he writes about the Paris ateliers, and he mentions the very difficult examinations for admission to the École

des Beaux-Arts. In the second letter, he discusses Duran's atelier, where he has been for almost three weeks, and mentions painting his first head.[10]

Fitzwilliam Sargent writes to his sister that Sargent is working in the studio of an 'artist of reputation'; he describes his fellow-students and the daily routine of the atelier.[11]

He paints the interior of an unidentified atelier at this early period and other academic studies (see chapter 1, p. 35).

3 July: The studio closes for the summer. Sargent spends time with his family in Caen, Rouen, and at the Hôtel Imbert, Beuzeval (the modern Houlgate), on the Normandy coast.

September: He returns to Paris to prepare for the *concours des places* at the École des Beaux-Arts (the exams in perspective and anatomy, ornament drawing and life drawing take place from 26 September to 16 October). He lives with his family at 52, rue Abbatrice.[12]

October: Sargent meets the American artist J. Alden Weir.[13] He works in the studio of the American J. Carroll Beckwith.[14] Among Sargent's fellow-students are Will Low, C. M. Newton, John Tracey, Stephen Parker Hills, Paul Batifaud-Vaur and Robert C. Hinckley. According to Charteris,[15] he also works in the studio of Léon Bonnat in the evening.

19 October: Carolus-Duran's atelier reopens.

27 October: Sargent passes the *concours* and matriculates at the École. He is placed 37th out of 162 entrants.[16] Beckwith comments on Carolus-Duran's teaching of drawing.[17] Sargent and his sister Emily are confirmed by the Bishop of Maine at the Episcopalian church in Paris, Holy Trinity, in 1874.[18]

1875 January: Sargent goes to Nice with Stephen Parker Hills, Robert C. Hinckley and Carolus-Duran.[19]

16 March 1875: Sargent passes the *concours* and matriculates at the École for a second time. He is placed 39th.[20]

March: Sargent is working a good deal with Beckwith in the latter's studio.[21] He describes a ball in the Latin Quarter in a letter to Ben del Castillo.[22]

June: Sargent joins his family in St Énogat, near Dinard in Brittany.[23]

August: Sargent and Beckwith share a rented studio, 73, rue de Notre-Dame-des-Champs.[24]

October: He lives at Mme Darode's boarding house, 19, rue de l'Odéon.[25] He is working at the atelier Carolus-Duran and the École. He spends Christmas with Beckwith and his family at St Malo.[26]

1876 January: He draws Fanny Watts in Breton headdress at St Énogat (private collection).

April: There is no firm evidence of a meeting between Sargent and Claude Monet at this date. However, according to Charteris, who quotes from conversations he had with Monet in 1926, Sargent and Paul César Helleu met Monet at Durand-Ruel's gallery and dined with him 'vers 1876'.[27] Mrs C. D. Howard Johnston, Helleu's daughter, has recorded that her father said that the meeting took place at the second Impressionist exhibition at Galerie Durand-Ruel in April 1876. It is similarly difficult to confirm the date of Sargent's first meeting with Helleu. Dates

between 1876 and 1882 have been proposed.[28] Their meeting is traditionally dated to 1876, but evidence for such an early meeting is anecdotal.

Possibly Grez-sur-Loing—the visit is undocumented. Grez is recalled in a letter from Sargent to Vernon Lee.[29]

13 May: Sargent sails for America from Liverpool with his mother and Emily. Fitzwilliam Sargent and Violet stay behind in Switzerland.

Sargent visits the Centennial Exhibition in Philadelphia and meets his Newbold and Sargent cousins.

The Sargents are guests of Admiral Augustus Ludlow Case in Newport, where Sargent paints a portrait of Case's son-in-law, Charles Deering (Early Portraits, no. 4). They sail up the Hudson River. They visit the Weirs (the family of J. Alden Weir) and move on to Montreal via Lake George and Lake Champlain and then to Niagara Falls by way of the St Lawrence Rapids before returning to Philadelphia.

September: Sargent goes to Chicago for a few days with an artist friend from Paris.[30]

4 October: With his mother and sister, he sets sail for Liverpool. He paints seascapes and shipboard scenes on his transatlantic journeys (see chapter 4, pp. 81–83, 96–107).

November: He returns to the École and the atelier Carolus-Duran.

Emily describes Sargent's Paris studio and recalls painting in oils by lamplight in Florence.[31]

1877 January: The Finnish artist Albert Gustav Edelfelt describes a dance party at the Sargents' apartment in Paris.[32]

March: Sargent passes the *concours* and matriculates at the École for a third time. He is placed 2nd, and he receives a third-class medal for ornament drawing (see fig. 12).[33] This is the first time a student of Carolus-Duran's has been so highly rated, and it is the highest place yet awarded to an American.

March: He completes a portrait of Fanny Watts (Early Portraits, no. 20), which is selected for the Salon.[34]

May: Emily writes about Sargent having receiving a third-class medal for ornament drawing.[35] His portrait of Fanny Watts is exhibited at the Salon.

June–August: Sargent spends the summer at Cancale in Brittany, where he paints marine subjects and studies for *Oyster Gatherers of Cancale (En route pour la pêche)* and *Fishing for Oysters at Cancale* (nos. 670, 671). He visits the Sorchan family at St Senoch, near Lyons.

September: He joins his family in Bex, Switzerland.[36]

October: Sargent is in Genoa with his family. He goes sketching with Heath Wilson.[37] He returns to Paris and works both at the atelier Carolus-Duran and the École. He and Beckwith help Carolus-Duran with a ceiling decoration for the Palais du Luxembourg.[38] Emily describes Sargent's busy life in Paris.[39]

By the latter part of the year, Sargent has met Augustus Saint-Gaudens, who includes him in a list of American artists who would be interested in contributing works to the first exhibition of the Society of American Artists.[40] Through Saint-Gaudens, he probably meets the architect Stanford White.

He is elected as one of the jurymen for the new Association of American Artists. Founded in June, it was later called the Society of American Artists.[41] In a letter to Gus Case of November or December 1877, Sargent writes that he is at work on a picture for the American Art Association; this was *Fishing for Oysters at Cancale* (no. 671).[42]

1878 March: Sargent may have been in Venice at some time in the preceding months.[43] He exhibits *Fishing for Oysters at Cancale* (no. 671) at the first Society of American Artists exhibition at the Kurtz Gallery, New York. It is bought by the artist Samuel Colman for $200.[44]

May: He exhibits *En route pour la pêche (Oyster Gatherers of Cancale,* no. 670) at the Salon. The picture is bought by Admiral Augustus Ludlow Case, an old family friend.[45]

Carolus-Duran's ceiling mural for the Palais du Luxembourg is exhibited at the Salon. Duran agrees to sit to Sargent for his portrait.[46]

Sargent's portrait of Fanny Watts is exhibited at the Exposition universelle in Paris.

Last week in July: Sargent leaves Paris and travels to Naples via Marseilles.

By 10 August: Sargent has sailed from Naples to Capri. He stays at Marina Grande and meets the English artist Frank Hyde, who invites him to use his own studio space at the ex-convent of Santa Teresa in Capri town and introduces him to the model Rosina Ferrara.[47]

Sargent paints several studies of children on the beach, a number of paintings of Rosina and some architectural studies (see pp. 137–79).

October–November: Nice, with his family. He returns to Paris at the beginning of December.[48]

Hamilton Minchin records meeting Sargent for the first time this autumn.[49]

1879 March: He exhibits *A Capriote* (no. 702) at the Society of American Artists, New York.

April: He exhibits *Neapolitan Children Bathing* (no. 692) at the National Academy of Design, New York.

May: He exhibits *Carolus-Duran* and *Dans les oliviers à Capri (Italie)* (Early Portraits, no. 21, and either no. 703 or no. 704) at the Salon. The portrait of Duran receives an Honourable Mention.

August: Château de Ronjoux. He paint portraits of the Pailleron family, including *Madame Édouard Pailleron (Early Portraits,* no. 25), and a sketch of the kitchen garden (no. 647).[50] He visits his family at Aix-les-Bains.[51]

Late August/early September: He travels overland to Spain and is in Madrid in October.

14 October: He registers to copy works by Velázquez at the Prado.[52] He travels south, stopping at Granada and Seville. He paints a series of architectural studies in oil and water-colour at the Alhambra (see pp. 227–29, 235–41).

End of December: He crosses to Morocco, beginning work on *Fumée d'ambre gris* (no. 789) and painting street scenes in and around Tangier (see pp. 284–85, 287–94).[53]

At some point, probably in the later half of this year, Saint-Gaudens gives Sargent a copy of his medallion of Jules Bastien-Lepage. In return, Sargent gives him a water-colour of a Capri girl.[54]

He paints *Boats in Harbour I* in 1879, possibly at Nice

(no. 686), one of a series of port and harbour scenes (see pp. 86–87, 126–35).

1880 January: He is in Tangier and Tunis, returning to Paris by the end of February.[55]

Spring: He shares Auguste Alexandre Hirsch's studio at 73, rue de Notre-Dame-des-Champs, next door to the studio he shared with Beckwith (see n. 24)

March–April: His portrait of Carolus-Duran is exhibited at the Society of American Artists, New York.

May: *Madame Édouard Pailleron* and *Fumée d'ambre gris* are shown at the Salon. *Fumée d'ambre gris* is sold to a Frenchman, probably the artist Paul Borel, for 3,000 francs.[56]

June: Beckwith returns to Europe for the summer. There are numerous references to Sargent and others in their circle, several of them students of Carolus-Duran, in Beckwith's diary (NAM): Henry A. Bacon; Becker; the Burckhardt family; Carolus-Duran; Ralph Curtis; Charles Du Bois; Auguste Alexandre Hirsch; George Hitchcock; Louis Le Camus; (?Paul-Marie le Noir); Levy; the Sargent family.

15 August: He goes to Holland with the American artists Ralph Curtis and Francis Brooks Chadwick and copies paintings by Frans Hals in Haarlem (see pp. 199–201, 216–19). He paints a portrait of Curtis relaxing on the beach at Scheveningen and a sketch of Chadwick (*Early Portraits,* nos. 82, 84).[57]

Mid-September: He travels to Venice, where he meets his mother and sister.[58]

He sets up a studio in the Palazzo Rezzonico.[59] During the autumn months in Venice, Sargent meets with artists of the Anglo-American community (see pp. 308–11).

1881 After 10 January: He meets Luke Fildes in Venice.[60]

February–March: He leaves Venice.

March: Ralph Curtis writes to Mrs Gardner that Sargent is visiting his family in Nice and that he [Curtis] is keeping his studio warm.[61]

March–April: Sargent exhibits a profile head of Rosina Ferrara (*Capri Peasant—Study,* no. 709) and a small portrait of Edward Burckhardt at the Society of American Artists, New York (*Early Portraits,* no. 31).

April: He exhibits two Venetian interiors at the second exhibition of the Cercle des arts libéraux on the rue Vivienne (23 April–25 May).

May: He exhibits *The Pailleron Children, Madame Ramón Subercaseaux* (*Early Portraits,* nos. 37, 41) and two Venetian water-colours, both under the title 'Vue de Venise' at the Salon (see pp. 315–16, 322). He is awarded a second-class medal for the portrait of *Madame Ramón Subercaseaux.*

Sargent goes to England to see his mother and Emily off to America.

June: Beckwith returns to Europe for the summer with a group of American artists, including (?Abraham Archibald) Anderson, Robert Blum, William Merritt Chase (who meets Sargent for the first time on 29 June) and Herbert Denman. Frequent references to Sargent and other friends in their circle appear in Beckwith's diary (NAM): Mrs Louise Burckhardt; George Burnap; Carolus-Duran and family; Ben del Castillo; Jean-Charles Cazin; George Hitchcock; Alexis Marie Lahaye; Louis Le Camus; Levy; the Lit-

tle family; the Norris family; Jules-Étienne Pasdeloup and his wife; Georges Petit; St Georges; (?Edwin Scott); the Sorchan family; the Watts family; and J. Alden Weir.

21 June: Sargent takes Vernon Lee to see Edward Burne-Jones in his Fulham studio, London.[62]

23 June: He paints Vernon Lee at 84 Gower Street, London (*Early Portraits,* no. 67).

5 July: Vernon Lee says that Sargent has finished his work in London and is off to Paris in a hurry.[63]

5–6 July: Sargent visits Fontainebleau and Grez with Beckwith, Mrs Louise Burckhardt and the Sorchans.[64]

13–15 July: Sargent and the Burckhardts visit Beckwith at Andé in Normandy.[65]

August: Paris. He is working on his portrait of *Dr Pozzi* (*Early Portraits,* no. 40).[66]

November: He is working on *El Jaleo* (no. 772).[67]

1882 March: He exhibits four works, including one entitled 'Une Rue à Venise' and 'Tête d'étude' (*Capri Peasant—Study,* no. 709), at the third exhibition of the Cercle des arts libéraux on the rue Vivienne.

May: *El Jaleo* and *Lady with the Rose* (*Early Portraits,* no. 55) are shown at the Salon, *Dr Pozzi* at the Royal Academy, and two Venetian interiors and a 'study' at the Grosvenor Gallery.

8 June: John and Emily Sargent go to see Édouard Pailleron's *Le monde où l'on s'ennuie* at the Comédie-Française with Vernon Lee. They also go to the Salon and to an exhibition of Paul Baudry's work.

23 June: Vernon Lee writes to her mother that Edmund Gosse says that Sargent, whom everyone is talking of as 'quite *the* painter, is on the abyss'.[68]

June: Beckwith travels to Europe with a group of American artists, including (?Abraham Archibald) Anderson, Robert Blum, William Merritt Chase and Frederic Porter Vinton. Frequent references to Sargent and other friends in their circle appear in Beckwith's diary (NAM).

Sargent goes to Aix-les-Bains and Chambéry to visit his parents.[69]

August: Venice. He stays with his cousins the Curtises at the Palazzo Barbaro.

October: Sargent visits the Pagets in Florence.[70]

Late October/November: Paris.[71]

El Jaleo is shown at the Schaus Gallery, New York, and later in Boston.

December: Sargent exhibits *The Daughters of Edward Darley Boit,* a portrait sketch of *Vernon Lee,* a portrait of *Madame Allouard-Jouan* (*Early Portraits,* nos. 50, 67, 52), *Street in Venice, Sortie de l'église* (nos. 808, 806), and two other unidentified Venetian subjects, at the first of Georges Petit's exhibitions in his gallery, 8, rue de Sèze.

1. The drawing is in the collection of the Sargent-Murray-Gilman-Hough House Association, Gloucester, Massachusetts.

2. Charteris 1927, p. 10; and Olson 1986, pp. 20–21, 282 n. 12. Welsch may have been a more substantial figure than has previously been recognized. It seems probable that he was the Theodore Charles Welsch who exhibited in 1859, 1865 and 1866 at the Paris Salon, in whose catalogues his birthplace is given variously as New York and Frankfurt. In a letter of 1871, Dr Sargent wrote: 'A friend of ours, an Germanico-American Artist of reputation, has invited him to spend the summer with him in the Tyrol and the neighbouring highlands where they will sketch together'. FWS to Winthrop Sargent, 20 May 1871, AAA, roll D 317, frame 252. Our thanks to Richard H. Finnegan, who made this connection.

3. Alpine sketchbooks: *Splendid Mountain Watercolours,* The Metropolitan Museum of Art, New York, Gift of Mrs Francis Ormond, 1950 (50.130.146), and *Album No. 3, Switzerland,* 1870, The Metropolitan Museum of Art, New York, Gift of Mrs Francis Ormond, 1950 (50.130.148). See Stephen D. Rubin, *John Singer Sargent's Alpine Sketchbooks: A Young Artist's Perspective,* The Metropolitan Museum of Art, New York, 1991 (exhibition catalogue).

4. The visit to Bologna took place in 1873, *not* 1872. Vernon Lee misremembered the date, which was followed by her biographer. Stanley Olson had it correctly as 1873 in his biography (Olson 1986, p. 2, and in his chronology in Hills *et al.* 1986, p. 277). The primary sources are letters from FWS to sister, 26 September [1873] and 29 October [1873] (MHS). Neither has a year date, but both can be securely dated to 1873. We are grateful to Stephanie Herdrich for the 25 September reference. The visit is recalled in a letter from VL to JSS of 4 September 1874, private collection; see Ormond, *Colby Library Quarterly,* 1970, pp. 158–59, 160.

5. Walter Launt Palmer's diary entry for 14 November 1873, in Maybelle Mann, *Walter Launt Palmer: Poetic Reality* (Exton, Pennsylvania, 1984), p. 12.

6. The original letters are now lost but are quoted in Charteris 1927, pp. 18, 19–20.

7. FWS to George Bemis, 23 April [1874], MHS.

8. FWS to his father, 19 May [1874], AAA, roll D 317, frames 370–72.

9. FWS to his father, 30 May 1874, AAA, roll D 317, frames 519–20.

10. Two letters from JSS to Heath Wilson, 23 May and 12 June 1874, Maggs Bros. Ltd, London, *Autograph Letters and Documents,* Spring 1935, lot 201; with William H. Allen, booksellers, Philadelphia, lost in transit to the Pierpont Morgan Library, New York, c. 1980; as well as the description in the Maggs catalogue, partial transcripts were made by William H. Allen (catalogue raisonné archive).

11. FWS to his sister Anna Maria, 25 June [1874], AAA, roll D 317, frames 373–75.

12. 'Well, we have decided to spend the winter here [Paris]. I am sorry to leave Italy—that is to say, Venice, but on the other hand I am persuaded that Paris is the place to learn painting in. When I can paint, then away for Venice!' JSS to VL, 4 September 1874, private collection.

13. J. Alden Weir to his mother, Weir correspondence, 4 October 1874, AAA, roll 71, frame 301.

14. 'My talented young friend Sargent has been working in my studio with me lately and his work makes me shake myself'. 13 October 1874, Beckwith Diary, Beckwith Papers, NAM.

15. Charteris 1927, p. 36.

16. See *Procès-verbaux originaux des jugements des concours des sections de peinture et de sculpture, 23 octobre 1874–22 octobre 1883* (AJ 52:78), École des Beaux-Arts, Paris; cited in Weinberg 1991, p. 278, n. 81.

17. Beckwith writes in a diary entry: 'Duran I am most happy to observe is becoming much more severe in our drawing, some body has awakened him to the realization of his neglect with us on this point and his latest criticisms have been very strict on this point, it is where [?] has been my only question of Duran's ability as a master and as he is now changing I am to [sic] glad for expression'. 27 October 1874, Beckwith Papers, NAM.

18. See Promey 1999, p. 28.

19. 'Our annual dinner to Duran came off in January and was a great success the following week he left for a trip to Nice taking with him Hinckley Parker and Sargent'. Recalled in Beckwith's diary entry for 16 March 1875, Beckwith Papers, NAM.

20. Cited in Weinberg 1991, p. 278, n. 81.

21. 16 March 1875, Beckwith Diary, Beckwith Papers, NAM.

22. Letter of 6 March 1875, quoted in Charteris 1927, p. 37.

23. See letter of 29 June 1875 to Ben del Castillo, quoted in Charteris 1927, p. 38; and FWS to sister, 9 January 1876, AAA.

24. 'I [Beckwith] have however taken an atelier for the winter in which Sargent shares with me the price 1000f'. 3 August 1875, Beckwith Diary, Beckwith Papers, NAM. In March of the following year, Sargent writes about his new studio to Fanny Watts, 10 March 1876, private collection. The land-registry documents at the Archives of Paris, the *cadastre,* give details of the building and tenants at 73, rue de Notre-Dame-des-Champs (D.1 PA 0811). There were and still are three buildings at no. 73, one behind the other, reached by an alleyway running between nos. 73 and 75. The studio shared by Beckwith and Sargent was apartment no. 16, on the first floor of the third building, and comprised a living room, cabinet and studio. Beckwith is listed there in 1877 and Sargent in 1880. In 1884, Sargent is listed at no. 17, with Auguste Alexandre Hirsch (for Hirsch, see appendix 1, p. 387). These dates are retrospective and do not accurately record actual dates of occupancy; for example, Sargent was already at 41, boulevard Berthier by the end of 1883. The proprietor of all three buildings was Dr Abel Lemercier, to whom Sargent inscribed *Atlantic Sunset* and *The Onion Seller* (nos. 665, 801). Sargent sometimes gave his address as 73 *bis,* rue de Notre-Dame-des-Champs, but this seems to have been an error, since the land registry lists 73 *bis* as a separate group of buildings at the far end of the alleyway. Mount correctly identified the building occupied by Sargent and Beckwith without the aid of the land-registry documents (Mount 1963, pp. 396–97).

25. FWS to George Bemis, 20 November [1875], MHS.

26. Recalled, 21 August 1876, Beckwith Diary, Beckwith Papers, NAM.

27. Charteris 1927, p. 130.

28. See Donelson F. Hoopes, 'John S. Sargent: The Worcestershire Interlude, 1885–1889', *Brooklyn Museum Annual,* vol. 7 (1965–66), pp. 76–77, n. 3.

29. JSS to VL, 15 August [1881], private collection.

30. ES to VL, 24 September 1876, CC.

31. 'We used to paint in oils by lamplight often, & the results were quite passable sometimes at night, but by daylight the colours looked very differently'. ES to VL, 22 November 1876, CC.

32. Letter to his mother, quoted in *Ur Albert Edelfelt Brev: Drottning Blanca och Hertig, Carl Sant Några* (Helsinki, 1917), p. 12.

33. Cited in Weinberg 1991, p. 278, n. 81. Sargent had written to Fanny Watts (10 March 1876) about the *concours* the previous year: 'The Concours is now raging and tomorrow is the last and most anxious day. The question ought to be no longer merely to get in, but to get in high, which makes it much more interesting. Two weeks of suspense however must pass before we know the result'. Private collection.

34. FWS to George Bemis, 24 March 1877, MHS.

35. ES to VL, 5 June 1877, CC.

36. FWS to George Bemis, 27 June 1877, MHS; FWS to his sister, 20 August [1877], AAA, roll D. 317, frames 423–24; ES to VL, 5 June 1877, 29 July 1877 and 19 September 1877, CC; and 23 September 1877, Beckwith Diary, Beckwith Papers, NAM.

37. ES to VL, 16 October 1877, CC.

38. 'Sargent aide son illustre maître Carolus à faire le plafond pour le Luxembourg'. Albert Gustav Edelfelt to J. Alden Weir, 22 February 1878, AAA, roll 71. 'Duran made an excellent portrait of John in it [the ceiling for the Luxembourg], & John made one of him which so delighted Duran, that he told John he would sit for his portrait, & John has begun it but expects to go to Capri in a few days'. ES to VL, 24 July 1878, private collection.

39. ES to VL, 16 October 1877, CC.

40. Augustus Saint-Gaudens, undated note [probably written during the latter half of 1877], Saint-Gaudens archive, Rauner Special Collections Library, Dartmouth College, Hanover, New Hampshire, roll 13, frame 41. Sargent's is the first name on the list.

41. See Augustus Saint-Gaudens to Edwin Blashfield, 19 January 1878, Blashfield Papers, The New-York Historical Society.

42. Letter in a private collection.

43. Mary Cassatt wrote to J. Alden Weir from 13, avenue Trudaine, Paris: 'Your letter only reached me yesterday evening. Mr Sargent forwarded it to me from Venice where it had followed him, that accounts for the delay'. Mary Cassatt to J. Alden Weir, 10 March 187[8?], Weir correspondence, AAA, roll 71, frame 1088.

44. FWS to his brother Tom, 3 April [1878], AAA, roll D 317, frames 553–54.

45. JSS to Gus Case, 18 July 1878, private collection; FWS to his brother Tom, 14 June 1878, AAA; ES to VL, 24 July 1878, private collection; quoted in Ormond, *Colby Library Quarterly,* 1970, p. 162.

46. ES to VL, 24 July 1878, private collection.

47. JSS to Ben del Castillo, 10 August 1878, quoted in Charteris 1927, pp. 47–48.

48. ES to VL, 22 December 1878, CC.

49. Minchin 1925, p. 735.

50. ES to VL, 9 August 1879, CC.

51. FWS to his brother Tom, 20 September [1879] AAA, roll D 317, frame 438; and ES to VL, 3 September 1879, CC.

52. See pp. 197–99; and Ormond and Pixley 2003, pp. 632–40.

53. See letter to Ben del Castillo, 4 January 1880, quoted in Charteris 1927, pp. 50–51.

54. The water-colour and a sketch (medium unknown) of Saint-Gaudens by Sargent were destroyed in a fire at Saint-Gaudens's studio in Cornish, New Hampshire, in 1904. Homer Saint-Gaudens, ed., *The Reminiscences of Augustus Saint-Gaudens,* 2 vols. (New York, 1913), vol. 1, p. 250, and vol. 2, p. 248.

55. ES to VL, 16 March 1880, CC.

56. VL to ES, 23 May 1880, CC (at the 1880 exchange rate of 25.51 francs to the pound, this would be approximately £120 or $575).

57. 'John left Paris about ten days ago for a tour in Holland and Belgium with two very nice friends to make a tour in Belgium & Holland before going to Venice. I had a letter from him [illegible] just as he was leaving Rotterdam for Haarlem. He has enjoyed the pictures immensely & thinks one can have no adequate idea of the works of Rubens, Rembrandt, Memling & Frans Hals without having seen them in those countries'. ES to VL, 25 August 1880, CC. 'Mamma had a nice letter from John, Haarlem, where they were going to spend a week & make a copy or two of Frans Hals'. ES to VL, 31 August 1880, CC.

58. 'John writes from Haarlem "1st [?] Sept" saying he has lost all count of the days but cannot possibly join us [in Aix-les-Bains] before ten days or a fortnight from the time he wrote'. ES to VL, 5 September 1880, CC.

59. JSS to Mrs Paget, 27 September [1880]: 'I am crazy to see Florence and Rome and before very long must devote a few months to them. But not this winter. I must do something for the Salon and have determined to stay as late as possible'. See also JSS to VL, 22 September and 22 October 1880, all three in a private collection; and ES to VL, 22 September 1880, CC.

60. See L. V. Fildes, *Luke Fildes, R.A.: A Victorian Painter* (London, 1968), pp. 68–69. L. V. Fildes records that his father, Luke Fildes, arrived in Venice on 10 January, met Sargent sometime afterwards and saw him frequently over the course of the following two months. If correct, this implies that Sargent might have stayed in Venice until mid or late March.

61. Ralph Curtis to Mrs Gardner, 20 March [1881], ISGM archive.

62. VL to her mother, 21 June 1881, *Vernon Lee's Letters* 1937, p. 63.

63. VL to her mother, 5 July [1881], ibid., p. 70.

64. Beckwith Diary, Beckwith Papers, NAM.

65. Ibid.

66. 8 September 1881, ibid.

67. 'I have done several portraits and the Spanish Dancers are getting along very well. I shall send you a photo of it & it will probably be engraved in an illustrated paper during the Salon time if it is exhibited'. JSS to VL, 20 November [1881], private collection.

68. 'While she was there came little Gosse, whom I heard talking a great deal about John (he has written a miserable penny a lining Salon notice) and taking it upon himself to decide that John (whom every body talks of as quite *the* painter) is on the abyss'. *Vernon Lee's Letters* 1937, p. 90.

69. FWS to his sister Anna Maria, 12 August 1882, AAA, roll D 317, frame 449.

70. JSS to VL, 2 November [1882], private collection.

71. 'John is busy in Paris, so much so that he has been unable to pay us a visit at this time, as we had hoped for, but he expects to come down [to Nice] later'. FWS to his brother Tom, 29 October 1882, AAA, roll D 317, frame 451.

STRUCTURE OF THE CATALOGUE

This is the first of the volumes cataloguing Sargent's complete works in oil and water-colour other than portraits and murals: included herein are landscapes, seascapes, architectural studies, subject works, figure studies, studies of models and studies from the old masters. The murals will be the subject of a further volume by Mary Crawford Volk.

The authors are confident that the pictures included in this catalogue are the work of John Singer Sargent. Only a small number posed any serious issues of attribution. Inevitably, there are a number of pictures purporting to be the work of Sargent, or accepted as his work in the past, which on current evidence have been regarded as doubtful. Although such pictures have not been included, their exclusion should not be taken as final proof that they are by an artist other than Sargent, but simply that, in the view of the authors, the case is unproven.

CATALOGUE CHAPTERS
The authors have grouped together by chapter those pictures that are similar in subject, theme or geographical location, in order to emphasize the phases and development of Sargent's early work. The introduction to each chapter highlights common themes and stylistic characteristics. As a result, the catalogue gives a wider view of Sargent's work than the bare record of individual entries in strictly chronological order. The chapters represent a subjective view of the development of Sargent's art.

CATALOGUE NUMBERS
Works catalogued in the catalogue raisonné of John Singer Sargent are numbered sequentially throughout the volumes. Works catalogued in volume I *(Early Portraits)* carry nos. 1–231; in volume II *(Portraits of the 1890s)*, nos. 232–381; in volume III *(Later Portraits)*, nos. 382–619; in the present volume IV, nos. 620–837.

TITLES
Pictures are given the title under which they were first exhibited or by which they are best known. Alternative titles are given below the main title.

DATING
It is normally assumed that exhibited paintings without inscribed dates were painted near to the time of first exhibition. The dating of undated sketches is more problematic. Having spent hours comparing one picture with another, and assembling sketches

into groups, the authors are well aware of the subjective nature of judgements bearing on chronology.

MEDIUM, SUPPORT AND DIMENSION
Pictures are designated as oil on canvas or water-colour on paper, without further analysis of materials and support used by the artist. Dimensions are normally those of the stretcher, board or sheet of paper and are given first in inches then in centimetres (height before width).

SIGNATURES AND INSCRIPTIONS
It is normally assumed that signature and date were added to a picture at the time of its completion, but this is not always the case, and, where inscribed pictures are concerned, there may be a gap of time between completion and gift. Sargent's normal form of signature is 'John S. Sargent' but there are a number of early variants. Changes in script have not yet been subjected to a rigorous process of analysis in order to aid dating. Inscriptions on the reverse of pictures have been noted only if they are in the artist's hand or if they have a particular relevance.

COMMENTARY
Every effort has been made to document each picture securely, to explain the context in which it was created, with the aid of contemporary sources and critical reviews, and to discuss issues bearing on its history and significance. Critical and aesthetic judgements have been restricted in favour of factual analysis.

APPARATUS
The traditional apparatus of a catalogue raisonné has been retained, with sections on provenance, exhibition history and literary references. This is the bedrock on which attribution rests. Every effort has been made to include references to contemporary and primary sources, but the catalogue cannot claim to be comprehensive in its listing of exhibition and bibliographic references.

DOCUMENTARY SOURCES
Many of Sargent's exhibited pictures are well documented in terms of contemporary manuscript sources and references, and in early exhibition histories. Documentation for the sketches is more sporadic, some well recorded at the time they were painted, others with few or no contemporary references. Sargent himself kept no known records of his work.

The earliest catalogue of Sargent's work, with descriptions and quotations from critics, was published by William Howe Downes in his monograph of 1925. Evan Charteris and Charles Merrill Mount both included checklists of pictures in oils in their respective biographies of 1927 and 1955. Other important source materials include the catalogues of the three major retrospective exhibitions which followed the artist's death, held in Boston in 1925, and New York and London in 1926; the sale catalogue of his work at Christie's, London, in 1925; the *Sargent Trust List* [1927] and subsequent exhibition catalogues from the 1950s onwards.

Exhibition and bibliographic references are cited in abbreviated form. The corresponding full citations are provided in Exhibitions Cited in Abbreviated Form and Bibliography Cited in Abbreviated Form (pp. 423–31).

TECHNICAL ANALYSIS
No sustained analysis of Sargent's technique has yet been undertaken, although some preliminary work has been carried out by conservators at the Tate, London, and the Fogg Art Museum, Harvard University Art Museums, Cambridge, Massachusetts. In the absence of scientific data, the catalogue authors have restricted their commentary to general points on technique and condition.

FRAMES
There are no references to frames in this volume, a lacuna that reflects the climate of opinion when the catalogue was first conceived. Subsequent volumes will include a discussion of frames.

NOTE ON TRANSLATIONS
Unless otherwise stated, translations are by the authors.

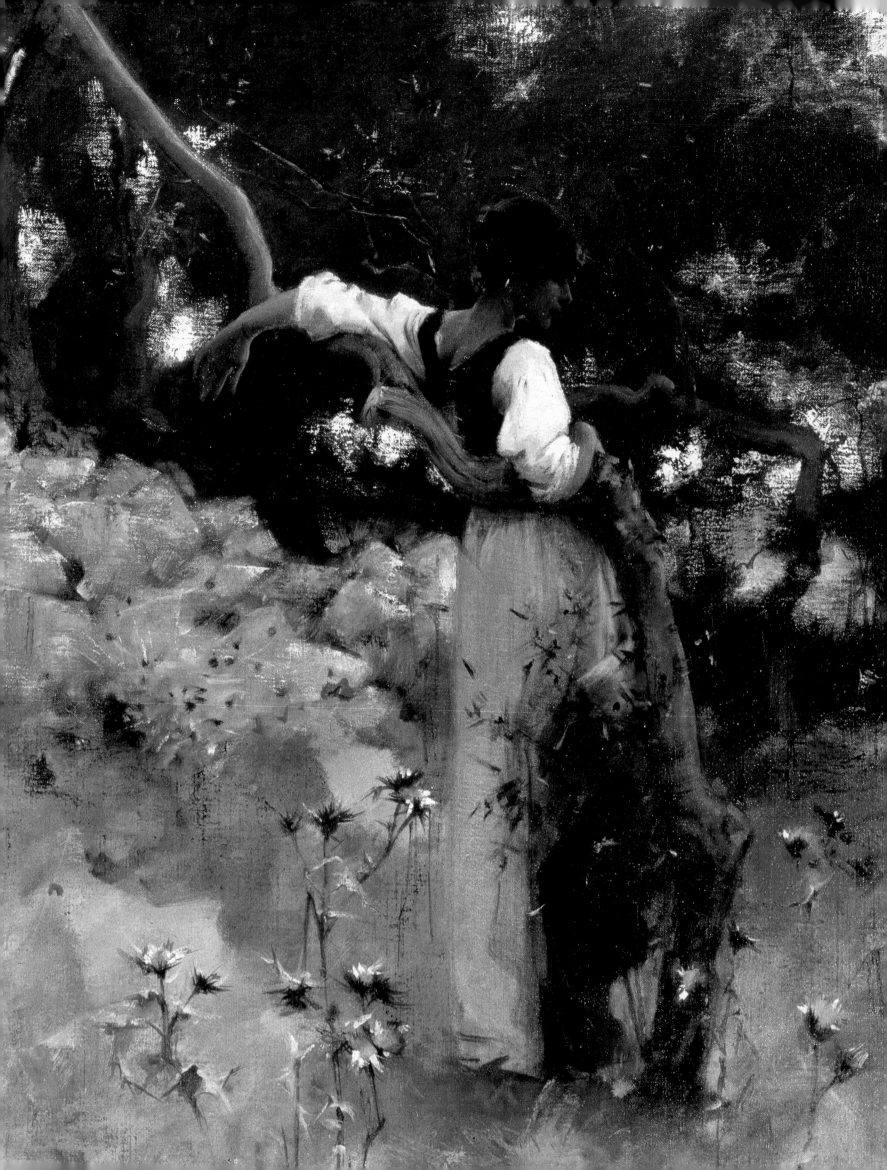

This volume is concerned with the work that John Singer Sargent (1856–1925) painted outside the realm of portraiture from the spring of 1874, when he travelled to Paris, entered the atelier of Carolus-Duran (1838–1917) and enrolled at the École des Beaux-Arts, until 1882, a year that began with his second visit to Venice, peaked with a highly significant Salon season and ended with an important group exhibition in Paris organized by the dealer Georges Petit. The work he produced in these eight years is remarkable for its volume, breadth and variety. The arc of Sargent's career as a portraitist is a more public, familiar and well-charted one, and it is interlaced with his experience as a land-scapist and figure painter; but his work outside formal portraiture presents him in different roles, working in the studio and *en plein air,* travelling in search of subject matter, atmosphere and light, copying the work of old masters in museums, experimenting with genre, motif and technique and, through this range of experience, forging his artistic personality (fig. 1).[1]

Paris as an artistic, cultural and intellectual centre helped to shape Sargent's mode of thinking and establish his aesthetic values; it provided an important network of personal and professional relationships and its institutions communicated an ethos which inspired and guided him as he steered the course of his early career. So immersed was he in the French system and its ideologies that he came to be identified as a French artist.[2] It is tempting to describe the Paris to which Sargent arrived in May 1874 as heady with the intoxication of the first Impressionist exhibition and to see the art world as poised at a moment of defining change, but this would present a distorted perspective. Recent scholarship has demonstrated that the landscape of the French art world at this period was more complex and nuanced and that the beguiling narrative which placed the avant-garde heroes fighting the good fight against the conservative villains was an over-simple duality. The drawing of distinct battle lines has been, to some extent, an act of retrospective analysis: there was not academic art on the one hand and progressive or modern art on the other, and, for many artists working at the time, continuities pertained quite as much as did the more seductive excitements of new beginnings. It is interesting that Puvis de Chavannes (1824–1898) was regarded as an independent and revered as something of a hero by a younger generation of artists even though his mural paintings linked him to the world of official art. The developing aesthetic, which proposed that the informal description of immediate experience was as pressing as the

Fig. 1
John Singer Sargent, *Self-Portrait,* c. 1882. Pen, ink and wash, dimensions unknown, untraced.

representation of traditional subject matter in resolved, structured compositions, was a liberating one, but, in responding to it, an aspiring artist might embrace both experiments with new techniques and aspects of the values of an established system.

The image of Sargent as an elder statesman of the art world is a very powerful one, but it is instructive to shift perspective, chart his rich and untidy artistic education and try to paint a portrait of the artist as a young man. Depictions of Sargent when young are rare, but a series of lively sketches by Sargent's fellow-student J. Carroll Beckwith, with whom he shared a studio at 73, rue de Notre-Dame-des-Champs (see chronology, p. 15, n. 24), showing him variously at work, reading Shakespeare, practising the piano in his studio and in the company of his fellow-students, provides a useful counterbalance (figs. 2–5). In an environment which had its shifts and contradictions, the options were more subtly varied than conventional art-historical categories might suggest: tradition and innovation were not necessarily apprehended as diametrical opposites, and navigating a route through them did not necessarily produce splintered artistic personalities. Sargent's experience in the atelier of Carolus-Duran was significant. Carolus-Duran's atelier was both independent (that is, it was not sponsored by the École des Beaux-Arts) and, in comparison

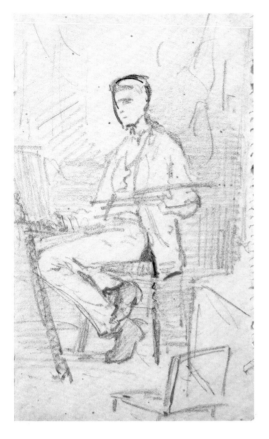

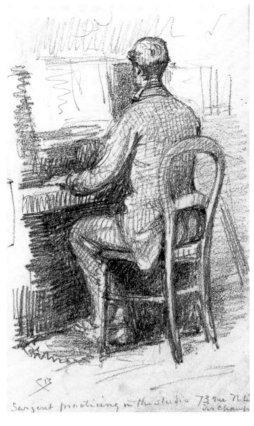

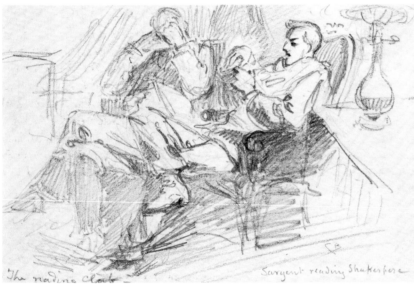

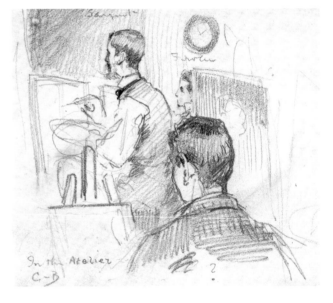

with those run by successful academic painters such as Alexandre Cabanel and Jean-Léon Gérôme, progressive. A friend of Manet and Fantin-Latour, Carolus-Duran had at the beginning of his career been viewed as a modernist; he painted portraits of Manet, Fantin-Latour and Monet and was the subject of an equivocal character sketch in Louis-Émile-Edmond Duranty's key essay, 'The New Painting' (1876), which concluded: 'He set out with this movement, was a brother in art, a mate of those I mentioned earlier. He preferred, however, to return to a firmly established approach to execution, and was content to occupy the top rung of art's middle class. Now he dabs no more than the tip of his finger into that original art in which he was born and bred, and in which he once was immersed, right up to his neck'.[3] Carolus-Duran taught an immediate *au premier coup* technique, which involved applying pigment wet-on-wet directly onto the canvas,

eschewing the traditional academic procedure of careful preliminary drawing and extensive underpainting, and he advocated that his students appropriate Velázquez, both a revered old master and a focus of admiration for the avant-garde, as their guiding star.

In nineteenth-century France, the established hierarchy of art remained a powerful intellectual force. In this framework, the representation of the human figure in the context of a large-scale, heroic, historical, mythological or religious scheme, what was known as *la grande peinture,* was the ultimate in terms of technical skill and artistic ambition and stood at the pinnacle. Beneath these lofty heights came the portrayal of the individual that was the modern portrait, then the *petits genres,* landscapes and marines, with animal painting and still life somewhere on the lower levels. The École des Beaux-Arts, that grand edifice situated on the rue Bonaparte and the cornerstone of the French

system of art education, acted as both the symbol and the guardian of this artistic creed. The École advocated an approach to art based on gaining mastery of the human form in emulation of classical models and insisted on draughtsmanship as the syntax of visual representation. Sargent took the academic tradition and discipline of the École des Beaux-Arts seriously and was a conscientious student, passing the *concours* and matriculating there three times.[4] He approached the examinations in a competitive, ambitious spirit. When he took the examination in 1877, he told Augustus Case: 'This is a very exciting season for us artists, for besides this vital question of the salon, there is an important examination on history, anatomy, perspective and the drawing of the figure. My good luck followed me here also and we must shake hands again as I was received no 2 out of 90'.[5]

Sargent was absorbing a variety of influences and working at an intense pace. In a letter to Vernon Lee, Emily Sargent outlined what was a typical day for her brother: 'He will be returning to Paris in a few days, unfortunately for us, and there he works like a dog from morning till night. Part of the time last winter we would breakfast together between 7 & eight o'clock, & he would only return for a hasty dinner & be off again to the Life School till after ten. Afterwards he would still leave us early, but would go to the Beaux-Arts before dinner'.[6] Sargent studied in the life school of Adolphe Yvon at the École des Beaux-Arts (see no. 620), and the artist's first biographer, Evan Charteris, also tells us that he attended classes with the very orthodox Léon Bonnat.[7] Sargent's visual education was inclusive and comprehensive, and he was receptive to a range of stimuli. When he was not working in the studio or at the École, he was often working 'in the field', sketching and painting in Brittany, Nice or at Grez-sur-Loing on the outskirts of the forest of Fontainebleau,[8] where an artists' colony had sprung up as an alternative to the increasingly popular Barbizon.[9] The eclectic quality of his experience was a natural aspect of art education in Paris at this period, and it allowed a young artist to explore a rich context and to assert his own identity in response. A glance at the chronology of his career for 1877 tells us that, in May, he received his third-class medal for ornament drawing (see fig. 12) and saw his portrait of Fanny Watts on the Salon walls (*Early Portraits*, no. 20), but he also found time to visit the third Impressionist exhibition and execute a small sketch of Degas's pastel *L'Étoile* (Worcester Art Museum, Massachusetts);[10] in the summer he was in Brittany painting marine studies and preliminary work for his Cancale pictures, in the autumn he was sketching with a friend in Italy and, in October, he and Beckwith were helping Carolus-Duran paint a ceiling decoration, *Gloria Mariae Medicis* for the Palais du Luxembourg (see fig. 26). The latter was Sargent's initiation into the sphere of public art, which would come to strike a dominant chord in his career; the energy and commitment he dedicated to the three mural cycles he was commissioned to paint for the Boston Public Library, the Museum of Fine Arts, Boston, and the Widener Library at Harvard University bear eloquent witness to his allegiance to the tenets of his academic training.

The culture of the École upheld the importance of venerating and copying the old masters in a manner that might seem arid and passive, but this was balanced by the possibility of a vital, dynamic and ambitious relationship with the old masters as demonstrated in the work of Manet. An understanding of this background highlights the aesthetic defiance of *El Jaleo* (no. 772), a vast and ambitious canvas in the *grande peinture* tradition, conceived and executed as a huge sketch. In depicting a contemporary subject but interpreting it in the visual language of the old masters (most vividly Velázquez and Goya), representing members of a despised social group but placing them and their culture within the frame of high art, and expressing a raw, savage energy with more than a glance towards classical monumental design, the painting both embraces and subverts the theology of conventional art. In this respect, *El Jaleo* is close to the spirit of Manet's *Olympia* (1863, Musée d'Orsay, Paris), which Sargent so admired that, in 1889, he spearheaded, with Monet, the campaign to secure it for the French nation. *El Jaleo* may encode an artistic allusion to Manet: Elizabeth Prettejohn has suggested that the orange on the empty chair to the left of the canvas might be an *hommage* to Manet's practice of including a small, discrete still life in compositions such as *Woman with a Parrot* (1866, The Metropolitan Museum of Art, New York) and *The Luncheon in the Studio* (1868, Bayerische Staatsgemäldesammlungen, Munich).[11] In dramatizing the culture of an underclass, *El Jaleo* might be described as romantic in feeling; but the technical virtuosity which was so disturbing to contemporary critics still reads as startlingly modern, particularly the attempt to render sound synaesthetically through spare and discrete colour notes. The painting inspired a contemporary debate on the subject of 'lack of finish' but, in a work that is about unfinished movement, handling acts as metaphor for motif. Everything about the painting is still in progress, the dancer is caught in mid-performance, her fingers are blurred with the speed of their clicking, the fringe of her shawl swirls, a cigar cast aside on the floor smoulders with fire, a musician's mouth is contorted in a continuing wail. Sargent had been awarded a second-class medal at the Salon of 1881 for his portrait of Mme Ramón Subercaseaux (*Early Portraits*, no. 41) and was subsequently *hors concours* (not in competition): he used this new freedom to submit to the Salon of 1882 a work charged with energy, challenge and artistic nerve (though he calibrated the risk by sending it in the company of the captivatingly sweet and artistically deferential *Lady with the Rose* [*Early Portraits*, no. 55], a fine example of Sargent's ability both to extend and propitiate his audience). Sargent was just twenty-six when *El Jaleo* appeared at the Salon, and it stands as a high point of white-heat creativity, artistic adventure and confidence.

The two principal old master influences on the young Sargent were Velázquez and Frans Hals (see introduction to chapter 7, pp. 197–201). From the mid-nineteenth century, artists and commentators had perceived a correspondence between the work of these two seventeenth-century painters and modern impulses and preoccupations, studying them had become programmatic in the more advanced ateliers and admiration of them codified into an ongoing debate about colour, line and finish.[12] Writing under the name Wilhelm Bürger, the French critic and collector Théophile Thoré (1807–1869) played an important role in re-evaluating Hals and in signalling his contemporary relevance, but his spectacular 'rediscovery' of the art of Vermeer was an art-historical landmark.[13] Vermeer was venerated as a practitioner of pure painting, painting which employed the elements intrinsic to itself—colour, light and shade—rather than using the tools that were the province of the draughtsman. Sargent's com-

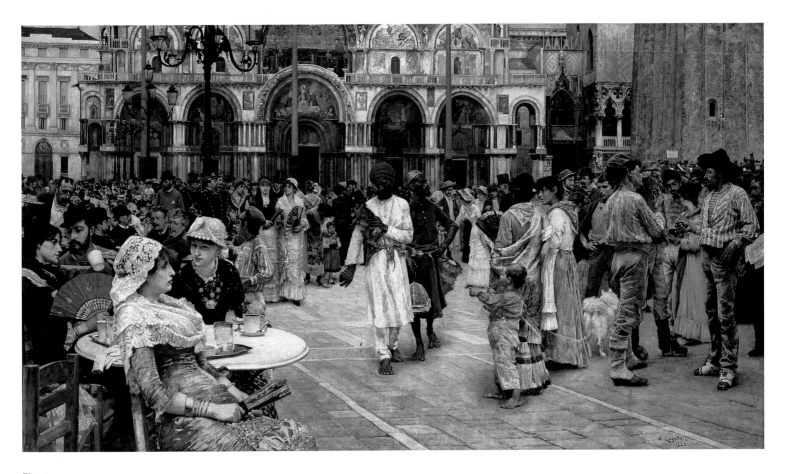

Fig. 6
William Logsdail, *Piazza of St Mark's Square, Venice,* 1883. Oil on canvas,
49⅝ x 87½ in. (126.2 x 222.3 cm). Birmingham Museum and Art Gallery, U.K.

ments on other artists are very rare but, in an undated [probably
1884] letter to Vernon Lee, Vermeer is named as one of a select
band of quintessentially painterly artists: 'You are quite right in
going out of Italy, to Spain and Holland for that quality which the
French call aspect [the surface quality of the paint] and that
the Italian painters never dreamt of. *Not even the Venetians . . .* But
some day you must assert that the only *painters* were Velasquez,
Franz Hals, Rembrandt and Van der Meer of Delft, a tremendous
man'.[14] In August 1880, Sargent was in Holland, before moving
on to Venice,[15] and it is notable that he did not respond to the
picturesque possibilities of Venice as so many of his friends and
contemporaries did, putting Venetian life on canvas with an
'extreme of gaiety and brilliance of colour' (see fig. 6), but to her
courtyards, streets and domestic interiors, the architecture of the
everyday world, bringing something of Vermeer's quiet geome-
tries, the relationship of his figures to the space they inhabit, the
sense of distilled private experience, and cool evocative light and
elusive mood (fig. 7) to his darkly laconic studies of the city.[16]

The French art system at this period was a tripartite one,
based on the atelier, the École and the Salon. The annual Salon
was still the principal public forum for the display of contempo-
rary art in Paris, and it was here that Sargent, like Manet, chose to
exhibit his most important work.[17] He began his Salon career
with a portrait of Fanny Watts, but the subsequent symmetry
between portrait and subject works suggests a deliberate balance
(portraits only began to dominate his Salon contributions after
1882): 1878, *Oyster Gatherers of Cancale (En route pour la pêche);*
1879, a portrait of Carolus-Duran and *Dans les oliviers à Capri*

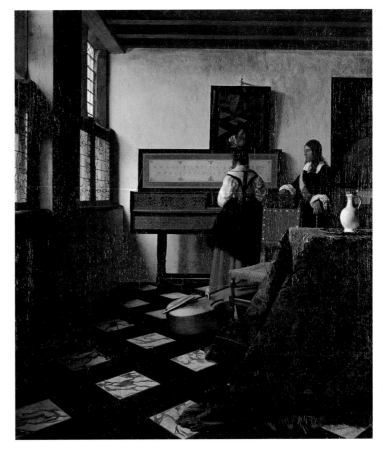

Fig. 7
Johannes Vermeer, *A Lady at the Virginal with a Gentleman (The Music Lesson),*
c. 1662–64. Oil on canvas, 28⅞ x 25⅜ in. (73.3 x 64.5 cm). The Royal
Collection, Windsor Castle.

(Italie); 1880, a portrait of Mme Édouard Pailleron and *Fumée d'ambre gris;* 1881, two portraits (Mme Ramón Subercaseaux and the children of Édouard Pailleron) and two Venetian water-colours (both entitled 'Vue de Venise'); 1882, *El Jaleo* and a portrait of Louise Burckhardt *(Lady with the Rose)*.[18] His Venetian studies aside, the only important subject work that Sargent did not send to the Salon in these years was the sparkling *Neapolitan Children Bathing* (no. 692), the intimacy and delicacy of which would, he might have calculated, have been lost on the crowded Salon walls. It is probable that a combination of commercial considerations, personal contacts and a sense of national loyalty led Sargent to begin cultivating a reputation in America at an early stage. He was a founding member of the organization initially called the American Artists' Association, which subsequently became the Society of American Artists, and he sent the smaller of his two versions of his Cancalaise fishing scene, *Fishing for Oysters at Cancale* (no. 671), to its first exhibition in New York in 1878. The following year he was even-handed, sending *A Capriote* (no. 702) to the Society of American Artists and *Neapolitan Children Bathing* to the more established (and more establishment) National Academy of Design. He showed a canny awareness of national taste and prejudice. In London, he exhibited Venetian works at the forward-looking Grosvenor Gallery and portraits at the Royal Academy, but he did not hazard a subject picture at the Royal Academy until 1887, and only then with a painting, *Carnation, Lily, Lily, Rose* (Tate, London), that was English in sentiment and subject (if not in technique).[19]

The Salon was much vilified, but it was a more inclusive institution than has been appreciated. It had responded, albeit slowly, to changes in the understanding and practice of art, and it served a double function, providing both an umbrella under which artists from across a broad spectrum could shelter and a monolith against which they could define themselves. It was not unusual for artists, even among the radical avant-garde, to move between the Salon and other exhibition societies and venues as they formulated strategies to present their work publicly. Even among the stellar artists of the period, stances were shifting and shaded, and experience variegated and pragmatic. Renoir decided against contributing to the fourth Independent Impressionist exhibition in 1879, but he showed *Madame Georges Charpentier and Her Children* (1878, The Metropolitan Museum of Art, New York), a full-length portrait of the actress Jeanne Samary (1878, State Hermitage Museum, St Petersburg) and two pastels at the Salon that year. Monet, who had exhibited twenty-nine paintings at the fourth group show in 1879, may have been inspired by Renoir's success. In any event, he submitted two paintings to the Salon the following year, though only one was accepted. They were both Lavacourt works, part of a series of large paintings he executed in the studio from smaller studies painted out-of-doors.[20] Monet's comments illuminate the role the Salon played in influencing the art market. In early March 1880 he wrote to his friend the critic Théodore Duret: 'I'm working hard at three large canvases only two of which are for the Salon, because one of the three is too much to my own personal taste to send and would be rejected, and I have had to execute in its place something more judicious, more bourgeois'. He went on to say that the dealer Georges Petit had promised to buy from him if he exhibited at the Salon, but complained that the critics and the public had paid scant attention to 'our little shows' [the Impressionist group exhibitions], which he described as 'much preferable to this official bazaar'.[21]

If we were to take Lord Henry Wotton's pithy comments in Oscar Wilde's *The Picture of Dorian Gray* (1890) and substitute the Salon and one of the smaller, alternative exhibition venues in Paris for the Royal Academy and the Grosvenor, we would arrive at an accurate summary of the state of affairs in the French capital: '. . . The Academy is too large and too vulgar. Whenever I have gone there, there have been either so many people that I have not been able to see the pictures, which was dreadful, or so many pictures that I have not been able to see the people, which was worse'.[22] Attempts to accommodate the sheer number of exhibiting artists and the diversity of their aesthetics exposed stresses in the official exhibition system, which was less and less able to meet the needs of its constituency. A long-standing fault line deepened: changes to the organization of the Salon in 1881 left its prestige diminished and facilitated the growth of alternative exhibitions staged in the private sphere, the avant-garde turning to radical breakaway groupings and the *juste-milieu* artists, who tried to marry aspects of modernity and tradition, forming artists' societies and responding to the opportunities presented by private clubs or *cercles* and by commercial galleries and dealers:

> *Today, the huge hall of the Champs Elysées is no longer big enough; the crowd of works which are officially stacked up no longer satisfy our eyes. It is thanks to our insatiable curiosity that we have, beyond the scope of the annual salon, many small exhibitions set up by artists and enthusiasts. And the pattern is so set that we now have 'the exhibition season' without which no future spring or summer will be complete.*[23]

The *cercles* held annual exhibitions, and they aimed for an aura of intimacy, glamour and exclusivity, which made the huge, public and amorphous Salon seem unwieldy and *démodé*. *Cercle* exhibitions had become an accepted feature of the social season and, while entry was nominally available only to members and their guests, it was not difficult for art devotees to secure invitations. The splendid interiors in which the pictures were displayed were draped in velvet and tapestries and lit by glittering chandeliers, creating an ambience calculated to appeal to an increasingly prosperous, leisured class which might be disposed to turn to collecting as an investment. Opinion as to the artistic value of these *petits salons* was mixed, and commentators were apt to refer to them in condescending tones, regarding them as part of the *arriviste* social scene: 'These little salons, as our friend Jules Claretie has christened them, have never purported to render real service to the cause of art; at least, as long as they were limited in number, they had their use and the critic found pleasure in seeing artists there who were already famous, catching a glimpse of them in their more familiar modes, showing a lapse in good taste'.[24] In some quarters, it was felt that the artists themselves did not take these exhibition venues altogether seriously: 'The "cercle" exhibitions follow on one from another: one might add that they are all alike, and that their interest diminishes as they grow in number. Most of the famous artists who take part in these shows only send minor works and these are lost in a flood of works signed by amateurs or newcomers'.[25] These jaded comments are not untypical, but they present a partial point of view.

The factors driving a particular artist's exhibition strategy may be lost to us and such strategies may have developed organically rather than logically. It seems startling that, as Marc Simpson discovered, Renoir contributed his huge, important canvas *Luncheon of the Boating Party* (1880–81, Phillips Collection, Washington, D.C.) at the Cercle des arts libéraux in April 1881, almost a year before it was shown at the seventh Impressionist exhibition as *Un déjeuner à Bougival,* but its initial appearance at the *cercle* does not seem to have attracted particular attention at the time.[26] Degas also showed one of two versions of the first of his theatrical pictures, *The Ballet from Robert le Diable* (1871, The Metropolitan Museum of Art, New York, or its larger variant, 1876, Victoria and Albert Museum, London), at this show and, while this may not have been the occasion of its first public display, it hardly ranks as a minor work.[27] An assessment of contemporary exhibition practice would underline the miscellaneous character of these smaller shows and reveal some names in unlikely juxtapositions, supporting the view that there were fluid, overlapping communities of artistic sympathy and aspiration at this period rather than conscious and fixed groupings. The 1881 Cercle des arts libéraux exhibition included two of Sargent's Venetian interiors (see p. 319), Jean-Charles Cazin's *Sainte Madeleine,* Carolus-Duran's *La Vision* and *Champ de bataille,* and works by Gustave Doré, Charles Giron, Édouard-Alexandre Sain, Robert-Fleury, Louise Abbéma and Maurice Poirson, whose brother, Paul, would later become Sargent's landlord at 41, boulevard Berthier.[28] It was not incongruous for artists with such different aesthetics and agendas as Degas, Cazin, Renoir, Carolus-Duran and Sargent to exhibit in the same show, and it was natural for Sargent, in writing to invite his friend Mme Allouard-Jouan to the exhibition, to mention some of them in the same sentence: 'Here are some tickets for the cercle. The exhibition will probably open tomorrow Saturday. You will see beautiful things by Degas there, and fine works by Cazin and two studies by Carolus'.[29]

The expanding capitalist economy in France in the latter half of the nineteenth century had given rise to an increasingly confident consumerism, which meant that Paris gained a worldwide reputation as a capital for culture and luxury goods. The art market boomed and dealers became more influential, cultivating rich collectors and mediating between them and the artists for whom they acted. Principal among them were Paul Durand-Ruel (1833–1922), whose vision and acumen were so important in advancing the cause and the fortunes of Impressionist painters, and Georges Petit (1856–1920), who became his rival. Petit was the son of the dealer Francis Petit, who founded his firm of picture dealers in 1846 and had a gallery at 7, rue St Georges, Paris. When Francis Petit died in 1877, his son inherited a château and an estate valued at 2,500,000 francs, including works by Ernest Meissonier worth some 300,000 francs. Petit had a taste for opulence and ostentation and, in 1881, he set himself up in a huge house, 12, rue Godot-de-Mauroy, behind the Église de la Madeleine. The house comprised Petit's private residence, the gallery's offices, a printing workshop (Petit published prints and several artistic publications) and several exhibition spaces, including a hall of more than 2,700 square feet. The entrance to the exhibition space was from the rue de Sèze, and it was here that the inaugural exhibition of Petit's Société internationale de peintres et sculpteurs was held in December 1882 (fig. 8). The opening

was a noteworthy occasion in the Parisian social and artistic calendar: 'Altogether more important is the exhibition on the rue de Sèze, installed in the luxurious rooms in which Monsieur Georges Petit has made a veritable palace of contemporary art, organized by the most brilliant of our young artists who are joined by a certain number of foreign artists of different nationalities, several of whom are already known to and appreciated by Parisian art lovers'.[30]

This exhibition is a valuable lens through which to look at that area of the artistic landscape that could broadly be described as left of centre.[31] It comprised works by twenty-two artists, all relatively young (they were nicknamed 'les jeunes'), including the Frenchmen Jules Bastien-Lepage, Jean Béraud, Jean-Charles Cazin, Ernest-Ange Duez, Gustave Courtois, the Finn Albert Gustav Edelfelt, the Italian Giovanni Boldini, the Spaniard Rogello de Egusquiza, the German Max Liebermann, the Englishman William Stott of Oldham, the Belgian Jan van Beers and the Americans Sargent and Julius L. Stewart. Paul Mantz, who was sympathetic to the particular aesthetic strand that they represented, tried to define their place within the spectrum: 'As soon as you walk into the gallery on the rue de Sèze, you realise that you are dealing with honest, ultra-subtle people who are at pains to say unexpected things. There are even those among them who gladly forget the most basic rules, looking for difficulties where

Fig. 8
'The New Exhibition Space at the rue de Sèze', *La Vie parisienne,* 25 February 1882. Bibliothèque Nationale, Paris.

there are none. You can be certain of this: we're not entering into the temple of intransigence here, but we are perhaps in its less militant wing'.[32] This venture was emphatically internationalist but, individual as these artists were, they were united by an acquired Frenchness of manner and by an allegiance to a French technique: 'What emerges from this collection of works from the hands of artists of different nationalities is the lack of truly distinguishing characteristics. In general, the spirit of individual place, the scent of foreign soil, is missing. In taste, feeling and means of expression they are all closer to home. Almost everywhere one looks one sees the same thing; or rather, the dominant note to be heard is French or, to be precise, Parisian'.[33]

Sargent made a significant contribution to the exhibition. His large, unconventional group portrait *The Daughters of Edward Darley Boit* (*Early Portraits,* no. 56) was shown there six months before it appeared at the Salon, in company with a sensitive portrait study of Mme Allouard-Jouan (*Early Portraits*, no. 52), a spirited, epigrammatic sketch of his friend, the writer Vernon Lee (*Early Portraits,* no. 67) and four Venetian paintings (see p. 320).[34] The inventiveness and ambiguity of *The Daughters of Edward Darley Boit* meant that it attracted a large share of critical attention, but the portrait studies and the Venetian group were noticed and admired. Louis Leroy, the critic noted 'the striking originality of a series of studies done in Venice and elsewhere. If Mr Sargent continues to pursue this route—maintaining his guard against impressionism—he is destined to become the [George] Washington of American art!'[35]

Several of Sargent's fellow-exhibitors were men with rising reputations: Jules Bastien-Lepage (1848–1884), whose sense of immediacy and quasi-photographic realism made him an influential figure, particularly among circles of young artists, and William Stott of Oldham (1857–1900), whose delicate, poetic mood pieces had been appreciatively received in France.[36] Some of the other exhibitors were Sargent's personal friends. He painted portraits of Duez and his wife (*Early Portraits,* nos. 149, 150), inscribed paintings to Cazin, Duez and Edelfelt[37] and owned works by Duez, Bastien-Lepage and Stott.[38] These were all *juste-milieu* artists occupying the aesthetic middle ground and, although Sargent described himself as 'an impressionist [a hardline radical] and an "intransigeant"', he was closer to this artistic fellowship in spirit and in technique.[39]

There were certain coincidences of taste, patronage and influence within this loosely defined group. Stott's *La Tricoteuse* and *Rêve de midi* were exhibited at the Salon in 1881 and both were bought by Ramón Subercaseaux, the Chilean ambassador to Paris, a portrait of whose wife by Sargent was awarded a second-class medal at the same Salon. Sargent had been brought to the attention of the Subercaseaux by *Fumée d'ambre gris*. Both Ernest and Constant Coquelin, who owned works by Sargent (see nos. 806, 795, 809), also owned paintings by his friends and by artists with broadly similar aesthetics. In London in 1881, Stott exhibited his *Prince ou Berger,* which was now known as *Girl in a Meadow* (fig. 9), at the Grosvenor Gallery, and the single-figure-in-a-landscape composition, the vertical format and high horizon, the dreamy mood and aspects of the realization of space and of the facture recall Sargent's *Dans les oliviers à Capri (Italie),* which had been shown at the Salon in 1879. These artists were also drawn to similar subject matter. Edelfelt painted only one large

Fig. 9
William Stott of Oldham, *Girl in a Meadow,* 1880. Oil on canvas, 28¼ x 22¾ in. (71.8 x 57.8 cm). Tate, London.

plein-air picture during all his years in Paris (the vast majority of his outdoor studies were painted on visits to his native Finland), a study of nannies and children in the Luxembourg Gardens (fig. 10; see nos. 721, 722).

Sargent's name was kept in the public eye by the work he showed at the Salon and at smaller, private exhibition venues and by images of his work illustrated in contemporary journals in the form of engravings or caricatures. Changes in social patterns had repercussions for the art market, and artists were working on a smaller, more intimate scale in order to address the tastes and circumstances of potential private collectors. Sargent had responded to the demands of the market in that most of his subject pictures were small-scale works depicting scenes from daily life (*Neapolitan Children Bathing* measures little more than 10 by 16 inches). The exception, in terms of scale, was *El Jaleo,* which spans almost 8 by 12 feet, but its size did not deter its purchase by a Boston financier and diplomat, T. Jefferson Coolidge. It would be a fair summary to say that commercial success came to Sargent primarily through exhibitions and portrait commissions rather than through the intervention of dealers, and even a cursory list would draw attention to the importance of American patronage: *Fishing for Oysters at Cancale* (bought by an American artist); *Neapolitan Children Bathing* (by an American collector); *A Capriote* (by an American with a significant collection, much of it French art), *Fumée d'ambre gris* (probably by a French artist); *Oyster Gatherers of Cancale* (by an American, and an old family friend); *In the Luxembourg Gardens* (by John H. Sherwood, a New York art dealer and

Fig. 10
Albert Edelfelt, *The Luxembourg Gardens, Paris,* 1887. Oil on canvas, 55¾ x 73⅜ in. (141.5 x 186.5 cm). Ateneum Art Museum, Finland. Antell Collection.

uncle of Sargent's friend J. Carroll Beckwith); *Venetian Loggia* and *Spanish Gypsy Dancer* (by a wealthy American, Louis Butler McCagg); *Gitana* (by a French painter, Alfred Philippe Roll); and a picture entitled 'Conversation vénitienne' (by a French physician, aesthete and portrait subject, though the two latter works may possibly have been gifts).[40]

Sargent gave numerous paintings as gifts, and a brief survey of their recipients in conjunction with the portrait sketches he made of friends and artists indicates the breadth of his circle.[41] He gave a version of *Dans les oliviers à Capri (Italie)* to the mother of his friend and fellow-student Eugène Lachaise (no. 703), two paintings to his landlord Dr Abel Lemercier (nos. 665, 801), pictures to personal friends such as Fanny Watts and Arthur Rotch (nos. 666, 705, 673), a Venetian work to the Irishman and art enthusiast Frederick Lawless (no. 804), a Spanish painting with musical connotations to the French composer Emmanuel Chabrier (no. 768) and an exquisite water-colour to the French aesthete Dr Samuel Jean Pozzi (no. 791). As one would expect, a significant number of works were given to fellow-artists, to some of whom he was connected artistically, and to some of whom he was personally close (friendships crossing aesthetic boundaries and making for a heterogeneous medley): Venetian studies to J. Carroll Beckwith, Jean-Charles Cazin, François Flameng, Henry Lerolle and Gustav Natorp (though Lerolle's picture might possibly have been a purchase; see nos. 794, 795, 819, 798, and 829, respectively);[42] water-colours to Ernest-Ange Duez, William Logsdail and Ramón Subercaseaux (nos. 690, 835, 836), the latter two Venetian in subject; four marine paintings and a study of the Pasdeloup Orchestra rehearsing to Henry A. Bacon (nos. 663, 668, 669, 681, 724); a study of a young woman seeking alms and a Capri beach scene to Edelfelt (nos. 697, 726); paintings

to fellow Americans Kenyon Cox, William Walton and William Turner Dannat (nos. 686, 638, 631, 632), a study of a model to Carl (Cecil) van Haanen (no. 635) and a group of works to Auguste Alexandre Hirsch (see appendix 1, p. 387). He also gave paintings to little-known artists such as Frank Hyde, who was an important figure in his sojourn on Capri, and to [Georges?] Lacombe, Louis Schoutetten, [Jules-Guillaume-Auguste?] Ringel and Hippolyte de Vergèses, whose roles in Sargent's life have yet to be discovered (nos. 710, 622, 712, 630, 725).[43]

Sargent was born in Florence and much of his formative artistic experience was rooted in the high realms of Italian art, but he is also very likely to have encountered recent, experimental trends in Italian painting, particularly I Macchiaioli, the group of Italian artists based primarily in Florence and Tuscany, who took their name from the Italian word *macchia* (from the Latin *macula:* blot or stain) meaning mark, spot, blotch, patch, stain or splash.[44] The term was not a new one (Giorgio Vasari used it in describing Titian's late style), and it was associated as much with a particular approach to painting as with physical technique.[45] The formation of the group (between 1853 and 1860) roughly coincided with the excitement that surrounded the Exposition universelle in Paris (1855), and with the growth in appreciation of the work of the Barbizon school and of Camille Corot in France. The group had effectively dissolved by 1862, and various artists associated with it went on to pursue their individual aesthetics, but Macchiaioli works were on public display in Florence in the early 1870s when the Sargent family was living there for part of the year, and Sargent would certainly have had opportunity to see their work exhibited once he moved to Paris.[46]

The Macchiaioli had developed in opposition to the formal teaching of the Accademia delle Belle Arti in Florence, rejecting

its emphasis on the defining line in favour of the representation of an object by means of the contrast of light and shadow. Sargent had himself studied briefly at the Accademia in the spring of 1874, and his father's negative opinion supports the general view that it was, at this time, a hapless and ineffective organization.[47] There are affinities between the Macchiaioli and the Barbizon school and, to an extent, between the Macchiaioli and the Impressionists (though the Italians were decidedly less scientific in approach); they asserted that a painting's effect should reside in the integrity of its painted surface rather than in incident, anecdote or narrative; they adopted a technique notable for its sketchiness and based on the application of patches of colour (promoting the experimental use of colour even more than did the Impressionists); they looked to nature, rather then to classical models; and they were interested in painting *all' aperto,* and in light and atmosphere. Sargent's handling is clearly indebted to the teaching of Carolus-Duran, but there is a sympathy between the *macchia* technique of laying pigment down in quick, large strokes and the concern with representing an object by vivid contrasts of light and shade and Sargent's own evolving facture. The area of real divergence *vis-à-vis* the Impressionists was in what might be described as collective artistic temperament. The Macchiaioli were closely tied to the struggle for Italian independence and nationhood, and their aesthetic was deeply rooted in a rural tradition, whereas the Impressionists came from a society that was bourgeois, urban and industrialized. The Macchiaioli were averse to heroic Grand Tour imagery and were motivated by an impulse to elevate everyday life with its agrarian, domestic and familial concerns, creating small-scale productions in a distinctively Italian idiom, but they had no modern life agenda. Sargent painted few pictures which could be described as depictions of modern, urban life, the exceptions being the two paintings of the Luxembourg Gardens (nos. 721, 722), the two studies of rehearsals of the Pasdeloup Orchestra (nos. 723, 724), and, to a more ambiguous extent, the Venetian studies. His 'modernity' does not, on the whole, manifest itself in the subject matter he chooses. Temperamentally, Sargent was much more attuned to the romantic nostalgia of the Macchiaioli. This is a thread that runs throughout his career, expressed in his preoccupation with vanishing worlds, in studies of oxen and depictions of classical architecture and gardens, rural activities, traditional sailing ships and ancient olive groves. In this respect, he is spiritually closer to artists such as Giovanni Fattori (1825–1908), Silvestro Lega (1826–1895), Giuseppe Abbati (1830–1868) and Telemaco Signorini (1835–1901). The mood of melancholic reverie in Telemaco Signorini's painting of a girl reading in the crook of a tree, for example, is similar to that evoked in Sargent's *A Capriote,* not to mention the near synchronicity of pose (see fig. 80).

Paris was Sargent's geographical base during these years and, while his experience radiated outwards to Brittany, to southern Italy, Spain, North Africa, Holland and Venice (and across the Atlantic to America in 1876), he brought to these places a sophisticated, *raffiné* sensibility that is French in character and at least partially literary in inspiration.[48] Sargent spoke fluent French and, throughout his life, his taste was for French literature, his library biased towards the French classics.[49] He was sensitized to the rarefied aspects of early Decadent or Symbolist strain of French aesthetics rather than to the more literal, documentary concerns of the realist and naturalist schools.[50] Vernon Lee famously noted his predilection for 'the *bizarre* and outlandish', something she considered 'may have been connected with the Parnassian, the Heredia and Leconte de Lisle movement in literature' and which persisted as a reaction against 'the "tastefulness" of the worldly people who sat for him'.[51] He is known to have admired Flaubert, Fromentin and Stendhal, and he would certainly have read the writings of Théophile Gautier and Charles Baudelaire, who, weary of the banalities of modern European ideas of progress and uniformity, looked to the Orient to mend the flaws and supply the deficiencies of contemporary life.[52] Disenchantment with modern urban life and the triteness of bourgeois experience spawned esoteric cults in art and literature and was articulated in a longing for sensual escape and abandon, in an interest in dissolution and dilapidation and in a fascination with the exotic and with occult philosophy. Imagining and imaging 'otherness' took a firm hold on the French psyche. It inspired Baudelaire's 'Parfum exotique', 'La chevelure' and 'Invitation au voyage' in *Les fleurs du mal* (1857), generated the enervated mythology in Leconte de Lisle's *Poèmes barbares* (1872) and found visual expression in 'la peinture orientale'. Théophile Gautier argued that artists needed to look beyond the boundaries of their national traditions towards a universal art, and Sargent's interest in southern Mediterranean physiognomy acts as a reply to Gautier's complaint about 'the monotony of the European type' and the need for it to be balanced or challenged by 'the exotic charms of Hindu beauty, Arab beauty, Turkish beauty, Chinese beauty'.[53] It does not seem far-fetched to see something of Verlaine's poetry of mood permeating Sargent's early work, a Baudelairean insistence on the essential artificiality of art and celebration of the esoteric informing the high artifice, hyper-stylishness and mystery of *Fumée d'ambre gris* and a Baudelairean love of grotesque beauty inflecting *El Jaleo.*[54]

Vernon Lee's comment that the young Sargent 'goes in for art for art's own sake, says that the subject of a picture is not always in the way etc' alludes to the French mantra 'l'art pour l'art' (usually credited to Théophile Gautier), which had many celebrated adherents.[55] This aesthetic creed, which emphasized formalist concerns and valued the essential integrity of an art object without reference to a moral or narrative framework, was also associated with a way of seeing that shunned the obvious and elevated the individual perspective, the quirky, inflected point of view. Sargent never espoused specific artistic theories, but ideas such as these made up the prism through which he scrutinized the world and mediated his experience. His travels and subject matter had their counterparts in those of many artists of his generation; his themes and motifs are not singular, but they are alchemized by the refinement of his sensibility and transformed by the obliquity of his gaze.

—*Elaine Kilmurray*

1. The self-portrait was illustrated in Claude Phillips, 'The Modern Schools of Painting and Sculpture, as Illustrated by the "Grands Prix" at the Paris Exhibition. Great Britain and the United States of America', *Magazine of Art*, 1891, p. 208.

2. 'Sargent is American by birth but his technique is all French' (*Echo de Bruxelles* [Press clipping scrapbook, 1884, unpaginated], Archives de l'Art Contemporain, Musées Royaux des Beaux-Arts de Belgique). Arthur Baignères introduced a discussion of Sargent at the Georges Petit exhibition in 1882 with 'Faut-il compter M. Sargent parmi les étrangers? Il est né en Amérique [*sic*], mais il appris à peindre à Paris, sous la direction de M. Carolus Duran. Il fait honneur à la ville et au professeur' ('Must we count Mr Sargent among the foreigners? He was born in America, but he learned to paint in Paris, under the direction of Mr Carolus Duran. He honours the city and his teacher') (Arthur Baignères, 'Première Exposition de la Société internationale de peintres et sculpteurs', *Gazette des Beaux-Arts*, vol. 27 [February 1883], p. 189). When he moved to England, Sargent confided to an artist friend that 'it might be a long struggle for my painting to be accepted. It is thought beastly french' (Sargent to [Edwin] Russell, 10 September [1885], Tate archives, London). For further definitions of Sargent as a 'French' painter (by French, American and English critics), see Simpson 1997, pp. 42–43.

3. '. . . il était parti avec le mouvement, il était frère d'art, il était matelot avec quelques-uns de ceux dont j'ai parlé tout à l'heure. Il a préféré rentrer dans les conditions communes et déterminées de l'exécution, se contentant d'occuper le haut de l'échelle dans la moyenne bourgeoisie des artistes, ne trempant plus que le bout du doigt dans l'art original où il avait été bercé et élevé, où il avait plongé jusqu'au cou' (Louis-Emile-Edmond Duranty, 'La nouvelle peinture', in Charles S. Moffett *et al., The New Painting: Impressionism 1874–1886* [San Francisco, 1986], p. 480). The English translation quoted in the text is in Moffett *et al., The New Painting*, p. 42.

4. He was placed 37th out of 162 entrants in October 1874, 39th in May 1875 and 2nd in March 1877, when he also received a third-class medal for ornament drawing. For an illustration of the ornament drawing, with the examiner's annotations, see fig. 12. See also *Le Voyage de Paris: Les Américains dans les écoles d'art 1868–1918, Les Dossiers du Musée du Blérancourt*, no. 1 (Paris, 1990), fig. 42.

5. Sargent to Augustus Case, 7 April 1877, private collection.

6. Emily Sargent to Vernon Lee, 19 September [18]77, Special Collections, Millar Library, Colby College, Waterville, Maine.

7. See Charteris 1927, pp. 22, 36.

8. Dr Fitzwilliam Sargent wrote to his father at the end of May 1874: 'Next month, or rather in July, the teacher [referring to Carolus-Duran] moves out to Fontainebleau—a couple of hours or less from Paris, by railway,—and those of the pupils who choose can accompany him and continue their studies there, where the forest is one of the finest, perhaps the finest, in France; it has always been the property of the State, and has always been cared for. It will be a pleasant change to all of us, to leave the heat & crowds of Paris & fix ourselves in the quiet shades of Fontainebleau' (Dr Fitzwilliam Sargent to his father, 30 May [1874], Archives of American Art, Smithsonian Institution, Washington, D.C.).

9. A visit made by Sargent and J. Carroll Beckwith to Grez in July 1881 in company with the family of Louise Burckhardt and the Sorchans is recorded in Beckwith's diary (see chronology, p. 14). The village is recalled in a letter to Vernon Lee: '. . . So you are going to Grez! How did you ever hear of the place. It is very pretty but a very nest of Bohemians, English Bohemians, who will swoop down upon you. Tel le vautour. You will meet the irresistible O'Meara and my very good friend Arthur Heseltine. You will probably be introduced to these gentlemen's heads bobbing about with hats on, for they are all the time bathing from your garden. There are two inns at Grez, the disreputable and the semi-reputable one, the latter is called Chez Chévillon, the latter Chez Laurent or Lambert. And now heaven protect you. Perhaps I may take a holiday and swoop down upon you at Grez' (Sargent

to Vernon Lee, 16 August [1881], private collection).

10. Degas's *L'Étoile* (Musée d'Orsay, Paris) was the work exhibited as 'Ballet' in the third Impressionist exhibition in 1877.

11. Prettejohn 1998, p. 17.

12. For a bibliography on Velázquez, see p. 202, n. 2; and Tinterow *et al.* 2003. For critical response to Sargent's work indicating the influence of Velázquez, see Simpson 1998, pp. 3–12. For Hals, see Frances S. Jowell, 'The Rediscovery of Frans Hals' in Slive *et al.* 1989, pp. 61–86. See the bibliography for Bürger's publications on Frans Hals and on Dutch art. See also 'Le Modernisme de Frans Hals', *L'Art Moderne*, no. 38 (23 September 1883), pp. 301–3.

13. See Wilhelm Bürger, 'Van der Meer de Delft', *Gazette des Beaux-Arts*, vol. 21, pp. 297–330, 458–70, 542–75.

14. Special Collections, Millar Library, Colby College, Waterville, Maine; quoted in Ormond, *Colby Library Quarterly*, 1970, p. 171.

15. In a letter to his friend Fanny Watts written some years later, Sargent noted: 'If you go to Holland you will find Amsterdam & Haarlem the most interesting places. In Amsterdam mind you go to the Musée Van der Hoop & see the *Van der Meer of Delft*, a little woman in blue standing at a window. Also two *Van der Meer of Delft* at the House of Burgomaster-Six' (Sargent to Fanny Watts, 5 October [1884], private collection). The works by Vermeer are *Woman in Blue Reading a Letter*, c. 1663–34, *The Little Street*, c. 1657–58 and *The Milkmaid*, c. 1658–60, then in the collection of Jonkheer Jan Pieter Six van Hillegom and Jonkheer Pieter Six van Vromade, Amsterdam. The underlining in the quoted text is Sargent's own. All three paintings are now in the Rijksmuseum, Amsterdam.

16. 'Royal Academy: Second Notice', *The Times*, 12 May 1884, p. 4; quoted in Simpson 1997, p. 97. The reviewer is describing two paintings by Luke Fildes, *Venetian Life* and *The Venetian Flower Girl*.

17. In a letter to Augustus Case, son of Admiral Case, an old family friend, Sargent explained the ordeal of the Salon admission procedure: 'Towards the beginning of January I began a large portrait of a young American lady [his portrait of Fanny Watts, *Early Portraits*, no. 20] with a view to send it to the Salon or annual exhibition of fine arts which opens on the first of May. About 6000 pictures are sent every year two or three thousand being accepted and the rest refused, by a jury who sits on them in the early part of April. It was with a good deal of anxiety that I waited for the decision of my fate, but after a fortnight's doubt I saw my name printed on the list with a capital A, which means accepted. So I am in. Three cheers' (Sargent to Augustus Case, 7 April 1877, private collection).

18. *Oyster Gatherers of Cancale* (*En route pour la pêche,* no. 670); portrait of Carolus-Duran (*Early Portraits*, no. 21); *Dans les oliviers à Capri (Italie)* (no. 703 or 704); portrait of Mme Édouard Pailleron (*Early Portraits*, no. 25); *Fumée d'ambre gris* (no. 789); portraits of Mme Ramón Subercaseaux (*Early Portraits*, no. 41) and the children of Édouard Pailleron (*Early Portraits*, no. 37); and two Venetian water-colours (both entitled 'Vue de Venise') (see pp. 315, 320, 322).

19. *Carnation, Lily, Lily, Rose,* was a great success at the Academy and was immediately acquired for the nation under the terms of the Chantrey Bequest. It is an art-historical irony that, of the several countries in which Sargent lived and worked, it was conservative England that made the first national purchase.

20. The Monet exhibited at the Salon in 1880 was *Lavacourt* (Dallas Museum of Art, Texas); the painting that was rejected was *The Ice-Floes* (Shelburne Museum, Shelburne, Vermont).

21. Claude Monet to Théodore Duret, 8 March 1880: 'Je travaille à force à trois grandes toiles dont deux seulement pour le Salon, car l'une des trios est trop de mon goût à moi pour l'envoyer et elle serait refusée, et j'ai dû en place faire une chose plus sage, plus bourgeoise' 'nos petits expositions . . . bien préférables à ce bazar officiel' (Daniel Wildenstein, *Claude Monet: Biographie et catalogue raisonné*, vol. 1 [1840–1881] [Lausanne and Paris, 1974]), p. 438.

22. *The Picture of Dorian Gray*, ed. Peter Ackroyd (1890; reprint Harmondsworth, England, 1985), p. 6.

23. 'Aujourd' hui, le vaste hall des Champs Elysées ne saurait suffire; la cohue d'ouvrages qu'on y entasse officiellement ne comble plus nos yeux; à notre curiosité

inlassable il faut, en outre du Salon annuel, beaucoup de petites expositions dues à l'initiative de groupes d'artistes et d'amateurs. Et le pli en est si bien pris que nous avons maintenant "la saison des expositions"; de laquelle nous ne pourrions pas plus nous passer désormais que d'étés ou de printemps' (Olivier Merson, 'Exposition du Cercle artistique et littéraire, rue Volney, et du Cercle de l'union artistique, place Vendôme', *Le Monde Illustré*, vol. 52, no. 1353 [3 March 1883], p. 134).

24. 'Ces petits Salons, comme les a spirituellement appelés notre confrère Jules Claretie, n'ont jamais eu la prétention de rendre des services très sérieux à la cause de l'art; du moins, tant que leur nombre était restraint, ils avaient leur utilité et la critique trouvait plaisir à venir surprendre chez eux des artistes déjà célèbres, entrevus sous des aspects plus familiers et comme dans le laisser-aller d'une intimité de bon goût' (Jules Comte, 'Les Derniers Expositions d'art', *L'Illustration*, no. 2079 [30 December 1882], p. 454).

25. 'Les Expositions de cercles se suivent; on peut ajouter qu'elles se ressemblent, et que leur intérêt va chaque jour diminuant, à mesure qu'elles deviennent plus nombreuses. La plupart des artistes célèbres qui y prennent part n'y envoient plus que des oeuvres sans importance, qui se trouvent perdues dans un déluge d'ouvrages signés de noms d'amateurs ou de débutants' ('Chronique des Beaux-Arts', *L'Illustration*, no. 1929, vol. 75 [14 February 1880], p. 114).

26. See Simpson 1997, p. 160 n. 13; and Marc Simpson, 'The Earliest Public Exhibition of Renoir's "Luncheon of the Boating Party"', *Burlington Magazine*, vol. 139, no. 1129 (April 1997), pp. 261–62.

27. It is not known which of the two versions of *The Ballet from Robert le Diable* Degas exhibited at the Cercle des arts libéraux in 1881. Degas had sent the earlier version to the *Fourth Exhibition of the Society of French Artists* in 1872. For information about the provenance and exhibition history of both works, see Jean Sutherland Boggs *et al., Degas*, The Metropolitan Museum of Art, New York, and National Gallery of Canada, Ottawa, 1988, pp. 171–73 and 269–70.

28. Maurice Poirson (1850–1882) exhibited a work entitled *Le Canotier.*

29. 'Voici des billets pour le cercle. L'exposition ouvrira probablement demain samedi. Vous y verrez de beaux Degas, de beaux Cazin et deux études de Carolus' (private collection). The letter, headed 'Vendredi', is undated, but the context suggests that Sargent was referring to the exhibition of the Cercle des arts libéraux on the rue Vivienne in spring 1881. Sargent's portrait of Mme Allouard-Jouan was one of the works included in the exhibition at the Galerie Georges Petit in December 1882 (see *Early Portraits*, no. 52).

30. 'Tout autrement importante est l'exposition de la rue de Sèze, installée dans la salle somptueuse dont M. Georges Petit a fait le veritable palais de l'art contemporain, organisée, sans prétention d'école, par les plus brilliants de nos jeunes, qui se sont adjoint d'un certain nombre d'artistes étrangers, de nationalités diverses, dont plusieurs déjà connus et appréciés des amateurs parisiens' (Jules Comte, 'Les Derniers Expositions d'art', *L'Illustration*, no. 2079 [30 December 1882], p. 455).

31. For Albert Boime's definition and discussion of a Third Republic *juste milieu*, see *The Academy and French Painting in the Nineteenth Century* (London, 1971), pp. 15–21.

32. 'Dès qu'on pénètre dans la galerie de la rue de Sèze, on s'aperçoit qu'on a affaire à d'honnêtes gens ultra-raffinés qui s'étudient à dire des choses imprévues. Il en est même quelques-uns qui oublieraient volontiers les lois les plus élémentaires de l'horlogerie pour chercher midi à quatorze heures. Sachons-le bien: nous n'entrons pas ici dans le temple de l'intransigeance, mais nous sommes peut-être dans la section des agités' (Paul Mantz, 'Exposition de la Société internationale', *Le Temps*, 31 December 1882, p. 3).

33. 'Ce qui ressortirait même de l'ensemble de ces ouvrages venus de climats divers, c'est le manque de caractères franchement distinctifs. En general, l'intimité locale, le parfum de terroir exotique font défaut. Le goût, le sentiment, les moyens d'expression sont à peu près, presque partout, les mêmes; ou plutôt, ce qui domine c'est la note française, j'entends, pour être tout à fait exact, la note parisienne' (Olivier Merson, 'Pre-

mière Exposition de la Société internationale de peintres et de sculpteurs—Galerie Georges Petit, rue de Sèze, 8', *Le Monde Illustré, no. 1348, vol. 52 [27 January 1883], p. 58).

34. In 1885, after the public and critical response to his portrait of Mme Gautreau had damaged his reputation in Paris, Sargent exhibited two formal portraits, a head and shoulders study of Rodin (*Early Portraits*, no. 146) and an *esquisse* (*Le verre de Porto* [A Dinner Table at Night], *Early Portraits*, no. 133) in the Exposition internationale de peinture, which was inaugurated at Petit's gallery in May 1882 as a separate series of annual exhibitions. Albert Besnard and Monet also exhibited with Petit in 1885 and Petit organized a joint Monet-Rodin retrospective in 1889.

35. '. . . une série d'études prises à Venice et ailleurs, d'une originalité puissante. Si M. Sargent continue de marcher dans cette voie,—en se tenant en garde contre l'impressionisme,—il est appelé à devenir le Washington de l'art américain!' (Louis Leroy, 'Beaux-Arts', *Le Charivari*, 28 December 1882, p. 2).

36. See Roger Brown, *William Stott of Oldham, 1857–1900: A Comet Rushing to the Sun* (London, 1993).

37. Sargent's *A Venetian Interior* (no. 795) is inscribed to Cazin and *Filet et Barque* (no. 690) to Duez. For paintings inscribed to Edelfelt, see nos. 697, 726.

38. The oil study of hydrangeas by Duez that Sargent owned is in a private collection. *Fishing Boats Leaving a French Harbour* by Bastien-Lepage and *A Sheep Pasture* by Stott were in the artist's sale, Christie's, London, 27 July 1925, lots 306 and 313, respectively. Sargent also owned a copy of Saint-Gaudens's medallion of Bastien-Lepage; see chronology, p. 13.

39. Sargent is using the appellation 'impressionist' in the inclusive sense that it held for his contemporaries, that is, embracing art that was not academic. For a discussion of Sargent's identification as an 'impressionist' painter, see Simpson 1997, pp. 50–51; and *Early Portraits*, p. 20, n. 16.

40. For discussion of the identity of 'Conversation vénitienne' see pp. 321–22.

41. Sargent's portrait studies of friends and fellow-artists and associates are catalogued in *Early Portraits*.

42. *Venetian Interior* (no. 798) belonged to the artist Henry Lerolle (1848–1929), though it is not known how or when he acquired the work. Lerolle moved in the same circles as Sargent in the 1880s, being a particular friend of Albert Besnard. His scenes of contemporary life were influenced both by the Impressionists and the naturalists, and place him, like Sargent, as an artist of the *juste milieu* (see fig. 96). He also painted religious scenes and carried out a number of decorative mural schemes. His own collection included works by Puvis de Chavannes, Henri Fantin-Latour, Albert Besnard, Camille Corot, Edgar Degas and Pierre-Auguste Renoir. Music may have provided a further link between the two men—Lerolle was a talented violinist and the brother-in-law of the composer Ernest Chausson. Besnard may also have owned one of Sargent's Venetian works (see introduction to chapter 10, p. 321).

43. In the opinion of the authors, the inscription (upper right) on *Unknown Woman* (*Later Portraits*, no. 616, pp. 277, 278, ill.), which was described as indecipherable, reads *à mon ami Lahaye/John S. Sargent* and probably refers to Alexis Marie Lahaye (1850–1914), a French artist whose name occurs in J. Carroll Beckwith's diary (see chronology, p. 14). The paintings which were gifts to Alma Strettell, Mrs Gardner, George Henschel, Charles Follen McKim and Philip Sassoon (nos. 699, 763, 762, 723, 722, 625, 713) were all probably given at a later date.

44. For more detailed discussion of I Macchiaioli, see Manchester City Art Gallery and Edinburgh City Art Centre, *The Macchiaioli: Masters of Realism in Tuscany* (Rome, 1982); Raffaele Monti, *Le Mutazioni della 'Macchia'* (Florence, 1985); *The Macchiaioli: Painters of Italian Life 1850–1900,* ed. Edith Tonelli and Katherine Hart (University of California at Los Angeles, 1986); Norma Broude, *The Macchiaioli: Italian Painters of the Nineteenth Century* (New Haven and London, 1987); Albert Boime, *The Art of the Macchia and the Risorgimento: Representing Culture and Nationalism in Nineteenth-Century Italy* (Chicago and London, 1993); and Roberta J. M. Olson *et al., Ottocento: Romanticism and Revolution in 19th-Century Italian Painting* (New York and Florence, 1993).

45. Vasari was discussing Titian's Crucifixion in the church of San Domenico in Ancona.

46. Various Macchiaioli artists participated in exhibitions held under the auspices of the Società d'Incoraggiamento delle Belle Arti in Florence in 1871, 1873 and 1874, when the Sargents were living there for part of the year.

If we were to take the years that are bracketed in this volume (1874–1882) as parameters, we could trace something of the lattice of cross-currents between Italian and French art of the period. The more internationalist Telemaco Signorini and Giovanni Boldini (1841–1931) worked together in the Marne and Seine in 1874; Signorini would go on to develop a more Impressionist, and Boldini a more virtuoso, style. Giovanni Fattori exhibited at the Salon in 1875 and 1876, Giovanni Boldini in 1876, 1879 and 1880, Vito D'Ancona (1825–1884) in 1877 and Vincenzo Cabianca (1827–1902) in 1878. Federico Zandomeneghi (1841–1917) exhibited at the Salon in 1877 and with the Impressionists in Paris in 1879, 1880 and 1881 (and again in 1886). Diego Martelli (1839–1896) lectured on the French Impressionists to the Circolo filologico in Livorno in 1879 (a lecture that was subsequently published as a pamphlet). Giuseppe de Nittis exhibited, at the invitation of Degas, with the Impressionists in their first exhibition, and an exhibition of his pastels was held at the Cercle de l'union artistique in Paris in 1881. A number of Macchiaioli artists also travelled to and exhibited in Britain. Giovanni Costa (1826–1903) had a circle of English friends, notable among them Lord Leighton, and he contributed to shows at the Royal Academy, the Grosvenor and the Fine Art Society, Cabianca exhibited at the Royal Academy and the New Gallery and Telemaco Signorini exhibited at several venues in London: the Dudley Gallery, Grosvenor, the New Gallery and the Royal Academy. For Degas and Italy, see Ann Dumas, *Degas and the Italians in Paris* (Edinburgh, 2003).

47. In a letter to his own father (25 April [1874]), Dr Fitzwilliam Sargent wrote: 'We are going to Paris, to see what we can do in the way of getting John under some good instruction. He has made good progress this winter in spite of disadvantages—the instruction at the Academy here [Florence] not being what it ought to be' (Archives of American Art, Smithsonian Institution, Washington, D.C.).

48. During his Paris years, Sargent developed a network of contacts in the literary world. The playwright Édouard Pailleron, whose father-in-law, François Buloz, was editor of the conservative but influential *Revue des Deux Mondes*, was an early patron; he painted portraits of the Polish-born novelist Charles Edmond, the poet and essayist Charles Frémine, the writer Judith Gautier and the eminent art critic Louis de Fourcaud (*Early Portraits*, nos. 93, 102, 76–81, 123), and counted among his circle the connoisseur and collector Dr Pozzi (see

no. 791), the poet Robert de Montesquiou and the novelist Paul Bourget. Bourget's essay on Baudelaire was published in 1881: Paul Bourget, 'Essai de psychologie contemporaine: Charles Baudelaire', *Nouvelle Revue*, vol. 13 (1881), pp. 398–417.

49. In conversation with Lucia Fairchild, Sargent called Flaubert's work 'respectable', which was a term of high praise (Lucia Fairchild Diary, 2 October 1890, p. 32). He also spoke enthusiastically about Balzac (Lucia Fairchild Diary, p. 41). Lucia Fairchild Fuller's papers are in the collection of Dartmouth College, Hanover, New Hampshire (and on microfilm at the Archives of American Art, Smithsonian Institution, Washington, D.C., reel 3825, frames 1–266). After Sargent's death, Hamilton Minchin wrote that he 'was, like Delacroix, a great reader, and more intellectual than artists usually are; the only books, however, that I remember his praising were *Madame Bovary* and Fromentin's *Une Année dans le Sahel* and *Un Été dans le Sahara*, partly because, like Delacroix, he had been there himself; also *Les Maîtres d'Autrefois*, a masterly study of the Flemish and Dutch schools' (Minchin 1925, p. 738). For Sargent's admiration of Stendhal, see p. 281. In her personal memoir, Emily Sargent's friend Eliza Wedgwood wrote that: 'he cared little for English Literature, and explained this to me as having been brought up to care for French letters and the French style'. She also noted among the books that he would take on sketching trips to the Continent, Montaigne's essays, G. Lenotre's [the pen name of Théodore Gosselin] books on the French Revolution, books about Louis XIV's time and Madame de Pompadour's letters (Eliza Wedgwood, 'Memoir', in the form of a letter to Sargent's biographer Evan Charteris, 22 November 1925, p. 10, catalogue raisonné archive). Sargent died with a copy of Voltaire's *Dictionnaire philosophique* open on the bed beside him. Sargent's extensive library of the French classics is in a private collection.

50. I am grateful to Angus Wrenn for elucidating some of the complex developments in French literature of the period. See Angus J. Wrenn, *A Reading of the Fiction of Henry James within the context of the French Literature of the Second Empire with particular reference to novelists published in the Revue des deux mondes* (Ph.D. thesis, University of London, 2002).

51. Vernon Lee, 'J.S.S.: In Memoriam', published in Charteris 1927, pp. 251, 252–53. For Vernon Lee on Sargent's use of the word 'curious' in the context of his interest in the bizarre and fantastic, see p. 281. Lucia Fairchild records that, in an informal conversation, Sargent said that Leconte de Lys [*sic*] was: 'a sort of Bible to so many people, but he couldn't abide it!' (Lucia Fairchild Diary, p. 41).

52. For Baudelaire as a possible inspiration for one of Sargent's studies of a Spanish Madonna, see no. 760. Sargent owned a copy of the poems of the American decadent poet Edgar Allan Poe: *Les Poèmes d'Edgar Poe,* translated by Stéphane Mallarmé, with a portrait and illustrations by Édouard Manet (Paris, 1889). The book was in the sale of Sargent's library, Christie's, London, 29 July 1925, lot 88.

53. Théophile Gautier, 'Salon de 1849' in *Voyage en Algérie,* ed. Denise Brahimi (Paris, 1989), p. 176; quoted in Roger Benjamin, *Orientalist Aesthetics: Art, Colonialism, and French North Africa 1880–1930* (Berkeley, Los Angeles and London, 2003), p. 19.

54. This is supported by the language used in contemporary reviews, notably of *Fumée d'ambre gris*. See Simpson 1997, pp. 92, 94.

55. Vernon Lee to her mother, 21 June 1881, *Vernon Lee's Letters* 1937, p. 63.

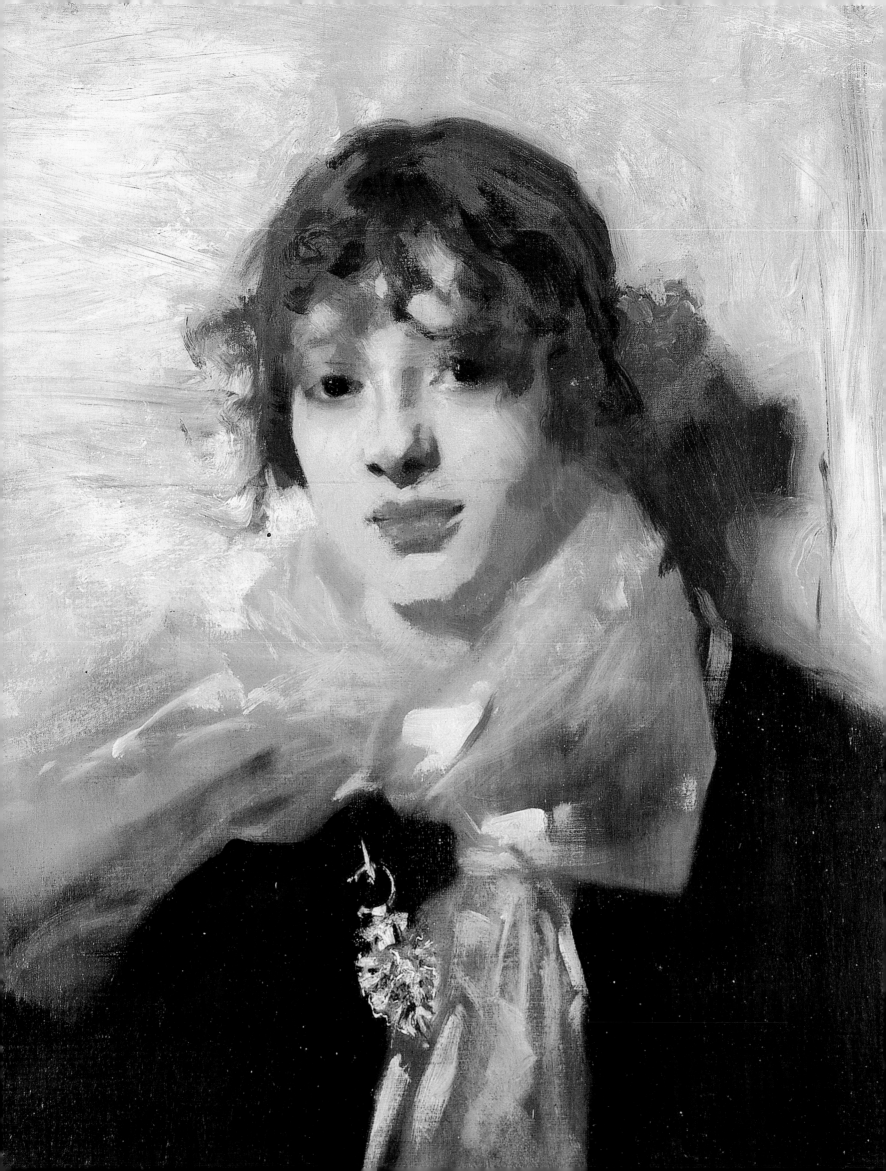

The studies of models in oil and water-colour catalogued here represent only a fraction of the work which Sargent must have executed in the various ateliers and art schools he attended in Paris. Fellow-student Will Low records how Sargent, when he first came to Carolus-Duran's studio as a prospective student in May 1874, brought with him 'a great roll of canvases and papers, which unrolled displayed to the eyes of Carolus and his pupils gathered about him sketches and studies in various mediums, seeming the work of many years . . . an amazement to the class, and to the youth [Low] in particular a sensation that he has never forgotten'.[1] Of that great bundle of pre-Paris material which secured Sargent's entry to the atelier, *The Dancing Faun, after the Antique* (fig. 11) is a rare survival, demonstrating his secure grasp of the principles of academic draughtsmanship as taught in the Accademia delle Belle Arti in Florence. The only known drawing of comparable finish and complexity is the *Dessin d'ornement* (fig. 12),[2] a superb study of a Renaissance plinth, with which Sargent won a third-class medal in the *concours d'ornement* at the École des Beaux-Arts on 24 May 1877; no medal higher than his was awarded that year.

The few recorded drawings of models from the period of Sargent's studentship in Paris are free and sketchy in comparison with *The Dancing Faun* and the *Dessin d'ornement*. The selection of studies illustrated here (figs. 13–16, 20) shows models, mostly male nudes, posed on the model stand in a series of academic attitudes. Sargent's heavy use of cross-hatching allows him to draw out form through the interplay of light and dark values, as recommended by Carolus-Duran. These studies come from a group of early drawings that were exhibited at Grand Central Art Galleries, New York, in 1928, mostly untraced.[3] They were photographed

at the time by Peter A. Juley, and these negatives are now held by the Smithsonian American Art Museum, Washington, D.C.

Carolus-Duran's atelier had been founded eighteen months before Sargent joined it. An American art student, Robert C. Hinckley, had asked the older artist for advice and criticism of his work. This request Carolus refused, but said he would give regular instruction if Hinckley organized an atelier. This Hinckley duly did, establishing it first in rue de Notre-Dame-des-Champs, where Sargent would have his own studio, later in boulevard du Montparnasse. Carolus-Duran's emphasis on painting rather than drawing singled out his from other ateliers, where students had to draw from casts, then from life, before they were allowed to touch a paintbrush. He soon established a following, mostly English and American art students, attracted by his growing reputation as an innovator and his unconventional methods. He taught his pupils to paint with great exactitude, recording what they saw in terms of the relative values of light and dark, and putting down a single stroke for each variation of tone. 'Search for the half-tone', he told them, 'put in some accents and then the lights . . . Velasquez, Velasquez, Velasquez, relentlessly study Velasquez'.[4]

This was a method of teaching that called for precision of observation and great confidence in the handling of paint, and it suited Sargent down to the ground. To an artist friend, Heath Wilson, he wrote three weeks after joining:

I am quite delighted with the atelier where, with the exception of two nasty little fat Frenchmen, the pupils are all gentlemanly, nice fellows. . . . Duran comes regularly twice a week to our atelier and carefully and thoroughly criticises the pupils' work staying a short time with each one. He generally paints a newcomer's first study, as a lesson,

and, as my first head had rather too sinister a charm, suggesting immoderate use of ivory black, he entirely repainted the face, and in about five minutes made a fine thing out of it, and I keep it as such.[5]

Sargent was soon recognized as the star pupil of the establishment, looked upon as the benchmark against which other students measured their progress, and he became close to Carolus-Duran himself. In the spring of 1875, the two men travelled together to the South of France, sharing a hotel room, and two years later they were in Lille, Carolus-Duran's home town, where Sargent painted a copy in oil on panel of the famous wax bust of a young woman in the museum (no. 727). When Carolus-Duran won a commission to paint a ceiling decoration for the Palais du Luxembourg (fig. 26), he turned to Sargent and J. Carroll Beckwith to give him assistance, a sure sign of his confidence in them. Sargent continued to frequent his master's atelier for more than five years. Hamilton Minchin, an English art student, records meeting him there in the autumn of 1878: 'Sargent, as a Salon exhibitor or artist *arrivé,* did not come regularly to the studio, but attended much more frequently in the summer months of '79 than in the previous winter. He had a great reputation already in the American colony, a *Tu Marcellus eris!* for, in '78, he exhibited "Beach at Cancalé", which I saw in his studio, and, in '79, a portrait of Carolus-Duran looking, as some wag said, like a fashionable dentist'.[6]

Sargent's surviving studies of models reflect very clearly the lessons of his master, in their expressive realism, dramatic contrasts of light and dark and their bold brushwork. The art critic R. A. M. Stevenson, who was a contemporary of Sargent's in the atelier, summarized the essence of Carolus-Duran's teaching in his book on Velázquez:

Fig. 11 *(left)*
The Dancing Faun, after the Antique, 1873–74.
Black chalk and charcoal on paper,
30⅛ x 19⅝ in. (76.6 x 49.9 cm). Fogg Art
Museum, Harvard University Art Museums,
Cambridge, Massachusetts. Gift of Mrs Francis
Ormond, 1937 (1937.8.16).

Fig. 12 *(below)*
Dessin d'ornement, 1877. Pencil on paper,
24¾ x 19⅛ in. (63 x 48.5 cm). Various
inscriptions, top right. École Nationale
Supérieure des Beaux-Arts, Paris (PC 8628).

Fig. 13 *(below)*
In the Studio, c. 1874.
Dimensions unknown.
Untraced. From a negative
by Peter A. Juley, c. 1928.
Peter A. Juley & Son Collection.
Smithsonian American Art
Museum, Washington, D.C.
(PPJ-22531).

By his method of teaching, he hoped at least to give the student a knowledge of what he saw, and a logical grasp of the principles of sight. After a slight search of proportions with charcoal, the places of masses were indicated with a rigger dipped in flowing pigment. No preparation in colour or monochrome was allowed, but the main planes of the face must be laid directly on the unprepared canvas with a broad brush. These few surfaces—three or four in the forehead, as many in the nose, and so forth—must be studied in shape and place, and particularly in the relative value of light that their various inclinations produce. They were painted quite broadly in even tones of flesh tint, and stood side by side like pieces of a mosaic, without fusion of their adjacent edges. No brushing of the edge of the hair into the face was permitted, no conventional bounding of eyes and features with lines that might deceive the student by their expression into the belief that false structure was truthful. In the next stage you were bound to proceed in the same manner by laying planes upon the junctions of the larger ones or by breaking the larger planes into smaller subordinate surfaces. You were never allowed to brush one surface into another, you must make a tone for each step of a gradation. Thus, you might never attempt to realise a tone or a passage by some hazardous uncontrollable process.[7]

Sargent understood the importance of underlying structure in expressing form through the precise control of tonal values. His studies of heads and figures are fully formulated as studio exercises, but at the same time they are atmospheric and painterly. In his brooding pictures of beautiful Italian young men and women or his sensual studies of children, he exhibits an aesthetic sensibility allied to academic rigour.

Most of Sargent's studies of models were painted between 1874 and 1880, and it is difficult to be precise about their dating. The *Head of a Woman,* dated 1874 (fig. 17), was taken off the books of M. Knoedler & Co., New York, in 1922, as a business-loss expense, meaning that they doubted its authenticity, and it has not been seen since (stock no. 15117). If it is right, which is possible, it would be the earliest oil study of a

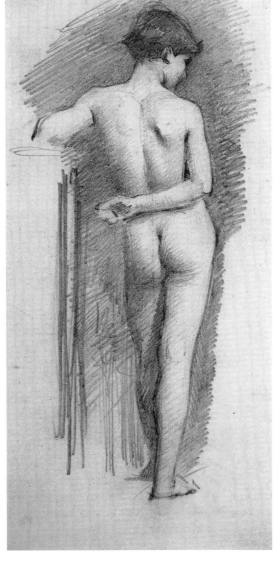

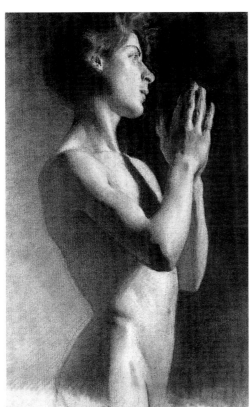

Fig. 14 *(far left)*
Study of a Woman's Head, c. 1874–77.
Pencil on paper, 6¼ x 4 in.
(15.9 x 10.2 cm). Private collection.

Fig. 15 *(left)*
Study of a Nude Youth, c. 1874–77. Pencil
on paper, 9 x 5 in. (22.9 x 12.6 cm).
Private collection.

Fig. 16 *(below left)*
Light and Shade, c. 1874–77. Charcoal
on paper, 13 x 8¹¹⁄₁₆ in. (33 x 22 cm).
Private collection.

Fig. 17 *(below)*
Attributed to John Singer Sargent,
Head of a Woman, 1874. Oil on canvas,
15¾ x 12¾ in. (40 x 32.5 cm). Inscribed,
bottom right: *J. S. Sargent/Paris Dec. 1874.*
Untraced. From a Knoedler & Co.,
New York, negative, c. 1920.

model to survive. *A Male Model Standing before a Stove* (no. 621), which is tentatively dated c. 1875–77, may have been painted in Carolus-Duran's studio. A rare description of the studio in 1878–79, when it was in the boulevard du Montparnasse, is given by Hamilton Minchin: 'The studio had no furniture but about thirty easels and stools, a platform for the model, and a stove for the winter months.'[8] The studies of children in studio interiors (nos. 629, 630) are to be dated later, and they would probably have been painted in the artist's own studio or that of a friend, since children were not generally employed as models in the ateliers or art schools. *Blonde Model* (no. 622) is close in style to the Carolus-Duran ceiling decoration for the Palais du Luxembourg (fig. 26) and probably dates from the same period.

Dating the soulful studies of beautiful Italian young men is more problematic (nos. 623–26). In his description of Carolus-Duran's atelier, Will Low records that the models, chosen by vote, 'were of all types, ages, and of colour, I might say, for the Negro and the Arab were of the number'.[9] However, the male models he remembered were mostly veterans: the old model who had sat to Ingres, père Gélon, another ancient, père Lambert, the brawny Schlumberger and the Herculean Thullier. Female models were younger and chosen for their looks, but there is no mention of young Italian men. Though dated '1876', Sargent's *Study of a Male Model* (no. 628) seems close stylistically to pictures painted in Capri in 1878. The three half-lengths of Italian models (nos. 623–25), possibly the same person, are also likely to date from the end of the 1870s. Similar in date is a group of studies of female models who may be Spanish or Venetian: *Head of a Woman with Gold Earrings, Head of an Italian Woman, Head of a Young Woman, Gitana* and *Study of a Model* (nos. 633–37). These are powerful independent studies and not schoolroom exercises.

Sargent painted one intriguing *Interior of a Studio* (no. 620), with students ranged on tiers of benches drawing from a female model. This might be the École des Beaux-Arts, since the size of the room and the fixed furniture suggest a degree of formality absent from Carolus-Duran's atelier. Sargent was an active participant in the École des Beaux-Arts, where he was first admitted as a student on 22 October 1874. Located then as now in the rue Bonaparte in the Latin Quarter, the École combined the school proper, where students drew from casts and the live model, with private ateliers run by recognized academic masters. There were also lectures in anatomy, perspective and art history.[10] Only about seventy students were admitted to the school proper each half-year as a result of competitive examination that included anatomy, perspective and drawing. Despite his apprehension at the size of the competition, Sargent was admitted at his first attempt in October 1874. This entitled him to spend two hours each afternoon drawing under the instruction of Adolphe Yvon. He matriculated at the École in March 1875, and again in March 1877, but he is missing from the lists in 1876. We do not know what studies he made at the École, but his experience there clearly honed his draughtsmanship and contributed to the development of his style. It also served to reinforce in his mind the traditional hierarchies of art, in which monumental mural painting was foremost.

It is Sargent's biographer Evan Charteris who says that Sargent attended classes at the atelier of Léon Bonnat,[11] a realist painter like Carolus-Duran in the modern manner who also had a large following of American students. According to Charteris, Sargent set himself a punishing schedule. After breakfasting at seven, he was in the atelier by eight, and he worked through until five in the afternoon, when he went to the École. Dinner was followed by a class at Bonnat's atelier, which lasted from eight until ten p.m.

—*Richard Ormond*

1. From a typescript, 'The Primrose Way', quoted by H. Barbara Weinberg, 'Sargent and Carolus Duran', in Simpson 1997, p. 5. Her article is the most complete account of Sargent's art training.
2. The drawing was exhibited at *Le Voyage de Paris: Les Américains dans les écoles d'art, 1868–1918,* Musée National de la Coopération Franco-Américaine, Château de Blérancourt, 1990; the catalogue, published by the Réunion des Musées Nationaux, Paris, is a useful source of information on Sargent's career at the École des Beaux-Arts.
3. *Exhibition of Drawings by John Singer Sargent,* Grand Central Art Galleries, New York, 14 February–3 March 1928; the unpaginated catalogue illustrates a good selection of early drawings.
4. Charteris 1927, p. 28: '"Cherchez la demi-teinte" he would add, "mettez quelques accents, et puis les lumiéres [*sic*]". But above all, to his pupils his advice was "Velasquez, Velasquez, Velasquez, étudiez sans relache [*sic*] Velasquez"'.
5. Letter to Heath Wilson, 12 June 1874; passages from this letter and an earlier one of 23 May 1874 to the same correspondent were communicated to Stanley Olson, 2 March 1985 (copies of partial transcripts, catalogue raisonné archive) by Catherine Barnes, who had catalogued the items for the Philadelphia bookseller William H. Allen; see also Maggs Bros Ltd, London, *Autograph Letters and Documents,* Spring 1935, pp. 92–93, where the letters were first catalogued. Both letters were inadvertently destroyed while being shipped from William H. Allen to the Pierpont Morgan Library, New York, c. 1980.
6. Minchin 1925, p. 736.
7. R. A. M. Stevenson, *Velasquez* (London, 1895), pp. 105–6. See also Low 1908, pp. 12–24 for a discussion of Carolus-Duran's methods.
8. Minchin 1925, p. 736.
9. Low 1908, p. 17.
10. See H. Barbara Weinberg in Simpson 1997, pp. 8–9 for a description of the curriculum at the École; and H. Barbara Weinberg, 'Nineteenth-Century American Painters at the École des Beaux-Arts', *American Art Journal,* vol. 13, no. 4 (Autumn 1981), pp. 66–84.
11. Charteris 1927, p. 36.

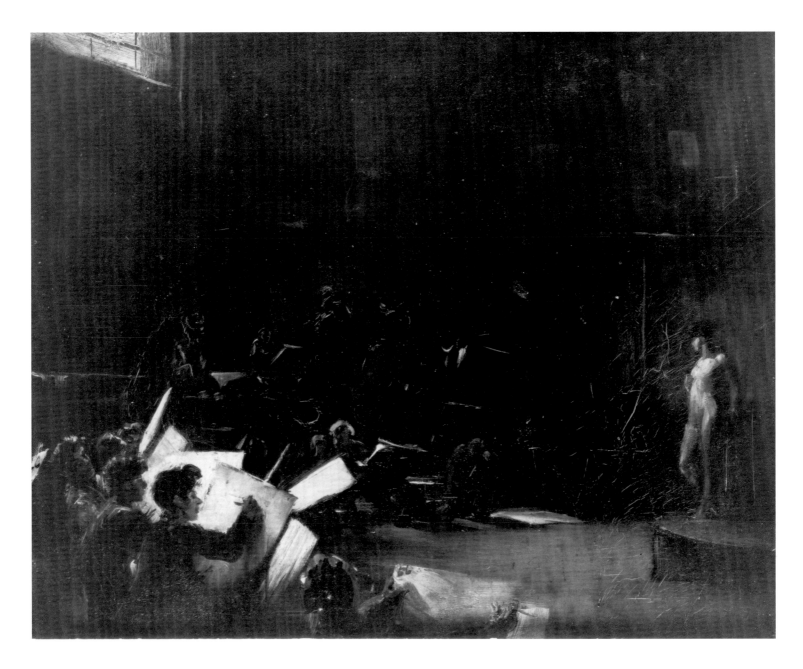

620
Interior of a Studio

c. 1874–77
Alternative titles: *The Life Class at Julian's;*
The Studio of Léon Bonnat
Oil on canvas (dimensions unknown)
Faint inscription visible in the 1925
photograph, upper right, apparently
reading: *J. S. Sargent*
Untraced

This picture is untraced and until it reappears the attribution to Sargent must remain provisional, although it is probably right. The picture was with Grand Central Art Galleries, New York, in 1925, and was photographed by them at that time. They had held an important exhibition of the artist's work in the preceding year (New York 1924), and they handled the sale of several oils and drawings by Sargent after his death. The *Interior of a Studio* was said to have come from the estate of the artist, but this cannot be verified since it was not included in the studio sale or in any of the extant inventories of his possessions. The attribution to Sargent is supported by the evidence of a related drawing in the Metropolitan Museum of Art, New York (fig. 18), possibly a preliminary study (see Herdrich and Weinberg 2000, p. 133, no. 55).

The interior was identified as the Académie Julian by Grand Central Art Gal-

leries in 1925, and it may be the picture listed by Mount as the studio of Léon Bonnat (Mount 1955, p. 442, no. K761), but no firm evidence exists to link it to either of these ateliers. The Académie Julian was a much-frequented studio, and easy of access, where artists could draw from the model and receive instruction from a variety of masters. It is doubtful if Sargent would have had much time to attend the atelier, since he is known to have frequented the studio of Léon Bonnat (see Charteris 1927, p. 36) and also went regularly to classes at the École des Beaux-Arts.

Sargent's picture represents a type of studio interior with a long iconographical tradition going back to the eighteenth century and earlier. A group of male art students are ranged in a series of semicircular benches around a platform on which stands a female model. The gloomy, cavernous space is lit with faint rays from a window

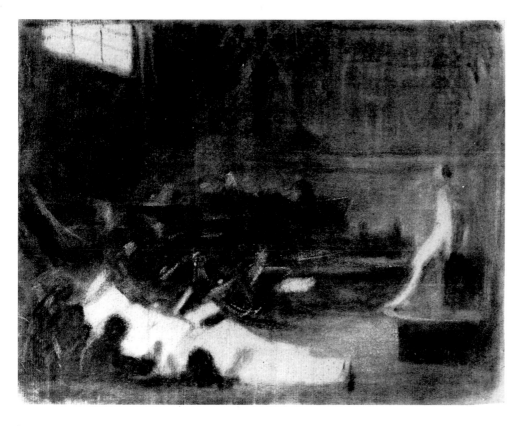

Fig. 18
Life Study Class, c. 1874–77. Charcoal on paper,
6¹¹⁄₁₆ x 9¹⁄₁₆ in. (17 x 23 cm). The Metropolitan
Museum of Art, New York. Gift of Mrs Francis
Ormond, 1950 (50.130.128).

high up on the left-hand wall. It is not easy
to make out the composition or to guess at
the proportions of the room, although the
drawing provides a clearer image of the
space. The model is holding a classic pose,
one leg bent at the knee, body twisted at
the waist, left arm and shoulder drawn
back, and left hand resting on a high stool.
Light sculpts her body, throwing into relief
the cheek, neck, torso, hip and knee, while
leaving other features in deep shadow.

The foreground students are picked
out as dark shapes and profiled against the
white of their drawing paper. The head and
shoulders of a figure bottom centre can just
be made out, viewed almost vertically from
above, with his board before him. Next
comes a young man with a huge coif of
hair, a third apparently wearing glasses, a
fourth leaning back and looking up at us,
and two more round the corner. These fig-

ures are treated semi-humorously, with a
hint of caricature (entirely absent in the
drawing, where the students are not indi-
vidualized). It is the interaction of the fore-
ground group with the model, across the
darkness of the intervening space, which
gives the image its pictorial and psycholog-
ical thrust. The picture anticipates *Rehearsal
of the Pasdeloup Orchestra at the Cirque d'Hiver*
(no. 724) in its semicircular structure, short-
hand notation, and play of white on black.

Another 'Interior of a Studio' attrib-
uted to Sargent was sold by the New York
collector George S. Hellman at the Ameri-
can Art Association, Anderson Galleries,
New York, 14 December 1932 (lot 93, with
sizes 30 x 20 in.; inscribed upper left, 'J. S.
Sargent'). In a letter to David McKibbin of
22 June 1950 (McKibbin papers), Hellman
described it: 'The standing model (male) is
facing a group of, I think, five or six fellow

students of Sargent in the studio of Carolus-
Duran'. Hellman claimed to have bought
the picture, together with the study of a
young man, from the American artist Mer-
ton Clivette (1868–1931) (Hellman to Mc-
Kibbin, 14 June 1950), 'who had acquired
them at a Storage Warehouse auction some
years earlier. Clivette told me that they had
come from Sargent's studio in Boston. I have
no way to verify this, but have no doubt that
this is so as they were in the original frames'.
Hellman's collection included works by or
attributed to Courbet, Millet, Monet, Signac
and Vlaminck, as well as works by Ameri-
can artists and a scattering of old masters.
The study of a young man, also attributed
to Sargent in the 1932 Hellman sale cata-
logue (lot 92), is now in the Tweed Museum
of Art, University of Minnesota, Duluth.

621
A Male Model Standing before a Stove

c. 1875–77
Oil on canvas
28 x 22 in. (71.1 x 55.9 cm)
The Metropolitan Museum of Art,
New York. Gift of The Marquis de
Amodio, O.B.E., 1972 (1972.32)

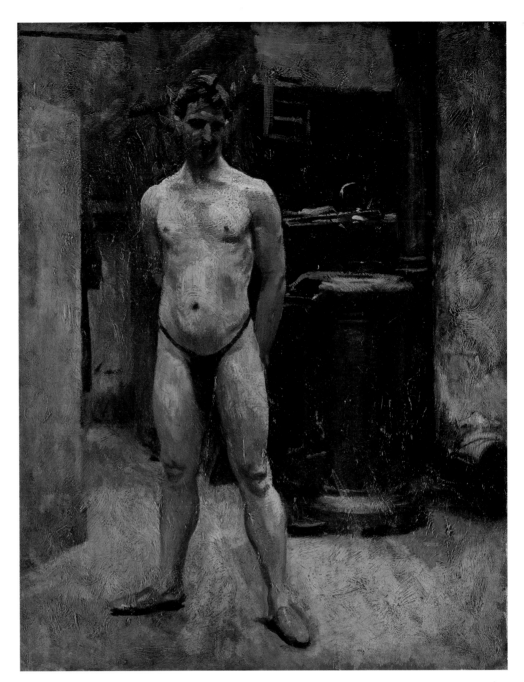

The stance of this model, with legs parted, standing foursquare, with his hands behind his back, is reminiscent of Holbein's portrayal of *Henry VIII* (cartoon for lost fresco, National Portrait Gallery, London). Seen from the viewpoint of the artist in the act of posing, he looks down to his left with a thoughtful expression on his features, which are broadly blocked in. The posing strap worn by the model is not integrated with the paint surface and may be a later addition; such a strap would normally be worn only when women were present. Behind the figure is a simple iron stove of the period, and a series of objects (not easily decipherable) suggestive of a studio interior: a screen to the left with the outline of a coat or costume hanging behind it; a frame on the wall; a stand of some kind behind the statue with the top of what may be a portfolio visible above it; a high cabinet further back; then a dark niche or recess; a simple frame with two slats suspended above it; and a strip of wall far right. These pieces make a complicated pattern of interlocking rectangular shapes offset by the

curved forms of the stove and flue pipe. The location of the studio has not been identified, but it is more likely to be a private atelier (possibly Carolus-Duran's) than the École des Beaux-Arts (see Burke 1980, p. 221). The picture is heavily impastoed, with a rough, congealed surface, and it is painted in a limited range of earth colours, indicating that it may have been painted a little earlier than some of the other studies of models.

The picture was in the artist's sale at Christie's, London, in 1925 (lot 199), and was acquired there by the Marquis de Amodio, a French aristocrat then living in London. It passed to his son, who inherited the title in 1934 and who lived mostly in Geneva; he was half American. His wife, Anne, was the daughter of Count Gabriel de la Rochefoucauld and the chatelaine of

the Château de Verteuil in Charente, which had once housed the famous Unicorn tapestries now owned by the Metropolitan Museum of Art, New York (see Margaret B. Freeman, *The Unicorn Tapestries* [New York, 1976]). Her aunt, the Duchesse de Richelieu, had left a number of objects to the museum and the gift of this picture to the same institution by the marquis in 1972 may have been prompted by these earlier family connections. From 1949 to 1972, he had loaned the picture and a number of old masters to the Dallas Museum of Fine Arts to express his gratitude for the kindness shown to British Royal Air Force trainees in Texas during World War II, in his capacity as vice-president of the Royal Air Forces Association (see his letters to Doreen Bolger Burke of 26 February and 15 March 1976, The Metropolitan Museum of Art files).

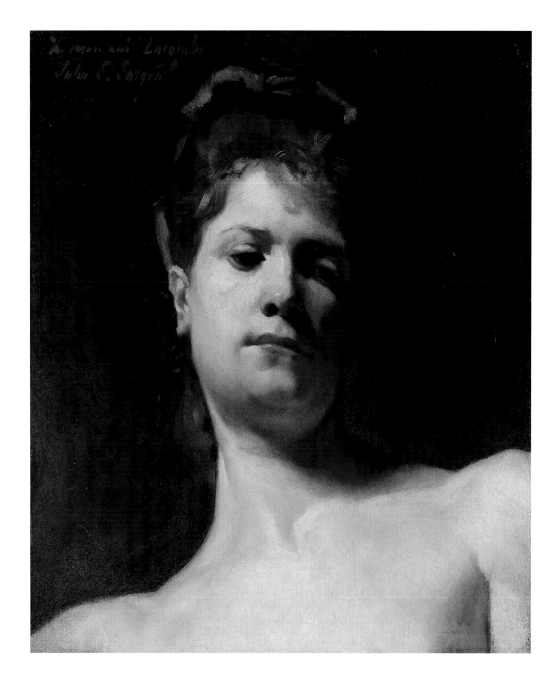

622
Blonde Model

c. 1877
Alternative titles: *Head of a Woman
(bare shoulders); Head of a Female Model*
Oil on canvas
17¹⁵⁄₁₆ x 14¹⁵⁄₁₆ in. (45.6 x 37.9 cm)
Inscribed, upper left: *a mon ami Lacombe/
John S. Sargent*
Sterling and Francine Clark Art Institute,
Williamstown, Massachusetts (574)

This head and shoulders study of a nude
female model is unusual in format. The head
is turned gracefully; the piled-up hair is
drawn back from the forehead and ears and
is surmounted by a small cap, the only item
of personal adornment; one strand of loose
hair hangs below the sitter's right ear along
the line of the neck. The arbitrary cropping

of the shoulders and torso and the upward
angle at which the figure is painted give the
study a condensed and monumental form.
The strong-minded character of this mature
model comes across in the firm set of the
jaw, the compressed lips and the air of self-
possession. The model's left hand originally
had come across the chest to rest at the neck.
This hand was painted out with an opaque
pigment, which introduced false cracks,
probably by an early restorer (see Clark Art
Institute 1990, p. 158). Without the presence
of the hand, the foreshortened left shoulder
looks odd.

Several recent commentators have
pointed out that the low viewpoint of the
study and the looking-down pose would
be appropriate for a mural or ceiling deco-
ration. Sargent assisted Carolus-Duran with
his commission for the *Gloria Mariae Medicis*
ceiling in the Luxembourg Palace (fig. 26),

and this study bears some resemblance to
the female figures in that work, but there is
no precise connection between them. The
ceiling dates from 1877–78, and this accords
well with the style of the study, which
strongly reflects the influence of Sargent's
master, Carolus-Duran.

The original owner of the study, to
whom it is dedicated, has been identified
by recent authorities as Georges Lacombe
(d. 1916), a painter and sculptor associated
with the Nabis and a pupil of Alfred Philippe
Roll, to whom Sargent presented a sketch of
Gitana (no. 636). However, the form of the
inscription is early, and if Lacombe's birth
date of 1868, given in Bénézit, is correct, he
would have been a boy. Another name pro-
posed by Richard H. Finnegan is Camille
Lacombe de Presles, an artist born in Brit-
tany who was awarded an Honourable Men-
tion in the Salon des artistes français in 1891.

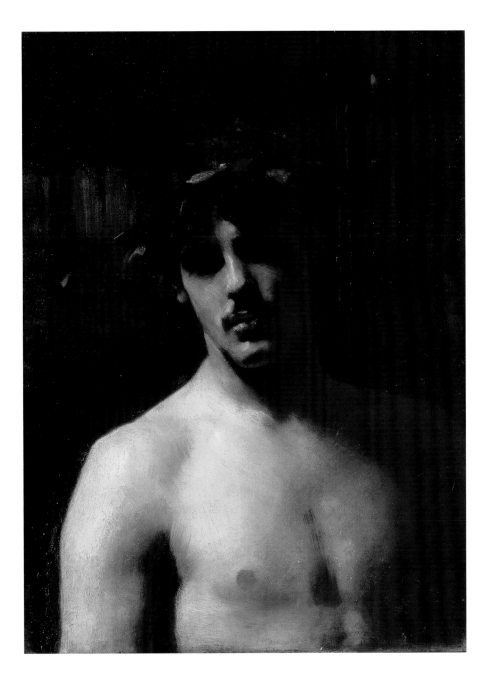

623
A Male Model with a Wreath of Laurel

c. 1878
Alternative titles: *A Man, wearing laurels;
Study of a Man; Portrait of a Man wearing
Laurels; The Victor; Study of a man wearing
laurels; Portrait of a Man*
Oil on canvas
17½ x 13³⁄₁₆ in. (44.5 x. 33.5 cm)
On the reverse is the studio stamp:
JSS circled
Los Angeles County Museum of Art.
Mary D. Keeler Bequest (40.12.10)

This study of the male nude is an exercise
in expressive form and tonal values as
taught in the atelier of Carolus-Duran. The
torso of the model is caught in a raking
light that emphasizes his rounded, three-
dimensional form. Smooth contours are
contrasted with declivities of neck, right
arm and breastbone; a line of light runs
across the left shoulder, leaving it in deep
shadow; the shoulder and arm on that side
are cropped and left unfinished. The head,
cocked slightly to one side, is rendered as a
series of dramatically contrasted lights and
darks that gives it an enigmatic and brood-
ing presence. Only the faintest gleam in his
deeply shadowed eyes tells us that the
young man is looking directly out at us.
His nose, lips and chin are heavily sculpted,
but the left side of his face is left almost
entirely in shadow. So, too, are his hair and
wreath, arranged to make him look like a
victor of antiquity.

The figure emerges from a dark back-
ground. The pattern of wooden panelling,
or perhaps a piece of furniture, is visible to
the left, with thin upright members and a
wide cross-strut or shelf parallel with the
top of the model's head. The thin lines of
white paint on the right seem to indicate
the folds of a hanging or curtain. The model
is almost certainly Italian and is likely to
have posed for the artist either in his studio
or that of a friend rather than in the formal
setting of a student atelier or the École des
Beaux-Arts. Comparison with other early
studies of models suggests that it may have
been painted around 1878, rather than ear-
lier. The model appears to be the same per-
son as the *Study of a Man's Head* and possibly
the *Head of a Male Model* (nos. 624, 625). At
the artist's sale at Christie's, London, 27 July,
1925, the picture was sold in the same lot as
a study titled 'An Angel' (lot 237); this was,
in fact, a copy of the figure of Apollo from
Velázquez's *The Forge of Vulcan* (see no. 734).

624
Study of a Man's Head

c. 1878
Oil on canvas
22 x 17¼ in. (56 x 43.8 cm)
Untraced

Though the authors have not seen this work, they have little doubt of its authenticity. The model appears to be the same person as *Male Model with a Wreath of Laurel* and possibly *Head of a Male Model* (nos. 623, 625), and it is painted in the same format, with the model posed full face and gazing directly out at us. The study is one of a group of early works belonging to the French artist Auguste Alexandre Hirsch (1833–1912), who shared a studio with Sargent at 73, rue de Notre-Dame-des-Champs (for a discussion of the group, see appendix 1, p. 387). This study, together with eleven others, was acquired from Hirsch's widow by M. Knoedler & Co., London, on 7 January 1914. The picture was given by Charles S. Carstairs of Knoedler to Natalie Pearson, an American, in 1915, the year of her marriage to Reginald Nicholson (1869–1946) (see *Who Was Who 1941–1950*, vol. 4 [London, 1952], p. 849). The present illustration comes from a Knoedler London photograph taken at the time.

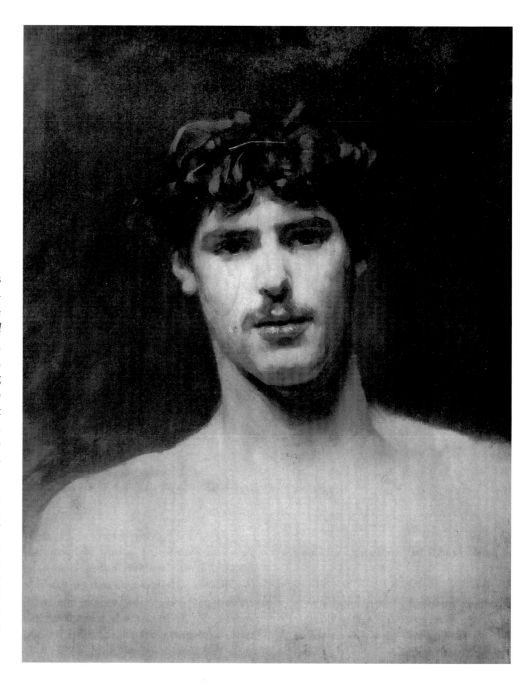

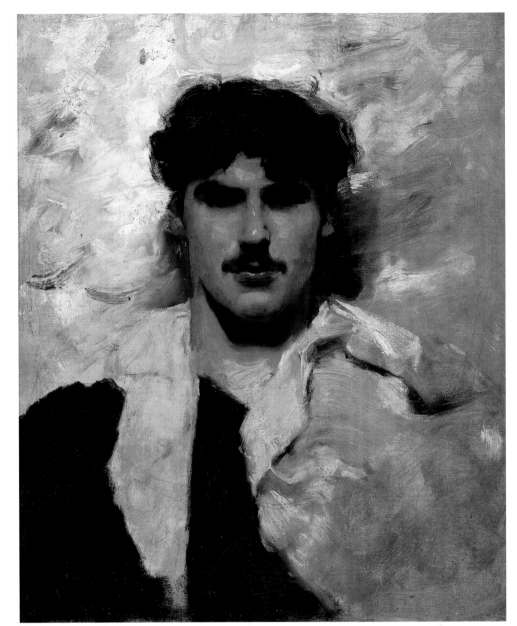

625
Head of a Male Model

c. 1878
Alternative title: *Head of a Gondolier*
Oil on canvas
23½ x 19½ in. (59.7 x 49.5 cm)
Private collection

Though described in earlier Sargent litera-
ture as 'Head of a Gondolier' and variously
dated 1896 and 1905 (Mount 1955, p. 435,
no. 9614; and Charteris 1927, p. 287), in the
view of the authors, this head of a model
relates in style to other studies dating from
around 1878. The frontal pose, intense ex-
pression, absence of spatial recession and
tight facture are typical of these works, and
different in kind from the looser studies of
gondoliers of c. 1900. There is nothing in
the present study to indicate that the young
man is a gondolier. He is clearly of Italian
type, probably a professional model, and
possibly the same man who posed for *A
Male Model with a Wreath of Laurel* and *Study
of a Man's Head* (nos. 623, 624). He is almost
certainly the model of a drawing in the
Fogg Art Museum (fig. 19). In this oil study,
he wears a dark blue jersey or shirt, with a
loose white garment or drape casually
thrown over one shoulder and around his
neck. Light plays over his features, accentu-
ating his lower lip and nose, throwing his
eyes, tousled hair and moustache into dark
relief, and casting the shadow of his head
against a textured background of splashes
of white impasto with green highlights.

The study belonged to Sargent's close
friend Sir Philip Sassoon (1888–1939), who
owned a choice collection of the artist's
early work and was painted by him in 1923
(*Later Portraits,* no. 604).

Fig. 19 *(left)*
Head of a Model
('Portrait of Man
with Hat'). Pencil on
paper, 10¼ x 8¾ in.
(26.1 x 22.2 cm).
Fogg Art Museum,
Harvard University
Art Museums,
Cambridge, Massa-
chusetts. Gift of
Miss Emily Sargent
and Mrs Francis
Ormond, 1931
(1931.78).

626
Head of a Young Man

c. 1878
Alternative titles: *Portrait Head, Study;*
Portrait of a Sailor
Oil on panel
8¾ x 4¾ in. (22.3 x 12.2 cm)
Collection of Cheryl Chase and Stuart Bear

This study is similar to other heads of male
models dating from the late 1870s. The sit-
ter looks out with that directness and
intensity of gaze typical of Sargent's charac-
terizations at this early period. In the past,
the model has been called a sailor because
of his cap and open-necked shirt, but there
is nothing specifically nautical in his outfit.
The *Head of a Male Model* (no. 625), which
could possibly represent the same sitter, has
also been identified as a gondolier, and it is
just possible that both pictures were painted
in Venice in 1880. However, professional
Italian models were available in Paris and
an earlier dating is preferred.

The *Head of a Young Man* is one of a
large group of early studies belonging to
the French artist Auguste Alexandre Hirsch
(1833–1912), with whom Sargent shared
a studio at 73, rue de Notre-Dame-des-
Champs (see appendix 1, p. 387). The picture
descended to Hirsch's nephew, Raymond
Bollack, and was sold by him at auction in
1965. It was acquired in 1966 by the well-
known New York collector David Daniels
(1927–2002), who owned a number of later
drawings and water-colours by Sargent.

627
Study of a Man Wearing a Tall Black Hat

c. 1880
Alternative titles: *Portrait of a Man, wearing a large black hat; Portrait of a Dutchman; A Dutchman*
Oil on canvas
24 x 18 in. (61 x 45.8 cm)
Private collection

The picture was first identified as a Dutchman in the Royal Academy exhibition of 1926, probably on the basis of the sitter's appearance. A year earlier the picture had been described simply as 'Portrait of a Man, wearing a large black hat' in the artist's sale catalogue (Christie's 1925, lot 195). With his bushy whiskers and moustache, the sitter looks Northern European and possibly nautical. Sargent must have been struck by the rugged, down-to-earth character of the man, and the way his flowing moustache and bushy whiskers are framed by his black hat and simple black upper garment. The head is solidly modelled, but the rest is thinly stained, the pigment liberally diluted with medium. Mount tentatively dated the picture to 1891 (Mount 1969, p. 457), but in the view of the present authors, it is earlier.

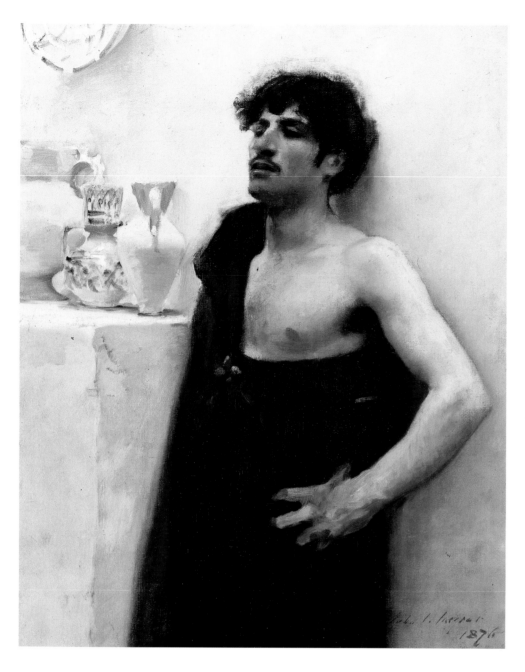

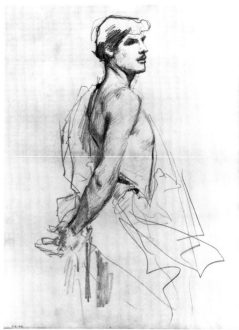

Fig. 20
Life Study, c. 1878. Dimensions unknown. Untraced. From a negative by Peter A. Juley, c. 1928. Peter A. Juley & Son Collection. Smithsonian American Art Museum, Washington, D.C. (PPJ-22640).

628
Study of a Male Model

c. 1878
Alternative titles: *Study of a Man; Young Man in a Reverie; Sketch of a Laborer*
Oil on canvas
30¼ x 24 in. (76.8 x 60.9 cm)
Inscribed, lower right: *John S. Sargent/1876*
The Hevrdejs Collection, Houston

The model in this life study is posed in a setting of whitewashed wall and buttress with Moorish blue and white pottery. He leans back against the wall in an attitude of reverie, head tilted up, eyes half-closed, his expression abstracted and withdrawn. He is partially draped in a brown cape, with a loose collar visible on the left, secured in the middle of his chest with a clasp in the shape of three acorns. The cape is arranged

so that it frames the model's bare left shoulder and area of chest as a rectangle, and enfolds the rest of the body in a column-like structure of brown drapery, in deliberate contrast to the white wall; for a drawing of a similarly draped model, see fig. 20. The nude torso is finely modelled as a deliberate exercise in life painting. The most unusual feature of the picture is the splayed, claw-like left hand, which grips the material and side of the body at hip level. In contrast to the smooth texture of the torso, the hand is blocked in with a few broad strokes and looks unfinished. It hints at an inner tension at odds with the model's dreamy expression.

With his olive complexion, thin moustache and tousled hair and sideburns, the model belongs in type to the Italian young men who modelled professionally, and whom Sargent painted at this early period. In an essay for the *John Singer Sargent* exhi-

bition at the Whitney Museum of American Art, New York (Hills *et al.* 1986, p. 31), Patricia Hills associates the picture with the group painted in Capri in 1878. The luminous white tones of the picture link it to works like the 1878 *Staircase in Capri* (no. 719) and the 1880 *Fumée d'ambre gris* (no. 789), and a date of c. 1878 is preferred to the inscribed date of '1876', which was added by the artist many years later. There is insufficient evidence to identify the setting. The blue and white plate on the wall and the blue and white jug are Hispano-Moresque in style, and so are the unglazed white two-handled jar and the large jug behind, which occupy the top of the jutting-out section of wall.

According to the records of M. Knoedler & Co., New York (stock no. WC 966), the picture was sent to Sargent in Boston on behalf of Mrs Dudley Olcott, who had bought the picture at auction in New York in 1920, so that he could sign and date the work. The picture originally had belonged to the artist Auguste Alexandre Hirsch (1833–1912), who shared Sargent's studio at 73, rue de Notre-Dame-des-Champs (see appendix 1, p. 387). The picture was one of the works sold by Hirsch's widow to M. Knoedler & Co., London, in 1914. They sold it in the same year to Harris B. Dick of New York, who had previously purchased from them Sargent's painting *Bringing Down Marble from the Quarries to Carrara* (The Metropolitan Museum of Art, New York).

629
Two Nude Boys and a Woman in a Studio Interior

c. 1878–79
Alternative titles: *A Study of Three Figures, with a Martyr on the reverse; Three Figures (with Study of a Martyr on reverse); Two Boys Modelling in a Studio; Boys in Studio*
Oil on canvas, originally on panel
18½ x 11¾ in. (47 x 30 cm)
Private collection

The picture of *A Martyr* (no. 642) was formerly on the reverse of this work and is catalogued separately. The two sides were separated in 1969 and transferred from panel to canvas. They were then in the possession of Alfredo Valente, director of the Gallery of Modern Art with the Huntington Hartford Collection, New York, and a noted collector and photographer. The studio interior shows a group of two nude boys with a woman behind, possibly their mother or another model, cut in half by the edge of the panel. The foremost boy is striking a pose, perhaps for the benefit of a painter or while resting between sittings. Wound round his hips is a black shawl or length of material that falls between his crossed legs and ends in a soft white fringe; what appears to be the same shawl is worn by the model in the picture of *A Young Girl Seeking Alms* (no. 726). The boy's body is slightly twisted at the waist, which, together with the crossed legs, gives his pose an engaging *contrapposto*. His right foot does not appear to be resting on the ground, and he steadies himself by leaning one hand on the edge of the stool, while the other rests casually on his hip. The handling of the flesh tones is fluid and sensual, with highlights on the shoulders, upper arms, groin and thighs. Some details, like the right foot, are unfinished. The eyes of the boy are shadowed by the fringe of his pudding-basin hairstyle, but he seems to be looking out at us with a self-confident expression that matches the bravado of his pose. The patch of lighter pigment to the right of the head may indicate its position at an earlier stage of composition.

Though he rests his hand on the edge of the stool, the foreground boy seems unrelated to the other two figures and is disproportionately large, as if he had been inserted in the sketch at a later stage. The little boy with his back to us hugs his arm close to his body and turns his head with tousled hair in profile to the right. He sits on a high stool used for modelling purposes.

The woman looks straight ahead with her left hand resting on her hip. Her costume —grey skirt, short black strapped garment over a white shirt with puffed sleeves, and a red sash and cap—suggests a form of local dress, almost certainly Italian. The two boys are similarly Mediterranean in type and belong to that fraternity of boy models who were so often painted and photographed at this time. Two pictures on the wall behind the figures and a curtained doorway or niche to the left evoke the setting of an artist's studio. Mount dated the picture to 1879 (Mount 1955, p. 443, no. K7923), and a date around this time or a little earlier is probably correct.

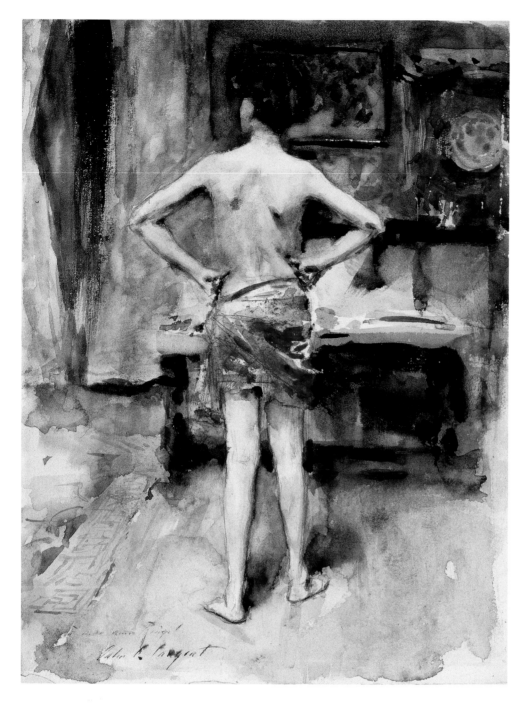

630
The Model: Interior with Standing Figure

c. 1878–79
Water-colour on paper
11⅝ x 9 in. (29.5 x 22.7 cm)
Inscribed, lower left: *à mon ami Ringel/
John S. Sargent*
The Museum of Fine Arts, Houston.
Gift of Miss Ima Hogg (39.68)

It is difficult to be certain of the sex of the young model posing in this studio interior. The way the hair is gathered up and faint indications of a double-chain necklace argue in favour of a female model. The figure is naked except for a piece of cloth tied round the hips. Beyond the figure is a low wooden table placed against the wall, with a picture above and what looks like a ceramic plate with teal-coloured decoration in a wall case to the right. Below this is what appears to be a ledge or the top of a dado, with more objects on top of it. The depth of the room is emphasized by the Greek key pattern of the tiles, or possibly the border of a rug, running from the lower left-hand corner of the picture towards the table. In the background on the left, two

parted curtains reveal a dark space beyond, perhaps a doorway.

The back view of the figure suggests that he/she has been caught unawares, perhaps resting between modelling sessions rather than posing formally. The intimate character of the sketch and its subtle eroticism differentiate it from those genre scenes of artists' studios with naked female models so popular at the period. Both David McKibbin (letter to Mr Sobotik, 27 March 1975, The Museum of Fine Arts, Houston, files) and Annette Blaugrund (in Hills *et al.* 1986, p. 212) link the work with the water-colours Sargent was painting in Venice in the early 1880s, though still dating the study to the previous decade, presumably on the assumption that it was painted during his student days. There is no evidence that this was the case, and the picture does not compare closely with the early oil studies of models.

The 'Ringel' to whom the water-colour is dedicated is probably the French artist Jules-Guillaume-Auguste Ringel (active 1877–81), a member of an Alsatian family of artists, the best known of whom is the sculptor Jean-Désiré Ringel (1847–1916), an elder brother. Interestingly enough, the younger Ringel's first Salon exhibit was a water-colour, contributed in 1877. The Salon that year devoted a small room to water-colours for the first time, and two years later French water-colourists established the Société d'aquarellistes français, among them Sargent's friends Ernest-Ange Duez and Joseph Roger-Jourdain. Ringel may well have been part of this group (see Blaugrund in Hills *et al.* 1986, pp. 210, 212). The subsequent history of Sargent's water-colour is unknown until it came into the possession of the Texas collector and benefactor Miss Ima Hogg (1882–1975). She donated more than a hundred works on paper to the Museum of Fine Arts, Houston, including works by Paul Cézanne, Pablo Picasso, Emil Nolde, Lionel Feininger and Paul Klee, as well as the Sargent. Her large and important collection of American decorative arts is displayed at her former home at Bayou Bend, designed by John F. Staub in the 1920s (see David B. Warren *et al.*, *American Decorative Arts and Paintings in the Bayou Bend Collection,* The Museum of Fine Arts, Houston, 1998). Efforts to track down references to the water-colour in her surviving papers at the museum and the University of Texas at Austin have not been successful. The authors would like to acknowledge the assistance of Emily Ballew Neff in preparing this entry.

631
Head of a Young Woman

c. 1878–80
Alternative title: *Native Woman*
Oil on canvas
22 x 18 in. (55.8 x 45.7 cm)
Inscribed, across the top: *to my friend*
Dannat John S. Sargent
Private collection, on loan to the
Allentown Art Museum, Pennsylvania
(EL 82.40)

This grisaille study of a sultry young woman of Mediterranean type is close in style to Sargent's studies of Capri and Venetian models, and probably dates from the period 1878–80. The model is not entirely naked, as she appears to be at first sight. An irregular strip of dark paint at the level of her breasts indicates the presence of a costume. Her well-developed shoulders, untidy fringe of hair, sensual mouth and silver drop earrings with ribbons and matching necklace across bared flesh give her a wild and primitive look. No doubt this was the reason that the picture was titled 'Native Woman' when it reappeared on the art market in recent times.

The exotic character of the sketch is accentuated by the strong chiaroscuro, which throws the features into strong relief against a deeply shadowed background. The eyes are partially covered by the fringe, making it impossible to know if the model is looking directly out at us or towards some other point. This ambiguity adds to the enigmatic nature of the image. The picture could have been painted in Capri or Spain during Sargent's visits of 1878 and 1879, or in Paris from a professional model. Morocco, as suggested by David McKibbin (note on back of a photograph of the picture, catalogue raisonné archive), seems less likely.

The picture was given by Sargent to the American artist William Turner Dannat (1853–1929), a fellow-student at Carolus-Duran's atelier. It appears among a group of pictures in two studio interiors painted by Dannat in Paris in 1882; the larger of the two (fig. 21) was exhibited at Hirschl & Adler, New York (*Important Recent Acquisitions*, 1972, no. 13); the smaller is in a private collection. The picture, together with a second work given to Dannat by Sargent, *Back View of a Nude Model* (no. 632), belonged to Otis Alan Glazebrook (c. 1845–1931); for more details about him, see the entry for *Back View of a Nude Model*. The *Head of a Young Woman* was purchased in 1956 by the New York dealer Victor D. Spark from

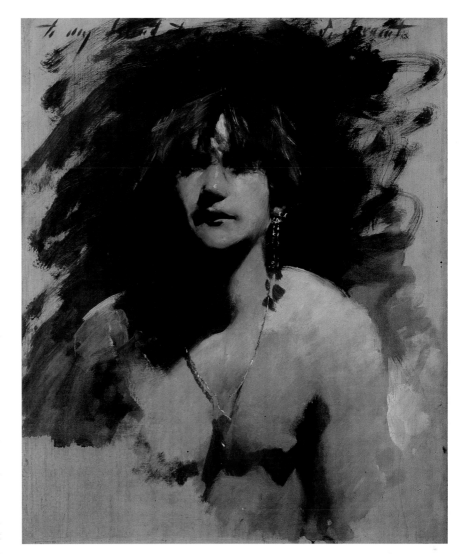

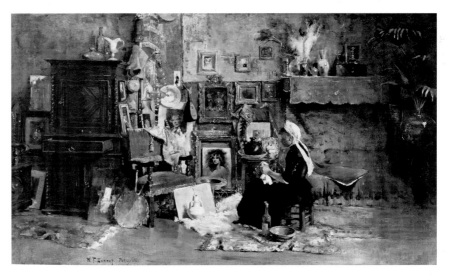

Fig. 21
William Turner Dannat, *Studio Interior*, 1882. Oil on canvas, 19¾ x 32¾ in. (50 x 83 cm). Private collection.

what he calls the Glazebrook estate, which was probably the estate of Otis Glazebrook, Jr (Spark to McKibbin, 7 June 1957, McKibbin papers). Writing again to McKibbin on 30 August 1975 (McKibbin papers), Spark could no longer 'recollect where or to whom I sold it'.

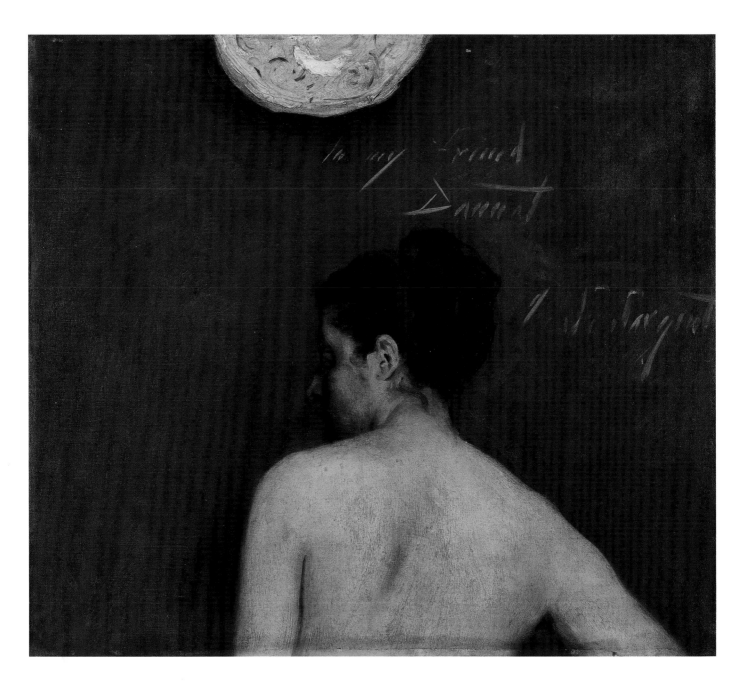

632
Back View of a Nude Model

c. 1880
Oil on canvas
20⅝ x 23¾ in. (52.5 x 60.5 cm)
Inscribed, upper centre and right:
to my friend/Dannat/John S. Sargent
Private collection

This study of a model is strangely reminiscent of Sargent's portrait of Madame Gautreau (*Early Portraits,* no. 114) in its profile pose, prominent ear, and pallid flesh tones. It must, however, date from considerably earlier, probably around 1880. The model seems to be standing, with her right arm stretched out to steady herself and her head turned sharply in profile, almost *profil perdu*. Her hair is done up in a bun at the back of her head. Above her is the lower half of a

cream-coloured ceramic dish picked out in gold lustre with a floral design. The presence of the dish and the artist's flamboyant signature, coupled with the large area of surrounding space, impart a sense of drama into what is essentially an academic study from life.

The picture was given to the American artist William Turner Dannat (1853–1929), a fellow-student at Carolus-Duran's atelier and a good friend of Sargent. He made a name for himself with Spanish subjects, exhibiting *The Quartette* (The Metropolitan Museum of Art, New York), a scene with four Spanish musicians reminiscent of *El Jaleo* (no. 772), to acclaim at the Paris Salon of 1884. *Back View of a Nude Model,* together with a second picture given by Sargent to Dannat, *Head of a Young Woman* (no. 631), was acquired by Otis Alan Glazebrook (c. 1845–1931), but how and when is

not recorded. After serving in the American Civil War on the southern side as a boy soldier, Glazebrook became an Episcopalian minister, and acted as Theodore Roosevelt's chaplain during the Spanish-American War. After that he became a diplomat, first in Jerusalem (1914–21), and then in Nice (1922–29). He is listed in the U.S. Federal Census of 1880 (with his family in Macon, Georgia), and in that of 1910 (in Elizabeth, New Jersey, living with his second wife). It is assumed that he acquired the picture during his time in France, when he is said to have helped his impoverished neighbours by buying their things, but it is possible that he was a personal friend of Dannat. The authors are grateful to Christine Wooding for information about the Glazebrook family (letter from her, 21 June 2003, catalogue raisonné archive), and to Richard H. Finnegan for biographical details about Glazebrook.

633
Head of a Woman with Gold Earrings

c. 1878–80
Alternative title: *Head of a Girl,
with gold ear-rings*
Oil on canvas
20 x 16 in. (50.8 x 40.6 cm)
Inscribed, upper left: *to my friend
Mrs Branson/J. S. Sargent*
Private collection

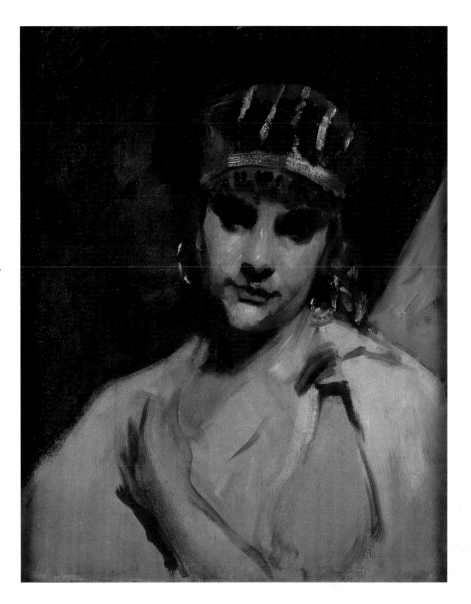

The model in Sargent's oil study is dressed
rather theatrically in a loose robe, an exotic
oriental-looking hat with gold bands and a
red top, and large gold earrings with coral
drops; for a model with similar earrings see
Head of a Capri Girl (no. 714). With her hand
flung across her chest, the model looks as if
she is playing a part.

The picture was consigned for sale in
June 1926 to Christie's, London, by Mrs
Juliet Branson(1851–1938), to whom the
picture is inscribed. She was the widow of a
solicitor, Charles Edward Branson, living in
Letchworth, Hertfordshire, and she was
killed in a motor accident (information
from Marcus Ormond). It is not known
how she came into possession of this pic-
ture and *Head of an Italian Woman* (no. 634).
The buyer of both pictures at the 1926 sale
is given as 'Cintas', almost certainly Oscar
B. Cintas (1887–1957), a Cuban sugar and
railroad magnate, sometime ambassador to
the U.S. (1932–34), and art collector. He
established the Cintas Foundation in New
York shortly before his death, to foster art
and to provide fellowships for Cuban artists.
His collection of paintings was divided
between Cuba and New York. Fidel Castro
nationalized the first, and eventually sold it
off, and the second went to the foundation.
A sale of Cintas's old masters was held at
Parke-Bernet, New York, 1 May 1963, to
raise funds for the foundation; this included
works by, or attributed to, Bellini, Bronzino,
Frans Hals, El Greco, Rembrandt, Rubens,
Van Dyck and Élisabeth Vigée-Lebrun.

634
Head of an Italian Woman

c. 1878–80
Oil on canvas
16¼ x 15 in. (45.2 x 38.1 cm)
Private collection

This sketch of an Italian woman in regional
dress has the same early provenance as the
Head of a Woman with Gold Earrings (no. 633);
see that entry for a discussion of prove-
nance. The picture was acquired in 1976 by
Mr and Mrs Louis Sosland of Kansas City,
Missouri. They were local art collectors
who presented a second Sargent painting,
Oyster Gatherers Returning (no. 678), to the
Nelson-Atkins Museum of Art, Kansas City,
Missouri.

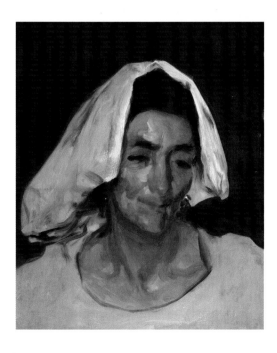

635
Head of a Young Woman

c. 1880–82
Alternative titles: *Head of a Lady;*
A Spanish Gypsy; Portrait of Gypsy;
Marie-Genevieve Duhem; Head of
a Venetian Woman
Oil on canvas
24½ x 18 in. (62.5 x 46 cm)
Inscribed, upper left: *a mon ami M. Van*
Haanen/John S. Sargent
Private collection

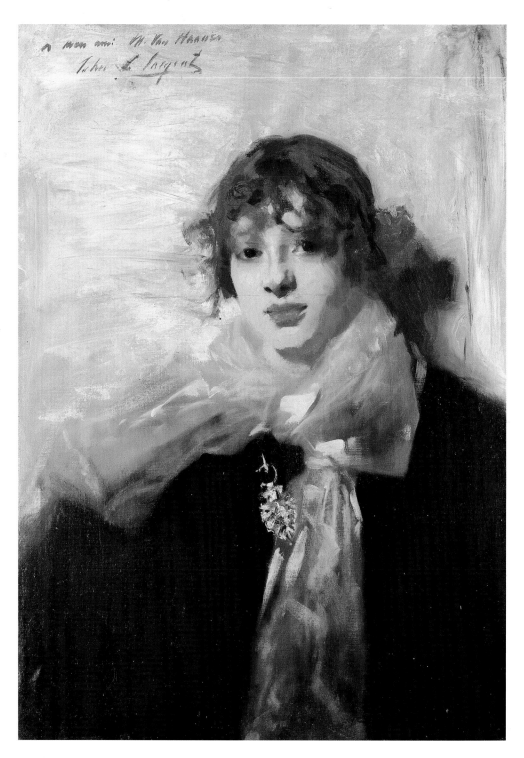

The young woman in this picture has many
of the characteristics of Sargent's Venetian
models, though it has been suggested that
she is Spanish and a gypsy. Mount (1969,
p. 437) listed her as 'Marie-Genevieve
Duhem', a name also given by him to
another work now called *Portrait of a Young*
Girl (Early Portraits, no. 64), but his reasons
for this identification are not known.

The model looks out with that dis-
concerting directness and independence of
spirit which characterizes Sargent's studies
of models. Though the young woman in
this study may reveal a passionate nature,
suggested by the wild strands of hair and
rippling scarf, there is also a touch of pathos
to her youth and beauty. She wears a simple
black garment, set off by the dazzling silver-
pink mousseline scarf, which is tied in a
bow at the neck and floats out over her
shoulders and down her front. The striking
silver brooch, markedly aesthetic in style, is
in the form of a semicircular ring with an
oval pendant drop. The upper ring, with a
pin and finials at either end, is a simplified
version of the revival Celtic ring brooches,
known as penannulars, which were popular
at the time (see *The Art of the Jeweller. A Cat-*
alogue of the Hull Grundy Gift to the British
Museum: Jewellery, Engraved Gems and Gold-
smiths' Work, ed. Hugh Tait [London, 1984],
vol. I, p. 161, no. 993, and p. 210; the authors
are grateful to Charlotte Gere for this ref-
erence). A brooch of identical design but
smaller in size is worn by Marie-Louise
Pailleron in *The Pailleron Children (Early*
Portraits, no. 37). The hair of the model in
Head of a Young Woman is worn as a fringe
in front and gathered in a bunch at the
nape of the neck and decorated with a red
flower, hence no doubt the gypsy title. The
flower and the model's red lips provide the
only notes of strong colour.

This study is inscribed to the Dutch
artist Carl van Haanen (1844–1904), known
in Britain as Cecil van Haanen, who was
famous in his day for his works of Venetian
genre (see the introduction to chapter 10,
p. 308). His picture of *Venetian Bead Stringers*
(fig. 200) had been exhibited to acclaim at
the Paris Salon of 1876 and inspired a host
of followers; Venetian narrative paintings
became all the rage. It is likely that van
Haanen and Sargent first met in Venice in
the early 1880s, though it could have been
Paris, but there are no written sources to
document their friendship. The history of
the picture is otherwise obscure. It is said to
have belonged to the Anglo-American por-
trait painter Harrington Mann (1865–1937),
who spent much of his professional life in
the U.S. It was consigned for sale by C. C.
Miller of 24 Holly Hill, Hampstead, Lon-
don, to Christie's, London, in 1943, where
the buyer's name is also confusingly given
as 'Mann'. It subsequently belonged to Mrs
Winifred Cooling, an English art collector.

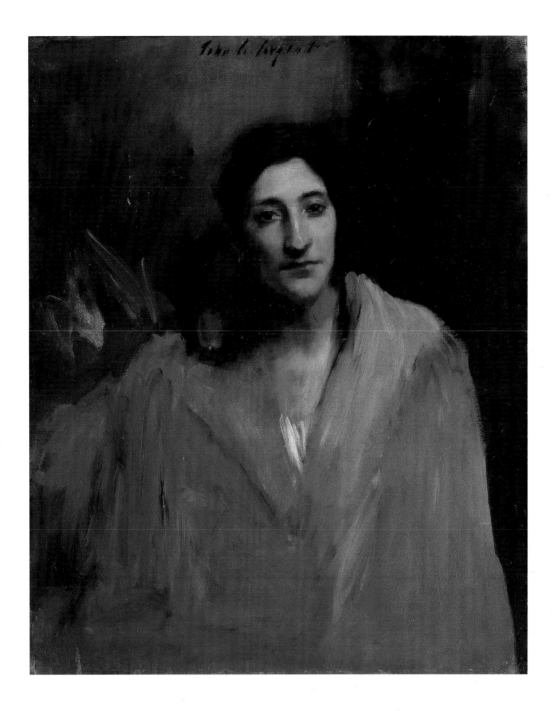

636
Gitana

c. 1879–82
Oil on canvas
29 x 23 ⅝ in. (73.6 x 60 cm)
Inscribed, upper centre: *John S. Sargent*
The Metropolitan Museum of Art,
New York. Gift of George A. Hearn,
1910 (10.64.10)

Earlier authors have dated the picture to
1876 in the belief that it was painted during
or soon after Sargent's first visit to the U.S.
In Spanish 'Gitana' means a gypsy, and the
title of the picture in English would be
'Spanish Gypsy Woman' (the authors are
grateful to Nancy Heller for this transla-
tion). The model was probably Spanish or
possibly Venetian.

The study is remarkable for the strong
and striking features of the model, which
are ugly-beautiful, for her soulful expres-
sion, and for the loose red garment which
forms a vivid contrast to the dark interior
behind the figure. The model wears her
hair in a long plait forming concentric cir-
cles on either side of her head. Her gar-
ment appears to be a red shawl over a loose
wrap of the same colour but darker, with a
sliver of white shirt visible at the bottom of
the deep V-shaped cleavage.

The picture belonged to the popular
and successful French subject painter Alfred
Philippe Roll (1846–1919) and is visible in a
photograph of his studio reproduced in the
winter issue of the magazine *Studio* in
1896–97 (no. 8, p. 28) and in John Milner's
The Studios of Paris (New Haven and London,
1988, p. 180, fig. 217). According to Mount

(1955, p. 152), Sargent persuaded Roll to
contribute 500 francs to the purchase of
Manet's *Olympia* for the French nation in
1889, but the friendship between the two
men is otherwise unrecorded. Roll is
known to have studied with Léon Bonnat,
and it is possible that the two artists met in
his atelier. *Gitana* was acquired from Paris
art dealers by M. Knoedler & Co., in 1909,
and sold to George A. Hearn (1835–1913),
a prominent businessman in New York, a
distinguished collector, and a trustee and
noted benefactor of the Metropolitan
Museum of Art. William Howe Downes
(1925, p. 120), followed by Evan Charteris
(1927, p. 280), listed the picture as having
been exhibited in New York in 1898,
Philadelphia in 1899, and San Francisco in
1915; this was a confusion with a different
picture, *Spanish Gypsy Dancer* (no. 767).

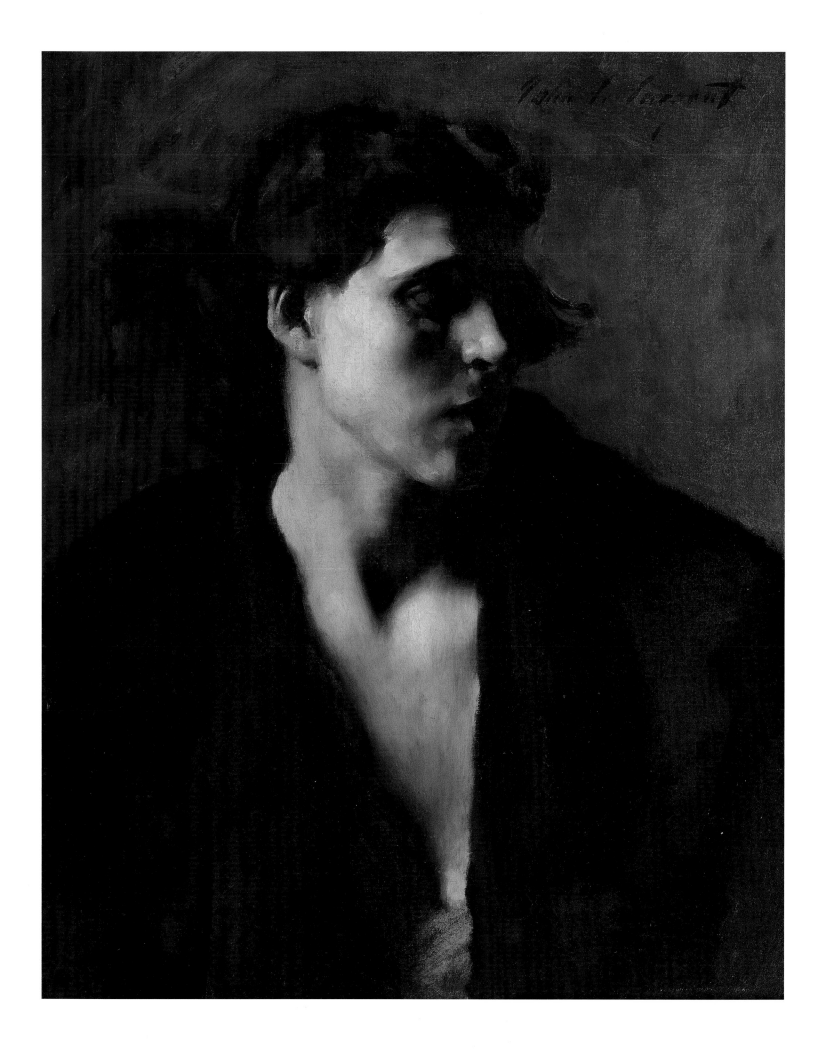

637
Study of a Model

c. 1879–80
Alternative titles: *A Spanish Woman; Portrait of a Spanish Woman; Gigia; Gigia Viani*
Oil on canvas
24 x 20 in. (61 x 50.8 cm)
Inscribed, upper right: *John S. Sargent*
Faintly inscribed on the back of the stretcher in ink, not in the artist's hand: *Gigia John S. Sargent*. Also on the stretcher is a Christie's stencil, *885EE*.
Private collection

The title 'A Spanish Woman' appears to have been given to the picture by the Irish painter Sir William Orpen (1878–1931) when he acquired it from an unnamed Bond Street art dealer around 1927. Although inscribed 'Gigia' on the reverse, the name of Sargent's elusive Venetian model, it is not known when this was added. The picture was exhibited under that title at the Leicester Galleries in 1935 (*Exhibition of Fifty Years of Portraits [1885–1935]*, no. 63). The features of the model do not resemble those of other Venetian models used by Sargent, and the inscription should be treated with caution.

The raking light in the present work highlights the strong planes of the model's jawline, forehead, cheek, nose, neck and plunging cleavage. She is dressed in a loose black robe, which highlights her naked flesh and partly exposed breast. Her black hair, billowing out behind her head in loose strands, adds to the impression of wildness. Writing about the picture in the *Ladies' Home Journal* (vol. 6, no. 7 [July 1927], p. 12), Orpen praised Sargent extravagantly:

It is painted in tremendously strong tonality, and yet it is very sensitive in form and colour. The model herself must have been a most interesting woman; one who had known the buffeting of life. The face shows that many dark shadows had passed over her, soul and body. She must have interested Sargent, and he seems to have put all the power of his youth into this work, a work of love, strong yet tender. He has read this woman's soul and put it on canvas with infinite power and pity, for all who will to read.

Sargent's picture appears in the background of a still life of *Chrysanthemums* by Orpen's pupil James Sleator (1889–1950) (fig. 22).

The stencil on the back of the picture reveals that it was taken into Christie's, London, on 12 March 1926 by R.S. Hunt, who gave his address as 5 Pall Mall, London; it was subsequently returned to the owner

Fig. 22
James Sleator, *Chrysanthemums*. Oil on canvas, 30 x 25 in. (76.2 x 63.5 cm). Private collection.

without being offered for sale (information from Christie's, who have an index to all their stencil numbers). The owner was Reginald Sidney Hunt, long-serving secretary of the Royal Society of Painters in Water Colours (now the Royal Watercolour Society), which was then located at 5A Pall Mall, London. Sargent was a member of the society and a regular contributor to its annual exhibitions from 1904 onward. Hunt also owned Sargent's water-colour of the *Campo San Canciano, Venice* (no. 807). Neither this picture nor the Venetian water-colour has an earlier provenance.

Sir William Orpen described the dramatic circumstances in which he came to acquire the picture around 1927, seeing it by chance one evening in the gallery of a dealer who claimed that it had just been sent in from the country. Orpen came back by daylight, paying a cheque there and then, and taking the picture home in triumph in

a taxi. He belaboured his friends with the merits of his new acquisition. Beverley Nichols records a visit to Orpen's studio when the artist showed him 'the head of a Spanish girl, turned in half-profile: an inspired study in russet and bronze and gold' (*Oxford–London–Hollywood: An Omnibus* [London, reprint 1938], p. 518):

'Look at that eye', said Orpen. 'The off eye, shove your nose into it. Right up against it. Paint won't come off '. I shoved my nose as desired. 'The eye isn't there any longer', I said. 'Of course it isn't', chuckled Orpen. 'Take your nose away. Right away. Yards away. Now, what about that for an eye?'

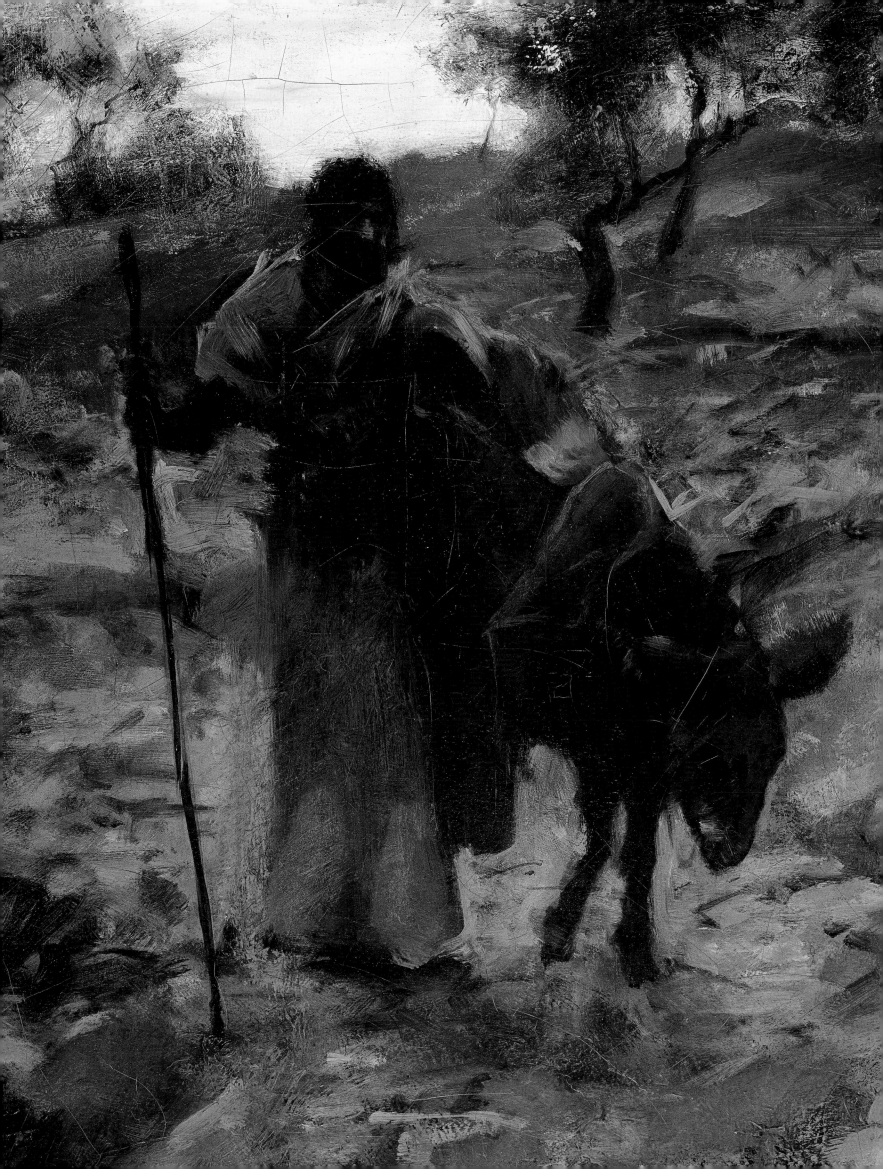

CLASSICAL AND RELIGIOUS SUBJECTS, c. 1874–1879

The pictures in this section reveal Sargent's response to the traditional subject matter of academic art. Some works, like *The Flight into Egypt* (no. 641), may have been schoolroom exercises. Since May 1874, Sargent had been a student in the atelier of Carolus-Duran. Treating a subject from the Bible in terms of contemporary naturalism was very much in the spirit of Carolus-Duran's teaching. Indeed, this particular motif had been one of the subjects set by the master in the atelier to encourage his students' ability to draw upon their own experiences to convey the emotion of a traditional story. Sargent's treatment of the theme can be compared to religious works by Jean-Charles Cazin (1841–1901), an artist he is known to have admired, and to whom he later presented one of his Venetian interiors (no. 795). Cazin's picture of *Hagar and Ismaël* (fig. 23), like Sargent's *Flight into Egypt,* brings home the emotion and anguish of a biblical story in terms of modern figures set in a bleakly realistic landscape.

Though the artist's sympathies lay with modern realism, he was, at this early stage in his career, subject to a wide range of eclectic influences. He was a student at the École des Beaux-Arts, where the belief in history painting as the highest form of art remained unchallenged. His master, Carolus-Duran, painted allegorical and religious works, alongside contemporary realist subjects and society portraits. Works by Carolus-Duran such as *Le Jeune Italien à la Source* (fig. 25), *Obsession* (1872, untraced) and *Hebe* (1874, Palais des Beaux-Arts, Lille) would have encouraged Sargent to experiment with similar themes.[1] It is no coincidence that he and fellow-student J. Carroll Beckwith were chosen by Carolus-Duran to assist him with his ceiling decoration for the Palais du Luxembourg, the *Gloria Mariae Medicis* (fig. 26). All three artists recognized the significance of this monumental decorative work for a major public building. Sargent's hand can be recognized in at least two heads Carolus-Duran included in the ceiling decoration, while he and Beckwith served as models for other figures; it was a collaborative effort.[2] Sargent's own grander ambitions as an artist would be revealed in 1890, when he accepted the commission to decorate the stairway hall on the second floor of the Boston Public Library. The realist impulses of his portraiture and landscape work gave way before the loftier claims of high art. The academic disciplines in which he had been raised and its value system of aesthetics continued to be a source of inspiration long after he had abandoned his studies. For him, as for so many others of his generation, there was no higher goal than the decoration of public spaces with elevating allegorical themes. He is known to have admired the decorations at the Paris Opéra by Paul Baudry (1828–1886), an artist who 'infused his grandiose scheme with a modern spirit'.[3]

Sargent's few recorded comments on contemporary academic painters are not particularly complimentary. In a letter to an artist friend, Heath Wilson, he wrote on 23 May 1874, after visiting the Paris Salon: 'With Gérôme's pictures I was rather disappointed, they are so smoothly painted, with such softened edges and such a downy appearance as to look as if they were painted on ivory or china. Their colouring is not very fine either'.[4] Jean-Léon Gérôme (1824–1904), a leading academic painter and a favourite at the Salon, specialized in neoclassical and orientalist subject matter. Sargent expressed relief that he had not chosen to study at the ateliers of Gérôme or of his rival, Alexandre Cabanel (1823–1889), both because of the brutal initiation ceremonies to which new students were subjected and also because the professors 'only occasionally visit the studio in a stately manner without taking much individual interest in each of the pupils'.[5] Carolus-Duran, by contrast, came to the atelier twice a week, carefully scrutinized the work of his students and offered them constructive advice.

In his recollections of Sargent, Hamilton Minchin records a link between Sargent and Gérôme. He reports that the former was disappointed to learn that Gérôme planned to paint a subject that he had in mind, the burning of Shelley's body on the beach at Lerici.[6] Sargent's lack of respect for Gérôme's work, however, did not prevent him from borrowing motifs from the older painter. The figure in his oil sketch called *A Martyr* (no. 642) derives from the dead Julius Caesar in Gérôme's picture of *The Death of Caesar* (fig. 28), a work much admired at the time.[7]

At this early stage in his career, Sargent was trying out all kinds of experiments, and his frame of reference is broad. His *Nude Oriental Youth with Apple Blossom* (no. 643), for all its decorative oriental features, is a work in the classical idiom. Sargent's softly rendered nude is more subtly contemporary than the idealized female figure in *Le Printemps* (fig. 24) by Laurent-Joseph-Daniel Bouvier (1841–1901), but the inspiration for both works goes back to a common academic vision. One of Sargent's neighbours at 73, rue de Notre-Dame-des-Champs was William Bouguereau (1825–1905), a painter of large-scale figure subjects and the doyen of the classical school. It was reported to Hamilton Minchin that Bouguereau thought Sargent 'a clever youth but on the wrong track'.[8] Certainly, there is little trace of Bouguereau's influence in the classical subjects by Sargent that survive. In their mixture of pagan symbolism and broadly painted naturalistic effects, *A Summer Idyll* and *Two Figures by an Altar*

(nos. 638, 640) seem closer in mood to the mythological scenes by the German painter Arnold Böcklin (1827–1901), an influential figure who was well known in France.[9]

—*Richard Ormond*

1. See Lille 2003, p. 70, no. 9, p. 112, no. 31, p. 126, no. 38.
2. Four oil studies related to the ceiling have, at various times, been attributed to Sargent. They are more likely to have been the work of Carolus-Duran. They are as follows: *A Seated Woman* (with Sotheby's, New York, November 1987); *Drapery Study* (Birmingham Museum of Art, Alabama); *Drapery, Head and Arm Studies* (Portland Art Museum, Oregon); and *Figure Studies* (private collection, Paris, 1963); the last two studies were published by Mount 1963, p. 386, ill. p. 391, figs. 3–4.
3. See Minchin 1925, p. 738.
4. Letter formerly with the Philadelphia bookseller W. H. Allen, and subsequently lost in transit to the Pierpont Morgan Library, New York. See also Maggs Bros Ltd, *Autograph Letters and Documents,* Spring 1935, pp. 92–93 (copies of partial transcripts, catalogue raisonné archive).
5. Letter to Heath Wilson, 12 June 1874, with the same provenance as the letter of 23 May 1874 quoted above (see n. 4).
6. Minchin 1925, p. 738. No such subject by either artist is known.
7. The original painting by Gérôme, exhibited at the Salon of 1859, is now lost. The picture in the Walters Art Museum reproduced here (fig. 28) is a later version. An engraving by the artist of the figure of Caesar alone was published in *Sonnets et Eaux-Fortes* (Paris, 1869); this rare and important book paired an impressive group of contemporary artists and poets.
8. Minchin 1925, p. 736.
9. See, for example, Böcklin's pictures of *Pan in the Reeds* (1859, Bayerische Staatsgemäldesammlungen, Munich) and *The Sacred Wood* (1882, Öffentliche Kunstsammlung, Basel).

Fig. 23 *(left)*
Jean-Charles Cazin, *Hagar and Ismaël,* c. 1880. Oil on canvas, 99¼ x 79½ in. (252 x 202 cm). Musée des Beaux-Arts, Tours.

Fig. 24 *(below left)*
Laurent-Joseph-Daniel Bouvier, *Le Printemps,* 1870. Oil on canvas, 66⅞ x 27⁹⁄₁₆ in. (170 x 70 cm). Musée des Arts Décoratifs, Paris.

Fig. 25 *(below)*
Carolus-Duran, *Le Jeune Italien à la Source,* 1864. Oil on canvas, 51³⁄₁₆ x 33³⁄₁₆ in. (130 x 84 cm). Private collection.

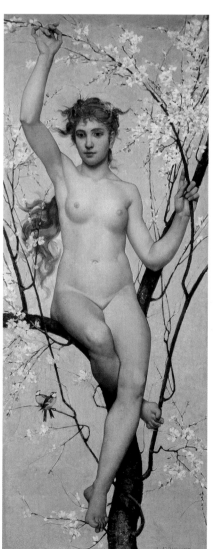

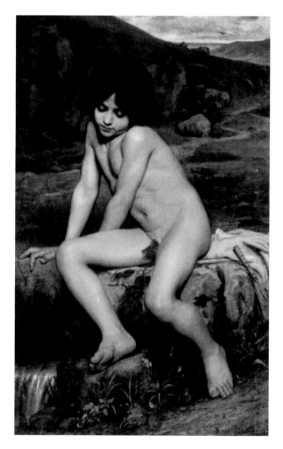

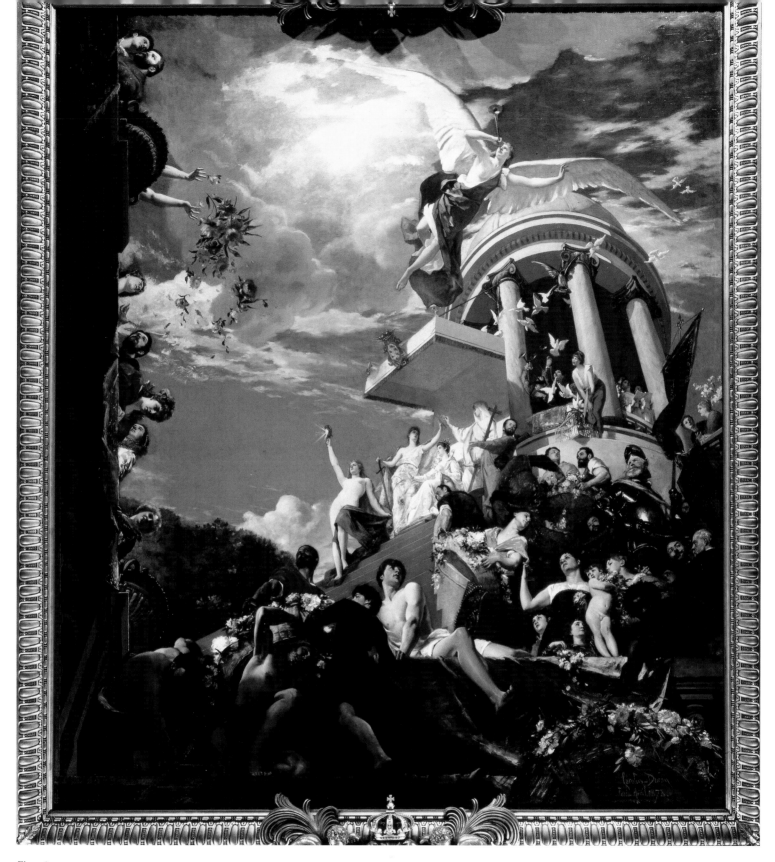

Fig. 26
Carolus-Duran, *Gloria Mariae Medicis. Ceiling decoration
for the Palais du Luxembourg.* Musée du Louvre, Paris.

638
A Summer Idyll (recto)
and *Study of a Head* (verso)

c. 1877–78
Oil on canvas
12¾ x 16 in. (32.5 x 40.7 cm)
Inscribed, lower right: *to my friend*
Walton/John S. Sargent
Brooklyn Museum, New York. John
B. Woodward Memorial Fund (14.558)

The picture shows three young boys resting on a bank dotted with blue flowers, silhouetted against a partly cloudy blue sky. Only the head and shoulders of the boy on the left are visible; his body is out of sight on the far side of the bank. He gazes intently at the head of the boy in the centre, who lounges back in a louche, abandoned pose, his right arm and leg extended, his leg acutely bent at the knee and drawn up. The third boy is lying on his front with his back to us, buttocks prominent, playing a pair of pipes. The dark-toned bank, almost black in places, sets off the warm flesh tones of the boys and the light blue sky. The blend of naturalism, sensuality and pagan mythology is common enough in the work of contemporary neoclassical painters but rare in

Sargent's oeuvre. The picture is an isolated experiment, combining life studies of children, for which there are parallel examples in his early work (see, for example, the studies of boys on a beach at Capri, nos. 692–97), with an arcadian setting suggestive of the antique. The inspiration for the subject may well have come from Carolus-Duran, who experimented with neoclassical subject matter; see the latter's *Jeune Italien à la Source* of 1864 (fig. 25).

Sargent's study is painted on top of an earlier sketch of the head of a woman, probably a model, which supports the idea that it was a studio exercise. The head is clearly legible in an X-ray photograph (fig. 27). On the reverse of the painting is a strangely scumbled image of a bearded man. The picture is inscribed to 'Walton', probably the American artist, art critic, author and translator William Walton (1843–1915), who, like Sargent, had studied at Carolus-Duran's atelier. A portrait of Walton by J. Carroll Beckwith, another Carolus-Duran student, which was exhibited at the Paris Salon in 1887, hangs in the Century Club, New York. Walton was drowned in New York, possibly a suicide. *A Summer Idyll* was acquired by the New York dealers Cottier and Sons in 1914 from an unidentified source, and it was

purchased by the Brooklyn Museum in the same year. Both Downes (1925, p. 121) and Charteris (1927, p. 280) identify the picture as one exhibited at the New English Art Club in 1911. Four of the five paintings Sargent exhibited there that year have 'summer' in their titles, but *A Summer Idyll* had long since been in an American collection.

Fig. 27
X-ray photograph of *A Summer Idyll,* showing the study of a head under the present paint surface.

639
Judgement of Paris

1877
Oil on plaster
23¼ x 25½ in. (59 x 64.8 cm)
Inscribed, bottom right: *J.S.S./Aug 24th*
[possibly '23rd' or '29th'] *1877*
Inscribed on a label on the reverse:
*Mrs Horace Binney/61 Co. Ave./Boston
Mass./Sargent panel*
Vizcaya Museum and Gardens, Miami
(T89-6.1)

Sargent painted the *Judgement of Paris* directly
on the wall of the nursery at the Sorchan
country house at St Senoch near Lyons.
Marius Alexander Sorchan (1825–1914) was
a wealthy Frenchman involved in the silk
business whom Sargent painted in 1884
(*Early Portraits*, no. 125). His wife, born Car-
oline Thorn, was American and had previ-
ously been married to another Frenchman,
Armand Lachaise; she owned a version of
Dans les oliviers à Capri (Italie) (no. 703) and

an early sketchbook. The son of that mar-
riage, Eugène Lachaise, was a fellow art stu-
dent and close friend of Sargent in Paris.
The pair spent the summer of 1877 paint-
ing at Cancale in Brittany, and then trav-
elled south to stay with the Sorchans at St
Senoch, before Sargent moved on to Bex
in Switzerland, where he spent some three
weeks with his family. It was during his
visit to St Senoch that Sargent decorated
the panel above the fireplace of the nursery
for the benefit of the Sorchans' young
daughter Marie (later Mrs Horace Binney,
Sr). In a letter of 17 November 1966 to
David McKibbin (McKibbin papers), Con-
stance S. Binney, the first wife of Horace
Binney, Jr, but by then divorced, recalled
her mother-in-law 'saying that Sargent
painted it directly on the wall panelling of
her nursery, and that the Judgement of Paris
figures were scratched in the paint with a
knife. When St. Senoch, the Sorchans' place
(near Lyon, not Tours) was sold, this panel
was removed and framed. As you know
it hung over the parlor mantel at "61"

[Commonwealth Avenue, Boston]'. A sim-
ilar account, written by the second Mrs
Horace Binney at the time of the gift, is in
the files of the Vizcaya Museum.

Sargent has taken considerable liber-
ties with the traditional iconography of the
subject. Paris is usually represented seated,
whereas Sargent shows him as an effete
Florentine youth, in the style of the fif-
teenth century, leaning on a stick and
holding the golden apple he will award to
one of the three goddesses. One would
expect the seated figure in black, with
Cupid at her knee, to be Venus, which
leaves the figure with an album of music
and a long-necked lute, or banjo, and the
shadowy figure on the left, to stand for
Juno and Minerva. Flowers and trees are
decoratively arranged around the figures in
the manner of a Renaissance tapestry; there
is a coat of arms top right and a scroll with
an indecipherable inscription along the
bottom. The picture is a skit on a well-
worn theme intended to entertain the
young half-sister of a friend.

640
Two Figures by an Altar

c. 1875–78
Oil (support and dimensions unknown)
Untraced

This classically inspired picture shows two hooded figures standing at a little distance from a marble altar of antique design, decorated with swags. Smoke rising from the altar implies a sacrifice at which the two figures are officiating. In the background is a low bank with trees on the right outlined against the sky. It is not easy to decipher the figures in this reproduction from an old negative. The one in front is dressed in a darker shade of grey than his companion, who sports a thick black sash wound round his

waist and falling to the ground. The picture is painted in broad brush strokes with scattered blobs of paint. The combination of mythological subject and naturalistic landscape is typical of late nineteenth-century neoclassical art, and shows Sargent experimenting in a new mode. Comparisons can be made with the work of contemporary artists such as Arnold Böcklin, Paul Baudry, Alexandre Cabanel and Jean-Jacques Henner. It is possible that the subject was painted in response to one of the 'lessons' given by Carolus-Duran to his students, like *The Flight into Egypt* (no. 641). The picture was photographed for Sir Robert Witt around 1927, when it was in the collection of Emily Sargent; the original negative is now in the Witt Library, Courtauld Institute, London (no. D53/1721).

641 *(opposite)*
The Flight into Egypt

c. 1877–79
Alternative title: *The Rest on the Flight into Egypt*
Oil on canvas
17½ x 21 in. (44.5 x 53.5 cm)
Inscribed, lower right: *to Emily with happy/Xmas* [?] *from/J.S. Sargent*
Collection of Joseph F. McCrindle

The picture shows Joseph walking beside a donkey with a staff in his right hand and his left arm supporting the figure of the Virgin Mary, who leans against him. *Pentimenti* showing through the present paint surface on his right side indicate that Sargent moved the position of the figure to the right. The Virgin cradles the unseen infant Christ in her robe, perhaps nursing him, her face lost in shadow. The donkey bends down its head in a similar state of weariness, while Joseph peers anxiously down the path ahead of them. The image of this weary group in a lonely landscape as night falls is touching and poignant. There is a

grove of olive trees above to the right, and a few scattered trees on the other side of the path to the left, silhouetted against the sky, but the general aspect of the landscape is rocky and unprepossessing.

Twice a month, Carolus-Duran set his students a particular subject as a lesson in painting, and he then reviewed the sketches in open session. One of his students recorded six of these lessons stenographically, and they were published in the *Century Magazine* under the title 'A French Painter and his Pupils'; sadly the dates of these lessons are not recorded. The subject set for the second lesson was 'The Flight into Egypt', and it may be that Sargent's picture was painted in response to this. Carolus-Duran urged his students to forego the heroic aspects of the subject in order 'to find our own experiences in their melancholy, their terrors, their passions'. He invoked the

many scenes of the flight painted by Tiepolo and told his students not to copy Tiepolo but to proceed like him:

It is the only way to avoid the commonplace—the only way to find charmingly intimate scenes; the child Jesus crying, smiling, or being nursed by his mother. The travelers have rested in the shade, as you might have done; they have had in their flight a crowd of emotions, such as you may have felt in your journeys. Call up your remembrances and apply them, so that the personages may be before your eyes, moving, walking, resting, forming a whole with the nature that surrounds them and of which they reflect the influence (Century Magazine, vol. 31, no. 3 [January 1886], pp. 374–75).

Sargent's picture is a remarkably accurate illustration of Carolus-Duran's teaching. He was at pains to humanize the Holy

Family and to set them in an austerely realistic landscape in order to give the story a contemporary resonance. His picture is in the same modern mode as the religious paintings by his friend Jean-Charles Cazin, which combine spiritual figures with vernacular landscapes. Both painters were responding to a new view of the Christian story, exemplified by Ernest Renan's *Vie de Jésus* (Paris, 1863), with its human conception of Christ and its rationalist approach to the Bible story; for Renan's influence on Sargent's later mural work in the Boston Public Library, see Sally Promey, *Painting Religion in Public: John Singer Sargent's 'Triumph of Religion' at the Boston Public Library* (Princeton, 1999, pp. 37–42).

Stylistically, Sargent's picture relates to the landscapes he was painting in Capri and North Africa, and it is likely to date from the late 1870s.

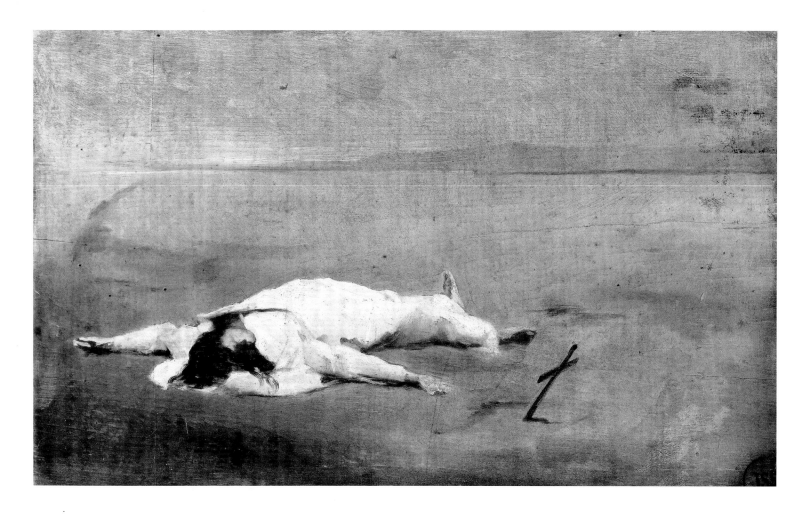

642
A Martyr

c. 1874–77
Alternative titles: *A Study of Three Figures,
with a Martyr on the reverse; Three Figures
(with Study of a Martyr on reverse); Penetentia*
Oil on canvas, originally on panel
11¾ x 18½ in. (30 x 47 cm)
Lower right, studio stamp: *JSS* circled
Private collection

This picture was formerly on the reverse of
*Two Nude Boys and a Woman in a Studio Inte-
rior* (no. 629). The two sides were separated
in 1969 and transferred from panel to can-
vas when in the possession of Alfredo
Valente, a noted photographer and collec-
tor, and then director of the Gallery of
Modern Art with the Huntington Hart-
ford Collection, New York; they are cata-
logued here separately. *A Martyr* represents
a figure wrapped in a white robe, with a
white undergarment, stretched out on the
ground in a sparse, desert-like setting. The
long, loose hair, partially veiling the face,
suggests that the person is female. The pose
of the figure, arms outstretched with palms
facing outwards and feet bare mimics that
of a crucifixion. The small upright cross
beside the figure underlines the Christian

iconography of the subject, though the
title, 'A Martyr', was probably an invention
by the cataloguer of the 1925 Sargent sale,
in which the picture had first appeared
(Christie's 1925, lot 182). The pose of the
figure is taken almost verbatim from Jean-
Léon Gérôme's famous painting of *The
Death of Caesar* (Salon 1859, version in the
Walters Art Museum, Baltimore, fig. 28).
The subject set for the sketch competition

at the École des Beaux-Arts in 1875 is said
to have been the death of Julius Caesar.

Mount dated the picture to 1879
(Mount 1955, p. 443, no. K7923), and a date
around that time or possibly a little earlier
is probably correct.

Fig. 28
Jean-Léon Gérôme, *The Death of Caesar*, c. 1859.
Oil on canvas, 85 x 145 in. (215.9 x 368.3 cm).
Walters Art Museum, Baltimore.

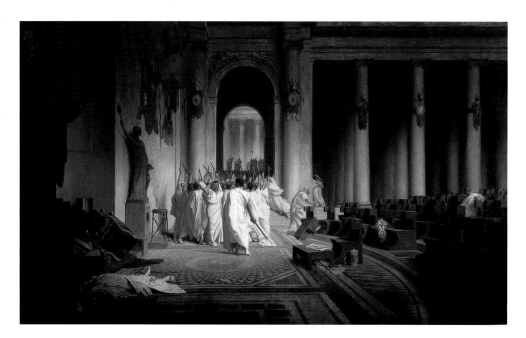

Nude Oriental Youth with Apple Blossom

c. 1878–79
Alternative titles: *Spring; Oriental Youth; Japanese Boy and a Blossoming Bough*
Oil on canvas
35½ x 25½ in. (90.3 x 64.8 cm)
Inscribed within a block, lower left:
John S. Sargent
Western Reserve Historical Society, Cleveland (76.46.5)

This odd picture demonstrates academic rigour in the treatment of the nude within an aesthetic-cum-decorative ensemble. Like other artists of his generation, Sargent was intrigued by oriental art, and he collected Japanese prints and ornamental items. His picture depicts a nude Japanese youth wearing koto sticks in his hair and reaching up to grasp the branch of an apple tree with his left hand. His other arm is also extended, and his lithe figure presents an uninhibited image of young male sexuality. The effect of the nude figure, the apple tree and the scattered pink blossoms against the flat abstract background of olive green is stylized and decorative, reminiscent of poster designs and illustrations.

The artist has signed his name on a rose-coloured block, or *signateuron,* in the manner of a Japanese *satsuma* stamp. The faint impression of an earlier block below indicates that the artist altered its position; it forms part of the decorative pattern. One can only speculate on the reasons that led the artist to experiment with such an unusual subject. It may have been done as a student project or to demonstrate the artist's versatility. A closely related drawing in the Fogg Art Museum (fig. 29) may be a record of the picture, which it follows faithfully, rather than a preliminary study.

The picture was one of a group of early sketches that came into the possession of the painter Auguste Alexandre Hirsch (1833–1912), with whom Sargent shared a studio at 73, rue de Notre-Dame-des-Champs (see appendix 1, p. 387, for the Sargent studies belonging to Hirsch).

Fig. 29
Nude Oriental Youth ('Standing Male Nude'), c. 1878–79. Pencil on paper, 5¼ x 3⁹⁄₁₆ in. (13.4 x 9.1 cm). Fogg Art Museum, Harvard University Art Museums, Cambridge, Massachusetts. Gift of Miss Emily Sargent and Mrs Francis Ormond, 1931 (1931.87.A).

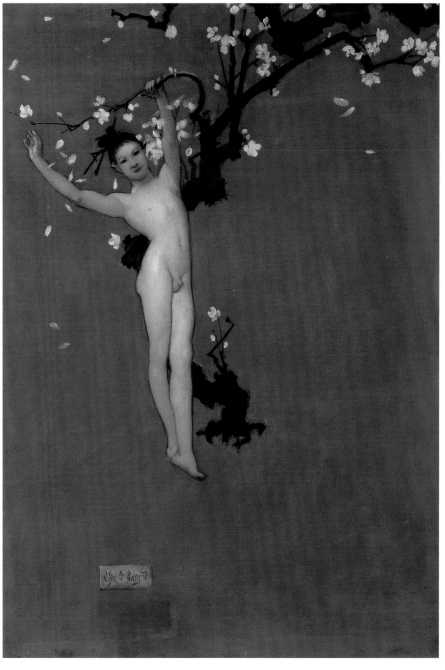

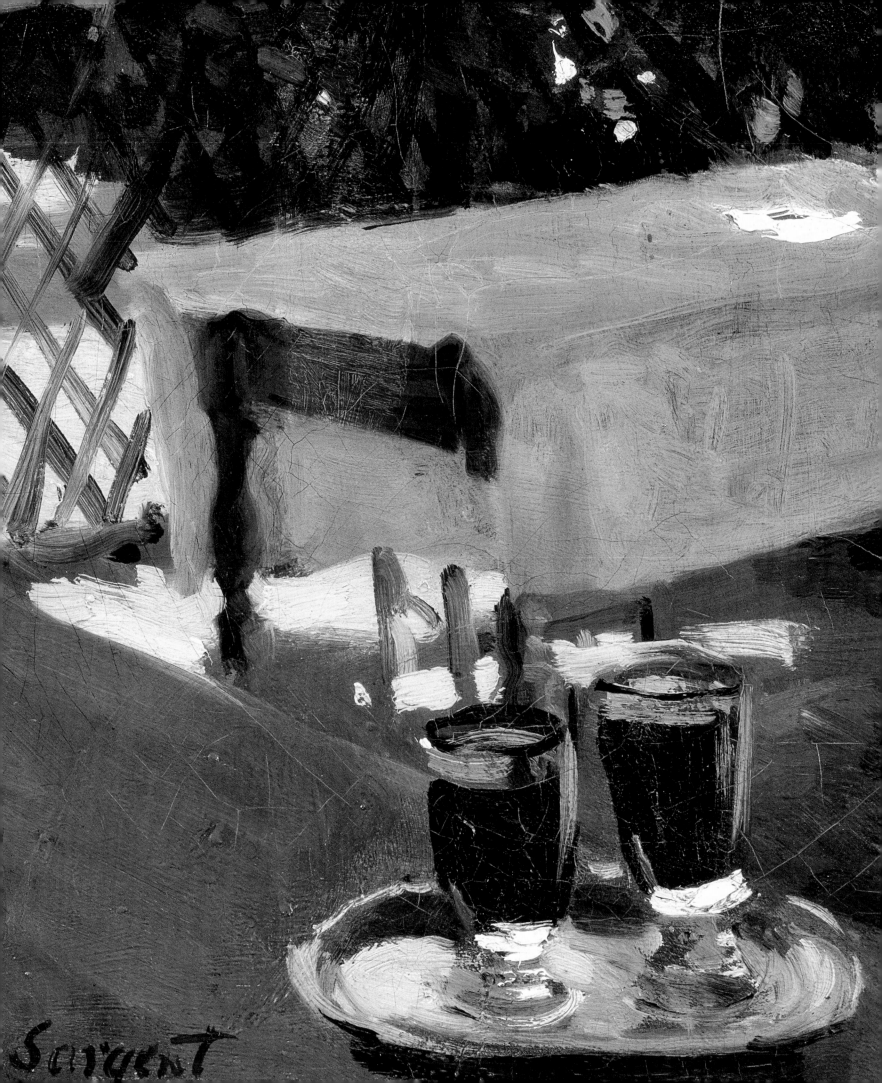

LANDSCAPE AND ARCHITECTURAL STUDIES, C. 1875–1880

Most of Sargent's early *plein-air* paintings relate to specific expeditions: Brittany in 1877, Capri in 1878, Spain in 1879, Morocco in 1880 and Venice in 1880–81 and 1882. The pictures catalogued in this chapter remain outside this framework, and as a result they appear to be more heterogeneous. The location of some of the paintings is known or conjectured: Gard in the South of France for the water-colour of *The West Portals of Saint-Gilles-du-Gard* (no. 653); Haarlem for the *Interior with Stained-Glass Window* (no. 651); La Motte-Servolex, Savoy, for the study of a kitchen garden, *Un Coin de potager* (no. 647). *La Table sous la tonnelle* (no. 644) and the *Corner of a Garden* (no. 646) were probably painted in northern France, possibly Paris.

La Table sous la tonnelle is an accomplished, avant-garde work that has no parallels in Sargent's early work. The inscribed date, '1874', has been doubted because art historians cannot believe that the artist could have produced such a sophisticated work so early in his career. There is nothing to compare with it until the Breton beach studies of 1877, and it remains a puzzle. So, too, does *A Road in the South* (no. 654), a picture generally associated with the Nice landscapes of 1883. In the view of

the authors, it is earlier, possibly painted in Naples or Capri in 1878, or a year later in Spain. With its deep, recessional perspective, it anticipates some of the compositional motifs of Sargent's Venetian work, while its white-on-white colour scheme links it to the Capri and Moroccan studies of 1878 and 1880. One recent authority has placed the *Staircase* (no. 652) in a monastery in Capri, an intriguing idea since the style of Gothic architecture feels more southern than northern, but it has yet to be substantiated. Like the *Interior with Stained-Glass Window,* the picture explores the subtleties of spatial relationships and the treatment of light from multiple sources that the artist would take further in Venice. *The West Portals of Saint-Gilles-du-Gard* (no. 653) is an essay in architectural topography, reminiscent of the Alhambra studies (see nos. 748–53). The artist captures the play of light across the richly sculpted and decorated façade of this medieval masterpiece. With characteristic boldness, he places the church front more than halfway up the sheet of paper, leaving the whole of the foreground as bare space.

Sargent had been an inveterate recorder of buildings since boyhood, and his understanding of architectural form was the

result of sustained study and practice. Early drawings in the Fogg Art Museum, Harvard University Art Museums, Cambridge, Massachusetts, and other collections represent churches and public buildings in French, Italian and Spanish cities.[1] These important structures are precisely and elegantly drawn, and reveal a passion for design and architectural and sculptural detail that would last throughout his career.

Sargent's early landscapes are slight in comparison with his architectural works. *Three Figures on a Beach* (no. 649) is a sketch of women mending nets or sails on a beach somewhere in southern Europe. *Pumpkins* and *Un Coin de potager* (nos. 645, 647) are works of rustic naturalism, recording simple processes of horticulture in the countryside. Sargent would return to such domestic and bucolic subjects in the pictures he painted at Nice in 1883 and later at Broadway in England.

—*Richard Ormond*

1. For architectural drawings in the Fogg Art Museum, see nos. 1937.8.6, 1937.8.53 and 1937.8.54 (Leon); 1931.99 and 1937.8.19 (Tarragona); 1931.103 (Seville); 1931.72, 1931.73, and 1931.102 (Turin); 1937.8.29 and 1937.8.30 (Verona); 1931.89 (Chartres); and 1937.8.57 (Rouen).

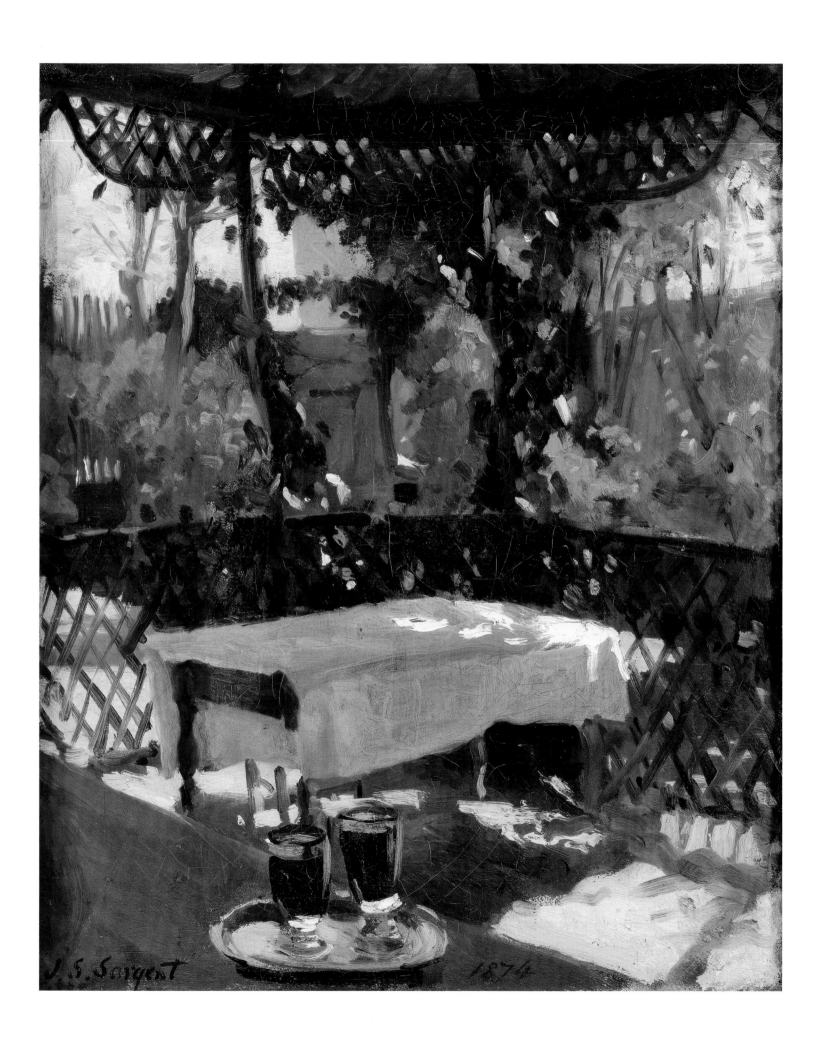

644
La Table sous la tonnelle

c. 1875
Alternative titles: *Wine Glasses; An Arbour;*
The Arbor; Wineglasses; Two Wine Glasses
Oil on canvas
18 x 14½ in. (45.7 x 36.8 cm)
Inscribed, lower left: *J. S. Sargent;*
lower centre: *1874*
Private collection

Fig. 30
Photograph of *La Table sous la tonnelle,* in which the earlier inscribed date '1875' is legible. Catalogue raisonné archive.

The picture represents a section of a garden, which might belong to a café, an inn or a private house. Part of a pergola or an arbour, circumscribed by a low trellis fence, its roof supported by two uprights and edged with trelliswork, occupies the foreground. Intense sunlight filters through the pattern of trellis and foliage, falling in patches of impasto on the shaded white tablecloth and the variegated floor. The garden space is enclosed by high brown walls or fencing, partly covered in greenery, with a niche, possibly an arch, door or gate, just left of centre. It is difficult to read the background beyond the garden walls or fencing.

The focal point of the composition is the two glasses, filled with red wine, which stand on a silver or metal tray; they seem to form a discrete still life at the lower edge of the picture space and are highly reminiscent of the work of Édouard Manet. The intimate scale of the painting, its lack of obvious subject and incident, its flickering brushwork and handling of light and abrupt cropping imply an awareness of the preoccupations of the Impressionists. The informality of the scene is deceptive, however, because the boldly sliced composition depends on a set of taut right angles—the lines of table, sideboard, roof and fence—for its formal coherence.

The dating of the picture has presented difficulties. An early photograph of the painting shows an inscribed date, '1875', below the signature (fig. 30); this date is no longer distinguishable and may have been abraded or cut off during framing. The form of the signature is early, but the inscribed date '1874', now visible at the lower centre of the canvas, is different in character and is probably a later addition. Charteris notes that the picture was dated twice, but gives the dates as '1873' and '1874', adding that 'it was signed and dated by Sargent as recently as 1923' (Charteris 1927, p. 39), possibly when it was acquired by Sir Philip Sassoon.[1]

The year 1875 is the more probable date. It seems unlikely that Sargent could have painted such a technically accomplished work when he was just eighteen and had only joined Carolus-Duran's studio in May 1874. The location of the scene has not been identified. It is not known whether the site is urban or rural (no landscape is visible beyond the enclosed garden space). In his diary, J. Carroll Beckwith mentions a number of Parisian cafés which were regular haunts for Sargent and his circle, among them Boeuf à la Mode, Cagnard's, Foyot's, Lavenue (which certainly had a garden), Ledoyen's and the Lion d'Or (Beckwith Diary, National Academy Museum and School of Fine Arts, New York). Richard H. Finnegan has also nominated the Closerie de Lillas, a modest *relais de poste* (still in existence as a restaurant), situated at 171, boulevard du Montparnasse, on the corner with avenue de l'Observatoire, which also had a garden; it would have been very close to Carolus-Duran's studio at 81, boulevard du Montparnasse. The scene depicted might, however, be rural, in which case there would be several further options. Sargent was in Normandy—Caen, Rouen, Beuzeval—with his family in the summer of 1874; but the scene might have been painted in Nice, where Sargent, Robert C. Hinckley and Stephen Parker Hills accompanied Carolus-Duran early in 1875; at St Énogat in Brittany, where he spent the summer of 1875 with his family, or at the village of Grez-sur-Loing on the southern borders of the forest of Fontainebleau, which was a popular sketching venue for Carolus-Duran's students (see pp. 12, 14, 21, 28, n. 8).

The archives of M. Knoedler & Co., New York, indicate that the picture was in Carolus-Duran's collection and came to them via the Galerie Georges Petit in Paris in 1923. It was bought from Knoedler by Sargent's wealthy friend Sir Philip Sassoon (see *Later Portraits,* no. 604), who owned an important collection of the artist's work. The painting was one of six works by Sargent shown in an exhibition entitled *Modern British Art together with a Group of Oil Paintings by J. S. Sargent, R.A.,* which was held at the Goupil Gallery in London in the summer of 1924. The exhibition comprised works by British artists including Walter Sickert, Philip Wilson Steer, Henry Lamb, Augustus John, Sir William Orpen, Laura Knight, George Clausen, James Pryde, William Nicholson and James Shannon. The Sargents, all loans from Sassoon's collection, were the only works not for sale.

The exquisite picture has attracted praise, notably from the Bloomsbury critic Roger Fry, who was generally unsympathetic to Sargent's work. When Fry went to see the Sargent memorial exhibition at Burlington House in 1926, he noted:

So I went patiently through the exhibition to see whether I could get from any of the canvases that particular pleasure which I look for from pictures, namely, the delight in certain visual relations regarded in and for themselves. In Gallery no. V. I did, in fact, discover what I was in search of. A little picture ('Wineglasses') of a Suburban French café, a table with two wineglasses in the foreground, a trellised arbour, and sunlit verdure beyond. As a composition it was satisfying without being in any way remarkable, but the pale grey greens of the foliage made with the warm grey shadows on the pavement and the cooler grey of the table a very agreeable and deliberate harmony —a harmony which was intensified by the discreet notes of dull violet and blue grey in the wineglasses (Fry 1926, p. 126).

1. In the list 'Sargent's Pictures in Oils' at the end of his biography, Charteris includes 'Wine Glasses' under its inscribed date '1874'; he also lists the title 'The Arbor', given at the picture's first exhibition in 1924. In all three editions of his biography, Charles Merrill Mount dates the picture '1875' and 'incorrectly dated 1874' (Mount 1955, p. 442; 1957 ed., p. 351; 1969 ed., p. 458).

This small picture, painted on one of the thin mahogany panels used by Sargent during the period 1877–80, depicts a field of pumpkins. One large pumpkin is visible in the foreground, and plant stems, sticks and broad green leaves above a background of brown earth stretch away to a distant line of trees and bushes. A young girl of Mediterranean type, in a white shirt, red cap and brown skirt, stands in the middle distance clasping a large round pumpkin. The dark brown colours of earth and trees, the spiky patterns of the plants and the presence of the solitary girl create a poetic effect with the simplest of means. The picture belongs to a well-established genre of rural subject matter much in vogue during the post-Barbizon era. It may have been painted in Capri in the summer of 1878, near Nice, where Sargent was visiting his family in the same year, or in Spain the following year.

The picture belonged to the artist's sisters Emily Sargent and Violet Sargent (Mrs Francis Ormond) and was given by them to Sir Alec Martin (1884–1971), together with other pictures and drawings, to thank him for organizing the highly successful Sargent sale at Christie's in 1925. Sir Alec, in turn, gave it in 1958 to his friend the Rt Hon Edward Heath (1916–2005), later leader of the Tory party and British prime minister, to mark his [Martin's] retirement from Christie's (see Sir Edward Heath's letter to David McKibbin, 31 July 1969, McKibbin papers). It was given together with two Near Eastern watercolours by Sargent of *Lake Tiberias* and *Mar Saba* (to be catalogued in a subsequent volume). Heath's parents and the Martins were near neighbours in Kent, and the young Edward Heath, in his early days as a collector, leant heavily on the advice of Sir Alec, who had risen from office boy to become chairman of Christie's, London (Sir Edward Heath in conversation with Richard Ormond, 2004).

645
Pumpkins

c. 1878–80
Oil on panel
10 x 12½ in. (25.4 x 31.8 cm)
Heirs of The Rt Hon Sir Edward Heath, K.G., M.B.E.

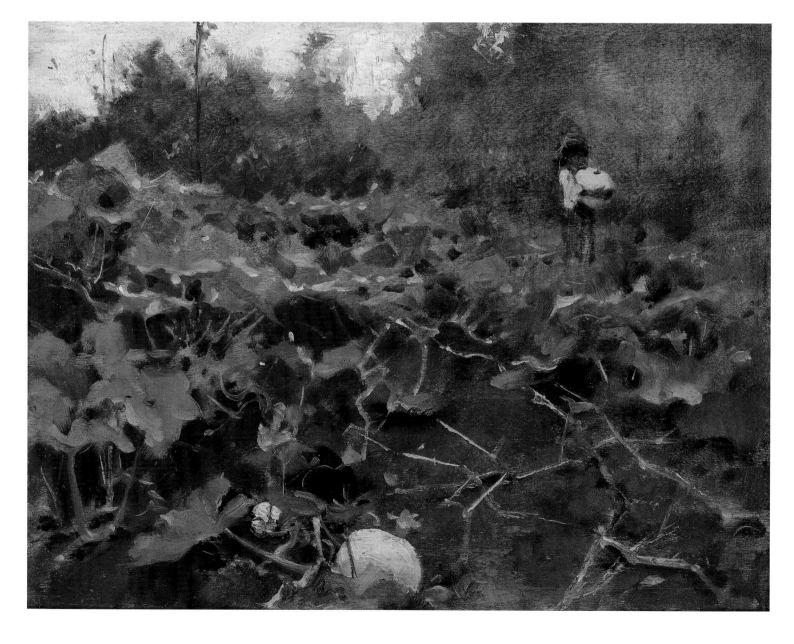

646
Corner of a Garden

c. 1878–80
Oil on panel
14 x 10 in. (35.5 x 25.5 cm)
Inscribed, bottom left: *to my friend . . .*
[indecipherable]/*John S. Sargent*
Westervelt-Warner Museum,
Tuscaloosa, Alabama

This colourful view of a herbaceous border
shows a row of bright red salvias in the
foreground to the right, then a second row
of pink and white flowers (the pink possi-
bly carnations), and finally, tall white and
pink hollyhocks growing through clumps
of red dahlias. A single yellow rose can be
seen below the first two hollyhocks on the
left. In the background is a dense green
hedge silhouetted against a pale blue sky.
The coloration of the flowers, though not
their precise arrangement, and the shape of
the trees mirror those in the background of
In the Luxembourg Gardens (no. 721; see also
detail p. 180) and may have served as a
study for it. The picture is painted on one
of the thin mahogany panels Sargent was
using for his small-scale sketches in the
period 1877–80. Another study of holly-
hocks (Adelson Galleries, New York, 2005),
probably painted a few years later in the view
of the authors, will be catalogued in a sub-
sequent volume of the catalogue raisonné.

Due to the partial obliteration of the
inscription, it has not been possible to
identify the person to whom the picture is
inscribed. The name has, in the past, been
read as 'Dannat', and the person identified
as William Turner Dannat (1853–1929), a
fellow American artist in Paris to whom
Sargent presented the *Head of a Young
Woman* and *Back View of a Nude Model* (nos.
631, 632); the authors are not convinced by
this reading.

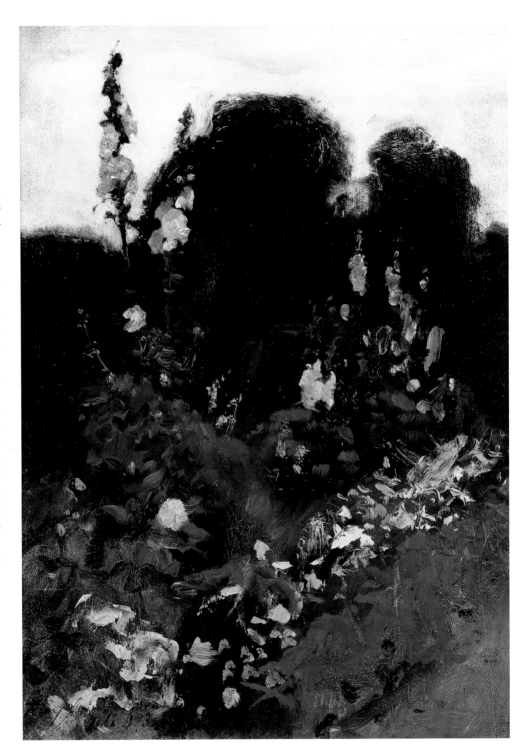

647
Un Coin de potager

1879
Oil (support and dimensions unknown)
Untraced

The photograph of this oil sketch of a veg-
etable garden was sent to David McKibbin
with a letter of c.1947 from Marie-Louise
Pailleron (McKibbin papers): 'I enclose with
this letter two photos of small *croquis* made
by J. S. Sargent. They were taken in my house
of Ronjoux in Savoie where I passed the
late season'. The other photograph was of a
water-colour sketch of Marie-Louise Pai-
lleron, also painted in 1879 (*Early Portraits,*
no. 19). Marie-Louise Pailleron (1870–1950)
was the granddaughter of François Buloz,
editor of the highly influential *Revue des
Deux Mondes,* and of Christine Blaze de
Bury, and the daughter of the playwright
Édouard Pailleron and Marie Buloz. Like
her parents and her grandmother, Marie-
Louise sat to Sargent for a formal portrait,
with her brother Édouard, in 1881 (*Early
Portraits,* no. 37). She gives a vivid descrip-
tion of the artist in her delightful book of
reminiscences, *Le Paradis Perdu* (Paris, 1947).

 Marie-Louise was nine at the time
that Sargent painted the vegetable garden
at the Château de Ronjoux, the Buloz
family home in La Motte-Servolex, near
Chambéry in Savoy, during his visit there
in the summer of 1879 to paint the full-
length portrait of *Madame Édouard Pailleron*
(*Early Portraits,* no. 25); the artist probably
gave the sketch to his hostess, Mme Buloz,
or her daughter, Mme Pailleron. In compo-
sition and technique, it is similar to his
other landscape sketches of this period. The
softly painted rows of vegetables are set off
by the counter-diagonals of the building,
path, gate and line of trees. Though the
authors have not seen the original picture,
now untraced, they have little doubt of its
authenticity. They are grateful to Richard
H. Finnegan for pinpointing the Château
de Ronjoux.

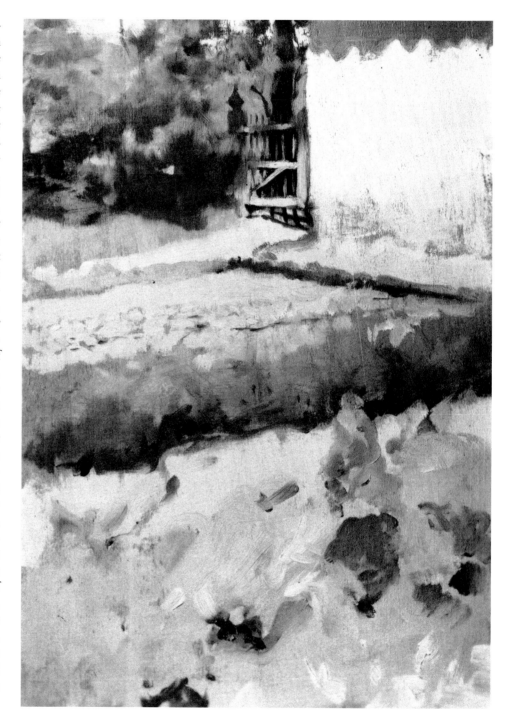

648
Landscape with Two Children

c. 1878–79
Water-colour and graphite on paper
14 x 9⅞ in. (35.7 x 25.2 cm)
Inscribed, lower right: *John S. Sargent*
Inscribed on the verso in the artist's hand:
*a encadrer en carton blanc de . . . [chine?]/à
petit biseau d'or—la toute dans une/baguette
d'or, simple./à porter chez M[adam]e la
Baronne de Poilly/5 rue du Colisée-/Très
pressé/facture à M. Sargent. 41 Bd Berthier*[1]
Private collection

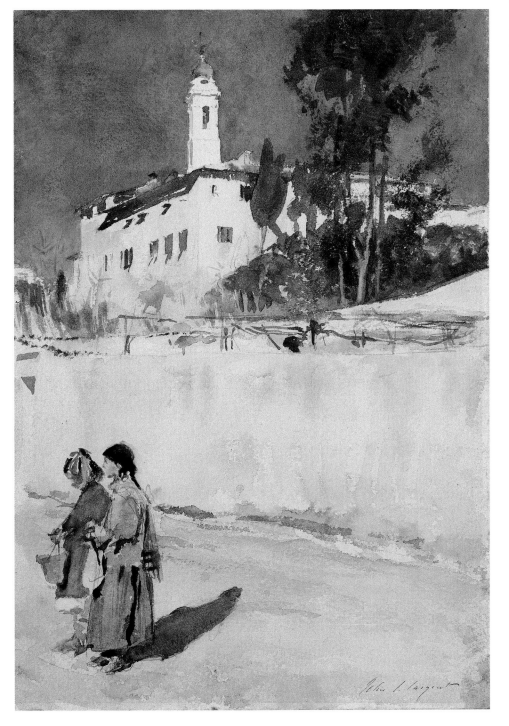

This water-colour is likely to have been executed either in the summer of 1878 on Sargent's visit to Naples and Capri or the following autumn in southern Spain. The tower of the church or chapel, with its green onion dome, is southern European in style, and the two little girls are of Mediterranean type. They are standing in a roadway patiently waiting, perhaps with things to sell in their bags. The one in front, seen in profile, has dark hair falling below her waist, a shawl round her neck and shoulders, and a bluish jacket and a darker shirt of the same colour. Her companion is looking down, her features barely discernible under a simple domed hat or cap with stripes. She is also wearing blue, with a white border to her short dress. Behind the figures is a high wall with a trellis visible above it. There is a second wall behind, and then a group of trees on the right and to the left a square building. The presence of a bell tower suggests that this is a religious community ranged around a church or chapel. The artist uses thin washes of greyish blue, pale blue and beige over the white of the paper to evoke the textures and tones of roadway, wall and building. Contrasting with this subtle symphony of whites are the denser blues of the two figures, the green foliage and the vivid blue sky.

The inscription on the back, which refers to the boulevard Berthier, is an instruction to the framer for mounting and framing the water-colour. As the work was to be sent to the Baronne de Poilly, one can assume she was the first owner. Sargent did not move to boulevard Berthier until 1883, so he cannot have given or sold the water-colour before that date. The Baronne de Poilly (1831–1905) was the daughter of the Marquis du Hallay-Coëtquen. She married first the Comte de Brigode and, following his death, the Baron de Poilly. She was a celebrated beauty and a prominent figure in the society of the Second Empire. The arts played a large part in her life, and she numbered several artists among her intimate circle, including Henri Gervex and Eugène Lami. The latter was a member of the Société d'aquarellistes, as were Sargent's friends Ernest-Ange Duez and Joseph Roger-Jourdain, and Lami may have been the intermediary.

1. 'To be framed in a mount of white/with small gold bevel—the whole in a simple gold frame/to be taken to the home of M[adam]e La Baronne de Poilly/as soon as possible/invoice to M. Sargent 41 Bd Berthier'.

649
Three Figures on a Beach

c. 1878–80
Water-colour and pencil on paper
10 x 13¾ in. (25.4 x 35 cm)
Private collection

The foreground details of this water-colour are not easy to read. To the left an old woman in black, with a blue scarf and a cap, is seated on the sand mending a fishing net or a sail, the folds of which spread out to fill the bottom right-hand corner of the picture. To the right of the old woman, a blonde-haired younger woman, very sketchily delineated, appears to be involved in the same task. Further to the right, a young woman in blue, with a bright red shawl, leans back, watching her companions at work. Behind her are long strips of brown material (nets or sails) laid out to dry. The steeply shelving beach curves away from the figures to form a small bay. A line

of square, whitewashed houses defines the upper limit of the beach, with a strip of blue sky above them.

In his index card for the picture (McKibbin papers), David McKibbin tentatively proposed the coast of Algiers as the location. However, the three figures look European rather than Moorish, and the water-colour is likely to have been painted in southern Italy or Spain. It is early in style, and the costume and physiognomy of the figures are reminiscent of Sargent's Venetian models. The water-colour could have been painted on his visit to Naples and Capri in 1878, or in southern Spain during his journey of the following year.

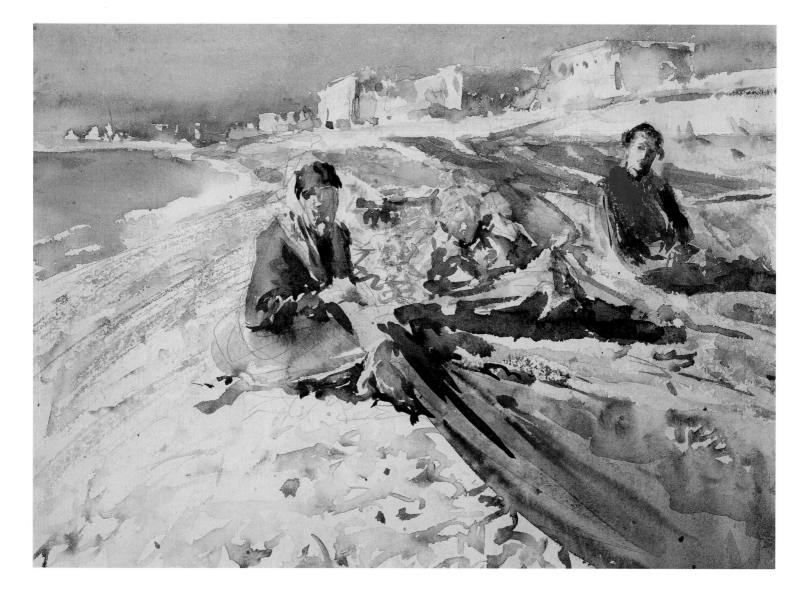

650
Church Interior

c. 1880
Alternative titles: *Interior of a Church
—Spain; Spanish Church Interior*
Water-colour on paper
13¾ x 9¾ in. (35 x 25.8 cm)
Collection of Joseph F. McCrindle

In the view of the authors, the style of this water-colour is early, although it could possibly date from the early 1890s. The identification of the church as Spanish is speculative, though it might well be correct. The church is simple in character with a Baroque altar at the far end framed by a Gothic arch, and a pulpit on the left, with an upright object in front of it, possibly a crucifix. From the bright buff and yellow tones of the foreground, we are led into the dark, mysterious depths of the space. A second, suffused light source is visible beyond the pulpit, throwing up shimmering blue-grey shadows on the arch and walls of the apse and gilding details of the altar. Two candles in glass holders punctuate the darkness with vivid accents of red.

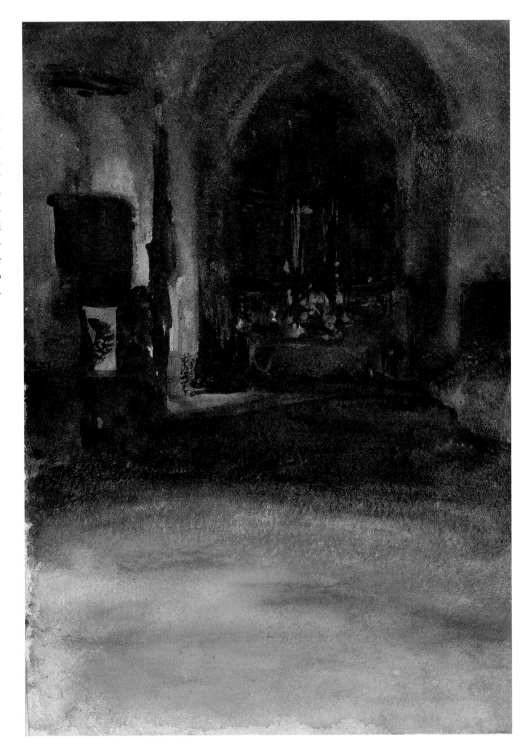

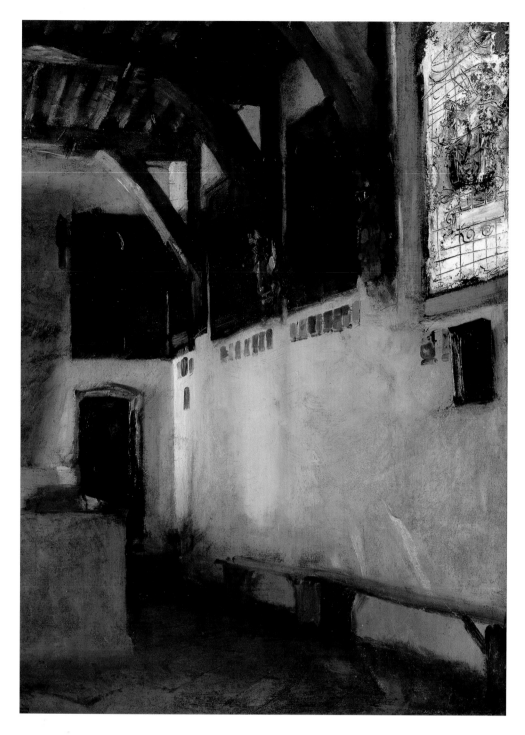

651
Interior with Stained-Glass Window

c. 1880
Oil on canvas
30 x 23 in. (76.2 x 58.4 cm)
Collection of Rhoda and David Chase

This little-known picture represents the upper landing and hallway of an unidentified historic building, possibly in or around Haarlem, Holland. The armorial window in the picture has been tentatively attributed to Pieter Holsteyn of Haarlem (1614–1673) and dated to the mid-seventeenth century by the Dutch art historian Dr Zsuzsanna van Ryven-Zeman (letter from Michael Archer, 13 December 2002, catalogue raisonné archive). Holsteyn was a portrait and animal painter as well as a glass painter and an etcher. If the picture was painted at Haarlem, it is likely to date from Sargent's trip there in 1880.

The hall represented in the picture could be part of a grand private residence, or more probably an official institution or guild, displaying the heraldry of its members. To the left of the window, between the wooden trusses supporting the beamed roof, are two dark panels, possibly shutters in front of more windows. A carved moulding is visible on the upper-left corner of the second panel, and lighter-toned rectangles of colour are noticeable at the bottom of both panels. A third panel can be seen between the third truss and the end wall, and a fourth over the doorway or niche to the left. Below the first two trusses are wooden armorial carvings in the form of shields with helmets above them. Two rows of seven small particoloured carvings, also armorial in character, hang below the first two panels, and four more (three in a row and a fourth underneath) below the third panel. A slender object to the left of the panel over the doorway or niche appears to be a wall light. There are two small armorial carvings beneath the stained-glass window, one with a shield bearing an emblem, a larger black carving, possibly hinged, and the edge of a third smaller one cut off by the frame.

The white plaster wall below the window and trusses reflects warm light from unseen windows on the opposite side of the hallway. A wooden bench runs along the wall. To the left is the simple stone surround to what appears to be the top of a stairwell, the opening to which would be out of the picture to the left. A rim runs round this enclosure, with a slightly higher section of wall on the farther side. There are two steps down from the elegantly framed doorway or niche. Faint markings in the dark interior of this feature may indicate a flat, pictorial space rather than an opening. The floor appears to be composed of floorboards painted grey rather than flagstones.

The picture shares several stylistic characteristics with Sargent's Venetian interiors and street scenes of the period 1880–82: the atmosphere of strangeness and solitariness; the luminous receding space along a diagonal line; the geometric patterning of shapes and structures; the play of light against dark; the subtle colouration and dragged brushwork used for the wall; the crisp highlights on armorial carvings, beams, plinth and door frame; and the use of a palette knife and brush end to evoke the textures and squiggles of the stained glass.

652
Staircase

c. 1878–80
Oil on canvas
21⅞ x 16⅛ in. (55.6 x 41 cm)
Sterling and Francine Clark Art Institute,
Williamstown, Massachusetts (582)

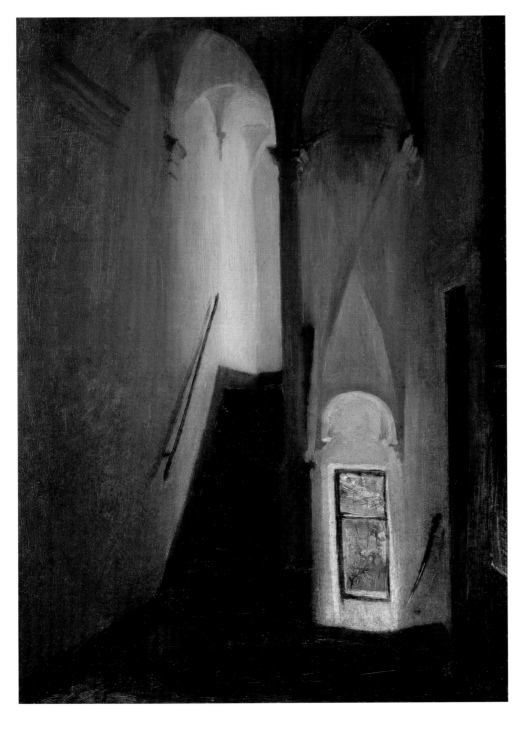

The picture represents a narrow white-washed staircase with Gothic vaulting. The artist positioned himself on a first-floor landing with views up and down the staircase. Dark treads and a simple handrail lead upwards on the left to a half-landing, lit from an unseen window, where the staircase turns back on itself to go up to the second floor. To the right we look steeply downwards (the handrail is visible but not the steps) to a window overlooking a garden. There, a fruit tree and trellis stand out against the vivid green of the grass, providing a vision of bright summer set against the cloistered seclusion of the interior. The artist uses the architectural details to compose a symmetrical design of elegant, elongated Gothic forms, vaults, arches, pillar and bosses. Soft backlighting from the windows bathes the walls in a luminous glow, creating a subtle play of white against white. Anchoring this airy, soaring architecture are the dark rectangular shapes of landing, stairs and doorway.

In her catalogue of the Clark collection, Margaret Conrads associates the picture with Sargent's visit to Capri in the summer of 1878 (Clark Art Institute 1990, p. 160). Quoting Professor Edgerton, of Williams College, she states that the picture 'depicts an inner stairwell of an Italian monastery', mentions Sargent's studio in the abandoned nunnery of Santa Teresa in Capri, and relates the picture to other Capri works. The picture seems thinner in surface and more tentative than the architectural studies Sargent painted in Tangier in 1880 and Venice in 1880–82, although the presence of the staircase and the effect of the backlighting are similar to the interiors with bead stringers he painted in a Venetian palazzo (nos. 794, 795, 798). The location of the picture cannot be settled until the staircase itself is identified, but a date between 1878 and 1880 is plausible in terms of subject and style.

The picture was originally wider. At some point between 1925 and 1939, the canvas was reduced by two inches on the left-hand side by wrapping more of the canvas round the stretcher. This removed from view a strip of unworked canvas, with some blocking-in, which is not part of the image. A narrower strip, painted brown, on the right-hand side is still visible. In 1926 the picture was acquired by James Carstairs (b. 1880) of Philadelphia, who was in the distilling business with the family firm, Carstairs, McCall & Co., later Carstairs Bros. Distilling Co., which was famous for its blended whisky, Carstairs White Seal. He owned a second work by Sargent, a water-colour of the *Gattamelata* in Padua (untraced). He was the brother of the art dealer Charles Stewart Carstairs (1865–1928), who was associated with M. Knoedler & Co. A third brother, Daniel H. Carstairs (b. 1872), owned Sargent's picture of *An Orchard in Blossom near Nice* (c. 1883, private collection), which was also acquired from Knoedler & Co. The authors are grateful to Richard H. Finnegan for information on James Carstairs and his family.

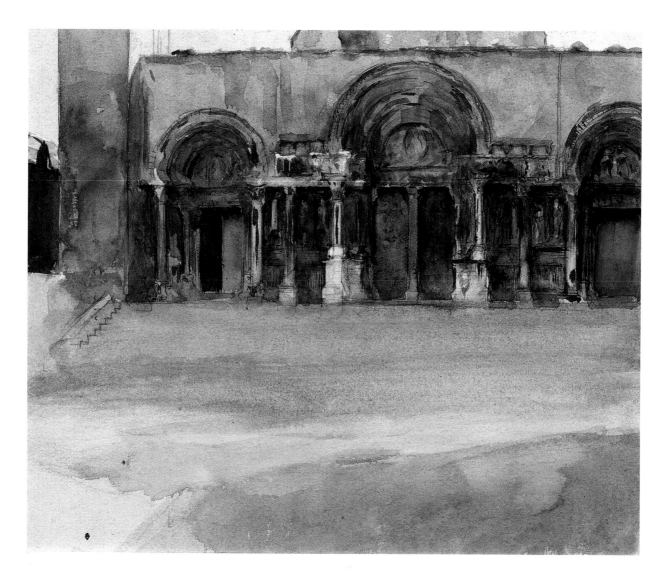

653
The West Portals of Saint-Gilles-du-Gard

c. 1880
Alternative title: *Venetian Façade*
Water-colour and pencil on paper,
with touches of body colour
9¾ x 13 in. (24.8 x 33.1 cm)
Inscribed in pencil on reverse of mount:
*Chairman of Christie/Executor of Estate/
Sir Alec Martin/Leicester Gallery*
Hood Museum of Art, Dartmouth
College, Hanover, New Hampshire.
Purchased through the Robert J.
Strasenburgh II 1942 Fund and the
Julia L. Whittier Fund (W.988.54)

This water-colour represents the elaborate portals on the western façade of Saint-Gilles-du-Gard, a celebrated masterpiece of Romanesque art in the small town of Gard, twenty miles south-east of Nîmes in the South of France. The dating and the iconographical interpretation of the sculpted façade have been the subject of much academic debate; for a recent bibliography, see the *Grove Dictionary of Art,* vol. 27 (London, 1996, pp. 560–61).

With characteristic boldness, Sargent leaves the foreground bare, omitting the wide sweep of steps leading up to the portals (save for a slight indented pencil line on the left) and the railings in front, and pushing the façade to the top of the paper, and cropping it on the right-hand side. By adopting a low viewpoint and setting off the church with a large area of foreground space, Sargent adds atmosphere and drama to what is essentially an architectural study. Tight underdrawing establishes the main lines of the façade and some of the detail. Carefully laid-in washes of soft brown, mauve and blue create the rich overall effect of the decoration. This is done quite impressionistically, recording the subtle play of light and shadow across the complicated forms of the façade, with much less detail than the eye perceives. The scene is bathed in a soft pinkish-beige light suggesting late afternoon or early evening. In order to accentuate the impression of sunlight, Sargent used touches of an unusual body colour with a metallic glint.

Given his passion for richly decorated medieval and Renaissance buildings, it is easy to see why Sargent would have been attracted to Saint-Gilles-du-Gard. He was frequently in the South of France visiting his family, and it is probable that he painted the water-colour on one of his journeys to and from Nice. Stylistically the work relates closely to the group of early Venetian water-colours (see chapter 10).

The picture was photographed for Sir Robert Witt around 1927 when the water-colour was in the collection of the artist's elder sister, Emily Sargent; the original negative is now in the Witt Library, Courtauld Institute, London (no. D53/1715). Its provenance from that time until its reappearance in 1969 is uncertain. The inscription to Sir Alec Martin on the reverse may or may not be indicative. Sargent's sisters did give a number of sketches to Sir Alec Martin (1884–1971), who was chairman of Christie's, London, to thank him for masterminding the highly successful Sargent sale at Christie's in 1925, but whether this was one of them is uncertain.

654
A Road in the South

c. 1878–80
Alternative titles: *Road in Midi;*
Road with Wall on Right
Oil on canvas
12¹³⁄₁₆ x 18⅛ in. (32.5 x 46 cm)
Sterling and Francine Clark Art Institute,
Williamstown, Massachusetts (577)

The picture represents a simple roadway flanked by high, whitewashed walls somewhere in southern Europe. Two pink buildings can be seen far right and upper centre between a row of olive trees. An entranceway is marked by the bright, bluish-green sections of wall close to the farther of the two buildings. More trees are contained by the wall beyond. The lane appears to end at a T-junction, with a low wall marking the line of a road running crossways. A distant landscape with trees goes uphill beyond this wall, with a pale yellowish sky above. To the left is the edge of a third building with two cypresses rising above its red-tiled roof, and then another short run of wall. The scene is bathed in a soft opalescent light, which, with the deep recessional space and absence of people, gives the picture a dreamy atmosphere, for all its telling realism.

The picture is difficult to date. The sophisticated design, with its receding lines of perspective and its subtle handling of tones and textures, provokes comparisons with Sargent's Venetian street scenes of the period 1880–82. On the other hand, the treatment of the trees and the light buff tones of wall and roadway are strongly reminiscent of Sargent's Capri pictures of 1878 (see nos. 701, 705, 719, 720); white on white is also typical of the landscapes he painted in Morocco in the first two months of 1880. The Nice landscapes of about 1883 to which *A Road in the South* has sometimes been compared, are more broadly handled, with broken brush strokes and a different palette. The present authors have, therefore, opted for an earlier date than the one usually assigned to the picture. The location could be southern Italy, Spain or the South of France; for example, Sargent stayed with his family in Nice during the autumn of 1878, and the picture could have been painted then.

The first owner of the picture was the artist Auguste Alexandre Hirsch (1833–1912), with whom Sargent shared a studio at 73, rue de Notre-Dame-des-Champs in the early 1880s (see appendix 1, p. 387). His widow, Mme Hirsch, sold a group of pictures, including this one, to M. Knoedler & Co., London, in January 1914. It was bought by Captain (later General Sir) Joseph Frederick Laycock (1867–1952), who served in the British army during the Boer War and the First World War (see *Who's Who 1927* [London, 1927], p. 1723, and an obituary in the London *Times*, 11 January 1952, p. 6d). Laycock was a cousin of Augustus Alhusen, whose wife Sargent painted in 1907 (*Later Portraits*, no. 528), and this may have stimulated his interest in the artist; he also owned Sargent's portrait of his sister *Violet Sargent*, aged seven (*Early Portraits*, no. 8).

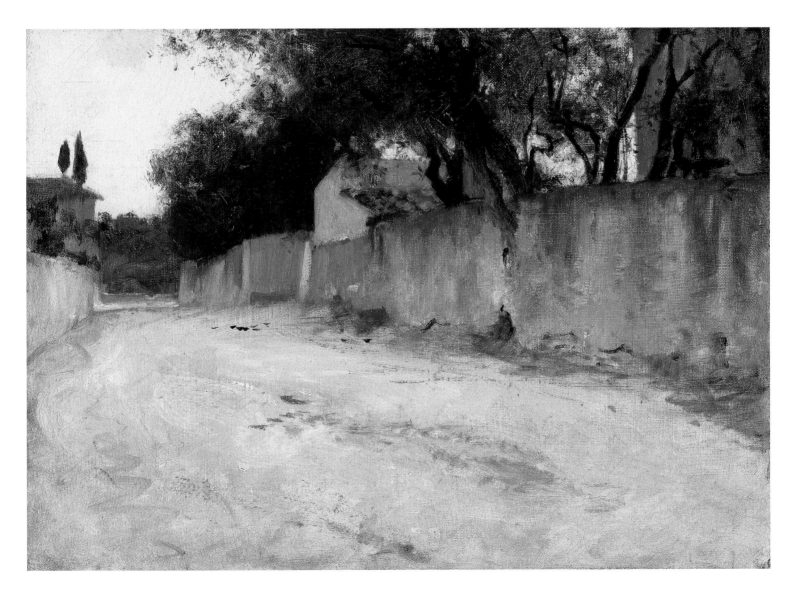

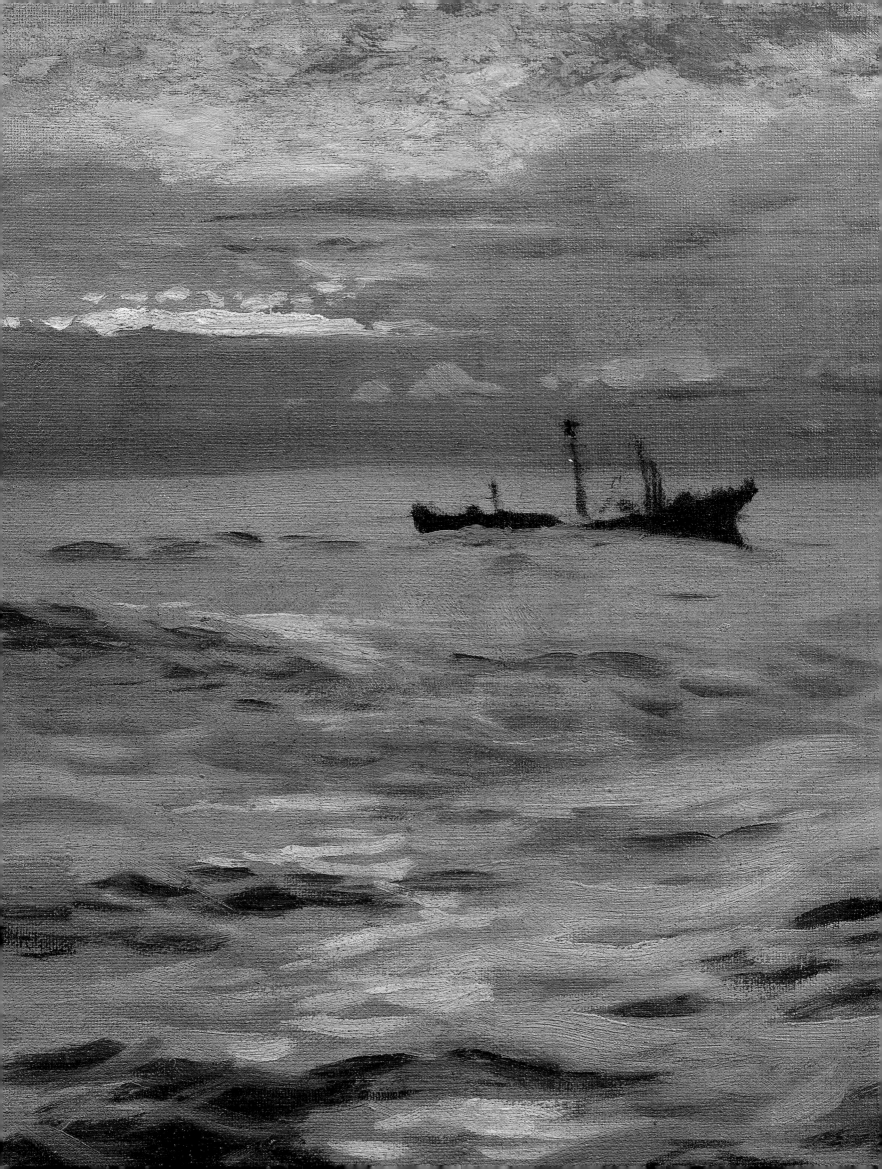

BRITTANY AND THE SEA, c. 1874–1879

NORMANDY AND BRITTANY, 1874–1875

This chapter covers Sargent's visit to Normandy in 1874, his two summers in Brittany, 1875 and 1877, his transatlantic visit to America in 1876, and a series of later port scenes. The themes of fishing and the sea, which he explored in this early phase of his career, read over from one season to the next, and they constitute a coherent body of work linked by subject and style. His background may have pre-disposed him to maritime themes, for he came of shipping stock. His grandfather was a shipowner out of Gloucester, Massachusetts, who had been forced out of business by a series of disastrous losses in the 1820s.[1] The Sargent name is still preserved in Gloucester through the Sargent-Murray-Gilman-Hough House, a historic home open to the public, which Sargent himself helped to support in its early years.[2] The artist's father, Dr Fitzwilliam Sargent, had a fondness for the U.S. Navy, visiting U.S. warships in European ports whenever he had the opportunity and entertaining the officers. Whether he had really set his heart on a naval career for his son, as their childhood friend Vernon Lee asserts,[3] is doubtful, but two of Sargent's boyhood friends, Charles Deering and Gus Case, both served in the U.S. Navy. The father of Gus, Admiral Augustus Ludlow Case, had retired to live in Europe, and he became a close family friend of the Sargents; it was he who purchased *Oyster Gatherers of Cancale* (no. 670) in 1878. Sargent himself exhibited an interest in ships from an early age; in 1865 the family made a detour to Sheerness in Kent en route between London and Paris, so that he could visit I. K. Brunel's famous ship, the *Great Eastern*.[4]

The Sargent family would have been attracted to the French coastline by its proximity to Paris, for they wished to remain close to their son at the start of his studentship. That Normandy and Brittany were much frequented by painters would have been an added attraction. Here were opportunities for painting scenes of local life as well as seascapes, both of which were much in vogue. This was the beginning of the age of the annual holiday and the exodus to the seaside. All along the French coasts, resorts were being developed, hotels and seaside villas built, and the infrastructure of the nascent tourist industry put in place. People who went in search of beach life and fresh air, solitude and relaxation, liked to be reminded of the remote agricultural and fishing communities where they stayed, as well as the wide expanses of sea and sky. Artists recreated for their bourgeois patrons a beguiling image of the simple life and the picturesque surroundings they had enjoyed on holiday.

Naturalist painters in the Barbizon mould promoted a heroic vision of local life, commemorating the traditions, folklore, ceremonies and regional costumes of rural and fishing communities. The distinctive form of Breton devotional pilgrimage known as the Pardon, the Breton wedding, the summer harvest and the gathering of oysters became familiar subjects in pictures of the period.[5] The romantic picture of a traditional society rooted in values and customs of the past was deeply attractive to an urban population experiencing the uncertainties and pressures of a fast-changing world. It was not only the Salon painters who were exploiting the seaside. Eugène Boudin had marked out a new style of *plein-air* painting with sparkling effects of light and brilliant colour in beach scenes, harbour views and seascapes painted in the environs of Le Havre. He was to be followed by Claude Monet, Édouard Manet and other members of the Impressionist circle, responding to the same market for sea subjects, but in a style that broke with convention.[6]

The northern French coast offered Sargent the opportunity to sketch out-of-doors and to experiment with seascapes and figure scenes in a popular genre. In late June 1874, little more than a month after he had joined the atelier of Carolus-Duran, he accompanied his family to Beuzeval on the Calvados coast in Normandy, a small fishing village now absorbed into the township of Houlgate. They stayed at the Hôtel Imbert through the months of July and August, spending the later part of September in Rouen, before returning to Paris early in October. Their 'very pleasant & satisfactory summer here' is described by Dr Sargent in a letter of 8 September 1874 to his close friend George Bemis, written from Beuzeval shortly before their departure to Rouen.[7] They were not without company, for the Watts family, whose daughter, Fanny, Sargent would paint in 1876–77 as his first Salon contribution,[8] came to stay, as did the Norrises, another family they knew. Among the Fanny Watts Papers is a photograph of Beuzeval with the Hôtel Imbert clearly visible, dated 1874 (fig. 31), along with a musical scale dated 'Rouen/74', and the drawing of an octopus inscribed 'Beuzeval' (fig. 45).[9] This is one of the few drawings that can be identified from the Normandy holiday; there are drawings of seagulls with descriptive notes, dated 18 August 1874 (see fig. 44), on the recto and verso of a single sheet, and a water-colour of two boys, *Oscar and Bobino on the Fishing Smack,* dated 25 August 1874 (no. 655).[10]

Fig. 31
Photograph of the beach at Beuzeval (incorporated into Houlgate), Normandy, 1874. The Hôtel Imbert is the prominent building right of centre. Fanny Watts Papers. Private collection.

Fig. 32 *(below)*
Ramparts at St Malo—Yacht Race, 1875.
Pencil on paper, 3¹⁵⁄₁₆ x 6½ in. (10 x 16.5 cm).
Corcoran Gallery of Art, Washington, D.C.
Gift of Emily Sargent and Violet Ormond (49.148c).

In the summer of 1875, the Sargent family chose Brittany as their destination, moving to the Maison Lefort in the fishing village of St Énogat near Dinard, a few miles west of St Malo. The house, done up in the medieval style, aroused Sargent's enthusiasm. 'My bedroom is the most beautiful interior I have ever seen in anything short of a palace or a castle', he told his friend Ben del Castillo in a letter of 20 June 1875. Of his artistic activities he had little to add: 'There is much to paint, but it has poured ever since we have been here, so I have accomplished little as yet'.[11] Dr Sargent's letters to George Bemis written over the summer and autumn describe life at St Énogat. In one, dating from 21 August 1875, he writes: 'I vary my quiet meanderings amongst the newspapers and heavier readings, by a tournée of foraging amongst the farmhouses of the vicinity, in search of poultry, eggs & butter & fruit, or a stretch over the windmill-covered hill-tops and the downs ... occasionally we make a cruise to some of the islands'.[12] Dr Sargent noted the presence of several friends who had come to St Énogat, in order 'to enjoy our society', including the Austins, the Wattses, the Sorchans and the Norrises, and he wrote up the social life of the small colony. Sargent returned to Paris to resume his studies in the third week of October. His parents decided to stay on and to winter in St Énogat instead of heading south to Florence or Nice, attracted by the low rent, which dropped from 120 francs to 80 francs at the beginning of November. Sargent came down with two friends to spend Christmas and New Year's with his family, and during this time drew a charming portrait of Fanny Watts in Breton headdress, which is dated 1 January 1876.[13]

Sargent's sketching activities in Brittany are recorded in a group of drawings mounted in a scrapbook in the Metropolitan Museum of Art, New York. One of these, *St Malo* (fig. 47), is dated May 1875, and another, of the famous prehistoric menhir (standing stone) at *La Pierre de Champ Dolent,* June 1875.[14] A drawing of a sabotier, a maker of sabots or clogs, now in a private collection, is also dated June 1875, and one of spectators watching a yacht race from the ramparts of St Malo must also date from this time (fig. 32).[15] Sargent's drawings are mostly of ships, boats, sailors and views of the sea, but they do include a harvest scene or two. The drawings are strongly tonal in style, with heavy cross-hatching to emphasize the dark forms of rocks, ships or trees and more delicate pencil work in the open passages of seascape and landscape to suggest space and distance. The seascapes with rocky foreshores are particularly atmospheric in their feeling for the force and immensity of the sea, and their sense of solitude and silent communing on the part of the artist (see figs. 46–50). They anticipate the themes which Sargent would explore more fully in the pictures painted while crossing the Atlantic.

One oil study, *An Old Boat Stranded* (no. 659), can be related to these drawings and seems certain to have been painted at this date. A hulk, lying in the shallows of a rocky cove, is set against the elegant lines and billowing white sails of a yacht just coming into view. Sargent plays off the jagged forms of the foreground rocks and stones, and the exposed timbers of the old boat, with the sunlit vista and space of the sea beyond, as he does in the drawings. Hulks of boats possess the power to move us with thoughts of past times, and voyages and sailors of long ago, and Sargent exploits this association to deepen the mood of his modern-day seascape. Another picture in the same vein is *Seascape with Rocks* (no. 660), a dreamy view across a bay to a distant shoreline. The subtle range of tones em-

ployed to capture the reflections of the rocks in the water and the delicate boundary between sea and sky show a degree of sophistication possibly more compatible with work done at Cancale. The two pictures of boatmen are untraced (nos. 680, 681), and it is difficult to judge their quality from black-and-white photographs; they could have been done around 1877. The splendid study of *Two Octopi* (no. 657) was signed and dated by the artist many years after its completion, but there is no reason to question the note on the back, which says that it was painted in the bottom of a Breton fishing smack in 1875. Sargent had drawn an octopus at Beuzeval in 1874 (fig. 45), and he took the opportunity of painting these viscous cephalopod molluscs as an exercise in still-life painting.

CROSSING THE ATLANTIC, 1876

On 13 May 1876, Mrs Sargent set sail for America with her two eldest children, sailing out of Liverpool aboard the Cunard liner *Abyssinia* and docking in New York at 6 p.m. on 23 May.[16] The vessel of some three thousand tons, with a single screw and auxiliary sails, carried two hundred first-class passengers and over a thousand third-class passengers; she was the first Cunarder to have individual, private bathrooms.[17] This was the first time that the twenty-year-old Sargent and his nineteen-year-old sister Emily had travelled across the ocean to see their native country and to meet their numerous Newbold and Sargent cousins. They went first to Philadelphia, Mrs Sargent's home town, to fraternize with their relatives and to visit the enormous Centennial Exhibition, an American version of the Great Exhibition of 1851 at the Crystal Palace in London. In Philadelphia, Sargent painted a portrait of his aunt, *Mrs Emily Sargent Pleasants* (*Early Portraits,* no. 3), and at Newport, where they stayed with Admiral Augustus Ludlow Case and his wife, Sargent painted a portrait of their son-in-law, *Charles Deering* (*Early Portraits,* no. 4). There are three drawings from a sketchbook Sargent was using at Newport:[18] one is an amusing study of three intertwined male figures aboard a vessel, of which Sargent made a second version for a presentation album of March 1877 to the Canadian soprano Dame Emma Albani (1847–1930).[19] From Newport, the Sargents travelled up the Hudson River, visiting the family of Sargent's fellow Parisian art student J. Alden Weir on their way to

Fig. 33
Photograph of SS *Algeria.* National Maritime Museum, Greenwich, U.K. (P15903).

Montreal. From Philadelphia, Sargent made a fleeting trip to Chicago with an unnamed artist friend before it was time for the family to pack their bags and make their way to New York.[20] They sailed from New York on 4 October 1876 aboard the SS *Algeria* (see fig. 33), sister ship of the *Abyssinia* on which they had travelled out, arriving in Liverpool on 21 October.[21]

Sargent's transatlantic voyages resulted in a significant corpus of works compared to the paucity of sketches while he was on land. The experience of being aboard ship brought out the romantic strain in his character, and he responded to the effects of an Atlantic storm with two remarkable seascapes. In the best-known of these, *Atlantic Storm* (no. 662), we are looking down the sliding deck of the ship towards a mountainous sea that might at any moment engulf us. This is full-blooded romantic painting, recalling storm scenes by J. M. W. Turner, Gustave Courbet and the Dutch masters. The picture was inspired by the violent storm which Sargent had experienced while crossing the Atlantic in the *Algeria. Mid-Ocean, Mid-Winter* (no. 663) seems to be another record of this storm, with the same high horizon line and the ship's wake again defining the vessel's passage through stormy seas. A related drawing (fig. 52) shows the ship's wake by moonlight in a romantic image recalling the seascapes of the German painter Caspar David Friedrich.

Rays from another setting sun cast pink and gold reflections across a softly mottled blue ocean in the small upright *Seascape*

(no. 666), which was also probably painted on this same voyage. The mood of the piece is contemplative, almost mystical. The image of an abandoned, half-submerged vessel is the theme of a major seascape, *Atlantic Sunset* (no. 665), for which there is a related oil sketch (no. 664). The story behind this grim reminder of the perils of ocean travel is unknown, but the picture clearly relates in theme and style to his other works painted at sea. The picture is reminiscent of the seascapes painted by Claude Monet in Normandy and those painted by James McNeill Whistler and Gustave Courbet at Trouville in 1865 in its layering of tone and colour to record the subtle effects of light on water and the illusion of space and distance.[22]

As well as looking out to sea, Sargent also painted scenes on board ship. There are two characterful oil sketches of the artist's mother resting on a deck chair and the cook's boy washing dishes—a version of upstairs/downstairs (nos. 668, 669). In both pictures the figure composition is compressed within the armature of masts and spars and rigging. Both these pictures, together with *The Brittany Boatman* (no. 681), belonged to Sargent's friend the American artist Henry A. Bacon, and it is instructive to compare them with the latter's shipboard picture *The Departure* (fig. 34), painted three years later. In contrast to Bacon's contrived and sentimental genre scene, Sargent offers us a taste of the real thing.

Several drawings of life at sea by Sargent are contained in the same scrapbook in the Metropolitan Museum of Art from which the Brittany drawings of 1875 come

Fig. 34
Henry A. Bacon, *The Departure,*
1879. Oil on canvas, 28½ x 20 in.
(72.4 x 50.8 cm). Courtesy of
Christie's, New York.

Fig. 35
Woman Looking out to Sea (?Emily
Sargent), 1876. Pencil on paper,
7⁵⁄₁₆ x 4³⁄₁₆ in. (18.5 x 10.7 cm).
The Metropolitan Museum of Art,
New York. Gift of Mrs Francis
Ormond, 1950 (50.130.140c).

Fig. 36
Two Sailors Furling Sail,
c. 1876. Pencil and
water-colour on paper,
3¹⁵⁄₁₆ x 6⁹⁄₁₆ in. (10 x 16.7 cm).
The Metropolitan Museum
of Art, New York. Gift of
Mrs Francis Ormond, 1950
(50.130.154v).

(see above).[23] These include *Woman Looking out to Sea* (fig. 35), *Two Sailors Furling Sail* (fig. 36), *Sailors on Sloping Deck, Lifeboats on Davits* and *Men Sleeping on Deck of Ship* (figs. 54–56). These drawings demonstrate not only what it looked like to travel by sea in the late nineteenth century but what it felt like.

CANCALE, 1877

Sargent came to the small Breton port of Cancale, lying a few miles east of St Malo, in June 1877 with his friend Eugène Lachaise specifically to paint a picture for the Salon. He had already opened his account at the Salon with his portrait of *Fanny Watts*,[24] and he wanted now to make a mark as a subject painter. It is probable that he selected Cancale with the idea of a fishing subject already in his mind. Cancale oysters were and remain famous, and the spectacle of people in traditional Breton garb progressing to and from the banks in large groups was an eminently pictorial subject, as others before Sargent had discovered. Two brothers in particular had made a speciality of Cancale subjects, Eugène Feyen (?1815–1908) and François-Nicolas-Augustin Feyen-Perrin (1826–1888). The former was the more prolific of the two, and there are numerous pictures and studies of female oyster workers by him (see fig. 37).[25] The latter had exhibited a picture at the Salon of 1874, which made a big stir at the time, and which may well have influenced Sargent more directly. This was *Retour de la pêche aux huîtres par les grandes marées à Cancale* (fig. 38), which shows a long procession of figures, led by three attractive young women in front, winding its way up the beach from the oyster banks with baskets full of oysters.[26] Sargent's picture is the reverse, with the oyster gatherers going down to the sea rather than returning, but he, too, uses the processional idea to underscore the timeless and traditional rituals of the sea.

The huge Bay of Mont St Michel, stretching from the Pointe du Grouin just north of Cancale in the west to the Pointe du Roc beside Granville in the north-east, is ideal for the cultivation of oysters. Its high tides, clean water and vast low-lying beaches suit the oysters and permit access to the oyster banks from the land at low tide. In the nineteenth century, oysters were gathered at sea by fleets of *bisquines,* the specialized fishing vessels used for this purpose. They went out at fixed times of the year in a flotilla known as the 'Caravane', which was carefully regulated by the

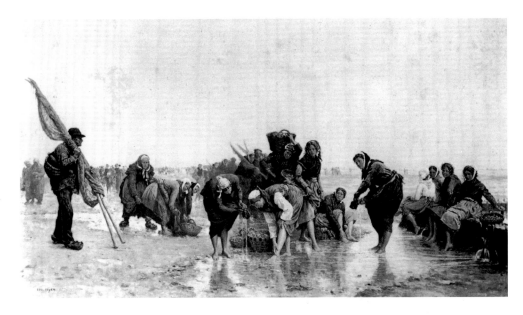

Fig. 37
Eugène Feyen, *La Toilette des Cancalaises, après la pêche* ('Cancalaise women washing after oyster fishing'), c. 1877. Oil on canvas, dimensions unknown. Untraced.

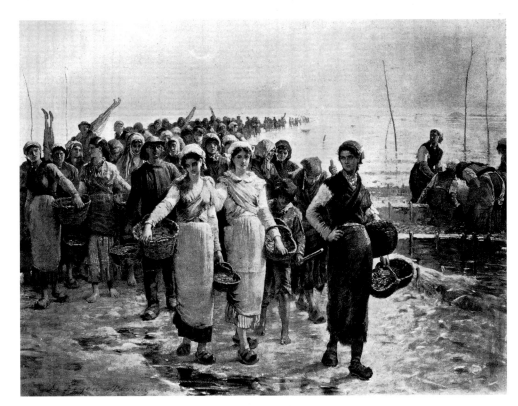

Fig. 38
François-Nicolas-Augustin Feyen-Perrin, *Retour de la pêche aux huîtres par les grandes marées à Cancale* ('Return of the oyster fishers at Cancale'), c. 1874. Oil on canvas, 58⅝ x 78¾ in. (149 x 200 cm). Formerly Musée du Luxembourg, Paris. Untraced.

authorities (see fig. 39). The oysters which were too small to be sold were kept in special banks, protected by barriers of stone, to be fattened up. The women had the task of tending the banks at low tide, retrieving oysters scattered by storms, rebuilding the barricades and bringing back the fully grown oysters. They then had the job of washing, rinsing and sorting them into categories (see fig. 40). It was tough and demanding work. Today most oysters are cultivated from larvae, taking four to five years to mature, and the process still involves hard physical labour, in spite of the use of mechanical aids. The flat oyster for which Cancale was famous, Ostrea edulis, was devastated by an epidemic in the 1920s, and it has only slowly recovered; it represents a small percentage of total oyster production in France. Most oysters cultivated today are the Portuguese variety, Crassostrea gigias, usually the Japanese variant, Crassostrea angulata, as the true Portuguese was wiped out in its turn at the start of the 1970s.[27]

Cancale has long been noted for the quality of its oysters, the beauty of its women and the picturesque appearance of its port. Well before Sargent's time, tourists were coming to enjoy the place and to savour its oysters. The oyster banks themselves were an attraction then as now, and tourists were fitted out with sabots (clogs) before venturing onto the muddy sand. There is a tradition that some of the Cancalaise were descended from Spanish seafarers, which would explain their dark good looks. With his liking for exotic southern women, Sargent would not have been slow to detect this unusual ancestry.

Cancale is divided between the genteel upper town and the rough port, often called La Houle (see figs. 41, 42). The hotel at which Sargent stayed may well have been the Hôtel de L'Europe (now the Hôtel du Vague) at the corner of the road leading from the port to the town above. The prominent lighthouse on the quay was constructed in granite in 1863. Below it was a short jetty descending steeply into the sea; this was replaced in 1897 with the long mole, which is what we see today. Known as La Fenêtre, it has a second lighthouse, the one operational now, at its tip. To the west of the lighthouse, a broad slipway ran down to the beach, as it still does.[28] Sargent painted his picture of Oyster Gatherers of Cancale (no. 670) from this beach looking back towards the slipway and the lighthouse; see the photograph of the beach as it is today (fig. 43). Between the slipway and

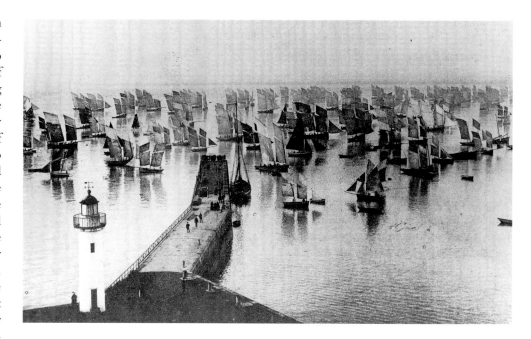

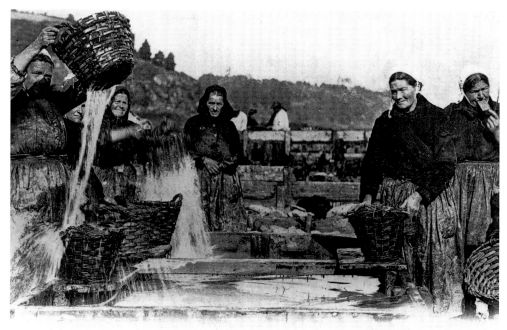

Fig. 39 (top)
Photograph of Le Départ de la Caravane, Cancale ('Departure of the oyster fishing fleet from Cancale'), c. 1890. Private collection.

Fig. 40 (above)
Photograph of Lavage des Huîtres, Cancale ('Washing the oysters, Cancale'), c. 1890. Private collection.

Fig. 41 (opposite top)
Postcard with aerial view of Cancale (showing the upper and lower town). Catalogue raisonné archive.

Fig. 42 (opposite middle)
Postcard of the lower town of Cancale, with shipbuilding activity, 1913. Catalogue raisonné archive.

Fig. 43 (opposite bottom)
Photograph of the beach at Cancale, with lighthouse and quay, c. 1971. Catalogue raisonné archive. This is roughly from where Sargent painted Oyster Gatherers of Cancale; the lighthouse was there in his time but not the quay.

the sand is a series of low-lying rocks. These are accurately depicted in Sargent's first sketch for the picture (no. 672), but he omitted them in the final version (no. 670), preferring to place his figures against an uninterrupted sweep of beach.

Sargent arrived in Cancale with his friend Eugène Lachaise sometime in late June 1877. On the fifth of that month his sister Emily wrote to Violet Paget (Vernon Lee) to say that her brother was staying in Paris 'to work for some time longer, and then expects to spend some time at Cancale where he has to go to make studies'.[29] Further news of his movements is contained in a letter from Dr Fitzwilliam Sargent to George Bemis of 21 June 1877: 'He is about leaving Paris, I suppose, for Brittany, but he has not told us positively when he intends to leave'.[30] In late July Emily relayed more information about her brother to Violet Paget in a letter of 29 July 1877:

He has had a good deal of rainy and cloudy weather at Cancale, which has interfered a great deal with his work, so he may be detained longer than he expected. He has great difficulty in finding people willing to pose, the married women never will, and they dislike their children to be painted, and the young girls rarely will consent. When he does find anyone willing, the crowd around him is so great, that he cannot work, so he has to make friends with some old woman, and get her to let him paint in her court. An old French artist [possibly one of the Feyen brothers] who has been going to Cancale for the last fifteen years, is at the same and only Hôtel there, and even he finds the same difficulty as John does, in spite of his age & experience. When he first went there, he says they were all willing to pose, but now they are so independent that a much higher price will not tempt them.[31]

The last reference to Sargent's summer expedition to Cancale occurs in a letter from Dr Sargent to one of his sisters of 20 August 1877: 'John is still at Cancale, on the coast of Brittany—the famous oyster garden of France—where he has been all the month of June [in fact, he only arrived in late June, see references above] and July and up to this day—for I suppose he left Cancale this morning, or will do so this evening, for Paris, prior to spending a short time with us, before going into his winter campaign at the École des Beaux Arts in Paris. He has been very well all summer, and has been busy in making drawings and sketches of the fishermen and fisherwomen, for pictures. We hope to see him in the course of a week'.[32]

In order to make worthwhile sketches for his picture, Sargent must have had the concept in mind from early on. A small oil sketch (no. 672), which he gave to his great friend J. Carroll Beckwith, seems to represent the first idea for the composition, and was probably painted on the spot. It shows a group of men and women on the beach, some with baskets, setting out for the oyster banks. Beyond them stretches the rocky foreshore and the slipway leading to the lighthouse. When he came to paint the larger versions (nos. 670, 671), Sargent altered his viewpoint, bringing the figures further down the beach, pushing the slipway and lighthouse into the upper right-hand corner and opening up the panorama to the left. This allowed the figures to be seen from below, silhouetted against the sky, rather than looking down on them against a background of sand and rocks.

In addition to the Beckwith picture, there are five oil studies for individual figures. Four of these have come down as a group and show individual figures with rocks and sea behind. Two of them, the young woman with a white headscarf and the young boy in a straw hat (nos. 674, 675), show the same models as the two leading figures in the versions at the Corcoran Gallery of Art, Washington, D.C., and the Museum of Fine Arts, Boston (nos. 670, 671). The other two studies show different models in variant poses to those finally adopted by the artist (nos. 676, 677). The fifth oil sketch, not part of this group, is a three-quarter-length study of a woman with a basket seen from above against a neutral background (no. 673). Apart from the oil sketches, there are also several related drawings (see figs. 58–61).

We know that Sargent was at work on *Fishing for Oysters at Cancale,* the Boston version of *Oyster Gatherers* (no. 671), sometime in late 1877, for he wrote to his friend Gus Case at that time: 'I am painting away as usual, and am at present engaged on a picture that I am going to send to the "American Art Association" exhibition in New York'.[33] It is probable that Sargent was working on the Boston version alongside the larger and more definitive Washington version (no. 670). The former is altogether sketchier than the latter; the figures appear more enveloped by the landscape; the handling is more sketch-like, with bold passages of impasto. There are also significant differences in the poses and accessories of the figures in the two versions.

Both versions show the same grouping of figures descending to the beach from the higher ground occupied by the lighthouse and the slipway. In moving from the smaller picture to the larger, Sargent transformed the *plein-air* qualities of the first into the full-blown academic exercise of the second. The women in the Washington version are far more studied and finished than those in the Boston version. Though they put one foot before the other, they appear strangely static, as if frozen in time, like figures from a classical frieze. This may be partly deliberate and partly due to inexperience, for Sargent was not convincingly to capture the illusion of figures in motion until *El Jaleo* (no. 772). The stilted composition has the effect of lifting the figures from their immediate surroundings and endowing them with heroic and universal values. There is little sign of the hard lives and drudgery associated with the Breton fishing communities. Sargent's foremost models are young, attractive and neatly turned out. On the other hand, he avoids the ingratiating interaction between viewer and models typical of more conventional genre painting; there is no false sentiment and no obvious narrative. Sargent's figures remain unconscious of the viewer and hold themselves with quiet dignity and reticence.

What impressed contemporaries was Sargent's ability to combine formality of design with sparkling effects of light and highly keyed colour. As joyful evocations of rural life, the pictures raised people's spirits and reminded them of the pleasures of the seaside and its picturesque fisherfolk. The Washington version was the subject of a complimentary review in the *Gazette des Beaux-Arts,* and it was awarded the privilege of a woodcut reproduction in the same magazine (see fig. 62 for the original pen-and-ink drawing). In America, where the Boston version was much more widely noticed, critics were still recalling the impact made by the picture at the Society of American Artists two or three years after the event. It must have been a source of encouragement to the artist that both pictures sold so easily. He can scarcely have hoped for such a high-profile beginning to his career as a subject painter.

The two pictures of *Oyster Gatherers* and the studies associated with them were not the only fruit of Sargent's Brittany campaign. One of the most intriguing pictures to re-enter the canon of Sargent's early art is *Oyster Gatherers Returning* (no. 678), previously called 'Mussel Gatherers'. The picture had been doubted in the past, but it belongs to the group of early works owned by Auguste Alexandre Hirsch with whom Sargent shared a studio at 73, rue de Notre-Dame-des-Champs (see appendix 1, p. 387, for a discussion of the group), and in the view of the authors it is an autograph work. In comparison with the sparkling morning vision of *Oyster Gatherers* going out to the oyster banks, this is a sombre scene of women returning.

Low Tide at Cancale Harbour (no. 679) is one of those condensed and cropped images with a disconcerting perspective with which Sargent liked to tease and disorientate the viewer; it may possibly be a fragment from a larger work. It shows the jetty at Cancale with a young boy gazing down towards two sailing ships moored there. The two oil studies of boatmen, *Man and Boy in a Boat,* and *The Brittany Boatman* (nos. 680, 681), both under awnings of sail, are also likely to have been painted at Cancale.

PORTS AND HARBOURS, c. 1879

Sargent's enthusiasm for maritime subject matter continued with a group of related pictures of ports and harbours which have been assigned to the period, c. 1879, on the basis of one dated work, *Boats in Harbour I* (no. 686). In place of the beach scenes which he had painted in Brittany and Capri (though there are some Capri boat subjects, see nos. 698, 700), the artist concentrated on working boats, the business of shipping and the processes of seaborne trade.

Two versions of the same subject, in oil and water-colour, *Boats in Harbour I* and *II* (nos. 686, 687) show a harbour with a sailing vessel and a boat moored at the quay. The structure of the warehouse alongside the quay and the rectangle of the basin provide the armature of the composition. The artist plays off the black-hulled ship, the translucent water of the dock and the distant hillside against the gleaming white textures of the stonework. *Wharf Scene* (no. 683) is a more studied, close-up view of a ship and boat moored at a quayside, and there is an implied narrative in the interplay between the foreground figures. The composition is similar to an oil sketch of *Two Nude Figures Standing on a Wharf* (no. 684), associated with a group of works painted in Spain and Morocco in 1879–80. A water-colour of *Ships and Boats* (no. 685) shows a mass of vessels moored alongside one another, with water shimmering below and a dense tangle of masts and spars rising above. One picture that is rather different in style and design is *Port Scene I* (no. 682), sometimes identified as Genoa. More aes-

thetic in feeling than the other harbour studies, it is reminiscent of *Atlantic Sunset* (no. 665) in its flowing treatment of the sea and its opalescent colouring.

The last works catalogued in this section are sparkling water-colours of fishing boats and one port scene, which may be later in date than the works already discussed. Two of them show the same little harbour (nos. 688, 689) with a similar grouping of brightly coloured boats and fishing tackle on the quay behind. Similar in style and tonality is the sketch called *Filet et Barque* (no. 690), which the artist gave to the French painter Ernest-Ange Duez, who became his near neighbour when Sargent moved to 41, boulevard Berthier. Finally there is the highly keyed little water-colour *Port Scene II* (no. 691), which shows a view down a whitened street towards a harbour with sailing ships.

—*Richard Ormond*

1. This was Winthrop Sargent IV (1792–1874), who moved to Philadelphia and later became a Presbyterian minister; see *Epes Sargent of Gloucester and His Descendants,* arranged by Emma Worcester Sargent (Boston, 1923), pp. 78–79.
2. A number of works by Sargent are displayed in the house, including the portraits of his parents (see *Early Portraits,* nos. 62, 63).
3. See Vernon Lee in Charteris 1927, p. 240; however, in none of his extensive surviving correspondence does Dr Sargent make reference to his hopes of a naval career for his son.
4. Sargent to Ben del Castillo, 13 October 1865, Charteris 1927, p. 9.
5. See Centre de Recherche des Arts de l'Ouest, Rennes, *Bretagne: Images et Mythes* (Rennes, 1987); Sylvie Courtade and Elizabeth Chapuis, *La Bretagne vue par les peintres* (Lausanne, 1987); Denise Delouche, *Les Peintres et le Paysan Breton* (Le Chasse-Marée, Douarnenez, Brittany, 1988); and Léo Kerlo and René le Bihan, *Peintres de la Côte d'Émeraude* (Le Chasse-Marée, Douarnenez, Brittany, 1998).
6. See, for example, Juliet Wilson-Bareau and David Degener, *Manet and the Sea,* Philadelphia Museum of Art, 2003 (exhibition catalogue).
7. George Bemis Papers, Massachusetts Historical Society, Boston. George Bemis, another American expatriate, was Dr Sargent's most intimate male friend, and the doctor's letters to him (1866–77) are more revealing than those which he sent to his family. He attended Bemis on his deathbed through December 1877 and early January 1878 and was left a bequest of $10,000 by his friend.
8. See *Early Portraits,* no. 20.
9. The Fanny Watts Papers are in a private collection. The building of the Hôtel Imbert survives, but it is no longer a hotel.
10. Both works are in the Metropolitan Museum of Art, New York; see Herdrich and Weinberg 2000, pp. 132–33, nos. 53–54.
11. Letter quoted in Charteris 1927, pp. 38–39.
12. George Bemis Papers, Massachusetts Historical Society, Boston; four more letters written by Dr Sargent from St Énogat are dated 3 October and 20 November 1875, and 13 January and 6 March 1876.
13. Private collection, ill. Adelson *et al.* 2003, p. 85.
14. See Herdrich and Weinberg 2000, pp. 140–45, nos. 71, 73–87.
15. The drawing of the sabotier was formerly with Hirschl & Adler, New York. The drawing of the ramparts of St Malo is in the Corcoran Gallery of Art, Washington, D.C., for which see Nygren 1983, p. 46, no. 17.
16. Details of the voyage from *Lloyds List* (London, 1876).

17. See Duncan Haws, *Merchant Fleets* (Burwash, East Sussex, 1987), no. 12, 'Cunard Liners', pp. 40–41.
18. The Metropolitan Museum of Art, New York; see Herdrich and Weinberg 2000, pp. 148–49, nos. 93–95.
19. This second drawing was sold with other items from the album at Sotheby's, New York, March 1992, ill. Herdrich and Weinberg 2000, p. 148, fig. 67; the album was presented to the diva by a group of American art students when she visited Paris in the spring of 1877.
20. The best account of the family's travels is contained in Emily Sargent's letter of 24 September 1876 to Violet Paget (Vernon Lee), written from Philadelphia, Vernon Lee Papers, Special Collections, Millar Library, Colby College, Waterville, Maine.
21. Details of the voyage from *Lloyds List* (London, 1876); for the ship, see Duncan Haws, *Merchant Fleets* (n. 17 above), p. 41.
22. See Gary Tinterow and Henri Loyrette, *Origins of Impressionism,* The Metropolitan Museum of Art, New York, 1994, pp. 237–39 (exhibition catalogue).
23. The Metropolitan Museum of Art, New York; see Herdrich and Weinberg 2000, pp. 149–51, nos. 96–106. A related drawing is in the Fogg Art Museum, Harvard University Art Museums, Cambridge, Massachusetts (no. 1937.8.79).
24. See *Early Portraits,* no. 20.
25. A number of Eugène Feyen's fishing scenes at Cancale are ill. Léo Kerlo and René le Bihan, *Peintres de la Côte d'Émeraude* (Le Chasse-Marée, Douarnenez, Brittany, 1998), pp. 75–89.
26. See *Le Musée du Luxembourg en 1874,* Grand Palais, Paris, 1974, ill. p. 71, no. 80 (exhibition catalogue).
27. For the history of Cancale oysters, see Joseph Pichot-Louvet, *Les Huîtres de Cancale,* privately printed (Cancale, 1982) (copies available in the libraries of Cancale and St Malo). There are two booklets by the same author, *The Oysters of Cancale* and *Cancale et sa Baie,* published by Éditions du Phare (Cancale, 1998). See also Thierry Huck, *Cancale 2000 Ans,* published by Éditions du Phare (Cancale, 1999); and Thierry Huck and Guy Mindeau, *Regards sur Cancale, images d'hier et d'aujourd'hui* (Cancale, 1990).
28. Details of Cancale topography from Pichot-Louvet, *Cancale et sa Baie* (n. 27 above).
29. Vernon Lee Papers, Special Collections, Millar Library, Colby College, Waterville, Maine.
30. George Bemis Papers, Massachusetts Historical Society, Boston.
31. Vernon Lee Papers, Special Collections, Millar Library, Colby College, Waterville, Maine.
32. Fitzwilliam Sargent Papers, Archives of American Art, Smithsonian Institution, Washington, D.C.
33. Private collection.

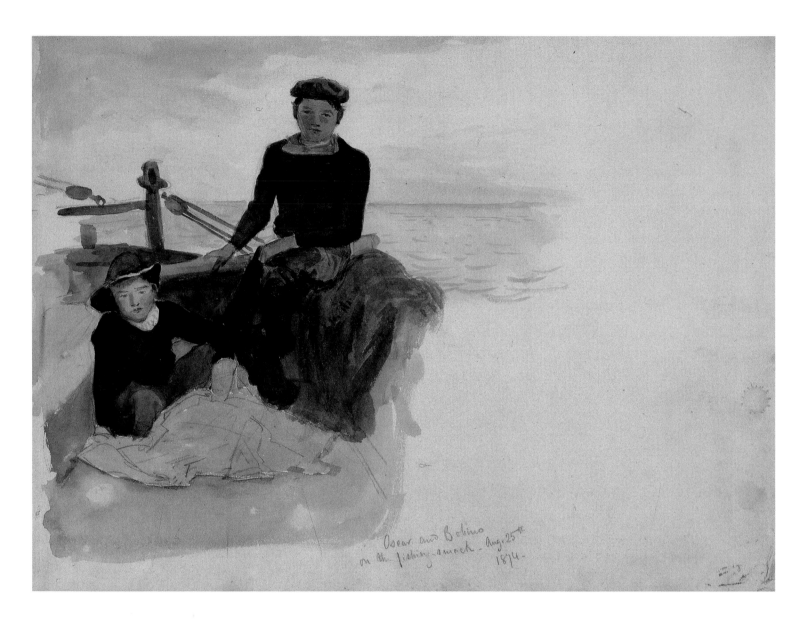

655
Oscar and Bobino on the Fishing Smack

1874
Water-colour and pencil on paper
11⅞ x 16½ in. (30.2 x 41.9 cm)
Inscribed, lower centre: *Oscar and Bobino/
on the fishing smack. Aug. 25th/1874.*
The Metropolitan Museum of Art, New
York. Gift of Mrs. Francis Ormond, 1950
(50.130.154pp)

This water-colour comes from a scrapbook containing several early studies of marine subjects as well as a large group of illustrations and photographs. It shows two boys in dark blue jerseys, one wearing a cap and the other a hat, sitting in the stern of a fishing smack. Behind them the tiller can be seen secured by two lines with pulleys. One boy squats on the deck, with a coat or oilskins lying in a pile in front of him, while the other rests on the edge of the gunwale. The water-colour must have been painted

in the vicinity of Beuzeval on the Calvados coast in Normandy (now a district of the township of Houlgate), where the Sargent family spent the summer of 1874. Sargent had presumably gone out to sea with a local fisherman, and the two boys are either relatives of his or the children of fellow-visitors to Beuzeval. The water-colour is painted in the rather naïve style of Sargent's juvenile water-colours, soon to be replaced by a more sophisticated handling of the medium.

656
Studies of a Dead Bird

c. 1874–78
Alternative title: *Two Studies of a Bluebird*
Oil on canvas
20 x 15 in. (50.8 x 38.1 cm)
The Metropolitan Museum of Art,
New York. Gift of Mrs. Francis Ormond,
1950 (50.130.23)

This sketch shows a dead bird in two positions: at the top as if in flight with its body raised and its wings outstretched with the aid of two props; below flopped on one side with one wing partly extended and looking very dead. Sargent depicts the bird as an ornithologist might have done as a documentary record, except that the sketchy treatment of the subject has insufficient detail to identify which species of bird is represented. Charles Merrill Mount called it a bluebird (Mount 1955, p. 442, no. K7810), but Richard L. Plunkett of the National Audubon Society was unable to offer a definite opinion (letter of 10 June 1976, The Metropolitan Museum of Art files). He thought the bird was likely to be of the sparrow family, 'with a great deal of grime or soot obscuring the finer details of the plumage', or just possibly a tit. Sargent is known to have had a keen interest in birds as a boy and in natural history in general. In 1874, for example, he made two careful drawings of the head of a seagull (fig. 44), with a kingfisher on the verso of the sheet, which are accompanied by detailed colour notes. The present picture was dated 1878 by Mount but could be earlier. It shows signs of having been rolled at some point in the past.

Fig. 44
Seagull, Beuzeval (Calvados), Normandy, 1874. Pen and ink on paper, 7¹⁵⁄₁₆ x 5⅝ in. (20.2 x 14.3 cm). Inscribed, top centre and right: *Seagull / Aug. 18th 1874 / Beuzeval.* The Metropolitan Museum of Art, New York. Gift of Mrs Francis Ormond, 1950 (50.130.86 recto).

657
Two Octopi

c. 1875
Alternative titles: *Octopus; The Octopus*
Oil on canvas
16 x 12⅝ in. (40.6 x 32.1 cm)
Inscribed, upper left: *John S. Sargent;*
upper right: *1875*
Inscribed, on the reverse: *painted
on board of a fishing smack in Brittany
by John S. Sargent 1875*
Private collection

This vivid still life of two viscous octopi lying on the deck of a Brittany fishing smack was probably painted during the artist's stay at St Énogat, a village close to Dinard, where he joined his family in June 1875. The inscription, according to Frederic Fairchild Sherman (see below), was done later. A drawing of an octopus made at Beuzeval, later incorporated into Houlgate in Normandy, in 1874 (fig. 45), provides additional evidence for dating the oil to this early period. For the painting, the artist stood almost vertically above the molluscs, which are spread out like specimens on a laboratory table. The sinuous patterns of the tentacles and the moist pink and grey textures of the flesh are recorded with unerring realism. The two molluscs, dramatically lit up against a dark background, are both sinister and cruelly exposed in death. With its cool tone and beautiful treatment of light and texture, the picture is reminiscent of still lifes by Antoine Vollon and Édouard Manet.

The picture was one of a group of sketches belonging to the French artist Auguste Alexandre Hirsch (1833–1912), a good friend with whom Sargent shared a studio at 73, rue de Notre-Dame-des-Champs (for further details of the group of early Sargent studies belonging to Hirsch, see appendix 1, p. 387). The picture of *Two Octopi* was purchased in 1914 from his widow by M. Knoedler & Co., London, shipped to Knoedler, New York, and in 1918 was with Charles Knoedler, to whom the artist sent a letter about the picture on 4 January 1918 from Boston. The letter (now untraced) was quoted in the 1942 Parke-Bernet sale catalogue: 'Accompanied by a manuscript letter from the artist stating that the "Octopus" was "a sketch done on the deck of a fishing boat in Brittany when I was about 19 years old . . . "' The picture was subsequently acquired by Frederic Fairchild Sherman, who wrote about it in 1933 ('Some Early Paintings by John S. Sar-

gent', *Art in America and Elsewhere,* vol. 21, no. 3 [June 1933], p. 94):

There is no indication of indecision anywhere in the picture. It was carried through to completion at one sitting and with so sure an understanding of its peculiar artistic difficulties and of its possibilities as a medium for the exposition of technical proficiency that no revision was required. Indeed Sargent after the lapse of almost fifty years was so completely satisfied with its effectiveness that he signed and dated it across the top and furthermore inscribed it in ink on the back of the canvas. Not a prepossessing subject, he nevertheless seldom if ever in after years surpassed it as a technical tour de force, though he was a master of technic [sic].

The picture was sold from Sherman's collection at Parke-Bernet Galleries, New York, in 1942, and was bought by Nelson C. White (1900–1989), an American Impressionist painter. In a letter to David McKibbin of

Fig. 45
Octopus and Starfish, Beuzeval (Calvados), Normandy, 1874. Pencil on paper, 6⅜ x 8 in. (16.2 x 20.3 cm) (irregular). Inscribed, bottom: *J. S. Sargent/Beuzeval/Calvados.* Private collection.

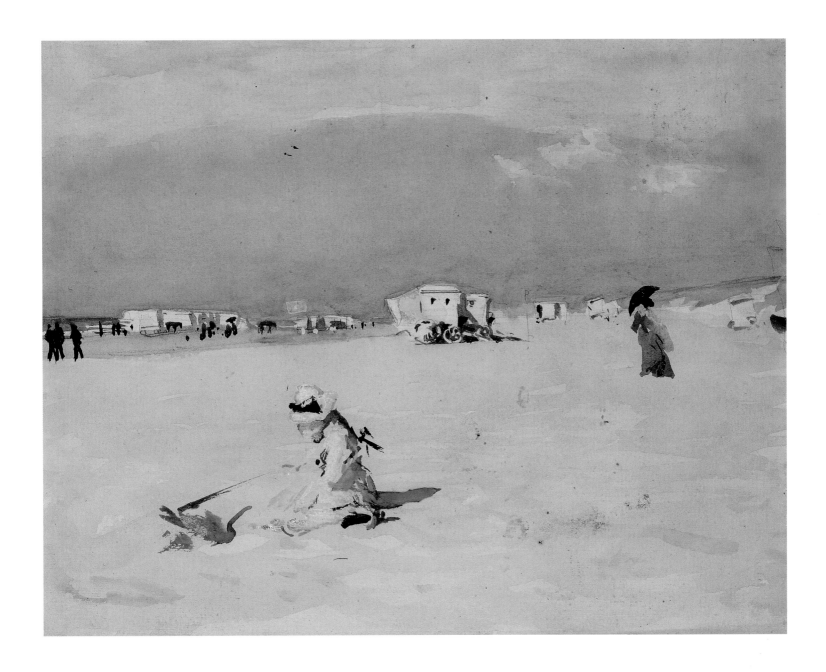

23 September 1973 (McKibbin papers), White wrote of Sherman: 'I knew him quite well and once in the 1920's asked him his price for "The Octopus" and he said $1200. At his auction which was, I think, somewhere between 1944 or 1946 I felt almost guilty in getting it for $50!' White had inherited from his father a painting by Sargent of a male model and two self-portrait drawings on a single sheet (inscribed to Mrs Barnard) (both private collection); further details of these were given to McKibbin in a letter of 22 February 1949 (McKibbin papers).

658
On the Sands

c. 1877
Water-colour on paper
8⅞ x 11¾ in. (22.5 x 29.8 cm)
Inscribed on the reverse: *On the sands*
Private collection

It is not certain where this unusual water-colour was painted. It cannot be St Énogat or Cancale, both of which are enclosed by cliffs. It could be the village of Beuzeval, later incorporated into Houlgate, in Normandy, where the Sargents spent a summer holiday in 1874, but it looks too sophisticated to be so early. In the foreground a young girl in a white dress and bonnet trimmed with black ribbon sits on her haunches playing in the sand; the artist's swift notation does not allow us to see exactly what she is doing. A woman in black with a parasol is walking away from us on the right. To her left are two bathing machines, those distinctive vehicles allowing women to descend into the sea without offending their modesty. A further group of the machines can be seen drawn up in a line at the edge of the water on the left, with a scattering of figures. Reflections from the clear blue sky play across the foreground, which is left bare to suggest the staring whiteness of the sand under bright sunlight. The style and imagery of the picture suggest parallels with the work of Eugène Boudin.

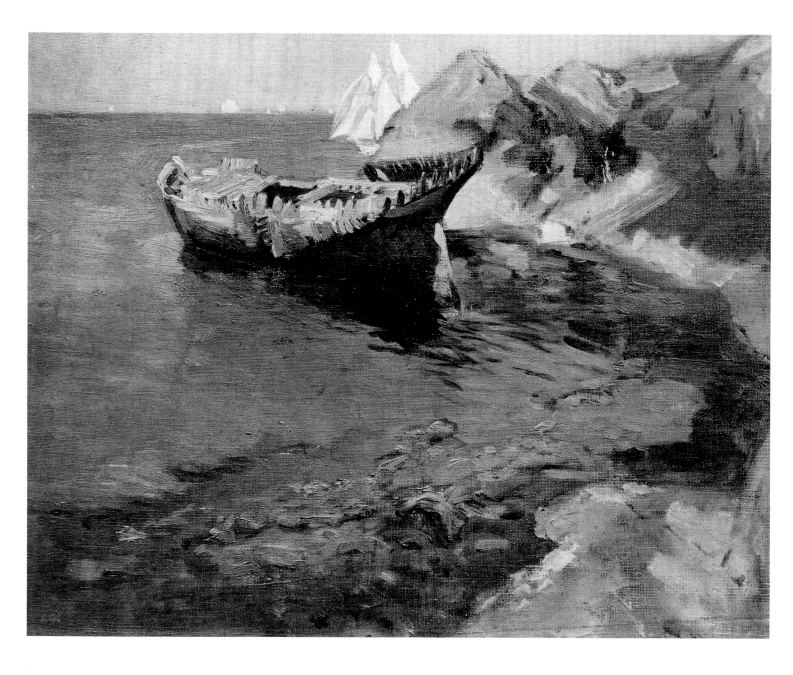

659
An Old Boat Stranded

c. 1875
Alternative title: *Sea Coast with (a) Wreck*
Oil on canvas
13 x 16¾ in. (33 x 42.5 cm)
Untraced

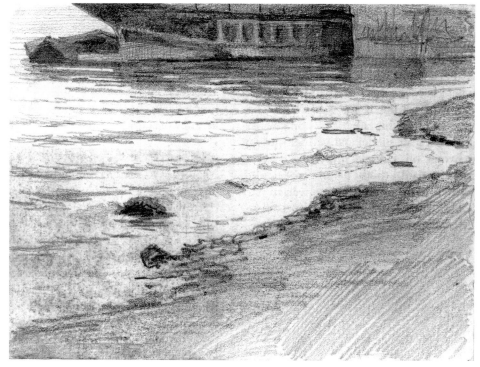

Though untraced and not seen by the authors, there seems little doubt that the picture is a genuine work by Sargent. The hulk of an old wooden sailing vessel, probably a fishing boat, is shown stranded in a small rocky cove. A two-masted sailing vessel is just coming into view round a rocky outcrop, pointing up the contrast between the old wreck and the gleaming white sails of the modern yacht. More sailing vessels can be seen in the distance. The style of the picture is similar to that of the *Seascape with Rocks* (no. 660), and it was possibly painted at St Énogat on the Brittany coastline in the summer of 1875. There is a similar drawing of a sailing ship coming round a rocky promontory, inscribed *St. Malo/Mai 1875,* in the Metropolitan Museum of Art, New York (fig. 47). Other drawings in the same collection with compositional features similar to the painting include *Water's Edge, Two Small Boats Moored to Beach* and *Rocky Coast* (figs. 46, 48, 49) (for further details of the drawings, see Herdrich and Weinberg 2000, pp. 140–45, nos. 71, 78, 84, 87).

This picture belonged to the French artist Auguste Alexandre Hirsch (1833–1912), with whom Sargent shared a studio at 73, rue de Notre-Dame-des-Champs in Paris (see appendix 1, p. 387). The picture was sold by Hirsch's widow to M. Knoedler & Co., London, in 1914 and went to the collection of Mrs H. W. Jefferson in London; she was possibly the wife of Henry Wyndham Jefferson, listed in the *London Post Office Directory for 1916* (London, 1916, part 2, p. 2100) at 12 Berkeley Square West.

Fig. 46 *(opposite)*
Water's Edge, c. 1875. Pencil on paper, 5½ x 7½ in. (14 x 19.1 cm). The Metropolitan Museum of Art, New York. Gift of Mrs Francis Ormond, 1950 (50.130.154nn).

Fig. 47 *(top)*
St Malo, 1875. Pencil on paper, 3½ x 5¹¹⁄₁₆ in. (8.9 x 14.4 cm). Inscribed, bottom left: *St. Malo/Mai 1875.* The Metropolitan Museum of Art, New York. Gift of Mrs Francis Ormond, 1950 (50.130.154w).

Fig. 48 *(middle)*
Two Small Boats Moored to Beach, c. 1875. Pencil on paper, 3¹⁵⁄₁₆ x 6½ in. (10 x 16.5 cm). The Metropolitan Museum of Art, New York. Gift of Mrs Francis Ormond, 1950 (50.130.154hh).

Fig. 49 *(bottom)*
Rocky Coast, c. 1875. Pencil on paper, 4 x 6½ in. (10.8 x 16.5 cm). The Metropolitan Museum of Art, New York. Gift of Mrs Francis Ormond, 1950 (50.130.154r).

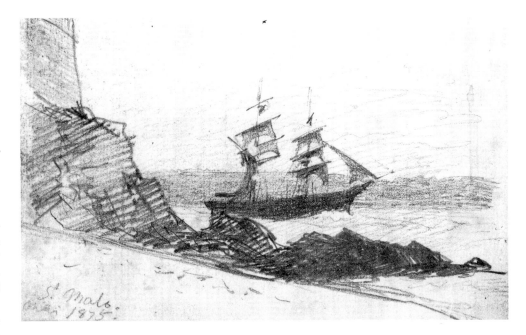

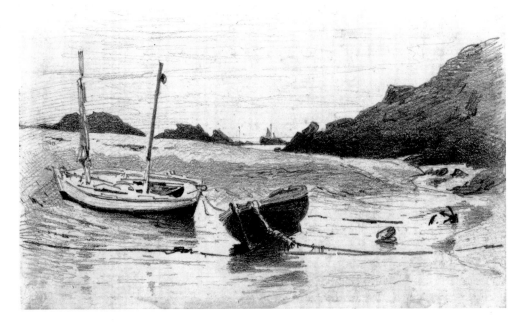

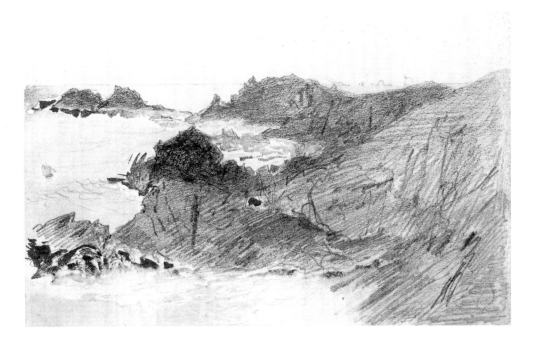

660
Seascape with Rocks

c. 1875–77
Alternative title: *Sea and Rock*
Oil on canvas
17 x 14 in. (43.2 x 35.6 cm)
Collection of Joseph F. McCrindle

This seascape dates either from Sargent's summer visit to St Énogat on the Brittany coastline in 1875 or his visit to Cancale in 1877. There are similar drawings of the rocky foreshore dating from this period in the Metropolitan Museum of Art, New York, including *Rocky Coast* and *Waves Breaking on Rocks* (figs. 49, 50) (for details of the drawings, see Herdrich and Weinberg 2000, pp. 142–43, nos. 77, 78). In the oil, two outcrops of rock covered in seaweed, one parallel to the plane of the picture, the other stretching diagonally into the sea, define the composition. Their rugged forms and dense textures stand out against the smooth opalescent sea, the misty line of the distant shore and the pale yellow sky. The only movement is a gentle ripple as the sea meets the land. The soft radiance of the scene, suggestive of sunlight filtered through layers of hazy atmosphere, underlines the artist's obsession with effects of light from the very start of his career.

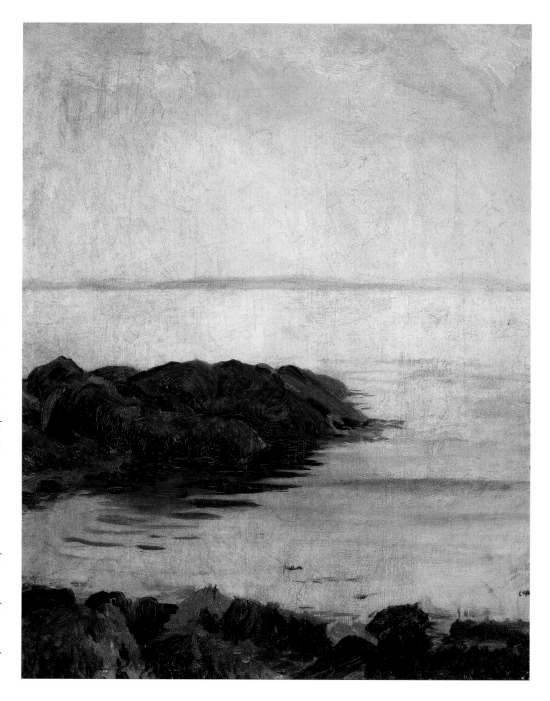

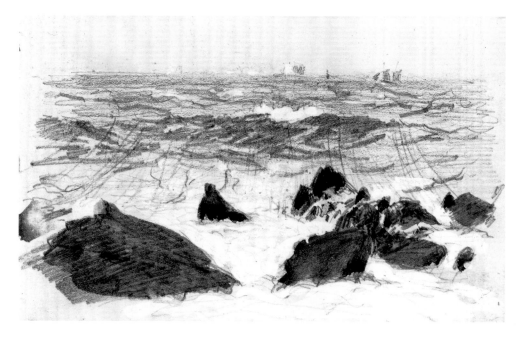

Fig. 50
Waves Breaking on Rocks,
c. 1875. Pencil and water-colour on paper, 4 x 6½ in. (10.2 x 16.5 cm). The Metropolitan Museum of Art, New York. Gift of Mrs Francis Ormond, 1950 (50.130.154q).

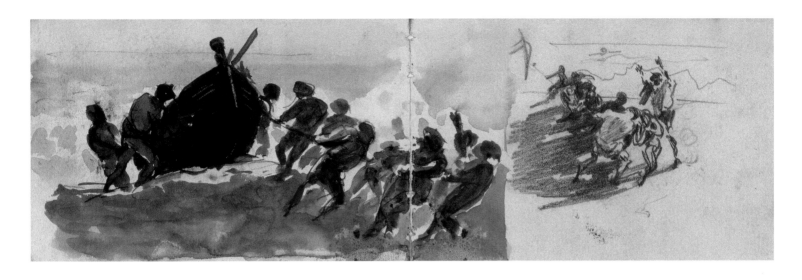

661
Men Hauling a Boat up a Beach (recto)
and ***A Sailor Drinking*** (verso)

c. 1876
Alternative title: (recto) *Men Hauling
Lifeboat Ashore (from scrapbook)*
(verso) *Sailor (from scrapbook)*
Water-colour and pencil on paper
3¾ x 11¾ in. (9.5 x 29.8 cm)
The Metropolitan Museum of Art,
New York. Gift of Mrs. Francis Ormond,
1950 (50.130.154n)

This sheet comes from an early scrapbook
containing several drawings of marine sub-
jects as well as a large number of illustra-
tions and photographs. The marine studies
are mostly related to Sargent's visit to Brit-
tany in 1875 and his transatlantic voyages of
1876. The subject represented on the recto
of this sheet in two separate studies, one in
water-colour, the other in pencil, is differ-
ent in character. These studies show men
straining to bow-haul a boat up a steeply
shelving beach, and they relate to a more
finished drawing of the same scene which
is dated 1876 (fig. 51). The latter depicts a
fishing boat rather than a lifeboat (as sug-
gested by Herdrich and Weinberg 2000,
p. 146, no. 89), with painted *occhi* (eyes) on
either side of the bowsprit, which is a
Mediterranean form of decoration. The
men, too, with their bare torsos and legs
and oriental-looking loincloths, are clearly
not of North European origin. It is possible

that Sargent took the subject from an illus-
tration rather than recording a scene he had
actually witnessed; Richard H. Finnegan
has suggested parallels with the graphic
style of Eugène Delacroix (communication
to authors, 22 June 2004).

The three treatments of the subject
represent an evolving composition of which
the drawing (fig. 51) is the most finished.
In the sheet catalogued here, the water-
colour shows the scene in close-up, with
the line of figures more spread out but with
less detail; the small separate drawing shows
the figures as they appear in fig. 51, but
with the boat omitted, apart from a squig-
gle for the bow. The verso of the sheet is
mostly bare, but does include a water-
colour study of a sailor drinking and two
slight pencil sketches of a man apparently
fishing; the sailor could be Breton.

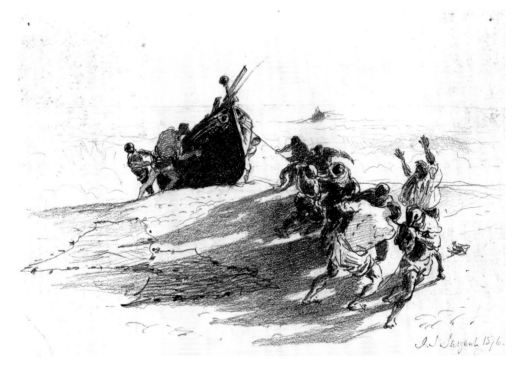

Fig. 51
Men Hauling Boat onto Beach, 1876. Pencil on paper, 6⅝ x 9¾ in. (16.8 x 24.8 cm).
The Metropolitan Museum of Art, New York. Gift of Mrs Francis Ormond, 1950 (50.134.1540).

662
Atlantic Storm

1876
Alternative titles: *The Steamship's Track;*
Steamship Track; After the Storm
Oil on canvas
23 x 32 in. (58.5 x 81.5 cm)
Curtis Galleries, Minneapolis

This dramatic seascape was inspired by a south-west gale during Sargent's return journey from the U.S. with his mother and sister Emily in October 1876 aboard the SS *Algeria*. It is difficult to believe that the artist could have painted the picture on deck during a storm, and the presence of an earlier study of a nude underneath the present paint surface suggests that the picture may have been painted in the studio on his return to Paris. Sargent explored the effects of the storm in another picture, *Mid-Ocean, Mid-Winter* (no. 663), and he painted other seascapes and shipboard pictures on his transatlantic voyages in 1876 (see nos. 664–69). The present picture shows the ship rising from the trough of one wave to the crest of the next in a following sea. We are looking down the aft deck, which is pitched at a terrifyingly precipitous angle, accentuated by a pair of figures beating up wind and trying to stand upright, and by the acutely angled lines of the decking, the railing and the two lifeboats. A double-sided bench runs down the centre of the deck, with a woman sitting at one end; two more figures can be made out by the deck-house at the stern.

Behind the ship, the enormous size of the waves is emphasized by the silvery line of the ship's wake streaming out behind. The topmost wave, seemingly thirty or forty feet above the level of the deck, is capped by a surging crest of foam. Spray cascading from the sides of other waves, like spouting waterfalls, adds to the impression of the ocean's immensity, its restless energy and gigantic force. Despite the brightness of the day, we sense the menace in the tossing waves and windswept sky. In true romantic fashion, Sargent involves us physically and emotionally in the drama of a ship likely at any moment to be engulfed by the huge waves. The perspective of the sliding deck bears no relationship to the perspective of the seascape, and this disjunction is exploited expressionistically to heighten feelings of fear and awe.

The picture was relined, probably around 1914. The relining was removed during conservation work by Jack Key Flanagan, an associate of the Houston Museum of Fine Arts, in 1970. On the back of the original canvas, he discovered an abraded stencilled stamp for the original Parisian supplier, 'Hardy-Alan, 36 rue du Cherche-Midi Paris . . . [illegible] Toiles et Couleurs Fines'. Infrared photography undertaken at the same time revealed a full-length study of a nude under the present paint surface.

This picture, like *The Derelict* (no. 664), another of Sargent's transatlantic seascapes, belonged to the French artist Auguste Alexandre Hirsch (1833–1912), with whom Sargent shared a studio at 73, rue de Notre-Dame-des-Champs in Paris. He owned a number of early pictures by Sargent (see appendix 1, p. 387). This picture was sold by Hirsch's widow to M. Knoedler & Co., London, on 7 January 1914. It was purchased from Knoedler, New York, by Philip J. Gentner, director of the Worcester Art Museum, Massachusetts, in July 1914, together with a picture called 'The Sailor's Procession' (untraced). Gentner advised local collectors in Worcester, and the picture was probably bought on behalf of one of them, possibly Frank Bulkeley Smith from whose collection it was sold at auction in New York in 1936. Prior to that, the picture had been on loan at the Worcester Art Museum, together with 'The Sailor's Procession', where it was the subject of an article in a local newspaper (clippings file, Boston Public Library):

The terrible majesty of the sea is pictured in all its sublimity. The clouds have drifted apart and seem to be torn in shreds by the gale. The sea is tossed in angry passion, its great waves breaking in cold white spray against the horizon. But through all this rush of waters, the eye follows with unfailing certainty the tortuous wake of the vessel by its ribbon of white foam, flung far out behind like a pennant fluttering in the breeze.

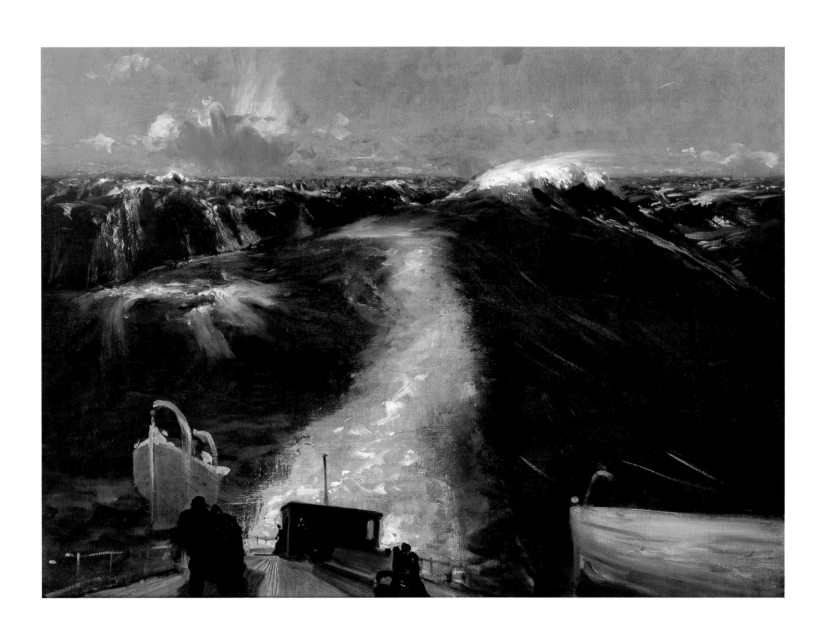

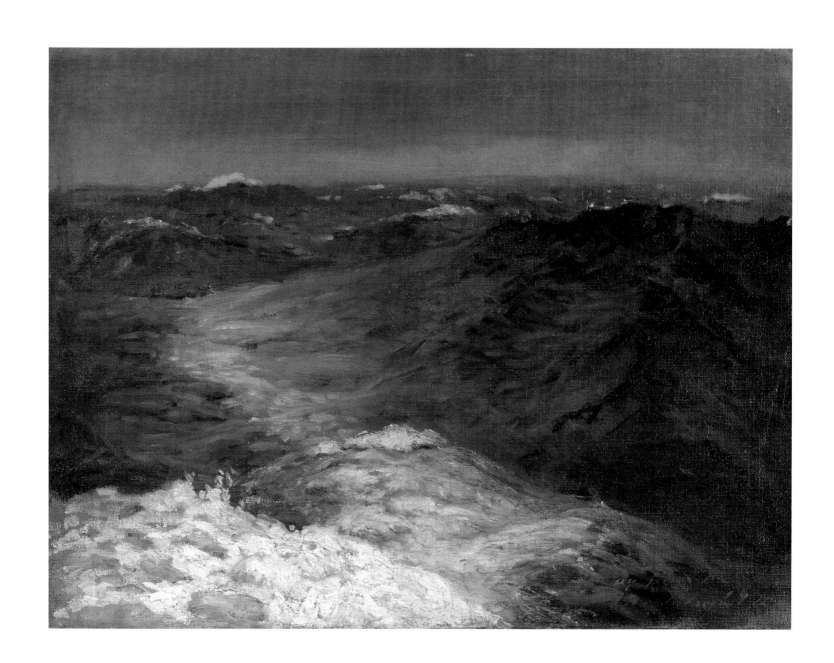

663
Mid-Ocean, Mid-Winter

1876
Alternative titles: *Mid-Ocean in Winter;*
Mid Winter, Mid Ocean
Oil on canvas, mounted on panel
13⅛ x 17¼ in. (31.8 x 42 cm)
Inscribed, lower right: *to my friend Henry*
Bacon/John S. Sargent 1876
Private collection

This picture, like *Atlantic Storm* (no. 662), is a record of the storm that struck the SS *Algeria* on its passage from New York to Liverpool in October 1876, with Sargent, his mother and sister Emily on board. The title, *Mid-Ocean, Mid-Winter,* given to the picture when it was first exhibited in Boston in 1925, is not, therefore, strictly accurate as to season. It is unlikely that the artist could have painted the picture on deck during the storm itself, and it was probably done in the studio back in Paris. The view from the stern of the ship leads the eye along the silvery line of the ship's wake until it disappears between mountainous waves; for a similar treatment of the wake, but in less stormy conditions, see the drawing *Moonlight on Waves* (fig. 52). In the painting we are made to feel the immensity of the ocean, which fills three-quarters of the picture space, and the sense of loneliness and desolation.

The picture was one of four marines given by Sargent to the American artist Henry A. Bacon (1839–1912); he also owned a version of the *Rehearsal of the Pasdeloup Orchestra at the Cirque d'Hiver* (no. 724). Like Sargent, Bacon was resident at the time in Paris, where he had studied under the French Academician Alexandre Cabanel and the genre painter (Pierre) Édouard Frère. According to his wife, Louisa Lee Bacon (who was later Mrs Frederick Eldridge) (1856–c.1947)[1], in a letter of 27 January 1927 to Robert C. Vose of the Vose Galleries, Boston (copy, catalogue raisonné archive),

It was Mr. Bacon who first, when Sargent was but 18 years old, wrote to 'The Boston Transcript' that 'a new star of first magnitude had arisen above the Art horizon'. Sargent was Mr. Bacon's junior by ten and more years, but they were always great friends, as they lived in the same vicinity, first in Paris and then for many years in Chelsea, London.

The other marines given by Sargent to Henry A. Bacon were two shipboard scenes, *The Artist's Mother Aboard Ship* and *The Cook's Boy* (nos. 668, 669), and *The Brittany Boatman* (no. 681). Bacon was noted for his

Fig. 52
Moonlight on Waves, c. 1876. Pencil on paper,
3¾ x 5⅞ in. (9.5 x 14.9 cm). The Metropolitan Museum of Art, New York. Gift of Mrs Francis Ormond, 1950 (50.130.154l).

pictures of life at sea (see fig. 34) and was clearly successful, living in the Faubourg-St-Honoré in Paris and later in Chelsea, London, and moving in fashionable social circles. It is just possible that Bacon was a fellow-passenger on one of the two transatlantic crossings Sargent made in 1876; Bacon is known to have sailed in 1875 aboard the SS *Scythia* bound from New York to Liverpool (see *New York Times,* 2 September 1875, p. 8). Bacon included a flattering section on Sargent in his book *Parisian Art and Artists* (Boston, 1883), and it is evident that the two men were close friends for many years, but the circumstances in which Sargent gave away the five paintings are unknown.

Mrs Eldridge was in negotiation with Vose Galleries, Boston, in January 1927, to sell this picture and the three other marines, but in the event no sale took place (copies of correspondence, catalogue raisonné archive). *Mid-Ocean, Mid-Winter,* together with *The Artist's Mother Aboard Ship* and *The Cook's Boy,* was purchased from the estate of Mrs Eldridge by her niece, Caroline T. Andrews, wife of Vice-Admiral Henry Raymond

Thurber (secondly Mrs Caroline Tooley); she gave details of these pictures in two letters to David McKibbin, 25 August 1958 and 11 March 1967 (McKibbin papers). Charlotte Huffington, Mrs Eldridge's executor, had sold *The Brittany Boatman,* but she could not remember the name of the buyer (undated letter to McKibbin, McKibbin papers).

1. Her birth date is given in the U.S. Census of 1860. Her parents, Richard Snowden Andrews and Mary Lee were living at that time in the home of his father, Thomas P. Andrews, in Baltimore, with eight servants. Her approximate death date is confirmed by two letters to David McKibbin (McKibbin papers), from an unidentified correspondent (?Abby C. Myer), who clearly knew her well, dated 30 January 1949 ('Mrs. Frederick Eldridge, who died about two years ago ...'), and from Mrs Eldridge's executor, Charlotte Huffington, undated but not earlier than 1947 ('About a year ago you wrote to Mrs Frederick Eldridge Ardsley-on-Hudson. As executor this letter came to me, Mrs Eldridge had died some months before').

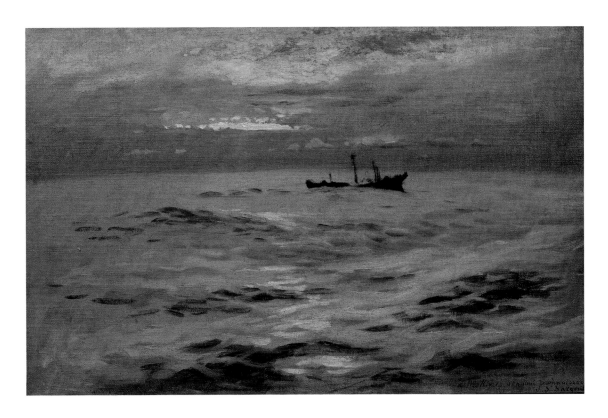

664
The Derelict

c. 1876–78
Oil on canvas
13¼ x 20 in. (33.7 x 50.8 cm)
Inscribed, lower right: *à M. Hirsch
son ami reconnaissant /J. S. Sargent*
Private collection

This previously unrecorded picture has
come down with a letter from Sargent to
the then-owner of the painting, John T.
Harding, dated 18 October 1920 (collec-
tion of the heirs of Patricia Macaulay
Hutchinson):

*My dear Mr Harding
I have no doubt that the sea-scape you mention is
one of several sketches done on board ship on my
voyage to America in 1875 [sic]—I gave them to
my neighbour and fellow artist Auguste Hirsch,
who was a good friend of mine in student days, and
whose widow, I know, has sold them. If you wish
me to sign a photograph of it you had better send it
in a couple of months to c/o Thomas A. Fox, St.
Botolph Club, 4 Peabody Street, Boston—I am
going to Boston this winter for six months or more,
and as the date of my going is very uncertain it
would be safer to have it wait for me there—*
 *Yours very truly
 John S. Sargent*

John T. Harding (1866–1946) was an attor-
ney in the law firm of Harding, Murphy &
Tucker of Kansas City, Missouri, and a
modest art collector. A 1939 inventory of
his pictures, which he had by then given to
his wife, Mrs Harding (born Lucia Byrne),
lists works by, among others, William
Bouguereau, Ralph A. Blakelock, Henry
Golden Dearth, Peter Graham, Birge Har-
rison, Jean-Jacques Henner, George Inness,
Leonard Ochtman, F. Hopkinson Smith
and Dwight W. Tryon (inventory and other
documents discussed below, collection of
Barbara Elliott, great-niece of Lucia Byrne).
A copy of a letter from Harding to Howard
Young of New York, dated 26 September
1930, when he was considering selling part
of the collection, including the Sargent,
gives further details of the pictures; there is
also a photograph showing a group of them
hanging in Harding's home. In 1922 Hard-
ing offered some of his paintings on loan to
local schools in Kansas City.

The Sargent picture originally be-
longed to the French artist Auguste Alex-
andre Hirsch (1833–1912), who shared a
studio with Sargent at 73, rue de Notre-
Dame-des-Champs, Paris. His widow sold
a group of twelve early pictures to M.
Knoedler & Co., London, in 1914, and a
further five were sold by Hirsch's nephew,
Raymond Bollack, at Parke-Bernet Gal-

leries, New York, in 1965 (for further infor-
mation on pictures belonging to Hirsch,
see appendix 1, p. 387). This picture pre-
sumably descended to Mme Hirsch with
the other Sargents her husband owned and
was disposed of separately. In September
1919 it was sold by the Galerie A. M. Reit-
linger of 12, rue la Boétie, Paris, to Louis
Ralston Art Galleries, New York. They, in
turn, sold it to John T. Harding on 31 March
1920 (invoice of that date, collection Bar-
bara Elliott).

The Derelict is a smaller version of the
picture called *Atlantic Sunset* (no. 665), which
appeared on the market for the first time a
few months after the smaller version in
2003, also quite unrecorded in the Sargent
literature. The latter is inscribed with the
date '1878', and both pictures most likely
represent a scene Sargent had witnessed on
one of his transatlantic passages in 1876 (see
the introduction to this chapter for further
details of the ships and Sargent's visit to
America). The immediacy of the large
rollers indicates that the picture was painted
out at sea, from the side of a vessel.

An abandoned ship is always a melan-
choly sight, and Sargent draws on the
imagery of death and disaster at sea to
charge his work with emotion. The ship
looks like a small merchantman, dismasted
and lying low in the water. The seascape

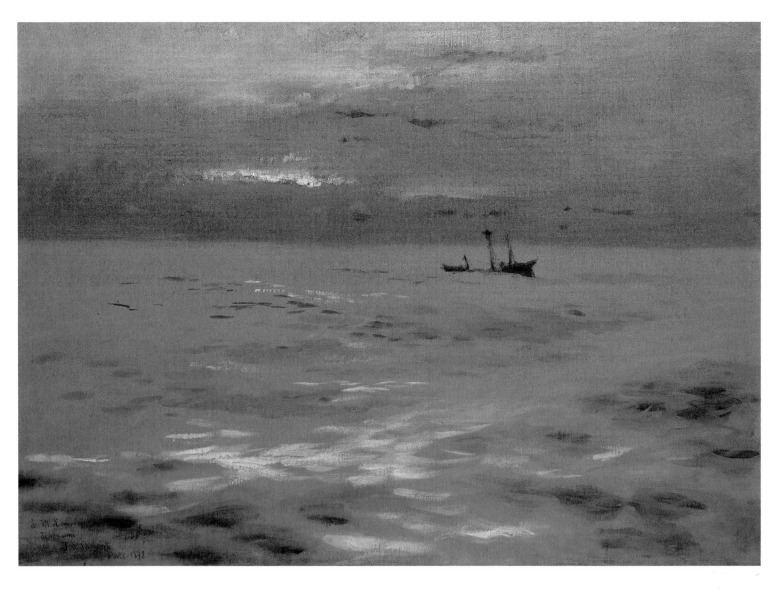

itself is an evocation of light shimmering on water at close of day. The artist achieves the effect by placing short, square brush strokes of strong colour, mostly blues of various shades, pink and yellow, over a smooth greenish-grey tone. The sky is a bank of deep grey and bluish-grey cloud formations, shot through with streaks of brilliant orange and gold. (The authors are grateful to Deborah Harris and her cousin Barbara Elliott for help with this entry.)

665
Atlantic Sunset

c. 1876–78
Oil on canvas
25½ x 36¼ in. (64.8 x 92 cm)
Inscribed, bottom left: *à M. Lemercier/ de son ami/J.S. Sargent/Paris 1878*
Private collection

This larger version of *The Derelict* (no. 664), previously unrecorded, came onto the market within months of the reappearance of the smaller version—a dramatic double event. Together with the recently discovered *Seascape* (no. 666), these two new discoveries emphasize the strong maritime content of Sargent's early art. *Atlantic Sunset* derives from the smaller sketch, which may have been painted on the spot. The composition of the larger work is grander, and the nervous touch in the sketch has been smoothed away, presenting a broader, more aesthetic effect. The evening sky casts an opalescent sheen over the gently undulating ocean. The diagonal trough between waves

in the foreground leads the eye past the stricken ship deep into the picture space. The abandoned merchantman, already low in the water, appears to be on the point of sinking, and provides the note of human drama around which the composition is orchestrated. It must have been a scene which captured Sargent's imagination, recorded by him in the small sketch and then worked up into a finished picture in the studio.

It is likely that the smaller version was painted on one of the artist's transatlantic journeys in 1876. The inscribed date of '1878' on the larger version is difficult to explain unless one assumes that it was painted in the artist's Paris studio, with the aid of the sketch. *Oyster Gatherers of Cancale* (no. 670), for example, also dated 1878, was based on sketches painted in Brittany during the summer of 1877. If the sketch was painted in 1876, it would mean that the larger version was executed two years later, a less likely scenario than an interval of a few months. Naples and Capri, where Sargent spent the summer of 1878, can almost

certainly be discounted as the location of the two seascapes.

The painting is inscribed to Dr Abel Lemercier, a medical doctor who was the proprietor of 73, rue de Notre-Dame-des-Champs, where Sargent shared a studio for five years, first with J. Carroll Beckwith and then with Auguste Alexandre Hirsch (for the latter, see appendix 1, p. 387). Lemercier is recorded in the land-registry documents in the Archives de Paris with an address in 1872 at 90, rue d'Orsay. *Atlantic Sunset* descended in the Lemercier family until its sale to Adelson Galleries, New York, in 2003. For a second picture belonging to Lemercier, see *The Onion Seller* (no. 801).

666
Seascape

c. 1876–77
Oil on canvas
11 x 8⅝6 in. (28.6 x 21.1 cm)
Private collection

This shimmering seascape under the hazy pink light of late afternoon was probably painted on one of the two transatlantic voyages made by Sargent, his mother and sister Emily in May and October 1876, although it is possible that the picture was painted in Brittany during the summer of 1877. It was painted from the side of a ship, the two waves crested with spray having been thrown up by the ship's bow. The greenish-grey sea is flecked with pink where the waves catch the light from the setting sun, gleaming through clouds. A brilliant patch of sunlight falls on the water in the middle distance at the centre of the composition; for a similarly romantic effect see the drawing of a *Coastal Scene* (fig. 53).

The picture belonged to Sargent's close friend Fanny Watts (1858–1927), whom he had painted in 1877 (*Early Portraits*, no. 20). It descended to her god-daughter, Kathleen Blanche Antoinette ('Tony'), Baronne d'Aubas de Gratiollet (1914–2002), the daughter of Raoul, Baron d'Aubas de Gratiollet and his wife, Marie Cornelie Dracopoli. She inherited two other works from Fanny Watts, *Capri Girl on a Rooftop* (no. 705) and a drawing of Fanny in Breton headdress, dated 1 January 1876 (illustrated in Adelson *et al.* 2003, p. 85). Sargent's spirited correspondence with Fanny Watts, which also belonged to her goddaughter, is now in a private collection. (Thanks to Colin Gray for information about the family.)

Fig. 53
Coastal Scene, c. 1875. Pencil on paper, 6⅝ x 4 in. (16.8 x 10.2 cm). The Metropolitan Museum of Art, New York. Gift of Mrs Francis Ormond, 1950 (50.130.154s).

667
Deck of a Ship in Moonlight

1876
Water-colour and pencil on paper
9 x 11¾ in. (22.9 x 29.8 cm)
The Metropolitan Museum of Art,
New York. Gift of Mrs. Francis Ormond,
1950 (50.130.154bb)

Fig. 55 *(left)*
Lifeboats on Davits (with colour notes), 1876.
Pencil on paper, 4⁵⁄₁₆ x 7¼ (11 x 18.4 cm).
The Metropolitan Museum of Art, New York.
Gift of Mrs Francis Ormond, 1950
(50.130.154j).

Fig. 56 *(below)*
Men Sleeping on Deck of Ship, 1876. Pencil on
paper, 4 x 6⅝ in. (10.2 x 16.8 cm) (irregular).
The Metropolitan Museum of Art, New York.
Gift of Mrs Francis Ormond, 1950
(50.130.154m).

Fig. 57 *(bottom)*
Scene on a Ship Deck, 1876. Pencil on paper,
4 x 6¾ in. (10.2 x 17.1 cm). Fogg Art Museum,
Harvard University Art Museums, Cambridge,
Massachusetts. Gift of Mrs Francis Ormond,
1937 (1937.8.79).

This deck scene was painted on one of the two transatlantic crossings made by Sargent, his mother and sister Emily in May and October 1876 (see the introduction to this chapter for details of the ships and Sargent's visit to America). Sargent painted a number of seascapes and shipboard scenes on these two voyages and also sketched incessantly. His shipboard drawings include *Sailors on Sloping Deck, Lifeboats on Davits, Men Sleeping on Deck of Ship* and *Scene on a Ship Deck* (figs. 54–57) (for details of the shipboard drawings in the Metropolitan Museum of Art, New York, see Herdrich and Weinberg 2000, pp. 149–51, nos. 96–103).

In this atmospheric wash drawing, we are looking along the tilting deck towards the bow of the vessel. A boom projects out from the mast, and the billowing sail forms a canopy above our heads. In the foreground, a thick cable or chain runs diagonally across the deck. To the right are the ratlines of the rigging and various lines, blocks and pieces of tackle. In the distance to the left is a trumpet-shaped ventilator, a foresail above the bow and, to the right, the davits for lowering lifeboats. The sky behind is lit up by a gleaming band of moonlight. There is an eerie stillness to the scene, accentuated by the absence of people. The water-colour is mounted in a scrapbook with drawings and reproductions from the period 1875–80.

Fig. 54 *(opposite)*
Sailors on Sloping Deck, 1876. Pencil on paper,
4⁵⁄₁₆ x 7¼ (11 x 18.4 cm). The Metropolitan
Museum of Art, New York. Gift of Mrs Francis
Ormond, 1950 (50.130.154i).

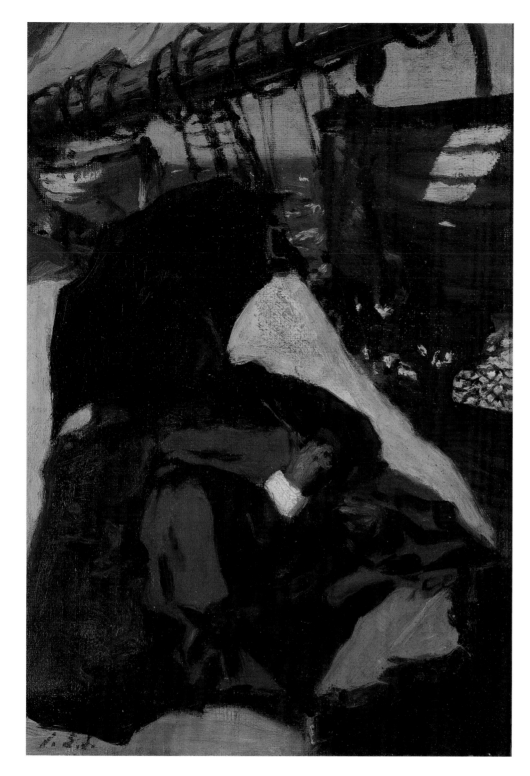

668
The Artist's Mother Aboard Ship

1876
Alternative title: *The Artist's Sister
Aboard Ship*
Oil on canvas
11 x 7¾ in. (28 x 19.8 cm)
Inscribed, lower left: *J.S.S.*
Private collection

This picture was painted on board ship during one of the two transatlantic voyages made by Sargent, his mother and sister Emily in May and October 1876. The present picture shows Mrs Sargent wrapped up in layers of clothing, seated on a deck chair or bench covered in a cream-coloured blanket or cloth, enjoying a bright, breezy day at sea. Her head is indistinct under the shadow of her parasol; it may be turned to her left as if she is looking out to sea or asleep. Faint white streaks appear to indicate the presence of a white bonnet of some kind. Her complicated costume is not easy to disentangle. The figure is framed by a boom and sail, two lifeboats and a sliver of deck; glimpsed between them is a sparkling vista of seahorses and sky. Brilliant patches of sunlight fall on the cuff of Mrs Sargent's white shirt, on the red shawl and the yellow blanket, and on the sides of the lifeboats and the crests of the waves. The picture reads both as a formal study of simplified shapes and blocks of colour and as a vivid record of life at sea.

The picture was one of four marine subjects given by Sargent to his friend and fellow-artist Henry A. Bacon (1839–1912); see *Mid-Ocean, Mid-Winter* (no. 663) for further details of these and their provenance.

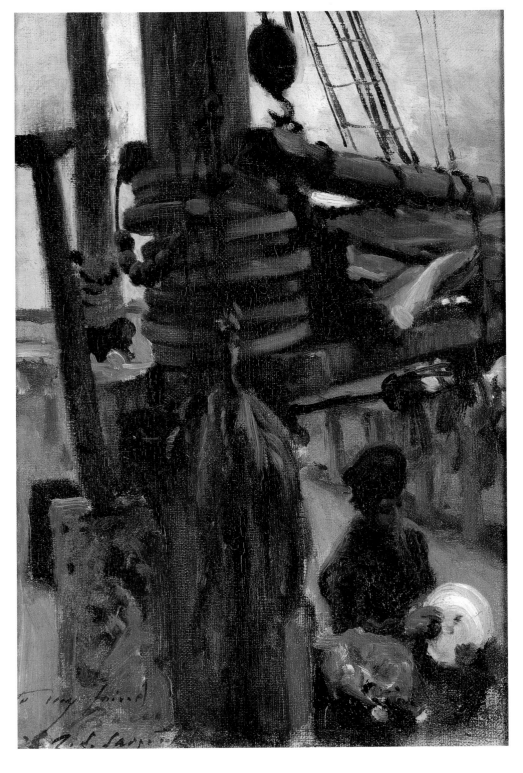

669
The Cook's Boy

1876
Oil on canvas, mounted on board
10⅞ x 7⅝ in. (27.6 x 19.3 cm)
Inscribed, lower left: *to my friend/Bacon/*
John S. Sargent
Private collection

This picture of a cook's boy was painted on one of the two transatlantic voyages made by Sargent, his mother and sister Emily in May and October 1876, when he sketched constantly and painted several seascapes and shipboard scenes (see nos. 662–68). *The Cook's Boy* is similar in format and style to *The Artist's Mother Aboard Ship* (no. 668), and it offers a revealing glimpse of work below deck as compared with the leisured life of a first-class passenger. In this picture, the young boy appears to be seated while washing or drying a large white dinner plate, which he holds with a cloth in both hands; the round object to his right may represent a basin or plate. He sits under the boom with the sail down, and the armature of boom and mast provide the powerful forms around which the composition is organized. The careful rendering of the hoops on the masts, the blocks, hooks, lines, ratlines and parts of the rigging reveal Sargent's close interest in the detail of ships' equipment and how ships work. The tall object on the left appears to be the chimney of the ship's galley. Beyond the figure of the boy we glimpse a section of deck and gunwale, but the view of the sea is obscured by the boom.

The picture was one of four marine subjects which Sargent gave to his friend and fellow-artist Henry A. Bacon (1839–1912); for further information on these and their provenance, see *Mid-Ocean, Mid-Winter* (no. 663).

670
Oyster Gatherers of Cancale

1877–78
Alternative title: *En route pour la pêche*
Oil on canvas
31⅛ x 48½ in. (79 x 123.2 cm)
Inscribed, lower right: *JOHN. S. SARGENT. /
PARIS 1878*
Corcoran Gallery of Art, Washington, D.C.
Museum Purchase, Gallery Fund (17.2)

Oyster Gatherers of Cancale was Sargent's first significant figure composition and the first subject picture he sent to the Paris Salon, where it was shown in 1878 (no. 2008). For an artist who was barely twenty-two, it was a remarkably assured performance. It was painted in Sargent's Paris studio over the winter of 1877–78 and the following spring from sketches he had made at Cancale in Brittany. A smaller, less worked-up version is in the Museum of Fine Arts, Boston (no. 671). It is likely that the two pictures were developed alongside each other, for they are both inscribed 'Paris'. For differences between these two versions, see the entry for the Boston picture (no. 671), and for a fuller discussion on the background to the paintings, see the introduction to this chapter (p. 86).

The effort which went into the production of the picture is evident from the number of surviving studies. The first idea for the composition is recorded in an oil sketch which he gave to his friend and fellow-artist J. Carroll Beckwith (no. 672). Sargent also painted separate oil sketches of five figures (nos. 673–77), of which two are similar to the figures in the finished painting, those of the leading woman with a basket and the boy behind her. There are related drawings of women carrying baskets (figs. 58, 59), a pencil study for the figure of the young boy (fig. 60), and a drawing of a Breton woman carrying a baby, which is similar in character (fig. 61). The studies reveal the process by which Sargent transformed ordinary working-class women into the graceful and refined models of his Salon painting.

The finished work shows a group of four women and two boys in the foreground walking across the beach to the Cancale oyster banks at low tide; all but the smallest boy carry baskets of various shapes and sizes. The two younger women wear white kerchiefs, and they have rough aprons over their skirts, that of the woman in the centre showing a hem of vivid red (possibly an underskirt); the latter wears her shawl criss-crossed over a white chemise, like the older woman behind her, and she is the only person wearing stockings. All four women wear traditional sabots or clogs. The two older women are more somberly dressed with black scarves over their heads, showing a strip of white at the forehead, and darker-coloured costumes. The two boys, one in white, the other in dark blue, are both barefoot. The processional theme of the composition was carefully worked through to lend stature and dignity to the figures. Additional emphasis was given by outlining the heads and shoulders of the women against the sky. Behind the leading group, seven or eight more figures can be seen descending to the beach down the slipway from the lighthouse; they are mostly female, but led by an older man in a white shirt or jersey.

What distinguishes the picture from conventional genre scenes of Breton fishing subjects is the brilliant treatment of light and the highly keyed colour. The time is early morning, for the sun is in the east, casting the shadows of the figures across the sand and the shallow pools left by the retreating tide. Accents of pure white impasto record the glancing effects of the sunlight falling across the figures and the watery sand. The pools reflect the vivid blue tones of the sky and lend an air of lightness and transparency to the foreground. Beyond the figures, the beach stretches away into the distance, to the foreshore on the left dotted with fishing boats, and the great expanse of the blue sky studded with cumulus clouds. Though the figures have an unnatural stillness, as if frozen in time and posed for the event, the landscape behind suggests a breezy day, in which you can almost taste the salty, tangy air of the Atlantic. The free and expressive brushwork lessens the effect of studio production and half convinces us that what we are experiencing is something the artist actually saw and recorded on the spot.

When the picture was shown at the Salon in 1878, the French art critic Roger-Ballu admired its broad touches (*Gazette des Beaux-Arts*, vol. 18, no. 1 [July 1878], p. 185):

I found much pleasure in looking at Mr Sargent's picture, En route pour la pêche. *This artist paints with free, broad strokes, which seem confused when viewed up close, but which give a sense of relief and energy to the figures when seen at a distance. He creates the feeling of the sun shining on the wet sands of the beach, dappled here and there by the blue reflections of the sky in the shallow pools of water.* [1]

The *Gazette des Beaux-Arts* also paid Sargent the compliment of asking him to execute a pen-and-ink drawing after his design, which was illustrated as a woodcut to accompany Roger-Ballu's article (fig. 62); it was the first of several such drawings he was to contribute to illustrated catalogues and magazines over the next few years. However, in comparison to the much smaller and sketchier Boston version, which Sargent sent to the Society of American Artists in New York, where it was widely reviewed and praised, the Salon picture attracted relatively little notice. Nor did it win the artist an Honourable Mention at the Salon as stated by his early biographer Evan Charteris and repeated by subsequent authors (see Fairbrother 1986, p. 80, n. 21).

News of Sargent's success spread quickly through the family circle. The artist's father Dr Fitzwilliam Sargent wrote to his brother Tom on 14 June 1878 from Paris (Fitzwilliam Sargent Papers, Archives of American Art, Smithsonian Institution, Washington, D.C.): 'And in the Salon of this season he has a picture representing a lot of fishermen and fisherwomen returning from the Oyster beds at Cancale. The picture I have not yet had time to see, but it is very well spoken of by the French papers, and also by the Atlantic Monthly for June but this last speaks (I remember now) of the picture which he sent to New York, and which is very similar, I believe'.

The painting was purchased by Admiral Augustus Ludlow Case, an old family

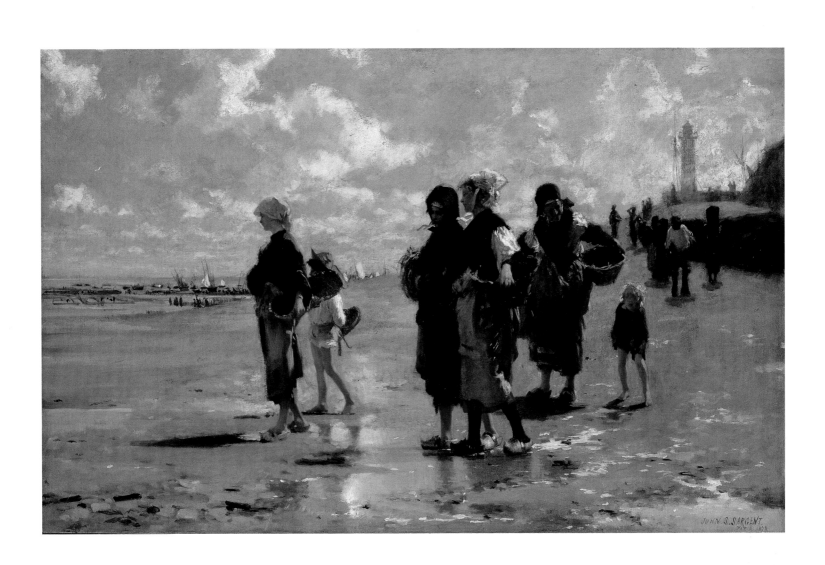

Fig. 58 *(far left)*
Woman Carrying Basket, Study for 'Oyster Gatherers of Cancale', c. 1877. Pencil on paper, 5⅞ x 3½ in. (14.9 x 9 cm). Fogg Art Museum, Harvard University Art Museums, Cambridge, Massachusetts. Gift of Miss Emily Sargent and Mrs Francis Ormond, 1931 (1931.87.B).

Fig. 59 *(left)*
Woman with Basket, c. 1877. Pencil on paper, 5⅝ x 3⁷⁄₁₆ in. (14.3 x 8.7 cm). Inscribed, bottom right: *J.S.S. 1875.* The Metropolitan Museum of Art, New York. Gift of Mrs Francis Ormond, 1950 (50.130.92).

Fig. 60 *(below left)*
Child, Study for 'Oyster Gatherers of Cancale', c. 1877. Pencil on paper, 8¼ x 5 in. (21 x 12.7 cm). The Metropolitan Museum of Art, New York. Gift of Mrs Francis Ormond, 1950 (50.130.114).

Fig. 61 *(below)*
Portrait of Neville Cain and Study of Mother and Child, c. 1877. Pencil on paper, 8⅞ x 11 in. (22.6 x 27.9 cm). Fogg Art Museum, Harvard University Art Museums, Cambridge, Massachusetts. Gift of Miss Emily Sargent and Mrs Francis Ormond, 1931 (1931.97).

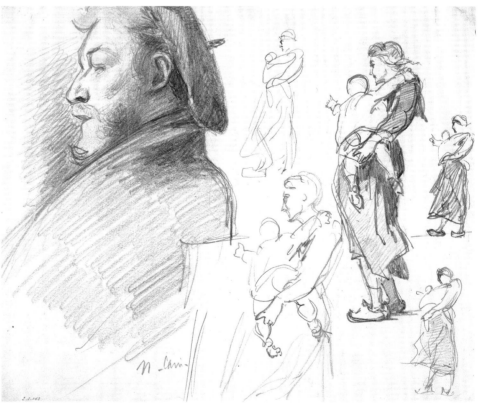

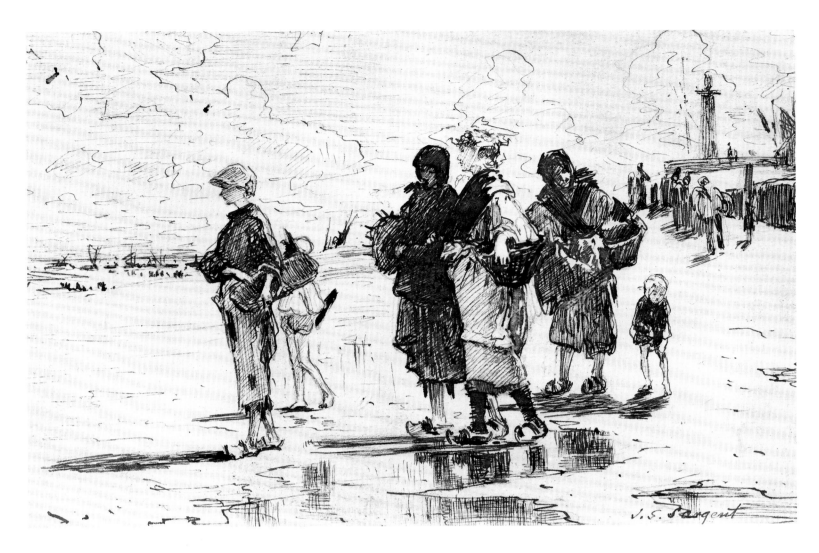

friend of the Sargents from Florence days, with whom they had stayed at Newport, Rhode Island, in the summer of 1876. Sargent wrote to his son Gus Case in some embarrassment (letter of 18 July 1878, private collection):

While your father was in Paris he came to my studio with your mother. They also went to the Salon and saw my picture. On his return he expressed to me his desire to buy it which delighted me exceedingly. I must confess that before the deed was done I pumped Dan [another son] very hard on the Admiral's sentiments; I have misgivings that his old kind feelings had come in; but Dan swore the Admiral liked the picture and wanted it for its own sake, and on these grounds I would not but be delighted that it would go to his house.

The sale of the picture is also briefly mentioned by Emily Sargent in a letter of 24 July 1878 (private collection) to their great friend Violet Paget (the author Vernon Lee). The provenance of the Corcoran picture has frequently been confused in the past with that of the Boston version (no. 671), and its first owner erroneously said to be Samuel Colman.

Some months after the sale, Admiral Case offered Sargent a further commission, which seems never to have been carried out. Sargent wrote to the admiral on 14 April 1879 (private collection): 'I shall do my best to give you something more interesting and in every way better than what I have yet done. Very likely in Spain I may come across some good motive, and as you are in no hurry I shall wait till I have taken the trip I look forward to . . . No one can value such good friends more than I and I will do my best to merit and keep your good will'. In 1877 Sargent painted two posthumous portraits of the admiral's much-loved daughter Annie Rogers Case, wife of Charles Deering, who had died in childbirth (*Early Portraits,* nos. 6, 7). Both Deering, later one of Sargent's greatest patrons, and Gus Case were in the U.S. Navy, serving on the same ship in the Far East. His correspondence with both men survives from this time.

Fig. 62
Sketch after 'The Oyster Gatherers of Cancale', 1878. Pen and ink and pencil on paper, 4½ x 7 in. (11.4 x 17.8 cm). Corcoran Gallery of Art, Washington, D.C. (1976.57). Reproduced as a woodcut, *Gazette des Beaux-Arts,* vol. 18 (1 July 1878), p. 179.

1. 'J'ai eu beaucoup de plaisir à voir le tableau de M. Sargent: *En route pour la pêche.* Cet artist procède par touches franches et larges qui, examinées de près, semblent confuses, mais donnent, vues à distance, du relief et de l'éclat aux figures. On a la sensation du soleil éclairant les sables mouillés de la plage tachée çà et là par les reflets bleus du ciel dans les petites nappes d'eau'.

671
Fishing for Oysters at Cancale

1877–78
Alternative titles: *Oyster Gatherers of
Cancale; Oyster Gatherers; Study for
Oyster Gatherers*
Oil on canvas
16⅛ x 24 in. (41 x 61 cm)
Inscribed, lower right: *John S. Sargent/Paris*
Museum of Fine Arts, Boston. Gift of
Miss Mary Appleton (35.708)

This picture of fisherwomen and small boys
going to the oyster banks at low tide was
most likely begun during the summer of
1877, although completed later in Sargent's
Paris studio. In an undated letter probably
written in November or December 1877
(private collection), Sargent told his friend
Gus Case: 'I am painting away as usual, and
am at present engaged on a picture that
I am going to send to the "American Art
Association" exhibition in New York'. The
larger version of the same subject, in the
Corcoran Gallery of Art, Washington, D.C.
(no. 670), which Sargent sent to the 1878
Paris Salon, was also worked up in the Paris
studio over the winter of 1877–78 and
the following spring. It was purchased by
Admiral Augustus Ludlow Case, the father
of Gus Case.

The Boston version is a smaller variant
of the Salon painting. It is likely that the
two pictures were developed alongside
each other. The main lines of the figure
composition are the same in both works,
although the Boston version is less formal
and less orchestrated; the figures are also
smaller in scale in relation to the picture
space. There are several differences in the
details of the costumes and accessories: for
example, in the arrangement of the kerchief
of the leading fisherwoman; the absence of
a basket carried by the boy behind her; the
lack of a sliver of red underskirt visible on
the woman in the centre; a differently
shaped basket held by the old woman on
the right; brown hair for the boy beside her
instead of blonde. There are also fewer fig-
ures in the background of the Boston ver-
sion. The treatment of the beach and the
sky varies in the two works; in the Wash-
ington version the rocks behind the leading
figures are eliminated, and the slope has
been smoothed out and elongated. The
foreground pools are differently arranged,
and so is the distant view of the foreshore
on the left with its scattering of fishing
boats. The clouds in the Boston version are
more ragged and painterly, as if recording a

precise moment in time, unlike the well-
ordered cloud formation of the Washing-
ton version. Writing of the former work,
Carol Troyen remarks (Troyen, *The Boston
Tradition: American Paintings from the Museum
of Fine Arts, Boston* [Boston, 1980], p. 168):
'The color of *Oyster Gatherers* is equally
effective; it is composed almost entirely of
shades of blue, gray, and brown, with glit-
tering white highlights that animate the
surface. Here Sargent's free brushwork and
his brilliant color harmonies evoke the sil-
ver light and damp, tangy air of the Atlantic
coast town even more expressively than in
the more richly colored and tightly painted
final version'. For a fuller discussion of the
background to Sargent's paintings of *Oyster
Gatherers of Cancale,* see the introduction to
this chapter (p. 86).

The Boston version was the first work
by Sargent to be publicly exhibited in
America. It went early in March 1878 to
the first exhibition in New York of the
Society of American Artists, a splinter
group of younger, more avant-garde artists
who had broken away from the conserva-
tive National Academy of Design. Sargent's
friend and fellow-artist J. Carroll Beckwith
and other painters in their circle may have
encouraged him to lend support to the
new group by contributing. Sargent must
have been gratified by the keen interest
aroused by his picture, which struck a new
note in its brilliant depiction of sunlight.
Unlike his Salon painting (no. 670), which
attracted few reviews, the sketch-like
Boston version was the subject of extensive
press coverage, most of it complimentary.
In the *Atlantic Monthly* (vol. 41 [June 1878],
p. 785), Roger Westbrook claimed that no
word but 'exquisite' would do to describe
the picture:

*We envy a mind, that can look thus at common
life, the bliss of its daily existence. Where another
would see but a group of rude fish-wives plod-
ding heavily in the sand, he shows us a charming
procession coming on with a movement almost*

*rhythmical. The light is behind and throws their
shadows forward in a dusty violet bloom. Small
pools in front give back reflections. The close
skirts show the action of the figures. The line of a
descending hill in the background is cut by the
straight sea horizon. All is as fresh and crisp as
the gray and blue of the shifting sky. The light
touches only in scattering points upon the forms,
which are for the most part in shade. It is man-
aged with a delicious skill.*

A similar description by S. N. Carter
appeared in the *American Art Journal* (vol. 4
[April 1878], p. 126):

*The silvery hue of this painting is what first
attracts the attention, and immediately the eye
rests upon a group of women and children, half in
silhouette, rambling among the quiet pools left by
the retreating tide. Their shadows, dark and
vapoury, are cast on the ground, while the reflec-
tion of their figures appears in the still water
around their feet. A little way off the ripples of the
blue sea roll up against the steep shore, and lumi-
nous clouds shimmer with sunlight.*

The picture remained so firmly rooted in
the memory of American art critics that
they alluded to it frequently in later reviews
of Sargent's work exhibited in New York.

The picture caught the eye of the
prominent landscape painter Samuel Col-
man (1832–1920), more than twenty years
Sargent's senior, who purchased it; he was
one of the founding members of the Soci-
ety of American Artists. The writer G. W.
Sheldon recalled Colman's comment when
asked why he had bought it (*American
Painters* [New York, 1879], p. 72):

*In fresh, translucent, humid atmospheric effects,
this picture was the best there displayed; and
when asked by a friend why he had purchased it,
Mr. Colman replied promptly: 'Because I wanted
to have it near me to key myself up with. I am
afraid that I may fall below just such a standard,
and I wish to have it hanging in my studio to
reproach me whenever I do'.*

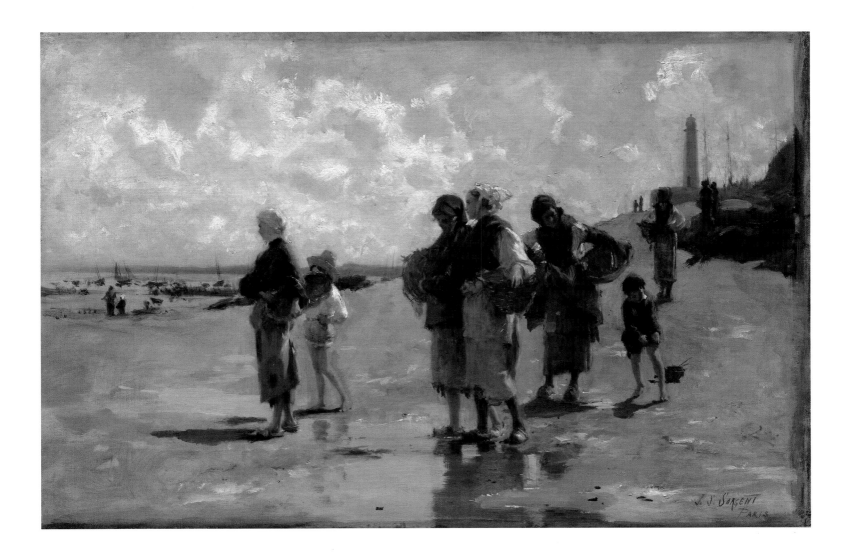

The sale is mentioned in a letter from Dr Fitzwilliam Sargent to his brother Tom dated 3 April 1878 (Fitzwilliam Sargent Papers, Archives of American Art, Smithsonian Institution, Washington, D.C.): 'A picture, or rather a sketch, which he sent to the New Art Exhibition in New York, was very much thought of, apparently by two artists who drew lots as to who should purchase it for $200, the price he had put upon it'.

According to David McKibbin (McKibbin papers), Samuel Colman's house in Newport, Rhode Island, together with its contents, including this picture, was sold by the artist to Susan Travers at some point prior to 1903, when she lent the picture to the Pennsylvania Academy of the Fine Arts, Philadelphia.[1] She was the daughter of William R. Travers of New York, a Wall Street financier and a horse-racing enthusiast (the Travers Stakes for three-year olds at Saratoga, one of the oldest classics in America, is named for him); he had a house in Newport remodelled for him by Richard Morris Hunt. Susan's sister Matilda was married to the American artist Walter Gay, an old friend of Sargent's from Paris days

(see William Rieder, *A Charmed Life: The Art and Life of Walter and Matilda Gay* [New Haven and London, 2000]). Susan Travers lent *Fishing for Oysters at Cancale* and a picture by Claude Monet, *Seine at Giverny* (now Museum of Fine Arts, Springfield, Massachusetts), to the Museum of Fine Arts, Boston, on 4 November 1904. A month later she died, leaving the Sargent to Mary Appleton, a fellow Newport resident and evidently a close friend, together with a portrait of George Washington by Rembrandt Peale, which Mary Appleton later sold to the Museum of Fine Arts, Boston. Ownership of *Fishing for Oysters at Cancale* was formally transferred to Mary Appleton on 10 April 1905, when the picture was still on loan to the museum, on the authority of Walter Gay, presumably acting for the executors of his sister-in-law's will (information in museum records). Mary Appleton was born in New York around 1850 (her age given in the 1880, 1920 and 1930 U.S. Censuses varies), the daughter of William H. Appleton (b. 1815), who appears to have been the son of Daniel Appleton of Haverhill, Massachusetts, founder of the

well-known publishing house D. Appleton & Co. Mary Appleton is listed as a resident of Newport in the 1920 U.S. Census at 17 Red Cross Avenue, and in the 1930 census she is recorded in Boston living with four servants. She gave *Fishing for Oysters at Cancale* to the Museum of Fine Arts, Boston, in 1935. The authors are indebted to Erica Hirshler of the Museum of Fine Arts, Boston, for assistance with this entry, and to Richard H. Finnegan for genealogical information on Mary Appleton.

1. This was confirmed shortly before the catalogue went to press. Colman and his wife sold a house and parcel of land on Red Cross Avenue to Susan Travers on 27 September 1901 for $35,000 (Deed Book no. 78, Newport City Hall, Rhode Island, pp. 271–73). This was almost certainly no. 17 Red Cross Avenue, where Susan Travers is recorded as a resident in Newport City directories, 1902–4. There is no mention in the document of the sale of paintings or contents. The authors are indebted to Christine Lamar for researching the sale of house and land.

672
Sketch for 'Oyster Gatherers of Cancale'

1877
Alternative titles: *Mussel Gatherers;*
Normandy Coast Fisher Folk; Oyster Gatherers;
Study for Oyster Gatherers of Cancale
Oil on canvas
8¾ x 11½ in. (22.2 x 29.2 cm)
Inscribed, lower right: *to my friend*
Beckwith/John S. Sargent
According to the records of M. Knoedler
& Co., New York, 8 April 1941 (stock no.
CA 1682), inscribed on the reverse in
pencil: *Sketch for Les Pecheurs de Cancale*
Untraced

This small oil sketch, painted at Cancale on the north coast of Brittany, seems to be Sargent's first idea for the composition of his large Salon painting *Oyster Gatherers of Cancale* (no. 670) and its related version (no. 671). It was probably painted on the beach in the open air and records a foreground group of two men and two women with baskets, and a boy with a fishing rod, making their way to the oyster banks at low tide. More figures are seen coming down from the lighthouse and promontory to the right. The masts of sailing vessels lying alongside the jetty and the quay are, like the lighthouse, outlined against the sky. Behind the figures are series of rocks, which are still there today. In fact, the topmost outcrop, in the shape of two tooth-like projections, is readily identifiable. When he came to paint the finished version of the composition, Sargent omitted the rocks altogether, preferring an uninterrupted sweep of beach.

In contrast to the larger versions of the subject, the figures in the sketch are comparatively small in relation to the space as a whole, and much less conspicuous, being posed against the background of the beach rather than silhouetted against the sky. Sargent's viewpoint is also different; he is further up the beach towards the town and on higher ground, so that he looks down on the figures rather than up towards them. The two women wear the usual white kerchiefs, rough skirts, dark shawls and sabots, but they are posed differently than the women in the larger versions. The two men and the boy in white shirts, dark trousers and berets do not reappear. The feeling in the sketch is one of casual grouping rather than that of a carefully orchestrated figure composition, which the artist later developed. It explores the theme of reflected light, sparkling in the shallow pools and glancing off the figures. Sargent was careful to preserve this aspect, and the sweeping

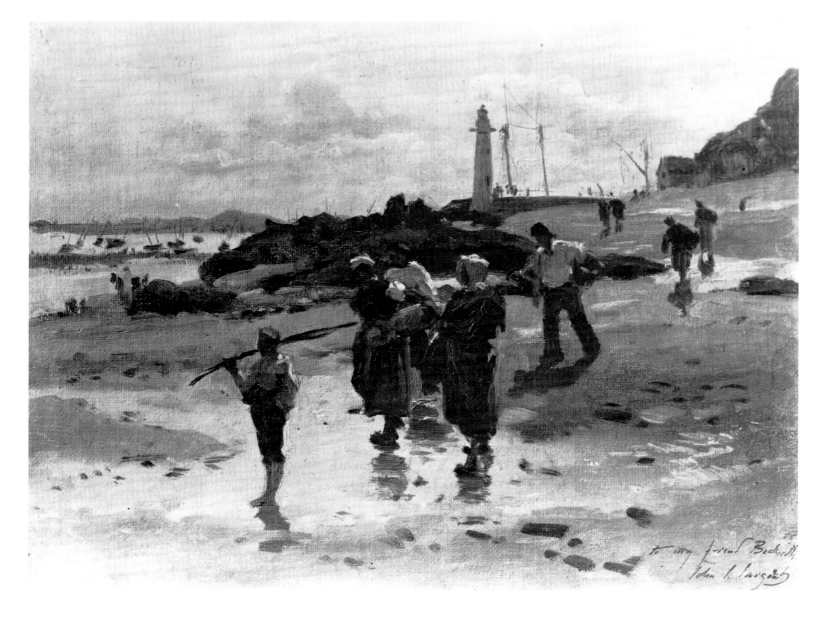

sense of space and sky, in the larger pictures. For a fuller discussion of the relationship between the sketch and these versions, see the introduction to this chapter (p. 86).

J. Carroll Beckwith, to whom the sketch is inscribed, was Sargent's close friend and fellow-artist from student days in Paris, and with whom he shared a studio. It is likely that Sargent would have needed the sketch to help with the two versions, which were finished if not begun in his Paris studio; if this is so, the sketch may not have been given to Beckwith before the spring of 1878. The two friends spent time travelling together immediately after the Cancale expedition in the summer of 1877. According to Mount (Mount 1955, p. 169), Beckwith lent the sketch in 1880 to another American artist, William Merritt Chase, with whom he was intimate. The sketch can be seen in photographs of Beckwith's studio of the 1890s (see Fairbrother 1986, p. 80, n. 22).

The sketch was consigned by Beckwith's widow to M. Knoedler & Co., New York, in 1924, probably with Sargent's knowledge; he is said to have touched up some of Beckwith's paintings after the latter's death in 1917. By 1925, the sketch was owned by Mrs J. Elias Jenkins (b. 1860) of 2625 Prairie Avenue, Chicago, then a fashionable address and now once more so. Born Mary Otis, Mrs Jenkins had married J. Elias Jenkins (1849–1918) in 1885. She was still living on Prairie Avenue in 1937, but she is not recorded thereafter (information about Mrs Jenkins from McKibbin papers). In February 1941 the picture was consigned to Knoedler by the New York dealer Maynard Walker, whose records are in the Archives of American Art in Washington, D.C., and it was returned to him in April of the same year. It is currently untraced. The picture is reproduced here from a photograph taken by Knoedler in 1924; it was also photographed by the Museum of Fine Arts, Boston, when the picture was loaned there by Mrs Jenkins in 1925 for the *Memorial Exhibition of the Works of the Late John Singer Sargent* (neg. no. 25B148.3).

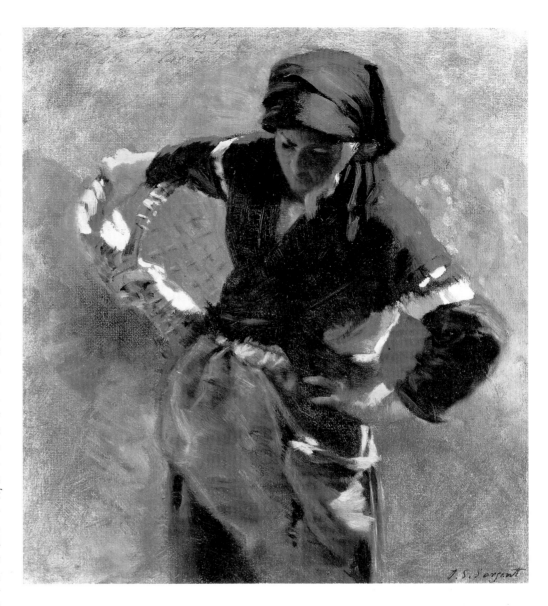

673
Study for 'Oyster Gatherers of Cancale'

c. 1877
Alternative titles: *Woman with Market Basket; The Oyster Gatherer; Woman with Basket*
Oil on canvas
11½ x 10½ in. (29.2 x 26.7 cm)
Inscribed, upper left: *to my friend Rotch, souvenir of/John S. Sargent* and, bottom right (probably not in the artist's hand): *J. S. Sargent*
Private collection

This study shows a woman wearing a black scarf over her head, a fringed shawl crisscrossed over a white chemise, and a buff apron over a dark skirt. She carries a basket under her right arm supported on her hip. The woman does not bear close resemblance to any of the figures in the two main versions of *Oyster Gatherers of Cancale* (nos. 670, 671), and she is differently posed; the closest parallel is to be found with the woman second from the left in the larger picture. There is, however, little doubt that Sargent executed this study in Cancale in preparation for his 1878 Salon painting. In contrast to the other surviving figure studies, this is painted from an odd angle, with the artist looking down on the model from above, and it is painted with a neutral background rather than a view of the beach.

The picture was given to Arthur Rotch of Boston (1850–1894), and not, as sometimes misspelled in the past, 'Roach'. He was the son of Benjamin Smith Rotch, a philanthropist of the arts, in whose memory

his children established the Rotch Scholarship, one of the oldest and most prestigious of all architectural awards. One of his sisters married Winthrop Sargent, a distant cousin of the artist. Arthur Rotch, who studied architecture at the École des Beaux-Arts in Paris from 1874 to 1879, was co-founder of the successful architectural practice Rotch and Tilden. The naming of the Arthur Rotch Library of Architecture and Planning at the Massachusetts Institute of Technology and the Arthur Rotch Professorship of Architecture at Harvard University reflect the influential role he played in the development of architectural teaching in the U.S.

Rotch and two of his sisters overlapped with the Sargents at St Énogat in Brittany during the summer of 1875 (see Dr Fitzwilliam Sargent's letter of 21 August 1875 to his close friend George Bemis, Bemis Papers, Massachusetts Historical Society, Boston). Rotch was also responsible for recommending Sargent as a portraitist to Henry St John Smith through their mutual friend, Gussie Jay (see *Early Portraits*, no. 30). Rotch's wife was Lisa De Wolfe Colt, who, after his death, married Sargent's cousin and close friend Ralph Curtis as her second husband. It is not known when Sargent presented this sketch to Rotch, but probably at some point between 1877 and 1880.

674
Study for 'Oyster Gatherers of Cancale'

c. 1877
Alternative titles: *Breton Girl with Basket, Sketch for 'The Oyster Gatherers of Cancale'; Oyster Gatherer of Cancale (female); Female Study for 'The Oyster Gatherers of Cancale'*
Oil on canvas
19 x 11½ in. (48.3 x 29.2 cm)
Inscribed, lower right: *John S. Sargent*
Terra Foundation for the Arts, Daniel J. Terra Collection, Chicago (1999.129)

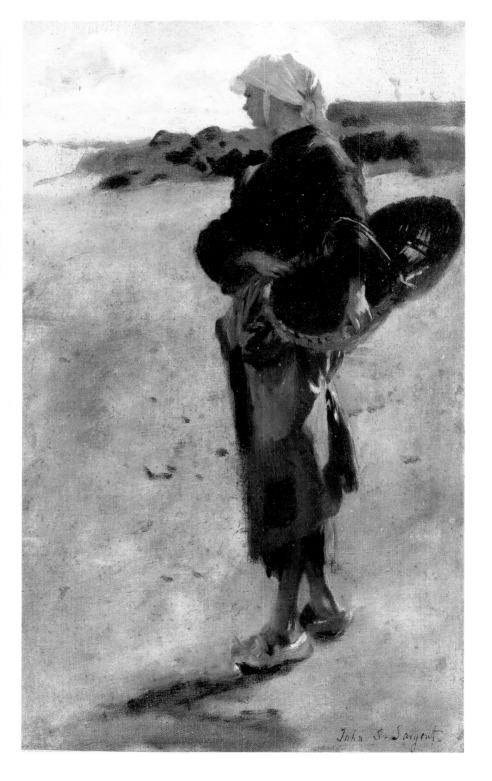

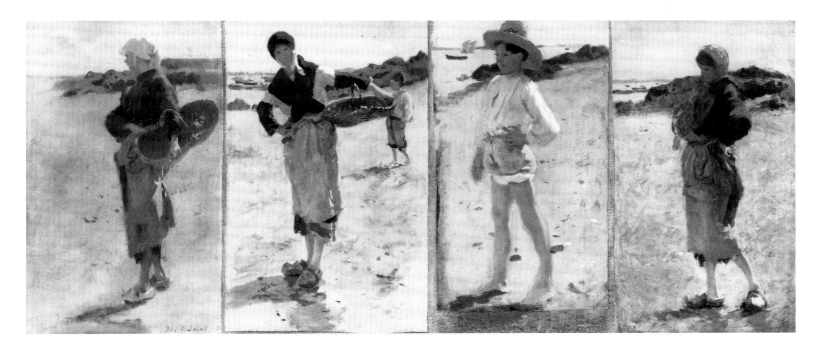

The young fisherwoman shown in this oil study wears a white kerchief over her head with a tie below the chin, a dark blue jersey or similar garment, a rough brown apron over a dark skirt, and sabots or clogs on her feet. She has a basket for collecting oysters resting on her left hip and held in place with both hands. Behind her lies a stretch of beach with rocks and a section of sea wall, with a glimpse of sea to the left and a narrow strip of sky above. The sea wall could be the jetty extending from the lighthouse, but it appears longer than the structure shown in the first sketch for *Oyster Gatherers of Cancale* (no. 672), and so may not be the same. The sketch is clearly a preliminary study for the leading woman in Sargent's big picture, of which two versions are extant (nos. 670, 671). Her headdress is like the one worn by the model in the finished Washington version and not like the one shown in the smaller Boston version. The pose and the details of the costume and accessories of the model in the Washington version closely mirror those in the study

catalogued here; the background, however, is quite different.

This is one of four related figure studies for *Oyster Gatherers of Cancale* (see also nos. 675–77). All four studies have the same background of beach and rocks, and they share the expressiveness and atmosphere of works painted on the spot. There are, however, distinctions to be drawn. Two of the studies, this example and the study of a boy (no. 675), relate closely to the figures in the finished work and represent a refined image of working-class fishing people. It is possible, therefore, that these two studies were studio productions rather than *plein-air* sketches. The other two studies (nos. 676, 677) represent preliminary figurative ideas for the composition that were subsequently modified. The women in these studies look much more like genuine local Cancalaise types, and it seems highly probable that they at least were painted locally. Whether they posed on the open beach is debatable in view of the reluctance of fisher-women to sit and given the artist's prefer-

Fig. 63
Four oil studies for *The Oyster Gatherers of Cancale* (nos. 674–77), as originally mounted on a single piece of canvas, prior to the auction at Parke-Bernet Galleries, New York, 1971.

ence for painting in sheltered surroundings to avoid the crush of onlookers.

The early history of the four sketches is not known. Prior to their sale at Parke-Bernet Galleries in New York in 1971 (7–8 April, lots 30–33), all four were mounted upon a single piece of canvas (see fig. 63), with a stretcher bearing the stencilled inscription, 'Guerde Paris' (noted by one of the authors at the 1971 sale). There are no signs of tacking holes on any of the sketches. They had presumably been trimmed off when the four studies were mounted as a group, whether at the instigation of the artist or someone else is unknown.

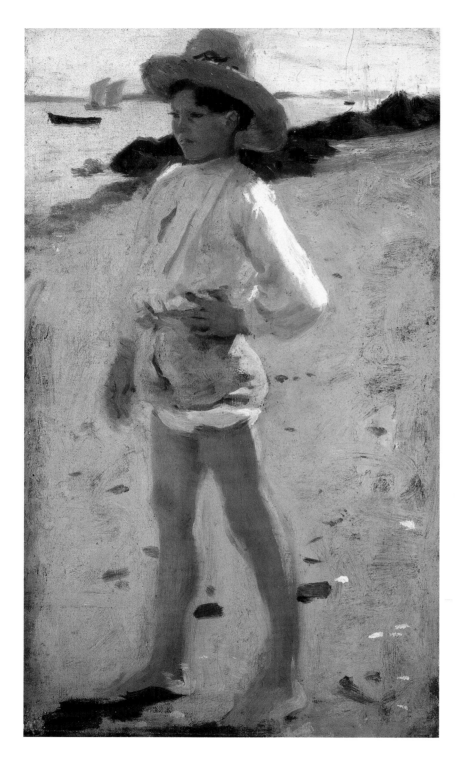

675
Study for 'Oyster Gatherers of Cancale'

c. 1877
Alternative titles: *Young Boy on the Beach,
Sketch for 'The Oyster Gatherers of Cancale';
Oyster Gatherer of Cancale (male); Male
Study for 'The Oyster Gatherers of Cancale'*
Oil on canvas
17¼ x 10¼ in. (43.8 x 26 cm)
Terra Foundation for the Arts, Daniel
J. Terra Collection, Chicago (1999.132)

This oil sketch shows a young Breton boy
in a straw hat and a white shirt over which
he wears a pair of beige-coloured shorts.
He is barefoot. Behind him lie a stretch of
beach with rocks and a view of the fore-
shore with a *bisquine,* the traditional Can-
cale fishing boat, and a narrow strip of sky.
The sketch is a study for the boy who walks
immediately behind the leading fisher-
woman in Sargent's picture of *Oyster Gath-
erers of Cancale,* of which two versions are
extant (nos. 670, 671). In both his face is
partly hidden by the basket carried by the
leading fisherwoman. In the Boston ver-
sion, he is posed with his hand on his hip in
almost exactly the same pose as that shown
in this study; in the Washington version, he
is turned more in profile, his straw hat is
placed further back on his head revealing a
fringe of hair, his left leg is bent more
acutely, and he carries a basket with his left
hand, which is no longer on his hip but
behind his back. Interestingly, the study for
the leading fisherwoman (no. 674) is closer
to the Washington than to the Boston ver-
sion. A drawing of a young boy in hat, jer-
sey and shorts (fig. 60), similar in pose to
the boy in this study, seems to represent the
first idea for the figure. The oil sketch is one
of four related studies originally mounted
on the same piece of canvas; for further de-
tails of the group, see the entry for no. 674.

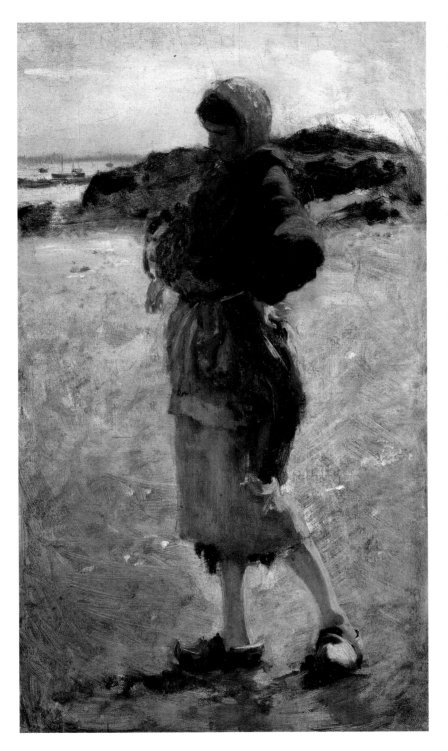

676
Study for 'Oyster Gatherers of Cancale'

c. 1877
Alternative titles: *Breton Woman on the
Beach, Sketch for 'The Oyster Gatherers of
Cancale'; Sketch for the Oyster Gatherers
of Cancale; Girl on the Beach, Sketch for
'Oyster Gatherers of Cancale'; Second Female
Study for 'The Oyster Gatherers of Cancale'*
Oil on canvas
19 x 11½ in. (48.3 x 29.2 cm)
Terra Foundation for the Arts, Daniel
J. Terra Collection, Chicago (1999.131)

This oil sketch shows a young fisherwoman
on the beach at Cancale. She wears a red-
dotted scarf over her head, a dark blue jer-
sey or similar garment, a rough brown
apron over a dark skirt and wooden sabots
or clogs on her feet. She has one hand on
her hip and carries a basket for collecting
oysters in the other. Behind her is a stretch
of beach leading to a rocky promontory
similar to the one shown in no. 677, with a
view of seashore and fishing boats to the
left and a strip of sky above. The sketch was
clearly painted in preparation for Sargent's
picture of *Oyster Gatherers of Cancale* of
which two versions are extant (nos. 670,
671). The pose of the figure in this study
relates most closely to that of the figure in
the centre of the composition in the larger
work. However the models are not the
same (brown-haired here, red-haired in the
big picture), they wear different clothes,
and hold their baskets one on the right hip,
the other on the left. It is interesting to
note the process by which Sargent trans-
formed an ordinary Breton fisherwoman in
the study into the refined and attractive
model of the large painting. This is one of
four related studies originally mounted on
the same canvas; for more details of the
group, see the entry for no. 674.

677
Study for 'Oyster Gatherers of Cancale'

c. 1877
Alternative title: *Breton Woman with Basket:
Sketch for 'The Oyster Gatherers of Cancale'*
Oil on canvas
18½ x 11½ in. (47 x 29.2 cm)
Terra Foundation for the Arts, Daniel
J. Terra Collection, Chicago (1996.53)

This oil sketch shows a fisherwoman on
the beach at Cancale. She wears a black
scarf with a white tie under the chin, a
black shawl criss-crossed over a white che-
mise with black over-sleeves, a buff apron
over a dark skirt and sabots or clogs on her
feet. A basket for collecting oysters rests on
her left hip and is held in place by her left
hand. Her right hand rests on the other hip.
Behind her and further up the beach is a
small boy in shirt and shorts. A rocky
promontory is visible upper right, a view of
the foreshore with fishing boats on the left,
and a narrow strip of sky above. The sketch
was clearly painted in preparation for Sar-
gent's picture of *Oyster Gatherers of Cancale*
of which two versions are extant (nos. 670,
671). The pose of the figure relates most
closely to the older woman on the right of
the figure composition in the larger ver-
sion. There are, however, significant differ-
ences in pose, costume and accessories, and
the present study represents a preliminary
stage in the evolution of the design. This
is one of four related studies originally
mounted on the same piece of canvas; for
further details of the group, see the entry
for no. 674.

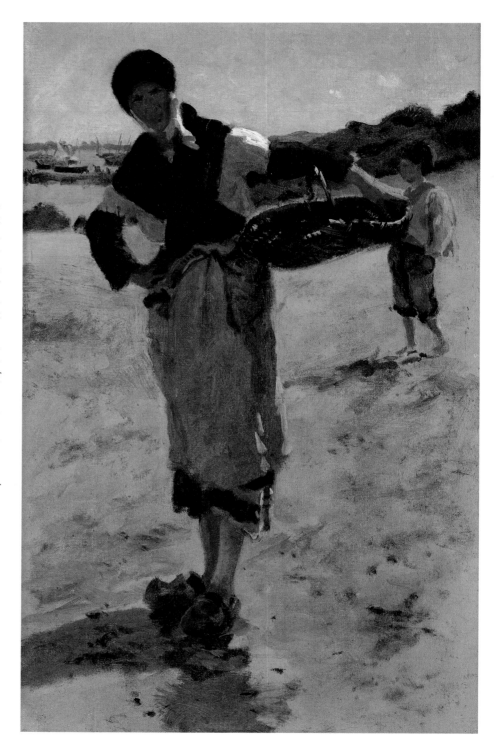

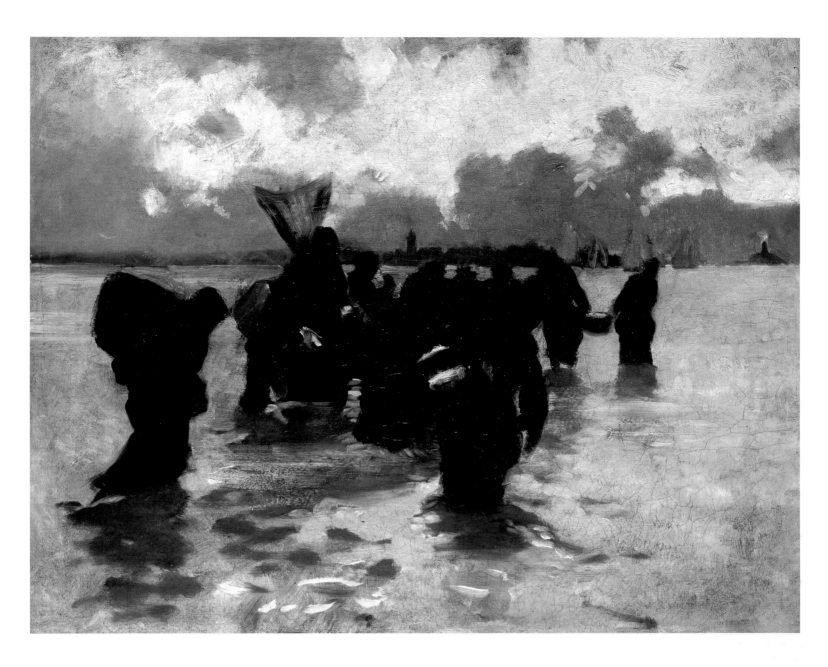

678
Oyster Gatherers Returning

c. 1877
Alternative title: *Mussel Gatherers*
Oil on canvas
19⅝ x 24¼ in. (49.8 x 61.4 cm)
Nelson-Atkins Museum of Art, Kansas
City, Missouri. Gift of Mrs Louis Sosland
(F77-36/1)

The picture was almost certainly painted
on Sargent's visit to Cancale in Brittany
during the summer of 1877, and it presents
the composition of *Oyster Gatherers of Can-
cale* (see no. 670) in reverse. It may indeed
represent Sargent's first idea for an alterna-
tive Salon subject. Instead of a bright morn-
ing scene of women cheerfully setting out
for the oyster banks, the women here are
struggling home heavily laden through the

shallows of the beach. We see them from
behind as a group of black shapes, with
bunched skirts, and shawls over their heads,
bent over by the weight of the baskets they
carry; these contain oysters rather than
mussels, for the women are oyster gatherers
and not mussel gatherers, as the picture was
titled in the 1965 sale catalogue (Parke-
Bernet Galleries, New York, 19 May 1965,
lot 105). Without faces or individuality, the
women, like figures in a funeral procession,
bear mute testimony to the hard conditions
of their working lives. Their dark forms are
thrown into relief by the evening light
shimmering across the shallow waters of
the wide beach through which they wade.
In the distance is a small fleet of *bisquines*,
the distinctive two-masted fishing boats
used for oyster fishing, with a lighthouse
flashing on the right. The topography of
the distant port is difficult to reconcile with

Cancale, which has an upper town on a hill
above the port and a lighthouse on the jetty
rather than one on a separate islet so far
out. It is possible that it represents Cancale
from an unusual angle (the artist must have
been wading or sketching from a boat) or
that it was painted elsewhere in the vicinity
of the town.

This picture is one of a large group of
early studies that belonged to the French
subject painter Auguste Alexandre Hirsch
(1833–1912), who shared a studio with Sar-
gent at 73, rue de Notre-Dame-des-Champs
and became a close friend (see appendix 1,
p. 387). *Oyster Gatherers Returning* descended
to Hirsch's nephew, Raymond Bollack, and
was sold by him at auction in 1965. Mr and
Mrs Sosland of Kansas City, Missouri, who
bought it, were prominent local collectors
who owned a second work by Sargent,
Head of an Italian Woman (no. 634).

679
Low Tide at Cancale Harbour

1877–78
Alternative titles: *Low Tide, Cancale;*
Cancale Harbour, Low Tide; Idle Sails
(Low Tide, Cancale Harbor)
Oil on canvas
19⅛ x 11⅛ in. (48.6 x 28.3 cm)
Inscribed, lower right: *John S. Sargent/1878*
Museum of Fine Arts, Boston. Zoe Oliver
Sherman Collection (22.646)

This is a view of the harbour at Cancale looking west along the quayside to the steeply plunging jetty at the end. The lighthouse is just out of sight to the left of the jetty, which was later replaced by a stone sea wall. The steeply receding perspective adopted by the artist adds drama and movement to an otherwise peaceful scene and is a device he employed in other works of this early period. Erica Hirshler of the Museum of Fine Arts, Boston, has made the interesting suggestion that the picture may be a fragment, cut from another projected Salon composition, noting the heavy reworking of the foreground boat (communication to the authors, 11 August 2004).

In the foreground of the painting, a young boy lies on his front by the quayside, with folded arms, looking down on the boats. The stern of a fishing vessel can be seen immediately below him, with a prominent tiller and hatch. Above the curved edging of the deck is a block with lines drawn tight but leading nowhere; another line coming down from top right also disappears into space. What seems to be partially obliterated is the boom to which both lines would be attached. The foresail, belonging to a second vessel lying immediately behind the first, is hanging loose to dry. The mainmast and rigging also belong to this second vessel. Other fishing boats can be seen resting on the sand at low tide, including two *bisquines,* the distinctive Cancale fishing boats, also with unfurled sails. The beach stretches away to the distant coastline on the far side of the Bay of Mont St Michel under a lowering sky. The restrained palette and cool tonality of the picture are in contrast to the brightly sunlit scene of *Oyster Gatherers of Cancale* (nos. 670, 671). Trevor Fairbrother has written perceptively about the picture (Fairbrother 1990, p. 31):

A youth sleeps or daydreams at the quay's edge, his relaxed body given prominence through its alignment with the major diagonals of the composition. Sargent expresses a mood of sad and quiet longing with exquisite grays and browns, cloudy weather, low tide, and a wistful figure aligned with a boat (which one might see as a symbol of escape).

The early provenance of the picture is not recorded. It was in the collection of Henry Hall Sherman (1859–1937) and Zoe Oliver Sherman (1861–1945) by 1916, when they lent it to an exhibition at the Museum of Fine Arts in Boston. Both husband and wife were from prominent Boston families and formed a distinguished collection of European and American works of art. They left a number of pictures to the Museum of Fine Arts, Boston; the Fogg Art Museum, Cambridge, Massachusetts; and the Worcester Art Museum, together with a purchase fund for the Museum of Fine Arts, Boston (information kindly provided by Carol Troyen of the Museum of Fine Arts, Boston, August 2001). The Sargent was given by Henry Hall Sherman and Zoe Oliver Sherman to the Museum of Fine Arts in 1922. The next year they gave Sargent's watercolour *The Shadowed Stream* (23.727) to the museum. In 1939, at her request, the credit line for pictures given to the museum was altered to Zoe Oliver Sherman Collection.

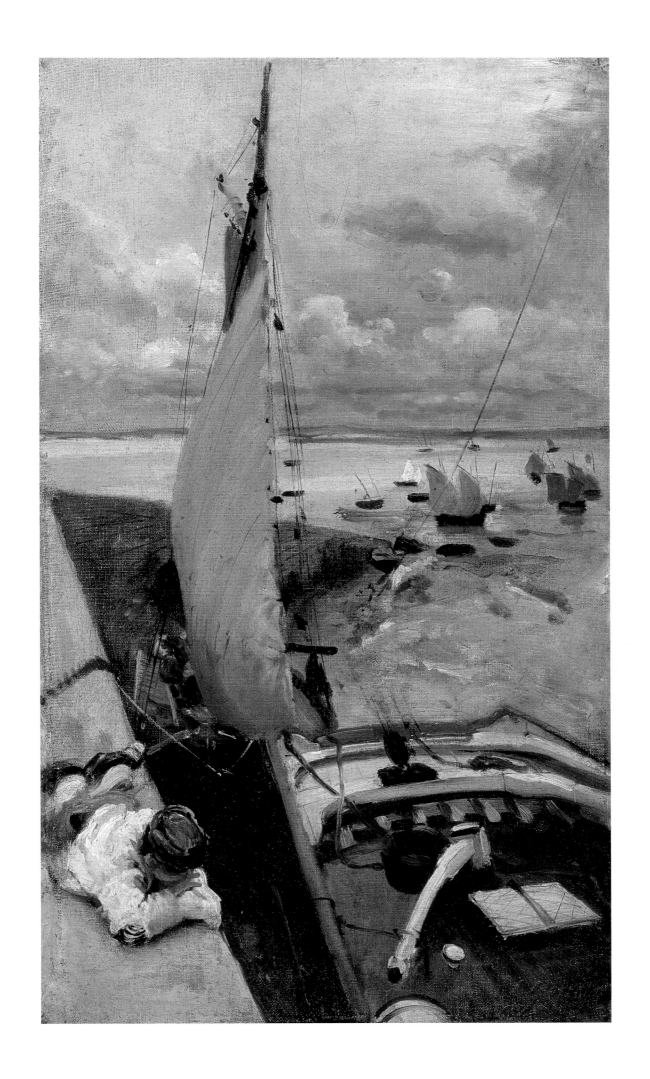

680
Man and Boy in a Boat

c. 1877–78
Oil on panel
13½ x 10¼ in. (34.5 x 26 cm)
Untraced

This picture shows an older man in profile, dressed in a white shirt and dark trousers, standing in the waist of a wide-bodied boat, with his hands on a pair of oars with which he is propelling the boat forward. Behind, seated on the gunwale, is the shadowy figure of a young boy, with arms stretched out behind him. Above the figures is the edge of what looks like a canvas awning secured by tackle to the bow, and billowing out in front is a small jib sail. The awning casts a shadow on the right side of the boat, while sunlight splashes the gunwale and bottom of the boat on the left. In the distance across a stretch of water is a crowded port scene in bright sunlight with various sailing ships at anchor and a hillside behind them. The foreground boat could be either a fishing boat or a local ferryboat, more possibly the latter as there is no sign of fishing gear.

The artist must have been aboard the boat when he painted the sketch, for the effect of the close-up viewpoint is to turn us, the viewers, into seated passengers looking out across the bay, which is framed by the symmetry of oars, awning and the curving sides of the boat. The picture is painted on one of the thin mahogany panels of uniform size which Sargent was using in the period 1877–80. Stylistically, it is closest to the sketches Sargent was painting in Brittany in the summer of 1877; for example, three drawings in the Metropolitan Museum of Art, New York (catalogued by Herdrich and Weinberg 2000, p. 158, nos. 122–24), one of which is reproduced here, *Two Men in Boats* (fig. 64). However, it is possible that the oil sketch was painted in Naples or Capri the following year, or even later at some other seaside location.

The picture is one of a small group of works belonging to Sargent's fellow-artist and close friend Henry Tonks (1862–1937) and was probably a gift. In a letter of 12 November [c. 1950] to David McKibbin (McKibbin papers), Myles Tonks, the painter's nephew and himself a painter, wrote: 'There was a small oil on panel "the deposition", I apologize for saying it was very dull—on the reverse side was a most beautiful sketch in oil *in* a gondola at Venice shewing a figure in a white shirt

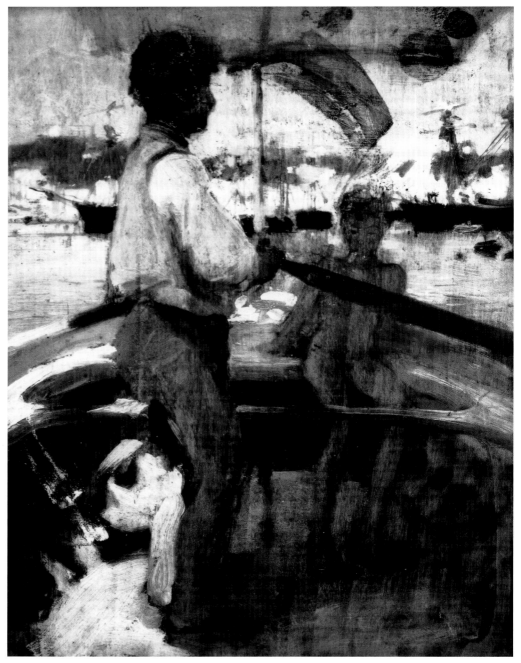

shadowed by the awning which was painted in answer to a challenge by my uncle (as to tone)—"all right—paint *that*". This was in the 1937 sale as "the deposition" & fetched the ridiculous sum of £16.16.0!' There are several inconsistencies in this story. Tonks and Sargent did not know each other at this early period, and the oil sketch by Sargent of *The Descent from the Cross, after Giandomenico Tiepolo* (no. 744), which was in the Tonks sale at Christie's, London, 29 July 1937 (lot 46), does not have a boating scene on the reverse. It seems probable that Myles Tonks got the two pictures confused in his memory, but his description of the figure in the boat tallies with the picture catalogued here. For information on other works by Sargent owned by Tonks, see the entry for *The Descent from the Cross, after Giandomenico Tiepolo. Man and Boy in a Boat* was photographed when in the possession of Tonks for Sir Robert Witt; the original negative is now in the Witt Library, Courtauld Institute, London (no. D53/1333).

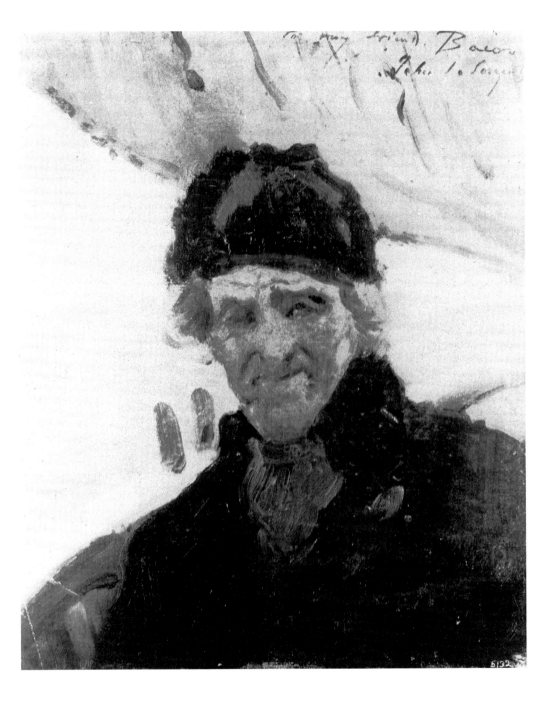

681
The Brittany Boatman

c. 1877
Alternative title: *The Sailor*
Oil on panel
13½ x 10¼ in. (34.3 x 26 cm)
Inscribed, upper right: *to my friend
Bacon/John S. Sargent*
Untraced

This picture was probably painted in 1877 at Cancale on the coast of Brittany. It represents a rough, weather-beaten old sailor in the stern of his boat, while under sail. He has a quizzical expression and appears (from the black-and-white illustration) to be blind in one eye. He has an odd pudding-basin hat with ribbons tied at the top, possibly holding up ear-flaps, and wears a high-necked coat and shirt. Above his head are the edge of the sail and a section of gunwale to the left. The picture was given by Sargent to the American artist Henry A. Bacon (1839–1912) together with three other marine subjects; for details of these and their provenance, see *Mid-Ocean, Mid-Winter* (no. 663). The executor for Bacon's widow (Mrs Eldridge), Charlotte Huffington, wrote to David McKibbin as follows (undated, McKibbin papers): "'The old Brittany Seaman' I sold—at the moment I cannot remember the name of the buyer but I can easily find it if needed'.

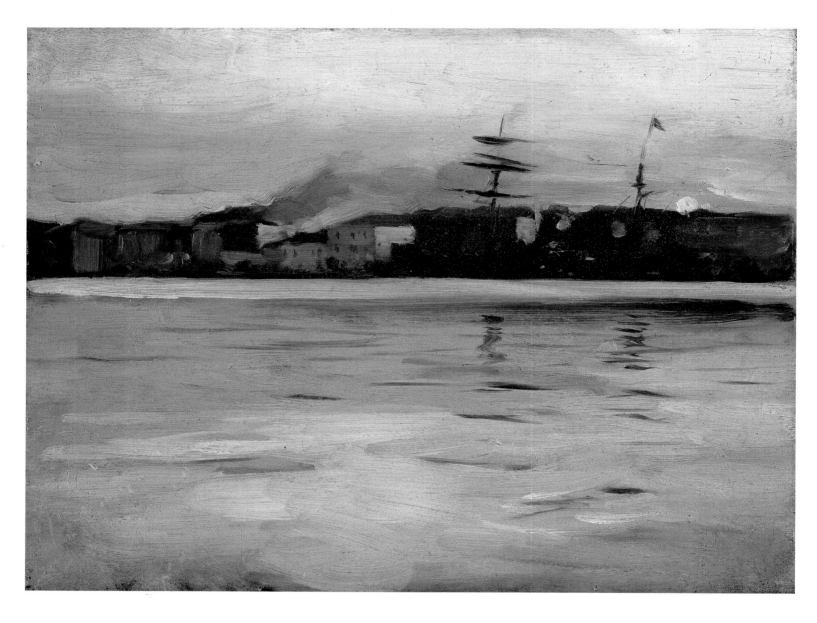

682
Port Scene I

c. 1877
Alternative title: *Port of Genoa*
Oil on panel
10 x 13½ in. (25.3 x 34.5 cm)
Private collection

In his card for this picture, David McKib-
bin (McKibbin papers) relates this port
scene to an entry in the supplementary list
of the *Sargent Trust List* [1927], no. 87, 'Port
of Genoa'. However, the latter was listed
under 'Drawings', with different sizes and a
description that does not tally: 'Big white
boat pinkish church on right in distance'.
The present picture reveals a foreground
expanse of pale greyish-blue water reflect-
ing a cloudy sky, with streaks of black to
indicate ripples, and a thin line of white
impasto defining the water close to the
quayside. To the right is the black shape of a
merchant vessel with two masts and a fun-
nel. The buildings behind, their ends catch-
ing the sunlight, look like warehouses. There

are two smaller houses with windows,
white and pink, to the left of the ship's bow,
and then a group of larger structures, prob-
ably warehouses.

The picture could have been painted
in Genoa or at a number of other Mediter-
ranean locations. Emily Sargent records her
brother sketching with a friend, Heath
Wilson, during a family holiday in Genoa
in a letter of 16 October 1877 to Vernon
Lee (Vernon Lee Papers, Special Collec-
tions, Millar Library, Colby College, Water-
ville, Maine). The sketch is painted on one
of the thin mahogany panels Sargent was
using in the period 1877–80. Its bold com-
position and subtle tonality relate to other
landscapes of the time frame.

683
Wharf Scene

c. 1879
Alternative title: *The Dock*
Oil on canvas (grisaille)
12⅞ x 18⅟₁₆ in. (32.7 x 46 cm)
Inscribed lower right: *John S. Sargent*
Private collection

Sargent rarely painted in grisaille (see *Man and Woman on a Bed,* no. 775, for another example), and this picture may possibly have been intended for an illustration. It is similar to *Two Nude Figures Standing on a Wharf* (no. 684), which is associated with a group of works he painted in Spain and Morocco in 1879–80. Both pictures could have been painted at the same port. *Wharf Scene* is also similar to a water-colour of *Ships and Boats* (no. 685), which is inscribed 'Nice' on the verso, but not in the artist's hand. The setting of all three works appears to be Mediterranean, and they compare closely in style to *Boats in Harbour I* and *II* (nos. 686, 687), one of which is dated 1879.

The steps and quayside in the foreground of *Wharf Scene* are occupied by a group of lounging, bare-legged young men. The two on the right, one of whom gesticulates with his right hand, are engaged in lively conversation with another pair of young men to their right. Behind the latter are more youths looking towards a female figure, with a shawl over her head and a bag by her side, who holds out her hand as if soliciting alms. In the distance is a fortress-like building or rampart, with a grand pillared entrance, beside which more figures are sketchily indicated.

A barge and a sailing vessel are moored by the quayside. The barge is of typical Mediterranean type, with a single mast, a tented canopy amidships, a tall bow post, and painted *occhi* (eyes) on either side of it. A thin securing line runs from the bow and is secured to a ring set into the steps. A small rowing boat lies alongside. We see the lower masts and shrouds of the square-rigged sailing vessel lying behind the barge, and a jumble of spars and masts belonging to other ships in the distance. To the left,

across the water, can be seen a vessel with her sails set. More masts and rigging far left indicate further port activity. Raking streaks of sunlight, catching the side of the barge's canopy, tracing the gunwale of the sailing vessel and flecking the top of the stone bollard, suggest a scene painted in the late afternoon or evening.

In a letter to David McKibbin of 9 January 1968 (McKibbin papers), William J. Miller wrote:

The painting was purchased by Moorhead B. Holland, Mrs. Miller's father, from the J. J. Gillespie Co. in Pittsburgh, December 1929 for $2750.00. It was designated at that time as Painting #4831 'The Dock' by John Singer Sargent.

Gillespie's apparently received it from the John Levy Gallery in New York which had purchased it from A. M. Reitlinger, a dealer at 12 Rue La Boetie, Paris. Mr. Reitlinger said 'The picture by Sargent was bought in 1918 at an auction after the death of an American Lady, who was a great friend of the painter. The gentleman from whom we bought the picture was unable to give us the name of the lady'.

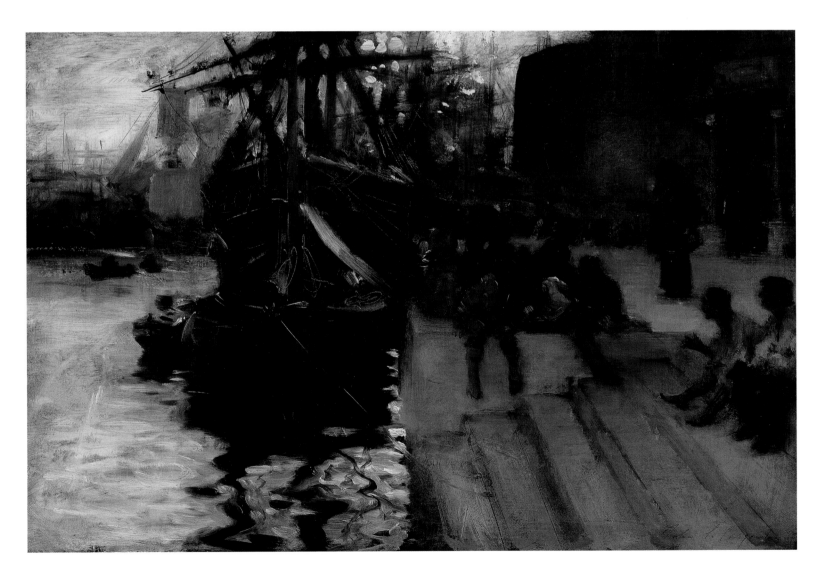

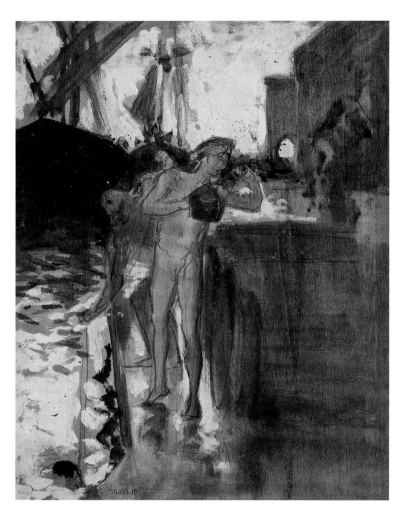

684
Two Nude Figures Standing on a Wharf
(recto) and ***The Balcony*** (verso)

c. 1879–80
Alternative titles: *Two Nude Bathers
Standing on a Wharf* and variants; and
(verso) *The Balcony, Spain*
Oil on panel
13¾ x 10½ in. (34.9 x 26.7 cm)
The Metropolitan Museum of Art,
New York. Gift of Mrs Francis Ormond,
1950 (50.130.10)

This double-sided panel belongs to a group of works relating to Sargent's expedition to Spain and Morocco in 1879–80. The study of *The Balcony* on the verso looks more Spanish than Moroccan, and *Two Nude Figures Standing on a Wharf* on the recto could be anywhere in the Mediterranean. The latter is similar in style and composition to *Wharf Scene* (no. 683), and both were possibly painted in the same location. *Two Nude Figures Standing on a Wharf* shows two sketchy figures drawing up water and pouring it into barrels behind them. They are not bathers, as described in the title given to the picture in 1950. The foremost figure wears a turban but is otherwise naked. He holds a bucket up as he pours the contents into the second large barrel in a row of three. The figure behind, wearing a cap and also seemingly naked, is in the process of filling his bucket with water from the dock before drawing it up, guiding the long rope through the fingers of his right hand with

his arm extended downwards. Beyond the figures is a sailing vessel with black hull and rigging. To the right are two plain buildings, the farther one pierced by a Moorish-style archway.

The study of *The Balcony* shows a window and balcony within an arched niche in what looks like a courtyard space. The edge of a second arched niche is visible to the right. A blind is pulled down and outwards from the window to rest on the top rail of the delicate balustrade. The white shape visible below the blind could be the figure of a woman. Various garments and a large white cloth are spread out over the rail, and what look like onions hang in bunches to the right of the window, with flowers below. There is a small doorway to the right. The balcony itself is supported on thin metal brackets. At the bottom of the picture, the double doors of a workshop, wine cellar or store stand open, revealing a dark interior.

685
Ships and Boats

c. 1879
Water-colour and pencil on paper
9 x 11 in. (22.8 x 28 cm)
Inscribed on the reverse: *Nice*
Private collection

This water-colour is very similar to *Wharf Scene* (no. 683); the sailing vessels look almost identical. The water-colour is inscribed 'Nice', but not in the artist's hand. Both the water-colour and the oil relate stylistically to *Boats in Harbour I* and *II* (nos. 686, 687), one of which is dated 1879. All four represent Mediterranean harbours. In the present water-colour we see the complex rigging of a small flotilla of sailing vessels moored alongside one another. On the right are two fishing vessels, stern view, with dinghies trailing behind. In the centre is the bow view of a larger, two-masted, square-rigged sailing vessel. A smaller sailing vessel, also seen from the bow, comes next, and then the stern view of a third vessel far left. A second line of vessels lies behind the first, contributing to the complicated web of masts and spars. Reflections from the ships' hulls darken the rippling water in front. Across the harbour in the background runs a line of low buildings, with a pedimented archway outlined in pencil.

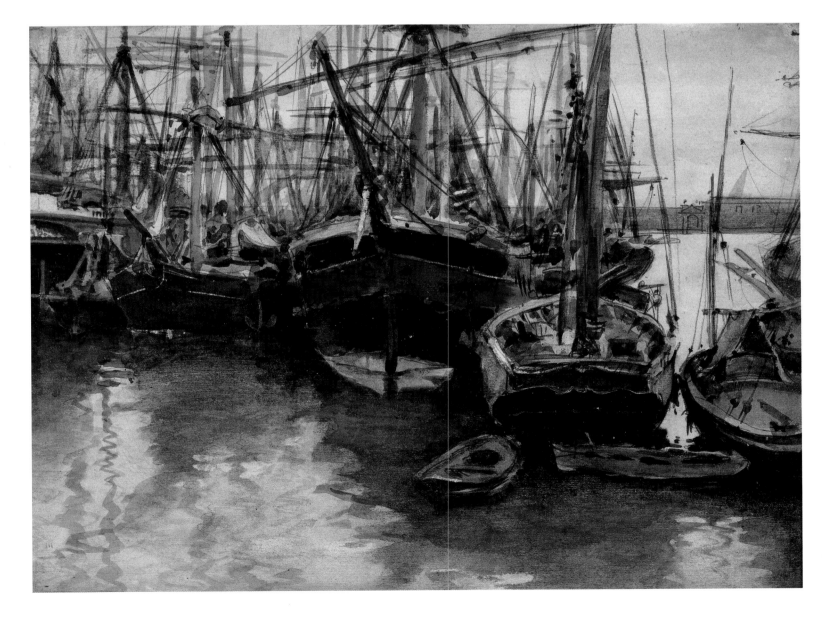

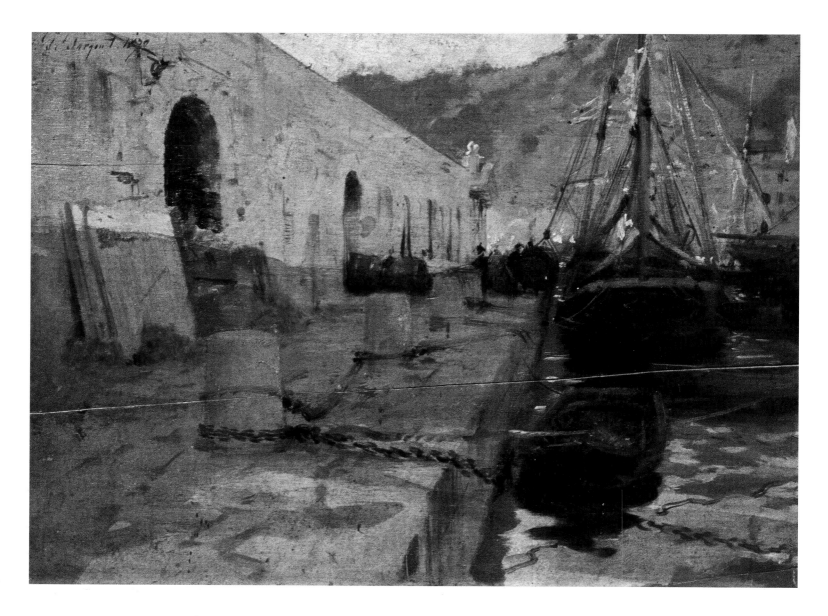

686
Boats in Harbour I

1879
Oil on panel
10 x 13 in. (25.3 x 33 cm)
Inscribed top left: *to my friend Cox /
J. S. Sargent 1879*
Collection of Dr Cornelius Lansing

This harbour scene is identical in composition to a water-colour of the same subject (see no. 687). If the inscribed date, '1879', represents the date of execution, rather than the date of presentation, it might have been painted in Nice. One of another pair of harbour scenes, *Ships and Boats*, similar to this picture in style, is inscribed 'Nice', but not in the artist's hand (see no. 685). The composition of *Boats in Harbour I* is organized around the steeply receding diagonals of a wharf and a low warehouse building with arched openings on the left, and the rectangular dock basin on the right;

the geometry of building and wharf recalls Sargent's Moroccan street scenes. In the foreground is a rowing boat, and, in front of it, a chain, attached to the first of four stone bollards, runs out to an unseen vessel on the right. Behind the boat is a small two-masted, square-rigged sailing vessel, which is being loaded with barrels of wine or oil. One barrel is about to be hoisted aboard by two workers, while a third man in a hat appears to be directing operations. More barrels are shown at the second arched entrance to the warehouse, awaiting their turn. Panels of wood or stone stand to the left of the first entrance, with piles of an orange-coloured material in front of them. The warehouse building terminates in a grand pedimented gateway, and the wharf then continues at right angles along the far side of the basin. The stern of a second vessel is visible on the right, and the mast of a third behind it. In the background on the right three buildings can be seen, and more on the crest of the hillside.

The picture is painted on one of the thin mahogany panels which Sargent was using in the period 1877–80. A thin crack is visible across the middle of the panel. The picture was painted rapidly and thinly, the reddish–brown panel left bare in places to provide a warm middle tone. Highlights of white paint in the middle distance denote splashes of sunlight at low level, suggesting that the scene was painted late in the afternoon or early in the morning. Otherwise the colour scheme is restricted to muted greys and browns against which the black forms of the vessels stand out strongly.

The picture was given by Sargent to his friend Kenyon Cox (1856–1919), an American painter, illustrator and writer who had studied with Jean-Léon Gérôme and Carolus-Duran. He claimed to have modelled for the hands of the guitarist in *El Jaleo* (see p. 267). He also wrote a perceptive critique of Sargent's art in *Old Masters and New: Essays in Art Criticism* (New York, 1908, pp. 255–65).

687
Boats in Harbour II

c. 1879
Water-colour and pencil on paper
8½ x 11 in. (21.6 x 28 cm)
Private collection

This water-colour shows the same scene as *Boats in Harbour I* (no. 686). There are differences of detail: the fore-edge of the basin is included where it turns at right angles, with more of the quayside visible; an additional arched opening is shown in the building on the left; the chain in the foreground goes down into the water rather than being stretched in front of the rowing boat; the barrels read as black shapes; the piles of orange material appear in the foreground but not the panels of wood or stone;

the pedimented gateway is shown with a house nearby, as well as the buildings on the far right. In general, the scene is simplified in the water-colour, and the tonality is pitched in a brighter key. Thin washes of pale grey, beige and mauve over pencil outlines allow the white of the paper to show through and create effects of strong reflected light. The hillside, the buildings and the hulls of the ships are in shadow, and so are the sides of the quay, resulting in contrasting patterns of light and dark.

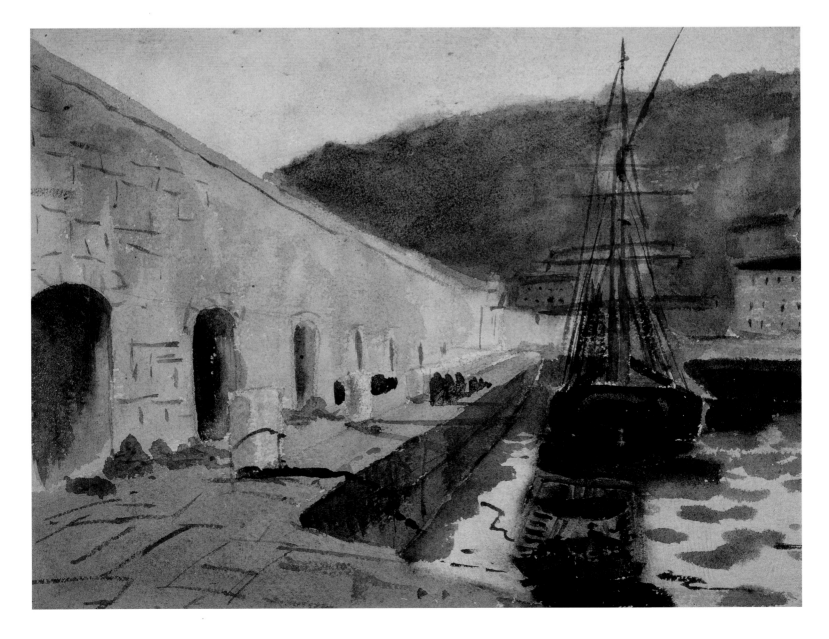

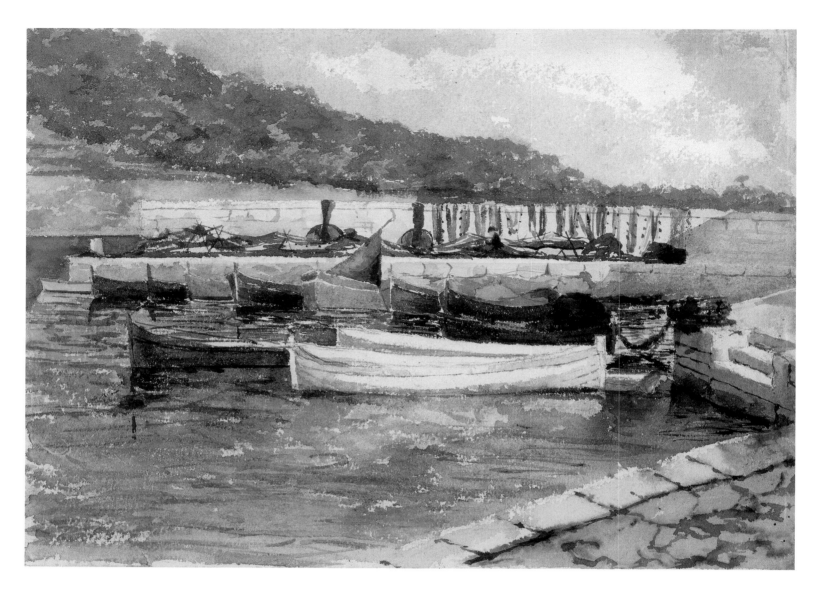

688
Boats I

c. 1879
Water-colour and pencil on paper
10⁵⁄₁₆ x 14³⁄₁₆ in. (26.3 x 36.1 cm)
Inscribed on the verso: *BOATS*
The Metropolitan Museum of Art,
New York. Gift of Mrs Francis Ormond,
1950 (50.130.80q)

This water-colour was recently listed among doubtful works in a catalogue of the water-colours and drawings by Sargent in the Metropolitan Museum of Art (Herdrich and Weinberg 2000, p. 360). However, it represents the same port as a second, similar water-colour (no. 689), and, in the view of the authors, both works are correctly attributed to Sargent. Like *Boats II,* this water-colour shows a group of boats enclosed by the protective walls of a small fishing port. Richard H. Finnegan has pointed out that the scene is more likely to be a lake than the sea and has proposed the Lac de Bourget, near Aix-les-Bains, where Sargent visited his parents in the summer of 1879, as the possible location (communication to

the authors, 14 June 2004). The same right-angled quayside appears in *Boats II,* with steps cut into it, and at the back a long quay and sea wall stretch the length of the picture space. More detail is shown here with fishing nets hanging over the sea wall and other equipment below. The three boats highlighted in the centre look identical to those shown in *Boats II,* and a similar line of moored boats is ranged along the farther quay. Behind is the same low-lying promontory. The scene, empty of people and saturated with sunlight, belies its function as a working environment. Sargent would paint similar boating pictures in the port of San Vigilio on Lake Garda in 1913, more than thirty years later.

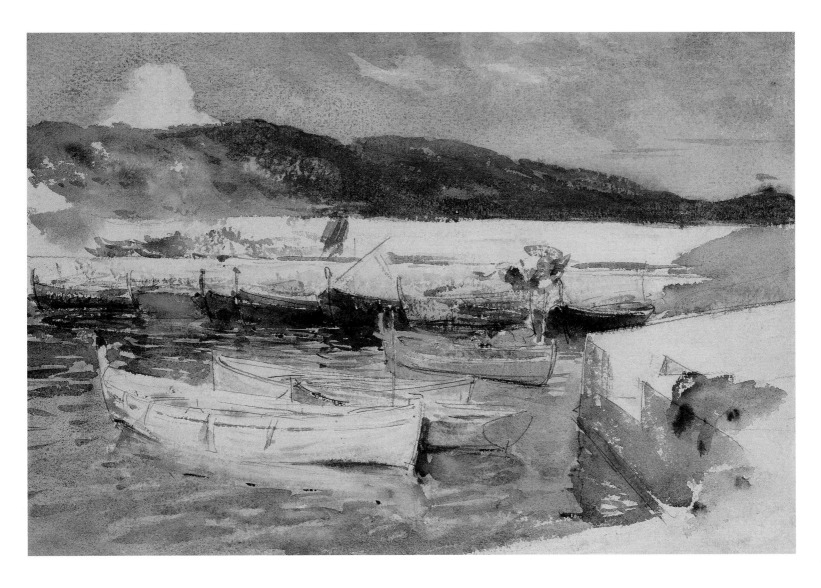

689
Boats II

c. 1879
Water-colour and pencil on paper
10 x 14 in. (25.5 x 35.6 cm)
Private collection

This water-colour represents the same small Mediterranean harbour as *Boats I* (no. 688). The latter was listed among doubtful works in the recent catalogue of water-colours and drawings by Sargent in the Metropolitan Museum of Art, New York (Herdrich and Weinberg 2000, p. 360); in the view of the authors both water-colours are correctly attributed to Sargent. In subject, they relate to the group of Mediterranean harbour scenes (see nos. 682–85) datable to 1879, but they may possibly be a year or two later. They are pitched in a brighter key, with vivid effects of sunlight, and the execution is more spirited.

In common with the harbour scenes, the composition of these two water-colours is articulated by the square geometry of stone quays enclosing a harbour basin. In the foreground of the present water-colour three rowing boats are moored close to-gether. The pencil underdrawing is clearly visible, and the artist uses the white of the paper to create the brilliant effect of sunlight on the boat nearest to us. The second boat is blue, and the artist uses the same wash for it as for the water, with a line of yellow to define its interior. The third boat, like the first, is left as bare paper. A fourth boat, in light blue with orange stripes, lies a little way off, and against the farther quay seven boats in various shades of blue and grey are moored by the stern. The quay itself is left unfinished; in *Boats I* (no. 688), fishing nets are shown hanging over the wall with fishing tackle below. Beyond the sea wall is a low-lying promontory and above, a fresh blue sky. With the simplest of means, Sargent creates the effect of bright sunlight falling on the stone-coloured quays, boats and rippling water of the little port.

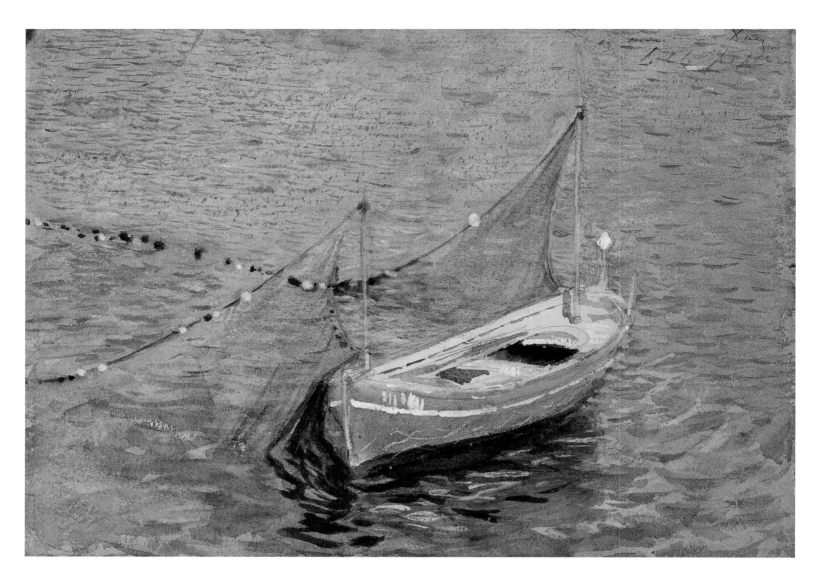

690
Filet et Barque

c. 1879
Water-colour and pencil on paper
10 x 13¾ in. (25.3 x 35 cm)
Inscribed top right: *a mon ami Duez/*
J.S.S. popol [?]
Private collection

This water-colour of a fishing boat corresponds in style and subject to two views of boats in a small Mediterranean port (nos. 688, 689). The indecipherable word after Sargent's initials in the inscription, 'popol [?]', may have indicated where the water-colour was painted. Richard H. Finnegan has suggested to the authors that it might be 'Paimpol', on the north coast of Brittany in the département des Côtes-d'Amor. The water-colour shows a drag net attached by posts to the bow and stern of the boat; the absence of fishermen suggests that the net has been left in position to fill up with fish.

We are looking down on the boat, with the stern nearest to us and the upright bow post with a bulbous top at the far end; the artist may have painted the picture from the deck of a vessel, which would explain the high viewpoint. The boat is painted blue with a white line running below the gunwale and identifying marks at the stern (not legible). The interior of the boat has the mellow tone of natural wood. The black and white floats, which keep the fishing net buoyant, are shown. The high viewpoint allows the artist to dispense with a horizon and to project the boat and the net against a shimmering background of blue water. The consequent flattening of space adds to the decorative quality of the composition.

The water-colour was given to the French landscape painter Ernest-Ange Duez (1843–1896), with whom Sargent became friendly in the early 1880s; he painted portraits of Duez and his wife (*Early Portraits,* nos. 149, 150).

691
Port Scene II

c. 1879
Water-colour and pencil on paper
10 x 14 in. (25.5 x 35.7 cm)
Private collection

This water-colour has some of the characteristics of the harbour scenes datable to 1879 (nos. 683–89), but it is more sophisticated in the feeling for light and atmosphere, and thus may be a little later in date. The setting could be Nice, where the artist's family often spent the winter. In the foreground is a broad, brightly lit roadway; to the right, a house with three doorways, the one on the right with a three-legged object outside and a fluttering blue curtain; above is a greenish-blue trellised veranda and a window with green shutters. The narrowing street, with a whitewashed building on the right and a low fence on the left, leads the eye towards a three-storey house of pale pinkish colour with an elegant archway on the right, and to a busy port scene with masts and rigging silhouetted against the sky on the left. The picture captures the way in which Mediterranean sunshine bears down on forms and drains them of colour, creating a sense of saturating white light. In common with Sargent's other port scenes, people are noticeable by their absence.

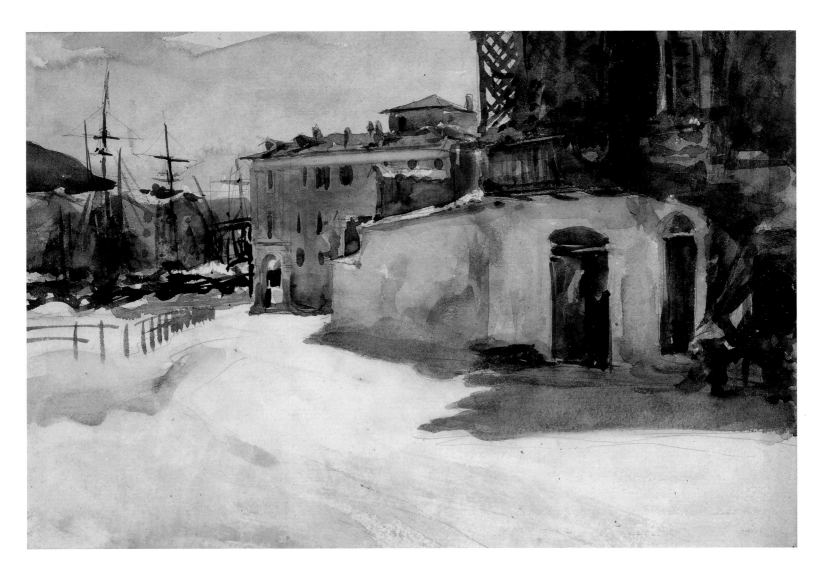

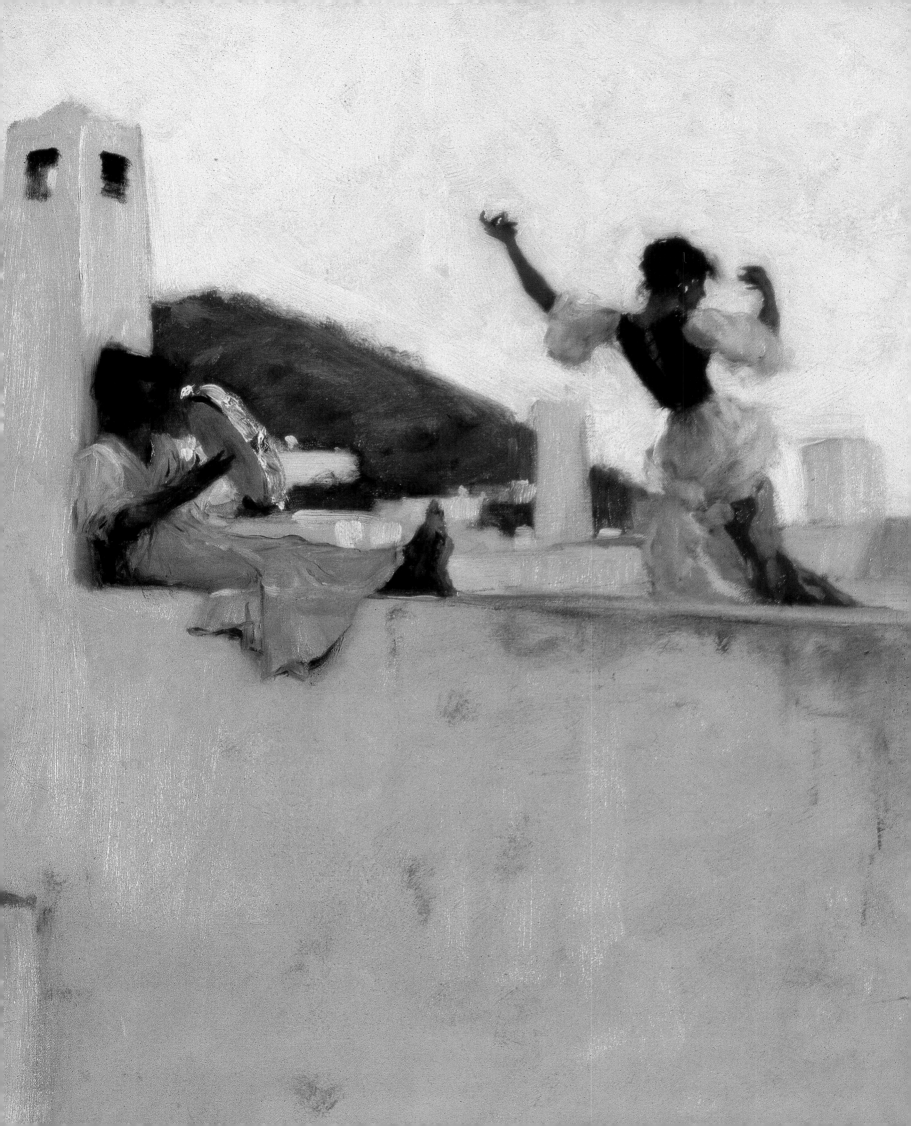

NAPLES AND CAPRI, 1878

The bay of Naples, with its dramatic backdrop of volcanic hills, its ancient history and classical sites and the shabby splendours and fabled licence of its great city, was a potent lure to English, French and German travellers in the eighteenth and nineteenth centuries. The excavations at Pompeii and Herculaneum, which began in 1748, meant that Naples became the requisite last stop on the European Grand Tour, and the glories of the city and its environs percolated into Northern European consciousness through the tales and images disseminated by the cultured tourists who visited them. Within a few decades, expatriates and travellers from France, Germany, England, Scandinavia and America were coming to Capri, the most beautiful of the islands in the bay, drawn by the promise of its light, landscape and local colour.[1] Capri turned protagonist in terms of international attention when, in 1826, a German poet, August Kopisch, and a painter, Ernst Fries, 'discovered' the Grotta Azzurra, a cave on the north-western coast of the island, in which the effects of light refraction make for a preternatural turquoise luminosity.[2] Writers such as Wilhelm Waiblinger (*La Favola della Grotta Azzurra*, 1830), Hans Christian Andersen (*Improvisatoren*, 1835), Ferdinand Gregorovius (*L'Isola di Capri—Un idillio Mediterraneo*, 1856), and Kopisch himself (*La Scoperta della Grotta Azzurra*, 1838) provided a literary context for the iconic images of the grotto.

Sargent first visited Naples, the region of Campania, Sorrento and the island of Capri in the spring of 1869 when he was thirteen years old. He was with his family, and they followed a traditional tourist route, exploring volcanoes, museums and archaeological sites on the mainland and admiring the Blue Grotto, the ruins of Tiberius's villa and the dramatic Arco Naturale on Capri. Sargent's account of the visit, written in a letter to his friend Ben del Castillo from the Hotel Cocumella in Sorrento on 23 May, is full of enthusiasm for the antiquities and natural beauties he has seen:[3]

The day after we arrived at Naples, we went to the old town of Pozzuoli and Baiae and on the way there we went to the crater of the Solfatara a volcano near Pozzuoli. We also saw the cavern of the Cumaean Sybil, on the banks of the Lake Avernus [Lago d'Averno]. The Museum of Naples is very fine and more interesting than either the Capitol or Vatican at Rome, because all the bronzes and frescoes from Pompeii and Herculaneum are there.

We went to Pompeii a few days ago by railway only three quarters of an hour from Naples. It is very interesting, and you see the houses of Glaucus and the heroes of Bulwer's 'Last Days of Pompeii'.

The houses are very well preserved and the walls of the rooms are generally covered with frescoes, but they have taken away the finest frescoes to the Museum of Naples. In the house of Diomed you see the cellar where Julia his daughter and a lot of women were suffocated, and we saw the oven where 81 loaves of bread were found, which have been taken to the museum, they are enough cooked by this time. You are not allowed to give anything to the guide who shows you about, and they sell photographs of Pompeii to you instead.

Day before yesterday we sailed for the Island of Capri 14 miles off. We went first to see the Blue Grotto the entrance of which is so small that you get into a little boat and lie down in the bottom of it. But when you are in, it is very large. The light all comes from the water, which is of a light blue and is reflected on the roof. From the Blue Grotto we went to the Villa of Tiberius [Villa Jovis], which is perched up on a peak about 1360 feet above the sea, and a little lower down is a place called the Salto di Tiberio, where Tiberius used to throw off his victims into the sea. It is 1335 feet high, and if you throw a large stone over it is

almost 30 seconds before it falls into the sea. Then we saw the natural arch which is very fine.[4]

Naples had been an international centre for artists since the middle of the eighteenth century and, by the middle of the nineteenth century, Capri had become known as an artist's island. Painters were attracted to its relative remoteness, the dramatic, pictorial beauty of its scenery, its limpid light and iridescent waters, and its traditional way of life. The first significant representation of Capri may be the gouache *Il Monte Solaro nell'isola di Capri* (1792, Palazzo Reale, Caserta, Italy) by the German landscape painter Jakob Philipp Hackert, which marked the beginning of a love affair between artists and the island.[5] There was a flourishing market for Neapolitan *vedute*, and a successful local school, known as the Scuola di Posillipo, led by the Dutch painter Anton Sminck Pitloo and Giacinto Gigante, who, influenced by changing trends in European landscape painting, specialized in romantic, lyrical depictions of local scenes. Another group, the Scuola di Resina, founded in the early 1860s in Naples by Marco De Gregorio and joined by Federico Rossano and a young Giuseppe de Nittis, shared an interest in *all'aperto* (open-air) painting and in the effects of light and atmosphere, but with a more overtly anti-academic bias. By the mid-1850s, Capri had become established as both a venue and a subject for international artists, who became a 'characteristic feature of the island, for they are everywhere to be seen, sitting at their work'.[6] Favourite subjects were the shallow crescent of the harbour at Marina Grande with its fringe of vaulted houses, the view looking upwards towards Capri town and the hills beyond from the position of Marina Grande, the narrow streets in Capri town, the Church of Santo Stefano, views of the town from

various roads leading out to and from the country, Marina Piccola, the Faraglioni rocks[7] and the native Caprese, whose appearance and way of life were so pictorially appealing. In 1879, the American critic Margaret Bertha Wright wrote an article on Capri, in which she imagined a conversation between three artists who 'had been dwelling for many days upon the same subject, seeking knowledge of some sylvan spot where, during the months that Rome was uninhabitable, Nature would pose most graciously for their spring's exhibition pictures'. One of her trio listed the island's aesthetic attractions: 'To be sure, Capri is infested with painters . . . but models and living are still cheap there, the peasants are far handsomer than those of the mountain-towns, the little island is wonderfully rich in *motifs,* and is so tossed into hills and hillocks and ensphered by sea and sky that one sees a Jules-Breton outlined like sculpture against space at every turn'.[8]

The American artist Dwight Benton, who was in Capri in 1877, described the attractions of the island from an artist's point of view: 'It would seem hardly possible that so much of picturesque motive could be comprehended within so small a space as nine square miles, but a few days acquaintance with the dream-like air of Capri will convince the visitor that the name "Walls of Paradise" has not been misapplied. Artists of all nationalities have not been slow to discern its qualities, and it is almost by right of conquest, their especial field. Every available month in the year is sure to find numbers of these seekers for the beautiful wandering over the rocky heights or seated among the bare-legged fishermen on the beach, who have become so accustomed to being painted as to accept it as one of the most ordinary incidents of their lives'.[9] Benton was following the example of a number of American artists who had visited Capri and whose depictions are inflected with their own aesthetic sensibilities: Albert Bierstadt investing the island with a sense of romantic grandeur, Sanford Robinson Gifford with luminist calm and William Stanley Haseltine bringing to his studies of its coastline his feeling for dramatic geological precision.[10] A list of European artists visiting and working in Capri in the middle of the nineteenth century would include the Germans Franz von Lenbach, Carl Jungheim, August Albert Zimmerman, Alfred Diethe, C. W. Allers, Carl Friedrich Werner and Johan Christian Dahl; the Austrian Franz Richard Unterberger; the English artists Rudolf

Lehmann, Frederic Leighton and J. Talmage White; the Danes Wilhelm Kyhn, Holger Hvitfeld Jerichau, Emil Wenerwald and Wilhelm Jakob Rosenstand; the Swede Josef Magnus Stäck; and the Dutchman Jacques François Carabain.

It is unsurprising that Sargent should have decided to make a second visit to Capri. Paintings with Caprese subject matter had become a regular feature of the Paris exhibition season, and he may have had a more immediate inspiration, as his studio neighbours, Auguste Alexandre Hirsch and J. Carroll Beckwith, had visited the island in August 1877 and April 1878, respectively.[11] In any event, when Sargent made his second visit to Naples and Capri in 1878, he travelled with the express intention of garnering material to paint. For most of July he was in Paris, where he had begun painting a portrait of his master Carolus-Duran (see *Early Portraits,* no. 21). On 18 July, he wrote to Augustus Case: 'The man who in July is just going to start off for Naples ought not to say anything about heat. I am that man and in a week or two I expect to be sweating [?] at Capri. I want to spend a month or two there painting. After that I shall rejoin my people wherever they will be, and I hope that your father & mother will still be with them'.[12] His sister Emily wrote to their mutual friend Violet Paget [Vernon Lee] from Vichy (24 July 1878): 'John has begun it [his portrait of Carolus-Duran] but expects to go to Capri in a few days, so will not be able to finish it now. John wants to see Italy in the heart of summer and hopes to make some interesting studies in the neighbourhood of Naples, before joining us for a little while in the autumn'. Emily's long letter to Violet seems to have been written over several days. She continued at a later point: 'Since I began this we have heard from him [John] twice, once the day he was leaving Paris, & once just before embarking at Marseilles for Naples, where he was to arrive last Tuesday evening. He looked forward to seeing Italy again with delight, & I only wish we could share it with him'.[13] Sargent seems to have left Paris at some point in the last week of July and to have been in Capri by 10 August, having spent a week in Naples. He wrote to his old friend Ben del Castillo from Capri [the date 'Aug. 10th' was added by Ben] describing Naples as:

simply superb and I spent a delightful week there. Of course it was very hot and, one generally feels used up. It is a fact that in Naples they eke out their wine with spirits and drugs, so that a glass

of wine and water at a meal will make a man feel drunk. I had to take bad beer in order not to feel good-for-nothing. I could not sleep at night. In the afternoon I would smoke a cigarette in my armchair or on my bed and at five o'clock wake up suddenly from a deep sleep of several hours. Then lie awake all night and quarrel with mosquitoes fleas and all imaginable beasts. I am frightfully bitten from head to foot. Otherwise Italy is all that one can dream for beauty and charm.[14]

We also know from Sargent's letter to Ben del Castillo that he was invited to lunch on board the SS *Vandalia* by a Captain Robson on 'Tuesday' of the week in which he was writing.[15] He declined the invitation and at lunchtime on the named day was 'sailing past the Vandalia's bows in the Capri market boat, packed in with a lot of vegetables and fruit'.[16] If the date inscribed by Ben del Castillo on Sargent's letter is correct, Sargent would have arrived in Capri from Naples on Tuesday, 5 August.

The local boat in which Sargent was travelling would have moored at Marina Grande, the harbour situated at an approximately midway point on the north-eastern coast of Capri and its oldest inhabited settlement (fig. 65). Marina Grande was a working harbour at this date (a rudimentary wharf had been built in 1876), and most of the one-storey houses lining the sea front were built to store boats and nets in the harsh winter months. The beginnings of tourism in the second half of the nineteenth century brought significant changes: the height of the buildings was increased and some of the houses and outdoor staircases were enclosed by vaults. The profile of the island, as approached from the Neapolitan coast, is defined by the dramatic peak of Monte Solaro on its western side and by a group of lower peaks on its eastern side, the town of Capri sitting in a saddle of lower ground between the two limestone ridges, and Anacapri, the island's second town, perching on the slopes of Monte Solaro. For a view of Capri town at around this date, with Monte Solaro in the left background, see the painting of a young Caprese woman and a child by the English artist William H. Thurlow Hunt (fig. 66). The small landing place and fishing village Marina Piccola faces Marina Grande on the opposite (southern) side of the island. Historically, these several settlements had independent and, in some cases, mutually antagonistic, existences; but a carriage road to Anacapri opened in 1877 (prior to this, the only connection between the two communities was the Scala Fenicia, an ancient

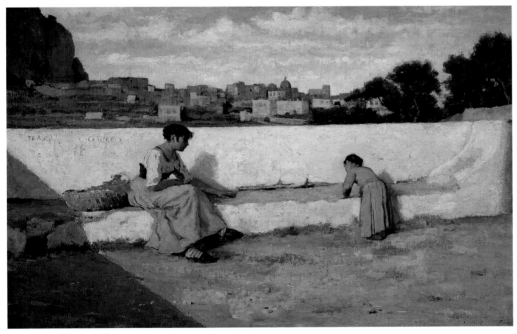

Fig. 65 (top)
Photograph of Marina Grande, Capri, c. 1885.
Private collection.

Fig. 66 (above)
William H. Thurlow Hunt, *A Sunny Afternoon,
Capri*. Oil on canvas, 24 x 35½ in. (61 x 90 cm).
Private collection.

out from the central piazza to the medieval quarters and are conjoined by vaulted houses and passages, winding alleyways and steep stairwells. The covered streets with arched houses, external stairways, terraces and balconies were predominately built of whitewashed stone, creating a sense of prevailing whiteness, of mass over space, irregular angles, unexpected patches of sun and sky, and shifting patterns of light and shade, so that 'in every direction peep out low, white houses, all of stone, with roofs flat around the edges, but swelling up in the centre into a flattened dome in the saracenic style—just such houses as are seen everywhere in Syria and Palestine'.[18] The modest, whitewashed, barrel-roofed, stone house with certain variables—arches, internal and external staircases, a pergola constructed from rustic columns but perpetuating the marble pillars of antiquity, a stone balcony —created a particular architectural vernacular.[19] These organic forms, with natural and apparently spontaneous juxtapositions—houses with flights of steps on the outside connecting the ground floor to the upper storey and precipitous stairways linking a street at one level to another at a higher level—were inevitably appealing to artists, who 'sketched some of the peculiar Oriental, many-roofed and lavishly columned stone houses gleaming whitely through gold-spangled veils of lemon and orange-groves'.[20] Sargent would respond to the architectural idiom of the island, using its bold white houses as a setting (nos. 705–8), and painting a study of a steep stairwell with bright light striking its white, reflective surfaces and a sketch of two children lingering on an external staircase (nos. 719, 720).

At the beginning of his visit, Sargent stayed at Marina Grande at the house of a local peasant:

It was at one of the charmingly picturesque houses of the contadini *that Sargent and I once stayed, Pagano's being then full. We breakfasted every morning under a vine-covered pergola, where we could pick the grapes as we wanted them. The table covered with a clean white cloth of coarse homespun, and laden with Capri delicacies, was flecked with patches of sunlight that filtered in through the leaves above; the sweet scent of orange-blossom filled the air, and now and again a tantalising aroma would reach us of the delicious coffee being roasted by the pretty waiting-girl in the garden below.*[21]

We are indebted for this information to the English artist Frank Hyde (1849–1937),

and precipitous flight of steps leading up from Marina Grande), and a carriage road from Marina Grande to Capri town opened in 1878.[17] By the time of Sargent's second visit, the island would have retained its sense of dreamy timelessness, but it was less sequestered and more navigable than it had been previously.

The architectural environment of Capri is highly individual, a result of its physical geography, which has dictated that its settlements were built on the perpendicular, and its historic vulnerability to invasions, which means that it has been defensive and subject to a range of influences. In Capri town, narrow, labyrinthine streets radiate

Fig. 67
Photograph of Via Madre Serafina with the steps and entrance to the convent of Santa Teresa visible on the left, c. 1895. Private collection.

Fig. 68 (opposite)
Photograph of Capri town, with the Albergo Pagano on the left, c. 1880. Private collection.

whose name is noted in a pencil annotation in Emily Sargent's commonplace book for 1878 as 'John's Capri friend' and his address given as 'Hogarth Club, 84 Charlotte Street, Fitzroy Square, London'.[22] Hyde, who worked in a more traditional vein than Sargent, has left few traces in the literature of art history, but he exhibited intermittently at the Royal Academy from 1872, including two works with Capri subjects, *A Pergola, Capri* in 1912 and *Roses and Lilies, Capri* in 1914 (both private collection).[23] Hyde played a significant role in the narrative of Sargent's stay in Capri by facilitating his working life, providing him with studio space and introducing him to the model whose looks and demeanour were such a potent source of inspiration that she became his model of the season. According to Evan Charteris, it was he who invited Sargent to work at the local monastery of Santa Teresa: 'Mr Hyde had never met Sargent and had never seen his work, but hearing that an American artist had arrived and was staying at one of the inns, he called and found him with no place to work in, but perfectly content and revelling in the beauty of the island. Mr Hyde invited him to come and work at the monastery'.[24] The monastery in question was actually a convent, Santa Teresa, which is situated in Capri town, next to the Church of SS Salvatore on via Madre Serafina, occupying one of oldest parts of the settlement of Capri (the earlier buildings had dated from the fourteenth century) (fig. 67).[25] It was built on a cloistered, rectangular plan, the cloister on the ground floor with generous,

round arches supported by pillars and the nuns' cells upstairs. It was secularized around 1808, as were many religious buildings, at the time of the Napoleonic wars, was initially requisitioned as a military barracks and subsequently fell into a state of disrepair. It has since been converted to several purposes: one area is used as private homes, another as an elementary school (Asilo Infantile G. Rodriguez d'Acri), and another section has been restored and converted into a hotel, the Albergo Aranciera delle Teresiane, approached from via Castello. Its high position, with uninterrupted, north-facing views across the bay towards Naples, would have made the rooms and corridors looking onto via Madre Serafina perfectly suited as artists' studios.[26] The convent was clearly established as a centre for artists by this time. In an article published a year after Sargent's visit, the American critic Margaret Bertha Wright described several fictitious artists taking 'a studio in a gray old monastery, through whose dim corridors, into which the yellow sunlight stole only tremulously, cowled and sandalled ghosts wandered in the absence of the foreign artists, who now looked out daily from its casemented windows over the dazzling bay to the phantom shore opposite where Vesuvius rose grim and wizard-like'.[27]

When Frank Hyde mentions 'Pagano's', he is referring to the Albergo Pagano, which, established in 1822, was the first hotel on the island (August Kopisch was staying there at the time of his celebrated 'discovery' of the Grotta Azzurra in 1826): it became a Capri institution and a social and artistic

centre for visiting painters. The hotel, situated on via Vittorio Emmanuele II, not far from the town's square Piazza Umberto I, still exists, although it has been significantly enlarged, renovated and renamed the Hotel La Palma.[28] It is prominent in contemporary photographs of the town (fig. 68) and was the subject of paintings by a number of artists. When he was in Capri in 1859, the English artist Frederic Leighton painted a view from the hotel's garden, showing a pergola and the celebrated palm tree, and also executed an exquisite pencil drawing of a lemon tree in the garden,[29] and the Italian artist Gabriele Carelli painted *La chiesa di Santo Stefano e l'Hotel Pagano* in 1865.[30]

Shortly after his arrival on the island, and presumably before his meeting with Hyde, Sargent lamented to Ben del Castillo: 'If it were not for one German staying at the Marina, I should be absolutely without society and he is in love and cannot talk about anything but his sweetheart's moral irreproachability'.[31] Charteris also lists 'besides the enamoured German, several French and three English artists'. The island was particularly popular with Germans, and this particular German remains anonymous, but the English artists, other than Frank Hyde, may well be the English couple Sophie and Walter Anderson, who had settled in Capri in 1871, and whose house Villa Castello, on via Castello (very near the convent of Santa Teresa) was something of a social centre. It seems that Sargent moved to the Albergo Pagano at some point during his stay. The Registro d'Ingresso of the Albergo Pagano, which the Municipio

di Capri required as a record of visitors to the island, notes that Sargent stayed there from 14 September and left on 21 April [1879], although the second date is clearly wrong, as Sargent was with his family by the end of October 1878. The accuracy of this document is not entirely reliable: dates of leaving, for example, are frequently left blank or are only partially completed.[32]

During the late summer and early autumn of 1878, the Libro degli Ospiti (guest book) of the Albergo Pagano records that the guests included several French artists: Théobald Chartran (1849–1907), Charles-Edmond Daux (born 1855) and Armand-Eugène Bach (d. 1921), Édouard-Alexandre Sain (1830–1910) and Jean Benner (1836–1909).[33] Théobald Chartran is presumably the 'Chartrau' listed by Charteris as one of the guests at an evening entertainment Sargent gave for his friends at which the tarantella was danced (see no. 705).[34] Charteris also lists Bonnet, Sain, Doucet and Frank Hyde as being among his guests and, while Doucet is probably the French painter Lucien Doucet, we have been unable to identify 'Bonnet'. Sargent's name does not appear in the Pagano Libro degli Ospiti with those of so many of his friends and fellow-artists. His friend J. Carroll Beckwith, who visited Capri for only a day in the spring, signed the guest book, and the names of several of Sargent's Paris friends are also there: (Albert) Besnard and Auguste Alexandre Hirsch (with whom Sargent shared a studio; see appendix 1, p. 387) were there in 1877. Frank Hyde's name is there in 1878 and 1879. The signa-

tures of Édouard-Alexandre Sain and Jean Benner appear with the wide date brackets 1864–85 and 1865–85, respectively. It is probable that Sargent met the French pair Charles-Edmond Daux and Armand-Eugène Bach for the first time on the island: they travelled to Spain with him the following year and, like Sargent, copied works by the old masters in the Prado (see introduction to chapter 8, p. 225).

Sargent's meeting with Frank Hyde probably changed his social, as well as his

artistic, experience of Capri. It is apparent from Frank Hyde's accounts of his time on the island that life was communal and convivial, the artists meeting at Scoppa's Café (now the Gran Caffè) in the piazza, at the tobacco shop beneath an archway just off the piazza, and on the church steps, where they chatted and gossiped and made plans for picnics and dinners.[35] Pagano's, however, was the artists' social centre. Many artists decorated the walls of its dining room (fig. 69), and drew caricatures, which are an index to the character of their life on the island. As Frank Hyde recalled: 'Pagano's, where the artists congregated, still bears evidence in the form of sketches of the many eminent men who have at one time and another made a sojourn there'.[36] Dwight Benton's account makes clear the extent to which the artists made their mark on the fabric of the building:

The Albergo Pagano, which is one of the curiosities of Capri . . . many years since surrendered itself as a home for artists, who, feeling a sort of pride in their possession, have abundantly embellished it with the marks of their industry. There is not a panel of its doors or a dormer-window available for decoration that has not been made to subserve the purpose of pictorial effort. The variety of

Fig. 69
The dining room of the Albergo Pagano with wall decorations by various visiting artists. Hotel Pagano Albums, Biblioteca del Centro Caprense Ignazio Cerio, Capri.

subjects, and their treatment, are as unlimited as the invention of two generations of painters could devise, and many even of the caricatures are masterly in their conception, and possess a charming freshness often wanting in the most highly-finished pictures. Some of them, by the death of those who wrought so lovingly in the early days of their career, have become of great value, but to the credit of the proprietor, it may be said they are unpurchaseable. There are also volumes of sketches and portraits of the distinguished limners who have made the house their abiding-place and contributed by their skill to perpetuate its interest.[37]

These sketches are either lost or untraced, but some of their zest and spirit is preserved in surviving photographs. For example, a drawing of Benner, Chartran and others riding up to Anacapri by donkey (fig. 70) is a vivid illustration of the steepness of the ascent. Théobald Chartran's monogram indicates that he was the author of many of the caricatures, and his drawings include this sketch of Daux, Benner and Bach riding up to Anacapri by donkey; of himself and Bach sketching on a hillside with the caption, 'I really don't know what you do to break your brushes so' (fig. 71); of Bach and Benner painting, with the inscription, 'Were we to wish [it?], would that change the motif?' (fig. 72); and of Daux and Benner on a hillside.[38] There is a lively caricature of Daux by Frank Hyde (fig. 73), caricatures of Sargent seated at the piano with Daux, Benner and others (fig. 74) and of Sargent alone playing the piano (fig. 75), sketches of Benner himself, and of Sain by Benner. It cannot have been all high spirits because Sargent would not be the only artist to contribute the fruits of this Capri season to exhibition venues: Armand-Eugène Bach exhibited *Dans le Chemin de la Grande-Marine à Capri* and Charles-Edmond Daux exhibited a study of Rosina at the Salon in 1879.

Édouard-Alexandre Sain and Jean Benner were particularly important in translating images of Capri to a Parisian audience and Parisian critics. Sain had known Sargent's master, Carolus-Duran, in Rome, but, by 1866, he was so integrated into Caprese life that his entry in the 1866 Salon catalogue gave the Hotel Pagano as one of his two addresses (the second is a Parisian address), and he eventually earned the title 'le peintre des Capriotes'.[39] His work reveals an interest in local traditions and festivals: he painted, for example, wedding scenes and a scene of a man and woman dancing the tarantella (*Tarantella a Napoli*, 1879, Sotheby's, New York, 18 March 1998,

Fig. 70
Photograph of a drawing showing Théobald Chartran and others riding up to Anacapri by donkey. c. 1878. Hotel Pagano Albums, Biblioteca del Centro Caprense Ignazio Cerio, Capri.

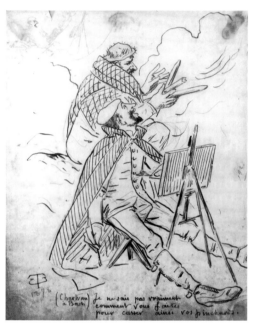

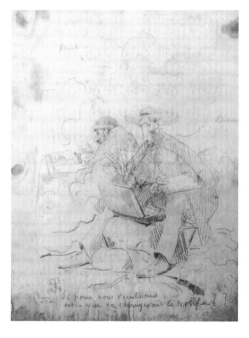

Fig. 71 *(above left)*
Photograph of a drawing by Théobald Chartran of himself and Armand-Eugène Bach sketching on a hillside, c. 1878. Hotel Pagano Albums, Biblioteca del Centro Caprense Ignazio Cerio, Capri.

Fig. 72 *(above)*
Photograph of a drawing by Théobald Chartran of Jean Benner and Armand-Eugène Bach painting, c. 1878. Hotel Pagano Albums, Biblioteca del Centro Caprense Ignazio Cerio, Capri.

Fig. 73 *(left)*
Photograph of a caricature drawing by Frank Hyde of Charles-Edmond Daux, c. 1878. Hotel Pagano Albums, Biblioteca del Centro Caprense Ignazio Cerio, Capri.

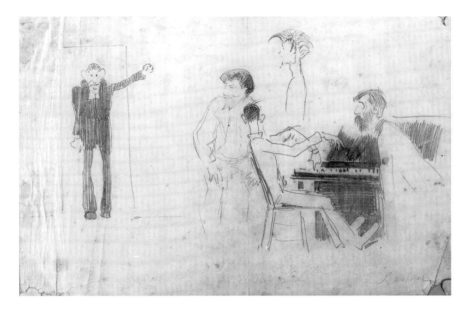

Fig. 74 (left)
Photograph of a drawing of Sargent at the piano with Daux, Benner and others, c. 1878. Hotel Pagano Albums, Biblioteca del Centro Caprense Ignazio Cerio, Capri.

Fig. 75 (left below)
Photograph of a drawing of Sargent playing the piano, c. 1878. Hotel Pagano Albums, Biblioteca del Centro Caprense Ignazio Cerio, Capri.

Fig. 76 (below)
Jean Benner, Bellezza caprese. Oil on panel, 16½ x 13⅛ in. (41.3 x 33.8 cm). Private collection.

Fig. 77 (bottom)
Jean Benner, Un coin d'ombre à Capri, c. 1886. Oil on canvas, 104 x 59⅞ in. (264.2 x 152.1 cm). Courtesy Sotheby's, New York.

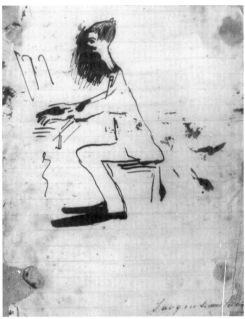

lot 151), the latter a traditional, genre-like work that stands in marked contrast to Sargent's depictions of the dance (see nos. 705, 707).[40]

The Alsatian artist Jean Benner, who first visited the island in 1866, also became known as a 'spiritual founder of the École de Capri'.[41] It is evident from the number of works with Caprese themes he sent to the Paris Salon that he appropriated its architecture and people as his own artistic territory.[42] His thematic interests coincide more with Sargent's than do those of others working in Capri at the time: he painted at least two profile heads of Capri girls (see Bellezza caprese, fig. 76), and he was drawn to a less obvious side of Caprese life, describing out-of-the-way scenes and corners. His Un coin d'ombre à Capri (Kunstmuseum, Basel) and its variant (Sotheby's, New York, 13 October 1993, lot 248, fig.

77) depict a Capri staircase similar to that in no. 719, but the staircase in Sargent's study is unpeopled and is remarkable for its formal elegance and stylized spareness.

It is apparent from the letter Sargent wrote to Ben del Castillo that, even at an early stage in his visit to the island, he was working: 'I am painting away very hard and shall be here a long time'.[43] He may well not have produced any work during his one week in Naples. It is almost certain that the title of the picture exhibited at the National Academy of Design in April and May 1879, Neapolitan Children Bathing (no. 692), was Sargent's own, but the term 'Neapolitan' was used generically to identify inhabitants of the area as a whole rather than to define those specific to Naples. The Faraglioni rocks visible in the background make it certain that Nude Boy on Sands (no. 696) was painted on the beach at Marina Piccola, and it is highly probable that the other studies for Neapolitan Children Bathing were also painted there or at Marina Grande. We know from contemporary accounts and photographs that the local boys spent their days 'guiltless of garments playing in the water or sunning themselves at intervals on the long stretches of sand'.[44] The two oil studies of the head of a boy in traditional Neapolitan dress (nos. 715, 716) were given their titles at the artist's studio sale in 1925, but, similarly, we know from photographs and paintings that this dress was worn in Capri as well as Naples.

Frank Hyde made another important intervention by introducing Sargent to a local model:

Sargent, who had only just arrived in Capri, chatting one day in my studio, asked me if I could find him a model of a particular type; he

explained what he wanted. I at once thought of 'Rosina'; when he saw her he was so fascinated with her that he made three studies in profile of her, all of which he painted in my studio; one he signed and gave to me [no. 710], one his sister possessed and was in an exhibition of his work at Burlington House [no. 709] [the Royal Academy Memorial Exhibition in London in 1926 (cited as London 1926)], but what became of the other I didn't know. I tried my hardest to trace it, for I felt sure that it was still to be discovered in Capri. To show how casual Sargent was about his work, I saw in his bedroom at the Grand Marina stacks of these studies on the floor and even on the bed.[45]

She was Rosina Ferrara, and she became the principal model of Sargent's Capri campaign and one of his most important muses. According to Hyde, she was 'about fourteen', had been discovered by Théobald Chartran and 'soon became a great favourite with all the artists; very quick to understand the pose required of her, and able to speak French fluently'.[46] This would suggest that she was a semi-professional model or, at least, that she was something more than a local ingénue. Several years after Sargent's visit to Capri, the English artist Adrian Stokes wrote:

It used to be very easy for artists to find models, but now the grown-up girls are rather shy of strangers, and the priests think it is dangerous for them to pose. For all that, there are some regular models to be had. Rosina is considered the first on the island, and certainly is a remarkably handsome young woman. She sits as perfectly as any model of London or Paris.[47]

Capri was famous for the beauty of its local inhabitants, some of whom were said to have both Phoenician and Greek ancestry, and Sargent was clearly drawn to what was a very distinctive physiognomy. Olive-skinned, dark-haired, southern European looks engaged his pictorial imagination, and Sargent responded to something wild and proud in Rosina's nature, to the graceful strength of her physique and to the sense of 'otherness' that she embodied, qualities that would continue to fascinate him throughout his career. He painted her in a sequence of pictures; she is in profile in almost all of them and, in those in which she is represented full-length, she is barefoot and wearing the same traditional local costume, pastel-pink skirt, full-sleeved white blouse and midnight blue corset. He depicted her entwined around an olive tree with her face in severe profile (in three versions, nos. 702–4); dancing a tarantella on a rooftop, also in profile (two versions, nos. 705, 707); and in two related oil sketches standing on a rooftop (nos. 706, 708). He also painted two studies of her head in academic profile (nos. 709, 710) and executed drawings of her singing (fig. 78) and holding a fan (fig. 79).

The picturesque peasant as monumentalized by Jean-François Millet and popularized by Jules Breton appealed to the fantasies of a metropolitan elite and became a staple of the Paris Salon.[48] Sargent had a fastidious aversion to the obvious, and, although his subject matter, whether Breton, Caprese, Spanish or Venetian, might be traditional, it is transmuted by refinement of motif and technique. There is nothing ingratiating or overtly picturesque in his portrayals of Rosina. The canvases depicting her are small and intimate in scale, but her figure is invested with an elusive, dignified presence which lifts her above the everyday and endows her with a grand, almost mystical, pictorial persona. In his studies of her in an olive grove Rosina is positioned at a remove from the spectator: she is self-contained, sealed off from the outside world, in a private, sylvan bower of which she is mistress and into which we are intruding—a graceful, mysterious, unknowable being. Similarly, in the small paintings of her dancing the tarantella at twilight on the flat roof of a traditional white house, she is presented lyrically, in a trance-like state, bathed in a soft, crepuscular light, but in an active role, lost in the ecstasy of the dance. These pictures show an affinity with French painting of the period or of the recent past. The silvery tonalities and meditative mood are reminiscent of Corot's dreamy pastorals, while the evocation of the spirit of place, suffused lighting and poetry of atmosphere recall the work of Jean-Charles Cazin (see chapter 10, p. 309, and no. 795).[49] Sargent's nostalgic impulses also connect him to the sensibilities of the Italian group known as the Macchiaioli, whose work he had probably encountered in Florence and in Paris (see introduction, pp. 26–27). In addition to a shared temperamental affinity, there are some specific echoes. In composition, pose and theme, *A Capriote* (no. 702) and nos. 703 and 704 are particularly close to Telemaco Signorini's study of a girl in profile leaning in the crook of an olive tree reading a letter, *Fra gli ulivi a Settignano* (fig. 80). Contemporary commentators were alert to the underlying Italian tone. When *A Capriote* was exhibited at the Society of American Artists in March 1879, one American critic noted that it showed

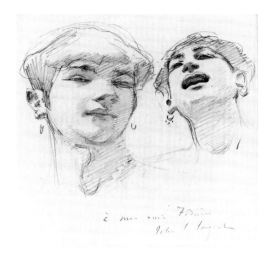

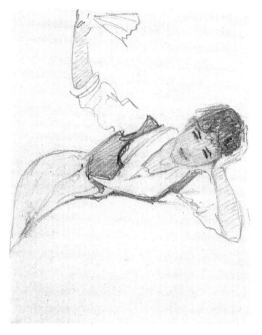

Fig. 78
Rosina, 1878. Pencil on paper, 7½ x 7½ in. (19 x 19 cm). Private collection.

Fig. 79 *(below)*
Rosina Holding a Fan, 1878. Pencil on paper, 5½ x 3⅞ in. (14 x 9.8 cm). Private collection.

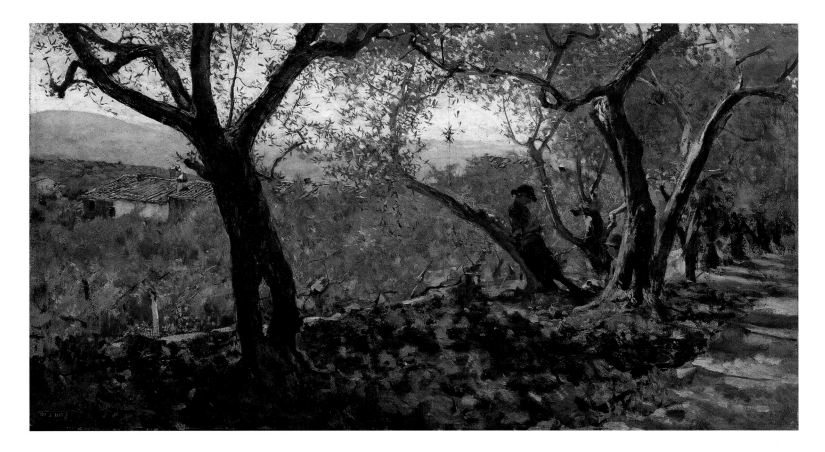

the influence of Francesco Michetti, 'a charming quaint bright-colorist whom some want of appreciation has kept thus far from being much imitated', but the range of reference was quite broad, as comparisons were also made with the Spaniard Mariano Fortuny and the French academic painter Ernest Hébert.[50]

Rosina has left behind her a considerable pictorial legacy, but the facts of her life are more mundane. She was born in Anacapri on 19 November 1862, the daughter of Bartolomeo Ferrara or Ferraro. Evan Charteris described her as 'an Ana-Capri girl, a magnificent type, about seventeen years of age, her complexion a rich nut-brown, with a mass of blue-black hair, very beautiful, and of an Arab type'.[51] She was painted by numerous artists, including Sain (fig. 81), Benner and Daux. When the American artist Charles Sprague Pearce (1851–1914) exhibited a cabinet portrait of her at the Paris Salon in 1882 (fig. 82), one reviewer described her as 'the tawney-skinned, panther eyed, elf-like Rosina, wildest and lithest of all the savage creatures on the savage isle of Capri'.[52] Rosina had an illegitimate daughter, Maria Carlotta, in 1883, and she married the American painter George Randolph Barse (1861–1938) in Rome in January 1891.[53] They travelled to America the following year, taking with them Rosina's niece, Maria

Primavera (who later married Pompeius Michael Bernardo), whom they had adopted. They lived in Katonah in Westchester County, New York. Later in life, Rosina seems to have used the shortened form 'Rosa', rather than 'Rosina'. A pastel of her by her husband, executed in 1900 (fig. 83), emphasizes the lines of her profile as Sargent's studies of her had done.[54] According to the *New York Times,* she died on 7 November 1934, and her cremation was held in Kansas City, Missouri.[55]

Rosina has an iconic place in Sargent's oeuvre, but the attraction she held for him exists in the context of an established literary and artistic tradition. The Neapolitan/ Capri girl had captured the imagination of nineteenth-century writers as a symbol of picturesque beauty and innocence. Alphonse de Lamartine's popular romance *Graziella* (1849, translated in 1876) is loosely based on an incident in the writer's own life and tells the story of a sophisticated Frenchman who fell in love with the daughter of a Neapolitan fisherman on the island of Ischia and later abandoned her. In *A Doll's House,* written when Henrik Ibsen and his wife were living in Rome and Amalfi and first performed in 1879, Ibsen used the theme as a metaphor for Nora's entrapment. When she goes to a fancy-dress ball as a Neapolitan fisher girl and dances the tarantella, Helmer patronizes her as 'my

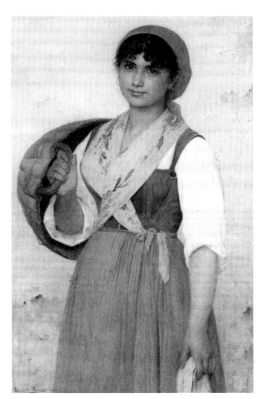

Fig. 80 *(top)*
Telemaco Signorini, *Fra gli ulivi a Settignano.* Oil on canvas, 13¾ x 24⅞ in. (35 x 63 cm). Private collection.

Fig. 81 *(above)*
Édouard-Alexandre Sain, *Rosina.* Oil on canvas, 41⅜ x 25 in. (105 x 63.5 cm). Sotheby's, New York, 17 October 1991, lot 187.

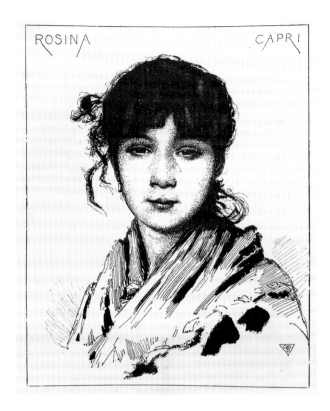

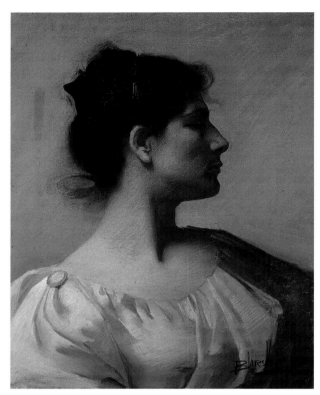

Fig. 82 *(far left)*
Engraving after Charles
Sprague Pearce, *Rosina*,
c. 1881–82. *L'Art*,
vol. 30 (1882), p. 139.

Fig. 83
George Randolph Barse,
Rosa Ferraro Barse, 1900.
Pastel, 25½ x 20¼ in.
(64.8 x 51.4 cm). The
Speed Art Museum,
Louisville, Kentucky.
Gift of George Randolph
Barse, Jr, 1945.

beautiful little Capri signorina—my capricious little Capricienne'; and, when her dancing excites him, he exclaims—'When I saw you dance the tarantella, like a huntress, a temptress, my blood grew hot . . .': responses which embody the nexus of innocence and sensuality that had been associated with the contemporary image of the Capri girl.[56]

The Capri girl was something more than a fictional heroine:

Many foreign artists are attracted to Capri by the fine rock-studies and the pure Greek type of the women, and in every direction may be seen the large windows of their studios. The pretty girls of the island are no less dangerous sirens, I think, than those of old. At least, it is no uncommon thing for an artist to fall in love with and marry the model whom his pencil has so often delineated, and whose beauty has perhaps given him his first success in his profession.[57]

A positive retinue of artists married local women and the aristocracy were apparently particularly vulnerable to the charms of the female Caprese.[58] Brinsley Norton (later 4th Baron Grantley), the younger son of the English writer Lady Caroline Norton, fell in love with, and married, a Capri girl, Maria Chiara Elisa Federigo in 1854 and had two children by her. This minor scandal was reported in a letter from Charles Dickens to Angela Burdett Coutts (13 November 1853):

[Brinsley Norton] has recently turned Catholic, and married a Peasant girl at Capri, who knows nothing about anything—shoes and hairbrushes included—and whom he literally picked up off the beach. He had not been married a fortnight when I was there. One of the attachés had just seen him in his 'Island home', translating Longfellow's poems which he is supposed not to understand in the least, into Neapolitan—of which he knows nothing—for the entertainment of his wife—who couldn't possibly comprehend a line under the most favourable circumstances. His brother is supposed to be going to marry a sister of the young lady's, and altogether it seems to be a most deplorable affair.[59]

Much of the contemporary response to the island and its womenfolk is overly adjectival and sentimental, and Dickens's acerbic tones provide a welcome antidote. It is also refreshing to come upon Henry James's astringent pen reflecting on the romance of Capri after the turn of the nineteenth century. Watching a celebration of the feast of Saint Antony in Anacapri, he was sceptical about the freshness of the romantic myth of Capri and alert to the stereotypes that it had generated:

Oh, the queer sense of the good old Capri of artistic legend, of which the name itself was, in the more benighted years—years of the contadina [peasant] and the pifferaro [fifer]—a bright evocation! Oh, the echo, on the spot, of each romantic tale. Oh, the loafing painters, so bad and so

happy, the conscious models, the vague personalities! The 'beautiful Capri girl' was of course not missed, though not perhaps so beautiful as in her ancient glamour, which none the less didn't at all exclude the probable presence—with his legendary light quite undimmed—of the English lord in disguise who will at no distant date marry her. The whole thing was there; one held it on one's hand.[60]

Sargent painted Rosina in landscape and studio settings. He also painted her dancing the tarantella, a feature of Caprese life that, even at that date, was approaching the realms of cliché and pastiche. Sargent had had some experience of the tarantella before his visit to Capri. In April 1874, when the family was living in Florence, Sargent sprained his ankle badly on the steps of the Accademia delle Belle Arti, where he was studying. He was housebound for several weeks. During this time, he had 'a very handsome Neapolitan model to draw and paint, who plays on the Zampogna [pan pipes] and tamburino and dances tarantella for us when he is tired of sitting'.[61] In his Capri recollections, Hyde reminisced about the local girls who 'carrying on their heads large glass Piretti of red Capri wine, to be drunk that evening at the "Tarantellas" given on the threshing-floors, and roofs of the Artists' studios: the most delighted of the spectators being Sargent'.[62] Contemporary narratives are full of vivid descriptions of the complex move-

Fig. 84 *(left)*
Thomas Uwins, *An Italian Mother
Teaching her Child the Tarantella,* 1842.
Oil on panel, 17⅛ x 22 in. (43.5 x 55.9 cm).
Victoria and Albert Museum, London.

Fig. 85 *(below)*
Photograph of the tarantella, c. 1887.
Centro Archivistico Documentale
dell'Isola di Capri.

*The women were barefooted and hoopless, and
they gave us the Tarantella with all the beauty of
natural movement and free floating drapery, and
with all that splendid grace of pose which ani-
mates the antique statues and pictures of dancers.
They swayed themselves in time with the music;
then, filled with its passionate impulse, advanced
and retreated and whirled away;—snapping their
fingers above their heads, and looking over their
shoulders with a gay and a laughing challenge to
each other, they drifted through the ever-repeated
figures of flight and wooing, and wove for us pic-
tures of delight that remained upon the brain like
the effect of long-pondered vivid colours, and still
return to illumine and complete any representa-
tion of that indescribable dance.*[64]

It is clear that Sargent is enthralled by the
dance and by the dancers' absorption in
the music and movement, but he avoids the
pictorial traps of picturesque description
and narrative in his depictions of the taran-
tella: he does not explain what is happening
but evokes the mood created by the dance.
It is a long way from, for example, Thomas
Uwins's lively but literal painting of an
Italian mother teaching her daughter the
tarantella (fig. 84). In painting Rosina danc-
ing on the rooftop of a house, Sargent was
also alluding to an aspect of Caprese life
infrequently depicted in painting:[65]

*In Capri the house-tops are the World. Therefore,
every evening, after the primitive country supper,
upon the numerous roofs of the rambling Oriental-*

ments, gestures and meanings of the dance
(for example, see fig. 85):

*For a full half hour the dancers floated to and
fro to the weird beat of the tambourine and the
rhythmic click of their castanets without paus-
ing. They advanced toward each other and with-
drew coquettishly, carrying the idea of fleeing yet
willing maidens pursued by ardent yet angry
lovers through every motion of the dance. The*

*girls waved white handkerchiefs lightly over
their heads: they advanced, retreated, smiled,
frowned, allured like sirens and repelled like
austere and saintly virgins wooed by roistering
pagans . . .*[63]

In his *Italian Journey* (1867), the American
writer William Dean Howells described
the tarantella as it was presented to and
produced for tourists:

looking albergo, from whose half-latticed windows one would expect to see peeping the liquid eyes of laughing odalisques one might see almost always gathered there, smoking or sketching, men and women-painters, Rome-drawn from every quarter of the globe. And through the moonlight and the starlight, on the perfumed summer darkness, roof called unto roof, and roof unto roof replied, and fire-tipped cigarettes flitted hither and yon, like the stars of a fallen firmament'.[66]

If Sargent's visit to Capri is poorly documented (in the conventional sense of letters and diary entries), it is richly documented in terms of the paintings he produced there. Sargent contributed three works from his painting campaign in southern Italy to the 1879 exhibition season: *A Capriote* (no. 702), to the second exhibition of the Society of American Artists in New York in March; a variant version, *Dans les oliviers à Capri (Italie)* (either no. 703 or no. 704), to the Paris Salon in May; and a small canvas *Neapolitan Children Bathing* (no. 692), to the National Academy of Design in New York in April. He sent the profile study of Rosina (no. 709) to the fourth exhibition of the Society of American Artists in New York in March 1881 and then to the Cercle des arts libéraux in Paris in March 1882.

At least one work from Sargent's visit to Capri has been lost: Augustus Saint-Gaudens owned a water-colour of a woman painted in Capri, which was later destroyed in a fire at his studio.[67] As Sargent was notoriously casual about his work, it is quite possible that other sketches have not survived. Frank Hyde recounts a particular instance during Sargent's stay in Capri:

I remember he and I were one day in the local carpenter's shop, and to more fully explain what he wanted took from a sheaf of pochard boards he had under his arm one, but having no paper he drew on it a design of the alteration he wanted made to his studio window and left it with Arcangelo the carpenter. Many months afterwards I saw on the floor in this same shop amidst a mass of shavings and dirty rubbish the board Sargent had used; picking it up and removing the dirt I discovered a most delightful sketch of an Olive orchard; Archangelo [sic] said he had no further use for it and gave it to me.[68]

The sketch of an olive orchard mentioned by Hyde is untraced. A study entitled 'The Capri Girl', apparently signed and inscribed 'To my friend Heseltine', was sold as part of the collection of J. P. Heseltine at Sotheby's, London, 27 May 1935, lot 85, and has subsequently remained untraced.[69] As the authors have seen neither the picture nor a reproduction, they have been unable to include it in the catalogue raisonné.

Sargent probably stayed in Capri for little more than two months. He was in Nice, where he stayed with his family, by the end of October, and he was back in Paris early in December. Emily Sargent wrote to Vernon Lee (22 December 1878) from the Maison Romilly, 4, rue Longchamp, Nice: '[John] spent 5 weeks with us here & returned to Paris 3 weeks ago. He is very busy'.[70] Dr Fitzwilliam Sargent wrote to his sister Anna Maria on 11 December: 'John —who had spent the summer, or most of it, at Capri, on the Bay of Naples, painting, —spent a month with us here lately, but has now returned to Paris. He is a good boy, & gives promise of success as an artist'.[71]

—Elaine Kilmurray

1. Special thanks to Elizabeth Oustinoff for her invaluable contribution to the Capri material, for her persistence in pursuing research routes and for her photography.
2. See Anna Ottani Cavina, *Paysages d'Italie: les peintres du plein air (1780–1830)* (Paris, 2001), p. 69, ill. (colour).
3. The hotel, built as a Jesuit monastery in the seventeenth century, is today called the Grand Hotel Cocumella.
4. Charteris 1927, p. 12. The full text of the letter is published on pp. 11–13. The original letter is untraced, as are all the letters Sargent wrote to Ben del Castillo. Sargent was also in Naples briefly two years later when the family made a month's visit to Sicily, sailing from Leghorn to Naples, travelling to Messina, Catania and Syracuse by rail, by steamer to Girgenti and by diligence to Palermo.
5. Jakob Philipp Hackert (1737–1807) was born in Prenzlau and trained in Berlin. He adopted neoclassical principles of landscape painting, worked in Italy from 1768 and became court painter to Ferdinand IV of Naples.
6. Ferdinand Gregorovius, *The Island of Capri,* translated by Lilian Clark (German ed. 1856; Boston, 1879), pp. 42–43.
7. 'They are jagged, wild and picturesque: the water breaks in showers of foam around their bases, and thousands of gulls have a home on their inaccessible summits. No visitor to these shores who has any skill in the use of brush and pallet [sic] but bears away a sketch of these crags. Their irregular outlines look well in a picture, and the weather-stained gray and the iron rust of their sides can easily be imitated by the colours of the tourist' (Robert McLeod, 'On a Housetop in Capri', *Lippincott's Magazine,* vol. 18 [September 1876], p. 313).
8. Margaret Bertha Wright, 'Rambles of Three. Two Papers.—I. A Summer Isle', *Lippincott's Magazine,* vol. 24 (October 1879), pp. 393–94. The French realist artist Jules Breton (1827–1906) specialized in paintings describing an idealized rural way of life.
9. Dwight Benton, 'The Artists' Island', *Lippincott's Magazine,* vol. 23 (January 1879), p. 24.
10. See, for example, Albert Bierstadt, *Fishing Boats at Capri* (1857, Museum of Fine Arts, Boston), *The Marina Piccola, Capri* (1859, Albright-Knox Art Gallery, Buffalo, New York), *Capri* (1857, Tarzoli Gallery, San Rafael, California); Sanford Robinson Gifford, *La Marina Grande, Capri* (1861, Lorenzo State Historic Site, New York State Office of Parks, Recreation and Historic Preservation, Cazenovia, New York); William Stanley Haseltine, *Natural Arch at Capri* (1871, National Gallery of Art, Washington, D.C.), *The Sea from Capri* (1875, High Museum of Art, Atlanta, Georgia).
11. Hirsch's signature is in the Libro degli Ospiti of the Hotel Pagano (Biblioteca del Centro Caprense Ignazio Cerio, Capri). There is no date, but his name is close to those dated August 1877. Beckwith visited Capri for a day in April 1878. His name is also found in the Libro degli Ospiti. The visit to Capri on 20 April is mentioned in an entry in Beckwith's diary (Beckwith Diary, Beckwith Papers, National Academy Museum and School of Fine Arts, New York). A drawing of the island, inscribed 'Sorrento 19 April [18]78', is in one of Beckwith's sketchbooks (The New-York Historical Society, Album A 1935. 85-A p. 6).
12. Sargent to Augustus Case, 18 July 1878, private collection.
13. Emily Sargent to Violet Paget, 24 July 1878, private collection.
14. Sargent to Ben del Castillo [10 August] 1878, quoted in Charteris 1927, pp. 47–48. According to Charteris, the date was added to the letter by del Castillo.
15. The SS *Vandalia*, a screw sloop of war, was laid down in the Navy Yard, Boston, in 1872 and commissioned there in 1876. The ship was deployed with the European squadron and spent three years sailing in the Mediterranean, along the coasts of the Middle East, Turkey and Africa. Former President Ulysses S. Grant embarked at Villefranche in December 1877, and he disembarked in Naples on 18 March 1878. The *Vandalia* made other cruises in the Mediterranean that year, but she had clearly put into Naples in August.
16. Sargent noted: 'There is a steamer from Naples and Capri, but it has no particular day for going, so that if one comes to the quai of Sta. Lucia every morning as

I did with one's luggage, one is sure of getting off in less than a week' (Sargent to Ben del Castillo [10 August] 1878, quoted in Charteris 1927, p. 48). Sargent elected to travel by the Capri market boat, which transported merchandise from the mainland.

17. For a contemporary description of the building of the carriage road, see Robert McLeod, 'On a Housetop in Capri' (see n. 7 above), pp. 312–13.

18. Ibid., p. 311.

19. Some architectural historians argue that the vaulted roofs of Capri do not owe their existence to the Saracenic invasions of the ninth and tenth centuries. They contend that these and other distinctive architectural forms are not unique to Capri but can be seen along the Neapolitan coastline, the Sorrentine peninsula and inland areas, and that, descending from traditional influences, they are Byzantine, rather than Arab, in origin. For a discussion of Caprese architecture, see Roberto Pano, *Capri Walls and Vaulted Houses*, 2nd ed., translated by Anthony Thorne (Naples, 1967). The accelerated pace of tourism has brought with it extensive new building and a corresponding relaxation of building regulation, and the Capri that Sargent and his fellow-artists saw in the nineteenth century can be best appreciated through the medium of their own paintings and contemporary photographs, while the areas in which traditional architecture survives are those around Listrieri and Santa Teresa in Capri town, Le Boffe, Filietto and Follicara in Anacapri and in certain country areas.

20. Margaret Bertha Wright, 'Rambles of Three. Two Papers.—I. A Summer Isle' (see n. 8 above), p. 396.

21. Hyde 1914, p. 285.

22. Emily Sargent's commonplace book, private collection.

23. Frank Hyde was the eldest son of Captain John Francis Hyde and Elizabeth Gudge (formerly Meeson). His artistic career began with drawings he executed as a war artist documenting the Franco-Prussian War for *The Graphic*. In 1897, he enlisted as first lieutenant in the Royal Engineers. A painting of two Capri girls on rocks overlooking the Arco Naturale, *Capri Coast Scene with Figures,* is in the collection of the Maidstone Museum and Bentlif Art Gallery in Kent. A list of Hyde's paintings, kindly supplied by the Hyde family, is in the catalogue raisonné archive.

24. Charteris 1927, p. 48.

25. The convent complex (the church and convent) was built between 1661 and 1685, much of it under the supervision of the Neapolitan architect Dionisio Lazzari. It began with a retreat house for nuns, in a building owned by Domenico Antonio Di Leo and was given to Suor Serafina di Dio, a sister of a Capri priest and an important figure in the religious life of the island in the seventeenth century. The plaque outside the monastery reads: 'The conventual complex of the Carmelite nuns with SS Salvatore church built in the second half of the seventeenth century by order of the venerable nun Serafina di Dio'.

26. For a painting of the convent of Santa Teresa, see *In convento delle Teresiane* by Wilhelm Kyhn, in Giancarlo Alisio *et al., Capri nell'Ottocento: Da meta dell'anima a mito turistico,* Naples, 1995 (exhibition catalogue), p. 79.

27. Margaret Bertha Wright, 'Rambles of Three. Two Papers.—I. A Summer Isle' (see n. 8 above).

28. Contemporary travel books give an indication of the character of the hotel: 'Pagano, kept by Pagano, on the outskirts of the town, much frequented by artists; civil landlord, and good fare; charges moderate; pension, 6 to 7 frs; the garden contains the well known and often painted palm' (*A Handbook for Travellers in Southern Italy,* 7th ed. [London, John Murray, 1873], p. 271). And: 'Antico Albergo di Michele Pagano, of modest pretensions, especially recommended to gentlemen alone, good pension 5 fr., a favourite resort of artists who occasionally spent several months in the house; the garden contains a magnificent palm' (K. Baedeker, *Italy: Handbook for Travellers,* part 3, Southern Italy, Sicily, The Lipari Islands [London and Edinburgh, 1867], p. 164.

29. There are two oils: 1859, private collection, and an extended replica, Birmingham City Art Gallery, U.K. (the latter exhibited at the Royal Academy in 1861). See Stephen Jones, Christopher Newall, Leonée Ormond, Richard Ormond, and Benedict Read, *Frederic Leighton,* Royal Academy of Arts, London, 1996 (exhibition catalogue), no. 19, p. 116, ill. (colour). Leighton also painted a number of architectural studies

during the same visit, see ibid., nos. 16, 17, 18. For Leighton's drawing of the lemon tree, see ibid., no. 3, p. 103, ill; and Ernest Rhys, *Sir Frederic Leighton Bart., P.R.A.: An Illustrated Chronicle* (London, 1895), pp. xviii, 10, 11, ill. xviiia.

30. For the painting of the Hotel Pagano by Gabriele Carelli, *La chiesa di Santo Stefano e l'Hotel Pagano,* 1865, see Giancarlo Alisio *et al., Capri nell'Ottocento* (n. 26 above), p. 54. For a water-colour by Antonino Leto, see Antonella Basilico Popert from Naples on 21[?] August. The Pisaturo, *Painters on Capri 1850–1950: Pictures, Personalities & Documents* (Capri, 1997), p. 137.

31. Sargent to Ben del Castillo, [10 August] 1878, quoted in Charteris 1927, p. 47.

32. The Registro d'Ingresso is in the Biblioteca del Centro Caprense Ignazio Cerio, Capri.

33. Théobald Chartran and his wife arrived from Sorrento on 19 August, Bach and Daux from Amalfi on 29 August, and Charlotte Popert from Naples on 21[?] August. The entry for Frank Hyde is incomplete, stating merely '14th' with no month given (Registro d'Ingresso of the Hotel Pagano, Biblioteca del Centro Caprense Ignazio Cerio, Capri). It is interesting that Charlotte Ida Popert (1848–1922) was in Capri at this time. An artist, she was born in Hamburg and studied in Weimar, Rome and, with Léon Bonnat, in Paris. For Sargent's letter to her of 1884 addressed to 'Interesting Mad One', see *Early Portraits,* p. xix n. 65. For information about works by Sargent in her collection, see no. 711.

34. Charteris 1927, p. 48.

35. See Hyde 1914, p. 286.

36. Ibid.

37. Dwight Benton, 'The Artists' Island' (see n. 9 above), pp. 24–25.

38. 'Je ne sais pas vraiment comment vous faites pour casser ainsi vos pinchards [pinceaux?]' and 'Si nous nous veullions est-ce que ça changerait le motif?' A slight sketch of Théobald Chartran by Sargent, drawn on a visiting card and inscribed *témoinage d'admiration/John S. Sargent,* is in a private collection.

39. Edwin Cerio, *The Masque of Capri,* La Conchiglia ed. (Capri, 1999), p. 117.

40. A glance at his Salon exhibits indicates the extent of his preoccupation with Capri subject matter: *Une fileuse à Capri* (1865); *Kiarella (Capri)*(1866); *Jeune fille de l'île de Capri* (1867); *Récolte des oranges à Capri* (1869); *Napolitaine; marchande de citrons* (1870); *La convalescente en pèlerinage à la Madone d'Angri; environs de Naples* (1873); *La Marina de Capri* and *Une fille d'Ève* [*Ragazza*] (1874); *Maccaroni di sposalizio;—repas de noce chez un paysan de Capri (Italie)* (1875); *La bénédiction paternelle avant le mariage,—Capri* (1882); and *Rosina:—Capri* (1886).

41. Edwin Cerio, *The Masque of Capri* (see n. 39 above), p. 118.

42. *Maison à Ana-Capri* (1867); *La petite folle de Capri* (1868); *Margherita* and *Luisella* (1870); *Après une tempête, à Capri* (1872); *Escalier d' Ana à Capri* [*sic*] (1873); *Après un baptême, à Capri* and *Sérénade du jour de l'an à Capri* (1874); *Canzonetta* (1875); *Une rue à Capri* (1880); *Une maison à Capri* (1881); *Jeune fille allant à la fontaine;—Capri* (1882); and *Un coin d'ombre à Capri* (1887).

43. Sargent to Ben del Castillo [10 August] 1878, quoted in Charteris 1927, p. 48.

44. Dwight Benton, 'The Artists' Island' (see n. 9 above), p. 19. For early photographs of the island, see Giovanni Fiorentino, *Il sogno è un' isola: Capri e la fotografia 1865–1918,* La Conchiglia ed. (Capri, n.d.).

45. From the account of Frank Hyde, typescript notes, 'Rosina. Sargent's Famous Ana Capri Model: The Type that Fascinated Him', made in 1935, when Hyde was living at Stockbury, near Sittingbourne in Kent, private collection.

46. Frank Hyde's notes, 1935, private collection.

47. Stokes 1886, p. 169.

48. Four tiny sketches by Sargent after etchings by or engravings after Millet's *La Faucheur, La Tondeuse de Moutons, Le Botteleur* and *Noon* are in the Metropolitan Museum of Art, New York. See Herdrich and Weinberg 2000, pp. 136–37, ill.

49. Emily Sargent wrote to Vernon Lee (1 August 1880): '[John] says that Cazin, one of the best French artists, who had two delightful pictures in the Salon [*Hagar and Ismaël* and *La Terre*], likes his last portrait very much & came to his studio & liked his things' (private collection).

50. 'The Two New York Exhibitions', *Atlantic Monthly,* vol. 43, no. 26 (June 1879), p. 781. For the full text of this review and of those comparing *A Capriote* to the

respective styles of Fortuny and Hébert, see Simpson 1997, p. 87.

51. Charteris 1927, p. 48.

52. 'American Art in the Paris Salon', *Art Amateur,* vol. 7, no. 3 (August 1882), p. 46. The same reviewer was unimpressed by Pearce's head: 'There is an element of the commonplace in this artist's work, clever as his technique is, and one needs no stronger proof of it than the uninteresting expression-less head which he painted from the tawney-skinned, panther eyed, elf-like Rosina, wildest and lithest of all the savage isle of Capri'.

53. George Randolph Barse was born to a wealthy family in Detroit and studied art in Paris at the École des Beaux-Arts, the Académie Julian and in the ateliers of Jules Lefebvre, Gustave Boulanger and Alexandre Cabanel. He worked in a classical/allegorical vein and painted frescoes for the Capitol building in Washington, D.C. He won several art prizes, notably the prestigious Shaw Prize at the Society of American Artists in 1898 for his *Night and Waning Day,* and a medal at the Buffalo Exposition in 1901, and he was granted a one-man show at the Art Institute of Chicago in 1907. He returned frequently to Capri to paint, and a small collection of his work at the Speed Art Museum, Louisville, Kentucky, shows his continued preoccupation with Capri subjects. The *New York Times* (26 February 1938, p. 30) recorded that Barse committed suicide on 25 February 1938 in Katonah, New York. Maria Bernardo was living with Barse and looking after him at the time of his death.

54. Frank Hyde also owned a small oil study showing Rosina's head in profile by the English artist Horace Fisher (private collection).

55. *New York Times,* 8 November 1934, p. 23.

56. Henrik Ibsen, *A Doll's House,* 1879, Act III.

57. Robert McLeod, 'On a Housetop in Capri' (see n. 7 above), p. 318.

58. Among the artists who married local women were the Italian nobleman Giovanni Giudice Caracciolo di Cellamare, Prince of Leporano (1841–1920), the Roman artists Andrea Cherubini (1830–1905) and Augusto Lovatti (1852–1921), the Englishmen James Talmage White (1833–1907) and Edward Binyon (born 1827), the Alsatian Jean Benner (1836–1906), who married a member of the Pagano family, the French artist Édouard-Alexandre Sain (1830–1910) and the Russian Michele Organovitsch (1878–1945).

59. Graham Storey, Kathleen Tillotson and Angus Easson, eds., *The Letters of Charles Dickens,* vol. 7 (1853–55) (Oxford, 1993), p. 189.

60. Henry James, *Italian Hours,* illustrated by Joseph Pennell (London, 1909), p. 351.

61. Sargent to Mrs Austin, 25 April 1874, quoted in Charteris 1927, pp. 19–20.

62. Frank Hyde's notes, 1935, private collection.

63. Margaret Bertha Wright, 'Rambles of Three. Two Papers.—I. A Summer Isle', pp. 401–2 (see n. 8 above).

64. W. D. Howells, *Italian Journeys,* enl. ed. (Boston, 1880), p. 125.

65. For two sugary representations of rooftop parties by the Austrian painter Franz Richard Unterberger, see Antonella Basilico Pisaturo, *Painters on Capri 1850–1950* (n. 30 above), pp. 112–13.

66. Margaret Bertha Wright, 'Rambles of Three. Two Papers.—I. A Summer Isle' (see n. 8 above).

67. 'Shortly after that [Sargent's painting a portrait of his master Carolus-Duran], in exchange for a copy of a medallion I had done of Bastien-Lepage, he gave me a delightful water-color of a female figure, made at Capri' (Saint-Gaudens 1913, p. 250).

68. Frank Hyde's notes, 1935, private collection.

69. John Postle Heseltine (1843–1929) was an etcher, a trustee of the National Gallery and the Royal College of Art, and a friend of Whistler. He exhibited in London at the Royal Academy, Dowdeswell Galleries and the Royal Society of Etchers. See 'Mr J. P. Heseltine. A true amateur of art', *The Times,* 4 March 1929, p. 11.

70. Vernon Lee Papers, Special Collections, Millar Library, Colby College, Waterville, Maine.

71. Dr Fitzwilliam Sargent to his sister, Anna Maria Low, 11 December [1878], Archives of American Art, Smithsonian Institution, Washington, D.C.

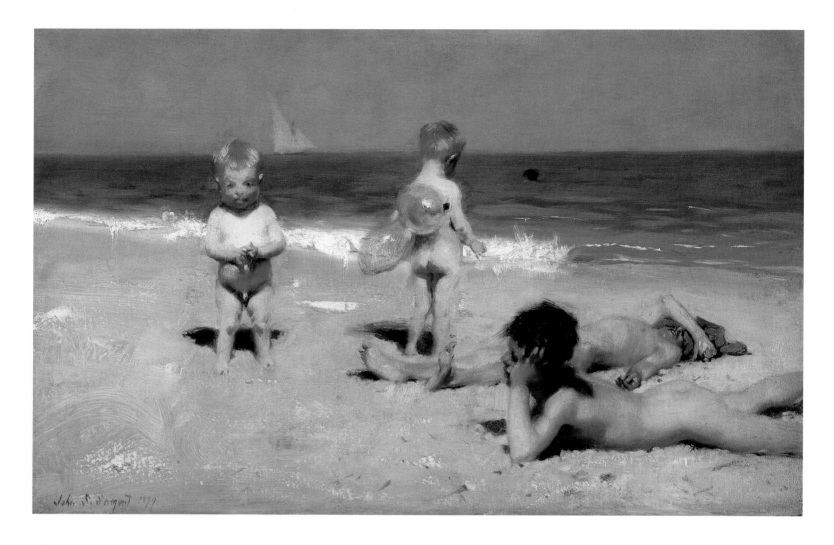

692
Neapolitan Children Bathing

1878–79
Alternative titles: *Innocence Abroad;*
Innocents Abroad; Boys on the Beach;
Boys on a Beach, Naples
Oil on canvas
10⁹⁄₁₆ x 16³⁄₁₆ in. (26.8 x 41.1 cm)
Inscribed, lower left: *John S. Sargent 1879*
Sterling and Francine Clark Art Institute,
Williamstown, Massachusetts (852)

This small canvas depicts four naked chil-
dren on a sunlit stretch of beach. Two boys,
both olive-skinned, are stretched out on
the sand in the right foreground, one lying
on his front and the second on his back,
and two younger and fairer boys are stand-
ing more centrally and slightly closer to the
sea; one, wearing water-wings (probably
animal bladders filled with air), faces the
sea, while the toddler looks out towards the
spectator. The figures are posed against a
background formed by several chromatic
layers: a pale blue sky, deep azure sea, a thin
line of white surf and an expanse of pale,
shining sand. The sea is punctuated by the

dark head of a single swimmer and the sky
with the white sails of a boat visible on the
horizon, while accents of deep purple in
the boys' shadows fall on the sand.

The date '1879' on the canvas might
imply that the picture was painted, or at
least completed, in Sargent's Paris studio
early in 1879 (it was in America for an
exhibition at the National Academy of
Design by late March), using oil studies
painted *en plein air* in southern Italy the
previous summer. Sargent had used a simi-
lar working method for his *Oyster Gatherers
of Cancale* (no. 670). Alternatively, the pic-
ture might have been painted in Capri, but
signed and dated at the time it was sold to
George Millar Williamson. Though the title
suggests that the painting and, by implica-
tion, the studies for it, were painted in
Naples, it is probable that they were con-
ceived and painted on the island of Capri
rather than on the Italian mainland (see
introduction to chapter 5, p. 143).

There are three surviving oil studies,
each painted on a small, and very portable,
mahogany panel: one depicts the two
standing boys (no. 693), though the elder of
the two boys is without the water-wings he

wears in the group picture; a second shows
the boy in the right middle ground lying
on his back (no. 694), with some variation
in the position of the left arm; and a third
(no. 695) represents the boy lying on his
front in the right foreground, though the
figure, cropped in the group picture, is here
painted full-length. Three further paint-
ings, while not related in a precise compo-
sitional sense, are clearly works painted
around the same time and in a similar loca-
tion (nos. 696, 697, 699).

The American critic Edward Strahan
narrated what he called a 'simple ballad-
like story', which gives some colourful, if
contradictory, background to the painting
of the picture and implies that it was a
commissioned work (*Art Amateur*, June 1879,
pp. 4–5). He recounts that:

*an elderly, modest man . . . called on the young
painter-amateur in Paris just after the latter's
'Cancalaises' [see no. 670] had made some sensa-
tion at the Salon, and remarked that he had
picked out the canvas as to his liking, and though
not rich, would like a smaller but similar one if the
artist could be tempted with a certain genteel price
which was named. Sargent, who had never had an*

order in his life, and had never figured before the world as a professional, took care to express no surprise or joy. He said quietly he would furnish something or other for the money, and on the visitor's departure tore away to his friends, proclaimed the splendor of the order he had got, and spent most of the price in a crowded American orgy. When the picture was applied for, for this exhibition, the messenger was directed to one of those hopeless addresses far beyond the ends of the most endless streets of Brooklyn, to attain which street-cars fail and cabs are a mockery. There, in a suburban wilderness, in a small house, he found the small Paris visitor hugging the solitary picture. Instead of being an art-patron with a collection, he was simply a man who had fallen in love with an artist's work and concluded to treat himself. So the 'Children bathing' went to a Brooklyn art-lover who had perhaps never bought a picture and never did again. And a young painter's vocation was settled; for Sargent determined to become a professional artist.

This anecdotal account by Strahan appeared in a review of the Fifty-fourth Annual Exhibition of the National Academy of Design, which opened in New York on 1 April 1879. *Neapolitan Children Bathing* was the first of Sargent's paintings to be shown at the National Academy of Design and only the third of his works to be exhibited in America (*Fishing for Oysters at Cancale* [no. 671] appeared at the first exhibition of the Society of American Artists in New York in March and April 1878, and *A Capriote* [no. 702] at the second exhibition of the Society of American Artists in March 1879). The owner of *Neapolitan Children Bathing* was listed in the National Academy's exhibition catalogue as G[eorge] M[illar] Williamson, but the available biographical details about him only partially fit the profile of the 'elderly, modest man' and the 'Brooklyn art-lover' of Strahan's vignette. Williamson was only twenty-nine in 1879 and his tastes and experience were certainly more sophisticated (he became a collector of literary manuscripts, specializing in the work of contemporary British and American writers) than those of the impulsive enthusiast described by Strahan: the 'extremely choice collection of first editions of English and American authors and association books formed by George M. Williamson of Grand-View-on-Hudson' was auctioned at Anderson Auction Company, New York, on 30 and 31 January 1908. George Millar Williamson also had a home, at one time, in Sparkill, a small community that was, like Grand-View-on-Hudson, in Rockland County, New York. An undated

letter from Sargent to 'Mr Williamson' might be addressed to the G. M. Williamson who bought this picture: the letter concerns the practicalities of arranging a meeting, and it is clear from the context that it was written while Sargent was living and working in Paris (The Huntington Library, Art Collections, and Botanical Gardens, San Marino, California, HM 25218). Williamson does seem to have had local Brooklyn connections. The picture was exhibited in January 1883 in an exhibition at the Brooklyn Academy of Music, where it was one of four works loaned by Williamson, the others being an 'Ideal Head' by Henri Gervex and 'At the Spring' and 'Tete a Tete in Cairo' [*sic*], both by Frederic Arthur Bridgman. A further complication is that Williamson's name with the address '6 Wall Street' is one of those listed in J. Carroll Beckwith's diary for 1878–79 (Beckwith Papers, National Academy Museum and School of Fine Arts, New York).

Sargent painted a portrait of Williamson (untraced) at an unknown date, but probably around the turn of the century, and a portrait of his daughter Dorothy in 1900 (see *Later Portraits*, nos. 390, 409, where she is identified as his granddaughter). Williamson loaned both portraits and the present work to the Seventy-first Annual Exhibition at the Pennsylvania Academy of the Fine Arts in Philadelphia in 1902. It was at this exhibition that the painting acquired the title 'Innocence Abroad', perhaps an echo of Mark Twain's popular account of his travel adventures, *The Innocents Abroad*, published in 1869. The painting passed to his son, Frederick J. Williamson, and was consigned to Knoedler, New York, by Mrs F. J. Williamson, Montclair, New Jersey, in December 1922. It was bought a year later by the noted collector and heir to the Singer sewing-machine fortune Robert Sterling Clark (1877–1956); it joined the collection of the Sterling and Francine Clark Art Institute, founded by Clark and his wife Francine Clary Clark, in 1955, in Williamstown, Massachusetts. Clark remained enthusiastic about the picture. He wrote in his diary (28 April 1942) about sending the picture to an associate at Macbeth's Gallery, New York: 'I told her I could prove Sargent was a fine artist with my pictures . . . Sent my nice small Sargent 1879 of "Small boys on a Beach". . . Miss Lewis acknowledged she had never seen such a fine Sargent' (Robert Sterling Clark diaries, Sterling and Francine Clark Art Institute archives, Williamstown, Massachusetts; quoted in Simpson, *Antiques*, 1997, p. 556).

In several respects—intimacy of scale and subject, interest in local life, use of light on reflective surfaces to create and modulate form, freedom of brushwork—the painting is an expression of progressive, contemporary impulses in painting. The New York critics responded to the naturalness and charm of the composition and to the bold treatment of Mediterranean light and colour when the sketch was exhibited there in 1879. The *New York Times* reviewer called it 'very natural, home-like, and out-of-doorsy', noting that 'in the next room, two Italians strive for bright out-of-doors effects ...[Pietro Gabrini (1856–1926), whose *The Trysting Place* was no. 503 in the exhibition' and Simonetti (either Attilio or Ettore), whose *The Lovers' Retreat* was no. 505 in the exhibition] but they do not express it half so well as the young Parisian' (*New York Times*, 2 May 1879, p. 5). Other critics also made allusions to paintings by contemporary Italian artists. The critic writing for the *Atlantic Monthly* compared *Neapolitan Children Bathing* to Francesco Michetti's *Springtime and Love* (c. 1878, The Art Institute of Chicago): 'This is not at all so full of figures, and they are boys instead of girls, but the same bluish and violet shadows are scattered about among them, and it is the same vivid blue sea against which the rosy flesh tints are projected. Such groups are seen of a blazing July day from the window of a train to Castellmare. The chubby little fellows, and one particularly who has two bladders, shining with water and giving out shell-like reflections, attached to his shoulders, are made to look like young Cupids' ('The Two New York Exhibitions', *Atlantic Monthly*, vol. 43, no. 260 [June 1879], p. 781).

The relationship of two slight sketches (Herdrich and Weinberg 2000, pp. 156–57, nos. 119, 120 recto) to *Neapolitan Children Bathing* and to other contemporary beach scenes is tenuous. The sketches might possibly represent very early ideas for a beach picture, but there is no direct compositional link between them and the present group of oils. The pencil studies may have been executed on the Breton coast in 1877, or they may be independent sketches with no connection either to Brittany or to southern Italy.

693
Two Boys on a Beach, Naples

1878
Alternative titles: *Innocents Abroad;*
Little Boys, Naples
Oil on panel
10 x 13½ in. (25.4 x 34.3 cm)
Private collection

This freely brushed painting is a prelimi-
nary study for *Neapolitan Children Bathing*
(no. 692), probably painted in Capri in the
summer of 1878. The picture depicts two
young boys standing on an expanse of
beach. The pose of the younger child varies
only slightly from that in the more fin-
ished, exhibited picture (his arms are held
more tightly to his body in the latter, and
the gesture of his hands is more fully real-
ized); but the older child wears water-
wings in the finished picture, turns more
towards the right and holds his right hand
outwards, rather than resting it by his side.
The broad strata of sky, sea, surf and sand is
common to both pictures, but certain details
(a sailing ship on the horizon and the dark
head of a sole swimmer) were added in the
more finished work.

694
Boy on the Beach

1878
Alternative title: *The Sun Bath*
Oil on panel
7½ x 11¾ in. (19 x 29.8 cm)
Inscribed, upper left: *John S. Sargent*
Private collection

This study of a boy lying on a beach was
almost certainly painted in Capri in the
summer of 1878. It is a study for the full-
length prone figure in *Neapolitan Children
Bathing* (no. 692), though the left arm,
which is extended straight outwards in this
picture, is held at a more acute angle to the
body in the exhibited group picture. The
boy's head appears to be covered in a scarf
or towel similar in colour to that worn as a
turban by the boy in *Nude Boy on Sands*
(no. 696), and the boy depicted may be the
same in both pictures. The purple textile
may also be the same as that cast aside on
the sand in no. 697.

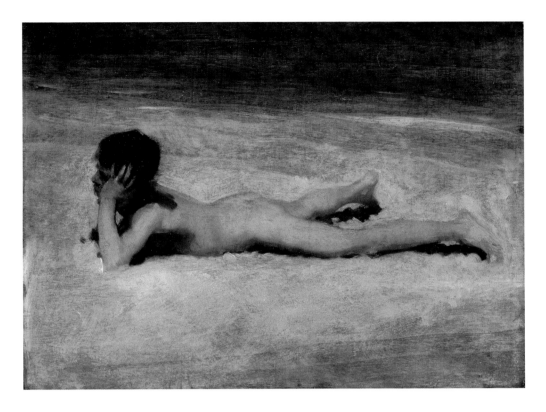

695
A Nude Boy on a Beach

1878
Alternative title: *Boy Lying on a Beach*
Oil on panel
10½ x 13¹³⁄₁₆ in. (26.8 x 35.1 cm)
Tate, London (T 03927)

This oil study of a boy lying on his stomach on a stretch of beach was almost certainly painted in Capri in the summer of 1878. The figure is closely related to that in the right foreground of *Neapolitan Children Bathing* (no. 692) and was presumably used as a study for it: here, the figure is full-length, while in *Neapolitan Children Bathing,* it is cropped at the knees by the right edge of the canvas.

The oil sketch was in the artist's studio sale in 1925, where it was one of four works bought by the city banker Leopold Sutro. Sutro was clearly interested in the visual arts. He bankrolled the independent filmmaker Alexander Korda, and together they formed London Film productions. Their first film, *The Private Life of Henry VIII* (1933), starring Charles Laughton and Elsa Lanchester, was internationally acclaimed, winning two Academy Awards, securing Korda's reputation in Hollywood and breathing life into an ailing British film industry.

The painting was bought at Sutro's sale in 1943 by John Tillotson (1913–1984).

Tillotson was nominally deputy chairman of Tillotson & Son, but his passion was for art, and he amassed a significant collection, which was displayed at his homes, Pertonhall and later Maid's Causeway in Cambridge. He owned some English pictures, but the most important works in his collection were his Barbizon school paintings and drawings, including works by Camille Corot, Charles-François Daubigny, Henri-Joseph Harpignies, Théodore Rousseau and Constant Troyon, which he bequeathed to the Fitzwilliam Museum, Cambridge. Exhibitions of his collection were held at the Arts Council Gallery in Cambridge in 1966, and the Tillotson bequest was shown at the Fitzwilliam Museum, Cambridge, and at Hazlitt, Gooden and Fox in London in 1986. He was a syndic of the Fitzwilliam Museum, Cambridge, from 1966 until his death in 1984 and a trustee of the Lady Lever Art Gallery, Port Sunlight. Tillotson bequeathed *A Nude Boy on a Beach* to the Tate, London, in 1984.

696
Nude Boy on Sands

1878
Alternative title: *Nude Girl on the Sands,
Capri*
Oil on panel
13 x 10 in. (33 x 25.3 cm)
Private collection

This study depicts a naked boy lying on his
stomach on a stretch of pale greyish sand
with rocks in the foreground, larger rocks
silhouetted in the background and a small
area of sea or shallow pools visible to the
right. He is leaning on his right arm, which
is propped at the elbow, with his head
wrapped in a pinkish/purple scarf or towel,
resting on his right hand.

Like the oil studies (nos. 693–95) for
Neapolitan Children Bathing (no. 692), this
sketch is painted on a small mahogany
panel. The location, unlike those in the
other beach scenes in this group, is clearly
identifiable as the island of Capri. The three
large outcroppings in the centre back-
ground are jagged geological formations
situated off the south-eastern coast of the
island and are famous landmarks (see fig.
86). They are known as the 'Faraglioni'
(crags or stacks); the rock closest to land,
and attached to it, is known as 'Stella', that
in the middle as 'Di Mezzo', and that far-
thest out to sea as 'Scopolo'.

Sargent was painting from the beach at
Marina Piccola, the island's southern land-
ing place, which, at the date the picture was
painted, consisted of no more than a small
beach, part sand and part pebble, and a few
fishermen's houses. At the present time
(2006), the view painted by Sargent is partly
obscured by a modern structure consisting
of bathing huts and a restaurant.

The boy appears to be wearing a scarf
or towel similar to that lying across the
head of the child in *Boy on the Beach* (no.
694) and, indeed, the same boy may be the
model in both works. This scarf is almost
certainly the piece of textile lying on the
sand in no. 697. *Boy on the Beach* is directly
related to *Neapolitan Children Bathing,* and
Nude Boy on Sands was certainly painted in
Capri, which would suggest that all the oil
studies for *Neapolitan Children Bathing* were
painted in Capri rather than Naples.

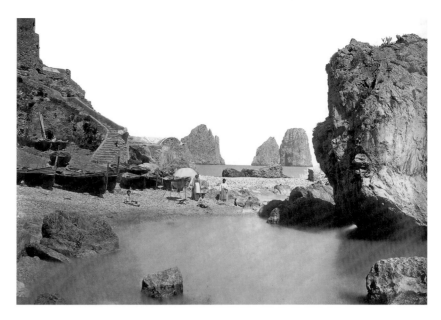

Fig. 86
Photograph of
Marina Piccola
and the
Faraglioni rocks,
Capri, c. 1880.

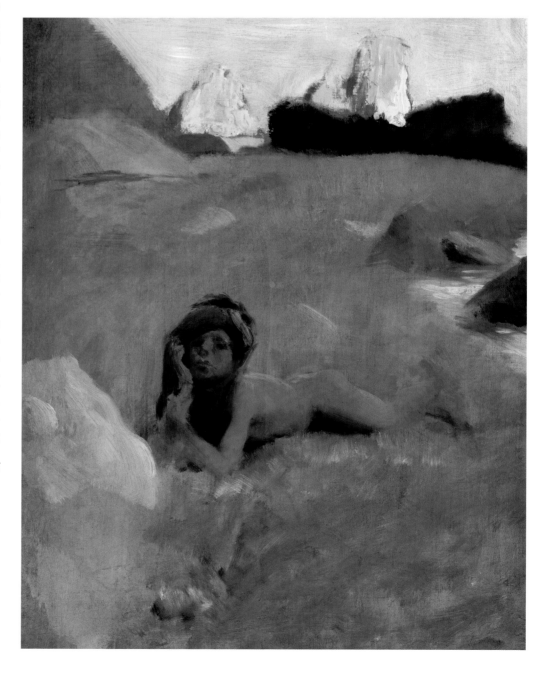

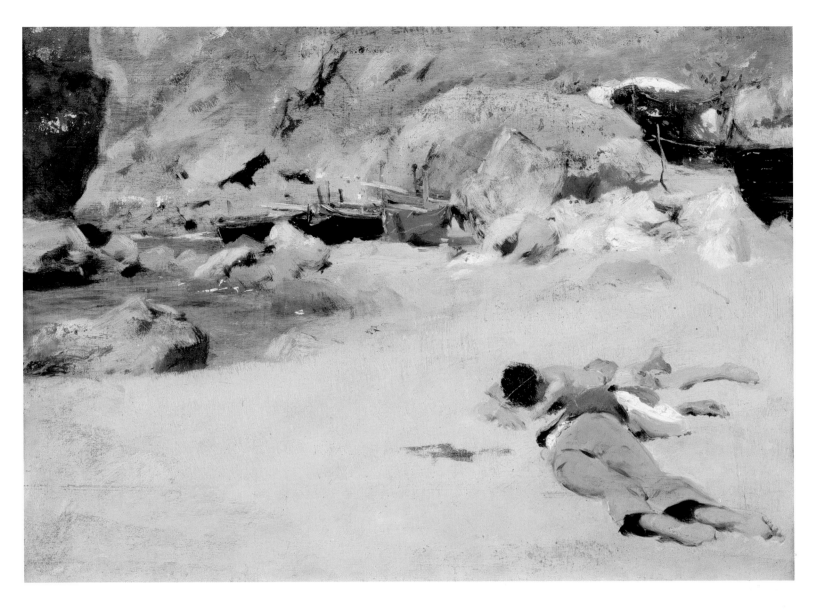

697
Two Boys on a Beach with Boats

c. 1878
Oil on panel
10 x 13¾ in. (25.3 x 35 cm)
Inscribed, upper left: *à mon ami Edelfelt*
John S. Sargent
Svenska litteratursällskapet i Finland
(Swedish Literature Society of Finland),
Helsinki

The study was almost certainly painted on the island of Capri in the summer or early autumn of 1878, and the scene represented is probably the beach at Marina Piccola facing west, in the opposite direction from the famous Faraglioni rocks (see no. 696). The bright sunlight suggests the intense heat of a summer's day. Two boys are lying face down on a stretch of beach with small rocks and the lower section of a cliff face in the background and fishing boats moored in the shallow water between the rocks. The younger boy is wearing short blue trousers and no shirt and the older boy is in long, khaki-coloured trousers, a white shirt, a darkbrown waistcoat and a straw hat. The piece of purple material cast aside on the sand may be the scarf or towel worn by the model in nos. 694 and 696. The small mahogany panel is similar to those on which Sargent painted other studies of boys lounging on the beach (nos. 693–96).

The painting is previously unrecorded in Sargent literature. It is inscribed to the Finnish artist Albert Gustav Edelfelt, whom Sargent knew well during his years in Paris. Edelfelt died in 1905, and his widow Baroness Anna Elise (Ellan), *née* de la Chapelle (1857–1921), married Baron Viktor Magnus von Born (1857–1956) in 1908. Ernst von Born (1885–1956), a son of Baron von Born's from a previous marriage, inherited the von Born house, Stor-Sarvlaks manor, Pernå, along with its contents, including the present work, probably in 1917. His widow, Alix von Born, lived at Stor-Sarvlaks manor until her death in 1967, when the house and the painting passed to Svenska litteratursällskapet i Finland (Swedish Literature Society of Finland). The painting now hangs at the manor in Pernå, some miles along the coast from Helsinki. Edelfelt was a native son of this area, having been born at Kiiala manor, Porvoo, in 1854. For another painting by Sargent inscribed to Edelfelt and for further information about him, see no. 726.

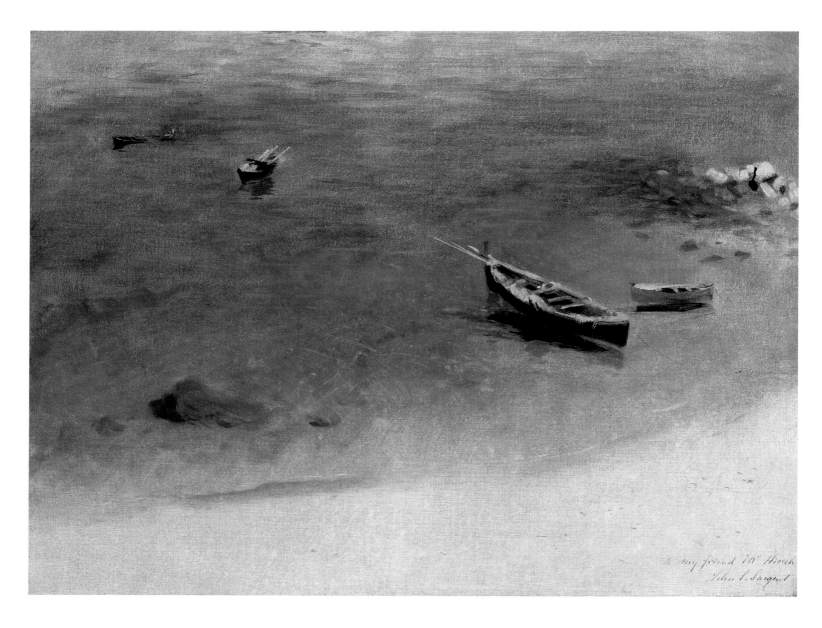

698
A Boat in the Waters off Capri

c. 1878
Oil on canvas
18 x 23½ in. (45.8 x 59.7 cm)
Inscribed, lower right: *to my friend
M. Hirsch/John S. Sargent*
Private collection

The intense emerald green colour of the sea is typical of the waters off Capri, and there seems no reason to doubt the traditional title. The artist has placed himself high above the beach looking down, which accounts for the steep perspective. A fishing boat and small rowing boat lie close inshore, and a third small boat lies further out, with a fourth, partially submerged boat beyond. There is nothing specific in the picture on which to base an identification of the scene; but there were small jetties, similar to the small rock structure at the upper right on the beach at Marina Grande around this date (see Giovanni Fiorentino, *Il Sogno è un'isola: Capri e la fotografia 1865–1918* [Capri, n.d.], no. 2.12, ill.), and Sargent might well be looking down from the road that climbs

up from the beach and leads towards Capri town. The sketch anticipates the later harbour scenes: see *Boats I* and *II* and *Filet et Barque* (nos. 688–90). The oil is one of a large group of early studies belonging to the French artist Auguste Alexandre Hirsch (1833–1912), with whom Sargent shared a studio at 73, rue de Notre-Dame-des-Champs; for the Hirsch group, see appendix 1, p. 387. In the 1983 auction catalogue, the picture is said to have been bequeathed by Hirsch to the Swiss artist Albert Anker (1831–1910); the latter, however, had died two years before Hirsch. The auction catalogue also deciphers the name of the dedicatee in the inscription as 'Von Hirsch': this is almost certainly erroneous.

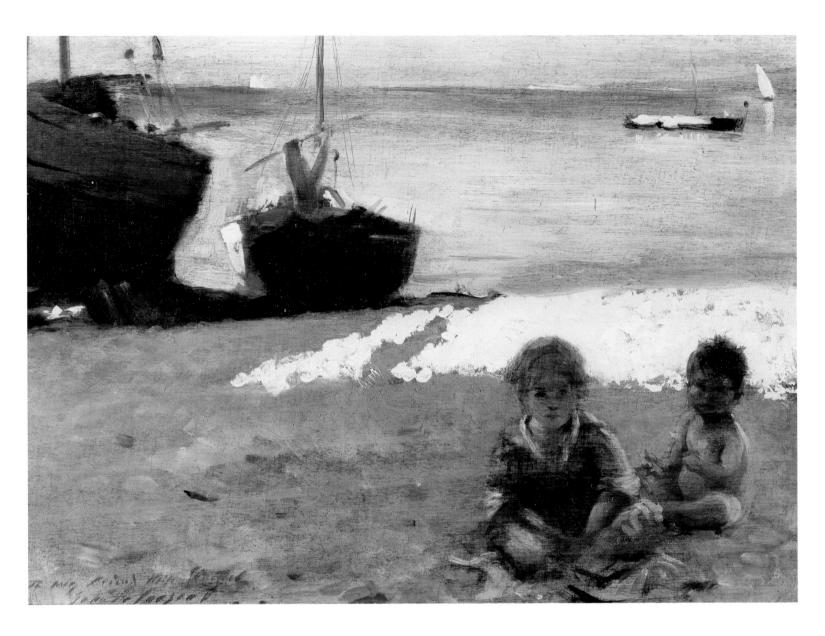

699
Beach at Capri

1878
Oil on panel
10¼ x 13¾ in. (26.2 x 35 cm)
Inscribed, lower left: *To my friend
Miss Strettel [sic]/John S. Sargent*
The Fine Arts Museums of San Francisco.
Bequest of Frederick J. Hellman to the
California Palace of the Legion of Honor
(1965.32)

This small panel depicts two young children seated on a beach, with two fishing boats in the left middle ground and sailboats on the sea in the background. The study is clearly related in subject, mood and technique to the beach scenes which were almost certainly painted at Marina Piccola in Capri in the summer of 1878 (see nos. 693–97). Unlike nos. 693, 694 and 695, however, it bears no direct compositional relationship to *Neapolitan Children Bathing* (no. 692).

The study is inscribed to Sargent's friend, the musician and poet Alma Strettell (1853–1939). She and her husband Lawrence ('Peter') Harrison (1866–1937) were close to Sargent: she published *Spanish & Italian Folk-Songs,* illustrated with reproductions of works by Sargent, in 1887 (see appendix 11, p. 388), and was the first owner of *The Spanish Dance* (no. 763). Sargent painted her around 1889 and executed a later water-colour of her (*Early Portraits,* no. 223, and *Later Portraits,* no. 482). Sargent painted Peter Harrison around 1902 (*Later Portraits,* no. 433), and he was the model for a number of water-colours executed on Alpine holidays in the early years of the twentieth century.

The sketch was probably given to Alma Strettell at a relatively early date: the inscription uses her maiden name, and she married Peter Harrison in 1890. It passed by descent to her daughter, Margaret (Mrs Arthur Porter). It has not been firmly established how the picture passed to Frederick J. Hellman, who bequeathed it to the museum in 1965; information in the museum archives suggests that he might have bought it from a gallery in Carmel, California, but this is unconfirmed. Hellman (1901–c. 1965) also bequeathed a painting by Van Gogh, *Shelter on Montmartre,* c. 1886, to the museum.

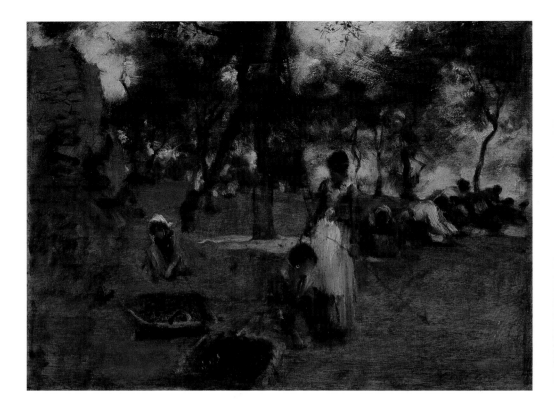

Fig. 87
Photograph of women gathering olives in Capri,
c. 1895. Private collection.

700
Gathering Olives (recto)
and ***Fishing Boats*** (verso)

1878
Oil on panel
10⅜ x 13⅞ in. (26.4 x 35.2 cm)
Inscribed, lower right: *John S. Sargent*
Private collection

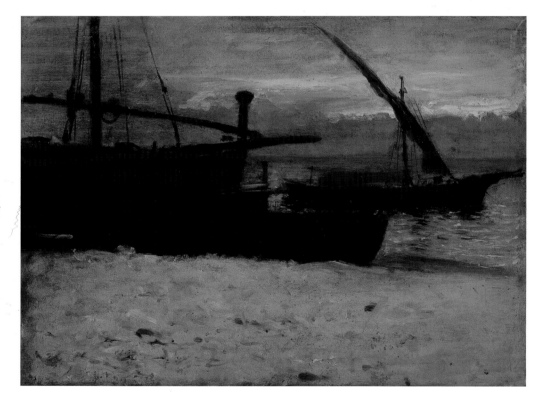

This panel depicts, in the foreground, two women and a child in a grove gathering olives, with large shallow baskets in front of them, while the people kneeling in the middle ground are presumably engaged in the same activity. The corner of a white building is visible at the upper left. The background, a blur of sky and olive trees, relates closely to the backgrounds in nos. 701–4, and the picture was almost certainly painted in Capri in 1878. For a contemporary photograph showing Caprese women gathering olives using similar rectangular baskets, see fig. 87.

The sketch is previously unrecorded in Sargent literature. On the reverse of the panel is a scene depicting the silhouettes of several boats moored on the beach or anchored close to the shore. The group of boats supports the proposition that the picture on the verso was painted in Naples or Capri in 1878 (see nos. 697, 699). The composition of the dark lines of the masts, spars and furled sails, forming a strong pattern against the roseate early morning or evening sky, relates closely to that in several early marine paintings (see nos. 683, 685–87).

The painting was owned by Sargent's friend and fellow-artist Edward Darley Boit (1840–1915) and was presumably given to him as a gift. Sargent's enigmatic group portrait of Boit's four daughters was painted in Paris in 1882 (see *Early Portraits*, no. 56). Sargent also painted a portrait of Boit himself in 1908 (see *Later Portraits*, no. 552).

701
Olive Trees

c. 1878
Alternative title: *Olive Trees (unfinished)*
Oil on canvas
18 x 21 in. (45.7 x 53.3 cm)
Private collection

Charles Merrill Mount identified the location of this picture as Corfu, thus relating it to Sargent's visit there in 1909, but in composition and facture it is close to *A Capriote* (no. 702) and its two related versions (nos. 703, 704), and may represent an early idea or preliminary sketch for the background to these studies of a figure in a landscape setting.

The olive grove is viewed at a greater distance than in no. 702 and the incline is certainly steeper; but the grey-green palette with touches of pink in the sky, the impressionistic handling of twisted trunks and gauzy foliage, the thinly applied paint and the white impasto, suggesting the use of a palette knife, all support an early date. Mount described the picture as unfinished and, while the spacious foreground is spare and barely differentiated, the picture is neither unarticulated nor unresolved.

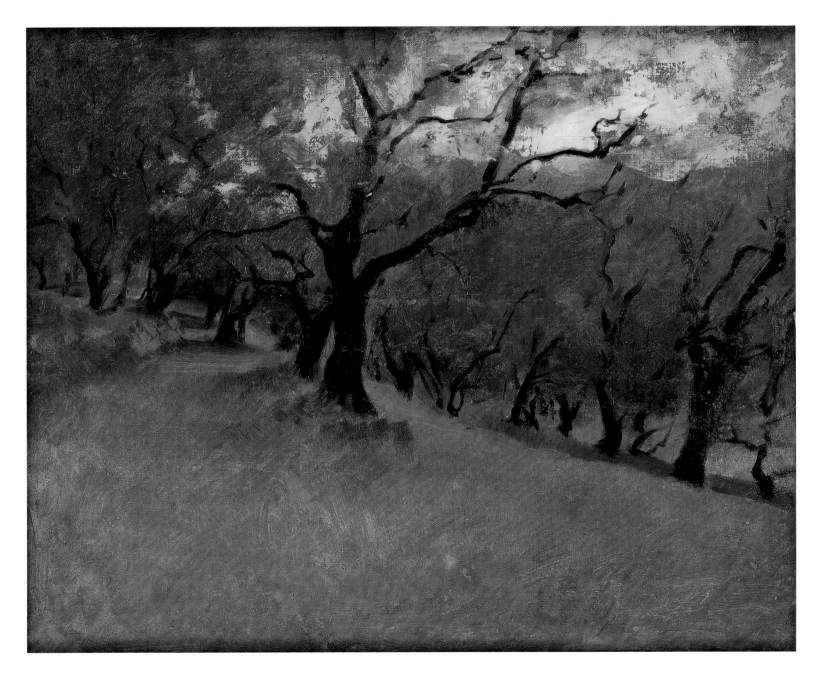

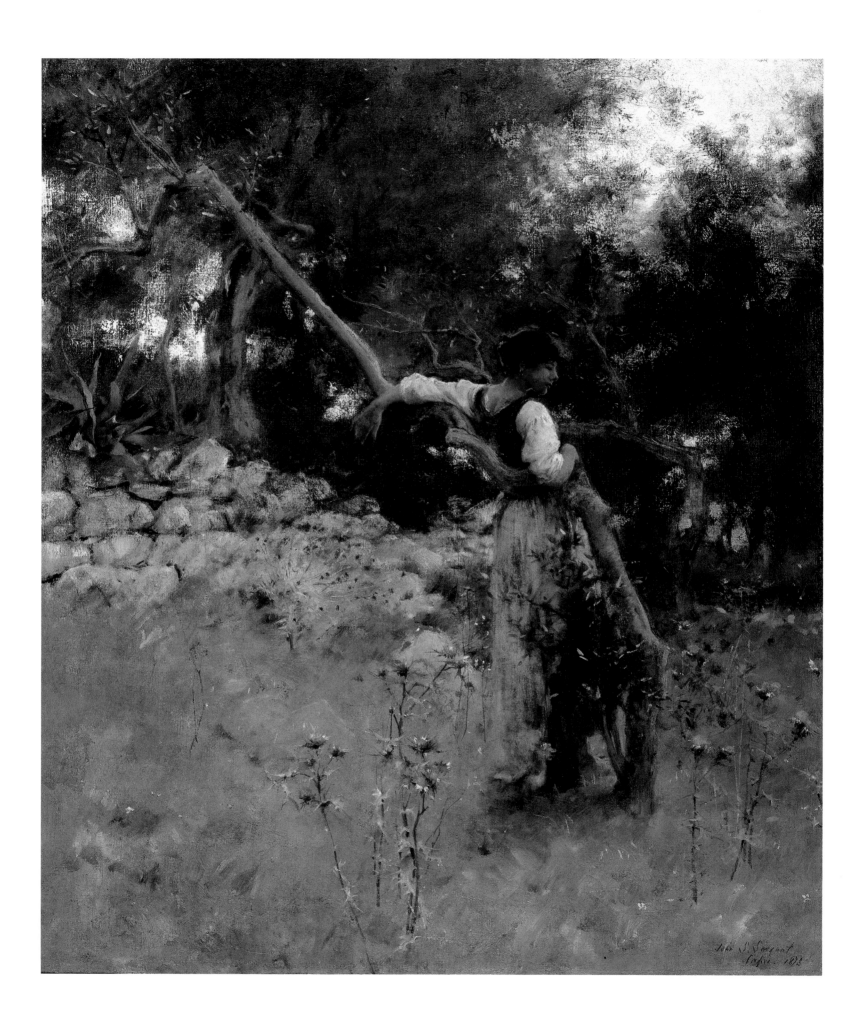

1878
Alternative titles: *A Girl of Capri; Capri*
Oil on canvas
30¼ x 24⅞ in. (76.8 x 63.2 cm)
Inscribed, lower right: *John S.
Sargent/Capri. 1878*
Museum of Fine Arts, Boston. Bequest
of Helen Swift Neilson (46.10)

Sargent represents his model Rosina Ferrara (see pp. 143–46) entwined around the sloping trunk of an olive tree, her back to the spectator, her face turned in profile, her contorted but graceful pose echoing the twisted form of the branches. In presenting the viewer with his model's back view and offering us only the exquisite profile of her face, Sargent protects her privacy and mystery: she is a complex creature, and the artist will not reveal her secrets too easily. The pose is also constructed to underline the relationship between the figure and the natural world: the line of Rosina's arms and back is interlaced with the upper section of the tree trunk, her lower body follows the linear rhythm of the lower section of the tree and her bare foot and skirt are caught up in the tangle of foliage around its base. In framing the scene so that the only natural light (and a glimpse of plumbago sea) comes from a small area at the upper right and a few glimpses through the foliage at the upper left, Sargent creates the illusion of an enclosed, interior space enhancing the atmosphere of solitude and seclusion. The poetic atmosphere is emphasized by the soft, silvery tonalities, hazy light and moody, grey-green palette. Olive trees and dry-stone walls characterize the island's environment, and the setting here could be the area towards the eastern end of the island, known as Lo Capo, where olive trees grow wild. Lo Capo is, however, some distance from Capri town, and it is more likely that Sargent worked in the olive groves that grew alongside the road up to Capri from the harbour at Marina Grande.

There are two other versions of the painting, both in private collections. One of these was exhibited at the Paris Salon in May 1879 with the title *Dans les oliviers à Capri*. The present work, which bears traces of underdrawing and some *pentimenti* in the position of the figure and the arrangement of the skirt, appears to be the earliest of the three versions and the one in which the artist's processes and progress are most evident. All three versions are characterized by

a brushy, flickering facture, but, here, there is a higher degree of finish in Rosina's facial features, in the drawing of the stone wall and in the depiction of the tall, spiky, flowering thistles in the foreground.

Sargent sent this version to the second exhibition of the Society of American Artists in New York in 1879. The exhibition opened on 10 March and, on 17 March, the *New York Herald* announced: 'The following pictures are already sold—John S. Sargent's "A Capriote", $400 to I. T. Williams' (*New York Herald,* 17 March 1879, p. 8).

The picture was favourably received, though critical enthusiasm was less marked than it would be for *Neapolitan Children Bathing* (no. 692) at the National Academy of Design a few weeks later, or than it had been for *Fishing for Oysters at Cancale* (no. 671), at the first exhibition of the Society of American Artists the previous spring. The artist Charles Édouard Du Bois wrote to J. Alden Weir (14 May 1879) that Sargent had made 'some remarkable studies in Capri last summer, far better than anything he ever painted you saw a specimen in the N.Y. Young men's Exhn' (Archives of American Art, Smithsonian Institution, Washington, D.C., roll 71, frame 1067). Critics responded to the synthesis of traditional subject matter and Parisian sophistication. One American critic compared the picture to the work of Francesco Michetti and praised it for 'the—what an English equivalent should be found for as soon as convenient—*chic* of the whole' ('The Two New York Exhibitions', *Atlantic Monthly,* vol. 43, no. 260 [June 1879], p. 781). Another critic described it as a 'delicate little Mediterranean idyll', praising its 'charming grace of line, originality of composition and opalescent purity of color', and noting that its 'delightful coolness, exquisite delicacy and bright effects of light' marked the author an artist of great 'freshness and originality' ('The Society of American Artists', *Daily Graphic,* 8 March 1879, p. 58).

The first owner of the picture, Ichabod Thomas Williams (1826–1899), was the

son of Thomas Williams, founder of a lumber business which specialized in mahogany and other imported cabinet woods. The company, the oldest and one of the largest in the world dealing in tropical hardwood, operated from 1838 to 1899 at the family's sawmill in Bayonne, New Jersey. Ichabod Williams was also a distinguished collector. His collection was sold in New York in 1915. It showed a bias towards Barbizon school paintings (Camille Corot, Thomas Couture, Charles-François Daubigny, Eugène Isabey, Jean-François Millet, Théodore Rousseau), though he also owned a painting by Constable, one by Delacroix and several works by contemporary American artists: Samuel Colman, J. Alden Weir, Will Low and John Henry Twachtman. A number of the paintings are pastoral and reflective in mood, but the Sargent is remarkable for its technical modernity.

The painting was bought at the Williams auction by M. Knoedler & Co., New York, as agent for Abram A. Anderson, and passed successively to his widow and to Scott and Fowles, New York. It was acquired from Scott and Fowles in 1922 by Helen Swift Neilson (1869–1945), daughter of Gustavus Swift, who had founded a huge meat-packing company in Chicago. She was first married to Edward Morris, another Chicago meat packer, on whose death in 1913 she inherited a second fortune, which made her one of the wealthiest women in the world. She married, secondly, the British politician, pacifist and writer Francis Neilson (1867–1961), with whom she supported a number of liberal causes. On her death in 1945, this painting was bequeathed to the Museum of Fine Arts, Boston (her parents came from Massachusetts). It was through her bequest of 1945 to the Metropolitan Museum of Art, New York, that Jan Steen's *The Lovesick Maiden* entered its collections, along with two portraits by John Hoppner and one by Henry Raeburn. She had previously donated Rembrandt's *Portrait of a Young Woman with a Fan* to the museum.

703
Dans les oliviers à Capri (Italie)

1878
Alternative title: *Among the Olive Trees, Capri*
Oil on canvas
32½ x 25 in. (80 x 63.5 cm)
Inscribed, lower right: *to my friend
Mme Sorchan/John S. Sargent*
Private collection

This painting is almost identical in size, pose and composition to *A Capriote* (no. 702), the painting that Sargent sent to the second exhibition of the Society of American Artists in New York in March 1879, and to no. 704. Aspects of the handling—small areas of *pentimenti* and the evidence of reworking in areas of the face—suggest that *A Capriote* was the first version. Sargent sent a second version to the Paris Salon in May 1879, but it has not been possible to determine whether this work or no. 704 was the painting exhibited.

This version differs from no. 702 in its sense of rapid, assured, and relaxed execution, a warmer, sunnier palette, and less-detailed description of the stone wall and the vegetation in the foreground. There are other small distinctions: the bare foot, which is so carefully drawn in no. 702 that one can see the individual toes, is here little more than an impressionistic smudge of dusky pigment, and the patch of blue between the trees to the right reads more lucidly as a glancing view of the sea. The paint is so thinly applied that the weave of the canvas is clearly visible, and there is less use of impasto to suggest texture. The delicate rendering of the profile in the present work also supports the premise that, having established the way in which he wanted to depict his model's face, the artist was liberated to freer, more spontaneous drawing and treatment. The overall impression is of a lighter and less taut and moody scene.

The picture is inscribed to Mme Sorchan, the mother of the artist's friend Eugène Lachaise, who was a fellow-student in Paris. The young American Caroline Thorn had married, first, Armand Lachaise, by whom she had a son (Eugène), and, secondly, Marius Alexander Sorchan. In the summer of 1877, Sargent was painting in Cancale, Brittany, with Lachaise and J. Carroll Beckwith. He then moved south, staying at the Sorchans' country house at St Senoch near Lyons, where he painted a decorative study, *Judgement of Paris,* on the wall of the nursery (no. 639), before moving on to the Savoy to paint a formal por-

trait of Mme Édouard Pailleron (see *Early Portraits,* no. 25). Sargent's portrait of Marius Alexander Sorchan, painted in 1884, is inscribed to Lachaise (see *Early Portraits,* no. 125).

Both Downes (Downes 1925, p. 122) and Charteris (Charteris 1927, p. 280) identify a painting entitled 'Dans les oliviers à Capri' with one exhibited at Copley Hall in Boston in 1917. A painting entitled 'Olive Grove', lent by Knoedler, was no. 6 in the *Exhibition of Paintings and Drawings by John Singer Sargent for the Benefit of the American Ambulance Hospital in Paris,* which was held at the Copley Gallery in Boston at the end of 1917. The painting exhibited there was almost certainly a later work.

For contemporary reviews of the Salon exhibition of 1879, which refer either to the present picture or to no. 704, see no. 704.

704 *(opposite)*
Dans les oliviers à Capri (Italie)

1878
Oil on canvas
30 x 25 in. (76.2 x 63.5 cm)
Inscribed, lower right: *John S. Sargent*
Private collection

This picture is one of three versions Sargent painted depicting the Capri model Rosina Ferrara interlaced with the gnarled branches of an olive tree. He exhibited *A Capriote* (no. 702), which is probably the earliest of the three versions, at the Society of American Artists in New York in March 1879, and either the present work or no. 703 as *Dans les oliviers à Capri* at the Paris Salon in May 1879. It has not been possible to determine whether this picture or no.

MADEMOISELLE LAOCOON, A CAPRI (Italie).

Fig. 88
'Le Salon de 1879 par STOP', *Le Journal Amusant,* no. 1191 (28 June 1879), p. 7.

The painting exhibited at the Salon was caricatured in *Le Journal Amusant:* the caricaturist used the image of the Trojan priest Laocoön with his sons wrestling against two serpents sent by Apollo to destroy them to lampoon the contorted pose of Sargent's figure (fig. 88). Laocoön struggling with the serpent (which depicts an episode in Book 2 of Virgil's *Aeneid*) was the subject of a famous Greek sculpture; the sculpture was 'discovered' in Renaissance Italy and became a source of inspiration to later painters and sculptors.

Contemporary reviews of the Salon exhibition refer either to this picture or to no. 703.

This version was owned by José Tomás Errázuriz, a Chilean diplomat and an artist, but it is not known whether it was commissioned or purchased from the artist, or given to Errázuriz by him as a gift. Sargent painted several studies of Errázuriz's wife, Eugenia (*Early Portraits,* nos. 69–72), and his formal portrait of Errázuriz's sister, Amalia, who was married to another artist, Ramón Subercaseaux, was exhibited at the Salon in 1880 (see *Early Portraits,* no. 41). Errázuriz also owned a study of Rosina dancing on a rooftop (no. 707). For Sargent's Venetian interior that belonged to Errázuriz's daughter, and which may have belonged to him and his wife, see no. 793.

703 was the painting exhibited at the Salon, nor to ascertain which of these two works was painted first. This version is closer to no. 703 than to no. 702 in atmosphere and treatment, differing principally in a slightly looser articulation of the foreground weeds.

Sargent's spirited portrait of his teacher Carolus-Duran (*Early Portraits,* no. 21) was also shown at the Salon in 1879, and it attracted most of the critical attention. Olivier Merson described the painting of Rosina as 'une charmante petite étude' before going on to discuss the portrait at length (*Le Monde Illustré,* 14 June 1879, p. 378). Arsène Houssaye linked the two works, tracing Sargent's journey from Capri and a figure in a landscape to Paris and a formal portrait: 'Mr John Sargent came by way of Capri before coming back to paint a very lively and elegant portrait of Mr Carolus Duran. He brings back from Tiberius' retreat the vision of a wild, sultry young peasant woman, who appeared to him in an olive grove in the midst of bushes and undergrowth that are shot through with the shimmering lights of emerald and opal'.[1] Another critic was ambivalent about the affinity with contemporary Italian art that he perceived in the painting, but paid tribute to the restless ambition indicated by Sargent's willingness to try new things: 'His other picture was rather an imitation of [Francesco] Michetti, and inferior to his bright, true pictures of the Normandy coast, with the fisherwomen descending the sands [no. 670]; but these deviations mark rather an excess of talent than the lack of it. A mind and eye continually on the *qui vive* sees so much that is beautiful and desires to accomplish all' (*Aldine,* vol. 9 [1879], p. 371).

1. 'M. John Sargent passe par Capri avant de revenir faire à Paris un très vivant et très élégant portrait de *M. Carolus Duran.* Il rapporte de la retraite de Tibère la vision d'une jeune fille des champs farouche et bronzée, qui lui est apparue *dans les oliviers,* au milieu de buissons et de broussailles éclairés de chatoiements d'émeraude et de reflets opalins' (Arsène Houssaye, *L'Artiste,* no. 50, part 2 [July 1879], p. 9).

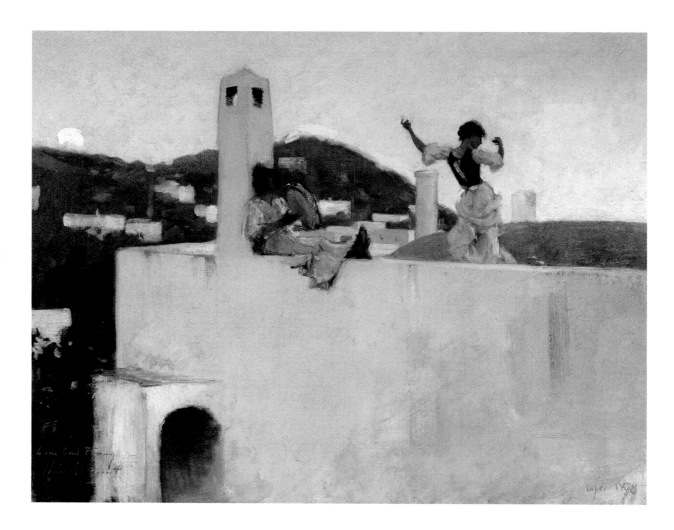

705
Capri Girl on a Rooftop

1878
Alternative title: *Capri*
Oil on canvas
20 x 25 in. (50.8 x 63.5 cm)
Inscribed, lower left: *to my friend Fanny/*
John S. Sargent; lower right: *Capri 1878*
The Westervelt-Warner Museum,
Tuscaloosa, Alabama

This painting shows the model Rosina Ferrara (see pp. 143–46) dancing on the rooftop of a white building against a twilight sky, with a dark green hillside dotted with white houses in the background. The pink rays of the setting sun catch the edges of the parapet and the sides of some of the houses on the background hill, while the moon, not yet completely up, is full or nearly so. Rosina is wearing the same traditional dress as in nos. 702–4, 706–8, 711, 712. She is almost certainly performing the tarantella, a traditional southern Italian folk dance, which consists of quick, light steps and expressive gestures that 'combines energy with grace and tells a love story in pantomime' (Stokes 1886, p. 169). A young

woman, seated, with her back against a tall white chimney, is singing and strumming a large tambourine in accompaniment. The flat roof, tall chimney and pronounced archway are typical of Capri's domestic architecture, and the distinctive grey hump or camber on the roof is known as a *schiena d'asino* (donkey's spine), which is designed to help rainwater drain off the flat surface (see fig. 89).

Sargent's first biographer, Evan Charteris, described an evening entertainment organized by Sargent for his fellow-artists at his hotel (named by Charteris as the Marina Hotel, but possibly another hotel in Marina Grande):

[Sargent] imported a breath of the Latin Quarter [of Paris], entertaining the artists on the island and organising a fête in which the tarantella was danced on the flat roof of his hotel, to an orchestra of tambourines and guitars. But no entertainment in the Latin Quarter could compete with the figures of the dancers silhouetted against the violet darkness of the night under the broad illumination of the moon, the surrounding silence, the faint winds from the sea, and a supper when the stars are giving place before the first orange splash of day (Charteris 1927, p. 48).

The present painting and nos. 706 and 707 may be pictorial allusions to that occasion. The architecture of the island has changed significantly since the late nineteenth century, and it has not been possible to identify the building, though it cannot be the Albergo Pagano (see fig. 68), the hotel that was frequented by artists on the island.

The English artist Frank Hyde described an occasion when the tarantella was danced on the flat roof of the peasant's house where he and Sargent stayed in 1878 (see introduction to chapter 5, p. 139):

Then, again, an evening scene comes back to me—the Tarantellas on the flat roof of the house, and I well remember with what delight we watched the effect of the graceful figures, silhouetted against the fading twilight, and, for a background, Vesuvius with his dark purple mantle and crown of fire (Hyde 1914, pp. 285–86).

If Sargent's painting depicts the scene that Hyde describes, the house must have been positioned on the road leading up from the beach and harbour, on the way to Capri, possibly near the church of San Costanzo, from which position Vesuvius would have been visible. The hill in the background

would be the undulating ground beneath Monte Solaro. It is difficult, however, to reconcile the geography of the actual scene with the perspective represented in the painting. If the location were in Capri town, the viewpoint would have to be south-eastwards with the hill of Tuoro in the background. The latter seems the more likely option.

This canvas demonstrates some of Sargent's preoccupations of the late 1870s and early 1880s: an interest in crepuscular tonalities and the poetry of atmosphere, and a bold, dramatic organization of the picture space. Rosina's figure, in stark profile and silhouetted against the night sky, and that of the singer, given up to the music and excitement of the dance, look forward to Sargent's ambitious evocation of the Spanish flamenco in *El Jaleo* (see no. 772).

The painting was a gift from Sargent to his friend Fanny Watts, the subject of the portrait which, in 1877, was his first contribution to the Paris Salon (see *Early Portraits*, no. 20). Sargent also executed a drawing of her in 1876 (see Adelson *et al.* 2003, ill. p. 85) and a later water-colour (see *Early Portraits*, no. 75). Fanny Watts also owned *Seascape* (no. 666).

The two inscriptions on the canvas are clearly from different dates: the blue inscription (lower right) is in an early, upright hand and may be contemporaneous with the painting of the picture, and the reddish inscription (lower left) may have been added at the time of the gift. When Fanny Watts married Colonel Frederick White in 1907, Sargent gave her away, and it is possible that the painting was a wedding present to her: the 1876 drawing of her was certainly a wedding gift.

A closely related version differs from the present work in that it lacks the arched doorway (no. 707). For two related pictures showing Rosina as a single and static figure, see nos. 706 and 707.

Fig. 89
Photograph of a Caprese house with typical roof vaulting and chimney, 2004.
Catalogue raisonné archive.

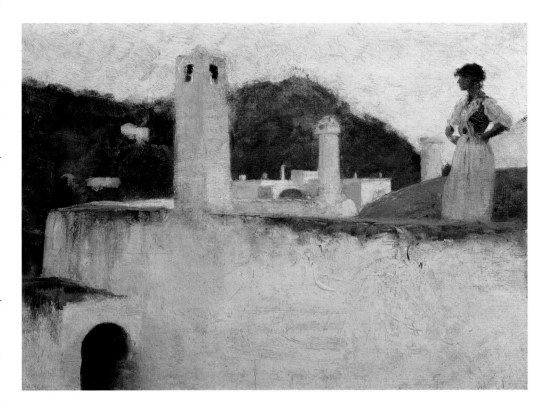

706
View of Capri

1878
Oil on academy board
10¼ x 13⅜ in. (26 x 33.9 cm)
Yale University Art Gallery, New Haven, Connecticut. Edwin Austin Abbey Memorial Collection (1937.2595)

A small study of Sargent's model Rosina Ferrara standing on the flat roof of a traditional, white Capri building; she is a solitary figure in profile with her hands on her hips, gazing out at the view before her. The setting, background and viewpoint are almost identical to those in nos. 705 and 707 (with some minor variations in the architectural detail), in which Rosina is seen dancing the tarantella as a woman accompanies her on a tambourine. The difference between this and the two related studies lies in the medium (this study is painted on academy board, while the other two are on canvas) and handling: this picture is very freely brushed and less fully realized than either no. 705 or 707, and the figure appears to have been painted onto the background, rather than being integrated with it.

The painting is part of the extensive Edwin Austin Abbey Memorial Collection at Yale University Art Gallery and was catalogued as a work by Abbey until Marc Simpson corrected the attribution in 1980 (see Simpson 1980, p. 9). Sargent met the American painter and illustrator Edwin Austin Abbey (1852–1911) in England in 1884, and they became lifelong friends. Abbey was born in Philadelphia, where he also studied art, but he spent most of his working life in England. He was, with Sargent, one of the leading lights of the artistic community at Broadway, Worcestershire, in the mid-1880s, and, in the 1890s, he and Sargent shared a studio at Morgan Hall, Fairford, Gloucestershire, where both artists worked on mural projects for America. When Abbey died in 1911, Sargent oversaw the selection of his works for a memorial exhibition at the Royal Academy (see E.V. Lucas, *Edwin Austin Abbey, Royal Academician: The Record of his Life and Work*, 2 vols. [London, 1921]). Sargent's charcoal drawing of Abbey (c. 1888–89) is in the Yale University Art Gallery.

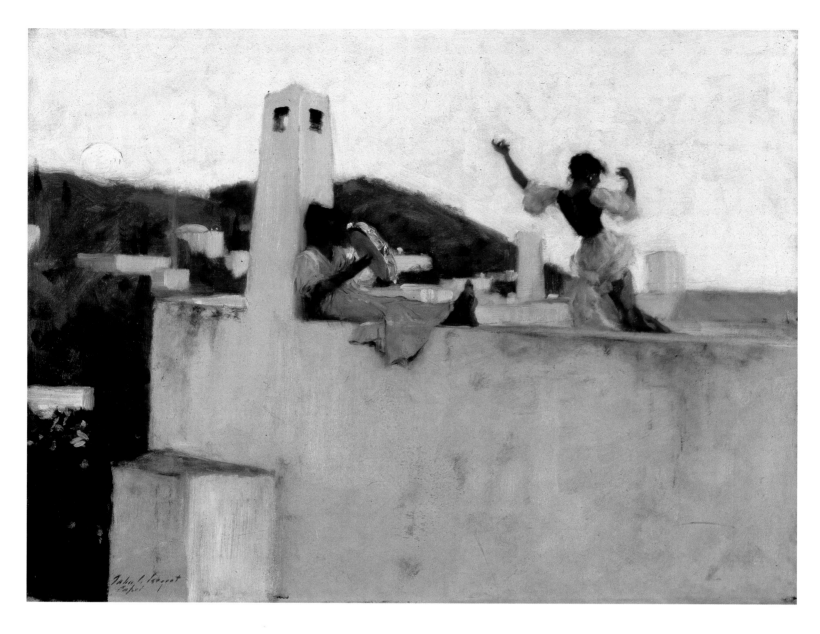

707
Capri

1878
Alternative titles: *Rosita; Rosita, Capri*
Oil on canvas
19½ x 25¼ in. (49.5 x 64.1 cm)
Inscribed, lower left: *John S. Sargent/Capri*
Private collection

There are three paintings of the Capri model Rosina Ferrara on the flat roof of a white house with a similar setting of a dark green hillside; in two of them she is dancing (see also no. 705), and in the third, she is standing and looking ahead (no. 706). The building in this picture differs from that in the other two in lacking the architectural details of the arch at the lower left of the building. This might suggest that the present work is an earlier version in which some aspects of the composition have not been fully resolved. In broad compositional terms, however, in refinement of motif, tonal and chromatic elegance and crepuscular mood, it is very close to no. 705.

The English artist Frank Hyde, who was with Sargent during his visit to the island of Capri in the summer and autumn of 1878, described a scene at which the tarantella was danced on the roof of a peasant's house in Marina Grande, the small harbour on the northern coast of the island where he and Sargent stayed (Hyde 1914, pp. 285–86; see introduction to chapter 5, p. 139, and p. 164). For possible locations of the scene, see no. 705.

The painting was probably a gift from Sargent to José Tomás Errázuriz, a Chilean diplomat and an artist whom Sargent knew from his early years in Paris. Sargent painted a formal portrait of his sister, Amalia Subercaseaux, in 1880–81 (see *Early Portraits,* no. 41) and several studies of his wife, Eugenia (see *Early Portraits,* nos. 69, 70, 71 and 72), a beautiful and artistic woman who was painted by a number of artists including Giovanni Boldini, Paul César Helleu, Augustus John, Henri Matisse and Pablo Picasso.

708
Capri Girl on a Rooftop (recto)
and *Man in a Gondola Sketching* (verso)

1878
Oil on panel
9½ x 13¼ in. (24.2 x 33.7 cm)
Verso inscribed, upper right: *MANET*
Berger Collection at The Denver Art
Museum, Colorado (TL16744)

This study of a young woman in Capri dress standing on a rooftop may represent Rosina Ferrara; her face is not sufficiently realized to make a firm identification, though her shock of hair falling forward is characteristic. The rooftop in this picture is a partially enclosed terrace with a low wall lined with potted plants in contrast to the open space in nos. 705, 706 and 707. Several columns cast long shadows across the floor, indicating late afternoon or early evening sun. The rooftop may be that of the peasant's house where both Sargent and Frank Hyde stayed in 1878 (see introduction to chapter 5, p. 139 and p. 164). The slightly bulging shape of the roof, a characteristic feature of Capri rooftops to facilitate water run-off, is known as a *schiena d'asino* (donkey's spine or back).

The painting on the reverse shows a sketchily rendered and thinly painted study of a man seated at an easel with a palette in his left hand. He appears to be painting in a boat, with areas of summarily treated blue water indicated as background. The man has a moustache and pointed beard and wears a bowler hat. The picture is too unresolved to enable an identification to be made; the inscription is uncharacteristic and unreliable, and may come from a hand other than Sargent's.

The first owner of the painting was Sargent's friend the artist Ramón Subercaseaux, whose wife Sargent painted in 1880–81 (see *Early Portraits*, nos. 41, 42). For a portrait of Subercaseaux by Sargent and a study of him painting in a gondola, see fig. 193 and *Early Portraits*, nos. 86, 87, and for a water-colour inscribed to him, see no. 836.

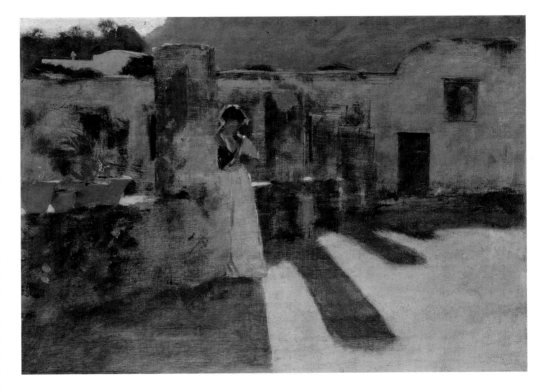

709
Capri Peasant—Study

1878
Alternative titles: *Head of Ana-Capri Girl;*
A Capri Girl; Profile of a Café Girl;
Tête d'étude; Study Head for the Capri Girl
Oil on canvas
9 x 10 in. (22.9 x 25.4 cm)
Private collection

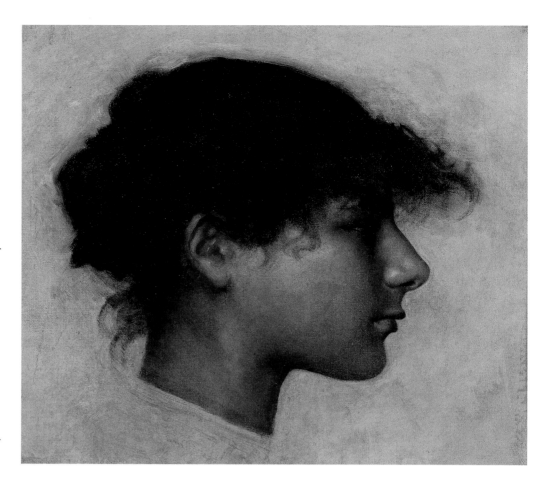

Sargent's refined but austere composition representing the head of Rosina Ferrara in pure, academic profile relates closely to the head of the same model in three versions of her entwined around an olive tree (nos. 702–4); however, this is an independent work rather than a study for the figure in a landscape. Sargent's rendition of his model's features is a highly controlled and subtle exercise in tonal modelling, which utilizes a minimal chromatic range (dull yellow, ochre and brown) and a dry, thin facture to create a spare but strikingly raw and powerful image.

The painting was shown in New York at the fourth exhibition of the Society of American Artists in March 1881 as 'Capri Peasant—Study' and described by Edward Strahan as 'modelled like a head on a Syracuse coin—the type like the last of the Greek daughters, imprisoned in an island and preserved to fade out among strangers: it is a small thing, but a masterpiece of care and insight' (*Art Amateur,* vol. 4, no. 6 [May 1881], p. 117). The critic writing for the *New York Times* also pointed to its antique echoes: 'The head of a Capri peasant-girl, by John S. Sargent, is firmly and neatly painted, and is in itself an interesting profile. One regards it with the curiosity of an ethnologist rather than the pleasure that one expects to get from a work of art. Is this a type from that distinct race settled in Anacapri which is said to have been introduced from Greece? It has the look of a Phenecian [*sic*], and may be profitably compared with the busts at the Metropolitan Museum which were found in Cyprus' (*New York Times,* 15 April 1881, p. 5). It was also one of four works exhibited in Paris at the Cercle des arts libéraux in March 1882. Reviewing the show, Olivier Merson wrote: 'Of Mr Sargent's four works, the best, without doubt, are *A Street in Venice* and, especially his study of a head, a delicious profile of a young Italian woman, as dark as the night'.[1]

The painting was reproduced as an engraving on the cover of journals in France and in America (*Scribner's Monthly,*

July 1881, p. 321). In France, an engraving by Charles Baude was illustrated in *Le Monde Illustré* in 1883 (fig. 90) as a mark of respect to those who had died in an earthquake in Ischia in 1882, with this accompanying text:

The young girls of Capri and Ischia are [like] the very Graziella [see introduction to chapter 5, p. 146] described by Lamartine and by the pen of our fine writers and the brush of our distinguished artists. Mr Sargent, whose name is well known in this journal, very much wanted us to share with you the original study of one of these beautiful creatures that he painted in the bay of Naples. We show it to represent those unfortunate victims crushed under the rubble in Ischia in the full flower of their youth, smiling at the sky, smiling at the sea, smiling at the stranger with that innocent, slightly wild grace that is particular to these girls of the Orient.[2]

Frank Hyde also described the picture in highly coloured language: 'Take for instance that firm but rather cruel mouth, not only did it show the *Will* but the *Courage* to face a danger, if needs be, to seek revenge for a wrong done. Again look at that small but powerful jaw, that drooping eye of the Orient, the beautifully rounded neck, and lissom young figure, none but a

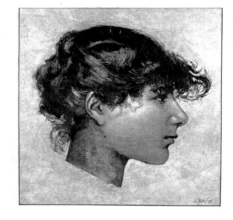

Fig. 90
Charles Baude, Engraving after 'Tête d'étude',
Le Monde Illustré, no. 1377 (18 August 1883), p. 97.

"Master" could express all these subtle points so accurately and above all so *rapidly* as "Sargent the greatest painter of our time"' (Frank Hyde, typescript notes, 'Rosina. Sargent's Famous Ana Capri Model: The Type that Fascinated Him', 1935, private collection).

The painting remained in Sargent's possession throughout his life. His Chelsea neighbour and friend, the painter, illustrator and etcher George Percy Jacomb-Hood (1857–1929) remembered it 'Holbeinesque in its severe and clean outline and subtle modelling' hanging on the walls of his Tite Street studio (Jacomb-Hood 1925, p. 236).

1. 'Des quatre cadres de M. Sargent, les meilleurs, sans contredit, sont *Une rue à Venise,* et principalement la *Tête d'étude,* délicieux profil de jeune Italienne brune comme la nuit' (Olivier Merson, 'Exposition des Artistes indépendants, rue Saint-Honoré, 251. Exposition du Cercle des Arts libéraux, rue Vivienne, 49', *Le Monde Illustré,* vol. 50, no. 1303 [18 March 1882], p. 167).

2. 'Les filles de Capri, les filles d'Ischia, ce sont les Graziella qu'a décrites Lamartine et que nous avons retrouvées sous la plume de bien des poètes, sous le pinceau de bien des artistes. M. John Sargent, dont le nom est bien connu dans notre publication, veut bien nous communiquer l'étude originale qu'il a faite dans la baie de Naples et l'une de ces belles créatures; nous la donnons comme type de ces malheureuses victims d'Ischia écrasées sous les décombres en pleine jeunesse, souriant au ciel, souriant à la mer, souriant à l'étranger avec la grâce naïve et un peu sauvage de ces filles d'Orient' ('Nos Gravures. A Capri', *Le Monde Illustré,* vol. 53, no. 1377 [18 August 1883], p. 100, engraving ill. p. 97).

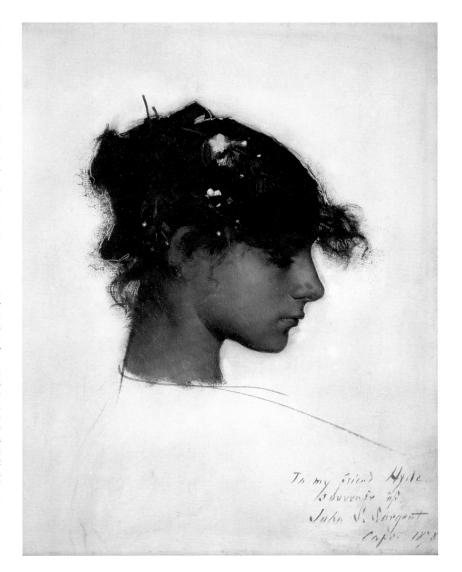

710
Head of Rosina

1878
Oil on paper on board
13 x 10¼ in. (33 x 26 cm)
Inscribed, lower right: *To my friend Hyde/souvenir of/John S. Sargent/Capri 1878*
Berger Collection at The Denver Art Museum, Colorado (TL17910)

This is a study of the head of the Capri model Rosina Ferrara in profile, and it is clearly related in intention and pose to no. 709, though the latter is more fully realized and taken to a higher degree of finish. The present work, bearing distinct lines of underdrawing at the base of the neck and with extensive areas of unpainted background, has the quality of a summarily executed sketch. Rosina, gazing demurely downwards, with flowers in her hair, is treated more pictorially, making for a less severe and uncompromising image than the controlled, spare and defiantly unpic-

turesque characterization of no. 709. The medium, oil on paper on board, is unusual in Sargent's oeuvre, as is the pronounced *sgraffito* used to emphasize the outline of her hair.

Sargent painted the picture in the convent of Santa Teresa in Capri town, inscribing it to the English artist Frank Hyde, who had provided him with studio space at the convent and who had introduced him to Rosina, and presenting it to him as a gift (see introduction to chapter 5, p. 140). In an article about Capri entitled 'The Island of the Sirens', which was published in 1914, Hyde wrote:

In those days we found no difficulty whatever in procuring splendid types as models. Especially was this so at Ana Capri, where the girls still retained the Oriental colouring and Saracenic features, legacies handed down from the time when that old Moorish pirate Barbarossa, made his raids upon the island and carried off the women. At my studio in the monastery [Santa Teresa], Sargent painted one of these magnificent types, a

girl named Rosina, and subsequently made me a present of it (Hyde 1914, p. 286).

Hyde also mentioned the painting in some unpublished notes on Rosina:

Sargent, who had only just arrived in Capri, chatting one day in my studio, asked me if I could find him a model of a particular type; he explained what he wanted. I at once thought of 'Rosina'; when he saw her he was so fascinated with her that he made three studies in profile of her, all of which he painted in my studio; one he signed and gave to me, one his sister possessed and was in an exhibition of his work at Burlington House [no. 709], but what became of the other I didn't know (Frank Hyde, typescript notes, 'Rosina. Sargent's Famous Ana Capri Model: The Type that Fascinated Him', 1935, private collection).

The third profile mentioned by Hyde is, at present, untraced.

711
Stringing Onions

1878
Alternative title: *Italian Interior, Capri*
Oil on canvas
17 x 13 in. (43.2 x 33 cm)
Inscribed, upper left (the inscription
has been partially lost): *to my friend . . ./*
John S. Sargent
Private collection

A young woman in traditional Caprese
dress, pink skirt, white blouse and dark
corset with a kerchief crossed and worn
over is standing weaving a strand of onions
in a bare, sunlit room, while a little girl, also
in traditional dress, is seated on the floor,
cradling a large onion in her lap (see fig.
91). It is a quiet, intimate scene of women
working—onions are hanging from the
shutter, lying across the window ledge and
spilling across the floor—with both figures
absorbed in what they are doing. The young
woman is probably the model Rosina Fer-
rara: her face is too summarily treated to be
identifiable, but the shock of frizzy hair
falling forward is characteristic. The austere
room with its high, shuttered window may
be one of the cells in the convent of Santa
Teresa in Capri, which Sargent used as a
studio (see p. 140).

The inscription has been partially lost.
It may read 'Centemeri', which accords with
an entry in J. Carroll Beckwith's diary for
1878–79: 'Centemeri/257 W 44th' (Beck-
with Papers, National Academy Museum
and School of Fine Arts, New York). See
no. 717 for a discussion of a similar inscrip-
tion which occurs on a second picture of
around this date.

The artist Charlotte Ida Popert (1848–
1922), who was in Capri in 1878, appears to
have owned three works by Sargent: a por-
trait of a child, a water-colour portrait of
the artist Ludwig Passini (1832–1903), both
untraced, and a painting of a Capri girl
with onions. In her will, dated 15 August
1921 (private collection Hamburg), she
bequeathed the painting to the Kunsthalle,
Hamburg, but the painting did not reach
the collection. (For a transcription of the
will, see Floriana Carosi, 'Charlotte Ida
Popert [1848–1922], pittrice, acquarellista,
acquafortista', Diss., Università degli Studi
Roma Tre, Rome, 1996–97.) It is possible
that the painting mentioned in Miss Pop-
ert's will is the present work, or it may be
an unknown painting which is, at present,
untraced. For Charlotte Popert's visit to
Capri, see p. 149, n. 33.

Fig. 91
Photograph of children in
a Caprese courtyard, c. 1895.
Private collection.

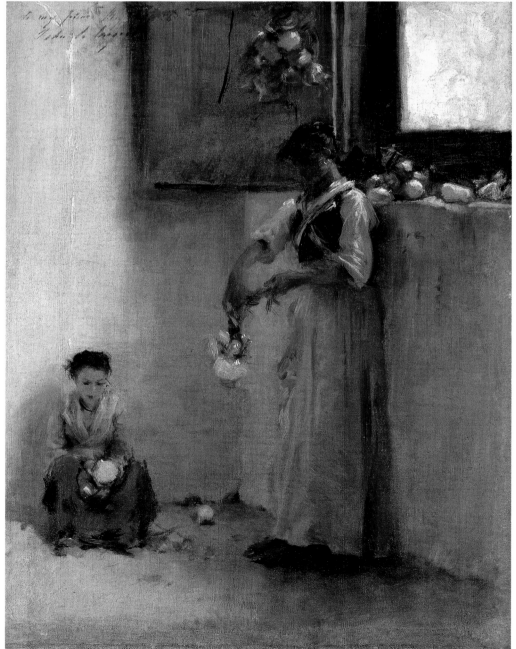

712
Rosina

1878
Oil on panel
13⅞ x 6¾ in. (35.3 x 17.2 cm)
Inscribed, across top (the inscription
is abraded and difficult to decipher):
à mon ami Schoutetten souvenir affectueux/
John S. Sargent
Private collection

This is a study of a model in traditional
Capri dress, standing with hand on hip in
what is a signature Sargent pose, a string
of onions slung over her right shoulder.
The model may be Rosina Ferrara (see
pp. 143–46). The inscription is a reference
to the French artist Louis Schoutetten
(1833–1907). Schoutetten was born in Lille
and had exhibited at the Salon since 1864;
his *Crépuscule* (Musée des Beaux-Arts, Lille)
received an Honourable Mention at the
Salon in 1882, the year Sargent exhibited
El Jaleo (no. 772) and *Lady with the Rose* (see
Early Portraits, no. 55). Nothing about Sar-
gent's relationship to Schoutetten has come
to light, though the connection between
them may be Lille, the town from which
Sargent's master Carolus-Duran came and
with which he maintained close links.

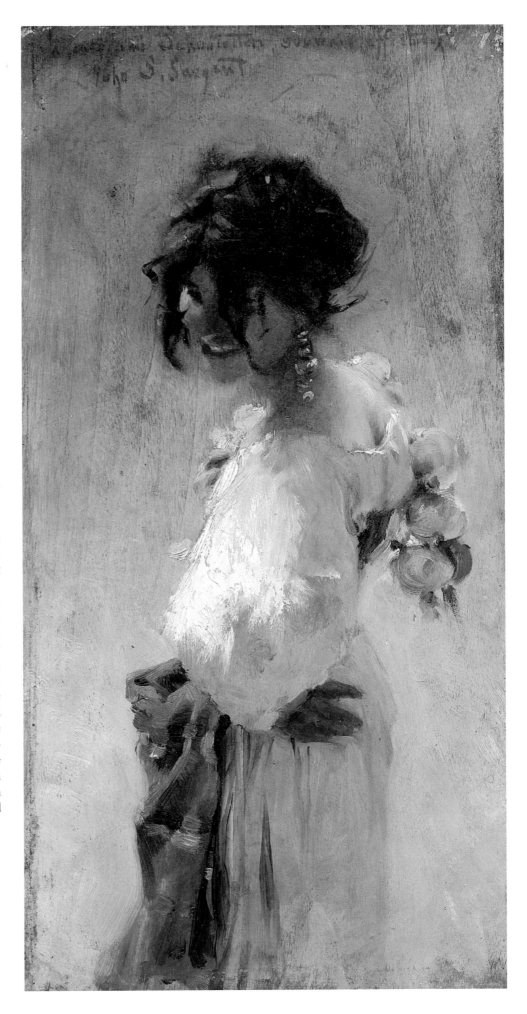

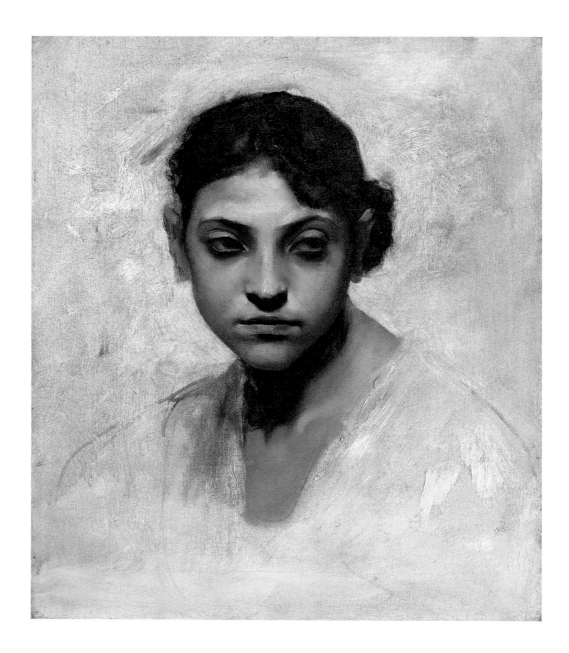

713
Head of a Capri Girl

1878
Alternative title [in error]: *Mlle L. Cagnard*
Oil on canvas
18½ x 15 in. (47 x 38.1 cm)
Private collection

This directly frontal head and shoulders study of a young woman with her hair drawn back and parted in the centre and with a flower behind her left ear was exhibited at the Sargent memorial exhibition at the Royal Academy in London in 1926, where it was erroneously identified as 'Mlle L. Cagnard'. Charteris perpetuated the misidentification in his biography of the artist (see Charteris 1927, p. 258), and the error only became apparent on the emergence of the actual portrait of Louise Cagnard (see *Early Portraits,* no. 61). Charles Merrill Mount related this episode and its implications for the present work in his 1957 article on Sargent:

The discovery of this canvas [Louise Cagnard] clarified the history of another early work by Sargent. Charteris' catalogue lists a portrait of Mlle L. Cagnard, painted in 1882 and belonging to Sir Alec Martin. Because it was in storage the picture could not be examined in London, though Sir Alec very graciously had it photographed. On receipt of the photograph it became clear that Sir Alec's picture was not of a Parisian Mademoiselle, but rather an unfinished sketch of the model who also figures in a study owned by the Marchioness of Cholmondeley [no. 714]. Any further doubt was dispelled by the discovery of the true portrait of Louise Cagniard [sic] (Mount, Art Quarterly, 1957, p. 313).

The model in this picture and in no. 714 has sometimes been identified as Rosina Ferrara (see Ormond 1970, p. 236 and *Early Portraits,* p. 73), but she appears to be a different, unidentified model. The painting almost certainly was one of a group of works given by the artist's sisters to Sir Alec Martin (1884–1971), an employee, later chairman of Christie's, London, who masterminded the Sargent estate sale in 1925 (see also nos. 645, 750).

714
Head of a Capri Girl

1878
Alternative title: *Head of a Sicilian Girl*
Oil on canvas
17 x 12 in. (43.1 x 30.4 cm)
Inscribed, lower left: *to Philip;* lower right:
John S. Sargent
Private collection

This rapidly executed sketch of a young, olive-skinned woman is described by early sources (see London 1926, p. 55 and Charteris 1927, p. 288) as a study of a Sicilian girl, but the picture almost certainly belongs to Sargent's visit to Capri in 1878. The model has sometimes been identified as Rosina Ferrara (see Ormond 1970, p. 236), whom Sargent painted in several compositions (see nos. 702–12); but the young woman depicted here has a longer, more oval face and smoother, finer hair. She is almost certainly a different model, and Sargent painted her more than once (see no. 713).

The fine facial oval is achieved by subtle delineations of tone, and the background colour, barely distinguished from that of her skin, is freely brushed. The paint is thinly applied over an umber ground (the weave of the canvas is clearly visible in places), and the whites of the fabric of dress or shawl are scumbled across in broad, dry strokes. A few bright accents—the shining gold of the hooped earrings and the vivid red ribbon in her hair—and a contrast of texture—the silkiness of her skin and the rough weave of the fabric—relieve a disciplined tonal exercise.

The painting was a gift from Sargent to his friend Sir Philip Sassoon, who owned an important collection of the artist's work. Sargent painted a formal, three-quarter-length portrait of Sassoon in 1923 (see *Later Portraits,* no. 604).

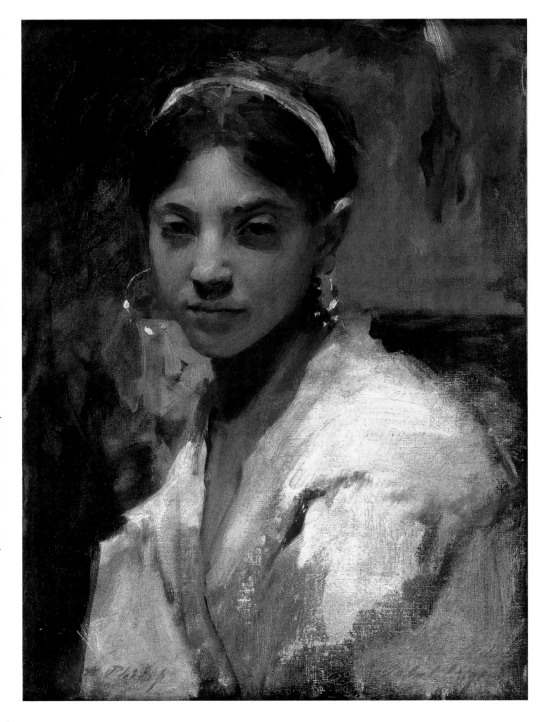

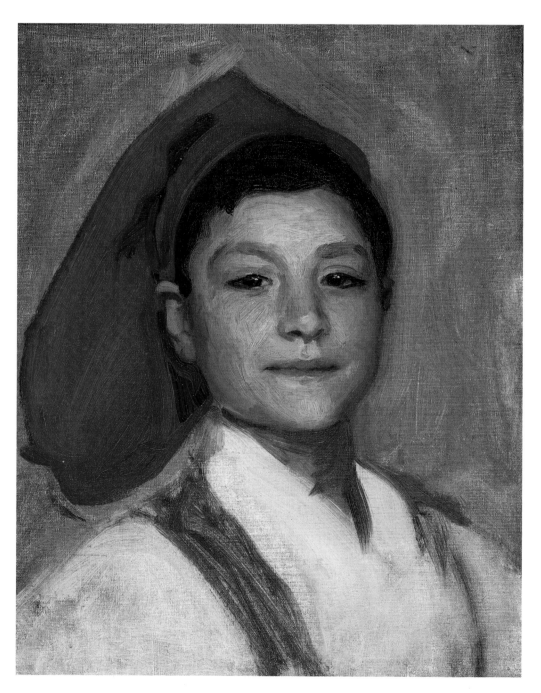

715
A Neapolitan Boy

1878
Oil on canvas
18½ x 13¾ in. (47 x 35 cm)
Private collection

This full-face study of the same model as in no. 716 was also painted in Naples or Capri in 1878. The boy is dressed in the same traditional local fisherman's costume he is wearing in the profile study: a red Phrygian cap, a loose white shirt and a red waistcoat.

This painting and no. 716 were bought at the artist's sale in 1925 by Thomas Agnew & Sons for the Boston collector, industrialist and governor of Massachusetts Alvan T. Fuller (1878–1958). Fuller bought twelve oils and two water-colours at the sale; for more information about his collection, see no. 731.

716
Sketch of a Neapolitan Boy

1878
Alternative titles: *Head of a Sicilian Boy;*
Head of a Neapolitan Boy, wearing a red cap;
Neapolitan Boy (profile)
Oil on canvas
19 x 13½ in. (48.3 x 34.3 cm)
Inscribed, upper left [in pencil]:
John S. Sargent
Private collection

A profile study of a boy painted in Naples
or Capri in 1878. The boy is wearing a red
Phrygian cap, loose white shirt and a red
waistcoat, the traditional costume of fisher-
men from the Neapolitan coast and its
islands. A label on the reverse of the paint-
ing in the artist's hand reads 'Sketch of
Neapolitan to be returned to London'; this
is similar to labels on pictures from the
artist's own collection which were sent to
Boston for the artist's one-man exhibition
at Copley Hall in 1899 and confirms that
this picture, rather than no. 715, was the work
exhibited as no. 61 in the show, 'Sketch of a
Neapolitan Boy'. A pencil sketch (fig. 92) is
very closely related to the present oil.

 This painting and no. 715 were bought
at the artist's sale in 1925 by Thomas Agnew
& Sons for the Boston collector Alvan T.
Fuller (1878–1958), an industrialist, gover-
nor of Massachusetts and trustee of the Mu-
seum of Fine Arts, Boston. Fuller acquired
twelve oils and two water-colours, in total,
at the artist's sale. See no. 731 for further
information about Fuller's collection.

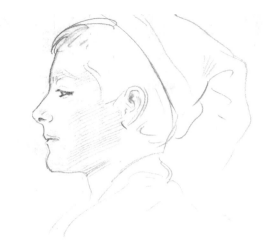

Fig. 92
Head of a Neapolitan Boy. Pencil on paper,
8¾ x 9½ in. (22.2 x 24.1 cm). Private
collection.

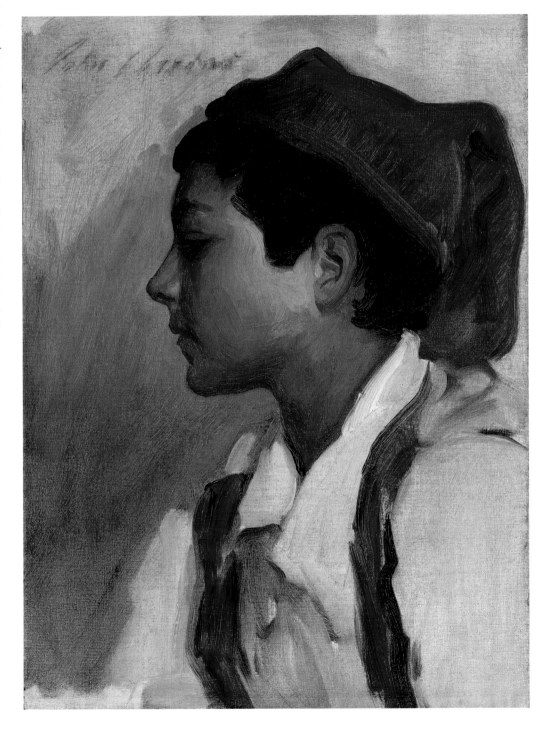

717
The Little Fruit Seller

1879
Oil on board
14 x 10¾ in. (35.6 x 27.3 cm)
Inscribed, upper right: *to my friend*
Mrs C[entemeri?]—1879/John S. Sargent
Private collection

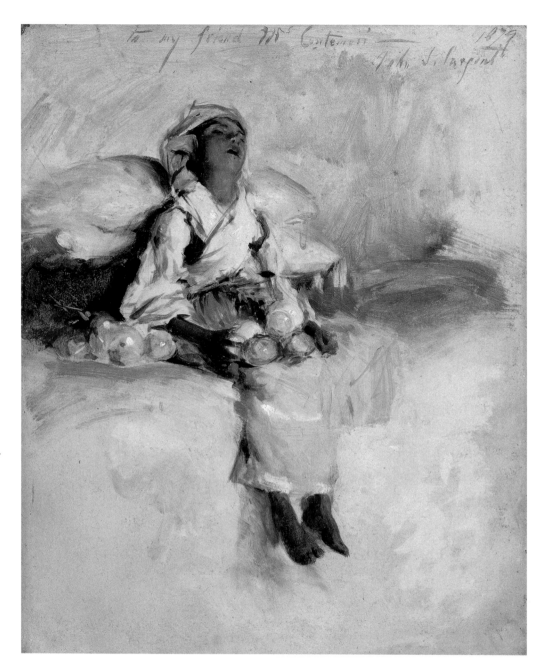

A young child is seated, apparently asleep, on a white couch or day-bed, leaning back against white, tasselled pillows, with a brown basket to his/her right and a white wall behind. The painting has traditionally been called 'The Little Fruit Seller', but the objects in the child's lap look like onions, with stalks and twine in preparation for stringing. The austerity of the interior depicted might suggest that the picture was painted in the convent of Santa Teresa in Capri town, where Sargent worked in 1878 (see fig. 67). The costume, white skirt, blouse with white puffy sleeves and dark bodice with material crossed and wrapped over the upper body, is typical of that worn by young Caprese girls (see fig. 91).

The inscription at the upper right of the canvas is abraded and difficult to decipher. The Knoedler, New York, stockbook noted it as 'Conternosi' and Charles Merrill Mount read it as 'Contemosi' (see Mount 1955, p. 442 [K791]; 1957 ed., p. 352 [K791]; 1969 ed., p. 460 [K791]). Another reading might be 'Centemeri', a name that appears in J. Carroll Beckwith's diary for 1878–79 with the New York address '257 W 44th' (Beckwith Papers, National Academy Museum and School of Fine Arts, New York). The New York census for that year lists P. Centemeri & Co., Manufacturers and Importers of Kid Gloves, at 896 Broadway, and Helen Centemeri, the widow of Peter, whose home was at 246 West 44th Street (at 8th Avenue, a stretch of street now occupied by the Milford Plaza, which was built in 1929). The Centemeri firm imported gloves from France, which might raise the possibility of a Parisian connection, and they were also involved in the manufacture of fine rugs. There is nothing, however, to support the notion that Sargent was acquainted with this family; nor is it known how the painting passed to its subsequent owner, Mrs Léonie de Chelminski, who consigned the painting to Knoedler in 1935. She was born Léonie Knoedler, and was, first, Mrs Henschel and, secondly, Mrs de Chelminski: she and her husband Jan de Chelminski lived in Paris until his death in 1925. Her son, Charles Henschel, was president of Knoedler from 1928 until his death in 1957. The subsequent owner of the painting, Frederick H. Prince, Jr, was a noted sportsman and aviator.

The costume, the activity of stringing onions and the white-on-white tonalities are all consistent with the themes of Sargent's Capri campaign of 1878. The date '1879' inscribed on the canvas is a year later than Sargent's visit; but the picture might have been finished and/or inscribed in his Paris studio at a later date, or it may have been inscribed and dated at the time the picture was given to its first owner rather than at the time of its completion. Barbara Gallati has suggested that the child is a boy and may be the same model as that in no. 696, which, if true, would confirm that the picture was painted in Capri (see Gallati *et al.* 2004, p. 208). There is no evidence, however, that boys wore the costume depicted in the painting.

For discussion of a painting of a girl with onions, owned by the artist Charlotte Ida Popert, see no. 711.

718

Head of an Italian Boy

c. 1878
Oil on canvas
15⁹⁄₁₆ x 12⅝ in. (39.5 x 32.1 cm)
Inscribed, upper right: *J. S. SARGENT 187[8?]*
Private collection

Sargent's study of the head of an Italian boy was probably painted in Naples or Capri in the late summer or early autumn of 1878. The last digit of the inscribed date is faint and difficult to decipher, but the authors read it tentatively as an '8'. The upright capitalized signature is an early form; similar examples can be seen in, for example, *Oyster Gatherers of Cancale* (no. 670) and *A Venetian Interior* (no. 795).

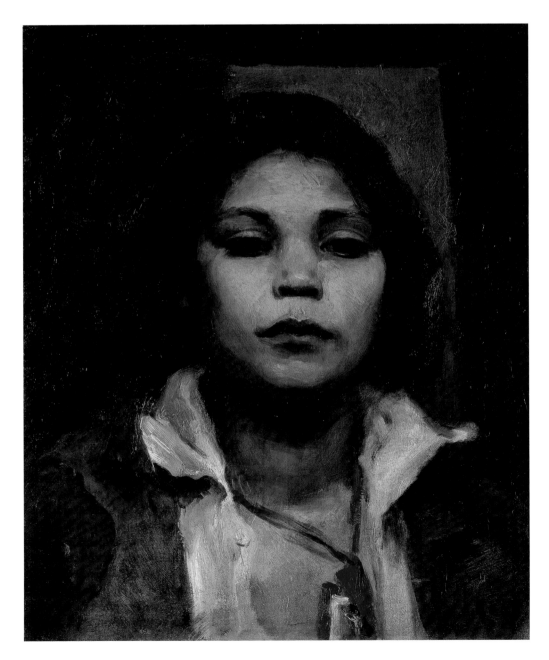

The boy, in an open-necked, white shirt and brown waistcoat, wears a charm, or a medal with a religious image, possibly of the crucifixion, tied around his neck with a red ribbon. The image, which may have been printed on paper or tin, is partially enclosed in a red cover or envelope, perhaps to allow for a printed prayer to be inserted: it is reminiscent of the religious images given to mark a significant event such as a confirmation.

The painting was apparently given to the Swiss-American artist Charles Édouard Du Bois in exchange for one of Du Bois's works. There is no painting by Du Bois recorded in Sargent's studio sale or in the collections of his descendants, and the present work may have been given to Du Bois as a gift. There is, in the collection of Du Bois's descendants, a scrapbook with repro-ductions of paintings by a number of artists which were owned by the family. *Head of an Italian Boy* is illustrated in the book with the title *Tête de petit Italien* accompanied by the following handwritten passage:

> *Célèbre peintre américain, ami du peintre Chs. Ed. Dubois qui lui avait échangé une de ses toiles contre ce tableau que je reçus d'oncle Favre qui l'avait reçu de peintre DuBois. Peinture extrêmement remarquable et de grande valeur.*

This book also contains illustrations of paintings by Léo-Paul Robert, Melle [Mlle?] Durr, Aurèle Robert, Albert Anker (see no. 698), Edmond de Purry, Paul Robert, E. Isembart, Albert de Meuron and Charles Édouard Du Bois himself.

Charles Édouard Du Bois (1847–1885), of Swiss descent, was born in West Hoboken, New Jersey, but he is regarded as a Neuchâtelois painter. He studied with the Swiss landscapist Andreas Jeklin and with Charles Gleyre in Paris, and exhibited at the Salon from 1869 and at the National Academy of Design in New York in 1873, 1874, 1875 and 1877. He worked chiefly in landscape, painting scenes from his travels across Europe and in Egypt; his work is well represented in the Musée d'Art et d'Histoire, Neuchâtel, Switzerland.

Little is known about Sargent's friendship with Du Bois, though his name appears intermittently in those entries in J. Carroll Beckwith's diary which cover Sargent's Paris years (Beckwith Papers, National Academy Museum and School of Fine Arts, New York). It is interesting that Du Bois had certainly seen some of Sargent's Capri work. Du Bois wrote to the American painter J. Alden Weir (14 May 1879) that Sargent had made 'some remarkable studies in Capri last summer, far better than anything he ever painted you saw a specimen in the N.Y. Young men's Exhn' [*Dans les oliviers à Capri (Italie)*, no. 703, shown in the second exhibition of the Society of American Artists in May 1879] (J. Alden Weir Papers, Archives of American Art, Smithsonian Institution, Washington, D.C., roll 71, frame 1067).

The present picture is previously unrecorded in Sargent literature.

719
Staircase in Capri

1878
Alternative titles: *Study of a Staircase;*
Study of a Staircase, Capri
Oil on canvas
32¼ x 18¼ in. (81.7 x 46.4 cm)
Inscribed, lower right [the inscription is
partially lost]: *John S. Sargent Capri 1878*
Private collection

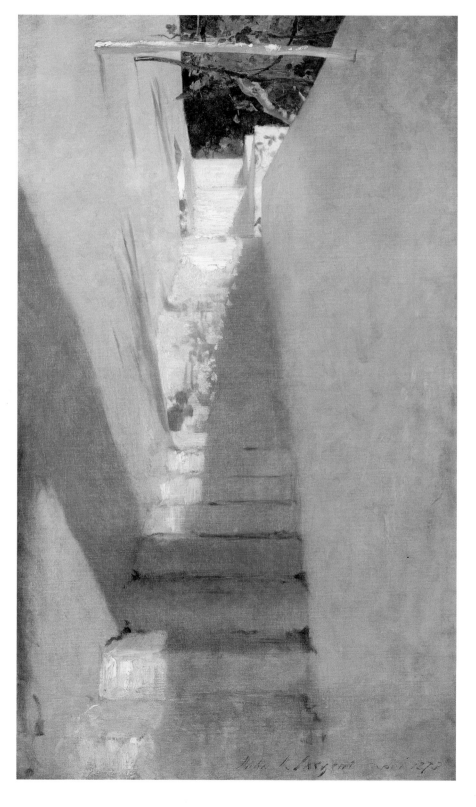

The topography of Capri town is characterized by its extreme verticality, and a number of its streets are connected, or its buildings approached, by vertiginous flights of steps. This near-abstract study represents one such staircase. It has not been possible to identify the site securely—tourism has brought accelerated development to Capri town since the 1870s, and its architecture is markedly changed—but similar narrow, perpendicular outdoor staircases still exist in several locations (for example, the steps at via Madonna delle Grazie, just off via Le Botteghe; Scalette di Sopramonte, also off via Le Botteghe and rising up to the via Sopramonte; Scala Tuoro, running between via Tragara and via Tuoro, and the steps at no. 167 via Marina Grande).

In a number of studies painted in Capri in 1878 and in North Africa in 1880, Sargent explored formal preoccupations with the geometry of architecture and with the effects of light and shade on white, reflective surfaces. This picture represents a steeply ascending flight of steps enclosed by white walls and viewed from a very low position so that the strict perspective and taut format create the impression of an inverted, light-filled mineshaft. White steps and walls, with shadows described in mauve, blue-grey, opal and silver, occupy the entire canvas, except for a small section at top centre, where there is a small arbour or pergola, with branches, foliage and a hint of bright blue sky just visible. In its tonal radiance and compositional elegance, the picture anticipates *Fumée d'ambre gris* (no. 789).

Staircase in Capri was one of a group of works owned by the French artist Auguste Alexandre Hirsch (1833–1912), with whom Sargent shared a studio at 73, rue de Notre-Dame-des-Champs. For a discussion of the pictures owned by Hirsch, see appendix 1, p. 387. The painting was later owned by the British-born diplomat, society hostess and celebrity Pamela Harriman (1920–1997), who was married first to Randolph Churchill (Winston Churchill's son), secondly to the Broadway and Hollywood producer Leland Hayward, and finally to the diplomat and former governor of New York, Averill Harriman. In 1993, President Clinton appointed her U.S. Ambassador to France. After her death in 1997, the painting was sold at auction at Sotheby's, New York, and is now in a private collection.

Jean Benner's *Un coin d'ombre à Capri,* exhibited at the Paris Salon in 1887, depicts a similarly steep and enclosed staircase, though Benner's composition is populated with figures reclining on the steps (fig. 77).

720
Ricordi di Capri

1878
Oil on panel
13½ x 10¼ in. (34.5 x 26.5 cm)
Inscribed, lower right: *John S. Sargent/Capri*
Private collection

Two little girls in traditional Caprese dress are standing on the exterior staircase of a white house in Capri, with olive trees in a garden or field behind. External staircases frequently connected the ground floor of the local houses to the first floor and were a feature of the architectural idiom of the island (see fig. 93). The curving lines of the farther wall of the staircase reveal the Saracen influence typical of the older architecture on the island. The picture relates thematically to Sargent's studies of children on the beach, also painted in the summer of 1878 (nos. 692–97, 699). The compositional preoccupations, a pictorial interest in blocks of white wall, the depiction of light effects on reflective surfaces and the dramatic disposition of space resemble those expressed in Sargent's studies of Rosina dancing or standing on a rooftop (see nos. 705–7) and to his near-abstract study of a stairwell, no. 719.

The title, 'Ricordi di Capri', meaning 'Memories' or 'Souvenirs of Capri', is traditional. The first recorded owner of the painting is a M. Charmoz of Paris; Charmoz is a Savoyard surname, but nothing, at present, is known about this particular individual, nor how he came to acquire the picture.

Fig. 93
Fulvio Roiter, Photograph of children on the external staircase of a Caprese house. Private collection.

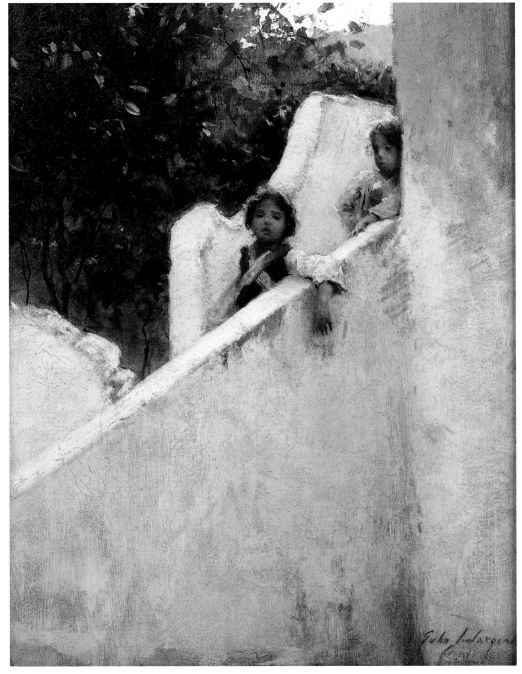

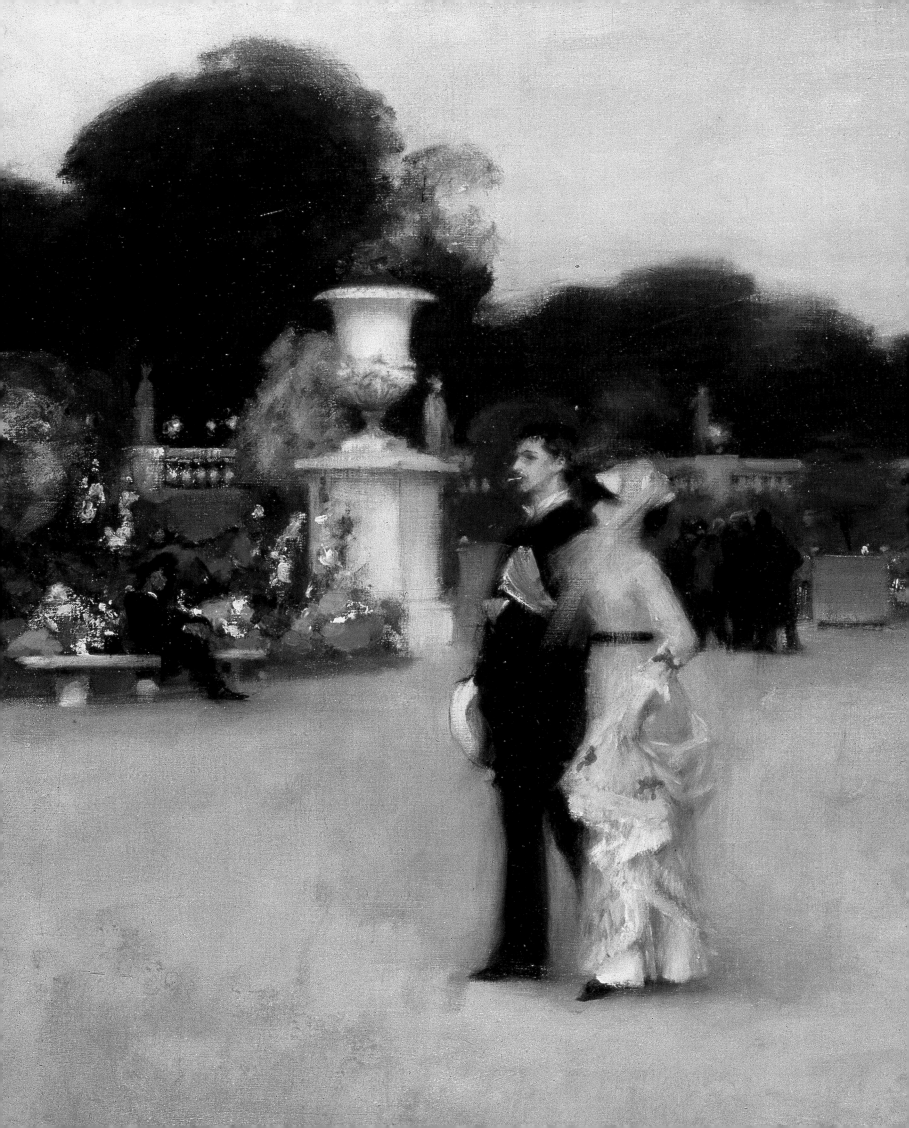

Under Napoleon III and the visionary town planner Baron Georges Haussmann (1809–1891), Paris was transformed from an organic city, where the medieval and the classical existed side by side, to a modern, stylish, urban environment that was visually harmonious and efficiently organized. The great network of boulevards that Haussmann planned, the avenues, parks and open spaces, created an elegant setting for the 'life on the streets' that became such a feature of Parisian life. This urban landscape inspired a generation of artists, who were captivated by a modern vision of light-filled beauty and lucid space. The Impressionists, in particular, claimed the city as a subject and made it pictorially their own. The Goncourt brothers mythologized this response in their description of the arrival in Paris of the Italian painter Giuseppe de Nittis (1846–1884). In their novelistic account, de Nittis arrived without friends, money or familiarity with the language, but his mood immediately lifted when he walked out from his lodgings and eventually found himself on the civilized expanse of the boulevard des Italiens: 'There, in this coming and going of men and women, in this movement, in this life of the Parisian crowd, under the gas lights, the sudden darkness that the artist felt inside, that darkness disappeared, and he was transported, enthused by the modernity of the spectacle'.[1]

Sargent lived in Paris for more than a decade, but he painted very few pictures of the city. His studies of the Luxembourg Gardens and the Cirque d'Hiver, which both exist in two versions (nos. 721–24), are exciting and innovative works that proclaim his modernist credentials. In contrast to the rural subjects of Brittany and Capri, the Paris pictures are a response to the urban themes developed by the Impressionists. The small number of Parisian works in Sargent's oeuvre reflects the circumstances of

his working life. During the winter and spring, he was occupied with portrait commissions and work in the studio; in the summer and autumn he travelled. *In the Luxembourg Gardens* (no. 721) was painted in 1879 during the one summer that he did spend at home, and it was the only Paris painting that he sent for exhibition.

The picture belongs to an established genre, that of the modern cityscape. The artist documented a favourite Parisian resort, peopled it with figures and drew out the atmosphere of a particular time of day, for example, the twilight hour. One is reminded of Claude Monet's scenes of the Parc Monceau, Édouard Manet's *Music in the Tuileries* (1862, National Gallery, London) and Auguste Renoir's *Le Moulin de la Galette* (1876, Musée d'Orsay, Paris).[2] Closer still in spirit to Sargent's painting are the city views by Italian contemporaries resident in Paris, such as Giovanni Boldini and Giuseppe de Nittis. In 1875, Boldini had painted a much-acclaimed view of the Place Clichy (Marzotto Collection) that seemed to express the very essence and vitality of Parisian life. Like Boldini, de Nittis was a friend of Edgar Degas and was, with Sargent, a fellow-exhibitor at the Galerie Georges Petit. His daring compositions and swift, incisive brushwork brought the city to life in a vivid way and made his reputation: *How Cold It Is!* (1874, private collection), showing three elegantly dressed Parisian women and a young child braving the chill of a winter's day on a path in the Bois de Boulogne, was a great success at the Salon; his picture of two young women sitting in a park, *Sulla panchina al bois* (fig. 94), sets dramatically posed figures against a spacious view of flowers and promenade, in a style akin to Sargent's, and *La Place du Carrousel: The Ruins of the Tuileries in 1882* (1882, Musée du Louvre, Paris) shows fashionable Paris going about its business against the

backdrop of the Arc de Triomphe du Carrousel and the ruins of the Tuileries Palace (destroyed by the Commune in 1871).

In the wake of Boldini and de Nittis, more commercially minded artists, such as Jean Béraud and Norbert Goeneutte, exploited the vogue for city views. There was an inexhaustible demand for images of modern Paris, and not just paintings. Photographers cashed in on the trend, issuing numerous albums and portfolios of photographs that charted every aspect of the city. It was the fashionable neighbourhoods around the Opéra, the Champs-Elysées, and the boulevard Haussmann that proved most popular with the public, along with parks and places of entertainment. Among the many images of the Luxembourg Gardens, one could cite Fritz Thaulow's glancing view of the upper terrace (*Jardin du Luxembourg,* 1883, National Gallery, Oslo), a similar view by Hubert-Denis Etcheverry (1894, sold Hôtel Drouot, 23 March 1984), another by Félix Vallotton (1895, private collection), Carpeaux's famous fountain by Eugène Galien-Laloue (c. 1900, Sotheby's, London, 22–23 June 1988, lot 695), a view of the pond by Édouard Henry Laurent (Musée Carnavelet, Paris), the terrace by Vincent van Gogh (*In the Jardin du Luxembourg,* 1886, Sterling and Francine Clark Art Institute, Williamstown, Massachusetts), and views towards the upper terrace similar to Sargent's by Auguste Leroux (Musée Carnavelet, Paris) and Antonio de la Gandara (1892, private collection). Edgar Degas and Albert Gustav Edelfelt painted scenes of nannies and babies or children in the Luxembourg, presenting the gardens as a setting for leisure, play and spectacle, a stage-set for the representation of modern life (*A Nanny in the Luxembourg Gardens, Paris,* c. 1875, Musée Fabre, Montpellier, and *The Luxembourg Gardens, Paris,* 1887, fig. 10). American artists translated the Impressionist vision of

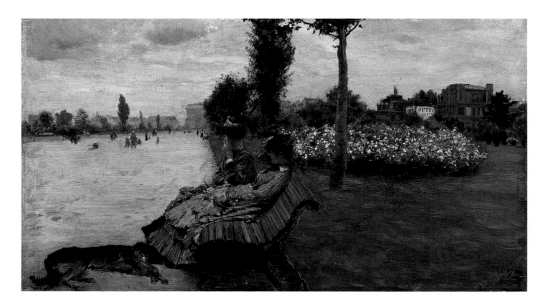

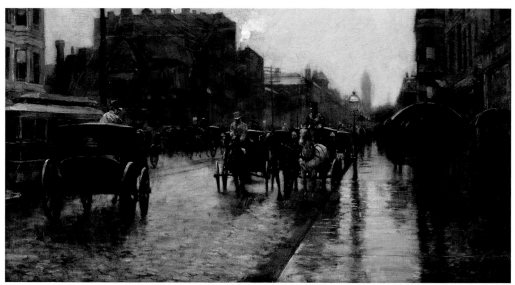

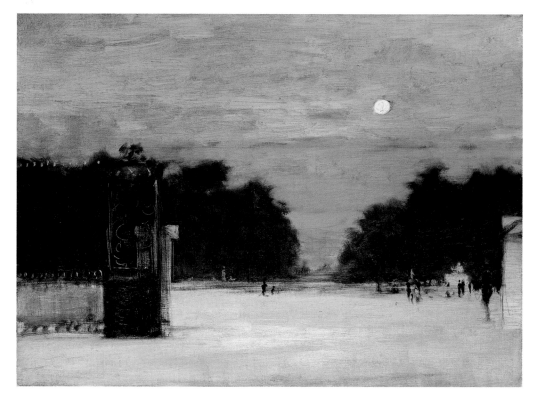

Paris to depictions of their own cities and neighbourhoods, such as Childe Hassam's paintings of the streets of his native Boston (fig. 95).

A picture that is extraordinarily close in handling and mood to *In the Luxembourg Gardens* is a view of the Tuileries Gardens (fig. 96) with a harvest moon hanging in the sky by Sargent's friend Henry Lerolle, who owned *Venetian Interior* (no. 798). It is comparatively slight in comparison to Sargent's finished work and lacks the foreground figures but is similar in its treatment of the spare foreground space and its subtle crepuscular atmosphere. A more conventional park scene is *The Tuileries Gardens, Children Playing* by the Finnish artist Akusti Uotila, dated 1880 (fig. 97). What appears so casual and suggestive in the Sargent, with its loose improvised technique, becomes, in Uotila's hands, a carefully detailed social document. Sargent's affinities lie more with the avant-garde; Degas's picture *Place de la Concorde* (fig. 98) provides a closer parallel in its evocation of a fleeting moment in time and its abrupt placement of the figures against the reach of the square. Sargent does not go as far as Degas in cropping figures, and his stiff couple are a world apart from the elegant and self-assured Viscount Lepic out for a walk with his daughters and his greyhound. Significantly, the men in both pictures are smoking—a characteristically modern touch.

Sargent produced *In the Luxembourg Gardens* as a picture to sell. In view of his earlier successes in America, he must have calculated that it stood a better chance in New York than in Paris. It appeared at the National Academy of Design late in 1879 to generally favourable reviews before being put up for auction by John H. Sherwood, who was probably acting as agent for the artist. The fact that it was exhibited at a commercial gallery in Boston in 1882 suggests that the picture had failed to sell two years earlier. This lack of success may have contributed to Sargent's reluctance to undertake any further Parisian subjects—his Italian and Spanish scenes were more popular—but he was also under pressure from portrait commissions.

In the middle of the nineteenth century, Paris was the musical capital of Europe. Berlioz's reputation had waned before his death in 1869, but grand opera, opéra comique, and virtuoso performance were flourishing in Paris. The Opéra, that great neo-Baroque symbol of Second Empire splendour with ceiling decorations by Paul Baudry, was completed in 1875 and, at the

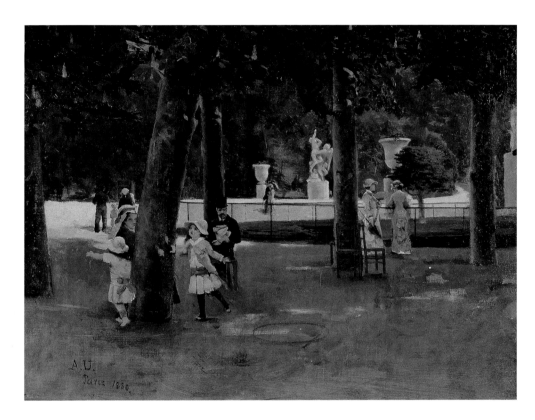

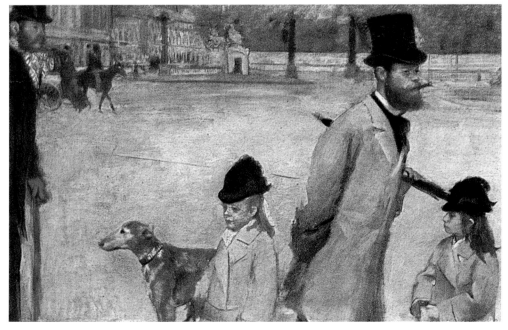

other end of the spectrum, café-concerts
were at the height of their popularity.

Sargent was passionately interested in
music, and his tastes were progressive and
adventurous. It was certainly music that
linked him to the French composer, con-
ductor and collector Emmanuel Chabrier,
who was close to Édouard Manet and his
wife Suzanne, a gifted musician to whom
he dedicated his *Impromptu in C Major.*
Sargent and Chabrier shared an enthusiasm
for *le wagnérisme* and for Spain: the vivid,
full-length oil sketch of a Spanish gypsy
dancer, 1879–80 (no. 768), which Sargent
inscribed to him, is a tribute to a fellow-
enthusiast.[3] Sargent would also paint three
oils, three water-colours and several drawings
of Judith Gautier, who was both an early
supporter of Wagner's music and one of
the composer's last passions. Jules-Étienne
Pasdeloup championed German music and
was in the vanguard introducing Wagner's
music to Paris. As Wagner was regarded as
both controversial and sensational, this van-
guard was not always a comfortable place:
Pasdeloup's concerts were frequently inter-
rupted by vociferous dissent, and he became
the scapegoat for those who were hostile to
Wagner's musical aesthetic. Pasdeloup was
motivated by a desire to bring contempo-
rary music to a democratic audience. When
his popular concerts were inaugurated in
1861, one music critic described their effect:

*Mr Pasdeloup has given three performances in
this Circus auditorium, and each time it had been
too cramped. And what fodder does he offer to the
eager dilettanti who dash to the boulevard Filles-
du-Calvaire from every corner of the capital city?
Beethoven's symphonies, overtures by Weber and
Mozart, concertos by Mendelssohn, everything
that is most serious in German art. If only he
were to offer it at prices that didn't hurt the wallet.
The programmes announce* A Popular Concert
of Classical Music. *Actually, I have seen some
working people there. But the middle classes make
up the great majority, music lovers and artists, and
especially artists, to whom the concerts are an ines-
timable kindness, because there aren't many
artists who can afford 6 francs to listen to a sym-
phony. One needs to be there to see the attentive-
ness of the crowd, how they understand, how they
follow everything, how involved they become, how
they applaud! One could not do better at the
Conservatoire. What are we to make of this suc-
cess? That the Parisian's taste for serious music is
much more lively than one would have thought,
that the high prices of the concerts is the only thing
keeping people away, and that, at moderate prices,
one could be sure of an audience of ten thousand
any time one wanted it.*[4]

Fig. 99
Concerts populaires,
1861. The concert
at the Cirque
Napoléon (later the
Cirque d'Hiver).
Bibliothèque
Nationale, Paris.

shot-like study. One of the Pasdeloup paintings was given by the artist to the musician George Henschel, while the other was owned, at an early date, by another friend, the artist Henry A. Bacon, and may also have been a gift. It is not known whether Sargent considered selling either work.

One can only speculate why Sargent chose not to pursue further the subject of modern city life which so entranced his contemporaries. It is possible that these all-too-rare slices of Parisian life were insufficiently commercial, or it may be that the modernity of the subject matter did not excite an artistic imagination that was so coloured by romantic nostalgia.

—*Elaine Kilmurray*

1. 'Là, dans cette allée et venue d'hommes et de femmes, dans ce mouvement, dans cette vie de la foule parisienne, aux lumières du gaz, tout d'un coup, le noir que le jeune homme a en lui s'évanouit. Il est transporté, il est enthousiasmé par la modernité du spectacle' (Edmond and Jules de Goncourt, *Journal. Mémoires de la vie littéraire* [Paris, 1956], vol. 12, p. 67). De Nittis first visited Paris in 1867 to see the Exposition universelle and settled there permanently in 1872. The Goncourts' diary entry, which is retrospective, is for 25 February 1880.
2. Monet painted three views of the Parc Monceau in the spring of 1876 and two further studies of the park in 1878. A painting from each of these two campaigns is in the Metropolitan Museum of Art, New York.
3. Chabrier's piano rhapsody *España,* in his own orchestrated version, was premiered in Paris in November 1883.
4. 'Voilà déjà trios séances que M. Pasdeloup donne dans cette salle du Cirque, qui, chaque fois, s'est trouvée trop étroite. Et quelle pâture offre-t-il à ces avides *dilettanti,* qui, de tous les points de la capitale, se précipitent vers le boulevard des Filles-du-Calvaire? Des symphonies de Beethoven, des ouvertures de Weber et de Mozart, des concertos de Mendelssohn, tout ce que l'art allemande a de plus sérieux. Seulement, il le leur offre à des prix qui n'effrayent aucune bourse. *Concert populaire de musique classique,* disent ses programmes. J'y ai vu, en effet, quelques ouvriers. Mais les *bourgeois* s'y trouvent en immense majorité, amateurs et artistes, artistes principalement, et ces concerts sont pour eux un bienfait inappréciable, car il n'y a pas beaucoup d'artistes qui puissant donner 6 fr pour entendre une symphonie. Il faut voir avec quelle attention recueillie cette foule écoute, comme elle comprend, comme elle tient compte de tout, comme elle jouit, comme elle applaudit! On ne fait pas mieux au Conservatoire.—Que faut-il conclure de ce succès? Que le goût des Parisiens pour la musique sérieuse est beaucoup plus vif qu'on ne l'a cru jusqu'à présent, que le haut prix des concerts est le seul obstacle qui les en éloigne, et qu'à des prix modérés on est certain de réunir dix mille auditeurs chaque fois qu'on le voudra' (G. Héquet, 'Chronique musicale', *L'Illustration,* 16 November 1861, p. 314).

The Pasdeloup concerts took place in the Cirque d'Hiver in the 11th arrondissement (fig. 99), where circus performances were regularly held. There were other indoor circuses operating as such in Paris at the period, notably the Cirque Fernando (later known as the Cirque Médrano) in Montmartre and the Nouveau Cirque. Degas's startling composition of the acrobat Miss La La being hoisted to the roof of the circus dome by a rope held between her teeth, *Miss La La at the Cirque Fernando* (1879, National Gallery, London), was exhibited at the fourth Impressionist exhibition in April 1879; Pierre-Auguste Renoir painted *Clown* (1868, Kröller-Müller Museum, Otterlo, The Netherlands) and *Jugglers at the Cirque Fernando* (1879, The Art Institute of Chicago); and Henri de Toulouse-Lautrec's *At the Cirque Fernando: the Ringmaster* (1887–88, The Art Institute of Chicago) indicates his obsession with circus performances.

It was natural that Sargent should be drawn to the Pasdeloup concerts by the music and, in painting studies of the orchestra in rehearsal, he was in fine artistic company. Degas, who was so committed to the depiction of modern life, was fascinated by the theatre in all its forms, by ballet, opera and café-concerts, famously painting dancers backstage, in rehearsal, in the wings and in performance in compositions of great daring and originality. For Degas, the world of the theatre was an artistic obsession, but many of his peers showed an interest in depicting the social experience of going to see a play or listen to a concert. If one were to list those pictures exhibited

in the Impressionist exhibitions as examples, it would become clear that artists frequently chose to depict the spectator rather than the performer as the principal figure in the scene: Pierre-Auguste Renoir's *La Loge* (1874, Courtauld Institute Galleries, London, Courtauld Collection), exhibited at the first Impressionist exhibition in 1874; Mary Cassatt's *In the Loge* (1878, Museum of Fine Arts, Boston), *Coin de loge* (*In the Box,* private collection) and *Femme dans une loge* (*Woman with a Pearl Necklace in a Loge,* 1878–79, Philadelphia Museum of Art), the latter two exhibited at the fourth Impressionist exhibition in 1879; Cassatt's etching and aquatint *Femme au théâtre* (*In the Opera Box,* The Metropolitan Museum of Art, New York), exhibited at the fifth Impressionist exhibition in 1880; and Degas's pastel of a theatre box without spectators (*Étude de loge au théâtre,* untraced), exhibited in the fifth Impressionist exhibition.

For his paintings of the Pasdeloup Orchestra rehearsing (nos. 723, 724), Sargent represents a section of the orchestra and the theatre from the position of the (unseen) spectator. From the sweep of the seats in the stalls we look down to the musicians below, Sargent exploiting the elevated viewpoint of the tier of seating to create a plunging view. The oblique, arbitrarily framed and partial view most closely relates to Degas's experimental and asymmetrical compositions, for example, *L'Orchestre de l'Opéra* (1870, Musée d'Orsay, Paris), which shows the musicians close-up in the foreground and the dancers in a blur of cropped legs and skirts in an arbitrarily truncated, snap-

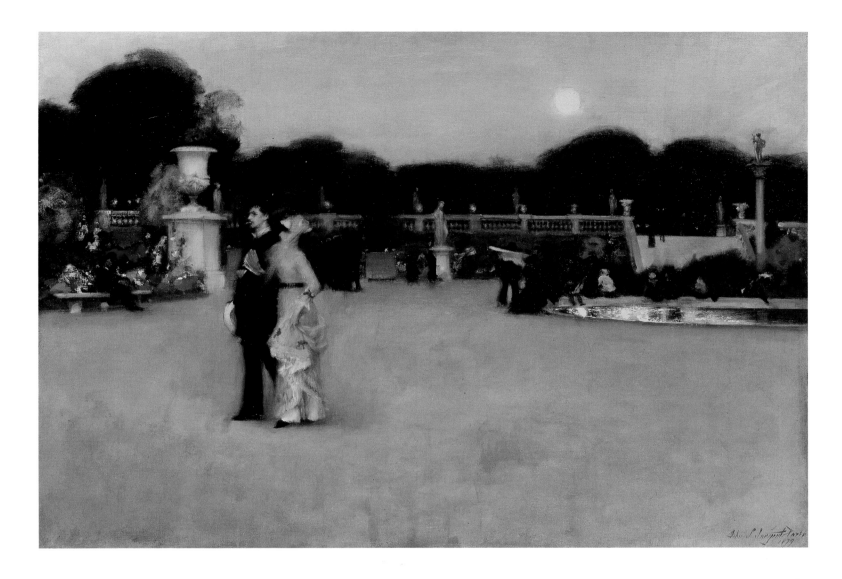

721
In the Luxembourg Gardens

1879
Alternative titles: *Summer Evening in
Luxembourg; The Luxembourg Garden,
twilight; The Luxembourg Gardens;
Garden of Versailles; Versailles Garden;
Luxembourg Gardens at Twilight*
Oil on canvas
25⅞ x 36⅛ in. (65.7 x 91.8 cm)
Inscribed lower right: *John S. Sargent
Paris/1879*
Philadelphia Museum of Art. The John
G. Johnson Collection, 1917 (cat. 1080)

This is one of two versions of the same
subject (see no. 722 for the other). The
artist was unable to remember which came
first, writing from the Copley-Plaza Hotel,
Boston, to Alan Burroughs of the Min-
neapolis Institute of Arts in a letter of 4
February (no year, probably 1924, when
Sargent was in Boston, and when Bur-
roughs is known to have written to him
about the picture, Institute archives):

*I am sorry to say I cannot remember which is the
original sketch and which is the replica of two ver-
sions of 'In the Luxembourg Gardens'. I think I
did them both at about the same time, and one
was exhibited and bought by Mr John G. John-
son, and the other I gave to McKim. I have not
seen either for more than thirty years—I am not
likely to go to Philadelphia or to Minneapolis, so
I fear my memory will remain unrefreshed.*

The Philadelphia picture is the more com-
posed and finished of the two, and it was
this painting which Sargent sold at the time,
retaining the other in his own collection,
until he gave it to the architect Charles

Follen McKim, probably at some date in
the 1890s; see the entry for the latter picture
(no. 722) for an analysis of the differences
between the two versions. A slight compo-
sitional sketch relating to both works is
among the J. Carroll Beckwith albums at
the New-York Historical Society (fig. 100).

The gardens of the Palais du Luxem-
bourg on the Left Bank (see figs. 101, 102)
were a popular place of resort for all sec-
tions of Parisian society. They had been
extensively remodelled in the 1860s, be-
coming more formal and architectural in
the process. The palace itself had been built
in the early seventeenth century for Henri
IV's widow, Marie de Medici, and in Sar-
gent's day it housed the State's collection of
contemporary art, the Musée du Luxem-
bourg. Today it is the home of the French
Senate. Nearby are several notable cultural
institutions, the École Nationale des Beaux-
Arts, the official art school of France where
Sargent had studied, the Institut de France
and the Sorbonne, the University of Paris.
The surrounding neighbourhood was full
of student lodgings and art studios, includ-

Fig. 100 *(top)*
Study for 'In the Luxembourg Gardens',
c. 1879. Pencil on paper, 7¹³⁄₁₆ x 12³⁄₁₆ in.
(198 x 310 cm). Collection of The New-
York Historical Society, 1935.85.3.153 recto
(Gift of the National Academy of Design).

Fig. 101 *(middle)*
Photograph of the Luxembourg Gardens,
c. 1890. Catalogue raisonné archive.

Fig. 102 *(bottom)*
Photograph of the Luxembourg Gardens,
c. 1955–60. Catalogue raisonné archive.

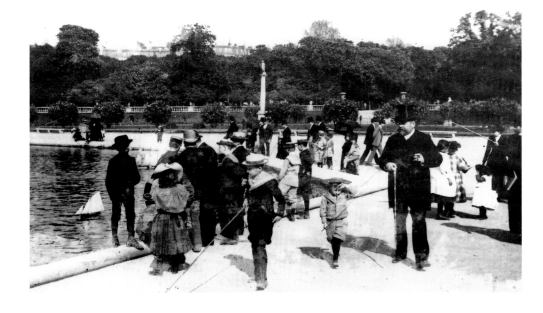

ing that of Sargent at 73, rue de Notre-Dame-des-Champs, and it retained some of the bohemian atmosphere of an earlier time. Taffy and 'the Laird', two characters in the novel *Trilby* (London, 1894) by George Du Maurier, always took a Monday morning stroll through the gardens to clear their heads; the novel recalled Du Maurier's art student days in Paris in the 1850s.

In painting a scene of contemporary life in an urban park, Sargent was demonstrating his modernist credentials. The Impressionists had been among the first artists to celebrate the restless energy and dynamism of the modern city, and they had done so in a style as radical as their imagery (see introduction to chapter 6). Sargent expresses the disconnectedness of modern life, with groups of people randomly gathered together but absorbed in their own lives. Even the foreground figures seem self-preoccupied and curiously indifferent to one another.

The picture depicts the area of the gardens in front of the Palais du Luxembourg, with part of the great basin that lies on the central north/south axis visible on the right. The basin is surrounded by two semicircular terraces, each one with a broad staircase in the middle, and we are looking eastwards across the park in the direction of the Pantheon and the Sorbonne. Unusually for an artist who prided himself on painting what he saw, Sargent suppressed the dome of the Pantheon, which is clearly visible from the spot where he painted the picture. Perhaps he felt that it detracted from the dense vegetation of the trees and the harvest moon hanging low in the sky. He did, however, include the dome in the second version of the subject (no. 722). The arrangement of the gardens has altered since Sargent's time: the statues are laid out differently, and there are no flowerbeds below the terraces now, but vases still line the balustrade, and the statue of David, atop a tall pillar, continues to face the matching statue of a nymph on the other side. Barbara Weinberg makes the interesting point that the artist chose to depict the architectural features of the gardens rather than the grassy banks and woodland, preferring the artificial to the natural (Weinberg 1994, p. 138).

The picture represents a young couple walking arm-in-arm across the wide gravel parterre that occupies more than half the picture space, and which, under the peculiar conditions of light, is rendered as a luminous sheen of soft mauve. This bold use of space serves to draw us into the scene as if we are observing the couple from the farther side of the terrace. The two are fash-ionably dressed, he in a black suit holding a straw boater by his side, she in a narrow pink walking dress that she holds up to protect the hem from the dust, a straw bonnet tied under her chin with a gauzy scarf, and a pale violet fan. The man is smoking a cigarette, a sign of casual and unconventional behaviour, especially in mixed company. The glow of his cigarette picks up the red edge of his companion's fan and the bright stabs of colour in the flowerbeds behind. The thin plume of cigarette smoke trailing behind indicates the slow passage of the couple across the space. Their class is difficult to determine, perhaps of the petit bourgeoisie, and they appear self-conscious and a little stiff with one another. Sargent highlights them at the front of his composition but gives them no role to play; soon they will walk out of the space and we will never know their story. *In the Luxembourg Gardens* looks back to *Oyster Gatherers of Cancale* (no. 670) in its processional theme of figures in a landscape, and forward to his scenes of Venice in its treatment of relations between the sexes in an urban setting.

Surrounding the great basin on the right of Sargent's picture are various figures, mostly in black: a man reading a newspaper; a seated female; another standing beside a small boy who clasps a sailing boat in his arms; and several more figures with their backs to us, one in white perched on the edge of the basin. Even on such a small scale, Sargent contrives to give these subsidiary figures character and life. Behind the basin is a flowerbed, and then comes a flight of steps leading to the terrace above, which is flanked by the sixteenth-century statue of David with the head of Goliath on a slender column. Two figures, a man and a woman, are moving up the steps, and three more stand at the top. Pinpricks of orange light from the street lamps gleam through the lower leaves of the trees, and above is a pale lavender sky. The top of the balustrade is decorated with vases holding geraniums, and behind stretches a ghostly row of seven marble statues of famous French women (mostly queens or saints), part of a group dating from the mid-century. Below the terrace in the centre is an eighth statue, with two women standing beside it, and a flowerbed in front of the terrace wall. On the left is a boxed tree, then a row of male figures, a monumental vase on a tall base, and finally a young man in black on a bench, clasping his knees, before a brilliant display of white, pink and crimson flowers. The border and trees behind (but not the balustrade) are the subject of a similar oil sketch, *Corner of a Garden* (no. 646) that may have served as a preliminary study.

Sargent sent the picture to John H. Sherwood in October 1879.[1] He was an art dealer with a gallery on 4th Street, New York, then a vibrant art centre. More significantly, he was the uncle of Sargent's close friend and fellow art student, J. Carroll Beckwith, who must have effected the introduction. The picture was briefly exhibited at the National Academy of Design, New York, before going to auction at Chickering Hall, New York, as the property of John H. Sherwood.[2] The auction price of $160 is recorded in a copy of the catalogue held by M. Knoedler & Co., New York, but as no buyer is listed, the picture may have been bought in. It was subsequently exhibited at Williams and Everett Gallery in Boston, where it was reviewed by the *Boston Daily Advertiser* (16 December 1882, p. 10). Two years later, the picture is recorded in the collection of Joseph M. Lichtenauer.[3] In 1887, the Philadelphia lawyer and collector John G. Johnson made an offer for the picture of $800 through M. Knoedler & Co., New York.[4] He, in turn, left it to the city of Philadelphia as part of his spectacular art collection, together with a later water-colour by Sargent, *Venetian Wine Shop*.

1. Sargent wrote to G. [Georges] Petit from Madrid on 20 October 1879, stating that the picture belonged to Sherwood and should have been shipped with another purchase. The letter was offered for sale by B. Altman & Co., New York, 1984 (see advertisement in *New York Times,* 11 November 1984, p. 53).
2. The sale contained a collection of works belonging to Sherwood and Benjamin Hart. The *New York Times* described them as 'gentlemen of wealth and dispositions to liberally patronize the fine arts' (18 December 1879; see also *Art Amateur,* no. 2 [January 1880], pp. 30–31).
3. A real-estate businessman in New York. His son, the painter J. Mortimer Lichtenauer, wrote that his father had bought the picture for $165 in 1884 (letter to Plimpton, 21 January 1926, The Minneapolis Institute of Arts archives).
4. Two letters from Knoedler concerning the purchase, 26 and 27 May 1887 (Philadelphia Museum of Art archives). In the second letter, the dealers wrote: 'Contrary to expectation, the owner accepts the offer for the Sargent though we have to scale down our commission. . . . This is evidently the time of the year to secure bargains'.

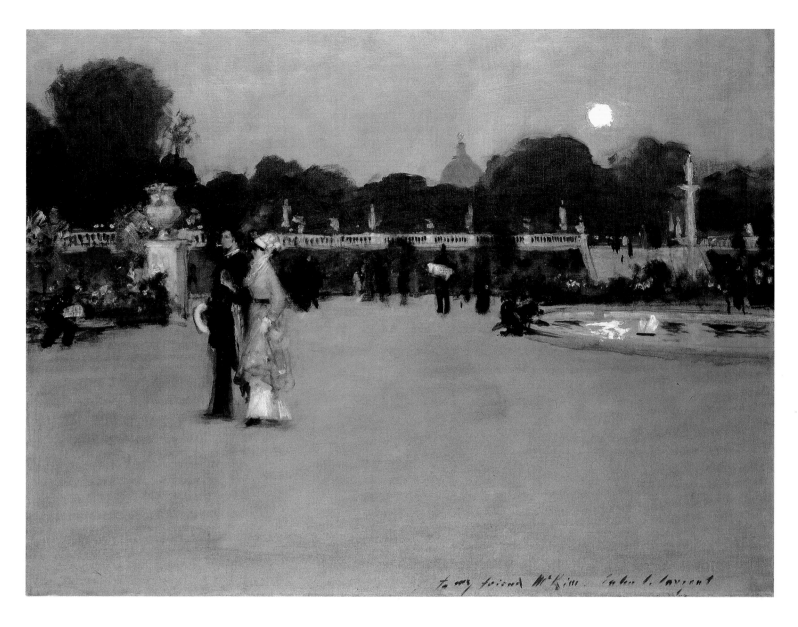

722
The Luxembourg Gardens at Twilight

1879
Alternative title: *Twilight in the
Luxembourg Gardens*
Oil on canvas
29 x 36½ in. (73.7 x 92.7 cm)
Inscribed lower right: *to my friend McKim
John S. Sargent*[1]
The Minneapolis Institute of Arts. Gift
of Mrs C. C. Bovey and Mrs C. D. Velie
(16.20)

This picture is one of two versions of the
same subject. The main lines of the compo-
sition and the foreground couple are simi-
lar in both, but the sketchier, more discursive
rendering of detail seen here is resolved
into a formalized design and a more fin-
ished effect in the Philadelphia version (no.
721). It was the latter which the artist chose
to exhibit and sell, while keeping the Min-

neapolis version for himself. Which of the
two versions came first was a question not
even the artist was able to resolve; see the
text of his letter on the subject to Alan
Burroughs in the entry for no. 721.

The Minneapolis version shows the
same couple walking across the gravel of
the sunken garden surrounding the great
basin of the Luxembourg Gardens as in the
Philadelphia picture, but there are differ-
ences in the treatment of the foreground
couple and the other figures. More of the
great basin is shown in this version (the
composition extends farther to the right),
and the figures crouching there are children
watching a toy sailing boat on the water
rather than adults with a single boy. The
man reading a newspaper is placed farther
away from the basin, and other figures are
scattered more casually in the background.
The trees on the terrace are quite thinly
painted and there are fewer flowers; no
geraniums are visible in the vases, for exam-

ple. The harvest moon is bolder and yel-
lower, and Sargent here includes the dome
of the Pantheon, inexplicably suppressed
in the Philadelphia version. Two of the stat-
ues on the upper terrace are here omitted,
the monumental vase on the left is bulbous
rather than straight-sided, the man on the
bench is reading a newspaper, and the dis-
play of flowers behind him is arranged dif-
ferently. Tonally, the Minneapolis version is
warmer, sketchier in treatment and more
spontaneous in mood than its companion.

1. Charles Follen McKim (1847–1909), a partner in the
 celebrated New York architectural practice of McKim,
 Mead and White; for a biography of McKim, see Moore
 1929. Offered for sale by McKim's daughter, Margaret
 McKim (Mrs William J. M. A. Maloney), to the Metro-
 politan Museum of Art, New York, in 1916, the picture
 was steered to the Minneapolis Institute of Arts by the
 director of the Metropolitan Museum, Edward Robin-
 son (for his portrait by Sargent, see *Later Portraits,* no.
 450). It was purchased for the Minneapolis Institute by
 two sisters, Mrs C. C. Bovey and Mrs C. D. Velie, at a
 price of $2,000 (correspondence between Mrs Maloney,
 Edward Robinson and Joseph Breek, director of the
 Institute, February 1916, Institute archives).

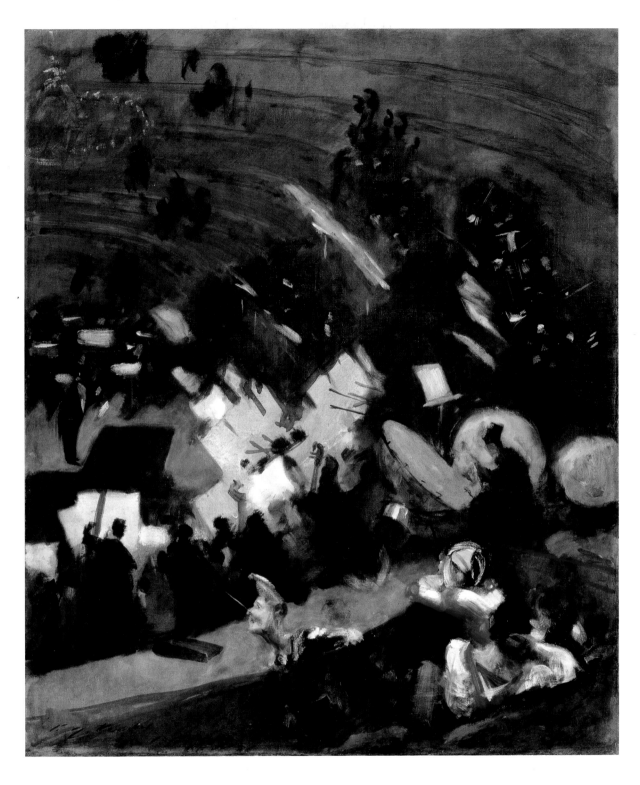

723
***Rehearsal of the Pasdeloup Orchestra
at the Cirque d'Hiver***

c. 1879
Alternative title: *Rehearsal of the
Lamoureux Orchestra, Paris*
Oil on canvas
35⅝ x 28¾ in. (90.5 x 73 cm)
Inscribed, lower left: *to G. Henschel/
John S. Sargent*
Private collection; on loan to The Art
Institute of Chicago (81.1972)

This painting represents a rehearsal of the
orchestra conducted by Jules-Étienne Pas-
deloup (1819–1887) at the Cirque d'Hiver.
The Cirque d'Hiver, originally the Cirque
Napoléon, is a small, ornate Second Empire
amphitheatre on the rue Amelot in the
11th arrondissement. It was built in 1852
under the direction of Jacques-Ignace Hit-
torff (1792–1867), who was also responsible
for the Gare du Nord and the decorative
design of the Place de la Concorde. It was,
and still is, principally a venue for circus
performances.

Pasdeloup, an advocate of progressive
music, had founded the Société des jeunes
artistes, in 1852. His aim was to facilitate
the performing of new music, and a year
later he also founded the 'Concerts popu-
laires de musique classique', based at the
Cirque Napoléon (fig. 99). In 1861, Pasde-
loup inaugurated a programme of popular
concerts of classical music, with tickets
costing 3 francs, 2 francs 50, 1 franc 25 and
75 centimes. The first of eight concerts took
place on 27 October and such was their
success that they were followed by a further

eight. The concerts were soon established as a feature of Parisian life: 'M. Pasdeloup has continued his concerts every year, during the winter season. They are given every Sunday, and at the same price. Only the music of the masters is played there: Beethoven, Mozart, Haydn, Weber, Meyerbeer, Mendelssohn, etc. The attendance is always enormous, and the success is growing. The Popular Concerts have become a Parisian habit' (Paul Féval *et al., Paris-Guide,* part 2, *La Vie,* Paris, 1867, p. 999). Pasdeloup also championed the music of Berlioz and, notably, Wagner, whose work was a recherché taste at this time, but which Sargent greatly admired. It may be that Sargent and his circle knew Pasdeloup personally: in his diary entry for 19 June 1881, Sargent's friend J. Carroll Beckwith described a visit to Versailles and then added: 'A chaise drove us home, where we found M and Mme Pasdeloup' (Beckwith Diary, Beckwith Papers, National Academy Museum and School of Fine Arts, New York).

In an article on Sargent written in 1896, the American artist and critic William Anderson Coffin recalled:

I remember how much we used to like to go to the Colonne concerts at the Châtelet, and to those given by Maître Pasdeloup at the Cirque d'Hiver, on Sunday afternoons. Some of us had heard Berlioz's 'Damnation de Faust' at the former place fifteen or sixteen times. Sargent, who dearly loved the music, was struck by the odd picturesqueness of the orchestra at Pasdeloup's, seen in the middle of the amphitheatre, the musicians' figures foreshortened from the high point of view on the rising benches, the necks of the bass-viols sticking up above their heads, the white sheets of music illuminated by little lamps on the racks, and the violin-bows moving in unison. While he listened he looked, and one day he took a canvas and painted his impression. He made an effective picture of it, broad, and full of colour (Coffin 1896, p. 172).

The reference to colour indicates that Coffin is referring to this picture rather than to the monochromatic version of the same subject (no. 724). The article also has a bearing on the date of the picture. William Coffin lived in Paris for three years from 1877, which would suggest that the '1876' date, given to no. 724 (see Literature) by Downes, Charteris and in the Boston 1925 and New York 1926 exhibition catalogues must be erroneous.

Several preliminary sketches suggest that the oils were less spontaneous than Coffin's account would imply, and that, in fact, they were the product of considerable

Fig. 103 *(opposite top)*
Study for 'Rehearsal of the Pasdeloup Orchestra at the Cirque d'Hiver', c. 1879. Pencil on paper, 3⅜ x 5⅜ in. (8.6 x 13.7 cm). The Metropolitan Museum of Art, New York. Gift of Mrs Francis Ormond, 1950 (50.130.154c).

Fig. 104 *(opposite middle)*
Musicians, Related to 'Rehearsal of the Pasdeloup Orchestra at the Cirque d'Hiver', c. 1879. Pencil on paper, 3³⁄₁₆ x 5½ in. (8 x 14 cm). The Metropolitan Museum of Art, New York. Gift of Mrs Francis Ormond, 1950 (50. 130. 154c2).

Fig. 105 *(opposite bottom)*
Sketch for 'Rehearsal of the Pasdeloup Orchestra', c. 1879. Pencil on paper, 3¾ x 5¾ in. (9.5 x 14.5 cm). Museum of Fine Arts, Boston. Gift of Thomas Alfred Fox (28.50).

Fig. 106
Study for 'Rehearsal of the Pasdeloup Orchestra at the Cirque d'Hiver', c. 1879. Untraced. From a negative by Peter A. Juley, c. 1928. Peter A. Juley & Son Collection. Smithsonian American Art Museum, Washington, D.C. (PPJ 22538).

Fig. 107 *(below)*
Study for 'Rehearsal of the Pasdeloup Orchestra at the Cirque d'Hiver', c. 1879. Untraced. From a negative by Peter A. Juley, c. 1928. Peter A. Juley & Son Collection. Smithsonian American Art Museum, Washington, D.C. (PPJ 22532).

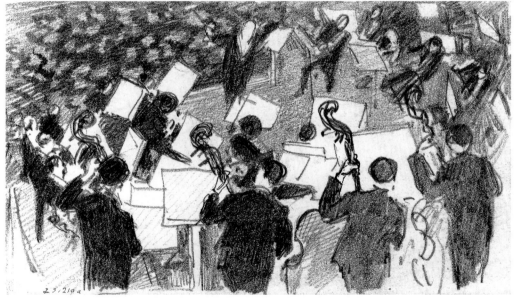

compositional deliberation. Three small sketches on sheets of similar size and with a similarly horizontal format may come from the same sketchbook. One drawing (fig. 103) describes the curving sweep of the rows of seats in the amphitheatre and several musicians with their instruments in dense, rapid hatching, which generates a vivid, animated impression. The tympanum at the lower right is in a similar position to those in both oils; but the figural element in the lower right-hand corner is difficult to read, though it may relate to the group of four clowns watching the rehearsal in the present work. The corresponding area in no. 724 is left blank and is occupied by the inscription and signature. A second drawing (fig. 104) concentrates on a single, carefully delineated figure with a bass viol on the right, while to the left there are the more summarily sketched forms of tympanum and a seated figure in a top hat playing a bass viol or cello. A third sketch (fig. 105) shows a larger section of the orchestra in abbreviated form so that the shapes of the instruments, especially the tympanum at lower right and that of the hats and sheet music, stand out. Two further preliminary drawings are boldly worked and more fully realized. In fig. 107, Sargent focuses on the activity of the orchestra as a body, creating both a charge of movement and energy and a powerful sense of formal pattern and design. The only drawing with a vertical format (fig. 106) stresses the diagonal lines of the viols (relating to the upper right of the composition in both oils) and gives descriptive prominence to the tympanum being played in the foreground. In the latter two drawings, the sheet music is prominently outlined and highlighted.

The present work is larger and more highly developed than no. 724 (two distinct features, the clowns in the right foreground and the chandelier in the upper left are absent in the Boston version), which might support the view that this is the first version, and that no. 724, refined and condensed, was executed later, perhaps expressly for illustration. This proposition is substantiated by three sheets with summary sketches by Sargent of clowns in a balcony which are in an album that belonged to J. Carroll Beckwith (fig. 108). One of these, which includes thumbnail sketches of the amphitheatre in a horizontal format, is on the verso of a pencil study for *In the Luxembourg Gardens*

(fig. 100). This suggests that the Pasdeloup and Luxembourg Gardens pictures (nos. 721, 722) must be similar in date.

The picture is inscribed to the musician Sir George Henschel (1850–1934), whom Sargent painted in 1889 (see *Early Portraits,* no. 180). It was included in his sale at Christie's, London, in July 1916, and was bought by M. Knoedler & Co., New York. It was bought by Sargent's friend the entrepreneur and collector Charles Deering (1852–1927) (see *Early Portraits,* no. 4; *Later Portraits,* no. 577) and has remained in the collection of his descendants.

Fig. 108
Three Studies for the 'Rehearsal of the Pasdeloup Orchestra at the Cirque d'Hiver', c. 1879.
Collection of The New-York Historical Society (Gift of the National Academy of Design);
upper left: pencil on paper, 7¹³⁄₁₆ x 12³⁄₁₆ in. (198 x 310 cm). 1935.85.3.153 verso;
bottom left and right: pencil on paper, 7⅞ x 12¼ in. (200 x 311 cm). 1935.85.3.154 recto and verso.

724
Rehearsal of the Pasdeloup Orchestra at the Cirque d'Hiver

c. 1879
Oil on canvas
22½ x 18⅛ in. (57.2 x 46 cm)
Inscribed, lower right: *rehearsal at the Cirque d'Hiver/John S. Sargent*
Museum of Fine Arts, Boston.
The Hayden Collection (22.598)

In this monochromatic study, the stage is grey and brown, and the musicians, in black tailcoats and top hats, are represented in a semicircle and seen from the same high vantage point as in no. 723. The musical instruments are described in brown and black, and the white of their sheet music is strongly highlighted. The composition is sparer and more considered than that of no. 723; it is lacking the chandelier and the group of brightly clad clowns who watch the orchestra from the position of a balcony above in no. 723, and the rows of seat-ing are less clearly defined. The palette is more refined and the handling less broad; the brass section of the orchestra to the right, for example, is treated with partic-ular delicacy. The compositional and tonal restraint enhances the sense of musical energy and movement and underlines the dramatic and experimental viewpoint. Sar-gent executed a theatrical study in mono-type entitled *The Dream of Lohengrin* (c. 1890, The Fine Arts Museums of San Francisco), which uses a more orthodox angle of vision but displays something of the blurred energy that catches the intensity of musical per-formance in the present work. For back-ground about the Pasdeloup concerts and for a discussion of the preparatory drawings and the issue of dating, see no. 723.

The painting was acquired directly from the artist by the American painter Henry A. Bacon (1839–1912). Sargent gave four marine studies to Bacon, and it is probable that the present work was also a gift. Bacon lived in Paris for many years; he studied under the French Academician Alexandre Cabanel and the genre painter (Pierre) Édouard Frère and exhibited at the Salon almost every year from 1867 to 1896. On Bacon's death, the picture passed to his widow, Louisa Lee Andrews Bacon, later Mrs Frederick L. Eldridge (1856–c.1947): it is visible in a photograph of the interior of their house at Ardsley-on-Hudson, New York, published in *Country Life in America* (January 1920, p. 54). The painting was with Doll & Richards, Boston, before 1922, when it was sold to the Museum of Fine Arts, Boston. For more information about Henry A. Bacon, see no. 663.

This was probably the work shown at the St Botolph Club, Boston, in November 1883 in an exhibition of pictures executed in black and white. The owner of the work was given in the exhibition catalogue as J. R. Osgood & Co. Osgood and Co. were the publishers of Henry A. Bacon's personal survey of the contemporary art scene in Paris, *Parisian Art and Artists,* which was published in 1883, and in which the present work was illustrated.

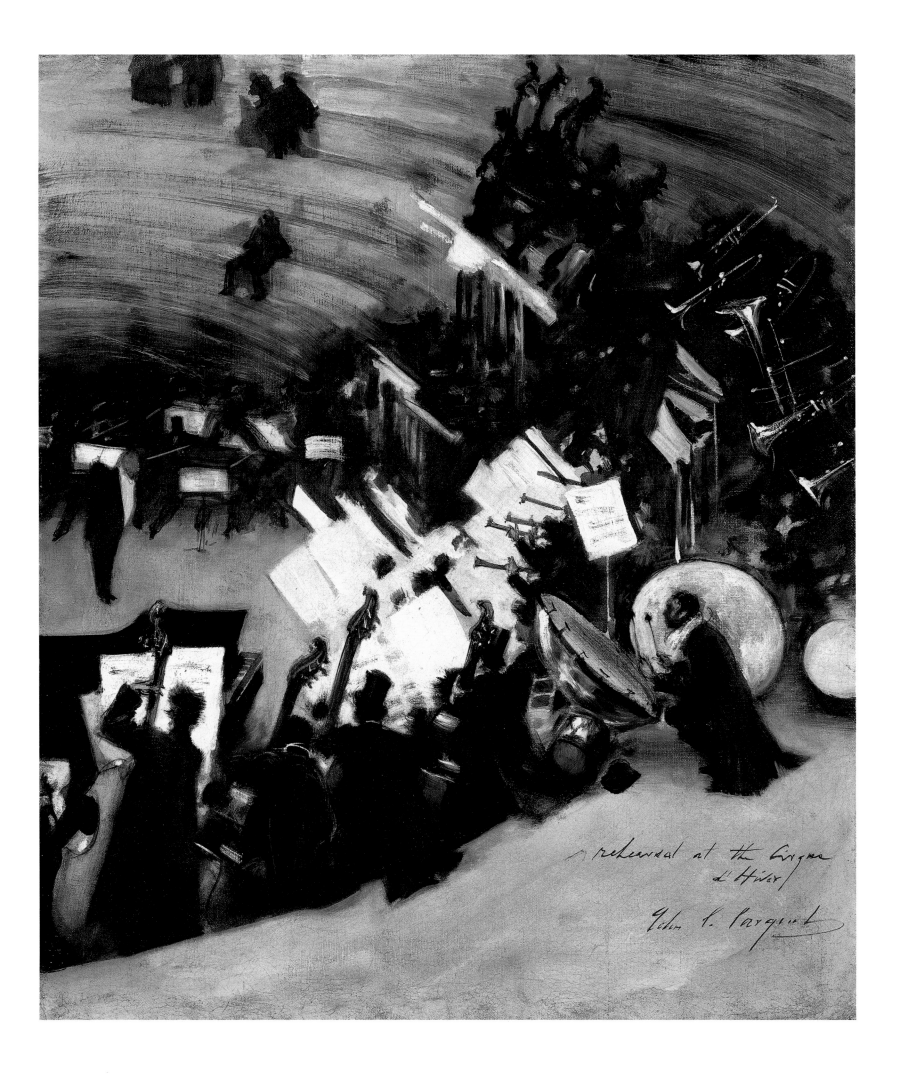

rehearsal at the Cirque
d'Hiver

John S. Sargent

725
Woman in Furs

c. 1879–80
Alternative titles: *Femme avec Fourrures;*
D. Vergèses; La Femme aux Fourrures
Oil on canvas
11⁵⁄₁₆ x 8¾ in. (28.7 x 22.2 cm)
Inscribed upper left: *à mon ami/*
D. Vergèses/John S. Sarg/ent
Sterling and Francine Clark Art Institute,
Williamstown, Massachusetts (578)

This picture has been compared to the work
of Édouard Manet in its stylish and simpli-
fied juxtaposition of a woman in black
against a field of snow. The woman is fash-
ionably dressed in a tall black hat, a black
overcoat or cape with a deep fur collar, and
a fur muff with a sliver of yellow glove just
showing. The forward slant of her upper
body suggests that she is walking, and this
sense of motion is enhanced by Sargent's
rapid execution and sketchy rendering of
features. In the entry for the picture for the
Clark Art Institute's catalogue, Margaret
Conrads discussed its technical aspects
(Clark Art Institute 1990, p. 177):

In Woman with Furs *the cropping of the image*
along the bottom magnifies the appearance of a
fleeting instant. At the same time, he considered
the effect of contrasting light and dark. Using a
palette based in black, brown, and white, he indi-
cated the figure and costume with broad strokes of
paint, so that they stand out against the gray
landscape. A few hints of peach and yellow in the
sky, the flesh color of the woman's face and wrist,
and the red of her lips provide counterpoints to the
stark image and its surroundings.

The field of snow reads at first sight like a
flat backcloth, and it is only as the eye takes
in the line of reeds or tall grasses at the top
of the space and the strip of sky that we
recognize it as a sloping field. It is likely
that the picture was painted in the environs
of Paris. Comparison with other early por-
traits and figure studies suggests a date of
c. 1879–80. In his card for the picture (cat-
alogue raisonné archive), David McKibbin
tentatively identified the woman as Mme
Errázuriz. Sargent painted two profile por-
traits of this Chilean friend and beauty
around 1880–82 (*Early Portraits*, nos. 69, 70),
whose cast of features accords well with
those of *Woman in Furs;* for two later por-
traits of Mme Errázuriz, see *Early Portraits,*
nos. 71 and 72.

The person to whom the picture is
inscribed has been identified by David

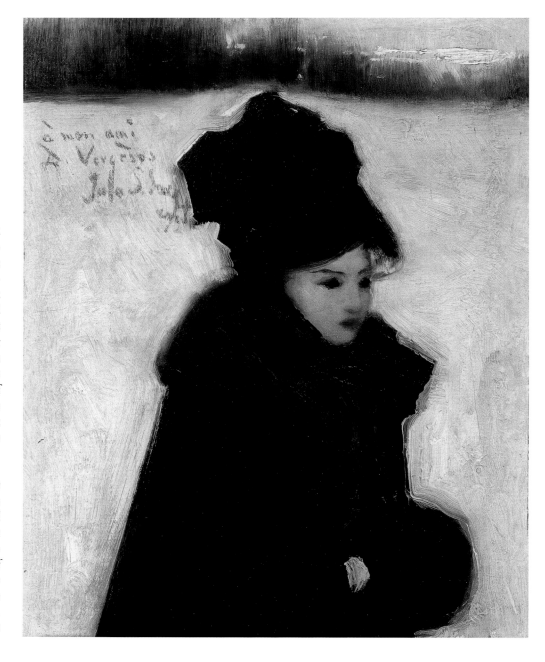

McKibbin, probably correctly, as Hippolyte
de Vergèses (1847–1896), who studied with
Carolus-Duran and Jean-Léon Gérôme.
He exhibited at the Salon in 1870 and then
again 1879–82, presumably studying at the
Carolus-Duran atelier in between, where
he would have met Sargent. When Sargent
inscribed the painting, he allowed insuffi-
cient room for the inscription and had to
write his surname on two separate lines,
close to the head of the model.

726 *(opposite)*
A Young Girl Seeking Alms

c. 1878–80
Alternative titles: *Spanish Beggar Girl;*
A/The Parisian Beggar Girl; Beggar Girl
Oil on canvas
25⅜ x 17³⁄₁₆ in. (64.5 x 43.6 cm)
Inscribed, bottom right: *À mon ami*
Edelfelt/John S. Sargent
Terra Foundation for the Arts, Daniel
J. Terra Collection, Chicago (1994.14)

The model in this early study looks more
like a girl at first communion than a beggar
girl. A white silky shawl covers her head and
wraps round her right arm, which juts out
with her hand on her hip, and then loops
down the other side under her left arm, held
out for alms, and across her waist. A long

black sash circles her hips and falls down over her white dress to a knot, the ends of which reach almost to the ground. Her pleated white shirt reveals a puffed sleeve, with a section of red visible below the elbow, and a frilly cuff. Part of a pink ribbon peeps out from her hair. The costume is exotic, the black sash giving it an oriental air.

With her head cocked to one side, the girl in the picture looks out with a brooding expression on her features, and the way she holds out her hand is defiant rather than submissive. She is typical of the sultry adolescent types Sargent was painting at this period, and she is probably Spanish or Italian. David McKibbin (McKibbin 1956, p. 84) speculatively identified her as Carmela Bertagna by comparison with the picture of the model catalogued in *Early Portraits,* no. 16. The black sash appears in another picture of this time, *Two Nude Boys and a Woman in a Studio Interior* (no. 629), worn by the elder of the two boys.

The title given to the picture when it was first acquired by M. Knoedler & Co., London, in 1922, was 'A Spanish Beggar Girl'; Sargent was still alive at the time, and Knoedler's was in touch with him, so the title may have had his blessing. However, by the time of the artist's memorial exhibitions in Boston and New York, 1925 and 1926, respectively, the picture was known as 'A Parisian Beggar Girl'. The picture was given by Sargent to the Finnish artist Albert Gustav Edelfelt (1854–1905), a friend and fellow art student in Paris, together with an oil sketch painted in Capri, *Two Boys on a Beach with Boats* (no. 697). Edelfelt's letters home during the period 1877 to 1883 are full of references to Sargent, whom he looked up to and admired. Edelfelt's letters were published under the title *Ur Albert Edelfelt Brev;* the volumes for the late 1870s and early 1880s are *Drottning Blanca och Hertig, Carl Sant Nägra* (Helsinki, 1917), and *Resor och Intryck* (Helsinki, 1921).

The picture was loaned by the artist's widow, Ellan Edelfelt (secondly, Ellan von Born), to the Finnish Art Association's Gallery, The Ateneum, Helsinki, from 1906 to 1912.[1] In 1922, the picture was sold to M. Knoedler & Co., London, by the well-known Finnish art historian resident in Britain, Dr Tancred Borenius (1885–1948), presumably on behalf of the widow, whom he must have known well. For biographical details of Borenius and his Finnish connections, see *Who Was Who 1941–1950,* vol. 4 (London, 1952, pp. 121–22). In October 1922, Knoedler, New York, sold the picture to the Chicago art collector Paul Schulze,

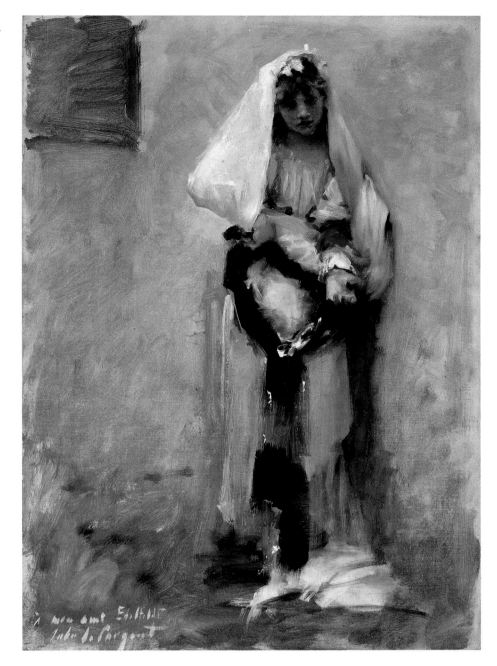

who owned a number of American pictures, mostly of the realist school. He opened a bakery at the time of the 1893 Chicago World's Fair, which grew to be one of the largest in the country (see Barter *et al.* 1998, p. 28); he and his wife donated a number of works to the Art Institute of Chicago. According to the exhibition catalogue of *The Burch-Schulze Collection of Masterpieces of American Painting* (Virginia Museum of Fine Arts, Richmond, 1937, p. 11): 'Mr. Schulze was on the lookout for a canvas by this pre-eminent American portrait and figure painter. While in Europe, word came that there was a Sargent in London. Mr. Schulze travelled posthaste, to find that the canvas had crossed the ocean to New York, where he finally purchased the coveted picture, "The Beggar Girl", a small canvas

reflecting a period in Sargent's career when he painted abstract types, much as did Hassam in his early painting days'. Knoedler records bear out this story, for the London office purchased the picture from Borenius in July 1922, shipped it across the ocean to the New York office in September, and they sold the picture to Schulze in October.

1. The picture is listed in [The Ateneum, Helsinki], *Finska konstföreningens matrikel för 1906* (Helsinki, 1907), p. 9, as having been deposited in the gallery by Edelfelt's widow, along with a number of other works. It is included in a later list of works on loan to the gallery in 1909, 'Förteckning öfver taflor, studier etc., tillhöriga E. von Born och deponerade i Finska konstföreningens galleri', in the Sarvlax Archives at the Svenska Litteratursällskapet i Finland, Helsinki; a pencil annotation states that the pictures were returned to the owner on 1 March 1912. The authors are enormously grateful for these references to the Finnish art historian Marie-Sofie Lundström, who is writing a Ph.D. dissertation on Edelfelt and other Finnish artists who travelled to Spain.

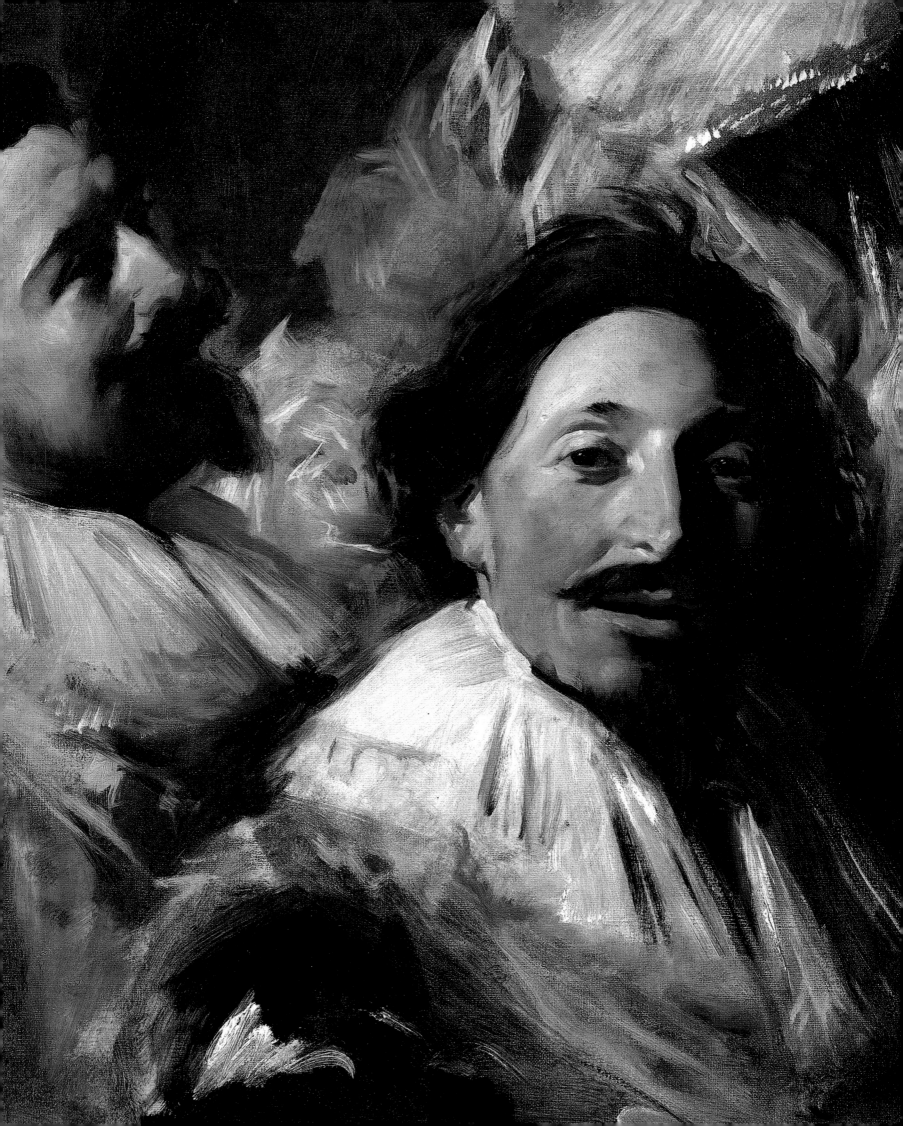

STUDIES AFTER THE OLD MASTERS, c. 1879–1880

VELÁZQUEZ

Of all the old masters whom Sargent studied, it was Velázquez above all whom he admired.[1] During his training in the studio of Carolus-Duran, he was instructed to believe that Velázquez had the most to teach him. From mid-century, the Spanish master had become an iconic figure for the younger generation of realist painters, a kind of proto-modernist revered for his faithful recording of reality and his mastery of tonal values. The 2002–3 exhibition *Manet/Velázquez: The French Taste for Spanish Painting,* in Paris and New York, demonstrated how pervasive was the influence of the Spanish master over French art of the nineteenth century and how closely entwined it was with notions of the avant-garde.[2]

A steady stream of artists made the pilgrimage to Madrid to study Velázquez's masterpieces in the Prado Museum, including Léon Bonnat, Thomas Eakins, Henri Regnault, and Carolus-Duran.[3] Among Sargent's contemporaries and friends who made the journey to Madrid were Charles Sprague Pearce and J. Alden Weir (1870s), William Turner Dannat and Walter Gay (both 1878), J. Carroll Beckwith (1880), and William Merritt Chase (1881).[4] Carolus-Duran constantly invoked the name of the Spanish painter, admonishing his students, "'Search for the half-tone'", he would add, "put in some accents and then the lights . . . Velasquez, Velasquez, Velasquez, relentlessly study Velasquez'".[5] Sargent did not need much encouragement to follow Carolus-Duran's advice to copy the work of Velázquez, for the latter's preoccupation with the properties of light and shade and painterly style mirrored his own.

Sargent arrived in Madrid around the middle of October 1879; for his stay in Spain, see the introduction to chapter 8 (pp. 225–27). Thirty-seven days passed between the time when Sargent started his first and finished his last two studies of Velázquez's paintings in the Prado Museum. The register of copyists in the Prado archives, the *Libro registro de los señores copiantes* (volume containing 1879), records Sargent's name on 14 October 1879, when he first applied, giving his address as [Calle de la] Salud 13, but leaving the column for referees blank. It is the daily register of copyists, the *Libros de copistas* (volume for 1879), that provides the vital evidence of which pictures Sargent actually copied.[6] The *Libros de copistas* records the consecutive number of each copy within the register, the name of each copyist, the title of the work to be copied, the dates on which it was begun and finished, and the measurements. In spite of some discrepancies in size, the authors are reasonably confident that the nine paintings by Sargent after Velázquez recorded in the *Libros de copistas* can be identified with the seven copies in the artist's sale of 1925 (Christie's, London, 27 July 1925, lots 229–35), and the two retained by the artist's sister, Emily Sargent, *Las Meninas* and the *Buffoon Juan Calabazas* (nos. 730, 729). The copy of the *Infanta Margarita* (no. 738), also in the artist's sale, was almost certainly painted in 1879, though not recorded in the *Libros de copistas*. In addition to the ten copies after Velázquez, Sargent painted one study after Jusepe de Ribera in the Prado (no. 732). He also copied *The Three Graces* by Rubens, Giandomenico Tiepolo's *Descent from the Cross* (nos. 745, 744), and *Angels in a Transept, Study after Goya* (no. 746). The copy of Titian's *Philip II* (private collection) seems to be later, and the copy after El Greco's *Pietà* (private collection) was painted in 1895.

Details of Sargent's copies from the *Libros de copista*s in 1879:

	Title	No.	Measurements	Date Begun	Date Finished
1.	*Principe Baltasar*	813	50 x 40 cm	17 October	
2.	*Tonto de Coria*	823	50 x 40 cm	21 October	5 November
3.	*Meninas*	835	100 x 110 cm	27 October	14 November
4.	*Principe Baltasar*	859	40 x 20 cm	11 November	20 November
5.	*Un Enano*	860	140 x 107 cm	11 November	22 November
6.	*Cristo de Rivere* [*sic*]	873	30 x 20 cm	15 November	15 November
7.	*Vulcano*	874	20 x 5 cm	15 November	15 November
8.	*Esopus*	881	30 x 20 cm	20 November	22 November
9.	*Un Soldado de Velazquez*	882	30 x 20 cm	22 November	22 November
10.	*Las Hilanderas*	884	20 x 30 cm	22 November	22 November

Current details of Sargent's copies:

	Title	Catalogue no.
1.	*Head of Prince Baltasar Carlos*	728
2.	*Buffoon Juan Calabazas*	729
3.	*Las Meninas*	730
4.	*Prince Baltasar Carlos on Horseback*	731
5.	*Dwarf with a Dog*	733
6.	*Christ, after Ribera*	732
7.	*Figure of Apollo from 'The Forge of Vulcan'*	734
8.	*Head of Aesop*	735
9.	*Buffoon Don Juan de Austria*	736
10.	*Las Hilanderas*	737

Detail of *Two Heads from 'The Banquet of the Officers of the St George Civic Guard', after Frans Hals* (no. 739)

Of Sargent's Prado copies after Velázquez, the four which record complete compositions (nos. 2, 3, 4 and 5) are also those to which he devoted the greatest amount of time. The *Buffoon Juan Calabazas* (no. 2), on which he spent fifteen days, is the most highly finished of the copies, and the one most faithful to the original painting. *Las Meninas* (no. 3) was the most ambitious of his copies, taking eighteen days and overlapping with the *Buffoon Juan Calabazas* for nine of them. The later copies of *Prince Baltasar Carlos on Horseback* and *Dwarf with a Dog* (nos. 4 and 5), the latter now given to Velázquez's workshop, are more painterly interpretations, both executed over roughly the same period, nine days for the former and eleven days for the latter. Sargent's first copy in the Prado was a study of the head of *Prince Baltasar Carlos* (no. 1), taken from the equestrian picture, and this is the only work where no completion date is given in the register. Of the remaining four copies, two are heads taken from full-length compositions (nos. 8 and 9), one is a figure from *The Forge of Vulcan* and the last is a partial reprise of *Las Hilanderas* (no. 10). Five of the copies, including the *Christ, after Ribera,* were painted in the last week of Sargent's activity in the Prado (nos. 6–10). With the end of his stay in Madrid in sight, he must have decided that the best way to use his limited time would be to substitute studies of parts of pictures rather than to attempt copies of complete works.

The pictures by Velázquez which Sargent chose to copy reveal a strong bias in favour of portraiture. The colour harmonies, limited palette, loose brushwork and ambiguous space of Sargent's early portraits already reveal an affinity with the art of Velázquez, even before his trip to Spain. *Las Meninas* is something of an anomaly, being both portrait and grand figure composition. The only subject works copied by Sargent were *Las Hilanderas* and *The Forge of Vulcan* (nos. 10 and 7); the first records about two-thirds of the original composition, and the second is a single figure. Four of the portrait studies are of dwarfs, buffoons (or court jesters) and the beggar-philosopher *Aesop* (nos. 2, 5, 8 and 9). A love of the bizarre and outlandish was an important part of Sargent's aestheticism, and he was naturally attracted to the human oddities who peopled the Spanish court. The portraits of Philip IV's buffoons by Velázquez, with their eccentricities and deformities, were perceived as masterpieces in the nineteenth century. The only royal personages to be painted by Sargent were the Infanta Mar-

garita in *Las Meninas* and the heir to the Spanish throne, Prince Baltasar Carlos, whose equestrian portrait he copied twice (nos. 1 and 4).

Early on in his Prado campaign, Sargent chose to copy the picture of the *Buffoon Juan Calabazas*, also known as the 'Idiot of Coria'. Sargent's copy (no. 729), painted on the same scale as the original, captures the detail of the face and figure, and the enveloping mood and atmosphere of the original work. The spirit of Juan Calabazas lights up several of Sargent's own portraits of strained and beautiful women of the early 1880s. The melancholy *Mrs Charles Gifford Dyer* (*Early Portraits,* no. 57) clasps her hands in a gesture very similar to that of the buffoon, while *Madame Errázuriz* (*Early Portraits,* no. 71) gazes up at us with her lips parted in a similarly enigmatic smile.

If the *Buffoon Juan Calabazas* gave Sargent a lesson in the technique of painting, then *Las Meninas* (no. 730), painted at the same time, taught him not only the principles of perspective and ambient space but also the art of relating the figures to the surrounding space. His copy, a third the size of the original, is a complete rendition of Velázquez's picture, though darker in tone; the original Velázquez has been restored and lightened in recent times. Sargent painstakingly reproduced the proportions of the room and the infinitely subtle gradations of tone and colour that mark its depths. In the years following his return from Spain, Sargent became a master of the dark interior. His 1882 portrait of *The Daughters of Edward Darley Boit* (*Early Portraits,* no. 56) has often been cited as a modern-day *Las Meninas,* but the two pictures are different in character. In place of the clear proportions and singular space of Velázquez's grand hall and the lighted space in the rear, Sargent presents a space of uncertain dimensions with an alcove opening out of it so dark you can see little more than the faint reflections of a window in the mirror. The motif of the inset alcove has more in common with *Las Hilanderas* (no. 737) than it does with *Las Meninas.*

The pictures that derive more directly from *Las Meninas* are the series of interiors the artist painted of an upper hallway of a Venetian palazzo in the period 1880–82 (see nos. 794, 795, 798). As in *Las Meninas,* the mystery of the people and of the lives they lead is inseparable from the mystery of the shadowy interiors they inhabit. The spaces become emotionally charged and expressive of the subjective inner world of the inhabitants in the way that the artist

arranges and poses the figures. His modern reading of female psychology in a working-class setting is far removed from the stately rituals of Spanish court life, but his use of deep ambient space to give meaning and resonance to the people within it links his work to that of Velázquez.

The two copies which occupied most of Sargent's time, after the completion of the *Buffoon Juan Calabazas* and *Las Meninas,* were *Prince Baltasar Carlos on Horseback* and *Dwarf with a Dog* (nos. 731, 733). Both present incongruities of scale that would have appealed to the artist. Sargent's copy of *Prince Baltasar Carlos* is a small-scale impression that catches the spirit of the original portrait but does not address the technical aspects of Velázquez's painting style. The self-possession and authority of the young prince must have touched Sargent's imagination, for he made a separate study of the prince's head and shoulders (no. 728).

The final four studies that Sargent undertook in the Prado are all fragments from larger works. Sargent was painting at speed and seeking to capture the general imagery and compositional lessons of Velázquez rather than trying to replicate details and technique. Two of the copies are heads, those of *Aesop* and the *Buffoon Don Juan de Austria* (nos. 735, 736). Much of the emotion of Velázquez's full-length picture of *Aesop,* dressed as a beggar-philosopher in a loose robe open at the neck, is concentrated in the expressive features and powerfully modelled head. In his copy of the *Buffoon Don Juan de Austria,* Sargent hones in on the strongly modelled, brightly lit structure of forehead, cheek, nose and eye, framed by a high silvery collar and a stylish black hat with plumes. The head of Don Juan, with its sparkling highlights and liquid impasto, would become an exemplar for several of Sargent's portrait heads in the 1880s.

The incandescent, supernatural figure of Apollo from *The Forge of Vulcan* was already famous in Velázquez literature when Sargent made his copy in the course of a single day (no. 734). The original picture shows Apollo on the far left disclosing to Vulcan and his assistants the news of Venus's infidelity with her lover Mars. Sargent copied the upper left-hand section of the picture, isolating Apollo against the rectangle of the window. The way that the orange robe wraps round the tenderly modelled torso of the adolescent male model reminds us of Sargent's own academic studies from life (see nos. 623, 628, 629).

The last of Sargent's copies, a fragment of *Las Hilanderas* (no. 737), was, according

to the record, painted on Sargent's last day in the Prado (22 November 1879). The artist chose to concentrate on the relationship between the young woman in front (possibly Arachne) and the action in the alcove behind. The young woman is reminiscent of the beautiful and sensual young models whom Sargent would employ in Venice in the period 1880 to 1882. The bared neck and subtly modelled arm of the model in *Las Hilanderas* seems to have stayed in Sargent's mind, and echoes of it occur in the pose of the dancer in *El Jaleo* (no. 772) and in Mme Gautreau's outflung arm in *The Toast* (*Early Portraits*, no. 116).

The influence of Velázquez remained potent in Sargent's art, not only in the years immediately following his return from Spain but throughout his subsequent career. He carefully kept the ten copies that he had made and no doubt made reference to them from time to time. Two of the copies, *Dwarf with a Dog* and *Las Hilanderas*, can be seen hanging prominently on the wall in a photograph of Sargent's Paris studio, 41, boulevard Berthier, taken around 1884 (fig. 109), together with his copy of two of the figures from the *Regentesses of the Old Men's Almshouse* by Frans Hals (no. 741). In 1908, Sargent and his sister Emily were persuaded to lend three of the studies after Velázquez to an exhibition at the Whitechapel Art Gallery, London, composed largely of copies by contemporary artists after the old masters. Two of them already belonged to Emily Sargent, *Las Meninas* and *Buffoon Juan Calabazas* (nos. 730, 729), and the third was *Dwarf with a Dog* (no. 733). Of the eight copies after Velázquez that appeared in the Sargent sale at Christie's in 1925, three went to the discerning Boston collector Alvan T. Fuller (*Prince Baltasar Carlos on Horseback, Head of Aesop* and *Las Hilanderas*, nos. 731, 735, 737), one each to Sargent's close friends Sir Philip Sassoon and his sister, Lady Cholmondeley (*Infanta Margarita* and the *Buffoon Don Juan de Austria*, nos. 738, 736), one to Archer M. Huntington for his new foundation, the Hispanic Society of America, New York (*Dwarf with a Dog*, no. 733), one to the New York collector Edwin Levinson (*Figure of Apollo from 'The Forge of Vulcan'*, no. 734), and one to a buyer called Van der Neut or Vanderneut (*Head of Prince Baltasar Carlos*, no. 728). This last copy made the staggering sum of £6,300, the third highest price paid in the sale and the subject of headlines in the newspapers; it had probably been bought in. Alvan Fuller owned no fewer than fourteen works by Sargent, including copies after Frans Hals,

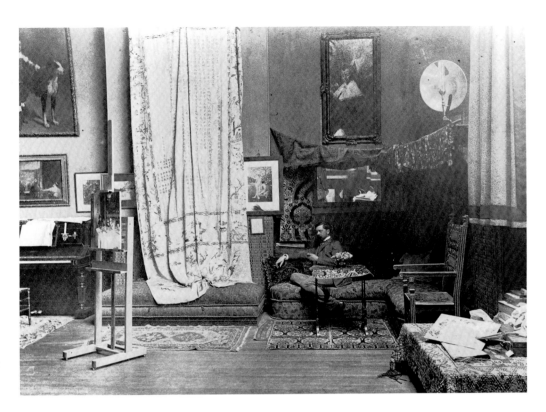

Fig. 109
Photograph of Sargent in his studio at 41, boulevard Berthier, Paris, c. 1884. Private collection. His copies of *Dwarf with a Dog* and *Las Hilanderas, after Velázquez,* and *Detail of Two Figures from 'The Regentesses of the Old Men's Almshouse', after Frans Hals* (nos. 733, 737, 741), can be seen hanging on the walls.

while Sir Philip Sassoon's collection was even larger. Clearly the copies appealed to a discerning type of collector, who could appreciate the importance of Velázquez's realism in the evolution of Sargent's style.

FRANS HALS

If Velázquez was the first of Sargent's old master heroes, then Frans Hals was unquestionably the second. Less than a year after making the pilgrimage south to the Prado Museum in Madrid, Sargent travelled north to the Frans Hals Museum in Haarlem, Holland. In a letter dating mid-August 1880 to his friend Vernon Lee, Sargent announced his departure from Paris: 'I am just starting for a trip to Holland and have just a moment to thank you for the book which interests me very much and for the charming article on Fautus & Helena'.[7] A fortnight later the artist's sister Emily Sargent took up the story in a second letter to Vernon Lee, dated 25 August 1880:

John left Paris about ten days ago with two very nice friends to make a tour in Belgium & Holland, before going to Venice. I had a letter from him yesterday just as he was leaving Rotterdam for Haarlem. He has enjoyed the pictures immensely & thinks one can have no adequate idea of the works of Rubens, Rembrandt, Memling & Frans Hals without having seen them in those countries. I have no idea of how long John will remain there, but he seems inclined to pick us up here [Aix-les-Bains], & I hope we shall get off somewhere about the 10th of September.[8]

Six days later Emily Sargent wrote again from Aix-les-Bains:

We expect, as I told you, to leave here about the 10th September but a good deal depends on John, who in his yesterday's letter again said nothing of coming here . . . Mamma had a nice letter from John, Haarlem, where they were going to spend a week & make a copy or two of Frans Hals.[9]

A third letter from Emily to Vernon Lee, dated 5 September 1880, is more revealing:

John writes from Haarlem, '1st Septr.', saying he has lost all count of the days, but cannot possibly join us before ten days or a fortnight from the time he wrote, & that we had better go on without waiting for him. It was postmarked Haarlem 3d. This is very disappointing as we ought to leave [Venice] by the 1st. of October.[10]

Sargent's two travelling companions were Ralph Curtis, his cousin and fellow-student at Carolus-Duran's atelier, and the American artist Francis Brooks Chadwick.

Sargent painted a dashing oil sketch of Curtis on the beach at Scheveningen, outside The Hague, and the head and shoulders portrait of Chadwick was probably done at this same time.[11] According to Ralph Latimer, Sargent's water-colour portrait of George Hitchcock, an American painter living in Holland, was painted in a meadow outside The Hague in August 1880.[12] Both Sargent and Curtis are recorded in the visitors' book of the Frans Hals Museum on 30 August 1880, presumably the first occasion on which they came into the museum.[13] Sargent paid a second visit to Holland in July 1883 in company with Paul César Helleu and Albert de Belleroche, and he may well have visited the Frans Hals Museum on that occasion, although he is not recorded in the visitors' book for that year.[14]

In his admiration for Hals, Sargent was following a well-established vogue for the Dutch master. There had been a resurgence of interest in the work of this forgotten painter since the mid-nineteenth century. The recovery of Hals's reputation owed much to the pioneering research work of the French art historian Théophile Thoré (Wilhelm Bürger), who wrote a book on Dutch museums in 1858, followed by a series of influential articles.[15] Thoré-Bürger discounted past criticism of carelessness and lack of finish in Hals's work and the persistent allegations of his dissolute life style. On the contrary, he praised Hals's consummate mastery and the cheerfulness and spontaneity with which he recorded the Dutch burghers. Thoré-Bürger's writings helped to turn the tide of public opinion in favour of Hals, and re-established him in the pantheon of Dutch artists. Collectors now vied with each other to secure his work, and his pictures, previously little sought after, began to make record prices. Where Thoré-Bürger led the way, other critics and historians soon followed. The French painter Eugène Fromentin contributed a chapter on Hals to his book on Dutch art, *Les Maîtres d'autrefois: Belgique-Hollande* (Paris, 1876), a work Sargent is known to have read and admired.[16] Fromentin praised the technical brilliance and virtuosity of Hals especially evident in his early group portraits. He was less certain of the late groups of the regents and regentesses of the hospitals, finding in them a weakening of Hals's mental and artistic powers, although he recognized something ineffable about these works of an expiring genius.

Another turning point in the recovery of Hals's reputation was the opening of the Frans Hals Museum in Haarlem in 1862.

Now easily accessible for the first time were the nine group portraits Hals had painted in Haarlem during the course of a long working career. A growing number of critics, collectors and artists beat a path to the doors of the museum to enjoy the work of this virtuoso painter, whose pictures seemed so full of life, and whose brilliant brushwork and palette seemed so modern. It was the realists and Impressionists who most readily identified Hals as a precursor and champion of their cause. Among early visitors to the museum were Gustave Courbet, Charles Daubigny, Théodule Ribot, Léon Bonnat, Carolus-Duran, Claude Monet and Mary Cassatt. Academics were also drawn there, among them Fernand Cormon, Paul Dubois, Jean-Léon Gérôme, Auguste Glaize and Jules-Joseph Lefebvre, so it would be naïve to suppose that admiration for Hals lay all on one side.[17]

Like Velázquez, Frans Hals remained a touchstone for the younger generation of painters throughout the 1870s and early 1880s. Frances Jowell quotes an anonymous critic writing in the Belgian art journal *L'Art Moderne* in 1883 who praised Hals's harmonies of tone and colour, the rendering of pictorial space, and the simplified modelling of faces and hands that embodied the aims and ideals of the younger school represented by Sargent, Whistler and Chase.[18] It is not difficult to understand why Sargent looked on Hals as a kindred spirit, and why he lost count of the days when copying his pictures in Haarlem. It was the Dutch artist's lively characterization of individuals, his technical mastery, his loose, open brushwork and economy of means that held Sargent spellbound. In the groups of civic guards, Hals broke with the conventions of formal portraiture to show people as they really are, carousing, laughing and enjoying themselves; portraiture did not need to be solemn and portentous, it could be fun. Hals's exuberant feeling for life, his confidence and brio, his sparkling effects of light and colour exerted a powerful influence on Sargent's imagination and manner of painting. What lessons Velázquez had taught him in terms of values, spatial relationships and expressive brushwork, Hals reinforced in a style that was more forceful and more immediate.

Sargent painted two separate studies of heads from Hals's group of *The Banquet of the Officers of the St George Civic Guard* (nos. 739, 740), which capture the essence of Hals's original picture (fig. 119) in a brilliant shorthand of Sargent's own. So spirited is Sargent's interpretation that you might

imagine his studies to be from life, rather than copies of an old master work. Sargent did a drawing of two heads from this same group and a drawing of four heads from *Officers and Sergeants of the St Hadrian Civic Guard* (figs. 110, 111). In graphic form, he explored the tonal relationships and firm incisive modelling that enabled Hals to achieve such vivid feats of characterization. The two drawings come from a group that belonged to the British sculptor Charles Sargeant Jagger; for a discussion of these, see *Studies of a Spanish Dancer* within the entry for *Spanish Dancer* (no. 770).

In spite of Fromentin's warning that the two last group portraits of the regents and regentesses of the Old Men's Hospital in Haarlem were not the best examples of Hals's work for artists to follow, Sargent did studies of both (nos. 741, 742). The profound and sombre vision of these late works, presenting such a contrast to the colourful and convivial portraits of the civic guards, made a big impression on Sargent and others of his generation. Hals had pared down his style to the bare essentials to create haunting images of the elderly administrators of the hospital. Sargent did a copy of the whole composition of the regents, intrigued perhaps by the effect of the faces and hands looming out of the darkness of an interior whose spaces are barely discernible. His most memorable study is that of the old regentesse and the servant woman from the far right-hand side of the group of regentesses of the hospital.[19] This is one of Hals's most gripping studies of old age, and Sargent's life-sized rendering is larger, more finished and more composed than his other studies after Hals. It shows with what insight and sympathy he had grasped the spirit of the Dutch artist's late style and his deep humanity. The study was prominently hung on the walls of Sargent's studio, along with copies after Velázquez (see fig. 109).

There is no doubt that Hals exerted a liberating effect on Sargent's art, in the immediacy with which he responded to the life and character of his sitters, in his wit and irreverence, and above all in the stunning confidence and expressiveness of his technique. Sargent well understood that there was much more to Hals than surface brilliance. Like the art of Velázquez, that of Hals was rooted in the accurate transcription of the visible world, in terms of the values of light and dark. In Hals's work the structure came from within. To William James, artist and nephew of the novelist Henry James, Sargent explained:

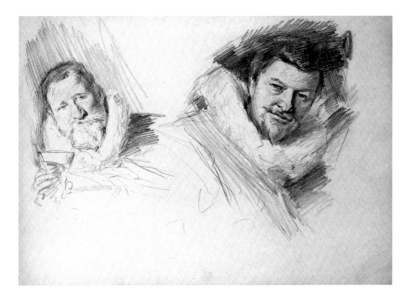

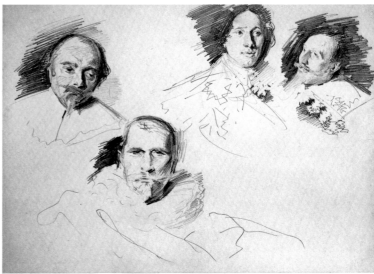

Fig. 110
Studies of Two Heads from 'The Banquet of the Officers of the St George Civic Guard', after Frans Hals, 1880. Pencil on paper, 10 x 13 in. (25.5 x 35 cm). Private collection.

Fig. 111
Studies of Four Heads from 'Officers and Sergeants of the St Hadrian Civic Guard', after Frans Hals, 1880. Pencil on paper, 10 x 13 in. (25.5 x 35 cm). Collection of Roberta J. M. Olson and Alexander B.V. Johnson.

You must classify the values. If you begin with the middle-tone and work up from it towards the darks—so that you deal last with your highest lights and darkest darks—you avoid false accents. That's what Carolus taught me. And Frans Hals—it's hard to find anyone who knew more about oil-paint than Franz Hals—and that was his procedure.[20]

What Hals taught was absolute veracity of tone and accent. Sargent told Miss Heyneman, another student:

Never leave 'empty spaces', every stroke of pencil or brush should have significance and not merely fill in, . . . copy one of the heads by Frans Hals in the National Gallery, then you will get an idea of what I mean by leaving no empty spaces in modelling a head, work at the fine head of the old woman rather than the superficial one of the man, I will come there and give you a criticism and haul you over the coals.[21]

Sargent advised Miss Heyneman to go to Haarlem, and on her return promised to visit her: 'I hope you'll have some copies of Frans Hals to show me . . . There is certainly no place like Haarlem to key one up'.[22] At the end of his life, in a rare address delivered at a Royal Academy dinner celebrating the bicentenary of the birth of Sir Joshua Reynolds, Sargent spoke of the way in which Hals and Van Dyck had transformed the art of portraiture by introducing a less formal and more intimate style of representation.[23]

OTHER OLD MASTERS

During the course of his atelier training, Sargent made various pencil drawings after the old masters. The highly worked study of the *Venus de Milo* in the Louvre (fig. 112), with its imperceptible modelling and subtle contrasts of light and shadow, is typical of academic draughtsmanship at the time and demonstrates the tight disciplines to which Sargent was subjected. Less formal but no less beautifully drawn is the pencil study of a woman and child, a detail from Tintoretto's *Miracle of Saint Mark* (fig. 113). Sargent's early sketchbooks are full of drawings after

Fig. 112 *(left)*
Copy of the 'Venus de Milo', c. 1874–77. Pencil on paper, 24 x 17½ in. (61 x 44.4 cm). Private collection.

Fig. 113 *(above)*
Detail from 'The Miracle of Saint Mark', after Tintoretto, c. 1873. Pencil on paper, 6¹⁵⁄₁₆ x 4 in. (17.6 x 10.2 cm). The Metropolitan Museum of Art, New York. Gift of Mrs Francis Ormond, 1950 (50.130.154e recto).

antique statues and Renaissance works of art, and he continued the habit once he had joined Carolus-Duran's atelier, though relatively few examples are known today.[24]

Apart from Velázquez and Hals, only a handful of oil copies after the old masters are recorded, though Sargent most likely painted more. Three of them were probably done in Madrid in the autumn of 1879, two of them in the Prado, when the artist was at work on his studies after Velázquez: *Two Figures from 'The Three Graces', after Rubens* and *The Descent from the Cross, after Giandomenico Tiepolo* (nos. 745, 744). The third was *Angels in a Transept, Study after Goya* (no. 746) from the fresco in San Antonio de la Florida. It is easy to understand Sargent's enthusiasm for Rubens and Goya, since the work of both artists mirrored his own painterly preoccupations at the time. So, to an extent, does Giandomenico Tiepolo, but the latter was a relatively minor figure, and his father, whose work Sargent greatly admired and which was well represented in the Prado, would have been a more obvious choice.

Sargent's surviving copies in oil were all painted in the period 1879–80, at the close rather than the start of his studentship. That he felt it necessary to go back to study the old masters at the very moment when he was establishing an independent career demonstrates how much he felt he still had to learn. He put himself through a final taxing course of study in an effort to understand what constituted high style and great art. In the process he sustained an ambition to measure himself against the masters of the past and developed the skills necessary to carry it through. The copies marked his rite of passage from apprenticeship to mastery of his craft.

—Richard Ormond

1. The Velázquez section of the introduction is derived from an article on Sargent's studies after Velázquez by Richard Ormond and Mary Pixley, 'Sargent after Velázquez: The Prado Studies', published in the *Burlington Magazine,* vol. 145, no. 1206 (September 2003), pp. 632–40. The entries for the individual studies after Velázquez are the joint work of these two authors. They were written while the authors were at the Center for Advanced Study in the Visual Arts at the National Gallery of Art, Washington, D.C., 2001–2, Richard Ormond as Kress Professor, Mary Pixley as research associate. They would like to thank the Trustees of the National Gallery and the Trustees of the Kress Foundation for the opportunity to undertake research on this subject.

2. The exhibition, held at the Metropolitan Museum of Art, New York, 4 March–8 June 2003 (for which see Tinterow *et al.* 2003), was an expanded version of *Manet/Velázquez: La manière espagnole au XIXe siècle,* 16 September 2002–12 January 2003, held earlier at the Musée d'Orsay, Paris. Three of Sargent's copies after Velázquez (or workshop) were in the New York showing, *Las Meninas, Dwarf with a Dog* and *Head of Aesop* (nos. 730, 733, 735). For early literature on Velázquez, see Jean-Louis Augé *et al., Velázquez et la France: la découverte de Velázquez par les peintres français,* Musée Goya, Castres, 9 July–3 October 1999 (exhibition catalogue).

3. See *Velázquez et la France* (n. 2 above), pp. 72–76, for details of artists travelling to Madrid.

4. For visits to Spain by Sargent's contemporaries, see Boone 1996, chapters 5 and 6. J. Carroll Beckwith's diaries, including the volume for Spain, are in the National Academy Museum and School of Fine Arts, New York.

5. Charteris 1927, p. 28: "'Cherchez la demi-teinte', he would add, "mettez quelques accents, et puis lumiéres [*sic*] . . . Velasquez, Velasquez, Velasquez, étudiez sans relache [*sic*] Velasquez'". See also H. Barbara Weinberg in Simpson *et al.* 1997, pp. 25, 27.

6. We are grateful to Dr MaryAnn Goley, director of art programs at the Federal Reserve Board, Washington, D.C., for copies of the relevant pages of the registers and for much subsequent help and advice. Her exhibition *The Influence of Velázquez on Modern Painting: The American Experience,* Federal Reserve, Washington, D.C., 3 July–1 December 2000, was a notable contribution to the subject.

7. Private collection.

8. Vernon Lee Papers, Special Collections, Millar Library, Colby College, Waterville, Maine.

9. Ibid.

10. Ibid.

11. See *Early Portraits,* nos. 82 and 84.

12. Letter from Latimer, a cousin of Curtis, to Lady Berwick, noted by David McKibbin, McKibbin papers; for the portrait of Hitchcock, see *Early Portraits,* no. 83.

13. The visitors' books of the Frans Hals Museum are held in the Archiefdienst voor Kennemerland in Haarlem, The Netherlands.

14. Sargent wrote to Mme Allouard-Jouan on 17 or 18 July 1883 to say that he had just returned from a quick trip to Holland, where he had celebrated Bastille Day (private collection). For Belleroche's drawing of Sargent asleep on the train to Holland, see Belleroche 1926, pp. 30, 34; and Dorothy Moss, 'John Singer Sargent. "Madame X" and "Baby Millbank"', *Burlington Magazine,* vol. 143 (May 2000), ill. p. 273, fig. 18. For visitors' books to the Frans Hals Museum, see n. 13 above.

15. Théophile-Étienne-Joseph Thoré, *Musées de la Hollande par W. Bürger,* 2 vols. (Paris, 1858–60). For a full discussion, see Frances S. Jowell, 'The Rediscovery of Frans Hals', in Slive *et al.* 1987, pp. 64–70.

16. Sargent's admiration for Fromentin's book is recorded by Hamilton Minchin, who met Sargent in Carolus-Duran's atelier in 1879; see Minchin 1925, p. 738.

17. See Petra Ten-Doesschate Chu, 'Nineteenth-Century Visitors to the Frans Hals Museum', in *The Documented Image: Visions in Art History,* ed. Gabriel Weisberg and Laurinda S. Dixon, with the assistance of Antje Bultmann Lemke (Syracuse, New York, 1987), pp. 111–44.

18. See Frances S. Jowell in Slive *et al.* 1987, pp. 74–75.

19. Copies of this group by Max Liebermann, William Merritt Chase and James Ensor are illustrated in Slive *et al.* 1987, pp. 72, 73 and 75, figs. 8, 9, 11.

20. Quoted in Charteris 1927, p. 29.

21. Ibid., p. 139.

22. Ibid., p. 140.

23. See ibid., pp. 197–98.

24. His drawings after the old masters are mostly to be found in the Fogg Art Museum, Harvard University Art Museums, Cambridge, Massachusetts, and the Metropolitan Museum of Art, New York.

727 (opposite)
Study of a Bust at Lille

c. 1877
Alternative titles: *Painting of the Wax Bust in the Museum at Lille; Raphael's Wax Head at Lille*
Oil on panel
12⅛ x 8⅛ in. (30.7 x 20.6 cm)
Private collection

The wax bust of a young woman, with drapery and base in painted terracotta had been bequeathed to the city of Lille by the French painter J. B. Wicar (1762–1834) together with a large collection of works of art. The bust had been attributed to the circle of Raphael, and, although there was little agreement as to the date and origin of the piece (some experts thought it Greek or Roman), it had generated widespread interest and debate and became the most famous work of art in the museum. Louis Gonse, who wrote a series of seven articles on the Lille Museum in the *Gazette des Beaux-Arts* in 1876–78, twice described the wax bust and illustrated it with no fewer than three engraved reproductions.[1] Gonse thought it Florentine, c. 1480, possibly by Orsino Benintendi (1440–c. 1498) or another sculptor in the circle of Verrocchio.

Gonse compared the bust to Leonardo de Vinci's *Mona Lisa,* in which 'everything contrived to make it strange and mysteriously enchanting: the rare combination of materials, the originality of style, the perfection of execution and the obscure provenance of this fragile piece'.[2] Gonse expanded on the merits of the bust, its realism, elegance of line, character of chaste youthfulness, attitude of tender reverie, even of suffering, and the mysterious smile of the model; these were qualities appealing to a late nineteenth-century audience. The function and attribution of the bust have continued to arouse debate in more recent times but without resolution. It is not clear if the wax bust is a devotional object, an anatomical fragment or an atelier model, and no convincing case has been made as to the author of the piece.

Sargent visited Lille in the spring or early summer of 1877 in company with Carolus-Duran, a native of the city. Writing to Fanny Watts, whose portrait he had recently finished (*Early Portraits,* no. 20), he told her that she could order photographs of it from Perichet's: 'Tomorrow morning I am off to Lille for a week, with Carolus. There is a fine museum and I will enjoy the change' (undated, private collection). It is

very possible that Sargent copied the bust on this visit. The copy is painted on one of the thin mahogany panels he was using in the late 1870s, especially when travelling.

The picture is a precise record of the original bust, taken from the left side, the one most commonly shown, with the head inclined towards the viewer. It replicates the delicate sculptural form of the head, the smooth translucent surface of the wax, and the coarser textures of the terracotta drapery. The copy has the character of a highly worked academic study, and it may have been done as a formal exercise by Sargent under the eye of his master. At the same time, it shares some of the same alluring and mysterious characteristics of his studies of adolescent models. The bust is separated from the background by a few touches of yellow paint, but the background tone is otherwise provided by the bare surface of the mahogany panel.

Sargent's colouration differs from the bust as it exists today. In contrast to the glowing flesh tones of the original, Sargent's tones are pale grey and muted. The degraded black colour of the drapery over a red ground in the original becomes greenish grey and pink in the copy. And the hair of the bust, again degraded black over red, is rendered by Sargent as pale yellow with the faintest of black streaks. Gonse described the flesh colour as amber and the lips as carmine, which accords with the look of the bust today. Sargent must have decided to render the bust in semi-grisaille for his own aesthetic reasons, although the light in which he painted it may also have had a part to play; did he paint it *in situ* in the public galleries, or was the bust made available to him to study privately, as it may have been through Carolus-Duran's influence? The pallor of the copy led earlier researchers for the catalogue raisonné to question whether Sargent had made his copy after the engraving by F. Gaillard reproduced by Louis Gonse,[3] which illustrates exactly the same view, rather than from the original bust. This seems unlikely, for Sargent's picture conveys the feel and texture of the wax, whatever its idiosyncrasies as to colour, which the engraving does not.

The artist Hamilton Minchin, who had met Sargent in the autumn of 1878 through Carolus-Duran's studio, recalled seeing the bust at some point around 1879–80 (he mentions it when discussing Sargent's copies after Velázquez): 'He had made a beautiful copy in oils of the famous "Wax Head of a Girl" at Lille; one day, I found him beginning a copy of it for some friend and he

told me it was much harder to copy his own work than to copy nature' (Minchin 1925, p. 738; this second version of the copy is untraced). Sargent exhibited his copy of the bust at the Grafton Galleries in London in 1894 and at his retrospective in Boston in 1899, so it was evidently a work of which he was proud. At some point, he put the copy in a sixteenth-century Florentine-style frame; the frame (formerly Ormond family, sold c. 1975) can be seen in the background of the portrait of *Elizabeth Chanler* (*Portraits of the 1890s,* no. 287), but with a different picture inside it.

1. Louis Gonse, 'Musée de Lille, Le Musée Wicar (Premier Article)', *Gazette des Beaux-Arts,* 2nd series, vol. 14 (1876), p. 411, ill. p. 406, and 'Musée de Lille, Le Musée Wicar (Septième et Dernier Article)', *Gazette des Beaux-Arts,* 2nd series, vol. 17 (1878), pp. 197–205, ill. facing pp. 197 and 201.

2. 'Mais que tout concourt à rendre étrange et mystérieusement enchanteresse: la rareté de la matière, l'originalité du style, le perfection désperante de l'exécution, et jusqu'à la provenance obscure de ce fragile morceau' (*Gazette des Beaux-Arts,* 2nd series, vol. 17 [1878], p. 197).

3. Ibid., ill. facing p. 197.

728
Head of Prince Baltasar Carlos, after Velázquez

1879
Alternative titles: *The Prince Balthazar Carlos, after Velásquez; (Copy of Velásquez) Prince Balthazar Carlos; Portrait of a Boy by John Singer Sargent after Velazquez; Don Baltasar Carlos—after the picture in the Prado by Velazquez;* and variants
Oil on canvas
21½ x 17¾ in. (54.6 x 45.1 cm)
Private collection

This small picture appears to be the first work after Velázquez that Sargent painted in the Prado Museum, Madrid, on his visit there to copy old masters (see the introduction to this chapter, p. 198). He commenced the painting on 17 October 1879, according to the register of copyists in the Prado archives, which does not record when he finished it (Prado archives, *Libros de copistas,* 1879: *Principe Baltasar,* #813, size 50 x 40 cm). Velázquez's equestrian painting of *Prince Baltasar Carlos* (1629–1646), son of Philip IV of Spain and Queen Isabel, dating from c. 1634–35 (see fig. 114), must have made a deep impression on Sargent, since a month later he painted another small study, this time of the entire portrait (no. 731). What seems to have attracted Sargent to this portrait was the combination of youth, vitality and composure of the young prince astride a bounding pony. In this first copy he concentrated on the head and shoulders, exploring the way in which Velázquez created a dominating image from one so young.[1]

Sargent's copy simplifies and elongates the sitter's face into a rectangle. Sargent also enlarged the dark, round pupils of the boy's eyes, which results in an exceptionally penetrating gaze. The dark hat underscores the boy's rank, and Sargent faithfully copies the geometry of its rakish angles and curves to recreate its singular silhouette. At the bottom of the composition, Baltasar's left arm crosses his waist to hold the reins, providing a suitably elegant right-angle frame for this important figure, which both stabilizes the composition as cropped and counteracts the diagonal thrust of the rose-coloured sash. His outstretched right arm is balanced by his cloak, which sweeps out behind him. In contrast to the face, the prince's costume consists of a flurry of broad, jagged strokes, which blurs details of the costume, while retaining their richness of effect.

At the Sargent sale at Christie's in 1925, the buyer's name is given as Van der Neut,

and the painting made the staggering sum of £6,300 (Christie's London, 27 July 1925, lot 231); only two other pictures in the sale made more and they were far more important works.[2]

1. For the original painting, see López-Rey 1963, p. 192, no. 199, ill. pl. 85; Brown 1986, pp. 109, 111, 116, ill. pls. 122, 135 (colour); and López-Rey 1996, vol. 2, p. 178, no. 72, ill. p. 179 (colour).
2. The picture may have been bought in; the interleaved sale catalogue used by the auctioneer (Christie's archive, London) has the words 'Buy in 6000 gns' against the entry for the picture (lot 231). A second work in the sale (lot 172), 'The Seasons', for which the buyer's name is again given as 'Van der Neut', was also bought in, suggesting that the name may have been a fictional one employed by the saleroom.

729 *(opposite)*
Buffoon Juan Calabazas, after Velázquez

1879
Alternative titles: *El Bobo (Idiot) di Coria (Velasquez); The Idiot of Coria; Portrait of the Dwarf Calabazas; The Jester Calabazas, Copy after Velázquez*
Oil on canvas
42 x 32½ in. (106.7 x 82.5 cm)
Private collection, Paris

This copy after Velázquez depicts the *Buffoon Juan Calabazas,* referred to sometimes as the 'Idiot of Coria' owing to the mistaken identification of the picture as the 'Bobo di Cori' in a 1794 inventory of the Royal Palace in Madrid.[1] Juan Calabazas was first

in the service of the Cardinal Infante Don Fernando (son of Philip III and Queen Margarita), and from July 1632 until his death in 1639 in that of Philip IV. His name, Calabazas, translates as gourds in Spanish, which explains the presence of the two large gourds on the floor next to him.

The portrait was better known in the second half of the nineteenth century than it is today, having been illustrated in books, photographed in the 1870s, and praised in contemporary guidebooks to Spain. Richard Ford recommended it in his *Handbook for Travellers in Spain* (Murray's Guides, London, 1878 ed., p. 52) as one of those 'wonderful portraits of Philip IV's dwarfs . . . amongst the best examples of his vigorous and facile brush, and of his unrivalled power of portraying character and expression'. Indeed, Velázquez's paintings of dwarfs and buffoons with their eccentricities and deformities were generally seen as masterpieces. As Théophile Gautier explained, Velázquez accepted and showed their monstrosities giving them the beauty of art (Gautier 1864, p. 284).

The complex and bizarre nature of this rather unassuming picture undoubtedly attracted Sargent to the subject. It was the second work he selected to study from Velázquez in the Prado, commencing the work on 21 October 1879 and finishing it by 5 November 1879 (Prado archives, *Libros de copistas,* 1879: *Tonto de Coria,* #823, size 50 x 40 cm). In the picture we look down at the buffoon, who sits on a low stool with one leg crossed beneath the other. The sense of physical discomfort he communicates in this awkward pose is intensified by his strangely forced smile and by the action of his right hand held clenched within the palm of the other. His crossed eyes make it impossible for us to know in which direction he is looking, creating a further sense of unease in the viewer.

This tension is continued into the background, which, with its lack of definition, seems to press in and down on Juan Calabazas. One cannot tell where the floor ends and the wall begins on the left side of the canvas, which causes the background to tilt forward. And the clearly visible and chaotic brushwork Sargent utilized for the dark upper half of the ground further contributes to this instability, which contrasts with the more blended application of paint adopted by Velázquez. The buffoon wears a bulky dark green and black costume, relieved by Flemish lace collar and cuffs. While Sargent modelled and brought the face of the buffoon to a relatively high degree of finish, his brushwork is generally much looser than Velázquez's. Nonetheless, he carefully studied the details of the picture, even copying the visible *pentimenti,* or changes, made by Velázquez during the course of the painting, as for example in the gourd on the right side of the canvas. Though only half the size of the original, Sargent's version of the portrait haunts us as he successfully translates the psychological force of Velázquez's original into his own painterly idiom.

The picture is the most highly worked of his copies after the Spanish master, and it was selected, along with *Las Meninas, after Velázquez* and *Dwarf with a Dog, after Veláz-quez* (nos. 730, 733), to represent this aspect of his work in an exhibition predominantly of copies by contemporary artists after the old masters held at the Whitechapel Art Gallery in London in the spring of 1908. The picture was lent to that exhibition by the artist's elder sister, Emily Sargent.

1. For the original painting of c. 1637–39, see López-Rey 1963, p. 265, no. 424, ill. pls. 50, 120; Brown 1986, p. 148, ill. pls. 172–73 (colour); and López-Rey 1996, vol. 2, p. 208, no. 83, ill. p. 209 (colour).

730
Las Meninas, after Velázquez

1879
Alternative titles: *Las Meninas (Velasquez);*
Copy of Velasquez 'Las Meninas',
and variants; *Study after Velasquez,*
'The Maids of Honor'
Oil on canvas
44¾ x 39½ in. (113.7 x 100.3 cm)
Private collection

Sargent began this copy of Velázquez's masterpiece *Las Meninas* (c. 1656) thirteen days after his initial registration to paint copies at the Prado Museum, Madrid. It was begun on 27 October 1879 and finished eighteen days later (Prado archives, *Libros de copistas,* 1879: *Meninas,* #835, size 100 x 110 cm, practically identical to the measurements of the canvas today, except that they are reversed). For nearly a week, it was the only work he had in hand, and it represents his largest and most sustained experiment in studying the work of the Spanish master.[1]

The picture represents the Infanta Margarita, daughter of Philip IV of Spain and Queen Maria Anna of Austria, standing in the centre foreground, attended by two maids of honour or *meninas.* A dwarf and buffoon stand in the right foreground while Velázquez himself stands before a gigantic canvas on the left, with his brush and palette in hand. He is apparently in the process of painting a portrait of the king and queen, whose ghostly reflections can be glimpsed in the mirror deep in the background of the chamber. On a canvas about one-third the size of Velázquez's, Sargent follows the original rather closely in the composition, spatial relationships, arrangement of light and shade and the colouration of his own painting. At the same time, he delighted in painting with looser and more fluid brushwork, leaving many passages only thinly painted or roughly indicated.

Sargent's adoption of such a large canvas for this study seems to reflect his deep interest in the underlying structure of the painting. He meticulously follows Velázquez's sophisticated arrangement of the figures, complex geometric underpinnings, use of large areas of empty space and dramatic recession. With the narrative so clearly set forth, Sargent uses light and the same impasto-like touches of red as Velázquez to emphasize certain gestures and figures and to move our eyes through the composition to discover the details of the narrative. The silver feathery brush strokes used throughout the composition find clear parallels in Sargent's work done after his trip to Spain.

And the influence of his study of the compositional structure of *Las Meninas* can be traced to several of his Venetian interior and exterior scenes, as well as his group portrait of *The Daughters of Edward Darley Boit* (*Early Portraits,* no. 56).

The picture was one of three copies after Velázquez by Sargent lent by his sister Emily to an exhibition largely of copies after the old masters at the Whitechapel Art Gallery in London in 1908.

1. For the original painting, see López-Rey 1963, pp. 204–5, no. 229, ill. pls. 147, 152, 456; Brown 1986, pp. 241–42, 252–53, 256–57, 259–61, 264, ill. pls. 321–24 (colour); López-Rey 1996, vol. 2, pp. 306–11, no. 124, ill. p. 307 (colour); and Tinterow *et al.* 2003, numerous references, ill. p. 58, fig. 1.57, and p. 125, fig. 4.13 (colour).

731
Prince Baltasar Carlos on Horseback, after Velázquez

1879
Alternative titles: *The Prince Balthazar Carlos, after Velásquez; Prince Balthazar Carlos (Velasquez);* and variants
Oil on canvas
18 x 14½ in. (45.7 x 37 cm)
Private collection

Although this painting of Prince Baltasar Carlos (1629–1646) measures slightly larger than the one recorded in the 1879 register of copyists in the Prado Museum, Madrid, there is little doubt that it is the same work which was completed between 11 and 20 November 1879 (Prado Archives, *Libros de copistas,* 1879: *Principe Baltasar,* #859, 40 x 20 cm). Sargent painted this study of the original equestrian portrait of the prince by Velázquez in the Prado (fig. 114)[1] about a month after painting the head and torso of the young rider (no. 728). Both studies remained in the artist's possession and were sold at the auction following his death.

While the young prince, who died at the early age of seventeen, was the subject of several portraits by Velázquez, Sargent chose to devote his attention to only one of these, the dramatic equestrian portrait of c. 1634–35. Positioned in the upper middle of the canvas, Prince Baltasar calmly sits astride a chestnut pony, bounding across a windswept wintry landscape in an image of youthful vitality. Though the horse fills more than half the canvas, the prince commands the composition through his regal comportment, his baton and outstretched gesture of authority, and his resplendent costume. The large, dramatic black hat further adds to his stature and dignity. The snow-capped mountains in the background are probably the Guardarrama range outside Madrid, and one might suppose the prince to be in the hunting field but for the presence of the baton, the emblem of command. We see the face of the prince from straight on, but the dramatic foreshortening, emphasizing the barrel shape of the pony's belly, is due to the fact that the picture was designed to be seen from below high up on the walls of the Hall of Realms in the Buen Retiro Palace, placed between the equestrian portraits of his parents, also by Velázquez.

The rougher brushwork used by Sargent endows his version with a greater sense of movement than the original. Nonetheless, the arrangement of the composition

Fig. 114 *(left)*
Diego Velázquez, *Prince Baltasar Carlos on Horseback,* c. 1634–35. Oil on canvas, 82¼ x 68 in. (209 x 173 cm). Prado Museum, Madrid (1180).

around a variety of horizontals and verticals serves to control the surge of energy created by Sargent's dynamic brush strokes, and the outward bounding movement and diagonals of the horse and drapery. This small classically balanced work, with its use of a mixed perspective, forceful silhouette and ruling gesture, cleverly recreates the impact of Velázquez's noble portrait of the Spanish heir.

The copy was purchased at the artist's sale in 1925 (Christie's, London, 27 July 1925, lot 233) by Thomas Agnew & Sons for the well-known Boston collector Alvan T. Fuller (1878–1958), together with eleven more oil paintings and two water-colours. These included two more copies after Velázquez and three after Frans Hals (nos. 735, 737, 739–41), as well as studies of two Neapolitan boys (no. 715, 716), *Javanese Dancer* (1889, private collection), *A Study of Architecture, Florence* (c. 1910, The Fine Arts Museums of San Francisco), and *San Vigilio, the Boat with the Golden Sail* (1913, private collection). Fuller was a leading industrialist, a U.S. congressman and governor of Massachusetts from 1925 to 1929. He was a trustee of the Museum of Fine Arts in Boston, to which he gave a number of pictures, and a generous supporter of the arts in his home town.[2]

1. For the original painting of c. 1634–35, see López-Rey 1963, p. 192, no. 199, ill. pl. 85; Brown 1986, pp. 109, 111, 116, ill. pls. 122, 135 (colour); and López-Rey 1996, vol. 2, p. 178, no. 72, ill. p. 179 (colour).
2. His collection embraced early Italian and Dutch works, eighteenth-century masterpieces by Venetian, French and British artists, and works by J. M. W. Turner, Sir John Everett Millais, Degas, Monet and Renoir. His enthusiasm for Sargent's copies after Velázquez and Hals is an indication of his enterprising taste. For a memoir of Fuller and his collection by Perry Rathbone, then director of the Museum of Fine Arts, Boston, see the catalogue of Fuller's memorial exhibition (Boston 1959, pp. 7–10).

732
Christ, after Ribera

1879
Oil (support and dimensions unknown)
Untraced
No image

In addition to the nine copies after Velázquez, Sargent made one study after Jusepe de Ribera in the Prado Museum, Madrid, on 15 November 1879 (Prado archives, *Libros de copistas,* 1879: *Cristo de Rivere* [sic], #873, size 30 x 20 cm). This study is untraced, and the title provided in the Prado register of copyists provides little help in determining exactly which painting Sargent copied. Three paintings by Ribera featuring the figure of Christ are recorded in the Prado at the time: *The Saviour, The Entombment of Christ,* and *The Holy Trinity* (see Pedro de Madrazo, *Catalogo de los cuadros del Museo del Prado de Madrid* [Madrid, 1878], pp. 187, 192, 193, nos. 955, 986, 990). While *The Saviour* and *The Holy Trinity* remain firmly attributed to Ribera and are to be found at the Prado today, *The Entombment of Christ* has been relegated to the status of a copy after an original Ribera, and it has been placed on deposit in the Museo Provincial de Bellas Artes in Játiva.

The size of Sargent's copy as recorded in the Prado register of copyists (30 x 20 cm) indicates an upright work (i.e., height before width). This fits both *The Saviour,* which shows only the head and shoulders of Christ, and *The Holy Trinity* (fig. 115). The latter is much more likely to be the work Sargent copied in view of its complex composition, *contrapposto* attitude of the dead Christ, and dramatic lighting. Sargent revisited this same theme when he painted a copy of El Greco's *The Holy Trinity* in the Prado in 1895 (private collection).

Fig. 115
Jusepe de Ribera, *The Holy Trinity.* Oil on canvas, 89 x 71¼ in. (226 x 181 cm). Prado Museum, Madrid (990).

733
Dwarf with a Dog, after Velázquez

1879
Alternative titles: *Don Antonio el Inglés*
(*Velasquez*); *A Dwarf, after Velazquez*
Oil on canvas
55½ x 41½ in. (141 x 105.4 cm)
The Hispanic Society of America,
New York (A1960)

Sargent painted this copy after a painting then thought to be by Velázquez while he was working in the Prado Museum, Madrid, in 1879.[1] According to that year's register of copyists at the Prado, he commenced the work on 11 November and finished it eleven days later (Prado archives, *Libros de copistas, 1879: Un Enano,* #860, size 140 x 107 cm). The painting depicts an elegantly dressed dwarf who holds the leash of a large, female hunting dog; in Sargent's day the dwarf was known as 'Don Antonio el Inglés' (the Englishman), an identification no longer supported. The extravagant costume, which sparkles from the daubs of paint replicating the golden threads of the dwarf's jacket and breeches, the thick plumes encircling his hat, his fine boots, and wide collar and cuffs, shows him dressed up for an important festive occasion.

The unfinished and painterly qualities of the original, which contributed to the misattribution of the painting, would have been part of the appeal of the work for Sargent. Indeed, he adopted the dimensions of the original for his version, and the work thus constitutes one of the two largest copies he completed at the Prado in 1879. The generous scale of the copy allowed Sargent to concentrate on the larger shapes of the figure, dog and hat. Details such as the sword hilt and the geometric pattern used in the original to distinguish the flat space behind the dwarf become absorbed into the composition. Nor did Sargent bother to correct an obvious difficulty the original artist encountered in the transitional area around the dog's neck where the dwarf holds the leash. The dwarf and the dog stand at attention as if on display, fully accoutered to greet their master and guests. The dwarf looks straight at us, both aware of his exhibitory role and of his difference from us, which is emphasized by his small size in comparison to the dog beside him. The psychological and physical reality of this pair, isolated and existing beyond time and space, explains Sargent's fascination with the original work despite its inferior quality with regard to the art of Velázquez, which

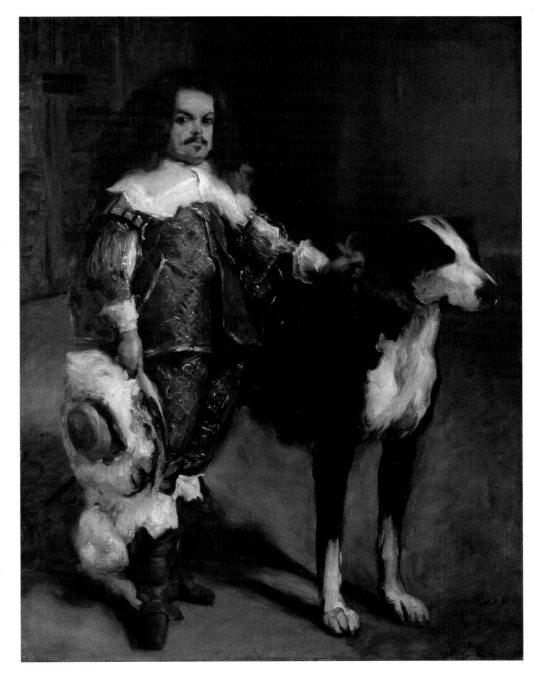

Sargent might have noticed. The high esteem Sargent felt for this study is shown by the prominence he afforded the work in his Paris studio at 41, boulevard Berthier (see fig. 109).

The picture was one of three copies after Velázquez by him shown at an exhibition largely of copies after the old masters held at the Whitechapel Art Gallery in London in 1908. It was lent by Emily Sargent, but evidently reverted to the artist and was included in his sale at Christie's in 1925 (Christie's, London, 27 July 1925, lot 229). It was purchased there by M. Knoedler & Co., London, and was sold by Knoedler, New York, in 1926 to the wealthy collector and philanthropist Archer M. Huntington, for his new foundation, The Hispanic Society of America, in New York.

1. While the authorship of the original composition has been variously attributed to Velázquez, Juan Carreño de Miranda (1614–1885), Juan Bautista Martinez del Mazo (1613–1667), and more generally to the workshop of Velázquez, when Sargent was copying the work, it was still attributed to Velázquez himself. See López-Rey, 'A Pseudo-Velazquez: the Picture of a Dwarf with a Dog', *Gazette des Beaux-Arts,* vol. 37 (October–December 1950), pp. 275–84; López-Rey 1963, pp. 269–70, no. 437, ill. pl. 414; and Tinterow *et al.* 2003, pp. 458–59, ill, p. 331, fig. 12.3 (colour), where a copy by J. B. Guignet is also reproduced, p. 330, fig. 12.2.

734
Figure of Apollo from 'The Forge of Vulcan', after Velázquez

1879
Alternative titles: *An Angel; Apollo;
(Copy of Velásquez) Apollo from 'The Forge
of Vulcan'; Apollo crowned with laurels in
brown draperies; Vulcan*
Oil on canvas on board
18 x 10½ in. (45.7 x 26.7 cm)
The Alfred Beit Foundation,
Russborough, Blessington, Ireland

Although this painting was titled 'An Angel'
in the artist's sale at Christie's in 1925,
Royal Cortissoz quickly identified the
source of the image as the figure of Apollo
from Velázquez's *The Forge of Vulcan* (fig.
117) in the Prado Museum, Madrid.[1] The
halo of light around the head of Apollo no
doubt explains the reason for this mistaken
identification. The copy can be associated
with the *Vulcano* Sargent is recorded as hav-
ing painted in the Prado Museum, even
though its size varies from that recorded in
the register (Prado archives, *Libros de copis-
tas,* 1879: *Vulcano, #874,* commenced and fin-
ished 15 November 1879, size 20 x 15 cm).

Velázquez's painting shows Apollo dis-
closing to Vulcan the infidelity of his wife
Venus with Mars. There is a startling con-
trast between the idealized and adolescent
figure of Apollo, with his aureole of light
and laurel wreath, and the rugged realism
of Vulcan and his assistants at the forge.
What intrigued Sargent was not the psy-
chological drama taking place or the con-
trast of types but the single, amazing figure
of Apollo. Energy and drama are implicit in
the declamatory pose of the figure, the
sweeping lines of the drapery and the burst
of light. The beautiful nude torso emerges
from the folds of an orange robe, with
mouth open and hand raised, in a way that
is reminiscent of Sargent's academic studies
of male nudes. What transforms Velázquez's
figure into something god-like and super-
natural is the incandescent treatment of
light. The lessons of lost profile and *contre-
jour* would not be lost on Sargent. His copy
is a free adaptation from the original paint-
ing. The rectangle of the window opening
behind the figure gives the composition a
firm structure, but Sargent has shortened
the length of robe flung over the shoulder
in order to narrow the format of his sketch.
He includes Apollo's shadowy left hand but
not that of Vulcan, which underlaps his in
the original picture. The copy is swiftly
painted, with areas of thin staining in the

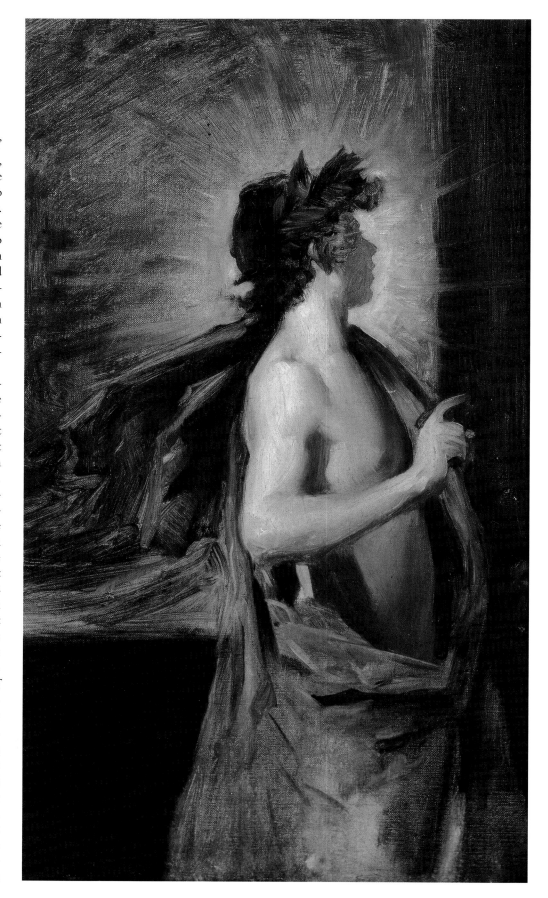

lower part of the costume and the background sky, and bolder passages of impasto for the creamy flesh tones and heavy folds of fabric. Of the ten works Sargent completed in the Prado in 1879, this is the most loosely painted.

Sargent was not the only person to admire the figure of Apollo, for it was the subject of a contemporary photograph after the Velázquez with almost the same proportions as Sargent's sketch (fig. 116). A photograph of *The Forge of Vulcan* is to be found in the Sargent scrapbook in the Metropolitan Museum of Art, New York (50.130.154, p. 48 verso). The picture was bought at the artist's sale in 1925 (Christie's, London, 27 July 1925, lot 237) by M. Knoedler & Co., London, and it was sold by Knoedler, New York, to Edwin D. Levinson of New York City. He owned two other works by Sargent, portraits of *Henri Lefort* and *Jacques Barenton* (*Early Portraits,* nos. 94 and 110).

1. Royal Cortissoz, 'The Field of Art', *Scribner's Magazine,* vol. 79 (March 1926), p. 331. For the original picture, see López-Rey 1963, p. 145, no. 68, ill. pls. 52–53, 56, 447; Brown 1986, pp. 71–72, 77, 90, 168, ill. pls. 83, 85–87, 91 (colour); and López-Rey 1996, vol. 2, p. 104, no. 44, ill. p. 105 (colour).

Fig. 116 *(left)*
Diego Velázquez, detail of Apollo from *The Forge of Vulcan* (Prado Museum, Madrid). From an old photograph in an album that may have belonged to the artist. Private collection.

Fig. 117 *(below)*
Diego Velázquez, *The Forge of Vulcan,* 1630. Oil on canvas, 87¾ x 114 in. (223 x 290 cm). Prado Museum, Madrid (1171).

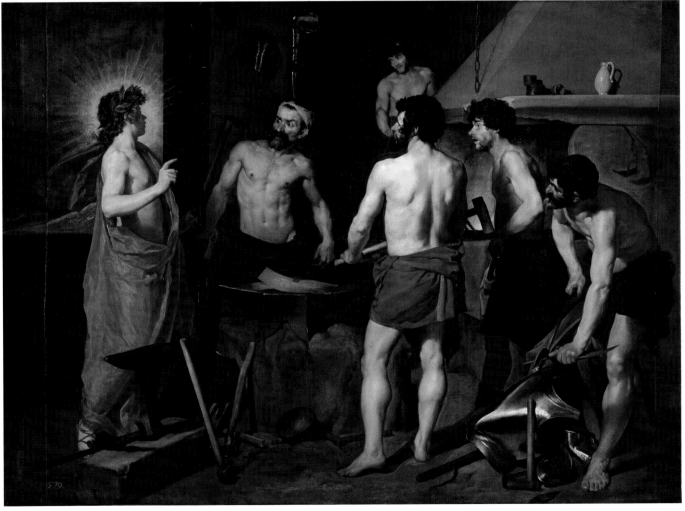

735
Head of Aesop, after Velázquez

1879
Alternative titles: *Head of Aesopus, after Velazquez* and variants; *Head of Aesop, after the picture by Velazquez in the Prado*
Oil on canvas
18⅝₁₆ x 14⅝ in. (46.4 x 37.2 cm)
Ackland Art Museum, University of North Carolina at Chapel Hill. Ackland Fund (75.16.1)

Sargent's portrait of Aesop, the famous early Greek author of fables, derives from a much larger canvas of c. 1639–42 by Velázquez measuring nearly six feet in height.[1] In the original work, a pair to the philosopher Menippus, also in the Prado and both intended for the Torre de la Parada in Madrid, Velázquez had depicted Aesop as a beggar-philosopher, a tired old man dressed in a loose robe open at the neck, a battered book under his arm and simple domestic utensils at his feet. Sargent painted his copy over the course of three days, from 20 November to 22 November 1879 (Prado archives, *Libros de copistas,* 1879: *Esopus,* #881, size 30 x 20 cm). Although the painting measures slightly larger than the record in the Prado register, there is little doubt that it is the same work.

This was the second time that Sargent had decided to concentrate on the head from a much larger figure composition near the end of his studies in the Prado (see *Head of Prince Baltasar Carlos* for the first, no. 728). One can see why he became fascinated with the face of this venerable old sage, because it was in his visage that Velázquez concentrated much of the drama and emotion of the painting. Velázquez's painting would have been familiar to artistic circles in France in 1878 owing to its appearance in that year as a full-page print by C. Kreutzberger in the French periodical *L'Art: Revue Hebdomadaire Illustré,* illustrating an article by Pedro de Madrazo, 'Quelques Velazquez du Musée de Madrid' (vol. 12, no. 1 [1878], pp. 172–73). In addition to discussing the genius of Velázquez as a designer and colourist who created surprising effects from a sober palette, the article emphasized how the Spanish painter designed with his brush, loading it with rich colors and spreading them widely and generously across the canvas.

Sargent, too, drew with his brush, but, as a comparison with Velázquez's work reveals, the two artists adopted very different approaches. The blending of detail and gradual shading used by Velázquez to reveal the topography of the face become fused into a textured fabric of clearly visible, angular strokes by Sargent. Highlights become brighter and shadows darker in his interpretation as he follows the lessons of his teacher Carolus-Duran. Trevor Fairbrother provides a good analysis of the technical aspects of the study (Fairbrother 2000, pp. 47–48). The only major adjustment Sargent made to the original picture was to elongate the face and raise the hairline, which lends his study a more dramatic air.

The study was bought at the artist's sale in 1925 (Christie's, London, 27 July 1925, lot 234), through Thomas Agnew & Son, London, by the well-known Boston collector Alvan T. Fuller (1878–1958), together with eleven more oil paintings and two water-colours. These include several copies after Velázquez and Frans Hals; for further information on Fuller, see the entry for *Prince Baltasar Carlos on Horseback, after Velázquez* (no. 731).

1. For the original picture, see López-Rey 1963, p. 147, no. 73, ill. pl. 110; Brown 1986, pp. 162–63, 168, ill. pls. 189, 192 (colour); López-Rey 1996, vol. 2, p. 226, no. 92, ill. p. 227 (colour); and Tinterow *et al.* 2003, pp. 454–55, ill. p. 211, fig. 9.11 (colour).

736
Buffoon Don Juan de Austria, after Velázquez

1879
Alternative titles: *Portrait of a Buffoon of Philip IV, after Velazquez; Portrait of a Buffoon of Philip IV; The Buffoon,* and variants
Oil on canvas
20½ x 16½ in. (52.1 x 41.9 cm)
Private collection, Paris

The register of copyists at the Prado Museum, Madrid, records Sargent as having painted *A Soldier after Velázquez* in two days, 20–22 November 1879 (Prado archives, *Libros de copistas,* 1879: *Un soldado de Velazquez,* #882, size 30 x 20 cm). This is most likely the present work, which is a copy of the head from the full-length portrait by Velázquez of the *Buffoon Don Juan de Austria* (c. 1632–33), one of the many popular jesters at the Spanish court (fig. 118).[1] In the original portrait, Velázquez depicted the buffoon with various implements of war, including pieces of armour, a musket, and cannonballs. In comic fashion, the portrait parodies the real Don Juan of Austria (1547–1578), who was the illegitimate son of Charles V and commander of the combined fleets of Spain, Venice, and the Papal States. The Christian alliance under his leadership defeated the Turks at the famous naval battle of Lepanto of 1571, which

Velázquez summarily indicates in the background of the picture. Although the sizes of the copy listed in the Prado register (30 x 20 cm) do not exactly match those of the present work, it is highly likely that they are one and the same picture.

Sargent completed the copy during the same time he was at work on the *Head of Aesop, after Velázquez* (no. 735). In both copies, the heads are boldly modelled in terms of light and dark and painted with broad strokes of flowing impasto that define their structure and character. However, in Sargent's version of Don Juan, the softened, slightly blurred treatment of the features in the original is given added force and clarity. The artist plays up the contrasts between

the rich, velvety blacks of the hat and doublet and the gleaming pinks and silvers of the sleeve, cloak strap, collar, hatband and plume. He seems especially to have enjoyed painting the rakish hat, similar to the one worn by Don Balthasar Carlos in the equestrian portrait by Velázquez, of which he made two copies (nos. 728, 731). His copy of Don Juan is an impression of the original portrait, painted in a bold modern style, and not a slavish copy. What it lacks in subtlety it gains in painterly bravura.

1. For the original picture, see López-Rey 1963, pp. 263–64, no. 422, ill. pl. 78; Brown 1986, pp. 97, 100–101, ill. pl. 117 (colour); López-Rey 1996, vol. 2, pp. 160, 162, no. 65, ill, p. 161 (colour); and Tinterow *et al.* 2003, p. 452, ill. p. 130, fig. 4.19 (colour).

Fig. 118 *(left)*
Diego Velázquez, *Buffoon Don Juan de Austria,*
c. 1632–33. Oil on canvas, 82⅝ x 48⅜ in. (210 x 123 cm).
Prado Museum, Madrid (1200).

737
Las Hilanderas, after Velázquez

1879
Oil on canvas
23 x 28 in. (58.4 x 71.1 cm)
The Alfred Beit Foundation,
Russborough, Blessington, Ireland

Commonly called *Las Hilanderas* ('The Spinners'), this famous work by Velázquez, dating from c. 1644–48, was also known as the 'Tapestry Manufactory of Saint Isabel de Madrid', according to the 1878 catalogue of paintings in the Prado Museum.[1] The painting portrays the fable of Arachne from the sixth book of Ovid's *Metamorphoses*. The proud Arachne, famous for her skill in spinning and weaving, challenged Pallas Athena, the goddess of wisdom and the patron deity of weavers, to a contest. Upon viewing Arachne's woven cloth showing the loves of the Olympian gods, Pallas Athena became enraged and struck the girl. The distraught Arachne proceeded to hang herself, but her life was spared by the goddess, who turned her into a spider.

There is debate about whether or not the young woman in the foreground on the right and the old woman spinning on the left represent Arachne and the goddess, or whether they are just ordinary weavers. In any case, the simplicity of the figures and their setting contrasts with the grandeur of the scene taking place in the background, where Pallas Athena, with arm raised, confronts the impudent Arachne. In his copy, Sargent greatly reduced the composition, eliminating the left third and bottom fifth of Velázquez's original painting. He chose to concentrate on the relationship of the young woman on the right with the action in the background alcove. The young woman is reminiscent of the beautiful and sensual models Sargent later employed in Venice, and the play of light along her arm finds echoes in the pose of the dancer in *El Jaleo* (no. 772). The complex spatial relations between the foreground and background

and the layering of the narrative in the painting would have appealed to him. With his brushy strokes, Sargent weaves a story that unwinds from the foreground to the background, where figures arranged on the left and right of the alcove help to frame the action taking place behind; Arachne and the goddess confront one another before a large tapestry, the design of which derives from Titian's *Rape of Europa* in the Prado. The relationship of foreground space to framed niche may well have inspired the composition of Sargent's portrait of *The Daughters of Edward Darley Boit* (*Early Portraits,* no. 56).

Sargent painted this sketchy rendition in only one day according to the register of copyists at the Prado Museum (Prado archives, *Libros de copistas,* 1879: *Las Hilanderas,* #884, commenced and completed 22 November 1879, size 20 x 30 cm). According to the register, this represents the last work Sargent completed at the Prado Museum in 1879. That the artist valued the work is clear from the fact that he hung it in his Paris studio underneath his *Dwarf with a Dog, after Velázquez* (no. 733), which he had also completed on 22 November (see fig. 109).

The picture was bought at the artist's sale in 1925 (Christie's, London, 27 July 1925, lot 230), through Thomas Agnew & Sons, by the well-known Boston collector Alvan T. Fuller (1878–1958), together with eleven more paintings by Sargent and two watercolours. These included several more copies after Velázquez and Frans Hals. For further information on Fuller, see the entry for *Prince Baltasar Carlos on Horseback, after Velázquez* (no. 731). The picture passed into the collection of the South African magnate and collector Sir Alfred Beit, at Russborough in Ireland. The latter also acquired Sargent's *Figure of Apollo from 'The Forge of Vulcan', after Velázquez* (no. 734).

1. For the original painting, see López-Rey 1963, pp. 139–41, no. 56, ill. pls. 122–23, 128, 451; Brown 1986, pp. 252–53, ill. pls. 318–19 (colour); López-Rey 1996, vol. 2, pp. 264–67, no. 107, ill. p. 265 (colour); and Tinterow *et al.* 2003, numerous references, ill. p. 121, fig. 4.11 (colour).

738
The Infanta Margarita, after Velázquez

1879
Oil on panel
13¾ x 9½ in. (34.9 x 24.1 cm)
Private collection

This is a study after the full-length portrait of *The Infanta Margarita* in the Prado Museum, Madrid, then attributed to Velázquez but now generally given to Juan Bautista Martinez del Mazo (1613–1667; see López-Rey 1963, pp. 258–60, ill. pl. 348). Sargent is not recorded as having painted a copy of this portrait in the *Libros de copistas* (Prado archives), but the spirited brushwork and sketch-like treatment of the picture link it closely to the group of Prado studies Sargent executed in the autumn of 1879. It is painted on one of the thin mahogany panels which Sargent was using during the period 1877–80. There is an intriguing reference to 'a Velazquez head of an Infanta, in perfect condition, delicious in colour' in a letter of 14 October 1898 from Sargent to the architect Stanford White (Mount 1969, pp. 225–26). The picture had arrived in Sargent's studio in a box, and he wrote to White asking him what he wanted done with it.

739
Two Heads from 'The Banquet of the Officers of the St George Civic Guard', after Frans Hals

c. 1880
Alternative titles: *Two Heads out of the Repast of the Officers of St. Jorisdoelen in Haarlem, after Frans Hals,* and variants
Oil on canvas
23 x 25⅜ in. (58.4 x 64.5 cm)
Private collection

This copy depicts the heads of two of the officers from the group picture by Frans Hals of *The Banquet of the Officers of the St George Civic Guard* of c. 1627 in the Frans Hals Museum, Haarlem (fig. 119). The man on the left is Lieutenant Jacob Olycan and, on the right, Captain Michiel de Wael.[1] Sargent painted another figure out of this same group (no. 740) and sketched two more heads in pencil (fig. 110).

Sargent's copy of the two heads of the officers captures the exuberance and vitality of Hals's style. The figure on the right looks out at us with flushed cheeks and a smile on his face, the very image of a happy party-goer. His companion, with squarer face and shorter hair, looks up to his left, where we see the ruff and midriff of one of the standard bearers, with an alert and humorous expression. A strong light source from the left, accentuating the brilliance of the flesh tones and the depth of the shadows, gives added character to this festive scene. It was the expressive qualities of the heads that Sargent was studying, and he worked them up to a fair degree of finish. The rest is left vague and sketchy—the falling white ruffs, the light blue sashes of the foreground figure and the standard bearer, and the white and red pattern of the flag. This copy reveals Sargent's admiration for Hals's spirited brushwork and sparkling effects of light and colour.

The picture remained with the artist and was purchased at his sale in 1925 (Christie's, London, 27 July 1925, lot 226) by the well-known Boston collector Alvan T. Fuller through the London art dealers Thomas Agnew & Sons. The price paid by Agnew's was one of the highest realized in the sale, £1,417.10, and among the copies was exceeded only by the *Head of Prince Baltasar Carlos, after Velázquez* (no. 728). Fuller (1878–1958) owned fourteen works by Sargent, including two more copies after Hals and three after Velázquez (nos. 731, 735, 737, 740, 741). For further information on Fuller and his collection, see the entry

for *Prince Baltasar Carlos on Horseback, after Velázquez* (no. 731).

1. For a full discussion of Hals's picture, see Slive 1970–74, vol. 3, pp. 29–31, no. 46, ill. 2, pls. 83–85; and Koos Levy-van Halm and Liesbeth Abraham, 'Frans Hals, Militia-man and Painter: The Civic Guard Portrait as an Historical Document', in Slive *et al.* 1989, pp. 89–102, ill. p. 96, fig. 13.

Fig. 119 *(directly above)*
Frans Hals, *The Banquet of the Officers of the St George Civic Guard,* c. 1627. Oil on canvas, 70¾ x 101¾ in. (179 x 258 cm). Frans Hals Museum, Haarlem.

740
The Standard Bearer from 'The Banquet of the Officers of the St George Civic Guard', after Frans Hals

c. 1880
Alternative titles: *The Standard Bearer out of the Picture of the Officers of St. Jorisdoelen in Haarlem, after Frans Hals,* and variants
Oil on canvas
25 x 23 in. (63.5 x 58.5 cm)
Private collection

The standard bearer is the figure on the far right of *The Banquet of the Officers of the St George Civic Guard* of c. 1627 by Frans Hals in the Frans Hals Museum, Haarlem (fig. 119). He is one of three standard bearers seen parading the standards as part of the ceremonial of the banquet, and he is identified as Ensign Jacob Schout.[16]

Standards feature prominently in all five pictures of civic guard officers painted by Hals in Haarlem, contributing a colourful note of pageantry and martial spirit to these convivial gatherings. The figure in this copy is wearing a large black hat, an accessory the artist clearly enjoyed painting and one reminiscent of the black hats in his two copies of *Prince Balthasar Carlos* and that of *Buffoon Don Juan de Austria,* all three after Velázquez (nos. 728, 731, 736). Like Sargent's oil copy of two heads from this same composition by Hals (no. 739), and the pencil sketch of two more heads (fig. 110), Sargent draws out the character of the standard bearer and his beaming expression of humour and goodwill. The head is the point of the copy and the only part taken to any degree of finish. Without the aid of the original, one would not recognize the blurred white strokes in the centre of the right edge as the gloved left hand of the standard bearer grasping his furled flag. The head of the servant Arent Jacobsz. Koets to his right is taken no further than the underpainting. The forehead of the seated officer below the standard bearer, Captain Nicholaes le Febure, is seen bottom right, but that of a second seated figure, Lieutenant Frederik Coning, is indicated only by a circular patch of lighter tone bottom left; an old photograph in the Frick Art Reference Library, New York, shows details of forehead and eyes that appear to have been obliterated by more recent cleaning. The head of the standard bearer is vignetted in the centre of Sargent's picture, and set off by the broadly brushed textures of ruff, sash and flag.

The copy remained with the artist and was purchased at his sale in 1925 (Christie's, London, 27 July 1925, lot 228) by the well-known Boston collector Alvan T. Fuller (1878–1958). Fuller owned fourteen works by Sargent, including two more copies after Hals and three after Velázquez (nos. 731, 735, 737, 739, 741). For further information on Fuller and his collection, see the entry for *Prince Baltasar Carlos on Horseback, after Velázquez* (no. 731).

1. For a full discussion of Hals's group, see Slive 1970–74, vol. 3, pp. 29–31, no. 46, ill. 2, pls. 83–85; and Koos Levy-van Halm and Liesbeth Abraham, 'Frans Hals, Militiaman and Painter: The Civic Guard Portrait as an Historical Document', in Slive *et al.* 1989, pp. 89–102, ill. p. 96, fig. 13.

741
Detail of Two Figures from 'The Regentesses of the Old Men's Almshouse, Haarlem', after Frans Hals

c. 1880
Alternative titles: *Two Figures of the Administrators of the Old Men's Hospital in Haarlem, after Frans Hals* and variants; *Two Figures from Administrators of the Old Women's [sic] Hospital at Haarlem*
Oil on canvas
50½ x 22 in. (128.3 x 56 cm)
Birmingham Museum of Art, Alabama
(1962.62)

This is a copy of the regentesse and servant on the far right of Frans Hals's group of *The Regentesses of the Old Men's Almshouse* of c. 1664 in the Frans Hals Museum, Haarlem (fig. 120).[1] The names of the four regentesses are known—Adriaentje Schouten, Marijtje Willems, Anna van Damme and Adriana Bredenhoff—but there is no key to identify which figure is which. The name of the female servant entering with a message is unknown, like that of the male servant in the regents' group, which Sargent also copied (no. 742).

Sargent's copy, in common with those of the civic guard officer pictures (nos. 739, 740), is essentially a study of heads. However, the sombre mood and restrained dignity of the elderly regentesse and the servant are far removed from the bonhomie of Hals's smiling cavaliers. Sargent's picture is a worked-up copy of the right-hand side of the Hals group and painted on the same scale. The head of the frail but indomitable regentesse is one of Hals's most moving characterizations, and she dominates the composition and her fellow-administrators through sheer force of personality. The gaunt, bony structure of the head of the regentesse indicates her old age, but her firm jaw, mobile lips and deep-set, expressive eyes, accentuated by the black lines of the arching eyebrows (repeated in the shape of the cap), and the eyelashes, speak of her humanity and strength of will. The servant, from a different social milieu, provides a submissive foil to the grand old woman in front. Interestingly, Sargent omits the regentesse's left hand, as moving a testament to age and character as the head, and cuts off the hand of the servant. The vertical juxtaposition of the heads, one above the other, and the pattern of white collars, cuff and cap, allowed Sargent to turn his partial copy into a coherent design of its own.

The copy can be seen hanging in a photograph of Sargent's Paris studio, 41, boulevard Berthier (fig. 109), together with two copies after Velázquez, *Dwarf with a Dog* and *Las Hilanderas* (nos. 733,737). The copy was included in the artist's sale in 1925 (Christie's, London, 27 July 1925, lot 225), and it was purchased there by the London art dealer Thomas Agnew & Sons, on behalf of the well-known Boston collector Alvan T. Fuller (1878–1958). Fuller owned fourteen works by Sargent, including two other copies after Hals and three after Velázquez (nos. 731, 735, 737, 739, 740). For a discussion of Fuller and his collection, see the entry for *Prince Baltasar Carlos on Horseback, after Velázquez* (no. 731).

1. For a full discussion of the original painting, see Slive 1970–74, vol. 3, p. 113, no. 222, ill. 2, pls. 346–52; and Slive *et al.* 1989, pp. 362–69, no. 86, ill. pp. 365–66, 369 (all colour).

Fig. 120 *(below)*
Frans Hals, *The Regentesses of the Old Men's Almshouse,* c. 1664. Oil on canvas, 67⅞ x 100¾ in. (172.5 x 256 cm). Frans Hals Museum, Haarlem.

742
Regents of the Old Men's Almshouse,
Haarlem, after Frans Hals

c. 1880
Alternative titles: *The Administrators*
of the Old Men's Hospital at Haarlem,
after Frans Hals, and variants
Oil on canvas
30 x 41 in. (76.5 x 104 cm)
Untraced

This is a copy of Frans Hals's *Regents of the*
Old Men's Almshouse, dating from the early
1660s, in the Frans Hals Museum, Haarlem.
The original is a pair to *The Regentesses of*
the Old Men's Almshouse (fig. 120), of which
Sargent made a copy of two of the figures
(no. 741).[1] It is known that the five regents
painted by Hals were Jonas de Jong,
Mattheus Everswijn, Dr Cornelis Wester-
loo, Daniel Deinoot and Johannes Walles,
who held office between 1662 and 1665,
but there is no key to identify which figure
is which. The servant delivering a message
in the background is unidentified. Hals's

picture has darkened considerably over
time, making it difficult to work out the
proportions of the space and obliterating
much of the detail. Because of this and the
loss of middle tones, the heads, set off by
large white collars, loom out of the dark-
ness with a disembodied air. The only
accent of colour is the red stocking of the
regent on the right, showing at the knee.

In 1877, the obscure Dutch critic Jo.
De Vries claimed that the regent seated sec-
ond from the right was drunk, and that
Hals had painted the group in a satirical
spirit to exact revenge for his poverty and
lack of recognition. Other nineteenth-
century commentators interpreted the tech-
nical freedom of this group and its com-
panion as evidence of Hals's declining
powers and linked it with his supposedly
dissolute way of life (see Frances S. Jowell,
'The Rediscovery of Frans Hals', in Slive *et*
al. 1989, pp. 61–86). Both pictures were the
subject of controversy and debate, and it is
revealing that Sargent was among those
who early on recognized in these sombre
late works, so different from the colourful

groups of civic guard officers, two of Hals's
greatest masterpieces.

Sargent's study of the regents is the
only complete composition by Hals that he
copied. It is also the sketchiest and the least
finished. There is no attempt to replicate
the pattern of Hals's brush strokes; the
modelling of the faces is perfunctory—just
a few broad blocks of pigment, and the var-
ious items of linen register as almost flat
passages of white. What seems to have
intrigued Sargent was the pattern of faces
and hands looming out of the shadows of a
dark, mysterious space with strange intensi-
ty and enigmatic meaning. Hals had broken
the conventions of Dutch civic portraiture
to express a more profound vision of the
human condition. And the boldness and
economy of his technique demonstrated as
never before his sureness of touch and his
mastery of his medium.

1. For the original painting of the regents, see Slive
1970–74, vol. 3, pp. 112–13, no. 221, ill. 2, pls. 340–45;
and Slive *et al.* 1989, pp. 362–68, no. 85, ill. pp. 363–64
(colour).

743
Saint Roch with Saint Jerome and Saint Sebastian, after a Picture attributed to Alessandro Oliverio

c. 1880–81
Alternative titles: *St. Jerome [or Gerome], St. Roch and St. Sebastian; Three Saints by Giorgione; (Copy of Girolamo da Treviso the Younger) St. Gerome, St. Roch, St. Sebastian; Saints Jerome, Roc and Sebastian*
Oil on canvas
31½ x 31⅜ in. (80.1 x 79.8 cm)
On the reverse are two identical printed labels for the Venetian colourman: *Giuseppe Biasutti/Presso La Regia Accademia/N. 1024 Venezia/Deposito oggetti/per/pittura e disegno*
Hood Museum of Art, Dartmouth College, Hanover, New Hampshire. Gift of M. R. Schweitzer (P959.121)

This picture of three saints in the sacristy of Santa Maria Salute in Venice has in the past been attributed to Giorgione and Girolamo da Treviso the Younger. It was attributed by Bernard Berenson to Alessandro Oliverio (c. 1500–after 1544), a minor artist in the circle of Giovanni Bellini, Giorgione and Palma Vecchio (see Berenson, *Italian Pictures of the Renaissance: Venetian School* [London, 1957], vol. 2, pl. 686). In Sargent's painting, Saint Jerome is shown on the left in the robes of a cardinal holding a copy of the Bible in his left hand. Saint Roch, patron saint of the plague-stricken, is in the centre pointing to the ulcerated wound in his thigh; he wears the scallop shell of a pilgrim, the cross keys of the papacy and a clasp with the image of Christ on the collar of his cloak, and holds a staff on which is suspended his pilgrim hat. On the right, Saint Sebastian is seen enduring martyrdom at the hands of archers, with a townscape visible in the background. Commenting on the difference between Sargent's copy and the original, Custis Spencer wrote (*Reflections of the Original: Copies in the Dartmouth College Collection,* ed. Arthur R. Blumenthal [Hanover, New Hampshire, 1978], p. 47):

Sargent, although he maintains the essential structure and composition of Oliverio's original, gives his painting a much more impressionistic quality. Sargent's brushwork is broader and looser than Oliverio's. Sargent pays less attention to detail and fine execution. His figures are less precise, seeming to merge with the background; Sargent's forms are hidden and obscured by his heavy use of shadow. The suggestion of movement in Oliverio's composition and the diagonal accents of the figures are developed and emphasized in Sargent's painting.

Spencer goes on to suggest that Sargent has imbued the original with a depth of feeling and pathos not present in the original, as if he was reinterpreting the work in his own idiom. Richard H. Finnegan has suggested

that Sargent may have been intrigued by the square format of the Oliverio painting and its formal depiction of a male nude, as well as the challenge of the famous palette of Venetian painters in the first half of the sixteenth century (communication to the authors, 6 November 2004).

On the reverse of Sargent's copy is a label for Giuseppe Biasutti, a Venetian supplier of artists' materials. The same labels appear on the reverse of three other Venetian paintings, *The Onion Seller* and two street scenes, all datable to 1880–82 (nos. 801, 808, 810), and it is reasonable to assume that this copy was executed during the same period; see the entry for *Street in Venice* (no. 808) for more details of Biasutti.

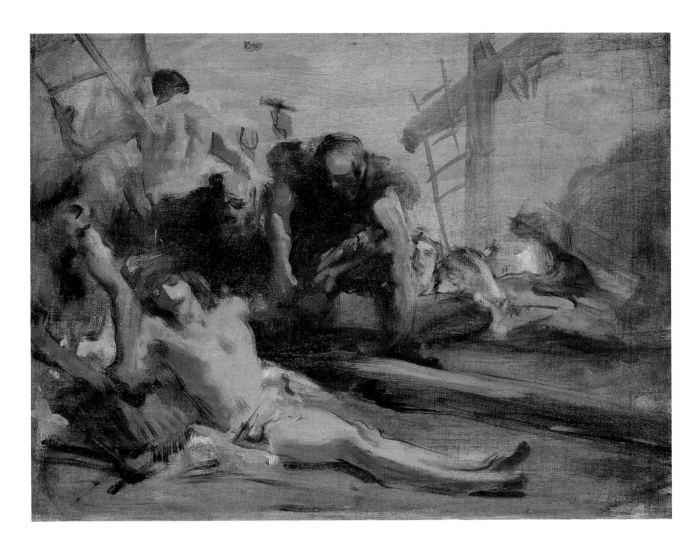

744
The Descent from the Cross,
after Giandomenico Tiepolo

c. 1879
Alternative titles: *The Deposition;*
Cristo inchiodato sulla Croce
(After Giandomenico Tiepolo)
Oil on panel
10 x 13 in. (25.5 x 33 cm)
Private collection

This slight sketch is after the painting of *The Descent from the Cross* by Giandomenico Tiepolo (1727–1804), son of the more famous Giambattista Tiepolo, in the Prado Museum, Madrid. It is painted on one of the thin mahogany panels Sargent was using in the period 1877–80. Though not recorded in the Prado's register of copies, it must have been done at the same time as the copies after Velázquez in the autumn of 1879. Giandomenico Tiepolo's picture is one of a series of eight pictures by him on the theme of the Passion originally painted for the church of the Convent of St Philip Neri in Madrid, and transferred to the Museum of the Trinity in 1836.[1] In Tiepolo's

picture, the dead figure of Christ is shown lying beside the wooden cross on which he has been crucified, his shoulders propped up on a wicker trestle of some kind, attended by three male figures who have helped to release him, one holding aloft a hammer. A fourth man, with his back to us, raises a ladder on the left side of the picture. To the right the heads of the two Marys are visible at ground level below a second cross and ladder. Sargent's sketch captures the main thrust of Tiepolo's composition, but it is painted summarily, with abbreviated detail. The mahogany panel shows through in several places, providing a useful middle tone.

Sargent was a keen admirer of the work of Tiepolo father and son, and he was to be influenced by their decorative work when he came to paint his own schemes of mural art. A water-colour by him of the ceiling by Giambattista Tiepolo in the Palazzo Clerici in Milan is in the Metropolitan Museum of Art, New York (no. 50.130.25; see Herdrich and Weinberg 2000, pp. 294–96, no. 265, ill. p. 295, colour). A related water-colour of the *Golden Room of the Palazzo Clerici* is in the Baltimore Museum of Art, and a drawing

said to be after a Tiepolo ceiling decoration of trumpeting angels is in the Fogg Art Museum, Harvard University Art Museums, Cambridge, Massachusetts (no. 1937.8.56). Sargent owned a drawing of *The Martyrdom of Saint Catherine* by the elder Tiepolo and a set of four biblical paintings by his son, Giandomenico (Christie's, London, 27 July 1925, lots 271 and 317, respectively).

This sketch belonged to the artist's close friend and fellow-artist Henry Tonks (1862–1937), another fan of rococo art.[2] Sargent, in his turn, owned works by Tonks, including *Sodales* (Tate Gallery, London), *Interior of a Carpenter's Workshop* (private collection), and an amusing series of water-colour caricatures of Sargent (various private collections). The two men travelled together to the Western Front in France in 1918 during World War I.

1. See Pedro de Madrazo, *Catalogue des Tableaux du Musée du Prado* (Madrid, 1913), pp. 75–76, nos. 355–62; *The Descent from the Cross* is no. 361.
2. Other works by Sargent belonging to him are as follows: *A Moroccan Street Scene* (no. 782); *Man and Boy in a Boat* (no. 680), an oil sketch of *Mrs Hugh Hammersley* (*Portraits of the 1890s,* no. 285); a water-colour of *Gondolas, Venice* (private collection); and a portrait drawing of himself (Fitzwilliam Museum, Cambridge).

745
Two Figures from 'The Three Graces',
after Rubens

c. 1879
Alternative titles: *Study from*
'The Three Graces', by Rubens;
(Copy of Rubens) Three Graces;
Rubens: Three Graces;
The Three Graces, after Rubens,
and variants
Oil on canvas
18¼ x 11⅞ in. (46.4 x 30.2 cm)
The Wichita Art Museum, Kansas. Gift of
Mr and Mrs Arthur W. Kincaid, Sr (1964.1)

This copy is a fragment from Rubens's
well-known picture of *The Three Graces* in
the Prado Museum, Madrid. It represents
the upper left-hand quarter of the painting,
with the cropped figures of two of the
Three Graces, a piece of fabric hanging
from the branch of a tree, and a back-
ground of blue sky. Though Sargent is not
listed in the Prado's register of copies as a
copyist of this work, it seems highly likely
that this study was painted at the same time
as the studies after Velázquez in the autumn
and early winter of 1879. Its spirited,
painterly style compares well with several
of the smaller copies made from parts of
Velázquez's larger compositions (see nos. 734,
737). The authors are grateful to Stephen
Gleissner, chief curator at the Wichita Art
Museum, for assistance with this entry.

746
Angels in a Transept, Study after Goya

1879
Alternative titles: *Study of Goya in an Arch at San Antonio, Madrid; Study of Goya (at San Antonio, Madrid); Goya (from an Archway at San Antonio, Madrid)*
Oil on panel
13⅝ x 10¼ in. (34.6 x 26 cm)
Inscribed, upper left: *John S. Sargent, after Goya/to E.C. [Evan Charteris]*
Private collection

In 1798, Francisco Goya was commissioned to decorate the recently rebuilt church of San Antonio de la Florida in the outskirts of Madrid. There, he painted a series of exuberant and light-filled murals, *The Adoration of the Trinity* in the apse and *The Miracle of Saint Anthony of Padua* in the dome. The latter illustrates a famous incident in the life of the saint when he brings a murdered man back to life in order to prove the innocence of his father, who had been accused of the crime. On the undersides of the four arches supporting the dome, Goya painted groups of angels and cherubs celebrating the miracle above. Sargent copied the lower section of one of these arches, with two angels at the base in an attitude of prayer and a third flying off into space (embracing a fourth angel in the Goya but omitted in the copy).[1] Advising Vernon Lee on what she should see in a forthcoming visit to Spain and Morocco in 1888, Sargent singled out the church (letter dated 1888 in another hand, Vernon Lee Papers, Special Collections, Millar Library, Colby College, Waterville, Maine):

At Madrid there is a little church outside the walls all decorated by Goya, St. Antonio de la Florida, and some very fine Goyas at the Almeida del Duque d'Osuna wherever that is, and at the Academy of St Luke where they will show you besides pictures the early proofs of his books of etchings.

Don't judge Goya only by the things at the Prado & the Escorial.

Goya was second only to Velázquez in Sargent's pantheon of Spanish artists, and his influence can be traced in several early paintings, not least in *El Jaleo* (no. 772). Contemporary critics also recognized the connection as they compared *El Jaleo* with the work of the Spanish master. Sargent's admiration for Goya, and especially for his graphic work, can be traced throughout his life, in letters to friends and recommendations for museum purchases. He himself owned several volumes of Goya's etchings (see introduction to chapter 8, p. 233, n. 18). What must have struck Sargent about Goya's murals in San Antonio de la Florida was their scintillating style, with brilliant effects of light, by means of which the Spaniard transformed the traditional imagery of religious art.

This oil was a gift to Sir Evan Charteris (1864–1940), Sargent's friend and first biographer. According to a letter attached to the painting, Charteris owned two preliminary studies by Goya for the fresco in San Antonio de la Florida. Charteris dated the present work to 1902, perhaps reflecting the date of the gift rather than that of execution. The paint handling and the use of the mahogany panel indicate a date of 1879.

1. For a description of Goya's murals in the church, see Pierre Gassier and Juliet Wilson, *Goya: His Life and Work with a Catalogue Raisonné of the Paintings, Drawings and Engravings*, ed. François Lachenal (London, 1971), pp. 191–93, nos. 717–35, with illustrations. A booklet by M. José Rivas Capelo is available at the church, *Goya's Frescoes: A Guide to the Church of San Antonio de la Florida* (Madrid, Área de las Artes, 1995).

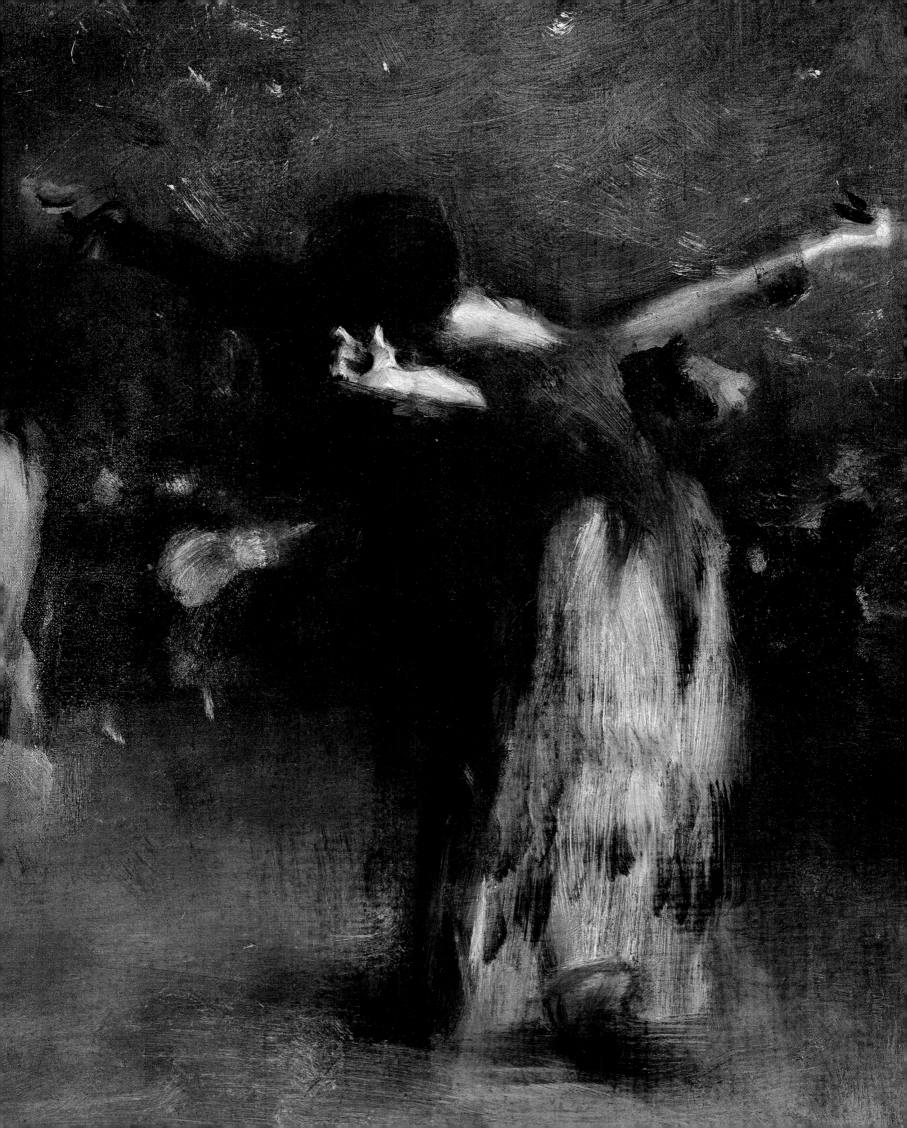

SPAIN AND *EL JALEO,* 1879–1882

SPAIN

The primary purpose of Sargent's visit to Spain in the autumn of 1879 was to study the works of Velázquez in the Prado Museum, Madrid (see chapter 7, pp. 197–99). In the spring of 1868, when Sargent was twelve, his family had made a lengthy tour of Spain, travelling from Barcelona to Madrid, and thence to Valencia, Córdoba, Seville, Cadiz and Gibraltar.[1] The sights and experiences of that expedition must have left a mark on his imagination. Spain was regarded by some travellers as a backward but exciting country, especially in the south with its traditions of bullfighting, gypsies, flamenco dancing and Moorish architecture. To some visitors, the Spanish appeared proud, superstitious, religious, sensual, lazy and sometimes cruel. Travel was difficult, the dirty and flea-infested inns notorious, and stories of travellers waylaid by bandits not unknown. But, with all that, there was a romance to the country, and most visitors, while cursing the shortcomings of the Spaniards, would not have wanted it to change. They admired Spain because it was unreformed, traditional, picturesque and unlike anywhere else.[2]

Sargent's vision of Spain would not only have been fed by his own early experiences but also by those painters he admired who had travelled there before him. First and foremost was Carolus-Duran, who held up Velázquez as a beacon of light to his students and whose early pictures demonstrated the lessons of the Spanish master.[3] Henri Regnault, a tragic victim of the Franco-Prussian War of 1870–71, had cast a spell over Sargent and artists of his generation with his bravura realism and sensational subject matter.[4] His picture of *The Arrival of General Prim outside Madrid on October 8, 1868, with the Spanish Revolutionary Army* (1869–70, Musée d'Orsay, Paris) caused a sensation at

the Salon of 1870, and continued to excite admiration throughout the 1870s. Regnault had painted studies in the Alhambra in Granada (see fig. 121), and he made the palace the setting for his orientalist masterpiece *Execution without Judgement in the Time of the Moorish Kings of Granada* (1870, Musée d'Orsay, Paris). The Spaniard Mariano Fortuny, another of Sargent's favourites (see fig. 179), had established an international following with his carefully researched and exquisitely crafted Spanish genre scenes.[5] And for those with avant-garde tastes there was the example of Édouard Manet, who had made scenes of bullfighting and Spanish dance the epitome of the modern-life subject.[6] All four artists had made a point of copying Velázquez, seeking in their study of his work to find precedents for their own innovations in style and technique. By following in the wake of such painters, Sargent was declaring his own modernist sympathies and allegiances.

The lure of Spain was not only pictorial but literary. *Don Quixote* was a favourite book of Sargent's, who came to own several editions of this Spanish classic by the seventeenth-century writer Cervantes.[7] The fantastical adventures of Don Quixote and Sancho Panza would have appealed to his love of the bizarre and his sense of the absurd. Two other books in his library were by the idiosyncratic British author George Borrow, *A Bible in Spain,* describing his adventures as a Protestant missionary, and *The Zincali: An Account of the Gypsies of Spain,* though whether Sargent owned them this early is not known.[8] With his passion for serious reading, it is unlikely that he had overlooked other seminal books on Spanish culture, art and travel. He may well have carried Richard Ford's celebrated *Handbook for Travellers in Spain* in his luggage, for it remained one of the best accounts of where to go and what to see, and it had

been reprinted many times.[9] Another pioneering study of Spanish art was Sir William Stirling-Maxwell's *Annals of the Artists of Spain* (1848), and this again is to be found in Sargent's library, together with *Spain and the Spaniards* by Edmondo de Amicis, though the edition Sargent owned was published after his visit to Spain.[10] Amicis was a much-read Italian author who had also published a book on Morocco. Since the 1830s, a succession of famous French authors had made their pilgrimage to Spain and returned home to write up their adventures, contributing in the process to a cult of *hispanism* that influenced art, music, theatre, novels, fashion, design and architecture.[11]

Sargent's visit to Spain in the autumn of 1879 is not well documented. It is Sargent's biographer Evan Charteris who provided the names of his two travelling companions, 'Daux and Bac'.[12] These were Charles-Edmond Daux and Armand-Eugène Bach, both students of the French academic painter Alexandre Cabanel. Like Sargent, they had begun exhibiting at the Salon in the late 1870s and continued to exhibit through the 1880s. Sargent had met them in Capri during the summer of 1878, where they are recorded in the visitors' book of the Hotel Pagano (see the introduction to chapter 5, pp. 141–42); both men exhibited Capri scenes at the Salon of 1879, that by Daux being a study of the model Rosina.[13] Both artists appear with Sargent as copyists in the Prado Museum records.[14] Sargent had signed in to the Prado on 17 October 1879, so we know he was in Madrid by that date, probably having travelled overland by way of Barcelona or San Sebastian. His address in the record is given as Calle de la Salud 13, a street lying between the Grand Via, the Calle Major and the Calle de la Montera. J. Carroll Beckwith stayed at the same boarding house when he came to Madrid in 1880,

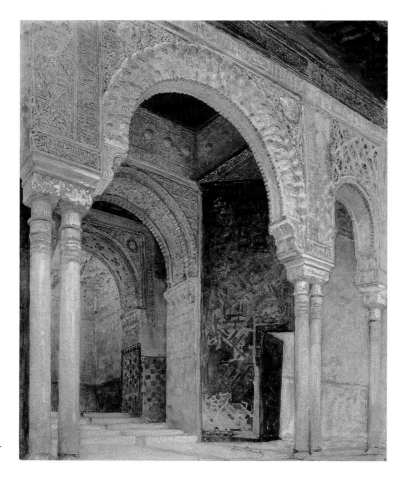

Fig. 121
Henri Regnault,
*The Alhambra, Granada,
Entrance to the Hall of
the Two Sisters,* c. 1869.
Water-colour and
gouache on paper,
24 x 19¼ in. (61 x 49 cm).
Musée du Louvre, Paris.

no doubt on Sargent's recommendation. Other records are fragmentary: a torn-in-half receipt for a Madrid hatmaker, M. Villasante, that Sargent used for two sketches of dancing scenes (figs. 126, 127);[15] a letter of 16 March 1880 from his sister Emily to their mutual friend Vernon Lee:

Did I tell you that John sent me a guitar from Madrid at Mamma's request? It is a very nice one in tone & size, only it has the old fashioned pegs which sound prettier than the new fashioned mécanique and I was delighted. I soon found however that it would not keep in tune, & the picturesque pegs kept flying back & hurting my knuckles so that I had to give up in despair, & beg John to send down the mécanique from our broken guitar, to have it applied to this one.[16]

We can gain some insight into the things which Sargent saw and admired in Madrid and Toledo from the evidence of two later letters sent by him to Vernon Lee and the American sculptor Augustus Saint-Gaudens. Here is the first to Vernon Lee, dated 1888 in another hand:

At Toledo mind you see a church within the walls with a tomb of a cardinal by Berruguete and a magnificent picture by Greco in another church. It used to be almost impossible to see Alonso Cano's St. Francis in the Cathedral & one had to write to

a cardinal at least. At Madrid there is a little church outside the walls all decorated by Goya, St. Antonio de la Florida, and some very fine Goyas at the Almeida del Duque d'Osuna wherever that is, and at the Academy of St Luke where they will show you besides pictures the early proofs of his books of etchings.

> *Don't judge Goya only by the things at the Prado & the Escorial.*[17]

The mention of San Antonio de la Florida is interesting, for the only study which Sargent made in Madrid, apart from the studies after Velázquez in the Prado, was taken from Goya's decorations in the church (see no. 746). Sargent was a keen admirer of Goya's etchings, and came to own several volumes of his prints.[18] As Mary Crawford Volk has shown, the influence of Goya on Sargent's work, especially evident in *El Jaleo* (no. 772), has been very much underestimated.[19] The second letter to Saint-Gaudens, written ten years after the first, amplifies the advice which Sargent had given to Vernon Lee:

I am writing to tell you, in case this reaches you before starting, to be sure and spend a day at Burgos and see the magnificent gothic retablos at the Cartuja [Charterhouse] de Miraflores a couple of miles out of town and in the church of [crossed out: S Tome] [?] near the cathedral—And if you

go to Toledo, which not being a damned fool I suppose you will, mind you see the pictures by El Greco at Sto Tome in the sacristy of the cathedral, at the Museum, and wherever else you hear of any—and also the splendid tomb by Berraguete of Cardinal Tavera in the church [crossed out] 'Hospital de Afuera'—And mind you see the Academy of San Fernando at Madrid as well as the Prado.[20]

Further evidence of what Sargent saw and admired comes in the form of photographs of buildings and works of art that he collected and mounted in a scrapbook at the time, which is now in the Metropolitan Museum of Art, New York. Apart from reproductions of pictures by Velázquez and other masters, the scrapbook includes architectural views and photographs of objects: two suits of Chinese armour from the Royal Armoury and the portal of La Latina in Madrid; from Toledo the celebrated statue of Saint Francis of Assisi by Alonso Cano in the cathedral, and the splendid Renaissance tomb of Cardinal Tavera in the church of the Hospital de Tavera (formerly Afuera), both mentioned in the letters to Vernon Lee and Saint-Gaudens quoted above; the Moorish interior of Santa Maria la Blanca, a former synagogue, of which Sargent made an oil study (no. 747); and two details of Moorish ornament.[21]

Of the photographs of buildings outside Madrid and Toledo, the majority, significantly, are also architectural, for this was to be the theme of his Granada studies, and he was clearly excited by building and ornament, both Moorish and European. The inclusion of buildings in far distant cities does not necessarily mean that Sargent went there, for many of the views had been taken by the Madrid photographer J. Laurent and could have been purchased at his shop. The photographs are mostly details of Romanesque and Gothic structures: the cloister of the College of Santiliana in Santander (fig. 122); the ornate doorway of the cathedral at Tarragona; the Romanesque apse of San Isidore in Leon; the Romanesque apsidal chapels of Salamanca's old cathedral; and the Casa de los Momos, an old Castilian mansion, in Zamora.[22] The photographs of Granada will be discussed later in this chapter.

Of Sargent's social life in Madrid we know little. We can assume that he enjoyed some of the same pleasures as Beckwith, who records in his diary that he followed Sargent's directions for the theatre La Bolsa in July 1880. When the Prado closed in the late afternoon, Beckwith took lessons in

Spanish and the guitar, and then strolled to a café for a drink with his friends, or listened to music at one of Madrid's many theatres.[23] Given his range of contacts in the French art world and his friendship with Carolus-Duran, it would be surprising if Sargent had not come armed with introductions. In later life, he established friendships with several Spanish artists,[24] but of his contacts with the artistic community in Madrid on this occasion the record is silent, apart, that is, from the names of his fellow copyists in the Prado. Robert C. Hinckley, another member of Carolus-Duran's atelier and a good friend of Sargent, is recorded as a copyist in September and October 1879, and it is possible that the two met up.[25] Another person Sargent is likely to have called on is the American minister in Madrid at the time, James Russell Lowell (1819–1891), a celebrated author and diplomat, a hispanophile who wrote *Impressions of Spain* (Boston, 1899), and a close friend of Henry James, whom Sargent was soon to meet.

Fig. 122
Photograph of the cloister of the College of Santiliana, Santander. From an album of early drawings and reproductions belonging to the artist. The Metropolitan Museum of Art, New York. Gift of Mrs Francis Ormond, 1950 (50.130.154, p. 64 verso).

THE ALHAMBRA

Sargent's last day as a copyist in the Prado was 22 November 1879. Soon after that date he must have headed south, in company with one or the other or possibly both of his French friends Daux and Bach. His itinerary would take him to Córdoba, Granada, Seville, Málaga, and finally through the Ronda Mountains to Gibraltar, though in what order he visited the cities is unclear. He would later regret 'the many months spent in Spain in the rain and bad weather that quite spoiled the trip as far as painting and enjoyment goes'.[26] Part of the inscription on the drawing of a crucifix and domed shrine (fig. 143) reads: 'J. W. Watson Esq./15 Plaza de la Infanta Isobel/U.S. Consul Malaga, Mr Guals'. Evidence of Sargent's stay in Seville comes from the drawing of a café scene, inscribed 'John S. Sargent. Seville' (fig. 123) and from a photograph of the Casa de Piletos (Pilate's House) in his scrapbook.[27] It may have been in Seville or Granada that Sargent painted the oil sketches of the statuette of a Madonna decked out for some special ceremony (nos. 760–62) and the haunting study of a Spanish crucifix (no. 759). Sargent later used these studies, and others with Spanish themes, for illustrations to Alma Strettell's book *Spanish & Italian Folk-Songs,* published in London in 1887 (see appendix 11, p. 388).

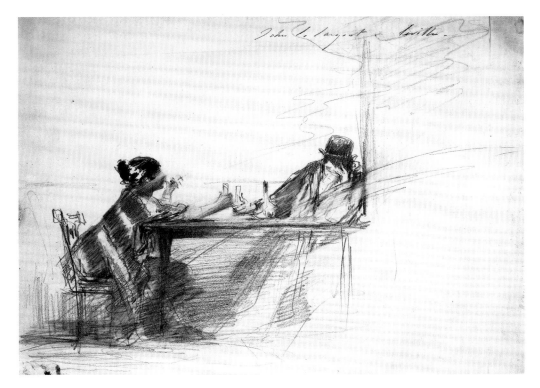

Fig. 123
Café Scene, Seville, 1879. Pencil on paper, 9⅜ x 13 in. (23.9 x 33 cm). Inscribed, upper right: *John S. Sargent. Seville.* From Sargent sketchbook. Isabella Stewart Gardner Museum, Boston.

Córdoba is recorded in the scrapbook with a photograph of the famous mosque,[28] but of all the cities of the south it was Granada which fired Sargent's imagination. There he experienced the raw emotion and haunting music of Spanish gypsy dancing that would inspire his three great dance pictures, *The Spanish Dance, Spanish Dancer* and *El Jaleo* (nos. 763, 770, 772). While responding to the passion and excitement of the flamenco, Sargent was also engaged on a very different project—recording the architecture and decoration of the Alhambra. This former palace of the Moorish kings of Granada and their Christian successors had come to be recognized as one of the wonders of Europe. Its romantic history, vividly brought to life in Washington Irving's *Alhambra* (first published 1832), which remains a best-seller in Granada to this day, and the exquisite beauty of its halls and courtyards made it a magnet for travellers to Spain.

Many passages of purple prose were expended on the glories of the palace, and it inspired a wealth of paintings and prints. Alexandre Laborde was among the first to explore its graceful forms and delicate decoration in a series of engravings published in his *Voyage Pittoresque et Historique* (Paris, 1806–20). He was followed by two well-known English artists with similar portfolios, J. F. Lewis with *Sketches and Drawings of the Alhambra* (London, 1835) and *Sketches of Spain and Spanish Character* (London, 1836), and David Roberts with *Picturesque Sketches in Spain* (London, 1837). Thereafter, artists visiting Granada never failed to paint pictures of the Alhambra as a trophy of their travels. It features in topographical views like those by the German painters Eduard Gerhardt and Franz von Lenbach and the American Samuel Colman; in genre scenes such as those by the Spaniard Mariano Fortuny and the Frenchman Adrien Dauzats; and in the background of historical paintings such as Henri Regnault's *Execution without Judgement in the Time of the Moorish Kings of Granada* (Musée d'Orsay, Paris).

Sargent's half-dozen studies of the Alhambra lack both figures and narrative. While ostensibly studies of architecture and decoration, they do convey the magic of the palace complex through their special qualities of light and atmosphere. Shafts of sunlight falling across façades contrast with shadowed halls and mysterious openings within. Sargent plays with voids and solids and the interplay of light and shadow, form and colour, to give resonance to his records of this famous monument. Dr Fitzwilliam

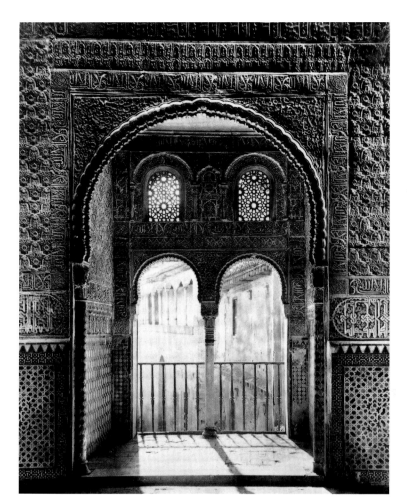

Fig. 124
Photograph of the Room of the Ambassadors, The Alhambra, Granada. From an album of early drawings and reproductions belonging to the artist. The Metropolitan Museum of Art, New York. Gift of Mrs Francis Ormond, 1950 (50.130.154, p. 21 verso).

Sargent had told his brother Tom that his son was going to Spain on 'a sketching & studying tour',[29] and here it was in action. Sargent had won a medal for ornamental design in 1877 (see fig. 12), and the discipline continued to fascinate him long after he had ceased to be an art student, emerging again as a potent force in his murals for the Boston Public Library and the Museum of Fine Arts, Boston. Sketching in the Alhambra, he was architectural draughtsman and ornamental designer learning his trade.

What especially caught Sargent's eye and captured his interest were the arcades surrounding the main courtyards, with their groups of slender pillars and Moorish archways. The most finished of the pictures is the frontal view of one of the projecting pavilions in the famous *Patio de los Leones (Court of the Lions)* (no. 748). This is a luminous picture, all gold and yellow, contrasting the depth of the space with the repeating pattern of massed columns and arches in almost perfect symmetry. It achieves what Sargent does best—the accurate transcription of architectural form in terms of light and colour. Another picture closely related to it in style and mood is the *Patio de los Arrayanes (Court of Myrtles)* (no. 752), a

honey-coloured view of an arcade from further away, its curving forms and pillars reflected in the pool in front. More detailed are the various water-colour studies of the Alhambra, including a vista of columns from the Patio de los Leones (no. 749), two water-colours of a highly ornate door in the same court, seen at floor level (nos. 750, 751), and a beautifully crafted study of the famous Alhambra vase (no. 754).

Sargent's fascination with the complexities of Hispano-Moresque design is evident from the photographs of the Generalife and the Alhambra that he mounted in the scrapbook already described above.[30] These are mostly of highly ornate archways and interiors, including a view of a honey-combed ceiling and another from inside a pavilion in the Patio de los Leones (fig. 139). The photographs demonstrate Sargent's interest not just in the magical effect of Moorish architecture and decoration but in its fine detail and principles of design. He included some precise drawings of design features in the Alhambra in an album of later studies relating to his mural work.[31]

Sargent's visit to Spain had a profound influence on the development of his art. It gave him a lifelong passion for Spanish

music and dance, fostered a love of Spanish architecture and landscape and aroused his sympathy for the Spaniards themselves. Sargent was to pay several later visits to Spain, in 1895, for example, when he was carrying out research on Spanish art and Christian iconography for his murals in the Boston Public Library, and after 1900 when he came on sketching expeditions. He was consulted as an expert on Spanish acquisitions by American museums, and he was involved in the organization of two exhibitions of Spanish art in London in 1895 and 1920.[32] He himself owned a version of El Greco's *Saint Martin and the Beggar* (John and Mabel Ringling Museum of Art, Sarasota), which hung prominently over the fireplace in the studio of 33 Tite Street. El Greco, Velázquez and Goya continued to occupy a leading place in his pantheon of the old masters and to inspire his art.

EL JALEO AND SPANISH DANCE

Sargent was captivated by Spanish music. In a much-quoted letter to Vernon Lee, he described his experiences:

You wished some Spanish songs. I could not find any good ones. The best are what one hears in Andalucia, the half African Malaguenas & Soleas, dismal, restless chants that it is impossible to note. They are something between a Hungarian Czardas and the chant of the Italian peasant in the fields, and are generally composed of five strophes and end stormily on the dominant *the theme quite lost in strange fiorituras and guttural roulades. The gitano voices are marvellously supple . . .* [33]

A sketch of two guitarists, with a transcription of four stanzas of a Spanish song (fig. 125), was probably done in Spain in 1879.[34] There is a similar transcription of six stanzas of another song in the Fogg Art Museum, Harvard University Art Museums.[35] In 1887, Sargent contributed six illustrations to Alma Strettell's book *Spanish & Italian Folk-Songs,* drawing on sketches he had made in Spain eight years earlier (see appendix 11, p. 388).

Sargent was not alone in his passion for Spanish gypsy music. Only four years before his visit to Spain, George Bizet's opera *Carmen,* based on the story of a gypsy *femme fatale* by Prosper Mérimée, had opened controversially in Paris before going on to international success in Vienna and New York. What was unusual about Sargent's enthusiasm for gypsy music was the depth of his knowledge and his commitment. In December 1883, he wrote to

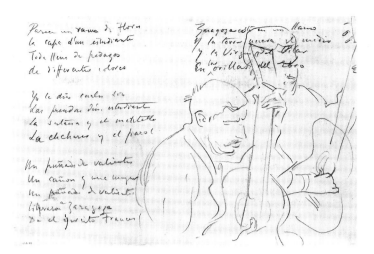

Fig. 125 *(left)*
Spanish Musicians, with Poem, c. 1879. Pencil on paper, 10⅟16 x 14¹¹⁄16 in. (25.5 x 37.3 cm). The Metropolitan Museum of Art, New York. Gift of Mrs Francis Ormond, 1950 (50.130.103).

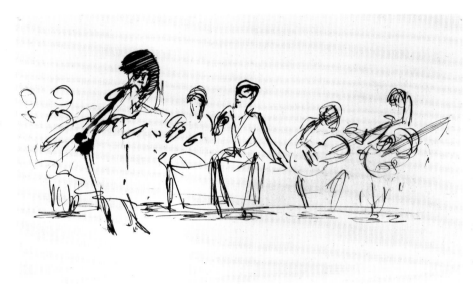

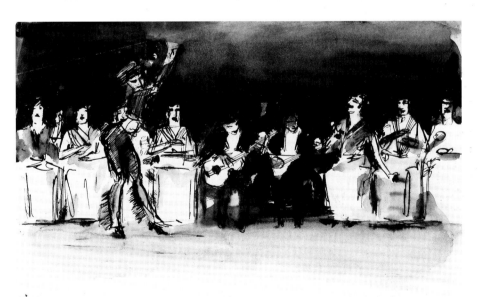

Fig. 126 *(middle)*
(?)Female Spanish Dancer before Six Seated Figures, 1879. Pen and ink on paper, 5¼ x 8¼ in. (13.3 x 21 cm). Fogg Art Museum, Harvard University Art Museums, Cambridge, Massachusetts. Gift of Mrs Francis Ormond, 1937 (1937.8.12).

Fig. 127 *(bottom)*
Male Spanish Dancer before Nine Seated Figures, 1879. Pen and ink and wash on paper, 5¼ x 8¼ in. (13.3 x 21 cm). Fogg Art Museum, Harvard University Art Museums, Cambridge, Massachusetts. Gift of Mrs Francis Ormond, 1937 (1937.8.2).

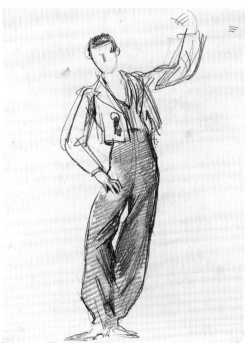

Fig. 128 *(top)*
Male Spanish Dancer, c. 1879. Pencil on paper,
14½ x 10 in. (36.8 x 25.4 cm). Private collection.

Fig. 129 *(bottom)*
Male Spanish Dancer, c. 1879. Pencil on paper,
14⅜ x 10¹⁄₁₆ in. (37.1 x 25.5 cm). The Metropolitan
Museum of Art, New York. Gift of Mrs Francis
Ormond, 1950 (50.130.137).

the French composer Emmanuel Chabrier, himself the author of a famous rhapsody of Spanish airs, *España,* inviting him to a party at his studio:

Would you like to hear the Malagueña and the Solea marvellously sung by a pure female flamenco singer, a splendid contralto with a terrific deep throaty voice? I would like various musicians and artists and some amateurs to hear her who might then perhaps ask her to sing at their soirées. Who knows if the philistines will appreciate her; in any case you will be ravished by her, dear Andalusian.[36]

This does not seem to have been an isolated event, and Sargent continued to extol the qualities of Spanish music to his friends. In 1890, he held a party in his New York studio for the Spanish dancer La Carmencita, whose career he helped to foster and whose flamboyant personality he celebrated in a full-length portrait (*Portraits of the 1890s,* no. 234). In later years, he frequently regaled his portrait sitters with gramophone records of Spanish music, and he gave a collection of these to Mrs Gardner, which survives in the archives of the Isabella Stewart Gardner Museum in Boston.

During his trip to Spain in 1879, Sargent made notes of Spanish dancing as well as Spanish music. A drawing in a sketchbook at the Fogg Art Museum shows a group of four Spanish women and one man performing what looks like a folk dance.[37] Among the photographs collected by the artist during his trip to Spain is one of a troupe of Spanish dancers and musicians.[38] Two pen-and-ink sketches on the back of a torn-in-two Madrid invoice show a scene of flamenco dancing (figs. 126, 127), which would grow into the composition for *El Jaleo,* with the upright figure of a dancer balanced by a horizontal band of musicians. The dancer in one drawing at least, and possibly in the other, is male, and a sequence of drawings of individual male dancers (see figs. 128, 129) may represent early ideas for a dance picture.[39]

At what point Sargent decided to paint a scene of flamenco as an exhibition piece is unknown, but it was probably before he left Spain for North Africa. The two versions of *Spanish Gypsy Dancer* (nos. 767, 768) may well have been painted in Spain, for the dancer herself has the earthy physicality of a genuine gypsy. In these two sketches, the artist established the pose that would evolve into *Spanish Dancer* and *El Jaleo* (nos. 770, 772)—one arm extended, the other on the hip with out-turned hand,

and the heavy white satin dress and fluttering shawl. That Sargent considered other ideas for the pose is suggested by various front-view studies of a female dancer (see figs. 130–34), and his illustration of a dancer in Alma Strettell's *Spanish & Italian Folk-Songs* (no. 769).

While exploring poses for an individual flamenco dancer, Sargent was also developing ideas for an atmospheric scene of Spanish dancing that would become *The Spanish Dance* (no. 763). Illuminated by sparks from spent fireworks, three couples perform the *jota* under a night sky. We cannot gauge the dimensions of the space nor see more of the musicians in the background than a faint blur of faces, but we can feel the excitement of the dance pulsing through the darkness. The picture is a mood piece, like a Whistler nocturne, communicating an air of strangeness and tension. According to Ralph Curtis, an oil sketch for the picture, which he owned (no. 766), was a reminiscence of a tango Sargent had seen in Granada. The existence of studies for the picture reveals that, like *El Jaleo,* it was a studio production, but one which he never exhibited.

It seems likely that in the two years between his return from North Africa and the opening of the Paris Salon in the spring of 1882, Sargent was at work on three dance pictures. That he was absorbed in things Spanish is evident from studio sketches showing friends and models dressed up in Spanish costume (see figs. 135, 136), a grisaille of *Man and Woman on a Bed* (no. 775), and a portrait of *Albert de Belleroche* (fig. 137). Apart from a solitary reference to *El Jaleo* in a letter from Sargent to Vernon Lee of November 1881, there is no contemporary documentation for the pictures. We cannot, therefore, determine the sequence in which they were painted, whether simultaneously or one after the other. The recently rediscovered *Spanish Dancer* (no. 770) may plausibly be considered as Sargent's first project for a Salon painting. Warren Adelson and Elizabeth Oustinoff argue that it was Sargent's failure to resolve the crowded composition of the painting, which originally included musicians in the background, that led him to abandon it in favour of *El Jaleo* (no. 772). This is conjecture. The artist may have been planning a large, horizontal picture from the beginning, in which case *Spanish Dancer* represents a related but independent work that was dropped, not in favour of *El Jaleo,* but because the artist had lost interest in it. In the latter picture, the pose of the dancer was intensified, drama-

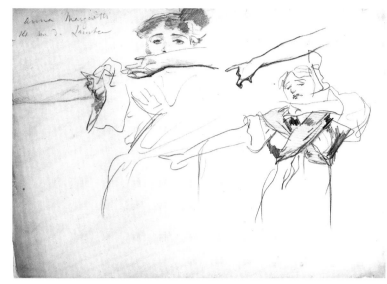

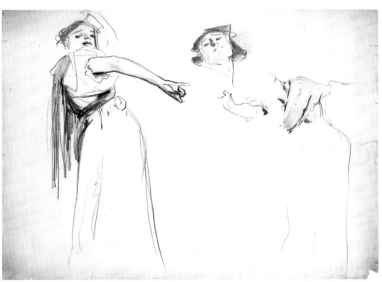

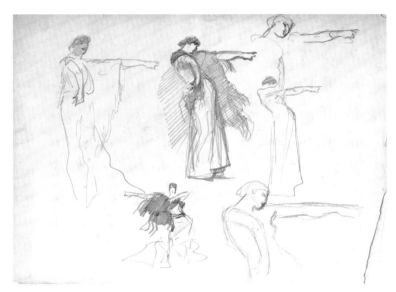

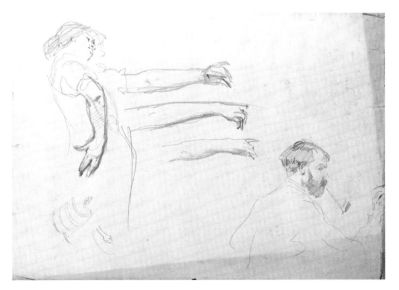

Fig. 130 *(top left)*
Hand of Spanish Dancer, c. 1880–81.
Pencil on paper, 10¼ x 13¹³⁄₁₆ in.
(26 x 35 cm). The Metropolitan
Museum of Art, New York. Gift
of Mrs Francis Ormond, 1950
(50.130.143s verso). The hand seems
to belong to the model in fig. 131,
both sheets apparently having once
been adjacent to one another in the
same sketchbook.

Fig. 131 *(top right)*
Studies of a Spanish Dancer,
c. 1880–81. Pencil on paper,
10 x 13 in. (25.4 x 33 cm).
Inscribed, top left: *Anna
[?]Margaretti/14 rue de Lambec.*
Formerly Fine Arts Society,
London; stolen and now untraced.

Fig. 132 *(middle left)*
Studies of a Spanish Dancer,
c. 1880–81. Pencil on paper,
9 x 12¾ in. (22.9 x 32.4 cm).
Private collection.

Fig. 133 *(middle right)*
Studies of a Spanish Dancer,
c. 1880–81. Pencil on paper,
10⅛ x 13½ in. (25.8 x 34.2 cm)
(irregular). Fogg Art Museum,
Harvard University Art Museums,
Cambridge, Massachusetts. Gift
of Mrs Francis Ormond, 1937
(1937.7.24, f. 5 verso).

Fig. 134 *(right)*
Studies of a Spanish Dancer,
Bearded Man with Pipe, c. 1880–81.
Pencil on paper, 10¼ x 13⅜ in.
(26 x 34 cm). Fogg Art Museum,
Harvard University Art Museums,
Cambridge, Massachusetts. Gift
of Mrs Francis Ormond, 1937
(1937.7.21, f. 9 verso).

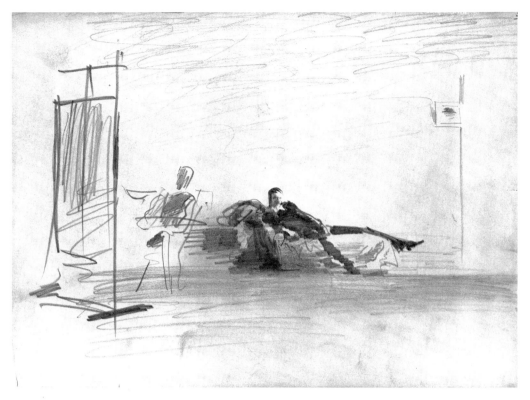

tized and pitched up in comparison with *Spanish Dancer*, whose gypsy origins are more evident. The model for *El Jaleo* was said to be the Parisian dancer Marie Renard, and, in spite of her theatrical staging, she is a more convincing icon of the flamenco than any of her predecessors.

Sargent may have started work on *El Jaleo* in 1880, but his most concentrated period of work on the picture is likely to have occurred between the summer of 1881 and the spring of 1882. The picture is painted quite freely, with only minor retouchings, suggesting that the artist encountered few problems once he had the composition in his mind's eye. The large number of surviving studies demonstrate how much concentrated effort and thought went into the preliminary stages of the design. Significantly, there are no figure studies for the dancer, but heads and hands are worked out in a sequence of lively drawings that capture the play of light and dark.

—*Richard Ormond*

Fig. 135
Sketch of a Studio Interior with Reclining Figure, c. 1880–81. Pencil on paper, 10⅛ x 13½ in. (25.8 x 34.2 cm). Fogg Art Museum, Harvard University Art Museums, Cambridge, Massachusetts. Gift of Mrs Francis Ormond, 1937 (1937.7.24, f. 5 recto).

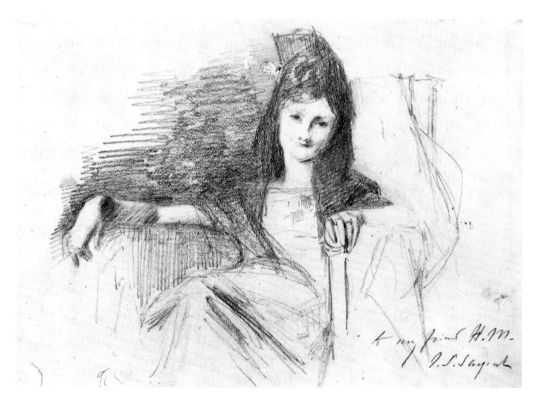

Fig. 136
Sketch of a Seated Woman, c. 1880–81. Pencil on paper, 6⅝ x 8⅞ in. (16.9 x 22.5 cm). Inscribed, lower right: *to my friend H .M. [Hamilton Minchin]/J. S. Sargent*. British Museum, London. Gift of Hamilton Minchin (1924-8-7-1).

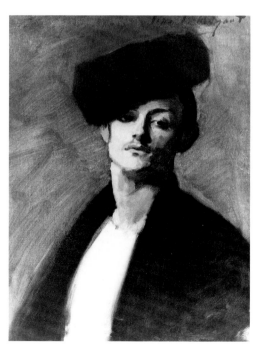

Fig. 137
Albert de Belleroche, c.1882. Oil on canvas, 27¾ x 19½ in. (70.5 x 49.5 cm). Colorado Springs Fine Arts Center, Purchase funds in Memory of Mrs. A. E. Carlton from her friends (61-4).

1. See Charteris 1927, p. 10, and Dr Sargent's letter of 8 June 1868 to his father, Fitzwilliam Sargent Papers, Archives of American Art, Smithsonian Institution, Washington, D.C., announcing their recent return from Spain.

2. See Alisa Luxenberg's thoughtful essay 'Over the Pyrenees and Through the Looking-Glass: French Culture Reflected in the Imagery of Spain' in *Spain, Espagne, Spanien: Foreign Artists Discover Spain 1800–1900,* curated by Suzanne L. Stratton, The Equitable Gallery in association with the Spanish Institute, New York, 1993, pp. 11–31 (exhibition catalogue).

3. See H. Barbara Weinberg's essay 'Sargent and Carolus-Duran' in Simpson *et al.* 1997, pp. 5–29; see also Annie Scottez de Wambrechies, *Carolus-Duran,* Palais des Beaux-Arts, Lille, 2003 (exhibition catalogue).

4. For Sargent's admiration for Regnault see the introduction to chapter 9, p. 283.

5. For Sargent's admiration for Fortuny, see ibid.

6. See Tinterow *et al.* 2003.

7. See the sale of Sargent's library, Christie's, London, 29 July 1925, lot 19, Leipzig edition of *Don Quixote,* 2 vols., 1836; lot 20, Madrid edition, 4 vols., 1765–82; lot 21, Amsterdam edition, 2 vols., 1748; lot 141, Madrid edition, 4 vols., 1780. The first of these (lot 19) was apparently presented to Sargent by Daniel Sargent Curtis and was bought back at the sale by the Curtis family (see letter from Theodore Steinert to David McKibbin, 12 June 1965, McKibbin papers).

8. Sargent had the fourth edition of *A Bible in Spain,* 2 vols. (London 1843) and the second edition of *Zincali,* 2 vols. (London, 1843). These and other works by Borrow with Sargent's nameplate have descended in the family of Sargent's younger sister, Violet Sargent (Mrs Francis Ormond).

9. First published in London in 1845 but based on Ford's travels in the previous decade.

10. Sale of Sargent's library, 1925 (see n. 7 above), lots 26 and 114.

11. Hispanism stretched far beyond France; see, for example, *Spain in America: The Origins of Hispanism in the United States,* ed. Richard L. Kagan (Urbana and Chicago, 2002).

12. See Charteris 1927, p. 49.

13. Bach exhibited *Dans le chemin de la Grand-Marine, à Capri,* and Daux exhibited *Rosina;* Elizabeth Boone was the first art historian to note these works in connection with Sargent (Boone 1996, p. 188, n. 13).

14. Daux and Bach are listed in the *Libro registro de los señores copiantes,* Prado archive, Madrid, 3 November 1879, and in the *Libros de copistas,* 1879; Bach is recorded as having copied a dwarf ('un enano'), presumably after Velázquez, 20–22 November 1879; Daux is recorded with copies after Tiepolo, 11 November 1879, an unnamed portrait and a figure of Christ, both 20–22 November 1879.

15. See Washington 1992, pp. 136–39, nos. 7 and 8.

16. Vernon Lee Papers, Special Collections, Millar Library, Colby College, Waterville, Maine.

17. Ibid.

18. See sale of Sargent's library, 1925 (n. 7 above), lot 203, *Los Desastres de la Guerra* (Madrid, 1863); lot 204, *Los Proverbios* (Madrid, 1864); lot 205, *Treinta y Tres Estampas que representan differentes suertes y actitudes del Arte de Lidiar los Toros,* presented to Sargent by Ralph Curtis (Madrid, 1887); also in the sale were two volumes of Beruete y Moret's book on Goya (Madrid, 1918–19), lot 153.

19. Washington 1992, pp. 41–44.

20. Saint-Gaudens's Papers, Special Collections, Dartmouth College Library, Hanover, New Hampshire, quoted in Washington 1992, pp. 88–89. The Carthusian monastery of Miraflores outside Burgos was designed by Juan de Colonia (a native of Cologne) in the mid-fifteenth century and completed by his son, Simón de Colonia. The spectacular retable of 1496–99 is the work of another architect, Gil de Siloé (active c. 1467–1505). The second retable mentioned in the letter (with the name of the church San Tomé crossed through) may have been that in San Nicolás, which lies opposite the cathedral, designed by Simón de Colonia's son, Francisco, or possibly the altar in San Gil, designed by Gil de Siloé; the authors are indebted to Richard H. Finnegan for information in this note.

21. Scrapbook, The Metropolitan Museum of Art, New York (50.130.154, pp. 45v, 54r, 55v, 56r, 58r, 61v).

22. Scrapbook, The Metropolitan Museum of Art, New York (50.130.154, pp. 64r, 64v, 65r, 65v, 66r).

23. Beckwith's diaries are in National Academy Museum and School of Fine Arts, New York; see also Boone 1996, pp. 162–63, and 189, nn. 23 and 24.

24. Sargent corresponded with Joaquin Sorolla y Bastida and presented him with a water-colour of a mule (Sorolla Museum, Madrid). He wrote the introduction to the catalogue of the travelling exhibition of paintings by Ignacio Zuloaga and successfully recommended the purchase of the latter's *My Uncle Daniel and his Family* (1910) to the Museum of Fine Arts, Boston. Another artist whose work he promoted was the Catalan landscapist Eliseu Meifren; for Sargent's

relationship with these artists, see Washington 1992, pp. 87–88; and *Later Portraits,* pp. 18–21. In 1908, Sargent established friendly relations with a group of artists in Majorca, including Santiago Rusiñol, Salvador Florensa, Antonio Gelabert and Francisco Bernareggi, of whom he did a portrait (see *Later Portraits,* no. 551). Rusiñol presented Sargent with a copy of his book *Jardins d'Espanya,* included in the sale of Sargent's library, 1925 (see n. 7 above), lot 200; for Sargent's links with the Majorca artists, see Ormond in Adelson *et al.* 1997, pp. 117–18.

25. Hinckley is listed in the *Libro registro de los señores copiantes,* Prado archive, Madrid, under the date 9 September 1879. In the *Libros de copistas,* he is recorded as having done two Velázquez copies, 12 September–1 October, and 1 October 1879.

26. Sargent to Ben del Castillo, Tangier, 4 January 1880, quoted in Charteris 1927, pp. 50–51.

27. For the drawing, see Volk 1992, pp. 170–71, no. 27; for the photograph, see scrapbook, The Metropolitan Museum of Art, New York (50.134.154, p. 58v).

28. Scrapbook, The Metropolitan Museum of Art, New York (50.134.154, p. 56v).

29. Fitzwilliam Sargent Papers, Archives of American Art, Smithsonian Institution, Washington, D.C., 15 August 1879.

30. Scrapbook, The Metropolitan Museum of Art, New York (50.134.154, pp. 20, 21r, 21v, 22r, 22v, 23, 24r and 57v).

31. Fogg Art Museum, Harvard University Art Museums, Cambridge, Massachusetts (1937.10).

32. See Washington 1992, pp. 85–90.

33. Letter of 9 July 1880, private collection.

34. See Washington 1992, p. 134, no. 6; and Herdrich and Weinberg 2000, p. 164, no. 139.

35. Fogg Art Museum, Harvard University Art Museums, Cambridge, Massachusetts (1937.8.23).

36. Roger Delage and Frans Durif, eds., *Correspondance/Emmanuel Chabrier* (Paris, 1994), pp. 220–21, n. 2. The full text of the letter in the original French, with English translation, is given in the entry for *Spanish Gypsy Dancer* (no. 768, p. 258), a picture presented by Sargent to Chabrier.

37. Fogg Art Museum, Harvard University Art Museums, Cambridge, Massachusetts (1937.7.28, f. 2).

38. Scrapbook, The Metropolitan Museum of Art, New York (50.134.154, p. 66v). The photograph is illustrated in Washington 1992, p. 37, fig. 13.

39. Four studies of male dancers performing and a fifth of a seated dancer are catalogued in Washington 1992, pp. 130–33, nos. 1–5.

Fig. 138
Photograph of the interior of Santa Maria La Blanca, Toledo. Catalogue raisonné archive.

747
Santa Maria La Blanca, Toledo

1879
Alternative title: *Interior with Moorish Collonade* [*sic*]
Oil on panel
13½ x 10 in. (34.3 x 25.3 cm)
Private collection

David McKibbin correctly identified the subject of this oil study on the basis of a photograph of Santa Maria La Blanca in a scrapbook belonging to the artist (The Metropolitan Museum of Art, New York, 50.130.145, p. 58v). The building dates from the twelfth century and was designed as a synagogue for the Jewish community of Toledo. It was converted to a Christian church early in the fifteenth century. Sargent's picture shows a view of the nave and the right-hand aisle, very much as they are today (see fig. 138). The faceted pillars, with capitals in the shape of pineapples, are surmounted by horseshoe arches of typically Moorish form. The eye is led down the avenue of arches that divides the lighted nave from the shadowed aisle in a deliberate contrast of light and dark. Light comes both from the unseen doorway behind the artist's viewpoint and from round openings in the wall. In the foreground, one of the slabs of pavement is decorated with a diamond-shaped pattern, and there is a skirting of tiles around the pillar in the extreme foreground on the left that acts as a *repoussoir*. In a modern approach to picture construction, Sargent is already experimenting by cropping foreground features and playing with angles. The study is painted on one of the thin mahogany panels which he used in the period 1877–80. Though Sargent was to make sketches on later trips to Toledo, this is the only one associated with his 1879 visit to Spain. The picture descended in the family of Sargent's younger sister, Violet Sargent (Mrs Francis Ormond), until its sale at Christie's, London, in 1976.

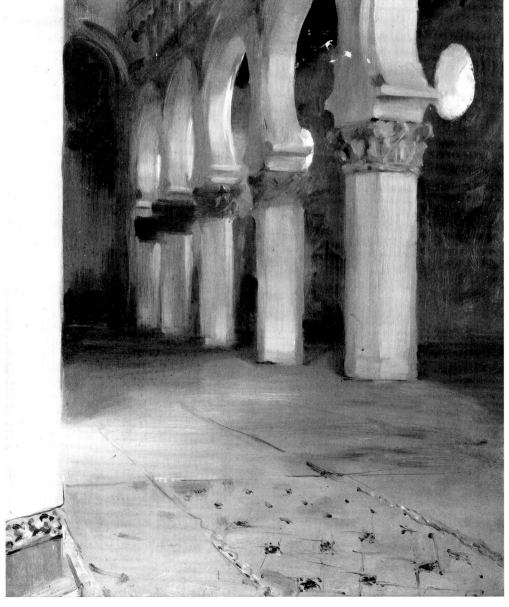

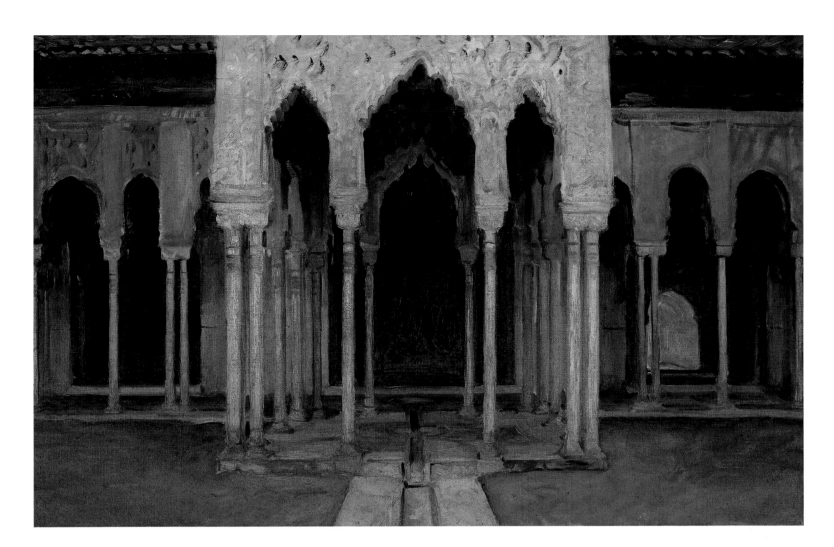

748
Alhambra, Patio de los Leones
(Court of the Lions)

1879
Alternative titles: *The Court of (the) Lions,
Alhambra; The Court of Lions*
Oil on canvas
18¾ x 31½ in. (47.7 x 77.5 cm)
Private collection

The Patio de los Leones, so named after the stone lions supporting the basin of the fountain in the centre of the courtyard, is the most famous feature of the Alhambra Palace in Granada and a masterpiece of Moorish architecture. It was built during the time of the Moorish Sultan Muhammed V in the second half of the fourteenth century. Though giving the impression of great size and magnificence, the courtyard is, in fact, quite small, roughly 93 by 51 feet. It is flanked by arcades with projecting pavilions on the short east and west ends supported by a complicated arrangement of single, triple and quadruple pillars.

It was this ensemble of slender pillars and arcades which attracted Sargent's inter-est. He painted the western end of the courtyard head-on to emphasize its symmetrical proportions. He included the full width of the façade and indicated the roof-line of the main structure but not that of the pavilion. The artist centred his easel over the water channel running from the fountain towards the interior of the arcade. The space beyond is the Sala de los Mocárabes, and the doorway visible on the right leads from there to the Patio de los Arrayanes (see no. 752).

The picture is an elaborate study in perspective and architectural form. The eye is led down the water channel, through the arcade of the pavilion to the dark interior space of the Sala, and then out to the flanking arcades. The complicated pattern of decoration on the upper surface of the pavilion is rendered freely in swift strokes of white, black and yellow pigment over a buff ground. The pillars below, painted in graduated tones of luminous white in front to golden yellow within the pavilion, are more carefully studied. The uniformly bluish-grey pavement and the deep browns of the roof and interior provide an effective foil to the gleaming pillars and arcade.

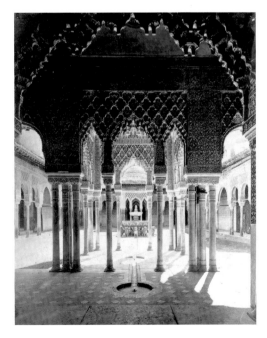

Fig. 139
Photograph of the Court of the Lions, The Alhambra, Granada. From an album of early drawings and reproductions belonging to the artist. The Metropolitan Museum of Art, New York. Gift of Mrs Francis Ormond, 1950 (50.130.154, p. 24 recto).

The overall effect of the picture is vivid and rather theatrical. One has the feeling that at any moment people might arrive from all sides to populate the space. Sargent's ability to infuse his architectural studies with the feeling of presences, mysteries and interior atmosphere is readily apparent in this early study. The *Patio de los Arrayanes* (no.752) is closely related stylistically to this picture. For water-colour studies of the pavilion, see nos. 749–51, and for a contemporary photograph mounted in a scrapbook put together at this time, see fig. 139.

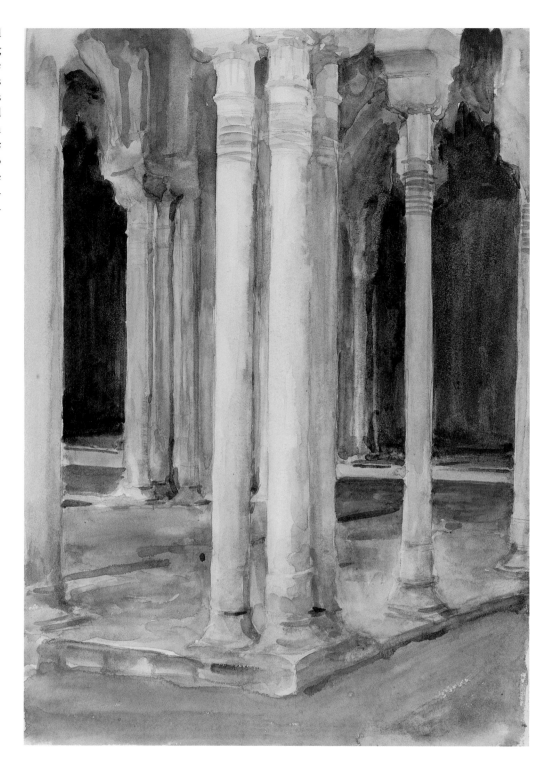

749
Alhambra, Patio de los Leones
(Court of the Lions)

1879
Alternative title: *The Alhambra, Granada*
Water-colour on paper
18 x 12 in. (45.7 x 30.5 cm)
Private collection

This study shows an oblique view across one of the two projecting pavilions in the famous Patio de los Leones (Court of the Lions) in the Alhambra, Granada. It is probably identical with the pavilion represented in the oil painting of the same title (no. 748), which is the pavilion at the western end of the court. The artist positioned himself close to one corner of the pavilion, with a group of three linked pillars in the foreground flanked by two single pillars. Behind, on the left, are quadruple pillars supporting the back of the pavilion, and to the right, the single pillar and central arch of the Sala de los Mocárabes.

Out of this symphony of vertical forms the artist conjures a design of great elegance and sophistication. The dark washes of the interior recesses and the mauvish tones of the pavement set off the pale yellow and golden tones of the pillars. Though dated to 1912 by some earlier researchers on the catalogue raisonné project, the water-colour is so close in style and spirit to the oil that it seems highly probable that it was painted at the same period.

750
Alhambra, Patio de los Leones (Court of the Lions)

1879
Alternative titles: *Alhambra Interior;
A Moorish Patio*
Water-colour on paper
9¾ x 13½ in. (24.9 x 34.2 cm)
British Museum, London
(1959.1.2.8 recto)

This work seems to show the other side of the same entrance way to the famous Patio de los Leones in the Alhambra Palace as the water-colour in the Metropolitan Museum of Art, New York (no. 751). The matching double pillar is seen in the foreground, with the left-hand door behind, and, on the right, the watercourse running through the middle of a flight of steps, with a panel of tiles upper right (see fig. 140 for a recent photograph). Like the Metropolitan Museum of Art water-colour, this is a subtle study of shapes, textures, and tones, contrasting the luminous white surface of walls, pillars and pavement with dark patterned woodwork, colourful tiles and dark interior space. The water-colour was one of a number of sketches given by the artist's sisters to Sir Alec Martin (1884–1971), an employee, later chairman, of Christie's, London, to thank him for masterminding the Sargent sale in 1925.

On the verso of the water-colour is a pencil sketch for the elaborate jewellery seen in *Fumée d'ambre gris* (see fig. 189).

Fig. 140
Photograph of the interior colonnade of the Court of the Lions, The Alhambra, Granada. Catalogue raisonné archive.

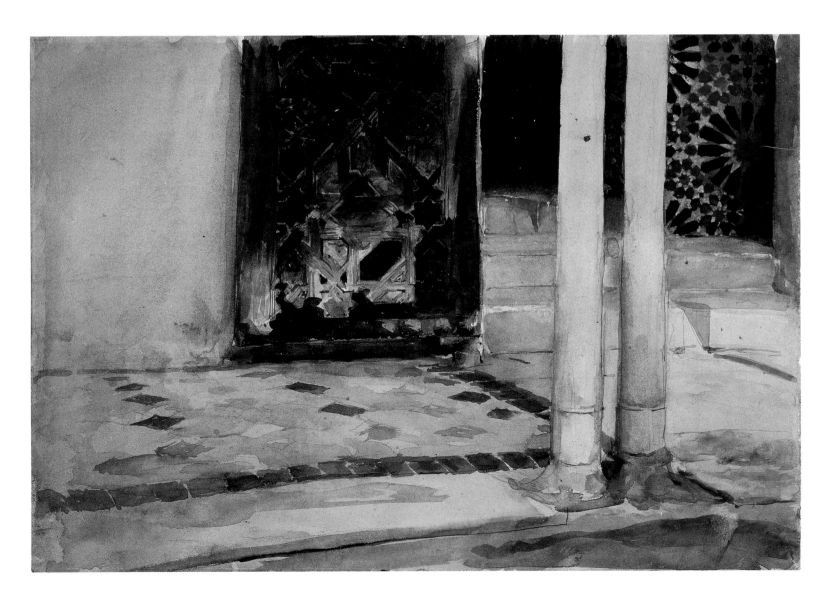

751
Alhambra, Patio de los Leones (Court of the Lions)

1879
Alternative title: *Architectural Sketch*
Water-colour, gouache and pencil on paper
9¾ x 13½ in. (24.8 x 34.3 cm)
Inscribed (verso): *Architectural sketch*
The Metropolitan Museum of Art,
New York. Gift of Mrs Francis Ormond,
1950 (50.130.36)

This water-colour marks the entrance to one of the two chambers opening off the famous Patio de los Leones of the Alhambra Palace in Granada on the north and south sides. The courtyard takes its name from the fountain in the centre supported by five lions, from which four watercourses run off symmetrically to the main entrances of the courtyard; one of the channels can be seen in this study, running diagonally across the lower space. The projecting pavilions to the east and west have complicated arrangements of pillars, but the arcades to the north and south have repeating double and single pillars exactly as represented here. The carved doorway with a complex geometrical pattern seen to the left is no longer *in situ*. The water-colour in the British Museum (no. 750) shows the same entrance way from the other side. In contrast to Sargent's carefully composed oil painting of the courtyard (no. 748), the sketches are 'snapshots', oblique, diagonal studies of doorways, channels, pavements and decorative woodwork. Broad, smooth washes define the luminous surfaces of plaster, tile and marble, against which the dark, intricate patterns of the doors stand out in bold relief.

A scrapbook belonging to the artist in the collection of the Metropolitan Museum of Art, New York (50.130.154) contains a number of photographs of the Alhambra, which were collected by Sargent during his visit to Spain in 1879, including one showing a side view of this same courtyard (f. 57).

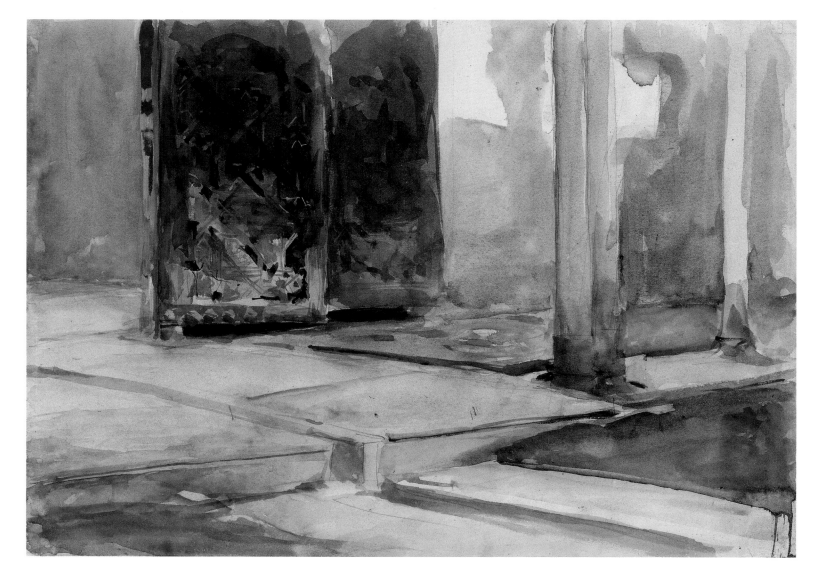

752
*Alhambra, Patio de los Arrayanes
(Court of the Myrtles)*

1879
Alternative title: *The Alhambra*
Oil on canvas
22⅝ x 19¼ in. (57.5 x 48.8 cm)
Private collection

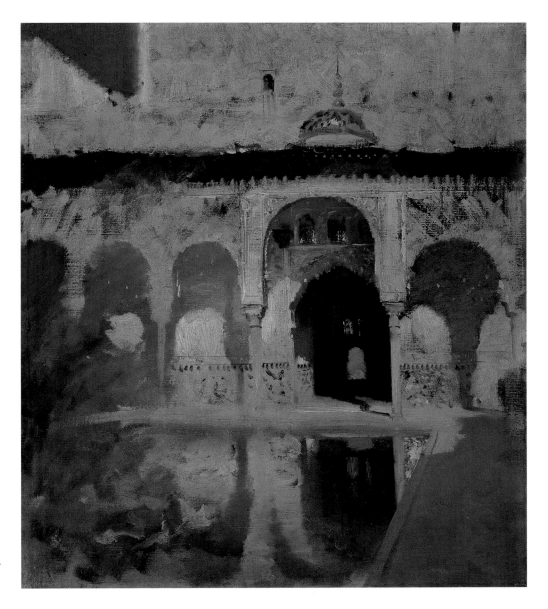

The Patio de los Arrayanes is one of the centrepieces of the fourteenth-century Alhambra Palace, and, with the Patio de los Leones (see no. 748), one of the two most celebrated courtyards of the complex. It is a rectangular space with a long narrow pool in the centre flanked by myrtle bushes from which the courtyard takes its name. At either end of the space are arcades or loggias with seven openings supported on six slender columns. Sargent chose to paint the arcade to the north, with the truncated wall of the Torre de Comares containing the Salon de Embajadores (Hall of the Ambassadors) rising above it. To the left is a small triangle of deep blue sky. The little cupola atop the central arch was there in Sargent's time but has since been removed. The roofline has been altered, but Sargent has not accurately recorded the slits and apertures of the fortified tower. He also omits the small round fountain at the end of the basin.

The picture relates closely in style and theme to the *Patio de los Leones* (no. 748). As in that picture, the harmonious rhythm of the architecture and the play of light over honey-coloured walls captured the artist's imagination. Especially important here is the way the water mirrors the building and reflects light back on the wall surfaces. The view is oblique, with the path on the right steeply foreshortened. Only the central bay of the arcade is in any degree 'finished'. On the left, the picture shades off into a misty blur. To the right, only the first of the three bays is included, with a mere smudge of green at the extreme edge of the picture space to indicate the line of the myrtle hedge. The pattern of the tiled dado within the arcade is suggested in a few flecks of colour. The deep shadows cast by the pillars and arched openings indicate that the picture was painted shortly before noon. Within the central opening, the sunlight in the arcade gives way to the dark interior of the Sala de la Barca (Hall of the Boat), with a small lighted opening beyond to the Salon de Embajadores. The sense of reces-sion, of one space opening into another, is a foretaste of the themes Sargent would explore in Venice. The saturating atmosphere of summer heat is, however, quite different. Sargent evidently painted this picture over an earlier study. Visible to the left of the cupola is an area of red not fully obliterated that may represent flowers or part of a dress.

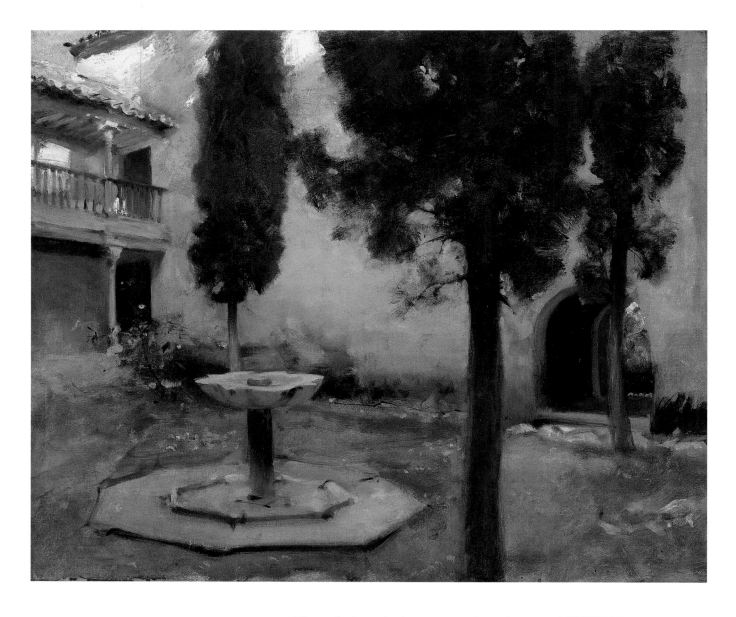

753
Alhambra, Patio de la Reja
(Court of the Grille)

1879
Alternative title: *At Assisi*
Oil on canvas
18½ x 21½ in. (46 x 54.6 cm)
Private collection

This small courtyard in the Alhambra Palace at Granada lies immediately to the east of the Patio de los Arrayanes (see no. 752) and the Sala de la Barca. Previously identified as a scene in the Italian hill town of Assisi, it was correctly identified by David McKibbin in the 1950s (see fig. 141 for a recent photograph). The picture was painted from the south-west corner of the courtyard looking north-east. The small fountain in the centre is still flanked by four cypress trees, and upper left is the covered walkway at first-floor level linking the Torre de Comares to the Peinador de la Reina.

Through the arched opening to the right we catch a glimpse of the Jardin de Lindaraja.

The picture is closely related stylistically to the *Patio de los Arrayanes* and the *Patio de los Leones* (nos. 752, 748). The slender trunks of the trees and the column on which the bowl of the fountain rests stand in for pillars. The arched opening, suggesting a succession of spaces opening inwards, is similar to the one in the *Patio de los Arrayanes,* with the angled building and patch of sky top left. The hexagonal geometry of the fountain itself is emphasized by thick black lines drawn around the base. The flat top of the bowl catches the sunlight and is recorded in thick strokes of white paint, while the curve of the shadowy underside is delicately modelled. Sharply observed features such as the upper walkway contrast with sketchy areas like the rose bushes to the left of the furthest cypress tree. With its brooding trees and subdued colouring, the picture gives off an air of eerie silence and solitude.

Fig. 141
Photograph of the Court of the Grille, The Alhambra, Granada. Catalogue raisonné archive.

754
The Alhambra Vase

c. 1879
Alternative titles: *The Vase; Persian Vase*
Water-colour on paper
13 ½ x 9⅞ in. (34.3 x 25.3 cm)
Inscribed (verso): *By J. S. Sargent* and:
V. O. [Violet Ormond]
The Walters Art Museum, Baltimore
(37.2469)

The celebrated Alhambra vase was made in Málaga, Andalusia, in the fourteenth century during the Nasrid Period. It is perhaps the only surviving vase with wing-shaped handles that once decorated the Garden of the Andarves in the Alhambra Palace, Granada. The vase is remarkable for its elegant shape, large size, distinctive handles and brilliant combination of white and cobalt blue enamels with gold lustre. The Alhambra vase is damaged and has lost one of its handles, but it still retains its vivid colouring. In Sargent's day, it was displayed in a niche in the Sala de las Dos Hermanas (Hall of the Two Sisters); it is now conserved in the Museo Arqueológico de la Alhambra.

Sargent must have painted the water-colour in the Sala de las Dos Hermanas, but he gives no indication as to the vase's setting or support. The shape is carefully drawn as are the octagonal ribs at the mouth of the jar. The body of the vase, on the other hand, is more impressionistically rendered, with loose marks and squiggles for the decoration. A photograph of the vase from the same angle was mounted by Sargent in a contemporary album (see fig. 142). Carol Osborne has pointed out that the vase is similar to the wing-handled Nasrid vase which Mariano Fortuny had painted and which featured in a widely distributed photograph of his studio (Carol M. Osborne, 'Yankee Painters at the Prado', in *Spain, Espagne, Spanien: Foreign Artists Discover Spain 1800–1900,* curated by Suzanne L. Stratton, The Equitable Gallery in association with the Spanish Institute, New York, 1993, p. 70). Sargent's treatment of the Alhambra vase also recalls Whistler's illustrations of Chinese vases for *A Catalogue of Blue and White Porcelain forming the collection of Sir Henry Thompson, illustrated by the autotype process from drawings by James Whistler, Esq., and Sir Henry Thompson* (London, 1878); for Whistler's original water-colours, see Margaret F. MacDonald, *James McNeill Whistler: Drawings, Pastels and Watercolours: A Catalogue Raisonné* (New Haven and London, 1995), pp. 217–37, nos. 592–651.

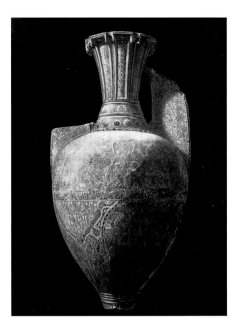

Fig. 142
Photograph of the Alhambra vase. From an album of early drawings and reproductions belonging to the artist. The Metropolitan Museum of Art, New York. Gift of Mrs Francis Ormond, 1950 (50.130.154, p. 57 verso).

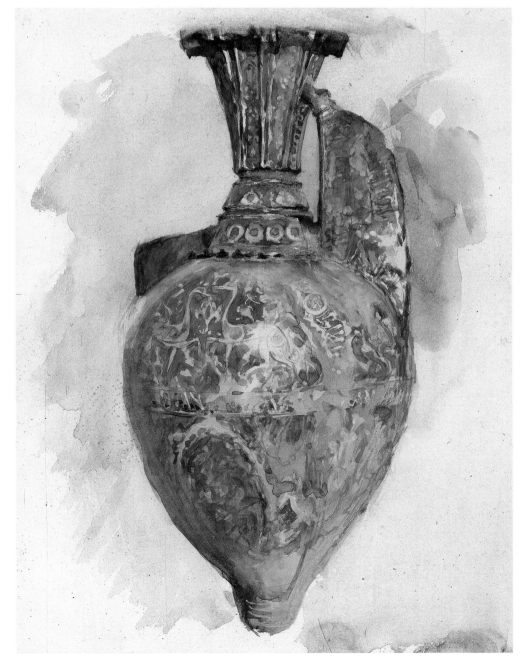

755
An Archway

c. 1879–80
Alternative title: *Moorish Archway*
Oil on canvas
18½ x 14¾ in. (47 x 37.5 cm)
Private collection

This imposing archway appears to be the entrance to a church or public building. Within the inner recess is a groined roof, low steps running parallel to the recess, a gold-framed picture or tablet on the wall, and a small, dark doorway, possibly with a curtain in front of it. David McKibbin, in his catalogue card for the picture (McKibbin papers), suggested Tetuan in Morocco as the possible location of the archway, presumably on comparison with *Entrance to a Mosque,* also called 'Courtyard, Tetuan, Morocco' (no. 780). However, the architecture looks distinctively European and Renaissance in form, and Spain seems a far more likely location than Morocco. The picture is similar in style and subject to the architectural studies painted by Sargent in southern Spain late in 1879, especially in the subtle treatment of light; the honey-coloured tones of the pillars, arch and pavement stand out against the cool greens of the recess.

756
Turkey in a Courtyard

c. 1879–80
Oil on panel
14 x 10½ in. (35.6 x 26.7 cm)
Private collection

Richard H. Finnegan has pointed out that
the courtyard in this work is also depicted
in paintings by Sargent (*A Moorish Courtyard,*
private collection, signed and dated 1913)
and Wilfrid de Glehn painted in southern
Spain, possibly Granada, in 1912 (the in-
scribed date of 1913 on the Sargent was
presumably added upon its completion in
the studio). These latter pictures were sold
from the Forbes Collection at Christie's,
New York, 29 November 2001, lots 102–3.
The style of *Turkey in a Courtyard* is clearly
early, and it is painted on one of the thin
mahogany panels which the artist was using
in the period 1877–80. It almost certainly
dates from Sargent's journey to southern
Spain in 1879. In its architectural emphasis,
it relates both to the Alhambra studies and
the Tangier street scenes. A whitish-grey
wooden pillar supports a veranda of darker
wood at the corner of the courtyard, with a
part of the balustrade visible top left. To the
right of the pillar is a narrow entrance in
the form of a keyhole, and another larger
Moorish arch frames a niche or opening
upper right. The turkey is not closely related
to the spatial proportions of the courtyard
and appears almost as an afterthought or a
bold full-stop to bring the composition to
life. In later life, Sargent cast a model of a
turkey in bronze (casts in the Hirshhorn
Museum of Art, Washington, D.C., and pri-
vate collection).

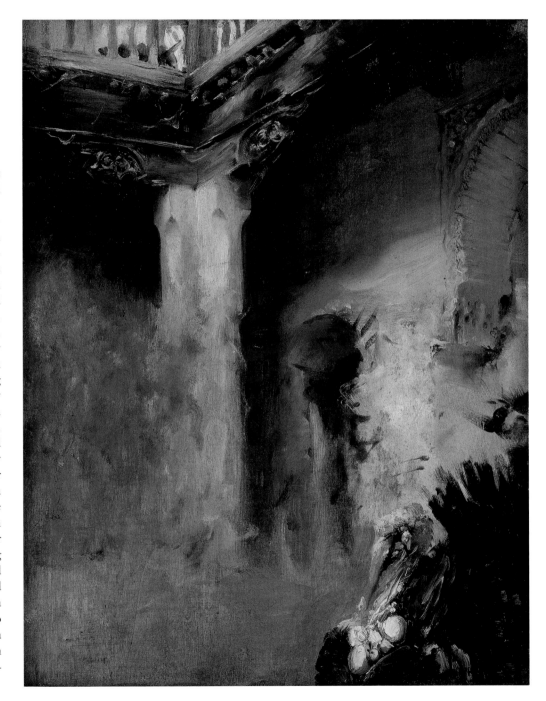

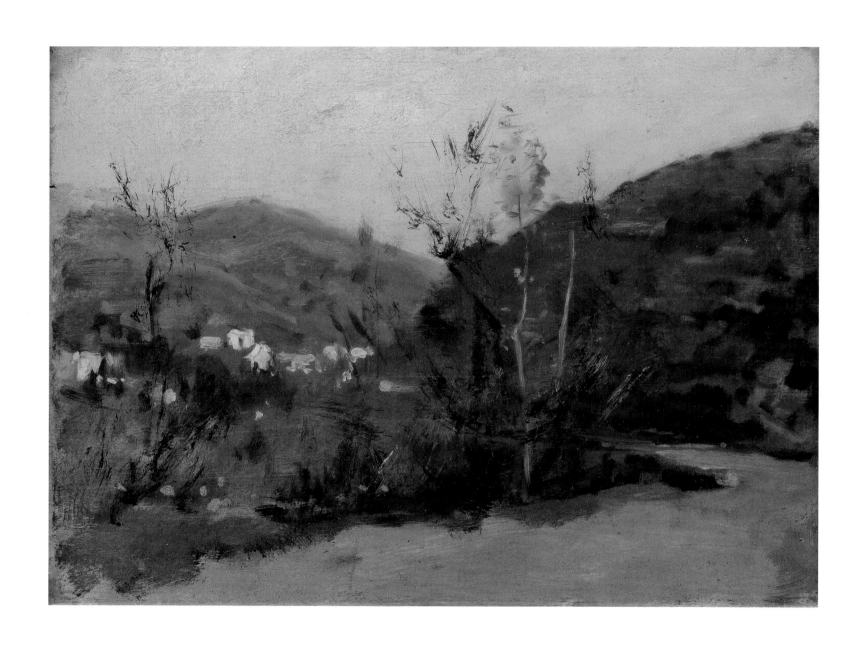

757
Spanish or Moroccan Landscape

c. 1879–80
Alternative titles: *Spanish Landscape;*
Landscape with Hills
Oil on panel
10¼ x 13⅝ in. (26 x 34.6 cm)
The Metropolitan Museum of Art,
New York. Gift of Mrs Francis Ormond,
1950 (50.130.8)

This landscape depicts a road winding along the edge of a hillside towards a village or hamlet of whitewashed houses, with straggly bushes in the foreground. The landscape is rendered in a range of soft whites, greys, greens and browns, with touches of blue and a cloudy sky. It is painted on one of the thin mahogany panels Sargent was using in the period 1877–80. It could have been painted in southern Spain in the autumn of 1879, or in the early months of the following year in Morocco.

758
A Spanish Figure

c. 1879–80
Alternative titles: *A Moor; Monk's Cell*
Oil on panel
13 x 11 in. (33 x 28 cm)
Private collection

This is an enigmatic picture; a strange figure robed in white with folded arms stands before an arched doorway. His vocation is uncertain; possibly he is a religious devotee. He sports heavy side-whiskers and wears a cone-shaped hat with a deep, upturned brim and a bobble on top, of a type associated with the gypsies of southern Spain. It is, therefore, probable that the figure is Spanish, though he has been considered Moorish in the past. A triangular piece of brown, furry material with green flecks visible lower left does not seem to be part of the man's costume. A long white object, like a rolled document, immediately to the right of his left shoulder is difficult to decipher. A rough-hewn door, with one hinge visible, can be seen to the right of the figure, with a white fabric, possibly a towel, thrown over it. Another mauve-coloured textile hangs above the door, providing the only accent of strong colour. Sargent uses the brown tone of the mahogany panel to suggest the brickwork of the building, over which he floats a thin layer of white pigment. The brilliantly lit figure, also in white, is set against a semicircle of pure black. He is painted in richly worked passages of creamy impasto; so, too, is the grey door with streaks of white for highlights. The sketch shades off into black at the top left, and the shadowed foreground is painted in a thin transparent wash over the bare panel.

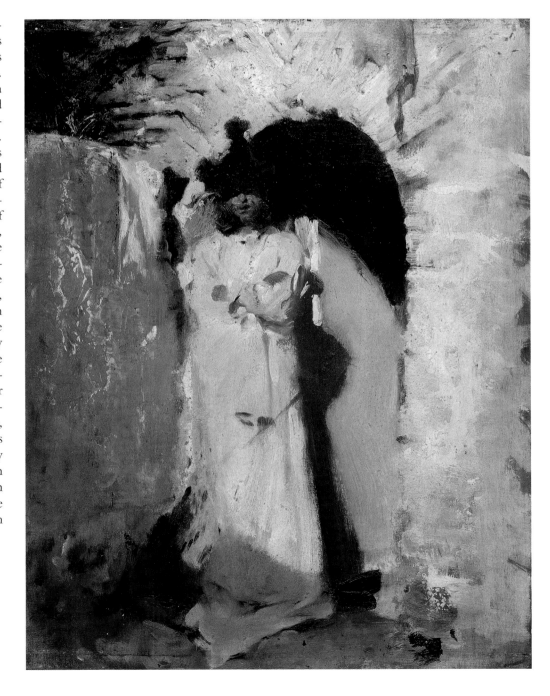

759
Sketch of a Spanish Crucifix

c. 1879
Oil (support and dimensions unknown)
Untraced

In 1887, the poet Alma Strettell (1853–1939) published translations of Spanish and Italian folk songs, and Sargent provided six of the twelve illustrations for her book. This illustration to Strettell's *Spanish & Italian Folk-Songs* (London, 1887, ill. facing p. 124) appeared on the last page of the book opposite the final stanza of a Corsican folk song entitled 'Vocero (Dirge)':

> *Up and down the hills I wander,*
> *Past the Holy Stations, crying*
> *Always after thee, my father,*
> *Do but speak one word, replying . . .*
> *They have crucified him, even*
> *Like to Jesu's crucifying!*

The crucifix is shown on the wall of what is probably a church or chapel, with a window sill visible above. The sketch was probably painted on Sargent's visit to Spain in 1879, possibly in Seville or Granada, and it was subsequently selected as an image for Alma Strettell's book. The crucifix is Spanish and early seventeenth century in date. For a drawing of what appears to be the same crucifix, from a slightly different angle, together with a drawing of a cupola, see fig. 143; the inscribed names of people in Málaga and Tetuan point to a southern Spanish location. Sargent's haunting rendering of the crucifix anticipates the crucifix he would himself sculpt as the centrepiece of the Christian end of his mural scheme for the Boston Public Library in the 1890s. And in Austria in 1914, he would paint another memorable series of crucifixes in oil and watercolour.

Two old photographs of the oil sketch survive, perhaps taken contemporaneously with the publication of the book. The larger photograph, showing the inner edge of the frame, is reproduced here. The smaller photograph is in the same format as other photographs of sketches for the Strettell illustrations, with a pencil inventory number in the hand of Thomas Fox, 'JSS 245'; unfortunately, no copy of the Fox inventory has yet come to light. According to Charles Merrill Mount (1969, p. 466), the illustrations for the Strettell book were given in Fox's charge in 1926 and subsequently disappeared. For a fuller discussion of the illustrations as a group, see appendix II, p. 388.

Fig. 143
Crucifix and Church Dome, c. 1879. Pencil on paper, 9¾ x 13⅝ in. (24.9 x 34.5 cm). Fogg Art Museum, Harvard University Art Museums, Cambridge, Massachusetts. Gift of Mrs Francis Ormond, 1937 (1937.8.27).

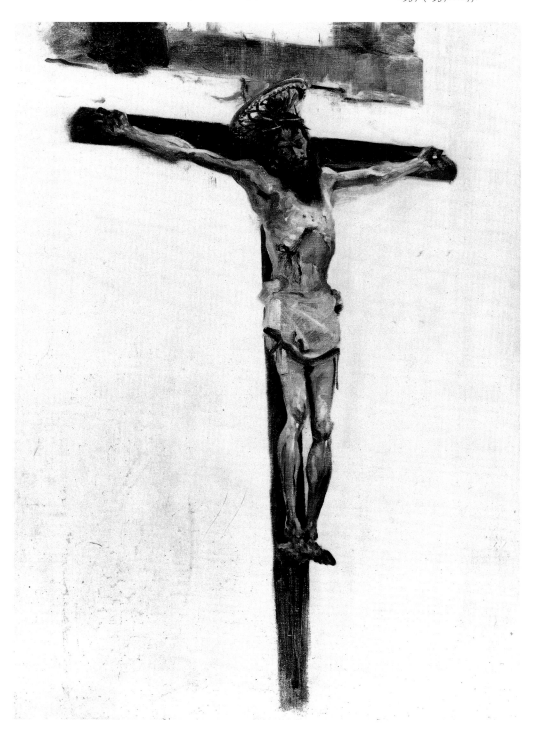

760
Sketch of a Spanish Madonna

c. 1879(?)
Oil (support and dimensions unknown)
Untraced

This illustration to Alma Strettell's *Spanish & Italian Folk-Songs* (London, 1887, ill. facing p. 9) appeared opposite one of the Spanish 'Soleares':

> *Come home with me, sweetheart;*
> *And I will tell my mother*
> *That our Lady of Grace thou art!*

The sketch is closely related to two other oil studies of the same statuette of a Spanish Madonna (nos. 761, 762) which were probably painted on Sargent's visit to Spain in 1879. This more finished version may have been done then, or it may have been painted specifically for the book illustration.

The sketch depicts a popular form of statuette type that goes back to the Renaissance but is here likely to be of more recent origin. The head is probably modelled in wax, as are the hands, which are held out in front with fingers touching. The figure is dressed in a tight-fitting costume with buttons down the front, a wide lace collar and frilly cuffs, and a wide-spreading cloak. Above the Madonna's head rises an elaborate metallic halo. The figure is placed on a low plinth under a canopy of cloth, flanked by a pair of candlesticks with a crucifix in front. A rectangular strip above the canopy may represent a window or opening of some kind. The way the figure is presented suggests a venerated icon dressed up for a special ceremony or festival.

Reviewing the publication of Alma Strettell's book, the anonymous critic of the *Athenaeum* wrote of 'the stiff yet delicate Madonna, whose enormous crown and barbaric heavy mantle recall the 'Ex Voto' of Baudelaire,—all these are conceived with poetic fervour, and the intense and electrified attitudes frequently affected by Mr. Sargent are here not out of place' (no. 3118 [30 July 1887], p. 142). Baudelaire's haunting description of the statue of the Madonna in his poem 'À une Madonne: Ex-voto dans le goût espagnol', published in *Les Fleurs du Mal,* may well have influenced Sargent's choice and treatment of the same subject.

Old photographs, with inventory numbers in pencil in the hand of Thomas Fox, exist for some of the original sketches on which the book illustrations are based, but not for the statuette of the Spanish Madonna; however, there is one for the related oil sketch in the Metropolitan Museum of Art, New York (no. 761). According to Charles Merrill Mount (1969 ed., p. 466), the sketches for the Strettell illustrations were given into the charge of Fox in 1926 and subsequently disappeared. For a fuller discussion of the illustrations as a group, see appendix II, p. 388.

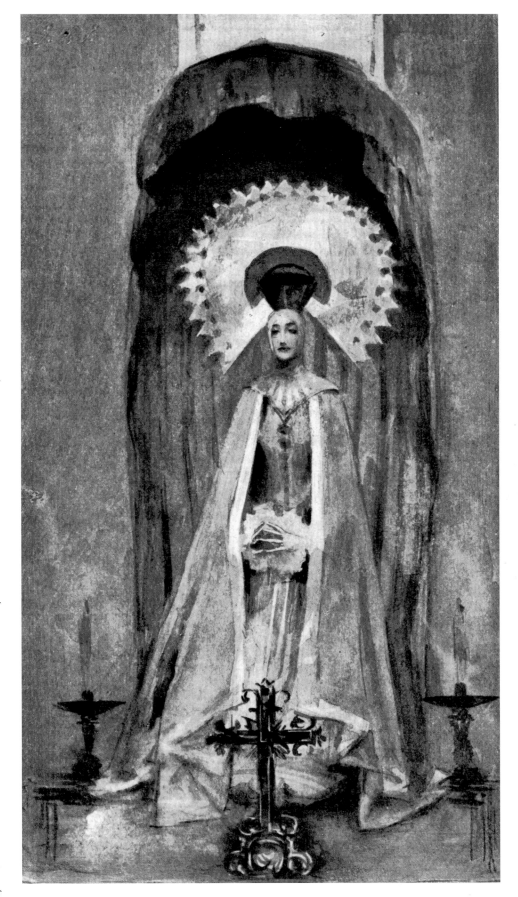

761
Sketch of a Spanish Madonna

c. 1879
Alternative title: *Madonna in Festive Robe*
Oil on panel
13¾ x 10¼ in. (35 x 26 cm)
The Metropolitan Museum of Art,
New York. Gift of Mrs Francis Ormond,
1950 (50.130.11)

This is a sketchier version of the painting
illustrated in Alma Strettell's *Spanish & Ital-
ian Folk-Songs* (see no. 760). It is wider in
format, shows more of the plinth, and has
only one candlestick (another columnar
object is sketchily indicated on the right).
In other respects, the two works are similar
in composition and treatment. An early
photograph of the picture, in the same
small-scale format as photographs of the
original sketches for the illustrations, is in
the catalogue raisonné archive. These early
photographs were possibly taken contem-
poraneously with the publication of the
book. The photographs bear pencil inven-
tory numbers in the hand of Thomas Fox,
the number for the work catalogued here
being 'JSS 247 [or 241]'; unfortunately, no
copy of the Fox inventory has yet come to
light. The sketch is painted on one of the
thin mahogany panels Sargent was using in
the period 1878–80, and it was probably
painted in Spain during Sargent's journey
there in the last months of 1879.

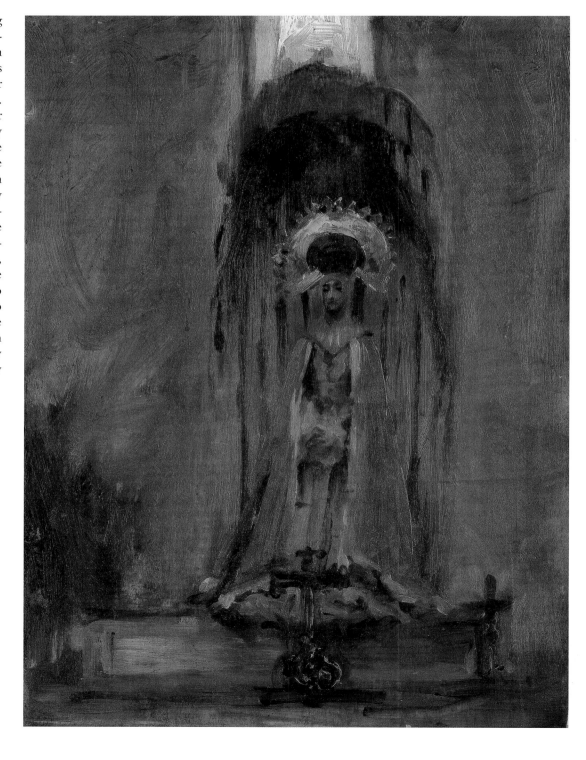

762
A Spanish Madonna

c. 1879
Oil on panel
13⅜ x 5⅞ in. (34 x 15 cm)
Inscribed, along the bottom:
To Mrs. / Gardner John S. Sargent
Isabella Stewart Gardner Museum,
Boston (P27w2)

This is the sketchiest of the three versions
of *A Spanish Madonna*. The figure is much
closer to the front of the picture plane than
in either of the other two versions (nos.
759, 760), and the narrower proportions of
the panel result in the figure and canopy
occupying almost all of the space. The cru-
cifix and pair of matching candlesticks
shown in the illustration in Alma Strettell's
Spanish & Italian Folk-Songs (no. 759) are
here omitted. Like the oil sketch in the
Metropolitan Museum of Art, New York
(no. 760), this version was probably painted
on Sargent's journey to Spain in the autumn
and early winter of 1879. It is painted on
one of the thin mahogany panels Sargent
used in the period 1877–80, with the same
height measurement as other panels but
half the width.

The panel was given to Sargent's close
friend Isabella Stewart Gardner and is now
in the museum that bears her name. Accord-
ing to David McKibbin's catalogue card for
the picture (McKibbin papers), the sketch
was purchased from Frank Bayley of the
Copley Gallery, Boston. This must be a mis-
take. In his MS notebook recording infor-
mation on the collection in the Isabella
Stewart Gardner Museum, Morris Carter,
the first director, wrote of the present sketch
(p. 124): 'Spanish Madonna, little sketch by
Sargent, given by him'. We are grateful to
Richard Lingner, assistant curator at the
Museum, for this last reference.

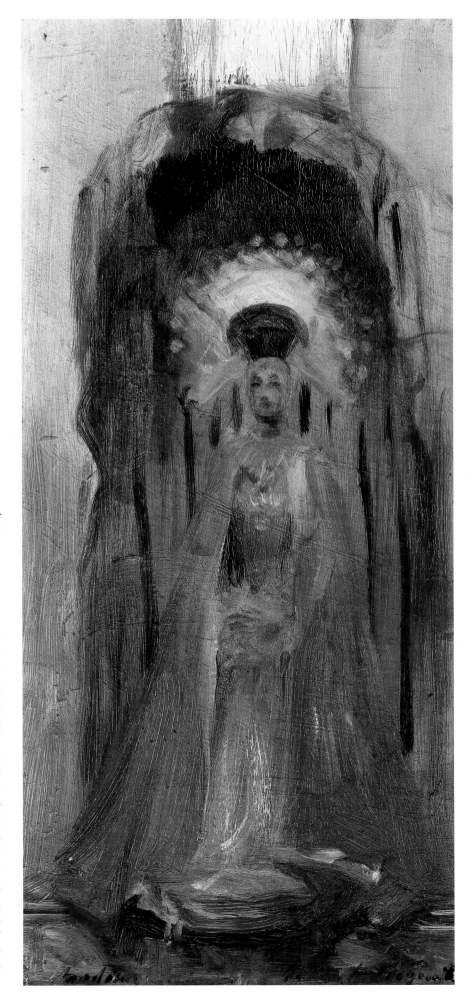

763
The Spanish Dance

c. 1879–82
Oil on canvas
35¼ x 33¼ in. (89.5 x 84.5 cm)
Inscribed, lower left: *John S. Sargent*
Hispanic Society of America, New York
(HSA A152), on long-term loan to the
National Gallery of Art, Washington, D.C.

The dancers in this dark and atmospheric scene are performing the tango, one of the most exciting and popular forms of Spanish dance. We see two couples swaying in the foreground, and our eye is led into the distance by a third couple and a distant line of musicians, including two guitarists whose instruments gleam in the faint light. The setting is almost certainly an outdoor one. Overhead, the dense night sky is pierced by stars and the streaks of what appear to be falling sparks from spent fireworks. Critics have made comparisons with the work of James McNeill Whistler, in particular with *Nocturne in Black and Gold: The Falling Rocket* (The Detroit Institute of Arts), which is markedly alike in mood and atmosphere. Sargent and Whistler had both been in Venice in the autumn of 1880, and they were well aware of each other's work.

It is not easy to decipher the figures, especially the men, whose black costumes merge into the darkness. The outstretched arms of the dancers, like signals in the night, are charged with passion and sensuous meaning. They create a rhythmic pattern across the space. The fluid painting of the figures and the streaky sky underline the fact that we are experiencing a fleeting moment. The female dancer in the foreground, wearing a mauve shawl over her white skirt and what seems to be a black overdress, has her head bent back acutely and her arms thrown out. Mary Crawford Volk identifies the specific movements as the *haciendo la bisagra* ('making the hinge'), when the woman leans back dramatically against her male partner (Washington 1992, p. 142). The woman on the right, also in mauve and white, bends down with her right arm pointing in front of her, her left curving upwards behind her back. Her partner stands to the side, legs parted, both arms aloft. The third female dancer has her back to us, one arm vertical, the other almost horizontal, as if performing a semaphore. Her partner, all but invisible behind her, has both arms in the air.

The picture of *The Spanish Dance* is closely related to *El Jaleo* (no. 772) in its dramatic presentation of a night-time scene of Spanish dancing, with figures fitfully lighted against a dark, mysterious space and a row of musicians in the background. However, it retains the character of a momentary impression, unlike the highly orchestrated figure composition of *El Jaleo*. Its unusual square format also contrasts with the horizontal composition of *El Jaleo*. It seems likely that both works were developed in concert rather than one inspiring or superceding the other. Sargent had the idea for a composition of a single figure dancing before a row of musicians very early on, as the drawings on the back of a torn-up Madrid invoice demonstrate (figs. 126, 127). *The Spanish Dance* is a different kind of event, with pairs of dancers performing in a cavernous space. It is impossible to be certain whether or not it records a specific event. Ralph Curtis recalled that an oil sketch for the picture, which he owned (no. 766), had been done from Sargent's memory of an open-air tango he had seen in Granada. The existence of several studies for the picture indicates that it was a studio production, probably carried out in Paris at the same time that he was developing *El Jaleo*. Studies for both pictures are to be found in the same sketchbook in the Isabella Stewart Gardner Museum, Boston.

Two preliminary oil sketches for this picture are known. The first of these (no. 765) shows two pairs of dancers, in the same pose as those on the left and right centre of the finished work but with less space between them. It is sketchily painted with a lighter-toned palette, enabling the viewer to make out more of the figures and the scene as a whole. The second oil sketch (no. 766) shows the same two pairs of dancers, but in a different alignment and with a streaky sky instead of the spangled effect of the picture and the other oil sketch. It may reflect an earlier stage of this composition, although the pose and conception of the dancing couples seem to have been there from the start. The omission in both sketches of the third pair of dancers on the right of the Hispanic Society painting may indicate

that they were a later addition to the design, perhaps intended to fill out the sparse foreground. As well as the oil sketches, Sargent executed a number of detailed studies for the figures of the dancers. Related drawings for the picture are as follows (all except no. 5 are catalogued in Washington 1992, pp. 140–45, nos. 9–12):

1. *Spanish Dancers* (fig. 147). Volk suggests that the placement of the dancing couple in the corner of an otherwise blank sheet of paper 'implies a broad setting for the picture and suggests Sargent was fascinated by this particular pair of dancers while perhaps watching a performance' (Washington 1992, no. 9; see also Herdrich and Weinberg 2000, p. 162, no. 137 verso).

2. *Two Dancers* (fig. 145). A tonal study exploring the twisting movement of the dancers, and the strong highlights on the woman's throat, arm and dress. From a sketchbook in the Isabella Stewart Gardner Museum, Boston, which contains many studies for *El Jaleo* (Washington 1992, no. 10).

3. *Two Dancers* (fig. 146). A slight sketch for the figures on the right of the picture (Washington 1992, no. 11).

4. *Spanish Dancer* (fig. 148). The strained attitude of this figure clearly caused the artist problems, which he worked through in this and the preceding drawing (Washington 1992, no. 12).

5. *Spanish Dancer* (fig. 144). Study for the figure of the female dancer in the background to the left of the composition. On the verso are figures from *Tristan and Isolde*.

Mary Crawford Volk has suggested that the picture might be understood in relation to the two smaller related oil studies as 'a further compositional study rather than as a finished work' and comments: 'Why he abandoned this composition without pursuing it further is unknown' (Washington 1992, p. 25). The fact that Sargent did not exhibit the picture at the time lends some support to this theory, although it is no less 'finished' than some of the Venetian streets and interiors he sent to contemporary

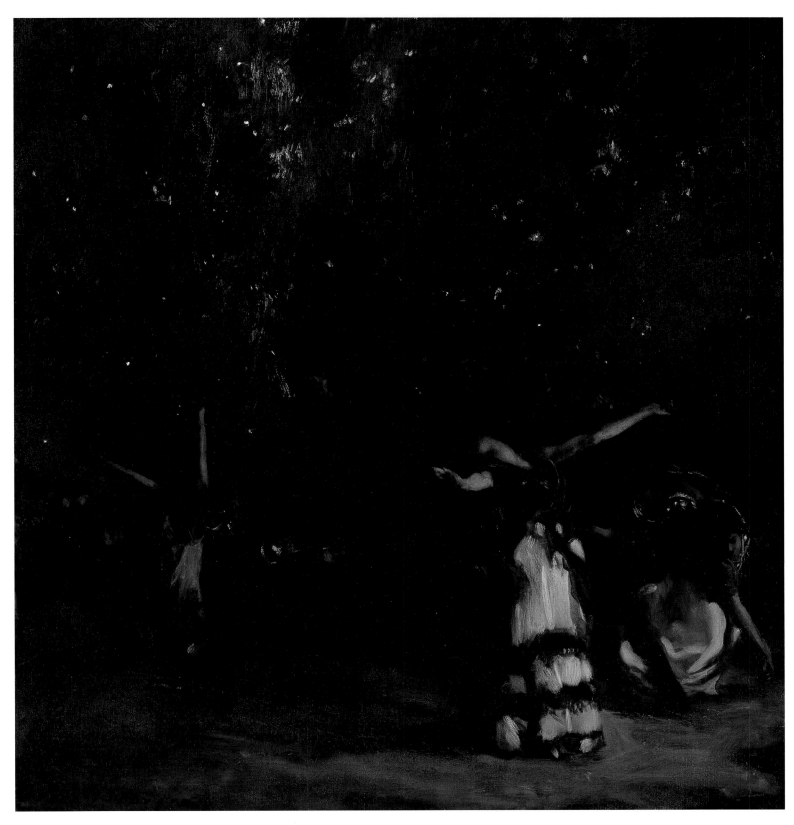

exhibitions. The photogravure illustration in Meynell (1903) and Meynell and Manson (1927, n.p., ill.) shows far more detail than is apparent today, so the picture has clearly darkened over the last century, even allowing for the skill of the platemaker.

Sargent gave *The Spanish Dance* to the poet Alma Strettell (Mrs Lawrence 'Peter' Harrison), possibly in or around 1887. In that year, she published *Spanish & Italian*

Folk-Songs with a number of photogravure illustrations after works by Sargent (see appendix 11, p. 388). The frontispiece of this book appears to be a grisaille sketch after *The Spanish Dance* (no. 764), from which it differs in a few minor details. However, the status of this presumed monochrome sketch in Sargent's oeuvre is uncertain. Alma Strettell, whom Sargent painted in 1889 (*Early Portraits,* no. 223), and her husband, 'Peter'

Harrison (see *Later Portraits,* no. 433), were among the artist's most intimate friends. Alma Strettell sold the picture to M. Knoedler & Co., London, in 1921, and the following year it was purchased by the Hispanic Society of America and almost certainly paid for by its founder, Archer M. Huntington, who had already given *Dwarf with a Dog, after Velázquez* (no. 733) to the institution.

Fig. 144 *(top left)*
Spanish Dancer, c. 1879–80. Pencil on paper,
9⅝ x 13¾ in. (25.5 x 35 cm). Fogg Art Museum,
Harvard University Art Museums, Cambridge,
Massachusetts. Gift of Mrs Francis Ormond,
1937 (1937.7.21, f.17).

Fig. 146 *(top middle)*
Two Dancers, c. 1879–80. Pencil on paper,
9 x 6¾ in. (22.9 x 17.2 cm). Fogg Art Museum,
Harvard University Art Museums, Cambridge,
Massachusetts. Gift of Mrs Francis Ormond,
1937 (1937.7.27, f.2 recto).

Fig. 147 *(bottom left)*
Spanish Dancers, c. 1879–80. Pencil on paper,
9¹³⁄₁₆ x 13³⁄₁₆ in. (24.9 x 33.4 cm). The Metropolitan
Museum of Art, New York. Gift of Mrs Francis
Ormond, 1950 (50.130.140s verso).

Fig. 145 *(top right)*
Two Dancers, c. 1879–80. Charcoal on paper,
13½ x 9¼ in. (34.3 x 23.5 cm). From Sargent
sketchbook. Isabella Stewart Gardner Museum,
Boston.

Fig. 148 *(bottom right)*
Spanish Dancer, c. 1879–80. Pencil on paper,
11 x 15 in. (28 x 38.2 cm). Fogg Art Museum,
Harvard University Art Museums, Cambridge,
Massachusetts. Gift of Mrs Francis Ormond,
1937 (1937.8.70).

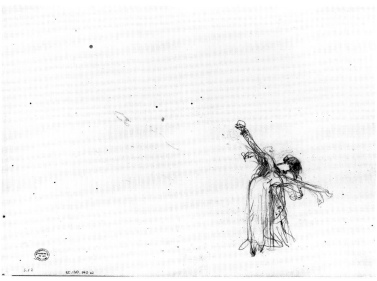
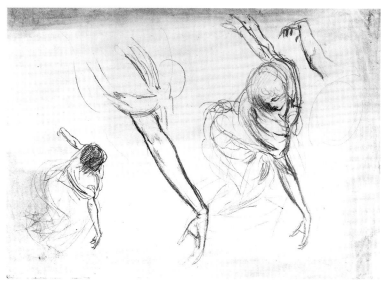

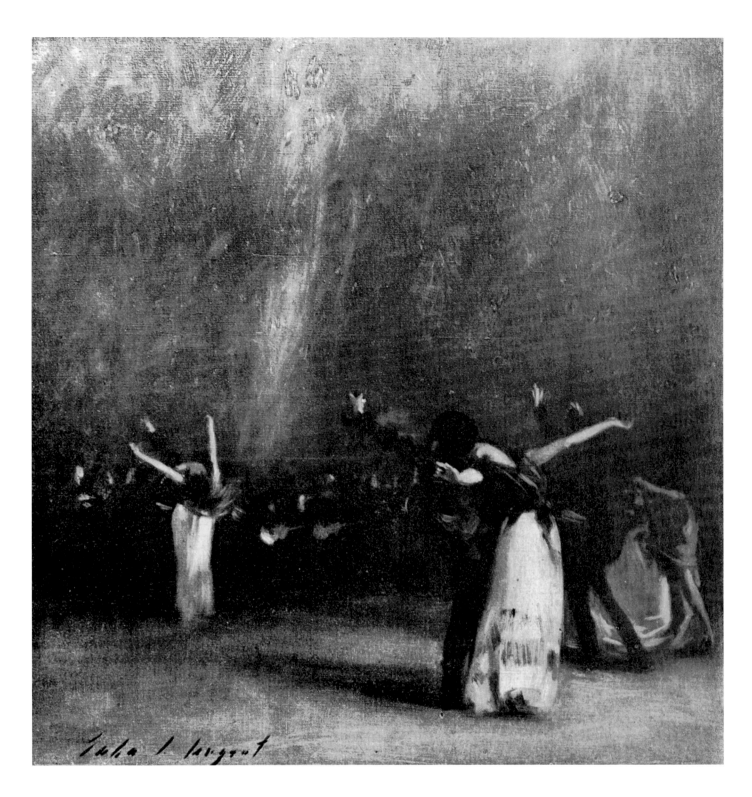

764
Sketch after 'The Spanish Dance'

c. 1880–87
Oil (support and dimensions unknown)
Inscribed, lower left: *John S. Sargent*
Untraced

This photogravure frontispiece to Alma Strettell's *Spanish & Italian Folk-Songs* (London, 1887) appears to have been taken from a sketch after the well-known painting of the same subject (no. 763). Compositionally, the two images are identical, but the illustrated frontispiece is lighter in tone than the oil, shows more streaks in the sky, gives more clarity to the musicians in the background, and differs in small details in the treatment of the dancing figures. The darkness of the large original oil may have prompted Sargent to produce a more visible version specifically for the purposes of illustration. Mary Crawford Volk suggests that the latter might have been a monochromatic oil sketch (Washington 1992, p. 152, no. 16). The original oil painting belonged to Alma Strettell (Mrs. 'Peter' Harrison) and was a gift from the artist. According to Charles Merrill Mount (1969, p. 466), the original sketches for Alma Strettell's illustrations were placed in charge of Thomas Fox in 1926 and have since disappeared. He does not include *The Spanish Dance* in his list, presumably because he assumed it had been taken directly from the large oil. For a fuller discussion of the illustrations to *Spanish & Italian Folk-Songs* as a group, see appendix 11, p. 388.

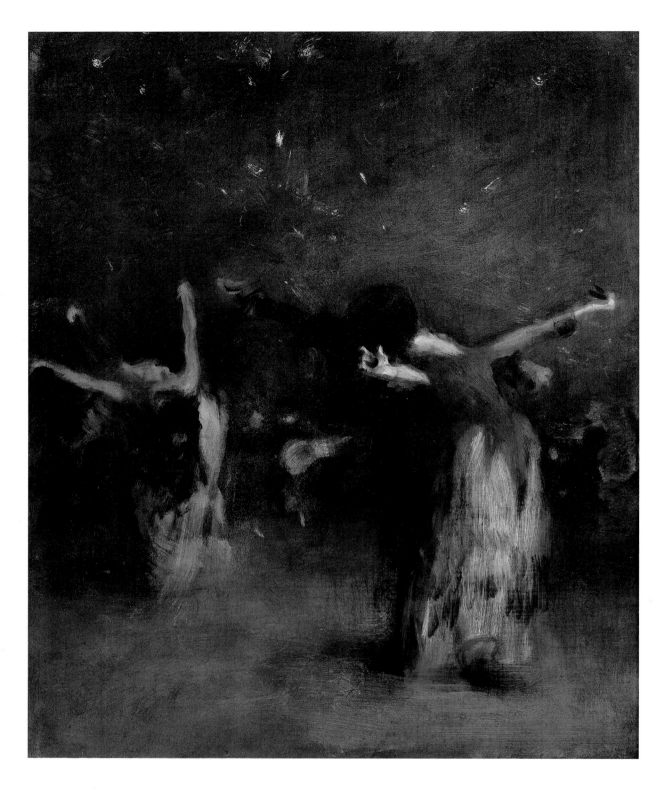

765
Study for 'The Spanish Dance'

c. 1879–80
Alternative title: *Sketch for 'Spanish Dancers—Night'*
Oil on canvas
19½ x 15⅝ in. (49.5 x 39.7 cm)
Private collection

In this lively and colourful oil sketch, two couples are shown dancing the tango under a night sky lit up by sparks from spent fireworks. A row of musicians and singers can be made out dimly in the background, the guitar of one of them catching a gleam of light. The picture relates closely to *The Spanish Dance* (no. 763), for which it is a preliminary study. The general idea of the larger version is given, but with less space above and between the pairs of dancers and a more concentrated composition. The study is more brightly lit than the large version,

enabling more detail to be made out, in spite of its summary and sketchy treatment. The female dancer on the right wears a red overdress in place of the black overdress selected for the Hispanic Society picture. The third pair of dancers on the far right of the latter picture is omitted in the study. The original frame of the study covered more than an inch of the painted surface on either side, thus significantly altering its proportions (the size given in the London 1926 exhibition is 19 x 13½ in.).

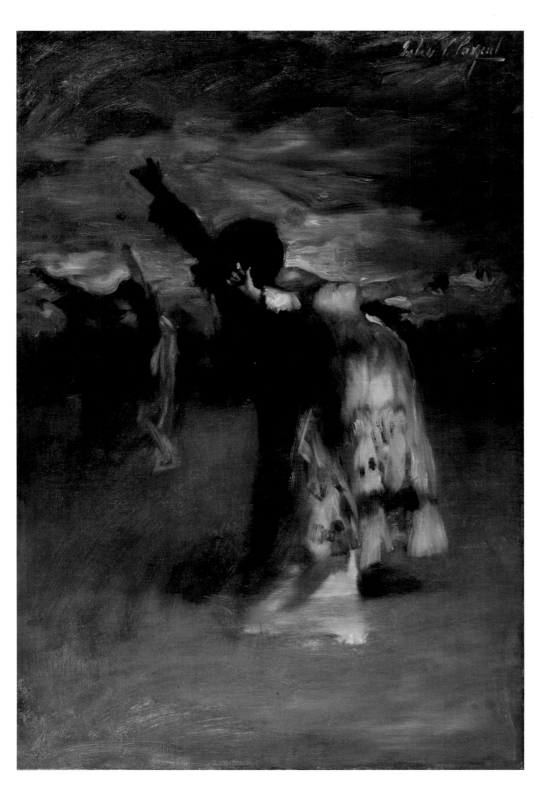

766
Study for 'The Spanish Dance'

c. 1879–80
Alternative title: *Study for 'At Seville'*
Oil on canvas
28⁷⁄₁₆ x 19 in. (72.3 x 48.2 cm)
Inscribed, upper right: *John S. Sargent*
The Nelson-Atkins Museum of Art,
Kansas City, Missouri. Gift of Julia and
Humbert Tinsman (F83-49)

A pair of figures dancing the tango are shown against a streaky night sky, with a line of musicians in the distance. Like no. 765, this is a preliminary study for Sargent's picture of *The Spanish Dance* (no. 763). The pose of the figures relates closely to the pairs of dancers on the left and right centre of that work. The yellow costume of the woman in the foreground group is, however, quite different in style, colour and texture to the costume shown in the study. Here, she is wearing a close-fitting dress with a train, rather than a skirt and an upper garment and shawl; the sweeping brush strokes define the sensual contours of her body. Unlike the figure in the larger work, her upper arms and throat are covered and not bare. The composition of the sketch is upright rather than square, the figures are shown much closer together, and there is no expansive darkness above them. However, the blurred treatment of the figures, the eerie lighting and the flowing shapes of the night sky give the sketch a greater sense of urgency, movement and dramatic intensity than the larger version. The bright sources of light behind the figures may represent fireworks or the after-effects.

According to a note on McKibbin's card for the picture (McKibbin papers), this sketch was made in Ralph Curtis's studio in Paris, from Sargent's 'memory of open air tango he saw at Granada'. McKibbin may have been given this information by Curtis's son and namesake. The elder Ralph Curtis (1854–1922), whose parents lived in the Palazzo Barbaro in Venice, was a distant cousin, close friend and fellow-artist of Sargent, who painted him on more than one occasion (see *Early Portraits,* no. 82, and *Portraits of the 1890s,* no. 367). He owned a number of works by Sargent.

767
Spanish Gypsy Dancer

c. 1879–80
Alternative titles: *Sketch of a Spanish Girl;
(The) Spanish Gypsy*
Oil on canvas
18¼ x 11¼ in. (46.4 x 28.6 cm)
Inscribed, upper left: *John S. Sargent/a m*
Private collection, Washington, D.C.

We do not know precisely when or where this sketch was painted. It clearly represents a dancer performing the flamenco, but it is an open question whether it was painted at the time of performance or, more likely, in the studio, with the dancer holding a pose. The attitude of the figure relates closely to that of the dancer in *El Jaleo* (no. 772), and it is reasonable to assume that it represents an early idea for that picture and for *Spanish Dancer* (no. 770). Common to all these works is the profile pose of the figure, with one arm resting on the hip, the other held out with extended fingers, the fluttering shawl draped over the shoulders and upper arms, and the heavy white skirt, forming cone-like shapes. The model in *Spanish Gypsy Dancer* is a much more earthy and recognizable gypsy type than either of the dancers in the finished pictures, with her flashing smile, gleaming teeth and strong physical presence. What Sargent did to refine and abstract the figure of the dancer, and to infuse her with mystery and suspense, is the story of how he created a masterpiece. He had drawn a pair of dancing scenes on the back of a torn-in-two Madrid invoice (figs. 126, 127) showing a single figure before a line of singers and musicians, which are similar in composition to *El Jaleo*. The figure of the dancer in the more finished of the two sketches is male. *Spanish Gypsy Dancer* may represent the first evolution of the dance concept with a female performer. Because of the realism of Sargent's study, one would like to think that it was painted in Spain from a dancer he had seen in action who inspired the pose; for a sketchier version of the study, see no. 768.

Louis McCagg (1861–1929), the first owner of the sketch, had graduated from Harvard in 1884, trained as a lawyer at Columbia University, New York, and cheerfully admitted that he had no occupation. A man of independent means, he was a habitué of Newport where he met and married his wife, and they then lived fashionably in New York and travelled. According to his son Louis B. McCagg, Jr (letter to

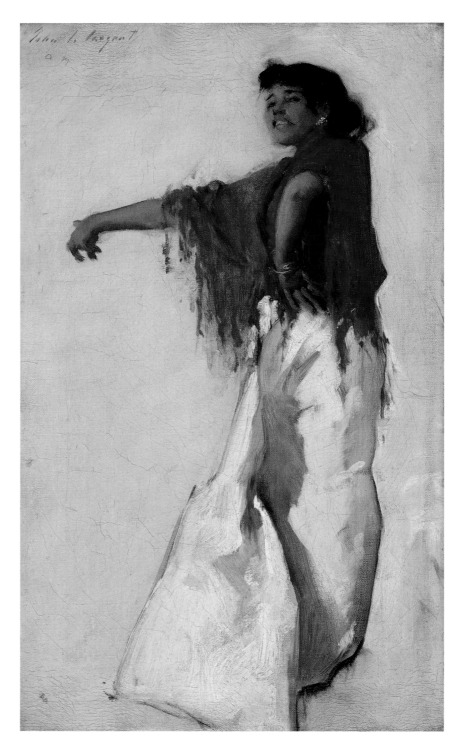

David McKibbin, 20 August 1948, McKibbin papers):

I have no recollection of father ever having said that he knew or met Sargent.

Shortly after his graduation from Harvard in '84 he was in London and while there purchased two Sargent paintings for the sum of five hundred dollars. One of these paintings, about 12 x 18″ was of a Spanish dancer and is now owned by my brother E. K. McCagg of Mt. Kisco, N. Y. The other painting, which must have been 3 x 4′ was a Spanish courtyard scene. This father sold in 1927 or 28 thru a dealer in New York and I do not think that any of the family ever knew who

had bought it. I do know that father got a very high price for it at that time.

The second work mentioned in the letter is the picture now known as *Venetian Loggia* (no. 802). According to McCagg's daughter-in-law, the pictures were bought in a Paris shop prior to 1898 (information from Washington 1992, p. 154). Though McCagg may not have known Sargent at the time he purchased these two paintings, he did later commission a portrait from the artist of his friend Dr Carroll Dunham (now destroyed, see *Portraits of the 1890s*, no. 238).

768
Spanish Gypsy Dancer

c. 1879–80
Oil on canvas
18¼ x 11¼ in. (46.4 x 28.6 cm)
Inscribed, upper left: *John S. Sargent/
à mon ami Chabrier*
The Spanish word *olé* is inscribed four
times across the canvas and the word
saludo once
Private collection

This is the less finished of the two known versions of this subject. The pose of the dancer is almost identical to that of the other sketch (no. 767), but a yellow shawl has replaced the red shawl in the latter work, and the young woman sports a silver ornament in her hair. Both sketches were probably painted at the same time; the slighter version may precede the more finished version; or, as the authors are inclined to believe, derives from it. The word *olé* is splashed across the canvas in four places, together with a single inscription, *saludo*, to indicate the presence of vocalization that always accompanies flamenco dancing. It was no doubt intended to underline the reality of the sketch as the record of a specific performance, the artist caught up in the excitement of the event. The looser treatment of this sketch in comparison to no. 767, especially the broken brush strokes of the shawl, evokes the movement and energy of the dance.

Emmanuel Chabrier (1841–1894), to whom the sketch is inscribed, was a composer and a collector. He and Sargent moved in the same musical and artistic circles. Chabrier was a close friend of Édouard Manet, who painted two portraits of him, and he owned several important Impressionist works, including Manet's masterpiece *Bar of the Folies Bergère* (Courtauld Institute Galleries, London); a sale of his collection took place in Paris (Hôtel Drouot, 26 March 1896), with works by Cézanne, Manet, Monet, Renoir and Sisley, and by three of Sargent's particular friends, Jean-Charles Cazin (for whom see *A Venetian Interior*, no. 795), François Flameng and Paul César Helleu (for whom see *Early Portraits*, nos. 89–92). In 1910, Helleu told André Chabrier that his father was 'the first to buy a picture from me' (quoted in *Chabrier: livre bilingue, français/anglais: Series Iconographie musicale*, ed. Roger Delage [Geneva, 1982], p. 70, where the Sargent sketch is also reproduced, p. 151). For reproductions of

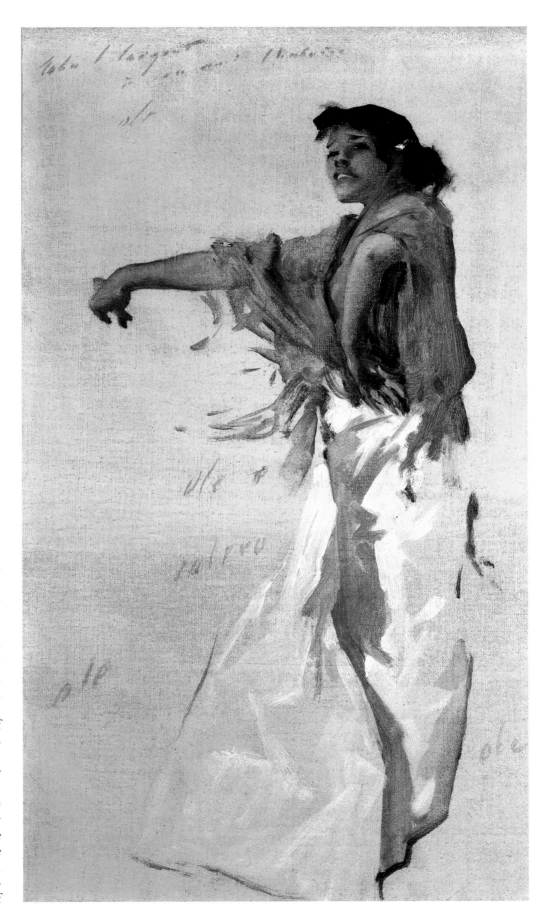

some of the Impressionist paintings belonging to Chabrier, see Roger Delage, 'Chabrier et ses amis impressionnistes' (*L'Oeil,* no. 108 [December 1963], pp. 16–23, 62).

Through music, Chabrier was connected with two more of Sargent's friends, the composer Gabriel Fauré, and Princesse Louis de Scey-Montbéliard (Winnaretta Singer), an important patron of contemporary music following her second marriage in 1893 to Prince Edmond de Polignac; both she and Fauré were painted by Sargent (see *Early Portraits,* nos. 157, 186). He also shared with Chabrier a passion for the music of Richard Wagner and for Spanish music. Though generally considered today to have been an elegant and charming lightweight, Chabrier enjoyed a considerable reputation during his lifetime and immediately afterwards, especially for his numerous works for piano. One of his best-known compositions is *España,* a rhapsody of Spanish airs, which was first performed in 1883. Sargent wrote enthusiastically to the composer after attending the third performance on 21 January 1884, sending this oil sketch at the same time (quoted in Roger Delage and Frans Durif, eds., *Correspondance/Emmanuel Chabrier* [Paris, 1994], p. 220, n. 2):

Dear Chabrier,
Here is the little flamenca [dancer] that I promised you so long ago. She begs your indulgence.
I had a St. Vitus' dance after going yesterday to Lamoureux.[1] España is amazing. I almost threw my hat, umbrella and cigars into the orchestra.
Come and lunch with me one of these days at midday.
Fraternal greetings.
John S. Sargent
I will send you soon a little frame for the flamenca.[2]

Chabrier added a note to this letter:

Sargent/American painter of great talent, pupil of Carolus-Duran, much noticed at the last three salons./His letter, by the way, is interesting./NB One uses the name flamenco or flamenca for the Andalusian singers and dancers (male and female gypsies) who interpret by tradition the Moorish and Spanish-Arab songs, etc, accompanied by the guitar and nothing else.[3]

In an earlier letter to Chabrier, dating from the end of December 1883, Sargent had written (*Correspondance/Emmanuel Chabrier* pp. 220–21, n. 2):

Dear Chabrier,
Would you like to hear the Malagueña and the Solea marvellously sung by a pure female flamenco singer, a splendid contralto with a terrific deep throaty voice? I would like various musicians and artists and some amateurs to hear her who might then perhaps ask her to sing at their soirées. Who knows if the philistines will appreciate her; in any case you will be ravished by her, dear Andalusian.
Come this Monday evening at 8 to 9 o'clock to my new studio 41 Bd Berthier near the Place Péreire, in a light coat or jacket. I am not yet fully installed and there will only be a guitar and piano to sit on.
You have never heard anything so good in Spain.
If you cannot come Monday evening send me a telegram and tell me the days when you can.
Fraternal greetings
John S. Sargent
73 rue N.D. des Champs[4]

The history of this study is obscure between the time of its gift to Chabrier in 1884 and its acquisition by Daniel H. Farr & Co. of Philadelphia by or before 1928. They sold it to Mrs George (Edith Kane) F. Baker, who also owned a study for *El Jaleo* (fig. 166).

1. The Orchestre Lamoureux was founded by Charles Lamoureux in 1881, specifically to champion contemporary French music.
2. 'Cher Chabrier,/Voici la petite flamenca promise depuis bien longtemps. Elle réclame votre indulgence./J'ai encore une Jota de S[ain]t Guy d'avoir été hier à Lamoureux. *España* est ébouriffant, j'ai manqué de jeter mon chapeau, mon parapluie et des cigares dans l'orchestre./ Venez déjeuner avec moi un de ces jours à midi./ Poignée de main./John S. Sargent/On vous apportera bientôt une petite bordure pour la flamenca' (The letter is in the Bibliothèque Nationale, Paris, Album d'autographes W39, no. 314).
3. 'Sargent/peintre américain *de grand talent,* élève de Carolus Duran, très remarqué aux trois derniers salons./Sa lettre, du reste, est intéressante./N. B. On nomme flamenco ou flamenca, les chanteurs et danseurs (*gitanos et gitanas*) Andalous qui interprètent, de tradition, les chants mauresques, hispano-arabes, etc.—avec acc[ompagne-men]t de guitare et de bien d'autres défauts'.
4. 'Cher Chabrier,/Voulez-vous entendre chanter la Malagueña et la Solea *merveilleusement* par une flamenca pur sang, un contralto splendide, avec des gargarismes épatants? Je voudrais la faire entendre à quelques musiciens et artistes et à quelques amateurs qui pourraient peut-être la faire chanter dans des soirées. Qui sait si les philistins l'apprécieront; en tout cas vous en serez ravi, cher Andalou./Venez donc lundi soir à 8½ 9 heures à mon nouvel atelier 41 Bd Berthier près la place Péreire, en redingote ou veston. Je ne suis pas encore installé et il n'y aura qu'une guitare et un piano pour s'asseoir./Vous n'avez jamais entendu en Espagne quelque chose d'aussi bien./Si vous ne pouvez pas venir lundi soir envoyez-moi une *dépêche* et dites-moi les jours où vous pouvez./ Poignée de main./John S. Sargent/73 rue N.D. des Champs' (The letter is in a private collection).

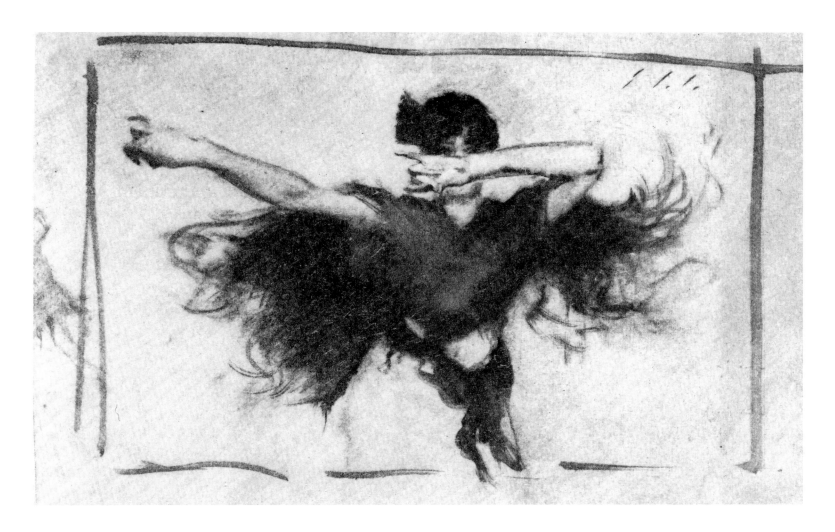

769
Sketch of a Spanish Dancer

c. 1879–80(?)
Oil (support and dimensions unknown)
Inscribed, upper right: *J.S.S.*
Untraced

This illustration to Alma Strettell's *Spanish & Italian Folk-Songs* (London, 1887, ill. facing p. 51), appeared opposite one of the 'Seguidillas Jitanas', a particular form of Spanish gypsy dance:

> *I am not of this earth,*
> > *Nor born of mortal mother,*
> *But Fortune, with her turning,*
> > *turning wheel,*
> *Hath brought me hither.*

The figure in the sketch is a gypsy dancer, her left arm covering her face, her right arm extended, her fringed shawl fluttering wildly to indicate the rapid movements of her dance. The sketch relates to studies of Spanish dancers that Sargent was making for two important pictures, *Spanish Dancer* and *El Jaleo* (nos. 770, 772). It relates closely to a thumbnail pencil sketch of a dancer on a sheet of studies in a sketchbook in the Fogg Art Museum, Cambridge, Massachu-

setts (fig. 133; see Washington 1992, p. 162, no. 22). The oil sketch may have been done at the same time as these early studies of Spanish dancers, or it could have been painted in 1887 especially for the illustration in the book of folk songs.

There is an old photograph of the original sketch, one of several for the Strettell illustrations, perhaps taken contemporaneously with the book, which is the image reproduced here. It has an inventory number in pencil in Thomas Fox's hand, 'JSS 246' (not 2116 as given in Washington 1992, p. 165); unfortunately, no copy of Fox's inventory has yet come to light. The sketch has roughly ruled lines around the figure, which were omitted in the illustration. According to Charles Merrill Mount (1969, p. 466), the sketches for the Strettell illustrations were given in Fox's charge in 1926 and subsequently disappeared. For a fuller discussion of the illustrations as a group, see appendix 11, p. 388.

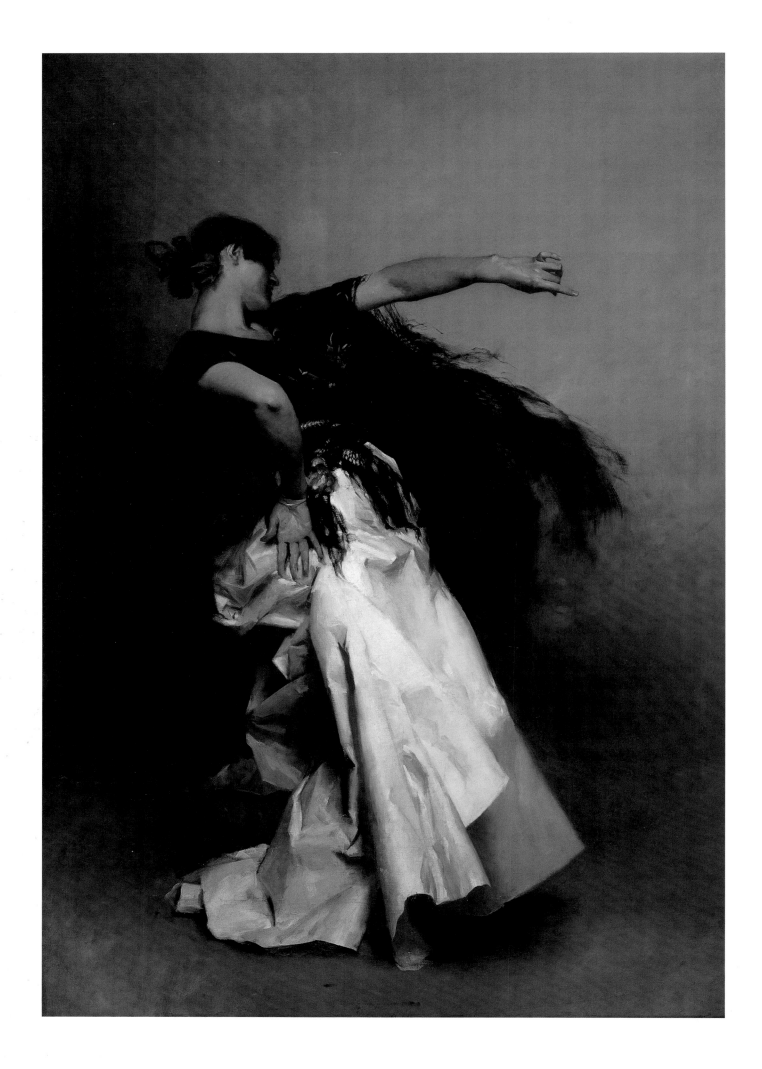

770
Spanish Dancer

c. 1880–81
Oil on canvas
87¾ x 59½ in. (222.9 x 151 cm)
Private collection

The appearance in 1988 of this hitherto unrecorded work was an event of great significance in Sargent studies. It added a major new work to his oeuvre and threw new light on the evolution of *El Jaleo* (no. 772), to which it is closely related. One can hazard a guess that such a finished painting on the scale of life can only have been intended for the Paris Salon. Why Sargent set it aside and then abandoned it we shall probably never know. His own comments made in two letters of 1897 to the first owner of the work, Isaac Val, are vague (see below). He says in one letter that he had 'lost sight' of the painting, and in the second that he 'must have left it behind in one of my moves in Paris'.

The picture shows a single female figure performing the flamenco and correctly records the movements and gestures of this popular gypsy dance. Her head and neck are bent towards her left shoulder; the left arm is flung out with fingers expressively pointing or bent; the right arm is acutely twisted at the elbow and rests on her hip with the flat palm of her hand facing outwards and holding up the folds of her train. The costume consists of a heavy satin skirt and train (the one item not typical of gypsy dress), a dark sleeveless upper garment, and a large fringed shawl held in place round her waist by a vivid blue cord with one tassel visible. This cord, the red and blue floral motifs on the shawl and the mauve flower or ribbon at the nape of the neck constitute the chief accents of colour in a palette otherwise composed of black and white and cool grey. The black hair of the dancer is drawn smoothly up over her ears and twisted into a roll at the back of her head. In contrast to *El Jaleo,* no shoe is visible below the skirt, and the figure here sports a thin silver bangle on her right wrist. The dancer's movements are implied by the broken outlines and indentations of her train, and the blurred and fluttering treatment of the shawl.

It seems that Sargent originally planned to include a row of musicians behind the figure of the dancer, as he subsequently did in *El Jaleo.* Two ghostly heads are visible to the eye below the dancer's right shoulder, both looking up and possibly in the act of

singing. Two more heads are faintly discernible further down the canvas, and not in alignment with the first two, below the fringe of the dancer's shawl on the right. Warren Adelson and Elizabeth Oustinoff (in Washington 1992, p. 113) suggest that Sargent abandoned the idea of including figures because 'the vertical canvas and the monumentality of the dancer would have compressed the musicians between her figure and the edges of the canvas, an arrangement that would have seemed self-conscious in its artifice and claustrophobic in its effect'. In abandoning supplementary figures, Sargent sacrificed a specific locality and ambiance in favour of a neutral space with no associations apart from those brought by the dancer herself. This type of background and even lighting relate to the Velázquez-inspired style of Sargent's formal portraiture of this period. However, the artist does not transform his study of the dancer into a portrait, as he would later do with another Spanish dancer, *La Carmencita (Portraits of the 1890s,* no. 234). The dancer here remains the embodiment of the flamenco, a type rather than an individual, absorbed in the creation of her art, her head turned away, her features lost in shadow.

The evolution of the design of *Spanish Dancer* is problematic. We may presume that the two oil studies of *Spanish Gypsy Dancer* (nos. 767, 768) represent an earlier stage in the conception of the figure. *Spanish Dancer* lies somewhere between these studies and the elegant refinement of the pose in *El Jaleo.* Common to all four works is the profile pose of the dancer's body, with one arm extended, the other resting on her hip, and the heavy white skirt and fringed shawl. The model in the two oil studies (nos. 767, 768) is more down-to-earth than her counterpart in *Spanish Dancer;* she faces left rather than right, turns her head to face the viewer and lacks any background or setting.

There are four drawings that relate to *Spanish Dancer* (catalogued in Washington 1992, pp. 158–64, nos. 20–23):

1. *Studies of a Spanish Dancer* (recto) (fig. 131). A study of an outstretched arm and two full-face studies of a dancer, one arm extended, the other bent across her face,

with a shawl criss-crossed over her breasts. Herdrich and Weinberg (2000, pp. 168–69, no. 149) conjecture that the isolated hand on the extreme right of a drawing in the Metropolitan Museum of Art, New York (fig. 130) is the continuation of the extended arm of the left-hand dancer in this drawing (i.e., that the two sheets once faced each other in the same sketchbook). On the verso of the sheet is a drawing of a reclining woman relating to *Fumée d'ambre gris* (fig. 190). This drawing comes from a group of six drawings that were given by the artist's elder sister, Emily Sargent, to Mrs Jagger, the housekeeper at 33 Tite Street, together with the water-colour *Head of a Venetian Model* (no. 834). Her son was the British sculptor Charles Sargeant Jagger (1885–1934), best known for his First World War memorials, including the famous Royal Artillery Memorial at Hyde Park Corner, London. The drawings descended to Jagger's son, Cedric, and were included for sale in the exhibition at the Fine Art Society, London, Spring 88, 3 May–3 June 1988, nos. 29 a–e and 30. The other five drawings are as follows: *Studies of a Spanish Dancer* (no. 2 below); two sketches after group portraits by Frans Hals (figs. 110, 111); *Studies of Venetian Female Models* (fig. 213); and a drawing of *Mrs George Batten* (ill. *Portraits of the 1890s,* p. 125, fig. 69).

2. *Studies of a Spanish Dancer* (fig. 132). Studies of a dancer facing right, left arm in the air and right extended; a detail of the face of the same model; and a study for the foreground female dancer in *Spanish Dance* (no. 763).

3. *Studies of a Spanish Dancer* (verso) (fig. 133). Six separate studies exploring different poses for *Spanish Dancer.* The most finished of these, in the centre, is similar to the figure in the painting, though lacking the indented folds of the train. There is also a full-face view of a dancer similar to no. 1. Sargent made use of this full-face type for his monochrome illustration to Alma Strettell's *Spanish & Italian Folk-Songs,* published in London in 1887 (no. 769). On the recto of drawing no. 3 is a sketch of a studio interior with a reclining figure on a bed and an artist before an easel (fig. 135).

4. *Studies of a Spanish Dancer, Bearded Man with Pipe* (fig. 134). A figure posed similarly to *Spanish Dancer* with two variant studies of the outstretched left arm. Warren Adelson and Elizabeth Oustinoff (1992, p. 465) conjecture that the model in this drawing is identical to the woman in the two oil studies of *Spanish Gypsy Dancer* (nos. 767, 768). The authors are not convinced. Also on the sheet is a study of a bearded artist sketching, with a pipe in his mouth.

For the water-colour study, which seems to be a preliminary *modello* for the picture, see no. 771.

The early history of the picture is obscure. According to a tradition handed down in the family of the first owner, Isaac Val, the picture was given to him by a female servant in his employ; she, in turn, had been given it by the artist, for whom she had temporarily worked in Paris; the Val family home was at Annonay in the Ardèche region of France. In a letter to Warren Adelson of 22 February 1988 (copy, catalogue raisonné archive), Vincent Thuret, great-grandson of Isaac Val, wrote:

During the years 1879–1881, the maid of my great-grandfather, Monsieur Isaac Jean Val, had to go to Paris and worked for awhile in the service of Monsieur J. S. Sargent.

In our family, the story is that during a cleaning of the atelier of the artist, the maid asked Monsieur Sargent what she should do with this canvas. The painter answered that he would give it to her if she so desired, because he had decided to redo it entirely, with other figures in the scene.

Knowing that my great-grandfather was very interested in paintings, the maid gave him the picture when she came back. My great-grandfather, unrolled it and framed it then hung it on the wall of our living room, where it has stayed until now.[1]

In 1897, Isaac Val wrote to Sargent in London seeking confirmation of the attribution of this and two other works. The artist replied, in French, on 11 March 1897 (copy, catalogue raisonné archive):

Sir,

The painting of which you sent me a photograph is indeed by me, and is a study for my picture 'El Jaleo'.

It is a painting which was done quite a number of years ago and which I had lost sight of. I would be curious to know by what circumstances it came to be in your possession, and by the way I congratulate you on it. If it is not too great an imposition, I would be pleased if you could tell me something about it.

I would even dare to ask you to be good enough to let me know in the event that you might be tempted to part with it.

Please accept my best wishes.
John S. Sargent[2]

Isaac Val wrote a second time to Sargent and received a reply dated 22 March 1897 (copy, catalogue raisonné archive):

Sir,

I thank you for your courtesy in replying to my letter in such a precise manner. The details of the provenance of my painting interested me although they form only one part of its adventures, which concern me, after all, only by way of curiosity. I must have left it behind in one of my moves in Paris.

The two other paintings which you mention do not seem to be by me. I do not recall any attempt in this genre.

In thanking you again for your letter, please accept, Sir, my best wishes.

John S. Sargent[3]

Warren Adelson and Elizabeth Oustinoff, in an essay on the picture (in Washington 1992, p. 111), cast doubt on the story that the picture left Sargent's studio as 'a result of the artist's indifference or as an implied gift'. It is clear from his first letter that Sargent was puzzled as to how Val had acquired the picture, and that he was keen to reclaim it. In the letter of 22 March 1897, Sargent surmised that he had 'left it behind in one of my moves in Paris'. The most significant of these occurred in 1883, when he transferred from his studio at 73, rue de Notre-Dame-des-Champs to a small house at 41, boulevard Berthier. It is possible that *Spanish Dancer* was left rolled up in the studio and forgotten. Evidence that it was rolled up early on in its history comes both from Vincent Thuret's memorandum of 22 February 1988 (see above) and technical examination of the canvas itself carried out by the conservator Alain Goldrach prior to restoration by him on behalf of Coe Kerr Gallery, New York, in 1988. This examination revealed crease lines from rolling and holes along the border of the canvas where Sargent had tacked it to the wall or a board—a common procedure at the time (see Adelson and Oustinoff in Washington 1992, p. 114, n. 8).

1. 'Au cours des Années 1879–1881, la Servante de mon arrière grand-père, Monsieur Val Isaac Jean, a dû aller à Paris et a travaillé quelque temps pour le compte de Monsieur Sargent J.S. L'histoire dans la famille raconte qu'au cours d'un rangement dans l'atelier du Peintre, la servante a demandé à Monsieur Sargent ce qu'elle devait faire de cette toile. Le peintre lui aurait alors répondu qu'il lui donnait cette toile, si elle souhaitait, car il avait décidé de la refaire plus complète, avec d'autres personages dans la scène. Sachant mon arrière grand-père amateur de peintures, la servante lui a offert cette toile, lors de son retour. Mon arrière grand-père l'a dépliée et faite tendre sur cadre, puis, l'a accrochée au mur du salon familial, où elle est restée en place jusqu'à ces jours'.
2. 'Monsieur,/La toile dont vous m'envoyez la photographie est en effet de moi, et est une étude pour mon tableau "El Jaleo"./C'est une peinture qui date de bien des années et que j'avais perdu de vue; je serais curieux d'apprendre par quelles circonstances elle se trouve en votre possession, et dont je la [*sic*] félicite du reste. Si cela n'est pas trop vous importunant un mot à ce sujet me ferait plaisir./J'oserais même vous prier, dans le cas où vous seriez tenté de vous en défaire, d'avoir la bonté de me prévenir./Veuillez agréer, Monsieur, mes salutations distinguées./John S. Sargent'.
3. 'Monsieur/Je vous remercie de votre obligeance en répondant d'une façon si précise à mon letter. Les détails de la provenance de ma toile m'ont interessé quoiqu'ils ne constituent qu'une partie de ses aventures, qui ne me touchent après tout qu'à titre de curiosité. J'ai dû l'abandonner dans un de mes déménagements à Paris./Les deux autres toiles que vous me signalez ne doivent pas être de moi. Je ne me souviens d'aucun essai de ce genre./En vous remerciant de votre letter, veuillez agréer, Monsieur, l'assurance de ma considération distingué./John S. Sargent'.

771
Study for 'Spanish Dancer'

c. 1880–81
Alternative title: *Study for 'El Jaleo'*
Water-colour and pencil on paper
11¾ x 7⅞ in. (29.8 x 20 cm)
Inscribed, upper right: *John J. Sargent*
Dallas Museum of Art. Foundation for
the Arts Collection, gift of Margaret
J. and George V. Charlton, in memory
of Eugene McDermott[1] (1974.1.FA)

Until the recent rediscovery of *Spanish
Dancer* (no. 770), this water-colour was
thought to be a study for *El Jaleo* and is so
described in Sargent literature prior to
1988. It is difficult to be certain of its rela-
tionship to *Spanish Dancer*. Certainly it dif-
fers in some significant details from the oil;
the train, for one thing, is less full; the
dancer here wears a sash tightly wound
round the waist; pencil underdrawing to
the right of the skirt suggests that Sargent
had originally considered a much fuller
profile for it. All this would argue in favor
of the sketch being a *modello* for the oil in
which the artist established the final form
of the composition in the fluid medium of
water-colour. On the other hand, the close-
ness of the water-colour to the oil in most
essentials could suggest that it is a reminis-
cence after the picture rather than a pre-
liminary study for it. This seems to be the
case with the water-colour of *Fumée d'ambre
gris* (no. 791), the only parallel example of an
early study in water-colour related to a fin-
ished oil painting.

1. Co-founder of Texas Instruments Corporation and a
generous philanthropist of the arts.

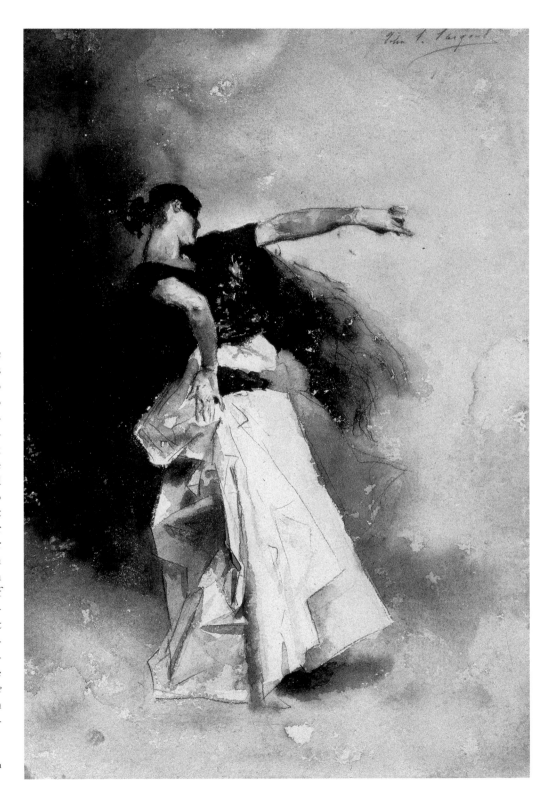

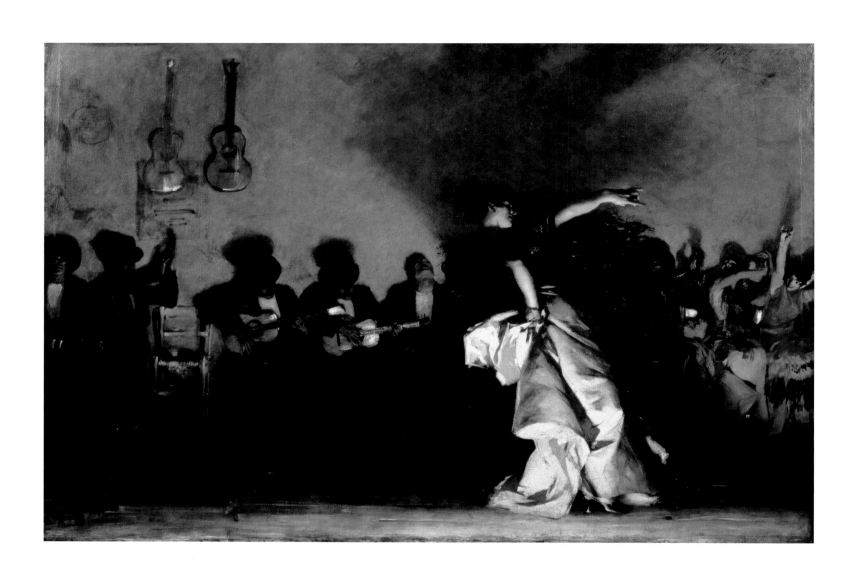

772
El Jaleo

c. 1880–82
Alternative title: *El Jaleo;—danse de Gitanes*
Oil on canvas
93⅜ x 138½ in. (237 x 352 cm)
Inscribed, upper right: *John S. Sargent 1882*
Isabella Stewart Gardner Museum,
Boston (P751)

DESCRIPTION

El Jaleo[1] represents a night-time perfor-
mance of flamenco dancing (*baile jondo* in
this example) accompanied by the piercing
wail and raw emotion of flamenco singing
(*cante jondo*). Nancy G. Heller has argued
convincingly that far from being an artistic
impression of Spanish dancing, Sargent's
picture is a precise and accurate rendering
of the 'real thing'. The contorted move-
ments of the dancer are faithful to flamenco,
which is here performed by a single female
accompanied by guitarists, singers and seated
dancers, who clap their hands (*palmas*), snap
their fingers (*pitos*) and shout *olés* to urge on
the dancer. It is the dancer who leads the
music, and the musicians and singers who
must follow the intricate timing of her
footwork. The title of the picture comes
from the word *jaleo,* an inclusive term used
to describe the hubbub of rhythmic sounds
that accompany a performance. It does not
refer to the dance known as *El Jaleo de Jerez,*
which belongs to the repertory of classic
Spanish dances (*escuela bolera*) and not to
flamenco; for further information on fla-
menco, see the *Diccionario Enciclopédico Ilus-
trado del Flamenco,* 2 vols. (Madrid, 1988), and
Matteo with Carola Goya, *The Language of
Spanish Dance* (Norman, Oklahoma, and
London, 1990).

Sargent's painting is dominated by the
undulating figure of the dancer, her body
angled at almost forty-five degrees as she
sways back before gliding forward; a fre-
quent criticism among reviewers of the
1882 Paris Salon was that no one could
hold such a pose without falling over. The
dancer's torso is twisted at the waist, and
her outflung left arm indicates the direc-
tion in which she is going. Her other arm is
acutely bent at the elbow and the palm of
the hand faces outwards while holding up
the folds of her heavy satin train. Every-
thing about the figure indicates suppleness,
fluidity, verve and action: the blurred hem
of her skirt revealing a glimpse of a high-
heeled shoe; the folds of her skirt falling
into cone and tubular shapes as she moves

forward; the fringe of her shawl with tur-
quoise sequins streaming out below her left
arm and behind her right shoulder; the play
of light and dark across face and arms and
fabric indicating the momentary nature of
what we are experiencing.

The dancer is crossing the stage in a
series of sequential steps, and Sargent has
chosen to depict her at a point of extreme
tension and concentration, condensing in a
single static image the illusion of movement
and sound. The dramatic under-lighting,
casting the cheek, nostril and eyebrow of
the dancer in high relief and the eye and
upper lip in deep shadow, gives her face the
appearance of a mask. Her hair is done up in
a bun on top of her head in a style known
as *modo galano*. She is totally self-absorbed
and trance-like. Not the least of Sargent's
achievements was to instill within the bra-
vado of her performance the sense of inward
experience and emotion. The fusion of outer
expressiveness and inner transcendence
makes the artist's conception of the dancer
both physically exciting and emotionally
compelling.

Behind the dancer a row of musicians
and dancers are ranged against the wall in a
long horizontal format. They seem diminu-
tive in comparison with her looming pres-
ence, and the stage insufficiently deep to
explain the disparity in scale between them.
This was a criticism voiced by reviewers of
the 1882 Paris Salon. However, the picture
has darkened over time, and this has the
effect of reducing the distance between
dancer and musicians; an old photograph of
the painting (fig. 149) shows more detail of
the floorboards and suggests more space
between the participants.

The musicians, like the dancer, are
similarly intense and self-absorbed, and they
communicate the idea of musical rhythm
and raucous sound through suggestive ges-
tures and repetitive poses. None more so
than the singer, who, with head thrown
back, neck sinews taut and open-mouthed,
gives voice to the guttural and vibrating
wail of the *cante jondo* (deep, or serious, fla-
menco singing). To his right are a pair of

guitarists, intently bent over their instru-
ments, their faces half-hidden under their
round hats, who represent, with the instru-
ments on the wall and a third guitarist on
the far left, the rhythmic music of flamenco
dancing. The musical motif of the hanging
guitars is emphatic, for nothing else is visi-
ble on the wall except a faded poster, a
mysterious round object on the left, and
some graffiti, including a hand print and the
drawing of a bull on the left, and the word
olé scrawled three times in red chalk on the
far right.[2]

Beside the two guitarists is an empty
chair with a single orange in the seat, a bril-
liant invention that breaks up the dense
line of figures like an interval in a line of
music. The chair is surely intended for the
dancer once she has completed her per-
formance, and the orange for her refresh-
ment. Next to the chair is a male dancer,
his lower face hidden in shadow, eyes
gleaming brightly, who claps flamenco-
style with arms thrown out to one side. In
the same way that the guitarists mirror and
repeat one another, so the gestures of the
clapping hands are taken up by a second
male figure and the female beside him in
the group on the far right of the picture.
The faces of this group are raised, and their
looks and gestures are exultant, in keeping
with the bolder and more sketch-like treat-
ment of the picture as you move from left
to right. The line of seated figures comes to
an end with a female dancer in a bright
orange shawl; she snaps the fingers of her
raised right hand as she looks animatedly
across at the dancer on stage. Her left arm is
cut off by the edge of the picture, in the
same way that the figure of the guitarist on
the left is cropped, to emphasize the frag-
mentary nature of the scene which is tak-
ing place before us.

Mary Crawford Volk has written elo-
quently of the 'demanding, percussive atmos-
phere of the picture' (Washington 1992, p. 35),
but her contention that the dancer's high-
heeled shoe implies the strenuous *zapateo*
(incredibly fast footwork and vibrating sound
of heel on bare board) is almost certainly

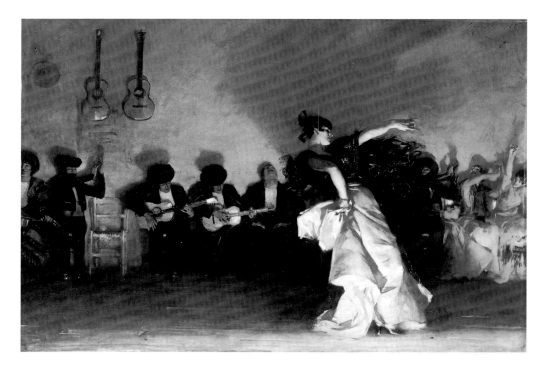

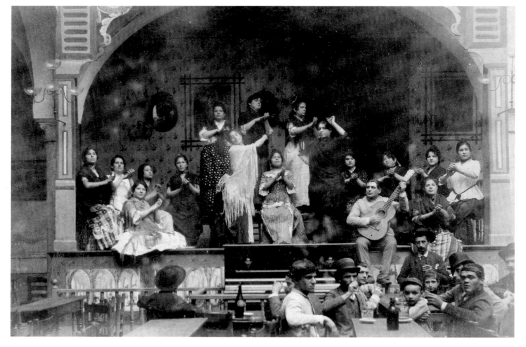

at the other (see fig. 150). Flamenco originally developed as an improvised dance among the gypsies of Andalusia in southern Spain. From the mid-nineteenth century, flamenco became increasingly theatrical, 'with greater stress placed on attractive female dancers in colorful costumes doing showy, crowd-pleasing movements in a light, happy tone to stimulate the patrons' interest in eating and drinking' (Heller 2000, p. 11). The dynamic movement and raucous sounds of flamenco, which Sargent evokes in his image of dancer and musicians, are intensified by the masterly chiaroscuro he employs to evoke the atmosphere of a *café cantante* at night. Light gleams along the polished floorboards in the foreground, but darkness envelops the stage and the lower bodies of the seated figures. It is against this velvety blackness that the artist projects the gleaming white textures of the dancer's skirt, articulating its complicated forms and tactile surfaces. He also highlights the underside of the arms and face to emphasize her physical presence within this shadowy interior. Behind on the wall, her figure throws a huge and menacing shadow. The heads and arms of the musicians and supporting dancers are also shadowed against bursts of light thrown up by the footlights.

Other details are picked out across the space: the gleam on one of the hanging guitars, the instruments and shirt fronts of the two guitarists, the orange on the chair, the thrown-back head of the singer, the bold accents of white between the figures on the right. What Sargent achieves through this play of light and dark is the sense that we are present at an actual performance; our eyes gradually adjust to the dark and take in the details of the scene, as would be the case in reality. We are drawn in to explore the hidden recesses of the space and dimly outlined figures, while at the same time the dancer's profile pose, parallel to the picture plane, affirms the distance between stage and audience. We are on the far side of the footlights, spectators rather than participants in the event unfolding before us. We can imagine the steps that have brought the dancer to her present position just right of centre, and the succeeding steps that will take her out of the picture space. Because of the implied dynamic in the way she struts, Sargent is able to convey the essence of a dance form that in reality depends for its effect on a continuous series of movements.

Fig. 149 *(top)*
Early photograph of *El Jaleo*. Isabella Stewart Gardner Museum files, Boston.

Fig. 150 *(above)*
Café Cantante, photograph by Emilio Beauchy, c. 1880. The Hispanic Society of America, New York.

incorrect. In Sargent's day, it was only male dancers who performed any loud, floor-beating footwork; women moved almost soundlessly, emphasizing the movement of the arms and upper body rather than the legs and feet (see Heller 2000, p. 18). Another common mistake made by contemporary reviewers and later critics was either to see castanets in the picture, where none exist, or to regret their absence. Castanets are used in Spanish classical dance and folk dance but rarely in true flamenco.

The setting of Sargent's picture is almost certainly intended for a *café cantante,* a kind of flamenco nightclub, with a raised stage at the one end of the room and a bar

El Jaleo was completed and exhibited more than two years after the visit to Spain which had inspired it. The picture is painted on a monumental scale and went through a long process of studio production. In spite of its highly sophisticated pictorial devices and complex composition, the painting retains the vivid feeling of an actual performance. The dynamism of the picture can be explained in part by the speed with which it was painted. When he came to put paint to canvas the artist seems to have known exactly what he wanted to do and the picture exhibits the freshness and bravura of an over-life-size sketch. Technical analysis of the picture (see Washington 1992, pp. 115–28) demonstrates that it was carried out at speed and with little reworking.[3]

The inspiration for *El Jaleo* goes back to the autumn of 1879. Two drawings on the back of a torn-in-two Madrid invoice depict a horizontal scene of flamenco, with a single dancer performing before a row of musicians (figs. 126, 127). In the more finished of the two sketches, the dancer is clearly male, as may be the dancer in the slighter sketch. The drawings could have been made in Seville or Granada, the home of gypsy flamenco, rather than in Madrid. What the drawings demonstrate is Sargent's first essay in a horizontal composition with the upright form of the dancer balanced by a long row of musicians, and dramatic effects of light and dark.

Sargent's two oil sketches of a Spanish gypsy dancer (nos. 767, 768) first establish the pose that Sargent would refine and evolve in *El Jaleo* by way of *Spanish Dancer* (no. 770). Common to all four works is the pose of the dancer, one arm extended and the other on the hip with hand out-turned, in the heavy white dress and the fluttering shawl. The model for the two Spanish gypsy dancers is a more earthy and recognizable gypsy type than the dancer in *El Jaleo*. The two oil sketches of her may have been painted in Spain as a record of a performance Sargent had actually watched, but they may also represent studio studies.

The pose of the gypsy dancer was elaborated in *Spanish Dancer* (no. 770), a full-length work recently rediscovered, which in view of its scale and formality may plausibly be considered as Sargent's first idea for a Salon painting. There was originally a row of musicians behind the dancer, but this was subsequently painted over. The effort and work that went into the creation of *Spanish Dancer* may explain why there are no studies of the whole figure for the dancer in *El Jaleo,* although there are studies for the head and arms (see listing of studies below). In *El Jaleo,* the face of the dancer is highlighted and not in *profil perdu*, as in *Spanish Dancer;* her right hand clutches the fabric instead of resting against it; her arms are more acutely angled and catch the brilliant light from below; the folds and shapes of the skirt are here transformed into structured cones of great elegance and plasticity.

The American artist Walter Gay, who knew Sargent well in Paris, says that the dancer for *El Jaleo* was modeled by Marie Renard (Walter Gay in conversation with Morris Carter, first director of the Isabella Stewart Gardner Museum, 13 May 1930, Carter notebook, museum records). Marie Renard was a professional model and she sat to several artists among the avant-garde, including Edgar Degas, Ernst-Ange Duez, Mary Cassatt and Berthe Morisot. She wrote of her experiences as a model in the magazine *Verve* (vol. 1, no. 4 [January–March 1939], p. 71), where she said that she had posed for seventy painters; however, she does not refer to Sargent or *El Jaleo*. In an earlier conversation with Carter (19 September 1929, Carter notebook), Allyn Cox told him that his father, the artist Kenyon Cox, another of Sargent's Paris friends, had modelled for the hands of a guitar player. In a later letter to David McKibbin (22 July 1958, McKibbin papers, catalogue raisonné archive), Allyn Cox wrote:

The hands in the picture are a perfect likeness of his oddly shaped hands. In the version I got, Sargent had the guitar players themselves to pose for the figures and heads, but could not afford to pay for any more sittings. My father did not know how to play any stringed instrument, but had watched the dancing over and over, and mimicked the gestures.

Another candidate for the figures of the guitarist is the artist Albert de Belleroche, a close friend of Sargent, who posed for a portrait in Spanish costume (fig. 137).

We do not know when Sargent began work on *El Jaleo* and little about the stages of its development. We can be fairly certain that it was not begun until after Sargent's return from Spain and Morocco, at the end of February 1880. It would have been unwieldy to move about, unless rolled up, and earlier subject works exhibited at the Salon had all been completed, if not begun, in his Paris studio. The picture cannot have been finished any later than April 1882, when Sargent submitted it to the Paris Salon. Between these two dates there is only one documentary reference to the work. In a letter to Vernon Lee dated 20 November (private collection), which must on internal evidence belong to 1881, Sargent wrote: 'I have done several portraits and the Spanish Dancers are getting along very well. I shall send you a photo of it and it will probably be engraved in an illustrated paper during the Salon time if it is exhibited.' Though he refers to 'Dancers' in the plural, his use of the word 'it' in the following sentence leaves little doubt that the work referred to is *El Jaleo*. Immediately on his return from Morocco, Sargent was occupied with the completion of *Fumée d'ambre gris* (no. 789) for the 1880 Salon. He must also have begun, if not finished, his full-length portraits of *The Pailleron Children* and *Madame Ramón Subercaseaux* (*Early Portraits,* nos. 37, 41) before August 1881, when he travelled to Holland with friends. From September 1880 to late February 1881, Sargent was resident in Venice. He spent part of June and July 1881 in England, and he was hard at work on the portrait of *Dr Pozzi* (*Early Portraits,* no. 40) in August of that year. He may have begun *El Jaleo* at some stage between March and August 1880, when he was probably also working on *Spanish Dancer* and *The Spanish Dance* (nos. 770, 763), but it is a fair assumption to make that his most concentrated period of work on the picture occurred between August 1881 and the spring of 1882. This was also the period when he was painting two other large works, his full-length portrait of *Louise Burckhardt* and his group picture of *The Daughters of Edward Darley Boit* (*Early Portraits,* nos. 55, 56). This was arguably the most creative six months of his entire career.

There are a considerable number of studies for the picture, but no compositional sketches and, as already noted, no figure studies for the dancer. Either they do not survive or the artist was sufficiently confident to work directly on the large canvas without their aid. There are two preliminary oil sketches in which Sargent explored figural poses and groupings for the seated guitarists, singer and hand-clapping accompanists to the left of the dancer, with three figures in each (see nos. 5 and 6 in the list of studies below). A drawing of the three figures to the right of the dancer is likely to be after the picture, in the opinion of the authors (list no. 22). There are two slight tonal sketches of seated musicians and another of the female figure on the far right (list nos. 1, 4, and 17), but the remaining studies are

exclusively of heads and arms. Some of them are very close to the visual solutions adopted in the finished painting and must have been done late in the process of the painting to assist the artist with specific details. These charcoal studies, expressive in form and chiaroscuro, replicate the lighting scheme of the painting. The faces pop off the page in vivid juxtapositions of raking light and deep shadow. Sargent had not previously produced drawings of such originality and force, and the picture clearly inspired a new vein of graphic experimentation. Fifteen of the drawings are mounted in an album, which the artist gave to Isabella Stewart Gardner in 1919.

STUDIES FOR AND AFTER THE PICTURE

The studies were individually catalogued by Mary Crawford Volk (Washington 1992, nos. 31–49, 50–53), together with six sketches of dancing figures, identified in the catalogue raisonné as studies for *Carmencita* (see *Portraits of the 1890s,* nos. 234–37). The drawings mounted in the album which the artist gave to Isabella Stewart Gardner (ISGM) in 1919 are mostly in charcoal on off-white wove paper, of similar overall size (approx. 9¼ x 12¹³⁄₁₆ in.), but irregular in shape and sometimes with torn edges.

1. *Seated Musician.* ISGM (fig. 151). Study for the figure second from left and similar in pose (Washington 1992, no. 32).
2. *Facial Studies for Seated Musicians.* ISGM (fig. 152). Three male heads, one relating to figure second from left (Washington 1992, no. 34).
3. *Head Studies for Seated Musicians.* ISGM (fig. 153). Relating to guitarists and man clapping his hands on the left (Washington 1992, no. 35).
4. *Seated Musicians.* ISGM (fig. 154). Relating to guitarist and singer fourth and fifth from left and similar in pose (Washington 1992, no. 31).
5. *Study for Seated Musicians.* Oil sketch. Fogg Art Museum (see no. 774 for separate entry and illustration). Man clapping hands on the left and two guitarists. Sargent omitted the red-lined cloak and separated the figures by including the empty chair (Washington 1992, no. 48).
6. *Study for Seated Figures.* Oil sketch. Fogg Art Museum (see no. 773 for separate entry and illustration). Female figure, man clapping hands on the left and the singer (Washington 1992, no. 47).
7. *Facial Studies for Seated Musicians.* ISGM (fig. 155). Variant poses for the head of

the singer and another for one of the guitarists (Washington 1992, no. 36).
8. *Head and Hand Studies for Seated Musicians.* ISGM (fig. 156). Two heads for the singer and hands of guitarists (Washington 1992, no. 33).
9. *Head Studies for Dancer.* ISGM (fig. 157) (Washington 1992, no. 37).
10. *Head and Hand Studies for Dancer.* ISGM (fig. 158). Head more acutely angled than in the picture (Washington 1992, no. 38).
11. *Hand and Arm Studies for Dancer.* ISGM (fig. 159). Twisting form of right arm, and out-turned right hand grasping the fabric of the skirt (Washington 1992, no. 39).
12. *Studies for Dancer's Hand, Head of Seated Woman.* ISGM (fig. 160). Study of right arm grasping the fabric of the skirt, and head of the woman far right (Washington 1992, no. 40).
13. *Study for Dancer's Drapery.* ISGM (fig. 161). Waist and upper part of the skirt (Washington 1992, no. 45).
14. *Study of Seated Woman's Head.* ISGM (fig. 162). Woman far right, here looking directly out rather than to her right, as in the picture (Washington 1992, no. 41).
15. *Head Studies for Seated Woman.* ISGM (fig. 163). Woman far right; study on the left similar to pose in the picture (Washington 1992, no. 42).
16. *Arm Studies for Seated Woman.* ISGM (fig. 164). Variant studies of raised right arm of the woman far right; below is an extended left arm, possibly that of the same figure, and, if so, cropped in the picture; head and shoulders and right arm of the woman second from right (Washington 1992, no. 43).
17. *Study of Seated Woman.* ISGM (fig. 165). Woman far right, lacks shawl; her eyes look down rather than up (Washington 1992, no. 44).
18. *Sketch after 'El Jaleo',* 1882. Private collection (fig. 167). Drawn by Sargent for a woodcut illustration in *Catalogue Illustré du Salon,* ed. F.-G. Dumas, Paris, 1882, p. 54 (Washington 1992, no. 51). Sargent had done similar drawings after earlier pictures for purposes of reproduction. Sargent's drawing was sold by Baron Bonde at Christie's, London, in 1926, and may have belonged before that to his relative Clementina Anstruther-Thomson, for whom see *Early Portraits,* nos. 216–17. It then passed into collection of the artist's great friend Sir Philip Sassoon (see *Later Portraits,* no. 604). Other early reproductions of *El Jaleo* are as follows:
 a. Heliograph by Dujardin, *Gazette des Beaux-Arts,* 2nd series, vol. 25, no. 6

(1882), p. 551, 'd'après une sépia de J. S. Sargent'.
 b. Etching by E. Bocourt, in *L'Art,* vol. 30, no. 3 (1882), facing p. 138.
 c. Louis Énault, *Paris-Salon 1882,* vol. 2, Paris, 1882.
 d. *La Vie Moderne,* 17 June 1882, pp. 376–77, 'dessin original de John S. Sargent, d'après son tableau'.
 e. Woodcut, *Le Monde Illustré,* vol. 50, no. 313 (27 May 1882), p. 330.
 f. *Daily Graphic,* 14 November 1882, p. 100.
 g. Lithograph copyrighted by James R. Osgood & Co., Boston, 1882.
 h. Heliotype by the Heliotype Printing Company, New York, announced in *Boston Evening Transcript,* 27 November 1882.
 i. Woodcut, *Magazine of Art,* vol. 6 (1883), p. 5.
19. *Sketch after 'El Jaleo',* 1882. Private collection (fig. 168). Similar to no. 18, and probably done with reproduction in mind (Washington 1992, no. 52).
20. *Sketch of Dancer, after 'El Jaleo',* 1882. Private collection (fig. 170). Possibly done for the press or presentation (Washington 1992, no. 53).
21. *Sketch of Dancer, after 'El Jaleo',* 1882. The Metropolitan Museum of Art (fig. 169). Name of Sargent's father and address in Nice, 4 rue Longchamp, inscribed on reverse (Washington 1992, no. 46).
22. *Sketch of Seated Dancers, from 'El Jaleo',* 1882. Private collection (fig. 166). Probably a drawing after the picture rather than a preliminary study. It may have been made with the idea of reproduction or presentation. Spanish word *olé* twice written above figures (Washington 1992, no. 49).

Fig. 151 *(opposite left top)*
Seated Musician, c. 1880–81. Charcoal on paper, 9¼ x 12⅝ in. (23.5 x 32.1 cm). Figs. 151–65 are from the same Sargent sketchbook. Isabella Stewart Gardner Museum, Boston.

Fig. 152 *(opposite left middle)*
Facial Studies for Seated Musicians, c. 1880–81. Charcoal on paper, 9⅜ x 12⅞ in. (23.9 x 32.7 cm). Isabella Stewart Gardner Museum, Boston.

Fig. 153 *(opposite left bottom)*
Head Studies for Seated Musicians, c. 1880–81. Charcoal on paper, 9⁵⁄₁₆ x 13⁷⁄₁₆ in. (23.7 x 33.5 cm). Isabella Stewart Gardner Museum, Boston.

Fig. 154 (right top)
Seated Musicians, c. 1880–81. Charcoal on paper, 9¼ x 12¹³⁄₁₆ in. (23.5 x 32.5 cm). Isabella Stewart Gardner Museum, Boston.

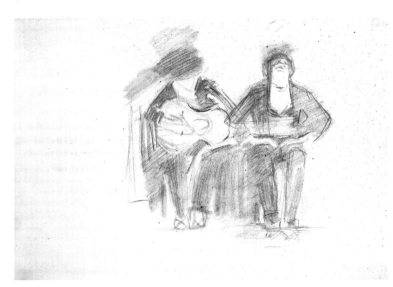

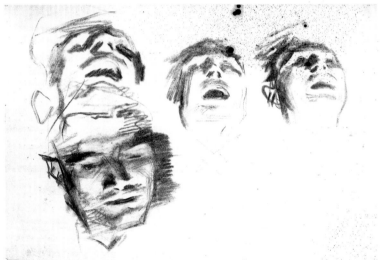

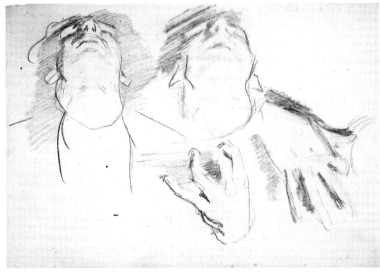

Fig. 155 (right middle)
Facial Studies for Seated Musicians, c. 1880–81. Charcoal on paper, 9⁵⁄₁₆ x 13 in. (23.7 x 33 cm). Isabella Stewart Gardner Museum, Boston.

Fig. 156 (right bottom)
Head and Hand Studies for Seated Musicians, c. 1880–81. Charcoal on paper, 9¼ x 12¹³⁄₁₆ in. (34 x 23.5 cm). Isabella Stewart Gardner Museum, Boston.

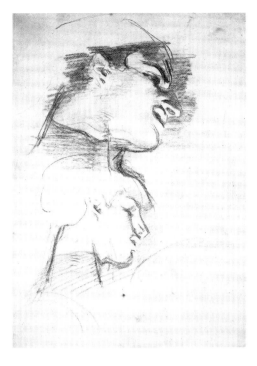
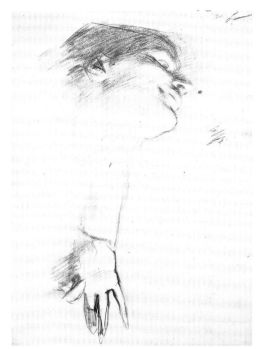

Fig. 157 (far left)
Head Studies for Dancer, c. 1880–81.
Charcoal on paper, 13⅜ x 9¼ in.
(34 x 23.5 cm). Isabella Stewart
Gardner Museum, Boston.

Fig. 158 (left)
Head and Hand Studies for Dancer,
c. 1880–81. Charcoal on paper,
13⁷⁄₁₆ x 9⅜ in. (34 x 23.9 cm). Isabella
Stewart Gardner Museum, Boston.

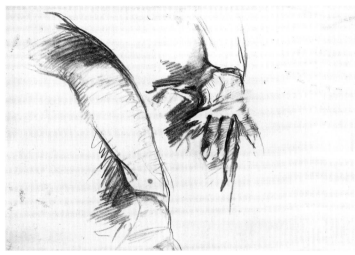
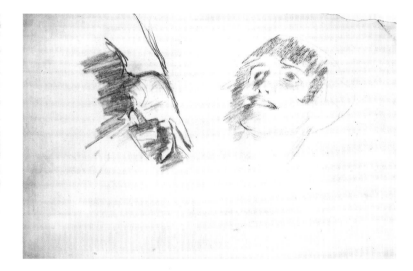

Fig. 159 (above left)
Hand and Arm Studies for Dancer,
c. 1880–81. Charcoal on paper,
9½ x 13⁷⁄₁₆ in. (24.1 x 34.2 cm). Isabella
Stewart Gardner Museum, Boston.

Fig. 160 (above right)
*Studies for Dancer's Hand, Head of Seated
Woman,* c. 1880–81. Charcoal on paper,
9¼ x 13¹³⁄₁₆ in. (23.5 x 33.5 cm). Isabella
Stewart Gardner Museum, Boston.

Fig. 161 (right)
Study for Dancer's Drapery, c. 1880–81.
Charcoal on paper, 13⁹⁄₁₆ x 9¼ in.
(34.5 x 23.5 cm). Isabella Stewart
Gardner Museum, Boston.

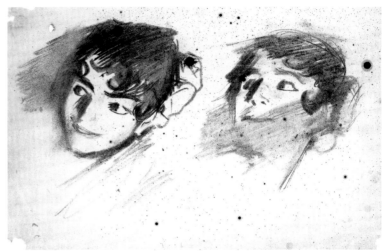

Fig. 162 (left)
Study of Seated Woman's Head, c. 1880–81. Charcoal on paper, 9¼ x 13⅝ in. (23.5 x 34.6 cm). Isabella Stewart Gardner Museum, Boston.

Fig. 163 (below)
Head Studies for Seated Woman, c. 1880–81. Charcoal on paper, 9¼ x 13⅝ in. (23.5 x 34.6 cm). Isabella Stewart Gardner Museum, Boston.

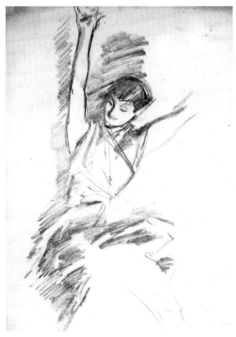

Fig. 164 (above left)
Arm Studies for Seated Woman, c. 1880–81. Charcoal on paper, 13⅝ x 9⁵⁄₁₆ in. (34.6 x 23.7 cm). Isabella Stewart Gardner Museum, Boston.

Fig. 165 (above)
Study of Seated Woman, c. 1880–81. Charcoal on paper, 13⅝ x 9¼ in. (34.6 x 23.5 cm). Isabella Stewart Gardner Museum, Boston.

Fig. 166 (left)
Sketch of Seated Dancers, from 'El Jaleo', c. 1882. Pencil on paper, 9⅜ x 6⅝ in. (23.8 x 16.9 cm). Inscribed, upper right (twice): *ole;* and, bottom right: *John S. Sargent*. Private collection.

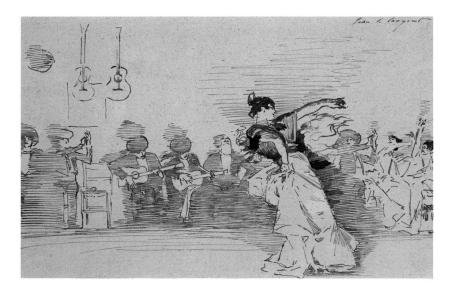

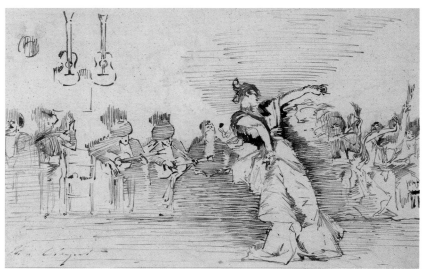

Fig. 167 *(left)*
Sketch after 'El Jaleo', 1882.
Pen and ink on paper, 9 x 13 in.
(23 x 33 cm). Private collection.

Fig. 168 *(below)*
Sketch after 'El Jaleo', 1882.
Pen and ink on paper,
8½ x 12⅞ in. (21.6 x 32.7 cm).
Private collection.

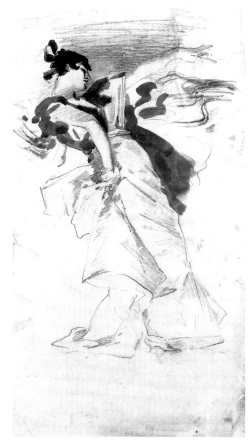

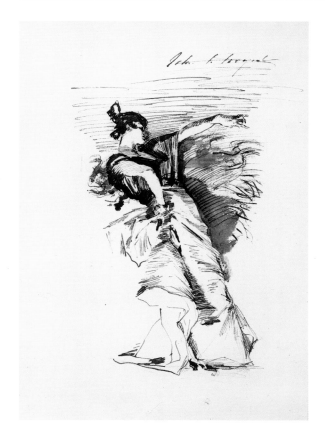

Fig. 169 *(above)*
Sketch of Dancer, after 'El Jaleo',
c. 1882. Pencil and water-
colour on paper, 10⅛ x 5½ in.
(25.8 x 14 cm). The Metro-
politan Museum of Art, New
York. Gift of Mrs Francis
Ormond, 1950 (50.130.139).

Fig. 170 *(right)*
Sketch of Dancer, after 'El Jaleo',
c. 1882. Pen and ink on paper,
12⅝ x 9½ in. (32.2 x 24.2 cm).
Private collection.

El Jaleo created a sensation at the Salon of 1882. Along with an even more controversial picture by Édouard Manet, *Bar of the Folies-Bergère* (Courtauld Institute, London), it dominated the Salon. The huge scale of the picture, the novelty of its subject matter, its theatrical presentation and the virtuosity of its execution took the public by storm. The very qualities which earned it such sensational publicity were also those which laid it open to attack. The plethora of adjectives applied to it in contemporary reviews indicate the variety of responses it aroused: 'audacious', 'fantastic', 'fearless', 'stunning', 'original', 'morbid', 'individual', 'strange', 'disconcerting', 'bizarre', 'vivid', 'realistic', 'spectral', 'strangely picturesque', 'preposterously clever', 'fascinating', 'reckless', 'slapdash', 'ostentatious'. The picture was the subject of two caricatures in the popular press (figs. 171, 172).

The majority of French art critics agreed that Sargent had pulled off a tour de force, in spite of weaknesses in drawing and design and above all in the sketchy, unfinished look of the picture. Olivier Merson in *Le Monde Illustré* (vol. 50 [27 May 1882], p. 330) declared:

One would, at least, like certain passages to be more fully realized, such as the principal figure, where the general line and the structure seem unresolved and difficult to read, even for those who are sympathetic to the artist's intention.

We agree, then, that this huge picture is only a sketch. But having said that, what a bold and living creation! What life! What fine skill behind the impression! And the beauty of the paint, the beauty of the colour! Carramba! [it's incredible!] You believe you are really there. They take you back to Granada or Jaen, this tall woman whirling in the foreground, the Andalusians strumming away at their guitars in a row at the back, against the bare grey walls, and the gypsies quivering with pleasure on chairs to the right, don't tell me that they come from the Opéra-Comique and that they would be making sad faces at the start of some sentimental song.[4]

Merson's views were echoed in the *Gazette des Beaux-Arts* (2nd series, vol. 25, no. 6 [June 1882], p. 550), by Antonin Proust, a former arts minister and a discerning critic of contemporary art:

The pose of the dancer, rendered in blurred lines, is thrilling in its effect; and, while the background figures are not drawn as precisely as one would like, the eye is so caught by the principal figure that one is ready to forgive Mr. Sargent for not reproducing on the canvas the full force of the taut studies, which he clearly made from life, of each of the minor figures in the highly charged scene that he depicts.[5]

Henry Houssaye, influential critic for the *Revue des Deux Mondes,* drew out the comparison with Goya, a constant refrain in reviews of *El Jaleo* (vol. 51, no. 3 [1 June 1882], p. 583):

Mr Sargent's Spanish Dancer is the most original work in the Salon—for those who are not familiar with Goya. The inspiration of the master of the Manolas and Los Caprichos is betrayed here. It is the extraordinary energy of the composition and its fantastic chiaroscuro that irradiate the scene with light and envelop it with darkness.[6]

The Goya comparison was disputed by Paul Leroi in *L'Art* (vol. 30, no. 3 [1882], p. 138), who regarded Sargent as far superior to the Spanish artist, both as a designer and colourist, 'more audacious, more complete, more powerful'. Contrasting Manet's *Bar of the Folies-Bergère* with *El Jaleo,* he wrote that nothing less resembled a work of art than the first and nothing more than the second: 'The whole secret depends on the prestige of the execution'. To those who complained that the dancer could not hold her vertiginous pose without falling over, he explained that her extended arm acted as a counterweight, and that with a flick of her heels she will 'rebound more alive, more supple, more agile than ever, at the far end of the room'. In comparison with real flamenco, which left him cold, Leroi found *El Jaleo* intoxicating: 'the intensity of life is such that it does not even leave us time to question what is excessive about such a subject being represented on such a huge canvas, where everything is in movement, agitation, turmoil, in pursuit of an aesthetic that seems to seize you, and to sweep you up into a dance that has neither truce nor respite'.[7]

Fig. 171
Caricature of *El Jaleo,* from 'Le Salon pour Rire, Par Draner. Troisième Promenade', *Le Charivari,* 18 May 1882, p. 3.

El Jaléo, danse espagnole
Traduction libre : la pochardska. Les musiciens eux-mêmes en sont scandalisés.

Fig. 172
Caricature of *El Jaleo,* from 'Le Salon de 1882—par STOP', *Le Journal Amusant,* no. 1342 (20 May 1882), p. 4.

The enthusiastic Leroi represented the middle ground of French art criticism. Avant-garde critics were less impressed. J.-K. Huysmans, author of the celebrated aesthetic novel *À Rebours,* dismissed Sargent's picture out of hand (*L'Art Moderne,* Paris, 1883, p. 272): 'The woman's flesh is painted any old how and the stuffs resemble those that Carolus Duran fabricates if I am not mistaken'.[8] Auguste Baluffe, another sceptical critic, wrote in the *Bulletin Hebdomadaire de l'Artiste* (30 April–7 May 1882, p. 67) that, while supporters of the Salon applauded the picture and Impressionist fans did not, the public gave no impression of understanding it: 'The public can be forgiven for not going wild with excitement when it doesn't know why it should do so. People have not been initiated into the mysteries of this new art, which dictates that, in the manner of Chinese shadow-play pantomimes which, until now, belonged more to the world of the phantasmagorical, pure and simple, than to true painting, pictures immediately enter the order of sublime creations'.[9]

English critics were generally warm in their praise of the painting, which is surprising in view of the hostility Sargent later faced when he began exhibiting in London. The critic of the *Art Journal* (1882, p. 218) wrote that Sargent 'now finds himself the most talked-about painter in Paris, with every opportunity to have his head turned by the admiration he has received'. This was echoed in the columns of the *Builder* (vol. 42, no. 2050 [20 May 1882], p. 605), which claimed to have been among the first to spot the talents of the young American painter. In their words, his painting was 'commanding an amount of attention that is most worthily deserved . . . [it] seems to have placed Sargent not only just now at the head of the American school, but to have placed him on equal ground with the most prominent French painters'. These views were repeated in the *Academy,* the *Athenaeum,* the *Fortnightly Review,* the *Magazine of Art* (where the picture was reproduced), the *Portfolio* and other English journals.

American critics were divided. 'But Sargent gave us something quite novel in conception', wrote one, 'and so artistic, so strong, so individual in execution that his name rose on every lip' (unidentified press cutting, Burckhardt scrapbook, McKibbin papers, p. 14). This was contradicted by the reviewer of the *Art Amateur* (vol. 7 [August 1882], p. 46):

Sargent disdains finish for ostentatious cleverness, and the result is a rough splash of hideous forms, of faces more like Japanese masks than Spanish countenances, with the light thrown up from invisible footlights upon the ugliest angles of a very ugly central figure. In this work, everything gives way to the dominant idea; form is so much sacrificed to the play of artificial light that the dancer might be hewn wood and moved by wires, and the musicians might be grotesquely daubed jointed dolls.

Here was the conservative voice criticizing the picture for its 'brilliant contempt for Academic rules'. Similar views were aired when the picture was exhibited in London in July 1882 and then in New York and Boston in October. In London, the *Magazine of Art* (vol. 6 [1883], pp. 6–7), which had praised the picture at the Salon, now called it 'an astonishing piece of clever, slap-dash, reckless clap-trap, and is no more like a work of art than a second-rate "bravura" song is like music'. In New York, the reviewer for *The Critic* (vol. 2 [21 October 1882], p. 286) complained about the sensational aspects of *El Jaleo*:

If Mr. Sargent has joined the ranks of the French impressionists, it is their gain and his loss . . . He is too good a painter, too much of a gentleman and a scholar, to be found is such company . . . His work has been quiet, simple, unostentatious—all the more expressive of the kind of life which he understands and with which he sympathizes. This 'El Jaleo', on the other hand, is loud, almost coarse; slipshod in execution; fearfully and wilfully wrong in drawing; weak in composition . . . Yet it has also some great merits,—those that the painter could not divest himself of if he would. It is original. It is beautiful and approximately true to the effect intended in tone, in color, and in light. This is a great deal.

The line taken by the *Boston Evening Transcript* (3 November 1882, p. 4) was a little different. While hoping that the artist would select a more elevated theme for his next painting, the reviewer recognized that 'Mr. Sargent is eminently "of his time", and his time is the time of Zola in art. The question is not nowadays so much the matter upon which you employ your art as with how much force and truth you can present it. The lower the subject, therefore, the greater the feat if you can raise it to the level of high art'. The longest and most sustained critique of the picture appeared in the *New York Times* (13 October 1882, p. 5), when the picture was on show at the Schaus Gallery in New York. After weighing up the virtues and faults of the painting, the critic came down firmly on Sargent's side, believing that as a tour de force the picture had more to do with art than technique, and that it deserved the praises heaped upon it by the French press.

LATER HISTORY OF THE PICTURE

The picture was purchased at the Paris Salon by the distinguished Boston merchant, financier and diplomat Thomas Jefferson Coolidge (1831–1920), who preferred to be known as T. Jefferson Coolidge, the great-grandson of the famous American president Thomas Jefferson. Mary Crawford Volk conjectures that Coolidge was attracted to *El Jaleo* because of its sweeping success at the Salon (Washington 1992, p. 69). During his visit to Paris in the spring of 1882, Coolidge bought other pictures by older and more established artists, including Jean-Léon Gérôme, Jean-Jacques Henner, Adolph Schreyer and Constant Troyon. The purchase price of *El Jaleo* was 10,000 francs, and Sargent signed a receipt for this amount on 11 May 1882 (ISGM records), and agreed to release the picture to William Schaus, proprietor of the Schaus Gallery, New York, who acted for Coolidge; Schaus's invoice to Coolidge for *El Jaleo* and a picture by Gérôme amounted to 52,500 francs. In a letter of 1 June 1882 to Coolidge, Schaus promised to ship these two pictures, and three others, in the near future. In fact, *El Jaleo* was temporarily diverted to London, where it appeared in an exhibition of recent Salon paintings by British and American artists at the Fine Art Society in July 1882, probably at the artist's request. From there it travelled to New York, appearing first in early October at the Schaus Gallery and later in the month at the Williams and Everett Gallery in Boston.

The picture hung in the residence of T. Jefferson Coolidge in Beacon Street, Boston, and the new owner resisted all requests to lend the picture outside Boston. It appeared in Sargent's first one-man show at the St Botolph Club, Boston, in January 1888, and Coolidge lent it to the Museum of Fine Arts, Boston, for four years in 1897–1902. This last loan was prompted by Coolidge's decision to sell his Beacon Street home and his subsequent move to Dartmouth Street, where the picture duly followed him. The picture was photographed for the first time in 1898, while still at the museum, and Coolidge made arrangements to hold the copyright (see Washington 1992, pp. 71, 105, n. 169). A second photograph, taken by the pioneering Boston photographer Baldwin Coolidge

in December 1901, is the earliest to survive.

The death of his only son in 1912 led Coolidge to review the future of his estate. He made a number of gifts to local institutions and once again lent the picture to the Museum of Fine Arts, Boston. He was close to his kinswoman by marriage, Isabella Stewart Gardner, who had created a palace of art in her home at Fenway Court, Boston, now the museum bearing her name. She made her admiration for the picture clear to Coolidge, and in 1914 she created a Spanish Cloister specifically to house it, as part of the remodelling of Fenway Court. The idea that *El Jaleo* would occupy a site specially designed for it, with original Spanish features, and that the picture would remain in the family must have appealed to Coolidge, who had yet to agree to the gift. Mrs Gardner's chief rival for the picture, the Museum of Fine Arts, was unable to match her offer, and she carried the day.[10]

The Spanish Cloister was one of the new spaces in Fenway Court, built on the site of the demolished Music Room. Above it was the Tapestry Room on the first floor, which was the main objective behind the remodelling scheme. Like Sargent, Mrs Gardner was an ardent Hispanist, traveling to Spain in 1888 and again in 1906, when she brought back several large artifacts, including a tomb and a Hispano-Moresque window. She subsequently purchased a set of Spanish tiles (*azulejos*) and incorporated all these features in the Spanish Cloister. Plans for the cloister were finalized before December 1913 and construction took place during 1914.

The Spanish Cloister is on the same axis as the front entrance to Fenway Court, and the picture, therefore, occupied a place of honour at the start of every visitor's tour. The cloister is reached by a flight of three steps down from ground floor level, and the picture is seen dramatically at the end of the space. It is framed by an archway, with delicate scalloped tracery, which rests on the backs of animals. A special lighting scheme was devised for the picture, consisting of ten electric 'footlights' directed upwards from floor level, which reinforced the artificial lighting scheme within the picture itself.[11] The splayed bottom section of the original frame also emphasized the idea of a staged performance. The frame was modified around 1915–16, when wooden strips were added to the inner edge of the sides and top, and shorter strips were inserted as spacers at each corner; these were removed in 1991 (see Washington 1992, pp. 79–81). The frame was supported close to floor level on specially constructed blocks, and it leans outwards supported by chains.

The artist expressed delight with the new installation for the picture. He is said to have told Mrs Gardner that she had done 'more for it than he had' (record of a conversation between Mrs Gardner and Morris Carter, Carter notebook, ISGM records, p. 37). In an undated letter to Mrs Gardner (ISGM archive), he wrote:

I cannot help thinking that if you had seen the Spanish Dancers in New York, and the brilliancy of their clothes, and the quality of their performance, you would have grave doubts about allowing my gloomy old picture to show its nose. It might be like the mummy at the feast unless I give her 'a new gauze gown all spangles' and pull the sword out of her heart.

In other words something tells me there would not seem, or might not seem, to be the remotest air de famille between the picture and the reality, and that you might be disappointed if the result was a family feud between the old and the new generation.

The courtyard with its flowers, if you could erect a stage over the mosaic, would, I believe, be the right setting for these particular dancers who are all sparkle and gaiety, and brilliant colour.

1. This entry is indebted to the extensively researched monograph *John Singer Sargent's 'El Jaleo'* by Mary Crawford Volk, published as the catalogue for the exhibition at the National Gallery of Art, Washington, D.C., in 1992 (Washington 1992). The authors have also gained insight from Nancy G. Heller's article 'What's There, What's Not: A Performer's View of Sargent's *El Jaleo*', published in *American Art*, Smithsonian American Art Museum, Washington, D.C., vol. 14, no. 1 (Spring 2000) (Heller 2000).

2. The guitar expert Gregory d'Alessio has criticized Sargent for showing the two guitarists hunched over their instruments instead of sitting straight up, for the angle at which they hold the guitars and the position of their hands, and for the anaemic proportions of the instruments (Gregory d'Alessio, 'On Sargent's "El Jaleo": It may be art but is it flamenco?' *Guitar Review*, no. 41 [Winter 1976], pp. 24–25). Other guitar experts disagree and argue that guitar playing was a matter of individual preference and not one of prescribed rules (see Heller 2000, p. 19).

3. Radiographs reveal surprisingly few *pentimenti*. There are some changes to the figure of the woman second from the right (her right arm, the reflections on her dress and possibly her position), the head of the singer (the angle of the face), and the dancer (the profile and shape of the skirt, the position of the train, the head and right arm). There were no significant alterations to the compositional structure of the picture, and the rapid execution indicates the artist's self-confidence once he had the idea of the subject in his mind; everything depended on the preparation. Even the dancer's skirt, the most elaborate feature of the work, is painted with large, loaded brushes and probably the use of the palette knife. An analysis of the pigments is given in Washington 1992, pp. 124–25; they include lead white and zinc white, ocher, sienna and umber, red lead, chromium orange and vermilion, cobalt yellow and cadmium yellow, verdigris, malachite and chrome green, smalt, prussian blue and verditer, and cobalt violet.

4. 'Du moins, on aimerait une réalisation plus poursuivie de certains passages, de la figure principale, entre autres, dont le mouvement général et la construction restent indécis et inexpliqués même aux regards les plus sympathetiques./Donc, la chose est convenue, cette vaste peinture est une esquisse seulement. Mais, cela dit, quelle fantaisie vaillante et vivante! quelle animation! quelle entente fidèle de l'effet! Et la belle pâte, la belle couleur! Carramba! on croit y être. C'est à donner la nostalgie de Grenade ou de Jaen, car cette grande fille tourbillonnant au premier plan, ces Andalous râclant le jambon assis au fond, en ligne, contre la muraille grise et nue, et les gitanes qui frétillent de plaisir sur leurs chaises, à droite, ne sorient [*sic*] pas, je vous jure, de l'Opéra-Comique et feraient triste mine en tête d'une romance'.

5. 'Le mouvement de la danseuse rendu par l'indécis des contours est d'un effet saisissant; et si l'on ne rencontre pas dans les personages du second plan la correction de dessin que l'on y pourrait désirer, l'oeil est tellement attiré par la figure principale que l'on est prêt à pardoner à M. Sargent de n'avoir pas reproduit sur la toile l'accent des études très serrées qu'il a évidemment faites d'après nature pour chacun des comparses de la scène très vivante qu'il a reproduite'.

6. '*La Danseuse espagnole,* de M. Sargent, est l'oeuvre la plus originale du Salon—pour ceux qui ne connaissent pas Goya. L'inspiration du maître des *Manolas* et des *Caprices* se trahit ici. C'est son prestigieux mouvement et son clair-obscur fantastique qui rayonne et enténèbre'.

7. 'Ce qui vous enivre, c'est la peinture de M. John Sargent; l'intensité de vie y est telle qu'elle ne vous laisse pas même le temps de vous apercevoir de ce qu'a d'excessif, pour un tel sujet, cette vaste toile, où tout s'y meut, s'agite, tourbillonne, à la suite d'un pinceau qui semble vous saisir et vous entraîne dans une ronde sans trêve ni répit'.

8. 'Les channures de la femme sont peintes par n'importe qui et les étoffes ressemblent, à s'y éprendre, à celles que M. Carolus Duran fabrique'.

9. 'Les salonniers exultent; les adeptes de l'impressionnisme ne se possédent pas d'enthousiasme. Des flots de prose dithyrambique font craindre un nouveau déluge. Mais il faut bien l'avouer, le public demeure assez froid devant ce paroxysme d'engouement. Il n'a pas l'air de cromprendre [*sic*]. On a oublié d'éclairer la lanterne magique. Le public est bien excusable de ne pas s'enflammer sans savoir pourquoi. Or, on ne l'a pas suffisamment initié aux mystères de cet art nouveau en vertu duquel des manières d'ombres chinoises, qui appartenaient jusqu'ici bien plus à la pure et simple fantasmagorie qu'a la véritable peinture, passent d'emblée à l'état de créations sublimes'.

10. See Morris Carter, *Did You Know Mrs. Gardner?: Morris Carter's Answer* (Boston, 1964), p. 53, for a colourful account of how Mrs Gardner extracted the picture from her kinsman.

11. For the involvement of the artist, Mrs Gardner and the architect and stage designer Joseph Urban in the design of the lighting scheme, see Douglass Shand-Tucci, *The Art of Scandal: The Life and Times of Isabella Stewart Gardner* (New York, 1997), pp. 258–61.

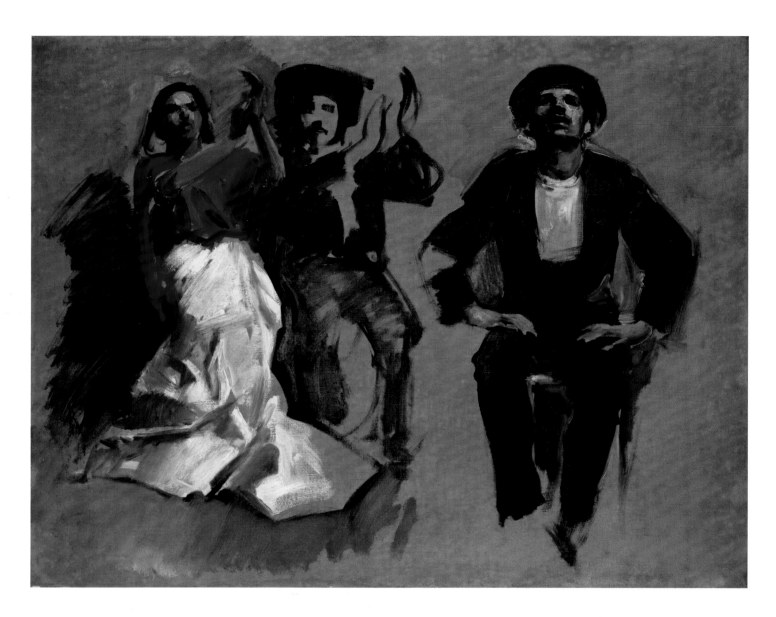

773
Study for Seated Figures, 'El Jaleo'

c. 1880–82
Alternative titles: *Three Spanish Figures,
El Jaleo; Sketch for El Jaleo; Study for El Jaleo*
Oil on canvas
25½ x 31⅜ in. (64.8 x 79.7 cm)
Fogg Art Museum, Harvard University
Art Museums, Cambridge, Massachusetts.
Bequest of Grenville L. Winthrop
(1943.152)

This work, together with no. 774, are the
only known oil studies for *El Jaleo* (no. 772).
They show groups of figures for the line of
musicians and performers in the back-
ground and were part of the process of
working through ideas for the composi-
tion, lighting and colour scheme. The fig-
ure on the right in *Study for Seated Figures*
is a study for the male singer to the left of
the dancer in the big picture, who, with
head bent back, gives voice to the *cante jondo*

(deep flamenco singing). Sargent intensified
the pose in the finished work, throwing the
head further back and tightening the neck
muscles to give the expression an almost
tortured look. The female figure on the left
of the study may be an early idea for one of
the two female performers on the far right
of *El Jaleo*, but if so the pose went through
a radical transformation between study and
painting. Her companion relates to the two
men clapping, one on the far left of the final
picture, the other to the right of the dancer.

A label on the back of a photograph
provided by Scott & Fowles, New York,
when they sold the picture to Grenville L.
Winthrop in 1932, reads: 'This study was
presented by the Painter to his friend
Renaudot, the Paris Sculptor, and was
recently disposed of in London by Renau-
dot's widow 1927'; a similar comment is
made on the receipt for the picture (both
photograph and receipt, Fogg Art Museum
records). If the information is correct, then
the sculptor concerned is likely to have

been Jules F. G. Renaudot (1836–1901), but
nothing else is known of his relationship
with Sargent. This picture and no. 774 were
sent for auction at Christie's, London, in
June 1927 by M. Knoedler & Co., London,
probably acting as agent for Renaudot's
widow. They were part of a consignment of
eighteen pictures from Knoedler, which
were auctioned at four separate Christie's
sales, May–July 1927 (information from
Christie's daybook, no. 454 EL). No details
of the other pictures are available in the
daybook, and they were probably by a var-
iety of artists. *Study for Seated Figures* was
bought at the 1927 sale by the London
dealer, D. Croal Thomson of Barbizon
House. *Study for Seated Musicians* (no. 774)
was bought in at the 1927 sale, auctioned
again in 1929 and bought in for a second
time, and finally sold in 1931 to Gooden &
Fox, London. How the two pictures came
together again with Scott & Fowles in
New York is not known.

774
Study for Seated Musicians, 'El Jaleo'

c. 1880–82
Alternative titles: *The Musicians, El Jaleo;*
Study for El Jaleo; Sketch for El Jaleo
Oil on canvas
23¾ x 31¼ in. (60.3 x 79.4 cm)
Fogg Art Museum, Harvard University
Art Museums, Cambridge, Massachusetts.
Bequest of Grenville L. Winthrop
(1943.153)

This picture, together with no. 773, are the only known oil studies for *El Jaleo* (no. 772). The three figures in this study were all included in the finished work: the man clapping his hands second from left in the big picture and the two guitarists hunched over their instruments, but not the empty chair, which separates them in the final version. Omitted in *El Jaleo* are the cloak with its vivid red lining worn by the guitarist in the centre of the oil study and the similarly bright red of the cummerbund belonging to the man clapping; Sargent must have found such accents of colour too strong when he came to the final version. The hands of the guitarists are positioned differently in the oil study and the second guitarist is shown without a hat. In other respects, the poses of the figures are quite similar in both the study and the large picture. For details of the provenance, see no. 773.

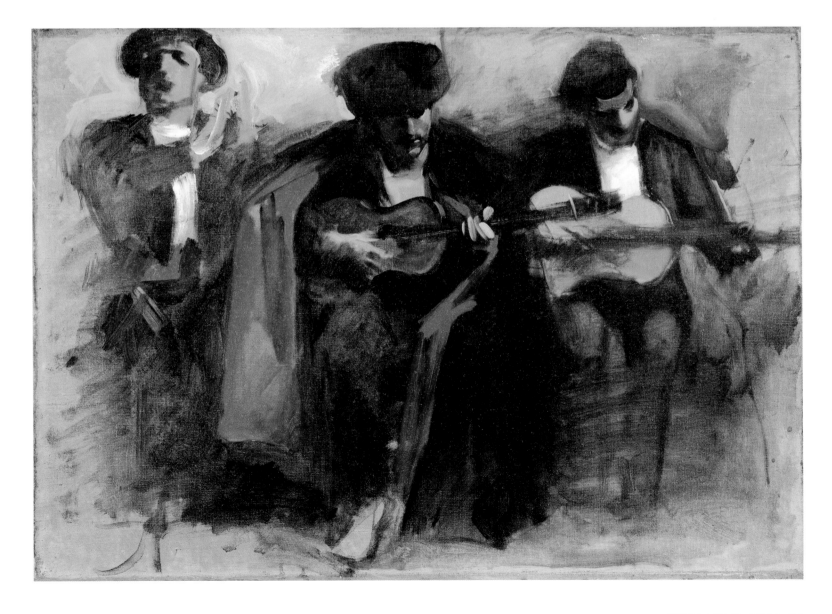

775
Man and Woman on a Bed

c. 1880–82
Oil on canvas
10¾ x 8¼ in. (27.5 x 20.7 cm)
Inscribed, bottom right: *John S. Sargent*
Private collection

This grisaille oil sketch looks like the source
for an illustration. A Spanish-looking woman
with a decorative comb in her hair, a carna-
tion between her teeth and a dark shawl
crossed over her breast, sits on the edge of a
bed rolling her eyes towards a man lying
beside her. With one hand propping up his
head, he gazes at her lustfully, while, with
the other hand, he seizes her right arm in a
deliberate physical pass. The woman inef-
fectually attempts to remove the offending
hand, while expressing mock horror at this
insult; the intertwined arms and hands of
the couple express an erotic *pas de deux*.

That the picture was more than just a
studio *jeu d'esprit* is suggested by the exis-
tence of no less than three related studies
(figs. 173–75). In the first of these the woman
is shown in a conventional evening gown
with an expression of deep emotion bor-
dering on ecstasy, and she makes no move
to remove the man's hand. The other two
studies, one in pencil, the other in pen and
ink, include a Spanish style hat and embroi-
dered waistcoat, and repeat the rolling
eyes, the flower clenched in the teeth and
the woman's resisting arm. The presence of
Spanish accessories associates the picture with
El Jaleo (no. 772), and a date of c. 1880–82
is proposed here. It is easy to imagine Sar-
gent's models taking time off from model-
ling to play about the studio; for other
studio sketches with Spanish accessories,
see figs. 135, 136.

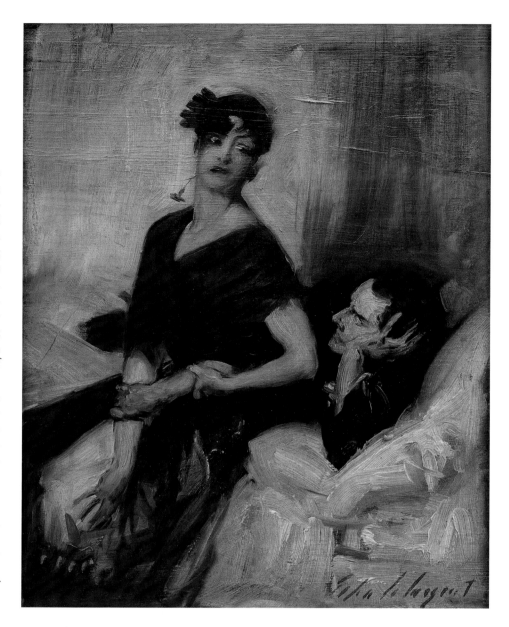

Fig. 173 *(below left)*
Study for 'Man and Woman on a Bed', c. 1880–82.
Pencil on paper, 7¼ x 9¾ in. (18.5 x 24.8 cm).
Fogg Art Museum, Harvard University Art
Museums, Cambridge, Massachusetts. Gift of Mrs
Francis Ormond, 1937 (1937.7.27, f. 3 recto).

Fig. 174 *(below right)*
Study for 'Man and Woman on a Bed',
c. 1880–82. Pencil on paper, 9¾ x 13½ in.
(24.6 x 34.4 cm) (irregular). Private collection.

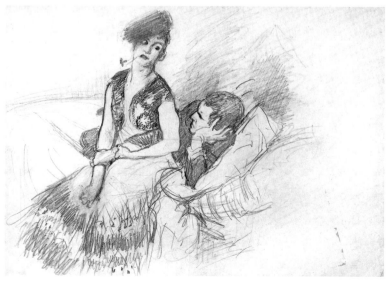

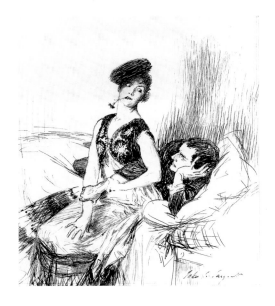

Fig. 175 (below)
Study for 'Man and Woman on a Bed', c. 1880–82.
Pen and ink on paper, 10⅜ x 8¹⁵⁄₁₆ in. (26.4 x 22.8 cm).
Fogg Art Museum, Harvard University Art Museums,
Cambridge, Massachusetts. Gift of Mrs Francis
Ormond, 1937 (1937.8.7).

776
Sketch of a Young Woman with Playing Cards

c. 1879(?)
Alternative title: *Fate*
Oil (support and dimensions unknown)
Inscribed, upper right: *J.S.S.*
Untraced

This illustration to Alma Strettell's *Spanish & Italian Folk-Songs* (London, 1887, ill. facing p. 35) appeared opposite one of the 'Soleares', a type of Spanish gypsy song:

> *May he who gave thee counsel*
> *To love not such as I,*
> *With blows and stabs be shriven,*
> *And raving die.*

A young woman of Spanish appearance, dressed in a shawl, rests her elbows on the edge of a table and clutches her head in both hands as she gazes down at the semicircle of playing cards with a transfixed stare expressive of horror or despair. She is evidently a fortune-teller who is appalled by what the cards are telling her. The illustration was one of those singled out by the reviewer for the *Athenaeum* (no. 3118 [30 July 1887], p. 142):'the fortune-teller shrinking back in horror from the unspeakable fate she reads in the outspread cards . . . all these are conceived with poetic fervour, and the intense and electrified attitudes frequently affected by Mr. Sargent are here not out of place'.

This sketch could date back to the period of Sargent's visit to Spain in 1879, or may have been painted specially for Alma Strettell's book. An old photograph of the sketch, in the same format as other photographs of sketches for the illustrations, was once in the catalogue raisonné archive, but is now misplaced. According to Charles Merrill Mount (1969, p. 466), the original sketches were placed in the charge of Thomas Fox in 1926 and subsequently disappeared. For a discussion of the book illustrations as a group, see appendix 11, p. 388.

MOROCCO, 1880

With its Hispano-Moresque architecture, Moorish traditions and gypsy dancers, southern Spain was a natural stepping-off point for North Africa. The tour of Spain often took in Morocco and Algeria, and some travel books combined the two, underlining the shared history and culture that linked the two regions. Many artists before Sargent had spent time in Granada and Seville before crossing the Straits of Gibraltar to Tangier and Algiers in search of oriental subjects. The popularity of orientalist paintings demonstrated Europe's continuing love affair with the East as somewhere far away, alien, exotic, sensual, primitive, barbaric and infinitely strange. Orientalism was made up of many strains, and it was as much a literary phenomenon as a pictorial theme. We know that Sargent admired the influential books by the orientalist painter-turned-author Eugène Fromentin, *Un Été dans le Sahara* (Paris, 1857) and *Une Année dans le Sahel* (Paris, 1859).[1] Fromentin had been part of the early wave of Romantic painters travelling to North Africa, along with Eugène Delacroix and Théodore Chassériau, and his spirited orientalist subjects and street scenes (see fig. 178) as well as his books would have been formative influences on Sargent. Another writer he would have known was Théophile Gautier, whose daughter Judith became a close friend and the subject of a number of avant-garde portrait sketches.[2] Gautier had written a famous series of articles on Spain between 1840 and 1843, later published in book form, and he followed this up with another work chronicling his experiences in Algeria.[3] Other influential writers who had travelled to the East and recorded their experiences include Alexandre Dumas, Gustave Flaubert, Alphonse de Lamartine and Gérard de Nerval, some of whose works Sargent may have read.[4] He is also likely to have followed up literary sources devoted purely to Morocco.[5]

The East was a literary inspiration for Sargent as well as a physical experience. As a child he almost certainly read *Tales from the Arabian Nights* and responded to its blend of adventure, magic and enchantment; the sale of his library contained an edition in French in sixteen volumes as well as two editions of James Morier's *Adventures of Hajji Baba in Isaphan* and a copy of Edward Fitzgerald's translation of the *Rubaiyát of Omar Khayyám*.[6] One of his favourite books in later life was *Vathek,* the oriental romance published in 1784 by William Beckford, the creator of the fabulous Fonthill Abbey.[7] Adrian Stokes, who travelled to the Alps with Sargent, provides another insight into his reading: 'Among those books I know him to have liked were "La Chartreuse de Parme", by Stendhal—which he remembered from beginning to end—Casanova's escape from a Venetian prison, and the early adventures of Layard in the East'.[8] Vernon Lee, Sargent's childhood friend, had noticed in him early on a predilection for things exotic and bizarre: 'The words "strange, weird, fantastic" were already on his lips—and that adjective *curious,* pronounced with a long and somehow aspirated *u,* accompanied by a particular expression half of wonder and half of self-irony'.[9] In 1910, Sargent exhibited one of the water-colours of his nieces and their friends dressed up as oriental odalisques under the title *Zuleika;*[10] the word is derived from Arabic and biblical sources, but it is also the name of the heroine of Lord Byron's poem *The Bride of Abydos.* For Sargent, the East represented a fantasy world where he could let his imagination roam wild quite as much as a present-day reality.

Sargent spent January and February 1880 in Morocco, chiefly in Tangier, where he took a house with an artist friend, probably either Charles-Edmond Daux or Armand-Eugène Bach, with whom he had travelled to Madrid in the autumn of 1879; the former painted a number of orientalist subjects (see fig. 176). In the letter to Vernon Lee of 1888 quoted below, Sargent talks of having come to Morocco with 'a party of Frenchmen', so Daux and Bach and others may have been with him. According to Charteris, the party rode through the Ronda Mountains to Gibraltar, from where they crossed over to North Africa.[11] We do not know exactly when this was, but Sargent had arrived in Tangier by 4 January 1880 (see his letter to Ben del Castillo of that date quoted below). The idea of visiting North Africa had clearly been in his mind since he first planned his trip to Spain. Writing to Vernon Lee in a letter of 9 August 1879, Emily Sargent told her: 'John hopes to cross over to Africa from Spain, & would like Mamma & me to join him for a month at Algiers, which would be delightful if we can manage it. We should enjoy a trip there immensely, especially were John there, but we are not at all decided yet'.[12] Dr Fitzwilliam Sargent wrote in similar terms to his brother Tom in a letter of 15 August 1879: 'After this [completing the portrait of *Madame Édouard Pailleron,* see *Early Portraits,* no. 25], he is going to Spain on a sketching & studying tour, and in the Autumn he thinks of crossing into Africa, to Tangier, Algiers etc. I hope he will bring back with him some good studies etc'.[13] Dr William White, who went with his wife and Sargent to Tangier in July 1895, described the latter's views of Morocco: 'Sargent, who knows Algiers and Egypt and northern Africa thoroughly says there is nothing so savage and picturesque and thoroughly Oriental to be seen anywhere else; and so far as Algiers and Egypt go they don't compare with this. It is his second visit here and yet he is enthusiastic about it'.[14]

There is no evidence to suggest that Sargent had much contact with the local

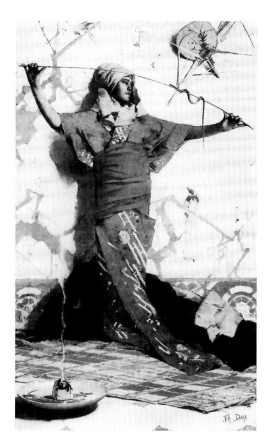

Fig. 176
Charles-Edmond Daux, *Girl with a Snake.*
Oil on canvas, dimensions unknown. Inscribed,
lower right: *Ch. Daux.* Formerly Louise
Whitford Gallery, London.

Moroccan society or that he concerned himself with the politics of the region. Morocco remained an independent sultanate, but it was increasingly coming under political pressure from the Great Powers, especially Spain and France. In 1880, the year of Sargent's visit, a major conference at Madrid settled some of the political and economic rivalries among the powers and laid certain conditions on the sultan. Sargent is unlikely to have concerned himself with such matters. He was a traveller in search of the exotic. Evidence of his involvement with the small expatriate community in Tangier is contained in a letter he wrote to Vernon Lee in 1888:

On inspection I find there is not a living creature in Spain or Morocco to whom I could direct you. That is the result of having gone there with a party of Frenchmen. In Tangiers we knew an old Belgian painter who has since died and the American consul Matthews, a capital fellow who lent us horses and villas and who has been turned out of his post by the intrigues of a Bostonian named Perdicaris in Tangiers. The latter was brought to my studio here [33 Tite Street, London] a year or two ago and went away displeased for I persisted in singing the praises of his victim.

Ralph Curtis knows everybody in Tangiers and in Seville and could put you up besides to a lot of things that I did not see during my short stay.

Tetuan is well worth going to see if you are up to a very long day's ride on horseback. We broke the journey & spent the night at an Arab caravanserai, a horrible experience against which I warn you. Don't go to Tetuan unless you have your tent or can ride a whole day. By the way when you hire horses it is a toss up whether they give you a saddle or not and that's where one finds it very useful to know some resident.

For 30 frs, I think we hired a Moorish house with a charming patio where we painted. I should recommend you to do the same if your hotel is tiresome during the day. Unless things have changed very much within the last eight years you will probably be told that it is not very safe to wander about outside the walls and for any ride or excursion you must take a soldier from the embassy. The devout Moor makes a point of killing you if you are without this representative of the Emperor's authority, and then you can get no damages. If they molest someone who has an escort all the inhabitants of the neighbourhood have their heads chopped off.[15]

The American consul was Colonel Felix Mathews, a colourful Civil War officer, whose bitter feud with a rival, Ion Perdicaris, lost him his post in 1887, though he did subsequently regain it. Perdicaris later became famous as the kidnap victim of Raisuli, a local chieftain of the Rif region. An inscription on a drawing of a Spanish crucifix and cupola (fig. 143) suggests that Sargent had introductions to other people in the community: 'Mr. & Mrs. Adams / Tetuan. Isaac D. Mahon / British vice consul'. His trip to Tetuan, an old city lying some seventy miles south-east of Tangier, is recorded in the letter to Ben del Castillo quoted below. Whether he visited other parts of the interior is unknown.

The only contemporary description of Sargent's residence in Tangier comes in a letter he wrote to Ben del Castillo from the Hotel Central on 4 January 1880:

Unchanging friend and dauntless correspondent it is very creditable of you to have written after such a long hiatus. But instead of cursing so malignantly why don't you guess that I have been doing so much jogtrotting on atrocious horses and mules that I can't sit down to write, and that the temperature in these tropical regions is such that one's fingers refuse to hold the pen. This is an exaggeration.

The other day on a ride from Ceuta to Tetuan, we essayed a most tremendous storm of hail and rain that made us shiver and set our half naked Arabs shaking in the most alarming way, but now the weather is beautiful and the temperature just what it ought to be. We have rented a little Moorish house (which we don't yet know from any other house in the town, the little white tortuous streets are so exactly alike) and we expect to enjoy a month or two in it very much. The patio open to the sky affords a studio light, and has the horseshoe arches arabesques, tiles and other traditional Moorish ornaments. The roof is a white terrace, one of the thousand that form this odd town, sloping down to the sea. All that has been written and painted about these African towns does not exaggerate the interest of at any rate, a first visit. Of course the poetic strain that writers launch forth in when they touch upon a certain degree of latitude and longitude—is to a great extent conventional; but certainly the aspect of the place is striking, the costume grand and the Arabs often magnificent.[16]

We know from Emily Sargent that *Fumée d'ambre gris* (no. 789), Sargent's one finished subject painting from this trip, was begun in the little house described in the letter to Ben del Castillo quoted above. (See her letter to Vernon Lee, 16 March 1880, quoted in the entry for *Fumée d'ambre gris*, p. 300). Sargent evidently finished the picture on his return to Paris, probably bringing back with him some of the accessories he needed. He was an inveterate collector of objects and souvenirs, although he had to admit defeat in his commission to buy a rug for Fanny Watts:

Those dreadful eighty francs have blighted my young life! I have begun many a note to explain why they are still intact and I have always stuck miserably. The fact is I have been living in hope of finding something among the bazaars here [Paris] that you might wish me to invest them in but it is in vain and I have asked my father to hand them over to you and I am now sighing noisily with a sense of relief 'Ouf!'

The eighty were my constant companions in Morocco. I know all the rugs in Tangier and know them to be of two categories either new and hideous or old and so tattered and disreputable that at best they can be excused in a painter's studio.

Long life to the eighty![17]

At the time that Sargent was visiting Morocco, the market for orientalist art had never been stronger. Every year more and more artists came to North Africa to feed an apparently insatiable demand for erotic images of the harem and the slave market, the cruel practices of pashas and sultans, the colourful rituals and ceremonies of Arab

life, the camel trains and victims of the desert, and the topography of famous sites.[18] The most influential orientalist painter of the period was Jean-Léon Gérôme, who combined sensational subject matter with meticulous detail and highly polished surfaces. He was not an artist Sargent admired, describing his nudes as 'all sugar and varnish'.[19] Much more to his taste was the art of Henri Regnault, a modern realist who painted with fire and dash.[20] Regnault had been killed in action during the Franco-Prussian War in 1871, earning a reputation as an artist-hero struck down at the height of his powers; he was an inspiration to the younger artists of Sargent's generation. Like Sargent, he had come to Morocco by way of Spain, setting his famous scene of oriental cruelty *Execution without Judgement in the Time of the Kings of Granada* (signed and dated 'Tangier 1870', Musée d'Orsay, Paris) in the Alhambra Palace, where he also painted architectural sketches (see fig. 121). These last are similar to Sargent's Alhambra studies in their treatment of reflected light on highly decorated surfaces. Regnault's most famous Moroccan subject was *Salomé* (fig. 177), a voluptuous, half-draped model in luxurious surroundings (in fact, the artist's studio in Rome). The subtle sensual-

ity of Sargent's hooded model for *Fumée d'ambre gris* (no. 789) is an antidote to the explicit eroticism of *Salomé,* but Sargent would have admired the spirited realism of Regnault's North African sketches with their feeling for light and colour and their bold brushwork.

Regnault had travelled to Morocco in 1869 in company with Georges Clairin, who painted exotic scenes like *Entering the Harem* (The Walters Art Museum, Baltimore). Other established orientalists who painted in Morocco include the following French artists: Eugène Fromentin, an artist Sargent is known to have admired and whose street scenes are similar in mood to Sargent's architectural studies in Morocco (see fig. 178); Alfred Dehodencq, who had first made his name with a scene of Spanish bullfighting, *Los Novillos de la Corrida* (1850, Musée des Beaux-Arts, Pau), and whose Tangier street scenes share something of the same atmosphere as Sargent's; Benjamin Constant, whose large-scale harem scenes like the *Intérieur de Harem au Maroc* (1878, Musée des Beaux-Arts, Lille) earned him a popular reputation at the Salon; the American Edwin Lord Weeks, whose first exhibited work at the Salon in 1878 was a Moroccan subject, *Chamelier marocain, à Tangier;* and the Spaniard Mariano Fortuny, whose Spanish and Moroccan genre scenes were widely admired for their exquisite finish, especially in America. He certainly influenced Sargent's early water-colour style, and a photograph of a scene in the mosque at Tangier by him appears in Sargent's album of early drawings and reproductions (fig. 179). The writer and picture agent Martin Birnbaum records an occasion when Sargent looked over a group of paintings by Boldini, Mancini and Fortuny that Birnbaum wanted to submit to the authorities of the Museum of Fine Arts, Boston: 'He decided to recommend only the works of Fortuny which came from the famous Stewart collection. For a long time, Sargent sat entranced in front of the pictures as if in wistful retrospect, and examined each detail with loving care, but his only comment was a sigh of homage and respect, and the almost whispered words, "What a genius!" Was he thinking of Fortuny's untimely death?'[21]

In conceiving his picture of *Fumée d'ambre gris* (no. 789), Sargent was certainly conscious of the weight of orientalist tradition lying behind him. What was original was his refusal to give out any narrative clues as to the subject and his aesthetic preoccupations with colour and design. The

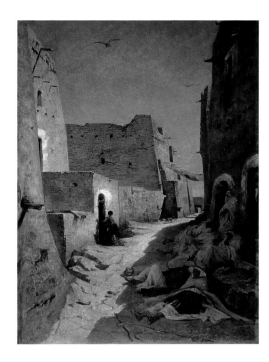

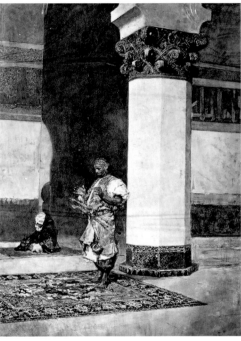

Fig. 177
Henri Regnault, *Salomé,* c. 1870. Oil on canvas, 63 x 40⅛ in. (160 x 102 cm). The Metropolitan Museum of Art, New York. Gift of George F. Baker, 1916 (16.95).

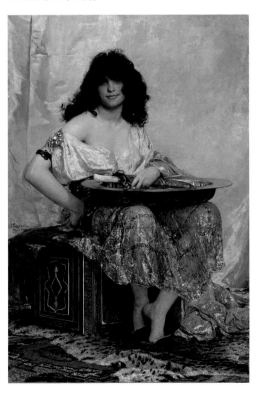

Fig. 178
Eugène Fromentin, *A Street in Laghouat,* 1859. Oil on canvas, 55⅞ x 40⁹⁄₁₆ in. (142 x 103 cm). Musée de la Chartreuse, Douai.

Fig. 179
Mariano Fortuny, *Chef kabyle dans la mosque de Tangier.* Water-colour, dimensions unknown. From a photograph in an album of early drawings and reproductions belonging to the artist. The Metropolitan Museum of Art, New York. Gift of Mrs Francis Ormond, 1950 (50.130.154, p. 53 verso).

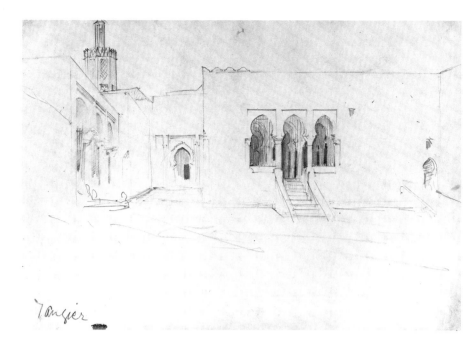

Fig. 180 *(top)*
Sketch of a Building, with Entrance of Three Ogival Arches, Tangier, 1880. Pencil on paper, 9¹³⁄₁₆ x 13⁷⁄₁₆ in. (25 x 34.2 cm). Fogg Art Museum, Harvard University Art Museums, Cambridge, Massachusetts. Gift of Mrs Francis Ormond, 1937 (1937.8.119).

Fig. 181 *(middle)*
Details of an Ogival Arch, Tangier, 1880. Pencil on paper, 9¾ x 13½ in. (24.9 x 34.3 cm). Fogg Art Museum, Harvard University Art Museums, Cambridge, Massachusetts. Gift of Mrs Francis Ormond, 1937 (1937.8.120).

Fig. 182 *(bottom)*
Two Sketches of Moroccan Figures, 1880. Pencil on paper, 9¹³⁄₁₆ x 13⁹⁄₁₆ in. (25 x 34.5 cm). Fogg Art Museum, Harvard University Art Museums, Cambridge, Massachusetts. Gift of Mrs Francis Ormond (1937.8.24).

picture is an orientalist work with a difference, at once more modern and more enigmatic than its competitors. We do not know if the picture is a reminiscence of something that Sargent had seen or if it reflects an imaginative response to his experiences in Tangier. The significance of the ritual and the identity of the figure are both lost to view. Sargent himself said that the only interest of the picture was the colour,[22] but there is more to the picture than that. The artist was doing a popular type of subject in an unconventional way, but in the hope of selling the picture for a good price.

Apart from his one large oil painting, Sargent's artistic output in Morocco was restricted to a group of small-scale architectural studies and landscapes, done for his own pleasure. They are bold sketches, painted out-of-doors on the thin mahogany panels he carried with him, and they reflect his direct response to the qualities of North African light and scenery. They are vivid impressions of the moment. The street scenes, of which Violet Sargent (Mrs Francis Ormond), the artist's younger sister, gave a group of six to the Metropolitan Museum of Art, New York, in 1950, are empty of people. What intrigued the artist were the straight lines and simple rectangular shapes of whitewashed houses, relieved by the pattern of doorways and horseshoe arches. The street scenes continue themes

Sargent had first explored in Capri, like *Staircase in Capri* and *Ricordi di Capri* (nos. 719, 720), with geometric structures, sharp contrasts of light and shadow, and the subtle play of white on white. The simplicity of these architectural studies is very different from the richly decorated surfaces and palette of the Alhambra studies painted only a month or two earlier (see nos. 748–52). They suggest that the artist was deliberately setting himself a course of study in formal composition and chiaroscuro. In addition to the oils there are two surviving architectural studies in pencil, both possibly from the same sketchbook, a drawing of a mosque or shrine and the details of a horseshoe arch, as well as two drawings of figures (figs. 180–82).

The landscapes demonstrate a greater interest on the part of the artist in the lives of the local population and their manners and customs. They show groups of figures engaged in everyday activities, mending nets on the seashore (no. 786), selling produce in the market (no. 784), watching over a resting camel train (no. 787), guarding a group of donkeys (no. 788) and walking in a hillside cemetery (no. 785). Most of the figures are shrouded in the long white robes known as haiks, and they give off an aura of mystery and otherness which Sargent would exploit in *Fumée d'ambre gris* (no. 789). These are people of desert regions, whose culture and way of life can only be guessed at from the outward display of costume, bearing and attitude. We see no faces in Sargent's pictures, and this heightens the sense of secret lives and alien rituals.

The visual impact of Morocco can be further demonstrated by the photographs of local scenes, more than twenty of them, which Sargent collected and put in a scrapbook full of early drawings, reproductions of pictures and photographs of Spain.[23] These include views of Tangier, crowded market scenes, women making rush mats or baskets, a boy with a loaded donkey, a group of children sitting on a wall, exotic palm trees and vegetation, Berber encampments and carte-de-visite pictures of male Moroccans, young women and boys— a gallery of pin-ups (see figs. 183, 184). The artist seems to have been hungry for visual images with which to fix his own more fleeting impressions. They were not souvenirs or aids to painting, but notes in another medium, and in the absence of written documents they constitute a record of the things that caught his eye and aroused his interest.

—*Richard Ormond*

Fig. 183 *(top)*
Photographs of crowd scenes, c. 1880. From an album of early drawings and reproductions belonging to the artist. The Metropolitan Museum of Art, New York. Gift of Mrs Francis Ormond, 1950 (50.130.154, p. 62 verso).

Fig. 184 *(bottom)*
Photographs of Moroccan models, c. 1880. From the same album as fig. 183 (p. 60 recto).

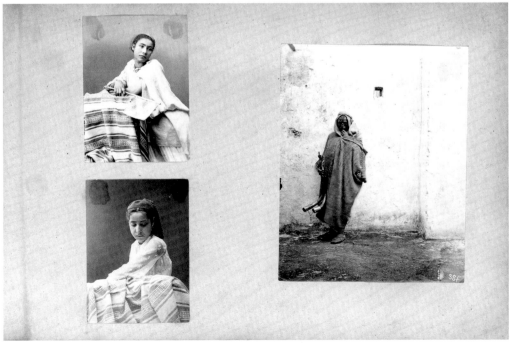

1. Sargent's enthusiasm for the books is recorded by Hamilton Minchin, who first met Sargent in 1879; see Minchin 1925, p. 738.

2. See *Early Portraits*, nos. 76–81.

3. Gautier's book on Spain was first published under the title *Tra Los Montes* and later as *Voyage en Espagne* (Paris, 1843). His book on Algeria was published as *Voyages pittoresques en Algérie* (Paris, 1845).

4. For writers on the East, see chapter 2, 'The Influence of Musicians, Travelling Poets and Writers', in Philippe Jullian, *The Orientalists, European Painters of Eastern Scenes* (Oxford, 1977).

5. A popular book of the time was *Marocco* by Edmondo de Amicis, published in French (1879) and English (1882) editions. English travel books include Mary Catherine Jackson, *Word-Sketches in the Sweet South* (London, 1873); Sir John H. Drummond Hay, *Western Barbary: Its Wild Tribes and Savage Animals* (London, 1844; rev. ed. 1861); Elizabeth Murray, *Sixteen Years of an Artist's Life in Morocco, Spain and the Canary Islands*, 2 vols. (London, 1859); Amelia Perrier, *A Winter in Morocco* (London, 1873); Gerhard Rohlfs, *Adventures in Morocco and Journeys through the Oases of Draa and Tafilet* (London, 1874); and Mrs L. Howard-Vyse, *A Winter in Tangier and Home Through Spain* (London, 1882).

6. Sale of Sargent's library, Christie's, London, 29 July 1925, lots 3, 77, 78 and 84.

7. Sargent named one of his pictures *Princess Nouronihar*

after the heroine of Beckford's novel, ill. Adelson *et al.* 1997, p. 111, fig. 104. Three editions of *Vathek* were included in the sale of Sargent's library, ibid., lots 7–9.

8. Stokes 1926, p. 55.

9. Vernon Lee in Charteris 1927, p. 249.

10. The water-colour is in the Brooklyn Museum, New York, ill. Adelson *et al.* 1997, p. 85, fig. 73.

11. Charteris 1927, p. 49.

12. Vernon Lee Papers, Special Collections, Millar Library, Colby College, Waterville, Maine.

13. Fitzwilliam Sargent Papers, Archives of American Art, Smithsonian Institution, Washington, D.C.

14. Dr White's diary, 2 July 1895, Journal of 1895, Dr James William White Papers, University Archives, University of Pennsylvania, Philadelphia.

15. Vernon Lee Papers, Special Collections, Millar Library, Colby College, Waterville, Maine.

16. Quoted in Charteris 1927, pp. 50–51.

17. Letter of 14 May 1880, Fanny Watts Papers, private collection.

18. There is an extensive literature on orientalist painting. See, for example, Philippe Jullian, *The Orientalists: European Painters of Eastern Scenes* (Oxford, 1977); Mary Anne Stevens, ed., *The Orientalists: Delacroix to Matisse*, Royal Academy, London, 1984 (exhibition catalogue); Roger Benjamin, *Orientalism: Delacroix to Klee*, Art Gallery of New South Wales, Sydney, 1997 (exhibition catalogue); Christine Peltre, *Les Orientalistes* (Paris,

2000); and Roger Benjamin, *Renoir and Algeria*, Sterling and Francine Clark Art Institute, Williamstown, Massachusetts, and Yale University Press, London and New Haven, 2003 (exhibition catalogue).

19. To Edmund Gosse in 1885, see Charteris 1927, p. 76.

20. Sargent owned a copy of the *Correspondance de Henri Regnault . . . suivie du catalogue complet de l'oeuvre de H. Regnault*, ed. Arthur Duparc (Paris, 1872), and he presented another copy to his cousin Ralph Curtis (information on this copy, inscribed 'R. W. Curtis from J. S. Sargent 1880', from Ralph Curtis's son-in-law, Theodore Steinert, in a letter to David McKibbin, 12 June 1965, McKibbin papers). Hamilton Minchin recalled Sargent pointing out Regnault's fiancée to him at a reception in Carolus-Duran's studio around 1879 (see Minchin 1925, p. 736). Two drawings by Regnault were included in Sargent's sale, Christie's, London, 27 July 1925, lots 267–68.

21. Birnbaum 1941, p. 29.

22. Sargent to Vernon Lee, 9 July 1880 (private collection): 'I shall send you a photograph of a little picture I perpetrated in Tangiers. It is very unsatisfactory because the only interest of the thing was the colour; but still it will give you a general idea of what your "twin" is about'.

23. The Metropolitan Museum of Art, New York (50.130.154, pp. 32r, 36v, 37r, 37v, 59r, 59v, 60r, 60v, 61r, 62v, 63r).

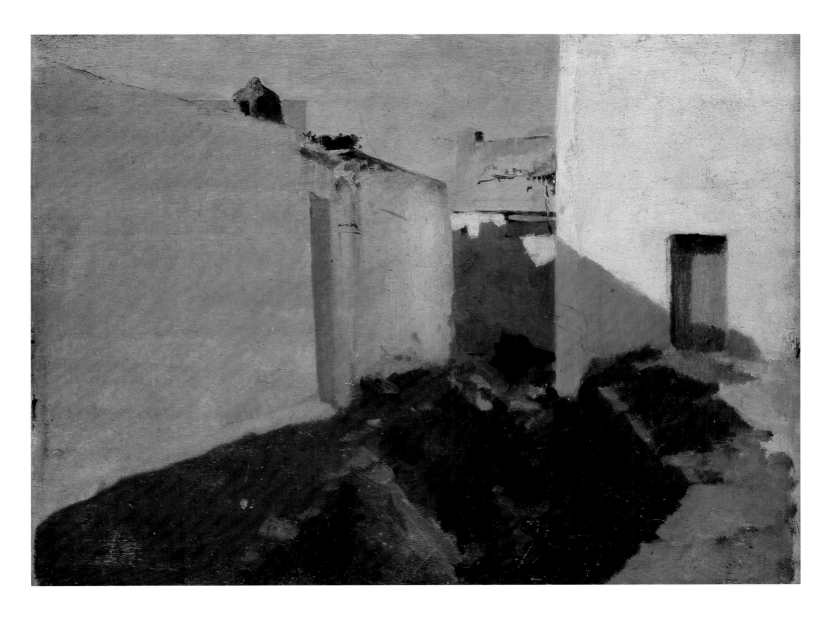

777
White Walls in Sunlight, Morocco

1880
Alternative titles: *Courtyard with Moorish Door; Morocco, White Walls in Sunlight*
Oil on panel
10¼ x 13¾ in. (26 x 35 cm)
Inscribed on the reverse: *by J. S. Sargent*
The Metropolitan Museum of Art, New York. Gift of Mrs Francis Ormond, 1950 (50.130.4)

This picture was probably painted in the medina (old town) or the kasbah (citadel) of Tangier and is similar to *A Moroccan Street Scene* (no. 782). A rough and rocky street leads past two buildings towards a narrow opening with a third building beyond. The long white wall of the building on the left, with a small domed structure peeping over and a sliver of projecting wall, leads the eye deep into the composition. The building on the right is seen more or less head-on, with a raised stone platform running from the front of the space to the small doorway in the middle. In common with other Tangier sketches, sunlight zigzags across the composition, emphasizing the sharp geometry of the forms and the bold contrasts of light and shadow. The broken ground in front is painted so loosely that it is difficult to read.

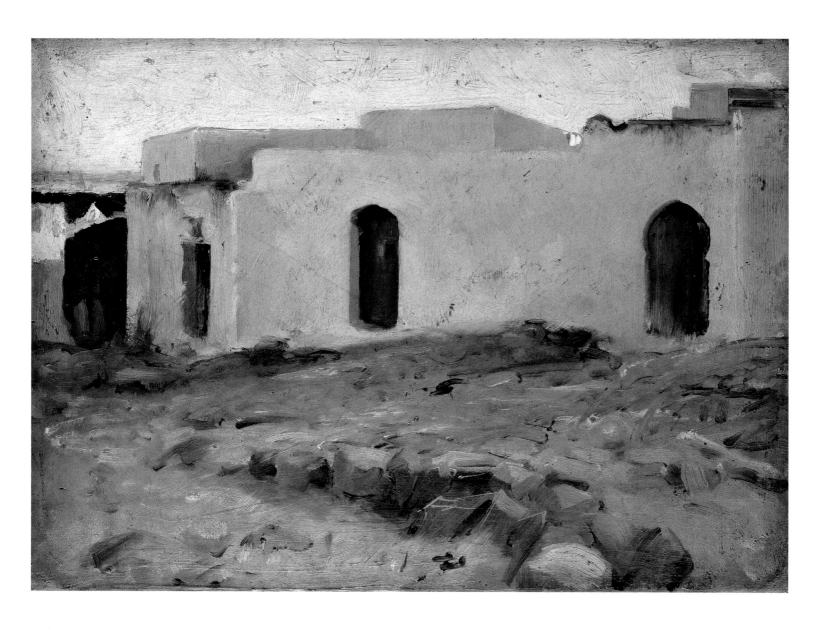

778
Moorish Buildings on a Cloudy Day

1880
Alternative title: *Moorish House on Cloudy Day*
Oil on panel
10¼ x 13¾ in. (26 x 35 cm)
Inscribed on the reverse: *by J. S. Sargent*
The Metropolitan Museum of Art, New York. Gift of Mrs Francis Ormond, 1950 (50.130.7)

This Moorish street scene was probably painted in the medina (old town) or the kasbah (citadel) of Tangier. The title is something of a misnomer for, though the sky is pale grey-blue, sunlight is clearly visible on the distant building far left, along the top edge of the central building, and on the sliver of sea beyond. No sunlight, however, is falling on the rough, stony street or the long white building, which is pierced by three green doorways. The soft, opalescent light which fills the scene suggests that the time of day is late afternoon or early morning. There is a strong textural contrast between the rugged surface of the street and the smooth, plastered walls of the house.

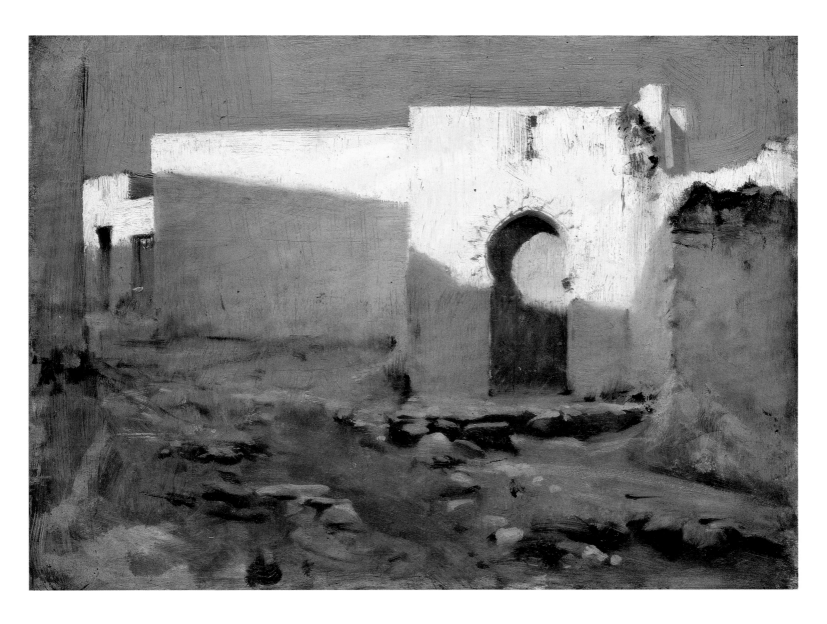

779
Moorish Buildings in Sunlight

1880
Alternative title: *Moorish Building
in Sunshine*
Oil on panel
10¼ x 13⅞ in. (26 x 35.3 cm)
Inscribed on the reverse: *by J. S. Sargent*
The Metropolitan Museum of Art,
New York. Gift of Mrs Francis Ormond,
1950 (50.130.9)

A rough and stony street leads past a square
white building with a projecting bay pierced
by an elegant horseshoe-shaped Moorish
doorway. The composition is framed by the
projecting walls of two buildings, to the left
and right, and a fourth building with two
doorways is visible in the distance. A line of
sunlight zigzags across the façade of the
main building, creating a band of creamy
white wall and blue sky above, and shad-
owed walls and broken ground below. The
sketch was probably painted in the medina
(old town) or the kasbah (citadel) of Tangier.

780
Entrance to a Mosque

1880
Alternative titles: *Courtyard, Tetuan, Morocco; Courtyard, Tetuan; Courtyard, Morocco*
Oil on panel
10¼ x 13¾ in. (26 x 35 cm)
Inscribed on the reverse: *by J. S. Sargent*
The Metropolitan Museum of Art, New York. Gift of Mrs Francis Ormond, 1950 (50.130.6)

Two Islamic keyhole doorways, one large and one small, pierce the walls of a building that runs along three sides of a space that may be a courtyard or a cul-de-sac. The larger doorway, with simple decoration around the arch and flanking pilasters, has a smaller entrance inset within it and a raised pavement in front. Sunlight makes a zigzag pattern along the wall, creating zones of warmer and cooler colour in this subtle symphony of white and cream. Deeper notes of colour are provided by the dark brown door within the main entrance, and the red door to the right. Though described as a courtyard in the past, the picture is likely to represent the entrance to a small mosque. The arrangement of a main doorway flanked by a smaller one is typical of mosques in Morocco. The picture was given its original title when it entered the collection of the museum, but the reasons for identifying the site as Tetuan rather than Tangier are not known. Sargent is known to have visited Tetuan.

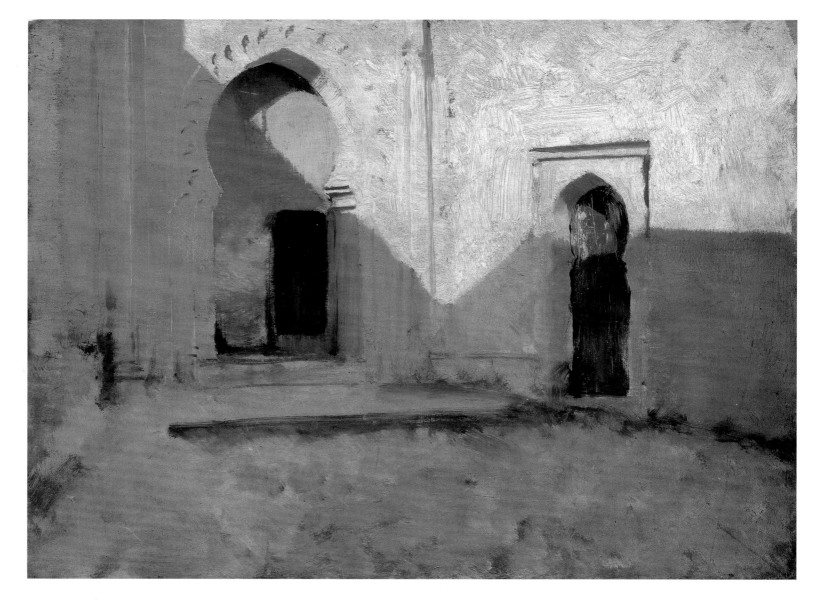

781
Open Doorway, Morocco

1880
Alternative titles: *Open Doorway,*
North Africa; Morocco, Open Doorway
Oil on panel
13⅞ x 10¼ in. (35.2 x 26 cm)
Inscribed on the reverse: *by J. S. Sargent*
The Metropolitan Museum of Art,
New York. Gift of Mrs Francis Ormond,
1950 (50.130.5)

A simple stone doorway is set into a white
plaster-rendered wall, with a path and a low
step leading up to it. One side of the dou-
ble green door is open, revealing a sunlit
courtyard with a low wall and a dark
brown building beyond. On the left of the
doorway is a dark brown bulbous object,
probably a ceramic pot or jar. On the right
is a patch of earth. The sketch was probably
painted in the medina (old town) or the
kasbah (citadel) of Tangier.

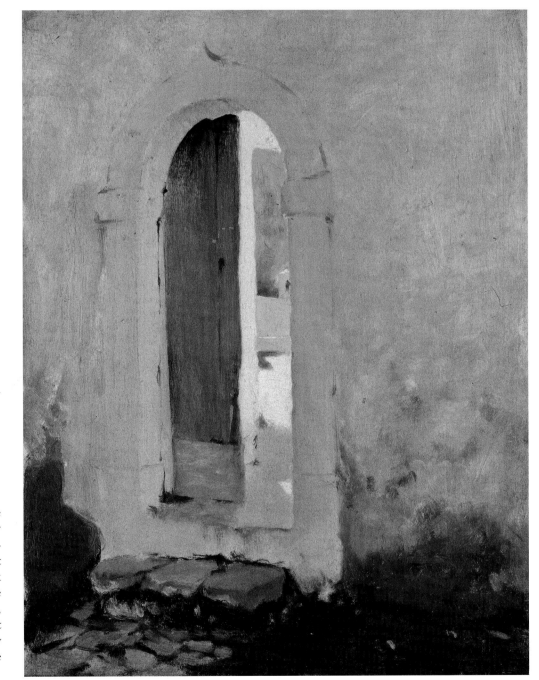

782
A Moroccan Street Scene

1880
Alternative titles: *An Eastern Street Scene;
Tunisian Street Scene*
Oil on panel
13¾ x 10¼ in. (35 x 26 cm)
Yale University Art Gallery, New Haven,
Connecticut. Bequest of Edith Malvina
K. Wetmore (1966.79.13)

This street scene was probably painted in
the medina (city) or the kasbah (citadel) of
Tangier on Sargent's visit in 1880. It is sim-
ilar to *White Walls in Sunlight, Morocco* (no.
777), and may have been painted in the same
vicinity. We are looking down a narrow
street with tall whitewashed buildings on
either side. The tightly structured composi-
tion, a geometry of rectangles, is relieved by
the vivid treatment of light and atmosphere.
A splash of sunlight falls on the building to
the right, defining the line where sun and
shadow meet at the corner in a bold trian-
gle. The shadowed blocks of foreground
building and pavement give way at the end
of the vista to sunlit houses and a sweep of
deep blue sky.

The sketch belonged to Sargent's close
friend, the artist and professor of art Henry
Tonks (1862–1937), who owned several
other works by Sargent. It has been sug-
gested that this was the picture in the
artist's sale, Christie's, London, 27 July 1925,
lot 186, with the title 'A Street in Algiers';
the latter is much more likely to have been
Moroccan Street (no. 783). The Tonks sketch
was later purchased by Edith Malvina K.
Wetmore (1870–1966), who left an impor-
tant gift of paintings, drawings and prints
to the Yale University Art Gallery. In a letter
of 23 February 1951 to David McKibbin
(McKibbin papers), Edith Wetmore remem-
bered that she had bought the picture from
M. Knoedler & Co., New York, for a very
reasonable price, 'as there was not much
interest in Sargent at that time'; she also
recorded that she had met Sargent, 'proba-
bly in London'. A sheet she sent with the
letter indicates that she bought the picture
in May 1939 (the receipted bill from
Knoedler is dated 3 June 1939). In her obit-
uary in the *New York Times* (11 March 1966,
p. 34), she was described as 'one of the last
dowagers of the Newport social set'. The
Wetmore house, Château-sur-Mer, was the
grandest of the Newport mansions when
first built (1852). Edith's father, George
Peabody Wetmore, was governor of Rhode
Island and a U.S. senator.

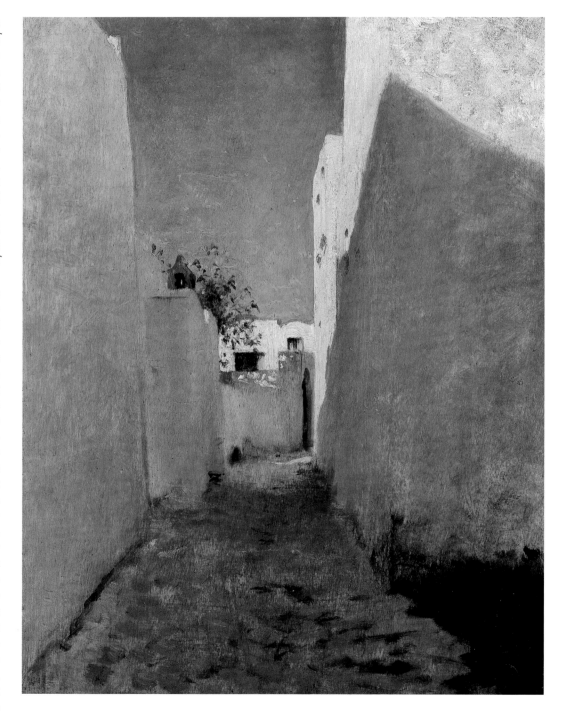

783
Moroccan Street

1880
Alternative titles: *A Street in Algiers;*
A Sun-Dappled Street Scene
Oil on panel
13 ½ x 10 in. (34.3 x 25.4 cm)
Private collection

This view up a narrow street of square whitewashed houses was probably painted in the medina (city) or the kasbah (citadel) of Tangier. Sunlight plays across the surfaces of the white walls, creating subtle tints of grey, blue-grey and pale beige. The immediate foreground of rough stones is in shadow; above is a strip of deep blue sky. The picture was bought at the artist's sale by Stevens & Brown for Charles Deering (1852–1927), chairman of the board of McCormick-Deering, later the International Harvester Co., which dominated the farm-equipment market. Deering had been a friend of Sargent from boyhood, and with his brother James, creator of the villa of Vizcaya at Miami, now the Vizcaya Art Museum and Gardens (Sargent painted there in 1917), became a major patron of the artist. Sargent painted Charles Deering in 1876 and again forty years later (see *Early Portraits,* no. 4, and *Later Portraits,* no. 577).

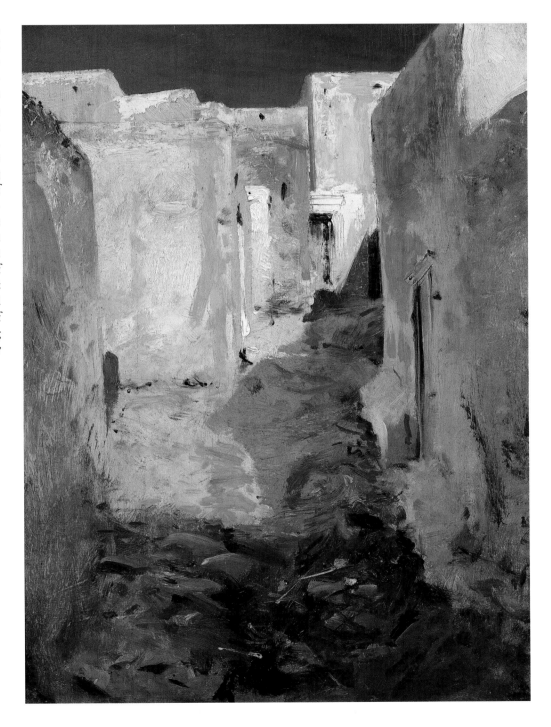

784
***Moroccan Fortress, with Three Women
in the Foreground***

c. 1880
Alternative title: *Bedouin Women*
Oil on panel
13⅞ x 10¼ in. (35.2 x 26 cm)
Inscribed on a note on the reverse of the
picture: *Miss Sargent/cut down frame/to fit
this take* [?make] *very little of picture*
Private collection

This picture was probably painted from the
medina (city) of Tangier looking up towards
the fortifications of the kasbah (citadel).
Despite research on the ground, it has not
been possible to fix the exact location of
the scene. In the foreground, three Berber
women in haiks, one of them wearing a
straw hat typical of the Anjira tribe, are
seated on the ground, with oranges laid out
in front of them. In her book *A Winter in
Tangier and Home Through Spain* (London,
1882, p. 160), Mrs L. Howard-Vyse describes
a market day in Tangier: 'Seated on the
ground were numerous women, with cloths
spread around them, upon which were piles
of orange blossom for sale. One woman
gave us handfuls of it'. In Sargent's sketch,
the triangular shapes of the seated women
are repeated in the tents beyond to which
they presumably belong. Above the white
walls of the end building, the rocky land-
scape rises to a line of fortifications, with
the same horizontal emphasis, and a strip of
deep blue sky. Among the street scenes
painted in Tangier, this one is unusual in
having figures, and it is less enclosed than
most. It is, however, composed on the same
tight geometrical lines, and the artist skil-
fully plays off shady and sunlit areas to cre-
ate sinuous patterns of light and dark across
the foreground.

The early provenance of the sketch is
unknown. The pencil note on the back,
apparently in Emily Sargent's hand, sug-
gests that the picture belonged either to her
or to her brother's estate. It was purchased
in 1961 by M. Knoedler & Co., New York,
on joint account from Anthony K. Bower,
managing editor of *Art in America*. In the
catalogue of the 1984 auction sale at Sothe-
by's, its provenance is confused with that of
Three Berber Women (no. 785).

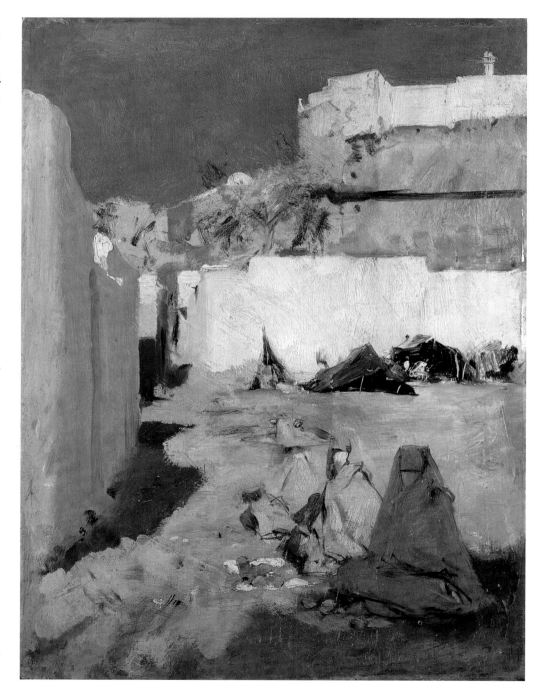

785
Three Berber Women

1880
Alternative titles: *Bedouin Women;*
A Bedouin Woman
Oil on panel
10¼ x 13½ in. (26 x 34.2 cm)
Private collection

Three women, who appear to be Berbers wearing their haiks, are seen descending a hillside. In the background is a cemetery, possibly that at Tetuan. The solidly painted figures, arranged in a processional composition reminiscent of *Oyster Gatherers of Cancale* (no. 670), are silhouetted against a creamy white sky with streaks of pink, perhaps indicating an evening scene. The vertical emphasis of the figures is offset by the horizontal lines of the hillside, part of it covered by trees, and by the tombs. The spare foreground of earth and rocks is loosely sketched in, in tones of pale brown and grey, with darker brown flecks and a scattering of white highlights.

Conway J. Conway (1881–1953), who bought the picture at the artist's sale in 1925 (Christie's, London, 27 July 1925, lot 187), was the son of Asher Wertheimer, one of Sargent's most important patrons; he changed his name from Conway Wertheimer to Conway Joseph Conway at the time of the First World War. He features in the group portrait by Sargent of *Hylda, Almina and Conway, Children of Asher Wertheimer* (1905, see *Later Portraits,* no. 483). He owned several works by Sargent, including a distinguished group of water-colours. The picture passed to Ernest Makower (1876–1946), chairman of Makower & Co., silk and cotton merchants and exporters. Conway sold seven pictures he had acquired at the artist's sale to M. Knoedler & Co., in March 1927, and he may well have sold *Three Berber Women* to Makower at the same period. The latter was a director of the Royal Academy of Music in London and a trustee of the London Museum, to which he donated important collections (see his obituary in the London *Times,* 3 May 1946, p. 6g). The picture was sold from the estate of his widow in 1961. Makower also owned *Fête Familiale* by Sargent (see *Early Portraits,* no. 154) and *Study for the Prophets, Two Heads of a Bearded Man* (private collection), which also had a Conway provenance.

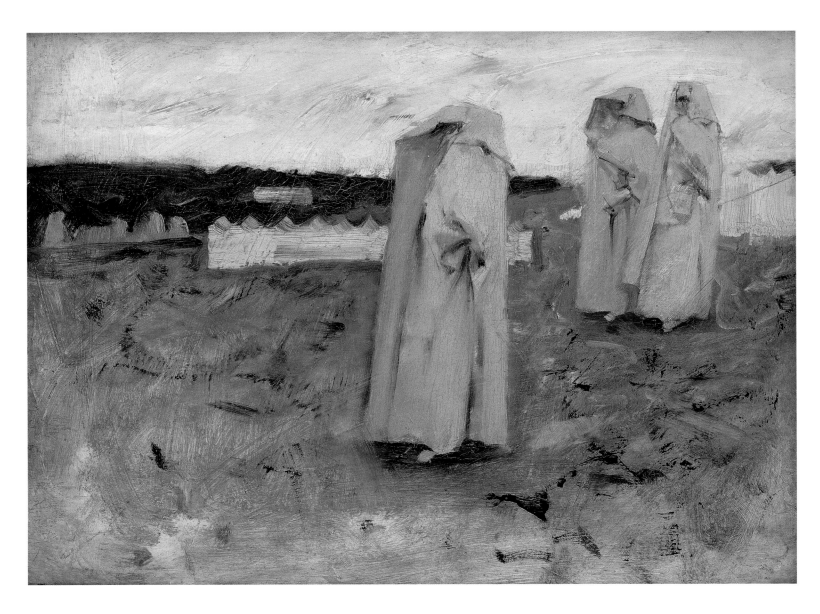

786
Moroccan Beach Scene

c. 1880
Alternative title: *The Coast of Algiers*
Oil on panel
10 x 13½ in. (25.4 x 34.3 cm)
Private collection

Probably painted on one of the beaches close to Tangier; research on the ground has so far failed to identify which one. Two pairs of female figures are shown laying out long fishing nets to dry in the sun. Beyond them is a rocky promontory with trees and bushes and a large white house. The nets repeat the curving shape of the beach and pick up the dark tones of the trees, in contrast to the ivory-coloured sand and the deep blues of the sea and sky. The spare, unencumbered foreground is typical of

Sargent's style at this time. The picture was titled 'The Coast of Algiers' when sold from the artist's estate in 1925, but it clearly belongs to the Moroccan group of sketches painted on thin mahogany panels. Leggatt Brothers, who bought the picture in 1925, sold it to Florence, Lady Boot (later Lady Trent, *née* Rowe, d. 1952), the wife of Sir Jesse Boot (d. 1931), chairman of the Boots Pure Drug Company. He was created a baronet in 1916 and Baron Trent in 1929.

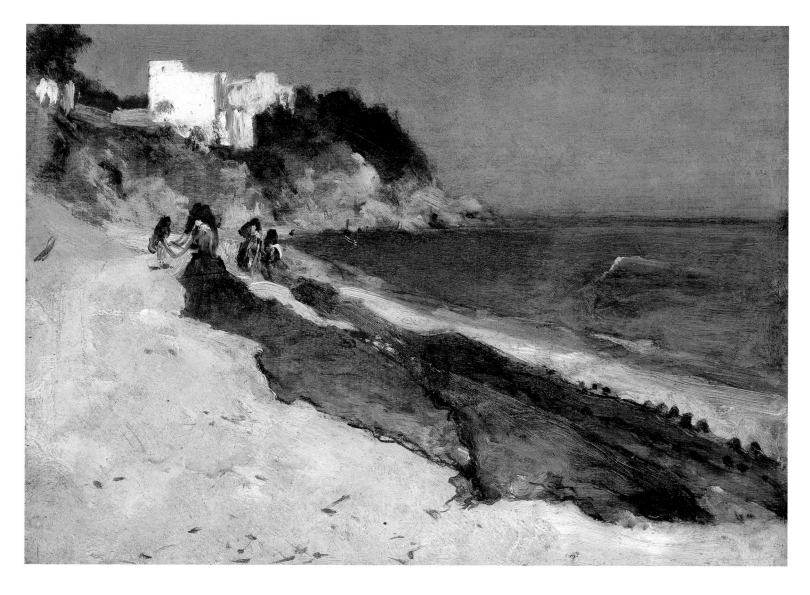

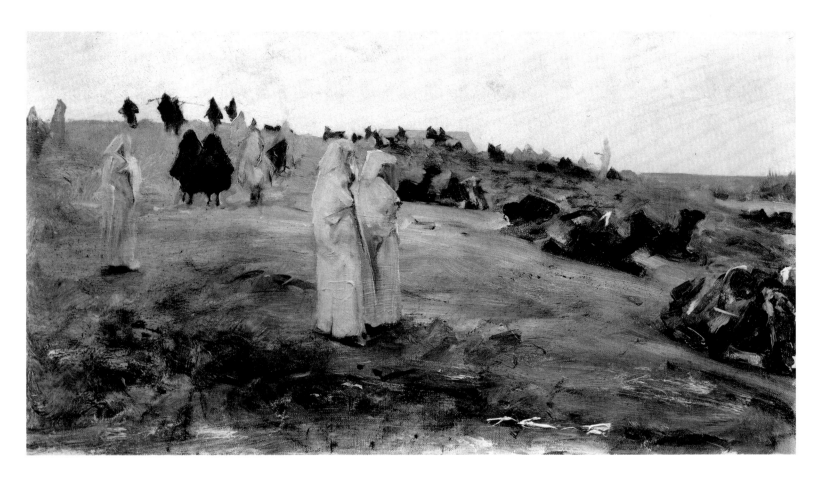

787
Arabs at Rest (Evening)

1880
Alternative title: *Bedouins*
Oil on canvas
10½ x 18⅛ in. (26.7 x 46 cm)
Untraced

Though seen only as a photograph by the authors, they are convinced that the picture is a genuine work by Sargent. In style it compares closely to other figure studies painted in Morocco early in 1880. A group of Moorish figures, almost certainly Berber tribesmen dressed in their long haiks, the characteristic costume of the region, are seen on a hillside, with a group of resting camels; two figures in white are prominent in the foreground. Distant figures, camels, and the roof of a tent or building are silhouetted against the skyline.

The picture was one of a group of early sketches belonging to the artist Auguste Alexandre Hirsch (1833–1912), who shared a studio with Sargent at 73, rue de Notre-Dame-des-Champs in Paris; for a discussion of the Hirsch group of works, see appendix 1, p. 387. The picture was sold by Hirsch's widow in January 1914, and later belonged to Mrs Clegg (*née* Maud Field), who lived at Wormington Grange, Broadway, Worcestershire, a house inherited by her daughter, Laura, wife of Major-General Sir Hastings Ismay (later Lord Ismay of Wormington); for the house, see *Country Life,* London, vol. 88 (21 September 1940), pp. 256–60.

788
Donkeys in a Moroccan Landscape (recto)
and ***Three Boats*** (verso)

1880
Alternative titles: *Donkeys in a (the) Desert;*
Two Donkeys in a Desert with Squatting Figure
Oil on panel
9¼ x 13 in. (23.5 x 33 cm)
Private collection

Three donkeys are shown resting below
a sand dune, probably in the vicinity of a
beach. The grey donkey nearest to us is sad-
dled and bridled and stands by a tall pole or
stake. A black donkey is behind, its front
legs almost invisible under white paint, and
beyond are the hindquarters of a third don-
key, also saddled. Above the animals, the
sand dune rises to a knoll at the upper left,
where seven figures in Moorish dress are
seated and one standing. They register as
black and brown squiggles outlined against
a cloudy sky with faint streaks of blue; some
tufts of grass are visible on top of the dune
to the right. Like so many of the Moroccan
sketches, this one is a tonal exercise, con-
trasting the creamy white tones of the sky
and sand with the grey of the donkey.
Darker tones are created by leaving patches
of the mahogany panel bare.

The sketch on the reverse shows three
working boats on greenish-grey water, with
a pair of posts and two doorways faintly
sketched in beyond them. The panel is left
bare at the top and bottom. The boats are
likely to be Venetian, and the presence of a
building suggests a canal scene. Dr Pieter
van der Merwe of the National Maritime
Museum, Greenwich (information to the
compilers, June 2001), suggests that the
larger boats may be of the *carolina* type, a
Venetian working boat decked fore-and-aft
with a mast dismountable through a centre
thwart, or *trasto*. The small boat in the mid-
dle may be a *sandolo,* the distinctive Venetian
scull. It is not possible to determine whether
the boats are flat-bottomed, which would
be conclusive evidence of their Venetian
origin. If this is the case, Sargent must have
reused the panel some months later when
he went to Venice in September 1880.

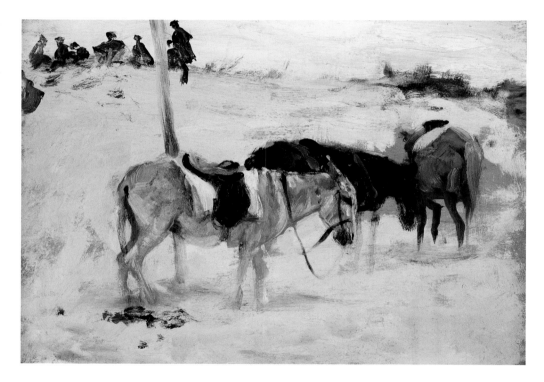

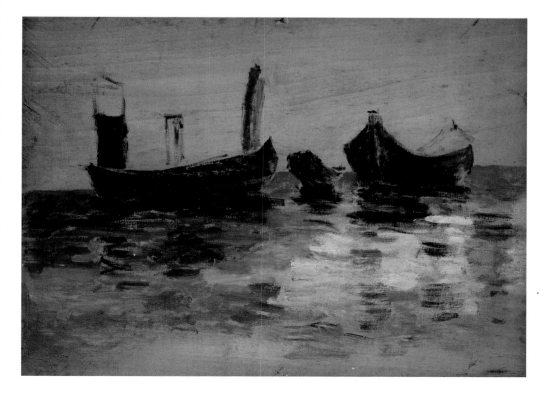

789
Fumée d'ambre gris

1880
Oil on canvas
54¾ x 35¹¹⁄₁₆ in. (139.1 x 90.6 cm)
Inscribed, lower right: *John S. Sargent Tanger* [*sic*]
A second inscription, *John S. Sargent Tanger,*
visible at the centre on the lower edge of the
canvas, has been painted over
Sterling and Francine Clark Art Institute,
Williamstown, Massachusetts (15)

The picture was begun in the patio of a small Moorish house which Sargent and an unidentified friend (see p. 282) had rented for use as a studio in Tangier (the inscription on the canvas, 'Tanger', is the French form), Morocco, in January 1880. Sargent described the house in a letter to his friend Ben del Castillo (4 January 1880) which is quoted in the introduction to this chapter (p. 282).

Sargent painted a series of oil sketches in Tangier and the surrounding area, describing the characteristic geometry of the local architecture, the dazzling white walls and the distinctive Moorish arches and doorways (see nos. 777–83 and, for related studies in pencil, see figs. 180, 181). In *Fumée d'ambre gris,* he integrates his interest in local architecture with figural concerns, placing his model in an architectural niche in the open courtyard of a building which appears to date from the eleventh or twelfth century. The image might suggest a mosque, but the architecture may be close to that of the patio space in Sargent's rented studio or it may indicate a conflation between an actual building and artistic imagination. The young woman whom Sargent used as a model is more likely to have come from the Jewish, rather than the Muslim, community in Tangier, as life for Muslim women was more circumscribed, even in the more cosmopolitan centres. The model is posed just right of centre beside a round column, which supports an arch decorated with distinctive Moorish scrollwork. She stands on a long, narrow rug with strong blocks of colour (yellow, red and black) and zigzag shapes which form geometric patterns with the traditional turquoise floor tiling (*zelij*). She infuses herself with grey smoke wafting up from an ornate, pierced-silver censer (*mbahra*), which stands directly in the centre foreground.

The title indicates that the smoke is produced by ambergris, a wax-like substance formed in the intestines of the sperm whale, which produces a sweet, earthy, musky scent. Ambergris has been extracted, venerated and traded since ancient times. It was prized in the East for both aphrodisiac and medicinal qualities and, once introduced to the West, used as a spice or flavouring, a scent and a fixative for perfumes. Both rare and costly, it was used in inhalation and fumigation rituals in North African Muslim and Judaic traditions. A fear of evil spirits is embedded in Moroccan culture, and these rites were performed to ward off demonic spirits and were associated with significant events such as marriage and childbirth and with specific conditions such as infertility. The ceremony may, however, be less highly charged, as the perfuming of clothes with ambergris or various substitutes was also an established feature of Moroccan culture.

The ivory robe worn by the figure in Sargent's picture is consistent with the traditional, generic Moroccan dress that has been worn as both day and night attire by men and women, Jews and Muslims, in North Africa and Spain since the eleventh century. While there are numerous variants—with regard to material, colour, decoration and style of draping (according to local or tribal custom and social class)—the garment is basically constructed from a single length of fabric, known as a *haik* (with variants spelled *hayk, huque, huke,* from the Arabic verb *hak,* to weave), *izar, milhafa* or the Berber variant *tamelhaft.* The cloth can be woollen or cotton, plain or striped; it may be worn with a belt, and sometimes a separate sheet of fabric is used to form the hood.

The costume here is close to that worn by the 'Hlot' people, an Arabic tribe who lived south of Tangier. The rectangular sheet of material in a garment such as this would be around five metres long and two metres wide. It is wound round the figure twice, draping rather than following her form; it is brought over the shoulders from the back and fastened at the front on either side by pins or fibulae. As worn by the model in Sargent's painting, it is then looped over the head to create a canopy to trap the smoky fumes, ending in a fringe at the figure's right. The model also wears a loose, white undergarment (*tsamir*) with billowing elbow-length sleeves edged with orange; a wimple, veil or *litham* of similar material, originally designed as protection against the elements and used as a modest veil to hide the female face, covers her neck and jaw.[1] Her jewellery consists of two large, silver, triangular brooches (*bza'im* or *tisernas* in Berber), spare and stylized in design and linked by a chain (*silsala*), which act as the fibulae pinning the haik (a similar device is visible in a painting by the American artist Frederic Arthur Bridgman, *Women of Biskra Weaving a Burnoose,* which was exhibited at the Salon in 1880, the same year as *Fumée d'ambre gris*).[2] She also wears a ring on the small finger of her right hand. The face of Sargent's model is elaborately and exotically made up: her lips, nails and eyebrows are stained with henna; her eyelids are enhanced with *kohl,* and her eyebrows are accentuated and extended to form one continuous, dramatic line, reflecting both an ancient Eastern tradition and a contemporary ideal of Eastern beauty.

It is clear that Sargent has been deliberate and selective in using elements of dress and decoration from different geographical locations and different traditions for his own artistic purposes. The costume, for example, is broadly northern Moroccan in its influences, and the pronounced zigzag pattern of the rug is similar to designs produced in the city of Rabat, which is situated on the Atlantic coastline of Morocco, but the triangular shape of the brooches is Berber in style.[3] His choosing so little, and such stylized, jewellery is striking: most local women would have worn several heavy pieces to adorn their neck and upper body. The elaborate censer in the foreground is distinctly elegant and urban: vessels in local communities would be made of clay. *Fumée d'ambre gris* is allusive, poetic and theatrical rather than literal and

Fig. 185
Sketch after 'Fumée d'ambre gris', 1880. Pen and
ink on paper, 11⅜ x 7¹³⁄₁₆ in. (28.8 x 19.9 cm).
Sterling and Francine Clark Art Institute,
Williamstown, Massachusetts.

Fig. 186 *(below left)*
Left Hand Study for 'Fumée d'ambre gris', 1880.
Pencil on paper, 9¹³⁄₁₆ x 13³⁄₁₆ in. (24.9 x 33.4 cm).
The Metropolitan Museum of Art, New York. Gift
of Mrs Francis Ormond, 1950 (50.130.140s recto).

Fig. 187 *(below right)*
Hand Studies for 'Fumée d'ambre gris', 1880. Pencil
on paper, 9¹³⁄₁₆ x 13⅜ in. (24.9 x 34 cm). Corcoran
Gallery of Art, Washington, D.C. Gift of Violet
Sargent Ormond and Emily Sargent, 1949 (49.130).

descriptive. Everything about his model and her environment is sophisticated (her make-up, the vessel at her feet), refined (the graceful gesture by which she pulls the edges of her headdress between the tips of her fingers) or pared-down (the dazzling white robe and the sparse decoration). Sargent has taken a popular orientalist theme and alchemized it through his own hyper-refined Parisian artistic sensibility to create an image that is indelibly aesthetic and luminescent.

When Sargent sent a photograph of the painting to Vernon Lee, he noted in an accompanying letter (9 July 1880, private collection): 'It is very unsatisfactory because the only interest of the thing was the colour'. The concept certainly posed considerable technical challenges—the clarity with which the figure and accessories stand out from the architectural background required the most subtle adjustment of tones and tints and precision in the recording of surfaces and textures—but Sargent's disclaimer strikes a disingenuous note. The colour scheme of white-on-white acts as the unifying formal principle of a painting that is an exquisite tone poem demonstrating Sargent's technical skills, his rarefied, esoteric interests and his pictorial mode of thinking.

Fumée d'ambre gris was inspired by Tangier, but it was certainly finished in the studio in Paris; Sargent had returned there in February owing to the onset of rain in Morocco. The artist's sister, Emily, wrote to Vernon Lee on 16 March 1880:

John returned to Paris about a month ago leaving Tangier in haste as the rains had begun, & he could not continue his picture of an Arab woman which he was painting in the Patio of the little house his friend & he hired for a studio. He sent us a little water-colour sketch to give us an idea of the picture. It is a figure all draped in white, against a white background, & standing on a rug of rich colour, chiefly orange, black & white, & there is a little blue in the tiles on the floor. She is standing with her arms raised & holding her head-dress over the smoke of an incense burner. It is very original, & I like it extremely. If it is photographed you shall have one. The 'Illustration' wants to engrave this one & John's portrait of Mme Pailleron [see Early Portraits, no. 25] before they are sent to the Salon, apparently, so we had to return the watercolour as John said it would be very useful to the wood engraver' (Vernon Lee Papers, Special Collections, Millar Library, Colby College, Waterville, Maine).

The pen-and-ink sketch after the painting (fig. 185) was presumably executed to assist potential illustrations for the Salon catalogue of 1880.

The process of development and elaboration can be partially traced through a small body of preliminary work. The overall design and chromatic arrangement of the composition are worked out in an oil sketch (no. 790); but the figure is more fully and finely realized in the present work, the silver incense burner at the feet of the figure has been added, and the details of the carpet and the tiled floor have been more carefully delineated. Two sheets show the attention Sargent paid to the expressive gestures of the hands and the delicate positioning of the extended fingers which hold up the hood of the robe; each sheet consists of recurring sketches of the hands with slight changes in the angle of the wrists and the placing of the fingers (figs. 186, 187). He also drew a detailed study of the large, intricate brooches that hold her robe together (fig. 189). For an engraving of similar North African decorative jewellery, see fig. 188.

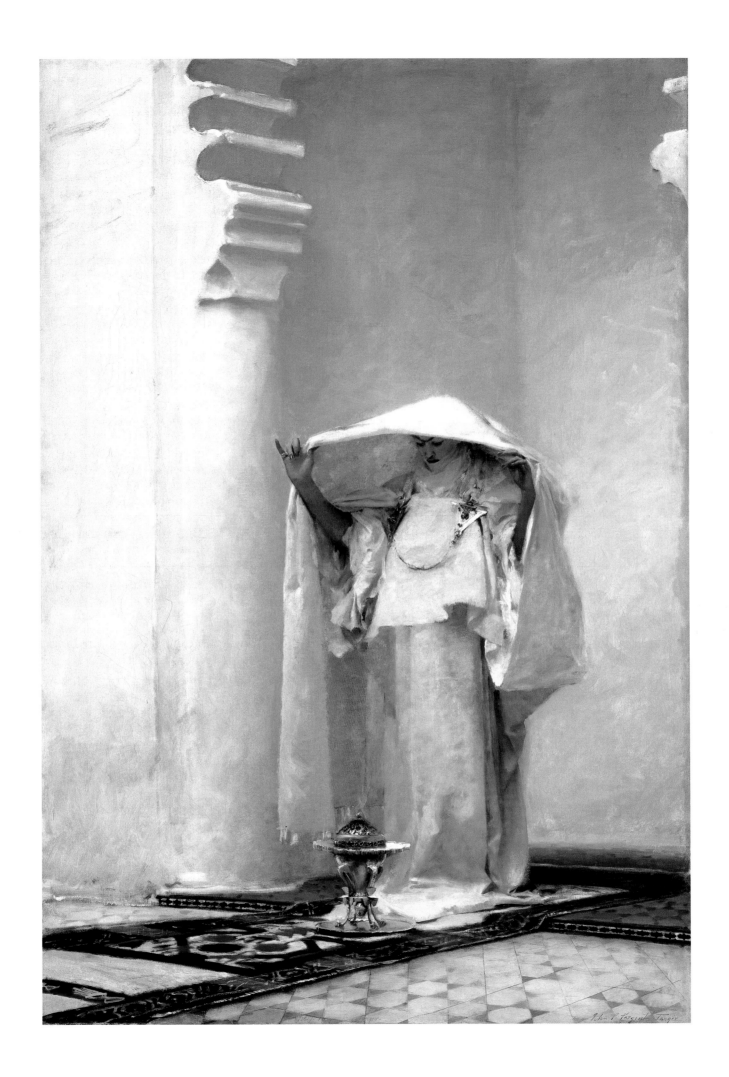

Boucle d'oreille à bosses (m'charef bos kroma), argent fondu d'une seule pièce plate qui est ensuite recourbée en cercle.

Boucle d'oreille (m'chreff), en or ciselé.

Pendant d'oreille (m'charef), en or, coulé d'une pièce.

Anneau d'oreille (chnachma), en or, orné de joaillerie.

Pendant d'oreille (m'charef), fil d'argent recourbé noué au corps principal, dont les fleurs, les filigranes et les huit anneaux destinés à recevoir des pendeloques, proviennent tous d'un seul moulage.

Pendant d'oreille (dalah khnachtem), argent et corail; gros fil d'argent et pièces latérales formées de lames d'argent martelées et soudées entre elles.

Pendant d'oreille (m'charef), orné de boucles de corail et d'une garniture d'or travaillée au repoussé avec des parties en filigrane.

Boucle d'oreille (dalah), gros fil d'argent travaillé en morisme, orné de chaînes de corail et de mains porte-bonheur.

Crochets d'oreille (khersa), fil d'or recourbé enrichi de diamants, de perles et de pierres.

There are two studies of hooded figures which, while not directly related to the composition of *Fumée d'ambre gris*, confirm Sargent's interest in swathed and hooded figures (figs. 190, 191). It is not certain whether the water-colour (no. 791), which is inscribed to Dr Pozzi (see *Early Portraits*, no. 40), is a study for, or a sketch after, the picture; it may be the small sketch described by Emily Sargent in her letter of 16 March 1880 (see p. 300).

The inscription in the centre on the lower edge of the canvas is presumably earlier in date than that at the lower right; it has been painted over, perhaps during a process of repainting, so as to integrate the floor area into the overall composition: it now registers as *pentimento*. The picture was finished in time for submission to the Salon, where it appeared in May 1880 alongside Sargent's portrait of Mme Édouard Pailleron (*Early Portraits,* no. 25). It received some strikingly favourable reviews. Several critics called on the spirit of that supreme French orientalist Théophile Gautier. Here is A. Genevay:

His [Sargent's] Fumée d'ambre gris *is one of the pictures in the Salon that most intrigues those members of the public who are unfamiliar with the refinements of sensual pleasure. If Théo [Théophile Gautier] were still alive, what an inspiration this canvas would have been to his writing. This Oriental woman who perfumes herself and awakens passion (they do say, such is the quality of ambergris, that the adventurer Casanova took it*

Fig. 188 *(left)*
Engravings of traditional gold and silver jewellery from North Africa, from *Revue des arts décoratifs*, 1901. Photographic plate, Bibliothèque Nationale, Paris.

Fig. 189 *(above right)*
Study for the Jewellery in 'Fumée d'ambre gris' (Metalwork designs), 1879–80. Pencil on paper, 9¾ x 13½ in. (24.9 x 34.2 cm). British Museum, London (1959.1.2.8 verso).

Fig. 190 *(below left)*
Reclining Figure (Study for 'Fumée d'ambre gris'), 1880. Pencil on paper, 10 x 13 in. (25.4 x 33 cm). Private collection.

Fig. 191 *(below right)*
Lady with Covered Head. Pencil on paper, 9¾ x 13⅜ in. (24.8 x 34 cm). Fogg Art Museum, Harvard University Art Museums, Cambridge, Massachusetts. Gift of Mrs Francis Ormond, 1937 (1937.8.180).

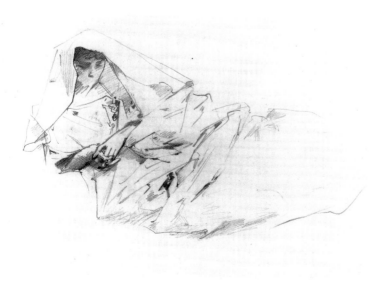

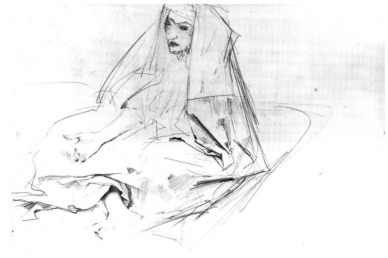

SARGENT.

3429

CHAMPIGNON DU SÉRAIL.
Espérons qu'il n'est pas vénéneux.

Fig. 192
'Le Salon Pour Rire—Par Paf (Troisième Promenade)', *Le Charivari*, 12 May 1880, p. 3.

as a powder in his chocolate) is a figure that is bizarre and original in effect. It is a very lovely picture for a private bedroom. I wonder if, amongst our pleasure-loving beauties, Mr Sargent will have the distinction of having introduced a practice which might become dear to those with ultra-refined tastes.[4]

In an intriguing piece in *Le Charivari* (13 May 1880, pp. 93–94; also see fig. 192), Louis Leroy imagined a conversation between Édouard Manet, William Bouguereau and Sargent's master, Carolus-Duran:

M. Manet: I like Sargent very much. The Portrait of Madame E. P. is extremely fine. The hands, the gown, aren't they well painted! And that Moroccan woman who is perfuming herself with amber-gris. It is a complete symphony in White Major. White on white, white everywhere.
M. Bouguereau: Is she perfuming herself or warming herself over that fancy heating apparatus.
M. Manet: It is strange! Sargent is one of my pupils on the rebound.
M. Carolus-Duran: He comes forth from my studio without rebounding anywhere. I entreat you to believe it.
M. Manet: Won't you accept that that high horizon in the portrait and that little building that gets lost at the top of the frame are in my usual style?
M. Carolus Duran: Is that why I never liked those details? (They laugh).[5]

Writing for *Le Temps* (20 June 1880, p. 1), Paul Mantz responded with enthusiasm to its rarefied but sensuous mood, which he compared with 'une fantasie mélodique'. A

few years later Henry James summed up its qualities: 'I know not who this stately Mohammedan may be, nor in what mysterious domestic or religious rite she may be engaged; but in her muffled contemplation and her pearl-coloured robes, under her plastered arcade, which shines in the Eastern light, she is beautiful and memorable. The picture is exquisite, a radiant effect of white upon white, of similar but discriminated tones' (James 1887, p. 688).

The painting also impressed the young Chilean diplomat Ramón Subercaseaux and his wife. After seeing 'a small picture of an oriental woman perfuming her clothing with aromatic incense from a brazier' (typed extracts from Mme Subercaseaux's diaries, catalogue raisonné archive), Subercaseaux sought out the artist and commissioned him to paint a portrait of his beautiful wife Amalia (see *Early Portraits*, no. 41).

Fumée d'ambre gris was sold to a Frenchman for 3,000 francs before the Salon exhibition closed. Emily Sargent wrote to Vernon Lee (23 May 1880): 'Mamma had a Postal some evenings ago from John, saying that the Tangier Arabe woman that he painted there last winter, has been sold to a Frenchman living in Paris for 3,000 francs only. I think it is too little. I am so glad to see it in the Salon now, for otherwise we might not be able to' (Vernon Lee Papers, Special Collections, Millar Library, Colby College, Waterville, Maine). According to the Bank of England, the exchange rate in 1880 was 25.51 francs to the pound, which would mean that the picture was sold for approximately £120 ($575).

The Frenchman was probably the artist Paul Borel (1828–1913), who painted historical and religious subjects; he worked on decorative frescoes for a number of ecclesiastical buildings, including several churches in his home town, Lyons. *Fumée d'ambre gris* was sold in July 1914, a year after Paul Borel's death, by a Mme Borel (presumably his widow) to the dealers Boussod, Valadon & Cie, Paris. They sold it to M. Knoedler & Co., London (6 July 1914). It was acquired from Knoedler in New York by the American collector Robert Sterling Clark on 10 September 1914, and is now part of the collection which forms the Sterling and Francine Clark Art Institute in Williamstown, Massachusetts. This information is contained in a letter from M. Knoedler & Co., New York (4 December 1957), to a member of the staff at the Sterling and Francine Clark Art Institute (archives), which indicates that the painting 'was bought from Madame Borel, Paris, in July 1914 and was

sold almost immediately to Mr R. S. Clark'. It is confirmed in *livre* 15, Boussod, Valadon & Cie stockbooks, Getty Research Institute, Los Angeles, and in the stockbooks of M. Knoedler & Co., New York. There are several references to the painting, and to the drawing after the painting (fig. 185), which Clark also acquired, in Clark's diaries (Robert Sterling Clark diaries, Sterling and Francine Clark Art Institute archives; several of the diary entries are quoted in Simpson, *Antiques*, 1997, pp. 556, 557 n. 6).

1. The Italian writer and author of popular travel books Edmondo de Amicis described the grace and variety of these garments: 'The greater part [of the population of Morocco] have nothing on but a simple white mantle; but what a variety there is among them! Some wear it open, some closed, some drawn on one side, some folded over the shoulder, some tightly wrapped, some loosely floating, but always with an air; varied by picturesque folds, falling in easy but severe lines, as if they were posing for an artist. Every one of them might pass for a Roman senator' (Edmondo de Amicis, *Morocco: Its People and Places*, translated by C. Rollin-Tilton [London, Paris and New York, 1882], p. 25).
2. The English traveller Mrs L. Howard-Vyse noted in her published account of a winter spent in Tangier: 'At the Arab shop to-day we saw some beautiful silver clasps with long chains, with which the women fasten on their haiks' (Mrs L. Howard-Vyse, *A Winter in Tangier and Home Through Spain* [London, 1882], p. 14).
3. In an undated letter to Vernon Lee [summer 1880], Emily Sargent wrote that her brother had brought back 'lots of pretty old rugs & properties' from North Africa for his studio (Vernon Lee Papers, Special Collections, Millar Library, Colby College, Waterville, Maine). See also Sargent's letter to Fanny Watts (14 May 1880), quoted on p. 282.
4. 'Sa *Fumée d'ambre gris* est une des toiles du Salon qui intrigue le plus le public peu au fait de ces raffinements de la volupté. Si "Théo" vivait encore, quelle belle manière à feuilletons lui aurait fournie cette toile. Cette Orientale qui se parfume et ravive ses ardeurs, car telle est, dit-on, la propriété de l'ambre gris, que l'aventurier Casanova prenait en poudre dans son chocolat, est une figure d'une effet bizarre et nouveau. C'est une fort jolie toile pour un boudoir secret, et, parmi nos épicuriennes beautés, Mr Sargent aura-t-il la gloire d'avoir introduit un usage qui deviendrait cher aux raffinées' (A. Genevay, 'Salon de 1880 [Huitième Article]', *Le Musée artistique et littéraire*, vol. 4 [1880], pp. 14–15).
5. 'M. Manet: Sargent me plaît beaucoup. Le Portrait de Mme E. P. est d'une distinction rare. Les mains, la robe, sont-elles assez bien peintes! Et cette marocaine qui se parfume d'ambre gris. Voilà une symphonie en blanc majeur réussie. Blanc sur blanc, blanc partout.
M. Bouguereau: Se parfume-t-elle ou se chauffe-t-elle, au dessus de ce grand réchaud.
M. Manet: Curieux! Sargent est un de mes élèves par ricochet.
M. Carolus-Duran: Il sort de mon atelier, sans avoir ricoché nulle part, je vous pris de le croire.
M. Manet: Osez donc soutenir que l'horizon montant du portrait et le petit pavillon qui se perd dans le haut du cadre ne sont pas dans ma manière habituelle?
M. Carolus-Duran: C'est pour cela que ces détails ne m'ont jamais plu? (On rit)'
(Louis Leroy, 'Le Congrès Artistique', *Le Charivari*, 13 May 1880, p. 94).

790
Study for 'Fumée d'ambre gris'

1880
Alternative titles: *Study for Fumée d'ambre gris; Study for 'Ambergris'; Ambregris—a Study*
Oil on canvas
32 x 21¼ in. (81.3 x 54 cm)
Private collection

This version of *Fumée d'ambre gris* was almost certainly painted in the Moroccan town of Tangier, probably in January 1880, as a study for the exhibited picture (no. 789). In the present work, Sargent has concentrated on the essential pictorial elements of the composition, working out the precise pose, gestures and placement of his model and establishing the architectural setting and overall tonality, but leaving certain aspects undeveloped (the model's right hand, for example, is summarily treated), with the result that the figure emerges from the stark and near-abstract background as a monumental and mysterious presence. It is apparent that Sargent's interests are modern, formal and aesthetic, his concerns with the poetic potential of the white-on-white tonal harmonies rather than with the specifics of ceremony and setting. The handling is broad and fluid, and the virtual absence of colour notation and the suppression of descriptive detail mean that the monochromatic principle of the composition is even more pronounced than in no. 789, which gives this canvas a discrete and distinctive tonal radiance.

The differences between the two works lie in their attention to decorative detail. In no. 789, Sargent takes the figure to a higher level of finish, introducing the silver incense burner with smoke emanating from it, delineating the intricate and colourful floor tiling, drawing the pattern of the carpet more precisely and adding bright orange paint to his model's fingernails.

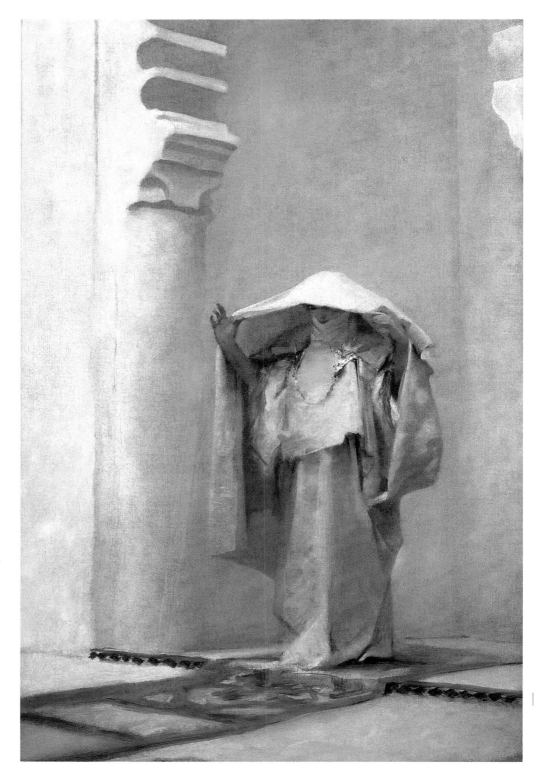

1880
Alternative titles: *Fumée d'ambre gris;*
Mauresque
Water-colour on paper
12¼ x 7¾ in. (31.1 x 19.7 cm)
Inscribed, lower right: *à Pozzi souvenir*
amical/John S. Sargent
Isabella Stewart Gardner Museum, Boston
(P3w33)

The composition of the water-colour is
almost identical to that of the finished oil
(no. 789) and may have been done after it.
It may, however, have been executed as an
aide-mémoire to assist Sargent in completing
the painting in his Paris studio, as heavy
rain had forced him to leave Morocco with
the work unfinished (see the entry for
Fumée d'ambre gris, p. 300).

The water-colour is more freely drawn
and less detailed than the oil, but there are
few substantive differences: the brooches,
chain and incense burner, for example, are
not carried to the same degree of finish;
there is no suggestion of smoke from the
incense burner; and the pattern of the
tiling is less specifically drawn. Decorative
details which are so striking in *Fumée d'am-
bre gris,* such as the model's red/orange fin-
gernails and the pattern of the floor tiling,
have not been incorporated. In responding
to the water-colour medium, Sargent has
used thin, transparent washes over white
paper, exploiting the reserve to create a
white-on-white radiance that, while less
resonant in timbre than that in the oil,
describes a singular, bright luminosity.

The painting is inscribed to Dr Samuel
Jean Pozzi (1846–1918), whose portrait
Sargent painted in 1881 (see *Early Portraits,*
no. 40); the inscription suggests that Sar-
gent presented it to him as a gift. Pozzi also
owned the lamplight study of Mme Gau-
treau drinking a toast, a water-colour of
Judith Gautier in a garden setting (*Early
Portraits,* nos. 116, 79, respectively), and an
unidentified 'Conversation vénitienne' (see
the introduction to chapter 10, p. 321).

In a letter to Vernon Lee of 16 March
1880, Emily Sargent notes that Sargent sent
a water-colour of the subject to his family
so that they would be able to see what he
had been working on, adding that they had
to return it to him because it would be
helpful to the wood engraver, who was
making an engraving for reproduction in
L'Illustration (the relevant section of the let-
ter is quoted in the entry for *Fumée d'ambre*

gris, p. 300). It is possible that the present
work is the same as that discussed in Emily's
letter: if the water-colour was indeed re-
turned to Sargent, he may have inscribed it
to Dr Pozzi at a later date.

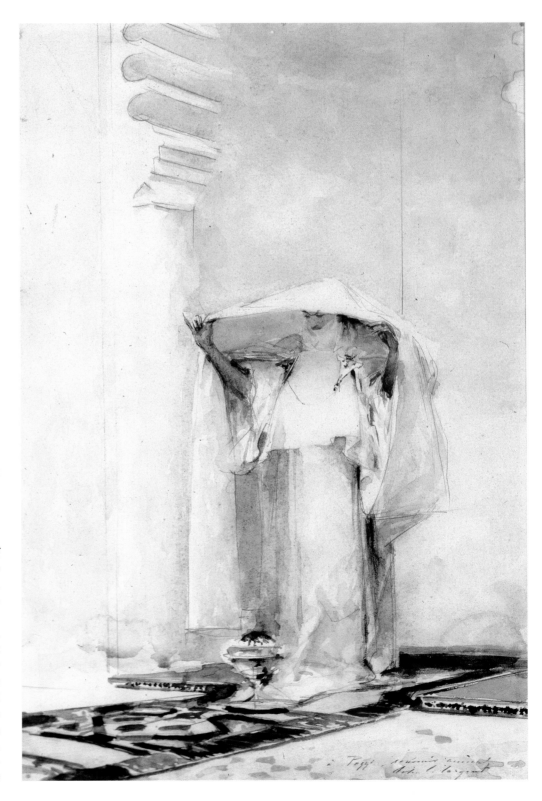

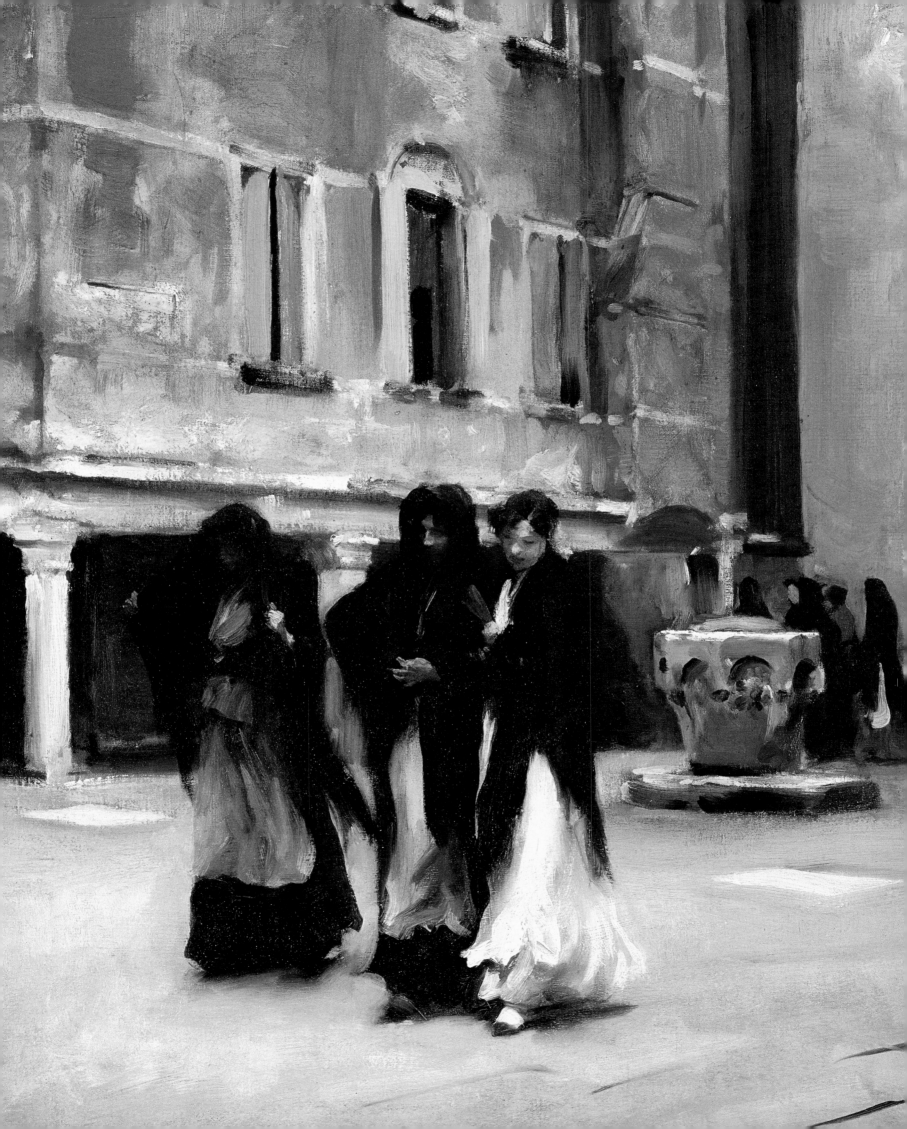

BIOGRAPHICAL BACKGROUND

Sargent spent two seasons in Venice, in the winter of 1880–81 and the summer of 1882, painting a group of figure subjects and topographical views that constitute one of the high points of his early art.[1] Biographical details of his two residences in Venice are fragmentary, though more information has come to light recently. The chronology of what he painted, and when it was executed, is still far from resolved, although the authors have attempted to distinguish between the works of the two periods (see 'Venetian Chronology and Exhibitions', pp. 319–22). Sargent was well connected, both within the community of artists in Venice and with a number of leading figures of expatriate Venetian society. Not for the first time, he combined an active social life with intense creative activity.

The artist first arrived in the city in mid-September 1880, in company with his Chilean patron and friend Ramón Subercaseaux, whom he was to portray at work in a gondola (fig. 193; see *Early Portraits,* no. 87). Intriguingly, it appears that Sargent's other Chilean friends José Tomás and Eugenia Huici Errázuriz were also in Venice, spending their honeymoon in the unnamed palazzo which the Subercaseauxs had taken on the Grand Canal.[2] According to the same source, Sargent was also a guest in the palazzo, working there on the portrait of *Madame Ramón Subercaseaux* (*Early Portraits,* no. 41) and sketching Eugenia Errázuriz. According to Mme Subercaseaux's diaries, her portrait was painted in the artist's studio in Paris, but it is possible that Sargent's vivid profile sketches of Eugenia were done in Venice, although his two full-face portraits of her are almost certainly later (see *Early Portraits,* nos. 69–72). Richard H. Finnegan, who supplied the authors with this reference, believes that the Errázuriz

couple may have posed for some of the Venetian figure subjects.

Sargent is known to have taken lodgings at 290 Piazza San Marco, a building close to the famous clock tower. His mother and sister Emily had preceded him to the city, taking rooms at the Grand Hôtel d'Italie, close to the church of San Moisè (now the Hotel Bauer-Grünwald and completely remodelled). They departed at the end of September 1880, leaving Sargent to his own devices. He was to remain in the city for approximately six months, departing for Paris in February 1881. He had come to find a subject for a Salon painting, in succession to *Oyster Gatherers of Cancale, A Capriote, Fumée d'ambre gris,* and the Spanish picture he already had in mind, and which he later completed in his Paris studio under the title of *El Jaleo* (nos. 670, 702, 789, 772). The ideas and preoccupations of his Spanish masterpiece fed into his Venetian studies, conceived and painted over the same span of time.

Unable to find a subject worthy of the Salon on his first visit to Venice, Sargent returned eighteen months later to take up the challenge again. His second residence was much shorter than his first, three rather than six months, from August to October 1882. Once more a Salon picture failed to materialize—the *Full-Length Study of a Venetian Model* (no. 800) is the closest he came to it—and he had to content himself with a second group of works in a minor key.

Sargent's Venetian scenes continue his sequence of working-class subjects with a largely female cast of characters. The city was popular with artists (the vogue for Venetian genre scenes was at its height), he had many friends there, and he liked exotic locations: Brittany, Capri, Andalusia, Tangier and now Venice. What is striking about his Venetian pictures is the extent to which they avoid the romantic vision of Venice as a fairy-tale

city, bathed in colour and light. Sargent's Venice of the 1880s is a very different sort of place: drab, dirty, decaying, working class, down-at-heels—a place where sex and danger lurk in dingy streets and gloomy hallways. Sargent was responding to the grainy realism of French painting in his choice of subject matter, and to Velázquez, Frans Hals and Vermeer in terms of style and painterly finesse. Shortly before coming to Venice in September 1880, he had been to Haarlem in Holland to study and copy the work of Hals, and the distilled quality of his interiors surely owes something to the work of Vermeer and Pieter de Hooch.

Well connected to the literary world of Paris, Sargent was also influenced by the aesthetic tastes and preoccupations of *fin-de-siècle* writers. Unlike the great art critic John Ruskin and earlier moralists of the mid-nineteenth century, who read in the decline of Venice a moral judgement on a corrupt government and decadent society, this new generation of writers revelled in the idea of the city as a place of decaying splendour and corroding beauty, of sensual indulgence and liberation from convention. 'The city was a theatre of masks and *maquillage*', wrote John Pemble in his influential book *Venice Rediscovered,* 'a temple of the abnormal and the perverse; a hospital of pathological process. And Venice was the quintessential city. There were no slums more slummy than the Venetian back canals, with their leprous buildings and odour of decay; while in the great Venetian palaces there was an unparalleled example of human contrivance at odds with nature. No further refinement of art was possible'.[3] Sargent's pictures are in tune with the writings of those contemporaries who relished Venice because it was so rarefied and dream-like, and so inexorably doomed. Henry James called it 'the most beautiful of tombs . . . The vast mausoleum has a turnstile at the door, and a functionary

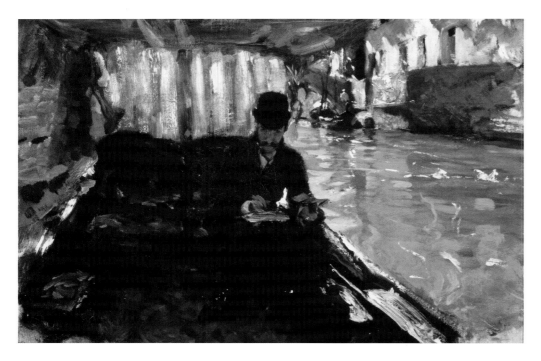

Fig. 193
Ramón Subercaseaux in a Gondola, c. 1880. Oil on canvas, 18½ x 25 in. (47 x 63.5 cm). The Dixon Gallery and Gardens, Memphis, Tennessee. Gift of Cornelia Ritchie (1996.2.13).

in a shabby uniform lets you in, as per tariff, to see how dead it is'.[4]

James captures the essence of what it is about modern-day Venice that is so compelling, not the grand set-pieces but the fragments of back-street life: 'A girl is passing over the little bridge, which has an arch like a camel's back, with an old shawl on her head, which makes her look charming; you see her against the sky as you float beneath. The pink of the old wall seems to fill the whole place; it sinks even into the opaque water . . . On the other side of this small water-way is a great shabby façade of Gothic windows and balconies—balconies on which dirty clothes are hung and under which a cavernous-looking doorway opens from a low flight of slimy water-steps. It is very hot and still, the canal has a queer smell, and the whole place is enchanting'.[5]

For the writer Vernon Lee, Sargent's childhood friend and exact contemporary, Venice was overpowering. In a later essay, but one which captures the sinister aspects of the city, she wrote: 'The very beauty and poetry of Venice, its shimmering colours and sliding forms, as of a past whose heroism is overlaid by suspicion and pleasure-seeking . . . the things which Venice offers to the eye and the fancy conspire to melt and mar our soul like some music of ungraspable *timbres* and unstable rhythms and modulations, with the enervation also of "too much": more sequences of colours on the water, more palaces, more canals, more romance, and more magnificence and squalor'.[6] Sargent's view of Venice, like that of Henry James and Vernon Lee, is aesthetic, modern, moody and oblique.

Venice, as seen through the eye of the imagination, was a very different place to the modern city contending with the practical problems of existence. Following the departure of the Austrians and the advent of Italian independence, the city had once again put on its festive airs. Economically, the city prospered during the last quarter of the nineteenth century, with the development of industry and port facilities, the improvement in road and rail links, and the advent of mass tourism; Thomas Cook brought his first party to the city in 1867 and liked what he found;[7] water mains were gradually installed from 1882, banishing the familiar sight of water carriers going to and from the well-heads; the vaporetto arrived soon afterward, to the dismay of Henry James, who hated this modern intrusion into the peace and quiet of the Grand Canal; sanitation was improved, lessening the threat of cholera; and large areas of the city were shored up and repaired. The evidence of poverty and destitution was there, but you had to leave the main tourist routes to experience it.

Sargent settled easily into the large Venetian art community where he already had many friends. He took a studio in the Palazzo Rezzonico, famous as the future home of 'Pen' Browning, son of the poet Robert Browning, which Emily Sargent describes in a letter to Violet Paget (the writer Vernon Lee) of 22 September 1880: 'He expects to remain on here indefinitely, as long as he finds he can work with advantage & has taken a studio in the Palazzo Rezzonico, Canal Grande, an immense house where several artists are installed, &

where one of his Paris friends has also taken a room to work in. Unfortunately there are no skylights, but those seem to be unknown here excepting to Photographers'.[8] The palazzo is the setting for the painting of *Venetian Women in the Palazzo Rezzonico* (no. 793).

The English painter Henry Woods, who was to make his home in the city, was much struck with Sargent's work when he visited his studio in October 1880: 'His colour is black but very strong painting'.[9] Woods and his brother-in-law Luke Fildes, who arrived in January 1881, became good friends of Sargent, as did a third English painter, William Logsdail, who had been in Venice since the autumn of 1880.[10] He had a studio in the Calle Capuzzi, close to the Campo Sant'Agnese in Dorsodoro, where, according to one source, another Sargent studio was located.[11] Sargent gave and inscribed a water-colour study of a Venetian mother and child to Logsdail as a sign of their friendship (no. 835).

Sargent had links with other painters among the colourful and polyglot community of international artists who swarmed to Venice in search of subjects. The dean of the current genre painters was the flashy and exuberant Dutchman Carl van Haanen, in England known as Cecil van Haanen, to whom Sargent presented an oil sketch of the head of a woman (see no. 635). A second successful artist was the Austrian Eugene von Blaas, who succeeded his father as director of the Accademia delle Belle Arti in Venice. Of Sargent's links with native Venetian artists there is no record, though he was to exhibit with them at the impor-

tant national exhibition of 1887, a precursor of the Biennale exhibitions.[12] It is probable that he was aware of the work of two especially talented artists, Giacomo Favretto and Ettore Tito. Favretto's genre scenes, like those by Sargent, have a sensitive feeling for the peculiar qualities of Venetian light and atmosphere, while Tito's work of the early 1880s already exhibits the painterly energy and dash that would earn him international recognition in the following decade (see fig. 194).

It would be interesting to discover if any of the French painters to whom Sargent presented Venetian pictures coincided with him in Venice. The most significant of these was Jean-Charles Cazin, a landscape and subject painter whom Sargent admired and by whom he was influenced. Cazin's spare and poetic style can be traced in Sargent's early Capri pictures and also in the Venetian street scenes.[13] The picture Sargent gave him was one of the interiors with bead stringers (no. 795), which would have appealed to Cazin because of its sense of structure and its haunting atmosphere. Sargent's only panoramic view of Venice, *Venise par temps gris* (no. 819), went to his exact contemporary François Flameng, an aspiring history painter, who appears with Paul César Helleu in a sensitive double portrait sketch by Sargent of this early period (*Early Portraits,* no. 90). Other recipients of Sargent's Venice works include the subject painter Alfred Philippe Roll and the Paris-based sculptor Gustav Natorp, a pupil of Rodin, who was also the subject of a portrait head in oils (*Early Portraits,* no. 147). Sargent's master, Carolus-Duran, is recorded as a guest at the Palazzo Barbaro,[14] and several Venetian canal views by him are known, but the date of his visit or visits is probably later. The most famous French artist to visit Venice at this time was Pierre-Auguste Renoir, who came in 1881. His scintillating views of the Grand Canal strike a very different note to Sargent's austere vision of back-street life.

The artists to whom Sargent was closest in Venice were his fellow-Americans. His cousin Ralph Curtis, with whom he had studied at Carolus-Duran's atelier, was a resident of the city, the only son of Daniel and Ariana Curtis (see below). It may well have been at the urging of Ralph Curtis that Sargent had decided to come to Venice in the first place, and the two friends seem to have worked closely together, on one occasion in 1882 painting the same street scene side by side (see no. 808 and fig. 219). Curtis's pictures have sometimes been mis-

taken for Sargent's, and his facility as a water-colourist may well have spurred Sargent to take up the medium once more. Writing a letter of introduction for Curtis to Violet Paget (Vernon Lee) on 22 October 1880 (private collection), Sargent wittily characterized his friend:

There is plenty of work to be done here and the only thing I fear is the ennui of living almost alone in a wet and changed Venice. All my friends are leaving. One of them, Mr Ralph Curtis of Boston I should very much like to present to you. He will pass through Florence on his way to Rome and will call upon your mother unless I receive telegraphic order to the contrary! His parents are very cultivated English and Americans, and he himself is a most delightful fellow who will surely find favour in your eyes and your brother's . . . He is a painter but does not wear long hair.[15]

Though he was eventually to abandon an artistic career, Curtis at this date was making his mark with Venetian figure paintings and views (see fig. 195). His first picture accepted at the Salon, in 1881, was a scene with a fishmonger entitled *Venise* (Salon no. 576); the description of it by his mother suggests close parallels with Sargent's street scenes.[16]

A lively group of young American expatriate artists gravitated around Curtis. They included the sons of two eminent sculptors resident in Rome: Gordon Greenough, whom Sargent painted in Venice in 1880 while he was terminally ill (*Early Portraits,* no. 85), and Julian Russell Story, whom he had known since boyhood. Charles Stuart Forbes, also painted by Sargent (*Early*

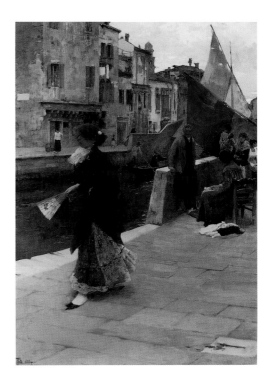

Fig. 194
Ettore Tito, *La Fa La Modela,* 1884. Oil on canvas, 37⅜ x 26⅜ in. (95 x 67 cm). Private collection.

Fig. 195
Ralph Curtis, *Drifting on the Lagoon,* 1884. Oil on canvas, 25½ x 37½ in. (64.8 x 95.3 cm). Private collection.

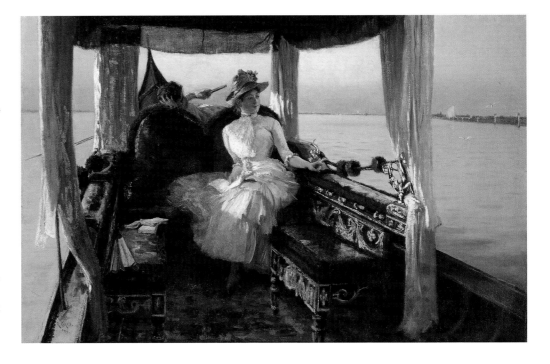

Portraits, no. 95), and Harper Pennington completed the group. In October 1881, four of them, Curtis, Story, Forbes and Pennington, and a fifth unnamed artist, set up their easels in the home of Mrs Katharine de Kay Bronson to paint her great friend Robert Browning.[17] Curtis and Story, along with Sargent and Whistler, contributed works to an exhibition organized by the Dublin Sketching Club in 1884; they were the only non-members represented, all of them American expatriates and linked to Venice.[18] The intermediary who arranged the loan was another member of the group, the charming Irish artist and aristocrat Fred Lawless, who succeeded his brother at the end of his life as fifth and last Baron Cloncurry.[19]

There seems little doubt that Sargent and James McNeill Whistler met in Venice, where their paths intersected for three months in the autumn of 1880. The English genre painter Henry Woods described Whistler's displeasure at talk in the artist colony of the prospect of 'a brilliant young American who lived in Paris named John Sargent' coming to Venice. Woods told Whistler a joke as they were going into a reception one day: '"Well, one sergeant doesn't make a battalion any more than one whistler makes an orchestra"'. Whistler asked if he could use the quip: '"I only want the bit about the sergeant and the battalion. I don't want the other bit"'.[20] Ralph Curtis was friendly with Whistler in Venice and provided reminiscences for Whistler's biographers, Joseph and Eliza-beth Pennell. His parents entertained the painter, and so did Mrs Katharine de Kay Bronson (1834–1901), the close friend of Robert Browning mentioned above, who lived at the palazzo Ca' Alvisi, at the mouth of the Grand Canal. The family of Mrs Bronson's brother-in-law, Theodore Bailey Bronson, had been well known to the Sargents in Florence in the 1870s,[21] and Sargent was to paint two portraits of her sister-in-law, Mrs John Joseph Townsend around 1881–82 (see *Early Portraits,* nos. 43–44).

Sargent's friendship with Mrs Bronson is recorded in a small group of drawings he contributed to an album of hers.[22] One of the drawings is a portrait sketch of Mrs Bronson's daughter, Edith, an eligible and attractive young woman who was later to marry Count Cosimo Rucellai. A second sketch shows Edith lounging back on a sofa with Gervase Ker (fig. 196). The latter was a 'sensitive and subdued' Englishman who lived in Venice, spoke the dialect and sometimes dressed as a gondolier. He was a gifted craftsman in wood and produced beautiful inlaid boxes. He was a favourite of Edith and remained in touch with her until his death in a concentration camp in 1940.[23] Ker's sister, Olga, was a friend of Browning and another popular figure in the Bronson/Curtis circle. Ker is interesting, too, because he owned Sargent's picture of the *Campo Sant' Agnese, Venice* (no. 815). A third Sargent drawing in the Bronson album is of Julian Russell Story, and a fourth shows two of the four Montalba sisters working at a table by lamplight. All four sisters were talented artists who lived with their parents and brothers at Palazzo Trevisan on the Zattere. Both Sargent and Whistler would send Mrs Bronson warm thank-you letters for her hospitality that are very similar in tone and sentiment.[24] A quotation from Sargent's letter reads as follows: 'Ralph Curtis tells me that you are surrounded with your guests as ever. It is difficult for me even to fancy your parlour without a glowing fire, yourself sitting near it in a particular chair; asking the Montalbas and me to write witty and beautiful verses, while . . . Miss Chapman brews pick-me-up at the Arabian bar'. Sargent is said to have advised Mrs Bronson on which pastels by Whistler she should buy when she wanted to help out the indigent artist, who was still recovering from his bankruptcy.[25]

The authors of the recent catalogue *Gondola Days* state that Sargent did not call on Daniel and Ariana Curtis during his visit to Venice in 1880–81 and did not know them before 1882.[26] This is contradicted by the letter from Sargent to Violet Paget (Vernon Lee) of 22 October 1880 quoted above, and it is inconceivable that so close a friend as Ralph Curtis would not have introduced the artist to his parents. The Curtises had yet to move into the Palazzo Barbaro, their legendary home on the Grand Canal, but they were already prominent in Anglo-Venetian society. In a letter to his sister Mary Curtis of 13 October 1879, Daniel records with pleasure how 'Whistler sat 2 yds off last evg in Piazza, so could see & hear him. He wears a little straw hat—& is ordinary of looks and speech & small of stature'.[27] Curtis drew a small sketch of Whistler in his straw boater in this same letter. Ralph Curtis, who was often in his company, recorded his own impressions of Whistler in the Piazza San Marco:

Very late, on hot scirocco nights, long after the concert crowd had dispersed, one little knot of men might often be seen in the deserted Piazza, sipping refreshment in front of Florian's. You might be sure that was Whistler in white duck, praising France, abusing England, and thoroughly enjoying Italy. He was telling how he had seen painting in Paris revolutionised by innovators of powerful handling: Manet, Courbet, Vollon, Regnault, Carolus Duran. He felt far more enthusiasm for the then recently resuscitated popularity of Velasquez and Hals.[28]

Sargent stayed with the Curtises at the Palazzo Barbaro when he came to Venice on his second visit in the summer of 1882. He painted a sensitive half-length portrait of

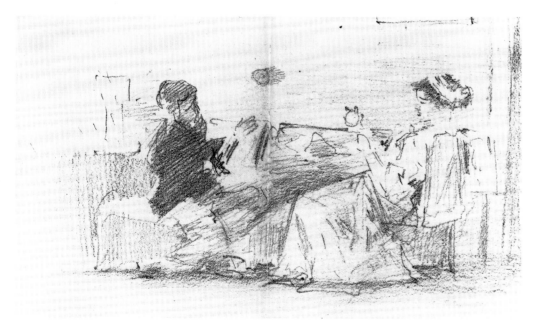

Fig. 196
Gervase Ker and Edith Bronson, later Countess Rucellai, c. 1880. Pencil on paper.
Inscribed, along bottom: *Gervase Ker E Rucellai / by Sargent.* Private collection.

Mrs Daniel Sargent Curtis, whom he nick-named the 'Dogaressa' to record his thanks (*Early Portraits,* no. 50). Daniel Curtis describes a dinner at which Sargent was present in a letter to his sister Mary of 5 October 1882.[29] There were the Endicotts, visiting from the States, Captain Avignone of the Italian navy, a consul or two, the Misses Timmini, the Brimmers and the philosopher William James, brother of the novelist Henry James. William James records his own impressions of the Palazzo Barbaro, when he lunched there a few days later, and saw 'their magnificent abode . . . They are very civilized people. Their son and his comrade Sargent (whose picture of a Spanish woman dancing, tumbling over backwards amid a whirl-wind of petticoats, with some black figures playing on banjoes agst. the wall, made a great sensation at the salon last year & was bo't by Algernon [*sic*] Coolidge) was there, a very pleasant modest-seeming young fellow. He & Curtis jr showed me their work, venetian streets and houses with people, very characteristic, & to my mind better than the Spanish thing'.[30]

Martin Brimmer, a friend of the Cur-tises and secretary of the Museum of Fine Arts, Boston, recorded his impression of Sargent's Venetian studies:

His [Daniel Curtis's] son is a very nice bright fel-low, with a love for his art and a nice feeling for it. Young Sargent has been staying with them and is an attractive man. The only pictures of his I have seen is a portrait of Thornton Lothrop, in which I thought the head a masterly piece of painting. He had besides some half finished pictures of Venice. They are very clever, but a good deal inspired by the desire of finding what no one else has sought here—unpicturesque subjects, absence of color, absence of sunlight. It seems hardly worthwhile to travel so far for these. But he has qualities to an unusual degree—a sense of values and faculty for making his personages move.[31]

A glimpse of life in the Palazzo Bar-baro is provided by Lady Layard, wife of the famous archaeologist and diplomat Sir Henry Austen Layard, in a diary entry for 7 October 1882: 'After dinner Mildred played piano, when Alice Henry & I went to see Mr. and Mrs. Curtis at Palazzo Barbaro the 2nd floor of wh. they have taken for 5 years & furnished very nicely. Met there Mr. Pennington and Mr. Sargent a young artist who is making himself a reputation, Mr. O. Browning & a few others whom I knew not. Home by 11'.[32] In a letter of this same period to Violet Paget (Vernon Lee), Sar-gent records with pleasure meeting Linda Villari, the English wife of the distin-guished Italian historian Professor Pasquale Villari, whose daughter Constanza by her first marriage would marry the painter William Hulton, another of Sargent's friends in Venice. His social network there spread far and wide.[33]

Whatever their personal relations may have been, and they were never intimate, Sargent and Whistler shared a remarkable artistic affinity at this time. They were both painting similar back-street scenes, with tall receding walls, backlit from behind, or bridges over side canals with sketchy fig-ures dashed in, or the sweep of the Riva, all atmosphere and no detail (see no. 819 and fig. 226). They also painted in the same hallway of an unidentified palazzo, which is the setting for at least one of Sargent's palazzo interiors (see no. 798 and fig. 217). Though they worked in different media, Whistler in pastel and etching, Sargent in oil, they shared the same underside view of the city and an aesthetic unique to them.

Several of Sargent's circle in Venice were pupils of the charismatic American painter Frank Duveneck, among them Charles Forbes, Harper Pennington and Julian Russell Story. Duveneck had trained in Munich, where he had been powerfully influenced by the expressive realism of the Munich School. A natural leader, he had acquired a following of American students, known familiarly as the 'Duveneck boys', who were attracted by his realist subject matter and forceful technique. When the master moved to Florence and then, in 1879, to Venice, his pupils followed him. Given Sargent's friendship with Forbes and Story, it is inconceivable that he did not meet Duveneck at some point in 1880. The 'Duveneck boys' provide another link between Sargent and Whistler. The latter moved in with a group of Duveneck's stu-dents in the Casa Jankowitz on the Riva; in the basement of the building Otto Bacher printed some of Whistler's early etched plates. Sargent painted the wife of one of Duveneck's followers, *Mrs Charles Gifford Dyer,* in a haunting oil sketch that is all black and moody (*Early Portraits,* no. 57). There are striking similarities between Sar-gent's *Pavement of St Mark's, Venice* (no. 812) and that by Robert Frederick Blum;[34] between Otto Bacher's etching of bead stringers (fig. 203) and Sargent's pictures of the same subject; and in his painterly stud-ies of Venetian models and those done by Duveneck. In time more evidence may come to light to document these relation-ships, but the aesthetic kinship is undeniable.

MODERN LIFE SUBJECTS

The presence of so many foreign artists in Venice was due to the vogue for Venetian genre paintings that was at its height in the early 1880s. Some critics talked about a 'Venetian school' as a distinct phenomenon. Here is Frederick Wedmore writing in 1883:

One of the characteristics of the Genre of the moment is that a whole group of the very best masters of it practise it in Venice. From Venice Mr. Van Haanen, Mr. Eugene de Blaas, and Mr. Henry Woods send to the Academy, and it is from Venice that Mr. Bartlett sends to the Grosvenor that delightful vision of summer on the Lagoons . . . The population is still the most picturesque, and perhaps the most varied in Italy, and the sep-arate life of the place and its unique position have created for it its own industries; so that the glass-blowers, and the bead-stringers, and the lace-makers can give the interest of novelty to the painters of every day.[35]

This was echoed by Julia Cartwright, who wrote a series of articles on artists in Venice in 1884:

Within the last few years we have seen the rise of a whole school of English and American artists who owe their inspiration to Venice, and have in a great measure formed their style from lessons learned in the lagoons. At no time have painters and etchers been more actively engaged in Venice than they are to-day and each year shows us larger and more important fruits of their industry. One by one they have drawn fresh treasures from the vast storehouse of her wealth, until the most remote byways and darkest courts have been explored and the wonders they contained have become familiar objects.[36]

Venice was not the place for graphic realism and very few pictures depict the grim conditions in many parts of the city and the suffering inseparable from urban poverty and destitution. The prevailing image of Venetian life is one of gaiety and vitality, of people who, though they may be poor, possess the key to happiness and enjoyment. Whether at work or play, they appear to be content with their lot and in harmony with the beauty of their sur-roundings. Even contemporary photogra-phers serve up an anaesthetized vision of the city, posing their figures in cunningly crafted compositions that make drudgery seem picturesque.

Of working-class occupations repre-sented in Venetian genre scenes, the most popular were those showing water carriers,

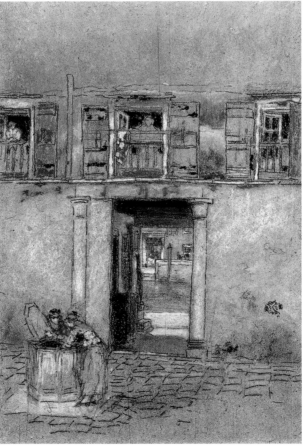

Fig. 197 *(above left)*
Photograph of Venetian water carriers.
Collection Osvaldo Böhm, Venice.

Fig. 198 *(above right)*
Frank Duveneck, *Venetian Water Carriers,* 1884. Oil on canvas, 48½ x 73½ in. (123.2 x 186.7 cm). Smithsonian American Art Museum, Washington, D.C. Bequest of Rev F. Ward Denys.

Fig. 199 *(right)*
James McNeill Whistler, *Courtyard on Canal: grey and red,* 1879. Chalk and pastel on brown paper, 11⅞ x 8 in. (30.1 x 20.2 cm). Saint Louis Art Museum, St. Louis, Missouri. Gift of J. Limberger Davis.

bead stringers and lace makers. Sargent covered the first two categories and added onion sellers to his repertoire (see nos. 793, 801). Prior to the introduction of water mains in the mid-1880s, Venice was dependent on a network of local wells, which, in dry weather, were liable to fail. Much of the fetching and carrying of water was done by professional water carriers or *bigolanti,* who were usually young women from the nearby north-eastern Alpine region of the Friuli. Scenes of women drawing and carrying water from the ancient well-heads, which still decorate the city's squares, were common both in art and photography (see fig. 197). In *Venetian Water Carriers* (no. 805), Sargent gives his own spin to this well-worn theme. In contrast to popular works by artists such as Eugene von Blaas, Luigi da Rios, Ellen Montalba and Frank Duveneck (fig. 198),[37] which are carefully posed and anecdotal in character, Sargent shows his water carriers in a private moment, caught off-guard and quite unconscious of being seen. A work which corresponds more closely to Sargent's aesthetic than the pictures by von Blaas and Duveneck is Whistler's pastel of *Courtyard on Canal: grey and red* (fig. 199), where the formal elements of the design and the feeling for atmosphere are remarkably similar.[38]

Venice is famous for its glass industry and for centuries its glass products, especially its glass beads, have been exported all over the world. A visit to the glass factories at Murano was part of the tourist itinerary,

and no one could miss the hundreds of Venetian women sitting in the streets and stringing beads. They formed part of the rich tapestry of local life, which so greatly appealed to the genre painters. In 1876, the Dutch painter Carl van Haanen had exhibited a picture of *Venetian Bead Stringers* at the Paris Salon (fig. 200), and the huge success of the picture helped to establish the vogue for this type of subject. Van Haanen depicted a scene of casual employment where the women sit and stretch, laugh and chat in a genial hubbub of activity. The interplay between the women, their distinctive individuality, picturesque costumes and characterful surroundings describe a whole society and way of life. Sargent's *Venetian Bead Stringers* (no. 804) takes the same diagonal design and a similar arrangement of the chairs in the foreground, but, in comparison with van Haanen's picture, it is sparse in incident and detail. The contemporary etching by the American artist Otto Bacher (fig. 203) reveals a close attention to detail, for all its technical innovation, which the Sargent avoids. The painting of bead stringers by Robert Frederick Blum is a colourful essay in genre painting (fig. 201), very different from the drab lives of bead stringers as recorded in contemporary photographs (see fig. 202).[39]

Bead stringing is the theme of Sargent's brilliant series of Venetian interiors. Two of them show the same upper dim hallway of a Venetian palace with a staircase at the far end (nos. 794, 795). A third interior (no. 798), showing a view down a hallway towards a balcony overlooking a canal, probably represents the same space. The hallway was also painted by Whistler in a pastel called *The Palace in Rags* (fig. 217). The same hallway was probably the setting for the *Full-Length Study of a Venetian Model* (no. 800), which is dated 1882, so Sargent could have painted there on both trips to Venice. A fourth interior, *Venetian Women in the Palazzo Rezzonico* (no. 793), differs markedly from those mentioned above, and some doubts as to its status remain.

Sargent's Venetian interiors draw on the conventions of Venetian genre painting but subtly subvert them. One of the seated women in the Albright-Knox Art Gallery picture is listlessly sorting beads, watched by her companions, but this is a world away from van Haanen's animated scene of activity (fig. 200). In the Clark Art Institute picture, two of the women in the background are stringing beads, but none of the three figures prominent in the foreground is working, and in the Carnegie Museum of

Art picture, the two young women in front are simply promenading. What significance then are we to read into these figures? With their slender figures, black shawls and pink and white dresses they do not conform to ordinary Venetian working-class types. Though Venetian hallways of the kind, with apartments opening off them, are communal spaces, Sargent is not recording typical scenes of Venetian working-class life. The young women are slender, beautiful, alluring and sensual, and they inhabit an enclosed mysterious feminine world to which we are not given the key. Several of them are posed in profile, with that combination of dark skin, hair drawn up to expose the ear, and fringe in front which the artist found so appealing.

This is a world away from the female figures in contemporary Venetian genre, with their theatrical gestures, animated exchanges and coy flirtatiousness. Sargent's figures appear self-contained and self-absorbed, and completely undemonstrative: gesture is minimal, hands rarely appear, eyes look down or across and only rarely engage the viewer, bodies are sheathed in shawls. The deep, resonant space inhabited by the women creates a similar sense of inward life. The receding perspective of walls, floor and ceiling draws us into the hallway to experience it as somewhere 'felt' as well as somewhere 'seen'. Daylight is pushed to the back, the everyday world lies just outside the windows, but inside everything is shadowy, ambiguous, uncertain and mysterious. Here and there the space is punctuated by highlights the artist wants us to notice; the flounce of a skirt, the tip of a fan, the gleam of a doorway or picture frame, a gash of sunlight across the floor. This is an art of great subtlety and confidence where the artist knows exactly what effects he is trying to achieve.

When Sargent went out-of-doors, he recreated the same spatial geometry and haunting sense of atmosphere. The street scenes are the reverse of the interiors. The women have emerged from their enclosed feminine world to be confronted by men in encounters that are unambiguously sexual. As single women, they are subjected to the male gaze and to male desire. The men are dressed in tight black trousers, black capes and black hats, and silhouetted against the light; one is reminded by them of the figure in the open doorway at the back of Velázquez's *Las Meninas* (Prado Museum, Madrid), which Sargent made a special feature in his copy of the picture (no. 730). We see even less of Sargent's men than of his

women, little more than a glimpse of their faces, so entirely are they contained by their capes. They have, in consequence, a rather sinister elegance. They eye the women or engage them in intimate conversation with an intense, predatory look.

In Sargent's painting *A Street in Venice* (no. 810), we see a man and a woman standing outside a wine shop framed by the high walls of a narrow passageway. The woman, curiously indifferent to the gaze of the man, looks out at us. The odd disjunction between them is intensified by the telescopic view of the alley. Other artists besides Sargent exploited the narrow alleys of Venice for dramatic effect, among them Carl van Haanen and Alexander Rousof.[40] Whistler, too, often used the device of high walls to frame a distant view and to effect transitions from one kind of space to another. And the narrow street scenes painted in the early 1880s in Florence by Telemaco Signorini and Odoardo Borrani, both members of the Macchiaioli group, are remarkably like Sargent's in their sense of enclosed, claustrophobic space and gloomy lighting.[41]

In *Street in Venice* (no. 808), the slender young woman walking towards us, kicking up the flounces of her dress as she moves, is perfectly well aware of the interest she is arousing. It is the sexual charge between her and the man on the right which gives the picture its frisson. A second picture in the same vein shows an attractive young couple confronting one another in a narrow alley as evening falls (no. 809). There is an obvious charge between the man and woman in the way they stand and intimately converse. What these pictures present is a modern reading of the relationship between the sexes every bit as daring as that of older avant-garde artists like Degas and Manet.

Venetian women are famed for their looks, style, quick verbal wit and independence, and it is these qualities which Sargent exploited. In most figurative painting of the time, women are presented as submissive, pliant, yielding and dependent. In Sargent's work, women reveal equality in their relationship to men and in the way they react to the latter's sexual advances. In the Clark Art Institute street scene (no. 810), the woman is coolly self-possessed and detached from the earnest figure at her side; she is thinking about something quite else. The woman in the Washington picture (no. 808) gives nothing away as she runs the gauntlet of the male gaze—there is no trace of coquetry or bashful embarrassment. In *Venetian Street* (no. 809), it is the woman who is

Fig. 200 *(top)*
Carl van Haanen, *Venetian Bead Stringers,*
c. 1876. Engraving, after an untraced oil painting,
Magazine of Art, 1887, frontispiece.

Fig. 201 *(middle)*
Robert Frederick Blum, *Venetian Bead Stringers,*
1887–88. Oil on canvas, 30¼ x 40¾ in.
(76.8 x 103.5 cm). Private collection.

Fig. 202 *(bottom)*
Carlo Naya, Photograph of Venetian bead
stringers. Collection Osvaldo Böhm, Venice.

Fig. 203 *(below)*
Otto Bacher, *Venetian Bead Stringers,* 1882.
Etching, 13 x 9 in. (33.3 x 22.5 cm). The
Cleveland Museum of Art. Gift of Charles
W. Bingham.

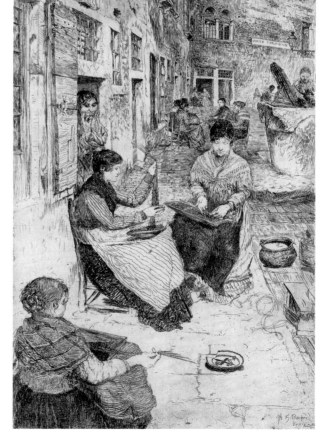

anxious to move away, the man who holds her in conversation. In *The Sulphur Match* (no. 803), the woman leans back in her chair with a refreshing lack of decorum, heels hooked over the front bar, and gazes without embarrassment at her companion as he lights his cigarette. There is something very direct and modern in the intimate way the couple respond to one another.

The relationship between the sexes lies at the heart of novels by contemporary writers like Henry James and Émile Zola. They explore a new emotional landscape in which the motives, feelings and passions of women often determine the action. The psychology of female characterization is complicated and subtle and so is the representation of a society that allowed them little influence or freedom. With his wide reading in contemporary French and English literature, Sargent seems to be instinctively in tune with this modern view of how men and women behave. His female portraits of the early 1880s express the tensions and anxieties, the passion and repression of which James writes with such perception and eloquence. But Sargent could not paint scenes of what men and women do to each other in the setting of polite society because nothing there is ever explicit. Taking the theme down a class, and removing it to a different location, gave him the opportunity to explore male/female relationships and human sexuality without subterfuge. The vision is avant-garde Paris expressed though lower-life Venice.

TOPOGRAPHICAL PAINTINGS

Sargent painted a large number of topographical studies at this early period both in oil and water-colour; few of them are well known, but they constitute a remarkable body of work. Here was born that enduring passion for Venetian architecture and canals, and for the magical properties of Venetian light, which would bear fruit once Sargent returned to *plein-air* painting in the period after 1900. Venice became his favourite sketching-ground, and the city to which he returned more often than any other. There were nearly as many view painters in Venice as genre painters. Several of the subject painters already discussed doubled as landscapists and found a ready market for their views, among them the Dutchman Carl van Haanen, the Norwegian Fritz Thaulow, the Italians Antonio Paoletti and Giacomo Favretto, the English artists Charles William Bartlett, William

Logsdail and Henry Woods, and the Americans Otto Bacher, Robert Frederick Blum, Frank Duveneck, Charles Gifford Dyer and Francis Hopkinson Smith.

The imagery of the city, distilled through the work of the Romantics and their successors, was a source of irresistible fascination to a wide public, as it had always been. If the city was less idealized and more domesticated by this later generation of artists, it was not made stale by familiarity. Views of the city continued to be highly marketable. Because Venice had inspired such a wealth of books and pictures, it was deeply embedded in the cultural consciousness of Europe and carried the weight of association and memory.

Sargent's topographical pictures fall into certain well-defined categories. We have already seen how he treats the narrow back streets of the city in his pictures of encounters between male and female figures in drab working-class surroundings. While they have tremendous atmosphere, they are also precise records of particular places, with due attention paid to perspective, proportion, architectural form and detail, and surface texture. This same discipline underlies his studies of Venetian squares, where the carefully modelled buildings frame open spaces made luminous by the play of light and shadow. The *Campo behind the Scuola di San Rocco* (no. 816) records one of Venice's great monuments and naturally dwarfs the group of women standing in its shadow. This is a picture that looks forward to the post-1900 Venetian studies in its grandeur of form and composition. More typical of Sargent's early style is the oil painting of the *Campo Sant'Agnese, Venice* (no. 815), a modest square lying behind the Zattere. The magnificent Renaissance wellhead that dominates the foreground is set off by a modest line of buildings behind. It is the sunlight flowing in from the right, glancing off doorways and window frames and the top of the well-head, throwing warm tints across the pink façade and casting long shadows from unseen trees or buildings in front, that gives the square a quivering presence.

The water-colour of the *Campo San Canciano, Venice* (no. 807), farther north in the neighbourhood of Cannaregio, is similar in mood and composition. A shaft of sunlight falls from the street leading out of the square, throwing the farther buildings and well-head into strong relief and leaving the entire foreground in shadow. The sunlight cutting across the square creates its own drama and sense of immediacy in an other-

wise solitary scene. When Sargent came to paint the same square for his modern life picture *Sortie de l'église, Campo San Canciano, Venice* (no. 806), he created a more unified and even lighting scheme. The water-colour of the *Campo dei Frari, Venice* (no. 823), lying beside the famous church of that name, is another essay in form and light. We are looking across the canal of the Frari towards a set of low steps with two young women in the foreground. Like the chimneys in the background, they stand as vertical accents in a format of horizontal shapes and planes. The picture is reminiscent of Whistler's pastel of *The Steps* (Freer Gallery of Art, Washington, D.C.), which shows a group of sketchy figures posed by the steps of a canal in a carefully structured composition of blocks and squares.

The *Campo dei Frari, Venice* is one of a pair of water-colours that may be identical with those shown at the Salon in 1881 (nos. 3413–14). Its companion is the *Ponte Panada, Fondamenta Nuove* (no. 822), a golden, luminous view across water to the bridge and the receding line of the Fondamenta, drawing the eye deep into the picture space. A gondola with its black *felze,* or canopy, drifts idly by the embankment, its elegant lines emphasizing the diagonal thrust of the composition.

A second pair of water-colours, which are also possible candidates for those exhibited at the Salon in 1881, share many of the same characteristics as the first, though they are upright rather than horizontal. In one of them, we see the bluish light of the Grand Canal reflected in the Renaissance façade depicted in *Venetian Canal, Palazzo Contarini degli Scrigni e Corfu* (no. 826). The palace is cropped in typical Sargent style, and the view slides away down the canal to the distant Accademia. The *Ponte Lungo, Zattere, Venice* (no. 825) is bolder still in composition, an acute view of the bridge and the distant façade of the Gesuati church in foreshortened perspective contrasted with the rippling reflections from the side canal where it meets the Canale della Giudecca.

As well as streets and squares, bridges and side canals, Sargent painted Venetian palaces. In *Palazzo Marcello* (no. 824), we see the building full face across the Rio del Gaffaro. The façade is punctuated by the dark shapes of windows and doorways, which stand out boldly from the soft, transparent washes that play across its surface. The deftness and subtlety of Sargent's touch, and the sense of melancholy and mystery with which he invests the palace, are reminiscent of Whistler's etchings of

Venetian palaces, which are also delicately drawn and atmospheric.

At this early period, Sargent seems almost consciously to have avoided painting the famous set-piece views of Venice. He was an artist of the side street and the side canal. One rare exception is *Venise par temps gris* (no. 819), a sweeping bird's-eye view of the Riva degli Schiavoni. The inspiration for the scene and the high viewpoint must have come from Whistler and Duveneck, both of whom etched similar views in 1880 which show scattered figures in the foreground and the Riva arcing away behind (see fig. 226). *Venise par temps gris* is unique in Sargent's oeuvre, a brilliant one-off experiment, and there is nothing like it either among paintings by his contemporaries. The water-colour of the *Café on the Riva degli Schiavoni, Venice* (no. 821) represents another famous view. In the foreground are figures sitting at the tables of the Caffè Orientale, named after its tented pavilion, which was a favourite haunt of the artists.[42] Whistler painted a water-colour from the same spot (private collection), with his viewpoint turned more to the left, which might well be mistaken as a work by the same artist, so alike are they in feeling and technique.[43]

VENETIAN MODELS

The painters who flocked to Venice came in search of picturesque and attractive models for their subject pictures. They also painted Venetian women, with suggestive accessories, as types of beauty. While there was widespread demand for models of both sexes, there is no doubt that the pretty models attracted a premium, and some of them may have been semi-professional. However, there is little evidence of how the model system operated, except that it seems to have been largely informal. Models are not recorded in official sources like the archives of the Accademia delle Belle Arti, nor are they named in the indices of the various photographic agencies which sold prints of working-class models. Describing life in Venice in the early 1880s, Arthur Griffiths noted the role of the gondolier in securing models, among the other services: 'If his master be an artist, he will wash brushes, clean palettes and set up an easel in the floating studio, which, but for the occasional oscillation, is the most charming form of out-of-door workroom. He will fetch and carry water for your bath, hunt up models, clean boots and run messages all day long'.[44]

A decade later the artist Frank Richards made the same point:

It is very difficult to get really good models, unless one is thoroughly accustomed to the place—the regular professional sitters being as a rule fat, coarse-looking women. We employed none of them, but used to go about with our gondolier and engage models as we came across them in our little voyages of discovery. We always found it most satisfactory to arrange terms beforehand, not commencing work until that was settled, which saved us a lot of inconvenience and misunderstanding; for no matter how badly a novice would pose, he usually expected full pay at the end of a séance, and would ask for it with a very independent air.[45]

The availability of models on this casual basis seems to have been so taken for granted in Venice that few writers bothered to mention it.

Sargent responded just as keenly to the sultry, dark-skinned looks of Venetian women as he had earlier responded to the women of Capri and southern Spain. They drew out the sensual elements in his nature, his attraction to women of another class and another nationality, whose exotic beauty and charged sexuality he found liberating and exciting. While often shy in ordinary company, Sargent was always able to communicate easily with working-class people, enjoying their directness and simplicity. One feels instinctively that he liked the company of these female models, and that they, in turn, responded to him with warmth and verve. The relationship was more than a simple business arrangement.

Sargent's only large-scale work from these Venetian years is the *Full-Length Study of a Venetian Model* (no. 800), shown in the guise of a glass worker, almost certainly in the same space where he painted his three interior scenes with bead stringers. Tall and slender, she steps forward boldly from the surrounding gloom, holding up her flounced skirt with one hand and clasping what appears to be a bundle of glass rods in the other. The same model appears in Sargent's *Head of a Venetian Model in a Scarlet Shawl* and as the leading character in two of the figure subjects, *Venetian Interior* and *Street in Venice* (nos. 799, 798, 808). She is also the subject of three related pen-and-ink and wash drawings, which highlight her haunting *femme-fatale* beauty (figs. 204–6).

The model has in the past been called Gigia Viani, a name accepted uncritically by all recent Sargent scholars, including the present authors in earlier publications. There is, in fact, no firm evidence that Gigia Viani

existed, or, if she did, that Sargent painted her. Efforts to trace the name through the records of the Venice commune and those relating to the different neighbourhoods of the city have not been successful thus far.[46] According to Bénézit, the French painter Théobald Chartran painted a picture called 'Gigia, jeune Vénitienne' (1880), which was sold at a Paris auction in November 1924. Gigia may have been a nickname for Luigia; it is also, in the Venetian dialect, the name for the coal tit or coalmouse, a small bird noted for its blue-black head and white cheeks.[47] The first picture by Sargent associated with Gigia's name is *Study of a Model* (no. 637), which was acquired by the Irish painter Sir William Orpen in 1927. Inscribed on the back of the picture is the title 'Gigia', and it was as such that the picture was exhibited at the Leicester Galleries in 1935.[48] Another work, described as the *Interior of the Artist's Studio in the Calle Capuzzi, Venice,* and said to represent Gigia Viani in two poses, was included in the sale of the collection belonging to the New York architect Whitney Warren at Parke-Bernet, New York, in 1943.[49]

David McKibbin accepted the identity of Gigia Viani and wrote a note on the back of a photograph of the *Full-Length Study of a Venetian Model* (no. 800) to say that a Venetian nobleman he had met, Count Sebastiano Barozzi, a prominent Venetian *antiquaire* (dealer in antiques), had personally known the model.[50] In his checklist of Sargent's

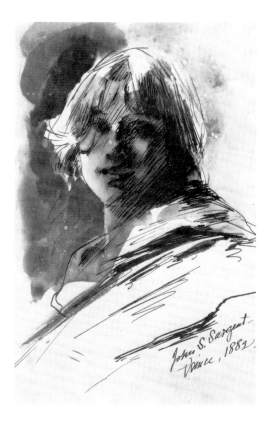

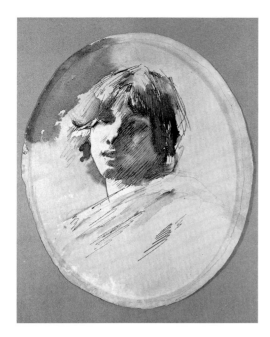

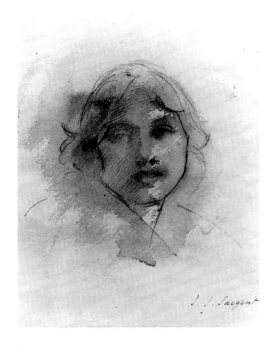

Fig. 204 *(opposite)*
Venetian Model, 1882. Pen and ink on paper, 7¼ x 4¾ in. (18.5 x 12.1 cm). Inscribed, lower right: *John S. Sargent / Venice* 1882. Untraced.

Fig. 205 *(top)*
Venetian Model (also called 'La Cottinella'), c. 1882. Pen and ink on paper, 7¾ x 6¼ in. (19.7 x 15.9 cm) (oval). Santa Barbara Museum of Art. Bequest of Margaret Mallory.

Fig. 206 *(bottom)*
Venetian Model, c. 1882. Pen and ink and wash on paper, 9¾ x 7¹⁄₁₆ in. (24.8 x 18 cm). Inscribed, lower right: *J. S. Sargent.* Private collection.

portraits published in 1956, McKibbin added a sentence to his entry on the model: 'Gigia appears in countless scenes of Venice painted in the eighties'.[51] In an attempt to bring some clarity to the miscellaneous identifications of the past, a list of the most prominent models is given below.

Sargent's studies of individual models have the same air of mystery, sensuality and even decadence as the women in the figure subjects. Several were painted in watercolour, and they combine directness of imagery with economy of means. In *Venetian Woman by a Bed* (no. 830), the model parts the mosquito-net curtains of a bed and gives us a smile of invitation and connivance. The sexuality here is quite explicit. In *Woman in a Gondola* (no. 831), we look down on the sensuous body of the woman laid out below us in a striking black outfit, with a rich rug covering her lower limbs. Other watercolours in this same vein include *Young Woman in a Black Skirt* and the head and shoulders of a pouting model with black hair and a vivid red shawl (nos. 832, 834).

Sargent's studies have greater realism than most works in this genre, they are less inhibited in showing women as objects of desire, and they are far more probing psychologically. They seem altogether more modern than the ingratiating models of van Haanen, von Blaas, Logsdail, Woods, Favretto and other popular painters of the day. The artists who come closest to Sargent are his fellow Americans. The oil studies of Venetian women by Frank Duveneck are done with a directness and *al primo* painterliness that are reminiscent of Sargent's experiments. So, too, are the water-colours by Robert Frederick Blum, which strike a similarly erotic note, and those by Sargent's cousin and close friend Ralph Curtis.

Sargent's Venetian models belong to a cast of strikingly attractive young women, some of whom feature in more than one picture. There are other models, often of older women, who appear to have sat only once, like the two seated figures in *Venetian Bead Stringers* (no. 794), those in the foreground and middle ground of *Venetian Loggia* (no. 802), the woman in *A Street in Venice* (no. 810), and the young woman on the right of *Venetian Glass Workers* (no. 792). Of the individual studies of Venetian women, both heads and whole figures, only those of Model A appear in more than one work.

MODEL A

The most distinctive of the models, with raven-black hair parted in the middle and forming two smooth loops over the ears:

Full-Length Study of a Venetian Model, no. 800
Head of a Venetian Model in a Scarlet Shawl, no. 799
Venetian Interior, the foremost figure on the right, no. 798
Street in Venice, no. 808
(?) *Venetian Woman by a Bed,* no. 830
(?) *Woman in a Gondola,* no. 831
Three related pen-and-ink and wash drawings, one of which is dated 1882, almost certainly represent the same model (see figs. 204–6).

MODEL B

Possibly identical with Model A, with raven-black hair drawn up in a bun at the back of the head, revealing the ears, and with a loose fringe in front:
The Sulphur Match, no. 803
(?) *Venetian Water Carriers,* no. 805
(?) *Sortie de l'église,* the figure on the right, no. 806

MODEL C

Lighter-coloured hair than either Models A or B, drawn smoothly into a bun clear of the ears and with a frizzed fringe:
Venetian Loggia, the second figure in from the front, no. 802
(?) *Venetian Interior,* the figure in the background by the balcony, no. 798

MODELS D–I

Lighter-coloured hair than either Models A or B, drawn up in a bun, showing more or less of the ears, and with a fringe; some or all may represent the same model, although neither the features nor the hairstyles is identical:
Venetian Bead Stringers, the standing figure, no. 794
Venetian Interior, the left-hand figure of the foreground pair, no. 798
The Venetian Bead Stringers, the two foreground figures, possibly the same model, no. 804
A Venetian Interior, figure left of centre, no. 795
The Onion Seller, no. 801

Male models appear in four of Sargent's works, three of them street scenes (nos. 803, 808–10). They all wear the same type of costume, black trousers, shoes, fur-lined capes and wide-awake hats. Their elegance and air of gentility have led to suggestions that they represent Sargent's friends and fellow-artists rather than local working-class men. There are two related sheets of pen-and-ink drawings in which Sargent explored variant poses for the figures, all

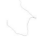

of them apparently modelled by the same man (figs. 207, 208). The standing figures mostly represent variants of the same pose, where the model stands hand on hip with his cape thrown open. Only the profile figure in fig. 207 corresponds with the pose of the models in the pictures. The seated figure in fig. 208 may relate to *The Sulphur Match* (no. 803).

Only a handful of drawings from the Venice period are known. A number of sheets in the Metropolitan Museum of Art, New York, appear to come from the same sketchbook.[52] There are drawings of gondoliers (figs. 209, 210), including one highly worked drawing of a young man in a hat (fig. 211), a drawing of two seated women (fig. 212), and a caricature of a man. Other drawings of gondoliers are known as well as a sheet of sketches of Venetian women with shawls (fig. 213). This last drawing came from a group of early sketches that belonged to the British sculptor Charles Sargeant Jagger; for a discussion of these, see *Studies of a Spanish Dancer* within the entry for *Spanish Dancer* (no. 770). The Fogg Art Museum, Boston, possesses a precisely drawn elevation of a palace, probably of this period (fig. 214), and a view of the Giudecca, which may date from an earlier visit.

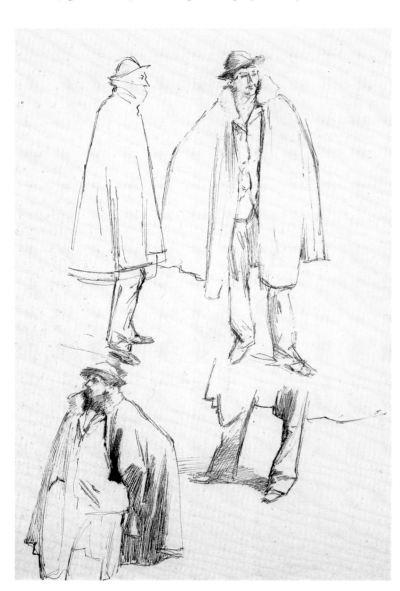

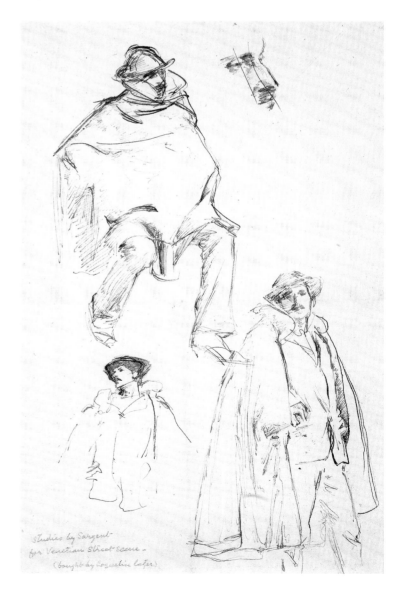

Fig. 207 *(left)*
Studies of Venetian Male Models, c. 1880–82. Pen and ink on paper, 14 x 9⅜ in. (35.6 x 23.8 cm). Private collection.

Fig. 208 *(below)*
Studies of Venetian Male Models, c. 1880–82. Pen and ink on paper, 15 x 10 in. (38.1 x 25.4 cm). Inscribed, bottom left: *studies by Sargent for Venetian street scene—(bought by Coquelin later).* Private collection.

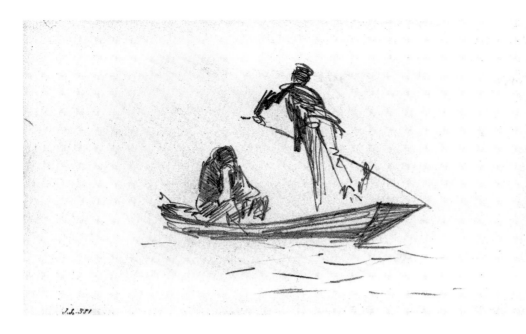

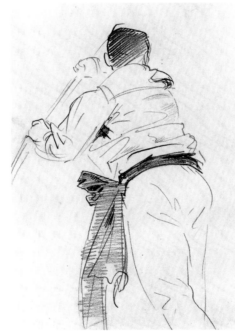

Fig. 209 *(above)*
Figures in a Gondola, c. 1880–82. Pencil on paper,
3¹³⁄₁₆ x 6¼ in. (9.6 x 15.9 cm). The Metropolitan
Museum of Art, New York. Gift of Mrs Francis
Ormond, 1950 (50.130.95 recto).

Fig. 210 *(right)*
Gondolier, c. 1880–82. Pencil on paper,
10¹¹⁄₁₆ x 7¹³⁄₁₆ in. (27.1 x 19.9 cm). The Metro-
politan Museum of Art, New York. Gift of Mrs
Francis Ormond, 1950 (50.130.111 recto).

Fig. 211 *(below left)*
Man in Hat, c. 1880–82. Pencil on paper,
6¼ x 3¹⁵⁄₁₆ in. (15.9 x 9.9 cm). The Metropolitan
Museum of Art, New York. Gift of Mrs Francis
Ormond (50.130.88).

Fig. 212 *(below right)*
Two Seated Women, c. 1880–82. Pencil on paper,
3⁹⁄₁₆ x 6⁵⁄₁₆ in. (9.1 x 16 cm). The Metropolitan
Museum of Art, New York. Gift of Mrs Francis
Ormond, 1950 (50.130.93a).

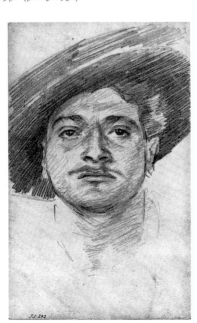

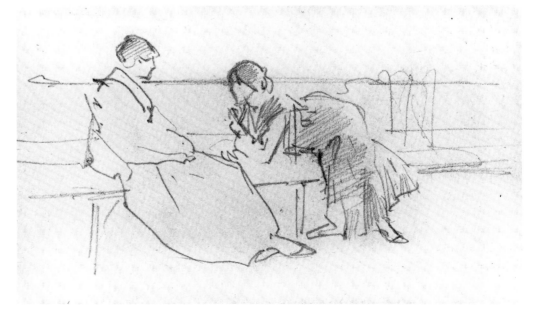

VENETIAN CHRONOLOGY AND EXHIBITIONS

The issue of which pictures Sargent painted on which of his two successive visits to Venice in 1880–81 and 1882 remains problematical. There are four dated works:

Head of a Venetian Model in a Scarlet Shawl,
 1880, no. 799
Mother and Child, 1881, no. 835
Full-Length Study of a Venetian Model, 1882,
 no. 800
The Sulphur Match, 1882, no. 803

Two other works, *Sortie de l'église* and *Street in Venice* (nos. 806, 808), were almost certainly painted in 1882. Sargent exhibited two pictures at the Cercle des arts libéraux, rue Vivienne, Paris, 23 April–25 May 1881, each under the title 'Étude fait à Venise', which must belong to the first trip; both were interiors, as we know from a contemporary review, but are otherwise unidentified.[53] The reviewer for *L'Art* was 'particularly struck by the eminently personal and distinguished qualities revealed in Mr John S. Sargent's studies of Venice', and compared them favourably to the mediocre studies by his master, Carolus-Duran.[54] Two further works from the 1880–81 visit, possibly the same as those shown in Paris, appeared at the Grosvenor Gallery, London, 1 May–31 July 1882, under the title 'Venetian Interior'.[55] In an article he wrote for *Harper's Magazine* to herald Sargent's arrival in America in 1887, Henry James recalled seeing one of them there. He may have misremembered the activity in which the young women are engaged, for the figures in Sargent's Venetian interiors are generally

stringing beads, not counting vegetables:

There stands out in particular, as a pure gem, a small picture exhibited at the Grosvenor, representing a small group of Venetian girls of the lower class, sitting in gossip together one summer's day in the big, dim hall of a shabby old palazzo. The shutters let in a clink of light; the scagliola pavement gleams faintly in it; the whole is bathed in a kind of transparent shade; the tone of the picture is

dark and cool. The girls are vaguely engaged in some very humble household work; they are counting turnips or stringing onions, and these small vegetables, enchantingly painted, look as valuable as magnified pearls. The figures are extraordinarily natural and vivid; wonderfully light and fine is the touch by which the painter evokes all the small familiar Venetian realities (he has handled them with a vigor altogether peculiar in various other studies which I have not space to enu-

merate), and keeps the whole thing free from that element of humbug which has ever attended most attempts to reproduce the Italian picturesque.[56]

Sargent showed two water-colours at the 1881 Paris Salon, both under the title of 'Vue de Venise'. These were probably a pair, and they may have been either *Campo dei Frari, Venice* and *Ponte Panada, Fondamenta Nuove* (nos. 823, 822) or *Venetian Canal, Palazzo Contarini degli Scrigni e Corfu* and *Ponte Lungo, Zattere, Venice* (nos. 826, 825).[57] Again, the reviews are too slight to allow for precise identification. Maurice du Seigneur called them 'impressionist sketches, but what light! what sparkle!',[58] but other reviewers were more critical. Here is Paul Leroi:

Mr Sargent is a colourist to his fingertips. All the more reason for him not to send to the Salon such unrealised splashes as his Vues de Venise, *which are far too free and easy. These preliminary studies should be kept in the studio as working notes and nothing more, especially when an artist has such very serious ability as the American who concerns us here.*[59]

Sargent exhibited four works at the Cercle des arts libéraux in March 1882, one of which was entitled 'Une Rue à Venise'. Reviewing the show, Olivier Merson wrote: 'Of Mr Sargent's four works, the best, without doubt, are *A Street in Venice* and, especially his study of a head (no. 709), a delicious profile of a young Italian woman, as dark as the night'.[60]

In December 1882, after his return to Paris from his second visit to Venice, Sargent exhibited four Venetian subjects at the Société internationale de peintres et sculpteurs at the Galerie Georges Petit, rue de Sèze, Paris. Two of these are identified: *Sortie de l'église* and *Street in Venice* (nos. 806, 808); a pen-and-ink drawing after the first (fig. 218) was used as a woodcut illustration in the 1882 exhibition catalogue; a similar drawing after the second in violet ink (fig. 221) was reproduced as a woodcut in *Gazette des Beaux-Arts*. The two unidentified oils in the 1882 exhibition were titled 'Intérieur vénitien' and 'Autre intérieur vénitien'.[61] Their avant-garde characteristics raised contradictory responses among contemporary reviewers. Writing, not without irony, in the *Gazette des Beaux-Arts*, Arthur Baignères took Sargent to task:

Mr. Sargent rounds off his contribution to the exhibition with views of Venice on a smaller scale than his vase family [The Daughters of Edward Darley Boit, Early Portraits, *no. 56*]. *Let us not*

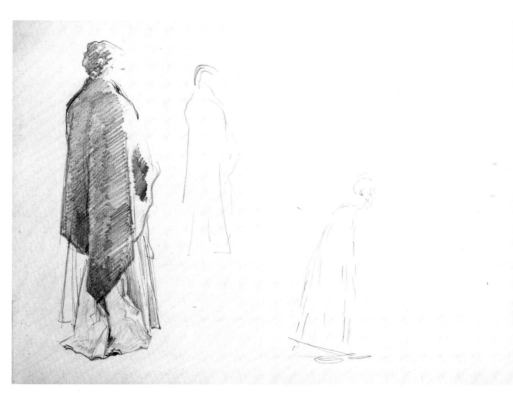

Fig. 213
Studies of Venetian Female Models,
c. 1880–82. Pencil on paper,
10 x 13 in. (25.5 x 35 cm).
Private collection.

Fig. 214
Drawing of a Venetian Façade,
c. 1880–82(?). Pencil on paper,
12¾ x 10¼ in. (32.5 x 26 cm).
Fogg Art Museum, Harvard
University Art Museums,
Cambridge, Massachusetts.
Gift of Miss Emily Sargent and
Mrs Francis Ormond, 1931
(1931.100).

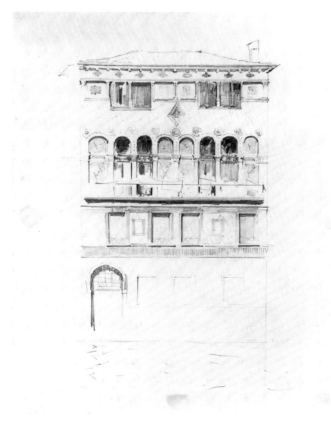

get too excited about Venice—we shall not see the Grand Canal or the Piazza San Marco; all that is trite and hackneyed. Mr. Sargent leads us into dark squares and low, dark rooms pierced by a single ray of sunlight. Where are Titian's beauties hiding? These women, whom we can scarcely make out under their dishevelled hair, wrapped in old, black shawls as if shivering with fever, are certainly not their descendants. Why bother going to Italy to gather such images? One can find equally sad looking streets and equally unhealthy looking women in La Vallette and in Belleville, without the trouble of travelling far.[62]

Paul Mantz in *Le Temps* was more appreciative:

Having seen Spain, he wanted to see Venice, and he brings back pictures which, while not fully developed, are still instructive. They are street corners and small rectangular squares adorned with one of those wells which have such a picturesque silhouette. These summarily painted studies are enlivened by several roughly drawn figures. M. Sargent is fascinated by elegant lines and he attenuates his figures to an extreme degree. In Sortie de l'église, *the three women chatting while they return [from church] seem out of proportion. These eccentricities need to be reviewed and put back into good order.*[63]

Another Venetian work was lent by Dr Pozzi, whom Sargent had painted in 1881 (see *Early Portraits,* no. 40), to the Cercle de l'union artistique, place Vendôme, Paris, 1883, under the title 'Conversation vénitienne'.[64] This may possibly be identical with an untraced picture, titled 'Intérieur vénitien' (16½ x 24⅜ in.), bought by Boussod, Valadon & Cie, Paris, in an auction at Hôtel Drouot, 18 June 1887 (lot 48). The picture was sold to 'Besnard' (possibly the artist Albert Besnard, a good friend of Sargent), on 11 July 1887. Boussod repurchased the picture, now titled 'Intérieur à Venise', and with different dimensions, possibly the frame size (19⅝ x 27½ in.), from Besnard on 13 April 1888, and sold it on to 'Ernezunio'.[65] A contemporary reviewer wrote of 'Conversation vénitienne': 'Mr Sargent's work is the direct opposite [of a picture by Lestrel]—mere effect—but how effective! Although a little black, his [Sargent's] 'Conversation Vénitienne' is true and spirited, and the artist shows himself an excellent disciple of Goya'.[66]

In June 1997, James Martin, then director of analytical services and research at the Sterling and Francine Clark Art Institute at Williamstown, Massachusetts, produced a draft paper on the interim results of a technical study of approximately twenty Venetian paintings.[67] This coincided with a colloquium on the Venetian works held at the time of the exhibition *Uncanny Spectacle: The Public Career of the Young John Singer Sargent,* at Williamstown in 1997. Martin differentiated the pictures in terms of ground type, fibre type, fibre surface characteristics and number of threads per square centimetre. No definite conclusions could be drawn from the analysis as regards specific dating, but the following pictures did share the same ground, fibre type, surface characteristics and threads per square centimetre (approximately 23 x 28):

Venetian Bead Stringers, no. 794
Venetian Glass Workers, no. 792
Venetian Interior, no. 798
Venetian Street, no. 809
Head of a Venetian Model in a Scarlet Shawl, no. 799

Sargent seems to have bought some of his canvasses already stretched with a commercially prepared ground, although he may also have bought canvas by the roll. The fact that the sizes of the pictures vary so much suggests that he may have stretched them after completion. The survival on the reverse of *The Onion Seller, Street in Venice* (his only work on panel), *A Street in Venice* and *Saint Roch with Saint Jerome and Saint Sebastian, after a Picture Attributed to Alessandro Oliverio* (nos. 801, 808, 810, 743) of labels for a local colourman, Giuseppe Biasutti, indicates that the artist bought some of his materials locally.

In terms of chronology, Sargent's Venetian interiors constitute one of the chief problems. Marc Simpson puts *Venetian Glass Workers* and *Venetian Women in the Palazzo Rezzonico* (nos. 792, 793) early, and the authors would agree with him. The former may have been one of those shown in Cercle des arts libéraux, Paris, in 1881, or at the Grosvenor Gallery in London the following year. Were it not for Henry James's mention of women handling vegetables instead of beads in his description of what he saw at the Grosvenor Gallery in 1882 (see quotation above), the picture might have been *Venetian Women in the Palazzo Rezzonico,* the Albright-Knox *Venetian Bead Stringers* or the Carnegie *Venetian Interior* (nos. 793, 794, 798). The fact that Whistler (see fig. 217) was painting the same space as *Venetian Interior* (no. 798) also argues in favour of an 1880–81 dating for the latter picture, except that stylistically it relates more closely to the Washington *Street in Venice* (no. 808), which is datable to 1882. The *Full-Length Study of a Venetian Model* (no. 800), dated 1882, also seems to depict this hallway. The question is, did Sargent paint there on both visits? Marc Simpson thinks so, and the present authors concur, although preferring to date the Clark *A Venetian Interior* (no. 795) to 1880–81 as against Simpson's date of 1882.

Of the other Venetian figure scenes, the authors would put the Clark *A Street in Venice, Venetian Water Carriers* and *The Onion Seller* (nos. 810, 805, 801) early, and also *Venetian Loggia* (no. 802). *Venetian Street* (no. 809) is here placed in 1882, because of its close connection to the Washington *Street in Venice* (no. 808), and so is the *Campo behind the Scuola di San Rocco* (no. 816), an odd picture unlike anything else. The Dublin *Venetian Bead Stringers* (no. 804) also seems closer stylistically to the 1882 street scenes than to the earlier 1880–81 group.

None of the architectural or topographical studies are dated. Most recent authorities have placed *Venise par temps gris* in 1882 because of its fluid, painterly style, possibly correctly; on the other hand, it is very alike in composition to the Whistler and Duveneck etchings of 1880 (see fig. 226). If Sargent was painting the *Pavement of St Mark's, Venice* (no. 813) at the same time as Robert Frederick Blum (see fig. 224), then that would argue for an 1880–81 dating, but stylistically the picture seems later and 1882 is preferred. The colouring and handling of *Campo Sant' Agnese* (no. 815) are reminiscent of *Sortie de l'église* (no. 806), and the *Portico di San Rocco* (no. 818) links up with the *Campo behind the Scuola di San Rocco* (no. 816).

The authors would place the majority of the water-colour studies in 1880–81. The group has remarkable homogeneity in terms of imagery and technique; Sargent spent longer in Venice on the first visit than the second, and two of the water-colour studies were exhibited at the Salon in 1881. *Campo San Canciano* (no. 807), which relates to *Sortie de l'église* (no. 806), is the only water-colour that can be associated with the 1882 visit.

On the basis of the discussion above, it is possible to attempt a tentative grouping of the 1880–81 and 1882 works. In the state of present-day knowledge, however, few firm conclusions can be drawn, and much of the proposed dating remains speculative. Some development in Sargent's style between his two visits is discernible, towards greater breadth, movement and painterly fluency, but all of the early Venice pictures

are sustained by a common vision and point of view. There is a danger of losing sight of this in the search to solve the chronological puzzle.

1880–81 OIL PAINTINGS

Venetian Glass Workers, no. 792
Venetian Women in the Palazzo Rezzonico,
 no. 793
Venetian Bead Stringers, no. 794
A Venetian Interior, no. 795
A Street in Venice, no. 810
The Onion Seller, no. 801
Venetian Loggia, no. 802
Venetian Water Carriers, no. 805
A Venetian Woman, no. 796
Head of a Venetian Model in a Scarlet Shawl,
 no. 799
Saint Roch with Saint Jerome and Saint
 Sebastian, no. 743

1880–81 WATER-COLOURS

Venetian Interior, no. 797
Venice, no. 811
Venetian Woman by a Bed, no. 830
Young Woman in a Black Skirt, no. 832
Figure in Costume, no. 833
Woman in a Gondola, no. 831
Head of a Venetian Model, no. 834
Mother and Child, no. 835
Study of a Boy Reclining against a Pillow,
 no. 836
Campo dei Frari, Venice, no. 823
Ponte Panada, Fondamenta Nuove, no. 822
Venetian Canal, Palazzo Contarini degli
 Scrigni e Corfu, no. 826
Ponte Lungo, Zattere, Venice, no. 825
Palazzo Marcello, no. 824
Palazzo Foscari, no. 827
Side Canal, no. 828
The Marinarezza, Venice, no. 820
On the Lagoons, Venice, no. 829
Café on the Riva degli Schiavone, Venice,
 no. 821

1882 OIL PAINTINGS

Venetian Interior, no. 798
Street in Venice, no. 808
Sortie de l'église, no. 806
Venetian Street, no. 809
The Venetian Bead Stringers, no. 804
Pavement of St Mark's, Venice, no. 812
Venise par temps gris, no. 819
Campo behind the Scuola di San Rocco,
 no. 816
A Canal Scene, no. 817
Portico di San Rocco, no. 818
Campo Sant'Agnese, Venice, no. 815
Full-Length Study of a Venetian Model,
 no. 800
The Sulphur Match, no. 803

1882 WATER-COLOURS

Campo San Canciano, Venice, no. 807

1883 OIL PAINTINGS

Pressing the Grapes: Florentine Wine Cellar,
 no. 814
Via delle Brache, Florence, no. 813

EXHIBITED WORKS 1881–84

Only three of the works listed below are certainly identified, nos. 98–99 in the Société internationale de peintres et sculpteurs and no. 226 in the 1884 Dublin exhibition.

Paris, Cercle des arts libéraux, rue Vivienne, 23 April–25 May 1881:
 11 'Étude fait à Venise'
 12 'Étude fait à Venise'

Paris, Salon de 1881, 2 May–20 June 1881:
 3413 'Vue de Venise—aquarelle'
 3414 'Vue de Venise—aquarelle'

Paris, Cercle des arts libéraux, rue Vivienne, March–April 1882:
 'Une Rue à Venise'

London, Grosvenor Gallery, 1 May–31 July 1882:
 135 'Venetian Interior'
 346 'Venetian Interior'

Paris, Société internationale de peintres et sculpteurs, rue de Sèze, Galerie Georges Petit, 20 December 1882–30 January 1883:
 96 'Intérieur vénitien'
 97 'Autre intérieur vénitien'
 98 'Sortie d'église' (no. 806)
 99 'Une Rue à Venise' (no. 808)

Paris, Cercle de l'union artistique, place Vendôme, 6 February–12 March 1883:
 135 'Conversation vénitienne'

Dublin, Dublin Sketching Club, Leinster Hall, 1–20 December 1884:
 226 'Bead Stringers of Venice' (no. 804).
 —*Richard Ormond*

1. A portion of this introduction was originally published as an essay under the title 'Modern Life Subjects' in the exhibition catalogue *Sargent and Italy,* Los Angeles County Museum of Art, 2003 (Los Angeles 2003).
2. See Alejandro Canseco-Jerez, *Le Mécénat de Eugenia Huica de Errázuriz* (Paris, 2000), p. 28.
3. John Pemble, *Venice Rediscovered* (Oxford, 1995), p. 2.
4. Henry James, 'The Grand Canal', 1892, essay reprinted in *Travelling in Italy with Henry James,* ed. Fred Kaplan (London, 1994), p. 71.
5. Ibid., p. 54.
6. Vernon Lee, 'Out of Venice at Last', essay in *The Golden Keys and Other Essays on the Genius Loci* (London, 1925), pp. 74–75.
7. See Piers Bendon, *Thomas Cook, 150 Years of Popular Tourism* (London, 1991), p. 112.
8. Private collection. See also Robert Browning's letter of 6 March 1889 to his son, 'Pen' Browning (*New Letters of Robert Browning,* ed. William Clyde DeVane and Kenneth Leslie Knickerbocker [London, 1951], p. 368): 'I dined with Broughton on Sunday, and met, among others, Sargent—who expressed his astonishment at your possessing the whole Rezzonico. "What, *all* of it?" He then said that he had lived in the room above—paid 10 f[ran]cs a month for it. I told him I knew that, and had seen his autograph and scratch of a drawing on the wall,—which you intended to keep uneffaced from its place,—whereat he seemed pleased'. The Palazzo Rezzonico has been extensively refurbished as an art gallery in recent years, and the autograph has disappeared.
9. Quoted in L. V. Fildes, *Luke Fildes R.A.: A Victorian Painter* (London, 1968), p. 67.
10. For an essay and entries on Logsdail's Venetian pictures, see the exhibition catalogue *William Logsdail 1859–1944: A Distinguished Painter,* Usher Art Gallery, Lincoln, 1994.
11. A picture attributed to Sargent, now in a private collection, was said to represent the interior of his studio in the Calle Capuzzi (see n. 49).
12. This was the *Esposizione Nazionale Artistica,* Venice, 1887. Sargent showed two portraits, which have not been identified (*Catalogo Ufficiale,* pp. 25–26, nos. 22, 54).
13. See, for example, Cazin's picture of *The Bakery of the Coquelin Family at Boulogne-sur-mer,* at the Musée J. Charles Cazin, Samer, Pas-de-Calais, ill. Gabriel P. Weisberg, *The Realist Tradition: French Painting and Drawing 1830–1900,* Cleveland Museum of Art, 1981, pl. 198 (exhibition catalogue).
14. Note by Daniel Curtis on interesting visitors to the Palazzo Barbaro, among the uncatalogued Curtis papers, Marciana Library, Venice.
15. Sargent to Vernon Lee, 22 October 1880, private collection.
16. Letter from Ariana Curtis to her sister-in-law Mary Curtis, c. 1881, Curtis papers, Marciana Library, Venice.
17. See *More Than Friend: The Letters of Robert Browning to Katharine de Kay Bronson,* ed. Michael Meredith (Waco, Texas, Armstrong Browning Library of Baylor University, 1985), p. 6, n. 1; and Grace Elizabeth Wilson, *Robert Browning's Portraits, Photographs and Other Likenesses and Their Makers* (Waco, Texas, Baylor University, 1943), pp. 114–16, 118.
18. A copy of the catalogue is in the National Library of Ireland, Dublin; the minute books of the Dublin Sketching Club Committee, together with related press cuttings, are in the Manuscript Department of the National Library of Ireland, acc. 4786. The Dublin exhibition was first researched and written up by Ronald Anderson and Anne Korval in *James McNeill Whistler: Beyond the Myth* (London, 1994), pp. 259–63.
19. Lawless (1847–1929) was an amateur artist and friend of Sargent, Whistler and other Anglo-American artists in Venice; see the entry for *The Venetian Bead Stringers* (no. 804) for further biographical information.
20. Quoted in Fildes (see n. 9 above), pp. 66–67.
21. For Sargent's 1870 drawing of Theodore Bailey Bronson, Jr, see Herdrich and Weinberg 2000, p. 77, no. 16hh, ill.
22. Private collection, Florence. Drawings by Sargent from the album were included in the exhibition *Robert Browning a Venezia,* Fondazione Querini, Venice, 1989, nos. 92, 94, 95, all three illustrated in the catalogue by Rosella Mamoli Zorzi; see also Boston 2004, pp. 91, 92, 219, figs. 59, 60, 153.

23. *More Than Friend* (see n. 17 above), p. 3, n. 3.

24. Both letters undated (Sargent's probably of 1881), private collection; brief quotations from both in *More Than Friend* (see n. 17 above), p. 9, n. 4, and p. 17, n. 6.

25. *More Than Friend* (see n. 17 above), p. 9, n. 4.

26. Boston 2004, pp. 74, 94.

27. Curtis papers, Marciana Library, Venice.

28. E. R. and J. Pennell, *The Life of James McNeill Whistler* (London and Philadelphia, 1911), p. 194.

29. Curtis papers, Marciana Library, Venice.

30. William James to his wife Alice, 11–13 October 1882, Houghton Library, Harvard University, Cambridge, Massachusetts, bMS AM 1092.9 (1292).

31. Martin Brimmer to Sarah Wyman Whitman, 26 October 1882, Archives of American Art, Smithsonian Institution, Washington, D.C., roll D 32, frames 184–85; quoted in Boston 2004, pp. 94–95. For the portrait of Lothrop, see *Early Portraits*, no. 111.

32. Diary of Lady Layard, British Library, London, Add. MS. 46.160, pp. 176–77.

33. Sargent to Vernon Lee, 6 October [1882], private collection.

34. See the entry for the *Pavement of St Mark's, Venice* (no. 812).

35. 'Genre in the Summer Exhibitions', *Fortnightly Review*, n.s., vol. 33, no. 198 (1 June 1881), pp. 868–69.

36. 'The Artist in Venice', *The Portfolio, An Artistic Review*, ed. Philip Gilbert Hamerton, vol. 15 (1884), part 1, p. 17.

37. See, for example, von Blaas's *At the Well*, sold Sotheby's, London, '19th-Century European Paintings', 23 November 2000, lot 60, and similar pictures by Rios and Montalba, ill. Philip Hook and Mark Poltimore, *Popular 19th-Century Painting: A Dictionary of European Genre Painters* (Woodbridge, Suffolk, 1986), pp. 597, 600.

38. See Margaret F. MacDonald, *James McNeill Whistler Drawings, Pastels and Watercolour: A Catalogue Raisonné* (New Haven and London, 1995), pp. 295–96, no. 790.

39. For a contemporary account of bead stringing, see Irene Ninni, *L'impirarressa* (Venice, 1893), translated by Lucy Segatti in *Beads, Journal of the Society of Bead Researchers*, ed. Karlis Karklins, Ottawa, Ontario, vol. 3 (1991), pp. 73–82; I am grateful to Ellen N. Benson of the Bead Society, Washington, D.C., for drawing this to my attention. For a more general account of the Venetian glass industry, see *Les Célébres Verreries de Venise et de Murano* (Venice, 1847); Peter Francis, Jr, *The Story of Venetian Beads* (Lake Placid, New York, 1979); and the exhibition catalogue *Perle e Impiraperle*, Venice, 1990.

40. For illustrations of pictures by Rousof and van Haanen, see Arthur Griffiths, 'Every-Day Life in Venice', *Art Journal*, 1881, pp. 358–59; and Percy E. Pinkerton, 'Cecil van Haanen', *Magazine of Art*, vol. 10 (1887), p. 2.

41. See Dario Durbé and Cinzia Folcini, *La Firenze dei Macchiaioli* (Rome, 1985), nos. 81, 86–89, 91.

42. For the Caffè Orientale, see Danilo Reato and Elisabetta dal Carlo, *La Bottega del Caffè* (Venice, 1991), pp. 103–7.

43. See MacDonald, *Whistler* (n. 38 above), p. 265, no. 725.

44. Griffiths, 'Every-Day Life in Venice' (see n. 40 above), p. 357.

45. 'Letters from Artists to Artists. no. X. Venice as a Sketching-Ground', *The Studio*, vol. 3 (1894), p. 175.

46. Our thanks to Rosella Mamoli Zorzi of the Università Ca' Foscari di Venezia for her efforts to trace Gigia Viani.

47. The authors are grateful to Richard H. Finnegan for this reference.

48. *Exhibition of Fifty Years of Portraits (1885–1935)*, May–June 1935, no. 63. The features of this model are unlike those of other Venetian women whom Sargent painted.

49. Parke-Bernet, New York, 7–9 October 1943, lot 264, 'Interior of the Artist's Studio in the Calle Capuzzi, Venice; in the right foreground the model Gigia Viani in two poses, dressed in sombre colours'. The attribution of this picture, now in a New York private collection, has been questioned. It is said to have been given by the artist to Gervase Ker, for whom see the entry for *Campo Sant'Agnese, Venice* (no. 815).

50. McKibbin papers.

51. Boston 1956, p. 98.

52. See Herdrich and Weinberg 2000, pp. 170–72, nos. 152–56.

53. See Olivier Merson, 'Exposition du Cercle des arts libéraux, rue Vivienne, 49', *Le Monde Illustré*, no. 1257 (30 April 1881), p. 282: 'M. Sargent est un vrai peintre; voyez les deux Intérieurs qu'il expose'.

54. 'Nous y avons été tout particulièrement frappé des qualités éminemment personnelles et distinguées que révèlent les études faites à Venise par M. John S. Sargent; ce disciple de M. Carolus Duran faisait là singulièrement tort à son maître; il nous est absolument impossible de nous expliquer comment ce dernier s'était décidé à exposer, sous prétexte d'esquisses, des pochades aussi médiocres que ce qu'il avait intitulé *Vision et la Gloire*' ('Expositions', *L'Art*, vol. 25, no. 2 [1881], p. 290). For other reviews, see J. Buisson, 'Le Salon de 1881', *Gazette des Beaux-Arts*, vol. 24, no. 1 (July 1881), p. 44; and *L'Année Artistique*, ed. Victor Champier, vol. 4 (1882), p. 169.

55. Marc Simpson tentatively identifies them as *Venetian Women in the Palazzo Rezzonico* and *Venetian Bead Stringers* (nos. 793, 794); see Simpson 1997, pp. 176, 177, nos. A41, A43.

56. Henry James, *Harper's New Monthly Magazine*, vol. 75, no. 449 (October 1887), p. 689. For another review of the exhibition, see 'The Picture Galleries.—IV', *Saturday Review*, vol. 53 (27 May 1882), p. 663.

57. Marc Simpson tentatively identifies them as *Café on the Riva degli Schiavoni, Venice* and *Venetian Interior* (nos. 821, 798); see Simpson 1997, p. 174, nos. A20, A21.

58. 'Les *Rues de Venise* à l'aquarelle, par M. John Sargent, ne sont que des ébauches d'impressionisme, mais quelle lumière! Quel éclat!' (Maurice du Seigneur, *L'Art et les artistes au Salon de 1881* [Paris, 1881], p. 230).

59. 'M. John Sargent est coloriste jusqu'au bout des ongles. Motif de plus pour ne pas envoyer au Salon de simples taches embryonnaires qu'il appelle des *Vues de Venise*, un baptême du plus extrême sans-gêne. Ces commencements de pochades-là, on les garde dans son atelier à titre de notes et rien de plus, surtout lorsqu'on a la très serieuse valeur de l'artiste américain qui nous occupe' (Paul Leroi, 'Salon de 1881: Aquarelles', *L'Art*, vol. 26, no. 3 [1881], pp. 78–79). The same review appeared in abbreviated form in *Le Musée Artistique et Littéraire* (Paris, 1881), p. 103, under the name of 'A. Genevay'.

60. 'Des quatre cadres de M. Sargent, les meilleurs, sans contredit, sont *Une rue à Venise*, et principalement la *Tête d'étude*, délicieux profil de jeune Italienne brune comme la nuit' (Olivier Merson, 'Exposition des Artistes indépendants, rue Saint-Honoré, 251. Exposition du Cercle des arts libéraux, rue Vivienne, 49', *Le Monde Illustré*, vol. 50, no. 1303 [18 March 1882], p. 167).

61. Marc Simpson tentatively identifies them as *A Venetian Interior* and *Venetian Interior* or *The Sulphur Match* (nos. 795, 798, 803); see Simpson 1997, p. 176, nos. A31–A33.

62. 'M. Sargent complète son exposition par des vues de Venise d'un format moins développé que sa famille de potiches. Ne nous montons pas la tête sur Venise; nous n'y verrons ni grand Canal ni place Saint-Marc; tout cela est banal et usé. M. Sargent nous conduit dans d'obscurs carrefours et dans des salles basses toutes noires que transperce un rayon de soleil. Où se cachent les belles du Titien? Ce ne sont certes pas leurs descendantes que nous apercevons à peine sous leur chevelure inculte, drapées dans un vieux châle noir comme si elles grelottaient la fièvre. A quoi bon aller en Italie pour y recueillir de pareilles impressions? Avec un bien moindre déplacement on trouve, à la Villette et à Belleville, des rues d'aussi triste apparence et des femmes d'aussi mauvaise mine' (Arthur Baignères, 'Première Exposition de la Société internationale de peintres et sculpteurs', *Gazette des Beaux-Arts*, vol. 27, no. 2 [February 1883], p. 190).

63. 'Après avoir vu l'Espagne, il a voulu voir Venise, et il en rapporte des peintures qui, pour n'être pas toutes achevées, sont déjà instructives. Ce sont des coins de rue, de petites places rectangulaires qu'agrémente un de ces puits sont la silhouette est si pittoresque. Ces études, d'un execution fort sommaire, s'animent de quelques figurines d'un dessin approximatif. Curieux des lignes élégantes, M. Sargent allonge ses personnages et ils ne sont plus à l'échelle. Dans la *Sortie de l'Église*, les trois Vénetiennes qui reviennent en causant apparaissent démesurées. Toute cette fantasie devra être revue et remise en bon ordre' (Paul Mantz, 'Exposition de la Société internationale', *Le Temps*, 31 December 1882, p. 3). For shorter reviews of the exhibition, see Albert Wolff, 'Société internationale de Jeunes Artistes', *Le Figaro*, 20 December 1882, p. 2; and Olivier Merson, 'Première Exposition de la Société

internationale de peintres et de sculpteurs—Galerie Georges Petit, rue de Sèze, 8', *Le Monde Illustré*, vol. 42 (27 January 1883), p. 58.

64. Marc Simpson tentatively identifies it as *Venetian Street* (no. 809); see Simpson 1997, p. 178, no. A47.

65. Dieterle Family Records of French Art Galleries, 1846–1986, Getty Research Institute, Los Angeles (900239). The first reference occurs in the Boussod Valadon stock book no. 11, p. 213, under inventory number 18667; the second in stock book no. 12, p. 27; and the third also in stock book no. 12, p. 61, with a new inventory number, 19180. We are grateful to Professor Richard Thompson of Edinburgh University for referring us to this source and to Mark Henderson of the Getty Research Institute for supplying us with copies of the entries.

66. 'Art Abroad' 'Paris Notes', *Artist*, vol. 4, no. 40 (1 April 1883), p. 124. See also Maurice du Seigneur, 'Les Expositions Particulières', *L'Artiste*, vol. 53, part 2 (August 1883), p. 125; 'The Chronicle of Art: Art in March', *Magazine of Art*, vol. 6 (March 1883), p. xxii, where the exhibition is said to be interesting for portraits by Carolus-Duran and Sargent (in fact, only 'Conversation vénitienne' by Sargent was shown); and Olivier Merson, 'Exposition du cercle artistique et littéraire rue Volnay et du cercle de l'union artistique Place Vendôme', *Le Monde Illustré*, vol. 53 (3 March 1883), p. 135.

67. The authors are grateful to James Martin and to Marc Simpson, curator of the exhibition *Uncanny Spectacle: The Public Career of John Singer Sargent*, Sterling and Francine Clark Art Institute, Williamstown, Massachusetts, 15 June–7 September 1997, for permission to make use of the results of Martin's technical study.

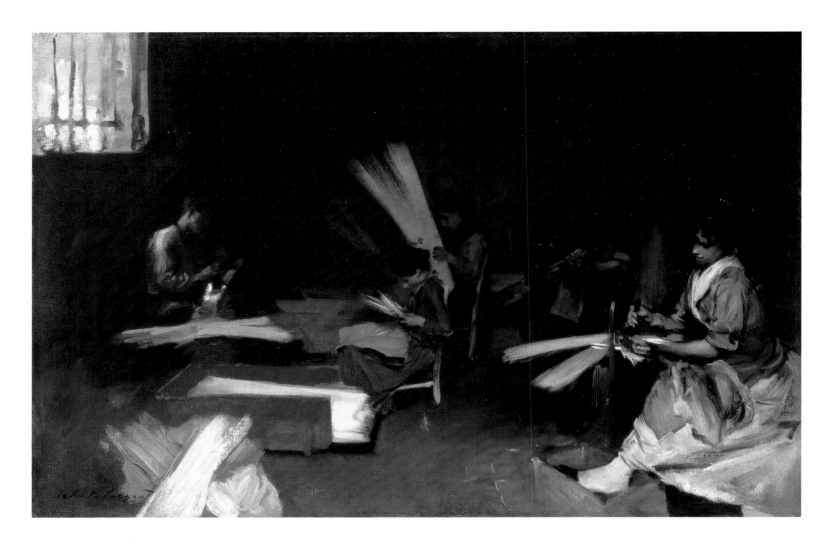

792
Venetian Glass Workers

c. 1880—81
Oil on canvas
22¼ x 33¼ in. (56.5 x 84.5 cm)
Inscribed, lower left: *John S. Sargent*
The Art Institute of Chicago.
Mr and Mrs Martin A. Ryerson
Collection (1933.1217)

The precise dating of Sargent's Venetian interiors is problematic, but, in the view of the authors, this example is likely to have been painted on his first visit; see the discussion of chronology in the introduction to this chapter (pp. 319—22). The picture represents the interior of a simple workshop, lit from above by a single barred window, where a group of glass workers, one male, five female, are engaged in the preliminary processes of turning glass tubes into glass beads. The tubes are sliced by hand into uniform lengths and then 'placed in a metal drum with a mixture of lime, carbonate, sand, carbon, and water. When the drum is heated and turned, the mixture acts as an abrasive that smooths the edges of the cut glass and forms rounded beads' (Judith A. Barter in Barter *et al.* 1998, p. 213; see also Peter Francis, Jr, *The Story of Venetian Beads* [Lake Placid, New York, 1979]; and *Perle e Impiraperle* [Venice, 1990]).

The manufacture of glass beads was an important cottage industry in Venice, and its products went all over the world. It also attracted tourists to the city, who visited the glass works and enjoyed the picturesque spectacle of young women stringing beads at street corners. William Dean Howells, in his book on Venice (*Venetian Life* [Edinburgh, 1883], vol. 1, p. 216), records that the process of making glass beads 'is one of the things that strangers feel they must see when visiting Venice'. Margaretta Lovell (San Francisco 1984, p. 103) quotes from the journal of the American writer Herman Melville, who visited a glass-bead manufactory in 1857: 'Drawing the rods like twine —making, cutting, rounding, polishing, coloring a secret'. She also records John Ruskin's vehement tirade against the whole business of glass-bead manufactory, which he thought frivolous, degrading and a sign of moral decay in Venetian society.

Sargent was to paint several scenes of bead stringing, but this picture is the only one to represent a real working environment. It shows three of the workers, one on the left and two on the right, slicing the glass tubes with a cutting instrument known as a *zocco*. The three workers in the centre are sorting the tubes into manageable sheaves. The figures here appear to be genuine craft people engaged in skilled work and not attractive models posed for effect, as seems to be the case with the other inte-

rior scenes. All are shown in profile, concentrating intently on the task in hand and self-absorbed.

The woman on the right, though young and attractive, appears different in kind to the stylish models of Sargent's palazzo scenes; she is more obviously working class in the way she dresses and comports herself. She is the most significant figure in the picture, more individualized and drawn out than the other figures, and a central focus of the composition. Her pose recalls that of the young woman on the right of Velázquez's famous picture of weavers, *Las Hilanderas* (Madrid, Prado Museum), which Sargent had copied in 1879 (no. 737). She is using the *zocco* on an upright support of some kind, and her left foot rests in the box into which the short lengths of tube are falling. Beyond her, and hidden in the shadows beside a pillar or outcrop of the back wall, a second, older woman is also at work using a *zocco* with the glass tubes across her knees. To her left is a row of three women bundling the sheaves of tube, the furthest of the three is all but invisible; she can only be faintly discerned in an early black-and-white photograph of the picture (fig. 215). On the left, below the barred window, a man is slicing tubes held across his knees. In the foreground on the left is a brown bag against which two crossed sheaves of tubing are resting. Then comes an open box of tubes, with more resting on a bench or support of some kind beyond. Earlier commentators have pointed out the bold patterns, almost abstract in shape,

which the bluish-white tubes create against the dark brown tones of the interior. Together with the white dress of the woman on the right, they create a powerful triangular form at the heart of the composition.

Marc Simpson has tentatively suggested that *Venetian Glass Workers* may have been one of the two Venetian studies exhibited at the Cercle des arts libéraux in Paris in 1881 (Simpson 1997, p. 174, no. A17). However, reviews of the exhibition are insufficiently detailed to identify which pictures were shown. The early provenance of the picture remains obscure. Together with *Venetian Water Carriers* (no. 805), it was bought by the American painter Charles Pepper (1864–1950) from the estate sale of someone he called a merchant of musical instruments, at the Hôtel Drouot, Paris, in the mid-1890s. In a letter to William Macbeth of 10 January 1912, Pepper wrote (Macbeth Records, Archives of American Art, Smithsonian Institution, Washington, D.C., roll NMc 10, frames 480–81): 'The two pictures I bought at Hotel Drouot in Paris some 14 years ago I should say. They were sold with the effects of a merchant of musical instruments. I understand Mr Sargent had exchanged them for some instruments he wanted. On the death of the merchant the sale occurred. I bought the two canvasses & sold one to Mr Crane who was with me at the sale'. A letter of 2 March 1912 from William Macbeth to Philip Gentner, director of the Worcester Art Museum (copy, Art Institute of Chicago files) gives the same information.

The Hôtel Drouot sale is likely to have been around 1896, rather than the date of 1898 implied by Pepper, because in the former year Pepper wrote to Sargent seeking further information on the pictures, presumably close to their date of acquisition. Sargent replied on 28 February 1896 (transcript by Macbeth, 1912, from untraced original, Art Institute of Chicago files): 'The pictures you refer to were both painted in Venice some fifteen years ago. One is the interior of a bead manufactory or glass work shop of some sort. I gave them to their late owner in exchange for a piano of his make'. While Pepper calls the previous owner a merchant of musical instruments, Sargent describes him as a piano-maker. Because Sargent is known to have owned a Bechstein piano, possibly the piano visible in photographs of his boulevard Berthier studio (fig. 109), several authorities have jumped to the conclusion that the two Venetian pictures had belonged to the well-known Berlin piano-maker Friedrich William Carl Bechstein (1826–1900). However, Bechstein was still alive when Pepper claims to have bought the pictures from the estate of the deceased merchant of musical instruments. The mystery will be solved only when the relevant Hôtel Drouot sale is identified.

Pepper traded *Venetian Glass Workers* for a painting of *Girl and Peaches* by Hawthorne, almost certainly his fellow-student at the studio of William Merritt Chase, Charles Webster Hawthorne (1872–1930); for the latter, see his obituary in the *New York Times* (26 August 1950, p. 13); *Hawthorne on Painting: from Student notes collected by Mrs Charles W. Hawthorne* (New York, 1960); and *From Hawthorne to Hofmann: Provincetown Vignettes 1899–1945,* Hollis Taggart Galleries, New York, 2003 (exhibition catalogue). Macbeth acquired *Venetian Water Carriers* at the same period from the artist Frederick Crane, to whom Pepper had originally sold it. *Venetian Glass Workers* was bought from Macbeth by the Chicago art collector Martin Ryerson in 1912 for five thousand dollars.[1]

1. Invoice dated 8 November 1912, The Art Institute of Chicago files; sale recorded in Macbeth Records, 2 November 1912, Archives of American Art, Smithsonian Institution, Washington, D.C., roll NMc 80, frame 95. Martin Ryerson (1856–1932) and his wife (c.1860–1937) were early supporters of The Art Institute of Chicago and donated important collections of European and Asian paintings and works of art ranging from the fifteenth to the twentieth centuries (see Barter *et al.* 1998, pp. 22–25).

Fig. 215
Lighter-toned photograph of *Venetian Glass Workers.*

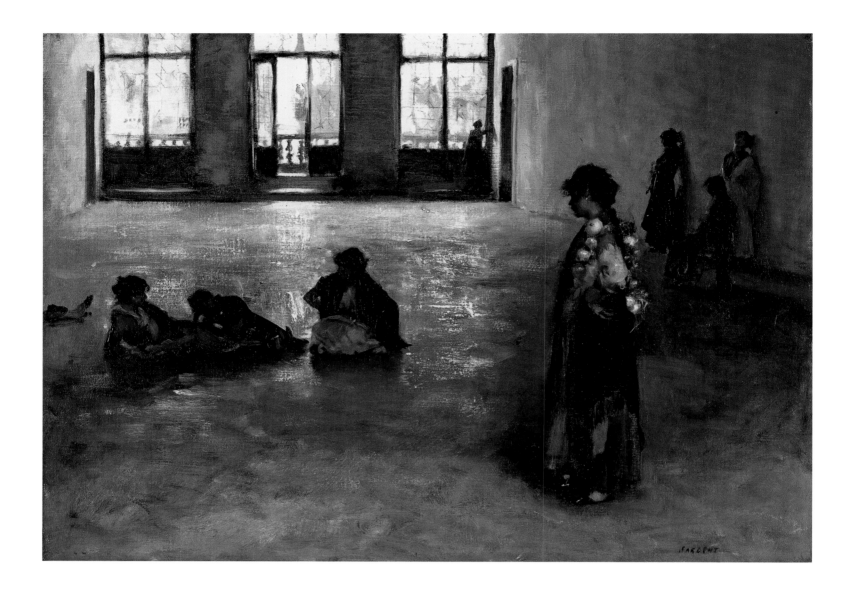

793
Venetian Women in the Palazzo Rezzonico

c. 1880–81
Alternative titles: *The Siesta; Siesta Time in the Doge's Palace*
Oil on canvas
17¾ x 25 in. (45.1 x 63.5 cm)
Inscribed, lower right: SARGENT
Inscribed on the reverse: 'La Siesta' *(una salla dei Palacio Ducal de Venezia), por John S. Sargent. (Collection de Carmen Errazuriz-Huici de Ogilvie Grant— Vina del Mar, Chili)*
Private collection

This picture remains a puzzle, and doubts over the attribution have been voiced in the past. The composition of the space, the character of the foreground figure (more Capri-like than Venetian), the relationship between her and the figures seated on the ground, and the thinly applied paint surface are different in treatment to the other pictures of Venetian interiors painted by Sargent. The unusual block form of the signature, SARGENT, compares to that in *A Venetian Interior* (no. 795), though lacking the prefix, 'John S.' Margaretta Lovell suggested that this 'cousinship may place the pair as products of a single season and as the two exhibited in London in the spring of 1882' (San Francisco 1984, p. 106). Marc Simpson agrees that *Venetian Women in the Palazzo Rezzonico* may have been one of the Venetian interiors exhibited at the Grosvenor Gallery, London, in the spring of 1882, but believes the other was *Venetian Bead Stringers* (no. 794) (Simpson 1997, pp. 176–77, nos. A41, A43). Both Lovell and Simpson relate *Venetian Women in the Palazzo*

Rezzonico to Henry James's description of a Venetian interior he had seen at the Grosvenor Gallery, London (for James's text, see the introduction to this chapter, p. 320).

The room most likely to be represented in the picture is the Portego dei Dipinti on the second floor above the Grand Salon. This was first proposed by David McKibbin (see his photograph of the room, fig. 216). The proportions of the room are similar and so is the arrangement of the windows and the balcony. However, it is not easy to reconcile the vague shapes visible through the windows in the picture with the buildings on the far side of the Grand Canal. The cartouches above the doorways are not shown, and the balcony balustrade is higher in the painting than it is in reality. It is, therefore, possible that the Palazzo Rezzonico is not the setting of the picture.

There are seven women in Sargent's painting, and the legs and feet of an eighth, chopped off by the edge of the picture on the left. It is not too fanciful to suppose that all seven women might have been painted

from the same model, so similar is their cast of feature and hairstyle (fringe over the forehead, bun at the back). Prominent in the foreground is a young woman in profile, hand on hip, a string of onions over her shoulder, wearing a red neck scarf over a white shirt, with a longer black shawl encircling her body (see *Stringing Onions* and *The Onion Seller,* nos. 711, 801, for other images of onion sellers). Highlights play on the onions, her silver earring and the points of her shoes. In character, she is closer to the Capri models than the more sophisticated women of the palazzo interiors and the street scenes. She is looking towards a group of three women lounging on the stone floor. The perspective here is uncertain, for the women appear to be on a different plane to the floor rising behind them; the diminutive figure in the middle of the group is especially oddly positioned. On the right is a seated woman, also in profile, and behind her two others leaning against the wall, while a fourth gazes out of the window in the background. There is an air of listlessness and disconnectedness about the women, which is similar in mood to the other Venetian interiors. Margaretta Lovell has perceptively noted that 'these women are reduced in part to silhouette while a "transparent shade" suffuses the enormous, empty space' (San Francisco 1984, p. 106).

According to David James, who wrote an article on Sargent's friendship with the Errázuriz family in a Chilean magazine, the picture of the Rezzonico, then thought to represent the interior of the Doge's Palace, was bought from the artist around 1912: 'Doña Carmen wished to have one of the earlier paintings of the American artist, one of those he painted during the romantic months in Venice during his youth. In the studio in Tite Street she found and bought *La siesta*, an oil painting showing a group of Italian young women in a room of the Doge's Palace. The *contrejour* effect and the reflections on the floor and the walls demonstrate the technical mastery of the author and his skill in avoiding the lapses committed in a moment of indolence'.[1] This story, together with the approximate date of purchase, was confirmed by David James in correspondence with David McKibbin in December 1966 (McKibbin papers).

The purchaser, Carmen Errázuriz-Huici de Ogilvie Grant,[2] was the daughter of the flamboyant and colourful Eugenia Errázuriz (1858–1951), who lived in Paris and London on the proceeds of vast mining interests in Chile. The latter was a woman of strong modernist sympathies, the friend and patron of many famous artists, writers and musicians, among them Walter Sickert, Baron de Meyer, Diaghilev, Stravinsky, Jean Cocteau and Cecil Beaton. Portraits of her by Boldini, Helleu, Augustus John, Picasso and Matisse are eloquent testimony to her charm and force of personality.[3] There are no fewer than four portraits of her by Sargent painted in the early 1880s (*Early Portraits,* nos. 69–72), as well as a later charcoal of 1905. Among other works by Sargent, she owned a version of *Dans les oliviers à Capri (Italie)* (no. 704) and *In a Garden, Corfu* (1909, private collection).

Eugenia's cousin Amalia Subercaseaux had also sat to Sargent, for a full-length portrait exhibited at the Paris Salon in 1880 (*Early Portraits,* no. 41). Amalia's husband, the colossally rich Ramón Subercaseaux, was Chilean consul in Paris and a talented painter. He and Sargent were both in Venice sketching together in the autumn of 1880; see Sargent's witty picture of Subercaseaux in a gondola in the act of sketching Sargent (fig. 193). Eugenia and her husband, José Tomás Errázuriz, are said to have spent their honeymoon in 1880 in the Venetian palace which Subercaseaux had rented (see the introduction to chapter 10, p. 307). It is possible, therefore, that the Rezzonico interior was acquired by the Errázuriz couple at the time it was painted, and not many years later by their daughter in London. However, David James, who was a friend of the family, presumably had the story of its acquisition from Carmen Errázuriz-Huici de Ogilvie Grant direct, and it is difficult to believe that she would knowingly have misled him.

1. 'Doña Carmen deseaba tener uno de los primitivos cuadros del artista norteamericano, de aquellos que pintara en los románticos meses pasados en Venecia en su juventud. En el studio de la calle Tite encontró y compró *La siesta,* apunte al oleo de un gruppo de muchachas italianas en una *sala* del Palazzo Ducale. El efecto de contraluz y los reflejos del suelo y las paredes son prueba de la maestria técnica del autor y de su pericia en esquivar los descuidos de un momento de indolencia' (David James, 'John Singer Sargent y sus amistades chilenas', *Zig Zag,* no. 2703 [January 1957], pp. 40–41).
2. Apart from this picture, Mrs Ogilvie Grant also owned an untraced water-colour, *Scene in Venice,* sold Sotheby's, London, 14 December 1938, lot 24.
3. See Philippe Jullian, 'The Lady from Chile', *Apollo,* vol. 89 (April 1969), pp. 264–66; Cecil Beaton, *The Glass of Fashion* (London, 1954), pp. 167–80; John Richardson, 'Tastemakers: Eugenia Errázuriz', *House and Garden,* New York, April 1987, pp. 76–84; and Alejandro Canseco-Jerez, *Le Mécénat de Eugenia Huici de Errázuriz* (Paris, 2000).

Fig. 216
David McKibbin, Photograph of the room above the Grand Salon, Palazzo Rezzonico, Venice, 1966. Catalogue raisonné archive.

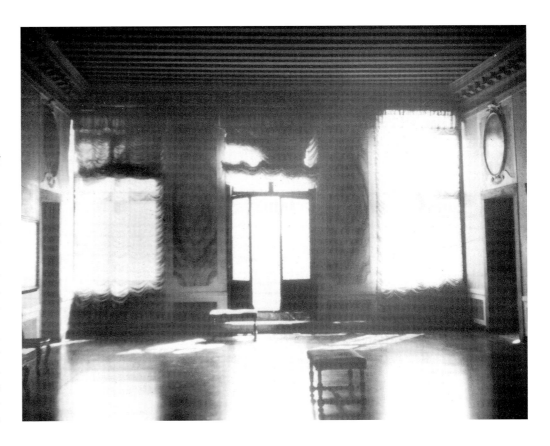

794
Venetian Bead Stringers

c. 1880–82
Alternative title: *Venetian Interior*
Oil on canvas
26⅜ x 30¾ in. (67 x 78.1 cm)
Inscribed, upper right: *John S. Sargent*
Albright-Knox Art Gallery, Buffalo,
New York. Friends of the Albright Art
Gallery Fund (16.2)

Venetian Bead Stringers is one of the best-known works from the modern life series painted by Sargent in Venice in the early 1880s. Represented in the picture is the upper hallway of a Venetian palazzo that is the setting for *A Venetian Interior* (no. 795) and probably also for *Venetian Interior* (no. 798). In *Venetian Bead Stringers,* the simple stone floor is complemented by a wooden ceiling supported by beams. The hall is closed off at the end by three arched openings, the two on the left revealing the upper and lower flights of a staircase, lit by windows at the half levels above and below. The third arch contains a window with slats, one side of it closed by a shutter. There is a doorway on the left, partly covered by a curtain, and a pedimented upright piece of woodwork, possibly not a doorway, on the right. Apart from the long bench running along the right-hand wall, the room is otherwise bare of furnishings. This is in marked contrast to *A Venetian Interior* (no. 795), where the walls of the same hall are shown covered in pictures and two tables are included as well as the long bench. In *Venetian Interior* (no. 798), probably a view of the same interior looking the other way, there are only a scattering of small pictures (five along one wall, two or three along the other), and the same bench appears and opposite it a cupboard.

In the foreground of *Venetian Bead Stringers* are three figures. Two of them, seated on simple wooden chairs, are dressed in black with white scarves, and they are evidently older than the young woman, who, in white skirt and black shawl, gazes

down on them. It has been suggested by Odile Duff (catalogue raisonné archive) that the object held by the young woman is a bunch of glass rods rather than a fan. The seated woman on the left has a shallow wooden tray, typical of the bead-stringing craft, on which she is sorting glass beads; her companion, with a hand resting on one end of the tray, may be assisting. There is something staged and studied about the three women isolated in the middle of the steeply receding space. This is not a scene of active industry or ordinary domestic life, but a contrived conversation-piece, where the models are posed with deliberate effect to counterpoint the architectural space and to create an air of strangeness and mystery. The dark costumes blend with the prevailing tones of grey and black, in which the pink fan of the young girl provides the only note of bright colour. She is the nearest to us and seemingly out of scale with the others, being too tall. Her slender figure provides the vertical shape anchoring the composition and acting as a foil to the seated figures in the centre. Her lovely profile head, with the hair drawn up in a bun and falling over the forehead as a fringe, echoes that of other models in the Venetian genre scenes.

The austere geometry of the space is softened by subtle lighting from a variety of sources. Backlighting is provided by windows on the stairs and the shuttered window on the right. Light from the stair window on the left beams golden bands across the stone floor, reproducing the pattern of the treads. A shaft of light falls through a doorway across the floor at right

angles to the stairs, like a searchlight in the dark—a powerful horizontal accent in the middle of the picture space. The vertical gleam of sunlight on the doorjamb is repeated in the upright of the wooden chair and the bars of the right-hand window. Light from the unseen balcony opening in front of the figures highlights their faces, scarves, and hands and the cream-coloured skirt of the young woman.

The picture is described as being for sale in a studio in New York in November 1887, together with *Street in Venice* (no. 808), in *Art Interchange* ('Art Notes', vol. 19, no. 10 [5 November 1887], p. 145). It was then given to Sargent's close friend J. Carroll Beckwith (1852–1927), with whom he had shared a studio in Paris, as a belated wedding present.[1] Beckwith lent the picture to Sargent's first one-man exhibition at the St Botolph Club, Boston, in 1888; for reviews of the exhibition, see *Street in Venice* (no. 808).

1. Beckwith had married on 1 June 1887, while Sargent was still in England. Beckwith sold the picture to the Albright Knox Art Gallery in 1916, writing at the time (museum files): 'I found that Mrs Beckwith was sensitive regarding the possible publicity of our parting with a *wedding present* from John, although he was cognizant of it'. Beckwith explained that he needed the money to help finance an extension to his summer home, and added ruefully that although he was regarded as one of the few American painters enjoying prosperity, 'it is not so great but that I have to study economy very carefully and am very thankful that our needs are so modest'. Sargent himself wrote to Miss Quinton about the picture in a letter of 3 January 1922 from Boston (museum files): 'The picture "Venetian Bead Stringers" was painted by me in Venice in, I should think, 1880 to 1890. I think it is the picture I gave to Carroll Beckwith years ago, and that the Albright Gallery purchased it from him'. Beckwith owned a version of Sargent's *Oyster Gatherers of Cancale* (no. 672).

795
A Venetian Interior

c. 1880–81
Oil on canvas
19¹⁄₁₆ x 23¹⁵⁄₁₆ in. (48.4 x 60.8 cm)
Inscribed, lower right: *to my friend*
J. C. CAZIN/John S. SARGENT
Sterling and Francine Clark Art Institute,
Williamstown, Massachusetts (580)

The picture presents the same view of the upper hall of a Venetian palazzo as *Venetian Bead Stringers* (no. 794) and probably *Venetian Interior* (no. 798). There has been much discussion as to which of the Venetian interiors may have been exhibited at the Cercle des arts libéraux, Paris, in 1881, the Grosvenor Gallery, London, in 1882, and the Société internationale de peintres et sculpteurs, Paris, in 1882–83. Those shown in the first two exhibitions would have to have been painted on Sargent's first visit to Venice in 1880–81, and there are grounds for thinking that all three Venetian interior scenes were painted at that time; see the discussion of chronology in the introduction to this chapter (pp. 319–22).

The figures in *A Venetian Interior* are more dispersed than those in *Venetian Bead Stringers*. The artist positioned himself further down the hall, this time revealing the two doorways at the lower end of the space. In place of the bare walls seen in no. 794, the artist has in this work included a dense hanging of pictures. The same long bench appears as in other paintings of the hall, supplemented by an oblong wooden table (right) and a small console table on the left. In the left foreground, an older woman and a younger woman in black shawls face one another, the older holding a gleaming necklace of beads. Immediately behind them sits a young girl in white, staring straight ahead at the wall. The stillness and passivity of the figures, and the lack of communication between them, make them appear stilted and stylized. This element of disjunction, favoured by Sargent at the time, creates a mood of psychological tension and a sense of otherness out of the materials of ordinary life. Sargent's obsession in these Venetian pictures, with the

profile heads of seductive young women, hair up and fringe over the forehead, recurs in this example. The three remaining figures in the scene, scattered along the further wall, are more conventional. The young woman on the right holds up the string she is threading with beads taken from the cloth-covered tray before her on the table. Her red shawl, standing out from her brilliant white shirt, provides the strongest note of colour in the picture. Two sketchy figures are shown further back sitting on the long bench. The nearest one, also in red and white, and looking towards us, is apparently holding up her shawl, though she may, in fact, be stringing beads.

A Venetian Interior is not only busier in content than *Venetian Bead Stringers* but more immediate in its effect, more painterly and sketch-like. The dark space is irradiated by vivid accents of light: the windows behind; a single spear-like shaft from the door at the upper left; the gleaming edges of gold picture frames, door frames, chair and table legs; the strings of beads; and the brilliant white costumes. The left-hand wall and stone floor, illuminated from the unseen window in front, are deliberately kept bare to set off the steeply receding atmospheric space. The perspective of the picture is deceptive, and it is a surprise to discover that the young woman nearest to us is, in fact, at the centre of the picture space.

The French artist Jean-Charles Cazin (1841–1901) to whom the picture is inscribed, was a successful landscapist and subject painter. He was a prominent figure at the Salon and a fellow-exhibitor with Sargent at the Société internationale de peintres et sculpteurs. He was admired by the young Sargent, whose early work bears

the stamp of his influence. In a letter to Vernon Lee of 1 August 1880 (private collection), Emily Sargent wrote with news of her brother in Paris: 'He says that Cazin, one of the best French artists who had two delightful pictures in the Salon, likes his last portrait very much, and came to his studio & liked his things'.

Although the picture is inscribed to Cazin, the latter's widow claimed that it had been given to her (letter to M. Knoedler & Co., quoted in the invoice to Robert Clark of 21 October 1913, Clark Art Institute files): 'I remember the picture quite well. It was presented to me by Sargent about 1881–1882. We liked it immensely and would not have parted with it had not Constant Coquelin, in his late years, expressed a wish to have it, which I could not refuse him. I have since learned that Coquelin gave it as a present to an actress'. Mme Cazin, *née* Marie Guillet (1844–1924), a former pupil of her husband, was a successful painter and sculptor in her own right. Constant Coquelin (1841–1909), the distinguished French comic actor, and elder brother of Ernest Coquelin, was from the same region as Cazin, the Pas de Calais, a close friend since youth and an important patron. According to the Knoedler invoice, the actress to whom Coquelin presented the picture was Mme Mieris, a name that remains to be identified. For other Sargent pictures owned by Coquelin and his brother, see *Venetian Street* and *Sortie de l'église* (nos. 809, 806). The picture was sold to M. Knoedler & Co., London, in September 1913 by the Paris art dealer Georges Bernheim, a friend and agent of Renoir and Monet. The picture was sold to Robert Sterling Clark by Knoedler, New York, in October 1913.

796
A Venetian Woman

c. 1880–81
Oil on panel
16½ x 12 in. (41.9 x 30.5 cm)
Private collection

This oil sketch, on a thin mahogany panel favoured by the artist at this early date, relates closely to *A Venetian Interior* (no. 795) and is likely to have been painted on his first visit to Venice in 1880–81; see the discussion of chronology in the introduction to this chapter (pp. 319–22). The young woman in the picture wears the familiar costume of the Venetian models, white shirt, black shawl and pink skirt; her head is unfinished and her hands only blocked in. She stands in the same pose, and in the same relation to the wall and the space as a whole, as the figure on the left of *A Venetian Interior.* However, in place of the young model in the sketch, Sargent substituted an older woman with a shawl over her head in the larger picture. The sketch shows the left-hand side of the hallway in the unidentified Venetian palazzo where Sargent painted other interior scenes. A shaft of light falls across the floor from the doorway higher up the hall on the left, and the bright patches of light beyond indicate a secondary source of back-lighting from the staircase window. Sargent uses the warm reddish tone of the mahogany panel to set off the thin washes of grey for the wall and floor, the strong blacks of the shawl, door, picture frames and stair-case, and the vivid pink and white of the costume. The two black patches immediately to the left of the figure may represent objects on a ledge or tabletop.

The first owner of the picture was Conway Joseph Wertheimer (1891–1953), son of Sargent's famous patron Asher Wertheimer. He was painted by Sargent in one of the groups of Wertheimer children (see *Later Portraits,* no. 483) and changed his name to Conway Joseph Conway during the First World War. He sold the sketch to M. Knoedler & Co., London, in 1927, and the New York office, in turn, sold it to Joseph Verner Reed (see correspondence with members of the Reed family, March–May 1965, McKibbin papers). Reed also owned *Rio Eremite* (private collection), and his brother, Verner Z. Reed, Jr, owned *Portico di San Rocco* (no. 818).

797
Venetian Interior

c. 1880–81
Water-colour and pencil on paper
20 x 14 in. (50.8 x 35.6 cm)
Private collection

This water-colour has much in common
with Sargent's oil paintings of Venetian
interiors in its choice of subject matter, its
evocation of dark, atmospheric space, its
dramatic backlighting and subdued tonality.
The old woman in the foreground appears
to be stringing beads, like the women in
the oil paintings, though there is insuffi-
cient detail to be certain. Her red-and-
white patterned neckerchief stands out
sharply from the surrounding gloom. A
younger woman wearing a black coat sits
with a tray of beads on her knees, watched
by a third female figure, hand on hip, lean-
ing against the wall. Two brightly lit square
windows and a doorway close off the space
at the back, through which a patch of blue
stands out, perhaps indicating a canal, and
the shadowy silhouette of a fourth figure.
Unlike the oil paintings, which are located
on the *piano nobile* of a palace, this scene is
set at ground level. The elegant form of the
architrave to the doorway on the right sug-
gests that it is a building of some distinction
but its location remains unidentified.

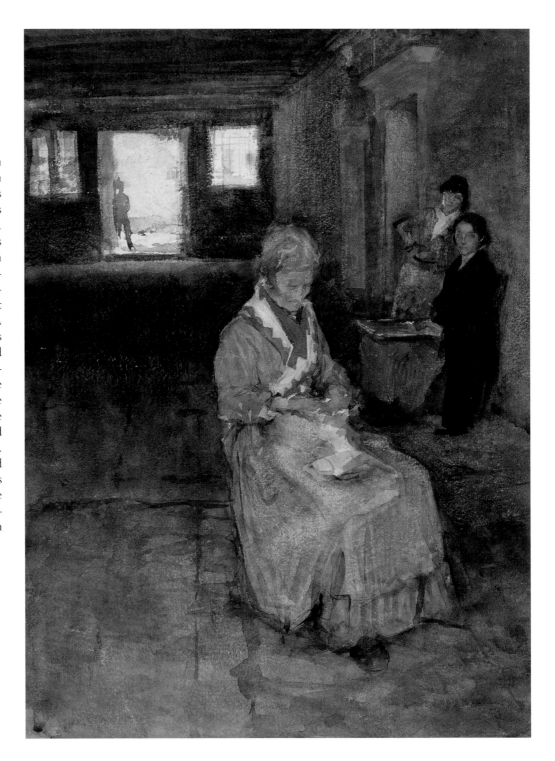

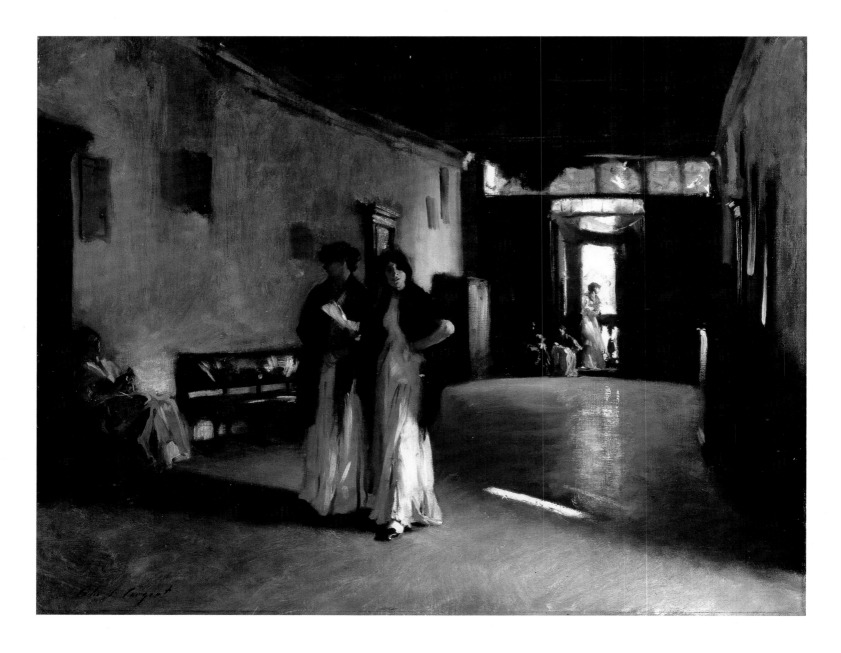

798
Venetian Interior

c. 1880–82
Oil on canvas
26⅞ x 34³⁄₁₆ in. (68.3 x 86.8 cm)
Inscribed, lower left: *John S. Sargent*
Carnegie Museum of Art, Pittsburgh.
Museum Purchase (20.7)

In the opinion of the authors, *Venetian Interior* represents the same hallway of a palazzo as *Venetian Bead Stringers* and *A Venetian Interior* (nos. 794, 795). There has been much discussion as to which of the interiors may have been exhibited at the Cercle des arts libéraux, Paris, in 1881, the Grosvenor Gallery, London, in 1882, and the Société internationale de peintres et sculpteurs, Paris, in 1882–83. Those shown in the first two exhibitions would have to have been painted on the artist's first visit in

1880–81, and there are grounds for thinking that all three of the Venetian interior scenes were painted at that time. Whistler painted the same view of the hallway as *Venetian Interior* in a pastel entitled *The Palace in Rags* (fig. 217), which was painted in 1879–80. The chief reason for considering a later dating for *Venetian Interior* is that the foremost model is identical to, and very much in the spirit of, the female model in *Street in Venice* (no. 808), which almost certainly dates from the second Venice visit in 1882. Marc Simpson (Simpson 1997, p. 176) suggests that the picture may have been shown at the Société internationale de peintres et sculpteurs at the Galerie Georges Petit, 20 December 1882–30 January 1883, under the title 'Autre intérieur vénetien'.

In *Venetian Interior,* the view of the hallway, assuming it to be the same space as represented in the two interiors discussed above, is reversed; this time we are looking

out towards the front of the palace, with the unseen staircase behind us. There are the matching doorways, further down the hall, seen in the foreground of *A Venetian Interior,* the same tall structure and long bench on the left with a cupboard beyond, and a cabinet on the right. The few scattered pictures on the walls are arranged quite differently to those in either of the other two interior scenes. The balcony, with its balustrade, pillar and awning, and the distant view of canal and buildings, is framed by curtains; above them is a long window in six partitions running the whole width of the space. In the foreground, two young women stroll down the hallway together. The nearer of the two, one hand on her hip, the other holding a fan, has a challenging and provocative look. She is identical to the model in *Full-Length Study of a Venetian Model, Head of a Venetian Model in a Scarlet Shawl* and *Street in Venice* (nos.

800, 799, 808; for a discussion of Sargent's Venetian models, see pp. 316–17). Linda Ayres made an intriguing comparison between the foreground model and Tanagra figurines, which influenced Whistler and other artists of the period (see Ayres in Hills *et al.* 1986, p. 54). Both she and the woman beside her have white dresses edged with yellow flounces, black shawls and square-cut black shoes. A seated woman on the left, also in white, appears to be stringing beads. Another in profile, with a red scarf, is framed in the doorway looking out across the canal. Two women crouch on the step at the end, one with a young child at her knee.

The hall is bathed in a pearly iridescent light that plays across the space, casting a pinkish glow on the further wall, lighting up the floor with dragged highlights, accentuating the edge of frames and furniture, throwing light upwards on the face and skirt of the nearest young woman, and falling as a single bar of orange light across the foreground. In common with the other two interiors, light enters the hall from a variety of sources: the opening and windows of the balcony, the doorway on the right, and the unseen staircase behind.

The first owner of the picture was the painter Henry Lerolle (1848–1929; see p. 182 and fig. 96).

Fig. 217
James McNeill Whistler, *The Palace in Rags,* 1879–80. Chalk and pastel on paper, 11 x 6½ in. (28 x 16.5 cm). Private collection.

799
Head of a Venetian Model in a Scarlet Shawl

c. 1880–82
Alternative titles: *Head of a Girl with red shawl; Head of a Girl; Head of a Sicilian Girl; Capri Girl; The Venetian Girl; Gigia Viani*
Oil on canvas
13⅞ x 10¾ in. (35.4 x 27.3 cm)
Inscribed, upper left and right:
John S. Sargent 1880
Fogg Art Museum, Harvard University Art Museums, Cambridge, Massachusetts. Bequest of Grenville L. Winthrop (1943.149)

The young woman in this picture was one of Sargent's favourite Venetian models and appears in at least three other pictures and possibly more; see the discussion of models in the introduction to this chapter (pp. 316–17). Her raven-black hair, parted in the middle and drawn over her ears in two smooth loops, her almond-shaped eyes and rounded chin are unmistakable in this and other pictures of the same model. In the Fogg study, she gazes out with a cool, appraising look, head tilted to one side, lips parted, a loose strand of hair across one eye, a narrow 'V' of bare flesh sensuously framed by the scarlet shawl and complementing the 'V' of her parted hair. She is the very image of a sultry beauty or pin-up girl. The picture is so closely related to the *Full-Length Study of a Venetian Model* (no. 800) in mood and look that it is difficult to believe it was not painted at the same period. Since this study is dated 1880 and the large picture 1882, it may mean that one or the other inscribed date is wrong. There is also the possibility that the 1882 picture was begun in 1880 and worked on again two years later, when it was signed and dated. The first owner of the picture was the painter George Henry Boughton (1833–1905).

800
Full-Length Study of a Venetian Model

1882
Alternative titles: *Lady with a Fan;*
Venetian Girl with a Fan; Italian Girl with
a Fan; A Venetian Girl; Venetian Woman
Oil on canvas
93¾ x 52½ in. (238.1 x 133.3 cm)
Inscribed, lower right: *John S. Sargent 1882.*
Inscribed in ink on a fragment of the
original stretcher, now attached to
the present stretcher: *J. S. Sargent Ven[ice]*
1883 [just possibly *1882*]
Cincinnati Art Museum, Ohio. The Edwin
and Virginia Irwin Memorial (1972.37)

The young woman in this picture was one of Sargent's favourite Venetian models, and she appears in several other paintings of the period; see the discussion of models in the introduction to this chapter (pp. 316–17). Her identity as Gigia Viani, a name indiscriminately attached to a number of figures in Sargent's Venetian pictures, rests on flimsy evidence and has yet to be substantiated. This large-scale figure subject may have been intended for the Salon picture which Sargent planned to bring back with him from Venice. Tall and slender, the model steps forward boldly from the surrounding gloom, holding up her pale-yellow flounced skirt with one hand and clasping in the other what appears to be a bundle of blue glass rods, rather than a fan as sometimes described in alternative titles for the picture. A brilliant white shirt with puffed sleeves, a deep scarlet fringed shawl tied at her breast, square-cut black shoes and white socks complete her costume. Her look is seductive and appealing, with lustrous dark eyes, raven-black hair drawn over her ears in two smooth loops, parted red lips, and head tilted to one side. An oil study of the same model dated 1880 (no. 799) is closely related, and it is likely that the two pictures were painted at the same date. It is possible that one or other was inscribed later and the date misremembered, or that this full-length study was begun in 1880 and worked on again in 1882, when it was signed and dated.

If the model is holding glass rods, as seems likely, then she is one of Sargent's familiar glass-bead workers. She was almost certainly painted in the same spacious hallway as the three well-known interior scenes of bead stringers (nos. 794, 795, 798). There is a similar arrangement of picture frames, table, doorway, textured wall and floor, and the same sense of mysterious space opening up behind the figure. As in the case of *Spanish Dancer* (no. 770), Sargent must have felt dissatisfied with the work, because he never exhibited it.

David McKibbin had access to Lady Berwick's copy of Evan Charteris's biography of Sargent (Charteris 1927), with annotations by Ralph Latimer, an artist and cousin of Ralph Curtis. McKibbin records this note by Latimer: 'Study, life-size—full lgth of model "Caterina" 1882 left unfin. here in Po Barbaro, subsequently carried further. When here in 1913 looking at it he [Sargent] said "I have never painted a better *head*"'. No reason for naming the model Caterina was given. Lady Berwick (1891–c. 1972) was the daughter of the artist William Hulton and his wife Constanza Marini, the stepdaughter of the Italian historian Professor Pasquale Villari, who were residents of Venice. She was the wife of the 8th Baron Berwick and lived at Attingham Park, Shropshire, now a National Trust property. It has not been possible so far to locate her copy of the Charteris biography with Latimer's notes. Her papers, including a memoir of Venetian society by her mother, are in the Bodleian Library, Oxford.

In 1887, the novelist Thomas Hardy and his wife Emma visited the Palazzo Barbaro, and Emma recorded the following note in her diary for 21 April: 'Picture of Venetian girl by Sargent hanging opposite me at dinner—painter a relative perhaps' (*Emma Hardy Diaries,* ed. Richard H. Taylor [Newcastle, U.K., 1985], p. 183). Laurence Curtis (1893–1989), who bought the picture in 1955, was the son of Louis Curtis, half-brother of Daniel Curtis; Louis also owned *The Sulphur Match,* another of Sargent's 1882 Venetian pictures (no. 803). Laurence Curtis was a prominent lawyer in Boston and a Massachusetts congressman, elected to the Eighty-third and four succeeding Congresses (3 January 1953–3 January 1963).[1]

1. See his letter of 13 November 1982 to Mrs Denny Young, curator of painting at the Cincinnati Art Museum: 'Sargent gave the picture to R. W. Curtis, friend and artist who ceased painting a few years later, probably soon after date of painting. R. W. C. presumably gave it to his father Daniel S. Curtis. Dan moved from US to Venice (pal Barbaro) in the sixties. The picture was probably there till RWC died & his daughter Sylvia (who married Owen) got it brought it to America about 1945. She put it up for sale about 1950. I bought it from her dealer, had it in my house in Washn. 1953–63 (when in Congress) loaned it to Corcoran Gallery, sold it when Cincin. Museum bought it'.

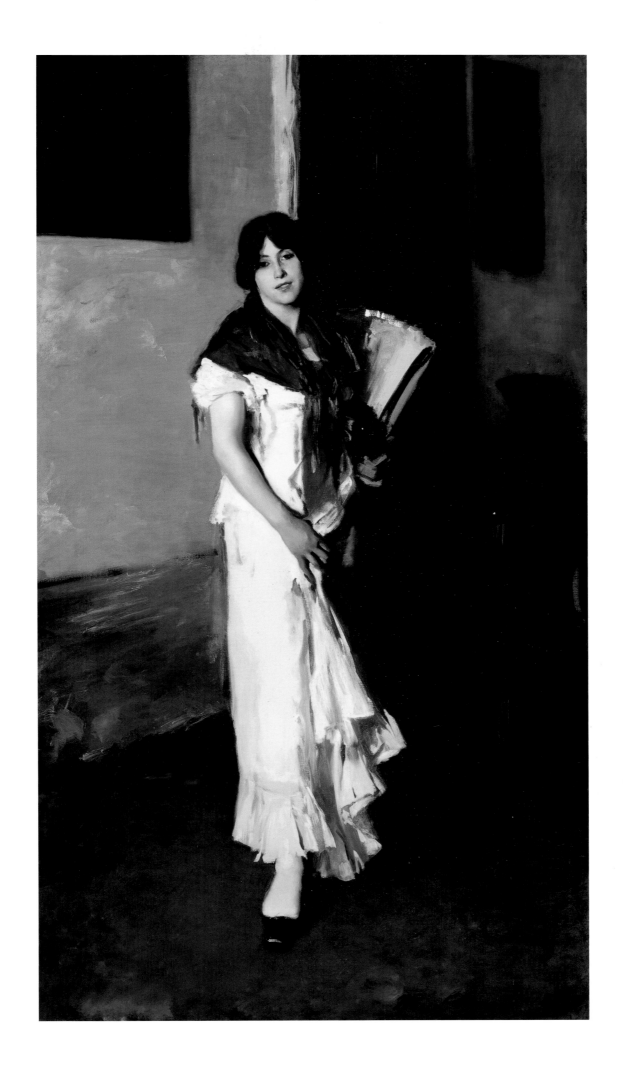

801
The Onion Seller

c. 1880–82
Alternative title: *Venetian Onion Seller*
Oil on canvas
37⅛ x 27½ in. (94.3 x 69.8 cm)
Inscribed, lower right: *à Monsieur Lemercier/souvenir amical/John S. Sargent*
Label, formerly on the back of the stretcher, for the Venetian supplier of artist's materials: GIUSEPPE BIASUTTI/PRESSO LA REGIA ACCADEMIA/N. 1024 VENEZIA/DEPOSITO OGGETTI/PER/PITTURA E DISEGNO
Museo Thyssen-Bornemisza, Madrid (731 [1979.56])

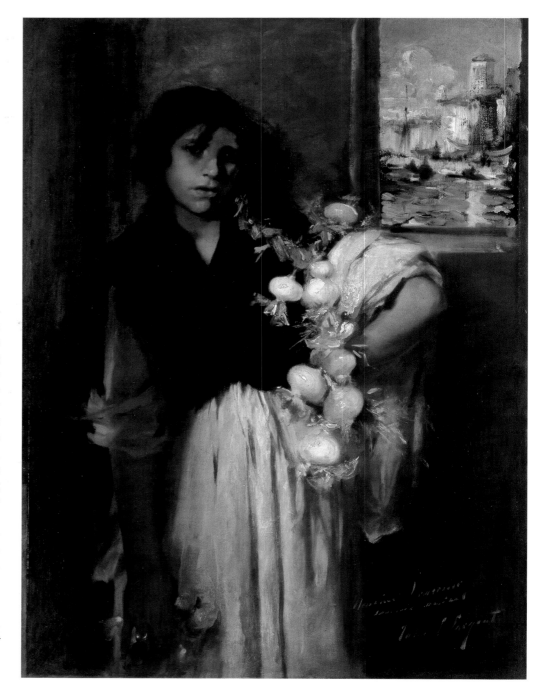

The character of *The Onion Seller* is different from the general run of Sargent's stylish Venetian models. She appears as a more humble member of the Venetian working class, though there are parallels with the model in *A Street in Venice* (no. 810), who also has her hand on her hip and a similarly disconcerting stare; see also *Stringing Onions* and *Venetian Women in the Palazzo Rezzonico* (nos. 711, 793) for other images of onion sellers. The picture is conceived in the spirit of contemporary genre, an attractive young woman offering her produce for sale. Her head is cocked to one side, with lips parted; a strand of hair falls across one eye; a triangle of bare flesh is framed by the criss-cross of her black shawl; her white skirt falls in slender vertical folds; in her right hand she carries a bunch or wreath of pink flowers (possibly roses); draped over her left arm is a piece of white drapery; over this the string of onions cascades in a virtuoso display of dazzling white, russet and pink brush strokes. The mysterious character of the model is accentuated by the insertion of a rectangular window or opening top right that reveals a view of water, boat and buildings. The juxtaposition is deliberately abrupt, setting the shadowed space within against the colourful, sunlit scene without. The square of light from a window in *Venetian Glass Workers* (no. 792) is similar in its effect.

When the picture appeared on the art market in 1951, the identity of Lemercier, to whom the picture is inscribed, was already known. In a letter to Mr Dlugosz of 8 April 1951, K. Hirago, apparently an art dealer in Paris, wrote (copy in the Museo Thyssen-Bornemisza files):

The stretcher is Venetian and the handsome gold frame is Sargent's. A dedication on the lower left hand corner (right from the point of view of spec-tator) is to his proprietor, Mr. Lemercier, from whom at the above mentioned period [1880–82] he was renting his studio.

The painting (La Marchande d'Oignons) has never been exhibited, having remained in the apartment of M. Lemercier until I purchased it from his heir.

The same information was contained in a letter of 26 February 1952 to David McKibbin from Simon Olshwang, a director of the Hall of Art Gallery, New York, who had recently acquired the picture, either from Dlugosz or Hirago (McKibbin papers).

Dr Abel Lemercier, a medical doctor, was indeed the proprietor of 73, rue de Notre-Dame-des-Champs, but, apart from the Lemercier family, nobody then would have known that fact unless they had consulted the land-registry documents in the Archives de Paris (*cadastre*, D.1PA 0811). The relevant documents list Lemercier as proprietor and itemize the apartments within the three buildings comprising no. 73. J. Carroll Beckwith and Sargent shared one studio apartment, and Auguste Alexandre Hirsch another, into which Sargent later moved. Lemercier was the recipient of a second early picture by Sargent, *Atlantic Sunset* (no. 665), which had also descended in the Lemercier family.

A second vital piece of evidence supporting the attribution is the label of Giuseppe Biasutti, the Venetian supplier of artists'

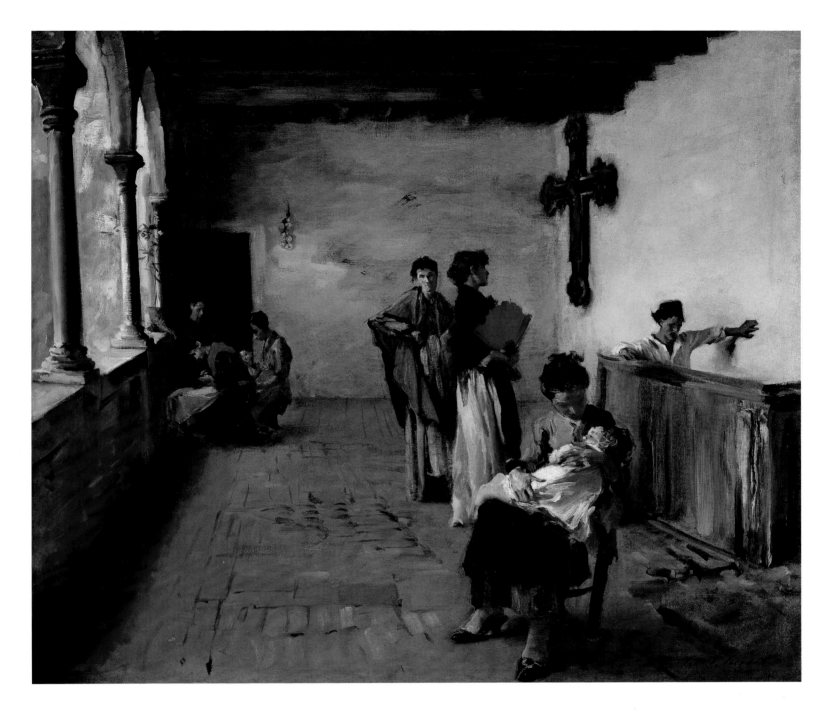

materials, which was formerly on the back of the original stretcher. This stretcher was replaced by Hall of Art Gallery in 1952, but the text was recorded by Simon Olshwang in the letter to McKibbin quoted above. Other Venetian pictures of 1880–82 by Sargent with this same label include *Street in Venice, A Street in Venice*, and *Saint Roch with Saint Jerome and Saint Sebastian, after a Picture Attributed to Alessandro Oliverio* (nos. 808, 810, 743); for more information on Biasutti, see the entry for *Street in Venice* (no. 808).

802
Venetian Loggia

c. 1880–82
Alternative titles: *Sketch of a Spanish Cloister; Spanish Courtyard; Spanish Interior; Venetian Interior*
Oil on canvas
28¼ x 31¾ in. (71.7 x 80.6 cm)
Inscribed, lower right: *John S. Sargent*
Private collection

This picture was bought by Louis McCagg in Paris in or around 1884 and lent by him to several exhibitions within the artist's lifetime, including the Sargent retrospective of 1899 in Boston, under the title 'Sketch of a Spanish Cloister', 'Spanish Courtyard', and variants. This might be thought to be conclusive as regards the location where the picture was painted, except that the style of the picture and the character of the models strongly point to a Venetian source. Additional information is provided by a painting of the same loggia by Ralph Curtis, entitled *Woman at the Window* (Richard York Gallery, New York, 1989). Sargent and Curtis were togther in Venice in 1880–81 and 1882, but not in Spain in 1879. In the view of the authors, it is more likely to

have been painted on his first visit to the city in 1880–81 than his second in 1882, though, as Marc Simpson perceptively remarks of this picture and *Campo behind the Scuola San Rocco* (no. 816), 'each startlingly composed and dashingly figured, elude the readily recognized characters of the 1880 and 1882 clusters' (Simpson 1997, p. 99); for a discussion of the chronology of the Venetian works, see the introduction to this chapter (pp. 319–22).

Though usually described as a 'courtyard' in Sargent literature, the picture, in fact, represents an upper loggia, which may or may not belong to a courtyard. The deeply receding space of the picture is typical of Sargent's Venetian pictures, but, in contrast to the usual dark and brooding atmosphere of his street scenes and interiors, this work is bathed in warm light. In the foreground, a young woman, sketchily painted in purplish skirt, brown shirt and black apron, is cradling a sleeping child dressed in white. A second woman, in pink skirt and black shawl, holding a brilliant red fan, stands in profile gazing into space. She has been compared to other models in profile in Sargent's Venetian pictures, and wrongly identified as Gigia Viani; for a fuller discussion of Sargent's Venetian models, see pp. 316–17. Beyond her is an older woman, in a brown shawl, one hand on the hip, and similarly disengaged. The head and shoulders of a moustachioed young man are visible about the banister of the staircase; he is supporting himself against the wall and the rail as if on the point of descending.

At the end of the loggia on the left is a group of three women, two seated and one standing, and a child, in various shades of brown, grey, white and black with accents of bright red and green. They are engaged in some activity, which might be bead stringing or some simple domestic chore. A potted plant with red flowers rests on the edge of the balcony, a string of onions hangs on the wall beside the doorway, and a large carved wooden crucifix is fixed to the right-hand wall. Light flows into the scene through the arches and pillars of the loggia, which are Gothic in style. The steep perspective is emphasized by the receding line of beams, the linear patterns of the brick floor, and the wall on the left.

The picture was first owned by Louis Butler McCagg (1861–1929), a graduate of Harvard University, who trained as a lawyer, and cheerfully admitted that he had no occupation. According to his son (letter of 20 August 1948 to David McKibbin, McKibbin papers): 'Shortly after his graduation from Harvard in '84 he was in London and while there purchased two Sargent paintings for the sum of five hundred dollars. One of the paintings, about 12" x 18" was of a Spanish dancer and is now owned by my brother E. K. McCagg of Mt. Kisco, N.Y. The other painting, which must have been 3' x 4' was a Spanish courtyard scene. This father sold in 1927 or '28 thru a dealer in New York and I do not think that any of the family ever knew who had bought it. I do know that father got a very high price for it at that time'. According to McCagg's daughter-in-law, the pictures were bought from a Paris shop before 1898 (see Washington 1992, p. 154). The second picture owned by McCagg was one of two versions of *Spanish Gypsy Dancer* (no. 767). He later commissioned a portrait from Sargent of his friend Dr Carroll Dunham (see *Portraits of the 1890s,* no. 238).

Venetian Loggia was acquired in 1928 from Flora MacDonald White of New York by John Hay Whitney (1904–1982). In the words of his obituary (*New York Times,* 9 February 1982), Whitney was 'master of one of the great American fortunes and a pace-setting leader in a kaleidoscope of fields . . . Sportsman, investor, publisher, philanthropist, political mover and ambassador, he hated to lose at anything, from polo to racing to golf to bridge to investing'. From his mother, Mrs Payne Whitney, another famous collector, he inherited Sargent's portrait of *Robert Louis Stevenson and his Wife* and the beautiful water-colour of *Madame Roger-Jourdain* (*Early Portraits,* nos. 162, 152). On his death, the pictures passed to his widow, Betsey Cushing Roosevelt Whitney (1908–1998), a prominent philanthropist in medicine and art (see her obituary in the *New York Times,* 26 March 1998), and on her death to the charitable Greentree Foundation she had established.

803
The Sulphur Match

1882
Oil on canvas
23 x 16¼ in. (58.4 x 41.3 cm)
Inscribed, upper right: *John S.*
Sargent/Venice 1882
Collection of Marie and Hugh Halff, Jr.

The Sulphur Match is unique in Sargent's Venetian oeuvre in its small scale and narrative subject matter. A young woman tips back her chair to rest precariously against the wall, her feet off the ground, while gazing idly and flirtatiously at her companion, who is lighting a cigarette. The wine bottle and broken glass in the lower right-hand corner suggest a tavern scene. In seventeenth-century Dutch art, the broken glass would stand for the young woman's loss of virtue, and Sargent may also be implying the same thing. The flaring match, which gives the picture its title, is an obvious erotic metaphor.

The young woman may be identical with the model identified as Gigia, who features in a number of Sargent's Venetian genre scenes; see the discussion of models in the introduction to this chapter (pp. 316–17). She wears the familiar outfit of pale-yellow skirt with flounced hem, square-cut black shoes with blue bows, and white shirt set off by a brilliant red shawl. In contrast to her summery costume, her male companion is dressed in a winter hat and coat with stand-up fur collar, reading darkly against her white. He appears to be the same model as the man on the right of *Street in Venice* and in *Venetian Street* (nos. 808, 809); see the discussion of Sargent's male Venetian models (pp. 316–18). In 1924, at the time of the Sargent exhibition at Grand Central Art Galleries, New York, the art critic Rose Berry reported that several artists acquainted with the circle of artists around Frank Duveneck 'felt that the man in this picture [*The Sulphur Match*] was Frank Currier. It is rather pleasing to believe that it might be, and since they often posed for each other, it is not unlikely' (Berry 1924, pp. 99–100). J. Frank Currier (1843–1909), like Frank Duveneck, was a leading figure among the colony of American artists studying and working in Munich. He may have overlapped with Sargent in Venice, but there is no record of their meeting there, and Rose Berry's statement that they often posed for one another is uncorroborated.

The Sulphur Match is modern in its wittiness and casualness of pose, in its atmos-

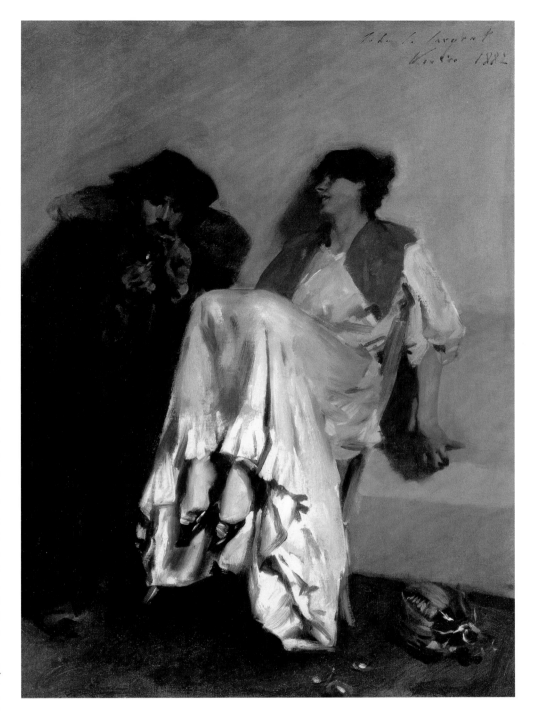

phere of easy-going intimacy between the sexes, and its inclusion of cigarettes and drink. It is also a carefully composed studio production. The relationship of the figures to the wall has strong affinities with the frieze of musicians and singers in *El Jaleo* (no. 772), and details like the splayed fingers of the woman's hand recall mannerisms in Sargent's early work. There is an air of suppressed excitement about the picture, evident in the attitude of the figures, the dramatic lighting of the woman's body, the spirited brushwork and the highly keyed colour. This is one of the rare Venetian works to be dated, and it helps to establish the character of the work painted on the artist's visit to Venice in 1882. Marc Simpson

(1977, p. 176) suggests that it may have been one of the two Venetian interiors exhibited at the Société internationale de peintres et sculpteurs in 1882, with *Street in Venice* and *Sortie de l'église* (nos. 808, 806).

The picture was included in Sargent's first one-man show at the St Botolph Club, Boston, in January 1888, along with *Street in Venice* and *Venetian Bead Stringers* (nos. 808, 794). Its first recorded owner was Louis Curtis of Brookline, Massachusetts, half-brother of Daniel Curtis, owner of the Palazzo Barbaro in Venice, where Sargent often stayed. His son, Laurence Curtis (1893–1989), a Boston lawyer and U.S. congressman, later acquired the *Full-Length Study of a Venetian Model* (no. 800).

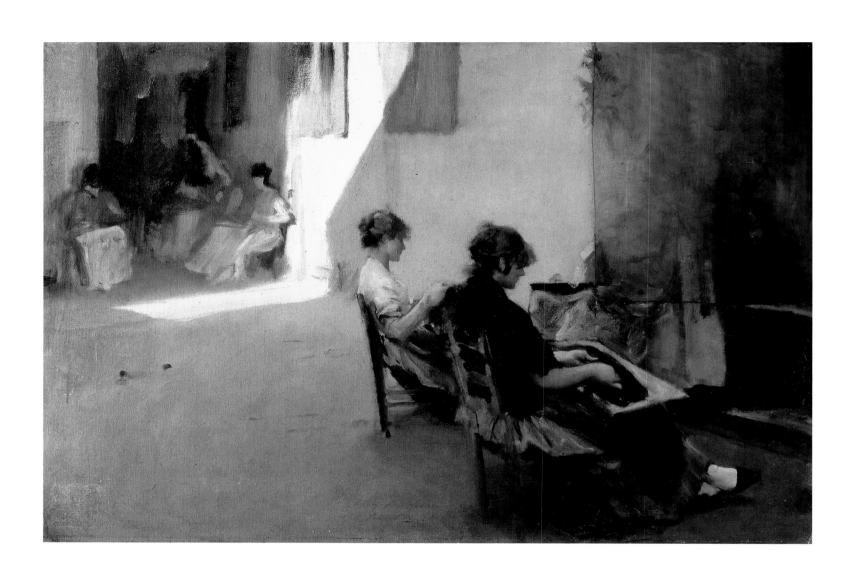

c. 1880–82
Alternative title: *Bead Stringers of Venice*
Oil on canvas
22⅛ x 32¼ in. (56.2 x 81.9 cm)
Inscribed, lower centre: *to my friend
Lawless/John S. Sargent*
National Gallery of Ireland, Dublin (921)

The figures in this picture are posed out-of-doors in a Venetian street or calle. In common with his other street scenes, Sargent adopts a steep diagonal perspective, but the space is less closed in than usual. The scene is bathed in soft reflected sunlight; a direct shaft of sunlight towards the back of the space has a similarly dramatic effect as the streaks of light found in the background of the Venetian interiors. Bright accents of colour appear on the house shutters and the red shawls of the women.

Two young women occupy the foreground, facing away from us towards a dark opening or doorway with a bench or piece of wood across it at low level. The heads of the women are in profile, with a third figure facing them. Three more seated women are sketchily indicated in the background, where the street narrows. All are industriously occupied stringing beads. The figure nearest to us, in lilac-coloured dress and apron, black shawl, white socks and square-cut shoes, has her hands inside the flap of a long pouch or bag with beads lying on a board on her knees. The second young woman, in a white blouse and greenish-grey apron, is holding up her right hand, apparently in the act of stringing beads. A third figure leans back in a chair against the wall, with raised knees and a work board. The square piece of canvas, inserted where the picture was mutilated in the top right-hand corner, shows the faint outline of the third woman's figure, what looks like a curtain to her left, and the dark shape of the opening or doorway. According to reviewers of the 1884 Dublin exhibition, presumably relying on information from Frederick Lawless, Sargent cut away a small section of canvas, before throwing the picture aside, 'but fortunately for the advantage of the Dublin Sketching Club, it was preserved from destruction by its fortunate owner' (unidentified newspaper cutting, 29 November 1884; see also *Dublin Evening Mail,* 3 December 1884, and *Irish Times,* 1 December 1884, where the same story is repeated; from a book of press cuttings, 1881–96, pp. 22–25, preserved with the records of the Dublin Sketching Club, on deposit at the National Library of Ireland, Dublin, acc. 4786). The damage to the canvas was probably made good at the time, either by the artist or by Lawless.

The two foreground figures may both have been painted from the same model—their profile outline is almost identical, and the differences in hair colour can be accounted for by the way the light falls. The street setting of the picture and the emphasis on working girls give it more the character of a conventional genre scene than Sargent's interior views with staged models. Charles Merrill Mount (1963, p. 400) suggested the influence of Carl van Haanen, and reproduced the latter's picture of *Venetian Bead Stringers* (fig. 200), while Margaretta Lovell cites Velázquez's *Las Hilanderas* as a source (San Francisco 1984, p. 102; see no. 737 for Sargent's copy). Linda Ayres (in Hills *et al.* 1986, p. 70, fig. 43) reproduces a photograph of bead stringers by Carlo Naya (fig. 202); see also the etching by the American artist Otto Bacher of bead stringers dating from this period (fig. 203).

The Honourable Frederick Lawless (1847–1929), to whom the picture is inscribed, was an Irish aristocrat with artistic leanings. Both Linda Ayres and Marc Simpson mistakenly identify him as 'Valentine Lawless', who was his brother (Ayres in Hills *et al.* 1986, p. 70, and Simpson 1997, p. 99). It was undoubtedly due to the influence of Frederick Lawless that a group of American expatriate artists was invited to contribute to the annual exhibition of the Dublin Sketching Club in 1884. Lawless himself lent three pictures, all by American expatriate artists and close friends: *Venetian Bead Stringers* by Sargent, *Venezia* by Ralph Curtis, and *Sèvres Bridge* by Julian Story. Lawless also contributed two of his own Venetian sketches, *From the P&O Buoy* and *Sunset over the Giudecca.* The star of the show was James McNeill Whistler, who lent twenty-six works, including the picture of his mother (Musée d'Orsay, Paris) and the portrait of *Thomas Carlyle* (Glasgow Museums and Art Galleries). Lawless was a friend of Whistler and must have persuaded him to lend.[1]

The introduction of so many loaned paintings to the Dublin Sketching Club's 1884 exhibition threw the modest work of the members into the shade. The resulting recriminations, chiefly aimed at Whistler, spilled into the press and aroused fierce controversy both within and outside the club. In spite of its visible damage, Sargent's picture was admired by contemporary Irish critics. The reviewer for an unidentified newspaper of 29 November 1884 wrote perceptively: 'Our readers will, no doubt, be surprised to learn that Mr. Sargent rarely outlines his work, but paints "right away", modelling after he has blotted in the values and tones of his subject. The principal figures are in shadow, and a ray of sunlight gleams upon the street wall in the upper part of the composition . . . The ease and grace of the figures, so life-like and supple, are painted with great truth'.[2]

1. Lawless appears in a photograph of Whistler's London studio of 1881, together with Julian Story, his brother Waldo Story and Frank Miles (ill. E. R. and J. Pennell, *The Life of James McNeill Whistler* [London and Philadelphia, 1908], vol. 2, facing p. 10). Lawless's presence in Venice is recorded by Daniel Curtis in a letter to his half-brother, Louis Curtis, of 15 June 1882 (Curtis Papers, Marciana Library, Venice): 'We have had a very amusing Mr F. Lawless, & many accompts [accomplishments], been everywhere, knows everyone. As he comes every year to Italy, we shall see more of him'. He was clearly part of the Venetian circle of artists at the time, as well as being an honorary member of the Dublin Sketching Club. Though described as a sculptor by the Pennells (see reference above), Lawless does not appear to have pursued an active professional career. He succeeded his brother, Valentine, as the fifth and last Baron Cloncurry in the year of his death, 1929 (see his obituary in the London *Times,* 19 July 1929, p.16c; see also 29 October 1929, p. 22d for details of his will).

2. For this and other reviews, see the press cuttings book, 1881–96, pp. 22–25, and, for the controversy, the minute book, 1882–96, pp. 49ff., of the Dublin Sketching Club, on deposit at the National Library of Ireland, Dublin, Acc. 4786; see also Ronald Anderson and Anne Koval, *James McNeill Whistler: Beyond the Myth* (London, 1994), pp. 259–63.

805
Venetian Water Carriers

c. 1880–81
Oil on canvas
25⅜ x 27¾ in. (64.5 x 70.5 cm)
Inscribed, lower right: *John S. Sargent*
Five labels removed from the back of the
picture, 1962[1]
Worcester Art Museum, Massachusetts.
Museum Purchase. Sustaining Membership
Fund (1911.30)

This picture is rare in Sargent's Venetian oeuvre in presenting an outdoor scene of active work. In the view of the present authors, it is more likely to have been painted on his first visit to the city in 1880–81 than his second in 1882; see the discussion of chronology in the introduction to this chapter (pp. 319–22). Marc Simpson, on the other hand, associates the picture with the 1882 group (Simpson 1997, p. 99). The picture shows two women engaged in the familiar business of drawing and carrying water from one of the many ancient well-heads that populate the city's streets and squares.[2] Venetian wells were public cisterns filled with rainwater filtered through sand. Until the arrival of piped drinking water in 1884, they were the only source of water available to the city. When the wells ran dry, water had to be transported in barges from Fusina. Professional water carriers, or *bigolanti* as they were called, were generally peasant girls from the mountains around Udine and the Friuli. They were a common sight in Venice, and they are mentioned in many travel accounts of the city.[3] The *bigolanti* supplied Venetian households with water from a pair of pails suspended at either end of a curved pole carried on the right shoulder. This can be seen in Frank Duveneck's picture of *Water Carriers, Venice* of 1884 (fig. 198), which forms an interesting contrast to the Sargent. Duveneck's work is a populist genre scene, making a public statement, while Sargent's is a private moment in

the domestic lives of two women caught off-guard as they work. A closer parallel to Sargent's picture is Whistler's pastel of *Courtyard on Canal: grey and red* (fig. 199).

The theme of water carriers at the well was popular with contemporary genre painters and photographers. In Sargent's picture, the figures of the two women possibly represent the same model in complementary frontal and back-view poses. The first has let down her pail and is about to draw it up, guiding the thin rope across her wrist and through the fingers of her other hand. The second, throwing her right hip out as she extends her left arm to balance the weight of the pail, moves towards the door of a house or store. The picture is remarkable for the accuracy with which it records the detail of the women's work and their grim surroundings. The women themselves, however, in matching white dresses and fringed shawls, belong to Sargent's staffage of elegant models and are not typically working class.

The composition is anchored by the well-head and its square base, around which the figures create a sense of energy and movement. The woman on the left, coping with the muscular effort of carrying the pail, is balanced by the battered door tilting to the right. Her off-balance pose is reminiscent of the dancer in *El Jaleo* (no. 772). The left arms of both women are flung out in matching symmetry, while their right arms, close to the body, take the weight of the pails. This rhythm of arms and bodies is

underscored by the stones and bricks of the floor, which enclose the well-head in a dynamic pattern of their own. The picture is remarkable for its powerful sense of realism, and its austere colour scheme of black and white and grey, offset by flashes of salmon and green in the pavement, and the pink scarf of the woman on the left. The picture is a study in bold shapes and gritty textures, from the stones, treated as single blocks of colour, to the stained well-head, the subtle contrasts of the weathered wall and the startlingly black interior revealed by the doorway, with gleams from a latticed window. For details of the early provenance of *Venetian Water Carriers,* see *Venetian Glass Workers* (no. 792).

1. Four of the labels are for exhibitions; the earliest, filled in by an entry clerk, possibly relating to an exhibition, gives the artist as Sargent and the address as 'London, Eng.', perhaps when Sargent owned it; two relate to exhibitions when Crane was the owner, one headed Worcester Art Museum, perhaps for the 1910 exhibition; the last two are for the Minneapolis Institute of Arts, presumably the 1915 exhibition, and the Metropolitan Museum of Art, for the 1926 exhibition (see Exhibitions).
2. E. J. Johnson, writing to Marc Simpson (relevant passage communicated in a letter of 4 April 1999 from Marc Simpson to David Brigham of the Worcester Art Museum, museum files), has proposed the private Corte Bottera, near the church of SS Giovanni e Paolo, as the location of Sargent's picture; for a full description of this courtyard, see Gianluca Aldegani and Fabrizio Diodati, *Le Corti: Spazi Pubblici e Privati nella Città di Venezia* (Milan, 1991), pp. 120–23, ill. p. 122; another photograph of the courtyard is illustrated in Giulio Lorenzetti, *Venice and its Lagoons* (reprint; Trieste, 1999), p. 344. A second possible site is the Corte Rota near the church of San Zaccaria.
3. See, for example, William Dean Howells, *Venetian Life* (Edinburgh, 1883), vol. 1, pp. 123–24; F. Eden, *A Garden in Venice* (London, 1903), pp. 86–88; Mary Lutyens, *Effie in Venice* (London, 1965), pp. 245–46.

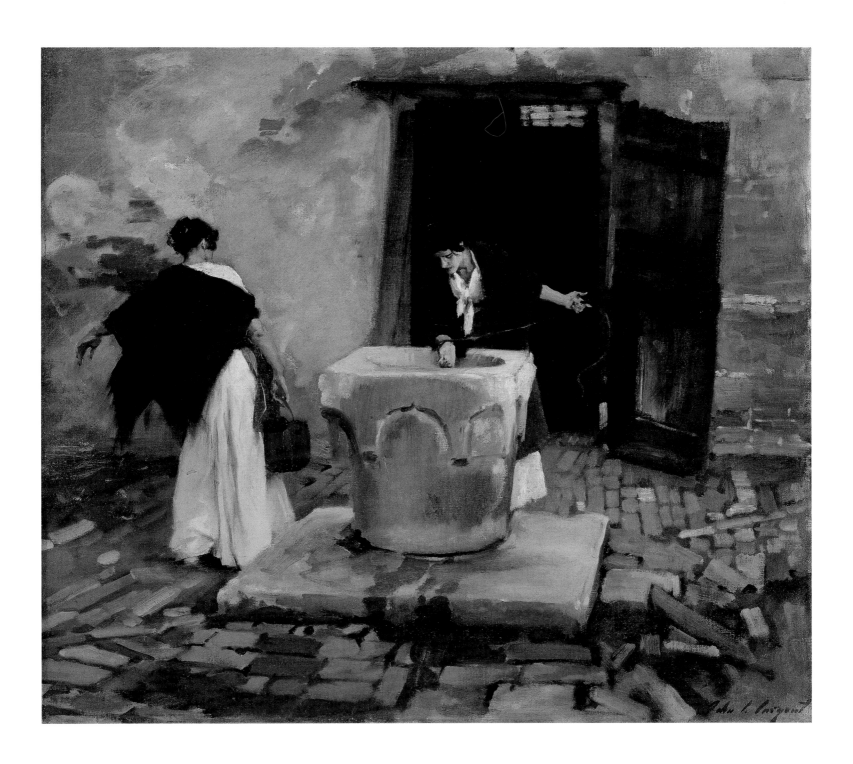

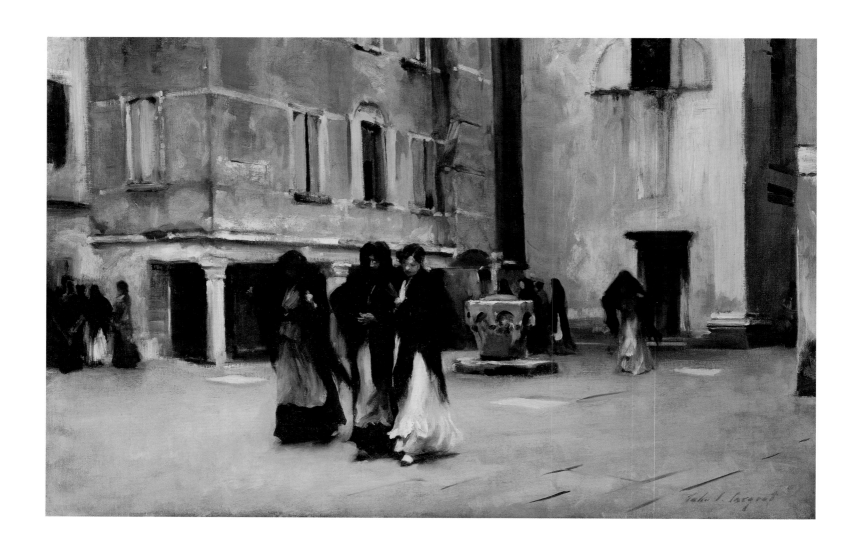

806
Sortie de l'église, Campo San Canciano, Venice

c. 1882
Alternative titles: *Sortie d'église; Sortie d'église en Espagne; Campo San Canciano*
Oil on canvas
22 x 33½ in. (55.9 x 85.1 cm)
Inscribed lower right: *John S. Sargent*
Collection of Marie and Hugh Halff, Jr.

The picture represents a group of figures in the Campo San Canciano, a square lying between the churches of SS Apostoli and Santa Maria dei Miracoli, not far from the Grand Canal. The Church of San Canciano, visible on the right of Sargent's picture with the front just out of sight, is a ninth-century foundation much modified over the ages and dedicated to three Christian martyrs of Aquileia (in the year 304), Canzio, Canziano and Canzianilla. The cult of San Canciano was popular in Venice and the surrounding region. Among the sixteenth-century parishioners was the painter Titian. The campo itself, with its prominent arcaded building to the left, and a handsome marble wellhead in the centre, is still very much as Sargent saw it. A highly finished water-colour of the same scene without figures (no. 807) may have served as a study for the oil and shows with what care Sargent painted the architectural features of the square.

The figures come from the familiar pool of Sargent's Venetian models; see the discussion of models in the introduction to this chapter (pp. 316–17). The three in the foreground sweep down the square in line abreast, two of them arm in arm, with an air of bravado. Loose, blurred brush strokes are used to convey the sense of clothes and bodies in motion. The older women, in black dresses with white muslin aprons, have shawls over their heads. The young woman is bare-headed and dressed in white, and she sports a vivid red fan. Other groups of departing female figures can be seen near the side door of the church and to the left of the arcade.

This picture and *Street in Venice* (no. 808) are the only certainly identified Venetian studies exhibited at the time, at the Société internationale de peintres et sculpteurs, Galerie Georges Petit, Paris, 20 December 1882 to 30 January 1883. *Sortie de l'église* was reproduced in the catalogue after the drawing reproduced here (fig. 218); it was common practice for works of art to be reproduced in this way. *Street in Venice* seems almost certainly to have been painted in

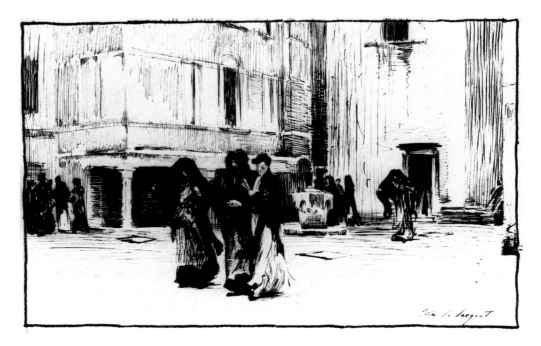

Fig. 218
Sketch after 'Sortie de l'église', 1882. Pen and ink on paper, 7½ x 12 in. (19 x 30.5 cm). Inscribed, lower right: *John S. Sargent;* and below ruled line enclosing image: *sortie de l'église—John S. Sargent.* Private collection. Reproduced as a woodcut in the catalogue of the *Société internationale de peintres et sculpteurs: première exposition* (Paris, 1882), n.p.

1882 from the evidence of a dated water-colour of the same scene by Ralph Curtis (fig. 219), and it is a reasonable assumption that *Sortie de l'église* also belongs to the second Venice trip; see the discussion of chronology in the introduction to this chapter (pp. 319–22). The two pictures received a mixed reception from the French critics, reflecting their experimental and avant-garde character.

Sortie de l'église was owned by the French comic actor Ernest Coquelin (1848–1909), known as Coquelin *cadet* to distinguish him from his brother Constant Coquelin *aîné.* Like Constant, Ernest owned an interesting group of works by the artists of Sargent's circle, many of them friends and fellow-exhibitors at avant-garde exhibitions in the early 1880s, including Jean Béraud, Jacques-Émile Blanche, Albert Besnard, Eugène Boudin, Jean-Charles Cazin, Giuseppe de Nittis, Ernest-Ange Duez, Henri Fantin-Latour, Henri Gervex, Henri Le Sidaner, Alfred Philippe Roll, Alfred Sisley, Joaquin Sorolla y Bastida, Fritz Thaulow and Édouard Vuillard. These were sold at auction in Paris in 1909, together with works of sculpture and several portraits of Coquelin, some in character. In a preface to the sale catalogue, the French art critic Jules Claretie wrote:

Coquelin Cadet's taste was for avant-garde paintings, for works that the public would not only accept but would later come to applaud. He sees

the future. He does not follow the crowd, he is in the vanguard . . . It is sad to see a collection, made with such devoted judgement by a dear, departed friend, dispersed. Other collectors will fight amongst themselves over these Bonvins . . . this Sargent . . . all these works that are here in the Catalogue, each one deserving particular attention. But it is Coquelin Cadet who has the distinction of having assembled this collection. It should also be added that, not the least part of the many sides of this most original artist, was that he could be a deliciously funny writer when he was in the mood, something he shared with his elder brother.[1]

For Ernest Coquelin and his brother as collectors, see F. Delacroix, L. Kalenitchenko and B. Noël, *Les 'Coquelin'. Trois générations de comédiens,* Société historique de Rueil-Malmaison, Rueil-Malmaison, 4 April–1 May 1998, pp. 53ff. (exhibition catalogue). For the two pictures by Sargent which were owned by Constant Coquelin, see nos. 795, 809.

1. 'Coquelin Cadet avait le goût des peintures d'avant-garde et le sens des oeuvres que le public devait non seulement accepter, mais acclamer plus tard. Il devinait. Il ne suivait pas la foule, il la précédait . . . Il est triste de voir se disperser la collection faite avec un amoreux discernement par un ami disparu. D'autres collectionneurs se disputeront ces Bonvin . . . ce Sargent . . . toutes ces oeuvres dont voici le Catalogue, et dont chacune meriterait d'être spécialement signalée. Mais c'est Coquelin Cadet qui aura eu le mérite de les assembler pour eux et à tous les titres de cet artiste si original, qui fut à ses heures un écrivain humouristique délicieux, il faut ajouter celui-ci, qui n'est pas des moindres et que son frère aîné partagera avec lui'.

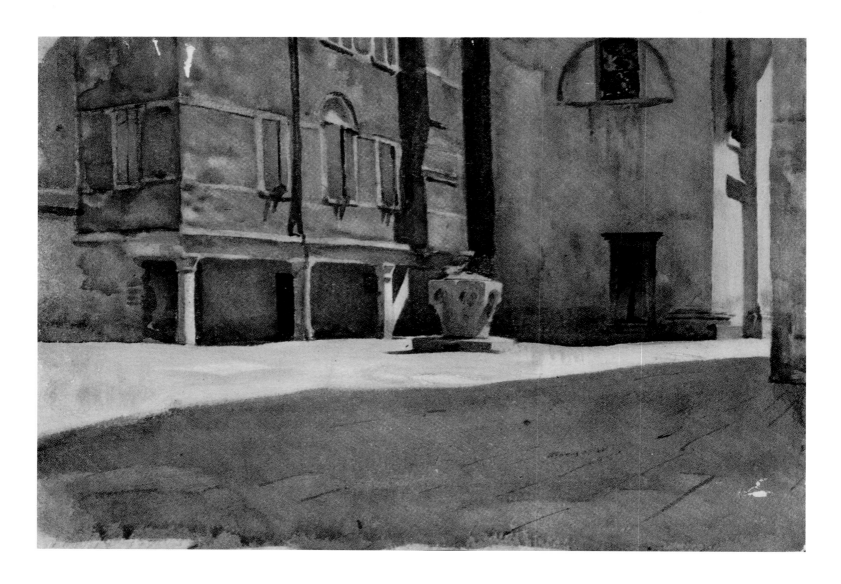

807
Campo San Canciano, Venice

c. 1882
Alternative title: *A Piazza at Venice*
Water-colour on paper
14 x 20 in. (35.6 x 50.8 cm)
Untraced

This is a view across the Campo San Canciano towards the church of the same name; the side entrance to the church is on the right, and a pink house with blue shutters and a colonnade to the left. For a description of the church and Campo San Canciano, see the entry for *Sortie de l'église, Campo San Canciano, Venice* (no. 806). The view is unchanged today, and the buildings and wellhead are much as Sargent painted them.

This highly finished water-colour reveals the artist's mastery of architectural perspective and detail, as well as his pleasure in recording the subtle interplay of light and shade. A brilliant shaft of sunlight dramatically divides the composition in two. The empty foreground is left in shadow, while the pink house and parts of the church are raked by strong light. Reverse walls and the well-head, again in shadow, counterpoint these sunlit surfaces. There are no people, and the picture gives off an air of

extreme stillness, as of the siesta hour. The setting of the water-colour is almost identical to that in *Sortie de l'église,* which, in the view of the authors, was almost certainly painted in 1882 (see the discussion of chronology in the introduction to this chapter, pp. 319–22), and it may have served as a preliminary study for it. This would explain its finished appearance, in contrast to the freer treatment of other Venetian water-colours.

The picture was owned by Reginald Sidney Hunt when it was reproduced by H. M. Cundall in his *History of British Water-Colour Painting* in 1929. Hunt was the long-serving secretary of the Royal Society of Painters in Water Colours (now the Royal Watercolour Society), where Sargent was a member and a regular contributor to their annual exhibitions from 1904 onward. Hunt also owned the early *Study of a Model* (no. 637).

808
Street in Venice

c. 1882
Alternative titles: *Une Rue à Venise;*
Venetian Street; Venetian Scene; Venice
Oil on panel
17¾ x 21¼ in. (45.1 x 54 cm)
Inscribed, lower right: *John S. Sargent*
Label (damaged) formerly on the reverse
(now curatorial files), for the Venetian
supplier of artist's materials: *GIUSEPPE*
BIASUT[TI]/PRESSO LA REG[IA
ACCADEMIA]/N. 1024 Ve[nezia]/DEPOSITO
OG[GETTI]/PER/PITTURA E DIS[EGNO]
The National Gallery of Art, Washington,
D.C. Gift of the Avalon Foundation
(1962.4.1)

The setting for this picture was identified
by David McKibbin as the Calle Larga dei
Proverbi, behind the Church of SS Apostoli,
and only a short distance from the Campo
San Canciano, where Sargent painted *Sortie*
de l'église (no. 806). It was painted looking
west towards the Salizzada del Pistor, which
runs across the end of the street, with the
Calle Vincenzo Manzini coming in from
the left, halfway down. The workshop on
the left is still almost as it was in Sargent's
day and is used for the production and
repair of furniture (see fig. 220). The run-
down street provided the right ingredients
for Sargent's brand of painterly realism. He
depicts the austere architectural details of
the street with great care: the weight and
volume and texture of weathered walls
and battered shop fronts; the telling line of
light across a doorstep and along a run of
stonework; a streak of light at the opening
to the calle on the left; a pink house at the
end with another above it in bright sun-
light and, at the top, a sliver of sky; and the
subtle tones and textures of the weathered
pavement.

The same street was painted in a water-
colour of 1882 by Ralph Curtis, Sargent's
cousin and fellow-student at Carolus-
Duran's atelier, from almost the same view-
point and almost certainly at the same
period (see fig. 219). This strongly supports
a dating of the National Gallery's picture to
1882. Curtis's picture shows a similarly
dressed male figure as the one on the right
of Sargent's picture. He also reveals that the
stall at the corner of the street running off
to the left is selling flowers and vegetables.

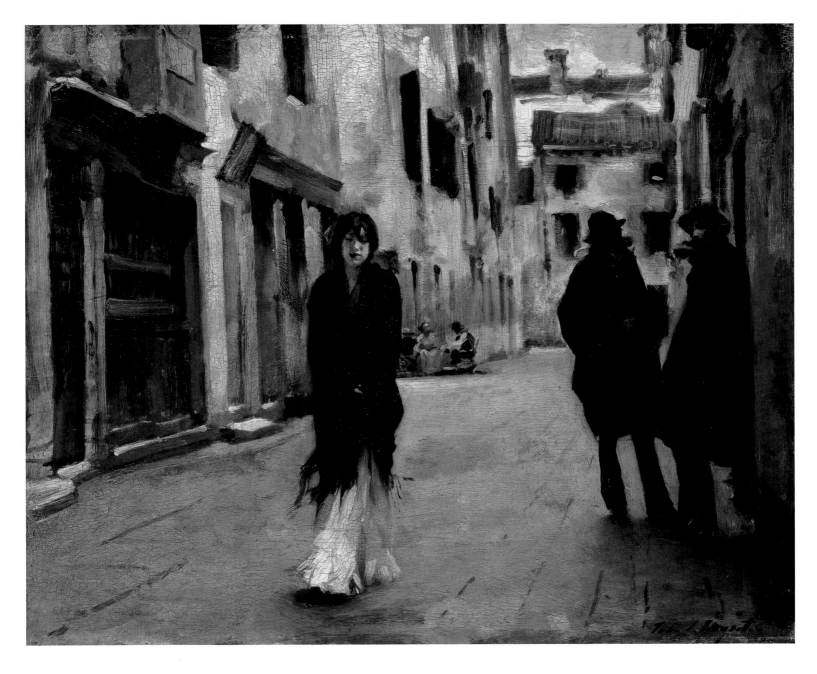

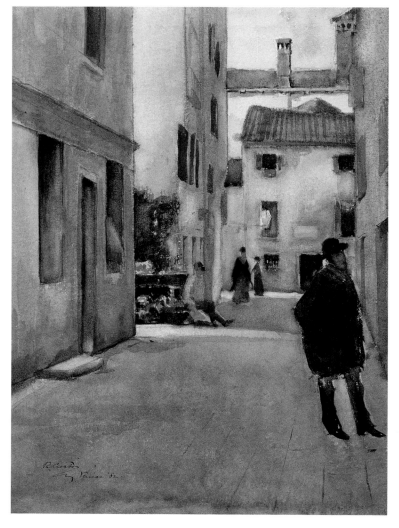

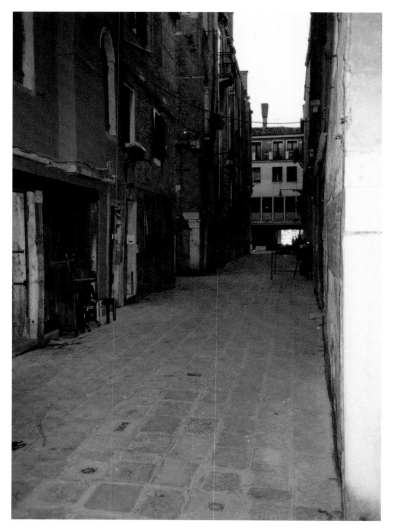

Fig. 219
Ralph Curtis, *Venice,* 1882. Water-colour on paper,
13½ x 9¾ in. (34.3 x 24.7 cm). Private collection.

Fig. 220
Photograph of the Calle Larga dei Proverbi,
the setting of *Street in Venice.*

Into his atmospheric street scene, bathed in the subdued light of a winter day, Sargent drops his figures with an unerring eye for the effect of placing and silhouette. The middle ground is defined by two seated street sellers. In front, centre stage, a young woman walks rapidly towards us, the kicked-up flounces of her skirt and the fluttering fringe of her shawl indicating rapid movement. The tightly drawn black shawl, emphasizing her slender, elongated figure, is set off by her red chemise and a red flower in her hair. She is identical with the model in *Full-Length Study of a Venetian Model, Head of a Venetian Model in a Scarlet Shawl* and *Venetian Interior* (nos. 800, 799, 798), identified in the past as Gigia Viani; see the discussion of models on pp. 316–17. As she passes by, she catches the attention of one of the two men shown in conversation on the right, dressed in matching fur-lined black capes, trousers and low-brimmed hats, who may have been posed by the

same model; see figs. 207, 208 for two sheets of studies in which Sargent explored the poses of male figures for this and other street scenes. In the view of the authors, the woman's cast-down eyes seem to reveal her awareness of the male gaze and the impression she is making. Trevor Fairbrother has written perceptively of the picture (Fairbrother 1986, p. 48): 'The dynamic recession of the street allows the central female figure to project forward, in contrast with the dark, caped men set at the edge of the perspective. The artist allows the personal relationship of the three figures to be an anecdotal, though deliberately enigmatic element'. Other commentators have gone further in explaining the sexual undertones of the encounter, one even suggesting that the woman is a prostitute (Stephen Kern, *Eyes of Love: The Gaze in English and French Culture 1840–1900* [London, 1996], p. 145).

This picture and *Sortie de l'église* (no. 806) are the only certainly identified Vene-

tian pictures exhibited at the time. They received mixed press from the French critics, reflecting their avant-garde character; for quotations from contemporary reviews, see pp. 320–21. Sargent executed a pen-and-ink drawing after the picture (fig. 221) for reproduction as a woodcut in the *Gazette des Beaux-Arts* (vol. 27, no. 2 [February 1883], p. 192); this drawing descended in the family of M. Gonse, the proprietor of the magazine.

Street in Venice is described as being for sale in a studio in New York in 1887, together with *Venetian Bead Stringers* (no. 794), in *Art Interchange* ('Art Notes', vol. 19, no. 10 [5 November 1887], p. 145). The picture was exhibited soon afterwards in Sargent's first one-man show at the St Botolph Club in Boston, and a little later at the National Academy of Design, New York, on both occasions with *Venetian Bead Stringers* (no. 794). The influential art critic Mrs Schuyler Van Rensselaer gave them unstinting praise

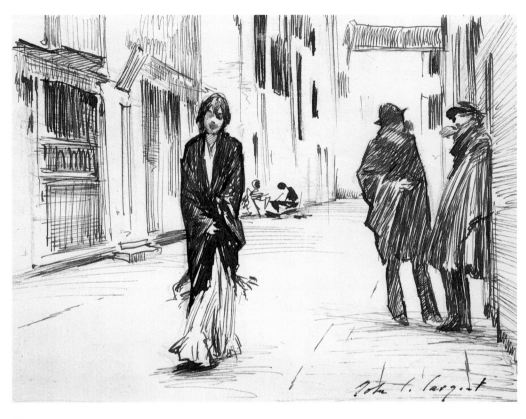

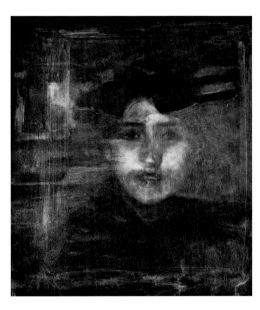

Fig. 221
Sketch after 'Street in Venice', 1882. Pen and ink on paper, 4½ x 5⅞ in. (11.5 x 15 cm).
Private collection. Reproduced as a woodcut in the *Gazette des Beaux-Arts,* vol. 27,
no. 2 (February 1883), p. 190.

Fig. 222
X-ray of *Street in Venice,* revealing the head of
a young woman under the present paint surface.

('Fine Arts. The Academy Exhibition', *Independent,* 26 April 1888, p. 519):

No one not thoroughly familiar with the most difficult problems of art and with the most successful solutions that have been arrived at by others, can quite appreciate the extraordinary power shown by Mr. Sargent in thus quickly, frankly, yet triumphantly dealing with these long perspectives and these effects of light, and in placing these unstudied, yet graceful and interesting figures. And no one else can know how true a colorist a man must be to manage so well these somber schemes in which scarce a note of what we commonly call color appears. Justness of eye and skill of hand can go no further than they have gone here.

An anonymous critic of the same exhibition wrote ('Portraits at the Academy', *New York Times,* 8 April 1888, p. 10): 'How delightfully he catches the slouchy picturesqueness of the Venetian girls! How well he paints the curves inside the inevitable shawl drawn closely round the figure!' Other critics were similarly complimentary.

According to David McKibbin (letter of 24 September 1963 to William Campbell, National Gallery of Art, Washington, D.C.), the picture was purchased by Elizabeth Chanler at the St Botolph Club exhibition of 1888 and given by her to the architect Stanford White and his wife; Charles Merrill Mount repeats the story (1955, p. 199) but says the gift was from Elizabeth Chanler and her sister. Elizabeth Chanler, whom Sargent was later to paint (*Portraits of the 1890s,* no. 287), came from a wealthy background, but she was only twenty-two at the time of the alleged gift, and it might be thought precocious of her to have given a picture to a well-known architect several years her senior. White was in possession of the picture by the spring of 1888, when it was lent to the exhibition at the National Academy of Design. He was to become a good friend of the artist, helping to find him clients and recommending him as a muralist for the Boston Public Library, a McKim, Meade and White building.

The label on the back of the picture for the supplier of artists' materials, Giuseppe Biasutti, is identical to those on the reverse of *A Street in Venice, The Onion Seller* and *Saint Roch with Saint Jerome and Saint Sebastian, after a Picture Attributed to Alessandro Oliverio* (nos. 810, 801, 743). In the *Guida commercial* of Venice for 1879, Biasutti appears as a seller of prints and artists' supplies with a shop in San Luca. He must have moved soon afterwards, for by 1887 his shop is listed at Accademia 1024 (information communicated to the National Gallery of Art by Sandra Moschini of the Venice Soprintendenza). X-radiography reveals that a half-length portrait of a woman lies beneath the surface of the present picture (fig. 222). The oval shape of the face and the central parting of the hair drawn up in two bunches suggest that she is one of the Venetian models.

809
Venetian Street

1880–82
Alternative title: *À Seville*
Oil on canvas
29 x 23¾ in. (73.7 x 60.3 cm)
Inscribed, lower left: *John S. Sargent*
Private collection

This picture relates closely to *Street in Venice* (no. 808), which the present authors think likely to have been painted in 1882; see the chronology in the introduction to this chapter (pp. 319–22). Marc Simpson (1997, p. 178, no. A47) speculates that *Venetian Street* may have been the painting called 'Conversation vénitienne' which was lent by Dr Pozzi to the exhibition of the Cercle de l'union artistique, 6 February–12 March 1883, no. 19; however, there is no strong evidence for this, and the picture owned by Pozzi remains to be identified. In the picture catalogued here, a couple are shown standing and conversing in a narrow street or calle, framed by tall grey walls. A second calle runs across the one in which the couple appear, and the view is closed off at the end by the windows and balcony of a building.

The box-like structure of the space is typical of Sargent's street scenes and interiors of this date, with its complex geometry of square forms and angles, its brooding atmosphere and generally dingy aspect. The young woman in her pink skirt and black shawl belongs to the group of models whom Sargent employed for his Venetian pictures. The man, too, in a black cape with a high fur-lined collar and a low-brimmed hat, is similar to other male models in these street scenes (see also figs. 207, 208). An oil sketch (20½ x 16½ in.) showing the same two figures in the same calle was sold at Parke-Bernet Galleries, New York, 27–28 October 1971 (lot 92). It is now untraced, and its attribution to Sargent remains uncertain.

In the picture catalogued here, there is an obvious erotic charge between the young man and woman in the way they stand and intimately converse. The woman's body is in profile, and Sargent draws attention to her left foot, which is turned away at right angles, with a thick stroke of white paint. She seems to be on the point of moving off but is held back by the man's importunity; for a fuller discussion of Sargent's modern reading of relations between the sexes, see the introduction to this chapter (pp. 313, 315). Behind the couple, a man in a white coat can be seen opening an

Fig. 223
Photograph of Coquelin's dressing room at the Comédie-Française (image reversed). From a reproduction in *Les Lettres et Les Arts,* vol. 3 (3 July 1888), between pp. 92–93.

umbrella, with a fourth figure visible to his right. The clothes or fabrics hanging above him may indicate that he is a salesman selling his wares at the street corner.

The scene is set at dusk on a winter day with the street lamp already lit. A soft opalescent light irradiates the space and lights up the weathered texture of walls and pavement and the black shapes of doorway and windows, cloaks and shawls. The main light source is from in front, but Sargent cannot resist a bright shaft of light cutting dramatically across the background, like a signature tune. The generally subdued tone of the painting is relieved by vivid accents of white: the curtains framing the tall window at the end; a piece of fabric hanging from the balcony to the right; the hanging street light; a crouching white cat; highlights on the collar of the man, the woman's pink skirt; and her red chemise, the brightest accent of colour in the whole picture.

This picture and *Venetian Interior* (no. 795) were owned by the well-known French comic actor Constant Coquelin (1841–1909). A photograph by M. Chalot shows this picture hanging on the wall of Coquelin's dressing room at the Comédie-Française, reproduced (in reverse) in *Les Lettres et Les Arts* (vol. 3 [3 July 1888], between pp. 92–93; see fig. 223). Coquelin owned a significant collection of works by leading French painters of the day, including Jules Bastien-Lepage, Léon Bonnat, Eugène Boudin, Jean-Charles Cazin, Camille Corot, Charles Daubigny, Jules Dupré,

Henri Fantin-Latour, J. Paul Laurens, Jean-Louis-Ernest Meissonier, Claude Monet, Camille Pissarro, Jean-François Raffaëlli, Alfred Sisley, Constant Troyon and Édouard Vuillard. He also owned works by many of Sargent's close friends and associates who were exhibiting together at avant-garde shows in the early 1880s, including Albert Besnard, Giovanni Boldini, Giuseppe de Nittis, Ernest-Ange Duez, Albert Gustav Edelfelt, Paul César Helleu, Alfred Philippe Roll, and Fritz Thaulow. Little is know about Coquelin's collecting activities, but it is possible that he was buying direct from exhibitions. Sargent may have been introduced to him by Cazin, or possibly by Henry James, who was a tremendous admirer of Coquelin and a friend, writing an important article on the French actor in the *Century Magazine* (January 1887) to herald his arrival in America, as he was to do for Sargent in the same year in *Harper's New Monthly Magazine* (October 1887).

Coquelin sold his first group of paintings, water-colours, pastels and drawings, including *Venetian Street,* at the Galerie Georges Petit in Paris on 27 May 1893. A second sale followed at the same gallery on 9 June 1906, including some works that had failed to sell in 1893. A third sale after his death followed at Hôtel Drouot on 3 June 1909. His brother Ernest Coquelin, known as Coquelin *cadet* to distinguish him from his older brother, owned Sargent's *Sortie de l'église* (no. 806). This was sold after Coquelin *cadet*'s death at yet another sale at

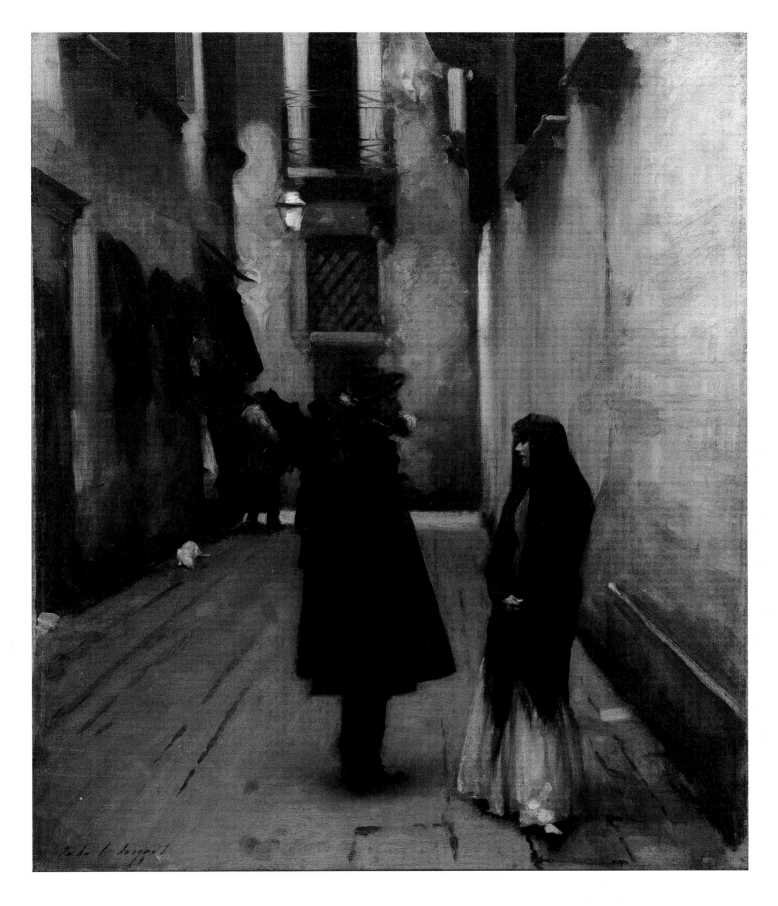

Hôtel Drouot, 26 May 1909, which included works by many of the same painters as those collected by his brother. Both were formidable patrons of contemporary French art; see F. Delacroix, L.Kalenitchenko and B. Noël, *Les 'Coquelin'. Trois génerations de comédiens,* Société historique de Rueil-Malmaison, Rueil-Malmaison, 4 April–1 May 1998, pp. 53ff. (exhibition catalogue).

The New York art dealer Victor D. Spark acquired *Venetian Street* from a private collector in Paris, through Dr Leo Collins, in 1955 (see copy of Spark's letter to Daniel Fraad, 17 December 1966, and his letter to David McKibbin, 19 January 1967, McKibbin papers).

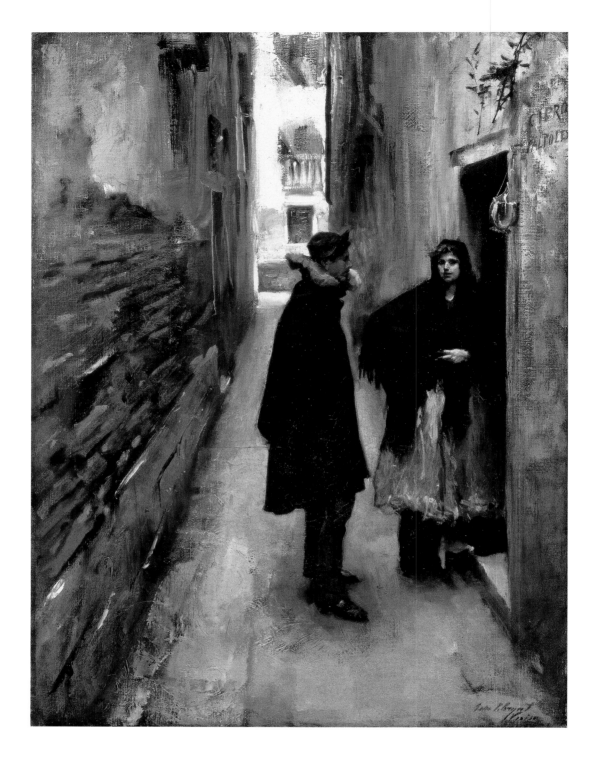

810
A Street in Venice

c. 1880–81
Alternative title: *The Wine Shop*
Oil on canvas
29⁹⁄₁₆ x 20⅝ in. (75.1 x 52.4 cm)
Inscribed, lower right: *John S.
Sargent / Venice*
Three labels on the reverse, the first for
the Venetian supplier of artists' materials:
*Giusep[pe] Biasutti / presso en Reg[ia
Accad]em[ia] / N. 1024 Venezia / deposito
oggetti / per / pittura e disegno*
The second is for Scott & Fowles,

667 Fifth Avenue, New York, no. 729.
The third is a fragment relating to
Nicolopuolo: *[John Singe]r Sargent /
[?Coll]ection of the Greek Minister
to France*
Sterling and Francine Clark Art Institute,
Williamstown, Massachusetts (575)

This is the most dramatic of Sargent's Vene-
tian street scenes and the one in which the
figures are most dominant. In the view of
the authors, it is more likely to have been
painted on Sargent's first visit to Venice in
1880–81 than on his second in 1882; see the
discussion of chronology in the introduction

to this chapter (pp. 319–22). The tunnel-like
walls of the alleyway create a daring tele-
scopic effect as if replicating the optical effect
we, as spectators, would experience if we
were there on the spot. The blurred courses
of brickwork on the left sweep us into the
space and down the length of the alley,
accentuating the height, depth and narrow-
ness of the space. Charles Merrill Mount
was the first to describe this 'ocular device
often used by Boldini and his confreres—
painting the foreground areas of a picture
in a blur and leading the eye deep into
depth by furnishing sharply focused objects
on middle and distant planes' (Mount 1963,

p. 399). Sargent contrasts the gloomy atmosphere of the alley and its grimy, weather-beaten walls with the brilliant patch of sunlight falling on the house fronting the alley; a low wall suggests that there is a rio (small canal) separating the alley from the house opposite with its elegant balcony (the authors are grateful to Richard H. Finnegan for pointing out the wall).

The darkly dressed figures match the gloom and dreariness of their surroundings, giving off an air of tension. The woman, in a black fringed shawl with a black underskirt and a short pink overskirt, stands arm akimbo (a favourite Sargent pose) in the doorway of a wine cellar, identified by the wine bottle hanging from a nail by the door and the names of Italian wines, *CIPRA* and *VALPOLI[CELLA]*, inscribed on the adjacent wall. She turns to confront us, while the man, in a black cape with a high fur-lined collar and low-brimmed hat, looks intently at her. Linda Ayres has written perceptively that 'Whether her gaze is hostile or a simple acknowledgement, her awareness of the observer makes this . . . a different sort of genre painting from those of Sargent's contemporaries' (Ayres in Hills *et al.* 1986, p. 59). As is the case in other Venetian pictures by Sargent the relationship between the figures seems dysfunctional rather than intimate, in spite of the sexual undertones of this encounter. The woman seems curiously indifferent to the gaze of the man and detached from him.

There are obvious parallels with *Venetian Street Scene* (no. 809), where the relationship of the figures is similar, especially the pose of the man. The model in that picture seems older and more heavily bearded than the man in this picture and the two women are quite different. Sargent explored variant poses for the male figures in his street scenes in two related drawings (see figs. 207, 208). According to the bill of sale of 2 November 1926 to Robert Sterling Clark from Scott & Fowles (Clark files), the picture was given by the artist to J. Nicolopuolo, then serving as Greek diplomatic minister in France. No information either on Nicolopuolo or his relationship to Sargent has yet come to light. The label on the back for the supplier of artists' materials, Giuseppe Biasutti, is identical to those found on to the reverse of *Street in Venice, The Onion Seller* and *Saint Roch with Saint Jerome and Saint Sebastian, after a Picture Attributed to Alessandro Oliviero* (nos. 808, 801, 743); see the entry on *Street in Venice* (no. 808) for more details of Biasutti.

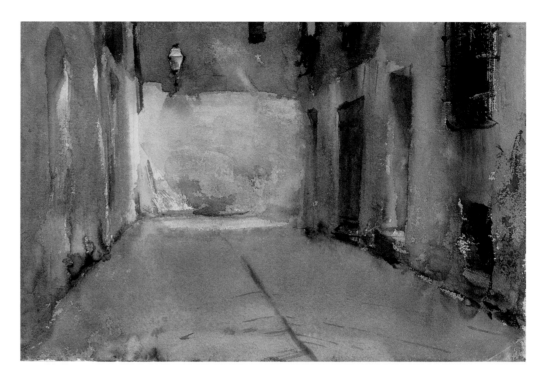

811
Venice

c. 1880–81
Water-colour and pencil on paper
9⅞ x 14 in. (25 x 35.5 cm)
Inscribed on the reverse, upper left: *109 Venice/By J. S. Sargent/E. S.* [initials of Emily Sargent] *8/J* [circled] and centre: *5/20*
The Metropolitan Museum of Art, New York. Gift of Mrs Francis Ormond, 1950 (50.130.29)

The scene depicted in this water-colour is a narrow street or calle in Venice. Windows and doorways are clearly delineated on the right, in particular the window nearest to us with its typical iron grille, and a dark aperture below. The left side is deliberately kept blurry to reproduce the optical effect we would experience if we were there observing the scene. The streaks of light shown further back suggest that another calle runs across the end of the street, or comes in from the left; it is not, as Margaretta Lovell describes it, a 'dead end' (San Francisco 1984, p. 124). The water-colour becomes vague and fuzzy at this point, though the street lamp on the end wall above the broad area of wash is carefully drawn. The authors believe that the majority of Sargent's water-colour studies were painted on his first visit to Venice in 1880–81; see the chronology in the introduction to this chapter (pp. 319–22).

The water-colour relates closely to Sargent's paintings of Venetian street scenes of this date in its box-like construction, oblique angles, steeply receding space and subdued tonality (see nos. 808–10). The way in which the scene is arbitrarily cropped in all its planes is done to emphasize its actuality, as if nothing stood between us and the reality Sargent has created. This effect of realism is created by the manipulation of space and the subtle transitions in tone between adjacent areas of smooth wash. Margaretta Lovell writes (San Francisco 1984, p.123): 'Sargent appeals to our sense of empathy with architectural space and form here, confronting us with the baffling character of Venetian streets through which one wanders—it was often remarked—as in a maze'.

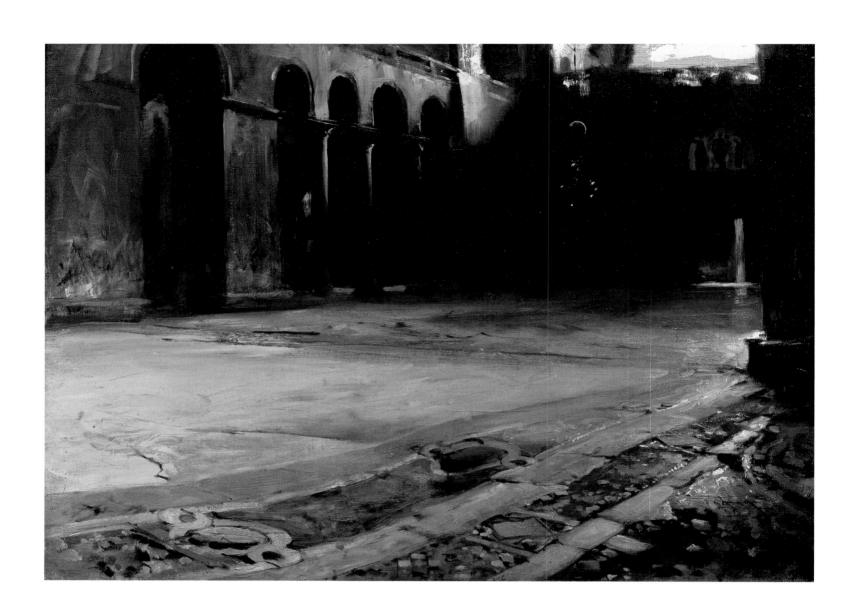

812
Pavement of St Mark's, Venice

c. 1880–82
Alternative titles: *St Mark's, Venice: the
Pavement; The Pavement; The Pavement, Venice*
Oil on canvas
21 x 28½ in. (53.3 x 72.4 cm)
Private collection

This picture represents the nave of St Mark's, Venice, looking westwards towards the main entrance and the Piazza of St Mark's. The dim interior of the ancient cathedral is suffused with light streaming in from the west window and from the partially open doorway beneath. Above the door is a later reinstatement of the Deesis, the medieval mosaic representing the figures of Christ flanked by the Virgin and Saint Mark. Beyond the pavement are the pillars of the nave, and glinting in the gloom above is a hanging crucifix, which is still *in situ*. The foreground is dominated by the undulating pavement of the cathedral, patterned in rare marbles with rectangles, guilloches, circles, lozenges and squares, in a symphony of blues, greens, greys, pinks and beiges.

The British architect George Edmund Street (1824–1881) had developed a theory that the floors, instead of being laid level, had deliberately been made to 'swell up and down as though they were the petrified waves of the sea, on which those who embark in the ship of the Church may kneel in prayer with safety, their undulating surface serving only to remind them of the stormy seas of life'.[1] Not everyone agreed with Street's ideas, and the pavement, along with other features of St Mark's interior, continued to be the subject of controversy between advocates of restoration, who argued rightly that the floor had simply subsided, and conservationists resisting change. It is probably no coincidence that Sargent should paint the pavement at a

time when its future was the subject of controversy and debate.

In the view of the authors, the picture unquestionably belongs to the early group of Venice pictures. Mount dated it to 1882 (1955, p. 444, no. K8210), but more recently it has been dated to 1898, because of its assumed similarity to *An Interior in Venice* (London, Royal Academy of Arts), which is known to have been painted in 1898. It is true that the treatment of the pavement is bolder than anything to be found in the early street scenes and interiors, but the box-like composition, the enveloping gloom and atmosphere of the place, the dramatic backlighting and the tight paint surface, with dragged highlights and scratchy brush strokes in the darks, connect it closely to works of 1880–82. A similarly atmospheric water-colour of the same scene, painted by the American artist Robert Frederick Blum in the early 1880s (fig. 224), adds circum-

Fig. 224
Robert Frederick Blum, *A Morning in St Mark's (Venice)*, c. 1882. Water-colour on paper, 9½ x 12⅞ in. (24.1 x 32.7 cm). Cincinnati Art Museum. Gift of Mrs. Henrietta Haller (1905.199).

stantial evidence to support the earlier dating of Sargent's painting. The two artists might well have painted their views side by side.

1. See Street, *Brick and Marble in the Middle Ages: Notes of a Tour in the North of Italy* (London, 1855), pp. 126–27. John Ruskin commended Street's thesis, and in 1879 he successfully lobbied the Italian authorities against proposals to relay the floor, although he was too late to save the left aisle, which is noticeably smoother in form (see John Unrau, *Ruskin and St. Mark's* [London, 1984], pp. 191–210). Henry James also compared the pavement to the waves of the sea (see James, *Italian Hours* [London, 1909], p. 9). The authors are grateful to Fabio Barry for help with this entry; he is the author of a forthcoming study, 'Painting in Stone: The Symbolic Identity of Coloured Marbles in the Visual Arts from Antiquity until the Age of Enlightenment', which includes a chapter on church floors.

813
Via delle Brache, Florence

c. 1883
Alternative titles: *A Street in Venice;*
A Venetian Street
Oil on canvas
18 x 21 ½ in. (45.7 x 54.6 cm)
Private collection

Previously known as 'A Street in Venice', the Florentine setting of this oil sketch was correctly identified by Piero Rossi Marchese of Florence University at the time of the Sargent exhibition in Ferrara in 2002. The picture represents the Via delle Brache in the Santa Croce neighbourhood of Florence, looking towards the Via de' Neri. The layout of windows and doorways is no longer quite the same as it was in Sargent's day, and there are now two lanterns instead of one, but the street is immediately recognizable from the shape of the overhanging barbican of the building on the right. Sargent is known to have been in Florence in 1883, and it was probably on that trip that

he painted this picture and *Pressing the Grapes: Florentine Wine Cellar* (no. 814).

Both pictures are very much in the same style as the Venetian street scenes and interiors. The narrowing walls of the Via delle Brache lead the eye towards a sliver of bright sunlight where the street joins the Via de' Neri. The space is made still narrower by the projecting angle of the building on the right, which introduces a strong triangular shape into the tight geometry of verticals, diagonals and rectangles. The grimness of the street is relieved by streaky white highlights, by the soft, luminous light filling the foreground, and the brightly lit aperture at the end. The picture is rapidly and thinly painted in parts, especially on the left-hand side, where scratchy lines, perhaps made with the end of the brush handle, reveal the ground. Earlier writers have commented on the forbidding mood of the picture and its sense of claustrophobia and menace. Trevor Fairbrother wondered if Sargent had originally intended to 'populate' the picture with figures, 'thereby making them genre works' (Fairbrother 1990, p. 34).

814 *(opposite)*
Pressing the Grapes: Florentine Wine Cellar

c. 1883
Alternative title: *Pressing Wine in a Cellar*
Oil on canvas
24⅛ x 19⅝ in. (61.3 x 49.8 cm)
Beaverbrook Foundation, Fredericton, New Brunswick, Canada (59.194)

This picture relates closely to Sargent's Venetian interiors in its depiction of local working-class people engaged in a traditional craft, in its dark and atmospheric space, and in its prevailing tonality of greys and blacks. Sargent is known to have visited Florence in October 1883, and he may also have been there in October 1882. The figures in the painting are set well back into the space of the wine cellar, and it is not

easy to make them out. Two men, one with a bare torso, and a third figure who looks female, are straining to turn an upright spindle, held in place above by a short beam, with the aid of two bars (or possibly a single bar running though the spindle), like a capstan. Around the spindle a rope is wound, attached to a long arm projecting from the press in the corner; the latter is all but invisible. Suspended from the rope is a fourth figure, also apparently female, whose role may be to stop the rope from snagging. It is extremely difficult to make out how the mechanism works, and it is certainly very unusual. The only way that the long arm can effectively be pulled by the rope is towards the spindle, and its angle of traverse is 90 degrees at most. In order to operate the press, this arm would also have needed some form of capstan or ratchet arrangement. Wine presses are usually much sim-

pler than this contraption, and grapes traditionally are trodden underfoot. The authors are grateful to Connal McFarlane for his efforts to unravel the mystery.

The light streaming into the cellar through a high barred window at the back, reminiscent of the window in *Venetian Glass Workers* (no. 792), plays across the shadowy space, accentuating an elbow, a cap, a shoulder, a shirt tail and other details in vivid flecks of white. The foreground is occupied by a large wooden vat on the left and by an array of wooden casks and buckets, illuminated from in front, presumably from an open doorway. These powerful forms, painted with the delicacy and refinement of a still life, frame and set off the mysterious vaulted space behind, with its grey and silvery tones. The art critic R. A. M. Stevenson included a brief description of the picture in an early article he

wrote on the artist (Stevenson 1888, p. 69): 'I have seen a sketch, a mere note of the interior of a cellar with naked figures turning a wine-press, that exactly demonstrates Mr. Sargent's wonderful power of suggesting a mysterious sentiment by light. The vicious tones of the wine stains on the floor and wall, the glimmer of light on bare flesh standing out sharply from the dim swimming atmosphere, and the threatening bulk of the wine-press reaching its arms into the darkness, all combined to produce the aspect of some hideous underground torture-chamber'.

Because Stevenson was also writing about pictures he had seen in an exhibition at the Fine Art Society in London in 1882, including *El Jaleo* (no. 772), Charles Merrill Mount mistakenly assumed that *Pressing the Grapes* had been included in the same exhibition (Mount 1963, pp. 410, 415, n. 2); this was not the case. Stevenson had probably seen the picture in the collection of its first owner, the English painter Arthur Lemon (1851–1912), who had been a fellow-student of his and Sargent at Carolus-Duran's atelier, and had remained a good friend of both men. According to Sargent's biographer Evan Charteris (Charteris 1927, p. 15), Sargent had met Lemon as early as 1870 in Florence, but the date is probably nearer 1873 (see Olson 1986, p. 30). In a letter to David McKibbin of 26 September 1968 (McKibbin papers), Sir Ralph Hawtrey, then aged eighty-nine, wrote: 'My uncle, the painter Arthur Lemon was a great friend of both Sargent and R. A. M. Stevenson, and I think you may assume that the picture was a gift from Sargent to him. He died in 1912, and his widow, Blanche Lemon bequeathed it to my sister, who eventually sold it. My uncle and aunt lived much in Italy, particularly in Florence, where her parents had a villa, up to about 1890, when they settled in England'. In a second letter to McKibbin of 11 November 1968, Sir Ralph gave more details of the Lemons: 'My aunt Blanche was daughter of William Strahan and of Elizabeth Anne, née Fisher. The villa where they lived in Florence was the Villa Santa Margherita, situated close to the lower end of the road leading up to the Piazzale Michelangelo. It is now a hospital for children'. Sargent owned two small oil sketches of Italian scenes by Arthur Lemon (private collection). *Pressing the Grapes* was sold by Blanche Lemon's niece, Miss Hawtrey, to Leicester Galleries, London, in 1954, and they sold it to the Beaverbrook Foundation.

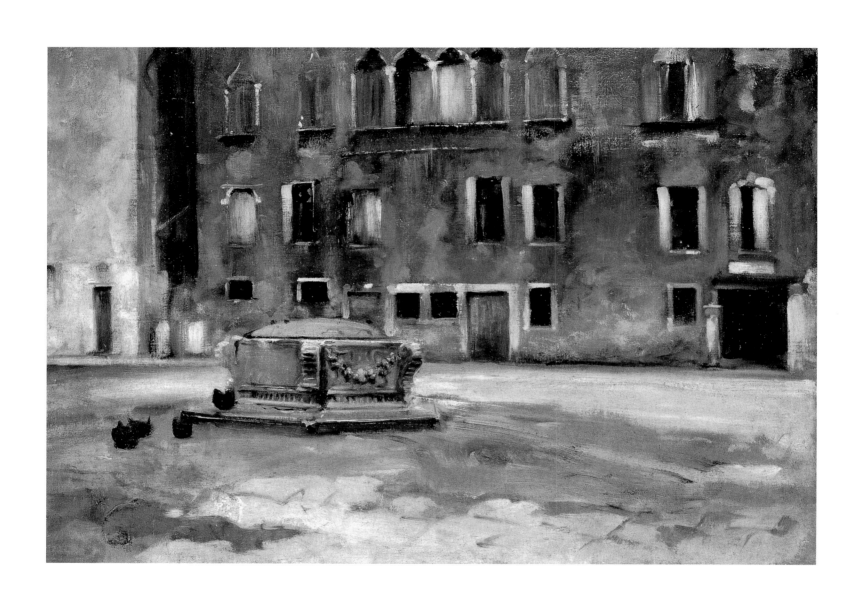

815
Campo Sant' Agnese, Venice

c. 1882
Oil on canvas
18 x 25½ in. (45.7 x 64.8 cm)
Davis Museum and Cultural Center,
Wellesley College, Massachusetts. Gift of
Strafford Morss, in memory of his wife,
Gabrielle Ladd Morss (Class of 1958)
(1969.5)

The artist painted this picture of the Campo Sant' Agnese with his back to the ancient church of that name, looking south towards the rear elevation of the buildings which front onto the Zattere, the broad promenade sweeping round the southern arm of the city. The square is linked to the Zattere by the passageway visible on the right of Sargent's picture, the Sottoportego Trevisan. There is a second sottoportego further to the right (not shown in the picture), and the square is closed off to the west by the flank of the former monastery of the Gesuati, now the Istituto Artigianelli. The prominent building shown in the picture is the Palazzo Trevisan degli Ulivi, now the Spazio Culturale Svizzero a Venezia. It has been altered since it was painted by Sargent. The four Gothic-style windows on the first floor, matching those on the floor above, appear to be a modern insertion, contrasting with the three modest rectangular windows shown in Sargent's picture. Otherwise the architecture is unchanged.

Prominent in the foreground of the picture is an unusually large and richly decorated Renaissance well-head of Istrian stone, ornamented with large volutes and carved garlands. This was commissioned in 1520 by Provveditore Donato Tiepolo (see Alberto Rizzi, *Vere da Pozzi di Venezia* [Venice, 1987], p. 248, no. 207, ill. p. 259). Beyond the well-head, the broad space of the square is empty save for a wittily painted gaggle of black hens; the motif of the hens recalls the etching of *Turkeys* by James McNeill Whistler of 1879–80 (ill. Grieve 2000, p. 129, fig. 158), where the birds are similarly clustered round a well-head. The austere geometry of door and window openings of the buildings beyond is relieved by the subtle play of light across the surface of the walls and the highlights on the stone surrounds and the green shutters.

Reflected light fills the square itself, creating passages of light and shadow across the pavement in contrasting tints of creamy beige and soft blue-grey.

The picture relates closely to *Sortie de l'église* and the related water-colour of the Campo San Canciano (nos. 806, 807) in its treatment of space and light, its careful rendering of architectural detail and surface texture, and its colour scheme. It probably dates from the second of Sargent's two visits to Venice, in 1882; see the discussion of chronology in the introduction to this chapter (pp. 319–22). Margaretta Lovell has written perceptively of this and other architectural studies that they 'cloak meditative solitude and a faint disquiet in painterly brilliance. *Campo S. Agnese* is particularly evocative of a sense of the past, a robust past juxtaposed to the diminishment of the present . . . Yet despite Sargent's lavish brush and the bright sunshine, the place is an empty one; it vibrates with the emptiness of completion, not of potential, and in that fact Sargent locates a subtle melancholy note which we do not often feel in the more constricted watercolor studies' (San Francisco 1984, p. 124).

The picture belonged to Gervase Ker, who lived in Venice at the time and obviously knew Sargent well. In *More Than Friend: The Letters of Robert Browning to Katharine de Kay Bronson* (ed. Michael Meredith [Waco, Texas, 1985], p. 3, n. 3), Ker is described as an 'Englishman, "sensitive and subdued", who lived in Venice, spoke the Venetian dialect and dressed as a gondolier. A fine craftsman in wood, he made inlaid boxes and gave some to the Bronsons. A particular favourite of Edith's, he kept in touch with her for over fifty years until his death in a Fascist concentration camp in 1940'. Sargent made a drawing of Ker with Edith Bronson, later Countess Rucellai, in

1880–82 (fig. 196). Ker and his sister had lived for a time in the Palazzo Barbaro before it was taken over by Daniel and Ariana Curtis in 1881.

Whitney Warren (1864–1943), who was the architect of Grand Central Station, New York (1913), in partnership with Charles Wetmore, acquired the picture. Warren owned a second picture attributed to Sargent and said to represent the artist's Venice studio in the Calle Capuzzi (private collection; sold from Whitney Warren's collection at Parke-Bernet Galleries, New York, 7–9 October 1943, lot 264); this latter picture was said to have been painted in 1885–86 and given by Sargent to Ker in 1890. The picture of *Campo Sant' Agnese* descended in the family of Whitney Warren and was given to the Davis Museum and Cultural Center of Wellesley College, Massachusetts, in 1969, in memory of his great-granddaughter, Gabrielle Ladd Morse, who had died in an accident in 1958, while still at Wellesley College. For details of Whitney Warren's career, see *Who's Who in America* ([Chicago and London, 1924–25], vol. 13, pp. 3321–22). A number of pictures from his collection, including a portrait of him by Dagnan-Bouveret, and works by Boldini, Fantin-Latour, Augustus John, Camille Pissarro, Vuillard and Whistler, were bequeathed to the Fine Arts Museums of San Francisco by his son, Whitney Warren, Jr, in 1986. Apart from the two Venetian pictures already discussed, Whitney Warren, Sr, owned three other pictures by Sargent: a portrait of his sister *Harriet Louise Warren* of c. 1877, which the artist gave him in 1922 (*Early Portraits,* no. 9), a portrait of *Paul Helleu* of c. 1880 (*Early Portraits,* no. 89), and *The Mosquito Net: Lady in White* (The White House, Washington, D.C.). Whitney Warren was the uncle of Beatrice Goelet, whom Sargent painted in 1890 (*Portraits of the 1890s,* no. 239).

816
Campo behind the Scuola di San Rocco

c. 1882
Alternative titles: *A Venetian Street
(Scala di San Rocca); An Inner Courtyard
of La Scuola di San Rocco, Venice*
Oil on canvas
26 x 27 in. (66 x 68.6 cm)
Inscribed, lower left: *John S. Sargent*
Private collection

This picture is not typical of Sargent's early Venetian street scenes, and in the view of the authors probably dates from the second visit of 1882; it could just possibly be later. The picture differs in scale and composition from other works of the period, and it is painted more loosely, with a rich impasto in place of dry, dragged brush strokes and palette knife effects. The closest parallel is to be found with *Sortie de l'église* (no. 806), but the treatment of the figures is different and so is the general mood and atmosphere of the scene. The picture was originally some six inches wider, showing more of the canal on the right-hand side. A narrow strip of canvas was cut off from the side of the painting (see no. 817). According to (Helen) Melville Russell Cooke, daughter-in-law of the first owners, William and Margaret Russell Cooke (letter to David McKibbin, 22 February 1967, McKibbin papers): 'The strip of canal was cut off by Sargent himself because he & Mrs Russell Cooke realized it entirely unbalanced the Scuola di San Rocco piazza. Sargent was a great friend of hers . . . I remember the bit of canal was around in a[n] attic or somewhere when I married in January 1922— but can't imagine what happened to it'. The narrow strip must have been cut off following the sale of the picture at Christie's in 1900, when the Cookes acquired it; the dimensions given in the catalogue are 25 by 31½ inches. The strip of canvas was consigned as an independent picture to M. Knoedler & Co., London, together with the *Campo* picture, in August 1925. Oswald Allen Harker, a son-in-law of the William Russell Cookes, who owned the *Campo* picture in the 1960s, was unable to shed any light on the whereabouts of the missing fragment (letter to McKibbin, 26 January 1965, McKibbin papers). The image of the fragment reproduced here is from a photocopy of a missing Knoedler photograph. It is just possible that the artist retouched the picture when the strip was cut off, which would explain the discrepancies in style and technique compared to other early Venetian scenes.

The picture represents the rear elevation of the Scuola di San Rocco in Venice, a monumental building designed by Bartolomeo Bon between 1515 and 1524. The interior is famous for the great cycle of religious paintings carried out by the Venetian master Jacopo Tintoretto. The figures in Sargent's picture seem rather overwhelmed by the splendour of the architecture: the salmon pink walls, the massive stringcourse, the double arcaded window and the arched portico. Reflected light fills the space, and brings out the colour and texture of this famous building, which Sargent was to paint in another oil of this period (no. 818) and in a number of later water-colours.

There is no trace in this picture of the claustrophobic space and the ambiguous encounters between men and women to be found in Sargent's other Venetian street scenes. The strolling women seem to be there to provide a human foil to the splendours of the architecture. A group of four young women occupy the foreground, close to the steps leading to the canal, in shawls of contrasting colours of red, black and white; a lovely flowing line of paint accentuates and lights up the silhouette of the foreground woman in white. A second group of female figures is placed further back on the left in a diagonal line, seemingly too small in scale given their distance from the first group and from the building beyond. Two more figures can be glimpsed inside the portico, which runs along the back of the Scuola.

Sargent contributed this picture and a second work, *Autumn on the River* (private collection), to an auction at Christie's, London, 1900, to be sold on behalf of the Artists' War Fund in support of British forces fighting the Boers in South Africa. *Campo behind the Scuola di San Rocco* was purchased there by William Russell Cooke and his wife, Margaret Mary 'Maye' Smith.[1]

1. Cooke (d. 1903) was a partner in the prominent London firm of solicitors Russell Cooke (now Russell Cooke, Potter & Chapman). She was the daughter of the wealthy Tyneside ship repairer and politician Thomas Eustace Smith and of his flamboyant wife Eustacia, both noted socialites and patrons of the arts. In 1876, she married the politician Ashton Wentworth Dilke, second son of Sir Charles Dilke, Bart, and in 1891, following his death, William Russell Cooke. She was the sister of Mrs Robert Harrison, whom Sargent had painted in 1886 (see *Early Portraits*, no. 142), and of Mrs Crawford, a central figure in the Dilke scandal. Cooke commissioned a portrait of his wife from Sargent in 1895 (*Portraits of the 1890s*, no. 314).

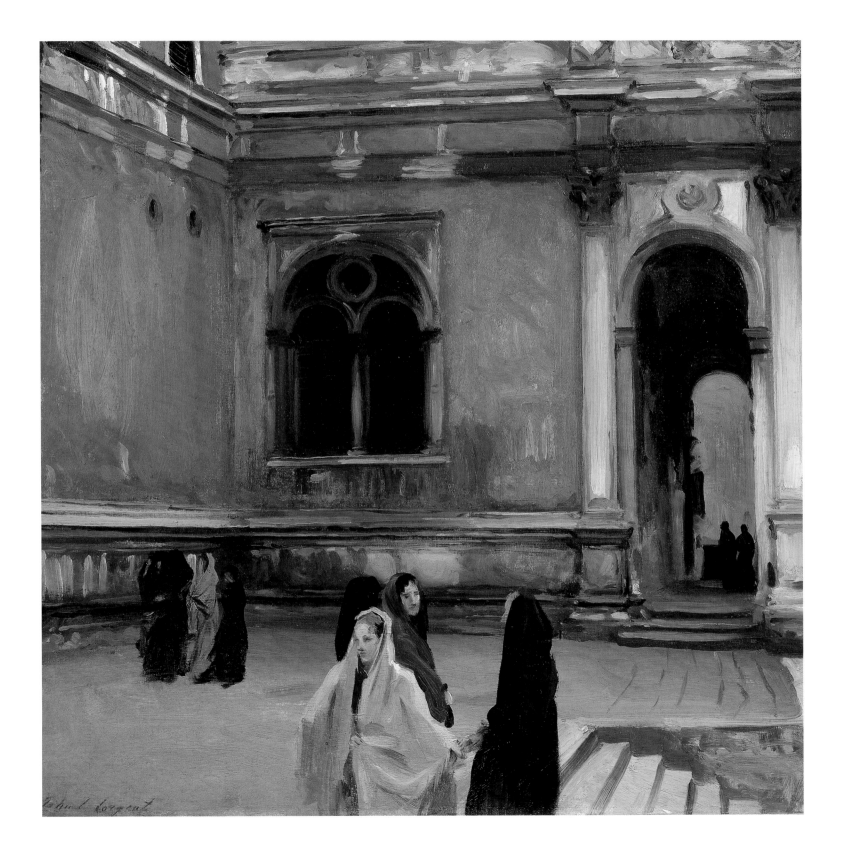

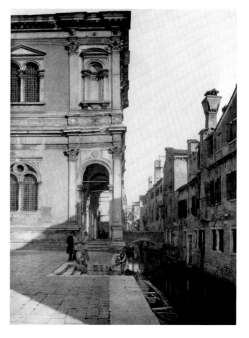

Fig. 225
Ferdinando Ongania,
Photograph of the Canal
San Rocco, and Portion of the
School of San Rocco.
The J. Paul Getty Museum,
Los Angeles.

817
A Canal Scene (fragment)

c. 1882
Oil on canvas
24 x 6⅛ in. (61 x 15.5 cm)
Untraced, possibly destroyed

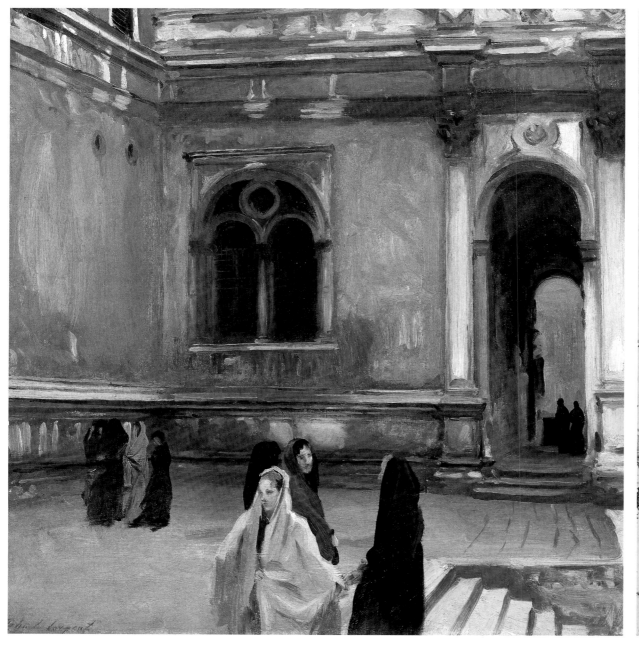

818
Portico di San Rocco

c. 1882
Alternative title: *Scene on a Side Canal,
Venice*
Oil on canvas
16⅝ x 12¾ in. (42.2 x 32.4 cm)
Collection of Dr and Mrs Henry
Landon III

This picture shows the steps leading to the elegant arcade or portico at the back of the Scuola di San Rocco. Originally a charitable fraternity, founded in the early sixteenth century to care for the victims of plague, it owes its fame today to the cycle of religious paintings by the Venetian master Jacopo Tintoretto. Sargent painted the arcade from the Calle a Fianco della Scuola, with the Ponte della Scuola on the right leading south to the Calle della Scuola. A pastel of *San Rocco* by James McNeill Whistler of 1879–80 also shows the back of the Scuola di San Rocco with a view down the Rio de la Frescada (Grieve 2000, ill. p. 73, fig. 73).

The picture is one of the few architectural studies in oils painted by Sargent in Venice at this early period. In the view of the authors, it probably dates from the second of his two visits to Venice, in 1882; see the discussion of chronology in the introduction to this chapter (pp. 319–22). The artist seizes on powerful architectural forms seen in close-up: the two massive soaring pillars which frame the steps and the house on the left—a complicated study in perspective; the overhanging cornices, pilasters, and ridges of stonework on the right; the low wall to the left running beside the canal; and the pavement in front. Sargent uses light to accentuate the details of the architecture and to bathe the scene in a soft and luminous atmosphere. The colour scheme is subdued and subtle; the dominant darkly grey pillars are relieved by the soft grey and beige tones of the foreground, the pinkish-red colour of the Scuola itself, and a different shade of smoky grey used for the house on the left.

The Scuola di San Rocco was a favourite building of the artist, and he depicted it in another oil of this period (see no. 816) and in several later water-colours. According to David McKibbin (McKibbin papers), the Cheyne Hospital for Children, London, solicited a contribution from the artist, which reached his house on the day of his death; his sister gave the picture to the hospital on his behalf. It was purchased from the hospital by M. Knoedler & Co., London, in May 1927, and later belonged to Verner Z. Reed, Jr, of Newport, Rhode Island. His brother, Joseph Verner Reed, owned *A Venetian Woman* (no. 796) and *Rio Eremite* (private collection).

819
Venise par temps gris

c. 1882
Alternative titles: *Venice; Venezia tempo grigio*
Oil on canvas
20⅝ x 27¾ in. (52.5 x 70.5 cm)
Inscribed, lower right: *à mon ami Flameng/
John S. Sargent*
Private collection

This extended view of the Riva degli Schiavoni is the only panorama painted by Sargent during his two early visits to Venice in 1880–81 and 1882. The picture reveals the view from beyond the Rio dei Greci looking westwards along the sweep of the Riva towards the Doge's Palace and the Campanile, with Santa Maria della Salute rising from the mist of early morning on the left. The sun is just beginning to emerge, catching the canopy of the stall in the foreground, bouncing off the hull of a boat in the middle distance in two bright patches of light, and gilding the façades of the distant buildings.

The artist painted the scene from a level well above the Riva close to Santa Maria della Pietà. The precise location is not identified, though David McKibbin suggested that it could have been the Hotel Gabrielli-Sandwirth (draft entry, McKibbin papers). The high viewpoint allows Sargent to exploit the topography of the scene with dramatic effect. The composition is determined by the sweeping curve of the Riva, reinforced by the lines of black boats around the void of the lagoon. The same type of compositional motif is to be found in the *Rehearsal of the Pasdeloup Orchestra at the Cirque d'Hiver* (no. 724), where the banked seats surround the pit, and the foreground is left bare. Sargent includes a few scattered figures as well as the stall in the Venice picture to provide scale and incident, but there is the same sparse foreground effect. The title of the picture is misleading, for the picture is luminous and opalescent in feeling rather than grey, and there are some lovely passages of colour and fleeting effects of light. The soft bluish greys of the water, melting into the lighter tones of the sky, contrast with the more solid colours of the Riva with its white bridges and distant buildings. Hugh Honour and John Fleming wrote of the picture (Honour and Fleming 1991, p. 59): 'This remarkable painting, the finest of all Sargent's views of Venice, perfectly catches the sad, empty, lost, "out of season" atmosphere of the city at this time of year: the lagoon is still, a veil of mist hangs over the buildings in the windless air and all colours are reduced to subtle nuances'.

In 1879–80, James McNeill Whistler executed two etchings of the Riva from a similar viewpoint to Sargent's picture, with the same sweep of promenade and buildings and sketchy figures peopling the foreground. Titled *The Riva, No. 1* and *The Riva, No. 2* from the first and second Venice Set, respectively (see fig. 226), they must have influenced Sargent in his choice and treatment of the subject. Lynda Ayres (Ayres in Hills *et al.* 1986, p. 54) compares Sargent's picture to Whistler's painting of *The Lagoon, Venice: Nocturne in Blue and Silver* (1879–80, Museum of Fine Arts, Boston). Another less obvious artist who may have influenced Sargent is the German painter Adolph Menzel. His bird's-eye views of Berlin, often painted from his upstairs studio windows, have the same modern feeling and painterly finesse. One in particular, *Die Berliner-Potsdam Bahn* (1847, Staatliche Museen zu Berlin), shows the sweep of the railway, like the curve of the Riva, around a grove of trees with a view of Berlin at the top of the composition; Sargent was certainly aware of Menzel's work and later owned a copy of the monograph on him by M. Jordans (Munich, 1895; Sargent library sale, Christie's, London, 29 July 1925, lot 216).

Venise par temps gris is inscribed to the French history painter, portraitist and decorative artist François Flameng (1856–1923); it is tempting to think that he might have been in Venice at this time and part of the group gravitating around Sargent, Whistler and Frank Duveneck. A portrait sketch of Flameng and Paul César Helleu by Sargent is in a private collection (*Early Portraits*, no. 90). The second owner of the Venice painting was the distinguished connoisseur Sir Philip Sassoon (1888–1939), a close friend of the artist, who owned a choice collection of his early work (for Sargent's portrait of Sassoon, see *Later Portraits*, no. 604).

Fig. 226
James McNeill Whistler, *The Riva, No. 1*, 1880. Etching, 7⅞ x 11½ in. (20 x 29.2 cm). Butterfly monogram, bottom left. Hunterian Art Gallery, University of Glasgow. Birnie Philip Gift.

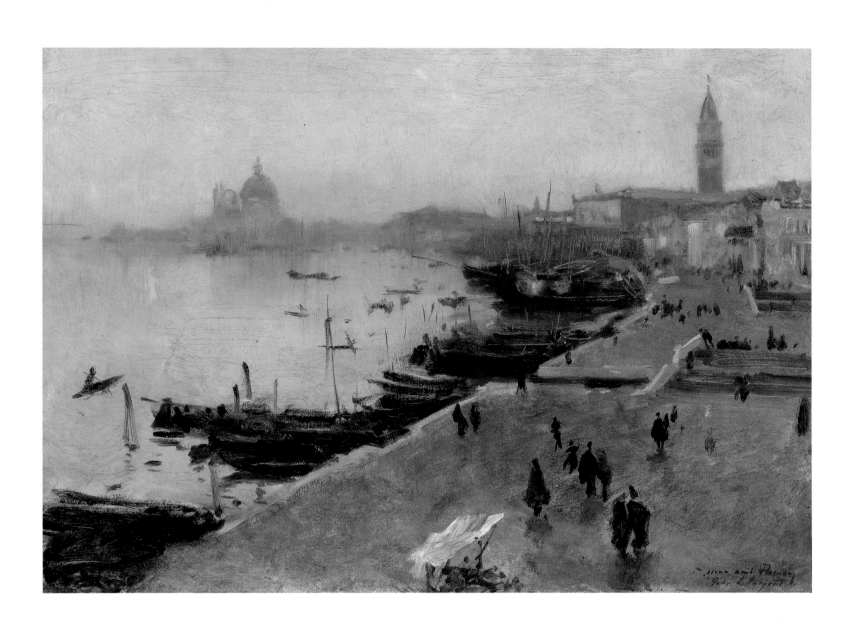

820
The Marinarezza, Venice

c. 1880–81
Alternative title: *Fondamenta Nuove, Venice*
Water-colour and pencil on paper
9 x 12 in. (22.9 x 30.5 cm)
Private collection

Traditionally called the *Fondamenta Nuove, Venice,* the location of this early water-colour was correctly identified by Professor Rosella Mamoli Zorzi and Marco Venturi d'Este. The three rear buildings of the Marinarezza, perpendicular to the Riva dei 7 Martiri, were constructed in 1332 as a refuge for elderly and infirm mariners who had served the Republic. The front of the Marinarezza, shown in Sargent's water-colour, was constructed in 1645. The Marinarezza still stands on the Riva, between the Ponte Veneta Marina and the Ponte dei Giardini (also known as the Ponte San Domenigo), with its distinctive tall arched entrances, rows of small windows along the façade and dormer windows in the roof. It is now separated from the waters of the Canale di San Marco by the wide pave-ment of the Riva, constructed since the time of Sargent's picture. As evident from the latter, the Marinarezza was still then an active boat centre, with boats drawn up on the slipway in front of the building. The houses to the left of the water-colour are still there, but the area in front of them, apparently then a location for boat build-ing, is now a garden.

Although the picture is pitched in a higher key of colour than most of the artist's early Venetian water-colours, its treatment of buildings and surface textures firmly link it to the group. In the view of the authors, the majority of the water-colour studies of Venice are likely to have been done on the first visit in 1880–81 rather than the second in 1882; see the introduction to this chapter, pp. 319–22.

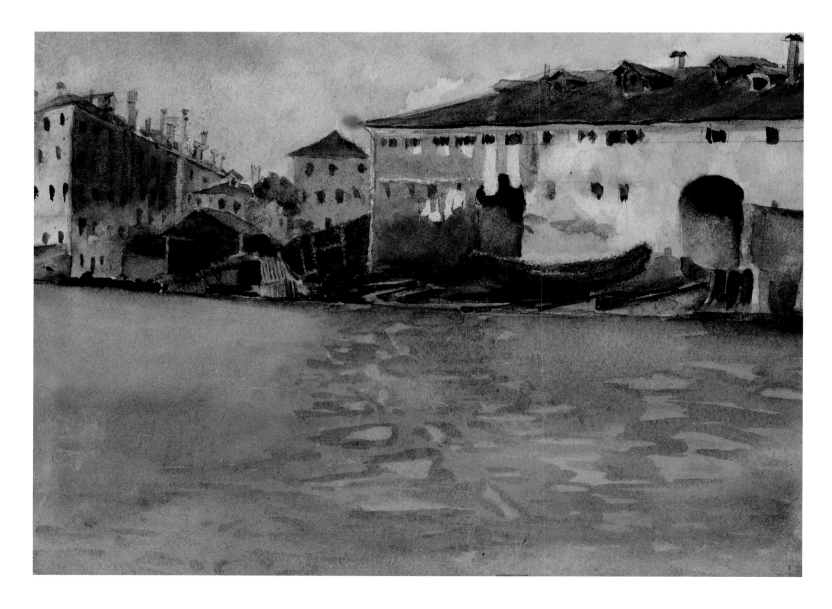

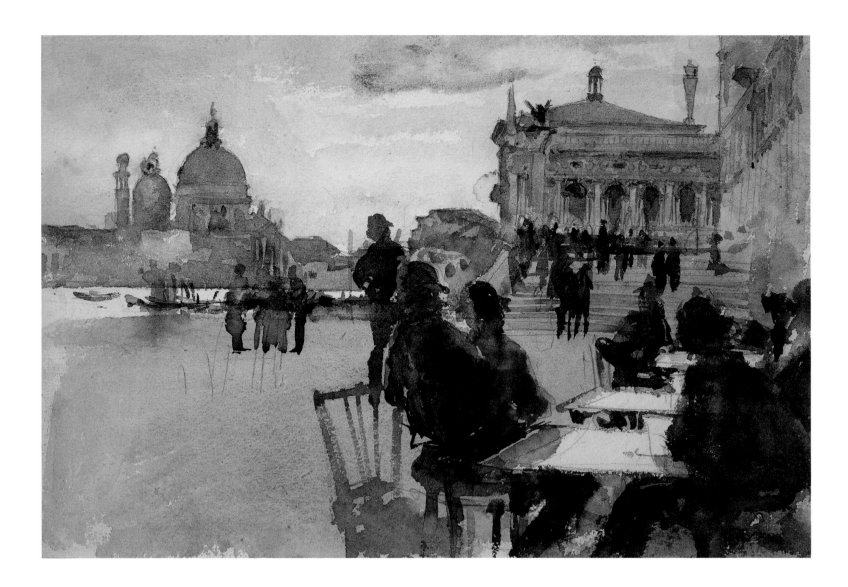

821
Café on the Riva degli Schiavoni, Venice

c. 1880–82
Alternative title: *Venice*
Water-colour on paper
9¾ x 13¾ in. (24.8 x 34.9 cm)
Private collection

This is a lively evocation of a Venetian street scene, crowded with figures and incident. The view is along the Riva degli Schiavoni towards the Ponte della Paglia, with St Mark's Column and the Libreria beyond it, the outline of the Doge's Palace on the right, and a view of Santa Maria della Salute across the mouth of the Grand Canal to the left. The café is the well-known Orientale, now replaced by an annexe to the Hotel Danieli, which derived its name from the tent pitched on the Riva itself; it was popular with artists because it was cheaper than the cafés on the Piazza San Marco.[1] A photograph by Carlo Naya of c. 1875 of the same view as Sargent's water-colour, show-

ing the Caffè Orientale on the right, is reproduced in Dorothea Ritter, *Venice in Old Photographs 1841–1920* (London, 1994, pp. 126–27). In her book on American artists in Venice, Margaretta Lovell (Lovell 1989, pp. 91, 93) questioned the accuracy of Sargent's view of the Riva, the position of St Mark's Column, and the relative scale of Santa Maria della Salute '(here brought forward and greatly enlarged)'. Comparison with the photograph shows that the church is perfectly in scale and that the artist did not alter details of the scene.

The composition of Sargent's water-colour is dominated by a boldly blocked-in group of figures on the right, contrasting with the open space of the Riva and the bridge, where other figures are promenading. The row of three tables provides a strong diagonal thrust into the picture space. The figures themselves, reduced to semi-transparent shadows, give vitality and character to the scene, without disturbing the grand effect of one of Venice's most famous views. The water-colour was evi-

dently done with extreme rapidity to catch the fleeting light effects of a typical late-afternoon scene, bathed in winter sunshine; the presence of warm coats and hats indicates the season. As in *Venise par temps gris* (no. 819), the muted colours and strong emphatic blacks and greys give the study the quality of a grisaille.

Marc Simpson suggests that this water-colour may have been one of the two exhibited at the Salon in 1881 (nos. 3413–14; Simpson 1997, p. 174). However, two pairs of water-colours, *Campo dei Frari, Venice* and *Ponte Panada, Fondamenta Nuove* (nos. 823, 822), and *Venetian Canal, Palazzo Contarini degli Scrigni e Corfu* and *Ponte Lungo, Zattere, Venice* (nos. 826, 825), are more likely contenders.

1. See Elizabeth Robins Pennell, *Nights: Rome–Venice in the Aesthetic Eighties; London–Paris in the Fighting Nineties*, 2nd ed. (Philadelphia and London, 1916), pp. 82–83; Danilo Reato and Elisabetta Dal Carlo, *La Bottega del Caffè* (Venice, 1991), pp. 103–7; and Grieve 2000, p. 161.

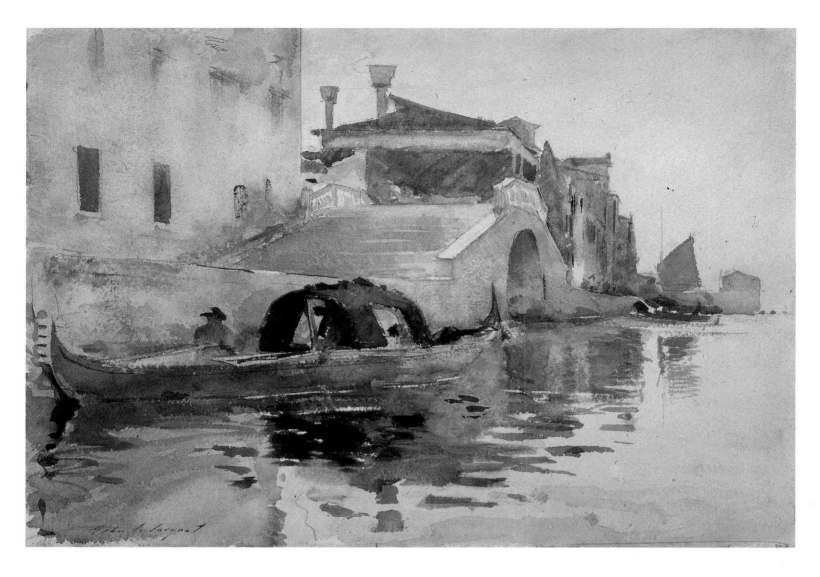

822
Ponte Panada, Fondamenta Nuove

c. 1880–81
Alternative titles: *A Canal Scene, Venice;*
Venice, Gondola on Canal; Canal Scene
(Ponte Panada, Fondamenta Nuove), Venice
Water-colour and pencil on paper
9⅞ x 13½ in. (25.1 x 34.3 cm)
Inscribed, lower left: *John S. Sargent*
Inscribed in pencil on the reverse:
No 1/SS-6S and in a different hand:
No 4° 15 cent [or cercle] *de Marge*
Corcoran Gallery of Art, Washington, D.C.
Bequest of Mabel Stevens Smithers (52-11)

David McKibbin identified the scene as the
Ponte Panada on the Fondamenta Nuove,
with the romantic Casino degli Spiriti in
the distance. The original sixteenth-century
bridge was reconstructed in 1881 (see Gian-
pietro Zucchetta, *Venezia ponte per ponte,*
2 vols. [Venice 1992], vol. 2, p. 391 no. 183,
p. 439 n.). Sargent must have painted the
scene from a boat a few yards off-shore.
The bridge and the building in the fore-
ground are still there, but the building
beyond the bridge has been replaced by a
modern apartment block. A stationary gon-
dola with a seated figure and canopy occu-
pies the foreground of the water-colour,
and a sailing vessel can be seen further
up the Fondamenta. The sliding, oblique
view of buildings, counter-pointed with

the waving reflections in the water, is a type
of composition favoured by Sargent at this
period. The golden glow cast over the scene
suggests that it was painted in the late after-
noon. With its companion piece, *Campo dei*
Frari, Venice (no. 822), it may have been one
of the two water-colours exhibited at the
Salon in 1881 (nos. 3413–14), which would
date it to Sargent's first trip in 1880–81; see
the discussion of chronology in the intro-
duction to this chapter (pp. 319–22). How-
ever, *Venetian Canal, Palazzo Contarini degli*
Scrigni e Corfu and *Ponte Lungo, Zattere, Venice*
(nos. 826, 825) are also contenders. For details
of the provenance of this water-colour, see
the entry for its companion piece, *Campo*
dei Frari, Venice.

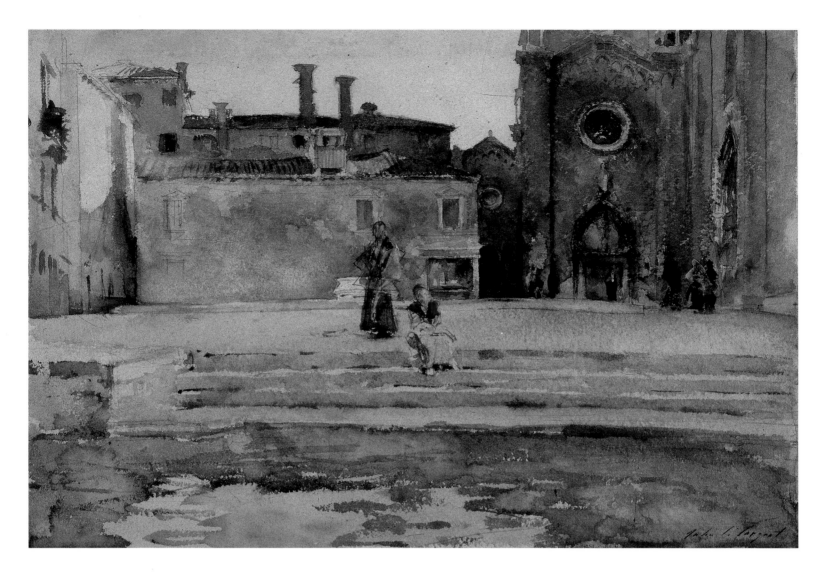

823
Campo dei Frari, Venice

c. 1880–82
Alternative titles: *A Piazza on a Canal,*
Venice; Piazza, Venice; Venetian Piazza
Water-colour and pencil on paper
9⅞ x 14 in. (25.1 x 35.6 cm)
Inscribed in ink, lower right: *John S. Sargent*
Inscribed on the reverse: *No. 2/pp blanc/*
de la même grandeur/NO 5 15 cent de Morge
[?Marge]
Corcoran Gallery of Art, Washington, D.C.
Bequest of Mabel Stevens Smithers (52.10)

David McKibbin identified this water-colour as a view of the Campo dei Frari, painted from the Fondamenta dei Frari looking south-west, with the canal of the same name in the foreground. Set back on the right is the Capella Emiliani of the famous fourteenth-century Franciscan Church of the Frari, the Chiesa di Santa Maria Gloriosa dei Frari, with the side entrance to the church shown on the extreme right-hand side, facing the campo; the main façade of the church is further to the right outside the picture frame. The house to the left of the church is not accurately rendered, or rather is missing several of its windows and doorways. There were, and still are, three upper windows on the right side of the building with two doorways and a shop front. Sargent shows only the latter feature and two windows, though faint pencil markings on the wall may indicate the position of others. A drawing by Joseph Pennell reproduced in Francis M. Crawford, *Gleanings from Venetian History,* 2 vols. (London, 1905, vol. 1, p. 457), shows the same view as Sargent's water-colour

with windows and doorways recorded in their correct positions.

Two figures occupy the foreground of Sargent's water-colour, a young girl with a red scarf seated on the steps leading to the canal, and a second, standing woman in a blue dress, through whose semi-transparent figure details of the well-head and building can be seen. Half a dozen women in shawls are scattered in the area behind, adjacent to the church. The study is more highly worked than most of Sargent's Venetian water-colours and is rare in its inclusion of foreground figures. With its companion piece (no. 822), it may have been one of the two water-colours exhibited at the Salon in 1881 (nos. 3413–14), which would date it to Sargent's first trip in 1880–81. However, *Venetian Canal, Palazzo Contarini degli Scrigni e Corfu* and *Ponte Lungo, Zattere, Venice* (nos. 826, 825) are also contenders.

The inscription on the reverse of the water-colour seems to be the notes of a framer to himself or his workers. Richard H. Finnegan has interpreted it as meaning that two sheets of white matting paper, of

the same size, should be cut to leave a 15 percent margin of the water-colour's paper visible beyond the image itself ('15 cent de Marge'). If the notes are contemporary, they reveal how particular the artist was about the framing of his work.

The first recorded owner of this water-colour and its companion piece, *Ponte Panada, Fondamenta Nuove* (no. 822), was Henry Schlesinger (1830–1912).[1] His connection with Sargent was either through the poet Robert Browning and his son, 'Pen' Browning, or through Schlesinger's nephew, Gustav Natorp.[2] Schlesinger's brother and sister-in-law, Ernst and Elizabeth Benzon (*née* Lehmann), had been close friends of the poet since 1861, and Schlesinger himself had entertained Browning as early as 1868.[3] Elizabeth left Browning a legacy in 1878, which was administered by Schlesinger. The latter's wife was a cousin of the American Fannie Coddington who married 'Pen' Browning in October 1887. Schlesinger gave the bride away, and the reception was held at his house in Kent, Hawkwell Place. Sargent had gotten to know Browning and 'Pen' in Venice and later in London; see the introduction to this chapter (p. 310). Following Schlesinger's death, the water-colours of the *Campo dei Frari* and the *Ponte Panada* were sent for sale at Christie's, London, by his son, Arthur H. Berly (c. 1863–1938), who had taken his mother's maiden name.[4] The authors are indebted to the Browning scholar Philip Kelley for information relating to the Brownings, Benzons, Lehmanns and Schlesingers.

1. For details of Schlesinger's will, see the London *Times*, 2 September 1912, p. 9d.
2. The sculptor and a close friend of Sargent, who painted him in Paris (*Early Portraits*, no. 147); see also the entry for the water-colour *On the Lagoons, Venice* (no. 829), which Sargent inscribed to him.
3. Ernst had taken his mother's maiden name. With his brother Sebastian Schlesinger and his brother-in-law Frederick Lehmann, he was a partner in the English iron-firm Naylor Vickers Co. Lehmann was also a close friend of Browning and other eminent Victorians, the brother of the artists Henri and Rudolph Lehmann, and the grandfather of the writers John and Rosamund Lehmann and the actress Beatrix Lehmann; see the reminiscences of his son, Rudolph Chambers Lehmann, *Memories of Half a Century* (London, 1908).
4. He was a stockbroker with Baer, Ellison & Co. He was born in Perth and died in Italy. The price of £35.14.0 paid for the water-colour, and £46.4.0 for its companion, at the Christie's sale is recorded in an annotated copy of the sale catalogue (Corcoran Gallery of Art files), together with a note: 'done about 1883/see Sargent's letter of 31 July 1913' (no trace of the letter has been found).

824
Palazzo Marcello

c. 1880–81
Alternative titles: *Venice; Pink Palace (Palazzo Marcello)*
Water-colour on paper
12¾ x 9¼ in. (32.4 x 23.5 cm)
Private collection

This is a view of the right-hand façade of the Palazzo Marcello, situated on the Rio del Gaffaro, with the main entrance surmounted by a beautiful Gothic ogee arch. The palace was built in the fifteenth century for the Marcello family, of whom the most famous member was the composer Benedetto Marcello (1686–1739); for a description of the palace, see Giannina Piamonte, *Venezia Vista dall'acqua, guida dei rii di Venezia e delle Isole* (Venice, 1968, pp. 258–59). Essentially unchanged, the palace is now occupied by the Hotel al Sole and should not be confused with the better-known palace of the same name on the Grand Canal. The palace is situated between the churches of San Pantaleone and San Nicolò di Tolentino in the western part of the city. The artist painted it from the Rio del Malcanton looking north towards the Fondamenta Minotto, with the Ponte Marcello to the left, just outside the picture frame. The water-colour is reminiscent of Whistler's views of palace façades in its subtle rendering of reflected light from buildings and water and its precise patterning of architectural features. The carefully delineated window and door frames, both square and Gothic, stand out as bold, dark shapes against the pale pinkish-yellow walls of the palace and the adjoining house. A similar view of the palace by Joseph Pennell was published in Francis M. Crawford, *Gleanings from Venetian History*, 2 vols. (London, 1905, vol. 1, p. 278).

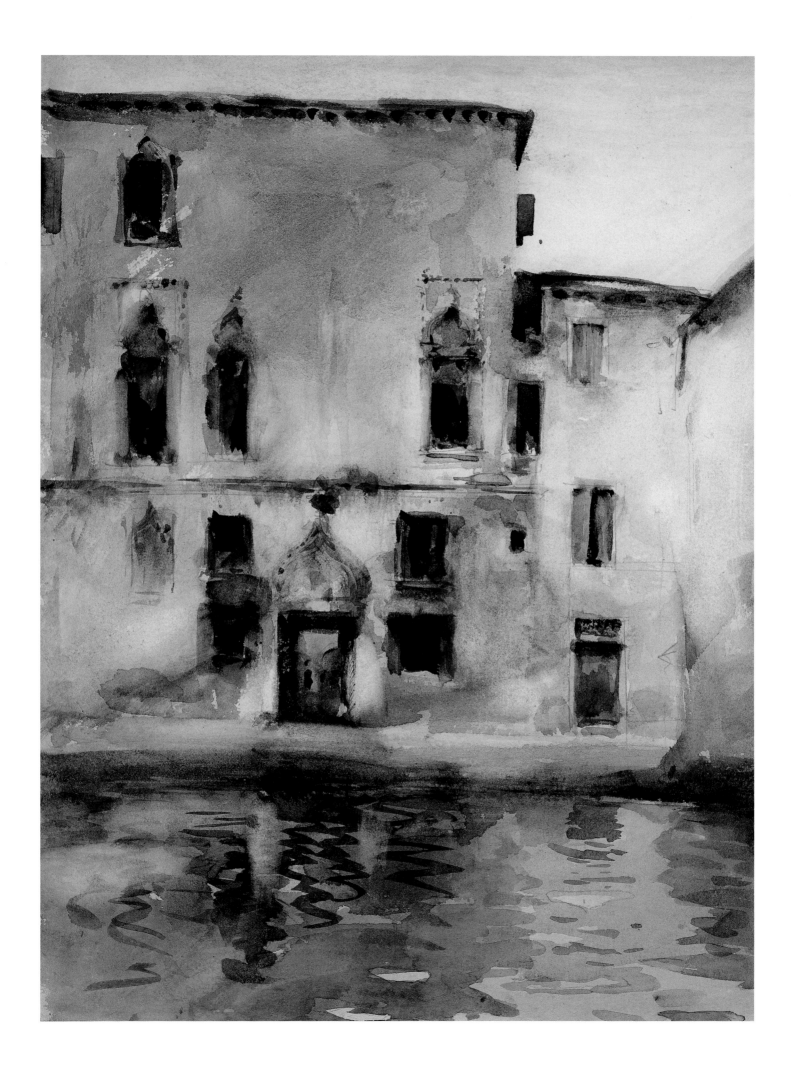

825
Ponte Lungo, Zattere, Venice

c. 1880–81
Alternative titles: *Bridge & Boat, view of Venice, bluish water; Venetian Scene; Venetian Scene, Boat and Bridge; Venetian Canal Scene*
Water-colour on paper
12½ x 9¼ in. (31.7 x 23.4 cm)
Inscribed, lower left: *John S. Sargent*
Untraced

This view along the Zattere in Venice, looking east, shows the Ponte Lungo over the Rio di San Trovaso in the foreground (see Gianpietro Zucchetta, *Venezia Ponte per Ponte*, 2 vols. [Venice, 1992], vol. 2, p. 783, no. 411), followed by the pediment of Sta Maria della Visitazione, and then the great Renaissance façade of the Gesuati. The ticket kiosk for the ferry to the Giudecca has since disappeared. Below the kiosk are a gaggle of small boats and, in the distance, the masts of two sailing vessels. This water-colour is similar to its companion, *Venetian Canal, Palazzo Contarini degli Scrigni e Corfu* (no. 826), in its glancing, side-view perspective, bold architectural features and distinctive patterned reflections in the water. The two water-colours may have been those exhibited at the Salon in 1881 (nos. 3413–14), which would date them to Sargent's first Venetian trip of 1880–81, but *Campo dei Frari, Venice* and *Ponte Panada, Fondamenta Nuove* (nos. 823, 822) are also contenders.

In 1929, M. Knoedler & Co., New York, bought the two water-colours in Paris from 'P. Guillaume'. This may have been the well-known Paris art dealer Paul Guillaume, for whom see the entry for *Venetian Canal, Palazzo Contarini degli Scrigni e Corfu* (no. 826). Mrs Houghton Metcalf (born Katharine Herrick), who later owned the water-colour, was a member of a prominent Rhode Island family. She owned several other works by Sargent, including *A Boating Party* and *Portrait of the Artist Sketching* (1889 and 1922, respectively, both Rhode Island School of Design), and water-colours from the artist's later career.

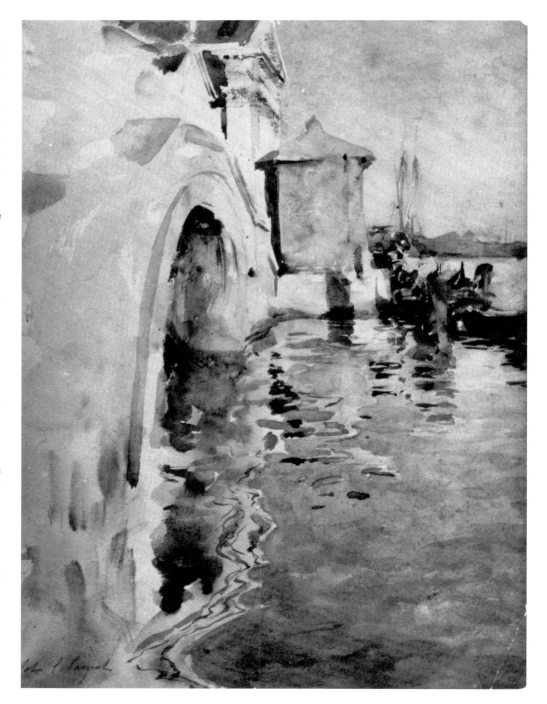

826
Venetian Canal, Palazzo Contarini degli Scrigni e Corfu

c. 1880–81
Alternative titles: *View of Venice and Houses;*
Venice; Venetian Canal; Venetian Canal,
Palazzo Corner Contarini dei Cavalli;
Venetian Canal, Palazzo Corner
Water-colour and pencil on paper
12¾ x 9 in. (32.4 x 22.9 cm)
Inscribed, lower right: *John S. Sargent*
Private collection

This view down the Grand Canal, Venice, represents part of the façade of the Palazzo Contarini degli Scrigni e Corfu, with the Accademia gallery visible in the background on the left. The identification was first proposed by David McKibbin. The Palazzo Contarini consists of two contrasting buildings, the first a delicate fifteenth-century Gothic façade, the second, a Baroque design by Vincenzo Scamozzi, completed in 1609. It is the first of these which is shown in Sargent's water-colour. The picture is typical of this early group in its careful delineation of architectural detail, its feeling for the weathered texture of buildings and its broad treatment of reflected light on water.

This and its companion water-colour (no. 825) may have been exhibited at the Salon in 1881 (nos. 3413–14), which would date them to Sargent's first trip in 1880–81. However, *Campo dei Frari, Venice* and *Ponte Panada, Fondamenta Nuove* (nos. 823, 822) are also possibilities. The records of M. Knoedler & Co., New York, list the vendor in 1929 as 'P. Guillaume'. This may have been the well-known Paris dealer Paul Guillaume (1891–1934), who dealt in avant-garde art prior to and following the First World War. However, Sargent would have been outside his normal range of artists, which included Giorgio de Chirico, André Derain, Henri Matisse, Pablo Picasso, Maurice Utrillo and Amadeo Modigliani. Knoedler sold the water-colour to Wadsworth Lewis, an important collector of English furniture, Aubusson tapestries, oriental rugs, Chinese ceramics and jade, pictures and books.[1]

1. The sale, following his death, at Parke-Bernet Galleries lasted for three days and contained 672 lots, of which only 22 were water-colours and drawings, among them this Sargent water-colour. Lewis owned a second Venetian water-colour, later in date, *Palazzo Corner-Contarini Cavalli* (ex Brooklyn Museum, private collection). As well as these two water-colours, Lewis also briefly owned the sketch of seated dancers from *El Jaleo* (fig. 166). The water-colour catalogued here was bought from the Lewis sale by Mrs John Lavalle of New York (see her letter to David McKibbin, 11 July 1969, McKibbin papers).

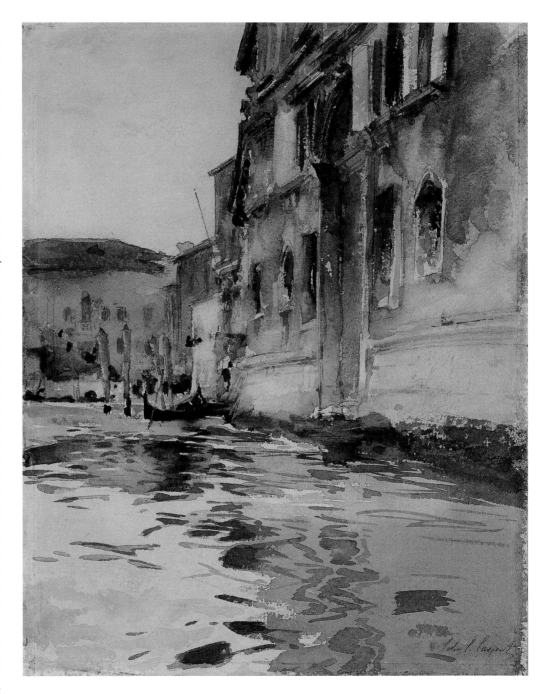

827
Palazzo Foscari

c. 1880—81
Water-colour and pencil on paper
12⅝ x 9¼ in. (32.1 x 23.5 cm)
Private collection

This view across the Grand Canal, Venice, shows the Palazzo Foscari to the right and a corner of the Palazzo Sagredo to the left, divided by the Traghetto di Santa Sofia, with the Campo Santa Sofia behind. The Palazzo Foscari, also known as the Palazzetto Foscari del Prà, should not be confused with the better-known Palazzo Ca' Foscari, which is much further down the Grand Canal, on the opposite bank, next door to the Palazzo Giustiniani. In this water-colour, several gondolas are shown tied up at the traghetto, in front of the palazzo. The architecture is carefully delineated, aided by pencil underdrawing. A darker band of water is flanked by the lighter gold and yellow tones reflected from the buildings. The picture is typical of the early Venetian water-colours in its tight wash technique and subtle treatment of light and surface texture. An etching by Whistler, *The Palaces,* of 1879—80, shows the Palazzo Sagredo and the Palazzo Pesaro across the Grand Canal from a similar viewpoint to Sargent's water-colour (ill. Grieve 2000, p. 64, fig. 56).

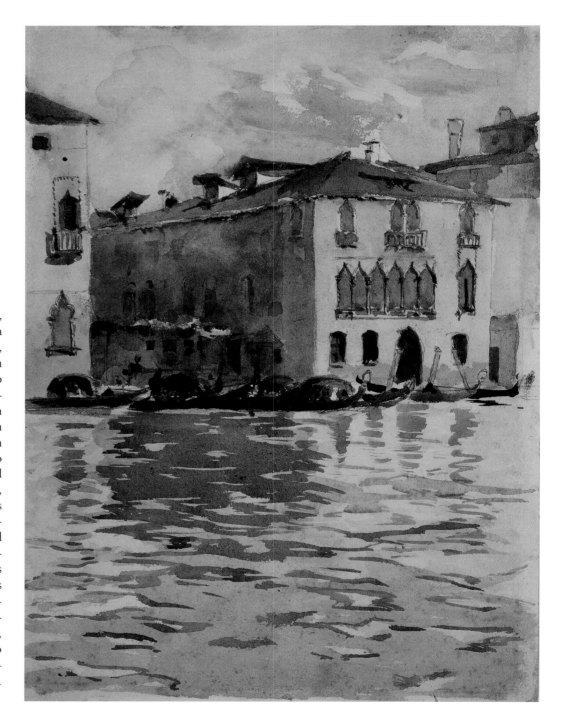

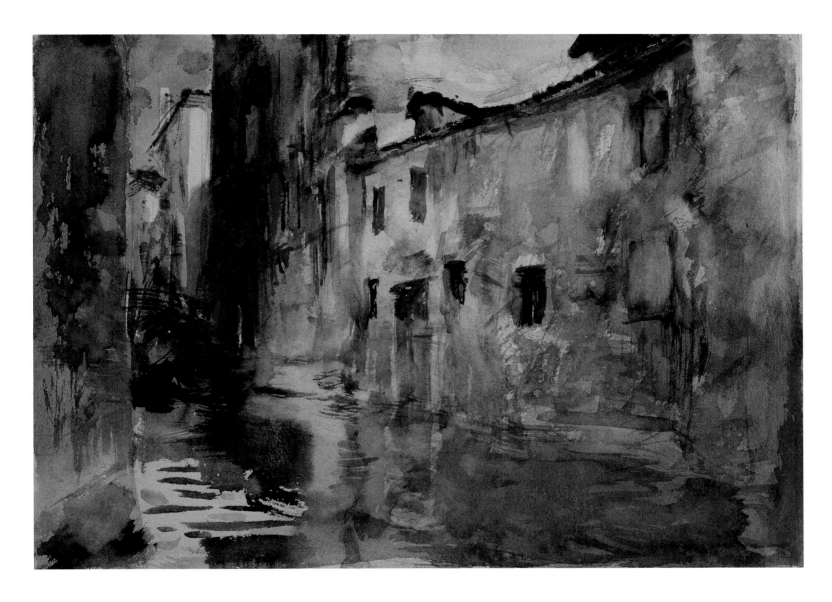

828
Side Canal

c. 1880–81
Water-colour on paper
8¾ x 12 in. (22.2 x 30.5 cm)
Private collection

This is freer and more sketch-like than most of Sargent's early Venetian water-colours. The oblique viewpoint, the contrast between the weathered surfaces of the walls, and the soft iridescent reflections in the water are, however, typical. The side canal is framed by a wall jutting into the scene from the left, like a theatre flat, and on the right by a long low building punctuated with small windows and two dormers in the roof. Further back is a more substantial house or palace, a bridge with a figure faintly indicated, the prow of a barge or gondola, and, in the distance, two more buildings in sunlight and a sliver of blue sky.

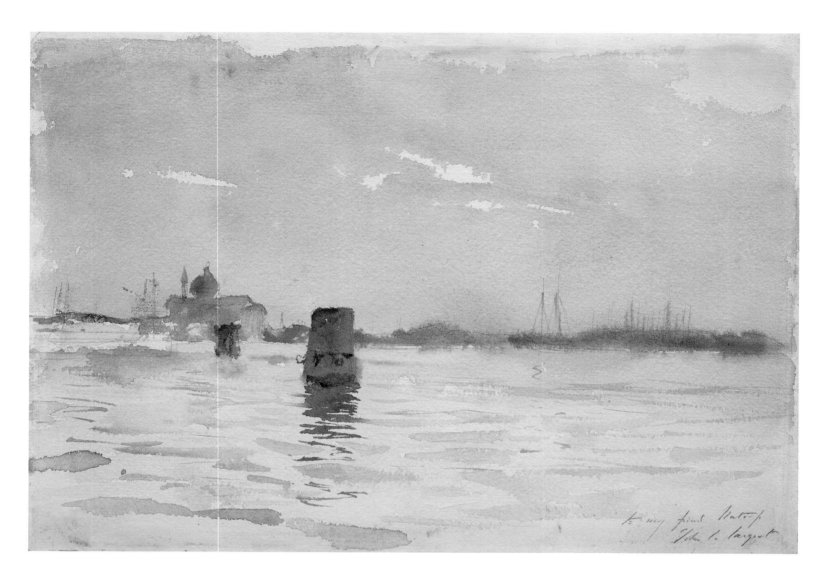

829
On the Lagoons, Venice

c. 1880–81
Alternative titles: *A View on the Lagoons, Venice; View from the Bacino, S. Giorgio Maggiore to the left, Venice*
Water-colour and pencil on paper
10 x 13¾ in. (25.4 x 34.9 cm)
Inscribed, lower right: *to my friend Natorp/John S. Sargent*
Private collection

This view was painted looking across the Giudecca Canal towards Andrea Palladio's famous church of the Redentore on the Giudecca. One of the two bell towers is visible to the left of the dome; since it is impossible to see this tower without also seeing the tip of the second tower to the right from anywhere along the Zattere, one must assume it was painted from the Riva or, more probably, from a boat. The tall masts of sailing ships moored on the Giudecca can be seen to the left of the Redentore and in a long line to the right of the picture. The black shape of a square-rigged fishing boat provides a dramatic motif in the middle distance, and there is a second boat beyond. This type of atmospheric, panoramic scene is not common in Sar-

gent's early work, and it may reflect the influence of Whistler, who did many such subjects in pastel and etching. In the view of the authors, the majority of Sargent's water-colour studies of Venice are likely to have been painted on his first visit to the city in 1880–81 rather than his second in 1882; see the discussion of chronology in the introduction to this chapter (pp. 319–22).

Gustav Natorp (1836–1908), to whom the water-colour is dedicated, was a German sculptor who first met Sargent in the early 1880s, when Natorp was studying with Auguste Rodin; for a portrait of Natorp by Sargent see *Early Portraits* 1998, no. 147. The water-colour was sold by Natorp's widow at Christie's, London, in 1922, and reemerged on the art market around 1980.

830
Venetian Woman by a Bed

c. 1880–82
Alternative titles: *A Venetian Girl;*
Venetian Lady
Water-colour on paper
19¾ x 13¾ in. (50.2 x 35 cm)
Private collection

A young woman coquettishly parts the mosquito curtains of a high bed and gives us a come-hither smile. Her hairstyle, fan, flounced skirt and shoes link her unmistakably to the female models of Sargent's Venetian interiors and street scenes. The sexuality here is explicit rather than implied; the figure is presented as a courtesan enticing us to join her in the shared pleasures of the large, opulent bed. The water-colour revolves around the delicately painted figure, the border of the bedspread and the floor. Sargent adds a minimum of additional detail, leaving us to read the scene intuitively from these few clues. Apart from the black fan, the palette is restricted to pale grey and brown. The water-colour belonged to Sargent's sisters and was photographed for Sir Robert Witt around 1927 when in the collection of Emily Sargent; the original negative is now in the Witt Library, Courtauld Institute, London (no. D53/1219).

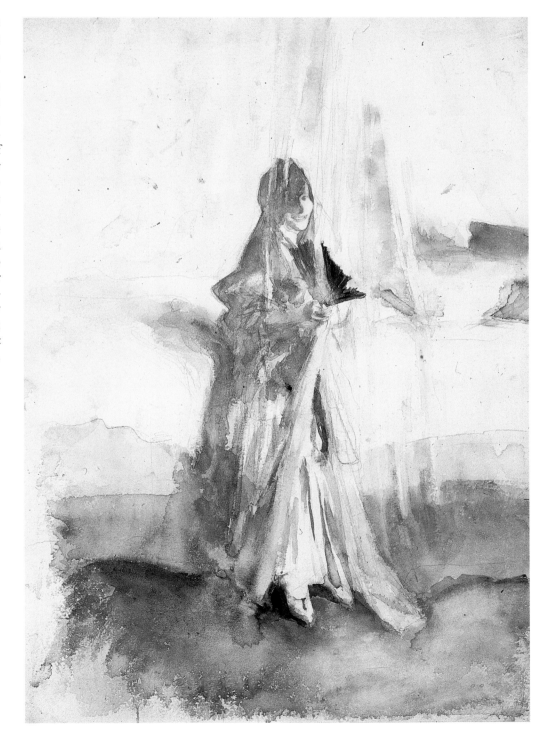

831
Woman in a Gondola

c. 1880–81
Water-colour and pencil on paper
13 x 9½ in. (33 x 24.1 cm)
Private collection

A young woman with closed eyes is shown reclining in a gondola, with the lines of the boat and gondolier faintly indicated in pencil. Behind is a view across the canal to a line of houses. It is not an easy image to read because the female figure, the only part of the water-colour at all finished, appears to be suspended in space. The artist painted her from above, probably placing his easel by the canal side, hence the steep angle of the gondola and the foreshortened perspective. The woman, with a black shawl round her head, belongs to the same group of models who people Sargent's street scenes and Venetian interiors. Like them, she gives off erotic signals as she abandons herself to sleep. She lies under a rich black rug, the red lining of which, visible at her waist and right side, provides the only accent of bright colour amidst the blacks and greys. In the opinion of the authors, the majority of Sargent's water-colour studies are likely to have been painted on his first visit to Venice in 1880–81; see the discussion of chronology in the introduction to this chapter (pp. 319–22).

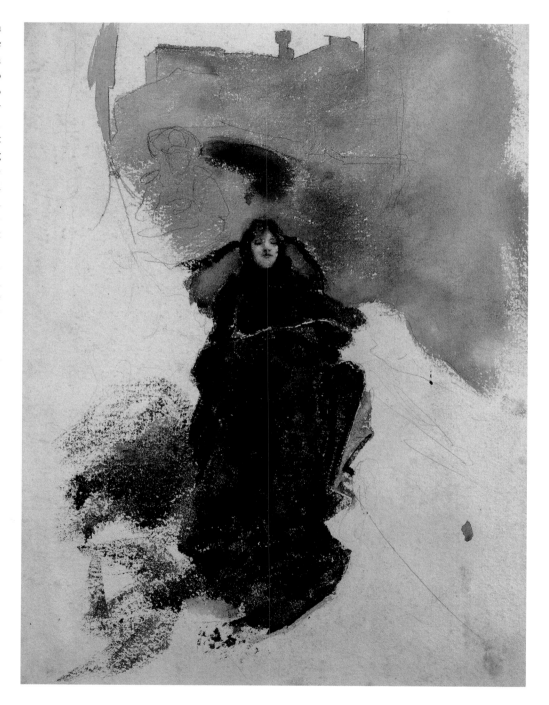

832
Young Woman in a Black Skirt

c. 1880–81
Water-colour on paper
14 x 9⅞ in. (35.5 x 25 cm)
Inscribed verso, upper centre: *6/28*
[circled] and lower left: *SW*
The Metropolitan Museum of Art,
New York. Gift of Mrs Francis Ormond,
1950 (50.130.33)

This water-colour almost certainly represents one of Sargent's Venetian models, an idea first proposed by Stephanie Herdrich and H. Barbara Weinberg (see Herdrich and Weinberg 2000, p.175). The young woman is posed in picturesque local costume as a type of Venetian beauty. She is quite different in character from conventional studies of picturesque Venetians by other contemporary artists, looking out at us with the cool self-possession of a modern young woman, hands clasped on her hip. One eye is so deep in shadow that it reads almost like an eye-patch or a void. The smooth outline of her black hair and her black skirt contrast with the loose folds and puffed sleeves of her linen shirt. The picture is essentially a study in black and white set against the soft grey washes of an indeterminate background. In the view of the authors, the majority of Sargent's Venetian water-colour studies are likely to have been painted on his first visit in 1880–81.

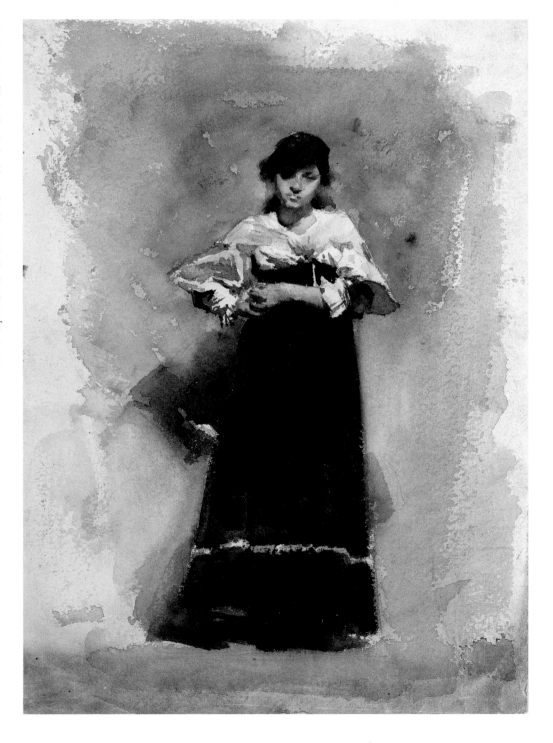

833
Figure in Costume

c. 1880–82
Water-colour on paper
14 x 9⅞ in. (35.5 x 25 cm)
Inscribed lower left: *1869* and on verso
at centre: *1869*
The Metropolitan Museum of Art,
New York. Gift of Mrs Francis Ormond,
1950 (50.130.34)

This water-colour relates closely in style to
Young Woman in a Black Skirt (no. 832) and
other water-colours of the early 1880s. The
inscribed date, not in Sargent's hand, is
clearly wrong. It would be nice to think
that this attractive young boy in a page's
outfit of vaguely historical character (six-
teenth or seventeenth century) is dressed
for a Venetian pageant or carnival. The pic-
ture may, on the other hand, simply be a
studio exercise. The young model is seen in
profile, with long curls, hand on hip, and a
thoughtful look on his face. The fluid
washes of the background suggest a dark
interior space behind him. It was Annette
Blaugrund who first linked together this
water-colour, the *Young Woman in a Black
Skirt* and *The Model: Interior with Standing
Figure* (no. 630) (see Blaugrund in Hills *et
al.* 1986, pp. 210–13). In the view of the
authors, the majority of Sargent's Venetian
water-colour studies are likely to have been
painted on his first visit in 1880–81; see the
discussion of chronology in the introduc-
tion to this chapter (pp. 319–22).

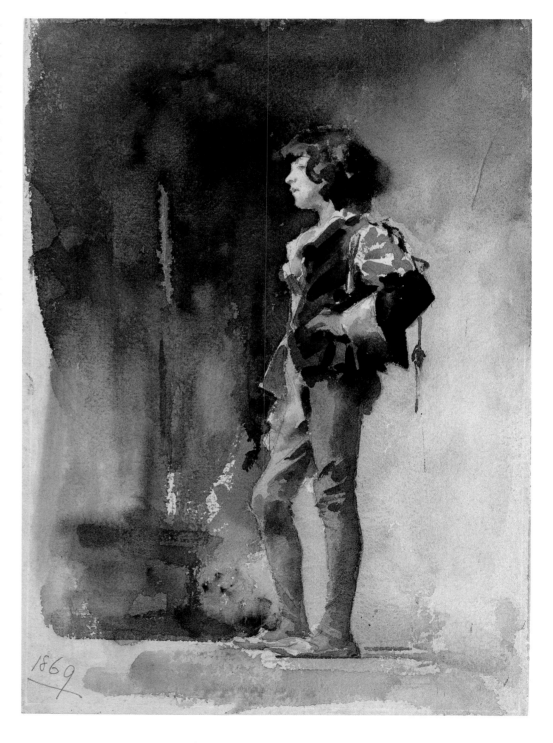

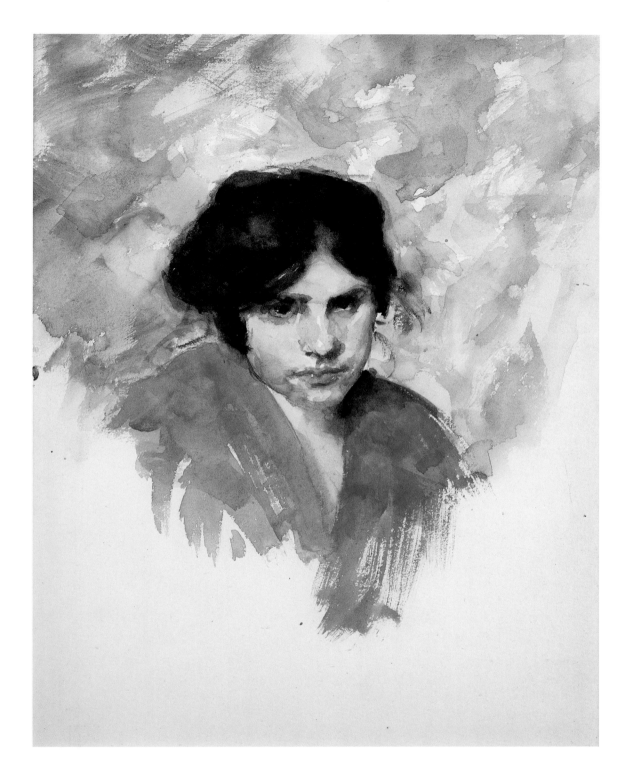

834
Head of a Venetian Model

c. 1880–81
Alternative titles: *Head of a Spanish Girl;*
Gigia Viani
Water-colour on paper
11½ x 9 in. (29.2 x 22.9 cm)
Private collection

The hairstyle and sultry expression of the model relate closely to those of other Venetian models painted by Sargent, and the style of water-colour is also early. The young woman in this study has the central parting and black hair but not the rounded features of the model sometimes identified as Gigia Viani; see the discussion of models in the introduction to this chapter (pp. 316–17). The carefully observed head is set off by the sweeping strokes of the shawl, revealing a 'V'-shaped sliver of bare flesh and translucent patches of pink wash suggesting a textured wall or fabric behind her.

The water-colour, together with a group of early drawings, including copies after Frans Hals (figs. 110, 111), studies for *Spanish Dancer* (figs. 131, 132), and *Studies of Venetian Female Models* (fig. 213), was given by Emily Sargent to Mrs Jagger, the housekeeper at 33 Tite Street. She was the mother of the British sculptor Charles Sargeant Jagger (1885–1934), best known for the Royal Artillery Memorial at Hyde Park Corner and other First World War memorials. The water-colour was sold by the sculptor's son, Cedric Jagger, to the Fine Art Society, London, in 1988.

835
Mother and Child

1881
Water-colour and pencil on paper
13 x 9¾ in. (33 x 24.8 cm)
Inscribed, lower right: *to my friend Logsdail/*
Venice 1881/ John S. Sargent
Untraced

The Venetian model in this unfinished water-colour appears to be seated, and she holds a child, probably a boy, in her lap. Only the head and shoulders of the woman are worked up; her figure and the child are merely indicated in a few pencil lines. The woman's head is sensitively modelled with deft touches of wash that record the play of light and shadow across the features and give them vividness and immediacy. Like the majority of Sargent's Venetian water-colour studies, this one was painted during the first of Sargent's two visits to the city.

William Logsdail (1859–1944), to whom the water-colour is inscribed, was one of a group of English artists in Venice whom Sargent knew well. Logsdail had arrived in Venice in the autumn of 1880, at much the same time as Sargent, and occupied a studio in the Calle Capuzzi in Dorsodoro, near the Campo Sant'Agnese, where Sargent is also said to have had a studio; see the introduction to this chapter (pp. 308, 323, n. 49). Logsdail remained in Venice for a number of years, painting popular subject works, including *The Piazza of St Mark's, Venice* (see fig. 6) and *A Venetian al Fresco* (1885, Christie's, London, 24 November 2004, lot 38); see the exhibition catalogue *William Logsdail,* Usher Art Gallery, Lincoln, 1994, which has an essay on his work in Venice and London by Robert Upstone.

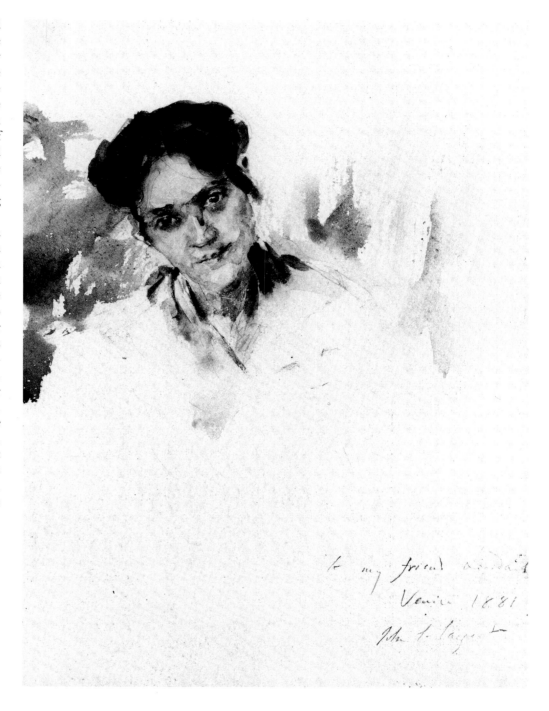

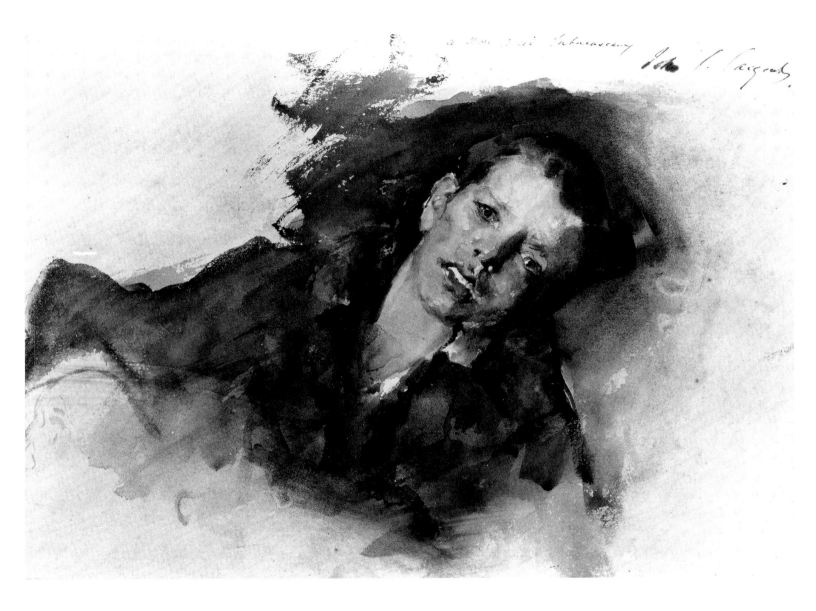

836
***Study of a Boy Reclining against
a Pillow***

c. 1880–81
Water-colour on paper
9 x 12 in. (22.8 x 30.5 cm)
Inscribed, top left: *a mon ami Subercaseaux /
John S. Sargent*
Untraced

This intimate study of a young boy resting, with lips parted, is similar to other heads of Venetian models. Ramón Subercaseaux, a wealthy Chilean friend of the artist, was with Sargent in Venice in 1880. Sargent was to paint a second head and shoulders sketch of Subercaseaux and a magnificent full-length portrait of his wife; for these and the portrait of Subercaseaux in a gondola, see *Early Portraits,* nos. 41, 86, 87, and fig. 193. Assuming that Venice is the location, it is probable that the boy is a local inhabitant rather than the son of one of the artist's friends. The water-colour descended to Gabriel Valdés, a grandson of Subercaseaux and an eminent Chilean statesman (b. 1926).

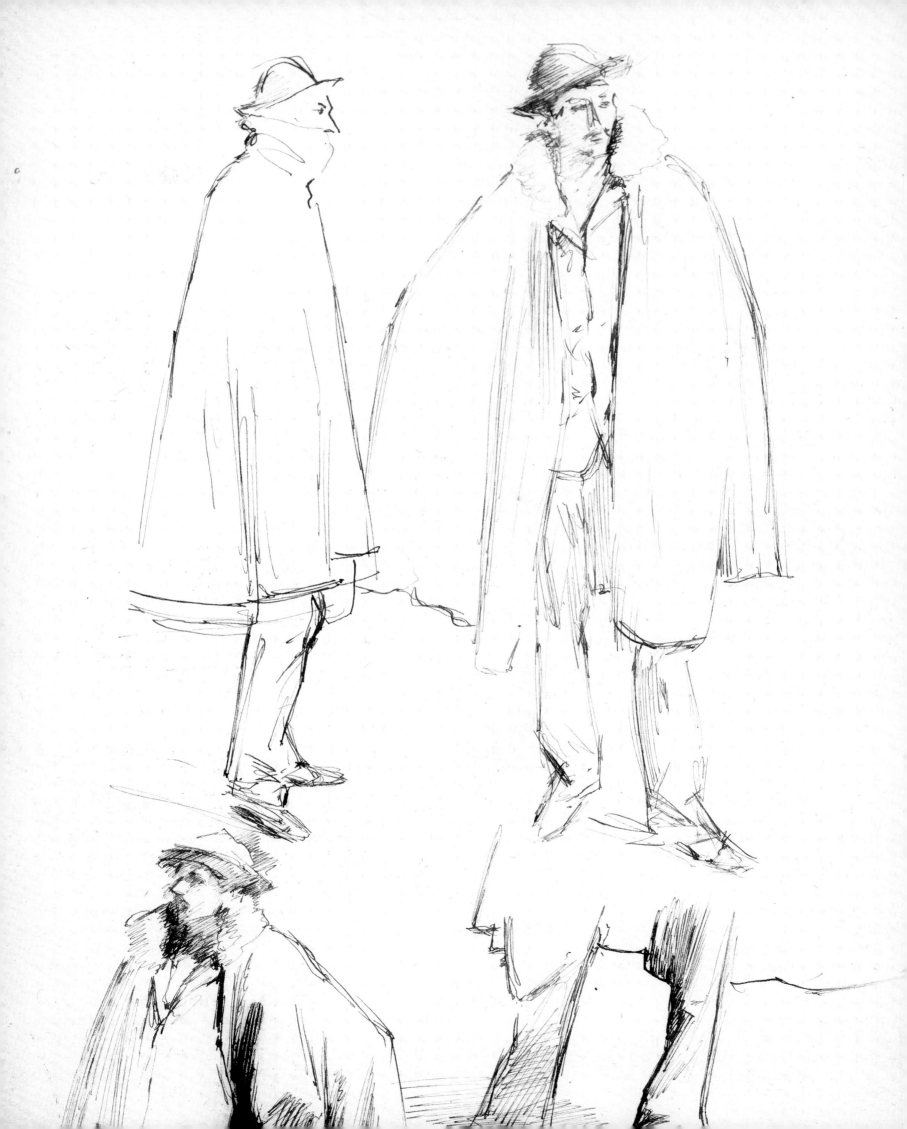

I. AUGUSTE ALEXANDRE HIRSCH

The French painter Auguste Alexandre Hirsch (1833–1912) shared a studio with Sargent at 73, rue de Notre-Dame-des-Champs from 1879 to 1883 and became a close personal friend. He owned at least nineteen pictures by Sargent, some inscribed to him, the others given to him or left behind when Sargent vacated the studio. They form one of the most interesting collections of Sargent's early work, ranging from portrait and figure studies to landscapes and seascapes. We owe it to Hirsch's guardianship that the group survived intact, since Sargent was notoriously casual about the preservation of his sketches.

Hirsch was more than twenty years older than Sargent. He was born in Lyons and studied at the École des Beaux-Arts there before moving to Paris. He was admitted to the École des Beaux-Arts in Paris in 1856, the year of Sargent's birth, and also attended the ateliers of Henri Flandrin and Charles Gleyre. He exhibited a wide range of subject pictures at the Paris Salon, including history works, genre pictures, figure studies, portraits and scenes painted in Morocco, including *Le retour des hadjis* in 1880. He was also known as a lithographer and illustrator. In 1877, he painted a ceiling decoration for the Théâtre des Célestins in Lyons. He was awarded bronze medals at the Expositions universelles of 1889 and 1900.

Hirsch is recorded at 73, rue de Notre-Dame-des-Champs in the land-registry document (*cadastre*) for 1872, on the first floor at no. 4, which he shared with an American artist (DIPA 0811, Archives de Paris). He is recorded again in the document for 1876 (DIPA 0811) at no. 17, on the first floor of the third building, next door to the studio shared by Sargent and fellow-student J. Carroll Beckwith (no. 16). The entry for the latter is as follows: '1877 Beckwith/1880 Sargent peint/1884 no. 17'. These dates are not accurate, for Sargent was sharing with Beckwith by early August 1875, and he presumably moved next door to share with Hirsch when Beckwith left Paris in 1879. By June of 1883, Sargent had moved to 41, boulevard Berthier.

As his fellow-tenant for four years, Hirsch must have played an important role in Sargent's life, but the record is silent both about their personal relationship and their influence on one another as artists. That he inscribed so many pictures to Hirsch is evidence of the strength of the friendship. Hirsch is among those artists listed in the visitors' book of the Hotel Pagano in Capri in the summer of 1878 (see chapter 5, p. 141). He may also have been in Morocco the same year as Sargent, 1880. The only reference to Hirsch in Sargent's correspondence occurs in a letter to John T. Harding of 18 October 1920 (private collection). The letter refers to the picture *The Derelict* (no. 664):

I have no doubt that the seascape you mention is one of several sketches done on board ship on my voyage to America in 1875 [sic]—I gave them to my neighbour and fellow-artist Auguste Hirsch, who was a good friend of mine in student days, and whose widow, I know, has sold them.

Of the studies owned by Hirsch, twelve were sold to M. Knoedler & Co., London, by his widow in 1914. A thirteenth, *The Derelict,* was sold separately and a fourteenth is said to have gone to the Swiss artist Albert Anker. Five more sketches descended to Hirsch's nephew, Raymond Bollack, and were sold at Parke-Bernet Galleries, New York, in 1965. Five letters from Raymond Bollack to David McKibbin about these pictures (1948–49) are among the McKibbin papers (catalogue raisonné archive). Those pictures which are untraced are not included in the catalogue because their status remains to be determined.

Pictures sold to M. Knoedler & Co., London, 7 January 1914:
1. *Road in the South* (no. 654)
2. *Old Boat Stranded* (no. 659)
3. *Two Octopi* (no. 657)
4. *Atlantic Storm* (no. 662)
5. *Arabs at Rest* (no. 787)
6. *Staircase in Capri* (no. 719)
7. *Sailor's Procession,* untraced, status uncertain (Knoedler stock nos. 5780/New York WC 963)
8. *Corner of a Beach,* untraced, status uncertain (Knoedler stock nos. 5781/New York WC 964/13620)
9. *Study of a Man's Head* (no. 624)
10. *Study of a Male Model* (no. 628)
11. *Violet Sargent* (*Early Portraits,* no. 8)
12. *Head of a Young Woman (blonde)*. Possibly a water-colour, dated 1871. Untraced, status uncertain (Knoedler stock nos. 5785/New York WC 968)

Picture sold by Louis Ralston Art Galleries, New York, 1919:
13. *The Derelict* (no. 664)

Picture said to have been bequeathed by Hirsch to Albert Anker:
14. *A Boat in the Waters off Capri* (no. 698)

Pictures sold by Hirsch's nephew, Raymond Bollack, at Parke-Bernet Galleries, New York, 19 May 1965, lots 104–8:
15. *Mary Turner Austin* (*Early Portraits,* no. 14)
16. *Oyster Gatherers Returning* (no. 678)
17. *Convent Interior,* untraced, status uncertain
18. *Head of a Young Man* (no. 626)
19. *Nude Oriental Youth with Apple Blossom* (no. 643)

II. SARGENT'S ILLUSTRATIONS TO
SPANISH & ITALIAN FOLK-SONGS, TRANSLATED BY
ALMA STRETTELL (LONDON, 1887)

The poet Alma Strettell (1853–1939), later Mrs Lawrence ('Peter') Harrison, was a close friend of the artist, who painted her portrait in 1889 (*Early Portraits,* no. 223). In 1887, she published translations of Spanish and Italian folk songs, a subject dear to Sargent's heart, and he furnished her with six of the twelve illustrations in the book; this was an exception to his normal rule against taking on illustrative work. None of the illustrations are titled in the book. The six illustrations are as follows:

1 *The Spanish Dance,* frontispiece. See no. 764 for the entry.
2 *Sketch of a Spanish Madonna,* facing p. 9. See no. 760 for the entry.
3 *Sketch of a Young Woman with Playing Cards,* facing p. 35. See no. 776 for the entry.
4 *Sketch of a Spanish Dancer,* facing p. 51. See no. 769 for the entry.
5 *Children Picking Roses,* facing p. 103. The original painting, also called 'Gathering Flowers at Twilight' (private collection), will be catalogued in a subsequent volume.
6 *Sketch of a Spanish Crucifix,* facing p. 124. See no. 759 for the entry.

In addition to the illustrations provided by Sargent, a further six were contributed by other artists, as follows:

7 Figure study of an Italian novice by Domenico Morelli (1826–1901); the picture from which this was taken belonged to Sargent and was included in the artist's sale, Christie's, London, 27 July 1925, lot 304; it must have been bought in for it passed down through descendants of the artist's sister, Violet Sargent (Mrs Francis Ormond), and was sold at Christie's, London, 1997.
8–9 Two figure drawings by Edwin Austin Abbey (1852–1911), one of a seated young woman, the other a scene with a young woman looking down on a bearded friar or mendicant.
10–12 Three landscapes by William James W. Padgett (1851–1904), presumably of Italian scenes.

At least two of Sargent's illustrations (nos. 1 and 5 in the list above) are related to extant paintings. In the case of the first, *The Spanish Dance,* it seems probable that Sargent did a new version based on the original painting of c. 1879–82 (no. 763). The second illustration, *Children Picking Roses,* seems to have been taken direct from the painting rather than an intermediate version. Of the remaining four illustrations, *Sketch of a Spanish Madonna* (no. 2 above) is the third version of a subject recorded in two sketches of c. 1879 (nos. 761, 762); *Sketch of a Spanish Dancer* (no. 4 above) is related to studies for the large *Spanish Dancer* and *El Jaleo* (nos. 770, 772); an old photograph of *Sketch of a Spanish Crucifix* (no. 6 above) shows it as a framed oil painting; only *Sketch of a Young Woman with Playing Cards* (no. 3 above) is without an obvious source, and it may have been painted for the book.

Whether Sargent produced a uniform set of monochrome sketches, as Charles Merrill Mount believed, is doubtful. Mount listed 'Six Monochrome Illustrations' in his 1955 biography of the artist (Mount 1955, p. 446, nos. K871–76). One of the illustrations listed, 'The Candlebearer' (K874), is, in fact, the illustration by Morelli listed above. It was dropped from the 1969 edition of the biography, and the six monochromes became five (Mount 1969, p. 466, K871–73, K875–76). The illustration listed in 1955 as 'Spanish Dance' (K873) appears in the 1969 edition under the same number as 'Spanish Dancer'. The sixth illustration, omitted in both editions, was, therefore, the frontispiece, 'Spanish Dance' (no. 1 above). According to the 1955 edition, the six monochromes belonged to the artist's sister, Violet Sargent (Mrs Francis Ormond). By 1969, this had changed to: 'Given in charge of Thomas Fox (1926). Disappeared'. A series of small-scale photographs, possibly taken contemporaneously with Alma Strettell's book, exist for three of the pictures used as illustrations (nos. 3, 4, 6 above), and for a fourth related to no. 4. These bear inventory numbers in pencil in Thomas

Fox's hand. Fox was Sargent's right-hand man in his Boston mural projects, and he was responsible for distributing a large number of Sargent studies to U.S. institutions after Sargent's death. Sadly, no copy of his inventory, to which the pencil numbers relate, has yet come to light.

Five of Sargent's illustrations are certainly of Spanish subjects. There is some correspondence between image and text, but Sargent's pictures are not illustrative in the conventional sense. He was using existing images to provide Spanish atmosphere and character for the folk songs. Two of the illustrations are taken from figure scenes in a landscape setting (nos. 1 and 5 above). Two are half-length studies of young women, one with playing cards, the other dancing (nos. 3 and 4 above), and two are sketches of Spanish religious sculptures (nos. 2 and 6 above). They are widely scattered throughout the book, from frontispiece to last page and form no discernible pattern as a group. How they were chosen and arranged in the book, or what part Sargent played in the process, is not known.

Alma Strettell's book is an early example of the growing interest in folk songs, music and dance from Mediterranean countries. Her aim was to draw attention to those folk songs 'which either in subject or form, in beauty or quaintness of expression, have seemed to me peculiarly interesting and characteristic' (introduction, p. vii). She was particularly drawn to the gypsy songs of southern Spain, the *cantes flamencos,* as Sargent had been, and she arranged them in her text by type, beginning with the melancholy 'Soleares', then the 'Seguidillas Jitanas', and finally the 'Serranas, Peteneras and Deblas'. In making her selection, she acknowledged that it was difficult to escape 'the charge of morbidness, for all the finest of them are tragic in tone, sometimes crudely realistic, restless, despairing, revengeful; all are characteristic of a race mysterious in its origin, wandering for centuries among alien peoples, downtrodden, suspected, and scorned' (introduction, p. x). The better-known Italian folk songs, the 'Rispetti' and 'Stornelli', are mostly taken from Sicilian and Tuscan sources, and they are lighter in mood and sentiment.

The book was well received by the critics, and the illustrations attracted their share of attention. In the *Magazine of Art* ('Chronicle of Art, Art in July', vol. 10 [1887], pp. xxxix–xl), the anonymous reviewer wrote:

Artistically, the book is very attractive. It is accompanied, rather than illustrated, by some tiny photogravure plates, reproducing sketches by John Sargent, Edwin Abbey, and other artists, which add greatly to its charm, and it is well printed on Dutch paper, and most tastefully bound, while the margins of the pages must satisfy the longing of every margin-loving soul.

The reviewer in the *Athenaeum* (no. 3118 [30 July 1887], p. 142) described the illustrations in greater detail:

But the illustrations are the most striking adjunct of Miss Strettell's verse. Those of Mr. Sargent display a violent and poetic imagination consonant with these wild Flamenco songs. The strange dance of gypsies under the stars . . . the fortune-teller shrinking back in horror from the unspeakable fate she reads in the outspread cards; the stiff yet delicate Madonna, whose enormous crown and barbaric heavy mantle recall the 'Ex Voto' of Baudelaire,—all these are conceived with poetic fervour, and the intense and electrified attitudes frequently affected by Mr Sargent are here not out of place . . . Taken altogether we can imagine no more successful rendering of a difficult subject in a small compass than that which is due to Miss Strettell and her friends.

In a later critical commentary, Royal Cortissoz caught the distinctive flavour of Sargent's illustrations (Cortissoz 1913, p. 226): 'In all the drawings there is an emotion not of the surface, a hint that the painter has caught the strain of *macabre* poetry in his material'.

620 *Interior of a Studio*

PROVENANCE

Grand Central Art Galleries, New York, 1925, as 'The Life Class at Julian's'; John Bowman, New York, 1925; untraced.

LITERATURE

'New York Collector Buys an Early Sargent', *Art News,* vol. 24 (17 October 1925), p. 8, as 'The Life Class at Julian's'; possibly the picture listed by Mount 1955, p. 442 (K761), dated 1876, as 'The Studio of Léon Bonnat'; 1957 ed., p. 351 (K761); omitted in the 1969 edition.

621 *A Male Model Standing before a Stove*

PROVENANCE

The artist's sale, Christie's, London, 27 July 1925, lot 199, bt. Smith, for the Marquis de Amodio, London; his son, the succeeding Marquis de Amodio, O.B.E., Geneva, 1934; loaned by him to the Dallas Museum of Fine Arts, 1949–72; presented by him to The Metropolitan Museum of Art, New York, 1972.

EXHIBITION

Bridgeport 1986, no. 34, ill. cat. p. 22, fig. 10 (colour).

LITERATURE

'Almost a Million at Sargent Sale', *Art News,* vol. 23 (15 August 1925), p. 4; Christie's 1925, p. 28; Downes 1926, p. 332; Charteris 1927, p. 295, undated; Mount 1955, p. 452 (XK6), undated; 1957 ed., p. 363 (XK6); 1969 ed., p. 479 (XK6); Dallas Museum of Fine Arts, *Four Centuries of European Painting,* exhibition of paintings on loan to the Museum from the collections of the 'Marquess and Marchioness of Amodio', and other lenders, especially assembled for the State Fair of Texas, 1951, n.p. (listed in catalogue among paintings from the Amodio collection on loan to the Museum, but not included in the exhibition); Burke 1980, pp. 220–21, ill. p. 220; Ratcliff 1982, p. 40, ill. p. 34, pl. 42 (colour).

622 *Blonde Model*

PROVENANCE

Lacombe; Scott & Fowles, New York; Robert Sterling Clark, 6 January 1927; Sterling and Francine Clark Art Institute, Williamstown, Massachusetts, 1955.

EXHIBITION

Williamstown 1957, unnumbered, ill. cat. pl. LVI.

LITERATURE

Charteris 1927, p. 295, undated, as 'Head of a Woman (bare shoulders)'; Ormond 1970, pp. 16–17, 236, pl. 9; Williamstown 1972, p. 96, ill. p. 97; New York 1980, checklist, n.p.; Ratcliff 1982, ill. p. 39, pl. 50, as 'Head of a Female Model'; Hills in Hills *et al.* 1986, p. 28, ill. p. 29, fig. 2; Williamstown 1984, p. 34, ill. p. 103, fig. 413; Clark Art Institute 1990, pp. 156, 158, ill. p. 157 (colour); Weinberg 1991, pp. 207, 210, ill. p. 206, fig. 220; Williamstown 1992, p. 99, ill.

623 *A Male Model with a Wreath of Laurel*

PROVENANCE

The artist's sale, Christie's, London, 27 July 1925, lot 237, as 'A Man, wearing laurels', bt. M. Knoedler & Co., London (stock no. 7582); Knoedler, New York, to M. A. Newhouse & Son, St. Louis, March 1926, as 'Portrait of a man' (stock no. 16263); Mary D. Keeler, Los Angeles; her bequest to the Los Angeles County Museum of Art, 1940.

EXHIBITIONS

New York, Knoedler, 1925, no. 19, as 'Study of a Man'; Los Angeles Municipal Art Department, Barnsdall Park, *The American Scene,* April–May 1956, unnumbered; New York Cultural Center, *Three Centuries of the American Nude,* 9 May–13 July 1975, no. 31, as 'Portrait of a Man'; also Minneapolis Institute of Arts, 6 August–21 September 1975, and University of Houston Fine Art Center, 3 October–16 November 1975.

LITERATURE

'Almost a Million at Sargent Sale', *Art News,* vol. 23 (15 August 1925), p. 4; Christie's 1925, p. 31; Downes 1926, p. 335, as 'A Man, wearing laurels'; Charteris 1927, p. 295, undated, as 'Portrait of a Man wearing Laurels'; 'Rembrandt Caps Group', *Los Angeles Times,* 2 December 1928, part 3, p. 17, ill. as 'The Victor'; Mount 1955, p. 429 (8019), dated 1880, as 'Study of a man wearing laurels'; 1957 ed., p. 337 (8019); 1969 ed., p. 458 (8019), dated 1876; Hilton Kramer, 'The American Nude Exposes the Comedy of Culture,' *New York Times,* 15 June 1975, p. D29; New York 1980, checklist, n.p.; Ilene Susan Fort and Michael Quick, *American Art,* Los Angeles County Museum of Art, 1991, pp.162–63, ill. p. 163; Fairbrother 2000, pp. 68, 71, ill. p. 69, pl. 3.2 (colour).

624 *Study of a Man's Head*

PROVENANCE

Auguste Alexandre Hirsch; Mme Hirsch, 1912; M. Knoedler & Co., London, 7 January 1914 (stock no. 5782); presented by Charles S. Carstairs of Knoedler, London, to Mrs Reginald Nicholson (*née* Pearson), November 1915 (stock nos. WC 965 and 13621); untraced.

LITERATURE

Probably the work listed in Mount 1955, p. 428 (806), dated 1880, as 'Gondolier (study of a man). 17¼ x 22, formerly Knoedler'; 1957 ed., p. 336 (806); 1969 ed., p. 463 (806).

625 *Head of a Male Model*

PROVENANCE

Sir Philip Sassoon, 1926; his cousin, Hannah Sassoon (Mrs David Gubbay), 1939; his sister, Sybil Sassoon, the Marchioness of Cholmondeley, 1968; her heirs, 1989; private collection.

EXHIBITIONS

London 1924, no. 33, as 'Head of a Gondolier'; London, RA, 1926, no. 305, as 'Head of a Gondolier'; London, Wildenstein, 1972, no. 36, as 'Head of a Gondolier'; London, Agnew's, *Sassoon: An Exhibition of Paintings and Drawings from the Collection of Philip and Sybil Sassoon,* 2003, unnumbered, as 'Head of a Gondolier'; Boston 2004, unnumbered, as 'Head of a Gondolier'.

LITERATURE
London 1926, p. 46, as 'Head of a Gondolier'; Downes 1926, p. 356, as 'Head of a Gondolier'; Charteris 1927, p. 287, dated 1905, as 'Head of a Gondolier'; Mount 1955, p. 435 (9614), dated 1896, as 'Head of a Gondolier'; 1957 ed., p. 344 (9614); 1969 ed., p. 469 (9614); London 1972, p. 56, fig. 43, as 'Head of a Gondolier'; Boston 2004, pp. 114, 274, ill. p. 114, fig. 86 (colour), as 'Head of a Gondolier'.

626 Head of a Young Man
PROVENANCE
Auguste Alexandre Hirsch; his widow, Mme Hirsch, 1912; his nephew, Raymond Bollack; sold by him, Parke-Bernet Galleries, New York, 19 May 1965, lot 107, bt. Ira Spanierman; Roderick Henderson; David Daniels, New York, 1966; private collection; Adelson Galleries, New York; Cheryl Chase and Stuart Bear.
EXHIBITION
New York, Adelson Galleries, The American Impressionists, 15 November–21 December 1996, no. 45, ill. cat., n.p. (colour).

627 Study of a Man Wearing a Tall Black Hat
PROVENANCE
The artist's sale, Christie's, London, 27 July 1925, lot 195, bt. Hugh Blaker (art dealer), as 'Portrait of a Man, wearing a large black hat'; Christie's, London, 5 July 1963, lot 8, bt. Manning, as 'A Dutchman'; Parke-Bernet Galleries, New York, 29 January 1964, lot 49, ill. cat., p. 22; private collection, New York.
EXHIBITION
London, RA, 1926, no. 599, as 'Portrait of a Dutchman'.
LITERATURE
Christie's 1925, p. 28; London 1926, p. 86, as 'Portrait of a Dutchman'; Downes 1926, pp. 332, 373, as 'Portrait of a Dutchman'; Charteris 1927, p. 278, as 'Portrait of a Dutchman'; Mount 1955, p. 441 (X5), undated, as 'Portrait of a Dutchman'; 1957 ed., p. 351 (X5); 1969 ed., p. 457 (X9; an error for X5), dated 1891(?), as 'A Dutchman'.

628 Study of a Male Model
PROVENANCE
Auguste Alexandre Hirsch; his widow, Mme Hirsch, 1912; M. Knoedler & Co., London, 7 January 1914 (stock no. 5783), as 'Study of a Man'; Knoedler, New York, sold to Harris B. Dick, August 1914 (stock no. WC 966); American Art Association, Hotel Plaza, New York, 14–15 January 1920, lot 120, ill. cat., as 'Sketch of a Laborer', bt. Mrs Dudley Olcott; Sotheby's, New York, 6 December 1984, lot 143, ill. cat., n.p. (colour), as 'Young Man in Reverie'; private collection; Sotheby's, New York, 1 December 1994, lot 12, ill. cat., n.p. (colour); The Hevrdejs Collection, Houston.
EXHIBITIONS
New York and Chicago 1986, unnumbered; Houston, Museum of Fine Arts, John Singer Sargent in Houston Collections, 9 October–8 November 1998, unnumbered, as 'Young Man in Reverie'; Fort Worth, Amon Carter Museum, Celebrating America: Masterworks from Texas Collections, 14 September–17 November 2002, unnumbered, as 'Young Man in Reverie'.
LITERATURE
'Ninety Pictures Fetch $376,000 at Big Art Sale', New York Herald, 15 January 1920; Charteris 1927, p. 296, undated, as 'Study of a Man'; Mount 1955, p. 443 (K802), dated 1880, as 'Study of a Man'; 1957 ed., p. 353 (K802); 1969 ed., p. 462 (K802); Hills in Hills et al. 1986, pp. 31, 286, ill. p. 41, fig. 13 (colour), as 'Young Man in Reverie'; Rebecca E. Lawton in Celebrating America: Masterworks from Texas Collections, Amon Carter Museum, Fort Worth, 2002, p. 46, ill. p. 47 (colour), as 'Young Man in Reverie' (exhibition catalogue).

629 Two Nude Boys and a Woman in a Studio Interior
PROVENANCE
The artist's sale, Christie's, London, 27 July 1925, lot 182, bt. 'Saxe' (the 'e'

of Saxe crossed through in the auctioneer's copy of the sale catalogue, perhaps an error for 'Sachs'), as 'A Study of Three Figures, with a Martyr on the reverse'; Peter Nicholson, New York, 1965; Kennedy Galleries, New York, 1966; Alfredo Valente, New York, by 1969, when recto and verso were separated and transferred to canvas; private collection.
EXHIBITION
New York 2004, unnumbered.
LITERATURE
Christie's 1925, p. 27; Downes 1926, p. 331 (with buyer's name at Christie's 1925 given as 'Saxe'); Charteris 1927, p. 286, as 'Three Figures (with Study of a Martyr on reverse)'; Mount 1955, p. 443 (K7923), dated 1879, as 'Three Figures (with study of a Martyr on reverse)'; 1957 ed., p. 353 (K7923); 1969 ed., p. 459 (K7923), as 'Two Boys Modelling in a Studio'; 'Past and Present, Two Hundred Years of American Painting Part Two: Nineteenth and Twentieth Centuries', The Kennedy Quarterly, Kennedy Galleries, New York, vol. 6, no. 4 (October 1966), p. 197, ill. p. 196, fig. 186, as 'Boys in Studio'; Gallati et al. 2004, pp. 208–10, 211, ill. p. 210, pl. 73 (colour).

630 The Model: Interior with Standing Figure
PROVENANCE
[?] Jules-Guillaume-Auguste Ringel; Miss Ima Hogg; given by her, with a collection of works on paper, to The Museum of Fine Arts, Houston, 1939.
EXHIBITIONS
Houston Symphony Society Music Hall, 1965 (no catalogue); Houston, Capital National Bank, 1966 (no catalogue); New York and Chicago 1986, unnumbered; Houston, The Museum of Fine Arts, American Painters in the Age of Impressionism, 4 December 1994–26 March, 1995, no. 16; Houston, The Museum of Fine Arts, John Singer Sargent in Houston Collections, 11 October–9 November 1998 (no catalogue).
LITERATURE
The Museum of Fine Arts, Houston: A Guide to the Collection, introduction by William C. Agee, The Museum of Fine Arts, Houston, 1981, p. 109, no. 188, ill.; Ratcliff 1982, ill. p. 38, fig. 48; Blaugrund in Hills et al. 1986, pp. 212, 289, ill. p. 210, fig. 170; Le Voyage de Paris–Les Américains dans les Écoles d'Art 1868–1918, Réunion des Musées Nationaux, Paris, 1990, ill. p. 17; Emily Ballew Neff and George T. M. Shackelford, American Painters in the Age of Impressionism, The Museum of Fine Arts, Houston, 1994, pp. 34, 75, ill. p. 75 (exhibition catalogue); Gallati et al. 2004, p. 210, ill. p. 211, pl. 76 (colour).

631 Head of a Young Woman
PROVENANCE
William Turner Dannat, by 1882; Otis Alan Glazebrook; sold from the Glazebrook estate (probably that of his son, Otis Glazebrook, Jr); Victor D. Spark, New York, 1956; James Graham & Sons, New York; private collection, on extended loan to Allentown Art Museum, Pennsylvania, since 1982.

632 Back View of a Nude Model
PROVENANCE
William Turner Dannat; Otis Alan Glazebrook; bt. in at an unidentified auction of his collection, 1932; Otis Alan Glazebrook, Jr; his daughter, Lucy Glazebrook Bradley, by 1960; her daughter, Christine Wooding; Jack Tilton Gallery, New York, 1997; Berry-Hill Gallery, New York; private collection.

633 Head of a Woman with Gold Earrings
PROVENANCE
Mrs Juliet Branson; sold by her at Christie's, London, 25 June 1926, lot 73, bt. Oscar B. Cintas, as 'Head of a Girl, with gold ear-rings Inscribed "to my friend Mr. [sic] Branson"'; with Sotheby's, New York, December 1991; private collection.

634 Head of an Italian Woman

PROVENANCE

Mrs Juliet Branson; sold by her at Christie's, London, 25 June 1926, lot 74, bt. Oscar B. Cintas; Gerhard Stern, New York, 1964; ACA—American Heritage Gallery, New York; Mr and Mrs Louis Sosland, Kansas City; given by Mrs Sosland to her daughter; private collection.

635 Head of a Young Woman

PROVENANCE

Carl van Haanen; [?] Harrington Mann; C. C. Miller of Hampstead, London; sold by him, Christie's, London, 16 April 1943, lot 127, bt. Mann, as 'Head of a Lady'; Mrs Winifred Cooling, Surrey, U.K.; Peter Nicholson, New York, 1964; Shore Galleries, Boston, 1964; private collection

EXHIBITIONS

London 1998 (ex catalogue, shown only in Boston); New York, Adelson Galleries, 2003, no. 8, as 'Head of a Venetian Woman'.

LITERATURE

Mount 1969, p. 437, as 'Marie-Genevieve Duhem', the first of two portraits of her listed; Adelson et al. 2003, p. 60. ill. p. 61 (colour), as 'Head of a Venetian Woman'.

636 Gitana

PROVENANCE

Alfred Philippe Roll; J. Chaine & Simondson, Paris; sold to M. Knoedler & Co., London, 6 October 1909 (stock no. 4591); shipped to Knoedler, New York, 16 October 1909 (stock no. 11911); sold to George A. Hearn, 10 November 1909; given by him to The Metropolitan Museum of Art, New York, 1910.

EXHIBITIONS

Palm Beach 1959, no. 1; New York, CKG, 1980, no. 7; Japan 1989, no. 2.

LITERATURE

Gabriel Mowrey, 'Some French Artists at Home', Studio, London, no. 8 (Winter 1896–97), ill. p. 28 (illustrated in a view of Roll's studio); George A. Hearn Gift to The Metropolitan Museum of Art and Arthur Hoppock Hearn Memorial Fund, New York, 1913, p. 70, ill.; Pousette-Dart 1924, ill. n.p.; Downes 1925, 1926, p. 120, dated 1876; Charteris 1927, pp. 43, 280, dated 1876; Mount 1955, p. 427 (761), dated 1876; 1957 ed., p. 336 (761); 1969 ed., p. 458 (761), as 'An American Indian (called "Gitana")'; New York 1980, n.p., no. 7, ill., and checklist; Burke 1980, pp. 221–22, ill. p. 221; Ratcliff 1982, ill. p. 36, fig. 43 (colour); Japan 1989, pp. 44, 135, ill. p. 44 (colour); Boone 1996, p. 172, ill. p. 363, fig. 5.17; London, Pyms Gallery, A Painter's Painting: A Spanish Woman (Gigia Viani), November 1998, pp. 13, 16, n. 15, ill. p. 12, fig. 8; Weinberg and Herdrich, MMA Bulletin, 2000, ill. p. 9, fig. 6 (colour).

637 Study of a Model

PROVENANCE

Reginald Sidney Hunt; consigned to Christie's, London, 12 March 1926, and subsequently returned to owner; bought by Sir William Orpen from an unnamed Bond Street art gallery, London, c. 1927; M. Knoedler & Co., London, 1931; sold by them to Mrs Irene Hamilton, Chobham, Surrey, 28 August 1932; London, Pyms Gallery, 1998; sold Phillips, New York, 22 May 2001, lot 99, bt. in; private collection.

EXHIBITIONS

London, Leicester Galleries, Exhibition of Fifty Years of Portraits (1885–1935), May–June 1935, no. 63, as 'Gigia', lent by Mrs Irene Hamilton, ill. cat., p. 17; Tokyo, Daimuru Museum, and other Japanese venues, British Impressionism, 1997, no. 65; London, Pyms Gallery, A Painter's Painting: A Spanish Woman (Gigia Viani), November 1998.

LITERATURE

Charteris 1927, ill. facing p. 56 as 'Spanish Woman'; Country Life, vol. 41, no. 1566 (22 January 1927), p. 114, 'Our Frontispiece', ill. p. 113, as 'Portrait of a Spanish Woman'; Sir William Orpen, 'Greater than the Mona Lisa: How I Found a Masterpiece', Ladies' Home Journal, vol. 6, no. 7 (July 1927), p. 12, ill. p. 13; unidentified news cutting, 'Orpen Acquires an Unknown Sargent [Special Cable to the Herald]', copyrighted 1927

by the New York Times Co., catalogue raisonné archive; Beverley Nichols, Oxford–London–Hollywood: an Omnibus, London, 1938 reprint, pp. 518–19; Mount 1955, p. 428 (8010), as 'Gigia', dated 1880; 1957 ed. p. 337 (8010); McKibbin 1956, p. 98, under 'Gigia', giving the earlier title, 'Portrait of a Spanish Woman'; Kenneth McConkey, British Impressionism, Tokyo, 1997, p. 144 (exhibition catalogue); London, Pyms Gallery, A Painter's Painting: A Spanish Woman (Gigia Viani), November 1998, pp. 1–22, ill. cover and p. 4 (colour), as 'A Spanish Woman (Gigia Viani)'.

638 A Summer Idyll (recto) and **Study of a Head** (verso)

PROVENANCE

[?] William Walton; Cottier and Sons, New York, 1914; Brooklyn Museum, John B. Woodward Memorial, 1914.

EXHIBITION

New York 2004, unnumbered.

LITERATURE

Downes 1925, 1926, p. 121; Charteris 1927, p. 280, dated 1878; Mount 1955, p. 442 (K789), dated 1878; 1957 ed., p. 352 (K789); 1969 ed., p. 459 (K789); Leeds 1979, p. 21; New York 1980, checklist, n.p.; Fairbrother 1990, p. 41; Gallati et al. 2004, p. 66, ill. p. 67, pl. 15 (colour).

639 Judgement of Paris

PROVENANCE

Marius Alexander Sorchan and his wife Caroline Thorn; their daughter, Marie Sorchan (Mrs Horace Binney, Sr), after 1914; her son, Horace Binney, Jr, 1955; his widow, Mrs Margaret Binney, 1981; presented by her to the Vizcaya Museum and Gardens, Miami, 1989.

LITERATURE

Early Portraits, p. 124.

640 Two Figures by an Altar

PROVENANCE

Emily Sargent, 1925; untraced.

641 The Flight into Egypt

PROVENANCE

Emily Sargent; Violet Sargent (Mrs Francis Ormond), 1936; her son F. Guillaume Ormond, 1955; his heirs, 1971; Christie's, London, 12 November 1976, lot 60, ill. cat., pl. 9, as 'The Rest on the Flight into Egypt', bt. Brian Sewell; Joseph F. McCrindle.

LITERATURE

Mount 1955, p. 452 (XK10), undated; 1957 ed., p. 363 (XK10); 1969 ed., p. 479 (XK10).

642 A Martyr

PROVENANCE

The artist's sale, Christie's, London, 27 July 1925, lot 182, bt. 'Saxe' (the 'e' of Saxe crossed through in the auctioneer's copy of the sale catalogue, perhaps an error for 'Sachs'), as 'A Study of Three Figures, with a Martyr on the reverse'; Peter Nicholson, New York, 1965; Kennedy Galleries, New York, 1966; Alfredo Valente, 1969, when recto and verso were separated and transferred to canvas; Sotheby Parke Bernet, New York, 13 September 1972, lot 101, ill. sale cat., p. 196; private collection.

LITERATURE

Christie's 1925, p. 27; Downes 1926, p. 331, as 'A Study of Three Figures, with a Martyr on the reverse'; Charteris 1927, p. 286, dated 1902, as 'Three Figures (with Study of a Martyr on reverse)'; 'Past and Present, Two Hundred Years of American Painting, Part Two: Nineteenth and Twentieth Centuries', The Kennedy Quarterly, Kennedy Galleries, New York, vol. 6, no. 4 (October 1966), p. 197, ill. p. 196, fig. 187, as 'Penetentia'; Mount 1955, p. 443 (K7923), dated 1879, as 'Three Figures (with study of a Martyr on reverse)'; 1957 ed., p. 353 (K7923); 1969 ed., p. 459 (K7923), as 'Penetentia'.

643 *Nude Oriental Youth with Apple Blossom*
PROVENANCE
Auguste Alexandre Hirsch; his widow, Mme Hirsch, 1912; his nephew, Raymond Bollack; sold by him at Parke-Bernet Galleries, New York, 19 May 1965, lot 108, as 'Spring'; Schweitzer Gallery, New York; Maxwell Galleries, San Francisco, 1967, as 'Oriental Youth'; Mr and Mrs William K. Wamelink; presented by them to the Western Reserve Historical Society, Cleveland, 1976.
LITERATURE
Mount 1969 ed., p. 459, dated 1879, as 'Japanese Boy and a Blossoming Bough'.

644 *La Table sous la tonnelle*
PROVENANCE
Carolus-Duran; Galerie Georges Petit, Paris; M. Knoedler & Co., New York, 7 June 1923 (stock no. 15709); Sir Philip Sassoon, 1923; his cousin, Mrs David Gubbay, 1939; Sassoon's sister, Sybil, later Marchioness of Cholmondeley, 1968; her heirs, 1989; private collection.
EXHIBITIONS
London 1924, no. 28, as 'An Arbour'; London, RA, 1926, no. 372, as 'Wineglasses'; Birmingham 1964, no. 2, as 'Two Wine Glasses'; London 1998, no. 1, as 'Wineglasses'.
LITERATURE
Fry 1926, p. 126; Downes 1925, p. 263, as 'An Arbor': Downes 1926, pp. 263, 358, 404; London 1926, p. 56, as 'Wineglasses'; Charteris 1927, pp. 39, 280, as 'Wine Glasses', dated 1874 (ill. facing p. 38), p. 294, as 'The Arbor'; Mount 1955, p. 442 (K752), dated 1875, as 'Wineglasses'; 1957 ed., p. 351 (K752), dated 1875; 1969 ed., p. 458 (K752), dated 1875; Ormond 1970, pp. 17, 235, as 'Two Wine Glasses'; Leeds 1979, p. 20, as 'Two Wineglasses'; Adelson in Adelson *et al.* 1986, p. 28, fig. 6, as 'Two Wine Glasses'; London 1998, pp. 61, 62, 76, ill. p. 63 (colour), as 'Wineglasses'; Prettejohn 1998, pp. 73–74, fig. 58 (colour), as 'Wineglasses'.

645 *Pumpkins*
PROVENANCE
The artist's sisters, Emily Sargent and Violet Sargent (Mrs Francis Ormond), 1925; given by them to Sir Alec Martin of Christie's, London, post 1925; given by him to the Rt Hon Edward Heath, c. 1958; Sir Edward Heath's heirs, 2005.
LITERATURE
Sargent Trust List [1927], 'Pictures Framed', p. 33, no. 9, as 'Man in white shirt in a pumpkin field'; Mount 1955, p. 444 (K8022), dated 1880; 1957 ed., p. 353 (K8022); 1969 ed., p. 462 (K8022).

646 *Corner of a Garden*
PROVENANCE
Unidentified friend; Grand Central Art Galleries, New York, c. 1925; Ralph Booth, Detroit; sold 'to close an account', American Art Association, Anderson Galleries, New York, 8 January 1930, lot 43, bt. Ferargil Galleries, New York; John Levy Gallery, New York; Victor D. Spark, New York; Mr and Mrs Maxwell Oxman, New York, 1971; Sotheby Parke Bernet, New York, 10 December 1981, lot 49, ill. cat., n.p. (colour), dated '*circa* 1910'; Gulf States Paper Corporation, Tuscaloosa, Alabama; The Warner Collection of Gulf States Paper Corporation, Alabama; Westervelt-Warner Museum, Tuscaloosa, Alabama.
EXHIBITIONS
Washington, D.C., Corcoran Gallery of Art, *Ten Years: The Friends of the Corcoran. 20th Century American Artists*, 23 October–21 November 1971, no. 72; Sylacauga Art Museum, Alabama, 24 February–24 March 1982; Jacksonville, Florida, Cummer Gallery of Art, 14 September–11 November 1984; Birmingham Museum of Art, Alabama, *American Masterpieces from the Warner Collection*, 31 January–29 March 1987; South Bend Art Center, Indiana, *American Masterpieces from the Warner Collection*, 9 December 1989–4 February 1990; Montgomery Museum of Fine Arts, Alabama, *Impressions of America*, 18 June–28 July 1991; Memphis, Dixon Gallery and Gardens, *Impressions of America*, 15 November 1992–24 January

1993; Richmond, Virginia Museum of Art, *American Dreams: Paintings and Decorative Arts from the Warner Collection*, 20 September 1997–25 January 1998.[1]
LITERATURE
Frederick D. Hill, 'The Warner Collection of Gulf States Paper Corporation', *The Magazine Antiques*, November 1986, p. 1039; Ormond in Adelson *et al.* 1997, p. 170, ill. p. 171, pl. 166 (colour); David Park Curry, with Elizabeth O'Leary and Susan Jensen Rawles, *American Dreams: Paintings and Decorative Arts from the Warner Collection*, Richmond, Virginia, 1997, p. 59, ill. (exhibition catalogue).

1. Information on exhibitions 1982–98 was kindly supplied by Candace C. Grant of the Gulf States Paper Corporation.

647 *Un Coin de potager*
PROVENANCE
Marie-Louise Pailleron, Château de Ronjoux, La Motte-Servolex; her heirs, 1950; untraced.
EXHIBITION
Paris, Hôtel Jean Charpentier, *Cents ans de vie française: Centenaire de la Revue des Deux Mondes, 1829–1929*, 1929, no. 194, as 'Coin de potager à Ronjoux, propriété de F. Buloz en Savoie'.

648 *Landscape with Two Children*
PROVENANCE
Given or sold by the artist to the Baronne de Poilly, in or soon after 1883; James MacKinnon, London, 1989; private collection.

649 *Three Figures on a Beach*
PROVENANCE
Violet Sargent (Mrs Francis Ormond), 1925; her daughter, Reine Ormond (Mrs Hugo Pitman), 1955; her heirs, 1971; private collection.

650 *Church Interior*
PROVENANCE
Violet Sargent (Mrs Francis Ormond), 1925; her son, F. Guillaume Ormond, 1955; his heirs, 1971; Christie's, London, 12 November 1976, lot 59, as 'Spanish Church Interior'; Joseph F. McCrindle.
EXHIBITION
Falmouth 1962, no. 43, as 'Interior of a Church—Spain'.
LITERATURE
Sargent Trust List [1927], 'water colours unframed', p. 24, no. 118, as 'Dark Interior of church. Pulpit on left, and red light on left of altar'.

651 *Interior with Stained-Glass Window*
PROVENANCE
Violet Ormond (Mrs Francis Ormond), 1925; her son, H. E. Conrad Ormond, 1955; his heirs, 1979; Coe Kerr Gallery, New York, 1983; Vulcan Materials, Birmingham, Alabama, 1984; Coe Kerr Gallery, 1987; private collection, U.K.; Adelson Galleries, New York, 2002; Rhoda and David Chase.
EXHIBITION
Japan 1989, no. 56.
LITERATURE
Japan 1989, pp. 99, 149, ill. p. 99 (colour).

652 *Staircase*
PROVENANCE
The artist's sale, Christie's, London, 27 July 1925, lot 188, bt. M. Knoedler & Co. (London stock no. 7573; New York stock no. 16254); shipped to New York, 2 October 1925; Knoedler, New York, to James Carstairs, Philadelphia, May 1926; James Carstairs to Knoedler and then sent back to him again, January 1930 (stock no. A 454); returned a second time, May 1936; Knoedler to Robert Sterling Clark, 24 February

1939 (stock no. A 1684); Sterling and Francine Clark Art Institute, Williamstown, Massachusetts.

EXHIBITIONS
New York, Knoedler, 1925, no. 13; Washington, D.C., Museum of Modern Art Gallery, *A Century of American Painting*, 10–24 March 1939, unnumbered (no catalogue); Williamstown, 1957, unnumbered, ill. cat. pl. LXV.

LITERATURE
Christie's 1925, p. 27; Downes 1926, p. 332; Charteris 1927, p. 280, dated 1874; 'American Painting Attribution Contest', *Art News*, vol. 37 (1 April 1939), p. 11; Mount 1955, p. 442 (K741), dated 1874; 1957 ed., p. 351 (K741); 1969 ed., p. 458 (K741); Williamstown 1972, p. 100, ill. p. 101; New York 1980, checklist, n.p.; Williamstown 1984, p. 34, ill. p. 102, fig. 411; Clark Art Institute 1990, pp. 158, 160, ill. p. 159 (colour); Williamstown 1992, p. 101, ill.

653 *The West Portals of Saint-Gilles-du-Gard*

PROVENANCE
Emily Sargent, 1925; Mrs Morton Baum, by 1969; Shepherd Gallery, New York; Coe Kerr Gallery, New York, 1981; Hood Museum of Art, Dartmouth College, Hanover, New Hampshire.

EXHIBITIONS
New York, Davis Galleries, *Turn of the Century English Watercolors and Drawings*, 5–29 March 1969, lent by Mrs Morton Baum, as 'Venetian Façade'; Dallas, Carol Taylor Gallery, *Americans: 19th and 20th Centuries*, 1982; New York, Taittinger Gallery, 1983; Atlanta, David S. Ramus Ltd, 1987 (no catalogues traced for 1969, 1982, 1983 and 1987 exhibitions); Hanover, New Hampshire, Dartmouth College, Hood Museum of Art, *From Copley to Dove: American Drawings and Watercolors at Dartmouth*, 1989 (no catalogue).

LITERATURE
Barbara J. Macadam, with contributions from others, including Derrick R. Cartwright, *Marks of Distinction: Two Hundred Years of American Drawings and Watercolors from the Hood Museum of Art*, Hood Museum of Art, Dartmouth College, Hanover, New Hampshire, 2005, p. 102, ill. p. 103 (colour).

654 *A Road in the South*

PROVENANCE
Auguste Alexandre Hirsch; his widow, Mme Hirsch, Paris, 1912; M. Knoedler & Co., London, 7 January 1914 (stock no. 5774); Knoedler, London, to Captain (later General Sir) Joseph Frederick Laycock, London, May 1914 (stock no. WC 957); Knoedler, London, from Laycock, May 1926 (stock no. LC 238), as 'Road in Midi', and purchased from him, 7 February 1927 (stock no. 7938); Knoedler, New York, to Robert Sterling Clark, 13 April 1927 (stock no. 16706); Sterling and Francine Clark Art Institute, Williamstown, Massachusetts.

EXHIBITION
Williamstown 1957, unnumbered, ill. cat. pl. LXIV.

LITERATURE
Downes 1925, 1926, p. 288; Charteris 1927, p. 296, undated, as 'Road with Wall on Right'; Mount 1955, p. 445 (K855), dated 1885; 1957 ed., p. 355 (K855); 1969 ed., p. 464 (K855); Ormond 1970, p. 34; Williamstown 1972, p. 98, ill., as 'A Road in the Midi'; New York 1980, checklist, n.p.; Williamstown 1984, p. 34, ill. p. 104, fig. 421, as 'A Road in the Midi'; Clark Art Institute 1990, pp. 160, 162, ill. p. 161 (colour); Williamstown 1992, p. 100, ill.

655 *Oscar and Bobino on the Fishing Smack*

PROVENANCE
Violet Sargent (Mrs Francis Ormond), 1925; given by her, with a large group of Sargent studies, to The Metropolitan Museum of Art, New York, 1950.

LITERATURE
Herdrich and Weinberg 2000, p. 132, no. 54, ill.

656 *Studies of a Dead Bird*

PROVENANCE
Violet Sargent (Mrs Francis Ormond), 1925; given by her, with a large collection of Sargent studies, to The Metropolitan Museum of Art, New York, 1950.

LITERATURE
Mount 1955, p. 442 (K7810), dated 1878, as 'Two Studies of a Bluebird'; 1957 ed., p. 352 (K7810); 1969 ed., p. 459 (K7810); Burke 1980, p. 222, ill.

657 *Two Octopi*

PROVENANCE
Auguste Alexandre Hirsch; his widow, Mme Hirsch; M. Knoedler & Co., London, 7 January 1914 (stock no. 5776), as 'Octopus'; Knoedler, New York, 1914 (stock nos. WC 959/13618); Charles L. Knoedler, April 1918; Frederic Fairchild Sherman; Parke-Bernet Galleries, New York, 4 June 1942, lot 22, as 'Octopus', bt. Nelson C. White; his son, Nelson H. White; Thomas Colville Fine Art, New Haven; private collection.

EXHIBITION
Phoenix 1982–83, no. 13.

LITERATURE
Downes 1925, 1926, p. 119, dated 1875, as 'The Octopus'; Charteris 1927, p. 280, dated 1875, as 'Octopus'; Frederic Fairchild Sherman, 'Some Early Paintings by John S. Sargent', *Art in America and Elsewhere*, vol. 21, no. 3 (June 1933), p. 94, ill. p. 99; Mount 1955, p. 442 (K751), dated 1875, as 'The Octopus' (with sizes reversed); 1957 ed., p. 351 (K751); 1969 ed., p. 458 (751), dated 1877, as 'Two Octopi'; Sellin and Ballinger 1982, p. 135, ill. p. 136.

658 *On the Sands*

PROVENANCE
Violet Sargent (Mrs Francis Ormond), 1925; her son, H. E. Conrad Ormond, 1955; his heirs, 1979; private collection.

659 *An Old Boat Stranded*

PROVENANCE
Auguste Alexandre Hirsch; his widow, Mme Hirsch, 1912; M. Knoedler & Co., London, 7 January 1914 (stock no. 5775); sold to Mrs. H. W. Jefferson, London, July 1914 (New York stock no. WC 958); Mrs Jefferson to Knoedler, London, 22 January 1919 (stock no, LC 104); returned to owner, May 1919; untraced.

LITERATURE
Downes 1925, 1926, p. 288; Charteris 1927, p. 296, undated, as 'Sea Coast with Wreck'; Mount 1955, p. 452 (K175), dated 1917, as 'Sea Coast with a Wreck'; 1957 ed., p. 362 (K175); 1969 ed., p. 479 (K175), as undated.

660 *Seascape with Rocks*

PROVENANCE
Emily Sargent, 1925; Violet Sargent (Mrs Francis Ormond), 1936; her son, F. Guillaume Ormond, 1955; his heirs, 1971; Christie's, London, 12 November 1976, lot 61, as 'Sea and Rock'; Joseph F. McCrindle.

LITERATURE
Mount 1955, p. 444 (K8035), dated 1880, with incorrect support and dimensions (panel, 10½ x 13 in.); 1957 ed., p. 354 (K8035); 1969 ed., p. 461 (K8035), under North Africa, 1880.

661 *Men Hauling a Boat up a Beach* (recto) and *A Sailor Drinking* (verso)

PROVENANCE
Violet Sargent (Mrs Francis Ormond), 1925; given by her, with a large collection of Sargent studies, to The Metropolitan Museum of Art, New York, 1950.

LITERATURE
Herdrich and Weinberg 2000, p. 146, no. 89, ill., as 'recto. *Men Hauling Lifeboat Ashore (from scrapbook)*', 'verso. *Sailor (from scrapbook)*'.

662 *Atlantic Storm*
PROVENANCE
Auguste Alexandre Hirsch; his widow, Mme Hirsch, 1912; M. Knoedler & Co., London, 7 January 1914 (stock no. 5777), as 'The Steamship's Track'; Knoedler, New York, to Philip J. Gentner, Worcester, Massachusetts, July 1914 (stock no. WC 960); sold from the collection of Frank Bulkeley Smith of Worcester, Massachusetts, American Art Association, Anderson Galleries, New York, 3 December 1936, lot 60, bt. Charles R. Woosley; Drury W. Cooper of Montclair, New Jersey; his son, Ted W. Cooper, Houston, Texas, by 1967;[2] sold Sotheby's, New York, 25 May 1995, lot 58, ill. sale cat. (colour); private collection; Curtis Galleries, Minneapolis, 1996.

LITERATURE
'Marine Painting, "After the Storm", is by John Singer Sargent at Art Museum', unidentified cutting from a Worcester newspaper, before 1936 (clipping files, Boston Public Library); Downes 1925, 1926, p. 288, as 'Steamship Track'; Charteris 1927, pp. 42, 176, ill. facing p. 42; Mount 1955, p. 442 (762), as 'The Steamship Track'; 1957 ed., p. 351 (K762); 1969 ed., p. 458 (K762); Ormond 1970, p. 17.

2. See letters from Ted W. Cooper to David McKibbin (McKibbin papers).

663 *Mid-Ocean, Mid-Winter*
PROVENANCE
Henry A. Bacon; his widow, Louisa Lee Andrews (Mrs Henry Bacon, secondly Mrs Frederick Eldridge), 1912; purchased from her estate by her niece, Caroline T. Andrews (Mrs Henry Raymond Thurber, secondly Mrs Caroline T. Cooley), c. 1947; sold Sotheby Parke Bernet, New York, 25 April 1980, lot 65, as 'Mid-Winter, mid-ocean', ill. sale cat., n.p.; private collection.

EXHIBITIONS
Boston, MFA, 1925, oil paintings, no. 9 (9); on loan to the Museum of Fine Arts, Springfield, Massachusetts, 1980–84.

LITERATURE
Boston 1925, p. 3; Downes 1925, 1926, p. 265, as 'Mid-Ocean in Winter'; Charteris 1927, p. 281, dated 1880, as 'Mid Winter, Mid Ocean'; Mount 1955, p. 442 (K763), as 'Mid-Winter, Mid-Ocean'; 1957 ed., p. 351 (K763); 1969 ed., p. 458 (K763).

664 *The Derelict*
PROVENANCE
Auguste Alexandre Hirsch; presumably his widow, Mme Hirsch, 1912; Galerie A. M. Reitlinger, Paris; Louis Ralston Art Galleries, New York, September 1919; John T. Harding, Kansas City, 31 March 1920; his wife, Lucia Byrne (Mrs John T. Harding), by 1939; Patricia Macaulay Hutchinson (formerly Mrs David Harris), the adoptive mother of Lucia Byrne's great-nieces, Deborah and Elizabeth Harris, by 1958; her heirs, 2002; Adelson Galleries, New York, 2003; private collection.

665 *Atlantic Sunset*
PROVENANCE
Dr Abel Lemercier; by descent in the Lemercier family; private collection, France; Adelson Galleries, New York, December 2003; private collection.

666 *Seascape*
PROVENANCE
Fanny Watts; her god-daughter, Kathleen Blanche Antoinette, Baronne d'Aubas de Gratiollet, 1927; sold by her heirs, Sotheby's, New York, 21 May 2003, lot 143; Adelson Galleries, New York.

667 *Deck of a Ship in Moonlight*
PROVENANCE
Violet Sargent (Mrs Francis Ormond), 1925; given by her, with a large collection of Sargent studies, to The Metropolitan Museum of Art, New York, 1950.

LITERATURE
Herdrich and Weinberg 2000, p. 151, no. 105, ill.

668 *The Artist's Mother Aboard Ship*
PROVENANCE
Henry A. Bacon; his widow, Louisa Lee Andrews (Mrs Henry Bacon, secondly Mrs Frederick Eldridge), 1912; purchased from her estate by her niece, Caroline T. Andrews (Mrs Henry Raymond Thurber, secondly Mrs Caroline T. Cooley), c. 1947; acquired from the heirs to Mrs Cooley's estate by Theodore Greene of the Greene Gallery, New Rochelle, New York, c. 1974; Hirschl & Adler, New York, 18 November 1974 (stock no. APG 2025); Coe Kerr Gallery, New York, 1979; Paul Peralta Ramos, New York, 1986; his heirs, 2003; Adelson Galleries, New York, 2004; private collection.

EXHIBITIONS
Boston, MFA, 1925, oil paintings, no. 37 (39), as 'The Artist's Sister Aboard Ship'; New York, Hirschl & Adler, *Selections from the Collection of Hirschl & Adler Galleries—American Paintings, 1876–1963,* 1975, unnumbered; Japan 1989, no. 1; New York, Adelson Galleries, 2003, no. 27.

LITERATURE
Boston 1925, p. 6; Downes 1926, p. 336, as 'The Artist's Sister Aboard Ship'; Charteris 1927, p. 284, dated 1890, as 'The Artist's Sister Aboard Ship'; Mount 1955, p. 442 (K764), dated 1876; 1957 ed., p. 351 (K764); 1969 ed., p. 458 (K764); *Selections from the Collection of Hirschl & Adler Galleries—American Paintings, 1876–1963,* New York, 1975, p. 29, ill. (exhibition catalogue); New York 1980, no. 3, ill.; Ratcliff 1982, ill. p. 25, pl. 25; Japan 1989, pp. 43, 135, ill. p. 43 (colour); Adelson *et al.* 2003, p. 98, ill. p. 99 (colour).

669 *The Cook's Boy*
PROVENANCE
Henry A. Bacon; his widow, Louisa Lee Andrews (Mrs Henry Bacon, secondly Mrs Frederick Eldridge), 1912; purchased from her estate by her niece, Caroline T. Andrews (Mrs Henry Raymond Thurber, secondly Mrs Caroline T. Cooley), c. 1947; acquired from the heirs to Mrs Cooley's estate in Arizona by Theodore Greene of the Greene Gallery, New Rochelle, New York, c. 1974; purchased from the Greene Gallery by Hirschl & Adler, New York, 18 November 1974 (stock no. APG 2024); private collection, Ohio.

EXHIBITION
Boston, MFA, 1925, oil paintings, no. 35 (37).

LITERATURE
Boston 1925, p. 6; Downes 1926, p. 336; Charteris 1927, p. 284, dated 1890; Mount 1955, p. 442 (K765), dated 1876; 1957 ed., p. 351 (K765); 1969 ed., p. 458 (K765).

670 *Oyster Gatherers of Cancale*
PROVENANCE
Admiral Augustus Ludlow Case, 1878; his son, Daniel Rogers Case, 1893; sold by him to the Corcoran Gallery of Art, Washington, D.C., 1917.

EXHIBITIONS
Paris, Salon, 1878, no. P2008, as 'En route pour le pêche'; Boston, MFA, 1925, no. 14 (5); West Palm Beach, Florida, Norton Gallery and School of Art, *Sea and Shore,* 12 January–3 February 1952, no. 17; Chicago 1954, no. 40; New York, Wildenstein Gallery, *Masterpieces of the Corcoran Gallery of Art,* 28 January–7 March 1959, ill. cat. p. 59; Washington 1964, no. 4, ill. cat., n.p. (colour); Baltimore Museum of Art, *From El Greco to Pollock: Early and Late Works by European and American Artists,* 22 October–8 December 1968, no. 83; Phoenix 1982–83, no. 12; New York and Chicago 1986, unnumbered; Giverny 1992, no. 56; Williamstown 1997, no. 3; London 1998, no. 2.

LITERATURE
Roger-Ballu, 'Le Salon de 1878 (Deuxième et Dernier Article)', *Gazette des Beaux-Arts,* vol. 18, no. 1 (July 1878), p. 185, woodcut after a drawing, ill. p. 179 (see fig. 62); Outremer, 'American Painters at the Salon of 1879', *The Aldine,* vol. 9 (1879), pp. 370–71; G. W. Sheldon, *American Painters,* New York, 1879, p. 72; Frank Fowler, 'An American in the

Royal Academy', *Review of Reviews,* vol. 9, no. 53 (June 1894), p. 687; Mrs Arthur (Nancy d'Anvers) Bell, *Representative Painters of the Nineteenth Century,* London and New York, 1899, p. 57, ill.; *American Art Annual,* American Federation of Arts, vol. 14 (1917), p. 75, ill. facing p. 76; *American Magazine of Art,* vol. 8, no. 6 (April 1917), p. 233, ill.; *Corcoran Gallery of Art, Catalogue of Paintings,* Washington, D.C., 1920, p. 81, no. 273, ill. facing p. 80; McSpadden 1923, p. 282; Mechlin 1924, p. 170; Downes 1925, 1926, pp. 8, 120–21, ill. facing p. 8; Minchin 1925, p. 736, as 'Beach at Cancalé'; Charteris 1927, pp. 38, 47, 281, dated 1880; Mather 1931, p. 239; *The Main Currents in the Development of American Painting,* Virginia Museum of Fine Art, Richmond, 1936, p. 35 (exhibition catalogue); *Corcoran Gallery of Art, Illustrated Handbook of Paintings, Sculpture and Other Art Objects,* Washington, D.C., 1939, p. 85, no. 313, ill.; A. Hammer, 'The Corcoran Gallery of Art: American Art at its Best', *The Compleat Collector,* March 1943, pp. 8ff., ill. p. 84; John Palmer Leeper, 'John Singer Sargent, a Revaluation', *Magazine of Art,* vol. 44, no. 1 (January 1951), p. 12, ill. p. 11; Chicago 1954, p. 44, ill.; Mount 1955, pp. 47–50, 442 (K783); 1957 ed., pp. 42–44, 352 (K783); 1969 ed., pp. 47–50, 458 (K783); McKibbin 1956, pp. 21, 114; *Corcoran Gallery of Art, Masterpieces of the Corcoran Gallery of Art,* Washington, D.C., 1959, p. 59, ill.; *Reproductions of American Paintings,* New York Graphic Society, 1962, p. 26, no. 8279, ill. (colour); Sutton 1964, p. 398; *Fine Art Reproductions of Old and Modern Masters,* New York Graphic Society, 1965, p. 279, no. 8279, ill. (colour); Diana F. Johnson in Gertrude Rosenthal ed., *From El Greco to Pollock: Early and Late Works by European and American Artists,* Baltimore Museum of Art, 1968, pp. 104–5, ill. p. 104 (exhibition catalogue); *American Paintings in the Museum of Fine Arts, Boston,* vol. 1, Boston, 1969, p. 225; Ormond 1970, pp. 17–19, 28, 34, 235, ill. pl. III (colour, detail), and pl. 4; Russell Lynes, *The Art-Makers of Nineteenth-Century America,* New York, 1970, p. 432, ill. p. 433; Dorothy W. Phillips, *A Catalogue of the Collection of American Paintings in The Corcoran Gallery of Art,* 2 vols., Washington, D.C., 1973, vol. 2, 'Painters born from 1850 to 1910', pp. 24–25, ill. p. 25; Sellin, 1976, p. 66, ill. p. 67, fig. 95; Leeds 1979, p. 21; Robertson 1982, pp. 21–24, 26, ill. p. 20, fig. 1; Ratcliff 1982, pp. 43, 44, 49, 50, ill. p. 53, fig. 71; Sellin and Ballinger 1982, pp. 9, 135, ill. p. 109 (colour); *Arts de l'Ouest,* University of Rennes, Brittany, 1984, ill. p. 107; William H. Gerdts, *American Impressionism,* New York, 1984, p. 76, ill.; Adelson in Adelson *et al.* 1986, p. 29, ill. fig. 8; Hills in Hills *et al.* 1986, pp. 27, 28–29, ill. p. 38, fig. 9 (colour); Olson 1986, pp. 65, 66, 78, 109; Fairbrother 1986, pp. 28–29, 31–32, 35, 38, 80, 81, fig. 3; Fairbrother 1990, pp. 30–31; Giverny 1992, pp. 41–42, 220–21, ill. p. 221 (colour); Weinberg in Weinberg *et al.* 1994, pp. 136, 138, ill. p. 136, fig. 124; Monique de Beaucorps, *Le Voyage des peintres en Bretagne,* Paris, 1995, ill. p. 11 (colour); Fairbrother 1994, pp. 16, 21; Adelson *et al.* 1997, pp. 12, 92, 219, 237, ill. p.12, pl. 2 (colour); Simpson 1997, pp. 26, 39–40, 62, 74, 83, 111, 128, 172, ill. p. 83 (colour), 172, fig. A3; Troyen in London 1998, pp. 62, 66, ill. p. 64 (colour), see also p. 25; Léo Kerlo and René le Bihan, *Peintres de la Côte d'Émeraude,* Le Chasse-Marée, Douarnenez, Brittany, 1998, pp. 90, 92; Weinberg and Herdrich, *MMA Bulletin,* 2000, p. 10, ill. p. 11, fig. 9 (colour); Moss in Heartney *et al.* 2002, p. 106, ill. p. 107 (colour).

671 *Fishing for Oysters at Cancale*

PROVENANCE
Samuel Colman, 1878; Susan Travers of Newport, by 1903; bequeathed to Mary Appleton, 1904; given by her to the Museum of Fine Arts, Boston, 1935.

EXHIBITIONS
New York, SAA, 1878, no. 23, as 'Fishing for Oysters at Cancale', lent by the artist (price $200); New York, MMA, 1880, no. 78, as 'Oyster Fishing at Cancale'; Philadelphia, Pennsylvania Academy of the Fine Arts, *Seventy-Second Annual Exhibition,* 19 January–28 February 1903, no. 10, lent by Susan Travers, as 'The Oyster-Gatherers'; Boston, Museum of Fine Arts, 1904–5, lent by Susan Travers, and later by Mary Appleton, when ownership was transferred (see provenance above); Boston, MFA, 1925, oil paintings, no. 13 (13), lent by Mary Appleton, as 'Oyster Gatherers'; Boston, Museum of Fine Arts, *Recent Accessions Gallery,* 1935 (no catalogue); Palm Beach 1959, no. 3, ill. cat. p. 11; Boston, First National Bank of Boston, 1960–61 (no catalogue); San Francisco, California Palace of

the Legion of Honor, and Santa Barbara Museum of Art, *Painters by the Sea,* 1961 (no catalogue); Boston 1973, no. 128; Washington, D.C., Smithsonian Institution, Traveling Exhibition Service, *American Art in the Making: Preparatory Studies for Masterpieces of American Painting, 1800–1900,* 1976, no. 59; Boston, Museum of Fine Arts, Faneuil Hall, *Americans Outdoors: Painters of Light from Homer to Hassam,* 1980 (no catalogue); *The Boston Tradition: American Paintings from the Museum of Fine Arts, Boston,* travelling exhibition organized by the Museum of Fine Arts, Boston, and the American Federation of Arts, 1981–82, no. 62, as 'Oyster Gatherers of Cancale'; Hanover, New Hampshire, Hood Museum of Art, Dartmouth College, *Drawings and Watercolors by John Singer Sargent,* 1983 (no catalogue traced); Springfield 1988, no. 55, ill. cat. p. 58, as 'Oyster Gatherers of Cancale'; Boston, Museum of Fine Arts, *European and American Impressionism: Crosscurrents,* 1992 (no catalogue); Giverny 1992, no. 55, as 'Oyster Gatherers of Cancale'; exchange loan to the Pennsylvania Academy of the Fine Arts, Philadelphia, 10 January–14 April 1996; Williamstown 1997, no. 2; London 1998, unnumbered (Washington, D.C., and Boston only); Nagoya/Boston Museum of Fine Arts, Japan, *9th Regular Exhibition: Impressionism in Boston,* 26 April–9 November 2003, no. 40, ill. cat. p. 75 (colour).

LITERATURE
S. N. Carter, 'First Exhibition of the American Art Association', *American Art Journal,* vol. 4 (April 1878), p. 126; Raymond Westbrook, 'Open Letters from New York', *Atlantic Monthly,* vol. 41, no. 248 (June 1878), p. 785; 'Fine Arts. The Lessons of a Late Exhibition', *The Nation,* vol. 26, no. 667 (11 April 1878), p. 251; 'Fine Arts', *New York Herald,* 3 March 1878, p. 10; 'Fine Arts', *New York Herald,* 10 March 1878, p. 8; 'Editorial, The Old Cabinet. The Society of American Artists', *Scribner's Monthly,* vol. 16, no. 1 (May 1878), pp. 124–26; Edward Strahan [Earl Shinn], 'The National Academy of Design', *Art Amateur,* vol. 1, no. 1 (June 1879), pp. 4–5; G. W. Sheldon, *American Painters,* New York, 1879, p. 72; 'Sketches and Studies', *American Art Journal,* vol. 6 (June 1880), p. 174; 'Fine Art Society of American Artists', *New York Daily Tribune,* 25 March 1880, p. 5; William C. Brownell, 'The Younger Painters of America', *Scribner's Monthly,* vol. 20, no. 1 (May 1880), p. 12, ill. p. 7 (engraving); Cortissoz 1924, p. 347; Boston 1925, p. 4; Downes 1925, pp. 120–21, confuses the provenance of no. 670 with this picture, which is otherwise unlisted; Downes 1926, pp. 120–21, and p. 336, as the picture exhibited Boston, MFA, 1925 (see exhibitions above); Charteris 1927, p. 281, dated 1880, and confusing it with the version given to Beckwith (no. 672); Mount 1955, p. 442 (K775), dated 1877, as 'Study for Oyster Gatherers'; 1957 ed., p. 352 (K775); 1969 ed., p. 458 (K775); McKibbin 1956, pp. 21, 114, ill. p. 20, fig. 5, as 'Oyster Gatherers of Cancale'; Boston 1969, vol. 1, pp. 224–25, no. 856, vol. 2, ill. p. 285, fig. 452, as 'Oyster Gatherers of Cancale'; Ormond 1970, p. 235; Dorothy W. Phillips, *A Catalogue of the Collection of American Paintings in the Corcoran Gallery of Art,* vol. 2, 'Painters born from 1850 to 1910', Washington, D.C., 1973, p. 25; Richardson 1976, p. 208; Sellin 1976, p. 66, ill. p. 67, fig. 96; Carol Troyen, *The Boston Tradition: American Paintings from the Museum of Fine Arts, Boston,* Boston, 1980, p. 168, ill. p. 169, as 'Oyster Gatherers of Cancale' (exhibition catalogue); Robertson 1982, pp. 21–24, 26, ill. p. 20, fig. 2; Ratcliff 1982, pp. 44, 49, ill. p. 53, fig. 72 (colour), and p. 48, fig. 61 (colour detail), as 'The Oyster Gatherers of Cancale'; Sellin and Ballinger 1982, pp. 9, 135; Fairbrother 1986, pp. 28–29, 32–35, 37, 38, 80, 81, ill. fig. 4; Olson 1986, pp. 65–66; Hills in Hills *et al.* 1986, p. 28, ill. p. 36, fig. 7, as 'The Oyster Gatherers of Cancale'; Clark Art Institute 1990, pp. 163–64, ill. p. 166, fig. 83, as 'Oyster Gatherers of Cancale'; Fairbrother 1990, pp. 31, 48, n. 7; Giverny 1992, pp. 41–42, 220–21, ill. p. 220 (colour), as 'Oyster Gatherers of Cancale'; Fairbrother 1994, pp. 16, 18, 21, ill. p. 17; Simpson 1997, pp. 37, 40, 74–75, 82–83, 172, 174, ill. pp. 82 (colour), 173, fig. A5, 175, fig. A14 ; Troyen *et al.* 1997, p. 244; Troyen in London 1998, pp. 62, 66, ill. p. 64, fig. 57 (colour); Gallati *et al.* 2004, p. 68, ill. fig. 13.

672 *Sketch for 'Oyster Gatherers of Cancale'*

PROVENANCE
J. Carroll Beckwith; his widow, Mrs J. Carroll Beckwith, 1917; M. Knoedler & Co., New York, 23 June 1924 (stock no. C 5690), as 'The Oyster Gatherers'; Knoedler to W. H. Dicks of Chicago, October 1924;

Mrs J. Elias Jenkins of Chicago, by 1925; deposited with M. Knoedler & Co., New York, by Maynard Walker of New York City, 18 February 1941; returned to owner, 8 April 1941 (Knoedler stock no. CA 1682); untraced.

EXHIBITIONS
New York 1924, no. 47, as 'Mussel Gatherers'; Chicago 1924, unnumbered, as 'Mussel Gatherers'; Boston, MFA, 1925, oil paintings, no. 10 (10), as 'Normandy Coast Fisher Folk'; on loan to the Art Institute of Chicago, summer 1929; Newport, Rhode Island, Art Association of Newport, *Fifty Famous Painters,* an exhibition arranged for the Art Association of Newport by Maynard Walker, 5–21 August 1938, no. 65, as 'Normandie Coast Fisher Folk'.

LITERATURE
New York 1924, p. 14; *Art News,* vol. 22 (26 April 1924), p. 10, as 'Mussel Gatherers'; 'Loans: Paintings and Sculpture–19 oil paintings by John Singer Sargent', *Bulletin of The Art Institute of Chicago,* vol. 28, no. 6 (September 1924), p. 81; Boston 1925, p. 3; Downes 1925, 1926, p. 121, as 'Mussel Gatherers'; Charteris 1927, p. 281, dated 1880, as 'Normandy Coast Fisher Folk'; 'Magazine of the Art World', *Chicago Evening Post,* 30 July 1929, p. 3; Mount 1955, pp. 169, 442 (K771), dated 1877, as 'Oyster Gatherers'; 1957 ed., pp. 144, 351 (K771); 1969 ed., pp. 169, 458 (K771), as 'Study for Oyster Gatherers'; McKibbin 1956, p. 114; Ormond 1970, pp. 17–18, 235, ill. p. 23, fig. 7, as 'Study for Oyster Gatherers of Cancale'; Dorothy W. Phillips, *A Catalogue of the Collection of American Paintings in the Corcoran Gallery of Art,* vol. 2, 'Painters born from 1850 to 1910', Washington, D.C., 1973, p. 25; Robertson 1982, p. 22, ill.; Fairbrother 1986, p. 80, n. 22; Olson 1986, p. 65.

673 *Study for 'Oyster Gatherers of Cancale'*

PROVENANCE
Arthur Rotch; his widow, born Lisa De Wolfe Colt, later Mrs Ralph Curtis, 1894; Ralph Curtis II, 1933; Mrs Ralph Curtis II; M. Knoedler & Co., New York, December 1960 (stock no. A 7798), as 'Woman with Market Basket'; Knoedler to Mrs Edward Patterson, Laurel Hollow, Long Island, New York, June 1961; Hirschl & Adler Galleries, New York, December 1971; John D. Rockefeller III, March 1972; his daughter; private collection.

EXHIBITIONS
New York, Hirschl & Adler, 1972, no. 65, as 'The Oyster Gatherer'; San Francisco, The M. H. de Young Memorial Museum, *American Art: An Exhibition from the Collection of Mr and Mrs John D. Rockefeller 3rd,* 17 April–31 July 1976, no. 90; also shown at the Whitney Museum of American Art, New York, 16 September–7 November 1976.

LITERATURE
Mount 1955, p. 443 (K806), dated 1880, as 'Woman with Market Basket'; 1957 ed., p. 353 (K806); 1969 ed., p. 458 (K806), dated 1877, as 'Woman with Basket'; Mount, *Art Quarterly,* 1957, p. 311, ill. p. 307, fig. 7, as 'Woman with Market Basket'; Ormond 1970, p. 235; *Important Recent Acquisitions,* Hirschl & Adler Galleries, New York, 1972, n.p., no. 65, ill. (exhibition catalogue); Richardson 1976, p. 208, ill. p. 209, as 'The Oyster Gatherer'.

674 *Study for 'Oyster Gatherers of Cancale'*

PROVENANCE
Parke-Bernet Galleries, New York, 7–8 April 1971, lot 30, ill. sale cat., as 'Breton Girl with Basket: Sketch for "The Oyster Gatherers of Cancale"', bt. Daniel J. Terra; Terra Museum of American Art, Chicago, 1980.

EXHIBITIONS
University Park, Pennsylvania State University, Museum of Art, *American Paintings from the Collection of Daniel J. Terra,* 5 June–17 July 1977, listed and ill. cat., n.p., as 'Oyster Gatherer of Cancale (female)'; Phoenix 1982–83, no. 15, as 'Breton Girl with a Basket, Sketch for the Oyster Gatherers of Cancale'; Chicago 1987, unnumbered, ill. cat. p. 195, pl. T-86 (colour), as 'Breton Girl with a Basket, Sketch for "The Oyster Gatherers of Cancale"'; Chicago 1988; Chicago 1989; Giverny 1992, no. 52, as 'Breton Girl with a Basket, Sketch for "Oyster Gatherers of Cancale"'; Chicago 1997; Giverny 2000, unnumbered, ill. cat. p. 36; Chicago 2001, unnumbered; Giverny 2002; Chicago 2002; Chicago 2004.

LITERATURE
Ratcliff 1982, ill. p. 52, fig. 68, as 'Female Study for "The Oyster Gatherers of Cancale"'; Sellin and Ballinger 1982, ill. p. 137; Giverny 1992, pp. 41–42, 216, 220–21, ill. p. 52, as 'Breton Girl with a Basket, Sketch for "Oyster Gatherers of Cancale"'; Cartwright 2000, p. 28, ill. p. 36 (colour); Bourguignon and Kennedy 2002, pp. 94, 204, ill. p. 95 (colour), 204; Elizabeth Kennedy, 'The Terra Museum of American Art', *American Art Review,* vol. 14, no. 6 (November–December 2002), pp. 128–29, ill. p. 132.

675 *Study for 'Oyster Gatherers of Cancale'*

PROVENANCE
Parke-Bernet Galleries, New York, 7–8 April 1971, lot 31, ill. sale cat., as 'Young Boy on the Beach: Sketch for "The Oyster Gatherers of Cancale"'; Daniel J. Terra; Terra Museum of American Art, Chicago, 1980.

EXHIBITIONS
University Park, Pennsylvania State University, Museum of Art, *American Paintings from the Collection of Daniel J. Terra,* 5 June–17 July 1977, listed and ill. cat., n.p., as 'Oyster Gatherer of Cancale (male)'; Phoenix 1982–83, no. 14, as 'Young Boy on the Beach, Sketch for the Oyster Gatherers of Cancale'; Chicago 1987, unnumbered, ill. cat. p. 197, pl. T-88 (colour), as 'Young Boy on the Beach, Sketch for "The Oyster Gatherers of Cancale"'; Chicago 1988; Chicago 1989; Giverny 1992, no. 54, as 'Young Boy on the Beach, Sketch for "Oyster Gatherers of Cancale"'; Chicago 1997; Giverny 2000, unnumbered, ill. cat. p. 37; Chicago 2001; Giverny 2002; Chicago 2002; Chicago 2003, unnumbered.

LITERATURE
Ratcliff 1982, ill. p. 52, fig. 69, as 'Male Study for "The Oyster Gatherers of Cancale"'; Sellin and Ballinger 1982, ill. p. 136; Henry Adams, 'Private Collector to Public Champion', *Portfolio Magazine,* vol. 5, no. 1 (January/February 1983), pp. 48–53, ill. p. 53; Giverny 1992, pp. 41–42, 216, 220–21, ill. p. 219 (colour), as 'Young Boy on the Beach, Sketch for "Oyster Gatherers of Cancale"'; Cartwright 2000, p. 28, ill. p. 37 (colour); Bourguignon and Mansfield 2002, ill. p. 94.

676 *Study for 'Oyster Gatherers of Cancale'*

PROVENANCE
Parke-Bernet Galleries, New York, 7–8 April 1971, lot 32, ill. sale cat., as 'Breton Woman on the Beach: Sketch for "The Oyster Gatherers of Cancale"', bt. H. Frisk; Daniel J. Terra; Terra Museum of American Art, Chicago, 1980.

EXHIBITIONS
Phoenix 1982–83, no. 16, as 'Sketch for the Oyster Gatherers of Cancale'; Chicago 1987, unnumbered, ill. cat. p. 196 (colour), pl. T-87, as 'Girl on the Beach, Sketch for "The Oyster Gatherers of Cancale"'; Chicago 1988, unnumbered; Chicago 1989, no. 34, ill. cat., n.p.; Giverny 1992, no. 53, as 'Girl on the Beach, Sketch for "Oyster Gatherers of Cancale"'; Chicago 1997; Giverny 2000, unnumbered, ill. cat. p. 37; Chicago 2001; Chicago 2002; Giverny 2002; Chicago 2004.

LITERATURE
Ratcliff 1982, ill. p. 52, fig. 70, as 'Second Female Study for "The Oyster Gatherers of Cancale"'; Sellin and Ballinger 1982, ill. p. 137; Giverny 1992, pp. 41–42, 216, 220–21, ill. p. 218 (colour), as 'Girl on the Beach, Sketch for "Oyster Gatherers of Cancale"'; Cartwright 2000, p. 28, ill. p. 37 (colour); Bourguignon and Kennedy 2002, ill. p. 94.

677 *Study for 'Oyster Gatherers of Cancale'*

PROVENANCE
Parke-Bernet Galleries, New York, 7–8 April 1971, lot 33, ill. sale cat., as 'Breton Woman with Basket: Sketch for "The Oyster Gatherers of Cancale"', bt. H. Goldston, New York; Adelson Galleries, New York, June 1996; Terra Museum of American Art, Chicago, 1996.

EXHIBITIONS
Chicago 1997; Giverny 2000, unnumbered, ill. cat., p. 36; Chicago 2001; Giverny 2002; Chicago 2002; Chicago 2003, unnumbered; Chicago 2004.

LITERATURE
Cartwright 2000, p. 28, ill. p. 36 (colour); Bourgignon and Kennedy 2002, ill. p. 94.

678 Oyster Gatherers Returning
PROVENANCE
Auguste Alexandre Hirsch; his widow, Mme Hirsch, 1912; by descent to Hirsch's nephew, Raymond Bollack; sold by him, Parke-Bernet Galleries, New York, 19 May 1965, lot 105, as 'Mussel Gatherers', ill. sale cat.; Mr and Mrs Louis Sosland of Kansas City, Missouri; Nelson-Atkins Museum of Art, Kansas City, Missouri, gift of Mrs Louis Sosland, 1977.
LITERATURE
New York 1980, checklist, n.p., as 'Mussel Gatherers'.

679 Low Tide at Cancale Harbour
PROVENANCE
Henry Hall Sherman and Zoe Oliver Sherman, by 1916; presented by them to the Museum of Fine Arts, Boston, 1922.
EXHIBITIONS
Boston, Museum of Fine Arts, *John Singer Sargent: Paintings,* 10 May–1 November 1916 (no catalogue traced); Boston, MFA, 1925, oil paintings, no. 5 (4); Washington 1964, no. 3; Boston 1973, no. 127; Phoenix 1982–83, no. 11; Paris, *American Artists in the American Ambassador's Residence in Paris: Art in Embassies Program,* 1998, no. 109; New York 2004, unnumbered.
LITERATURE
Boston 1925, p. 3; Downes 1925, 1926, pp. 8–9, 121, as 'Low Tide, Cancale'; Charteris 1927, p. 280, dated 1878, as 'Cancale Harbour, Low Tide'; Mount 1955, p. 442 (K774), dated 1877, as 'Idle Sails (Low Tide, Cancale Harbor)'; 1957 ed., p. 352 (K774); 1969 ed., p. 458 (K774); Boston 1969, vol. 1, p. 224, ill., vol. 2, p. 285, fig. 453; Ormond 1970, pp. 17, 235, pl. 6; Ratcliff 1982, ill. p. 52, pl. 67; Sellin and Ballinger 1982, ill. p. 135; Fairbrother 1990, pp. 31, 41, ill. p. 31, fig. 1; Troyen *et al.* 1997, p. 244; Gallati *et al.* 2004, p. 131, ill. p. 132, pl. 42 (colour).

680 Man and Boy in a Boat
PROVENANCE
Henry Tonks, 1926; untraced.
EXHIBITION
London, Tate, 1926, unnumbered.
LITERATURE
Mount 1955, p. 444 (K8021), dated 1880; 1957 ed., p. 353 (K8021); 1969 ed., p. 461 (K8021).

681 The Brittany Boatman
PROVENANCE
Henry A. Bacon; his widow, Louisa Lee Andrews (Mrs Henry Bacon, secondly Mrs Frederick Eldridge), 1912; sold from her estate, c. 1947; untraced.
EXHIBITION
Boston, MFA, 1925, oil paintings, no. 36 (38).
LITERATURE
Boston 1925, p. 6; Downes 1926, p. 336, as 'The Brittany Boatmen [*sic*]'; Charteris 1927, p. 284, dated 1890; Mount 1955, p. 442 (K776), dated 1877; 1957 ed., p. 352 (K776); 1969 ed., p. 458 (K776), dated 1876, as 'The Sailor'.

682 Port Scene I
PROVENANCE
Violet Sargent (Mrs Francis Ormond), 1925; her son, F. Guillaume Ormond, 1955; his heirs, 1971; private collection.

683 Wharf Scene
PROVENANCE
Said to have been sold at auction by an American female friend of the artist, 1918; Galerie A. M. Reitlinger, Paris; John Levy Gallery, New York; sold to J. J. Gillespie & Co., Pittsburgh, 1929; Moorhead B. Holland, Pittsburgh, December 1929; his daughter, Mrs William J. Miller, Pittsburgh; private collection, New York.
EXHIBITION
Pittsburgh, Carnegie Institute of Art, *Art in Residence; Art Privately Owned in the Pittsburgh Area,* 17 October 1973–6 January 1974, unnumbered, as 'The Dock', lent by Mr and Mrs William Miller (listed in exhibition brochure).

684 Two Nude Figures Standing on a Wharf (recto)
and **The Balcony** (verso)
PROVENANCE
Violet Sargent (Mrs Francis Ormond), 1925; given by her, with a large group of Sargent studies, to The Metropolitan Museum of Art, New York, 1950.
LITERATURE
Mount 1955, p. 444 (K8032), dated 1880, as 'Balcony (on reverse) Two nude bathers near wharf (panel)'; 1957 ed., p. 354 (K8032); 1969 ed., p. 461 (K8032), listed under North Africa, 1880; Burke 1980, p. 224, ill. p. 225; New York 1980, checklist, n.p., as 'Balcony, Spain and Two Nude Bathers Standing on a Wharf'; Boone 1996, p. 189, n. 27.

685 Ships and Boats
PROVENANCE
Violet Sargent (Mrs Francis Ormond), 1925; her son F. Guillaume Ormond, 1955; his heirs, 1971; private collection.

686 Boats in Harbour I
PROVENANCE
Kenyon Cox, c. 1879; his daughter, Caroline Cox (Mrs Ambrose Lansing), 1919; her son, Dr Cornelius Lansing, 1986.

687 Boats in Harbour II
PROVENANCE
Violet Sargent (Mrs Francis Ormond), 1925; her son, F. Guillaume Ormond, 1955; his heirs, 1971; private collection.

688 Boats I
PROVENANCE
Violet Sargent (Mrs Francis Ormond), 1925; given by her, with a large group of studies, to The Metropolitan Museum of Art, New York, 1950.
LITERATURE
New York 1980, checklist, n.p., as 'Boats I'; Herdrich and Weinberg 2000, p. 360, appendix 6, ill.

689 Boats II
PROVENANCE
Violet Sargent (Mrs Francis Ormond), 1925; her son, F. Guillaume Ormond, 1955; his heirs, 1971; private collection.

690 Filet et Barque
PROVENANCE
Ernest-Ange Duez; Duez sale, Galerie Georges Petit, Paris, 11–12 June 1896, lot 288; A. M. Adler Fine Arts, New York, 1980; Dr and Mrs Paul Hart; Vose Galleries, Boston, 2000; private collection.

691 Port Scene II

PROVENANCE

Violet Sargent (Mrs Francis Ormond), 1925; her son, F. Guillaume Ormond, 1955; his heirs, 1971; private collection.

692 Neapolitan Children Bathing

PROVENANCE

George Millar Williamson, by March 1879; his son, Frederick J. Williamson; Mrs F. J. Williamson; M. Knoedler & Co., New York, 19 December 1922 (stock no. C 5521), as 'Boys on the Beach'; Robert Sterling Clark, 22 December 1923; Sterling and Francine Clark Art Institute, Williamstown, Massachusetts, 1955.

EXHIBITIONS

New York, NAD, 1879, no. 431, as 'Neapolitan Children Bathing'; New York 1883, no. 168, as 'Napolitan Boys Bathing' [*sic*]; Philadelphia 1902, no. 80, as 'Innocence Abroad'; Williamstown 1957, no. 317, as 'Boys on the Beach'; Cincinnati 1981, as 'Boys on the Beach'; Springfield 1988, no. 56, as 'Boys on the Beach'; Williamstown 1997, no. 8; New York 2004, unnumbered.

LITERATURE

Edward Strahan [Earl Shinn], 'The National Academy of Design', *Art Amateur*, vol. 1 (June 1879), pp. 4–5; 'The Spring Exhibition—National Academy of Design. Second Notice', *Art Interchange*, vol. 2 (16 April 1879), p. 58; 'The Academy Exhibition', *Art Journal* (New York), vol. 5 (May 1879), p. 159; 'The Two New York Exhibitions', *Atlantic Monthly*, vol. 43, no. 260 (June 1879), p. 781; 'The Academy Exhibition', *Daily Graphic*, 29 March 1879, p. 207; 'The Academy Exhibition', *Evening Post*, 29 March 1879, p. 4; 'Fine Arts. Exhibition of the Academy of Design. —II', *The Nation*, vol. 28, no. 725 (22 May 1879), p. 359; 'National Academy of Design', *New York Daily Tribune*, 1 April 1879, p. 5; 'Academy of Design. Fourth Article', *New York Daily Tribune*, 26 April 1879, p. 5; 'Fine Arts. Fifty-fourth Annual Exhibition of the National Academy of Design—Second Notice', *New York Herald*, 31 March 1879, p. 5; 'Fine Arts. Fifty-fourth Annual Exhibition of the National Academy of Design—The Reception and the Private View—Third Notice of the Collection', *New York Herald*, 1 April 1879, p. 6; 'The Academy Exhibition', *New York Times*, 2 May 1879, p. 5; 'The Academy Exhibition. I', *The World–New York*, 30 March 1879, p. 4; 'John S. Sargent', *Art Amateur*, vol. 2 (May 1880), p. 118; 'Fine Art. Society of American Artists', *New York Daily Tribune*, 25 March 1880, p. 5; William C. Brownell, 'The Younger Painters of America. First Paper', *Scribner's Monthly*, vol. 20 (May 1880), p. 12; John W. Van Oost, 'My Notebooks', *Art Amateur*, vol. 46 (February 1902), p. 60, as 'Innocence Abroad'; 'Studio Talk', *Studio* (London), vol. 26 (June 1902), pp. 52, 62, as 'Innocents Abroad'; Cortissoz 1924, p. 347; Downes 1925, pp. 9, 122, as 'Neapolitan Children Bathing', p. 204 as 'Innocents Abroad'; Charteris 1927, (listed twice), p. 280, as 'Neapolitan Children Bathing', and p. 286, as 'Innocents Abroad', incorrectly dated 1902; McKibbin 1956, p. 131; Ormond 1970, pp. 22, 235, pl. 5, as 'Boys on a Beach, Naples'; Leeds 1979, p. 21, as 'Innocents Abroad'; Novak 1979, p. 227; New York 1980, n.p.; Fairbrother 1981, p. 78, n. 5; Robertson 1982, pp. 23, 24; Fairbrother 1986, pp. 37–38, 122, 362 n. 95, ill. fig. 7; Hills in Hills *et al.* 1986, ill. p. 37, fig. 8; *Lasting Impressions: French and American Impressionism from New England Museums*, Springfield, 1988, pp. 12, 58 (exhibition catalogue); Clark Art Institute 1990, pp. 163–66, ill. p. 165 (colour); Simpson 1997, pp. 37, 47, 77, 89–90, 173, ill. p. 89 (colour); Simpson, *Antiques*, 1997, p. 556, ill., p. 557 pl. IV (colour); Herdrich and Weinberg 2000, p. 123, fig. 54; Gallati *et al.* 2004, pp. 15, 65–66, 68, 70, 108, 189, 208–11, 248, ill. p. 66, pl. 14 (colour), and p. 208, fig. 81.

693 Two Boys on a Beach, Naples

PROVENANCE

Violet Sargent (Mrs Francis Ormond), 1925; her son H. E. Conrad Ormond, 1955; his heirs, 1979; private collection.

EXHIBITIONS

London, RA, 1926, no. 409, as 'Little Boys, Naples' (with incorrect dimensions); London, Tate, 1926, unnumbered, as 'Little Boys: Naples'; Birmingham 1964, no. 3; Leeds 1979, no. 2.

LITERATURE

London 1926, p. 62; Mount 1955, p. 442 (K788), as 'Innocents Abroad'; 1957 ed., p. 352 (K788); 1969 ed., p. 460 (K788); Ormond 1970, p. 235; Leeds 1979, p. 21, ill.; Clark Art Institute 1990, p. 166, fig. 82.

694 Boy on the Beach

PROVENANCE

Edward Runge; The American Art Association, The American Art Galleries, New York, 9 January 1902, lot 49; Frederick S. Gibbs, The American Art Association, Mendelssohn Hall, New York, 24–26 February 1904, lot 222, as 'The Sun Bath', bt. Mrs Josephine Schmid; [the subsequent stage of the provenance is unreliable]; Janet Marlin, New Haven, Connecticut, apparently from her father; John Bihler and Henry Coger (art dealers), Ashley Falls, Massachusetts, 1971; Alice M. Kaplan; by descent to her granddaughter; private collection.

LITERATURE

Linda Bantel, *The Alice M. Kaplan Collection*, New York, 1981, p. 176, ill. p. 177; Clark Art Institute 1990, p. 163, ill. p. 164, fig. 80; Gallati *et al.* 2004, p. 208, ill. pl. 69 (colour).

695 A Nude Boy on a Beach

PROVENANCE

The artist's sale, Christie's, London, 27 July 1925, lot 185, as 'A Boy Lying on the Beach', bt. Leopold Sutro; Sutro sale, Sotheby's, London, 10 November 1943, lot 100, as 'A nude Boy on the sands', bt. John Tillotson; bequeathed by him to the Tate Gallery, London, 1984.

EXHIBITION

New York 2004, unnumbered.

LITERATURE

Christie's 1925, p. 27; Downes 1926, p. 331, where the owner is erroneously given as Sir Alfred Sutro; Charteris 1927, p. 295, as 'Boy Lying on the Beach', undated; Mount 1955, p. 444 (K8020), as 'Boy Lying on a Beach', dated 1880; 1957 ed., p. 353 (K8020); 1969 ed., p. 461 (K8020); *The Tate Gallery, 1984–86. Illustrated Catalogue of Acquisitions Including Supplement to Catalogue of Acquisitions 1982–84*, Tate Gallery, London, 1988, p. 81; Clark Art Institute 1990, p. 163, fig. 79; Gallati *et al.* 2004, p. 208, ill. pl. 70 (colour).

696 Nude Boy on Sands

PROVENANCE

Violet Sargent (Mrs Francis Ormond), 1925; her son F. Guillaume Ormond, 1955; his heirs, 1971; private collection.

EXHIBITIONS

Falmouth 1962, no. 36; New York 2004, unnumbered.

LITERATURE

Mount 1955, p. 442 (K7811), as 'Nude Girl on the Sands, Capri'; 1957 ed., p. 352 (K7811), as 'Nude Girl on the Sands, Capri'; 1969 ed., p. 459 (K7811), as 'Nude Girl on the Sands, Capri'; Leeds 1979, p. 21; Gallati *et al.* 2004, p. 208, ill. p. 209, pl. 71 (colour).

697 Two Boys on a Beach with Boats

PROVENANCE

Albert Gustav Edelfelt; his widow, Ellan Edelfelt (secondly, Baroness Ellan von Born), 1905; Ernst von Born, probably in 1917; bequeathed by Ernst von Born to Svenska litteratursällskapet i Finland (Swedish Literature Society of Finland), Helsinki.

LITERATURE

Soili Sinisalo *et al.*, *Albert Edelfelt, 1854–1905: Jubilee Book*, Ateneum Art Museum, Finnish National Gallery, Helsinki, 2004, ill. p. 304 (colour).

698 A Boat in the Waters off Capri

PROVENANCE

Auguste Alexandre Hirsch; said to have been bequeathed to Albert Anker; Sotheby's, New York, 2 June 1983, lot 187, ill. sale cat., n.p. (colour); private collection.

699 Beach at Capri
PROVENANCE
Alma Strettell (Mrs L. A. Harrison); her daughter, Margaret Harrison (Mrs Arthur Porter), 1939; Frederick J. Hellman; bequeathed by him to the California Palace of the Legion of Honor, San Francisco, 1965 (1965.32).
EXHIBITIONS
M. H. de Young Memorial Museum, San Francisco, *The San Francisco Collector*, 21 September–17 October 1965, no. 142, dated 1890; New York, CKG, 1980, no. 4.
LITERATURE
T[homas] C[arr] H[owe], Jr, 'Growth of Collections', *Bulletin of the California Palace of the Legion of Honor*, vol. 23, nos. 9 and 10 (January and February 1966), p. 307; New York 1980, n.p., no. 4, ill., and checklist, n.p.; Clark Art Institute 1990, p. 163, ill. fig. 81.

700 Gathering Olives (recto) and **Fishing Boats** (verso)
PROVENANCE
Edward Darley Boit to 1915; his daughter, Julia Boit, to 1969; her half-brother, Julian M. Boit; private collection.

701 Olive Trees
PROVENANCE
Violet Sargent (Mrs Francis Ormond), 1925; her son H. E. Conrad Ormond 1955; his heirs, 1979; private collection.
LITERATURE
Sargent Trust List [1927], 'Pictures. Framed', p. 34, no. 12, as "Green hillside and olives'; Mount 1955, p. 449 (K094), as 'Olive Trees (unfinished)', dated 1909; 1957 ed., p. 359 (K094); 1969 ed., p. 474 (K094).

702 A Capriote
PROVENANCE
Ichabod Thomas Williams, New York, 1879; his sale, The American Art Association, Plaza Hotel, New York, 4 February 1915, lot 101, as 'A Girl of Capri', ill. sale cat.; bt. M. Knoedler & Co., New York, as agent for Abram A. Anderson (Anderson Galleries), New York, 1915; Elizabeth Milbank Anderson (Mrs Abram A. Anderson); her sale, The American Art Association, Plaza Hotel, New York, 16 February 1922, lot 60, ill. sale cat.; bt. Scott & Fowles, New York, 1922; Mrs Francis A. Neilson (Helen Swift Neilson), Chicago; Museum of Fine Arts, Boston, bequest of Helen Swift Neilson, 1946.
EXHIBITIONS
New York, SAA, 1879, no. 37, as 'A Capriote'; Boston, MFA, 1925, no. 129 (133), as 'Capri'; Utica 1953, no. 28; Palm Beach 1959, no. 2; Williamstown 1997, no. 6; London 1998, no. 3; Seattle 2000, no. 5; Ferrara 2002, no. 1; Los Angeles 2003, unnumbered.
LITERATURE
The Society of American Artists', *World–New York,* 8 March 1879, p. 4; 'The Society of American Artists', *New York Daily Tribune,* 8 March 1879, p. 5; 'American Art Methods: The Society of Artists', *New York Times,* 10 March 1879, p. 5; 'The Two New York Exhibitions', *Atlantic Monthly,* vol. 43, no. 260 (June 1879), p. 781; 'The Academy Exhibition', *Daily Graphic,* 29 March 1879, p. 207; 'Fine Arts: Exhibition by the Society of American Artists', *The Nation,* vol. 28, no. 716 (30 March 1879), pp. 206–7; 'The Academy Exhibition', *New York Times,* 2 May 1879, p. 5; J. B. F. W., 'Society of American Artists', *Aldine,* vol. 9, no. 9 (1879), p. 278; 'The Society of American Artists', *Art Interchange,* vol. 2 (1879), p. 42; 'Notes', *Art Journal* (New York), vol. 5 (1879), p. 128; S. N. Carter, 'Exhibition of the Society of American Artists', *Art Journal* (New York), vol. 5 (1879), pp. 156–58; 'Culture and Progress. The Art Season 1878–79, Society of American Artists', *Scribner's Monthly,* vol. 18 (May–October 1879), p. 312; 'Sargent's "El Jaleo" at the Schaus Gallery', *New York Times,* 13 October 1882, p. 5; W. C. Brownell, 'American Pictures at the Salon', *Magazine of Art* (London), vol. 6 (1883), p. 497; *Illustrated Catalogue of the Notable Collection of Valuable Paintings formed by the Late Ichabod T. Williams, Esq. of New York,* New York, 1915, n.p., ill.; Boston 1925, p. 13; Boston

1925a, p. 14; Downes 1925, 1926, pp. 122, 261; Charteris 1927, pp. 48–49, 280 (dated 1879); Mount 1955, p. 442 (K787); 1957 ed., p. 352 (K787); 1969 ed., p. 459 (K787); Boston, MFA, 1969, p. 224, no. 855, ill. fig. 451; Ormond 1970, pp. 22, 236; New York 1980, checklist, n.p.; Ratcliff 1982, pp. 43–44, ill. pl. 55; Robertson 1982, pp. 22–23, ill. fig. 4; Fairbrother 1986, pp. 36–37, ill. fig. 6; Hills *et al.* 1986, pp. 29, 31, ill. fig. 10; Troyen *et al.* 1997, p. 245; Simpson 1997, pp. 37, 58, 60, 76, 77, 87, 89, 90, 173, ill. p. 87 (colour); London 1998, p. 66, ill. (colour); Ferrara 2002, p. 162, ill. p. 163 (colour) and as a detail on the cover (colour); Ormond in Robertson *et al.* 2003, p. 52, ill. p. 53 (colour).

703 Dans les oliviers à Capri (Italie)
PROVENANCE
The artist to Mme Marius Alexander Sorchan; her husband, Marius Alexander Sorchan; her daughter, Marie Sorchan (Mrs Horace Binney, Sr), 1914; her brother, Victor Sorchan, to c. 1948; Mrs Walter (Beatrice) Binger, to 1996; Sotheby's, New York, 22 May 1996, lot 9; private collection.
EXHIBITIONS
Either this or no. 704, Paris, Salon, 1879, no. 2698; Chicago 1954, no. 39, ill.; Washington 1964, no. 5; Williamstown 1997, no. 7; New York, Adelson Galleries, 2003, no. 3.
LITERATURE
Outremer, 'American Painters at the Salon of 1879', *Aldine,* vol. 9 (1879), p. 371; Charles Tardieu, 'La Peinture au Salon de Paris, 1879, Itinéraire', *L'Art,* no. 17 (1879), p. 190; 'Le Salon de 1879 par STOP', *Le Journal Amusant,* no. 1191 (28 June 1879), p. 7 (caricature); F.-C. de Syène [Arsène Houssaye], 'Salon de 1879. II', *L'Artiste,* no. 50, part 2 (July 1879), p. 9; Olivier Merson, 'Salon de 1879. IV', *Le Monde Illustré,* no. 1159 (14 June 1879), p. 378; Downes 1925, p. 122; Charteris 1927, pp. 48–49, 280; Mount 1955, p. 442 (K786); 1957 ed., p. 352 (K786); 1969 ed., p. 459 (K786); Ormond 1970, pp. 22, 236; Fairbrother 1986, p. 36; Fairbrother 1994, p. 22; Oustinoff in Adelson *et al.* 1997, p. 219, ill. p. 220, pl. 228 (colour); Simpson 1997, pp. 46, 76, 89, 119, 172, ill. p. 88 (colour); Adelson *et al.* 2003, pp. 12, 26, 50, pl. 3 (colour); Ormond in Robertson *et al.* 2003, p. 52.

704 Dans les oliviers à Capri (Italie)
PROVENANCE
José Tomás Errázuriz; by descent in the Errázuriz family; Adelson Galleries, New York, 2000; private collection.
EXHIBITIONS
Either this or no. 703, Paris, Salon, 1879, no. 2698; Seattle 2000, no. 4.
LITERATURE
Outremer, 'American Painters at the Salon of 1879', *Aldine,* vol. 9 (1879), p. 371; Downes 1925, p. 122; Charles Tardieu, 'La Peinture au Salon de Paris, 1879, Itinéraire', *L'Art,* no. 17 (1879), p. 190; F.-C. de Syène [Arsène Houssaye], 'Salon de 1879. II', *L'Artiste,* no. 50, part 2 (July 1879), p. 9; 'Le Salon de 1879 par STOP', *Le Journal Amusant,* no. 1191 (28 June 1879), p. 7 (caricature); Olivier Merson, 'Salon de 1879. IV', *Le Monde Illustré,* no. 1159 (14 June 1879), p. 378; Olivier Merson, 'Salon de 1880', *Le Monde Illustré,* no. 1210 (5 June 1880), p. 354; Fairbrother 1986, p. 36; Simpson 1997, pp. 46, 76, 89, 119, ill. p. 88; Ormond in Robertson *et al.* 2003, p. 52.

705 Capri Girl on a Rooftop
PROVENANCE
Given by the artist to Fanny Watts; by descent to her god-daughter, Kathleen Blanche Antoinette (Toni), Baronne d'Aubas de Gratiollet, 1927; Coe Kerr Gallery, New York, 1981; Mr and Mrs Herbert Gelfand, 1981; Coe Kerr Gallery and Berry-Hill Galleries, New York, 1982; Gulf States Paper Corporation, Tuscaloosa, Alabama; The Westervelt-Warner Museum, Tuscaloosa, Alabama.
EXHIBITIONS
Leeds 1979, no. 4; New York and Chicago 1986, unnumbered; Washington 1992, no. 19; Indianapolis 1993, unnumbered; Richmond, Virginia Museum of Fine Arts, *American Dreams: Paintings and Decorative Arts from the Warner Collection,* 20 September 1997–25 January 1998, unnumbered; London 1998, no. 5 (exhibited Washington, D.C., only).

LITERATURE

Hyde 1914, pp. 285–86; Ormond 1970, p. 22; Leeds 1979, p. 23, pl. 4; Simpson 1980, p. 9, fig. 4; Ratcliff 1982, p. 44; Adelson in Adelson *et al.* 1986, p. 30, ill. fig. 9; Hills in Hills *et al.* 1986, pp. 31–32, ill. p. 41, fig. 12 (colour); Washington 1992, pp. 40, 156, ill. p.157 (colour); David Park Curry, *American Dreams: Paintings and Decorative Arts from the Warner Collection,* Virginia Museum of Fine Arts, Richmond, 1997, p. 51, ill. p. 50, pl. 18 (colour) (exhibition catalogue); Curry 1997, ill. p.167; London 1998, p. 68, ill. p. 69 (colour); Robertson *et al.* 2003, p. 55; Paul Soderberg, 'The Jack Warner Collection', *PleinAir [sic] Magazine,* vol. 2, no. 8 (August 2005), ill. p. 76, as 'Capri' (colour).

706 *View of Capri*

PROVENANCE

Edwin Austin Abbey (from the artist), to 1911; Mrs E. A. Abbey; Yale University Art Gallery, New Haven, Connecticut, Edwin Austin Abbey Memorial Collection (1937.2595).

LITERATURE

Simpson 1980, p. 9, ill. fig. 2; Ratcliff 1982, p. 44; Stebbins and Gorokhoff 1982, p. 122, no. 1267A, ill. p.123; Fairbrother 1994, p. 24, ill. p. 24 (colour).

707 *Capri*

PROVENANCE

José Tomás Errázuriz; his niece, Amalia Errázuriz Vergara; M. Knoedler & Co., London, May 1928 (stock no. LC 345); transferred to Knoedler, New York (no. CA 31); Mrs William Gower (later Mrs Huguette M. Clark), May 1929; Sotheby's, New York, 24 May 2001, lot 15; private collection.

EXHIBITIONS

Ferrara 2002, no. 2, as 'Rosina, Capri'; Los Angeles 2003, unnumbered; New York, Adelson Galleries, 2003, no. 2.

LITERATURE

Hyde 1914, pp. 285–86; Charteris 1927, p. 48; Mount 1955, p. 442 (K781), as 'Rosita [sic], Capri'; 1957 ed., p. 352 (K781); 1969, p. 459 (K781); Ormond, *Fenway Court,* 1970, pp. 12–13, ill. fig. 8; Simpson 1980, p. 9, ill. fig. 3; Ratcliff 1982, p. 44; Washington 1992, p. 156; London 1998, p. 68; Ferrara 2002, p. 164, ill. p.165 (colour); Ormond in Robertson *et al.* 2003, p. 55, ill. p. 54 (colour); Adelson *et al.* 2003, pp. 13, 26–27, 48, pl. 2 (colour).

708 *Capri Girl on a Rooftop* (recto)
and *Man in a Gondola Sketching* (verso)

PROVENANCE

The artist to Ramón Subercaseaux; thence by descent in the Subercaseaux family; Coe Kerr Gallery, New York, 1985; Walter Schwab, 1985; Adelson Galleries, New York, 1991; Gulf States Paper Corporation, Tuscaloosa, Alabama, 1991; Adelson Galleries, New York, June 1994; Berger Collection at The Denver Art Museum, Colorado.

EXHIBITIONS

New York 1985, no. 33, ill.; Japan 1989, no. 3; New York 1994, no. 25, ill.

LITERATURE

Japan 1989, pp. 45, 135, ill. p. 45 (colour); Ratcliff 1982, p. 44.

709 *Capri Peasant—Study*

PROVENANCE

Emily Sargent, 1925; Violet Sargent (Mrs Francis Ormond), 1936; her son, Jean-Louis Ormond, 1955; his heirs, 1986; private collection.

EXHIBITIONS

New York, SAA, 1881, no. 73, as 'Capri Peasant—Study'; Paris, rue Vivienne, 1882; Boston 1899, no. 79, as 'Profile of a Café Girl'; Liverpool 1925, no. 153; London, RA, 1926, no. 218, as 'A Capri Girl'; London, Tate, 1926, unnumbered; Leeds 1979, no. 3, as 'Head of Ana-Capri Girl'; Williamstown 1997, no. 5; London 1998, no. 4; Seattle 2000, no. 6; New York, Adelson Galleries, 2003, no. 6; New York 2004, unnumbered.

LITERATURE

'Some American Artists. Various Notable Pictures in the Exhibition', *New York Times,* 15 April 1881, p. 5; Edward Strahan [Earl Shinn], 'Exhibition of the Society of American Artists', *Art Amateur,* vol. 4, no. 6 (May 1881), p. 117; *Critic,* 4 June 1881, p. 153; William C. Brownell, 'The Younger Painters of America. III', *Scribner's Monthly,* vol. 12, no. 3 (July 1881), engraving by Elbridge Kingsley, ill. p. 321; Olivier Merson, 'Exposition des Artistes indépendants, rue Saint-Honoré, 251. Exposition du Cercle des arts libéraux, rue Vivienne, 49', *Le Monde Illustré,* vol. 50, no. 1303 (18 March 1882), p. 167; 'Nos Gravures. A Capri', *Le Monde Illustré,* vol. 53, no. 1377 (18 August 1883), engraving by Charles Baude, ill. p. 97; Boston 1899, p. 17; Cortissoz 1913, p. 238; Pousette-Dart 1924, ill. n.p.; Downes 1925, 1926 (listed twice), p. 172, as 'A Capri Girl', and p. 264 as 'Profile of a Café Girl'; Jacomb-Hood 1925, p. 236; London 1926, p. 33; Charteris 1927, p. 282, as 'A Capri Girl', dated 1882, ill. facing p. 48; Mount 1955, p. 428 (783), as 'A Capri Girl'; 1957 ed., p. 336 (783); 1969 ed., p. 459 (783), as 'Study Head for the Capri Girl'; McKibbin 1956, p. 120, as 'Head of Ana-Capri Girl'; Ormond 1970, pp. 22, 236, as 'Head of a Capri Girl'; Leeds 1979, p. 22, ill.; Ratcliff 1982, p. 41, pl. 53; Robertson 1982, pp. 22–23, fig. 8; Simpson 1997, pp. 37, 62, 86, 175, ill. p. 86 (colour); London 1998, pp. 66, 68, ill. p. 67 (colour); Adelson *et al.* 2003, pp. 13, 26–27, 56, pl. 6 (colour); Gallati *et al.* 2004, pp. 58, 70, 211–13, 242–43, ill. p. 211, pl. 77 (colour).

710 *Head of Rosina*

PROVENANCE

Presented by the artist to Frank Hyde, probably in 1878, and subsequently, according to the family, lost; apparently sold at an unknown date and by an unknown vendor to Edward Middleton Johnson; his sale, Alfred Savill & Sons, held at Park Grange, Sevenoaks, Kent, 26, 27 and 31 May and 1 and 2 June 1948; sold to a private collection; Christie's, New York, 5 June 1997, lot 27 (withdrawn); private collection; Berger Collection at The Denver Art Museum, Colorado.

EXHIBITIONS

Portland Museum of Art, Maine, *John Singer Sargent,* 3 July–25 September 1999, unnumbered (no catalogue); Los Angeles 2003, unnumbered (exhibited Denver only).

LITERATURE

Hyde 1914, p. 286.

711 *Stringing Onions*

PROVENANCE

Early provenance unknown; Harold Parsons (dealer) to Doll and Richards, Boston, 28 May 1926, as 'Italian Interior, Capri'; Harold Parsons, 15 January 1927; Newhouse Galleries, New York; Mrs Walter Harrison Fisher, Los Angeles, c. 1928–30; her daughter, Mrs G. Bromley Oxman, 1953; by family descent to 1983; Christie's, New York, 3 June 1983, lot 98, ill. sale cat., n.p. (colour); Coe Kerr Gallery, New York; private collection.

EXHIBITIONS

San Diego 1935, no. 627, as 'Italian Interior'; San Francisco 1984, no. 59; New York, Adelson Galleries, 2003, no. 4.

LITERATURE

Art News, vol. 28 (15 March 1930), ill. p. 24; Lovell 1984, pp. 106–7 (where it is said to be Venice, c. 1882), ill. p. 57 (colour); Adelson *et al.* 2003, p. 52, pl. 4 (colour).

712 *Rosina*

PROVENANCE

Louis Schoutetten; subsequent history unrecorded; private collection, Jerusalem; Adelson Galleries, New York, 2003; private collection.

EXHIBITION

New York, Adelson Galleries, 2003, no. 5.

LITERATURE

Adelson *et al.* 2003, pp. 12–13, 54, pl. 5 (colour).

713 Head of a Capri Girl
PROVENANCE
The artist's sisters; almost certainly presented by them to Sir Alec Martin of Christie's, London, c. 1925; his daughter, Mary Martin (Lady Flett), to 2005; Christie's, New York, 1 December 2005, lot 43, as 'Study of Rosina Ferrara'; private collection.
EXHIBITION
London, RA, 1926, no. 362, as 'Mlle L. Cagnard'.
LITERATURE
London 1926, p. 54, as 'Mlle L. Cagnard'; Charteris 1927, p. 258, dated 1882, as 'Mlle L. Cagnard'; Mount 1955, p. 428 (789), as 'Head of a Capri Girl (called Mlle L. Cagnard); 1957 ed., p. 336 (789); 1969 ed., p. 459 (789); Mount, *Art Quarterly,* 1957, pp. 312–13, fig. 6; Ormond 1970, p. 236; *Early Portraits,* p. 73 (where it is referred to as a 'study of Rosina Ferrara').

714 Head of a Capri Girl
PROVENANCE
Gift of the artist to Sir Philip Sassoon, before 1925; his sister, Sybil, Marchioness of Cholmondeley, 1939; her heirs, 1989; private collection.
EXHIBITIONS
London, RA, 1926, no. 365 as 'Head of a Sicilian Girl'; Birmingham 1964, no. 4; Detroit 1983, no. 58; London 1998, no. 7; Ferrara 2002, no. 3; Los Angeles 2003, unnumbered; New York, Adelson Galleries, 2003, no. 7.
LITERATURE
Downes 1926, pp. 359, 390, as 'Head of a Sicilian Girl'; London 1926, p. 55; Charteris 1927, p. 288, as 'Head of a Sicilian Girl', dated 1907; Mount 1955, p. 428 (788); 1957 ed., p. 336 (788); 1969 ed., p. 459 (788); Ormond 1970, pp. 22, 236, pl. 10 (colour); Ratcliff 1982, pp. 43–44, pl. 54 (colour); Kathleen A. Pyne in *The Quest for Unity: American Art between World's Fairs 1876–1893,* The Detroit Institute of Arts, 1983, pp. 128–29, ill. p. 129 (exhibition catalogue); London 1998, pp. 71–72, ill. (colour); Prettejohn 1998, p. 16, ill. fig. 9 (colour); Ferrara 2002, p. 166, ill. p. 167 (colour); Adelson *et al.* 2003, p. 58, pl. 7 (colour); Ormond in Robertson *et al.* 2003, p. 55, ill. (colour).

715 A Neapolitan Boy
PROVENANCE
The artist's sale, Christie's, London, 27 July 1925, lot 205, as 'A Neapolitan Boy', bt. Thomas Agnew & Sons Ltd for Alvan T. Fuller; his daughter, Lydia Fuller (Mrs George T. Bottomley), 1958; Sotheby Parke Bernet, New York, 4 June 1982, lot 14, as 'Head of a Neapolitan Boy' (dated 1879), ill. sale cat., n.p. (colour); private collection.
EXHIBITIONS
Boston, MFA, 1925, no. 133 (137); Worcester c. 1927, unnumbered; Boston 1928, no. 39.
LITERATURE
Christie's 1925, p. 29; Boston 1925, 1925a, p. 14; Downes 1926, p. 333, as 'Head of a Neapolitan Boy'; Charteris 1927, p. 280, dated 1879; Mount 1955, p. 428 (785), as 'Neapolitan Boy (three-quarter face)'; 1957 ed., p. 336 (785); 1969 ed., p. 459 (785).

716 Sketch of a Neapolitan Boy
PROVENANCE
The artist's sale, Christie's, London, 27 July 1925, lot 208, as 'Head of a Neapolitan Boy, wearing a red cap', bt. Thomas Agnew & Sons for Alvan T. Fuller; his daughter, Lydia Fuller (Mrs George T. Bottomley), 1958; sold Sotheby Parke Bernet, New York, 4 June 1982, lot 15, as 'Head of a Neapolitan Boy in Profile' (dated 1879), ill. sale cat., n.p., (colour); George Ablah; Berry-Hill Galleries, New York, 1984; Coe Kerr Gallery, New York, 1986; private collection; Adelson Galleries, New York, 1999; private collection.
EXHIBITIONS
Boston 1899, no. 61, as 'Sketch of a Neapolitan Boy'; Boston, MFA, 1925, no. 134 (138); Worcester c. 1927, unnumbered.
LITERATURE
Boston 1899, p. 14; *The Book of Italy* [for the Italian Red Cross], 1916,

ill., n.p. (colour); Christie's 1925, p. 29; Boston 1925, 1925a, p. 14; Downes 1925, 1926, p. 122, as 'Sketch of a Neapolitan Boy'; Downes 1926, p. 333; Charteris 1927, p. 280 (where there are three entries for the two heads of a 'Neapolitan Boy'); Mount 1955, p. 428 (784), as 'Neapolitan Boy (profile)'; 1957 ed., p. 336 (784); 1969 ed., p. 459 (784).

717 The Little Fruit Seller
PROVENANCE
Mrs Léonie de Chelminski; on consignment to M. Knoedler & Co., New York, 14 May 1935 (stock no. CA 878); bt. Frederick H. Prince, July 1936; to his widow, Mrs Virginia M. Prince, 1962; Sotheby's, New York, 30 November 1989, lot 143, ill. sale cat., n.p. (colour); bt. Wendell Cherry, 1989; Sotheby's, New York, 25 May 1994, lot 90, ill. sale cat., n.p. (colour); Guggenheim Asher Associates, New York; private collection.
EXHIBITION
New York 1935, no. 9.
LITERATURE
Mount 1955, p. 442 (K791); 1957 ed., p. 352 (K791); 1969 ed., p. 460 (K791); Gallati *et al.* 2004, p. 208, ill. pl. 72 (colour).

718 Head of an Italian Boy
PROVENANCE
The artist to Charles Édouard Du Bois, as a gift, or in exchange for a work by Du Bois; Du Bois's gift to Mr [Louis?] Favre, 1885; his nephew, Charles Édouard Bovet, 1890; his son, Edgar Bovet, 1935; his daughter, Mrs Huguette Bovet, 1952; her daughter, 1966; private collection.

719 Staircase in Capri
PROVENANCE
Auguste Alexandre Hirsch, Paris; Mme Hirsch, 1912; sold to M. Knoedler & Co., London, 7 January 1914 (stock no. 5779); to M. Knoedler & Co., New York (stock nos. WC 962); sold to Dr George Woodward, Philadelphia, January 1919; his son, Stanley Woodward; Ross Whittier; Constance Coleman; Alan Dillenberg; Ira Spanierman, New York, 1988; Pamela Harriman, 1990; Sotheby's, New York, 19 May 1997, lot 91, ill. sale cat., n.p. (colour); private collection.
EXHIBITIONS
New York 1925, no. 13; Boston, MFA, 1925, no. 1, as 'Study of a Staircase'; West Palm Beach 1987, no. 62; London 1998, no. 6 (exhibited London only).
LITERATURE
Boston 1925, p. 3, dated 1874; Boston 1925a, p. 3; Downes 1925, 1926, p. 261, as 'Study of a Staircase'; Charteris 1927, p. 280, dated 1874; Mount 1955, p. 442 (K782), as 'Study of a Staircase. Capri' (where the date has been deciphered as 1875); 1957 ed., p. 352 (K782); 1969 ed., p. 459 (K782); Weber and Gerdts 1987, pp. 11, 118, ill. p. 106; Carol Vogel, 'A Sale of Pamela Harriman's Style and Taste, and the Result is a Proper Success', *New York Times,* 20 May 1997, p. B3; London 1998, p. 71, ill. p. 70 (colour).

720 Ricordi di Capri
PROVENANCE
M. Charmoz, Paris; Parke-Bernet Galleries, Inc., New York, 9 December 1959, lot 45; Hirschl & Adler Galleries, New York, 1960; sold to Dr and Mrs Irving Burton, 29 January 1960; Sotheby Parke Bernet, New York, 18 October 1972, lot 23, ill. sale cat., n.p.; [Robert] Mann Galleries, Miami, Florida, 1972; Mr and Mrs Danzig, New Jersey, 1973; Coe Kerr Gallery, New York, 1986; private collection; Adelson Galleries, New York, 2003; private collection.
EXHIBITIONS
Flint 1961, no. 43; Detroit 1962, no. 102; Japan 1989, no. 4; New York 2004, unnumbered.
LITERATURE
Japan 1989, pp. 46, 135, ill. p. 46 (colour); Gallati *et al.* 2004, p. 15, ill. p. 17, pl. 1 (colour).

721 *In the Luxembourg Gardens*

PROVENANCE

Purchased in Paris by John H. Sherwood, 1879; in the sale of 'Valuable Paintings, the Collections of Mr. John H. Sherwood and Mr. Benjamin Hart', George A. Leavitt & Co., Chickering Hall, New York, 17–18 December 1879, lot 61, as 'The Luxembourg Gardens', probably bt. in; Williams and Everett Gallery, Boston, 1882; Joseph M. Lichtenauer, New York, 1884; on consignment from him to M. Knoedler & Co., New York, February 1887, as 'Summer Evening in Luxembourg'; sold to John G. Johnson, Philadelphia, 27 May 1887, as 'The Luxembourg garden, twilight'; John G. Johnson Collection, Philadelphia Museum of Art.

EXHIBITIONS

New York, National Academy of Design, *The Collections of Mr. John H. Sherwood and Mr. Benjamin Hart,* 1879, no. 61, as 'The Luxembourg Gardens'; Boston, Williams and Everett Gallery, 1882; New York, The American Fine Arts Society, *Loan Exhibition,* February 1893, no. 26, as 'Luxembourg Gardens, Paris'; Washington, D.C., Corcoran Gallery of Art, *Third Exhibition of Oil Paintings by Contemporary American Artists,* 13 December 1910–22 January 1911, no. 7, as 'Garden of Versailles'; Pittsburgh, Carnegie Institute, *The Fifteenth Annual Exhibition,* 27 April–30 June 1911, no. 236, as 'Garden of Versailles', ill. cat., n.p.; New York, Whitney Museum of American Art, *A Century of American Landscape Painting 1800–1900,* 19 January–25 February 1938, no. 70, as 'Summer Evening in the Luxembourg Gardens'; Pittsburgh, Carnegie Institute, Department of Fine Arts, *Survey of American Painting,* 24 October–15 December 1940, no. 196; Philadelphia Museum of Art, *Art in the United States,* 20 June–13 September 1942 (no catalogue); Palm Beach, Florida, The Society of the Four Arts, *From Plymouth Rock to the Armory,* 9 February–5 March 1950, no. 47; Washington, D.C., Corcoran Gallery of Art, *Twenty-Fifth Biennial Exhibition of Contemporary American Paintings,* 13 January–10 March 1957, no. 30; New York, Whitney Museum of American Art, *The Painter's America: Rural and Urban Life, 1810–1910,* 1974, no. 94; Dayton 1976, no. 42; New York and Chicago 1986, unnumbered; New York 1994, no. 63; London 1998, no. 16; Oklahoma City Museum of Art, *Americans in Paris: 1850–1910,* 4 September–30 November 2003, no. 102, ill. cat. p. 18.

LITERATURE

'Paintings on the Block', *New York Times,* 18 December 1879, p. 5; E. S. [Edward Strahan], 'The Hart-Sherwood Collection', *Art Amateur,* vol. 2, no. 2 (January 1880), pp. 30–31; 'John S. Sargent', *Art Amateur,* vol. 2, no. 6 (May 1880), p. 118; 'The Fine Arts, Gallery and Studio Notes', *Boston Daily Advertiser,* 16 December 1882, p. 10; *Johnson Collection Catalogue of Paintings,* Philadelphia, 1892, p. 69, no. 211, as 'Versailles Garden'; Thomas Wells Watson, 'Carnegie Exhibition', *Fine Arts Journal,* 25 September 1911, p. 139; W. R. Valentiner, *Modern Paintings,* vol. 3 of *Catalogue of a Collection of Paintings and Some Art Objects,* Philadelphia, J. G. Johnson, 1914, pp. 148–49, no. 1080; Hamilton Bell, 'Temporary Exhibition from the Johnson Collection', *Pennsylvania Museum Bulletin* [now Philadelphia Museum of Art], no. 66 (1920), p. 10; Christian Brinton, 'The Johnson "Modern Group"', *International Studio,* vol. 76 (October 1922), p. 12, ill. p. 7; Mechlin 1924, p. 170; Downes 1925, 1926, pp. 9–10, 123; Charteris 1927, pp. 49, 280, as 'Luxembourg Gardens'; Mather 1931, p. 240; *Johnson Collection Catalogue of Paintings,* Philadelphia, 1941, p. 66, no. 1080; Henri Marceau, 'Art in the United States', *Philadelphia Museum of Art Bulletin,* vol. 37, no. 194 (May 1942), ill. p. 5; *Johnson Collection: Two Hundred and Eighty-eight Reproductions,* Philadelphia, 1953, ill. p. 263; Chicago 1954, p. 45; Mount 1955, p. 442 (K793), as 'Luxembourg Gardens at Twilight'; 1957 ed., p. 352 (K793); 1969 ed., p. 460 (K793); Ormond 1970, p. 237; Patricia Hills, *The Painter's America: Rural and Urban Life, 1810–1910,* New York, 1974, p. 97, ill. p. 103, fig. 125 (exhibition catalogue); Quick 1976, p. 129, ill. cover (colour) and p. 130; Ratcliff 1982, pp. 50, 55, ill. p. 51, pl. 64; *New York Times,* 11 November 1984, p. 53; Adelson in Adelson *et al.* 1986, pp. 30–31, ill. p. 30, fig. 10; Hills in Hills *et al.* 1986, pp. 31–32, 286, ill. p. 45, fig. 17 (colour); Weinberg 1991, ill. p. 68, fig. 75 (detail), and p. 81, fig. 83 (both in colour); Weinberg *et al.* 1994, pp. 135–38, 143, 150, 154, 325–26, n. 24 (where J. Mortimer Lichtenauer is incorrectly given as an owner), 366–67, ill. p. 137, fig. 125 (colour); Eleanor Dwight, *The Gilded Age: Edith Wharton and Her Contemporaries,* New York, 1996, ill. p. 59 (colour); Adelson in Adelson *et al.*

1997, p. 12; Simpson 1997, pp. 28, 172, no. A10, ill. p. 173; London 1998, pp. 84–85, ill. p. 86 (colour).

722 *The Luxembourg Gardens at Twilight*

PROVENANCE

Given by the artist to Charles Follen McKim; his daughter, Margaret McKim (Mrs William J. M. A. Maloney), 1909; The Minneapolis Institute of Arts, Gift of Mrs C. C. Bovey and Mrs C. D. Velie, 1916.

EXHIBITIONS

Buffalo Fine Arts Academy, The Albright Art Gallery, *Thirteenth Annual Exhibition of Selected Paintings by American Artists,* 24 May–8 September 1919, no. 96; Boston, MFA, 1925, oil paintings, no. 7 (7); New York 1926, paintings in oil, no. 2; Baltimore Museum of Art, *A Survey of American Painting,* 10 January–28 February 1934, no. 28, ill. cat. p. 33; New York, The Metropolitan Museum of Art, *Landscape Paintings,* 14 May–30 September 1934, no. 77; Pittsburgh, Carnegie Institute, *A Century of American Landscape Painting 1800–1900,* 22 March–30 April 1939, no. 17; Chicago 1954, no. 41; The Minneapolis Institute of Arts, *Fortieth Anniversary: Exhibition of Forty Masterpieces,* 12 January–25 February 1955 (no catalogue); Grand Rapids 1955, no. 22; Pittsburgh 1957, no. 108; Washington 1964, no. 6; Minneapolis, Farmers and Mechanics Bank, 7–30 June 1965 (no catalogue traced); The Minneapolis Institute of Arts, *Great Expectations,* 1 June–15 July 1979, no. 13 (no catalogue); The Minneapolis Institute of Arts, *Donors and Directors: A Century of Collecting,* part 1, 9 January–18 July 1983 (no catalogue); the following five institutions: Carnegie Museum of Art, Pittsburgh; The Minneapolis Institute of Arts; The Nelson-Atkins Museum of Art, Kansas City, Missouri; the Saint Louis Art Museum; and the Toledo Museum of Art, Ohio, *Made in America: Ten Centuries of American Art,* 1995, unnumbered; Stanford University, California, Iris and B. Gerald Cantor Center for Visual Arts, *The Changing Garden,* 11 June–17 September 2003, no. 117, ill. cat., n.p. (exhibition travelled, but this picture was shown only at Stanford).

LITERATURE

'A Painting by John Sargent', *Bulletin of The Minneapolis Institute of Arts,* vol. 5, no. 4 (April 1916), pp. 25–26, ill. p. 25; *Handbook of The Minneapolis Institute of Arts,* Minneapolis, 1917, p. 81, ill.; 'The Thirteenth Annual Exhibition of Selected Paintings by American Artists at the Albright Art Gallery', *Academy Notes, Buffalo Fine Arts Academy, Albright Art Gallery,* vol. 14, no. 3 (July–September 1919), p. 77, ill. p. 79; Pousette-Dart 1924, ill., n.p.; Boston 1925, p. 3; Downes 1925, 1926, pp. 9, 122–23; 'Landscape by Sargent lent to Boston', *Bulletin of The Minneapolis Institute of Arts,* vol. 14, no. 12 (7 November 1925), p. 74, ill. p. 75; New York 1926, p. 3, ill. n.p.; H. B. Wehle, 'The Sargent Exhibition', *Bulletin of The Metropolitan Museum of Art, New York,* no. 21 (1926), p. 3; Charteris 1927, pp. 49, 280; Chicago 1954, p. 45, ill.; Mount 1955, p. 442 (K792); 1957 ed., p. 352 (K792); 1969 ed., p. 460 (K792); Lansdale 1964, p. 79, ill. p. 61; Sutton 1964, p. 398; E. P. Richardson, *Painting in America,* New York, 1965, p. 282; Denys Sutton, 'The Luminous Point', *Apollo,* vol. 75, no. 13 (March 1967), p. 221, ill. p. 220, fig. 13; Ormond 1970, pp. 22, 237, ill. pl. 14; Richard J. Boyle, *American Impressionism,* Boston, 1974, p. 67, ill. p. 68; New York 1980, checklist, n.p.; Ratcliff 1982, pp. 50, ill. p. 51, fig. 66; John Milner, *The Studios of Paris,* New Haven and London, 1988, p. 199, ill. p. 198, fig. 247 (colour); Sandra LaWall Lipschultz, *Selected Works: The Minneapolis Institute of Arts,* Minneapolis, 1988, p. 206, ill. (colour); *Made in America: Ten Centuries of American Art,* New York, 1995, p. 71, ill. (colour) (exhibition catalogue).

723 *Rehearsal of the Pasdeloup Orchestra at the Cirque d'Hiver*

PROVENANCE

Presented by the artist to Sir George Henschel at an unknown date; Sir George Henschel's sale, Christie's, London, 14 July 1916, lot 21; M. Knoedler & Co., New York (stock no. 13907); bt. Charles Deering, October 1916; his daughter, Mrs Chauncey McCormick; private collection; on loan to The Art Institute of Chicago.

EXHIBITIONS

Boston 1899, no. 92;[3] Chicago 1921, no. 169; Chicago 1933, no. 478, as 'Rehearsal of the Lamoureux Orchestra, Paris'; Chicago 1934, no. 410,

as 'Rehearsal of the Lamoureux Orchestra, Paris'; Chicago 1954, no. 38 (dated 1876); New York and Chicago 1986, unnumbered.

LITERATURE
Coffin 1896, p. 172; Boston 1899, p. 16; Charteris 1927, p. 223, as 'Rehearsal of the Bas de Loup Orchestra' [sic]; Mount 1955, p. 442 (K785), dated 1878; 1957 ed., p. 352 (K785), dated 1878; 1969 ed., p. 459 (K785), dated 1878; Ormond 1970, p. 236; Hills in Hills et al. 1986, p. 31, ill. p. 44, fig. 16 (colour); Olson 1986, p. 54.

3. Installation photographs for Sargent's one-man show in 1899 at Copley Hall in Boston confirm that this picture, rather than no. 724, was no. 92 in that exhibition.

724 Rehearsal of the Pasdeloup Orchestra at the Cirque d'Hiver

PROVENANCE
Acquired from the artist by Henry A. Bacon, probably by 1883; his widow, Mrs Henry Bacon, later Mrs Frederick L. Eldridge, 1912; Doll & Richards, Boston; purchased by the Museum of Fine Arts, Boston, Charles Henry Hayden Fund, 1922.

EXHIBITIONS
Probably Boston, St Botolph Club, 1883, no. 10; Boston, MFA, 1925, no. 3 (no. 2); New York, MMA, 1926, no. 1; Hartford 1935, no. 33; San Francisco 1935, no. 119; Hartford 1955, no. 73; New York 1959, no. 24; Washington 1959, no. 13; Paris 1963, no. 1; Washington 1964, no. 1; Boston 1973, no. 126; New York 1980, no. 5; London 1998, no. 15; Seattle 2000, no. 16.

LITERATURE
Bacon 1883, ill. facing p. 202; 'The Home of Mr F. L. Eldredge [sic]', Country Life in America, vol. 37, no. 3 (January 1920), ill. p. 54 (in situ); Boston 1925, p. 3, dated 1876; Downes 1925, pp. 119–20, dated 1876; New York 1926, p. 3, dated 1876, ill. n. p.; Charteris 1927, pp. 43, 280, dated 1876; Mount 1955, p. 442 (K784); 1957 ed., p. 352 (K784); 1969 ed., p. 459 (K784); Boston 1969, pp. 223–24, no. 853, ill. fig. 450; Ormond 1970, pp. 22, 28, 236, ill. pl. 8; Ratcliff 1982, ill. p. 38, fig. 47; Olson 1986, p. 54; Troyen et al. 1997, ill. p. 239; London 1998, pp. 83, 84, ill. (colour); Fairbrother 2000, p. 56, ill. fig. 2.11 (colour).

725 Woman in Furs

PROVENANCE
Possibly Hippolyte de Vergèses; Mlle Hess; M. Knoedler & Co., Paris, 28 April 1915 (stock no. 5922); Robert Sterling Clark, 29 April 1915; shipped to Knoedler, New York, for delivery (stock no. 13602); Sterling and Francine Clark Art Institute, Williamstown, Massachusetts.

EXHIBITIONS
Williamstown 1957, unnumbered, ill. cat. pl. LIX; New York, CKG, 1980, no. 8, as 'Femme aux Fourrures'; Williamstown, Massachusetts, Williams College Museum of Art, Highlights of American Art, 2 March–28 June 1992 (no catalogue); Williamstown, Massachusetts, Sterling and Francine Clark Art Institute, American Art at the Clark, 31 October 1992–28 March 1993 (no catalogue).

LITERATURE
Charteris 1927, p. 264, dated 1891, as 'D. Vergères. Inscr. "A mon ami Vergères"'; Mount 1955, p. 444 (K815), dated 1881, as 'Femme avec Fourrures', and secondly (following Charteris), p. 433 (912), dated 1891, as 'D Vergères'; 1957 ed., p. 354 (K815), and p. 342 (912); 1969 ed., p. 459 (K815), dated 1879; Ormond 1970, p. 236, ill. pl. 7, as 'La Femme aux Fourrures'; List of Paintings in the Sterling and Francine Clark Art Institute, Williamstown, Massachusetts, 1970, p. 43, as 'Femme aux Fourrures'; Williamstown 1972, p. 100, ill. p. 101; New York 1980, p. 21, as 'Femme aux Fourrures', ill.; Ratcliff 1982, p. 57, ill., as 'La Femme aux Fourrures'; Williamstown 1984, p. 34, ill. p. 103, fig. 410; Clark Art Institute 1990, pp. 177–79, ill. p. 178 (colour), as 'Woman with Furs'; Williamstown 1992, ill. p. 101, ill.; Simpson, Antiques, 1997, ill. p. 557, pl. V (colour).

726 A Young Girl Seeking Alms

PROVENANCE
Albert Gustav Edelfelt; his widow Ellan Edelfelt (secondly, Ellan von Born); sold by Dr Tancred Borenius, presumably on behalf of the widow, to M. Knoedler & Co., London, 7 July 1922 (stock no. 6912), as 'A Spanish Beggar Girl'; shipped to Knoedler, New York, 20 September 1922 (stock no. 15413); Paul Schulze of Chicago, October 1922; his daughter, Helen Schulze Burch, and thence by descent; sold Sotheby's, New York, 25 May 1994, lot 66, as 'A Parisian Beggar Girl', ill. cat., n.p. (colour); Terra Museum of American Art, Chicago, 1994.

EXHIBITIONS
On loan from Ellan Edelfelt to the Finnish Art Association's Gallery, The Ateneum (now The Ateneum Art Museum; The Finnish National Gallery), Helsinki, 1906–12; Boston, MFA, 1925, oil paintings, no. 12 (12), as 'The Parisian Beggar Girl', dated 1880; New York, MMA, 1926, paintings in oil, no. 3, as 'The Parisian Beggar Girl', dated 1880; Virginia Museum of Fine Arts, Richmond, The Burch-Schulze Collection of Masterpieces of American Painting, 9 October–22 November 1937, no. 30, as 'The Parisian Beggar Girl'; Dallas Museum of Fine Arts, exhibition celebrating the installation of the American Collection in the new east wing of the building, 19 May–1 September 1975, as 'Parisian Beggar Girl' (no catalogue); on loan to the Dallas Museum of the Fine Arts, 1975–81, 1985–89; Giverny 1992, unnumbered (shown only in the 1995 version of the exhibition); Giverny, Musée d'Art Américain, Un regard américain sur Paris ('An American Glance at Paris'), 11 April–31 October 1997, unnumbered, cat. p. 94, ill. p. 92; Chicago, Terra Museum of American Art, American Artists and the Paris Experience, 22 November 1997–8 March 1998; Giverny, Musée d'Art Américain, Giverny: une impression américaine, 1 April–1 November 1998; Giverny, Musée d'Art Américain, Ville et campagne: les artistes américains, 1870–1920 ('The City and the Country: American Perspectives, 1870–1920'), 1 April–15 July 1999, cat. p. 16, ill. fig. 11; also shown at the Terra Museum of American Art, Chicago, 10 December 1999–7 May 2000; Giverny, Musée d'Art Américain, Héroïque: les artistes américains, 1820–1920 ('The Extraordinary and the Everyday: American Perspectives, 1820–1920'), 1 April–30 November 2001, ill. cat., p. 36; Giverny 2002; Chicago 2002; Chicago 2003; Chicago, Terra Museum of American Art, American Classics, 13 December 2003–8 February 2004; New York 2004, unnumbered.

LITERATURE
[The Ateneum, Helsinki], Finska konstföreningens matrikel för 1906 (Helsinki, 1907), p. 9; (Original) Artists and Models Magazine, Floral Park, Long Island, vol. 1, no. 7 (February 1926), ill. p. 17; Boston 1925, 1925a, p. 4, as 'The Parisian Beggar Girl'; Downes 1925, 1926, p. 124, ill. facing p. 16, as 'A Spanish Beggar Girl'; New York 1926, p. 3, ill. n.p., as 'The Parisian Beggar Girl'; Charteris 1927, p. 51, as 'Spanish Beggar Girl', p. 281, dated 1880, as 'The Parisian Beggar Girl'; listed repetitiously, p. 282, as 'A Spanish Beggar Girl'; The Burch-Schulze Collection of Masterpieces of American Painting, Virginia Museum of Fine Arts, Richmond, 1937, p. 11, ill. p. 16 (exhibition catalogue); Mount 1955, p. 443 (K8010), dated 1880, as 'Beggar Girl'; 1957 ed., p. 353 (K8010); 1969 ed., p. 462 (K8010), where located in the Chicago Art Institute; McKibbin 1956, p. 84, under Carmela Bertagna, where located in the Schulze Memorial Room, Chicago Art Institute; Early Portraits, 1998, p. 34; Bourguignon and Kennedy 2002, pp. 96, 202, ill. pp. 14 (colour), 204; Gallati et al. 2004, pp. 213, 215, 238, n. 74, 241, ill. p. 214, pl. 79 (colour).

727 Study of a Bust at Lille

PROVENANCE
Emily Sargent, 1925; Violet Sargent (Mrs Francis Ormond), 1936; her son, H. E. Conrad Ormond, 1955; his heirs, 1979; private collection.

EXHIBITIONS
London, Grafton Galleries, Fair Women, London, 1894, no. 224, as 'Painting of the Wax Bust in the Museum at Lille'; Boston 1899, no. 71, as 'Study of a Bust at Lille'.

LITERATURE
Boston 1899, p. 17; Art Amateur, vol. 40, no. 5 (April 1899), p. 95; Cortissoz 1913, p. 241; Minchin 1925, p. 738; Downes 1925, 1926, p. 155; Charteris 1927, p. 296, undated; Mount 1955, p. 453 (XK16), undated; 1957 ed., p. 363 (XK16); 1969 ed., p. 459 (XK16), dated 1879, as 'Raphael's Wax Head at Lille'.

728 *Head of Prince Baltasar Carlos, after Velázquez*

PROVENANCE

The artist's sale, Christie's, London, 27 July 1925, lot 231, bt. Van der Neut, as 'The Prince Balthazar Carlos, after Velasquez'; Felix Gouled; French & Company, New York, 17 July 1944; sold to Samuel H. Vallance, Southampton, Long Island, July 1957; sold by him, Christie's, London, 16 June 1961, lot 73, bt. K. E. Maison, ill. sale cat., p. 21, as 'Don Baltasar Carlos—*after the picture in the Prado by Velasquez*'; private collection.

LITERATURE

Christie's 1925, p. 31; 'Almost a Million at Sargent Sale', *Art News*, vol. 23, no. 39 (15 August 1925), p. 4; '£175,260 for Sargents', *Daily Mail*, London, 28 July 1925, p. 7, ill.; 'Sargent Sale Ended', *Daily Telegraph*, London, 28 July 1925, p. 13; *Le Figaro Artistique*, Paris, no. 84 (15 October 1925), p. 14, where confused with 'Portrait d'un Bouffon de Philippe IV' (no. 736); 'Sargent Sale Total Nears $1,000,000 Mark', *New York Times*, 28 July 1925, p. 5; *The Year's Art*, London, 1926, p. 298; Downes 1926, p. 335, as 'The Prince Balthazar Carlos, after Velasquez'; Charteris 1927, p. 281, dated 1880, as 'Prince Balthazar Carlos. After Velasquez'; Mount 1955, pp. 64, 443 (K7913), dated 1879, as '(Copy of Vélasquez) Prince Balthazar Carlos' [*sic*]; 1957 ed., pp. 57, 352 (K7913); 1969 ed., pp. 64, 460 (K7913); *Arts*, New York, vol. 31, no. 8 (May 1957), p. 6, ill. (advertisement for French & Company); *Times*, London, 17 June 1961, p. 6e; Nahum 1993, p. 335; Oustinoff in Adelson *et al.*, 1997, pp. 234 and 235, n. 23; Simpson 1998, pp. 3–4; Ormond and Pixley 2003, pp. 635, 637 and n. 26, 640, ill. p. 635, fig. 19.

729 *Buffoon Juan Calabazas, after Velázquez*

PROVENANCE

Emily Sargent, before 1908; Violet Sargent (Mrs Francis Ormond), 1936; her daughter, Reine Ormond (Mrs Hugo Pitman), 1955; sold by her, Christie's London, 27 October 1961, lot 90, as 'The Idiot of Coria', bt. Peter Nicholson; Parke-Bernet Galleries, New York, 13–14 March 1964, lot 276, picture attributed to Sargent, as 'Portrait of the Dwarf Calabazas', and again 17–18 December 1964, lot 233; Alex Acevedo, New York, 1995; Jim Alterman, Lambertville, New Jersey; David David, Philadelphia, 2002; Agnew's, London, 2003; private collection, Paris.

EXHIBITION

London 1908, no. 99, as 'El Bobo (Idiot) de Coria'.

LITERATURE

London, 1908, p. 14; Mount 1969 ed., p. 460 (K7928), as 'The Idiot of Coria'; Tinterow *et al.* 2003, p. 398, ill. p. 399, fig. 14.78 (colour), as 'The Jester Calabazas, Copy after Velázquez'; Ormond and Pixley 2003, pp. 634, 635 and n. 18, 637, 640, ill. p. 632, fig. 13 (colour).

730 *Las Meninas, after Velázquez*

PROVENANCE

Emily Sargent, by 1908; Violet Sargent (Mrs Francis Ormond), 1936; her son, H. E. Conrad Ormond, 1955; consigned to M. Knoedler & Co., New York, 4 June 1965, and returned to owner, post 20 June 1969 (Knoedler stock no. CA 7193); Conrad Ormond's heirs, 1979; private collection.

EXHIBITIONS

London 1908, no. 97, as 'Las Meninas (*Velasquez*)'; London, RA, 1926, no. 364, as 'Copy of Velasquez' "Las Meninâs"'; London, Tate, 1926, unnumbered, as 'Copy of Velasquez' "Las Meninâs"'; Washington 1964, no. 10, as 'Study after Velasquez, "The Maids of Honor"'; M. Knoedler & Co., New York, *American Paintings: 1750–1950*, 20 May–20 June 1969, no. 74; Washington, D.C., Federal Reserve Board, *The Influence of Velázquez on Modern Painting: The American Experience*, 3 July–1 December 2000; Washington, D.C., Federal Reserve Board, *A Special Collection: Twenty-five Years of Art at the Federal Reserve Board*, November 2001, no. 2; New York 2003, no. 211.

LITERATURE

London 1908, p. 14; Laurence Binyon, 'Bond Street and Whitechapel', *Saturday Review*, vol. 105, no. 2737 (11 April 1908), p. 463; London 1926, p. 55; London, Tate, 1926, p. 10; Downes 1926, p. 358; Charteris 1927, p. 281, dated 1880; Mount 1955, p. 443 (K7911), dated 1879, as '(Copy of

Velásquez) Las Meninas'; 1957 ed., p. 352 (K7911); 1969 ed., p. 460 (K7911), as 'Las Menias' [*sic*]; Ormond 1970, p. 27; Ratcliff 1982, p. 75, ill. p. 77, pl. 108; Ayres in Hills *et al.* 1986, p. 54; Sidlauskas 1989, pp. xv, 156–59, 168–70, 178–80, ill. fig. 63; Weinberg 1991, p. 210; Washington 1992, pp. 32–33, ill. fig. 12; Nahum 1993, pp. 196–99, 343, ill. fig. 75; Boone 1996, p. 186; *Early Portraits*, p. 4, ill. fig. 7 (colour); London 1998, pp. 27, 98, ill. fig. 65; Simpson 1998, pp. 4, 6, ill. fig. 2 (colour); Goley 2000, pp. 4–5; Sidlauskas 2000, pp. 65, 173, n. 14; Kilmurray in Ferrara 2002, p. 39; Ormond in Robertson *et al.* 2003, p. 56; Tinterow *et. al.* 2003, pp. 298, 398, 529–30, ill. p. 298, fig. 10.43 (colour); Ormond and Pixley 2003, pp. 634, 635, 636 and n. 20, 637, 640, ill. p. 634, fig. 15 (colour).

731 *Prince Baltasar Carlos on Horseback, after Velázquez*

PROVENANCE

The artist's sale, Christie's, London, 27 July 1925, lot 233, as 'The Prince Balthazar Carlos, after Velazquez', bt. Thomas Agnew & Sons, for Alvan T. Fuller, Boston; Fuller Foundation, Boston, 1958; Christie's, London, 1 December 1961, lot 43, as 'Don Balthazar Carlos on Horseback, a sketch from the picture by Velazquez in the Prado', ill. sale cat., facing p. 15, bt. Agnew's; private collection.

EXHIBITIONS

Worcester c. 1927, unnumbered, as 'Prince Balthazar Carlos (Velasquez)'; Boston 1928, no. 37, as 'Prince Balthazar Carlos. (*Velasquez*)'; Boston 1959, no. 48, as 'Copy after Velasquez, "Don Balthasar Carlos on Horseback"', ill. cat., p. 30; Palm Beach 1961, no. 36; King's Lynn 1962, no. 1; Birmingham, 1964, no. 5, as 'Don Balthazar Carlos–Copy after Velasquez'.

LITERATURE

Christie's 1925, p. 31; 'Sargent Sale Ended', *Daily Telegraph*, London, 28 July 1925, p. 13; *Le Figaro Artistique*, Paris, no. 84 (15 October 1925), p. 14; *The Year's Art*, London, 1926, p. 298; Downes 1926, p. 335, as 'The Prince Balthazar Carlos, after Velazquez'; Charteris 1927, p. 281, dated 1880, as 'Prince Balthazar Carlos'; Worcester c. 1927, n.p.; Boston 1928, n.p.; Mount 1955, p. 443 (K7914), dated 1879, as '(Copy of Velásquez) Prince Balthazar Carlos'; 1957 ed., p. 352 (K7914); 1969 ed., p. 460 (K7914); Boston 1959, p. 30, ill.; Palm Beach 1961, n.p.; Theodore Crombie, 'Velázquez Observed New Looks at an Old Master', *Apollo*, vol. 78, no. 18 (August 1963), p. 128, ill. p. 127, fig. 10; Birmingham 1964, p. 8; Nahum 1993, pp. 197–99, 335; Simpson 1998, pp. 3–4; Ormond and Pixley 2003, pp. 634–35, 636, n. 23, 637, n. 25, 638, 640, ill. p. 635, fig. 18.

732 *Christ, after Ribera*

PROVENANCE

Untraced.

LITERATURE

Ormond and Pixley 2003, pp. 633–34 and n. 15, 640.

733 *Dwarf with a Dog, after Velázquez*

PROVENANCE

The artist's sale, Christie's, London, 27 July 1925, lot 229, as 'A Dwarf, after Velazquez' (inscription on back recorded in sale catalogue, 'Velasquez copied by J. S. Sargent, Madrid circa 1882'), bt. M. Knoedler & Co., London (stock no. 7579); shipped to Knoedler, New York, 2 October 1925; sold to Archer M. Huntington, July 1926 (stock no. 16260); Hispanic Society of America, New York. Gift of president and founder, Archer M. Huntington, 16 July 1926.

EXHIBITIONS

London 1908, no. 76; New York, Knoedler, 1925, no. 16; New York 2003, no. 213.

LITERATURE

London 1908, p. 11; Christie's 1925, p. 31; Downes 1926, p. 335; Royal Cortissoz, 'A Group of Pictures from the Recent London Sale', *New York Herald Tribune*, 8 November 1925, p. 9, ill.; Royal Cortissoz, 'The Field of Art', *Scribner's Magazine*, vol. 79 (March 1926), ill. p. 330; *The Year's Art*, London, 1926, p. 301; Charteris 1927, p. 281, dated 1880; Mount 1955, p. 443 (K798), dated 1879; 1957 ed., p. 352 (K798); 1969 ed., p. 460 (K798); Nahum 1993, p. 337; Boone 1996, pp. 161–62; Simp-

son 1998, p. 3; Tinterow *et al.* 2003, pp. 324, 398, 530–31, 534, ill. p. 323, fig. 11.15 (colour); Ormond and Pixley 2003, pp. 634, 637 and n. 23, 638, 640, ill. p. 636, fig. 20, and magazine cover (both colour).

734 *Figure of Apollo from 'The Forge of Vulcan', after Velázquez*

PROVENANCE

The artist's sale, Christie's, London, 27 July 1925, lot 237, as 'An Angel', bt. M. Knoedler & Co., London (stock no. 7582); shipped to New York, 2 October 1925; Knoedler, New York, to Edwin D. Levinson, November 1925 (stock no. 16263A); private collector, New York; Parke-Bernet Galleries, New York, 23–24 May 1957, lot 276, possibly bt. in, as 'Apollo', ill. sale cat., p. 49; Sotheby's, London, 11 December 1957, lot 197, bt. Ashwell, as 'Apollo crowned with laurels in brown draperies'; Sir Alfred Beit, through Marlborough Fine Art, London; The Alfred Beit Foundation, Russborough, Blessington, Ireland.

EXHIBITIONS

New York, Knoedler, 1925, no. 20, as 'An Angel'; King's Lynn 1962, no. 11, as 'Vulcan'.

LITERATURE

Christie's 1925, p. 31; Royal Cortissoz, 'A Group of Pictures from the Recent London Sale', *New York Herald Tribune,* 8 November 1925, p. 9; Royal Cortissoz, 'The Field of Art', *Scribner's Magazine,* vol. 79 (March 1926), p. 331; Downes 1926, p. 335; *The Year's Art,* London, 1926, p. 301; 'At the King's Lynn Festival: Old Masters into Newer Masters', *Illustrated London News,* vol. 241, no. 6417 (28 July 1962), p. 147, ill.; Mount 1955, p. 443 (K791s), dated 1879, as '(Copy of Velásquez) Apollo from "The Forge of Vulcan"'; 1957 ed., p. 352 (K791s); 1969 ed., p. 460 (K791s); Washington 1992, pp. 40, 98, n. 59, ill. p. 41, fig. 15; Nahum 1993, pp. 197–99, 332; Simpson 1998, p. 3; Goley 2000, p. 4; Ormond and Pixley 2003, pp. 634, 638–39, and n. 30, 640, ill. p. 638, fig. 2 (colour).

735 *Head of Aesop, after Velázquez*

PROVENANCE

The artist's sale, Christie's, London, 27 July 1925, lot 234, as 'Head of Aesopus, after Velazquez', bt. Thomas Agnew & Sons for Alvan T. Fuller, Boston; Fuller Foundation, Boston, 1958; Christie's, London, 1 December 1961, lot 41, ill. sale cat., bt. Agnew's; Robert H. Smith, Washington, D.C.; Agnew's, London, 1974; Ackland Art Museum, University of North Carolina, Chapel Hill, 1975.

EXHIBITIONS

Worcester c. 1927, unnumbered; Boston 1928, no. 44; King's Lynn 1962, no. 3; New York, The Equitable Gallery in association with the Spanish Institute, *Spain, Espagne, Spanien: Foreign Artists Discover Spain 1800–1900,* 2 July–18 September 1993, no. 41; Seattle 2000, no. 9; Paris, Musée d'Orsay, *Manet/Velázquez: La manière espagnole au XIXe siècle,* 16 September 2002–12 January 2003, no. 114, as 'Tête d'Ésope, d'après Diego Velázquez'; New York 2003, no. 212.

LITERATURE

Christie's 1925, p. 31; Downes 1926, p. 335; Charteris 1927, p. 281, dated 1880; Worcester c. 1927, n.p.; Boston 1928, n.p.; Mount 1955, p. 443 (K796), dated 1879; 1957 ed., p. 352 (K796); 1969 ed., p. 460 (K796); 'At the King's Lynn Festival: Old Masters into Newer Masters', *Illustrated London News,* vol. 241, no. 6417 (28 July 1962), p. 147, ill.; Theodore Crombie, 'Velázquez Observed: New Looks at an Old Master', *Apollo,* vol. 78, no. 18 (August 1963), p. 128, ill. p. 127, fig. 9; Ormond 1970, pp. 27, 254, ill. pl. 99; New York 1980, checklist, n.p.; Allan Braham, 'Introduction', *El Greco to Goya: The Taste for Spanish Paintings in Britain and Ireland,* National Gallery, London, 1981, ill. p. 36, fig. 46, mistitled 'Head of Mennipus, after Velasquez' (exhibition catalogue); Ratcliff 1982, p. 55, ill. p. 54, pl. 73; Luna 1988, p. 103, ill. p. 101; Volk 1992, pp. 57, 101, n. 116, ill. p. 56, fig. 28; Nahum 1993, pp. 197–99, 338, ill. fig. 74; Suzanne L. Stratton, *Spain, Espagne, Spanien: Foreign Artists Discover Spain 1800–1900,* The Equitable Gallery in association with the Spanish Institute, New York, 1993, pp. 81, 128, ill. p. 81 (colour) (exhibition catalogue); London, Pyms Gallery, 1998, p. 9, ill. p. 8; Simpson 1998, p. 3; Goley 2000, p. 4; Fairbrother 2000, pp. 47–48, 51, ill. p. 47, pl. 2.4 (colour); Trevor Fairbrother in *Manet/Velázquez: La manière espagnole au XIXe siècle,* Paris,

Musée d'Orsay, 2002, pp. 395–96, ill. p. 94, fig. 47 (colour) (exhibition catalogue); Tinterow *et al.* 2003, pp. 304, n. 148, 398, 530, 534, ill. p. 400, fig. 14.79 (colour); Ormond and Pixley 2003, pp. 634, 638 and n. 28, 640, ill. p. 637, fig. 22.

736 *Buffoon Don Juan de Austria, after Velázquez*

PROVENANCE

The artist's sale, Christie's, London, 27 July 1925, lot 232, as 'Portrait of a Buffoon of Philip IV, after Velazquez', bt. M. Knoedler & Co., London (stock no. 7580); Sybil Sassoon, Marchioness of Cholmondeley, 27 July 1925 (Knoedler, New York, stock no. 16261); her grandson, the present Marquess of Cholmondeley, 1989; Adelson Galleries, New York, 1998; private collection, Paris.

EXHIBITION

London, RA, 1926, no. 402, as 'Copy of "The Buffoon of Philip IV", by Velasquez'.

LITERATURE

Christie's 1925, p. 31; *Le Figaro Artistique,* no. 84 (15 October 1925), p. 14, as *'Portrait d'un Bouffon de Philippe IV',* where confused with 'Head of Prince Balthasar Carlos' (no. 728); Downes 1926, p. 335, as 'Portrait of a Buffoon of Philip IV, after Velazquez'; London 1926, p. 61, as 'Copy of "The Buffoon of Philip IV", by Velasquez'; Charteris 1927, p. 281, dated 1880, as 'Portrait of a Buffoon of Philip IV. After Velasquez'; Mount 1955, p. 443 (K797), as '(Copy of Velásquez) Portrait of a Buffoon of Philip IV'; 1957 ed., p. 352 (K797); 1969 ed., p. 460 (K797); Nahum 1993, pp. 337, 346, as 'Portrait of a Buffoon of Philip IV'; Simpson 1998, p. 3; Goley 2000, as 'The Buffoon'; Ormond and Pixley 2003, pp. 634, 638 and n. 28, 640, ill. p. 637, fig. 21 (colour).

737 *Las Hilanderas, after Velázquez*

PROVENANCE

The artist's sale, Christie's, London, 27 July 1925, lot 230, bt. Thomas Agnew & Sons for Alvan T. Fuller, Boston; Fuller Foundation, Boston, 1958; Christie's, London, 1 December 1961, lot 38, ill. sale cat., bt. Agnew's; Sir Alfred Beit, 1961; The Alfred Beit Foundation, Russborough, Blessington, Ireland.

EXHIBITIONS

Worcester c. 1927, unnumbered; Boston 1928, no. 43; King's Lynn 1962, no. 12.

LITERATURE

Christie's 1925, p. 31; '£175,260 for Sargents', *Daily Mail,* London, 28 July 1925, p. 7; 'Sargent Sale Ended', *Daily Telegraph,* London, 28 July 1925, p. 13; Royal Cortissoz, 'A Group of Pictures from the Recent London Sale', *New York Herald Tribune,* 8 November 1925, p. 9; 'Sargent Sale Total Nears $1,000,000 Mark', *New York Times,* 28 July 1925, p. 5; *Le Figaro Artistique,* no. 84 (15 October 1925), p. 14; Downes 1926, p. 335; *The Year's Art,* London, 1926, p. 298; Charteris 1927, p. 281, dated 1880; Worcester c. 1927, n.p.; Boston 1928, n.p.; Mount 1955, pp. 63–64, 443 (K799); 1957 ed., p. 352 (K799); 1969 ed., p. 460 (K799); Ayres in Hills *et al.* 1986, pp. 54–55; Nahum 1993, pp. 199, 344; Boone 1996, pp. 161–62; Simpson 1998, p. 3; Ormond in Adelson *et al.* 1997, p. 157; Goley 2000, pp. 4–5, ill. p. 4, fig. 2; Ormond in Robertson *et al.* 2003, p. 56; Tinterow *et al.* 2003, pp. 298, 304, n. 148, 398; Ormond and Pixley 2003, pp. 634, 636–637, 639 and n. 33, 640, ill. p. 639, fig. 24 (colour).

738 *The Infanta Margarita, after Velázquez*

PROVENANCE

The artist's sale, Christie's, London, 27 July 1925, lot 235, bt. M. Knoedler & Co., London (stock no. 7581; also Knoedler, New York, stock no. 16262); sold to Sir Philip Sassoon, October 1925; his nephew, Lord John Cholmondeley; sold by him to the Fine Art Society, London, in partnership with Anthony D'Offay, 25 January 1977; Davis & Long, New York, 1977; private collection, U.S.

LITERATURE

Christie's 1925, p. 31; Downes 1926, p. 335; Charteris 1927, p. 281, dated 1880; Mount 1955, p. 443 (K7910); 1957 ed., p. 352 (K7910); 1969 ed.,

p. 460 (K7910); Simpson 1998, p. 3; Goley 2000, p. 4; Tinterow *et al.* 2003, p. 304, n. 148; Ormond and Pixley 2003, p. 633 and n. 14.

739 Two Heads from 'The Banquet of the Officers of the St George Civic Guard', after Frans Hals

PROVENANCE

The artist's sale, Christie's, London, 27 July 1925, lot 226, as 'Two Heads out of the Repast of the Officers of St. Jorisdoelen in Haarlem, after Frans Hals', bt. Thomas Agnew & Sons for Alvan T. Fuller; Fuller Foundation, Boston, 1958; Agnew's, London, with Adelson Galleries, New York, 1999; private collection.

EXHIBITIONS

Worcester c. 1927, unnumbered; Boston 1928, no. 45; Boston 1959, no. 46; Palm Beach 1961, no. 35; London, Agnew's, *Agnew's Millennium Exhibition,* 8 June–21 July 2000, no. 28.

LITERATURE

Christie's 1925, p. 30; 'Sargent Sale Total Nears $1,000,000 Mark', *New York Times,* 28 July 1925, p. 5; two-page cutting from an unidentified U.S. journal reporting the artist's sale, Christie's, London, 24–27 July 1925, where the copy is illustrated (catalogue raisonné archive); Downes 1926, p. 334; Charteris 1927, p. 282, dated 1880; Worcester c. 1927, n.p.; Boston 1928, n.p.; Mount 1955, pp. 67, 444 (K8017), dated 1880; 1957 ed., pp. 60, 353 (K8017); 1969 ed., pp. 67, 462 (K8017); Boston 1959, p. 29; Palm Beach 1961, n.p.; Slive 1970–74, vol. 3, p. 31, ill. fig. 21; Frances S. Jowell, 'The Rediscovery of Frans Hals', in Slive *et al.* 1989, pp. 75, 85–86, n. 147; London, Agnew's, *Agnew's, Millennium Exhibition,* 8 June–21 July 2000, n.p., no. 28 (exhibition catalogue); Ormond and Pixley 2003, p. 640, n. 35.

740 The Standard Bearer from 'The Banquet of the Officers of the St George Civic Guard', after Frans Hals

PROVENANCE

The artist's sale, Christie's, London, 27 July 1925, lot 228, as 'The Standard Bearer out of the Picture of the Officers of St. Jorisdoelen in Haarlem, after Frans Hals', bt. Thomas Agnew & Sons for Alvan T. Fuller; Fuller Foundation, Boston, 1958; Agnew's, London, with Adelson Galleries, New York, 1999; private collection.

EXHIBITIONS

Worcester c. 1927, unnumbered; Boston 1928, no. 41; Boston 1959, no. 45.

LITERATURE

Christie's 1925, p. 31; Downes 1926, p. 335; Charteris 1927, p. 281, dated 1880; Worcester c. 1927, n.p.; Boston 1928, n.p.; Mount 1955, pp. 67, 443 (K8015), dated 1880; 1957 ed., pp. 60, 353 (K8015); 1969 ed., pp. 67, 462 (K8015); Boston 1959, p. 29; Slive 1970–74, vol. 3, p. 31, ill. fig. 20; Frances S. Jowell, 'The Rediscovery of Frans Hals', in Slive *et al.* 1989, pp. 75, 85–86, n. 147; Ormond and Pixley 2003, p. 640, n. 35.

741 Detail of Two Figures from 'The Regentesses of the Old Men's Almhouse, Haarlem', after Frans Hals

PROVENANCE

The artist's sale, Christie's, London, 27 July 1925, lot 225, as 'Two Figures of the Administrators of the Old Men's Hospital in Haarlem, after Frans Hals', bt. Thomas Agnew & Sons for Alvan T. Fuller; Fuller Foundation, Boston, 1958; Christie's, London, 1 December 1961, lot 40, ill. sale cat., n.p., bt. Leadbeater; Schweitzer Gallery, New York; Mr and Mrs Theodore Newhouse, New York; Birmingham Museum of Art, Alabama. Gift of Mrs Theodore Newhouse, 1962.

EXHIBITIONS

Worcester c. 1927, unnumbered; Boston 1928, no. 34; Boston 1959, no. 47; Decatur, Alabama, Decatur Festival of Arts, 27 April 1973 (no catalogue traced); Jackson, Mississippi Museum of Art, *With a Little Help from Our Friends,* 22 April–16 July 1978, no. 1.

LITERATURE

Christie's 1925, p. 30; Downes 1926, p. 334; Charteris 1927, p. 282, dated 1880; Worcester c. 1927, n.p.; Boston 1928, n.p.; Mount 1955, pp. 67, 443 (K8016), dated 1880, as '(Copy of Hals) Two Figures from Administra-

tors of the Old Women's [*sic*] Hospital at Haarlem'; 1957 ed., pp. 60, 353 (K8016); 1969 ed., pp. 67, 462 (K8016); Boston 1959, pp. 29–30, ill.; Alyce B. Walker, 'Museum here given noted Sargent canvas', *Birmingham News,* 12 August 1962, p. E-9; Slive 1970–74, vol. 3, p. 113, under no. 222; New York 1980, checklist, n.p., as 'Regentesses of the Old Men's Almshouse'; Frances S. Jowell, 'The Rediscovery of Frans Hals', in Slive *et al.* 1989, pp. 75, 85–86, n. 147, ill. p. 74, fig. 10; D. Dodge Thompson, 'Frans Hals and American Art', *Magazine Antiques,* November 1989, p. 1173, ill. p. 1172, pl. IV (colour); Washington 1992, p. 96, n. 36; *Masterpieces East & West from the Collection of the Birmingham Museum of Art,* Birmingham, Alabama, 1993, p. 215; Ormond and Pixley 2003, p. 640 and n. 35.

742 Regents of the Old Men's Almshouse, Haarlem, after Frans Hals

PROVENANCE

The artist's sale; Christie's, London, 27 July 1925, lot 227 as 'The Administrators of the Old Men's Hospital at Haarlem, after Frans Hals'; Arthur U. Newton; Christie's, London, 21 June 1929, lot 74, bt. Rayson; American Art Association, Anderson Galleries, New York, 14 December 1933, lot 32, 'Sold to Close an Account'; James A. Rafferty; Professor Boris I. Baranovic of Bethesda, Maryland, 1980; untraced.

LITERATURE

Christie's 1925, p. 31; Downes 1926, p. 335; Charteris 1927, p. 280, dated 1880; Mount 1955, pp. 67, 443 (K8014); 1957 ed., pp. 60, 353 (K8014); 1969 ed., pp. 67, 462 (K8014); Ormond and Pixley 2003, p. 640, n. 35.

743 Saint Roch with Saint Jerome and Saint Sebastian, after a Picture attributed to Alessandro Oliverio

PROVENANCE

The artist's sale, Christie's, London, 27 July 1925, lot 218, bt. (Newlin) Price of Ferargil Galleries, New York; Anderson Galleries, New York, 11–12 April 1928, lot 126, as 'After Giorgione, Three Saints' (sale catalogue records inscription on the back, 'J. S. Sargent, Pinxit'); Gabriel Wells, New York; Parke-Bernet Galleries, New York, 11 October 1951, lot 72, as 'Three Saints, after Giorgione'; Frederick W. Schumaker, Cincinnati, Ohio; Parke-Bernet Galleries, New York, 30–31 January 1959, lot 267, as 'Three Saints, after Giorgione'; Schweitzer Gallery, New York; Hood Museum of Art, Dartmouth College, Hanover, New Hampshire. Gift of M. R. Schweitzer, 1959.

EXHIBITIONS

Hanover, New Hampshire, Dartmouth College, Carpenter Galleries Exhibition, December 1962; Hanover, New Hampshire, Hopkins Center, Beaumont-May Gallery, *Reflections of the Original: Copies in the Dartmouth College Collection,* 24 May–4 July 1978, no. 6; Hanover, New Hampshire, Dartmouth College, Carpenter Galleries, 1 December 1978–2 February 1979.

LITERATURE

Christie's 1925, p. 30; Ferargil Galleries, *Ferargil Ink,* New York, vol. 1, no. 1 (December 1925), n.p., ill.; Downes 1926, p. 334; Charteris 1927, p. 286, dated '1902?'; Mount 1955, p. 443 (K7919), dated 1879, as '(Copy of Girolamo da Treviso, the Younger) St. Gerome, St. Roch, St. Sebastian'; 1957 ed., p. 353 (K7919); 1969 ed., p. 461 (K7919); Charles M. Mount, 'Some Works by Sargent at Dartmouth with Notes on the Dispersal of His Artistic Estate', *Dartmouth Bulletin,* vol. 1 (January 1966), n.p., ill. fig. 1; Custis Spencer, 'Saints Jerome, Roc [*sic*], and Sebastian', in *Reflections of the Original: Copies in the Dartmouth College Collection,* ed. Arthur R. Blumenthal, Hanover, New Hampshire, 1978, pp. 45–51, ill. p. 50 (exhibition catalogue); New York 1980, checklist, n.p., as 'Sts. Jerome, Roche [*sic*] and Sebastian'.

744 The Descent from the Cross, after Giandomenico Tiepolo

PROVENANCE

Henry Tonks; Tonks sale, Christie's, London, 29 July 1937, lot 46, as 'The Deposition', bt. Montagu; Redfern Gallery, London; George Prins, 1943; Dr Seymour Spencer; Christie's, London, 21 November 1995, lot

230, as 'Cristo inchiodato sulla Croce (After Giandomenico Tiepolo)'; private collection.

745 *Two Figures from 'The Three Graces', after Rubens*
PROVENANCE
The artist's sale, Christie's, London, 27 July 1925, lot 220, as 'A Study from "The Three Graces" by Rubens', bt. R. B. Hackley; given by him to the Hackley Art Gallery, Muskegon, Michigan, 1926; exchanged with Ferargil Galleries, New York, April or May 1946; sold from a New York estate, Parke-Bernet Galleries, New York, 16 February 1961, lot 95, ill. sale cat., p. 28; consigned again to Parke-Bernet by 'Cohen', 11 January 1962, lot 93, ill. sale cat., p. 26, as 'The Three Graces, after Rubens'; Ira Spanierman, with Robert Schoelkopf, New York; Wichita Art Museum, Kansas. Gift of Mr and Mrs Arthur W. Kincade, Sr,[4] 1964.
EXHIBITION
Washington 1964, paintings in oil, no. 9, as 'Study after Rubens, "Three Graces"'.
LITERATURE
Christie's 1925, p. 30; Royal Cortissoz, *New York Herald Tribune,* 25 July 1925, p. 12; Downes 1926, p. 334, as 'A Study from "The Three Graces", by Rubens, at Madrid', incorrectly giving the owner's name as 'R. B. Harshe'; Charteris 1927, p. 282, dated 1880, as 'A Study from the Three Graces by Rubens at Madrid'; Mount 1955, p. 443 (K7917), dated 1879, as '(Copy of Rubens) Three Graces', with owner's name incorrectly given as 'Haisle'; 1957 ed., p. 352 (K7917); 1969 ed., p. 460, as 'Rubens: Three Graces' (K7917); New York 1980, checklist, n.p.; Ormond and Pixley 2003, p. 634 and n. 16.

4. Arthur W. Kincade, Sr (1897–1989), was president of the Fourth National Bank & Trust Company and a leading figure in the business life of Wichita, Kansas. He and his wife Mary Igou lived in a house designed by Frank Lloyd Wright for Senator Henry J. Allen; for further information, see Arthur W. Kincade, *'Ad Astra Per Aspera' 'To the Stars Through Difficulties', The Story of the Fourth National Bank and Trust Company,* Wichita, Kansas (a copy of this booklet is in the Wichita Art Museum), and an obituary in the *Wichita Eagle Beacon,* 6 February 1989, pp. 1A and 4A.

746 *Angels in a Transept, Study after Goya*
PROVENANCE
Given by the artist to the Hon Sir Evan Charteris; his widow, Lady Dorothy Charteris, 1940; thence by family descent; Richard Thune, New York, c. 1994; private collection; Richard Thune, 2006; Adelson Galleries, New York; private collection.
EXHIBITION
London, RA, 1926, no. 515, as 'Study of Goya in an Arch at San Antonio, Madrid'.
LITERATURE
London 1926, p. 75, as 'Study of Goya in an Arch at San Antonio, Madrid'; Downes 1926, p. 368, with same title; Charteris 1927, p. 286, dated 1902, as 'Study of Goya (at San Antonio, Madrid)'; Mount 1955, p. 443 (K7921), as 'Study of a Goya at San Antonio, Madrid'; 1957 ed., p. 353 (K7921); 1969 ed., p. 461 (K7921), as 'Goya (from an Archway at San Antonio, Madrid)'; Volk 1992, pp. 42, 99, n. 69.

747 *Santa Maria La Blanca, Toledo*
PROVENANCE
Violet Sargent (Mrs Francis Ormond), 1925; her son, F. Guillaume Ormond, 1955; his heirs, 1971; Christie's, London, 12 November 1976, lot 58, ill. sale cat., pl. 8; private collection.
LITERATURE
Mount 1969, p. 461, dated 1880, as 'Interior with Moorish Collonade [*sic*]', Boone 1996, pp. 163, 164, 189, n. 27, ill. p. 355, fig. 5.6.

748 *Alhambra, Patio de los Leones (Court of the Lions)*
PROVENANCE
The artist's sale, Christie's, London, 24 July 1925, lot 97, as 'The Court of Lions, Alhambra', bt. Scott & Fowles, New York; Mrs Stevenson Scott; her daughter, Mrs Marie Scott Kaminer, 1961; private collection.

EXHIBITIONS
Boston 1899, no. 88, as 'The Court of Lions'; New York, Scott & Fowles, *Ten Sargents from Sargent's own Collection now owned by Mrs. Stevenson Scott,* 24 February–24 March 1948, unnumbered, as 'The Court of Lions, Alhambra'.
LITERATURE
Boston 1899, p. 21; Christie's 1925, p. 14; Downes 1925, 1926, p. 126, dated 1880, as 'The Court of the Lions'; Charteris 1927, pp. 51, 281, dated 1880, as 'Court of Lions, Alhambra'; *Ten Sargents from Sargent's own Collection now owned by Mrs. Stevenson Scott,* Scott & Fowles, New York, 1948, n.p., ill., as 'The Court of Lions, Alhambra' (exhibition catalogue); Mount 1955, p. 443 (K795), dated 1879, as 'Court of Lions, Alhambra'; 1957 ed., p. 352 (K795); 1969 ed., p. 460 (K795); Ormond 1970, p. 237; Boone 1996, p. 164, ill. p. 357, fig. 5.8.

749 *Alhambra, Patio de los Leones (Court of the Lions)*
PROVENANCE
Violet Sargent (Mrs Francis Ormond), 1925; her son, Jean-Louis Ormond, 1955; his heirs, 1986; Coe Kerr Gallery, New York, 1987; Richard L. Thune, by 1991; David Findlay, Jr, Inc., New York, 1997; Adelson Galleries, New York, 1998; private collection.
EXHIBITION
Japan 1989, no. 81.
LITERATURE
Japan 1989, pp. 123, 153, ill. p. 123 (colour).

750 *Alhambra, Patio de los Leones (Court of the Lions)*
PROVENANCE
Given by the artist's sisters to Sir Alec Martin, post 1925; presented anonymously to the British Museum, 1959.
EXHIBITIONS
New York and Chicago 1986, unnumbered, as 'A Moorish Patio' (shown only in New York).
LITERATURE
Sargent Trust List [1927], 'Water Colours. Unframed', p. 9, no. 40, as 'Alhambra Interior'; Martin Hardie, *Water-colour Painting in Britain,* vol. 3, *The Victorian Period,* ed. Dudley Snelgrove, Jonathan Mayne and Basil Taylor, London, 1968, ill. pl. 199, between pp. 170–71; Blaugrund in Hills *et al.* 1986, p. 289, ill. p. 213, fig. 173, as 'A Moorish Patio, c. 1880' (and erroneously said to have been given to the British Museum by Mrs Ormond); Boone 1996, p. 190, n. 30, as 'A Moorish Patio'.

751 *Alhambra, Patio de los Leones (Court of the Lions)*
PROVENANCE
Violet Sargent (Mrs Francis Ormond), 1925; given by her to The Metropolitan Museum of Art, New York, 1950.
EXHIBITIONS
New York and Buffalo 1971, no. 19.
LITERATURE
Boone 1996, p. 190, n. 30, as 'Architectural Sketch'; Herdrich and Weinberg 2000, pp. 161–62, no. 136, ill. p. 161.

752 *Alhambra, Patio de los Arrayanes (Court of the Myrtles)*
PROVENANCE
Emily Sargent, 1925; Violet Sargent (Mrs Francis Ormond), 1936; her son, F. Guillaume Ormond, 1955; his heirs, 1971; private collection.
EXHIBITIONS
Boston 1899, no. 89, as 'The Alhambra' (and so described in early exhibitions and literature); London, RA, 1926, no. 387; York 1926, no. 17; London, Tate, 1926, unnumbered; Aberdeen 1926, no. 276; Falmouth 1962, no. 1; Japan 1989, no. 6.
LITERATURE
Boston 1899, p. 21; Downes 1925, 1926, p. 126; London, RA, 1926, p. 58; London, Tate, 1926, p. 10; Charteris 1927, pp. 51, 286, dated 1902; Mount 1955, p. 442 (K794), dated 1879; 1957 ed., p. 352 (K794); 1969

ed., p. 460 (K794); Ormond 1970, p. 237, ill. pl. 18; Ratcliff 1982, ill. p. 24, pl. 23 (colour); Japan 1989, pp. 48, 136, ill. p. 48 (colour); Boone 1996, pp. 164, 165, ill. p. 356, fig. 5.7.

753 *Alhambra, Patio de la Reja (Court of the Grille)*
PROVENANCE
Emily Sargent, 1925; Violet Sargent (Mrs Francis Ormond), 1936; her son, H. E. Conrad Ormond, 1955; his heirs, 1979; Adelson Galleries, New York, 1994; private collection; Adelson Galleries, New York, 2004.
LITERATURE
Mount 1955, p. 444 (K813), dated 1881, as 'At Assisi'; 1957 ed., p. 354 (K813); 1969 ed., p. 463 (K813); Ormond 1970, p. 237; Boone 1996, p. 164, ill. p. 357, fig. 5.9; Adelson in Adelson *et al.* 1997, pp. 13, 43, ill. p. 13, pl. 3 (colour).

754 *The Alhambra Vase*
PROVENANCE
Violet Sargent (Mrs Francis Ormond), 1925; her daughter, Reine Ormond (Mrs Hugo Pitman), 1955; New York, Gertrude Stein Gallery, c. 1962; New York, Schweitzer Gallery, 1968; purchased by the Walters Art Gallery (now the Walters Art Museum), Baltimore, S. & A. P. Fund, 1971.
EXHIBITIONS
London, RA, 1926, no. 205, as 'The Vase'; Baltimore, Walters Art Gallery, *Connoisseur's Portfolio: 19th-Century Drawings in the Walters Art Gallery,* 17 March–24 April 1983, no. 14.
LITERATURE
London 1926, p. 32, as 'The Vase'; *Sargent Trust List* [1927], 'Water Colours. Unframed', p. 2, no. 5, as 'Persian Vase'; William R. Johnston, 'The Alhambra Vase, by John Singer Sargent', *The Walters Art Gallery Bulletin,* vol. 23, no. 8 (May 1971), pp. 23–24, ill. p. 23, fig. 3; Carol M. Osborne, 'Yankee Painters at the Prado', in *Spain, Espagne, Spanien: Foreign Artists Discover Spain 1800–1900,* curated by Suzanne L. Stratton, The Equitable Gallery in association with the Spanish Institute, New York, 1993, p. 70, fig. 44 (exhibition catalogue); Boone 1996, p. 190, n. 30.

755 *An Archway*
PROVENANCE
Violet Sargent (Mrs Francis Ormond), 1925; her son, Jean-Louis Ormond, 1955; his heirs, 1986; Coe Kerr Gallery, New York, 1987; Mr and Mrs Harry Spiro, 1990; private collection, 2002.

756 *Turkey in a Courtyard*
PROVENANCE
Violet Sargent (Mrs Francis Ormond), 1925; her son, Jean-Louis Ormond, 1955; his heirs, 1986; private collection.

757 *Spanish or Moroccan Landscape*
PROVENANCE
Violet Sargent (Mrs Francis Ormond), 1925; given by her, with a large collection of Sargent studies, to The Metropolitan Museum of Art, New York, 1950.
LITERATURE
Mount 1955, p. 444 (K8030), dated 1880, as 'Landscape with Hills'; 1957 ed., p. 354 (K8030); 1969 ed., p. 461 (K8030), under North Africa; Burke 1980, p. 224, as 'Spanish Landscape', ill.; Boone 1996, p. 189, n. 27.

758 *A Spanish Figure*
PROVENANCE
Emily Sargent, 1925; Violet Sargent (Mrs Francis Ormond), 1936; her son, H. E. Conrad Ormond, 1955; his heirs, 1979; private collection.
EXHIBITION
Washington 1964, paintings in oil, no. 8, as 'Monk's Cell'.

LITERATURE
Mount 1955, p. 444 (K8024), dated 1880, as 'A Moor'; 1957 ed., p. 353 (K8024); 1969 ed., p. 460 (K8024), as 'Monk's Cell (or The Moor)', and located in Spain.

759 *Sketch of a Spanish Crucifix*
PROVENANCE
The artist; untraced.
LITERATURE
Strettell 1887, ill. facing p. 124; Cortissoz 1903, p. 522; Cortissoz 1913, p. 226; Mount 1955, p. 446 (K875), dated 1887; 1957 ed., p. 355 (K875); 1969 ed., p. 466 (K875); Washington 1992, p. 165.

760 *Sketch of a Spanish Madonna*
PROVENANCE
The artist; untraced.
LITERATURE
Strettell 1887, ill. facing p. 9; *Athenaeum,* no. 3118 (30 July 1887), p. 142; Cortissoz 1903, p. 520; Cortissoz 1913, p. 226; Mount 1955, p. 446 (K876), as 'Monochrome'; 1957 ed., p. 355 (K876); 1969 ed., p. 466 ((K876), as 'Monochrome (Statue of the Virgin)'; Washington 1992, p. 165.

761 *Sketch of a Spanish Madonna*
PROVENANCE
Violet Sargent (Mrs Francis Ormond); given by her, with a large collection of Sargent studies, to The Metropolitan Museum of Art, New York, 1950.
LITERATURE
Mount 1955, p. 444 (K8033), dated 1880, as 'Madonna in Festive Robe'; 1957 ed., p. 354 (K8033); 1969 ed., p. 461 (K8033); Burke 1980, pp. 224, 226, ill. p. 225; Ratcliff 1982, ill. p. 143, pl. 212; Boone 1996, p. 189, n. 27.

762 *A Spanish Madonna*
PROVENANCE
Given by the artist to Isabella Stewart Gardner; Isabella Stewart Gardner Museum, Boston.
LITERATURE
Hendy 1974, p. 227, ill.; Burke 1980, p. 224, ill. p. 225; Ratcliff 1982, ill. p. 142, pl. 209.

763 *The Spanish Dance*
PROVENANCE
Given by the artist to Alma Strettell (Mrs Lawrence 'Peter' Harrison); consigned by her to M. Knoedler & Co., London, 20 June 1920 (stock no. LC 154); purchased from her, 8 July 1921 (stock no. 6789); shipped to Knoedler, New York, 3 August 1921 (stock no. 15221); sold to the Hispanic Society of America, New York, February 1922.
EXHIBITIONS
Washington 1992, no. 15; London 1998, no. 9; Atlanta 2003, no. 56.
LITERATURE
Meynell 1903, n.p., ill.; Camille Mauclair, 'John Sargent', *L'Art et Les Artistes,* Paris, vol. 4 (1906–7), p. 374, ill. p. 376; Cox 1908, p. 257; Cortissoz 1924, ill. p. 346; Downes 1925, 1926, p. 129; Charteris 1927, p. 282, dated 1883; Meynell and Manson 1927, n.p., ill.; Mount 1955, p. 443 (K803), dated 1880; 1957 ed., p. 353 (K803); 1969 ed., p. 462 (K803), as 'At Seville (also called Spanish Dance)'; Mount, *Art Quarterly,* 1957, p. 311; Ormond 1970, p. 28; Ormond, *Fenway Court,* 1970, pp. 7, 10, 18, ill. p. 6, fig. 4; Ratcliff 1982, pp. 57–58, ill. p. 56, pl. 78; Washington 1992, pp. 25, 150, ill. p. 151 (colour); Adelson and Oustinoff 1992, p. 465, ill. pl. IV (colour); Boone 1996, p. 169, ill. p. 360, fig. 5.14; London 1998, p. 74, ill. p. 73 (colour); Lacey Taylor Jordan in Merrill *et al.* 2003, p. 220, ill. p. 221 (colour).

764 Sketch after 'The Spanish Dance'
PROVENANCE
The artist; untraced.
LITERATURE
Strettell 1887, ill. frontispiece; *Athenaeum,* no. 3118 (30 July 1887), p. 142; Cortissoz 1903, p. 520; Cortissoz 1913, pp. 225–26; Washington 1992, p. 152, no. 16, ill.

765 Study for 'The Spanish Dance'
PROVENANCE
Emily Sargent, 1925; her nephew, F. Guillaume Ormond, 1936; his heirs, 1971; Coe Kerr Gallery, New York, 1988; Jan and Warren Adelson, 1988.
EXHIBITIONS
London 1926, no. 384, as 'Sketch for "Spanish Dancers—Night"'; York 1926, no. 18, as 'Sketch for "Spanish Dancers—Night"'; Falmouth 1962, no. 20; London, Fine Art Society, *One hundred years of exhibitions at the Fine Art Society Ltd: Centenary 1876–1976,* 23 March–30 April 1976, no. 22, cat. p. 16; Washington 1992, no. 13; New York, Adelson Galleries, 2003, no. 10.
LITERATURE
London, RA, 1926, p. 58; Downes 1926, p. 360, as 'Sketch for "Spanish Dancers—Night"'; Charteris 1927, p. 283, dated 1888, as 'Sketch for Spanish Dancers. Night'; Mount 1955, p. 443 (K8012), dated 1880; 1957 ed., p. 353 (K8012); 1969 ed., p. 462 (K8226), as 'Study for At Seville'; Washington 1992, pp. 25, 146, ill. p. 147 (colour); Adelson and Oustinoff 1992, p. 465, ill. p. 464, pl. III; Adelson in Adelson *et al.* 1997, p. 13, ill. p. 14, pl. 4 (colour); Adelson *et al.* 2003, p. 64, ill. p. 65 (colour).

766 Study for 'The Spanish Dance'
PROVENANCE
Ralph Curtis; his son Ralph Curtis II, 1922; Mrs Ralph Curtis II; M. Knoedler & Co., New York, December 1960 (stock no. A 7797); sold to J. William Middendorf II, Greenwich, Connecticut, 1961; Victor Spark, New York; Julia and Humbert Tinsman, 1965; given by them to The Nelson-Atkins Museum of Art, Kansas City, Missouri, 1983.
EXHIBITIONS
Washington 1964, paintings in oil, no. 11, ill. cat., n.p.; Washington 1992, no. 14; New York, Hollis Taggart Galleries, *España, American Artists and the Spanish Experience,* 30 January–4 April 1999, unnumbered.
LITERATURE
Charteris 1927, p. 282, dated 1883, as 'Spanish Dancer. Study for Spanish Dancers'; Mount 1955, p. 443 (K804), dated 1880, as 'Study for Spanish Dance'; 1957 ed., p. 353 (K804); 1969 ed., p. 462 (K804), as 'Study for At Seville'; Mount, *Art Quarterly,* 1957, p. 311, ill. p. 315, fig. 11; Washington 1992, pp. 25, 148, ill. p. 149 (colour); M. Elizabeth Boone, *España, American Artists and the Spanish Experience,* Hollis Taggart Galleries, New York, 1999, p. 92, ill. p. 93 (colour) (exhibition catalogue).

767 Spanish Gypsy Dancer
PROVENANCE
Louis B. McCagg, by c. 1884; his son, Edward K. McCagg, by 1948; his widow, Mrs Edward K. McCagg; her son, Rev Lauriston H. McCagg; Adelson Galleries, New York, 1999; private collection, Washington, D.C.
EXHIBITIONS
New York, SAA, 1898, no. 67, as 'Sketch of a Spanish Girl'; Philadelphia 1899, no. 234; Boston 1899, no. 52, as 'Spanish Gypsy'; San Francisco 1915, no. 3627, as 'Spanish Gypsy'; Boston 1925, oil paintings, no. 57 (60), as 'Spanish Gypsy'; New York 1926, paintings in oil, no. 4, as 'The Spanish Gypsy'; Washington 1992, no. 18; New York, Adelson Galleries, 2003, no. 12.
LITERATURE
Boston 1899, p. 13, as 'Spanish Gypsy'; Boston 1925, p. 7, 1925a, p. 8, as 'Spanish Gypsy'; Downes 1925, 1926, p. 241, as 'Spanish Gypsy'; New York 1926, p. 3, ill. n.p., as 'The Spanish Gypsy'; 'Sargent Exhibit', *Original Artists and Models Magazine,* vol. 1, no. 7 (February 1926), ill. p. 17, as 'The Spanish Gypsy'; Royal Cortissoz, 'The Field of Art', *Scribner's Mag-*

azine, vol. 69 (March 1926), ill. p. 331, as 'The Spanish Gypsy'; Charteris 1927, p. 282, dated 1880, as 'Spanish Gypsy'; Mount 1955, p. 444 (no. K811), dated 1881, as 'Spanish Gypsy'; 1957 ed., p. 354 (K811); 1969 ed., p. 463 (K811); Ormond, *Fenway Court,* 1970, p. 13, ill. p. 11, fig. 9, as 'Spanish Gypsy'; Ormond 1970, pp. 28, 238, ill. pl. 24, as 'The Spanish Gypsy'; Washington 1992, pp. 25, 154. ill. p. 155 (colour); Adelson and Oustinoff 1992, p. 465; Adelson *et al.* 2003, p. 68, ill. p. 69 (colour).

768 Spanish Gypsy Dancer
PROVENANCE
Given by the artist to Emmanuel Chabrier, 1884; purchased in Nice by Daniel H. Farr & Co., Philadelphia, by 1928; Edith Kane Baker, Locust Valley, New York; sold from her estate, Sotheby Parke Bernet, New York, 28–29 October 1977, lot 258, ill. sale cat., bt. Dr John E. K. Larkin; Coe Kerr Gallery, New York, by 1985; private collection.
EXHIBITIONS
Washington 1992, no. 17; New York, Adelson Galleries, 2003, no. 11.
LITERATURE
The Spur, vol. 41, no. 1 (1 January 1928), ill. p. 64 (colour); Mount 1955, p. 444 (K814), dated 1881; 1957 ed., p. 354 (K814); 1969 ed., p. 463 (K814); Rollo Myers, *Emmanuel Chabrier and His Circle,* London, 1969, p. 7; Ormond, *Fenway Court,* 1970, p. 13; *Chabrier: livre bilingue, français/anglais: Series Iconographie musicale,* ed. Roger Delage, Geneva, 1982, p. 151, ill. pl. 125; Washington 1992, pp. 25–26, 95, n. 15, 152–53, ill. p. 153 (colour); Adelson and Oustinoff 1992, p. 465, ill. p. 471 (colour); Roger Delage and Frans Durif, eds., *Correspondance/Emmanuel Chabrier,* Paris, 1994, pp. 220–21, n. 2; Roger Delage, *Emmanuel Chabrier,* Paris, 1999, p. 157; Adelson in Adelson *et al.* 2003, p. 66, ill. p. 67 (colour).

769 Sketch of a Spanish Dancer
PROVENANCE
The artist; untraced.
LITERATURE
Strettell 1887, ill. facing p. 51; Cortissoz 1903, pp. 520, 522; Cortissoz 1913, p. 226; Mount 1955, p. 446 (K873), dated 1887, as 'Spanish Dance'; 1957 ed., p. 355 (K873); 1969 ed., p. 466 (K873) as 'Spanish Dancer'; Washington 1992, p. 165, no. 24, ill.

770 Spanish Dancer
PROVENANCE
Isaac Jean Mathieu Val, before 1897; his son, Jean Albert Val; the latter's daughter, Edith, Mme Lucien Thuret; her son, Vincent David Albert Thuret; Coe Kerr Gallery, New York, 1988; Dorothy and Wendell Cherry; sold from the estate of Wendell Cherry, Sotheby's, New York, 25 May 1994, lot 93, ill. sale cat. (colour); private collection.
EXHIBITION
Washington 1992, no. 26.
LITERATURE
'In the Grand Manner' (the Wendell Cherrys' New York residence), *Town & Country,* New York, January 1991, pp. 112, 116, 118, ill. p. 113 (*in situ,* colour); Washington 1992, pp. 29–30, 31, 33–34, 35, 40–41, 44, 168, ill. p. 169 (colour); Warren Adelson and Elizabeth Oustinoff, 'Spanish Dancer' in Washington 1992, pp. 110–14; Adelson and Oustinoff 1992, pp. 460–71, ill. pls. 1 and 1a (colour); Boone 1996, p. 169, ill. p. 361, fig. 5.15.

771 Study for 'Spanish Dancer'
PROVENANCE
Emily Sargent, 1925; Violet Sargent (Mrs Francis Ormond), 1936; her daughter, Reine Ormond (Mrs Hugo Pitman), 1955; Stuart Feld, New York, 1967; Hirschl & Adler, New York, 1973; sold to Mr and Mrs George V. Charlton, 1974; Dallas Museum of Art, Foundation for the Arts Collection, gift of Margaret J. and George V. Charlton, in memory of Eugene McDermott.
EXHIBITIONS
Birmingham 1964, no. 54, as 'Study for El Jaleleo [*sic*]'; Los Angeles

County Museum of Art, *Eight American Masters of Watercolor,* 23 April–16 June 1968, no. 14, as 'Study for "El Jaleo"', also M. H. de Young Memorial Museum, San Francisco, 28 June–18 August 1968, and Seattle Art Museum, 5 September–13 October 1968; New York and Chicago 1986, unnumbered, as 'Study for *El Jaleo*'; Washington 1992, no. 25.

LITERATURE

Ormond 1970, p. 238; Ormond, *Fenway Court,* 1970, p. 13, ill. p. 12, fig. 11, as 'study for El Jaleo'; New York 1980, checklist, n.p.; Blaugrund in Hills *et al.,* 1986, pp. 212, 289, ill. p. 214, fig. 175, as 'Study for *El Jaleo*'; Washington 1992, pp. 30, 36, 166, ill. p. 167 (colour); Adelson and Oustinoff in Washington 1992, p. 113; Adelson and Oustinoff 1992, p. 465, ill. p. 469, pl. VI (colour).

772 *El Jaleo*

PROVENANCE

Purchased at the Paris Salon, 11 May 1882, by Thomas Jefferson Coolidge, Sr; given by him to Isabella Stewart Gardner, December 1914; Isabella Stewart Gardner Museum, Boston.

EXHIBITIONS

Paris, Salon, 1882, no. 2397, as 'El Jaleo;—danse de Gitanes'; London, Fine Art Society, *Collection of Pictures by British and American Artists from the Paris Salon,* July 1882, no. 9; New York, Schaus Galleries, 7–17 October 1882; Boston, Williams and Everett Gallery, 22–29 October 1882; Boston 1888, no. 19 in MS list; Boston, Museum of Fine Arts, 15 November 1897–19 March 1902; Boston, Museum of Fine Arts, 23 May–21 October 1912; Washington 1992, no. 50.

LITERATURE

Salon Reviews, 1882

E. F. S. Pattison, 'The Salon of 1882 (Third Notice)', *Academy,* vol. 21, no. 524 (20 May 1882), p. 366; Paul Leroi, 'Salon de 1882', *L'Art,* vol. 30, no. 3 (1882), pp. 138–39, ill. facing p. 138 (etching by E. Boucourt); 'The Paris Salon', *Art Amateur,* vol. 7, no. 1 (June 1882), p. 4; 'American Art in the Paris Salon', *Art Amateur,* vol. 7, no. 3 (August 1882), p. 46; Maurice Du Seigneur, 'L'Art et les Artistes au Salon de 1882', *L'Artiste,* vol. 52, part 1 (June 1882), pp. 645–46, and part 2 (July 1882), p. 18; Franck-Lhubert, 'Chronique des Lettres et des Arts', *L'Artiste,* vol. 53, part 1 (February 1883), p. 143; 'The Salon. From an Englishman's Point of View', *Art Journal,* 1882, pp. 217–18, and Victor Champier, 'The Salon. From a Frenchman's Point of View', p. 271; 'Le Salon de Paris: Premier Article', *L'Art Moderne,* vol. 2, no. 20 (14 May 1882), p. 155; 'Le Salon de Paris: Deuxième Article', vol. 2, no. 21 (21 May 1882), p. 162; 'The Salon, Paris (Third and Concluding Notice)', *Athenaeum,* no. 2850 (10 June 1882), p. 738; Richard Whiteing, 'Art and Artists', *Boston Evening Transcript,* 24 May 1882, p. 6; C. M. P. Hilliard, 'Paris Salon. Second Article', *Boston Evening Transcript,* 2 June 1882, p. 6; 'American Artists in Paris: Mr. John Sargent's Great Success in the Salon with his Spanish Scene, "El Jaleo"', *Boston Evening Transcript,* 26 July 1882, p. 2; 'American Art at the Paris Salon', *The Builder,* vol. 42, no. 2050 (20 May 1882), p. 605; Auguste Baluffe, 'Le Salon de 1882', *Bulletin Hebdomadaire de L'Artiste,* 30 April–7 May 1882, p. 67; Louis Leroy, 'La Révision du Salon de 1882', *Le Charivari,* 4 May 1882, p. 90; 'Le Salon pour Rire, par Draner', *Le Charivari,* 18 May 1882, ill. p. 3 (caricature); Rodolfe Salis, 'Une chronique du Salon', *Le Chat Noir,* vol. 6 (May 1882), p. 3; 'Salon de 1882', *Courrier de l'Art,* vol. 2, no. 25 (22 June 1882), p. 293; Emmanuel Ducros, *Un Cigale au Salon de 1882,* Paris, 1882, p. 66, ill. facing p. 66 (after a drawing); F.-G. Dumas, *Catalogue Illustré du Salon,* Paris, 1882, ill. p. 54 (woodcut after a drawing; see fig. 167); Louis Énault, *Paris-Salon 1882,* vol. 2, Paris, 1882, ill.; Albert Wolff, 'Le Figaro-Salon', supplement to *Le Figaro,* vol. 8, no. 17 (May 1882), n.p.; Edmund Gosse, 'The Salon of 1882', *Fortnightly Review,* n.s., vol. 31 (June 1882), p. 742; 'Salon de Paris', *Le Gaulois,* 2 June 1882; Antonin Proust, 'Le Salon de 1882 (Premier Article)', *Gazette des Beaux-Arts,* 2nd series, vol. 25, no. 6 (June 1882), p. 551, ill. facing p. 550 (heliograph by Dujardin, after a drawing; see fig. 167); J.-K. Huysmans, *L'Art Moderne,* Paris, 1883, p. 272; J. F. R. [John Forbes-Robertson], 'The Paris Salon: Second Notice', *Illustrated London News,* vol. 60, no. 2246 (20 May 1882), p. 494; Jules Comte, 'Les Salons de 1882, III: La Peinture (Suite)', *L'Illustration,* vol. 79, no. 2047 (20 May 1882), p. 335; Pierre Vérm, 'Chronique Parisienne. Le Salon de 1882', *Le Journal Amusant,*

6 May 1882, p. 3; Stop, 'Le Salon de 1882', *Le Journal Amusant,* 20 May 1882, ill. p. 4 (caricature); John Forbes-Robertson, 'The Salon of 1882', *Magazine of Art,* vol. 5 (1882), pp. 413–14; Olivier Merson, 'Le Salon de 1882', *Le Monde Illustré,* vol. 50, no. 313 (27 May 1882), p. 330; 'El Jaleo—Danse de Gitanes', *Le Monde Illustré,* vol. 41, no. 1335 (28 October 1882), p. 278, ill. p. 281 (engraving by Charles Baude); 'The Close of the Salon', *New York Daily Tribune,* 16 July 1882, p. 4; 'Dialogue sur quelques tableaux du Salon de 1882: un académicien—un impressioniste', *La Nouvelle Revue,* 16 May–June 1882, pp. 702–3; 'Art Chronicle', *The Portfolio,* 1882, p. 147; Judith Gautier, 'Le Salon IV', *Le Rappel,* 12 May 1882, p. 3; Henry Houssaye, 'Le Salon de 1882', *Revue des Deux Mondes,* vol. 41, no. 3 (1 June 1882), p. 583; 'Chronique: Le Salon en courant', *Le Temps,* 28 April 1882, p. 2; Jules Claretie, 'La Vie à Paris', *Le Temps,* 19 May 1882, p. 3; Paul Mantz, 'Exposition de la Société internationale, *Le Temps,* 31 December 1882, p. 3; 'The Salon', *Times,* London, 1 May 1882, p. 10a; Armand Silvestre, 'Le Monde des Arts. Le Salon de 1882', *La Vie Moderne,* vol. 22 (3 June 1882), p. 342; 'Burckhardt Scrapbook', a large collection of press cuttings relating to the Salon exhibition of *Louise Burckhardt (Lady with the Rose)* and *El Jaleo,* given to David McKibbin by Valerie Burckhardt's granddaughter, Mrs W. H. Scheide, 1951 (McKibbin papers).

Later Exhibition Reviews, 1882–88

'General Gallery Gossip', *Boston Daily Advertiser,* 21 October 1882, p. 9; 'The Fine Arts', *Boston Daily Advertiser,* 24 October 1882, p. 1; 'The Fine Arts: Sargent's "El Jaleo"', *Boston Daily Advertiser,* 3 November 1882, p. 5; 'Mr Sargent's "El Jaleo"', *Boston Evening Transcript,* 25 October 1882, p. 3; 'Art Notes', *Boston Evening Transcript,* 3 November 1882, p. 4; 'The Fine Arts: Mr. Sargent's "El Jaleo"', *The Critic,* vol. 2, no. 47 (21 October 1882), p. 286; 'Art and Artists', *Daily Graphic,* New York, vol. 29 (7 October 1882), p. 687; 'Art and Artists', *Daily Graphic,* New York, vol. 29 (14 October 1882), p. 736; 'Art Notes', *Magazine of Art,* vol. 5 (1882), p. xli; 'Fine Arts. Sargent's "El Jaleo—Dance of the Gypsies"', *New York Herald,* 8 October 1882, p. 8; 'Sargent's "El Jaleo" at the Schaus Gallery', *New York Times,* 13 October 1882, p. 5; 'The Exhibition of the Society of American Artists', *Art Journal,* 1883, p. 228; 'America in Europe', *Magazine of Art,* vol. 6 (1883), pp. 6–7, ill. p. 5 (woodcut after a drawing; see fig. 167); R. A. M. Stevenson, 'Art in France', *Magazine of Art,* vol. 7 (1884), p. 463; Montezuma [Montague Marks], 'My Note Book', *Art Amateur,* vol. 13, no. 3 (August 1885), p. 44; Greta, 'Art in Boston', *Art Amateur,* vol. 18, no. 5 (April 1888), p. 110; 'The Art Scene in Boston', *Art Amateur,* vol. 19, no. 1 (June 1888), p. 5; 'The Fine Arts', *Boston Daily Advertiser,* 2 February 1888, p. 4; *Boston Evening Transcript,* 30 January 1888, p. 4; *Boston Evening Traveler,* 8 February 1888, p. 1.

Other References

James 1887, pp. 686–88; Lucien Solvay, *L'Art Espagnol,* Paris, 1887, ill. p. 45; Stevenson 1888, pp. 30–31; Marianna Griswold Van Rensselaer, *Harper's Weekly,* vol. 34 (14 June 1890), p. 457; Theodore Child, *Art and Criticism: Monographs and Studies,* New York, 1892, pp. 102, 105; Raoul Sertat, 'Beaux-Arts, Expositions à Paris', *Revue Encyclopédique,* vol. 2, no. 42 (1 September 1892), p. 1258; Coffin 1896, pp. 172, 175; Cortissoz 1903, pp. 522, 524; Meynell 1903, n.p., ill.; Cortissoz 1913, pp. 226–28; McSpadden 1923, p. 285; Pousette-Dart 1924, ill., n.p.; Starkweather 1924, p. 6; Morris Carter, *Isabella Stewart Gardner and Fenway Court,* Boston, 1925, p. 241, ill. p. 240; Downes 1925, 1926, pp. 128–29; Ted Shawn, *Gods Who Dance,* New York, 1929, ill. p. 201; Charteris 1927, pp. 51, 55, 57, 97, 98, 111, 113, 251, 282, dated 1881; Meynell and Manson 1927, n.p., ill.; Philip Hendy, *Catalogue of the Exhibited Paintings and Drawings, The Isabella Stewart Gardner Museum,* Boston, 1931, pp. 316–17; *Boston Traveler,* 19 September 1933, p. 23, as 'El Jolo [sic]'; *New York Times Magazine,* 19 November 1933, ill.; *Fenway Court General Catalogue,* compiled by Gilbert Wendel Longstreet, under the supervision of Morris Carter, Boston, 1935, p. 53; *Vernon Lee's Letters* 1937, p. 84; Gilbert Chase, *The Music of Spain,* New York, 1941, ill. facing p. 257; Mount 1955, pp. 70–71, 73, 121, 133, 168, 172, 281, 367, 445 (K8221); 1957 ed. pp. 62, 65, 103, 143, 146, 230, 303, 354 (K8221); 1969 ed. pp. 70–71, 73, 121, 133, 168, 172, 281, 367, 463 (K8221); McKibbin 1956, pp. 33–34, 42, 103, ill. p. 28, fig. 13; Morris Carter, *Did You Know Mrs. Gardner?: Morris Carter's Answer,* Boston, 1964, pp. 52–53; Louise Hall Tharp, *Mrs. Jack,* New York, 1965, pp. 297–98; George L. Stout, *Treasures from the Isabella*

Stewart Gardner Museum, New York, 1969, p. 66, ill. p. 67; Ormond 1970, pp. 22, 28, 31, 89, 238, 243, ill. pls. 22, 23 (detail); Ormond, *Fenway Court,* 1970, pp. 2–19, ill. fig. 2; Marshall B. Davidson, *The American Heritage History of the Artists' America,* New York, 1973, p. 188, ill. p. 189; Hendy 1974, pp. 219, 221, ill. p. 220; Gregory d'Alessio, 'On Sargent's "El Jaleo": it may be art but is it flamenco?' *Guitar Review,* no. 41 (Winter 1976), pp. 24–25, ill. p. 24; Sellin 1976, p. 66, ill. p. 68, fig. 97; New York 1980, checklist, n.p.; Rollin van N. Hadley, *The Isabella Stewart Gardner Museum,* New York, 1981, pp. 106–7; Ratcliff 1982, pp. 57–58, 66, 67, 70–71, 73, 75, 77, 83, 84, 89, 99, 114, 122, 130, ill. pp. 68–69, fig. 99 (colour); Robertson 1982, pp. 25–26, ill. p. 25, fig. 9; Adelson *et al.* 1986, pp. 34, 35, 63; Olson 1986, pp. 71, 73, 74, 95, 98, 109, 110, 136, 143, 147, 162, 176, 267, ill. pl. IX, facing p. 108; Fairbrother 1986, pp. 51–59, 61, 63, 83, nn. 50–58, 84, 97, 127, 132, n. 4, 135, 175, 267, n. 12, 362, n. 99, ill. fig. 13; Hills *et al.* 1986, pp. 39–40, 51, 79, 181, 194, 212, 259, ill. p. 42, fig. 14; Fairbrother 1987, p. 59, ill. p. 58, fig. 3; José Blas Vega and Manuel Ríos Ruiz, *Diccionario Enciclopédico Ilustrado del Flamenco,* Madrid, 1988, vol. 1, p. 62, ill. p. 61; *Magazine Antiques,* vol. 138 (1 July 1990), ill. p. 128, pl. IV (colour); Fairbrother 1990, pp. 32, 33; Lois Marie Fink, *American Art at the Nineteenth-Century Paris Salons,* Washington, D.C., and Cambridge, 1990, pp. 198–99, ill. p. 198; Adelson and Oustinoff 1992, pp. 462, 463, 465, 467, 470, n. 3, 471, nn. 11, 13, 14, ill. p. 463, pl. II (colour); David Park Curry, 'Exhibition Reviews: Washington, National Gallery Sargent's "El Jaleo"', *Burlington Magazine,* vol. 134, no. 1073 (August 1992), pp. 552–54; Ann Daly, 'Art of the Dance: John Singer Sargent and the Dance', *Dance View,* vol. 10, no. 1 (Autumn 1992), pp. 9–13, ill. p. 8, fig. 1; Washington 1992; Patricia Hills, 'Art in Context: Sargent's El Jaleo, Bizet's Carmen', *Art New England,* October/November 1992, pp. 10–11, 52, ill. p. 10; Carol M. Osborne, 'Yankee Painters at the Prado', in *Spain, Espagne, Spanien: Foreign Artists Discover Spain 1800–1900,* curated by Suzanne L. Stratton, The Equitable Gallery in association with the Spanish Institute, New York, 1993, pp. 59, 72, 73, ill. p. 58, fig. 37 (exhibition catalogue); Fairbrother 1994, pp. 22, 23, 26–28, 31, 40, 44, 72, 86, ill. p. 20 (colour;); Boone 1996, pp. 158, 167, 169, 170, 171, 172–73, 174, 175, 176, 182, 185, 186, 187, n. 2, 194, n. 69, 70, ill. p. 351, fig. 5.2; Adelson *et al.* 1997, pp. 15–16, 57, 92, 222, 238, ill. p. 15, pl. 5 (colour); Simpson 1997, pp. 2, 47, 48, 51, 53, 55, 58, 59, 62, 63, 68, 106, 111, 113–14, 115, 120, 127, 136, 141, 150, 163 n. 108, 164, n. 115, 176, no. A 38, 177, nos. A 39 and A 45, ill. p. 48, fig. 19 (colour), p. 176, and p. 177 (twice); Douglass Shand-Tucci, *The Art of Scandal: The Life and Times of Isabella Stewart Gardner,* New York, 1997, pp. 79, 80, 246, 258–61, ill. p. 258 (*in situ*); *Early Portraits,* 1998, pp. xiv, 4–5, 13, 14, 16, 20, n. 16, 21, n. 34, 22, n. 42, 40, 50, 65, 80, 98, 99, 123, 195, ill. p. 5, fig. 8; London 1998, pp. 14, 25–27, 31, 241, ill. p. 26, fig. 27; Simpson 1998, pp. 4, 5, 8, 10, n. 15, 18, ill. p. 6, fig. 4 (colour); Fairbrother 2000, pp. 24, 65, 99, 101–2, 111, ill. p. 101, fig. 4.3, and p. 94 (detail) (both in colour); Heller 2000, pp. 8–23, ill. pp. 8–9 (colour); Herdrich and Weinberg 2000, pp. 124, 125, 177, 192, ill. p. 126, fig. 60; Ferrara 2002, pp. 30, 33, 36, ill. pp. 34–35 (colour); *Portraits of the 1890s,* pp. 12, 16, n. 24, 21, 24; Ormond and Pixley 2003, p. 639; Robertson *et al.* 2003, pp. 55, 56; Boston 2004, pp. 155, 210, 228, 251; Gallati *et al.* 2004, pp. 79, 82, 152, ill. p. 79, fig. 20.

773 *Study for Seated Figures, 'El Jaleo'*
PROVENANCE
[?] Renaudot; M. Knoedler & Co., London; Christie's, London, 24 June 1927, lot 82, bt. D. Croal Thomson, as 'Three Spanish Figures'; Scott & Fowles, New York; sold to Grenville L. Winthrop, 23 January 1932, as 'Study for El Jaleo'; Fogg Art Museum, Harvard University Art Museums, Cambridge, Massachusetts, bequest of Grenville L. Winthrop, 1943.
LITERATURE
Charteris 1927, p. 282, dated 1881, as 'El Jaleo'; Mount 1955, p. 445 (K8223), dated 1882, as 'Sketch for El Jaleo'; 1957 ed., p. 355 (K8223); 1969 ed., p. 463 (K8223); Ormond 1970, p. 238; Ormond, *Fenway Court,* 1970, p. 15, ill. p. 16, fig. 14, as 'Study for El Jaleo'; Sellin 1976, p. 66, ill. p. 68, fig. 100; New York 1980, checklist, n.p., as 'El Jaleo, Study'; Washington 1992, p. 186, ill. p. 187 (colour).

774 *Study for Seated Musicians, 'El Jaleo'*
PROVENANCE
[?] Renaudot; M. Knoedler & Co., London; Christie's, London, 24 June 1927, lot 83, bt. in, as 'The Musicians'; Christie's, London, 6 December 1929, lot 21, bt. in (erroneously said to be from the artist's sale, 1927); Christie's, London, 27 July 1931, lot 95, bt. Gooden & Fox, London; Scott & Fowles, New York; sold to Grenville L. Winthrop, 23 January 1932, as 'Study for El Jaleo'; Fogg Art Museum, Harvard University Art Museums, Cambridge, Massachusetts, bequest of Grenville L. Winthrop, 1943.
LITERATURE
Charteris 1927, p. 282, dated 1881, as 'El Jaleo'; Birnbaum 1941, ill. p. 57, as 'Study for "El Jaleo"'; Mount 1955, p. 445 (K8222), dated 1882, as 'Sketch for El Jaleo'; 1957 ed., p. 355 (K8222); 1969 ed., p. 463 (K8222); Ormond 1970, p. 238; Ormond, *Fenway Court,* 1970, p. 15; New York 1980, checklist, n.p., as 'El Jaleo, Study, Musicians'; Washington 1992, p. 188, ill. p. 189 (colour).

775 *Man and Woman on a Bed*
PROVENANCE
Violet Sargent (Mrs Francis Ormond), 1925; Denys Sutton, London, by c. 1970; private collection.
LITERATURE
Sargent Trust List [1927], pictures framed, no. 1, 'Spanish figures of Man and a Woman sitting on a bed. Monochrome'.

776 *Sketch of a Young Woman with Playing Cards*
PROVENANCE
The artist; untraced.
LITERATURE
Strettell 1887, ill. facing p. 35; *Athenaeum,* no. 3118 [30 July 1887], p. 142; Cortissoz 1903, p. 520; Cortissoz 1913, p. 226; Mount 1955, p. 446 (K871), dated 1887, as 'Fate'; 1957 ed., p. 355 (K871); 1969 ed., p. 466 (K871); Washington 1992, p. 165.

777 *White Walls in Sunlight, Morocco*
PROVENANCE
Violet Sargent (Mrs Francis Ormond), 1925; given by her, with a large group of Sargent studies, to The Metropolitan Museum of Art, New York, 1950.
LITERATURE
Mount 1955, p. 444 (K8028), dated 1880, as 'Courtyard with Moorish Door'; 1957 ed., p. 354 (K8028); 1969 ed., p. 461 (K8028); Burke 1980, p. 223, ill.; New York 1980, checklist, n.p., as 'Morocco, White Walls in Sunlight'; Ratcliff 1982, ill. p. 55, pl. 76; Fairbrother 1990, p. 32, ill. fig. 2; Boone 1996, pp. 189–90, n. 27.

778 *Moorish Buildings on a Cloudy Day*
PROVENANCE
Violet Sargent (Mrs Francis Ormond), 1925; given by her, with a large collection of Sargent studies, to The Metropolitan Museum of Art, New York, 1950.
LITERATURE
Mount 1955, p. 444 (K8029), dated 1880, as 'Moorish House on Cloudy Day'; 1957 ed., p. 354 (K8029); 1969 ed., p. 461 (K8029); Burke 1980, p. 224, ill.; New York 1980, checklist, n.p., as 'Moorish Buildings on a Cloudy Day'; Ratcliff 1982, ill. p. 24, pl. 24 (colour); Boone 1996, pp. 189–90, n. 27; Weinberg and Herdrich, *MMA Bulletin,* 2000, p. 10, ill. p. 11, fig. 11 (colour); Weinberg and Herdrich, *Antiques,* 2000, p. 231, ill. p. 229 (colour).

779 Moorish Buildings in Sunlight
PROVENANCE
Violet Sargent (Mrs Francis Ormond), 1925; given by her, with a large
collection of Sargent studies to The Metropolitan Museum of Art, New
York, 1950.
LITERATURE
Mount 1955, p. 444 (K8031), dated 1880, as 'Moorish Building in Sun-
shine'; 1957 ed., p. 354 (K8031); 1969 ed., p. 461 (K8031); Burke 1980,
p. 224, ill.; New York 1980, checklist, n.p., as 'Moorish Buildings in
Sunlight'; Ratcliff 1982, ill. p. 55, pl. 75; Boone 1996, pp. 189–90, n. 27.

780 Entrance to a Mosque
PROVENANCE
Violet Sargent (Mrs Francis Ormond), 1925; given by her, with a large
group of Sargent studies, to The Metropolitan Museum of Art, New
York, 1950.
LITERATURE
Mount 1955, p. 444 (K8026), dated 1880, as 'Courtyard, Tetuan', ill.
between pp. 144–45; 1957 ed., p. 353 (K8026); 1969 ed., p. 461 (K8026);
Burke 1980, p. 223, ill., as 'Courtyard, Tetuan, Morocco'; New York
1980, checklist, n.p., as 'Courtyard, Tetuan, Morocco'; Washington 1992,
p. 28, ill. p. 29, fig. 8, as 'Courtyard, Morocco'; Boone 1996, pp. 189–90,
n. 27, as 'Courtyard, Tetuan, Morocco'.

781 Open Doorway, Morocco
PROVENANCE
Violet Sargent (Mrs Francis Ormond), 1925; given by her, with a large
group of Sargent studies, to The Metropolitan Museum of Art, New
York, 1950.
LITERATURE
Mount 1955, p. 444 (K8027), dated 1880, as 'Open Doorway, North
Africa'; 1957 ed., p. 353 (K027); 1969 ed., p. 461 (K8027); Burke 1980,
p. 223, ill.; New York 1980, checklist, n.p., as 'Morocco, Open Doorway';
Volk 1992, p. 28, ill. p. 29, fig. 7; Boone 1996, pp. 189–90, n. 27.

782 A Moroccan Street Scene
PROVENANCE
Henry Tonks; sale of his estate, Christie's, London, 29 July 1937, lot 47,
bt. M. Knoedler & Co., New York (stock no. A 1915), as 'An Eastern
Street Scene'; sold to Edith Malvina K. Wetmore, May 1939; bequeathed
by her to Yale University Art Gallery, New Haven, 1966.
LITERATURE
Mount 1955, p. 443 (K801), dated 1880, as 'Tunisian Street Scene' (with
sizes reversed); 1957 ed., p. 353 (K801); 1969 ed., p. 461 (K801); New
York 1980, checklist, n.p., as 'An Eastern Street Scene'; Theodore E.
Stebbins, Jr, and Galina Gorokhoff, *A Checklist of American Paintings at
Yale University*, Yale University Art Gallery, New Haven, 1982, p. 121, no.
1260, ill.

783 Moroccan Street
PROVENANCE
The artist's sale, Christie's, London, 27 July 1925, lot 186, bt. Stevens &
Brown for Charles Deering, as 'A Street in Algiers'; his daughter, Barbara
Deering (Mrs Richard H. Danielson), 1927; Butterfield & Butterfield,
San Francisco, 14–15 December 1997, lot 5084, bt. Adelson Galleries,
New York, 1997; Sayn-Wittgenstein Fine Art, New York, 1998; private
collection.
EXHIBITION
New York, Adelson Galleries, *American Impressionism,* 28 April–30 June
1998, no. 16, ill. cat., n.p. (colour), as 'A Street in Algiers'.
LITERATURE
Christie's 1925, p. 27; Downes 1926, p. 332, recording the 1925 artist's
sale at Christie's, as 'A Street in Algiers'.

784 Moroccan Fortress, with Three Women in the Foreground
PROVENANCE
Acquired by M. Knoedler & Co., New York, on joint account from
Anthony K. Bower, December 1961 (stock no. A 8147); Sotheby's,
London, 18 December 1963, lot 263, as 'Bedouin Women', bt. Hahn;
Shore Gallery, London, 1964; Stephen Richard and Audrey Currier;
sold from their estate, Christie's, New York, 1 June 1984, lot 106c, as
'Bedouin Women'; private collection.

785 Three Berber Women
PROVENANCE
The artist's sale, Christie's, London, 27 July 1925, lot 187, as 'Bedouin
Women', bt. Conway J. Conway (formerly Conway J. Wertheimer);
E. S. Makower; sold from the estate of his widow, Sotheby's, London,
12 July 1961, lot 79, bt. Julius Weitzner; M. Knoedler & Co., New York,
December 1961 (stock no. A 8145); sold to Shirley Schlesinger of
Metairie, Louisiana, June 1964; Sotheby's, New York, 22 May 1996,
lot 16, as 'Bedouin Women'; private collection.
EXHIBITIONS
London, RA, 1926, no. 412, as 'Bedouin Women', lent by C. J. Conway;
York 1926, no. 27, as 'Bedouin Women'.
LITERATURE
Christie's 1925, p. 27; London, RA, 1926, p. 62; Downes 1926, p. 332, as
'Bedouin Women'; Mount 1955, p. 444 (K8025), dated 1880, as 'Bedouin
Women'; 1957 ed., p. 353 (K8025); 1969 ed., p. 461 (K8025).

786 Moroccan Beach Scene
PROVENANCE
The artist's sale, Christie's, London, 27 July 1925, lot 184, bt. Leggatt
Brothers, London, as 'The Coast of Algiers'; sold by them to Lady Boot;
her granddaughter, the Hon Barbara Norman, by 1952; Christie's, Lon-
don, 23 November 1993, lot 68, bt. Adelson Galleries, New York; private
collection.
EXHIBITION
New York, Adelson Galleries, *American Impressionism,* 15 November–
17 December 1994, no. 26, ill. cat., n.p. (colour), as 'Coast of Algiers'.
LITERATURE
Christie's 1925, p. 27; Downes 1926 ed., p. 331, as 'The Coast of Algiers';
Charteris 1927, p. 294, dated 1922, as 'The Coast of Algiers'; Mount
1955, p. 444 (K8019), dated 1880, as 'The Coast of Algiers'; 1957 ed.,
p. 353 (K8019); 1969 ed., p. 461 (K8019), as 'The Coast of Africa (called
The Coast of Algiers)'.

787 Arabs at Rest (Evening)
PROVENANCE
Auguste Alexandre Hirsch; sold by his widow, Mme Hirsch, to M.
Knoedler & Co., London, 7 January 1914 (stock no. 5778); sold to Otto
Gutekunst of P. & D. Colnaghi, London, July 1914 (Knoedler New York
stock no. WC 961); Mrs Henry Clegg of Wormington Grange, Broad-
way, Worcestershire, 1926; her daughter, Laura, Lady Ismay; Christie's,
London, 31 March 1978, lot 255; untraced.
EXHIBITION
London, RA, 1926, no. 552, as 'Bedouins'.
LITERATURE
London, RA, 1926, p. 80; Downes 1926, p. 371, as 'Bedouins'; Mount
1955, p. 447 (K9114), dated 1891, as 'Bedouins'; 1957 ed., p. 357 (K9114);
1969 ed., p. 467 (K9114).

788 Donkeys in a Moroccan Landscape (recto)
and Three Boats (verso)
PROVENANCE
Violet Sargent (Mrs Francis Ormond), 1925; her son F. Guillaume
Ormond, 1955; his heirs, 1971; Coe Kerr Gallery, New York, 1989; Mr
and Mrs Harry Spiro; private collection.

EXHIBITION
New York, Coe Kerr Gallery, *American Impressionism*, 19 May–23 June 1989, no. 37, ill. cat., n.p. (colour), as 'Donkeys in the Desert'.

LITERATURE
Mount 1955, p. 444 (K8034), dated 1880, as 'Two Donkeys in a Desert, with squatting figure'; 1957 ed., p. 354 (K8034); 1969 ed., p. 461 (K8034), as 'Three Donkeys in a Desert, with squatting figure'.

789 *Fumée d'ambre gris*

PROVENANCE
Sold to a Frenchman, probably the artist Paul Borel, May 1880; his widow Mme Borel, 1913; sold by her to Boussod, Valadon & Cie, Paris (stock no. 31108); M. Knoedler & Co., London (stock no. 5884), 6 July 1914; transferred to M. Knoedler & Co., New York, the same day as no. 13352; Robert Sterling Clark, 10 September 1914; Sterling and Francine Clark Art Institute, Williamstown, Massachusetts (15).

EXHIBITIONS
Paris, Salon, 1880, no. 3429; Williamstown 1955, no. 15; Williamstown 1997, no. 10; London 1998, no. 18.

LITERATURE
P. A. F., 'Le Salon Pour Rire—Par Paf', *Le Charivari*, 12 May 1880, p. 3 (see fig. 192); Louis Leroy, 'Le Congrès Artistique', *Le Charivari*, 13 May 1880, p. 94; Stéphane Loysel, 'Le Salon de 1880, IV', *L'Illustration*, vol. 75 (22 May 1880), p. 333, ill.; Frédéric de Syène [Arsène Houssaye], 'Salon de 1880: Peintres Étrangers', *L'Artiste*, vol. 52, part 1 (May 1880), p. 367; Olivier Merson, 'Salon de 1880', *Le Monde Illustré,* vol. 46, no. 1210 (5 June 1880), p. 354; 'Special Correspondence: American Artists at the Paris Salon', *Art Interchange,* vol. 4 (9 June 1880), p. 100; 'The Studio: American Art News', *Art Interchange,* vol. 5, no. 6 (15 September 1880), p. 52; Paul Mantz, 'Le Salon—VII', *Le Temps,* 20 June 1880, p. 1; J. J. R., 'Our Monthly Gossip: The Paris Salon of 1880', *Lippincott's Magazine,* vol. 26, no. 153 (September 1880), p. 384; 'Pencil Sketches', *American Art Journal,* vol. 33, no. 23 (2 October 1880), p. 363; Montezuma [Montague Marks], 'My Note Book', *Art Amateur,* vol. 3, no. 6 (November 1880), p. 113; Philippe Burty, 'Le Salon de 1880. I', *L'Art,* vol. 6, no. 21 (1880), p. 154; Philippe Burty, 'Le Salon de 1880: Les Étrangers', *L'Art,* vol. 6, no. 21 (1880), p. 299, ill. p. 304; Frédéric de Syène, 'The Salon of 1880', *American Art Review,* vol. 1 (1880), p. 543, ill. p. 542; Lucy H. Hooper, 'The Paris Salon of 1880', *Art Journal,* vol. 6 (July 1880), p. 222; Maurice De Seigneur, *L'Art et les artistes au Salon de 1880,* Paris, 1880, pp. 104–5; A. Genevay, 'Salon de 1880 (Huitième Article)', *Le Musée artistique et littéraire,* vol. 4 (1880), pp. 14–15; René Delorme, 'Genre', in Charles Carroll, ed., *The Salon,* 2 vols., New York, 1881, vol. 1, pp. 157–58; F.-G. Dumas, ed., *Salon de 1880: Catalogue Illustré,* Paris: H. Launette, 1882, p. 120, ill.; *1880 Catalogue illustré du Salon,* Paris, Motteroz and L. Baschet, 1882, pp. 60, 120; James 1887, p. 688; Theodore Child, 'American Artists at the Paris Exposition', *Harper's New Monthly Magazine,* vol. 79 (September 1889), p. 504; James 1893, pp. 103–4; Coffin 1896, pp. 169, 175; Dixon 1899, p. 115; Baldry 1900 I, p. 18; Brinton 1906, p. 282; McSpadden 1907, p. 285; Wood 1909, p. 76; Pousette-Dart 1924, ill. n.p.; Downes 1925, 1926, p. 124; Charteris 1927, pp. 51, 52, 251, 281; Mount 1955, pp. 70, 443 (K808); 1957 ed., pp. 62, 353 (K808); 1969 ed., pp. 70, 462 (K808); Ormond 1970, pp. 19, 27, 28, 237, ill. p. 36, fig. 12; New York 1980, checklist, n.p.; Ratcliff 1982, p. 57, fig. 77; D. Dodge Thompson, 'American Artists in North Africa and the Middle East, 1797–1914', *Antiques,* vol. 126, no. 2 (August 1984), p. 311, ill. pl. X (colour); Fairbrother 1986, p. 47, fig. 11; Ayres in Hills *et al.* 1986, pp. 50, 60; Boime in Hills *et al.* 1986, pp. 79, 84–85, 86, figs. 50, 68; Olson 1986, pp. 74, 78, 80, 92, 94, 98, 109, 147; Fairbrother 1994, p. 24, ill. p. 25 (colour); Fairbrother 2000, pp. 51, 53–54, 56, ill. fig. 2.7 (colour) and p. 42, as a detail (colour); Washington 1992, pp. 25, 26–28, 29, 30, 31, ill. p. 26, fig. 2; Ormond in Adelson *et al.* 1997, p. 90; Simpson 1997, pp. 59, 60, 62, 79–80, 92, 94, 111, 166 nn. 23, 26, 174, ill. p. 63, fig. 31 and p. 93 (colour); Simpson, *Antiques,* 1997, pp. 556, 557 n. 6, pl. II (colour); *Early Portraits,* pp. 8, 10, 11, 13, 14, 16, 47, 56, 57, 66, 92, fig. 14 (colour); London 1998, pp. 25, 61, 71, 88, 92, 96, 187, 241, 246, ill. p. 89 (colour); Prettejohn 1998, p. 12, ill. fig. 4 (colour); Ferrara 2000, p. 36, ill. fig. 10 as a detail (colour); Herdrich and Weinberg 2000, pp. 124, 177, 192, fig. 58; Adelson *et al.* 2003, pp. 13,

29, 46–47; Fort in Robertson *et al.* 2003, p. 147; Ormond in Robertson *et al.* 2003, p. 56; David Park Curry, *James McNeill Whistler: Uneasy Pieces,* Richmond, Virginia, and New York, 2004, pp. 81, 83, ill. p. 82, fig. 3.19 (colour); Kristian Davies, *The Orientalists: Western Artists in Arabia, The Sahara, Persia & India,* New York, 2005, p. 251, ill. (colour).

790 *Study for 'Fumée d'ambre gris'*

PROVENANCE
Emily Sargent, 1925; her nephew, Jean-Louis Ormond, 1936; his heirs, 1987; Coe Kerr Gallery, New York; private collection.

EXHIBITIONS
London, RA, 1926, no. 558, as 'Study for "Ambregris"'; Aberdeen 1926, no. 278, as 'Ambregris—a Study'; York 1926, no. 34, as 'Study for "Ambregris, 1880"'; Washington 1964, no. 12; Japan 1989, no. 7; New York, Adelson Galleries, 2003, no. 1.

LITERATURE
London 1926, p. 80; Charteris 1927, pp. 52, 281; Mount 1955, p. 443 (K809), as 'Study for Fumée d'ambre gris'; 1957 ed., p. 353 (K809); 1969 ed., p. 461 (K809); Japan 1989, p. 136, ill. p. 49 (colour); Clark Art Institute 1990, fig. 89; Washington 1992, p. 27, ill. fig. 4; Adelson *et al.* 2003, pp. 29, 46, pl. 1 (colour).

791 *Incensing the Veil*

PROVENANCE
Gift of the artist to Dr Samuel Pozzi; the latter's sale, Galerie Georges Petit, Paris, 23 June 1919, lot 24; M. Knoedler & Co., New York, 23 June 1919 (stock no. WC 1338), as 'Mauresque'; Daniel H. Farr, Philadelphia, December 1919; bt. Isabella Stewart Gardner, 17 November 1919; Isabella Stewart Gardner Museum, Boston (P3w33).

LITERATURE
Downes 1925, 1926, p. 280, as 'Fumée d'ambre gris'; Hendy 1974, pp. 227–28, ill. p. 228; New York 1980, checklist, n.p.; Ratcliff 1982, p. 57; Clark Art Institute 1990, fig. 91; Washington 1992, pp. 26–27, ill. fig. 3; Fairbrother 2000, p. 54, ill. fig. 2. 10 (colour); *Later Portraits,* p. 252.

792 *Venetian Glass Workers*

PROVENANCE
Given by the artist, together with *Venetian Water Carriers* (no. 805), to a piano-maker or merchant of musical instruments, in exchange for a piano; acquired by Charles Pepper, with *Venetian Water Carriers,* at an unidentified sale, Hôtel Drouot, Paris, c. 1896–98; acquired from Pepper by Macbeth Galleries, New York, by 1912; sold to Martin A. Ryerson, 8 November 1912; bequeathed by him to The Art Institute of Chicago, 1933, with a life interest to his wife (she died in 1937).

EXHIBITIONS
New York, Macbeth Gallery, *Thirty Paintings by Thirty Artists,* 3–16 January 1912, no. 23; The Art Institute of Chicago, *The Twenty-Fifth Annual Exhibition,* 5 November–8 December 1912, no. 227; Chicago 1914, no. 16; Boston, MFA, 1925, oil paintings, no. 15 (14); Chicago 1933, no. 480; Chicago 1934, no. 411; Appleton, Wisconsin, Lawrence College, New Alexander Gymnasium, *Loan Exhibition of Oil Paintings at Lawrence College,* 22 September–4 October 1937, no. 6; San Francisco, *Golden Gate International Exposition,* 'Historical American Paintings', 1939, no. 20; Milwaukee Art Institute, *Nineteenth-Century American Masters,* 1948, no. 36; Washington 1964, paintings in oil, no. 15; Dayton 1976, no. 43; Albi, France, Musée Toulouse-Lautrec, *Trésors Impressionnistes du Musée de Chicago,* 27 June–31 August 1980, no. 55, ill. cat. p. 63; San Francisco 1984, no. 57; New York and Chicago 1986, unnumbered; Japan, *Masterworks of Modern Art from The Art Institute of Chicago,* travelling exhibition, 1994, no. 48, p. 148, ill. p. 149; Williamstown 1997, no. 12.

LITERATURE
Downes 1925, 1926, p. 144, ill. facing p. 88; Boston 1925, p. 4; Charteris 1927, p. 282, dated 1881; Mount 1955, p. 445 (K8220), dated 1882; 1957 ed., p. 354 (K8220); 1969 ed., p. 463 (K8220); *Paintings in The Art Institute of Chicago,* Chicago, 1961, p. 411; Ormond 1970, p. 30; Quick 1976, pp. 37, 129, 130, ill. pl. 24 (colour); San Francisco 1984, pp. 99, 103–4, ill. p. 105;

Ayres in Hills *et al.* 1986, pp. 55, 64, 69–70, 71, n. 10, 72, n. 21, 286, ill. p. 58, fig. 30; *Master Paintings in The Art Institute of Chicago,* selected by James N. Wood and Katharine C. Lee, Chicago, 1988, p. 91, ill. (colour); Lovell 1989, pp. 77, 79, ill. p. 80, fig. 91; Honour and Fleming 1991, ill. p. 66 (colour); Simpson 1997, pp. 99, 102, 174, ill. p. 102 (colour), and p. 174, fig. A17; Barter in Barter *et al.* 1999, pp. 24, 213–15, no. 98, ill. p. 214 (colour); Ormond in Robertson *et al.* 2003, p. 62; Ormond and Pixley 2003, p. 639; Boston 2004, pp. 96, 252, ill. p. 254, fig. 195 (colour).

793 *Venetian Women in the Palazzo Rezzonico*
PROVENANCE
Said to have been purchased from the artist by Carmen Errázuriz (Doña Errázuriz-Huici de Ogilvie Grant), c. 1912; her daughter, Hester Ogilvie Grant; David Nissinson Fine Art, New York, 1983; Peter Terian, New York, 1985; his heirs, 2003.

EXHIBITIONS
San Francisco 1984, no. 58; Williamstown 1997, no. 13.

LITERATURE
Mount 1955, p. 444 (K8036), dated 1880; 1957 ed., p. 354 (K8036); 1969 ed., p. 463 (K8036), dated 1882; David James, 'John Singer Sargent y sus amistades chilenas', *Zig Zag,* no. 2703 (January 1957), p. 41, ill.; San Francisco 1984, pp. 104, 106, ill. p. 105; Lovell 1989, p. 84, ill. pl. 9 (colour); Simpson 1997, pp. 98, 99, 103, 167, n. 52 (incorrectly citing the Subercaseaux family as owners), 176, no. A41, ill. p. 103 (colour), and p. 177.

794 *Venetian Bead Stringers*
PROVENANCE
J. Carroll Beckwith, 1887; sold by him to the Albright-Knox Art Gallery, Buffalo, New York, Friends of the Albright Art Gallery Fund, 1916.

EXHIBITIONS
Boston 1888, no. 4; New York, NAD, 1888, no. 219, as 'Venetian Interior'; New York, SAA, Retrospective, 1892, no. 277; Boston 1899, no. 37; Buffalo 1901, no. 29; New York, The Metropolitan Museum of Art, 1908, temporary loan; The Art Institute of Chicago, *Twenty-Third Annual Exhibition of Oil Paintings by Contemporary American Artists,* 1910, no. 209; The Buffalo Fine Arts Academy, Albright Art Gallery, *Eighth Annual Exhibition of Selected Paintings by American Artists,* 10 May–31 August 1913, no. 102; Detroit 1916, no. 81; Dallas 1922, no. 78; New York 1924, oil paintings, no. 52; Chicago 1924, unnumbered; Boston, MFA, 1925, oil paintings, no. 24 (25); San Diego 1926, no. 71; Toronto 1926, no. 71; Stockholm and Copenhagen 1930, no. 86, ill. cat., n.p.; San Francisco 1935, no. 200; Binghamton, New York, Roberson Memorial Center, *Treasure House: New York State,* 5 December 1954–2 January 1955 (no catalogue traced); Chautauqua, New York, Chautauqua Art Association, *Fifteen Painters from the Albright Collection,* 2–18 July 1961 (no catalogue traced; the fifteen pictures in the show are listed in the *Albright-Knox Art Gallery Annual Report 1960–1961, Gallery Notes,* vol. 25, no. 1 [January 1962], p. 39); Oberlin, Ohio, Intermuseum Laboratory, Allen Art Building, 1963 (no catalogue traced); Washington 1964, paintings in oil, no. 21, ill. cat., n.p.; New York, Wildenstein, *From Realism to Symbolism: Whistler and His Own World,* 4 March–3 April 1971, no. 129; also shown at the Philadelphia Museum of Art, 15 April–23 May 1971; Leeds 1979, no. 9; New York, CKG, 1983, no. 32; San Francisco 1984, no. 55; New York and Chicago 1986, unnumbered; Williamstown 1997, no. 14; Buffalo 2001, no. 23; Los Angeles 2003, unnumbered.

LITERATURE
'Art Notes', *Art Interchange,* vol. 19, no. 10 (5 November 1887), p. 145; 'The National Academy of Design', *Art Amateur,* vol. 18, no. 6 (May 1888), p. 132; 'The Academy Exhibition', *Frank Leslie's Illustrated Newspaper,* 14 April 1888, p. 131; Mrs Schuyler Van Rensselaer, 'Fine Arts. The Academy Exhibition', *Independent,* 26 April 1888, p. 519; 'Catholicity in Art', *New York Herald,* 31 March 1888, p. 4; 'Portraits at the Academy', *New York Times,* 8 April 1888, p. 10; 'The Academy of Design', *New York Tribune,* 31 March 1888, p. 4; Boston 1899, p. 10; C. H. Caffin, 'The Picture Exhibition at the Pan-American Exposition, continued', *International Studio,* vol. 14 (September 1901), p. xxi, ill. p. xxii; Caffin 1902,

p. 65; Caffin 1903a, p. 448; Cortissoz 1903, p. 520; 'Notes', *Bulletin of the Metropolitan Museum of Art,* vol. 3, no. 8 (August 1908), p. 164; *Eighth Annual Exhibition of Selected Paintings by American Artists,* Buffalo Fine Arts Academy, Albright Art Gallery, 1913, p. 31 (exhibition catalogue); 'The Eighth Annual Exhibition of Selected Paintings by American Artists at the Albright Art Gallery', *Academy Notes, Buffalo Fine Arts Academy,* vol. 8, no. 3 (July 1913), p. 95, ill. p. 94; Cortissoz 1913, p. 225; *Blue Book of the Buffalo Fine Arts Academy,* 1916, ill. p. 34; *American Art News,* vol. 14 (1 April 1916), p. 7; *Academy Notes, Buffalo Fine Arts Academy,* vol. 12, no. 4 (October–December 1917), p. 143, ill. p. 142; Mechlin 1924, p. 185; New York 1924, p. 14; Boston 1925, p. 5; Downes 1925, 1926, pp. 144–45; Royal Cortissoz, 'Venice as a painting ground', *Personalities in Art,* New York, 1925, pp. 118–19; A. D. Patterson, 'Sargent: A Memory', *The Canadian Magazine,* vol. 65, no. 3 (March 1926), ill. p. 31; Charteris 1927, p. 283, dated 1886; Mather 1931, p. 240; *Catalogue of the Paintings and Sculpture in the Permanent Collection, The Buffalo Albright Art Gallery,* Albright Art Gallery, ed. Andrew C. Ritchie, Buffalo, 1949, pp. 38, 187, no. 16, ill. p. 39; Mount 1955, p. 444 (K826), dated 1882, erroneously lists inscription, 'To my friend J. C. Beckwith'; 1957 ed., p. 354 (K826); 1969 ed., p. 463 (K826); Mount 1963, ill. p. 394, fig. 13; Lansdale 1964, p. 59, ill.; *Munson-Williams-Proctor Institute Bulletin,* Utica, New York, December 1964, p. 1, ill.; Ormond 1970, pp. 29, 30, 238, ill. pl. 21; *From Realism to Symbolism: Whistler and His Own World,* ed. Allen Staley, New York, 1971, p. 127, ill. p. 47, pl. 129 (exhibition catalogue); Tintner 1975, p. 128; Kotik and Nash in Steven A. Nash, with Katy Kline, Charlotta Kotik and Emese Wood, foreword by Robert T. Buck, *Albright-Knox Art Gallery: Painting and Sculpture from Antiquity to 1942,* New York, 1979, pp. 308–9; Leeds 1979, pp. 26, 29, ill. p. 27; Fairbrother 1982, p. 32, n. 6; Ratcliff 1982, ill. p. 60, fig. 84 (colour); New York 1983, p. 18, ill. p. 50; San Francisco 1984, pp. 96, 100–102, ill. p. 101; Adelson in Adelson *et al.* 1986, p. 33, ill. fig. 15; Ayres in Hills *et al.* 1986, pp. 50–51, 52, 55, 68, 71, nn. 10, 11, 73, n. 52, 214, 286, ill. p. 51, fig. 23; Olson 1986, pp. 138–39, 148; Charlotta Kotik in *125 Masterpieces from the Collection of the Albright-Knox Art Gallery,* Buffalo and New York, 1987, p. 40, ill. p. 41 (colour); subsequently republished as *Masterworks at the Albright-Knox Art Gallery,* New York, 1999, with same pagination; Lovell 1989, pp. 81, 84, ill. pl. 7 (colour); Clark Art Institute 1990, pp. 179, 180, ill. p. 180, fig. 95; Simpson 1997, pp. 98, 99, 104, 176, no. A43, ill. pp. 104 (colour), 177; Oustinoff in Adelson *et al.* 1997, pp. 222, 235, n. 3, ill. p. 223, fig. 230 (colour); Grieve 2000, pp. 74–75, 199, n. 47; Helen Raye, with a contribution by Claire Schneider, *Circa 1900: from the Genteel Tradition to the Jazz Age,* Albright-Knox Art Gallery, Buffalo, 2001, p. 51, ill. (colour) (exhibition catalogue); Margaret Plant, *Venice: Fragile City,* New Haven and London, 2002, p. 184; Ormond in Robertson *et al.* 2003, pp. 67–68, ill. pp. 64–65 (colour); Simpson in Merrill *et al.* 2003, p. 43; Boston 2004, pp. 252, 253, ill. p. 252, fig. 190 (colour).

795 *A Venetian Interior*
PROVENANCE
Jean-Charles Cazin; Constant Coquelin; Mme Meiris; Georges Bernheim, Paris; sold by him to M. Knoedler & Co., London, 25 September 1913 (stock no. 5727); sold by Knoedler, New York, to Robert Sterling Clark, 21 October 1913 (stock no. 13339; this gives date of sale as 29 November; London stock no. as 20 October; but the invoice itself is dated 21 October, institute archives); Sterling and Francine Clark Art Institute, Williamstown, Massachusetts.

EXHIBITIONS
Williamstown 1957, unnumbered, ill. cat. pl. LXVII; New York, Wildenstein, 1967, no. 49; New York, MMA, 1970, no. 177, ill. cat., n.p.; New York and Chicago 1986, unnumbered; Boston 1992, no. 114; Williamstown 1997, no. 15; Seattle 2000, no. 25; Boston 2004, unnumbered.

LITERATURE
Cortissoz 1924, p. 347; Pousette-Dart 1924, ill., n.p.; Mather 1931, p. 240; Mount 1955, p. 445 (K8219), dated 1882; 1957 ed., p. 354 (K8219); 1969 ed., p. 463 (K8219); Mount 1963, ill. p. 394, fig. 12; Ormond 1970, pp. 29, 238; Ormond, *Fenway Court,* 1970, p. 12, ill. p. 9, fig. 7; Williamstown 1972, p. 100, ill.; Leeds 1979, p. 26; S. Lane Faison, Jr., *The Art Museums of New England: Massachusetts,* Boston, 1982, p. 324; Ratcliff 1982, ill. p. 26,

fig. 28; Williamstown 1984, p. 34, ill. p. 103, fig. 418; Fairbrother 1986, pp. 361–62, n. 95; Ayres in Hills *et al.* 1986, pp. 50, 52, 53, 70, 71–72, n. 12, 286, ill. p. 52, fig. 24 (colour); Lovell 1989, pp. 81–83, ill. p. 83, fig. 94; Clark Art Institute 1990, pp. 179–82, ill. p. 181 (colour); Hirshler in Stebbins *et al.* 1992, pp. 400, 402, ill. p. 401 (colour); Williamstown 1992, p. 101, ill.; Simpson 1997, pp. 99, 105, 176, ill. p. 105 (colour), and p. 176, fig. A31; Simpson, *Antiques,* 1997, pp. 555–56, ill. p. 554 (colour); Kilmurray in London 1998, p. 80; Grieve 2000, pp. 74–75, 199, n. 47; Ormond in Robertson *et al.* 2003, pp. 52, 67, 68, ill. p. 66 (colour); Simpson in Merrill *et al.* 2003, p. 43; Boston 2004, pp. 96, 252, 274, ill. p. 96, fig. 65 (colour).

796 *A Venetian Woman*

PROVENANCE

The artist's sale, Christie's, London, 27 July 1925, lot 183, bt. Conway J. Conway; sold by him to M. Knoedler & Co., London, 11 March 1927 (stock no. 7983); sold by Knoedler, New York, to Joseph Verner Reed, Denver, June 1927 (stock no. 16757); his son, Samuel P. Reed, 1961; private collection; Adelson Galleries, New York, 2005.

EXHIBITION

London, RA, 1926, no. 585.

LITERATURE

Christie's 1925, p. 27; London 1926, p. 86; Downes 1926, p. 373; Charteris 1927, p. 286, dated 1900; Mount 1955, p. 445 (K8217), dated 1882; 1957 ed., p. 354 (K8217); 1969 ed., p. 463 (K8217).

797 *Venetian Interior*

PROVENANCE

Violet Sargent (Mrs Francis Ormond), 1925; her son, H. E. Conrad Ormond, 1955; his heirs, 1979; Coe Kerr Gallery, New York, 1987; Mr and Mrs Harry Spiro; private collection.

EXHIBITIONS

London, Wildenstein, 1972, no. 35; Leeds 1979, no. 6; Japan 1989, no. 61.

LITERATURE

Sargent Trust List [1927], 'water colours unframed', p. 13, no. 64, as 'Venice interior. Old woman sitting in foreground, red and white kerchief. Two women middle distance; doorway and two windows high up in far distance'; Ormond 1970, p. 69; London 1972, p. 56, ill. fig. 42; Leeds 1979, p. 25, ill. p. 24; Japan 1989, pp. 104, 150, ill. p. 104 (colour); Honour and Fleming 1991, p. 64, ill. (colour).

798 *Venetian Interior*

PROVENANCE

Henry Lerolle, Paris; sold by him to the Carnegie Museum of Art, Pittsburgh, 1920.

EXHIBITIONS

Pittsburgh 1920, no. 297, ill. cat., n.p.; New York 1924, oil paintings, no. 44; Chicago 1924, unnumbered; Boston, MFA, 1925, oil paintings, no. 23 (24); San Diego 1926, no. 50; San Francisco 1926, no. 163, ill. cat., n.p.; Toronto, Art Gallery of Toronto, *Loan Exhibition of Great Paintings in Aid of Allied Seamen,* 4 February–12 March 1944, no. 64; Columbus Gallery of Fine Arts, Ohio, *Paintings from the Pittsburgh Collection,* 1952 (no catalogue traced); Utica 1953, no. 29; Grand Rapids 1955, no. 26, ill. cat. n.p.; Pittsburgh 1957, no. 109; Westmoreland Museum of American Art, Greensburg, Pennsylvania, 1961 (no catalogue traced); Boston 1983, no. 90; San Francisco 1984, no. 54; New York and Chicago 1986, unnumbered (shown in Chicago only); London 1998, no. 14.

LITERATURE

John O'Connor, Jr, 'Carnegie Institute International Exhibition, Six Illustrations', *Art and Archaeology,* vol. 14 (November–December 1922), p. 310; New York 1924, p. 14; Berry 1924, ill. p. 110; Mechlin 1924, p. 185; Boston 1925, p. 5; Downes 1925, 1926, p. 132, ill. facing p. 48; Charteris 1927, p. 283, dated 1886; Mather 1931, p. 240; *Permanent Collection of Paintings: Check List,* Carnegie Institute, Pittsburgh, 1936, p. 21; Mount 1955, p. 444 (K824), dated 1882; 1957 ed., p. 354 (K824); 1969 ed., p. 463 (K824); Mount 1963, p. 400, ill. p. 394, fig. 10; Fred A. Myers, 'Venetian

Interior', *Carnegie Magazine,* vol. 40 (September 1966), p. 249, ill.; Ormond 1970, pp. 29–30, 238; *Catalogue of Painting Collection, Museum of Art, Carnegie Institute, Pittsburgh,* Pittsburgh, 1973, p. 153; New York 1980, checklist, n.p.; Fairbrother in Stebbins *et al.* 1983, pp. 311–12, ill. p. 312; San Francisco 1984, p. 100, ill. p. 55 (colour), and p. 99; E. A. Prelinger in *Museum of Art, Carnegie Institute Collection Handbook,* introduction by John R. Lane, Pittsburgh, 1985, p. 194, ill. p. 195 and cover (both colour); Ayres in Hills *et al.* 1986, pp. 50, 52–54, 55, 59, 62, 72, n. 20, 73, n. 52, 286, ill. p. 53, fig. 25 (colour); Lovell 1989, pp. 81–84, ill. p. 82, fig. 93; Julian Halsby, *Venice: The Artist's Vision,* London, 1990, p. 115; Clark Art Institute 1990, pp. 179, 180, ill. p. 180, fig. 96; Honour and Fleming 1991, ill. p. 78 (colour); Diana Strazdes and others, *American Paintings and Sculpture to 1945 in The Carnegie Museum of Art,* New York, 1992, pp. 417–18, ill. p. 418 and pl. 10 (colour); Richard Dorment and Margaret MacDonald, *James McNeill Whistler,* Tate Gallery, London, 1994, p. 184, ill. p. 290, fig. 79 (exhibition catalogue); Boone 1996, p. 186, ill. p. 376, fig. 5.36; Simpson 1997, pp. 99, 176, no. A32, ill. p. 176; Seldin in Adelson *et al.* 1997, p. 183, ill. p. 182, fig. 177 (colour); London 1998, p. 80, ill. p. 81 (colour); Grieve 2000, pp. 74–75, 199, n. 47, ill. p. 75, fig. 76; Margaret Plant, *Venice: Fragile City,* New Haven and London, 2002, p. 184; Ormond in Robertson *et al.* 2003, pp. 67–68, ill. p. 66 (colour); Ormond and Pixley 2003, pp. 636–37 and n. 21, ill. p. 634, fig. 16; Simpson in Merrill *et al.* 2003, p. 43, ill. p. 44, fig. 37 (colour); Boston 2004, pp. 156, 252, ill. p. 157, fig. 109 (colour); Gallati *et al.* 2004, p. 33, ill. pl. 6 (colour).

799 *Head of a Venetian Model in a Scarlet Shawl*

PROVENANCE

George Henry Boughton; sold by his widow at Christie's, London, 9 June 1906, lot 90 as 'Head of a Girl with red shawl', bt. in; Fifth Avenue Galleries, New York; sold by them to B. A. Collins, 1906; Leicester Galleries, London, 1907; Burton Mansfield, New Haven, Connecticut; sold with his American art collection, American Art Association, Anderson Galleries, New York, 7 April 1933, lot 51, as 'Head of a Sicilian Girl', ill. sale cat. p. 21, bt. Scott & Fowles, New York; sold by them to Grenville L. Winthrop, 26 March 1934; Fogg Art Museum, Harvard University Art Museums, Cambridge, Massachusetts, bequest of Grenville L. Winthrop, 1943.

EXHIBITIONS

London, Leicester Galleries, 1907; Pittsburgh, Carnegie Institute, *Summer Loan Exhibition,* 1911, no. 50, as 'Head of a Girl'; Hartford, Connecticut, Wadsworth Athenaeum, Morgan Memorial, *Exhibition of Paintings and Pottery Loaned by Hon Burton Mansfield,* April 1920, as 'Head of a Girl' (no catalogue traced; invitation to private view and press cuttings, Athenaeum archives).

LITERATURE

Mount 1955, p. 428 (805), dated 1880, as 'Capri Girl'; 1957 ed., p. 336 (805); 1969 ed., p. 463 (805), dated 1882 (said to be 'Signed and incorrectly dated 1880'), as 'The Venetian Girl (called Capri Girl)'; Ormond 1970, p. 29, as 'Head of a Sicilian Girl'; New York 1980, checklist, n.p., as Head of a Sicilian Girl; Ayres in Hills *et al.* 1986, ill. p. 64, fig. 38, as 'Gigia Viani'; London, Pyms Gallery, 1998, p. 13, ill. p. 12, fig. 6, as 'Gigia Viani'; Boston 2004, p. 252.

800 *Full-Length Study of a Venetian Model*

PROVENANCE

Ralph Wormeley Curtis, or his father Daniel Sargent Curtis; Ralph's widow, Lisa De Wolfe Colt (Mrs Ralph Curtis), 1922; their daughter, Sylvia Curtis (Mrs Theodore Steinert, secondly Mrs Schuyler Owen), 1933; sold through Vose Galleries, Boston, to Laurence Curtis, c. 1950; Hirschl & Adler, New York, 1972; sold to the Cincinnati Art Museum, Ohio, the Edwin and Virginia Irwin Memorial, 1972.

EXHIBITIONS

London, Somerset Club, 1949 (no catalogue traced); Washington 1964, paintings in oil, no. 22, as 'Lady with a Fan', ill. cat., n.p.; New York, Hirschl & Adler, 1972, no. 64, as 'Lady with Fan', ill. cat., n.p., and frontispiece (colour); New York and Chicago 1986, unnumbered, as 'Italian

Girl with Fan'; Richmond, Virginia Museum of Fine Arts, *Masterpieces of American Painting from the Cincinnati Art Museum,* 19 November 1991–5 January 1992, no. 21, as 'A Venetian Girl', also shown Minneapolis Institute of Arts, 2 February–15 March 1992, and Phoenix Art Museum, 11 April–31 May 1992.

LITERATURE

Mount 1955, p. 429 (8213), dated 1882, as 'Lady with a Fan'; 1957 ed., p. 338 (8213); 1969 ed., p. 463 (8213); Mount 1963, pp. 400, 416, n. 49; John Simon, 'Too Many Sargents?', *Arts Magazine,* vol. 38, no. 10 (September 1964), p. 21, ill., as 'Lady with a Fan'; Ormond 1970, p. 29, as 'Venetian Girl with a Fan'; 'Recent Accessions of American and Canadian Museums', *Art Quarterly,* vol. 35, no. 3 (1972), p. 320, ill. p. 331, as 'Italian Girl with Fan'; Millard F. Rogers, Jr, *Favorite Paintings from the Cincinnati Art Museum,* New York, 1980, p. 104, ill. cat. back cover (colour), as 'Italian Girl with Fan'; Ratcliff 1982, ill. p. 71, pl. 101 (colour), as 'Italian Girl with Fan'; John Rewald, *The John Hay Whitney Collection,* National Gallery of Art, Washington, D.C., 1983, p. 169, as 'Italian Girl with a Fan' (exhibition catalogue); San Francisco 1984, p. 95, as 'Italian Girl with Fan'; *Masterpieces from the Cincinnati Art Museum,* Cincinnati, 1984, ill. p. 137, as 'Italian Girl with Fan'; *Emma Hardy Diaries,* ed. Richard H. Taylor, Newcastle, U.K., 1985, p. 183; Ayres in Hills *et al.* 1986, pp. 59, 62, 63, 72–73, n. 31, 286, ill. p. 65, fig. 39 (colour), as 'Italian Girl with Fan'; Olson 1986, p. 148, as 'Italian Girl with a Fan'; *Art Journal,* Winter 1987, p. 317, as 'Italian Girl with Fan'; John Wilson, *Masterpieces of American Painting from the Cincinnati Art Museum,* Cincinnati, 1991, p. 420, ill., as 'A Venetian Girl'; London, Pyms Gallery, 1998, p. 13, ill. p. 12, fig. 7, as 'Italian Girl with Fan'; *The Collections of the Cincinnati Art Museum,* Cincinnati, 2000, p. 263, ill. p. 262 (colour), as 'A Venetian Girl'; Boston 2004, pp. 158, 252, 258, nn. 9, 10, ill. p. 254, fig. 194 (colour), as 'Venetian Woman'.

801 *The Onion Seller*

PROVENANCE

Dr Abel Lemercier; by descent in the Lemercier family; K. Hirago, Paris; Dlugosz; Hall of Art, New York, February 1952; Harold Sterner; Ansbacher; Sam Baraf; Arthur Rocke; Victor Spark, New York; Andrew Crispo Gallery, New York, 1979; Museo Thyssen-Bornemisza, Madrid, 1979.

EXHIBITIONS

New York, Andrew Crispo Gallery, *Masterpieces of American and European Painting,* 1979, no. 44; Auckland, New Zealand, Auckland City Art Gallery, and Christchurch, New Zealand, Robert McDougall Art Gallery, *America & Europe,* 1980, no. 3, ill. cat. p. 132; Rome, Vatican City, Braccio de Carlo Magno, *Maestri americani della Collezione Thyssen-Bornemisza,* 15 September–15 November 1983, no. 51, ill. cat., p. 91, and Lugano, Villa Malpensata, 18 April–22 July 1984, no. 49; U.S. tour, *American Masters: The Thyssen-Bornemisza Collection,* 1984–86, no. 51, cat. p. 156, ill. p. 77; Barcelona, Palau de la Virreina, *Mestres Americans del segle XIX de la Col·lecció Thyssen-Bornemisza,* 1988, no. 69.

LITERATURE

Mount 1955, p. 442 (K807); 1957 ed., p. 353 (K807); 1969 ed., p. 462 (K807); Mahonri Sharp Young, 'Scope and Catholicity: Nineteenth- and Twentieth-Century American Paintings', *Apollo,* vol. 118, no. 257 (July 1983), p. 82, ill. fig. 2; San Francisco 1984, p. 104; Katherine E. Manthorne in Barbara Novak *et al., The Thyssen-Bornemisza Collection: Nineteenth-Century American Painting,* London, 1986, p. 268, no. 93, ill. p. 269 (colour); José Álvarez Lopera, *Maestros Modernos del Museo Thyssen-Bornemisza,* Madrid, 1992, pp. 123, 615, ill. p. 124.

802 *Venetian Loggia*

PROVENANCE

Louis Butler McCagg, c. 1884; sold through a New York dealer, c. 1927–28; Flora MacDonald White; John Hay Whitney, 1928; his widow, Mrs John Hay Whitney, 1982; The Greentree Foundation, New York, 1998; Sotheby's, New York, 'Property of The Greentree Foundation, from the collection of Mr and Mrs John Hay Whitney, American Paintings & Watercolors', 19 May 2004, lot 18; French & Co., New York; private collection.

EXHIBITIONS

New York, SAA, 1898, no. 293, as 'Sketch of a Spanish Cloister'; Philadelphia 1899, no. 54, as 'Spanish Interior'; Boston 1899, no. 53, as 'Spanish Courtyard'; San Francisco 1915, no. 3626, as 'Spanish Courtyard'; Boston, MFA, 1925, oil paintings, no. 56 (59), as 'Spanish Courtyard'; New York, MMA, 1926, paintings in oil, no. 5, as 'The Spanish Courtyard'; New Haven 1958, no. 114, ill. cat., n.p., as 'A Spanish Courtyard'; London, Tate Gallery, *The John Hay Whitney Collection,* 16 December 1960–29 January 1961, no. 52, as 'A Spanish Courtyard'; Washington, D.C., National Gallery of Art, *The John Hay Whitney Collection,* 29 May–5 September 1983, no. 71.

LITERATURE

Boston 1899, p. 14; Christian Brinton, *Impressions of the Art at the Panama-Pacific Exposition,* New York, 1916, ill. p. 101; Downes 1925, 1926, pp. 125–26, as 'Spanish Courtyard'; Boston 1925, p. 7, as 'Spanish Courtyard'; Boston 1925a, p. 8; New York 1926, p. 3, ill. n.p., as 'The Spanish Courtyard'; Charteris 1927, p. 282, dated 1880, as 'Spanish Courtyard'; Mather 1931, p. 240, as 'The Spanish Courtyard'; Mount 1955, p. 445 (K8212), dated 1882, as 'Venetian Courtyard (called Spanish Courtyard)'; 1957 ed., p. 354 (K212); 1969 ed., p. 463 (K8212); *The John Hay Whitney Collection,* Tate Gallery, London, 1960, n.p., no. 59, ill., as 'A Spanish Courtyard' (exhibition catalogue); Mount 1963, pp. 399–400, 416, n. 46, ill. p. 394, fig. 11, as 'Venetian Courtyard'; Ormond 1970, p. 30, as 'Venetian Courtyard'; John Rewald, *The John Hay Whitney Collection,* Washington, D.C., 1983, p. 169, ill. (colour), as 'Venetian Courtyard' (exhibition catalogue); Ayres in Hills *et al.* 1986, pp. 55–56, 64, 72, n. 14, 73, n. 52, ill. p. 61, fig. 34, as 'Venetian Courtyard'; Simpson 1997, p. 99, as 'Venetian Courtyard'; *American Paintings, Drawings & Sculpture,* Sotheby's, New York, sale catalogue, 19 May 2004, pp. 34–39, ill. p. 35 (colour), as 'Venetian Loggia'; the same catalogue material was used in a separate booklet at the time of the sale, *Property of The Greentree Foundation from the Collection of Mr and Mrs John Hay Whitney, American Paintings & Watercolors New York May 19, 2004,* Sotheby's, New York, pp. 38–43, ill. p. 39 and back cover (detail) (both in colour); Gallati *et al.* 2004, p. 33.

803 *The Sulphur Match*

PROVENANCE

Louis Curtis; his wife, Mrs Louis Curtis, by 1926; their son, the Hon Laurence Curtis; Hirschl & Adler Galleries, New York, 1975; JoAnn and Julian Ganz, 1976; James Maroney, New York; Mr and Mrs Hugh Halff, Texas.

EXHIBITIONS

Boston 1888, no. 14; Boston, Copley Gallery, 1917, no. 16a, as 'Cigarette' (loan agreed too late for the picture to be included in the catalogue); New York 1924, oil paintings, no. 37; Boston 1925, oil paintings, no. 16 (17); New York 1926, paintings in oil, no. 8; Washington 1964, no. 18; Washington, D.C., National Gallery of Art, *An American Perspective,* 4 October 1981–31 January 1982, unnumbered; also shown Fort Worth, Texas, Amon Carter Museum, 19 March–23 May 1982; Los Angeles County Museum of Art, 6 July–26 September 1982; New York and Chicago 1986, unnumbered; New York, James Maroney, *American Paintings: Some Elementary Examples,* May 1987, no. 9; Williamstown 1997, no. 16; London 1998, no. 12; Seattle 2000, no. 24; Ferrara 2002, no. 9; Los Angeles 2003, unnumbered.

LITERATURE

New York 1924, p. 13, ill. p. 47; Berry 1924, pp. 97, 100, ill. p. 96; Mechlin 1924, ill. p. 189; Pousette-Dart 1924, ill. n.p.; Downes 1925, 1926, p. 132, ill. facing p. 56; Boston 1925, p. 4, ill. n.p.; New York 1926, p. 4, ill. n.p.; Charteris 1927, p. 282; Mather 1931, p. 239; Mount 1955, p. 444 (K825); 1957 ed., p. 354 (K825); 1969 ed., p. 463 (K825); Ormond 1970, p. 29; James Normile, 'Art—In Praise of Women', *Architectural Digest,* vol. 32, no. 6 (May–June 1976), pp. 68, 155, ill. p. 69 (colour); Ratcliff 1982, ill. p. 70, fig. 100 (colour); John Wilmerding, Linda Ayres, and Earl A. Powell, *An American Perspective,* National Gallery of Art, Washington, D.C., 1981, pp. 67, 163–64, 179, ill. p. 69, fig. 60 (colour) (exhibition catalogue); Linda Ayres, 'An American perspective: nineteenth–century art from the collection of Jo Ann and Julian Ganz, Jr,' *Magazine Antiques,* vol. 121, no. 1 (January 1982), pp. 267–68, ill. p. 270, pl. XVIII (colour);

San Francisco 1984, p. 95; Ayres in Hills *et al.* 1986, pp. 55, 59, 64, 72, n. 24, 286, ill. p. 48, fig. 21 (colour); Adelson in Adelson *et al.* 1986, p. 32, ill. fig. 12; Fairbrother 1986, pp. 108, 134, n. 18, 136–37, n. 30; Olson 1986, p. 148; Lovell 1989, p. 84, ill. fig. 95; Fairbrother 1990, p. 33; Simpson 1997, pp. 98, 99, 106, 176, no. A33, ill. pp. 106 (colour), 176; Oustinoff in Adelson *et al.* 1997, pp. 222, 235, n. 3; London 1998, pp. 61, 78, ill. p. 77 (colour); Fairbrother 2000, pp. 76–77, ill. p. 78, fig. 3.9 (colour); Ferrara 2002, pp. 161, 178, ill. p. 179 (colour); Ormond in Robertson *et al.* 2003, pp. 72, 75, ill. p. 73 (colour); Boston 2004, pp. 158, 252, 253, ill. p. 159, fig. 112 (colour).

804 *The Venetian Bead Stringers*

PROVENANCE

Hon Frederick Lawless, later 5th Baron Cloncurry, by 1884; bequeathed by him to the National Gallery of Ireland, Dublin, 1929.

EXHIBITIONS

Dublin Sketching Club, Leinster Hall, Dublin, *Exhibition of Sketches, Pictures, and Photography,* 1–20 December 1884, no. 226, as 'Bead Stringers of Venice', lent by Hon F. Lawless'; Dublin, National Gallery of Ireland, *Centenary Exhibition, 1864–1964,* October–December 1964, no. 180; London, Wildenstein, 1972, no. 34; San Francisco 1984, no. 56; Japan 1989, no. 11; Cardiff 1992, no. 13; Boston 2004, unnumbered.

LITERATURE

Press cuttings book of the Dublin Sketching Club, 1881–96, on deposit at the National Library of Ireland, Dublin (acc. 4786), including reviews of the 1884 exhibition in the *Dublin Daily Express,* 27 November 1884, *Dublin Evening Mail,* 3 December 1884, *Freeman's Journal,* 2 December 1884, *Irish Times,* 1 December 1884, and other unidentified newspapers, pp. 22–25; *National Gallery of Ireland: Catalogue of Oil Pictures in the General Collection,* Dublin, 1932, pp. 113–14; Mount 1963, pp. 400, 405, 416, n. 50, 51, ill. p. 402, fig. 17; *Centenary Exhibition 1864–1964,* National Gallery of Ireland, Dublin, 1964, p. 45 (exhibition catalogue); *National Gallery of Ireland: Concise Catalogue of the Oil Paintings,* Dublin, c. 1965, p. 115; Mount 1969, p. 483 (K8227); *National Gallery of Ireland: Catalogue of the Paintings,* Dublin, 1971, p. 147; London 1972, p. 56, ill. fig. 40; Edward Lucie-Smith and Celestine Dars, *Work and Struggle: The Painter as Witness 1870–1914,* London, 1977, ill. p. 79, fig. 25; *National Gallery of Ireland: Illustrated Summary Catalogue of Paintings,* with an introduction by Homan Potterton, Dublin, 1981, p. 147, ill.; San Francisco 1984, pp. 102–3, ill. p. 103; Ayres in Hills *et al.* 1986, pp. 55, 70, 71, n. 10, 72, n. 23, ill. p. 59, fig. 31; Lovell 1989, pp. 77, 79, ill. p. 80, fig. 90; Japan 1989, pp. 53, 137, ill. p. 53 (colour); Simpson 1997, pp. 99, 178, no. A60, ill. p. 179; Ormond in Robertson *et al.* 2003, p. 62, ill. p. 63 (colour); Boston 2004, pp. 96, 252, 258, n. 8, 275, ill. p. 254, fig. 193 (colour).

805 *Venetian Water Carriers*

PROVENANCE

Given by the artist, together with *Venetian Glass Workers* (no. 792), to a piano-maker or merchant of musical instruments, in exchange for a piano; bought by Charles Pepper, together with *Venetian Glass Workers,* at an unidentified sale, Hôtel Drouot, Paris, c. 1896–98; sold by him to Frederick Crane; acquired from A. O. Crane by Macbeth Galleries, New York, 6 June 1911; sold to Worcester Art Museum, Massachusetts, 20 October 1911.

EXHIBITIONS

Seattle, *Alaska-Yukon-Pacific Exhibition,* 1909, Department of Fine Arts, no. 162; New York, NAD, 1910, no. 303; Worcester Art Museum, Massachusetts, *Thirteenth Annual Exhibition of Oil Paintings,* 1910; Buffalo 1910, no. 189, ill. cat. p. 53; St. Louis 1910, no. 193, ill. cat., frontispiece; Pittsburgh 1912, no. 272; Chicago 1912, no. 227; Minneapolis 1915, no. 278; Boston, MFA, 1925, oil paintings, no. 17 (18); New York, MMA, 1926, paintings in oil, no. 9; Worcester Art Museum, *Exhibition of Modern American Paintings, Objective and Subjective,* 3–24 February 1929 (leaflet with brief text, no catalogue); New York, Macbeth Gallery, *Fiftieth Anniversary Exhibition 1892–1942,* April 1942, no. 18; Worcester Art Museum, *Three Americans Abroad, Whistler–Cassatt–Sargent,* 10 July–10 November 1954 (no catalogue traced); subsequently shown at Boston

Symphony Hall for two weeks, late November–early December 1954; Worcester, Norton Company, *Exhibition of Paintings, Drawings and Prints from the Collection of the Worcester Art Museum,* 6 March 1962–3 January 1963; Washington 1964, paintings in oil, no. 17; Minneapolis Institute of Arts, *Fiftieth Anniversary Exhibition 1915–1965,* 4 November 1965–2 January 1966, unnumbered; Worcester Art Museum, *Art in America, 1830–1950, Paintings, Drawings, Prints, Sculpture from the Collection of the Worcester Art Museum,* 9 January–23 February 1969, unnumbered; New York, CKG, 1980, no. 12; San Francisco 1984, no. 53; New York and Chicago 1986, unnumbered; Worcester Art Museum, *John Singer Sargent: Painter of the Gilded Age,* 1 October–31 December 1995, unnumbered (no catalogue traced); Worcester Art Museum, *American Impressionism: Paintings of Promise,* 5 October 1997–4 January 1998, no. 33, ill. cat. p. 71, pl. 31; Seattle 2000, no. 20; Boston 2004, unnumbered.

LITERATURE

'Recent Acquisitions', *Bulletin of the Worcester Art Museum,* vol. 2, no. 4 (January 1912), p. 22, and vol. 3, no. 1 (April 1912), ill. p. 6; 'Purchases in 1911', *Worcester Art Museum Annual Report,* 1912, pp. 14, 22; 'Loans, *Worcester Art Museum Annual Report,* 1915, p. 21; W. Roberts, 'English Pictures at Boston, U.S.A.', *The National Review,* London, vol. 48 (September 1916–February 1917), p. 409; 'Watercolors by John Singer Sargent', *Bulletin of the Worcester Art Museum,* vol. 8, no. 4 (January 1918), p. 80; *Worcester Art Museum: Catalogue of Paintings and Drawings,* Worcester, Massachusetts, 1922, p. 202; Downes 1925, 1926, p. 145; Boston 1925, 1925a, p. 4; New York 1926, p. 4, ill. n.p.; Charteris 1927, p. 282, dated 1882; Louisa Dresser, 'Three Americans Abroad', *News Bulletin and Calendar Worcester Art Museum,* vol. 29, no. 8 (May 1954), p. 33; Loring Holmes Dodd, 'Art Museum Shows Work of 3 Greats', *The Evening Gazette,* Worcester, 26 July 1954, p. 26; Louisa Dresser, 'The Whistler–Cassatt–Sargent Exhibition', *Boston Symphony Orchestra Program,* 26–27 November 1954, pp. 243–44; Mount, 1955, p. 444 (K821), dated 1882 '(an inscription, probably to Bechstein, removed)'; 1957 ed., p. 354 (K821); 1969 ed., p. 463 (K821) (with no reference to a removed inscription); 'Sargent in Worcester', *News Bulletin and Calendar Worcester Art Museum,* vol. 29, no. 8 (May 1964), n.p.; New York 1980, n.p., no. 12, ill., and checklist, n.p.; Ratcliff 1982, ill. p. 72, pl. 103; Susan E. Strickler, 'John Singer Sargent and Worcester', *Worcester Art Museum Journal,* vol. 6 (1982–83), pp. 19, 27, 38, n. 38, ill. p. 27, fig. 12 and cover (detail, colour); San Francisco 1984, pp. 99–100, ill. p. 98; Ayres in Hills *et al.* 1986, pp. 56, 69–70, 72, n. 24, 249, n. 57, 286, ill. p. 62, fig. 36; Olson 1986, p. 148; Honour and Fleming 1991, pp. 62, 64, ill. p. 73 (colour); Simpson 1997, p. 99; Ormond in Robertson *et al.* 2003, p. 60, ill. (colour); Boston 2004, p. 274, ill. p. 253, fig. 192 (colour).

806 *Sortie de l'église, Campo San Canciano, Venice*

PROVENANCE

Ernest Coquelin; sold by his heirs, Hôtel Drouot, Paris, 26 May 1909, lot 44, ill. sale cat. facing p. 34, as 'Sortie d'église en Espagne'; Mme Lillias, Geneva; Paul and John Herring, New York; Wendell Cherry, Louisville, Kentucky, 1985; James Maroney, 1986; Mr and Mrs Hugh Halff, Texas.

EXHIBITIONS

Paris, Galerie Georges Petit, 1882, no. 98, as 'Sortie d'église', ill., n.p., as a woodcut after a drawing (see fig. 218); Williamstown 1997, no. 17; London 1998, no. 11; Seattle 2000, no. 23; Ferrara 2002, no. 7; Los Angeles 2003, unnumbered.

LITERATURE

Reviews

'Petite Chronique', *L'Art Moderne,* vol. 2, no. 42 (15 October 1882), p. 335; 'Petite Chronique', *L'Art Moderne,* vol. 2, no. 52 (24 December 1882), p. 414; 'The Chronicle of Art: Art in October', *Magazine of Art,* vol. 6 (October 1882), p. ii; Paul Mantz, 'Exposition de la Société internationale', *Le Temps,* 31 December 1882, p. 3; G. Duranty, 'Exposition internationale des peintres et des sculpteurs', *L'Art,* vol. 32, no. 420 (14 January 1883), pp. 36, 40; 'Chronique des Lettres et des Arts', *L'Artiste,* vol. 53, part 1, (February 1883), pp. 142–44; Maurice du Seigneur, 'Les Expositions Particulières', *L'Artiste,* vol. 53, part 2 (August 1883), pp. 123–24; Arthur Baignères, 'Première Exposition de la Société internationale de peintres et sculpteurs', *Gazette des Beaux-Arts,* vol. 27,

no. 2 (February 1883), p. 190; W. C. Brownell, 'American Pictures at the Salon', *Magazine of Art,* vol. 6 (1883), p. 497; 'Première Exposition de la Société internationale de peintres et de sculpteurs.—Galerie Georges Petit, rue de Sèze, 8', *Le Monde Illustré,* vol. 42 (27 January 1883), p. 58; Greta, 'The Art Season in Boston', *Art Amateur,* vol. 19, no. 1 (June 1888), p. 5, ill. as a woodcut after a drawing (for the original drawing, see fig. 218).

Other References

Charteris 1927, p. 282, dated 1883 (incorrect dimensions), as 'Sortie d'Église en Espagne'; Mount 1955, p. 443 (K7918), dated 1879 (incorrect dimensions), as 'Sortie d'Église en Espagne', no owner given; 1957 ed., p. 352 (K7918); 1969 ed., p. 460 (K7918); Ayres in Hills *et al.* 1986, pp. 63, 67, 73, n. 52; Honour and Fleming 1991, pp. 61–62, drawing (fig. 218) ill. p. 105; Simpson 1997, pp. 64, 98, 99, 107, 176, no. A34, ill. pp. 107 (colour), 176; London 1998, pp. 76, 78, ill. p. 76 (colour); Ferrara 2002, pp. 161, 174, ill. p. 175 (colour); Ormond in Robertson *et al.* 2003, pp. 72, 195, ill. p. 181 (colour), and dust cover (detail, colour); Boston 2004, pp. 251, 258, n. 7.

807 *Campo San Canciano, Venice*

PROVENANCE

Reginald Sidney Hunt, 1929; untraced.

LITERATURE

H. M. Cundall, *History of British Water-Colour Painting,* London, 1929, ill. facing p. 99, pl. LIII (colour), as 'A Piazza at Venice'.

808 *Street in Venice*

PROVENANCE

Stanford White, by 1888; his widow, Mrs Bessie Smith White, 1906; their son, Lawrence Grant White, 1950; his widow, Mrs Laura Astor Chanler White, 1956; The National Gallery of Art, Washington, D.C., gift of the Avalon Foundation, 1962.

EXHIBITIONS

Paris, Galerie Georges Petit, 1882, no. 99, as 'Une Rue à Venise'; Boston, 1888, no. 8, in MS list, as 'Small study of girl walking down street in Venice (two men behind)'; New York, NAD, 1888, no. 213, as 'Venetian Street', lent by Stanford White; New York, National Academy of Design, *New York Columbian Celebration of the Four-Hundredth Anniversary of the Discovery of America,* October 1892, no. 3, as 'Venice'; New York, SAA, Retrospective, 1892, no. 276, as 'Venetian Scene'; Washington, D.C., the Chapel of the Smithsonian Institution, *First National Loan Exhibition of the National Association,* 18–27 May 1892, no. 70, as 'Venice'; Boston 1899, no. 36; Buffalo 1901, no. 30; Boston, Copley Gallery, 1917, no. 9, as 'Venice'; New York 1924, oil paintings, no. 39; Chicago 1924, unnumbered; Boston, MFA, 1925, oil paintings, no. 68 (71); New York, MMA, 1926, paintings in oil, no. 13; New York, Century Club, *A Century of Centurian Art,* 14 January–16 February 1947, unnumbered; New York, National Academy of Design, *The American Tradition: Exhibition of Paintings,* 3–16 December 1951, no. 125; Wilmington, Delaware, Wilmington Society of the Fine Arts, *The American Tradition, 1800–1900,* paintings assembled from the recent exhibition at the National Academy of Design, New York, circulated by the American Federation of the Arts, 3–20 March 1952, no. 41; Washington 1964, paintings in oil, no. 16; Washington, D.C., National Gallery of Art, *Ailsa Mellon Bruce: A Memorial Exhibition,* 30 August–12 October 1969, unnumbered; Williamstown 1997, no. 18; New York, Adelson Galleries, 2003, no. 17.

LITERATURE

Reviews

'Petite Chronique', *L'Art Moderne,* vol. 2, no. 42 (15 October 1882), p. 335; 'Petite Chronique', *L'Art Moderne,* vol. 2, no. 52 (24 December 1882), p. 414; 'The Chronicle of Arts: Art in October', *Magazine of Art,* vol. 6 (1882), p. ii; Paul Mantz, 'Exposition de la Société internationale', *Le Temps,* 31 December 1882, p. 3; G. Duranty, 'Exposition de la Société internationale des peintres et des sculpteurs', *L'Art,* vol. 32, no. 420 (14 January 1883), pp. 36, 40; 'Chronique des Lettres et des Arts', *L'Artiste,* vol. 53, part 1 (February 1883), pp. 142–44; Maurice du Seigneur, 'Les Expositions Particulières', *L'Artiste,* vol. 53, part 2 (August 1883), pp.

123–24; Arthur Baignères, 'Première Exposition de la Société internationale de peintres et sculpteurs', *Gazette des Beaux-Arts,* vol. 27, no. 2 (February 1883), p. 190, ill. as a woodcut after a drawing by the artist, p. 192 (for the original drawing, see fig. 221); W. C. Brownell, 'American Pictures at the Salon', *Magazine of Art,* vol. 6 (1883), pp. 497–98, ill. p. 496; Olivier Merson, 'Première Exposition de la Société internationale de peintres et de sculpteurs.—Galerie Petit, rue de Sèze', *Le Monde Illustré,* vol. 52 (27 January 1883), p. 58; *Art Interchange,* vol. 19, no. 10 (5 November 1887), p. 145; 'The National Academy of Design', *Art Amateur,* vol. 18, no. 6 (May 1888), p. 132; Greta, 'The Art Season in Boston', *Art Amateur,* vol. 19, no. 1 (June 1888), p. 5, ill. as a woodcut after a drawing (for the original drawing, see fig. 221); 'The Academy Exhibition', *Frank Leslie's Illustrated Newspaper,* vol. 66 (14 April 1888), p. 131; Mrs Schuyler Van Rensselaer, 'Fine Arts: The Academy Exhibition', *Independent,* 26 April 1888, p. 519; 'Catholicity in Art', *New York Herald,* 31 March 1888, p. 4; 'Portraits at the Academy', *New York Times,* 8 April 1888, p. 10; 'The Academy of Design', *New York Tribune,* 31 March 1888, p. 4; 'An Exhibition of American Paintings', *Art Amateur,* vol. 27, no. 6 (November 1892), p. 138; 'The Society of American Artists: Retrospective Exhibition', *Art Amateur,* vol. 28, no. 2 (January 1893), p. 44; Boston 1899, p. 10; Charles Caffin, 'The Picture Exhibition at the Pan-American Exposition, continued', *International Studio,* vol. 14 (September 1901), p. xxi.

Other References

Cortissoz 1903, p. 520; Isham 1905, p. 4; Cortissoz 1913, p. 225; *Art News,* vol. 22 (26 April 1924), p. 10; New York 1924, p. 14; Cortissoz 1924, p. 64; Mechlin 1924, p. 185; Boston 1925, p. 8; Boston 1925a, p. 9; Downes 1925, 1926, pp. 30, 143–44; New York 1926, p. 4, ill. n.p.; Charteris 1927, p. 283, dated 1886; Mount 1955, pp. 199, 444 (K822), dated 1882; 1957 ed., pp. 164, 354 (K822); 1969 ed., pp. 199, 464 (K822); *A Pageant of Paintings from the National Gallery of Art,* ed. Huntington Cairns and John Walker, Washington, D.C., 1966, p. 496, ill. p. 497 (colour); Ormond 1970, pp. 29, 30, 238, ill. pl. 20; Charles F. Stuckey, *Toulouse-Lautrec: Paintings,* Art Institute of Chicago, 1979, p. 181, ill. fig. 1 (exhibition catalogue); New York 1980, checklist, n.p.; Ratcliff 1982, p. 73, ill. p. 74, pl. 106 (colour); San Francisco 1984, pp. 95, 96, 97, n. 15; Ayres in Hills *et al.* 1986, pp. 56, 63, 67, 68, 72, n. 26, 73, n. 47, ill. p. 61, fig. 35; Adelson in Adelson *et al.* 1986, pp. 33, 34, ill. p. 32, fig. 14; Fairbrother 1986, pp. 48–49, 122, ill. fig. 12; Lovell 1989, pp. 75–76, 83–84, ill. pl. 6 (colour); Clark Art Institute 1990, pp. 182, 184, ill. p. 182, fig. 97; Fairbrother 1990, pp. 33, 34, 38, ill. p. 33, fig. 4; Honour and Fleming 1991, ill. p. 94 (colour); Fairbrother 1993, p. 31, ill. p. 30; Stephen Kern, *Eyes of Love: The Gaze in English and French Paintings and Novels 1840–1900,* London, 1996, p. 145; Simpson 1997, pp. 98, 99, 108, 176, no. A35, ill. pp. 108 (colour), 176; Seldin and Oustinoff in Adelson *et al.* 1997, pp. 181, 222, ill. p. 182, fig. 176 (colour); *Early Portraits,* 1998, p. xvi; Torchia 1998, pp. 103–7, ill. p. 105 (colour); Simpson 1998, p. 5, ill. p. 8, fig. 6 (colour); *American Impressionism and Realism: The Margaret and Raymond Horowitz Collection,* National Gallery of Art, Washington, D.C., 1999, p. 131, ill. p. 132, fig. 3 (exhibition catalogue); *Portraits of the 1890s,* p. 68; Ormond in Robertson *et al.* 2003, pp. 71–72, 75, ill. p. 71 (colour); Adelson *et al.* 2003, p. 78, ill. p. 79 (colour); Boston 2004, pp. 251, 253, ill. p. 252, fig. 191 (colour).

809 *Venetian Street*

PROVENANCE

Constant Coquelin; Coquelin sale, Galerie Georges Petit, Paris, 27 May 1893, lot 54, as 'À Seville'; M. Gallet, his sale, Hôtel Drouot, Paris, 20 April 1896, lot 21, as 'À Seville'; private collector, Paris; Victor D. Spark, New York, through Dr Leo Collins, 1955; Grand Central Art Galleries, New York, 1956; Arthur Vining Davis, Pittsburgh; private collection, 1962; David David Gallery, Philadelphia; Hirschl & Adler Galleries, New York, 1964; Rita and Daniel Fraad Collection, 1964; private collection, 2004.

EXHIBITIONS

New York, Grand Central Art Galleries, 1956; New York, Whitney Museum of American Art, *Art of the United States: 1670–1966,* 1966, no. 248; New York, The Metropolitan Museum of Art, New York, *New York Collects,* 3 July–2 September 1968, no. 200; New York, CKG, 1983,

no. 31; Fort Worth, Texas, Amon Carter Museum, *American Paintings, Watercolors, and Drawings from the Collection of Rita and Daniel Fraad*, 1985, no. 12; New York and Chicago 1986, unnumbered; Boston 1992, no. 113; Williamstown 1997, no. 19; London 1998, no. 13 (exhibited Washington and Boston only); New York, Adelson Galleries, 2003, no. 16.
LITERATURE
New York 1983, pp. 17–18, ill. p. 49 (colour); San Francisco 1984, pp. 97, 98, n. 1; Ayres in Linda Ayres and Jane Myers, *American Paintings, Watercolors, and Drawings from the Collection of Rita and Daniel Fraad,* Amon Carter Museum, Fort Worth, Texas, 1985, pp. 26–29, ill. p. 27 (colour) (exhibition catalogue); Ayres in Hills *et al.* 1986, pp. 56, 58, 69, 73, n. 52, 286, ill. p. 60, fig. 32 (colour); Olson 1986, p. 148; Clark Art Institute 1990, p. 182, ill. p. 184, fig. 98; Fairbrother 1990, pp. 29, 32–34, 41, 45, 47, ill. p. 32, fig. 3; Hirshler in Stebbins *et al.* 1992, pp. 398, 400, ill. p. 399 (colour); Simpson 1997, pp. 99, 109, 178, no. A 47, ill. p. 109 (colour), and p. 178; London 1998, p. 79, ill. (colour); Torchia 1998, p. 104, ill. fig. 1; Ormond in Robertson *et al.* 2003, p. 72, ill. (colour); Adelson *et al.* 2003, p. 76, ill. p. 77 (colour).

810 *A Street in Venice*
PROVENANCE
J. Nicolopoulo; Scott & Fowles, New York, 1926; Robert Sterling Clark, 1926; Sterling and Francine Clark Art Institute, Williamstown, Massachusetts.

EXHIBITIONS
Williamstown 1957, unnumbered, ill. cat. pl. LXVI; New York, Wildenstein, 1967, no. 48; Williamstown, Massachusetts, Sterling and Francine Clark Art Institute, *A Scene of Light and Glory: Approaches to Venice,* 20 March–25 April 1982, no. 58, cat. p. 39, ill. p. 38; San Francisco 1984, no. 52; Williamstown 1997, no. 11; Seattle 2000, no. 18; Ferrara 2002, no. 5; Los Angeles 2003, unnumbered.
LITERATURE
Cortissoz 1924, p. 347; Mount 1955, p. 444 (K8211), dated 1882; 1957 ed., p. 354 (K8211); 1969 ed., p. 463 (K8211), as 'The Wine Shop (called Street in Venice)'; Mount 1963, pp. 399, 400, ill. p. 401, fig. 15; Sutton 1964, p. 399, ill. p. 397, fig. 3; Ormond 1970, p. 30; Williamstown 1972, p. 100, ill.; John H. Brooks, *Highlights: Sterling and Francine Clark Art Institute,* Williamstown, Massachusetts, 1981, p. 88, ill. p. 89 (colour); Williamstown 1984, p. 34, ill. p. 103, fig. 417; San Francisco 1984, pp. 97–99, ill. p. 97; Ayres in Hills *et al.* 1986, pp. 56, 58, 70, 72, n. 14, ill. p. 61, fig. 33; Olson 1986, p. 148; Lovell 1989, pp. 75–76, ill. p. 78, fig. 88; Clark Art Institute 1990, pp. 182–84, ill. p. 183 (colour); Fairbrother 1990, p. 33; Honour and Fleming 1991, ill. p. 62 (colour); Williamstown 1992, p. 101, ill.; Stephen Kern in *The Selections from the Sterling and Francine Clark Art Institute,* New York, 1996, p. 118, ill. p. 119 (colour); Simpson 1997, pp. 99, 101, 174, A16, ill. pp. 101 (colour), 174; Torchia 1998, pp. 104, 108, n. 1, ill. p. 104, fig. 2; London 1998, p. 79; Fairbrother 2000, pp. 56, 59, ill. p. 58, fig. 2.12 (colour); Ferrara 2002, pp. 161, 170, ill. p. 171 (colour); Ormond in Roberston *et al.* 2003, pp. 71, 72, 195, ill. p. 70 (colour); Boston 2004, pp. 251, 252, ill. p. 252, fig. 189 (colour).

811 *Venice*
PROVENANCE
Violet Sargent (Mrs Francis Ormond), 1925; given by her, with a large collection of Sargent studies, to The Metropolitan Museum of Art, New York, 1950.
EXHIBITIONS
New York and Buffalo 1971, no. 22; San Francisco 1984, no. 78; New York and Chicago 1986, unnumbered (shown only in Chicago); New York 2000, unnumbered.
LITERATURE
San Francisco 1984, pp. 123–24, ill. p. 124; Hills *et al.* 1986, p. 289; Lovell 1989, p. 91, ill. pl. 14 (colour, image reversed); Fairbrother 1990, p. 34, ill. p. 35, fig. 6; Honour and Fleming 1991, p. 60, ill. (colour); Fairbrother 1994, p. 31, ill.; London 1998, p. 79; Herdrich and Weinberg 2000, pp. 172–73, no. 157, ill. p. 173.

812 *Pavement of St Mark's, Venice*
PROVENANCE
Emily Sargent, 1925; Violet Sargent (Mrs Francis Ormond), 1936; her son, H. E. Conrad Ormond, 1955; his heirs, 1979; Coe Kerr Gallery, New York, 1981; private collection.
EXHIBITIONS
Boston 1899, no. 85; London, RA, 1926, no. 570; London, as 'St. Mark's, Venice: the Pavement'; Tate Gallery, 1926, unnumbered, as 'St. Mark's, Venice: the Pavement'; York 1926, no. 13, as 'St. Mark's, Venice: the Pavement'; Birmingham 1964, no. 29; New York, CKG, 1983, no. 33, as 'The Pavement'; New York and Chicago 1986, unnumbered, as 'The Pavement'; Boston 1992, no. 115.
LITERATURE
Boston 1899, p. 20; London, RA, 1926, p. 82, as 'St. Mark's, Venice: the Pavement'; *RA Ill.* 1926, p. 63; London, Tate, 1926, p. 10, as 'St. Mark's, Venice: the Pavement'; Downes 1925, 1926, p. 178; Charteris 1927, p. 115, as 'St. Mark's, Venice: the Pavement'; Mount 1955, p. 444 (K8210), dated 1882, as 'St. Mark's, Venice: the Pavement'; 1957 ed., p. 354 (K8210); 1969 ed., p. 464 (K8210); Birmingham 1964, p. 16; New York 1983, p. 90, ill. p. 51 (colour); San Francisco 1984, p. 24; Ayres in Hills *et al.* 1986, pp. 64, 288, ill. p. 68, fig. 43 (colour), as 'The Pavement'; Honour and Fleming 1991, ill. p. 98 (colour), as 'The Pavement, Venice'; Hirshler in Stebbins *et al.,* 1992, pp. 402–3, ill. p. 403 (colour); Seldin in Adelson *et al.* 1997, pp. 183–84, ill. p. 183, fig. 178 (colour); Boston 2004, pp. 163, 217, ill. p. 162, fig. 115 (colour).

813 *Via delle Brache, Florence*
PROVENANCE
Violet Sargent (Mrs Francis Ormond), 1925; her son, H. E. Conrad Ormond, 1955; his heirs, 1979; Coe Kerr Gallery, New York, 1987; Mr and Mrs Harry Spiro, New York, 1990; private collection, New York, 2001.
EXHIBITIONS
Birmingham 1964, no. 7, as 'A Street in Venice'; Japan 1989, no. 12, as 'A Street in Venice'; Ferrara 2002, no. 6, as 'Una calle veneziana'; Los Angeles 2003, unnumbered, as 'A Street in Venice'.
LITERATURE
Birmingham 1964, p. 9, as 'A Street in Venice'; Ormond 1970, p. 30, ill. p. 38, fig. 15, as 'A Street in Venice'; San Francisco 1984, pp. 97, 98, n. 1, as 'A Street in Venice'; Ayres in Hills *et al.* 1986, p. 58, ill. p. 63, fig. 37, as 'A Street in Venice'; Japan 1989, p. 137, ill. p. 54 (colour), as 'A Street in Venice'; Fairbrother 1990, p. 34; Honour and Fleming 1991, p. 60. ill. p. 61 (colour), as 'A Venetian Street'; Kilmurray and Ormond 1998, p. 79, ill. fig. 61, as 'A Street in Venice'; Ferrara 2002, pp. 161, 172, ill. p. 173 (colour), as 'Una calle veneziana'; Ormond in Robertson *et al.* 2003, pp. 74, 195, ill. p. 74 (colour), as 'A Street in Venice'.

814 *Pressing the Grapes: Florentine Wine Cellar*
PROVENANCE
Arthur Lemon, possibly by 1888 (see entry); his widow, Blanche Lemon, by 1912; her niece, Miss E. F. Hawtrey; Leicester Galleries, London, 1954; sold by them to the Beaverbrook Foundation, Fredericton, New Brunswick, Canada, 1954.
EXHIBITIONS
Fredericton, University of New Brunswick, Bonar Law-Bennett Library, *Exhibition of the Beaverbrook Collection of Paintings and Prints and Some Portraits from the Collection of Sir James Dunn, Bart.,* 8–20 November 1954, no. 33; Fredericton, Beaverbrook Art Gallery, *Sargent to Freud: Modern British Paintings and Drawings in the Beaverbrook Collection,* 24 May–13 September 1998, no. 32 (exhibition toured Canada, U.S. and Great Britain, 1998–2000); Ferrara 2002, no. 10; Los Angeles 2003, unnumbered.
LITERATURE
Stevenson 1888, p. 69; *Beaverbrook Art Gallery,* Fredericton, New Brunswick, 1959, p. 58, ill. pl. 46; Mount 1963, pp. 410, 415, n. 2; Mount 1969, p. 464, dated 1882, as 'Pressing Wine in a Cellar'; Richard Shone, *Sargent to Freud: Modern British Paintings and Drawings in the Beaverbrook Collection,* 1998, pp. 126–27, 191, ill. p. 127 (colour) (exhibition cata-

logue); Fairbrother 2000, pp. 137, 141, ill. p. 139, fig. 5.18 (colour); Ferrara 2002, pp. 160, 180, ill. p. 181 (colour); Ormond in Robertson *et al.* 2003, p. 62, ill. p. 61 (colour).

815 *Campo Sant'Agnese, Venice*
PROVENANCE
Gervase Ker; Whitney Warren, 1936; his daughter, Mrs William Greenough; her granddaughter, Gabrielle Ladd (Mrs Strafford Morss); her widower, Strafford Morss, 1958; on loan to Wellesley College Museum, c. 1961; gift of Strafford Morss, in memory of his wife, Gabrielle Ladd Morss, to Davis Museum and Cultural Center, Wellesley College, Massachusetts, 1969.
EXHIBITIONS
San Francisco 1984, no. 79; Ferrara 2002, no. 8; Los Angeles 2003, unnumbered.
LITERATURE
Margaretta M. Lovell, 'San Francisco/Legion of Honor Venice: The American View, 1860–1920', *FMR The magazine of Franco Maria Ricci,* vol. 6 (November 1984), ill. pp. 46–47; 'College Museum Notes, Acquisitions, 1800 to Present', *Art Journal,* vol. 27, no. 4 (Summer 1968), p. 412; San Francisco 1984, pp. 124–25, ill. p. 60 (colour), and p. 125; Lovell 1989, p. 67, ill. fig. 77; Honour and Fleming 1991, ill. p. 106 (colour); Lucy Flint-Gohlke, *Davis Museum and Cultural Center: History and Holdings,* Wellesley College, Massachusetts, 1993, ill. n.p., no. 147 (colour); Ferrara 2002, p. 176, ill. p. 177 (colour); Ormond in Robertson *et al.* 2003, pp. 74, 195, ill. p. 87 (colour; image reversed); Boston 2004, ill. p. 255, fig. 198 (colour).

816 *Campo behind the Scuola di San Rocco*
PROVENANCE
Given by the artist to be auctioned on behalf of the Artists' War Fund, Christie's, London, 24 and 26 February 1900, lot 139, as 'A Campo in Venice', bt. Cooke; William Russell Cooke and his wife, Margaret Cooke; their daughter, Margaret Cooke (Mrs Oswald Allen Harker), after 1914; her widower, Oswald Allen Harker, 1947; sold Sotheby's, London, 13 December 1967, lot 53, as 'An Inner Courtyard of La Scuola di San Rocco, Venice', bt. Lowndes Lodge Gallery, London; Hirschl & Adler Galleries, New York, 1968 (stock nos. APG 50, APG 1749D and APG 4441/3); Mr and Mrs John Dimick; Weshler's, Washington, D.C., 10–13 December 1981, lot 1683; Hirschl & Adler Galleries, New York, 1982; Bluford Walter Crain II, Texas; private collection.
EXHIBITIONS
New York, Knoedler, 1925, no. 22, as 'A Venetian Street, Scuola di San Rocco'; New York, Hirschl & Adler Galleries, *Twenty-Five American Masterpieces,* 23 April–11 May 1968, no. 18, ill. cat. (colour); New York, Hirschl & Adler, *Forty Masterworks of American Art,* 28 October–4 November 1970, no. 27, ill. cat. p. 40; New York, Hirschl & Adler Galleries, *Lines of Different Character: American Art from 1727 to 1947,* 13 November 1982–8 January 1983, no. 44, ill. cat. p. 60 (colour).
LITERATURE
Charteris 1927, p. 282, dated 1882, as 'A Venetian Street (La Scala di San Rocca [*sic*])', ill. facing p. 220, as 'Scene in Venice'; Mount 1955, p. 444 (K827), dated 1882, as 'Venetian Street (La Acala di San Rocca [*sic*])'; 1957 ed., p. 354 (K827), as 'Venetian Street (La Scala di San Rocca [*sic*])'; 1969 ed., p. 476 (K829), dated 1913, as 'La Scala di San Rocca'[*sic*,] giving the owner as Harry W. Anderson; Lee Hall, 'American Individualism: Twenty-five American Masterpieces at Hirschl & Adler', *Arts Magazine,* vol. 42, no. 7 (May 1968), p. 49, ill.; M. S. Young, 'Letter from U.S.A., The Sports in the Arts', *Apollo,* vol. 88, no. 78 (1968), p. 142, ill. p. 143, fig. 9; Ayres in Hills *et al.* 1986, p. 63, ill. p. 67, fig. 42; Honour and Fleming, 1991, p. 62, ill. (colour); Simpson 1997, p. 99; Grieve 2000, pp. 72, 199, n. 41.

817 *A Canal Scene (fragment)*
PROVENANCE
Cut off from the side of Sargent's *Campo behind the Scuola San Rocco* (no. 816), post 1900; William Russell Cooke and his wife, Margaret Cooke; their daughter, Margaret Cooke (Mrs Oswald Allen Harker); untraced, possibly destroyed.
EXHIBITION
New York, Knoedler, 1925, no. 23.
LITERATURE
Charteris 1927, p. 295, as undated; Mount 1955, p. 444 (K829), dated 1882, with incorrect sizes (16½ x 24 in.); 1957 ed., p. 354 (K829); 1969 ed., p. 476 (K829), dated 1913, and stating, 'destroyed 1940–45'.

818 *Portico di San Rocco*
PROVENANCE
Given on behalf of the artist by his sister, Emily Sargent, to the Cheyne Hospital for Children, London, 1925; purchased from the hospital by M. Knoedler & Co., London, 31 May 1927 (stock no. 8083), as 'Scene on a side canal, Venice'; sold by Knoedler, New York, to Verner Z. Reed, Jr, of Newport, Rhode Island, August 1935 (stock no. 16861); Hirschl & Adler, New York, 1973 (stock no. APG 1703); Craig and Tarlton Inc, Raleigh, North Carolina, 1974; Dr and Mrs Henry C. Landon III.
EXHIBITIONS
Newport 1935, no. 5; Raleigh, North Carolina, Craig and Tarlton, *Two Centuries of American Paintings,* 1974 (no catalogue traced); Charlotte, North Carolina, Mint Museum of Art, *American Paintings: The Landon Collection,* 9 September–28 October 1979, no. 28, as 'Scuoto [*sic*] di San Rocco', ill. cat. p. 56, exhibition travelled.
LITERATURE
Mount 1955, p. 445 (K8213), dated 1882, as 'Scene on a Side Canal, Venice'; 1957 ed., p. 354 (K8213); 1969 ed., p. 462 (K8213), dated 1880, as 'Scene on a Side Canal, Venice (actually Scala di San Rocca)[*sic*]'.

819 *Venise par temps gris*
PROVENANCE
François Flameng; Flameng sale, Schoeller, Hôtel Drouot, 13 June 1923, lot 47, bt. M. Knoedler & Co., London (stock no. 7097); sold to Sir Philip Sassoon, 11 October 1923; his cousin, Hannah Sassoon (Mrs David Gubbay), 1939; Sir Philip Sassoon's sister, Sybil, Marchioness of Cholmondeley, 1968; private collection, 1989.
EXHIBITIONS
London 1924, no. 34, as 'Venice'; New York, English-Speaking Union, 1925, no. 62; London, RA, 1926, no. 37, as 'Venice'; Birmingham 1964, no. 6; London, Wildenstein, 1972, no. 33; Cardiff 1992, no. 12; London 1998, no. 10; Ferrara 2002, no. 4, as 'Venezia tempo grigio'; Los Angeles 2003, unnumbered.
LITERATURE
Royal Cortissoz, *Personalities in Art,* New York, 1925, ill. facing p. 118 as 'Venice'; Downes 1925, 1926, p. 132, ill. facing p. 64; London 1926, p. 12; Charteris 1927, p. 282, dated 1882, as 'Venice'; Mather 1931, pp. 239–40; Mount 1955, p. 444 (K823), dated 1882; 1957 ed., p. 354 (K823); 1969 ed., p. 464 (K823); Birmingham 1964, pp. 8–9, ill. facing p. 17; Ormond 1970, pp. 30, 237, ill. pl. 13 (colour); London 1972, pp. 55–56, ill. fig. 44; Ratcliff 1982, p. 73, ill. pl. 105; Ayres in Hills *et al.* 1986, p. 54; Olson 1986, p. 148; Honour and Fleming 1991, pp. 57, 59, ill. p. 57 (colour); London 1998, pp. 26, 75–76, ill. p. 75 (colour); Grieve 2000, pp. 159, 203, n. 8 (chapter 3); Ferrara 2002, pp. 161, 168, ill. p. 169 (colour); Ormond in Robertson *et al.* 2003, pp. 72, 74, ill. p. 73 (colour); Simpson in Merrill *et al.* 2003, p. 43, ill. fig. 36 (colour); Boston 2004, p. 156, ill. p. 158, fig. 110 (colour).

820 *The Marinarezza, Venice*
PROVENANCE
Violet Sargent (Mrs Francis Ormond), 1925; her son, F. Guillaume Ormond, 1955; his heirs, 1971; private collection.
EXHIBITION
Falmouth 1962, no. 16, as 'Fondamenta Nuove—Venice'.

821 Café on the Riva degli Schiavoni, Venice
PROVENANCE
Violet Sargent (Mrs Francis Ormond), 1925; her daughter, Reine Ormond (Mrs Hugo Pitman), 1955; her heirs, 1971; private collection.
EXHIBITIONS
London, RA, 1926, no. 476, as 'Venice'; Chicago 1954, no. 86; New York, CKG, 1980, no. 11; New York 1983, no. 30; London 1998, no. 99; Boston 2004, unnumbered.
LITERATURE
London 1926, p. 70; Chicago 1954, p. 72, ill.; New York 1980, n.p., no. 11, ill.; John Russell, *New York Times*, 6 June 1980, p. 16, ill.; Ratcliff 1982, ill. p. 29, fig. 32 (colour); New York 1983, p. 17, ill. p. 48; Lovell 1989, pp. 91, 93, ill. p. 92, fig. 100; Honour and Fleming 1991, p. 61, ill. p. 63 (colour); Eleanor Dwight, *The Gilded Age: Edith Wharton and Her Contemporaries*, New York, 1996, ill. p. 51; Simpson 1997, p. 174, ill. fig. A20; London 1998, p. 210, ill. (colour); Boston 2004, pp. 228, 274, ill. p. 229, fig. 168 (colour).

822 Ponte Panada, Fondamenta Nuove
PROVENANCE
Estate of Henry Schlesinger, London, 1912; sold by his son, Arthur H. Berly (who, like his brother Ernst Leopold, changed his name), Christie's, London, 3 March 1913, lot 34, as 'A Canal Scene, Venice', bt. P. D. Colnaghi & Obach; M. Knoedler & Co., New York, 31 March 1913 (stock no. WC 905); sold to Robinson & Farr, Philadelphia, October 1913; Mabel Stevens Smithers, 1925; bequeathed by her to the Corcoran Gallery of Art, Washington, D.C., 1952.
EXHIBITIONS
New York, Macbeth Gallery, *American Masters Loaned for Exhibition*, 13–26 October 1925, no. 19; Washington, D.C., Corcoran Gallery of Art, *John Singer Sargent: Drawings from the Corcoran Gallery of Art*, travelling exhibition, 1983, no. 25; Washington, D.C., Corcoran Gallery of Art, *John Singer Sargent Draughtsman: Works from the Corcoran Gallery of Art*, 31 August–30 October 1999, unnumbered, ill. brochure (colour).
LITERATURE
Corcoran Gallery of Art Bulletin, vol. 6, no. 2 (July 1953), p. 20; New York 1980, checklist, n.p., as 'Venice, Gondola on Canal'; Simmons 1983, p. 105, no. 687, ill., as 'Canal Scene (Ponte Panada, Fondamenta Nuove), Venice'; Nygren 1983, p. 53, ill., as 'Canal Scene (Ponte Panada Fondamento [*sic*] Nuove), Venice'; Honour and Fleming 1991, p. 60, ill. (colour); Denker in Heartney *et al.* 2002, ill. p. 199 (colour), as 'A Canal in Venice'.

823 Campo dei Frari, Venice
PROVENANCE
Estate of Henry Schlesinger, London, 1912; sold by his son, Arthur H. Berly (who, like his brother Ernst Leopold, changed his name); Christie's, London, 3 March 1913, lot 33, as 'A Piazza on a Canal, Venice', bt. P. D. Colnaghi & Obach; M. Knoedler & Co., New York, 3 March 1913 (stock no. WC 904), as 'A Piazza on a Canal'; sold to Robinson & Farr, Philadelphia, October 1913; Mabel Stevens Smithers, 1925; bequeathed by her to the Corcoran Gallery of Art, Washington, D.C., 1952.
EXHIBITIONS
New York, Macbeth Galleries, *American Masters Loaned for Exhibition*, 13–26 October 1925, no. 18, as 'Piazza, Venice'; Washington, D.C., Corcoran Gallery of Art, *John Singer Sargent: Drawings from the Corcoran Gallery of Art*, travelling exhibition, 1983, no. 26; New York and Chicago, 1986, unnumbered; Washington, D.C., Corcoran Gallery of Art, *John Singer Sargent Draughtsman: Works from the Corcoran Gallery of Art*, 31 August–30 October 1999, unnumbered, ill. brochure (colour).
LITERATURE
The Corcoran Gallery of Art Bulletin, vol. 6, no. 2 (July 1953), p. 20; Ormond 1970, p. 69; New York 1980, checklist, n.p., as 'Venetian Piazza'; Simmons 1983, p. 105, no. 688, ill.; Nygren, 1983, pp. 53, 54, ill. p. 54; Ayres in Hills *et al.* 1986, pp. 214, 244–45, n. 13, 289, ill. p. 213, fig. 174; Honour and Fleming 1991, p. 61, ill. p. 102 (colour); Denker in Heartney *et al.* 2002, p. 198, ill. p. 199 (colour).

824 Palazzo Marcello
PROVENANCE
Violet Sargent (Mrs Francis Ormond), 1925; her daughter, Reine Ormond (Mrs Hugo Pitman), 1955; her heirs, 1971; private collection.
EXHIBITION
Boston 2004, unnumbered.
LITERATURE
Sargent Trust List [1927], 'water colours unframed', p. 10, no. 45, as 'Venice. Probably an early work. Pinkish houses. Little front door with mitre shaped top'; Boston 2004, p. 275, ill. p. 255, fig. 197 (colour), as 'Pink Palace (Palazzo Marcello)'.

825 Ponte Lungo, Zattere, Venice
PROVENANCE
P. Guillaume, Paris; sold by him to M. Knoedler & Co., New York, 22 May 1929 (stock no. WCA 158), as 'Bridge & boat, view of Venice, bluish water'; sold to Henry Braxton, September 1942; Mrs Houghton Metcalf, c. 1949; untraced.
EXHIBITIONS
Muskegon, Michigan, Hackley Art Gallery, *Pastels by Mary Cassatt, Arthur B. Davies, and John Singer Sargent*, January 1931, no. 646, as 'Venetian Scene'; the water-colour, together with other stock, was lent by M. Knoedler & Co to similar exhibitions, under different titles; Currier Gallery of Art, Manchester, New Hampshire, February 1933, no. 60; M. Knoedler & Co., New York, 1–15 April 1933, no. 3; Addison Gallery of American Art, Andover, Massachusetts, 22 May–26 June 1933; Columbus Gallery of Fine Arts, Columbus, Ohio, 1–31 October 1933; Cleveland Museum of Art, 14 February–14 March 1934; Newport, Rhode Island, 1935, no. 39; J. E. McClees Galleries, Philadelphia, 5 December 1935–17 January 1936; M. Knoedler & Co., New York, 1941, no. 31; Schneider-Gabriel Galleries, New York, *Nineteenth-Century Watercolors from Géricault to Sargent*, 24 February–21 March 1942, no. 15.

826 Venetian Canal, Palazzo Contarini degli Scrigni e Corfu
PROVENANCE
P. Guillaume, Paris, 1929; sold by him to M. Knoedler & Co., New York, May 1929 (stock no. WCA 159), as 'View of Venice and Houses'; sold to Wadsworth R. Lewis of Ridgefield, Connecticut, May 1930; sold following his death at Parke-Bernet Galleries, New York, 1–3 April 1943, lot 401, as 'Venice'; Mrs John Lavalle, New York; Richard Hoyt; Kennedy Galleries, New York, December 1976, as 'Venetian Canal, Palazzo Corner-Contarini dei Cavalli'; private collection, Missouri; Transco Energy Co., Houston, Texas; included in their sale of American Watercolours at Sotheby's, New York, 3 December 1992, lot 34, bt. Kennedy Galleries, as 'Venetian Canal, Palazzo Corner', ill. cat., n.p. (colour); private collection.
EXHIBITIONS
New York, Crispo Gallery, 1974, no. 127, ill. cat., n.p., as 'Venetian Canal'; Kennedy Galleries, New York, *The City as a Source*, 16 November–3 December 1977, no. 49. ill. cat. n.p.; U.S. and Japan, *Contemplating the American Watercolor: Selections from the Transco Energy Company Collection of American Watercolors*, travelling exhibition, May 1985–April 1992, no. 30, ill. cat. p. 54 (colour); New York, Kennedy Galleries, *American Art: A Fall Selection*, 2000, no. 15, ill. cat., n.p., and front cover (detail) (both in colour).

827 Palazzo Foscari
PROVENANCE
Violet Sargent (Mrs Francis Ormond), 1925; her daughter, Reine Ormond (Mrs Hugo Pitman), 1955; her heirs, 1971; private collection.
EXHIBITION
Bridgeport 1986, no. 40, ill. cat. p. 39.

828 *Side Canal*
PROVENANCE
Violet Sargent (Mrs Francis Ormond), 1925; her daughter, Reine Ormond (Mrs Hugo Pitman), 1955; her heirs, 1971; private collection, on loan to the Portland Museum of Art, Maine.

829 *On the Lagoons, Venice*
PROVENANCE
Gustav Natorp; his widow, Mrs Natorp (later Mrs Ernest Hawkings), 1908; sold by her at Christie's, London, 21 July 1922, lot 39, as 'A View on the Lagoons, Venice', bt. Sampson; unidentified sale at Bonhams, London, c. 1980, bt. Brian Sewell; Christie's New York, 30 November 1999, lot 9, as 'View from the Bacino, S. Giorgio Maggiore to the left, Venice'; private collection.

830 *Venetian Woman by a Bed*
PROVENANCE
Emily Sargent, 1925; Violet Sargent (Mrs Francis Ormond), 1936; her daughter, Reine Ormond (Mrs Hugo Pitman), 1955; Jacqueline Bouvier Kennedy Onassis; sold from her estate, Sotheby's, New York, 23–26 April 1996, lot 46, ill. sale cat. p. 69 (colour); private collection.
EXHIBITIONS
London, RA, 1926, no. 101, as 'A Venetian Girl'; London, Tate, 1926, unnumbered, as 'A Venetian Girl'; New York, Andrew Crispo Gallery, 1974, no. 128, ill. cat. n.p., as 'Venetian Lady'.
LITERATURE
London 1926, p. 21, as 'A Venetian Girl'; Larry Curry in *Ten Americans: Masters of Watercolor,* Andrew Crispo Gallery, New York, 1974, n.p., no. 128, ill., as 'Venetian Lady' (exhibition catalogue); Fairbrother 1990, p. 43.

831 *Woman in a Gondola*
PROVENANCE
Violet Sargent (Mrs Francis Omond), 1925; her son, F. Guillaume Ormond, 1955; his heirs, 1971; private collection.
EXHIBITIONS
Leeds 1979, no. 7; Boston 2004, unnumbered.
LITERATURE
Sargent Trust List [1927], water-colours unframed, p. 10, no. 44, 'Unfinished Study of Woman in black, leaning back in a gondola'; Leeds 1979, p. 25, ill.; Boston 2004, pp. 253, 275, ill. p. 254, fig. 196 (colour).

832 *Young Woman in a Black Skirt*
PROVENANCE
Violet Sargent (Mrs Francis Ormond), 1925; given by her, with a large collection of Sargent studies, to The Metropolitan Museum of Art, New York, 1950.
EXHIBITIONS
New York and Buffalo 1971, no. 8; New York, Andrew Crispo Gallery, 1974, no. 140, ill. cat. n.p.; New York, The Metropolitan Museum of Art, September 1980 (no catalogue traced); New York, Century Association, *Watercolors and Drawings by Centurian John S. Sargent,* 21 September–23 October 1982 (no catalogue); New York and Chicago 1986, unnumbered (shown only in Chicago); New York, The Metropolitan Museum of Art, *Images of Women: Nineteenth-Century American Drawings and Watercolors,* October 1996–February 1997, unnumbered; New York 2000, unnumbered.
LITERATURE
Blaugrund in Hills *et al.* 1986, pp. 64, 212, 289, ill. p. 211, fig.171; Herdrich and Weinberg 2000, p. 175, no. 158, ill. p. 174 (colour); Weinberg and Herdrich, *Antiques,* 2000, p. 231, ill. p. 229, pl. II (colour); Weinberg and Herdrich, *MMA Bulletin,* 2000, p. 13, ill. fig. 14 (colour).

833 *Figure in Costume*
PROVENANCE
Violet Sargent (Mrs Francis Ormond), 1925; given by her, with a large collection of Sargent studies, to The Metropolitan Museum of Art, New York, 1950.
EXHIBITIONS
New York, The Metropolitan Museum of Art, *200 Years of Watercolor Painting in America,* 8 December 1966–29 January 1967, no. 103; New York and Buffalo, 1971, no. 10; New York, The Metropolitan Museum of Art, September 1980 (no catalogue traced); Evanston, Illinois, Terra Museum of American Art, *Five American Masters of Watercolor,* 1981 (no catalogue traced); New York and Chicago 1986, unnumbered (shown only in New York); New York 2000, unnumbered.
LITERATURE
Blaugrund in Hills *et al.* 1986, pp. 212–13, 289, ill. p. 210, fig. 169; Herdrich and Weinberg 2000, pp. 175–76, no. 159, ill. p. 175; Gallati *et al.* 2004, p. 210, ill. p. 211, pl. 75 (colour).

834 *Head of a Venetian Model*
PROVENANCE
Emily Sargent, 1925; given by her to Mrs Jagger; her son, Charles Sargeant Jagger; his son, Cedric Jagger, 1934; sold to the Fine Art Society, London, 1988; private collection.
EXHIBITION
New York, Adelson Galleries, 2003, no. 15.
LITERATURE
Adelson *et al.* 2003, p. 74, ill. p. 75 (colour).

835 *Mother and Child*
PROVENANCE
William Logsdail; by descent to his great-grandson; sold at Christie's, London, 30 October 1970, lot 84, bt. Williams & Co., London; Ira Spanierman, New York; Dr and Mrs Jacob Y. Terner, Beverley Hills, California; untraced.

836 *Study of a Boy Reclining against a Pillow*
PROVENANCE
Ramón Subercaseaux; by family descent to Gabriel Valdés, 1963; Christie's, London, 26 April 1963, lot 108, bt. Fitch, ill. cat., p. 25; untraced.

EXHIBITIONS CITED IN ABBREVIATED FORM

NEW YORK, SAA, 1878. Society of American Artists, New York, Kurtz Gallery, Madison Square, *First Exhibition,* 6 March–5 April 1878.

PARIS, SALON, 1878. Ministère de l'instruction publique et des Beaux-Arts, *95e Exposition,* Palais des Champs-Elysées, Paris, 25 May–19 August 1878.

NEW YORK, SAA, 1879. Society of American Artists, New York, Kurtz Gallery, Madison Square, *Second Exhibition,* 10–29 March 1879.

NEW YORK, NAD, 1879. National Academy of Design, New York, *Fifty-fourth Annual Exhibition,* 1 April–31 May 1879.

PARIS, SALON, 1879. Ministère de l'instruction publique et des Beaux-Arts, *96e Exposition,* Palais des Champs-Elysées, Paris, 12 May–30 June 1879.

NEW YORK, MMA, 1880. The Metropolitan Museum of Art, New York, *Inaugural Exhibition,* April–October 1880.

PARIS, SALON, 1880. Ministère de l'instruction publique et des Beaux-Arts, *97e Exposition,* Palais des Champs-Elysées, Paris, 1 May–20 June 1880.

NEW YORK, SAA, 1881. Society of American Artists, New York, *Fourth Annual Exhibition,* 28 March–29 April 1881.

PARIS, RUE VIVIENNE, 1881. Cercle des arts libéraux, rue Vivienne, Paris, *Deuxième exposition,* 23 April–25 May 1881.

PARIS, SALON, 1881. Société des artistes français, *98e Exposition,* Palais des Champs-Elysées, Paris, 2 May–20 June 1881.

PARIS, RUE VIVIENNE, 1882. Cercle des arts libéraux, rue Vivienne, Paris, March–April 1882.

LONDON, GROSVENOR GALLERY, 1882. Grosvenor Gallery, London, *Sixth Summer Exhibition,* 1 May–31 July 1882.

PARIS, SALON, 1882. Société des artistes français, *99e Exposition,* Palais des Champs-Elysées, Paris, 1 May–20 June 1882.

LONDON, FAS, 1882. The Fine Art Society, London, *Collection of Pictures by British and American Artists from the Paris Salon,* July 1882.

PARIS, GEORGES PETIT, 1882. Galerie Georges Petit, Paris, *Société internationale de peintres et sculpteurs: première exposition,* 20 December 1882–30 January 1883.

NEW YORK 1883. Brooklyn Academy of Music, New York, *A Boke of ye Arte Loane and Fancie Bazaar in ayde of ye Sheltering Arms Nurserie,* 22, 27 January 1883.

PARIS, PLACE VENDÔME, 1883. Cercle de l'union artistique, place Vendôme, Paris, *Exposition,* 6 February–12 March 1883.

BOSTON, ST BOTOLPH CLUB, 1883. St Botolph Club, Boston, *An Exhibition of Pictures in Black and White,* November 1883.

DUBLIN 1884. Sketching Club, Leinster Hall, Dublin, *Annual Exhibition of Sketches, Pictures and Photography,* 1–20 December 1884.

BOSTON 1888. St Botolph Club, Boston, *John Singer Sargent's Paintings,* 28 January–28 February 1888; for a transcript of the typed MS list of works, see Fairbrother 1986, pp. 134–35.

NEW YORK, NAD, 1888. National Academy of Design, New York, *Sixty-third Annual Exhibition,* 2 April–12 May 1888.

NEW YORK, NAD, 1892. National Academy of Design, New York, *The Discovery of America,* 1892.

NEW YORK, SAA, RETROSPECTIVE, 1892. Society of American Artists, New York, *Retrospective Exhibition,* 1892.

NEW YORK, SAA, 1898. Society of American Artists, New York, *Twentieth Annual Exhibition,* 19 March–23 April 1898.

PHILADELPHIA 1899. Pennsylvania Academy of the Fine Arts, Philadelphia, *Sixty-eighth Annual Winter Exhibition,* 16 January–25 February 1899.

BOSTON 1899. Copley Hall, Boston, *Paintings and Sketches by John S. Sargent, R.A.,* 20 February–13 March 1899.

BUFFALO 1901. Albright Gallery, Buffalo, New York, *Pan-American Exhibition,* 1 May–1 November 1901.

PHILADELPHIA 1902. Pennsylvania Academy of the Fine Arts, Philadelphia, *Seventy-first Annual Exhibition,* 20 January–1 March 1902.

LONDON 1908. Whitechapel Art Gallery, London, *Spring Exhibition,* 12 March–26 April 1908.

BUFFALO 1910. The Buffalo Fine Arts Academy, Albright Art Gallery, Buffalo, New York, *Fifth Annual Exhibition of Selected Paintings by American Artists,* 11 May–1 September 1910.

NEW YORK, NAD, 1910. National Academy of Design, New York, *Annual Exhibition,* 1910.

ST LOUIS 1910. Saint Louis Art Museum, *Fifth Annual Exhibition,* 15 September–15 November 1910.

PITTSBURGH 1911. Carnegie Institute, Pittsburgh, *Fifteenth Annual Exhibition,* 27 April–30 June 1911.

NEW YORK, MACBETH, 1912. Macbeth Gallery, New York, *Thirty Paintings by Thirty Artists,* 3–16 January 1912.

PITTSBURGH 1912. Carnegie Institute, Pittsburgh, *Sixteenth Annual Exhibition,* 25 April–30 June 1912.

CHICAGO 1912. The Art Institute of Chicago, *Twenty-Fifth Annual Exhibition of American Oil Paintings and Sculpture,* 5 November–8 December 1912.

CHICAGO 1914. The Art Institute of Chicago, *The Friends of American Art. Loan Exhibition of American Paintings at the Art Institute of Chicago,* 8–28 January 1914.

MINNEAPOLIS 1915. The Minneapolis Institute of Arts, Minnesota, *Inaugural Exhibition,* 7 January–7 February 1915.

SAN FRANCISCO 1915. San Francisco, *Panama-Pacific International Exposition,* Department of Fine Arts, 20 February–4 December 1915.

DETROIT 1916. The Detroit Institute of Arts, *Second Annual Exhibition of Selected Paintings by American Artists,* May 1916.

BOSTON, COPLEY GALLERY, 1917. Copley Gallery, Boston, *Exhibition of Paintings and Drawings by John Singer Sargent for the Benefit of the American Ambulance Hospital in Paris,* 22 January–3 February 1917.

PITTSBURGH 1920. Carnegie Institute, Pittsburgh, *Nineteenth International Exhibition of Paintings,* 29 April–30 June 1920.

CHICAGO 1921. The Art Institute of Chicago, *Thirty-Fourth Annual Exhibition of American Paintings and Sculpture,* 3 November–11 December 1921.

DALLAS 1922. The Dallas Art Association, Texas, *American Art from the Days of the Colonists to Now,* 16–30 November 1922.

NEW YORK 1924. Grand Central Art Galleries, New York, *Retrospective Exhibition of Important Works by John Singer Sargent,* 23 February–22 March 1924.

CHICAGO 1924. A selection of twenty paintings from the New York 1924 exhibition (see above) was shown at The Art Institute of Chicago, 14 April–1 June 1924 (no catalogue: Grand Central Art Galleries receipts, dated 11 and 12 April 1924, list the twenty-one pictures and twelve water-colours that were shown, Art Institute of Chicago records).

LONDON 1924. The Goupil Gallery, London, *Modern British Art together with a Group of Oil Paintings by J. S. Sargent, R.A.,* Summer 1924 (the paintings by Sargent were lent from the collection of Sir Philip Sassoon).

NEW YORK, ENGLISH-SPEAKING UNION, 1925. Grand Central Art Galleries, New York, *Retrospective Exhibition of British Paintings under the Auspices of the English-Speaking Union,* 10 January–28 February 1925.

WASHINGTON 1925. Corcoran Gallery of Art, Washington, D.C., *Commemorative Exhibition by the Members of the National Academy of Design, 1825–1925,* 17 October–15 November 1925.

BOSTON, MFA, 1925. Museum of Fine Arts, Boston, *Memorial Exhibition of the Works of the Late John Singer Sargent,* 3 November–27 December 1925. The second edition of the catalogue, published in January 1926, incorporates some late additions to the exhibition into its chronological listing of works shown, which results in different numeration. We give the number of the work exhibited as it appears in the first edition and place the revised number in parentheses afterwards.

LIVERPOOL 1925. Walker Art Gallery, Liverpool, *Fifty-third Autumn Exhibition, including a collective exhibit of the works by the late John S. Sargent, R.A.,* 1925.

NEW YORK, KNOEDLER, 1925. Knoedler Gallery, New York, *Exhibition of Paintings by the Late John Singer Sargent,* 2–14 November 1925.

NEW YORK, MMA, 1926. The Metropolitan Museum of Art, New York, *Memorial Exhibition of the Work of John Singer Sargent,* 4 January–14 February 1926.

LONDON, RA, 1926. Royal Academy of Arts, London, *Exhibition of Works by the late John S. Sargent, R.A.,* Winter Exhibition, 14 January–13 March 1926.

TORONTO 1926. The Art Gallery of Toronto, *Inaugural Exhibition,* 29 January–28 February 1926.

YORK 1926. City of York Museum and Art Gallery, *Loan Exhibition of Works by the late John S. Sargent, R.A.,* 31 March–8 May 1926.

LONDON, TATE, 1926. National Gallery (Millbank), London (subsequently the Tate Gallery), *Opening of Sargent Gallery,* June–October 1926.

SAN DIEGO 1926. Fine Arts Gallery of San Diego, *Inaugural Exhibition,* 1926.

SAN FRANCISCO 1926. California Palace of the Legion of Honor, San Francisco, *First Exhibition of Selected Paintings by American Artists,* 15 November 1926–30 January 1927.

ABERDEEN 1926. Aberdeen Art Gallery, Aberdeen Artists' Society, *19th Exhibition of Works of Modern Masters,* November and December 1926 and January 1927.

WORCESTER c. 1927. Worcester Art Museum, Massachusetts, *Paintings in the Collection of Governor Alvan T. Fuller,* c. 1927.

BOSTON 1928. Boston Art Club, *Paintings Loaned by Governor Alvan T. Fuller,* 16–28 April 1928.

STOCKHOLM AND COPENHAGEN 1930. Kungl. Akademien för de fria Konstnerna, Stockholm, *Utställning av Amerikansk Konst,* 15 March–7 April 1930; Ny Carlsberg Glyptothek, Copenhagen, 3–22 May 1930.

CHICAGO 1933. The Art Institute of Chicago, *A Century of Progress: Exhibition of Paintings and Sculpture lent from American Collections,* 1 June–1 November 1933.

CHICAGO 1934. The Art Institute of Chicago, *A Century of Progress: Exhibition of Paintings and Sculpture,* 1 June–1 November 1934.

HARTFORD 1935. Wadsworth Atheneum, Hartford, Connecticut, *American Painting and Sculpture of the 18th, 19th and 20th Centuries,* 1935.

SAN DIEGO 1935. The Palace of Fine Arts, San Diego, California, *Official Art Exhibition of the California Pacific International Exposition,* 29 May–11 November 1935.

SAN FRANCISCO 1935. M. H. de Young Memorial Museum and California Palace of the Legion of Honor, San Francisco, *Exhibition of American Painting,* 7 June–7 July 1935.

NEWPORT 1935. M. Knoedler & Co., Newport, Rhode Island, *Paintings and Watercolors by John Singer Sargent, R.A.,* 19 August–3 September 1935.

SAN FRANCISCO 1939. San Francisco, *Golden Gate International Exhibition,* 1939.

NEW YORK, NAD, 1951. National Academy of Design, New York, *The American Tradition, Exhibition of Paintings,* 3–16 December 1951.

WILMINGTON 1952. Society of the Fine Arts, Wilmington, Delaware, *The American Tradition 1800–1900,* 3–20 March 1952.

UTICA 1953. Munson-Williams-Proctor Institute, Utica, New York, *Expatriates: Whistler, Cassatt, Sargent,* 4–25 January 1953.

CHICAGO 1954. The Art Institute of Chicago, *Sargent, Whistler and Mary Cassatt,* 14 January–25 February 1954; The Metropolitan Museum of Art, New York, 25 March–23 May 1954.

WILLIAMSTOWN 1955. Sterling and Francine Clark Art Institute, Williamstown, Massachusetts, *Exhibit Four: First Two Rooms,* 17 May 1955.

GRAND RAPIDS 1955. Grand Rapids Art Gallery, Michigan, *Cassatt Whistler Sargent Exhibition,* 15 September–15 October 1955.

HARTFORD 1955. Wadsworth Atheneum, Hartford, Connecticut, *Off for the Holidays,* 1955.

BOSTON 1956. Museum of Fine Arts, Boston, *Centennial Exhibition: Sargent's Boston,* 3 January–7 February 1956.

WILLIAMSTOWN 1957. Sterling and Francine Clark Art Institute, Williamstown, Massachusetts, *Exhibit Four and Exhibit Seven,* 18 May 1957.

PITTSBURGH 1957. Carnegie Institute, Pittsburgh, *American Classics of the Nineteenth Century,* 17 October–1 December 1957; exhibition travelled.

UTICA 1958. Munson-Williams-Proctor Institute, Utica, New York, *American Classics of the Nineteenth Century,* 5–26 January 1958.

NEW HAVEN 1958. Yale University Art Gallery, New Haven, *Art from Alumni Collections,* 25 April–16 June 1958.

NEW YORK 1959. American Academy of Arts and Letters, New York, *Impressionist Mood in American Painting,* 1959.

PALM BEACH 1959. The Society of the Four Arts, Palm Beach, Florida, *Loan Exhibition of Works by John Singer Sargent (1856–1925) and Mary Cassatt (1845–1926)*, 7 March–5 April 1959.

SAN FRANCISCO 1959. California Palace of the Legion of Honor, San Francisco, *Sargent and Boldini*, 24 October–29 November 1959.

WASHINGTON 1959. Corcoran Gallery of Art, Washington, D.C., *The American Muse*, 1959.

BOSTON 1959. Museum of Fine Arts, Boston, *A Memorial Exhibition of the Collection of the Honorable Alvan T. Fuller*, 1959.

PALM BEACH 1961. The Society of the Four Arts, Palm Beach, Florida, *Paintings from the Collection of Alvan T. Fuller Lent by the Trustees of the Alvan T. Fuller Foundation: 25th Anniversary Exhibition*, 7–29 January 1961.

FLINT 1961. Flint Institute of Arts, Michigan, *American Paintings 1860–1960*, February 1961.

DETROIT 1962. The Detroit Institute of Arts, *American Paintings and Drawings from Michigan Collections*, April 1962.

FALMOUTH 1962. The Polytechnic Arts Committee, Falmouth, Cornwall, *John Singer Sargent*, 1962; an exhibition of works belonging to F. Guillaume Ormond, the artist's nephew.

KING'S LYNN 1962. King's Lynn Festival, Norfolk, U.K., *Paintings after Old Masters*, 21 July–2 August 1962.

PARIS 1963. Centre Culturel Américain, Paris, *John S. Sargent 1856–1925*, 15 February–30 March 1963.

WASHINGTON 1964. Corcoran Gallery of Art, Washington, D.C., *The Private World of John Singer Sargent*, 18 April–14 June 1964; The Cleveland Museum of Art, 7 July–16 August 1964; Worcester Art Museum, Massachusetts, 17 September–1 November 1964; Munson-Williams-Proctor Institute, Utica, New York, 15 November 1964–3 January 1965.

BIRMINGHAM 1964. City Museum and Art Gallery, Birmingham, U.K., *Exhibition of Works by John Singer Sargent, R.A., 1856–1925*, 25 September–18 October 1964.

MINNEAPOLIS 1965. Minneapolis Institute of Art, Minnesota, *Fiftieth Anniversary Exhibition*, 1965–66.

NEW YORK, WHITNEY, 1966. Whitney Museum of American Art, New York, *Art of the USA*, 1966.

NEW YORK 1966. The Metropolitan Museum of Art, New York, *200 Years of Watercolor Painting in America: An Exhibition Commemorating the Centennial of the American Watercolor Society*, 8 December 1966–29 January 1967.

NEW YORK, WILDENSTEIN, 1967. Wildenstein & Co., New York, *An Exhibition of Treasures from the Sterling and Francine Clark Art Institute, Williamstown, Massachusetts*, 2–25 February 1967.

WORCESTER 1969. Worcester Art Museum, Massachusetts, *Art in America, 1830–1950*, 9 January–23 February 1969.

NEW YORK, MMA, 1970. The Metropolitan Museum of Art, New York, *19th-Century American Paintings and Sculpture: An Exhibition in Celebration of the Hundredth Anniversary of The Metropolitan Museum of Art*, 16 April–7 September 1970.

NEW YORK, HIRSCHL & ADLER, 1970. Hirschl & Adler Galleries, New York, *Forty Masterworks of American Art*, 28 October–14 November 1970.

NEW YORK AND BUFFALO 1971. The Metropolitan Museum of Art, New York, *John Singer Sargent: A Selection of Drawings and Watercolors from The Metropolitan Museum of Art*, 1 December 1971–15 February 1972; Albright-Knox Art Gallery, Buffalo, New York, 7 March–2 April 1972; Albany Institute of History and Art, Albany, New York, 11 April–14 May 1972.

NEW YORK, HIRSCHL & ADLER, 1972. Hirschl & Adler Galleries, New York, *Important Recent Acquisitions*, 2–23 February 1972.

LONDON, WILDENSTEIN, 1972. Wildenstein & Co., London, *A Loan Exhibition: Venice Rediscovered: In Aid of the Venice in Peril Fund*, 8 November–15 December 1972.

BOSTON 1973. Museum of Fine Arts, Boston, *Impressionism*, 15 June–14 October 1973.

NEW YORK, CRISPO, 1974. Andrew Crispo Gallery, New York, *Ten Americans: Masters of Watercolor*, 16 May–30 June 1974.

NEW YORK 1975. New York Cultural Center, *Three Centuries of the American Nude*, 9 May–13 July 1975; Minneapolis Institute of Arts, Minnesota, 6 August–21 September 1975; Fine Art Center, University of Houston, 3 October–16 November 1975.

DAYTON 1976. Dayton Art Institute, Ohio, *American Expatriate Painters of the Late Nineteenth Century*, 4 December 1976–16 January 1977; Pennsylvania Academy of the Fine Arts, Philadelphia, 4 February–20 March 1977; Los Angeles County Museum of Art, 12 April–29 May 1977.

LEEDS 1979. Leeds Art Galleries, Lotherton Hall, U.K., *John Singer Sargent and the Edwardian Age*, 5 April–10 June 1979; National Portrait Gallery, London, 6 July–9 September 1979; The Detroit Institute of Arts, 17 October–9 December 1979.

NEW YORK, CKG, 1980. Coe Kerr Gallery, New York, *John Singer Sargent: His Own Work*, 28 May–27 June 1980.

ALBI 1980. Musée Toulouse-Lautrec, Albi, France, *Trésors Impressionnistes du Musée de Chicago*, 27 June–31 August 1980.

CINCINNATI 1981. The Taft Museum, Cincinnati, *Small Paintings from Famous Collections*, 4 April–7 June 1981.

WASHINGTON 1982. Smithsonian Institution, Washington, D.C., Traveling Exhibition Service for the United States Communication Agency, *American Impressionism*, 30 March–30 May 1982.

PHOENIX 1982. Phoenix Art Museum, Arizona, *Americans in Brittany and Normandy*, 18 March–1 May 1983; Pennsylvania Academy of the Fine Arts, Philadelphia, 24 September–28 November 1982; Amon Carter Museum, Fort Worth, Texas, 16 December 1982–6 February 1983; National Museum of American Art, Washington, D.C., 10 June–14 August 1983.

WASHINGTON 1983. National Gallery of Art, Washington, D.C., *The John Hay Whitney Collection*, 29 May–5 September 1983.

BOSTON 1983. Museum of Fine Arts, Boston, *A New World: Masterpieces of American Painting, 1760–1910*, 7 September–13 November 1983; Corcoran Gallery of Art, Washington, D.C., 7 December 1983–12 February 1984; Grand Palais, Paris, 16 March–11 June 1984.

NEW YORK, CKG, 1983. Coe Kerr Gallery, New York, *Americans in Venice: 1879–1913*, 19 October–16 November 1983; Boston Athenaeum, 23 November–18 December 1983.

DETROIT 1983. The Detroit Institute of Arts, *The Quest for Unity: American Art Between World's Fairs, 1876–1893*, 1983.

SAN FRANCISCO 1984. California Palace of the Legion of Honor, San Francisco, *Venice: The American View 1860–1920*, 20 October 1984–20 January 1985; The Cleveland Museum of Art, 27 February–21 April 1985.

NEW YORK, CKG, 1985. Coe Kerr Gallery, New York, *American Impressionism*, 1985.

BOSTON 1986. Museum of Fine Arts, Boston, *The Bostonians: Painters of an Elegant Age, 1870–1930*, 11 June–14 September 1986; Denver Art Museum, Colorado, 25 October 1986–18 January 1987; Terra Museum of American Art, Chicago, 13 March–10 May 1987.

BRIDGEPORT 1986. Museum of Art, Science & Industry, Bridgeport, Connecticut, *American Artists Abroad: The European Influence*, 28 September–9 November 1986.

NEW YORK, CKG, 1986. Coe Kerr Gallery, New York, *Sargent at Broadway: The Impressionist Years,* Spring 1986.

NEW YORK AND CHICAGO 1986. Whitney Museum of American Art, New York, and The Art Institute of Chicago, *John Singer Sargent,* 7 October 1986–4 January 1987 and 7 February–19 April 1987, respectively.

CHICAGO 1987. Terra Museum of American Art, Chicago, *A Proud Heritage: Two Centuries of American Art: Selections from the Collections of the Pennsylvania Academy of the Fine Arts, Philadelphia, and the Terra Museum of American Art, Chicago,* 1987.

WEST PALM BEACH 1987. Norton Gallery and School of Art, West Palm Beach, Florida, *In Nature's Ways: American Landscape Painting of the Late Nineteenth Century,* 1987; travelled to the National Academy of Design, New York, and Terra Museum of American Art, Chicago.

CHICAGO 1988. Terra Museum of American Art, Chicago, *An American Revelation: The Daniel J. Terra Collection,* 28 February–1 October 1988.

SPRINGFIELD 1988. Museum of Fine Arts, Springfield, Massachusetts, *Lasting Impressions: French and American Impressionism from New England Museums,* 25 September–27 November 1988.

JAPAN 1989. Isetan Museum of Art, Tokyo, *John Singer Sargent: Sargent Exhibition in Japan,* 26 January–23 February 1989; Yamaguchi Prefectural Museum, 2 March–2 April 1989; Kumamoto Prefectural Museum of Art, 8 April–7 May 1989; Museum of Modern Art, Shiga, 13 May–11 June 1989.

CHICAGO 1989. Terra Museum of American Art, Chicago, *American Painters in France, 1830–1930,* 14 June–3 September 1989.

WASHINGTON 1992. National Gallery of Art, Washington, D.C., *John Singer Sargent's 'El Jaleo',* 1 March–2 August 1992; Isabella Stewart Gardner Museum, Boston, 10 September–22 November 1992.

GIVERNY 1992. Musée d'Art Américain, Giverny, *Impressions de toujours: les peintres américains en France, 1865–1915 (Lasting Impressions: American Painters in France, 1865–1915),* 1 June–1 November 1992; again 1 April–31 October 1993; 1 April–30 October 1994; and 1 April–31 October 1995.

CARDIFF 1992. The National Museum of Wales, Cardiff, *Impressions of Venice from Turner to Monet,* 25 July–20 September 1992.

BOSTON 1992. Museum of Fine Arts, Boston, *The Lure of Italy: American Artists and the Italian Experience,* 16 September–13 December 1992; The Cleveland Museum of Art, 3 February–11 April 1993; Museum of Fine Arts, Houston, 23 May–8 August 1993.

INDIANAPOLIS 1993. Indianapolis Museum of Art, Indiana, *American Tradition: Art from the Collections of Culver Alumni,* 12 December 1993–6 March 1994.

NEW YORK 1994. The Metropolitan Museum of Art, New York, *American Impressionism and Realism: The Painting of Modern Life, 1885–1915,* 10 May–24 July 1994; Amon Carter Museum, Fort Worth, Texas, 21 August–30 October 1994; Denver Art Museum, Colorado, 3 December 1994–5 February 1995; Los Angeles County Museum of Art, 12 March–14 May 1995.

NEW YORK, ADELSON GALLERIES, 1994. Adelson Galleries, New York, *American Impressionism,* 15 November–17 December 1994.

CHICAGO 1997. Terra Museum of American Art, Chicago, *American Artists and the French Experience,* 12 April–27 August 1997.

WILLIAMSTOWN 1997. Sterling and Francine Clark Art Institute, Williamstown, Massachusetts, *Uncanny Spectacle: The Public Career of the Young John Singer Sargent,* 15 June–7 September 1997.

LONDON 1998. Tate Gallery, London, *Sargent,* 15 October 1998–17 January 1999; National Gallery of Art, Washington, D.C., 21 February–31 May 1999; Museum of Fine Arts, Boston, 23 June–26 September 1999.

GIVERNY 2000. Musée d'Art Américain, Giverny, *Rivières et rivages: les artistes américains, 1850–1900 (Waves and Waterways: American Perspectives, 1850–1900),* 1 April–31 October 2000.

NEW YORK 2000. The Metropolitan Museum of Art, New York, *John Singer Sargent: Beyond the Portrait Studio, Paintings, Drawings and Watercolors from the Collection,* 6 June–10 September 2000.

SEATTLE 2000. Seattle Art Museum, *John Singer Sargent,* 14 December 2000–18 March 2001 (incorporating *John Singer Sargent: Portraits of the Wertheimer Family,* Jewish Museum, New York, 17 October 1999–6 February 2000, and other venues).

CHICAGO 2001. Terra Museum of American Art, Chicago, *Selections from the Permanent Collection: American Artists in France, 1860–1910,* 10 March–3 June 2001.

BUFFALO 2001. Albright-Knox Art Gallery, Buffalo, New York, *Circa 1900: From the Genteel Tradition to the Jazz Age,* 6 May–15 April 2001; Munson-Williams-Proctor Arts Institute, Museum of Art, Utica, New York, 3 March–15 April 2001; Herbert F. Johnson Museum of Art, Cornell University, Ithaca, New York, 8 September–25 November 2001; Albany Institute of History and Art, New York, 14 December 2001–3 March 2002; Everson Museum of Art, Syracuse, New York, 22 March–26 May 2002; Memorial Art Gallery of the University of Rochester, New York, 15 June–15 September 2002.

GIVERNY 2002. Musée d'Art Américain, Giverny, *D'une colonie à une collection: le Musée d'Art Américain Giverny fête ses dix ans (From a Colony to a Collection: Celebrating the Tenth Anniversary of the Musée d'Art Américain Giverny),* 30 March–16 June 2002.

FERRARA 2002. Palazzo dei Diamanti, Ferrara, *Sargent e l'Italia,* 22 September–6 January 2003 (see also Los Angles 2003).

CHICAGO 2002. Terra Museum of American Art, Chicago, *A Place on the Avenue: Terra Museum of American Art Celebrates 15 Years in Chicago,* 16 November 2002–2 March 2003.

LOS ANGELES 2003. Los Angeles County Museum of Art, *Sargent and Italy,* 9 February–11 May 2003 (the same exhibition as Ferrara 2002); Denver Art Museum, Colorado, 28 June–21 September 2003.

NEW YORK 2003. The Metropolitan Museum of Art, New York, *Manet/Velázquez: The French Taste for Spanish Painting,* 4 March–8 June 2003 (an expanded version of *Manet/Velázquez: la manière espagnole au XIXe siècle,* Musée d'Orsay, Paris, 16 September 2002–12 January 2003).

LILLE 2003. Palais des Beaux-Arts, Lille, *Carolus-Duran,* 9 March–9 June 2003; Musée des Augustins, Toulouse, 27 June–29 September 2003.

CHICAGO 2003. Terra Museum of American Art, Chicago, *The People Work: American Perspectives, 1840–1940,* 15 March–25 May 2003; Musée d'Art Américain, Giverny (*Le Travail à l'oeuvre: les artistes américains, 1840–1940),* 8 June–17 August 2003.

NEW YORK, ADELSON GALLERIES, 2003. Adelson Galleries, New York, *Sargent's Women,* 12 November–13 December 2003.

ATLANTA 2003. High Museum of Art, Atlanta, *After Whistler: The Artist and His Influence on American Painting,* 22 November 2003–8 February 2004; The Detroit Institute of Arts, 13 March–6 June 2004.

CHICAGO 2004. Terra Museum of American Art, Chicago, *A Narrative of American Art,* 13 February–31 October 2004.

GIVERNY 2004. Musée d'Art Américain, Giverny, *En Plein Air: personages dans un paysage (En Plein Air: Figures in a Landscape),* 1 April–31 October 2004.

BOSTON 2004. Isabella Stewart Gardner Museum, Boston, *Gondola Days,* 21 April–15 August 2004 (version of the exhibition shown at the Biblioteca Nazionale Marciana, Venice, 7 October–20 December 2004).

NEW YORK 2004. Brooklyn Museum, New York, *Great Expectations: John Singer Sargent Painting Children,* 8 October 2004–16 January 2005; Chrysler Museum of Art, Norfolk, Virginia, 25 February–22 May 2005; Portland Art Museum, Oregon, 18 June–11 September 2005.

BIBLIOGRAPHY CITED IN ABBREVIATED FORM

ADELSON AND OUSTINOFF 1992. Warren Adelson and Elizabeth Oustinoff, 'Sargent's Spanish Dancer—A Discovery', *The Magazine Antiques,* vol. 141 (March 1992), pp. 460–71.

ADELSON ET AL. 1986. Warren Adelson, Stanley Olson and Richard Ormond, *Sargent at Broadway: The Impressionist Years,* New York and London, 1986 (exhibition catalogue).

ADELSON ET AL. 1997. Warren Adelson, Donna Seldin Janis, Elaine Kilmurray, Richard Ormond and Elizabeth Oustinoff, *Sargent Abroad: Figures and Landscapes,* New York, 1997.

ADELSON ET AL. 2003. Warren Adelson, Deborah Davis, Elaine Kilmurray and Richard Ormond, *Sargent's Women,* New York, 2003 (exhibition catalogue).

BACON 1883. Henry Bacon, *Parisian Art and Artists,* Boston, 1883.

BALDRY 1900. A. Lys Baldry, 'The Art of J. S. Sargent, R.A.: Part I', *International Studio,* vol. 10 (March 1900), pp. 3–21.

BARTER ET AL. 1998. Judith A. Barter, Kimberley Rhodes and Seth A. Thayer, with contributions by Andrew Walker, *American Arts at The Art Institute of Chicago: From Colonial Times to World War I,* Chicago, 1998.

BELLEROCHE 1926. Albert de Belleroche, 'The Lithographs of Sargent', *The Print Collectors' Quarterly,* vol. 13 (February 1926), pp. 30–45.

BERRY 1924. Rose V. S. Berry, 'John Singer Sargent: Some of His American Work', *Art and Archaeology,* vol. 18 (September 1924), pp. 83–112.

BIRMINGHAM 1964. *Exhibition of Works by John Singer Sargent, R.A., 1856–1925,* City Museum and Art Gallery, Birmingham, U.K., 1964 (exhibition catalogue).

BIRNBAUM 1941. Martin Birnbaum, *John Singer Sargent, January 12, 1856–April 15, 1925: A Conversation Piece,* New York, 1941.

BOONE 1996. M. Elizabeth Boone, *Vistas de España: American Views of Art and Life in Spain 1860–1898,* Ph.D. diss., City University of New York, 1996; esp. chapter 5, 'John Singer Sargent, *Flamenco* and Bizet's *Carmen',* pp. 158–99.

BOSTON 1899. *Catalogue of Paintings and Sketches by John S. Sargent, R.A.,* Copley Hall, Boston, 1899 (exhibition catalogue).

BOSTON 1925. *Catalogue of the Memorial Exhibition of the Works of the Late John Singer Sargent, Museum of Fine Arts, Boston,* Boston, 1925, foreword by J. Templeman Coolidge (exhibition catalogue).

BOSTON 1925a. *Catalogue of the Memorial Exhibition of the Works of the Late John Singer Sargent, Museum of Fine Arts, Boston,* Boston, 1925, foreword by J. Templeman Coolidge (2nd edition of exhibition catalogue with revised numeration).

BOSTON 1928. *Exhibition of Paintings Loaned by Governor Alvan T. Fuller,* Boston Art Club, 1928 (exhibition catalogue).

BOSTON 1956. David McKibbin, *Sargent's Boston: With an Essay & a Biographical Summary & a Complete Check List of Sargent's Portraits,* Museum of Fine Arts, Boston, 1956 (exhibition catalogue). The checklist of portraits is listed separately as 'McKibbin 1956'.

BOSTON 1959. *A Memorial Exhibition of the Collection of the Honorable Alvan T. Fuller,* Museum of Fine Arts, Boston, 1959 (exhibition catalogue).

BOSTON 1969. *American Paintings in the Museum of Fine Arts, Boston,* 2 vols., Boston, 1969.

BOSTON 1986. Trevor J. Fairbrother, with contributions by Theodore E. Stebbins, Jr, William L. Vance and Erica E. Hirshler, *The Bostonians: Painters of an Elegant Age 1870–1930,* Museum of Fine Arts, Boston, 1986 (exhibition catalogue).

BOSTON 1993. Sue Welsh Reed and Carol Troyen, with contributions by Roy Perkinson and Annette Manick, *Awash in Color: Homer, Sargent and the Great American Watercolor,* Museum of Fine Arts, Boston; Toronto and London, 1993 (exhibition catalogue).

BOSTON 2004. Elizabeth Anne McCauley, Alan Chong, Rosella Mamoli Zorzi and Richard Lingner, *Gondola Days,* Isabella Stewart Gardner Museum, Boston, 2004 (exhibition catalogue).

BOURGUIGNON AND KENNEDY 2002. Katherine M. Bourguignon and Elizabeth Kennedy, *An American Point of View: The Daniel J. Terra Collection, Chicago, Illinois,* Terra Foundation for the Arts, Chicago, 2002; also published as *Un regard transatlantique: La collection d'art américain de Daniel J. Terra.*

BRINTON 1906. Christian Brinton, 'Sargent and His Art', *Munsey's Magazine,* vol. 36 (December 1906), pp. 265–84.

BRINTON 1908. Christian Brinton, *Modern Artists,* New York, 1908.

BROWN 1986. Jonathan Brown, *Velázquez: Painter and Courtier,* New Haven and London, 1986.

BURKE 1980. Doreen Bolger Burke, *American Paintings in The Metropolitan Museum of Art: A Catalogue of Works by Artists Born between 1846 and 1864,* vol. 3, New York, 1980.

CAFFIN 1902. Charles H. Caffin, *American Masters of Painting,* New York, 1902, pp. 55–67.

CAFFIN 1903. Charles H. Caffin, 'John S. Sargent: The Greatest Contemporary Portrait Painter', *World's Work,* vol. 7 (November 1903), pp. 4099–116.

CAFFIN 1903a. Charles H. Caffin, 'The Art of John Singer Sargent', *Current Literature,* vol. 24 (April 1903), pp. 443–48 (extracted from Charles H. Caffin, *American Masters of Painting,* New York, 1902).

CARTWRIGHT 2000. Derrick R. Cartwright, *Waves and Waterways: American Perspectives, 1850–1900,* Terra Foundation for the Arts, Chicago, 2000 (exhibition catalogue); also published as *Rivières et rivages: les artistes américains, 1850–1900.*

CHARTERIS 1927. Evan Charteris, *John Sargent,* London, 1927.

CHICAGO 1954. Frederick A. Sweet, *Sargent, Whistler and Mary Cassatt,* The Art Institute of Chicago, 1954 (exhibition catalogue).

CHRISTIE'S 1925. Christie's, *Catalogue of Pictures and Water Colour Drawings by J. S. Sargent, R.A. and Works by other Artists, the property of the late John Singer Sargent, R.A., D.C.L., LLD . . . which . . . will be sold by auction by Messrs. Christie, Manson & Woods . . . on Friday July 24, and Monday, July 27, 1925,* London, 1925.

CLARK 1937. Walter Clark, *Leaves from an Artist's Memory,* New York, 1937.

CLARK ART INSTITUTE 1990. Margaret C. Conrads, *American Paintings and Sculpture at the Sterling and Francine Clark Art Institute,* New York, 1990.

COFFIN 1896. William A. Coffin, 'Sargent and His Painting, with Special Reference to His Decorations in the Boston Public Library', *Century Magazine,* vol. 52 (June 1896), pp. 163–78.

CORTISSOZ 1903. Royal Cortissoz, 'John S. Sargent', *Scribner's Magazine,* vol. 34, no. 5 (November 1903), pp. 514–32; reprinted in Royal Cortissoz, *Art and Common Sense,* New York, 1913.

CORTISSOZ 1913. Royal Cortissoz, *Art and Common Sense,* New York, 1913.

CORTISSOZ 1924. Royal Cortissoz, 'Sargent: The Painter of Modern Tenseness, the Nature of His Genius', *Scribner's Magazine,* vol. 75 (March 1924), pp. 345–52.

COURNOS 1915. John Cournos, 'John S. Sargent', *Forum,* vol. 54 (August 1915), pp. 232–36.

COX 1908. Kenyon Cox, 'Sargent', *Old Masters and New: Essays in Art Criticism,* New York, 1908, pp. 255–65.

CURRY 1997. David P. Curry, 'American Dreams: The Warner Collection', *American Art Review,* vol. 9, no. 6 (December 1997), pp. 158–67.

DES MOINES 1980. Carol Troyen, *The Boston Tradition: American Paintings from the Museum of Fine Arts, Boston,* Des Moines Art Center; Museum of Fine Arts, Boston; American Federation of Arts, New York, 1980 (exhibition catalogue).

DIXON 1899. Margaret Hepworth Dixon, 'Mr John S. Sargent as a Portrait Painter', *Magazine of Art,* vol. 23 (January 1899), pp. 112–19.

DORMENT AND MACDONALD 1994. Richard Dorment and Margaret F. MacDonald, with contributions by Nicolai Cikovsky, Jr, Ruth Fine and Geneviève Lacambre, *James McNeill Whistler,* Tate Gallery, London, 1994 (exhibition catalogue).

DOWNES 1925. William Howe Downes, *John S. Sargent: His Life and Work,* Boston, 1925.

DOWNES 1926. William Howe Downes, *John S. Sargent: His Life and Work,* London, 1926.

EARLY PORTRAITS. Richard Ormond and Elaine Kilmurray, *John Singer Sargent: The Early Portraits, 1874–1899* vol. 1 of *Complete Paintings,* New Haven and London, 1998.

FAIRBROTHER 1981. Trevor J. Fairbrother, 'A Private Album: John Singer Sargent's Drawings of Nude Male Models', *Arts Magazine,* vol. 56 (December 1981), pp. 70–79.

FAIRBROTHER 1982. Trevor J. Fairbrother, 'Notes on John Singer Sargent in New York, 1888–1890', *Archives of American Art Journal,* vol. 22 (1982), pp. 27–32.

FAIRBROTHER 1986. Trevor Fairbrother, *John Singer Sargent and America,* New York, 1986.

FAIRBROTHER 1987. Trevor Fairbrother, 'John Singer Sargent's "Gift" and his Early Critics', *Arts Magazine,* vol. 61, no. 6 (February 1987), pp. 64–71.

FAIRBROTHER 1990. Trevor Fairbrother, 'Sargent's Genre Paintings and the Issues of Suppression and Privacy', *Studies in the History of Art,* National Gallery of Art, Washington, D.C., vol. 37 (1990), pp. 29–49.

FAIRBROTHER 1994. Trevor Fairbrother, *John Singer Sargent,* New York, 1994.

FAIRBROTHER 2000. Trevor Fairbrother, *John Singer Sargent: The Sensualist,* New Haven and London, 2000 (published in conjunction with the exhibition *John Singer Sargent;* see Seattle 2000).

FERRARA 2002. Elaine Kilmurray and Richard Ormond, *Sargent e l'Italia,* Ferrara, 2002 (exhibition catalogue).

FOWLER 1894. Frank Fowler, 'An American in the Royal Academy, a Sketch of John S. Sargent', *Review of Reviews,* vol. 9 (June 1894), pp. 685–88.

FRY 1926. Roger Fry, *Transformations: Critical and Speculative Essays on Art,* London, 1926.

GALLATI ET AL. 2004. Barbara Gallati, with contributions by Erica E. Hirshler and Richard Ormond, *Great Expectations: John Singer Sargent Painting Children,* Brooklyn Museum, New York, 2004 (exhibition catalogue).

GAUTIER 1864. Théophile Gautier, G. Arsène Houssaye and Paul de Saint-Victor, *Les Dieux et les demi-dieux de la peinture,* Paris, 1864.

GETSCHER AND MARKS 1986. Robert H. Getscher and Paul G. Marks, *James McNeill Whistler and John Singer Sargent: Two Annotated Bibliographies,* New York, 1986.

GIVERNY 1992. *Lasting Impressions: American Painters in France 1865–1915,* essay by William H. Gerdts, commentaries by D. Scott Atkinson, Carole L. Shelby and Jochen Wierich, Chicago, 1992 (exhibition catalogue for Musée d'Art Américain, Giverny); also published as *Impressions de toujours: les peintres américains en France, 1865–1915.*

GOLDFARB 1995. Hilliard T. Goldfarb, *The Isabella Stewart Gardner Museum: A Companion Guide and History,* Isabella Stewart Gardner Museum, Boston; New Haven and London, 1995.

GOLEY 2000. Mary-Anne Goley, *The Influence of Velázquez on Modern Painting: The American Experience,* Federal Reserve Board, Washington, D.C., 2000 (exhibition booklet).

GRIEVE 2000. Alastair Grieve, *Whistler's Venice,* New Haven and London, 2000.

HALE 1927. Mary Newbold Patterson Hale, 'The Sargent I Knew', *World Today,* vol. 50 (November 1927), pp. 565–70.

HARDY 1982. Richard Little Purdy and Michael Millgate, eds., *The Collected Letters of Thomas Hardy,* 7 vols., Oxford, 1978–88; vol. 3, 1982.

HEARTNEY ET AL. 2002. Eleanor Heartney, with Corcoran curators and contributors, and essays by Frank O. Gehry *et al., A Capital Collection: Masterworks from the Corcoran Gallery of Art,* Washington, D.C., 2002.

HELLER 2000. Nancy G. Heller, 'What's There, What's Not: A Performer's View of Sargent's *El Jaleo', American Art,* Smithsonian American Art Museum, Washington, D.C., vol. 14, no. 1 (Spring 2000).

HENDY 1974. Philip Hendy, *European and American Paintings in the Isabella Stewart Gardner Museum,* Boston, 1974.

HERDRICH AND WEINBERG 2000. Stephanie L. Herdrich and H. Barbara Weinberg, with an essay by Marjorie Shelley, *American Drawings and Watercolors in The Metropolitan Museum of Art: John Singer Sargent,* New York, 2000.

HILLS ET AL. 1986. *John Singer Sargent,* essays by Linda Ayres, Annette Blaugrund, Albert Boime, William H. Gerdts, Patricia Hills, Stanley Olson and Gary A. Reynolds, New York, 1986 (exhibition catalogue).

HONOUR AND FLEMING 1991. Hugh Honour and John Fleming, *The Venetian Hours of Henry James, Whistler and Sargent,* London, 1991.

HYDE 1914. Frank Hyde, 'The Island of the Sirens', *International Studio,* vol. 52, no. 204 (1914), pp. 285–88.

ISHAM 1905. Samuel Isham, *The History of American Art,* New York, 1905.

JACOMB-HOOD 1925. G. P. Jacomb-Hood, 'John Sargent', *Cornhill Magazine,* vol. 59 (September 1925), pp. 280–90.

JAMES 1887. Henry James, 'John S. Sargent', *Harper's New Monthly Magazine,* vol. 75 (October 1887), pp. 683–91.

JAMES 1893. Henry James, *Picture and Text,* New York, 1893.

JAMES 1956. Henry James, *The Painter's Eye: Notes and Essays on the Pictorial Arts,* London, 1956.

JAPAN 1989. Denys Sutton, ed., *Sargent,* Tokyo, 1989 (exhibition catalogue).

JULLIAN 1977. Philippe Jullian, *The Orientalists: European Painters of Eastern Scenes,* Oxford, 1977.

LANSDALE 1964. Nelson Lansdale, 'John Singer Sargent his Private World', *American Artist,* vol. 28, no. 9 (November 1964), pp. 58–63 and 79–83.

LATER PORTRAITS. Richard Ormond and Elaine Kilmurray, *John Singer Sargent: The Later Portraits, 1900–1925,* vol. 3 of *Complete Paintings,* New Haven and London, 2003.

LEEDS 1979. James Lomax and Richard Ormond, *John Singer Sargent and the Edwardian Age,* Leeds Art Galleries, The Detroit Institute of Arts, and National Portrait Gallery, London, 1979 (exhibition catalogue).

LEWIS HIND 1926. C. Lewis Hind, 'John Sargent', *Fortnightly Review,* vol. 119 (1926), pp. 403–12.

LILLE 2003. *Carolus-Duran, 1837–1917,* Palais des Beaux-Arts, Lille, 2003 (exhibition catalogue).

LONDON 1908. *Spring Exhibition,* Whitechapel Art Gallery, London, 1908 (exhibition catalogue).

LONDON 1926. *Exhibition of Works by the Late John S. Sargent, R.A.,* Royal Academy of Arts, London, 1926 (exhibition catalogue).

LONDON 1972. *A Loan Exhibition. Venice Rediscovered: In Aid of the Venice in Peril Fund,* Wildenstein & Co., London, 1972 (exhibition catalogue).

LONDON 1995. Kenneth McConkey and Ysanne Holt, with an essay by Anna Greutzner Robins, *Impressionism in Britain,* London, 1995 (exhibition catalogue).

LONDON 1998. Elaine Kilmurray and Richard Ormond, with essays by Richard Ormond and Mary Crawford Volk, contributions by Erica Hirshler, Theodore E. Stebbins, Jr, and Carol Troyen, *Sargent,* Tate Gallery, London, 1998 (exhibition catalogue).

LONDON, PYMS GALLERY, 1998. *A Painter's Painting: John Singer Sargent's A Spanish Woman (Gigia Viani),* introduction by Kenneth McConkey, Pyms Gallery, London, 1998 (exhibition booklet).

LÓPEZ-REY 1963. José López-Rey, *Velázquez: A Catalogue Raisonné of his Oeuvre with an introductory essay,* London, 1963.

LÓPEZ-REY 1996. José López-Rey, *Velázquez: Catalogue Raisonné,* 2 vols., Cologne 1996.

LOVELL 1989. Margaretta M. Lovell, *A Visitable Past: Views of Venice by American Artists, 1860–1915,* Chicago and London, 1989.

LOW 1908. Will Low, *A Chronicle of Friendships, 1873–1900,* New York and London, 1908.

LUNA 1988. Juan J. Luna, 'John Singer Sargent y el Museo del Prado', *Historia,* vol. 16 (June 1988).

MCKIBBIN 1956. 'A Complete Check List of Sargent's Portraits'. See Boston 1956.

MCKIBBIN PAPERS. David McKibbin's working papers for the catalogue raisonné project, initiated 1947, Sargent catalogue raisonné archive.

MCSPADDEN 1907. Joseph Walker McSpadden, 'John Singer Sargent: The Painter of Portraits', in *Famous Painters of America,* New York, 1907.

MATHER 1931. Frank Jewett Mather, *Estimates in Art: Series II,* New York, 1931.

MECHLIN 1924. Leila Mechlin, 'The Sargent Exhibition: Grand Central Art Galleries, New York', *The American Magazine of Art,* vol. 15, no. 4 (April 1924), pp. 169–90.

MERRILL *ET AL.* 2003. Linda Merrill *et al., After Whistler: The Artist and His Influence on American Painting,* High Museum of Art, Atlanta; London and New Haven, 2003 (exhibition catalogue).

MEYNELL 1903. Alice Christiana Meynell, *The Work of John S. Sargent, R.A.,* London and New York, 1903.

MEYNELL AND MANSON 1927. *The Work of John S. Sargent, R.A.,* introduction by J. B. Manson and A. C. Meynell, London and New York, 1927.

MINCHIN 1925. Hamilton Minchin, 'Some Early Recollections of Sargent', *Contemporary Review,* vol. 127 (June 1925), pp. 735–43.

MOORE 1929. Charles Moore, *The Life and Times of Charles Follen McKim,* Boston and New York, 1929.

MOUNT 1955. Charles Merrill Mount, *John Singer Sargent: A Biography,* New York, 1955.

MOUNT 1957. Charles Merrill Mount, *John Singer Sargent: A Biography,* London, 1957 (abridged version of Mount 1955).

MOUNT, *ART QUARTERLY,* 1957. Charles Merrill Mount, 'New Discoveries Illumine Sargent's Paris Career', *Art Quarterly,* vol. 20 (Autumn 1957), pp. 304–16.

MOUNT 1963. Charles Merrill Mount, 'Carolus-Duran and the Development of Sargent', *Art Quarterly,* vol. 26 (Winter 1963), pp. 384–417.

MOUNT 1969. Charles Merrill Mount, *John Singer Sargent: A Biography,* New York, 1969 (reprint of Mount 1955, with revised checklist of paintings).

NAHUM 1993. Katherine Coburn Harding Nahum, *The Importance of Velázquez to Goya, Manet and Sargent,* Ph.D. diss., Boston University, printed at Ann Arbor, Michigan, 1993.

NEW YORK 1924. *Retrospective Exhibition of Important Works of John Singer Sargent,* Grand Central Art Galleries, New York, 1924 (exhibition catalogue).

NEW YORK 1926. *Memorial Exhibition of the Work of John Singer Sargent,* introduction by Mariana Griswold Van Rensselaer, The Metropolitan Museum of Art, New York, 1926 (exhibition catalogue).

NEW YORK 1980. *John Singer Sargent: His Own Work,* introduction by Warren Adelson, checklist by Meg Robertson, Coe Kerr Gallery, New York, 1980 (exhibition catalogue with checklist of paintings and watercolours in public collections in the U.S. and Canada).

NEW YORK 1983. *Americans in Venice: 1879–1913,* introduction by Donna Seldin, New York, 1983 (exhibition catalogue).

NEW YORK 1994. H. Barbara Weinberg, Doreen Bolger and David Park Curry, with the assistance of N. Mishoe Brennecke, *American Impressionism and Realism: The Painting of Modern Life, 1885–1915,* The Metropolitan Museum of Art, New York, 1994 (exhibition catalogue).

NOVAK 1979. Barbara Novak, *American Painting of the Nineteenth Century: Realism, Idealism and the American Experience,* New York, 1979.

NYGREN 1983. Edward J. Nygren, *John Singer Sargent: Drawings from the Corcoran Gallery of Art,* Washington, D.C., 1983 (exhibition catalogue).

OLSON 1986. Stanley Olson, *John Singer Sargent: His Portrait,* London and New York, 1986.

ORMOND 1970. Richard Ormond, *John Singer Sargent: Paintings, Drawings, Watercolours,* London, 1970.

ORMOND, *COLBY LIBRARY QUARTERLY,* 1970. Richard Ormond, 'John Singer Sargent and Vernon Lee', *Colby Library Quarterly,* series 9, no. 3 (September 1970), pp. 154–78.

ORMOND, *FENWAY COURT*, 1970. Richard Ormond, 'Sargent's El Jaleo', *Fenway Court, Isabella Stewart Gardner Museum 1970,* Boston, 1971, pp. 2–18.

ORMOND AND PIXLEY 2003. Richard Ormond and Mary Pixley, 'Sargent after Velázquez: The Prado Studies', *Burlington Magazine,* vol. 145, no. 1206 (September 2003), pp. 632–40.

PALM BEACH 1961. *Paintings from the Collection of Alvan T. Fuller Lent by the Trustees of the Alvan T. Fuller Foundation: 25th Anniversary Exhibition,* The Society of the Four Arts, Palm Beach, 1961 (exhibition catalogue).

PENNELL 1921. Elisabeth Robins Pennell and Joseph Pennell, eds., *The Whistler Journal,* Philadelphia, 1921.

PORTRAITS OF THE 1890s. Richard Ormond and Elaine Kilmurray, *John Singer Sargent: Portraits of the 1890s,* vol. 2 of *Complete Paintings,* New Haven and London, 2002.

POUSETTE-DART 1924. Nathaniel Pousette-Dart, with an introduction by Lee Woodward Zeigler, *John Singer Sargent,* New York, 1924.

PRETTEJOHN 1998. Elizabeth Prettejohn, *Interpreting Sargent,* London, 1998.

PROMEY 1999. Sally M. Promey, *Painting Religion in Public: John Singer Sargent's 'Triumph of Religion' at the Boston Public Library,* Princeton, 1999.

QUICK 1976. Michael Quick, *American Expatriate Painters of the Late Nineteenth Century,* Dayton Art Institute, Ohio, 1976 (exhibition catalogue).

RA ILL. 1926. *Illustrations of the Sargent Exhibition Royal Academy 1926,* London, 1926.

RATCLIFF 1982. Carter Ratcliff, *John Singer Sargent,* New York, 1982.

RICHARDSON 1976. E. P. Richardson, *American Art: A Narrative and Critical Catalogue,* Fine Arts Museums of San Francisco, 1976 (published in conjunction with *An Exhibition from the Collection of Mr and Mrs John D. Rockefeller 3rd).*

ROBERTSON 1982. Meg Robertson, 'John Singer Sargent. His Early Success in America', *Archives of American Art Journal,* vol. 22 (1982), pp. 20–26.

ROBERTSON *ET AL.* 2003. Bruce Robertson, Jane Dini, Irene Susan Fort, Stephanie L. Herdrich, R. W. B. Lewis and Richard Ormond, *Sargent and Italy,* Los Angeles County Museum of Art, and Princeton, 2003.

SAINT-GAUDENS 1913. Augustus Saint-Gaudens, *The Reminiscences of Augustus Saint-Gaudens,* edited and amplified by Homer Saint-Gaudens, New York, 1913.

SAN FRANCISCO 1984. Margaretta M. Lovell, *Venice: The American View 1860–1920,* The Fine Arts Museums of San Francisco, 1984 (exhibition catalogue).

SARGENT TRUST LIST [1927]. *The Sargent Trust List of Pictures and Drawings,* London, [1927], catalogue raisonné archive.

SELLIN 1976. David Sellin, *American Art in the Making: Preparatory Studies for Masterpieces of American Painting,* Smithsonian Institution, Washington, D.C., 1976 (exhibition catalogue).

SELLIN AND BALLINGER 1982. David Sellin and James K. Ballinger, *Americans in Brittany and Normandy,* Phoenix Art Museum, 1982 (exhibition catalogue).

SIDLAUSKAS 1989. Susan J. Sidlauskas, *A 'Perspective of Feeling': The Expressive Interior in Nineteenth-Century Realist Painting,* Ph.D. diss., University of Pennsylvania, Philadelphia, 1989.

SIDLAUSKAS 2000. Susan J. Sidlauskas, *Body, Place, and Self in Nineteenth-Century Painting,* Cambridge, 2000.

SIMMONS 1983. Linda Crocker Simmons, with other contributors, *American Drawings, Watercolors, Pastels and Collages in the Collection of the Corcoran Gallery of Art,* Washington, D.C., 1983.

SIMPSON 1980. Marc Simpson, 'Two Recently Discovered Paintings by John S. Sargent', *Yale University Art Bulletin,* vol. 38, no. 1 (Fall 1980).

SIMPSON 1997. Marc Simpson, with contributions by Richard Ormond and H. Barbara Weinberg, *Uncanny Spectacle: The Public Career of the Young John Singer Sargent,* Sterling and Francine Clark Art Institute, Williamstown, Massachusetts, and New Haven, 1997 (exhibition catalogue).

SIMPSON, *ANTIQUES,* 1997. Marc Simpson, 'Sterling Clark as a Collector', *The Magazine Antiques,* October 1997, pp. 554–57.

SIMPSON 1998. Marc Simpson, 'Sargent, Velázquez, and the Critics. "Velasquez come to life again"', *Apollo,* vol. 148 (September 1998), pp. 3–12.

SLIVE 1970–74. Seymour Slive, *Frans Hals,* National Gallery of Art: Kress Foundation Studies in the History of European Art, 3 vols., Oxford, 1970–74.

SLIVE *ET AL.* 1989. Seymour Slive, with contributions by Pieter Biesboer, Martin Bijl, Karin Groen, Ella Hendriks, Michael Hoyle, Frances S. Jowell, Koos Levy-van Halm, Liesbeth Abraham, Bianca M. du Mortier and Irene van Thiel-Stroman, *Frans Hals,* Royal Academy of Arts, London, 1989 (exhibition catalogue).

SMITH 1902. F. Hopkinson Smith, *Gondola Days,* Boston, 1902.

STARKWEATHER 1924. William Starkweather, 'John Singer Sargent Master Portrait Painter', *Mentor,* vol. 12 (October 1924), pp. 1–29.

STEBBINS *ET AL.* 1983. Theodore E. Stebbins, Jr, Carol Troyen and Trevor Fairbrother, with essays by Pierre Rosenberg and H. Barbara Weinberg, *A New World: Masterpieces of American Painting 1760–1910,* Museum of Fine Arts, Boston, 1983 (exhibition catalogue).

STEBBINS *ET AL.* 1992. Theodore E. Stebbins, Jr, with essays by William H. Gerdts, Erica E. Hirshler, Fred S. Licht and William L. Vance, *The Lure of Italy: American Artists and the Italian Experience 1760–1914,* Museum of Fine Arts, Boston, and New York, 1992 (exhibition catalogue).

STEBBINS AND GOROKHOFF 1982. Theodore E. Stebbins, Jr, and Galina Gorokhoff, *A Checklist of American Paintings at Yale University,* New Haven, 1982.

STEVENSON 1888. R. A. M. Stevenson, 'J. S. Sargent', *Art Journal,* 1888, pp. 65–69.

STOKES 1886. Adrian Stokes, 'Capri', *Art Journal,* 1886, pp. 165–69.

STOKES 1926. Adrian Stokes, 'John Singer Sargent, R.A., R.W.S.', *The Old Water-Colour Society's Club 1925–1926,* vol. 3, ed. Randall Davies, London, 1926.

STRETTELL 1887. Alma Strettell, *Spanish & Italian Folk-Songs,* London, 1887.

STRICKLER 1982–83. Susan E. Strickler, 'John Singer Sargent and Worcester', *Worcester Art Museum Journal,* vol. 6 (1982–83), pp. 19–39.

SUTTON 1964. Denys Sutton, 'A Bouquet for Sargent', *Apollo,* vol. 79 (May 1964), pp. 395–400.

SWEET 1966. Frederick A. Sweet, *Miss Mary Cassatt: Impressionist from Pennsylvania,* Norman, Oklahoma, 1966.

TATE GALLERY CATALOGUE 1964. Mary Chamot, Dennis Farr and Martin Butlin, *Tate Gallery Catalogues: The Modern British Paintings, Drawings and Sculpture,* 2 vols., London, Tate Gallery, 1964.

TINTEROW *ET AL.* 2003. Gary Tinterow and Geneviève Lacambre, with Deborah L. Roldán and Juliet Wilson-Bareau, and with contributions by Jeannine Baticle, Marcus B. Burke, Ignacio Cano Rivero, Mitchell A. Codding, Trevor Fairbrother, María de los Santos García Felguera, Stéphane Guégan, Ilse Hempel Lipschutz, Dominique Lobstein, Javier Portús Pérez, H. Barbara Weinberg and Mattias Weniger, *Manet/Velázquez: The French Taste for Spanish Painting,* The Metropolitan Museum of Art, New York, 2003 (exhibition catalogue).

TINTNER 1975. Adeline R. Tintner, 'Sargent in the Fiction of Henry James', *Apollo*, vol. 102 (August 1975), pp. 128–32.

TORCHIA 1998. Robert Wilson Torchia, *American Paintings of the Nineteenth Century: The Collections of the National Gallery of Art Systematic Catalogue*, New York and Oxford, 1998.

TROYEN *ET AL.* 1997. Carol Troyen, Charlotte Emans Moore and Priscilla Kate Diamond, introduction by Theodore E. Stebbins, Jr, *American Paintings in the Museum of Fine Arts, Boston: An Illustrated Summary Catalogue*, Boston, 1997.

VAN DYKE 1919. John C. Van Dyke, 'John S. Sargent', in *American Painting and Its Tradition*, New York, 1919, pp. 245–70.

VERNON LEE'S LETTERS 1937. *Vernon Lee's Letters*, preface by I. Cooper Willis, London, 1937, privately printed.

WALTON 1893–95. William Walton, *World's Columbian Exposition: The Art and Architecture*, vol. 10, Philadelphia, 1893–95.

WASHINGTON 1992. Mary Crawford Volk, with an essay by Warren Adelson and Elizabeth Oustinoff, *John Singer Sargent's 'El Jaleo'*, National Gallery of Art, Washington, D.C., 1992 (exhibition catalogue).

WEBER AND GERDTS 1987. Bruce Weber and William H. Gerdts, *In Nature's Ways: American Landscape Painting of the Late Nineteenth Century*, West Palm Beach, Florida, 1987.

WEINBERG 1980. H. Barbara Weinberg, 'John Singer Sargent. Reputation Redivivus', *Arts Magazine*, vol. 54 (March 1980), pp. 104–9.

WEINBERG 1991. H. Barbara Weinberg, *The Lure of Paris: Nineteenth-Century American Painters and Their French Teachers*, New York and London, 1991.

WEINBERG *ET AL.* 1994. H. Barbara Weinberg, Doreen Bolger, David Park Curry, with the assistance of N. Mishoe Brennecke, *American Impressionism and Realism: The Painting of Modern Life, 1885–1915*, The Metropolitan Museum of Art, New York, 1994 (exhibition catalogue).

WEINBERG AND HERDRICH, *ANTIQUES*, 2000. H. Barbara Weinberg and Stephanie L. Herdrich, 'The Ormond Gift and The Metropolitan Museum's Sargents', *The Magazine Antiques*, vol. 157, no. 1 (January 2000), pp. 228–33.

WEINBERG AND HERDRICH, *MMA BULLETIN*, 2000. H. Barbara Weinberg and Stephanie L. Herdrich, 'John Singer Sargent in The Metropolitan Museum of Art', *The Metropolitan Museum of Art Bulletin*, vol. 67, no. 4 (Spring 2000).

WEIR YOUNG 1960. Dorothy Weir Young, *The Life & Letters of J. Alden Weir*, New Haven and London, 1960.

WILLIAMSTOWN 1972. *List of Paintings in the Sterling and Francine Clark Art Institute*, Williamstown, Massachusetts, 1972.

WILLIAMSTOWN 1984. *List of Paintings in the Sterling and Francine Clark Art Institute*, Williamstown, Massachusetts, 1984.

WILLIAMSTOWN 1992. *List of Paintings in the Sterling and Francine Clark Art Institute*, Williamstown, Massachusetts, 1992.

WOOD 1909. T. Martin Wood, *Sargent*, Masterpieces in Colour series, London, 1909.

WORCESTER C. 1927. *Catalogue of Paintings in the Collection of Governor Alvan T. Fuller*, Worcester Art Museum, Massachusetts, c. 1927 (exhibition catalogue).

YOUNG *ET AL.* 1980. Andrew McLaren Young, Margaret F. MacDonald and Robin Spencer, with the assistance of Hamish Miles, *The Paintings of James McNeill Whistler*, 2 vols., New Haven and London, 1980.

ZORZI 1989. Rosella Mamoli Zorzi, *Robert Browning a Venezia*, Fondazione Scientifica Querini Stampalia, Venice, 1989 (exhibition catalogue).

ZORZI 1998. Rosella Mamoli Zorzi, *Henry James: Letters from the Palazzo Barbaro*, London, 1998.

INDEX

Grant, Ulysses S., 148 n. 15
Grantley, 4th Baron. *See* Norton, Brinsley
Greenough, Gordon, 309
Greentree Foundation, 340
Gregorovius, Ferdinand, *L'Isola di Capri—Un idillio Mediterraneo* (1856), 137
Griffiths, Arthur, 316
Griswold, Marian Alley. *See* Van Rensselaer, Mrs Schuyler
Gudge, Elizabeth (Mrs John Francis Hyde, *née* Meeson), 149 n. 23
Guillaume, Paul, 374, 375
Guillet, Marie. *See* Cazin, Marie

H

Haanen, Carl (Cecil) van, 26, 50, 308, 313, 315, 317
 Venetian Bead Stringers, 50, 313, *314,* 343
Hackert, Jakob Philipp, 148 n. 5
 Il Monte Solaro nell'isola di Capri, 137
Halff, Marie and Hugh, Jr, collection of, 341, 347
Hallay-Coëtquen, Marquis du, 71
Hall of Art Gallery, New York, 338, 339
Hals, Frans, 14, 21, 22, 28 n. 12, 49, 199–201, 261, 307
 The Banquet of the Officers of the St George Civic Guard, 200, 216, *216,* 217
 Officers and Sergeants of the St Hadrian Civic Guard, 200
 The Regentesses of the Old Men's Almshouse, 199, *199,* 218, *218,* 219
 Regents of the Old Men's Almshouse, 219
Harding, John T., 100
Harding, Mrs John T. (*née* Lucia Byrne), 100
Hardy, Thomas and Emma, 336
Harker, Oswald Allen, 362
Harriman, Averill, 178
Harriman, Pamela (Mrs Averill Harriman; previously Mrs Randolph Churchill and Mrs Leland Hayward; *née* Digby), 178
Harrison, Lawrence ('Peter'), 251
Harrison, Mrs Lawrence. *See* Strettell, Alma
Harrison, Mrs Robert, 362 n. 1
Hart, Benjamin, 187 n. 2
Haseltine, William Stanley, 138
 Natural Arch at Capri, 148 n. 10
 The Sea from Capri, 148 n. 10
Hassam, Childe, *Columbus Avenue, Rainy Day,* 182, *182*
Haussmann, Baron George, 181
Hawthorne, Charles Webster, *Girl and Peaches,* 325
Hawtrey, Miss, 359
Hayward, Leland, 178
Hearn, George A., 51
Heath, Rt Hon Sir Edward, 68
Hébert, Ernest, 145
Heliotype Printing Co., New York, 268
Helleu, Paul César, 12–13, 166, 200, 257, 309, 327, 352
Hellman, Frederick J., 157
Hellman, George S., 36
Henner, Jean-Jacques, 60, 274
Henschel, Charles, 176
Henschel, Sir George, 29 n. 43, 184, 191
Heredia, José María de, 27
Herrick, Katharine. *See* Metcalf, Mrs Houghton
Heseltine, Arthur, 28 n. 9
Heseltine, John Postle, 148, 149 n. 69
Hevrdejs Collection, Houston, 44
Heyneman, Miss, 201

Hills, Stephen Parker, 12, 67
Hinckley, Robert C., 12, 31, 67, 227, 233 n. 25
Hirago, Mr, 338
Hirsch, Auguste Alexandre, 14, 26, 40, 42, 44, 63, 77, 86, 90, 93, 96, 100, 102, 121, 138, 141, 148 n. 11, 157, 178, 297, 338, 387
 JSS's paintings owned by. *See* appendix I, 387
 Le retour es hadjiis, 387
Hirsch, Mme Auguste Alexandre, 40, 44, 77, 90, 93, 96, 100, 297, 387
Hirshhorn Museum of Art, Washington, D.C., 243
Hispanic Society of America, New York, 209, 250, 251
Hitchcock, George, 14, 200
Hittorff, Jacques-Ignace, 189
Hogg, Miss Ima, 46
Holbein, Hans, *Henry VIII,* 37
Holland, Moorhead B., 127
Holsteyn, Pieter, 74
Hooch, Pieter de, 307
Hood Museum of Art, Dartmouth College, Hanover, N.H., 76, 220
Hoppner, John, 161
Hôtel Drouot, Paris, 325, 352, 353
Houssaye, Arsène, 163
Houssaye, Henry, 273
Howard-Vyse, Mrs L., 286 n. 5, 303 n. 2
 A Winter in Tangier and Home Through Spain (1882), 294
Howells, William Dean
 Italian Journey (1867), 147
 Venetian Life (1883), 324
Hulton, Constanza (*née* Marini), 311, 336
Hulton, William, 311, 336
Hunt, Reginald Sidney, 53, 348
Hunt, Richard Morris, 113
Hunt, William Henry Thurlow, 138
 A Sunny Afternoon, Capri, 138, *139*
Huntington, Archer M., 199, 209, 251
Huysmans, J.-K., 274
Hyde, Frank, 13, 26, 139–40, 141, 143–44, 146, 148, 149 n. 23, 164, 166, 168, 169
 Capri Coast Scene with Figures, 149 n. 23
 caricature by, *142*
 A Pergola, Capri, 140
 Roses and Lilies, Capri, 140
Hyde, Captain John Francis, 149 n. 23

I

Ibsen, Henrik, *A Doll's House* (1879), 145
Irving, Washington, *Alhambra* (1832), 228
Isabella Stewart Gardner Museum, Boston, 249, 265, 305
Isembart, E., 177
Ismay, Sir Hastings (later Lord Ismay of Wormington), 297
Ismay, Laura (*née* Clegg), 297

J

Jackson, Mary Catherine, 286 n. 5
Jacomb-Hood, George Percy, 169
Jagger, Cedric, 261, 383
Jagger, Charles Sargeant, 200, 261, 318, 383
Jagger, Mrs, 261, 383
James, David, 327
James, Henry, 146, 227, 303, 307, 315, 319–20, 321, 352, 357 n. 1
James, William, 311
James, William (Henry James's nephew), 200

Jay, Gussie, 116
Jefferson, Henry Wyndham, 93
Jefferson, Mrs H. W. (possibly Mrs Henry Wyndham Jefferson), 93
Jefferson, Thomas, 274
Jeklin, Andreas, 177
Jenkins, J. Elias, 115
Jenkins, Mrs J. Elias (*née* Mary Otis), 115
Jerichau, Holger Hvitfeld, 138
John, Augustus, 67, 166, 327, 361
John Levy Gallery, New York, 127
Johnson, John G., 185, 187
Johnston, Mrs C. D. Howard, 12
Juan de Colonia, 233 n. 20
Juan of Austria, Don, 213, *213*
Juley, Peter A., 31, *32, 44, 191*
Jungheim, Carl, 138

K

Ker, Gervase, 310, *310,* 323 n. 49, 361
Ker, Olga, 310
Knight, Laura, 67
Knoedler, Charles, 90
Knoedler, M., & Co., London, 40, 44, 77, 90, 93, 96, 100, 195, 209, 211, 251, 276, 330, 332, 362, 365, 387
Knoedler, M., & Co., New York, 44, 51, 67, 90, 93, 115, 151, 161, 176, 187, 191, 195, 211, 292, 294, 295, 303, 330, 332, 374, 375
Kopisch, August, 137, 140
 La Scoperta della Grotta Azzurra (1838), 137
Korda, Alexander, 153
Kreutzberger, C., print after Velázquez, *Aesop,* 212
Kyhn, Wilhelm, 138

L

Laborde, Alexandre, *Voyage Pittoresque et Historique* (1806–20), 228
La Carmencita (Spanish dancer), 230
Lachaise, Armand, 59, 162
Lachaise, Eugène, 26, 59, 83, 85, 162
Lacombe, Georges(?), 26, 38
Lacombe de Presles, Camille, 38
Lahaye, Alexis Marie, 14, 29 n. 43
Lamartine, Alphonse de, 281
 Graziella (1849), 145
Lamb, Henry, 67
Lami, Eugène, 71
Lamoureux, George, 258 n. 1
Lanchester, Elsa, 153
Landon, Dr and Mrs Henry, III, collection of, 365
Lansing, Dr Cornelius, collection of, 130
Latimer, Ralph, 336
Laughton, Charles, 153
Laurens, J. Paul, 352
Laurent, Édouard Henry, 181
Laurent, J., 226
Lavalle, Mrs John, 375 n. 1
Lawless, the Hon Frederick (later 5th and last Baron Cloncurry), 26, 310, 322 n. 19, 343 and n. 1
 From the P & O Buoy, 343
 Sunset over the Giudecca, 343
Lawless, Valentine, 343 n. 1
Layard, Sir Henry Austen, 311
Layard, Lady (*née* Mary Enid Evelyn Guest), 311
Laycock, Captain (later General Sir) Joseph Frederick, 77

INDEX OF WORKS

PHOTOGRAPHIC ACKNOWLEDGEMENTS

In most cases, the illustrations have been made from the photographs or transparencies provided by the owners or by the custodians of their works. Those for which further credit is due are the following:

Howard Agriesti, 669; Ali Elai, Camerarts, New York, 634, 663, 664, 683; Art Resource, New York, figs. 116, 117, 118; Ritva Bäckman, fig. 98; J. G. Berizzi, Réunion des Musées Nationaux/Art Resource, New York, fig. 121; David Bohl, 762; Steve Briggs, 815; Catalogue raisonné archive, 640, 647, 680, 681; figs. 1, 63, 89, 109; Christie's Images, New York, 744, 784, fig. 34; Debra Force Fine Art, New York, fig. 21; Piero Dini, Montecatini Terme, figs. 80, 94; Foto Brogi, figs. 65, 67; Foto Cerio, fig. 87; Foto Guido, fig. 85; Foto Lovatti, fig. 91; Foto Marburg/Art Resource, New York, fig. 120; Foto Summer, figs. 68, 86; Guggenheim/Asher Associates, New York, 717; Hannu Karjalainen, 697; Peter Harboldt, 798; Katya Kallsen, 774, 782; Kennedy Galleries, New York, 826; Knoedler Gallery, New York, 624, 659, 672, 836; fig. 17; Laurent-Sully Jaulmes, fig. 24; Allan MacIntyre, figs. 61, 144; Hugo Maertens, fig. 178; Mark Murray Fine Paintings, New York, fig. 66; David Matthews, fig. 11; Tim McAfee, 639; Melville McLean, 678, 828; Richard L. Ormond, fig. 138; Elizabeth Oustinoff, fig. 89; Prudence Cuming Associates, Ltd, London/Courtesy Adelson Galleries, New York, 682, 685, 687, 689, 691, 693, 696, 701, 713, 727, 730, 752, 756, 758, 819, 820, 831, fig. 92; Pym's Gallery, London, 637; Quesada/Burke Photography, New York, 641, 650, 660, 695, 700, 748, 783, 788, 797, 821, 824, 827, fig. 207; Réunion des Musées Nationaux/ArtResource, New York, fig. 23; © Fulvio Roiter, Venezia, fig. 93; The Royal Collection © 2005, Her Majesty Queen Elizabeth 11, fig. 7; Scala/Art Resource, New York, figs. 114, 115; Sotheby's, New York, 698, 719, 770, 802, 830, figs. 77, 81; Rick Stafford, fig. 180; John Bigelow Taylor, N.Y.C., 658, 796; Thomas Powel Photography/Courtesy Adelson Galleries, New York, 632, 635, 627, 649, 651, 665, 666, 668, 703, 704, 707, 708, 709, 712, 716, 720, 729, 736, 739, 740, 749, 753, 765, 767, 768, 786, 790, 809, 813, 829, 834, figs. 14, 15, 16, 78, 79, 95; John Webb, fig. 9.